The Italian American Heritage

Garland Reference Library of the Humanities
Volume 1473

THE ITALIAN AMERICAN HERITAGE

A Companion to Literature and Arts

GEORGE J. LEONARD
Editor-in-Chief

PELLEGRINO D'ACIERNO
Volume Editor

DIANE ROSENBLUM
Editor

ROBERT LEONARD
Editor

AMY FELDMAN
Editor

CHRISTINE OWENS
Associate Editor

THE ITALIAN AMERICAN HERITAGE

A Companion to Literature and Arts

PELLEGRINO D'ACIERNO
Editor

GARLAND PUBLISHING, INC.
A member of the Taylor & Francis Group
New York & London
1999

DEDICATION

To Charles Calitri, novelist, author of *Father*
and to Edwin Shapiro, humanitarian

—George J. Leonard

DEDICATION

In memory of my father, Pellegrino A. D'Acierno, M.D., F.A.C.S., physician to the Italian American community and one of its first poets.

Chè ogni forza di vita è nel pensiero,
Che mena ad opre franche e generose,
E attinge sua virtù sempre dal vero.

For all power of life lies on the will
To accomplish deeds right, noble and free,
Never departing once from the truth's course.

—Pellegrino A. D'Acierno, from "Sursum Corda" (1912)

And in deep gratitude to the genealogy of "Donne che [hanno] l'intelletto d'amore": Anna, Carla, Lisa, and Fosca. And now also in memory of Anna (1918–1996), *mater dulcissima* and madonna of the loophole, whose countenance appears throughout the tradition of Italian painters of maternity from Perugino to Joseph Stella.

For Thomas Belmonte (1946–1995), shape-changer, who like Vertumnus, dancer of walls, loved the things Pomona loved and who, after lifting the last disguise, revealed the radiance that became what Pomona loved;

For Tommaso, ethnographer of Naples and serene guide through the drunkenness of its labyrinth, who, upon exiting the broken world, smiled back at the crippled boy, Ribera's double, and conferred a valediction to labyrinths: "Be grateful for what is offered. Go lighthearted into Paradise";

For Tom, lover of wisdom and trickster, always already remembered in Diotima's emblem of Love, always already remembered in Cavafy's words: "Remember, body, how they trembled for you in those voices."

—Pellegrino D'Acierno

Copyright ©1999 George J. Leonard
All rights reserved

Library of Congress Cataloging-in-Publication Data

The Italian American heritage : a companion to literature and arts / Pellegrino D'Acierno, editor.
 p. cm. — (Garland reference library of the humanities ; vol. 1473)
 Includes bibliographical references and index.
 ISBN 0-8153-0380-7 (alk. paper)
 1. Italian Americans—Intellectual life. 2. Italian Americans—Social life and customs.
 3. American literature—Italian American authors—History and criticism. 4. Italian Americans in literature. 5. Italian American arts. I. D'Acierno, Pellegrino, 1943– .
II. Series.
E184.I8I675 1998
305.851073-dc21 98-7963
 CIP

Printed on acid-free, 250-year-life paper
Manufactured in the United States of America

Contents

xiii Acknowledgments
ix Contributors
xv Preface
 Making a Point of It
 George J. Leonard

xxiii Introduction
 The Making of the Italian American Cultural Identity:
 From *La Cultura Negata* to Strong Ethnicity
 Pellegrino D'Acierno

Part I. Identity

3 The Contradictions of Italian American Identity:
 An Anthropologist's Personal View
 Thomas Belmonte

21 The Genealogy of Ice
 Frank Lentricchia

41 Italian Catholic in My Bones: A Conversation with
 Camille Paglia
 Thomas J. Ferraro

61 On Being an Italian American Woman
 Mary Jo Bona

69 Italian Americans, Today's Immigrants, Multiculturalism, and the Mark of Cain
Richard Gambino

75 An Italian Journey: A Photographic Essay
Liana Miuccio

Part II. Roots, Traditions, and the Italian American Life-World

85 The Italian American Traditional Life Cycle
Frances M. Malpezzi and William M. Clements

109 Bread and Wine in Italian American Folk Culture
Frances M. Malpezzi and William M. Clements

115 Italian American *Feste*
Frances M. Malpezzi and William M. Clements

121 Il Caso della Casa: Stories of Houses in Italian America
Robert Viscusi

131 Stories and Storytelling, Italian and Italian American: A Storyteller's View
Gioia Timpanelli

Part III. Writing As an Italian American

151 Italian American Literary History from the Discovery of America
Robert Viscusi

165 Italian American Novelists
Fred L. Gardaphe

193 Italian American Women Writers
Helen Barolini

266 Italian American Poets: A Chronological Survey
Stephen Sartarelli

289 The Evolution of Italian American Autobiography
Fred L. Gardaphe

322	The Italian American Coming-of-Age Novel Mary Jo Bona

PART IV. THE ITALIAN AMERICAN PRESENCE IN THE ARTS

331	Catholic Ethnicity and Modern American Arts Thomas J. Ferraro
353	Sacraments: Italian American Theatrical Culture and the Dramatization of Everyday Life Jo Ann Tedesco
387	Italian American Musical Culture and Its Contribution to American Music Robert Connolly and Pellegrino D'Acierno
491	Madonna: The Postmodern Diva As Maculate Conception Fosca D'Acierno
499	From Stella to Stella: Italian American Visual Culture and Its Contribution to the Arts in America Pellegrino D'Acierno
553	The Italian American Culture of Scenes: Everyday Life As Spectacle—a Visual Essay Pellegrino D'Acierno
563	Cinema Paradiso: The Italian American Presence in American Cinema Pellegrino D'Acierno
691	Appendix I The Italian American Experience, 1492–1998 Compiled by Stanislao G. Pugliese
703	Appendix II Cultural Lexicon: Italian American Key Terms Compiled by Pellegrino D'Acierno
767	Index

Acknowledgments

On behalf of our contributors and myself, I want to thank George J. Leonard, *amico per la pelle* and a writer's editor par excellence, for providing us with this forum, for inspiring our work with his inclusive—Whitmanesque—vision of ethnicity, and for his enlightened and liberating view of what constitutes the writing of ethnicity.

I wish to acknowledge the generous contributions of two patrons who have made possible the visual dimension of this volume: Eva Fasanella for her gracious permission to use three of her late-husband Ralph Fasanella's paintings to adorn this volume; and Carla Margulies D'Acierno for her largesse in subventing the costs of illustrating *The Italian American Heritage*, a gesture with which she wishes to honor the memory of her mother:

> In memoriam Loretta Jill Margulies (1908–1994),
> mother and artist of the Italian American quotidian

—Pellegrino D'Acierno

Contributors

HELEN BAROLINI started her exploration of the Italian American experience when she received a National Endowment for the Arts grant that enabled her to write the transgenerational and transcultural novel *Umbertina* (1979). She is the author of three other novels, and her nonfiction books include *The Dream Book: An Anthology of Writings by Italian American Women* (1985), for which she won an American Book Award and the Susan Koppelman Award for the best anthology in the feminist study of American culture. Her short fiction and essays have appeared in many publications and also in collections. Barolini has translated several books from Italian and taught in Italy; in 1991 she was invited writer in residence at the Rockefeller Foundation's Bellagio Center on Lake Como in Italy. *Chiaroscuro: Essays of Identity*, a collection of her critical writings on ethnicity and Italian Americanness, was published by Bordighera in 1997 and will be reissued in revised form by the University of Wisconsin Press in 1999.

THOMAS BELMONTE (1946–1995) received his Ph.D. in anthropology from Columbia University in New York City. He was associate professor of anthropology at Hofstra University in Hempstead, New York. Belmonte was a specialist in mythology and media studies as well as urban anthropology and the ethnology of Mediterranean societies. His ethnographic study of the underclass of Naples, *The Broken Fountain* (second expanded edition, 1989) was named a Centennial Classic by its publisher, Columbia University Press. His long essay, "The Trickster and the Sacred Clown: Revealing the Logic of the Unspeakable," was published in *C.G. Jung and the Humanities: Toward a Hermeneutics of Culture* (1990).

MARY JO BONA teaches American literature at Gonzaga University in Spokane, Washington. Her anthology, *The Voices We Carry: Recent Italian/American Women's Fiction* (1993) is published by Guernica Press. She has written articles on Italian American women's narratives for the journals *MELUS: Multiethnic Literature of the*

United States and *Voices in Italian Americana: A Literary and Cultural Review.* She is working on a critical study of the Italian American women's literary tradition.

ROBERT CONNOLLY is the former curator of the Paterno Library of the Casa Italiana, the Italian cultural center of Columbia University in New York City. He has taught at Hofstra University in Hempstead, New York, Queens College, the American Studies Center in Naples, and the English Institute in Naples and is a regular contributor to *Film Comment, Opera News, Stereo Review,* and *The British Opera.* Among his translations from the Italian are *Female Film Stars of the Third Reich* (1991) by Cinzia Romani (Sarpedon Publishers) and the version of I. Tarchetti's novella *Fosca* (unpublished) upon which Stephen Sondheim based his musical drama *Passion.* New York opera buffs are familiar with his voice from the insightful analyses of Italian opera he presents as a regular guest on Stephen Zucker's weekly radio program *Opera Fanatic.*

FOSCA D'ACIERNO is a Ph.D. candidate and Kenyon Fellow in the Italian Studies Department at Brown University in Providence, Rhode Island. Her research interests include cinema theory, cultural criticism, and feminist and gender studies; *La Fusta* (Spring 1994) has recently published her essay, "Empty Desires: The Problem of Women in the Films of Antonioni." She resides in Florence, where she is researching and writing her thesis, *The Nights of Cabiria: The Representation of Women in Italian Cinema from Neo-Realism to the Present.* Formally trained in opera, she sings blues, jazz, and alternative music professionally in Italy.

PELLEGRINO D'ACIERNO is professor of comparative literature and the director of the program in Italian studies at Hofstra University in Hempstead, New York. He has taught a wide range of courses in comparative literature, Italianistica, critical theory, cinema, and intellectual history at Columbia, Cornell, and New York Universities, and the Southern California Institute of Architecture in Los Angeles, where he has served as visiting critic since 1991. Among his publications are the following: *F.T. Marinetti* (1989); the English translation of Manfredo Tafuri's *The Sphere and the Labyrinth* (1987) with Robert Connolly; *C.G. Jung and the Humanities: Toward a Hermeneutics of Culture* (coeditor, 1990); *The Itinerary of the Sign: Scenes of Seeing in Giotto's Frescoes in the Scrovegni Chapel* (1995); and *Strange Hoops: Architecture and Cinema As Spatial–Temporal Practices* (forthcoming). The American Academy in Rome awarded him the Rome Prize in Postclassical Humanistic Studies in 1988–1989, and the John Simon Guggenheim Memorial Foundation appointed him a Guggenheim Fellow for 1995.

THOMAS J. FERRARO, who formerly taught at the University of Geneva, Switzerland, is Associate Professor of English at Duke University in Durham, North Caro-

lina. He is the author of *Ethnic Passages: Literary Immigrants in Twentieth-Century America* (1993), "Ethnicity and the Literary Marketplace" in the *Columbia History of the American Novel*, as well as diverse essays on U.S. literature and film published here and abroad. He edited a special issue of *SAQ* (Summer 1994) titled "Catholic Lives/ Contemporary America," which, in 1997, was published, in expanded form, as a book by Duke University Press.

RICHARD GAMBINO is visiting professor of Italian American Studies at the State University of New York at Stony Brook. He is on leave from Queens College in New York City, where he founded a program in Italian American studies in 1973. His primary work, *Blood of My Blood: The Dilemma of the Italian-Americans* (1974), is a definitive study of the Italian American experience and one of the central texts in the founding of a discourse upon the Italian Americans. Among his other publications are *Vendetta* (1977), *Racing with Catastrophe* (1990), and the novel *Bread and Roses* (1981).

FRED L. GARDAPHE is professor of English at Columbia College in Chicago. He is associate editor of *Fra Noi*, Chicago's Italian American newspaper; editor of *New Chicago Stories* (1990) and *Italian American Ways* (1989); and co-contributing editor of *From the Margin: Writings in Italian America* (1991). Gardaphe is also cofounder and review editor of *Voices in Italian Americana: A Literary and Cultural Review*. He has written extensively on Italian American culture, criticism, and representation of ethnicity in twentieth-century literature. His book-length study, *Italian Signs, American Streets: The Evolution of Italian American Narrative* was published by Duke University Press in 1996.

FRANK LENTRICCHIA is Katherine Everett Gilbert Professor of Literature at Duke University in Durham, North Carolina. He is the author of *After the New Criticism* (1980), a magisterial history of, and landmark in, contemporary American literary-critical theory. Among his other works are: *The Gaiety of Language* (1968); *Robert Frost: Modern Poetics and the Landscapes of Self* (1975); *Criticism and Social Change* (1983); and *Ariel and the Police: Michel Foucault, William James, Wallace Stevens* (1988); and *Critical Terms for Literary Study* (coeditor, 1990). Two other works of his, *New Essays on White Noise* (1991) and *Introducing Don DeLillo* (1991) are dedicated to the novelist Don DeLillo. In addition to his impressive body of literary criticism, which has placed him at the center of contemporary critical debate, he has written an autobiographical "confession," *The Edge of Night* (1994) and two paired works of fiction, *Johnny Critelli* and *The Knifemen* (1996).

FRANCES M. MALPEZZI, professor of English at Arkansas State University, and WILLIAM M. CLEMENTS, professor of English and folklore at Arkansas State, are

the coauthors of *Italian-American Folklore* (1992), published by August House. Based on interviews, journals, and other primary sources as well as on the scholarly literature on the Italian American experience, the volume is a groundbreaking work in Italian American ethnography that provides an overview of Italian American folk culture that is at once generic and attuned to the differences stemming from regional distinctions. Malpezzi and Clements, who are married, document the entire panoply of Italian American cultural expression: language, particularly proverbs; customs; folk supernaturalism; folk medicine; recreation and games; the performative genres; and foodways. The journalist Gay Talese has described their work as "a major contribution to the understanding of Italian character in America."

LIANA MIUCCIO, a Manhattan-based professional photographer, has won numerous international photography awards, including, in 1997, the Yann Geffroy International competition for photographers under the age of 35. Her photographs have been featured in publications such as the *New York Times*, the *Village Voice*, and *Newsday* and in Italian publications including *L'Espresso* and *La Repubblica delle Donne*. Her photographic essay presented in this volume reproduces ten images from *An Italian Journey*, an exhibition first displayed at the Ellis Island Immigration Museum in the summer of 1997. The traveling exhibit has also been displayed at Villa Trabia in Palermo, Sicily, the Museo Italo-Americano in San Francisco, and the University of Pennsylvania's Museum of Archaeology and Anthropology. *An Italian Journey* has received international recognition. The reviewer Reid Frazier writes: "The photographs piece together a matrix of signs that constitute the photographer's Italian identity. The hand gestures and facial expressions, food preparation and religious ceremonies she captures make up the jigsaw of what she thinks of as *Italian*. In essence, we watch the photographer construct her Italian identity right before our eyes. Miuccio pulls it off because her photographs are filled with absolute love and genuine curiosity about her subjects." Miuccio has a Bachelor of Arts from McGill University in Montreal, Canada, and has studied at the International Center of Photography in New York City, where she assists in teaching. She is in the process of transforming *An Italian Journey* into book form.

CAMILLE PAGLIA is one of America's foremost and most original (and outspoken) cultural critics. Professor of humanities at the University of the Arts, Philadelphia, she is one of the few contemporary university-based intellectuals who have name and face recognition outside the academy. Paglia's chief work is *Sexual Personae: Art and Decadence from Nefertiti to Emily Dickinson* (1990), a far-ranging interdisciplinary history of Western culture from antiquity to the late nineteenth century in which she applies the Nietzschean categories of Apollonian and

Dionysian to practical criticism and elaborates a comprehensive theory and genealogy of Western modes of personality concerned with the textual and extratextual play of erotic, artistic, and theatrical personae. The great breadth of her interests and her specific attempt to hybridize academic and popular culture in her criticism are evidenced by her two recent collections of essays: *Sex, Art, and American Culture: Essays* (1992) and *Vamps & Tramps: New Essays* (1994).

STANISLAO G. PUGLIESE completed his doctoral dissertation, "Carlo Rosselli: Socialist Heretic and Antifascist Exile," at the City University of New York (CUNY) in 1995. Trained in modern European history, he has focused his work on the intellectual and cultural life of Italy in the twentieth century. He has studied at the University of Florence and has taught at City College of New York and Hunter College, both in New York City. Since 1995, he has served as assistant professor of history at Hofstra University, Hempstead, New York.

STEPHEN SARTARELLI, poet and translator, is the author of *Grievances and Other Poems* (1989) and has translated widely from Italian and French, winning the PEN-Renato Poggioli Award for translation from the Italian in 1984. His poems have appeared in such journals as *New Directions, New Criterion, American Letters and Community,* and *Talisman* and have been translated into Italian, French, Spanish, and Russian. He is also coeditor of the literary review *Alea* (New York).

JO ANN TEDESCO is a New York City playwright, actress, and director. Born in Syracuse, New York, she began her theater experience at the Boar's Head Children's Theater of Syracuse University at the age of seven and has continued unabated. After completing her undergraduate work at a small Jesuit college in upstate New York and then working in regional theaters and local television shows, she made her way to New York City, where she acted in commercials and in numerous Off and Off-Off Broadway productions. She went on to establish and run two Off-Off Broadway theaters that produced a number of successful plays. Her first full-length play, *Sacraments: A Not-So-Divine Human Comedy,* was performed in New York City at both the Public Theater and the HB Playwrights Foundation in 1984. She has described *Sacraments* as both a memory play and a rite-of-passage play that traces the coming of age of a precocious Italian American girl during the 1940s and 1950s against the backdrop of the two major influences in her life, her family and her church. In 1980 three of her one-act plays, *On the Rocks, Interesting,* and *Tit for Tat,* were performed Off-Off Broadway. She is developing a play about Eleanora Duse and Sarah Bernhardt, *Of Penguins and Peacocks,* with Lilliane Montevecchi and Taina Elg under the direction of Tom O'Horgan. Another play, *Perfidia,* was staged at the California State Theater, Sacramento in 1995.

CONTRIBUTORS

GIOIA TIMPANELLI, hailed as "the dean of American storytellers," is one of the master practitioners of the art of storytelling of her generation. As the last of the *cantastorie* and the first of the new storytellers, she has served as the unique depository of the repertoire of Italian and Sicilian stories and the relay through which the oral tradition has been passed to Italian America and introduced to the American common culture. In 1987 she won the Woman's National Book Association Award for bringing the oral tradition to the American public. She has complemented her work as professional storyteller by creating, writing, producing, and broadcasting her program for educational television. Her series *Stories from My House* (1970–1971) received two Emmy Awards. She is the author of *Stones for the Hours of the Night: Nuraghe Sardinia* (1975), a collection of poems accompanied by photographs; *Tales from the Roof of the World: Folktales of Tibet* (1984); *Travel Images and Observations: An Italian Travel-Diary* (drawings by Fulvio Testa, travel notes by Gioia Timpanelli, 1987); and *Sometimes the Soul: Two Novellas of Sicily* (1998), inspired by Sicilian folktales.

ROBERT VISCUSI, professor of English and executive officer of the Ethyle R. Wolfe Institute for the Humanities at Brooklyn College at the City University of New York, is also chair of the CUNY Italian Studies Advisory Council and president of the Italian American Writers Association. He has held grants from the National Endowment for the Humanities, the Professional Staff Congress of the City University of New York, and the John D. Calandra Italian American Institute of the City University. A member of the advisory boards of such journals as *Italian Americana*, *Voices in Italian Americana: A Literary and Cultural Review*, and *Italian Journal*, Viscusi is well known for his essays and studies of Italian American literature, Anglo-Italian literary relations, and questions of literary theory, which have appeared in many leading journals in the United States and in Europe. He has published, among other books, the long poem *An Oration upon the Most Recent Death of Christopher Columbus* (1993), which has been praised as the "definitive epic" on Columbus (Daniela Gioseffi) and as "an Italian American *Howl*" (Fred L. Gardaphe). His novel *Astoria*, published in 1995 by Guernica Editions, Montreal, dismantles the French Revolution and the Italian migration to the United States in order to reconstruct them as versions of each other.

Preface
Making a Point of It

GEORGE J. LEONARD

As the articles for this volume were forwarded to me, the non-Italian editor-in-chief, by this volume's editor, Pellegrino D'Acierno, Professor of Comparative Literature and Director of the Program in Italian Studies, Hofstra University, I began to see something take shape greater than our original plans. Professor D'Acierno had assembled a Who's Who of Italian American humanistic scholarship. Over the course of seven years, those contributors had slowly created a joint statement of unprecedented scale, in which we all rose to consciousness of a special moment in American cultural history: the Italian American Renaissance, one might call it. By the 1970s, Italian American men were pouring out of the nation's universities, graduate schools, law schools, medical schools, soon to be followed by Italian American women. (See Helen Barolini's article, p. 193.) By the 1980s, people with names like Ferraro and Cuomo were, respectively, the first woman candidate for Vice President from a major political party, and the front-runner for the presidential nomination. This was remarked on as something that had been unthinkable even twenty years earlier. But simultaneously—and this is just as a for instance—if American film had once been, as Neil Gabler has argued, piloted by Jewish studio chiefs, by the late 1970s, Hollywood was dominated by Scorcese, Coppola, De Niro, Travolta, Stallone, De Palma (and lately, Tarantino). Italian Americans similarly redefined other arts (like Madonna and Bruce Springsteen in rock music, Sinatra in pop music, Robert Venturi in postmodern architecture). What's more, from Madonna's erotic Mediterranean Catholicism to Springsteen's New Jersey drag-racer chic to Venturi's appeal that we "learn from Las Vegas," the most Sinatra-esque cityscape in the country, there seemed a strong *ethnic* component to their art.

Not until this volume's articles were massed together did anyone, even the authors, become aware of the extent of this phenomenon. An odd silence had

masked the event. During the Italian ascent, "multiculturalism" was unfashionable (it is highly controversial even now). Italians did not publicize what this book shows were important debts to what would have then been considered a "foreign" tradition. Take Frank Sinatra's account of his personal breakthrough on p. 423: "It occurred to me that maybe the world didn't need another Crosby. What I finally hit upon was the *bel canto* Italian school of singing, without making a point of it." Here we see Sinatra acknowledging he found his style by drawing on his ethnic tradition, *and* we see in the words he instantly adds—"without making a point of it"—how cautious even the ultraconfident Sinatra could be about that. Pellegrino D'Acierno confronts this very typical anxiety at length in his essay on "La Cultura Negata"—the "denied culture." One may have succeeded by drawing deeply on some part of one's Italian-ness—on being the boy from Jersey or the girl from Brooklyn, by loving Las Vegas and its arias of architecture—but one did so quietly, "without making a point of it." This book then, *makes a point of it*: uncovering those great debts without which one cannot fully understand these artists *or* their art, dealing with their denial, with "la cultura negata."

The Multicultural Curriculum: An Historic Moment in American Education

Pellegrino D'Acierno will specifically introduce this volume in the essay following this one. Let me, then, talk about the larger picture: the new American multicultural curriculum, one of the greatest challenges American education has ever faced. In the next few years reference librarians will be besieged by people seeking answers to new questions—besieged not only by students in the new multicultural courses but by instructors attempting to teach multiculturalism for the first time.

Why are the gangsters in Martin Scorcese's *GoodFellas* entirely different from the poetic gangsters in Francis Ford Coppola's equally classic *Godfather* trilogy? What exactly *does* "godfather" (*"compari"*) mean in Italian American culture? How is a student to learn? Turn, in this book, to Pellegrino D'Acierno's explication of the *Godfather*'s first scene (pp. 575–576). Puzo, Coppola, and Brando have packed the scene with significance, with insider references to codes of honor and social hierarchies and taboos. How I wish I'd known all that when I saw the film! But where was it written before now?

Not only the student but also the instructor will be coming to ask the librarian for help. Multiculturalism is so new that few of us were educated to teach it. People who quite likely took their degree in Chaucer or Dickens will be asked to explain a reference to the Festa di San Gennaro.

PREFACE

The "Companion"

If the student reading Madame Bovary is puzzled by a reference to Joan of Arc or to a "viscount," he or she can turn to Sir Paul Harvey's classic *Oxford Companion to French Literature*. But no such help exists for the student facing ethnic American literature and arts. If, in this volume, we had written our 27 articles about 27 different authors, composers, architects, we would have had to include, over and over, the same introductory explanations about *l'ordine della famiglia*, *campanilismo*, wedding *buste*, *onore*, the Mafia, the system of *compartatico* (or *comparaggio*—"godparentage").

Instead, we wrote long articles on *the topics that would unlock for the reader the greatest number of authors and artists now and for years to come*. There are topics such as "On Being an Italian American Woman," "Italian Catholic in my Bones—a Conversation with Camille Paglia," "Italian American Feste," "The Contradictions of Italian American Identity: An Anthropologist's Personal View," "Bread and Wine in Italian American Folk Culture." We have created a series of *tool kits*.

We have, to be sure, articles on the most-taught authors, and in all cases by great experts on them. If we consider Italian American gender roles, we have Frank Lentricchia on being an Italian American man and Camille Paglia on Italian American womanhood. "Italian American Women Writers," is by Helen Barolini, the Dean of that field, and it is 73 pages long. We have Robert Viscusi writing on "Italian American Literary History from the Discovery of America," Fred L. Gardaphe on "Italian American Novelists."

Timeliness, Usefulness

This is a crisis. Not only have we mandated multicultural courses, but even the old courses are being given multicultural additions. A college course on romanticism now, to be modern, will try to include ethnic American authors. The anthologies add them as rapidly as they can.

Across the nation, school administrations and Presidential commissions have been telling teachers "do it" without telling them how they were to do it or even exactly what they were to do. Students, encountering literature and art from each other's ethnic cultures, have needed special help. Yet few people now teaching were educated to give the help needed.

PREFACE

The "Multicultural" Classroom: From Experts Teaching Insiders, to First-Timers Teaching Outsiders

Our book is aimed at a new audience—the new multicultural classroom. This volume supports those students, instructors, and librarians facing this great change in the American canon.

When I first taught ethnic studies, I had to photocopy articles for my classes because there was no reference work to which I could send *my kind of students*. I emphasize "my kind of students." Ethnic studies—itself so new—was being taught, and is still generally taught, by experts teaching insiders. The professors trained in ethnic studies were almost always people from the ethnicity whose works they were teaching. As it turned out, they were usually speaking to classrooms filled with students primarily from the same ethnicity. There was a lot that didn't need to be explained. The artist's *weltanschauung* was partly shared, or at least easily entered. Work, teacher, and class drew from a common store of experiences.

Instead of experts teaching insiders, the new mandated "multicultural" courses, however, will be taught primarily by first-timers teaching outsiders. The majority of professors will be people *outside* the ethnicity whose works they are teaching; speaking to classrooms filled with outsiders like themselves. I found myself in that situation in 1986, when—fresh from working with Los Angeles' Asian American community—I redirected some existing courses toward "multiculturalism."

Furthermore, many ethnic authors shuttle their action back and forth between two locales with which the new teacher will probably be unfamiliar. Think of Puzo's and Coppola's *Godfather* trilogy. Not only will teacher and student find themselves coping with unfamiliar parts of *American* experience, but with Old Country Italian customs and experiences as well. The teacher will discover that the student who, watching the film on TV, permissively ignored everything he did not understand, is in a less forgiving mood when seated in a classroom. If you dare to stand in front of that classroom, you are Supposed To Know, and no one very much cares that you did your doctorate on Hawthorne.

There is serious peril here. John Dewey used to warn that the students are "always learning something" in class, but not necessarily what you wanted. They may be learning "math is boring" or "unlike me, boys do not have to raise their hands to speak." The new multicultural courses, taught by neophytes to outsiders, could wind up teaching them "even the teacher can't figure out these people," "nobody in class could guess why these people do these things," "I can't relate to people like this."

Excellent critical works exist, but they assume the older ethnic studies situation in which experts address insiders. The essays are more often arguments than information. They are not enough help for first-timers bravely trying to teach outsiders.

PREFACE

Humanities Students Have Different Needs

As if all that were not difficult enough, the new multicultural courses are generally taught by exposing students to literature or arts, albeit with reference to the political, sociological, and historical contexts of the works.

There are some reference works, such as the *Harvard Encyclopedia of American Ethnic Groups,* that address the needs of social scientists and historians. For years, however, I looked for reference works organized to help my liberal arts students comprehend ethnic literature and arts.

Books meant to help people reading novels, watching films, or confronting works of art must include *much different information than books meant simply for social scientists.* Indeed, standard reference works can lead the humanities student seriously astray. Imagine a student from another country trying to learn about American Easter from, logically enough, fine books such as the *New Dictionary of Theology* or the *Maryknoll Catholic Dictionary.* "The solemn celebration of Christ's resurrection, which begins on Holy Saturday night and includes the blessing of the paschal candle. . . ." Wouldn't the student conclude that Easter in America was a "solemn" and awesome time? How then to decipher literary references to the Easter Bunny, or Easter bonnets, or kids coloring eggs for Easter baskets, not to mention Irving Berlin's *Easter Parade* (a Jew writing famous songs about *Easter?*). "Solemn celebration of Christ's resurrection" would be—if taken by itself—actually an obstacle to understanding American Easter's music, literature, and films.

I asked our contributors always to remember that humanists needed not only *more information,* but *different information,* than social scientists. Even when the subject matter of the essays overlaps topics in social science references, the content and emphasis will be quite different.

Special Features

Our authors have sought to make this volume as useful as possible by offering help on a variety of levels.

For Students
Each section contains articles that are popularly written and accessible even to high school students.

For Instructors New to Multicultural Studies
Many articles are aimed at the person at the front of the classroom who is trying to teach a multicultural course for the first time—a person who, given America's demographics, is probably not an Italian American.

For Advanced Users

Each section contains articles by unique authorities in their field, articles so original or so definitive that even experts will be grateful to have them.

The articles address women's contributions in detail. They analyze not only books but drama and films, not only painting but cuisine and textile arts. The articles are written in varying genres, for sometimes a first-person memoir can humanize and personalize a cultural custom better than a work of formal scholarship.

Since we assume that this is one of the first books people will be using in what will be a continuing self-education in the new American canon, we encouraged all our authors to add, when appropriate, an annotated Further Reading section at the ends of their articles, or to incorporate such advice clearly within the work. We have also added an appendix providing a detailed chronology detailing useful statistics of the Italian American experience.

Each article makes a special effort to build the user's cultural vocabulary. We encouraged the authors to define as many terms and concepts as possible in their writing. This volume also establishes a lexicon of key terms that informs the Italian American linguistic universe. Alphabetized in a separate Cultural Lexicon, these terms appear in the chapters in bold type.

Notice too that we speak here of arts, plural. Many ethnic cultures, and especially the women in them, practiced arts that were, until recently, dismissed as "crafts."

Daring To Do It

Ethnic studies frequently involve politics, and hot politics at that. It makes for fascinating classes, classes students look forward to, classes in which people who never talk at all suddenly argue points as if their lives depended on it, classes in which silent immigrant newcomers are suddenly turned to as experts and listened to with respect, classes in which friendships form across racial and ethnic bounds. No bones about it, it can be dangerous to teach classes that excite students that much. But people who rely on this volume can lead those classes with confidence.

The first obstacle to multiculturalism is that most of us were not educated to teach it and information has been hard to come by. The second obstacle is that the topic is so politicized, we wonder if we even *dare* teach it, even if we are of the ethnicity we are teaching. When teaching a newer canon means having to undertake a second education, who could blame people for deciding it's just not worth it?

Our book overcomes these obstacles by giving a reference work constructed according to a rigorous methodology. All the authors are not only renowned in their specialties, most are from the ethnic group being written about.

Furthermore, all authors worked with novel and unique freedom. You cannot just *talk* about multiculturalism, you have to *do* multiculturalism. For that reason I declined to impose a "house style" on Dr. D'Acierno and the authors, aside from a few agreements about typography. You cannot create a book celebrating America's many voices and then try to homogenize them—cannot celebrate diversity by pouring their essays into the old prose melting pot.

I do not by any means wish to imply that only scholars from an ethnicity can write about its art. Each perspective has value and validity. However, I do claim that, by having leading scholars of a particular ethnicity *supervise,* we produced a portrait of what *they* think their emerging canon is, and what topics *they* think need to be understood. We have all thereby gained something historically valuable.

I hope the wealth of information in this volume will newly encourage people to break out from the old canon, to dare teach exciting new works, to dare discuss in class the most controversial, and important, topics in America today.

A Personal Note

I confess to a personal agenda. I have a son—half-Jewish, half-Chinese, all-American—and I don't want him, or anyone else's sons or daughters, growing up studying a curriculum that marginalizes or trivializes them. This work, then, has been a labor of love.

Add to this that my first teacher was the Italian American novelist Charles Calitri (*Rickey, Strike Heaven on the Face, Father, The Goliath Head*) and my debt to Italian America may be seen. His father, Antonio Calitri, had left the priesthood to become a famous Italian poet, immigrated, and had, by World War I, become "Il Professore" to a generation of Italian Americans. (See cartoon.) Charles' son, Robin, is the longtime principal of South Side High School, Rockville Centre, Long Island, one of a handful of American public high schools formally accorded "Blue Ribbon" status by the U.S. Department of Education. For a century the Calitris have taught Americans, and I was lucky enough to be one of their students. What better way to honor my debt than to do this book about the culture Antonio, Charles, and Robin Calitri have exemplified and loved?

Perhaps multiculturalism is little more than learning to love. Certainly there is nothing new or radical about it. It is the logical continuation of the Western humanist project. The finest art works, the poet Shelley claimed, have a power no polemic has: they make us human to each other. "The great secret of morals is love," Shelley argued. By enlisting our imagination, art can put us "in the place of another, and many others," so that the "pains and pleasures" of all humankind become "our own" (*A Defence of Poetry,* 1821). This volume will, I hope, help ethnic

PREFACE

artworks "leap the gap" to the wider audience and accomplish that noble goal—long a central goal for the best spirits in Western culture.

George J. Leonard
San Francisco, 1998

"Italian American Literature and Arts, 1913"
A group portrait of the fledgling Italian American cultural community—in 1913, scarcely twenty years old—debating in a restaurant in New York's now vanished "Italian Harlem." Amidst boxes carefully marked "Spaghetti," then an exotic ethnic food, the Italians hoist glasses of Chianti and make Italianate gestures. (Ruotolo mimics a Caesar, Samarelli and Calitri repeat Raphael's Plato and Aristotle.) Second from left, smoking a twisty toscano *cigar, sits "Painter G. Stella," arrived from Italy for good only the year before, and still "Giuseppe" (hence the initial "G."). Six years later, painting as "Joseph" Stella, his "Brooklyn Bridge" series will bring Italian Futurism to America and make him the first, and most acclaimed, Italian American artist. (See p. 499, "From Stella to Stella: Italian American Visual Culture and Its Contribution to the Arts in America.")*

"Where Italian Artists Find Bohemi[a]—In East 115th Street" from "Seeing New York With Fornaro," in The Evening Sun, *Dec. 15, 1913. Antonio Calitri, "Prof. Calitri," is identified at far right. Courtesy of Robin Calitri.*

Introduction

The Making of the Italian American Cultural Identity: From La Cultura Negata to Strong Ethnicity

Prospero's Books and This Book As Their Dangerous Supplement

As Prospero does at the conclusion of *The Tempest,* I ask for your indulgence, dear reader, to set me free to begin in an unconventional way. Rather than introduce you directly to the contents of this book, I shall project an imaginary volume, a fictitious book to which the materialized book you now hold in your hands will serve as an epilogue. But only in appearance will I speak of something else, for how often when we probe what is on the margins of a given problem do we discover the most useful keys for dealing with the problem itself. This will become clear to you as we pass from Prospero's books, the metaphor I use to describe Italian elite culture, to the notions of supplementarity and inbetweenness, the figures I use to locate the Italian American cultural experience.

The book that meticulously records and painstakingly documents the 3,000-year Italian contribution to world culture, including the elaborate 500-year migration to America of ideas, traditions, and movements, of artists and intellectuals and their works, and other things Italian—even that supreme fiction, the "Italy of the mind"—is virtually impossible to write. If it were to be written, it might take the physical form of an enormous and profusely illustrated tome, a book of books designed in the Florentine manner, perhaps with Arcimboldo's painting of the "man made of books" as its frontispiece. Perhaps it could be compressed into several labyrinthine chapters of that "total book" that Borges cannot seem to locate in the library of Babel or, if it were composed on a computer, perhaps it would take the form of an infinite hypertext that would map the intricate movement of Italian culture to other cultural spaces and from one period to another.

Boldface terms are defined in the Cultural Lexicon which starts on p. 703.

And who would be able to write such a compendium? Those individual authors who have attempted to write just a chapter or two of the cultural history of the Italian legacy have, with very few exceptions—for example, Jacob Burckhardt's *The Civilization of the Renaissance* (1860) or, more recently, William Vance's exhaustive *America's Rome* (1989)—traditionally proceeded by reducing that history to the shorthand of a series of pertinent and impertinent stereotypes, usually descriptive of the Italian national character. I say "impertinent" for as Giulio Bollati, in an essay on the history of the Italian identity, has pointed out: "Non esiste 'l'italiano,' ma esistono gli 'italiani.'" (The "Italian" does not exist, only "Italians" exist) (Bollati 1972). And, of course, Bollati's is itself a most pertinent cultural stereotype for it quite correctly exposes the lack of an organic and psychological Italian national identity and the historical reasons for such a lack: Italy's lateness in consolidating itself as a modern secular nation; its linguistic fragmentation as a country of dialectics; its **campanilismo** (allegiance to a local identity)—from *campanile* (church bell tower), indicating that identity was conceived in the local terms of the parish; and its status as a "heterotopia"—that is, its 3,000-year-long tradition as a culture of mixture, eclecticism, and grafting.

The most (im)pertinent stereotype regarding Italy is that it is a culture of differences. And one of the ironies of the Italian American cultural identity, the making of which the present volume will describe, is that the Italian differential identity in its transplantation to America has received in the name of ethnicity a stability and genericness that it lacked in the Old World. Indeed, one wonders whether Bollati's formula can be applied with the same apodictic force to Italian American identity—"The Italian American does not exist, only Italian Americans exist"—given that Americanization has produced, as a corollary to minorization, an ethnic construct through which Italian Americans have assimilated themselves and, insofar as that construct has been imposed by the majority culture, through which they have been assimilated. This construct is based primarily on the image, at once archetypal and stereotypical, that had crystallized around the southern Italian, the **Mezzogiorno** being the region that supplied the vast majority of immigrants. But since these southern Italians were, by and large, members of the Italian underclass, their class image was transferred to immigrants from other regions who also belonged to the same (transregional) subaltern class and who reconstituted their regional identities in terms of this generic ethnic construct. In other words, the United States served not only as a universal melting pot into which Italians were immersed together with other ethnicities and races and assimilated/hybridized as part of the process of Americanization, but as a specific "Italian" melting pot in which regional and local identities were amalgamated into

that formula of sameness that occludes difference—the "Italian American." As Micaela di Leonardo has amply demonstrated in *The Varieties of Ethnic Experience: Kinship, Class, and Gender Among California Italian Americans* (1984), the Italian American experience was, and continues to be, a diverse and heterogeneous phenomenon. On the other hand, the fact remains that the figure of the Italian American has been constructed by the majority culture, particularly the mythic stereotype fixed by the mass media as part of its Italic discourse—a highly contradictory and ambivalent "discourse," as is always the case in such ethnic constructions—that is at once Italophilic and Italophobic. It is precisely this long-established discourse that contemporary Italian Americans must come to grips with as they struggle to forge an identity that is not Other-induced but self-generated. One of the tasks of this volume is to describe the formation of this discourse upon the Italian American and to locate it within the larger discourse upon the Italian, to which it serves as a supplement.

But to return to the question of writing the "big book": It, of course, would have to contain an archive of (im)pertinent stereotypes for they, too, are a primary means for the transmission of culture. That archive might be divided into two sections, one containing the cultural stereotypes coined by non-Italians, another containing those devised by Italians themselves, beginning with Dante, who played out the characterological game by assigning historical figures who embodied the generic traits (vices) of certain regions or cities to an appropriate zone of hell. Central to the first section would be those impertinent stereotypes that exploit "the lurid exotic appeal of Italy"—for example, those devised by the Elizabethan dramatists who, as the English essayist Vernon Lee pointed out, employed "the darkened Italian palace" as their favorite background, exploiting what the Italian literary historian Mario Praz has called the "two sides of the Italian appeal": "the splendour of its princely courts, and the practice of poisoning." These sinister images were recycled in such popular Gothic novels as *The Castel of Otranto* (1764) and *The Monk* (1796). On the other hand, there is an Italophilic discourse extending from Chaucer and Shakespeare through Henry James and Edith Wharton to post–World War II Hollywood filmmakers who, in such films as *Roman Holiday* (1953) and *Summertime* (1958) would celebrate Italy—however superficially—as the mecca of mass tourism, the land of "three coins in the fountain" romance and erotic wish fulfillment.

As a paradigm of an (im)pertinent stereotype, consider the remarks of that most solemn of German philosophers, Immanuel Kant, who divided European national identities according to whether they have a feeling for either the sublime or the beautiful. Naturally, the Italians as aesthetes par excellence are located by Kant on the side of the beautiful, their genius seen to express itself in "music,

INTRODUCTION

painting, sculpture, and architecture." Here Kant is guilty of striking a grossly impertinent stereotype, for he ignores the significance of the Italian literary sublime as well as Italian philosophical and scientific culture. Kant wrote in *Anthropology* (1798):

> As the French prevail in their gusto for conversation, the Italians prevail in their gusto for the arts. The French prefer the private celebration; the Italians, public celebration: the pomp of the parade, processions, carnivals, the splendor of public edifices, paintings, mosaics, Roman antiquities in the noble style. They like to see and be seen within a numerous company.

Here we approach the pertinent stereotype that sees Italians as the people of the magnificent spectacle; the Italian world, including the world of everyday practices, as a work of total art; the idea of Italy as the site of a global aestheticization and theatricalization of reality. And at this point, we are not far from the Italy described by Luigi Barzini in *The Italians* (1961). Barzini has long been the foremost purveyor of impertinent stereotypes—that is, cultural stereotypes—that, regardless of their superficiality, can be recuperated if they are regarded as symptomatic of the ways in which Italians stereotype themselves. They thus become useful as instances of self-understanding. Consider his description of the everyday performance of the self as spectacle:

> *What exactly are those* cose all'Italiana? *They are things in which we reflect ourselves as if in mirrors: a gratuitous* beau geste, *a shabby subterfuge, an ingenious deception, a brilliant improvisation, an intricate stratagem, a particular act of bravery of villainy, a spectacular performance.* . . .

In addition to the scribe who would painstakingly catalog these (im)pertinent stereotypes, our conjured book would have to be written by many hands—by architects, painters, sculptors, poets, and other practitioners of the beautiful as well as the sublime; by scholars and historians of all of the above disciplines and many more and also by linguists and philologists conversant in Latin, medieval Latin, even Etruscan if such a scholar exists, as well as in modern Italian and its plurality of dialects, including the "spaghetti Italian" the Italian Americans have devised; but also by *bongustai* (gourmets) and others adept at the art of Italian cuisine; by archivists of desire who would document the Italian contribution to the *ars amandi* and its disparate practices of sacred and profane love; by modernists and futur-

ists who would write the history of twentieth-century Italian culture; and, above all, by semioticians of the spectacle who, unlike Kant and Barzini, would be armed with a magic philter that would protect them against the enchantment of a culture that unfolds through and as a spectacle, of which this projected book would also be a part.

Such a book of books would comprise more than the twenty-four books of ancient Italian wisdom that Shakespeare's Prospero, the deposed duke of Milan, brought with him in his exile from Italy—if we accept the count of Peter Greenaway, who has "rewritten" Shakespeare's *The Tempest* in his stunning film *Prospero's Books* (1991), itself a consummate postmodernist exercise in the recycling of Italian Renaissance visual and architectural culture. These twenty-four books form the basis of Prospero's "rough magic," enabling him, according to Greenaway, "to find his way across the oceans, to combat the malignancies of Sycorax, to colonize the island, to free Ariel, to educate and entertain Miranda, and to summon tempests and bring his enemies to heel." And, we should add, enabling him to replicate on his newfound island, as a way of cutting the melancholy of his exile, the lineaments and spectacles of far-distant Italy. The figure of Prospero, the bearer of culture and exponent of civilization par excellence who not only travels with books but is himself a book, a cultural text, is a perfect metaphor for the way in which Italian culture has traveled to other territories, especially the "brave new land" of America. Prospero is a fictional prototype of the "illustrious immigrant," a Renaissance forerunner of those Italian artists and intellectuals who have immigrated to America from its origins to the present: from Filippo Mazzei and Lorenzo Da Ponte (Mozart's librettist and the first professor of the Italian language in America who was the first great cultural mediator between the Old and the New World) to Giuseppe Garibaldi and Arturo Toscanini to Enrico Fermi and Bernardo Bertolucci.

But Prospero is also a colonialist of sorts, a decidedly Italian one, however, in that he "colonizes" primarily by the force of images and the "white magic" of his books and their traditional wisdom. I have deliberately chosen Prospero, rather than Columbus, as a figure of cultural transmission not in concession to recent Columbus bashing but to shake up assumptions regarding the "Children of Columbus": Italy never directly colonized America, although its role in Eurocentrism and Catholic imperialism makes it a paracolonial party; on the other hand, its immigrants, who belonged, for the great part, to the Italian underclass, were colonized by the American experience and, in turn, liberated by it, passing from a subaltern class that had no history to a socially integrated one that has a history within the larger history of America. Columbus was a bearer of history; the fic-

tional Prospero, a humanist and magus, a master of the "liberal arts" and "secret studies," was a bearer of civilization. If Italians have been thought of as bearers of universal culture, it has been that of humanism—hence, Prospero.

Although in a moment I shall describe the specific ways in which Italian culture—elite and popular—has traveled to America, it is important to point out that cultural transmission does not take place only through the Prospero-like agency of the individual talent—the great intellectual or artist—but by many diverse paths: from "ordinary" person to "ordinary" person, from situation to situation, from one historical period to another period, and, as in the case of the Italian Americans of the Great Immigration (1880–1920), from emigration to immigration, from (class) exile within the motherland to (class) exile within the promised land of America, eventually the homeland. This is to say that the collective cultural text the immigrants brought with them—very rarely that of Prospero's elite formation for many of the immigrants were illiterate, but instead that of a lived culture revolving around the everyday practices of **la famiglia** (the family)—must also be recognized as a primary means of cultural transmission. The present volume is dedicated both to describing the historical process by which the Italian Americans transplanted their "cultural text" from Italy onto American ground—that cultural text being primarily though not exclusively that of southern Italy, the region from which 80 percent of the immigrants came, although, regardless of the regional identities of the immigrants, they shared on the whole the generic culture of the subaltern—and to documenting how that translocated cultural text, however transformed by acculturation and assimilation, has provided the basis for the Italian American identity and for the cultural production of Italian American writers, artists, and intellectuals. Although this volume addresses the adventures in America of cosmopolitan Italian culture—that is, the culture deposited in Prospero's books as they have been augmented by post-Renaissance and modern Italian culture—its central concern is to construct a critical history of Italian American culture as it extends from the Great Immigration to postmodern culture. As such, this volume ought to be regarded as a supplement—a "dangerous supplement," as I shall demonstrate—to Prospero's books, for Italian American culture is both an appendix to Italian culture and an extension that completes it and, therefore, an integral part of it. With this notion of supplementarity—the immigrant experience is fundamentally an instance of supplementarity—we begin the difficult task of locating Italian American culture.

Before addressing this task, let us return to Prospero, who is at once a humanist—a strict philologist in the sense, still dear to Italians, of a traditional intellectual committed to the affirmation of the past and thus to the difference

that comes from repetition—and a consummate artist and stage director who operates through the magic of the spectacle. In this dual identity, he is a supreme example of those qualities that define Italian culture: on the one hand, the *pietas* (piety) toward tradition and its transmission, the joy rather than the anxiety of influence, as illustrated by the fact that Prospero's originality lies in his status as a duplicate and duplicator (a point Greenaway's film underscores)—that is to say, he is committed to the originality achieved through eclecticism, the mixture, the graft; on the other hand, those qualities of lightness, quickness, exactitude, visibility, and multiplicity as defined by the celebrated novelist, Italo Calvino (see Calvino 1988), all of which are at play in Prospero's art of the spectacle. Tradition and spectacle, these are the means through which Italian culture has exerted its Prospero function—its disciplining and magical effect—on world culture.

Remember that Prospero educates and entertains his daughter Miranda while also disciplining her suitor, Ferdinand. But also remember that Prospero works his "rough magic" in reference to his doubles: Ariel, the necessary angel of the imagination, who operates through the enchantment of music and spectacle; and Caliban, nature that refuses nurture, the chthonian force that rejects Prospero's discipline. For certain, Italian culture has not unfolded only under the rarified signs of Prospero and Ariel but also under the dark and transgressive sign of Caliban. You may recall the notorious stereotype—impertinent to the point of being pertinent—spoken by Orson Welles in the Machiavellian role of Harry Lime in the film *The Third Man* (1949):

> In Italy for thirty years under the Borgias they had warfare, terror, murder, bloodshed, but they produced Michelangelo, Leonardo Da Vinci, and the Renaissance. In Switzerland they had brotherly love, and they had five hundred years of democracy and peace. And what did that produce?— The cuckoo clock.

Here we approach the image of Italy as the dangerous Other, for Europeans as well as for American "innocents abroad," the labyrinth of labyrinths, a culture infiltrated by violence, be it of moonlight or *Machiavelleria* (Machiavellian intrigue). Those who have traveled to Italy are perhaps familiar with the most benign symptoms of its fatal gift: Roman fever, the Daisy Miller syndrome and its late-twentieth-century installment, the so-called Stendahl syndrome, that melancholy caused by the overwhelming effect of too much beauty. A chapter of the book would have to be dedicated to such symptoms and might follow the many chapters dedicated to Caliban and his heirs.

INTRODUCTION

Having projected a fictitious book, a book that cannot be contained within the covers of a single book, I want to identify once again this volume as its *supplement*. I borrow the notion of supplementarity from the French philosopher Jacques Derrida, who has explored the ways in which a supplement functions both as something that comes after, an appendix or addition, and as an element that is nevertheless intrinsic to and thus capable of modifying, the main body of a text, in this case the Italian cultural text. From this perspective the Italian American cultural experience (as well as this volume, which documents it) is a supplement at once extrinsic and intrinsic to Italian culture. I would add, following Derrida, that it is a distinctly "dangerous supplement" in that it exposes those things that in Italy were denied or suppressed. By "dangerous" I do not mean the scandal of the Mafia or the other elements of Calibanism that have led to the negative stereotyping of the Italian American, what Richard Gambino, one of the contributors to this volume, has summed up in the formula the "mark of Cain." The Italian American experience is a dangerous supplement to the Italian experience in that those subaltern groups who made up the immigrant class and were denied a history in postunification Italy came to America where they would have a history. Within this history, Italian Americans would occupy the postexilic role of supplements, as those who are simultaneously outside and inside their original culture. This historical condition of supplementarity would be eventually rotated into what might be called the position of "inbetweenness"—the contradictory position of a group that, of the outsiders, is the most inside and, of the insiders, is the most outside: the minority that denies its own minority status and that authentic, or more codified, minorities—Blacks, Jews, Latinos, Asians, and so on—regard as part of the White, European, Christian majority, and that the majority culture regards as the most alien, the most Other. (For a brilliant historical account of inbetweenness, see Robert Orsi's essay "The Religious Boundaries of an Inbetween People: Street *Feste* and the Problem of the Dark-Skinned Other in Italian Harlem in the September 1992 *American Quarterly*.) It is from these positions of supplementarity and inbetweenness that Italian Americans have produced their formidable culture and achieved great successes in America. On the other hand, their inbetweenness, their double status as both a paraminority and a paramajority, has placed them in a double-bind situation: Theirs is the liminal realm of the inbetween, a space of double demarcation, marginal yet overdetermined with respect to both majority and minority cultures. It should come as no surprise that they are the figures through whom the American unconscious is made to speak— and here we approach their (re)current role, that of the dangerous supplement, but this time with respect to American majority culture.

INTRODUCTION

Locating Italian American Culture:
From La Cultura Negata *to Strong Ethnicity: A Critical History*

The starting-point of critical elaboration is the consciousness of what one really is, and is "knowing thyself" as a product of the historical process to date, which has deposited in you an infinity of traces, without leaving an inventory. Therefore, it is imperative at the outset to compile such an inventory.

—ANTONIO GRAMSCI, *Selections from the Prison Notebooks*

Like the subject it treats, this volume, *The Italian American Heritage,* is a hybrid construction—a collection of essays, some profoundly personal, others more formal—designed to serve as both a reference work documenting the history of Italian American cultural production and a critical project dedicated to the analysis of the Italian American cultural self as it has constructed itself and been constructed by its elaborate intersection with the common culture of America.

Although the field of Italian American studies is in certain respects well established, this volume is probably the first to undertake a systematic mapping out of the entire field of Italian American culture, from everyday practices to literary and artistic accomplishments. Central to its attempt to locate Italian American culture are three historiographic tasks.

The first is the setting out of the history of Italian American cultural creation within the context of a more general history of the Italian American cultural experience.

The second is the delineation of canons in literature, music, drama, and cinema, many of which have not been previously established. That is in part because Italian American cultural production has not been regarded as an autonomous entity but has been relegated to the position of inbetweenness—too Eurocentric and too enmeshed in the culture of the masters to have the formal status of a minority culture, while at the same time too minor and too marginal, especially with respect to literary creation, to constitute a full-fledged and self-conscious tradition; its canonical writers and artists defined—either by exclusion or inclusion, but always through excision from the Italian American context—in terms of the dominant culture.

The third task is the elaboration of the Italian American worldview as it has evolved from the immigrant experience to the "strong ethnicity" of the late twentieth century and as it is embodied in the traditions, life practices, and cen-

tral literary and artistic texts of Italian America. Crucial to the understanding of this worldview is the lexical dimension, and each of our contributors has been asked to incorporate into his or her essay those keywords—whether in standard Italian or dialect—through which Italian Americans have organized their world.

In its function as a critical project, this volume interrogates the Italian American identity from multiple perspectives—among our contributors are an anthropologist, a storyteller, a playwright, several poets, several novelists, a singer, a photographer, an opera critic, and a number of literary critics and cultural historians—and in a critical spirit. That spirit is best epitomized by the quotation at the beginning of this section from *Selections from the Prison Notebooks* (1970) by Antonio Gramsci, probably the most significant Italian thinker of the twentieth century, who instructs us to make an inventory of those traces that American culture has deposited in us as it has constructed us as ethnic subjects and inserted us within a discourse on American Italianness by which our presence and persona in the majority culture have been fabricated. If the authors of this volume can be seen to share a project, it is to inventory those traces deposited by both the process of Americanization and the antecedent cultural experience in Italy by which the majority of those participants in the Great Immigration were constituted as a subaltern class. Gramsci described their social formation as that of **la cultura negata**, by which he meant a culture that is denied or suppressed and, as part of the vicious circle it imposes, self-denying and self-suppressing. Although it would be historically inaccurate to limit the great variety of Italian American ethnic experiences to a single denominator, it is nevertheless true that the great majority of the immigrants came from the *Mezzogiorno* and that an even larger number came from the transregional culture of poverty that was the underside of post-Risorgimento Italy. The immigrants were already strangers in their own land, preliterate or semiliterate **contadini** (peasants) who had no purchase on Prospero's books and whose primary text was the land.

To inventory those traces of the pre-immigrant experience in Italy requires us, in the first place, to derive a genealogy of the passage of the immigrant self to America and its subsequent generational transformations within the process of acculturation and assimilation in the United States. This involves, above all, tracing the history of *la famiglia* for, however that family may have been economically disadvantaged, it was extraordinarily resilient and imparted great cultural strength to its members. Nowhere has the ethos of *la famiglia* been better set out than in the political vision and example of former New York Governor Mario Cuomo.

In addition to this genealogical work, a more difficult task is also required: Given that the majority of our contributors write from the position of third-

generation Italian Americans twice removed from the immigrant experience and its Italian matrix, the problem becomes a question of excavating those traces as they have been displaced, fragmented, hybridized, and erased by the process of Americanization. Here we approach the contradictions that inform the late-twentieth-century Italian American identity: a destabilized identity that vacillates between Being Italian and Becoming Italian (to be more precise, between Being Italian by descent and Becoming Italian by consent and at a cultural level—by constructing a cultural persona that maintains the creative duality of Italian Americanness), between maintaining an archaeology of the self linked inherently to Italianness and fashioning a postmodern—post-immigrant and post-exilic—identity self-consciously and in terms of the play of those ever-receding traces, traces that can be reinforced by an intellectual and, therefore, ironic return to traditional and contemporary Italian cosmopolitan culture, the very culture from which the immigrants were denied access.

From this perspective this volume might be best described as a critical history written in the form of personal essays—that is, written, affectively not technically, in the first person and in the voice of third-generation (but also second- and fourth-generation) Italian Americans. This means three things:

First, our project—at once historical and critical—is also a linguistic project that raises, in its way, the problem of writing as an Italian American, one of the central themes in the cultural history this volume sets out. In other words, in defining the discourse of, and upon, the Italian American, the volume is in itself an instance of that discourse, a historical index—an archive in the making—that registers the current voice of Italian America as epitomized in some of its leading intellectuals and writers.

Second, the essays, considered as an ensemble, are concerned with writing a *history in the plural,* a history that operates on the many different territories of the Italian American cultural space and seeks to articulate the differential identity of Italian Americans, a pressing task given the manner in which Italian Americans have come to be stereotyped by the majority culture and, to a certain degree, have internalized that stereotyping.

Third, rather than producing a monumental and linear history such as that written by Jerre Mangione and Ben Morreale in *La Storia: Five Centuries of the Italian American Experience* (1992), we are concerned with presenting a provisional and somewhat fragmented version of **la storia** (history), one that is constantly being modified—rewritten and unwritten—by our contributors, who write from diverse disciplinary perspectives and often conflicting ideological positions. In this sense, the essay, considered as an open form, a fragment of an analysis, and a form

of writing that sets itself in crisis and yet moves toward synthesis, is the appropriate literary register with which to confront contemporary ethnic identity—in flux, in crisis, always inbetween.

We hope that our "essaying" of the Italian American identity remains in keeping with our founding editor George J. Leonard's enlightened idea of what constitutes the tasks of a work on ethnicity: to provide a general readership with an objective and scholarly account of the history of the cultural production of a given ethnic group written primarily by members of that ethnic group while also defining the cultural identity of that group in a personal way and thus speaking through the voice(s) of that group. This volume, then, is a medium with which to do the historical work, only just begun by Italian studies, of (1) establishing literary and artistic canons; (2) defining the specific nature of American Italian texts whether they be strictly Italian as the opera, strictly Italian American as the ***macchiette coloniali*** (colonial sketches: Americanized versions of the Neapolitan ***macchietta*** or character sketch) of the immigrant theater, or strictly Italian American as the "mean streets" films of Martin Scorsese; (3) elaborating a micronarrative of the Italian American cultural experience and situating it within the master narrative—*la storia*—of Americanization; and (4) formulating a lexicon of the linguistic terms that have served Italian Americans as a grammar of living. It is also a medium in which to "essay" the Italian American identity: to find a way of speaking about that identity and to inventory the traces that the historical process has deposited in it.

Since I have already lapsed into the "we" construction above, it is important to confront the question of the readership for which this volume is intended. All ethnic cultural texts are, to a certain extent, double voiced, addressed at once to an ethnic insider and a nonethnic outsider. Although this work is designed specifically to give that information that will permit the outsider to become an insider, it nonetheless remains double voiced. Whereas the general reader will find it to be a guide through the labyrinth of Italian American culture, and the ethnic but non-Italian reader might use it as a mirror with which to reflect his or her own ethnic experience, the Italian American reader is under a specific charge. Although the volume is a celebration of the Italian American cultural heritage, it is intended to do something more than engage the Italian American reader in an ego-affirming exercise or in a consoling game of recognitions. If the volume practices a politics of identity, it is that of an identity in crisis that needs to rethink in a critical way its history as it extends from *la cultura negata* of the first and second generations to the strong ethnicity of the acculturated third and fourth generations as well as the weak ethnicity of the assimilated members of those genera-

tions. Such historical work—the inventorying of traces—leads always from the question of Being Italian to that of Becoming Italian. Becoming Italian for the contemporary Italian American, the people of inbetweenness, the most assimilated of the minorities, involves making that inbetweenness into a strategy for forging a strong identity. This means, among other things, recognizing the weaknesses of strong ethnicity and the strengths of weak ethnicity.

Consider as an expression of immigrant strong ethnicity the tirade spoken by Maestro Farbutti in Pietro di Donato's *Christ in Concrete* (1939): "We are Italians! Know you what that means? It means the regal blood of terrestrial man! Richer than the richest, purer than the finest, more capable than an-y! an-y! race breathing under the stellar rays of night or the lucent beams of day! . . ." The maestro goes on with his aria of rage, listing the great Italian artists and concluding with the declamation: "We are the glory of Rome, *the* culture! By us the rest are scum! And it is the duty of us great Italians to—" Breaking off at this point, he transposes his fury into the singing of "Ritorno Vincitore." Of course, what di Donato gives us here is immigrant rage: the aria of the grandiose self that arises in reaction to the humiliation and stigmatization of the figure of Italianness. Because it is simply reactive, it is a negative version—a travesty—of strong ethnicity that, at least in my definition of it, is active in its affirmation of selfhood, inclusive and dialogic with respect to others, not self-referring. Furthermore, strong ethnicity requires the labor of the negative—that is, criticism and self-criticism that is not reactive but active. The challenge it presents is to pass from being an ethnic subject to a critical agent.

Italian Americans have traditionally been extremely lax in guarding their image (see the essays of Thomas Belmonte and Richard Gambino in this volume) and in adopting a critical stance toward the process of "Othering" to which they have been subjected. It has become a truism that the Italian Americans are the only group that can still be defamed with impunity in the public sphere. This volume is intended to provide information by which to gain a more accurate sense of the Italian American identity and the image Italian Americans hold of themselves. It is not intended, however, to codify the grievance Italian Americans have with the majority culture regarding their (mis)representation in the media and in the American imaginary itself. It is designed, instead, to provide models for reading through such (mis)representations and for critically analyzing the assumptions that underlie the stereotyping process.

Let me give three examples of the sort of critical work that needs to be done. The first pertains to the English critic John Sutherland's review in the *New York Times Book Review* (6 February 1994) of *The Edge of Night,* an autobiographical

"confession" by Frank Lentricchia, one of the contributors to this volume and a leading American literary critic who teaches at Duke University in Durham, North Carolina. (The first chapter of *The Edge of Night* appears in Part One here, retitled "The Genealogy of Ice.") The heading of Sutherland's review reads "The Don of Duke: A Literary Critic Fancies Himself Part Corleone and Part Prufrock." Throughout the (begrudgingly positive) review, Sutherland, a professor of literature at University College, London, has no other way of dealing with Lentricchia's aggressively ethnic style and his literary performance as blue-collar professor—"his Italian hoodlum act," as Sutherland puts it—engaged in an agon with T.S. Eliot than to resort to Italian stereotypes: the "don of Duke" is not Oxbridge in style but evocative of Al Pacino playing Michael Corleone; Lentricchia's literary persona is part "Raging Pasta," part Prufrockian. If one is to employ the codes of Italianness to frame a reading, why not employ the correct ones? To wit, those of Lentricchia's applied Gramscianism and Scorsese's mean-streets rage carried over into academia? What Sutherland gives us is, in effect, the equivalent of evaluating Scorsese's *Raging Bull* (1980), a text that Lentricchia both invokes and evokes, in categories proper to a Merchant and Ivory film. In this so-called Age of Hybridity in which the strategy of hybridity has been elaborated, why is not such a strategy seen to be at the heart of Lentricchia's attempt to write as an Italian American and through the persona of blue-collar professor? Why does Sutherland not bring to bear on his reading of *The Edge of Night,* Lentricchia's Gramscian attempt to theorize his own contradictory status as a traditional or cosmopolitan intellectual that places him at odds with the working class identity of his origins? And why are the class implications of Lentricchia's attempt to affiliate himself with his modernist "Godfather," T.S. Eliot—"my kinsman" as Lentricchia puts it—not explored and seen as an Italian American troping of Eliot's attempt to affiliate himself with his own "Godfather" and kinsman, Dante? And why is Lentricchia's attempt to forge a scriptural self not placed within the history of Italian American writing since, within that context, the violence of his language and his attempt to write as if he were speaking become comprehensible as the appropriate means with which to break through a collective, subcultural writer's block and to move from silence to confession? And why not read Eliot as a gangster, for are not masters literary gangsters of sorts?

The second example is initially linguistic but leads us into the area of Italian self-hatred. Let me preface my remarks by saying that they are neither politically motivated nor concerned with political correctness in speech. They are concerned, instead, with identifying the misusage of a particular term from the Italian lexicon and the implications of that violation for both the speaker and the Italian

social text. Bob Grant (an Italian American born Robert Gigante), the host of a program on WABC Talk Radio that commands an audience of one million listeners, launched a relentless attack against the then governor of New York Mario Cuomo during his campaign for re-election in 1994. Grant repeatedly designated the former governor as "the *sfaccimm*": "Down with the regime of the *sfaccimm!*" went Grant's rant. Grant translated *sfaccimma* (often shortened in speech to *sfaccim'*), a term appropriated from the Neapolitan dialect, as "low life, heel, low born." The word, in fact, is a *parola brutta* (prohibited or interdicted word) that means literally "sperm" or, more suggestively, "the sperm of the devil." At the connotative level it summons up all of the negative attitudes associated with the waste products of the human body: the word "scum," in one of its unprintable intensifications as a compound word, would be the approximate English equivalent. It is a word that epitomizes the linguistic violence of the dialect, with dialect understood as the language of the skin, of the vendetta, as the vade mecum of the streets. Since it designates the heterogeneous elements of the body, it is the perfect term to target an enemy.

What was disconcerting about Grant's deployment of it was his ignorance of the protocols of its usage. It is not to be addressed to the face of one's opponent for it is a fighting word, a word of aggravated insult that leads, at least in the private sphere, to escalating violence. Furthermore, it is a taboo word that has no place in the public forum. Its repeated use in a public way indicates that its user has no awareness of its shock value as a vicious slur and of how it indicates to the knowledgeable Italian speaker, who will take umbrage at its use, that its speaker is a **cafone**. (*Cafone,* literally a "peasant" but by extension a "barbarian" or "Yahoo," is one of the key terms in Italian American social language, marking the great divide between those who know and those who do not know the codes of their own cultural text. Even though it is a word of standard usage, the C-word cuts the Italian skin much deeper than the S-word.) Therefore, Grant's misusage was not simply a matter of political incorrectness but of transgressing a social language whose primary concern is the "face," showing respect for the territories of the self, especially those of an opponent. Thus the use of such a stigmatizing epithet is defamatory (in any other context other than the Italian American, it would be considered racist) and, from the Italian American point of view, *defacing* and tactically incorrect. I say tactically incorrect for however Grant intended to use the epithet as a provocation, its public—"in your face"—usage indicated that the speaker was ignorant of the word's meaning and the protocols determining its usage. It is a gutter word to be used behind the back of one's enemy or uttered to oneself or, when in the context of acting as a "with," addressed collusively to a

pack operating within the frame of street behavior. That this frame-breaking word succeeded in conveying an affective charge to an audience ignorant of its specific meaning, serving as a conduit to channel the political discontents of a right-wing audience against a political figure perceived as being all too liberal, is a testimony to the archaic power of the dialect. This power can be attributed to the phonetic properties of the word, its pronunciation taking the expulsive form of a spitting out or "ejaculation" that reinforces its semantic (dis)charge. But as is the case with all linguistic utterances, especially an affective word designating repulsion, one not only speaks language but language itself also speaks. In this case, language tells us that the speaker is unable to confront his opponent in the conventional language of political debate and that the repulsion directed at the target ought to be redirected toward the speaker himself. That the semantics of this word took place behind the broadcaster's back is indicative of a misappropriation of Italian American codes and ultimately a demonstration not of the stigmatization of a political enemy but of self-stigmatization. (This critique of Grant is not politically but culturally motivated; neither does it raise the characterological question of rivalry between the little man and the great man, nor the arbitrariness—authoritariansim—of Grant's on-the-air style, the preemptive strikes of which short-circuit all possibility of dialogue.)

On the other hand, one of the functions of this volume is to equip its reader with the knowledge to read through such linguistic disfiguration, such *disfacements*. Furthermore, the notion of self-stigmatization leads us to the area of Italian American self-hatred, to borrow a term that has seen hard service in Jewish and African American self-understanding. It is time that Italian Americans be strong and critical enough in their ethnicity to designate those texts in their tradition that involve self-hatred whether they take the social form of the Mafia, clearly the greatest instance of Italian self-hatred; the literary form of Albert Innaurato's 1977 play *Gemini;* or the self-stigmatization of Bob Grant's use of a linguistic signifier of his own ethnicity to violate the standards presumably sustained in broadcasting.

The third example pertains to the class stereotyping of Italian Americans as blue-collar creatures. Stanley Aronowitz, in *The Politics of Identity: Class, Culture, Social Movements* (1992), offers the following generalization about Italian Americans: "Their signal achievement has been to win a secure place in the industrial working class as semi-skilled and, especially in the construction and needle trades, as skilled workers." However such a totalizing generalization may have held for the second generation (in New York perhaps, but certainly not in California and elsewhere)—the sons and daughters of those immigrants who belonged to an exploited underclass in Italy, whose migration was thus in great part economi-

cally determined, and for whom blue-collar identity was an honorable means of achieving the first step of the American Dream—to invoke such a formula to describe the extremely diversified and evolved class positions of Italian Americans in the 1990s is to resurrect the superannuated and ironclad formulas of an essentializing sociology that seeks to keep Italians in their place in an innate class and racial hierarchy. This is all the more alarming since the seventies and eighties were the period of the third generation's great breakthrough. That breakthrough was trumpeted in the mass media (see, for example, Stephen Hall's "Italian-Americans Coming into Their Own," in the *New York Times Magazine,* 15 May 1983), and the group's entry into the upper echelons of the professions and managerial class carefully documented in the specialized literature. Theodore White's assessment in *America in Search of Itself* (1982) was typical in its identifying Italian Americans as "the most important among the rising ethnic groups." Moreover, it was in that period that Italian Americans made their great breakthrough into academia after a long resistance to the process of education, producing for the first time a group of intellectuals able to explain to Italian Americans their own history of cultural exclusion and to articulate the contradictions of their identity. Rather than refer to the recent literature on the transformation of the Italian American identity, such as that of Micaela di Leonardo's previously mentioned 1984 work or other statistically documented studies, Aronowitz persists in recycling the usual stock of stereotyping formulations: the "sports, entertainment, organized crime" model as the route for ethnic economic advancement, the tritest model of assimilation that explains nothing except the obvious; racial violence toward Blacks, what might be described as the Bensonhurst syndrome, which is taken as normative rather than as historically anomalous and without an accompanying attempt to understand that violence as being symptomatic (see the previously mentioned essays by Belmonte and Gambino in this volume and by Orsi in *American Quarterly*); and the invocation of the film *Moonstruck* (1987) as providing "relatively dignified portrayals"—albeit violent—of Italian American behavior when in fact that movie has very little to do with Italian American behavior and is a flagrant example of the fantasy history projected upon the Italian family by the majority culture. If this volume serves both the general reader and the Italian American reader as a counter-history to such stereotypical assumptions at work in the three examples set out above, it will fulfill its tasks as a critical project and a history written in the plural. Cultural historians—and, by extension, readers concerned with encountering cultural difference—must be workers in the plural because the ethnic subject is effectively plural and because not to confront that plurality is to repeat the stereotyping discourse by which the other is reduced to the same.

INTRODUCTION

Specific Instructions for Reading This Book

Having already laid out the general objectives and the rationale of this work, I want to alert the reader to a number of problematics that run through the entire volume and that are not indicated by its formal structure. That structure is threefold: (1) an opening section raising the general question of identity, past, present, and future; (2) a second section on traditions and everyday practices, including the traditional life cycle, the house as the locus of Italian American identity, and storytelling as a medium for transmitting the tradition; and (3) a large section—the heart of our study—treating Italian American cultural creation, which is subdivided into literature (the novel, women's writing, poetry, and other genres) and the arts (theater, music, the visual arts, and the cinema). Whereas this volume takes as its master narrative the passage from *la cultura negata* to strong ethnicity, it also unfolds a number of (his)stories within that history. Among them are the following:

The Discourse on the Italian American
First of all, let me indicate that, to ensure stylistic uniformity, we have followed Garland's protocol, based on those of the Library of Congress and the *Chicago Manual of Style,* regarding the graphic appearance of this volume's central term: *Italian American.* The editors had originally considered the possibility of taking the graphic risk of preserving all three of the different punctuations used by our authors: *Italian-American, Italian/American, Italian American,* the latter being the most neutral and politically correct form, whereas the first two variations are charged with polemical associations. (The present author introduces a fourth variant, ~~Italian American~~, to designate the bracketed or erased identity—the "weak ethnicity"—of the contemporary period.) That our contributors are equally divided over the punctuation of the term is a clear indication that the designation is itself under question and in flux within Italian American culture at large. The marking or unmarking of the term is, in effect, a declaration of one's attitude toward ethnic and self identification, a manifesto in brief by which difference or sameness is announced. The ambivalence of the term, as reflected in our authors' refusal to come to a consensus, is emblematic of the present crisis of the Italian American identity, which is far removed from its first terminological designation as *Italo-American,* a term to be abnegated as a sign of colonialization. Although the traditional term *Italian-American* is the most proper grammatical form (grammatical correctness often hides ideological impropriety, needless to say) and, as of 1996, is used, for example, by the *New York Times,* it is problematic because it foregrounds

the status of *Italian-Americans* as hyphenated Americans. The hyphen, when negatively construed, is a graphic marker of a fractured and incomplete identity, not necessarily the sign of a rich bicultural self. (For a reading of the hyphen as as positive mark, see the chapter by Thomas Belmonte in this volume.) Therefore, the use of *Italian American* removes the minus sign of the hyphen, thus neutralizing the fracturing effect of the hyphen and introducing in its place a gap that maintains a respectful silence. On the other hand, *Italian/American,* a usage advocated by Anthony Tamburri, to whom this discussion is greatly indebted, and employed polemically by our younger contributors, introduces the aggressive mark of the slash that activates all the contradictions at work in the hybrid identity of the *Italian/American,* thereby effecting a radical disturbance in the traditional equations and the nominal identities such equations enounce: Italian = American (the unity of the assimilated self); Italian - American (the separation and disjunction of the culturally divided or hyphenated self), Italian + American (the balance of the self enhanced by acculturation.) It is important, therefore, that the reader recognize that our usage of the term *Italian American* in this volume marks a terminological conflict and that the gap between the two terms ought to be read as a full sign—not an empty or insignificant blank—that activates and keeps in play all the terminological options discussed above.

Although no formal history of the formation of the discourse upon the Italian American is given, the various essays constantly refer to, and position themselves with respect to, it. A distinction ought to be kept in mind between (1) that discourse written primarily by non-Italians—usually from the disciplinary positions of ethnography, sociology, cultural anthropology, and urbanism, but also by journalists who assumed ideological and even racialist versions of the above positions—that first designated the immigrant as an ethnic Other, as a subject to be judged in terms of "meltability" (assimilation and genteelization); and (2) that discourse written by Italian Americans about themselves, usually from an emic position and concerned with self-exegesis.

The first discourse can be seen to extend from the documentary work of the journalist and social reformer Jacob Riis through the polemical literature that crystallized around the Sacco-Vanzetti case and on organized crime in the twenties to Edward Banfield's *The Moral Basis of a Backward Society* (1958), in which the thesis of "amoral familism" was first elaborated. The temper of the Italophobic side of this discourse is epitomized in such titles as "What Shall We Do with the 'Dago'?" and "The Importation of Italian Flees—An Infernal Plot." (See the 1973 anthology edited by Salvatore LaGumina, *Wop: A Documentary History of Anti-Italian Discrimination in the United States.*) In the sixties and subsequently, Italian Ameri-

cans tended to be treated as part of studies of White ethnicity in general, a sign not only of their assimilation but of the legitimization of the category of ethnicity.

The discourse by Italian America, on the other hand, despite its long but sporadic genesis from the colonial period onward, crystallizes in the post-1968 period, that moment in which *The Godfather* phenomenon—the novel by Mario Puzo and its cinematic adaptation by Francis Ford Coppola—and Scorsese's *Mean Streets* (1973) erupt within mainstream culture. (Perhaps the best source to trace the formation of that discourse is *A Documentary History of the Italian Americans,* edited by Wayne Moquin along with Charles Van Doren and Francis Ianni and published in 1974.) The formation of this discourse signifies that Italian America had produced a group of organic intellectuals, to use Gramsci's term, who were concerned with writing *la storia* from their own point of view and with bringing to the interpretation of their own culture the instruments of sociological and anthropological analysis, if not yet critical theory. The central foci of this discourse were the two elements that had traditionally dominated the stigmatizing discourse on the Italian Americans, but now they were approached from within and in terms of "thick description": *la famiglia,* the strong and enmeshed family considered as good object, and, as a corollary, its demonic displacement, the "bad family" or crime "family." Crucial to the formation of this discourse was Richard Gambino's *Blood of My Blood: The Dilemma of the Italian-Americans* (1974), which codified the forceful workings of *la famiglia* as a disciplinary and identity-forming structure in terms of such traditional ideals as the **uomo di pazienza** (literally man of patience, but implying masculine behavior governed by inner control and reserve) and the **donna seria** (a nurturing woman who embodies the ideal of seriousness in her role as the center of *la famiglia*), thereby providing Italian Americans with a cultural grammar with which to speak of their selfhood. On the other hand, such works as Francis Ianni's *A Family Business: Kinship and Social Control in Organized Crime* (1972) began to move beyond the denial of the Mafia and to come to grips with its historical genesis as a subcultural formation. These works, along with others such as Andrew Rolle's psychological portrait *The Italian Americans: Troubled Roots* (1980) and Humbert S. Nelli's authoritative history *From Immigrants to Ethnics: The Italian Americans* (1983), would establish a way of speaking about the Italian American experience from within while preserving the objectivity of historical analysis.

One of the characteristics of the Italian Americans' discourse upon themselves is that it has only rarely taken the form of an operative criticism concerned with mobilizing a political identity or with intervening at the levels of antidefamation and aggressive monitoring of their image. This can be seen as a result

of their position of inbetweenness and their political assimilation—Italian Americans have to some degree abandoned their traditional political affiliation as Democrats; they cannot be counted on to vote in a bloc either for a Democratic candidate such as Mario Cuomo or a Republican candidate such as Alfonse D'Amato, the styles of the two political figures representing the ideological schism within the Italian American political identity, a schism that the Republican Fiorello La Guardia and the leftist radical Vito Marcantonio, both of whom commanded large Italian American constituencies, did not need to brook.

In any case, this important groundwork established the foundation for more specialized work in the eighties such as Robert Orsi's *The Madonna of 115th Street: Faith and Community in Italian Harlem, 1880–1950* (1985) and Di Leonardo's previously mentioned *Varieties of Ethnic Experience* (1984), which were supplemented by a series of celebratory works such as *The Big Book of Italian American Culture*, edited by Lawrence DiStasi and published in 1989, and Allon Schoener's richly illustrated and documented *The Italian Americans* (1987), which features a magisterial introductory essay by A. Bartlett Giamatti. A key work of journalism, which had a tremendous impact upon the way Italian Americans were perceived within mass culture, was "Italian-Americans Coming into Their Own," the previously cited 1983 *New York Times* article written by Stephen Hall.

Into the 1990s Italian American discourse has evolved beyond its immediate concern with documenting its institutions and history and turned toward the more critical tasks of theorizing about its traditions and contemporary identity, locating its presence in the common culture, and probing its representation and self-representation in literature and the arts. In other words Italian American writers and intellectuals have moved toward an operative criticism in keeping with the notion of strong ethnicity. In addition to Richard Gambino, whose seminal role has been discussed above, most of our contributors have played crucial roles in the elaboration of the contemporary discourse on the Italian American. In *The Dream Book: An Anthology of Writings by Italian American Women* (1985), Helen Barolini, a distinguished novelist and one of the strongest practitioners of Italian American women's writing, has singlehandedly established a canon of Italian American women's writing, thereby transforming a previously neglected and dispersed— "negated," in the Gramscian sense—group of works into a viable literary tradition from which future writers can claim a legacy. This breaking of the silence that has enveloped the "minor literature" ("minor" in the territorial and nonpejorative sense elaborated by Gilles Deleuze and Felix Guattari in *Kafka: Toward a Minor Literature* [1986]) practiced out of necessity by Italian American woman writers is a model for understanding Italian American writing overall as

well as minority literature in general in that it provides a diagnosis of "negated" writing, that solitary form of writing that is perpetually infiltrated by two silences: the silence stemming from the impossibility of writing and the silence stemming from the impossibility of writing the literature of the masters. It is, of course, from this silence that Italian American writers have won their strong voice. Mary Jo Bona, a literary critic who works from a feminist perspective, has extended Barolini's work in her anthology, *The Voices We Carry: Recent Italian/American Women's Fiction* (1994). Thomas Belmonte, the distinguished cultural anthropologist and polymath, has in *The Broken Fountain* (1989) elaborated a detailed anatomy of the Neapolitan culture of poverty that provides an essential counterpoint to the understanding of the Italian American urban condition. A specialist on autobiography, Fred Gardaphe, together with Anthony Tamburri and Paolo Giordano, has edited an omnibus volume *From the Margin: Writings in Italian America* (1991), that is an invaluable compendium of creative works and critical essays that at once presents the voice of Italian American writing and theorizes its position—the margin—within the common culture. Through his critical work (*Italian Signs/American Streets: The Evolution of Italian American Narrative*) and journalistic reviews (gathered in *Dagos Read* [1996]), Gardaphe has come to define a new breed of scholar-activists who specialize in the emergent field of Italian American studies and who are attempting to integrate the study of Italian American culture into the curriculum of the contemporary American university. This institutionalization of Italian American studies remains the fundamental task of this generation of Italian American intellectuals. Frances M. Malpezzi and William M. Clements, her husband, have meticulously recorded and painstakingly documented the entire "lived" cultural text of Italian Americans in their *Italian-American Folklore* (1992). Robert Viscusi, executive officer of the Ethyle R. Wolfe Institute for the Humanities at Brooklyn College at the City University of New York and the president of the Italian American Writers Association, has been instrumental in defining the emerging field of Italian American studies, in which he stands as the most authoritative reader of the Italian American literary experience. He has been both a practitioner and a theorist of "writing as an Italian American" as evidenced by his creative writing—the novel *Astoria* (1995) and the long comic poem *An Oration upon the Most Recent Death of Christopher Columbus* (1993)—as well as by his extensive critical output. His attempt to bring contemporary theory to bear on Italian American literature is epitomized by the series of tropes he proposes, in his essay in this volume, for a radical revision of Italian American literary history. Thomas J. Ferraro's *Ethnic Passages: Literary Immigrants in Twentieth-Century America* (1993) is destined to become a classic in the field. His broad-ranging essay in this

volume on Catholic ethnicity, with its use of "Mediterranean Catholicism" to understand ethnic spirituality, constitutes an important redimensioning of the discourse upon Italian Americans by situating their Catholicism within the context of transethnic American Catholicism and by establishing a grid with which to read the applied Catholicism at work in "secular"—artistic and cultural—practices. As exponents of strong ethnicity, Camille Paglia and Frank Lentricchia, two of America's foremost literary critics, have defined the tasks of the contemporary Italian American intellectual. As academics who have gained wide recognition in the media culture, they have constructed their intellectual personae in the typical Italian fashion by practicing a ***divismo*** (superstar-ism) of the "aggressive ethnic edge," thereby subverting the "laid-back" style of the "WASP establishment," as Paglia describes it. Having moved out of the "small world" of academia and gained name and face recognition in the media culture, they embody the traditional worldliness of the Italian intellectual, but the hybridity of their positions can once again be seen as a version of the inbetweenness discussed above. Both write otherwise, as Italian Americans who bring a libidinal force to their writing—the alternating current of Dionysian flows and staccato of Paglia's *Sexual Personae* and the oral speech rhythms of Lentricchia's *The Edge of Night*. Both theorize otherwise, bringing a particular Italian perspective to their reading of cultural texts: In *Sexual Personae* Paglia reads Western culture in terms of Italian pagan Catholicism; in *Criticism and Social Change* (1983) Lentricchia uses Gramsci to theorize his own conflicted transformation from a working-class identity to the role of a "traditional intellectual," always with reference to the Italian American context. "Making it," Lentricchia writes, "in my kind of context, then, may be one of the most insidious forms of betrayal, because the conditions of 'success' underwrite the social and political interests of that *padrone* who exploited our ancestors."

The work of these writers, all of whom have contributed to the codification of Italian American studies as a discipline and have written, at least in some of their work, from the subject position of ethnicity, can be seen to culminate in their essays in this volume. Thus, the volume can be read as an attempt to focus and extend the contemporary discourse upon the Italian American and as a historical index—and an "archive in the making"—of that discourse. Moreover, among our contributors are a number of artists and performers who approach their subjects through the lens of métier: Gioia Timpanelli, hailed as the "dean of American storytellers," tells *la storia* of storytelling from her unique position as the last of the ***cantastorie*** (professional storytellers) and the first of the new storytellers; Jo Ann Tedesco, whose play *Sacraments* (1978) involves the dramatization of everyday life that is emblematic of Italian American theater, presents from

the perspective of a New York playwright and actress a historical overview of Italian American theatrical culture that builds upon the work done on immigrant theater by Emelise Aleandri and then surveys for the first time the contemporary period; Stephen Sartarelli, a poet and translator, presents a history of Italian American poetry that is concerned with both thematic and formal matters as well as with situating Italian American poetry within the context of American modernism; and Fosca D'Acierno, our youngest and most decidedly fourth-generation contributor, brings to her essay on Madonna the hybridity of her generation's cultural identity, a hybridity reflected in her own bordercrossing between academia and performance, between America, her birthplace, and Italy, where she makes the scene as a singer of blues and alternative music.

Where the volume breaks new ground are the areas of music—popular as well as classical—and dance, visual culture (painting, sculpture, and architecture), and popular culture and the media, including the cinema, which has become one of the primary forms of Italian American expression. With the exception of cinema, which has a rich critical literature dedicated to it, these areas have not been previously treated in a systematic way in part because Italian American musical culture and visual culture have been so integral to the mainstream. The essays in this volume titled "Italian American Musical Culture and Its Contribution to American Music" and "From Stella to Stella: Italian American Visual Culture and Its Contribution to the Arts in America" are highly provisional attempts at mapping out these intricate areas and establishing canons of composers and dancers-choreographers and artists, sculptors, and architects.

Here I want to express my gratitude to Robert Connolly, an opera historian and "naturalized" Neapolitan, for his ***sprezzatura*** and dedication in serving as all-purpose musicologist for this volume. Moreover, as coauthors of the essay on music, Robert Connolly and I want to express our gratitude to Walter Simmons, Ron Odrich, and Gene Lees for their contributions and advice. I also want to thank Stanislao Pugliese, assistant professor of history at Hofstra University, for supplying us with a detailed timeline that will give the reader a sense of the monumental and linear history of the Italian American experience as it extends from 1492 to 1998 (see Appendix 1).

Italian American Language: Key Terms

As previously mentioned, this volume establishes a lexicon of key terms that inform the Italian American linguistic universe. Alphabetized in a separate Cultural Lexicon, these terms and their definitions are integrated into the individual essays, where they appear in bold type. Since our authors share a common lexicon,

INTRODUCTION

most of the terms are repeatedly used, but they are often defined in slightly different ways by individual contributors. The idea is to preserve the sense each author has of a given term and, by repeatedly redefining these terms, to suggest the rich connotations they evoke. It is interesting to note that our lexicon of Italian American key terms is almost identical to the repertory of forty-two current Italian terms set out by Giorgio Calcano in *Bianco, Rosso e Verde: L'identità degli italiani* (1993). This is quite surprising given that the Italian American terms derive in great part from the Italian of the Great Immigration. Of course, there are some lexical displacements: For example, while our lexicon constantly employs the traditional term *cafone*, *Bianco, Rosso e Verde* uses instead *burino*, a more contemporary term that covers the same social language of boorishness. Also, our lexicon contains an additional number of terms rooted in the culture of the *Mezzogiorno* that do not come into play in the repertory of standard Italian.

The Making of a Linguistic Identity: From Silence to the Construction of a Scriptural Self
Perhaps the most important narration this volume sets out is that of the generational formation of a linguistic identity, of a way of speaking and writing as an Italian American. The *contadini* of the Great Immigration emigrated from a culture of poverty (primarily agrarian) to a culture of poverty (primarily urban). These *contadini*, who came primarily from the *Mezzogiorno*, the "place where Christ stopped" or failed to penetrate, to use the emblematic title of Carlo Levi's 1945 ethnographic novel, the place that Marx had called the *Lazaronitum* (from the Italian **lazzarone**, Neapolitan beggar, and thus a pejorative designating the wretchedness of the southern subproletariat and its supposed laziness and dishonesty), were disenfranchised from official Italian civilization. Theirs was the archaic culture of the enmeshed and enmeshing family and the class culture—essentially folkloristic—of the subaltern. It was a culture of silence. They were, by and large, estranged from the mother tongue, the standard Tuscan-based language that had been imposed as the official, and effectively utopian, language of Italian unification, the language of the **signori** (masters), of bourgeois domination, and of the system that marginalized them. They spoke primarily a local dialect, although some of them were bilingual. Their linguistic identities were thus constituted in terms of the subcultural language of difference. Their culture was not oriented toward writing (the text) or the Word—official, bourgeois, the law. They in fact systematized the exclusion from, and refusal of, the official wor(l)d by the practice of **omertà** (a word derived from *omo* [man] and originally meaning manliness or self-reliance, but coming to have the primary meaning of a code of silence and dissimulation observed by criminals when interrogated by the law and by which

· xlvii ·

they maintained a conspiratorial network of protection. The term also has the secondary meaning of the wall of silence erected by a subculture or subaltern class to mask the secrets of its inner life from the intrusiveness of the "Other.")

This prologue in the *Mezzogiorno* helps to understand the alienation suffered by the immigrants to America. Their original estrangement from standard Italian was compounded by a second linguistic estrangement: their exile within their new mother tongue, English. Italian American immigrants and their children would come to be perceived as English-breaking speakers, as sublinguistic subjects unable to appropriate the new language, a status that has hardened over the years into the stereotype of Italian Americans as a group who disfigures, and whose members are disfigured by, language. (See in this volume the essay on the cinema.) Jacob Riis was among the first to diagnose the language problem of the Italian immigrant in a stigmatizing way:

> *His ignorance and unconquerable suspicion of strangers dig the pit into which he falls. He not only knows no word of English, but he does not know enough to learn. Rarely only can he write his own language. . . . Even his boy, born here, often speaks his native tongue indifferently (Riis, 1890).*

Although this is not the place to read through this assessment as A. Bartlett Giamatti has done, it is important to take the passage—against the grain intended by Riis—as a document of the linguistic deterritorialization experienced by the immigrant, a stranger in the house of the language. A more living document of the immigrant linguistic condition is provided by the famous vaudevillian Eduardo Migliaccio in one of his famous *macchiette coloniali,* spoken in the voice of Farfariello (see the essay on drama and the theater by Jo Ann Tedesco for a full description of these character sketches and their importance for immigrant vaudeville). I present first the original text "a lingua 'nglese," followed by a translation. (This *macchietta* can be found in H.L. Mencken's revised 1936 edition of *The American Language.*) Infiltrated by Italianized English words, which I have italicized, the sketch is just as much in "broken Italian" as in broken English.

> *Ne sera dentro na* barra *american dove il patrone era americano, lo* visco *era americano, la birra era americana, ce steva na* ghenga *de* loffari *tutti americani; solo io non ero americano; quanno a tutto nu momento me mettono mezzo e me dicettono:"Alo spaghetti; iu mericano men?"*
> *"No! No! mi Italy men!""Iu biacco enze?""No! No!""iu laico chistu contri?""No, no! Mi laico mio contry!"A questo punto me*

chiavaieno lo primo fait! *"Dice: Orre for America!" Io tuosto:"Orre for Italy!" Un ato* fait. *"Dice: Orre for America!" "Orre for Italy!" N'ato* fait *e n'ato* fait, *fino a che me facetteno addurmentare; ma pero, orre for American nun o dicette!*

Quanno me scietaie, me trovale ncoppa lu marciapiedi cu nu pulizio *vicino che diceva:"Ghiroppe bomma!" Io ancora stunato alluccaie:"America nun gudde! Orre for Italy!" Sapete li* pulizio *che facette? Mi arresto!*

Quanno fu la mattina, lu giorge *mi dicette:"Wazzo maro laste naite?" Io risponette:"No* tocche ngles.*" "No? Tenne dollari." E quello porco dello* giorge *nun scherzava, perche le diece pezze se le piggliae!. . . .*

One evening in an American bar where the owner was American, the whisky was American, the beer was American, there was a gang of loafers—all of them Americans. Only I was not American. All of a sudden they surrounded me and asked me:"Hello, Spaghetti, are you an American man?"

"No! No! I'm an Italian man!" "Are you a black hand?" "No! No!" "You like this country?" "No! No! I like my country! I like Italy!" At this point they gave me the first punch! "Say: Hurray for America!" I said instead: "Hurray for Italy!" Another punch. "Say: Hurray for America!" "Hurray for Italy." Another punch, then another punch, until they knocked me out; but I never said, "Hurray for America!"

When I came to, I found myself on the sidewalk with a policeman nearby who said:"Get up, you bum!" I was still stunned:"America no good! Hurray for Italy!" Do you know what the policeman did? He arrested me.

When morning came, the judge asked me:"What was the matter last night?" I responded:"I don't speak English!" "No? Ten dollars." And that pig of a judge wasn't joking, because he took ten bucks from me!

Of course, the humor at play in this sketch intended for the immigrant audience lies in the use of "Italglish," the spoken language of the immigrants which, as Michael La Sorte has emphasized, was essentially an insider's language. ("Italglish" was coined by La Sorte in 1985 in *La Merica: Images of Italian Greenhorn Experience*, the definitive work on the immigrant idiom.) Italglish was at once a carnivalizing language through which the immigrants accommodated themselves to English and the idiom that opened them to stigmatization. The sketch is about linguistic identity: The American "loafers" attempt to coerce Farfariello to say "Hurray for America" while he staunchly refuses, a refusal already embedded in his use of a broken language, a language inbetween Italian and English. The event culminates

in the typical immigrant's loophole phrase addressed to the judge, "No tocche ngles!"—all too ironically, for the sketch is about the immigrant's experience of verbal hatred ("Hello, Spaghetti"; "Are you a black hand?") and his refusal to perform an "American" speech act, to "tocche ngles."

The linguistic history of the Italian American involves moving beyond this double estrangement from language and the silence that issues from it. Overcoming this estrangement has involved the appropriation of a monolingual American linguistic identity and, given that the Italian immigration preceded the late-twentieth-century pedagogy that seeks to engender bilingualism and biculturalism, a certain stripping away of the Italian linguistic identity. The problem for contemporary Italian Americans is the maintaining or, in many cases, the constructing of an Italian linguistic identity from scratch by formal study. This leads to another one of those typical Italian American double binds: the contemporary Italian American whose grandparents belonged to the world of the dialectic now learns to speak what Albert Innaurato calls "Harvard Italian." It is interesting to note that Innaurato in his play *Gemini* (1977) voices through the character Fran the deprecatory attitude toward the dialectic typical of second-generation Italian Americans: "You see dear, that's Harvard Italian. We don't speak that. . . . You see, my people over there was the niggers. The farm hands, they worked the land. We're abbruzzese; so we speak a kinda nigger Italian." Here the dialect is seen as the stigmatizing language of outsiders, its sense as an insider's language having been completely lost. It is important to point out that the dialect was a site of a rich cultural production in Italy: Some of Italy's greatest literary creations, such as the Roman poetry of Belli and the Neapolitan plays of Eduardo De Filippo, and its various local repertories of popular songs were written in the dialect. Furthermore, the dialect served as the visceral language of the skin, of blood: the deep language of identity in which its speakers lived out their familial and tribal scenarios. As Italy entered the Age of Mass Media, standard Italian has almost come to obliterate the subcultural worlds of the dialect. As *parole abbandonate* (abandoned words), certain dialectical terms, including those still employed by Italian Americans as part of their passional language, remain souvenirs of a receding past, ethnic signifiers that curiously enough maintain their primordial force, as in the previously discussed case of *sfaccimma*, because they enact the return of the repressed, bringing into play the effective remainder that standard speech has suppressed. All of this is to say the obvious: The linguistic side of the project of Becoming Italian involves constructing a strong linguistic identity in both languages, including awareness of the *parole abbandonate.*

The history of the Italian American linguistic identity can be seen to pass from the Italglish of the immigrants to Mario Cuomo's keynote address, "A Tale

of Two Cities," delivered at the Democratic National Convention on 16 July 1984. In that galvanizing speech the Voice of Italian America became one with the Voice of America for the first time. Cuomo presented the immigrant experience as a model of democratization and projected the strong Italian American family into a political paradigm for the "shining city." In that speech, St. Francis of Assisi became the "world's most sincere Democrat," and the Italian American became a figure of political and linguistic "normalcy." A measure of how far that normalization has come can be found in the notorious comment by then President Richard Nixon who, unable to brook his nemesis Judge John Sirica, said in the early 1970s during Watergate: "He's Italian and I don't deal with them. They're not like us." The line is "White" enough to merit inclusion in Emile De Antonio's documentary *Millhouse: A White Comedy* (1971), and it is too bad that De Antonio (1920–1989), one of America's most provocative documentarists and another of Nixon's Italian American nemeses, assembled his *humour-noir-et-blanc* documentary before Nixon uttered it.

Overcoming the silence, on the other hand, has involved the forging of a scriptural self, the great epic of which is Pietro di Donato's *Christ in Concrete,* in whose English the syntax and the grain of the immigrant's voice is registered. Whereas the deterritorialization of the first immigrants was expressed in the jargon of the greenhorn—broken English/broken Italian—di Donato's deterritorialization is expressed in English: He cannot write in Italian, which is no longer his language; he cannot write in English, which is not his language; nevertheless, he cannot write in any language other than English. Out of this linguistic double bind comes the destabilized language of *Christ in Concrete* in which that strategy of hybridity, to use the cultural critic Homi Bhabha's term, is employed, but rather than producing a polyphonic writing (for example, one in which the narrator speaks standard English and then assumes, whether through dialogue or free indirect style, the dialectic of his immigrant subjects), the entire novel is written in the language of the Other—a hybrid English, a palimpsestic writing in English through which Italian speaks. Di Donato raises the question of writing as an American Italian and Italian American for the first time. For the writers who come after him and who no longer write from the same linguistically hybrid position, the problem becomes that of writing as either an Italian American or an ~~Italian American~~. It is precisely this question of *writing as an Italian American* that the essays in this volume dedicated to literature seek to address. The problem of forging a scriptural self is always there as a subtext to Italian American writing: It appears in its negative form in Gay Talese's notorious query: "Where Are the Italian American Novelists?"; in Helen Barolini's assessment, in the Preface to *The Dream Book,* of the loneliness of Italian American woman writers: "We stand alone, seem-

ingly unconnected to any body of literature or group of writers—anomalies, freak occurrences, non repeaters, ephemera"; in Camille Paglia's triumphant assertion: ". . . look within one generation you get: *Sexual Personae*. One generation! I write English better than the English!"; in Frank Lentricchia's scriptural agon: "A sentence, a sentence, my family for a sentence."

Being-Becoming Italian American

We now leave the project of Being-Becoming Italian American in the hands of our readers. As the strong contribution by women writers to this volume will make clear, that project must be conceived in terms of a new dialogue between *donne* and *uomini*. Given the new multicultural terrain, it must also be forged in terms of a bordercrossing dialogue with other ethnicities and races, a model of which will be established by the publication of the succeeding volumes of *New Ethnic American Literature and Arts*. Perhaps most crucial, such a dialogue must address the common culture in such a way that strategies of selfhood and communal representations may be elaborated and that the "Italian cultural difference" may be maintained both through the ongoing process of assimilation and through a deeper commitment to acculturation—that is, to translating the heritage of Prospero's books, and what they omit, into contemporary terms and bringing it to bear on the fashioning of selfhood in the postmodern world. To our non-Italian readers: Know that our attempt to "translate" ourselves and to articulate the signs of our cultural difference is effectively addressed to you, for it is through the process of "translation" that the cultural self is most fully defined.

Again, I want to thank George J. Leonard for providing us with this forum and for his enlightened view of what constitutes the writing of ethnicity.

I also want to thank Garland Publishing for their strong and enabling support of this volume. We are particularly indebted to our editors Marianne Lown, Carol Buell, Adrienne Makowski, and Anne Vinnicombe, who have guided us in transforming a complicated and idiosyncratic manuscript into a well-wrought text. To our brave copyeditor and first reader Mary K. Cooney goes our profound gratitude: Never have we found an editor more skilled and exacting, nor one who has been more faithful to the process of readying a text for publication.

Further Reading

THE DISCOURSE UPON THE ITALIAN AMERICANS

Barolini, Helen, ed. *The Dream Book: An Anthology of Writings by Italian American Women* (New York: Schocken Books, 1985).

Bona, Mary Jo, ed. *The Voices We Carry: Recent Italian/American Women's Fiction* (Montreal: Guernica Editions, 1994).

Cuomo, Mario. *More than Words: The Speeches of Mario Cuomo* (New York: St. Martin's Press, 1993).

Di Leonardo, Micaela. *The Varieties of Ethnic Experience: Kinship, Class, and Gender Among California Italian Americans* (Ithaca, N.Y.: Cornell University Press, 1984).

Ferraro, Thomas. *Ethnic Passages: Literary Immigrants in Twentieth-Century America* (Chicago: University of Chicago Press, 1993).

Gambino, Richard. *Blood of My Blood: The Dilemma of the Italian-Americans* (Garden City, N.Y.: Doubleday, 1974).

Gardaphe, Fred. *Italian Signs, American Streets: The Evolution of Italian American Narrative* (Durham: Duke University Press, 1996).

Hall, Stephen. "Italian-Americans Coming into Their Own." *New York Times Sunday Magazine*, 15 May 1983.

Ianni, Francis A. J., with Elizabeth Reuss-Ianni. *A Family Business: Kinship and Social Control in Organized Crime* (New York: Russell Sage Foundation, 1972).

LaGumina, Salvatore, ed. *Wop: A Documentary History of Anti-Italian Discrimination in the United States* (San Francisco: Straight Arrow, 1973).

La Sorte, Michael. *La Merica: Images of Italian Greenhorn Experience* (Philadelphia: Temple University Press, 1985).

Lentricchia, Frank. *The Edge of Night* (New York: Random House, 1993).

Malpezzi, Frances, and William Clements. *Italian-American Folklore* (Little Rock: August House, 1992).

Mangione, Jerre, and Ben Morreale. *La Storia: Five Centuries of the Italian American Experience* (New York: HarperCollins, 1992).

Moquin, Wayne, ed., with Charles Van Doren and Francis A. J. Ianni. *A Documentary History of the Italian Americans* (New York: Praeger, 1974).

Nelli, Humbert S. *From Immigrants to Ethnics: The Italian Americans* (New York: Oxford University Press, 1983).

Orsi, Robert. *The Madonna of 115th Street: Faith and Community in Italian Harlem, 1880–1950* (New Haven: Yale University Press, 1985).

———. "The Religious Boundaries of an Inbetween People: Street *Feste* and the Problem of the Dark-Skinned Other in Italian Harlem, 1920–1990." *American Quarterly* 44, no. 3 (September 1992): 313–347.

Paglia, Camille. *Sexual Personae: Art and Decadence from Nefertiti to Emily Dickinson* (New Haven: Yale University Press, 1990).

———. *Sex, Art, and American Culture: Essays* (New York: Vintage Books, 1992).

Riis, Jacob A. *How the Other Half Lives: Studies Among the Tenements of New York* (New York: Charles Scribner's Sons, 1890).

Rolle, Andrew. *The Italian Americans: Troubled Roots* (New York: Free Press, 1980).

Schoener, Allon. *The Italian Americans* (New York: Macmillan, 1987). This volume contains an authoritative introductory essay by Bartlett Giamatti, a collection of essays and an archive of photographs documenting the Italian American experience, and an exhaustive bibliography compiled by Remiggio Pane.

Tamburri, Anthony. "To Hyphenate or Not to Hyphenate: The Italian/American Writer and Italianità." *Italian Journal*, 3, no. 5, 1989: 37–42.

Tamburri, Anthony, Paolo Giordano, and Fred Gardaphe, eds. *From the Margin: Writings in Italian*

America (West Lafayette, Ind.: Purdue University Press, 1991).

Viscusi, Robert. "'De vulgari eloquentia': An Approach to the Language of Italian American Fiction." *Yale Italian Studies* 1 (Winter 1981): 21–38.

———. "The Text in the Dust: Writing Italy Across America." *Studi emigrazione* 19, no. 65, 1982: 123–130.

———. "Circles of the Cyclopes: Schemes of Recognition in Italian American Discourse." In *Italian Americans: New Perspectives in Italian Immigration and Ethnicity,* ed. Lydio Tomasi (New York: Center for Migration Studies, 1996).

———. "'The Semiology of Semen': Questioning the Father." In *The Italian Americans Through the Generations,* ed. Rocco Caporale. (Staten Island, N.Y.: American Italian Historical Association, 1986).

———. "Breaking the Silence: Strategic Imperatives for Italian American Culture." *Voices in Italian Americana* 1, no. 1, 1990: 1–13.

The Discourse upon the Italians

Banfield, Edward. *The Moral Basis of a Backward Society* (New York: Free Press, 1958).

Barzini, Luigi. *The Italians* (New York: Atheneum, 1964).

Belmonte, Thomas. *The Broken Fountain,* 2d ed. (New York: Columbia University Press, 1989).

Bollati, Giulio. "L'Italiano." In *Storia d'Italia: I caratteri originali.* Vol. 1 (Torino: Einaudi, 1972): 951–1022.

Calcano, Giorgio. *Bianco, Rosso e Verde: l'identità degli italiani* (Bari: Laterza, 1993).

Calvino, Italo. *Six Memos for the Next Millennium* (Cambridge: Harvard University Press, 1988).

Gramsci, Antonio. *Selections from the Prison Notebooks* (New York: International Publishers, 1971).

———. *Selections from the Cultural Writings,* ed. D. Forgacs and G. Nowell-Smith (Cambridge: Harvard University Press, 1985).

Greenaway, Peter. *Prospero's Books: A Film of Shakespeare's* The Tempest (New York: Four Walls Eight Windows, 1991).

Levi, Carlo. *Christ Stopped at Eboli,* trans. Frances Frenaye (New York: Farrar, Straus, 1947).

Praz, Mario. *The Flaming Heart: Essays on Crashaw, Machiavelli, and Other Studies in the Relations between Italian and English Literature from Chaucer to T.S. Eliot* (Garden City, N.Y.: Doubleday, 1958).

Part I

Identity

The Contradictions of Italian American Identity
An Anthropologist's Personal View

Thomas Belmonte

In 1914, as Italian immigration into this country was close to peaking, the eminent sociologist E.A. Ross advised his readers to observe immigrants, not in their workclothes, but "washed, combed, and in their Sunday best. . . . Not that they suggest evil," he was careful to write, "they simply look out of place in black clothes and stiff collars, since clearly they belong in skins. . . . These oxlike men are descendants of those who always stayed behind."[1]

I am the son of the son of one of these "oxlike men." I have been more fortunate than he. Perhaps because I have encountered so little ethnic prejudice in my life, I have never become inured to it. I have never taken it for granted.

I don't remember my grandfather's hands, but my father does. My grandfather died when I was two years old. My father tells me how he bounced me on his lap and toasted his wife, whom he revered always as his bride. He praised the greatness, not of warriors, but of poets, and even composed verses of his own. My grandfather was a man of the Puglian earth, although he never owned even a small parcel of it. His index and middle fingernails were split from wielding a scythe that was so sharp it cut through the clothespins he used as makeshift guards.

Of America my grandfather also sang, of his pride in being a citizen, and in having the right to vote.

I can still see my father's hands. Even in old age, they are as powerful as a champion boxer's but capable of the finest precision. My father is a master mechanic, five years retired. The creases of his hands are still stained with black engine grease. His palm may not tell you his future, but from its lines you can read the story of his life. He labored.

In south Italy and in the cities of America, the children were early work-

Boldface terms are defined in the Cultural Lexicon which starts on p. 703.

ers, sent out into the city to forage or get a menial job. The early insistence that the child contribute to the family was to have portentous consequences in a society where the mastery of high literacy was the only legitimate means by which an immigrant might gain access to the corridors of power. So my father, who was the son of a peasant-poet, a bard, spent his youth gathering coal in rail yards and worked in a German American delicatessen. He never did earn a high school diploma.

After serving in the Pacific during World War II, my father worked, through the 1950s and 1960s, ten hours a day, six days a week, fifty-one weeks a year. Like so many Italian American men of his generation, he was a working man more than he was any other kind of man. He took great pride in his much sought after skills as a diagnostician of car engines. But the professional notion of "gratifying" work would have been alien to him. Like the gasoline he rinsed his hands with at the close of every day, the work saturated his pores and burned away at the nerve endings of his fingers.

As a child I took the full measure of my father's hands, but somehow I always knew that these overworked hands were possessed of a rage of their own and that he, himself, was a tender man, whose sense of grief and beauty was too great to ever be fully acknowledged. On Sundays and holidays he would tell vivid tales of the war, of New Guinea and Japan. Indeed, Kyoto was a place better known to me than Rome. My father never accompanied the rest of us to church. Our formica table was his altar. Italian bread and cheap California wine were sacred enough for him.

I recall many Easter Sundays, but one in particular stays in my mind, that of 11 April 1971. I was two years married. My daughter Christina was four months old.

The linen tablecloth that my mother had so carefully unfolded and spread out was interwoven with silken crowns and diadems that caught the sunlight in mauve and amber tints. What covers a table is important to Italian Americans.

On that day we began with **antipasto**, sliced eggs and anchovies and provolone cheese, oven-roasted red peppers, olives, and marinated shallots, known in Italian as *cipolline* (baby onions), but, in the far more expressive Pugliese dialect, referred to as *bombascione:* literally, bombs that split the air like an ax! We ate artichokes stuffed with garlic, bread crumbs, parsley, and cheese. We drank red wine and champagne. We didn't always eat pasta. That day, we ate roast turkey and baked ham, buttered asparagus, broccoli, salad, plenty of stuffing, and hot rolls.

For dessert there was **espresso** (Italian coffee) in decorous little cups that

belonged to my grandmother. My mother put out trays of pastries, egg biscuits covered with pink glaze, languishing in a sweet aura of anisette. She set down, ever so gently, a lemon meringue pie my sister made. (At Italian American meals you always credit the cook.) Finally, in the table's center, she placed a round, ruffled, milk-glass bowl, arranged with oranges, red grapes, and a lemon that shone with an April Sunday's lemon-yellow light. For Italian Americans the presentation, arrangement, and even the serving of foods is an art form that hides behind the appearance of spontaneity. To end the meal my mom poured out a heap of nuts directly onto the tablecloth, and we cracked them without regard for the mess.

We argued politics that day, my father and I. We talked unions, and music, and wine. And I heard, behind our boisterous voices, a lively, exuberant song, the voice of Lou Monte, singing "*Eh Cumpare!*" (literally, "Hey, co-father!" from the relationship of **comparaggio**, a ritualized fictive kin tie between a child, her parents, and her baptismal sponsor). Later, as the afternoon wore into dusk, the sounds of Puccini's "bel sogno di Doretta," from his opera *La rondine* drifted like a stream of liquid crystal to my ears, smooth and warm as a rich golden liqueur. You see, my father, the rough mechanic, was also a connoisseur.

I was reared in the multiethnic working-class suburbs of Long Island, far from the mean city streets that had been the testing ground of my father's manhood. Whereas, for centuries and perhaps millenia, my ancestral fathers had worked *beside* their fathers in wheatfields, vineyards, and olive groves to one day *become* their fathers, my father was the first to have a life radically torn from its paternal roots. My own Icarus-like ambition to fly upward and past the peasant and working-class origins of my ancestral grandfathers was not without peril. Like so many upwardly mobile Italian American men of my generation, I ran the risk of soul-loss and rigidity that comes to all of us when we lose all memory of our roots and of our fathers.

My father still has a jagged white scar above his heart. It is not a war wound. While he was seated in the immense and fantastically ornate Valencia Theater on Jamaica Avenue (in Jamaica, Queens), a gang enemy crept up behind him and plunged the dagger deep, with intent to kill.

As Americans have fled to the suburbs, it is easy to underestimate the role that demarcated and defended city neighborhoods played in amplifying the already fierce Mediterranean masculinity of the immigrant males and their sons. This fierce masculinity is often caricatured by the media and by Italian Americans themselves, who are eager to embrace a *mythos* that would bestow, if not dignity, at least brute strength.

Southern Italian men had always defended their honor through the concept of female inviolability.[2] As long as the women of the natal group had **vergogna** (shame), the men retained their **onore** (honor as self-respect, and the respect and fear of other men). Indeed, the word **rispetto** (respect) still has deep emotional resonances in Italian American life.

But in the years leading up to the Great Depression and beyond, on sidewalks and brownstone stoops, in tenement corridors and shared hallway bathrooms, they were confronted with the challenge of ethnic alien male suitors of their daughters and sisters, suitors who knew nothing of their ancient Mediterranean honor code and cared not to know.

A second factor that pressured toward a rigid and heavily armored masculinity among Italian American men was the emergent contradiction between the mother-centered and oral-commensal values of the home and the more Darwinian, male-dominated world of the street.[3] The cultural estrangement of second-generation sons from the austere world of their peasant fathers (a world that did not include baseball, boxing, and Coney Island) led them to redefine and readjust their code of manhood in terms that would compensate for the strong emotional hold that their mothers retained on their sexuality and that would also serve to keep outsiders out of local networks of illegal commerce and exchange. No wonder then that the favored American image of the Italian American male is still that of the prelinguistic tough guy. Toughness, more than the mere mastery of language, allowed a man to venture outside the home to a place other than church. Toughness could not be faked but was forged and tested in bloody combats of Homeric scale.

Gang wars of murderous ferocity were waged among Italian, Irish, Polish, and, to a lesser extent, African American and Hispanic youth on a weekly basis from the early years of the Great Migration (1880–1920) through the late twentieth century. *West Side Story* (1957), the Broadway musical by Leonard Bernstein, uses the plot of *Romeo and Juliet* to dramatize the severity of these interethnic tensions. More recently the 1987 film *China Girl,* by the Italian American director Abel Ferrara, documents, in terms again reminiscent of *Romeo and Juliet,* the love of a pizza boy in New York's Little Italy for the sister of a young Chinese gang leader. The tendency of all humans to "pseudospeciate," to treat members of another group as though they were members of an inferior, animal species, is portrayed through images that are both raw and poetic.

In September 1990 a young African American man named Yusuf Hawkins wandered into the Italian American neighborhood of Bensonhurst, Brooklyn, looking to buy a used car. He was brutally chased and murdered in cold blood by a

gang of Italian American youths who thought he was the African American lover of a local Italian American woman.

The furor surrounding this tragedy was attributed entirely to the undeniable racist hatred that these young men bore for members of other ethnic and racial groups. Hatred, after all, holds people together, roots them to a neighborhood, and keeps invaders at bay. But the deeper issue revolved around the ancient code of female inviolability as sacred and unassailable by *any* outsider on pain of death. The homicidal rage that led to Hawkins' murder was spurred by a young woman's willingness to relinquish her *vergogna* and the consequent diminution in the group's limited and vulnerable fund of male honor. Frank Pugliese's prophetic play *The Avenue U Boys* (1993) documents some of these same intergroup conflicts from the inside out.

It was in such inward-looking neighborhoods as Bensonhurst, Little Italy, and Italian Harlem that the American **Mafia** was born. As in Sicily, the Mafia spread in the manner of an opportunistic social infection. Because there was a break in the connective tissues of the local civil society—the apparatus of police and courts that was supposed to regulate immigrant life—the Mafia was able to germinate in the empty spaces in the body politic where legitimate power should have been.

In Sicily the absenteeism of the aristocratic estate owners (who preferred lives of luxury in Palermo and Paris to the gritty details of agricultural enterprise) gave rise to a new class of gun-toting estate managers and tax collectors, known as *gabellotti*. It was this intermediary class of entrepreneurs, many of them shepherds by derivation (with no ties to the soil), who forged the complex system of alliances and cultural codes that became, in Sicily and, to a lesser extent, in Naples and Calabria, a vast but invisible edifice of power and influence that rose parallel to that of the official state.

There is scant historical evidence to support the notion that the American Mafia was transplanted to the cities of America by settler-founders with a clear organizational mission. In the cities of America (as Jerre Mangione and Ben Morreale have emphasized), the Mafia probably began as an Italian variant of the gang and gangster subculture that had long been dominated by earlier ethnic arrivals.[4] Just as in America's contemporary urban war zones, two moralities contended for the hearts and minds of the community—one based on the "decent" values of the home; the other, on the code of the streets with its adulation of the power both to defend and to take. In the early part of the twentieth century, brutal but unstable gangs of extortionists (the most notorious of which was known as *The Black Hand*) attempted to intimidate local entrepreneurs and to control the food and retail trade within the ethnic enclave. During the Prohibition years,

these criminal gangs expanded their operations. If the Italian gangs were unique, it was in the way they were able to appropriate the "decent" code of the family and subvert it to the purposes of the street. Thus did the most brutal and parasitic of thugs gain renown as benificent neighborhood patriarchs. By skillfully utilizing both the substance and the symbolism of the ancient *famiglia,* Italian gangsters could more effectively consolidate control over an expanding resource base.

Through the 1950s and 1960s, Mafia extended "families" made inroads into the construction trades, into the rigging of unions and bids, and into liquor delivery and garbage hauling. More recently, they have moved their considerable wealth into legitimate family-run enterprises that both process the profits and serve to mask the illegal side of the business empire. As in the corporate organizations of Japan and northern Italy (both latecomers to capitalism), the evolving core of the mature Mafia corporation (so well described by anthropologist Frances Ianni) was a dynastic lineage of patrilineal kin—a father, his brothers, his sons, and their sons—who adhered to a strict code of obedience, vendetta, and silence.[5]

If the American Mafia can be said to have achieved anything positive, it was to demonstrate to the rest of American society the utility of kinship as a force for synchronizing behavior in the early phase of a business's growth. The popularity of the Mafia as a theme for the mass media testifies to a fascination with an exotic but highly successful form of high-risk entrepreneurship, operating on the economic and moral frontier. In both America and contemporary Italy, the Mafia represents the historical survival of a pre-Christian and even actively anti-Christian ethos. The Mafia ethos privileges males over females, greed over charity, deception, trickery, and blood vengeance over honesty, reparation, and forgiveness. It revels in terror and sadistic cruelty over healing and compassion. Italian American lives are destined to fall under its regressive shadow until Italian Americans themselves repudiate its creed as a violation of their humanistic, Christian, and American heritages.

Italians and Italian Americans are social beings. They would never understand the Kierkegaardian concept of identity as a sorrowful outgrowth of somehow "going it alone." Identity is the fruit of intense participation in relationships and groups. For males, especially, the capacity for daily and lively conversation with other males in the local *caffè* is one of the defining signs of manhood. The Italian never contemplates the philosopher's stone by himself but takes a *passeggiata* (a walk, usually arm in arm, with a close friend) in order to discover truth. Understanding is a Socratic process that unfolds before two people arguing and reasoning. Insight is achieved, not through a linear process but rather by going round and round the ***piazza*** (plaza), block, or neighborhood park and noting, step by step, previously un-

seen aspects of the truth. The south Italian word for a child who cannot yet speak is *una creatura* (meaning animal or creature). The implication is that selfhood and full membership in the social group are possible only in discourse.

Likewise, birth, marriage, and death are social occasions in Italian American life. These events assemble and unite a large group of kinfolk, co-godparents, friends, and neighbors around both the individual in transition and the symbolic, gustatory, and aesthetic accessories to that transition. Throughout the life cycle, and especially when one departs, one travels *in compagnia* (in the company of others).

I recall a funeral that I attended as a child for my aunt, a beautiful young woman, dead of breast cancer at age twenty-eight, leaving her husband and recently widowed father, and two small children (my cousins Jeannie and Guy), behind.

Great sprays of blood-red roses depicting a bleeding heart formed a rich canopy and fell to the floor like an expensive brocade around my aunt's coffin. The coffin was of dark, lacquered wood. Polished to gleaming, it seemed to catch and preserve within itself the fires of the myriad candles flickering about the room.

That day of her burial my aunt wore a dress I had never seen before, of stiff white lace and lavender silk. Apparently this had been a gift from my uncle, in the hope that she would wear it upon recovering. The rosary beads of mother of pearl, the ones she kept in a box on her vanity, were entwined around her wrists. I watched her lips intently to see if they moved in prayer.

Everyone wept loudly when they took my aunt to the cemetery in a shiny black Cadillac and buried her. As they lowered the casket into the earth, my grandfather dropped to his knees and beat his chest violently with his fists. He cried out in Italian, "*Gesù! Gesù! Perchè? Perchè?*" (Why Jesus? Why?). When the old man collapsed at the grave site, my widowed uncle, who was what they called an **uomo di pazienza**, (a man of patience), put his hand on grandpa's quaking shoulder and said in a voice infinitely stoical and sad, "C'mon, Pop. Time to go, Pop. Time to go." Only when I saw this proud, white-haired old man sprawled thus in the wet May grass, thrashing about, utterly ravaged by grief, did I truly realize that my aunt was dead, and joined in weeping with the others. Afterward we returned to my deceased aunt's home in Middle Village, Queens, where a lavish but solemn feast awaited.

Americans might be either repelled or amused by such open displays of emotion, but Italian Americans behave as if they believe that emotions themselves possess inalienable rights. The pounding fists and raucous shouts of anger, the spasms and high hoots of belly laughter, and the hard claw-like sobs of grief are heard, at some time or other, in most Italian American homes.

Children learn early that corporal punishment, taken at times to excess by middle-class American standards, is an outlet for parental frustration. Thus they also learn at a very early age that their parents are all-too-human and that the parable-ridden morality of the parental generation is compromised by outbursts of explosive passional feeling that clearly take priority over whatever lesson is supposed to be conveyed by this or that spanking. Life inside Italian American families tends to cut close to the bone, to expose the nerve in the marrow. The playwright Albert Innaurato has accurately captured the emotional drama and boisterous tones of Italian American family life in his play *The Transfiguration of Benno Blimpie* (1973). His more successful and famous work, however, the Broadway hit *Gemini* (1977), was a proletarian puppet show that, with its scatological language and depictions of hurled food and poor hygiene, confirmed for its predominantly upper-middle-class audiences every cliche that they ever wanted to believe about Italian Americans in particular and working people in general. In my own family, powerful emotions of love and anger found a nightly outlet at our table, but there were unspoken rules that reminded all of the essential sacredness of food and of the language that was appropriate in one's mother's presence. The emotion was raw, but the rules were strict.

Whether this propensity to accept the display of real feeling as the inevitable price of staying human has served those Italian Americans who want to join the upper-middle-class stratum of American life is doubtful. Adaptation at this level requires that genuine emotions be denied, restrained, or held in. Italian American childhoods simply do not prepare for these dubious skills.

It is not possible to comprehend the role that the family and family feeling play in Italian American life without returning to its origins in south Italy. So strong is the commitment to family values in south Italy that one American sociologist, Edward Banfield, coined the rather ethnocentric term "amoral familism" to describe it.[6] During his sojourn in a south Italian town, Banfield was appalled at the relative absence of volunteer-based civic and community organizations. The family seemed to be the omega point of social evolution.

Banfield interpreted family loyalty in negative terms, as a cramped pathological response to the failures of public institutions, but, when placed in the contexts of history and anthropology, unquestioned loyalty to the family begins to make good sense. Nor is it the only form of loyalty of which the peasants were capable.

The world of the south Italian was a world forged amid the ruins of the Roman Empire and the hierarchical feudal edifices and institutions that were built out of Roman rubble. The landscapes of south Italy still appear as they did in the

fifteenth century. The forests have long been cut down (for the navies of Venice, Genoa, and Naples), but the castles and defended hilltop towns, which seem from a distance to have been hewn from one block of chalk-white stone, remain. To the annoyance of speeding motorists, the mules remain. The sun-beaten faces of the mature and older women (the "women of the shadows," whose lives the writer Ann Cornelisen has spent a lifetime documenting) remain, to stare down and repel the hundreds of social scientific interrogators who have descended on their villages.[7] The respect-as-fear accorded the ruthless baronial strongman remains. Blood feud, and the rule of manly honor (known to Sicilians as **omertà**) that effectively seals this closed world off from the probing curiosity of all outsiders—these also remain.

Daily life in this world of ancient stones and plodding mules propagated its own theory of human nature and its own perspectives on the unalterable frameworks of existence. The historical demographer Rudolph Bell has shown why the concepts of fate, honor, family, and village made more sense to the peasants than their modern counterparts—knowledge, law, the individual and the nation.[8] At the heart of this worldview was the inability of either the individual or the society to control death.

Deaths peaked in August and December. The summer took the young, and the winter took the old. Rates of infant and child mortality in the Italian south were as high as 40 percent in the early years of the twentieth century. Babies died when their mothers left them in order to do the work of survival in the fields. They died from being fed *la pappa,* a nonsterile mixture of grain and animal's milk. They died of endemic typhoid, malaria, diphtheria, and meningitis. The death of a small child was so common that it was referred to as *un dolore accettato,* a pain that could be accepted. If the wail of the mourner pierced and echoed through the night, people only nodded, because wailing was the sound that honor made when it was under death's dominion and was no more avoidable than the horrid squealing that rips forth from the throat of the pig on the autumn morning of its inevitable slaughter.

It was sights such as these, endlessly repeated across lifetimes and generations, that created the perspectives on existence with which the immigrants viewed their experience of the great industrial hubs of America. Theirs was a tragic sense of life and a defended one, both ancient and wise. It was not optimistic or in any way utopian. It assumed that human beings were easily corrupted, easily self-deluded, easily selfish and cruel, and easily given over to madness. I remember my Pugliese grandmother's metaphor for the human mind. It was as fragile and as delicate, she once told me, as the golden and sheer silken skin that is first peeled off from the onion.

Not that the culture of the southern peasant was entirely circumscribed by these pessimistic, if tacit, understandings. If an ethos of cunning (*la furbizia*) was central to the worldview, so also were the prestige and approval accorded to any manifestation of generosity. In fact, generosity of spirit (and of one's table) is a hallmark of the Italian temperament. For example, the traditional strict taboo on May weddings in southern Italy is, according to Rudolph Bell, comprehensible in terms of the insufficiency of food for a feast in that month. If you can't feast, you can't marry.

Precisely because the arenas of economic survival were so harsh and unregulated in an essentially medieval society, where, *de facto,* might was right, the Italian immigrant sacralized the values of family loyalty and mutual help between close kinsmen. The primary human bond of Madonna and child was etherealized and symbolized in the figure of the *Pietà* as the highest manifestation of human love because, up to age twenty, sons did often die in their mother's arms, and because throughout the life cycle, for those ever-cognizant of its contingency and finitude, this bond, forged of nature and culture, was the most steady and reliable.

The word the peasants used for the hunger that came with famine was *la lupa* (the she-wolf). The word they used for the insect pests that devoured an entire crop in a matter of days was also *la lupa*. The peasants knew that men and locusts, when hungry, behave the same. Their view of all social forms was conditioned by their awareness of the depths to which human life could sink in a society without faith in the fairness of law. Southern Italians are only too aware of the impotence of mere morality in the face of hunger and want, envy, jealousy, and rage. So for the immigrant the bonds of blood and the organic sense of oneness that could be shared with parents, sisters, brothers, cousins, and perhaps spouses were the only real guarantees of human warmth and goodness in a fallen world. True friendship is a poorly developed concept in the Italian south, often confounded with hospitality. The category of the volunteer does not exist.

The world beyond the family might be civil or it might be barbaric, hostile or inviting, but the point was not to trust it or pledge one's allegiance to it, because in the worst-case scenario—of anarchy, chaos, and greed—the rabid wolves that are chained up in every human heart would run amok. Such terrible scenarios—of famine, conquest, plunder, earthquake, and disease—are part of the historical experience of south Italy and are, therefore, to be found at the center as opposed to the periphery of every Italian American's "sociological imagination."

But if the culture was feudal, the communal frameworks that contained it were not. The great mass of struggling **contadini** and **braccianti**, the small holders

and landless farm laborers who were hired by the day on the great ranch-like estates, known as *latifundia,* shared a class consciousness and worldview that were certainly as proletarian as they were rustic and provincial. The *contadino* also shared much in common with city folk, including a pattern of land tenure, settlement, and work that brought thousands of people together in a large densely populated town called a *paese*. Each *paese* gave birth to a distinctive local tradition and had its own madonna or protective patron saint. To be someone's **paesano**, coresident in the same *paese,* meant that you shared local lore and values as well as more general cultural understandings, even if you did not know that person directly. Thus, Banfield's designation of familistic devotion as "amoral" needs to be seen in the context of a wider sphere of collective sentiment referred to by the peasants themselves as **campanilismo***,* from the word *campanile,* meaning the village church bell tower. To feel *campanilismo* meant you shared common feelings of both identity and pride for all who lived within the territory where the ringing of your village's church bells could still be heard.

The *festa* (communal feast), brought all of the *paesani* together in a procession of collective adoration in which the patron saint or madonna was carried to the altar of the church. After the celebration of the Roman Catholic Mass, the townfolk indulged in a bounteous feast and then gave themselves over to a night of impassioned song as they danced furiously to the clash of cymbals and ancient shepherd's pipes and to the tinny, outdated popular music of the amateur local band.

In the Italian American slums of America's booming industrial cities, the tradition of the *festa* was retained and adapted to express in ritual terms the responsibilities of both men and women to meet, with *onore,* the great spiritual challenges and tasks that were imposed by the trauma of immigration. The sociologist Robert Orsi has described the feast of the Madonna of 115th Street in Italian Harlem, where a woman, her tongue licking the cold stone floor and steps, was ritually dragged by her menfolk up the aisle of the church to the feet of the madonna's statue. This ritual, since banned by the Catholic Church, enacted the commandments of servitude, chastity, self-sacrifice, and resignation to suffering that were graven into the Italian female soul. Lest she forget.

By way of counterpoint, in the Greenpoint section of Brooklyn, the Feast of the Giglio (the lily) is held every summer in July.[9] The feast memorializes a fifth-century miracle in the town of Nola, near Naples, the plot of which includes Turkish invaders, a saintly bishop, and a good sultan. Thus the feast poses questions about the humanity of one's enemies and reaffirms the power of a universalistic ethos. But this message is certainly secondary to that communicated by a giant tower, six stories high, representing a lily, that is carried, or rather "danced,"

about the neighborhood on the brawny backs of the local men. Perhaps this imposing, monumental flower (as the local priests will tell you) is only a reproduction of the lilies waved at the saintly bishop by the original celebrants. But to a psychoanalyst or a pagan they recall the regenerative powers of Priapus and Dionysius as well as the family's right to tame and harness them. Each tower weighs four tons, and the men of the *paranza,* or team of bearers, must achieve near-perfect synchrony with one another. The lead singer enjoins the *giglio* bearers to meditate well upon the awesome weight that sends jolts of hot pain shooting through their shoulders. Lest they forget.

In collective rites and celebrations such as these, both penitential and carnivalesque, the individual immigrant was vouchsafed the gift of identity. Men and women reaffirmed their membership in a new kind of urban *paese* and testified to their fellow immigrants of the wrenching agony and also the shared sense of achievement that come from bearing a new world on the ancient world's shoulders. But as the old neighborhoods are emptied by suburban flight and refilled with new Asian and Hispanic hopefuls, Italian Americans find themselves caught between the heavy gravitational pull of the past and the exhilarating moral weightlessness of contemporary (call it "postmodern") American life. At worst, the psychic management of these polarities can lead to a conservative rigidity that is anachronistic and insular. At best, Italian American innovators in politics, business, education, and the arts invent unusual creative syntheses that increase the vitality and resilience of American culture and its core institutions.

The pain of these internal contradictions for second- and third-generation Italian Americans can be more severe and debilitating than all of the contempt and prejudice that the first generation encountered on a foreign shore. The insults, the epithets, and the sneers—these were easy to deflect by comparison with the spiritual suffering that accompanies the realization that one is a stranger in two lands, so that wherever one dies it will be far from home.

Most Italian Americans mediate their existence in American society through a series of uneasy and shifting cultural compromises. But the hyphen that frequently joins the two words *Italian* and *American* is a link made of iron that is a potential source of power, knowledge, and strength. Look to the center, to the composition of the hyphen, when seeking an understanding of any ethnic American group.

The organizing premises of the American society that received the immigrants were fundamentally alien to the unwritten laws that the *contadino* lived by. Consider the contrasts. If **la miseria**, the chronic sense of impending disaster, was axiomatic to the south Italian's concept of the future, America was a frontier

culture on the move, glad at heart and confident in the bounty that lay in the fruited plains and broad vistas ahead.

But if America, as philosopher Allan Bloom has emphasized,[10] was the world's newest viable culture (albeit with the longest uninterrupted political tradition), the civilization of the Italian south embodies one of the world's most ancient continuous cultural traditions, going back to the Greek colonization of Sicily 1,000 years before Christ. The historical situation, the powerful presence of the past—as something that shapes the present and future moment—reminds one of India and China more than of other European societies. Here is a world where history is recorded and expressed not so much in libraries and museums as in dialect and slang, in folk music and architecture, in gestures, in food, in etiquettes, in magical rites and incantations.

America, by contrast, is a civilization committed to endless experiment and bold change, claiming continuity with no traditions other than its own. The American vision of how to construct a society and how to create a culture derives not so much from a seasoned historical tradition as from the Age of Enlightenment, with its faith in human reason and its conviction that laws, carefully and constitutionally framed, could provide a setting for the pursuit of a genuine and nearly universal human happiness. The Enlightenment was a repudiation and dismantling of the feudal worldview, with its emphasis on corporate and collective identities, as lord, monk, guild member, or serf, as mother, son, husband, or godfather. Blind loyalty, blind faith, and blind force cemented the various elements of feudal culture into a solid impregnable tower. If southern Italy in the early twentieth century was (with the possible exception of Russia) the most feudal society in Europe, America was the negation of everything that feudalism held sacred and inviolable. Into the funnel of this negation, millions of immigrant lives were poured.

The change in perspective could not have been more striking. The problems of adjustment experienced by Italians were not, as some writers suggest, the result of an agricultural people trying to find their way in a grimy, machine- and clock-driven urban-industrial society. At a much deeper level, Italians becoming Italian Americans were compelled to go to war with their own inner selves.

Certainly, they were in awe of America, in awe of the forces of nature, earthly and human, that the rational American mind had harnessed. Even as humble bricklayers, ditchdiggers, and railroad workers, they eagerly embraced the Protestant American ethic of work and success as no mere moral platitude and palliative but as a useful ideological formula for real economic improvement.

The predicament of the Italian American was a predicament of loss. How

to relinquish the medieval mind, with its sensuousness, its wisdom, its religious devotions, its oaths, its belief in envy-motivated magic and the power of incantation? How to become a "modern American" and condemn the old country's traditions of blood feud and vengeance? How to downplay its emphasis on virginal chastity and maternal sacrifice? How to renounce the fierce and noble manhood of the *barone*? How to understand and enact America's emphasis on the knowable and the rational and its recourse to law as the only legitimate source of justice? How to comprehend its strict separation of church and state, its mistrust of spontaneous emotional release, and its tendency to liberate all of the primordial forms of human identity, including "woman" and "mother," from their embedment and enslavement in outmoded tradition?[11]

America liberates. But when it liberates the Italian American, it creates a self that is painfully divided, between family and career, between reason and God, between the ancient containers of sexuality and the new forms of partnership and marriage that are based on the obliteration of gender boundaries rather than their clear and unmistakable outlining.

Unable to make the peace between these two cultures that war incessantly within him and her, between the feudal culture and the "Enlightened," the Italian American too often turns away from the work of forging a vigorous hybrid that might draw strength from such contradictions. Religion and family have been, and still are, important to Italian Americans, but their defensive loyalty to the family, and to the neighborhood as a transplanted *paese,* can seem provincial and xenophobic in American urban and suburban contexts. Their devotion to masculine and charismatic forms of leadership can appear as a naive romanticization of the opportunistic criminal mind. Finally, their protective and reverent attitude toward womankind, as virgin, wife, and mother, can seem oppressive and confining in a civil and affluent society that is secure enough to begin the work of dismantling its patriarchal foundations.[12]

Threatened with culture shock, drowning in a torrent of radically alien beliefs, the immigrant *contadini* swam, not toward the goddess of liberty but rather toward the beacon of the Church. But they embraced a Roman Catholicism that was mediated through ascetic Irish monastic culture and the Vatican-American bureaucracy. One might dare to assert that the *contadini* converted en masse to a new religion, based not on the polytheistic and polychrome figures of the madonna and the saints (whose pagan origins have been traced by the Italian American art historian Camille Paglia) but on the more austere vision of the dying son of God, writhing and pinioned to the opposed crossbeams of spirit and flesh.

Italian Americans have been able to mediate these various contradictions

because of an essential "heartiness" that is also part of the legacy of the peasant's world. They are a tough-minded, down-to-earth people, whose metaphysical convictions as to the essence of the good are closely linked to the essence of physical health. To an Italian American, the health of individuals and institutions is to be found first and foremost in a warm and spontaneous relatedness to others, in a suffused, tactile, almost erotic openness and frankness in interaction, and in a suspicious attitude toward the mind–body dualism of northern Christendom. To an Italian American, the soul is fused to belly and groin. *Festa* and *carnevale* are special occasions for stylized excess and for the worship of pre-Christian gods, both dark and whimsical. One's daily food and one's daily love, like Communion bread and Eucharistic wine, have spiritual implications.

For all of the resources of wisdom, humanism, and warmth that Italian Americans have contributed to American life, they have evidenced a certain reluctance to analyze and express in literature—and especially through the medium of the novel—the cultural and psychological forces that have shaped the Italian American concept of self. Italian Americans are not (to recall a controversial 1993 essay in the *New York Times Book Review* by Gay Talese) a people of the book.[13] Books do not line the walls of their homes, and the bookish child is a pariah in both the family and the peer group. The knowledge that such a child acquires is regarded as subversive, especially if it cannot help feed, house, and clothe a family. Moreover, Talese emphasizes, Italian American students are not expected by their teachers to evince literary ability. He accuses publishers of being dismissive of manuscripts submitted by writers with Italian American surnames.

But to attribute the thin literary canon of Italian Americans primarily to prejudice and stereotyping is to oversimplify the issue. Their relationship to their language (which is English) is ambivalent and complex, easily misunderstood because of its reliance on the expressive modes of the storyteller speaking dialect—rather than the writer, who has achieved command of the vernacular of the educated elite.

The storyteller offers counsel and useful, practical wisdom. He or she affirms, in the words of Walter Benjamin, faith in "the communicability of experience."[14] Storytellers are *with* people. Novelists and their readers are alone. To savor the sensuous, close-to-the-earth language of the peasantry it is necessary *to hear*. It may be that the novel, as the art form of the perplexed and isolated modern self, is incapable of encoding the Italian American's lingering sense of belonging to mystical and primal forms of human and divine association.

The novel was invented to plot a course for an uprooted self that no longer belonged anywhere. Unlike the folktale and the saga, which lend themselves

readily to the media of film and television, the novel demands that both author and reader develop a critical attitude toward the primordial and the unconscious dimensions of identity and personality. This critical, analytical attitude strikes at the heart of the cherished, often idealized memories and the unquestioned loyalties by which Italian Americans seek to insulate themselves from the challenges posed and the injuries inflicted on their values by a pluralistic democratic society—one that begins with the building block of the single citizen-atom, as opposed to the father-ruled lineage, and that privileges rights over duties. (It may be that only a woman can write the first truly autocritical, Italian American novel—in fury about and in love for—the phallocratic patriarchy.)[15]

Is it any wonder then that works of art that might document this clash of cultures and the possible points of fusion between them are rare indeed? The most popular Italian American novels and films, the works of Pietro di Donato and Mario Puzo, of Martin Scorsese and Robert De Niro, reveal the hidden figures of virgin, martyr, and knight (set always against a backdrop of lush Roman Catholic pageantry) as mythic anomalies that still manage to survive on American soil. But there is no work of literary art yet created by an Italian American Melville that can function as a therapeutic tool that might enable this people to both retell and criticize their most cherished myths and thus obtain a fuller awareness of the suffering and the joy that have attended their long journey across the seas of mythic and historical time. Such a work of art would enable Italian Americans to more fully appreciate their achievement, which has been to hold this history within their hearts and not consign it to oblivion. Electrical worker, labor organizer, and urban primitivist painter Ralph Fasanella points the way.[16] In his paintings entitled *Family Supper* (1972) and *Iceman Crucified* (1958), he portrays his own father, nailed and raised on a cross before his family—his head decorated with a crown of ice tongs! Where the word *I.N.R.I.* is, at the head of the cross, Fasanella has written, "Lest we forget."

Notes

1. See E.A. Ross, *The Old World in the New* (New York: Century, 1914): 285–286. For an analysis of Ross's thought in the context of the vast apparatus of academic racist theory that was constructed in response to the Great Immigration, see Thomas F. Gossett's meticulous historical study *Race: The History of an Idea in America* (New York: Schocken Books, 1965).

2. The southern Italian code of honor involved the murder not only of the encroacher but also of the sullied female. Sociologist Pino Arlacchi writes of the Calabrian variant: ". . . blood-vendetta was the obligatory recourse; the father or brother must first kill his own daughter or sister, and then her violator or lover. A husband, in the same way, must kill first his unfaithful wife and then her lover. Not to pursue the vendetta was to forfeit beyond recovery any claim to social standing. . . ." See Pino Arlacchi, *Mafia Business: The Mafia Ethic and the Spirit of Capitalism* (London: Verso Editions, 1986).

3. See William Foote Whyte's *Street Corner Society: The Social Structure of an Italian Slum* (Chicago: University of Chicago Press, Chicago: 1955). For a detailed and nuanced analysis of the conflicts that arose between the world of the home and that of the street, extending to the larger society, see Robert Orsi, *The Madonna of 115th Street: Faith and Community in Italian Harlem, 1880–1950* (New Haven: Yale University Press, 1985). For a discussion of a convergent ethical duality (decent vs. street) that increasingly divides African American families in the inner city, see Elijah Anderson's "The Code of the Streets," *Atlantic Monthly* (May 1994): 81–94.

4. See Jerre Mangione and Ben Morreale, *La Storia: Five Centuries of the Italian-American Experience* (New York: HarperCollins, 1992).

5. See Francis A. J. Ianni, with Elizabeth Reuss-Ianni, *A Family Business: Kinship and Social Control in Organized Crime* (New York: Russell Sage Foundation, 1972).

6. See Edward C. Banfield, *The Moral Basis of a Backward Society* (New York: Free Press, 1958).

7. See Ann Cornelisen, *Women of the Shadows* (Boston: Little Brown, 1976).

8. My discussion of the south Italian peasantry is greatly indebted to the scholarship of Rudolph Bell. See his *Fate and Honor, Family and Village: Demographic and Cultural Change in Rural Italy Since 1800* (Chicago: University of Chicago Press, 1979).

9. On the Feast of the Giglio, see Guy Trebay, "Our Local Correspondents: The Giglio," *New Yorker* 66 (4 June 1990): 78–89. Joseph Sciorra, a candidate for a Ph.D. in folklore at Pennsylvania State University, has done firsthand field research on this feast, but his work is not yet published.

10. See Allan Bloom, *The Closing of the American Mind* (New York: Simon and Schuster, 1987), especially chapter 1.

11. See Camille Paglia, *Sexual Personae: Art and Decadence from Nefertiti to Emily Dickinson* (New York: Vintage Books, 1990).

12. For an excellent discussion of the traits of the Italian American family that serve as resources for the individual but can also predispose him or her to neurosis, see Marie Rotunno and Monica McGoldrick, "Italian Families," in *Ethnicity and Family Therapy,* ed. Monica McGoldrick, John K. Pearce, and Joseph Giordano (New York: Guilford Press, 1982).

13. See Gay Talese, "Where Are the Italian-American Novelists?" *New York Times Book Review,* 14 March 1993: 1, 23, 25, 29. Talese might be accused of overstating the case against the existence of an Italian-American literary tradition. Certainly, the early work of Pietro di Donato (*Christ in Concrete*) and Mario Puzo (*The Fortunate Pilgrim*) ranks with the best of Richard Wright and Bernard Malamud. But the fact that neither di Donato nor Puzo fulfilled their early promise as "great" writers is not without cultural significance.

14. Walter Benjamin's classic essay "The Storyteller" appears in his *Illuminations* (New York: Schocken Books, 1969). Italian American poet and storyteller Gioia Timpanelli has revived and restored the fading ancestral voices of the first immigrants for countless audiences. Consider also the centrality of the folktale in Jerre Mangione's memoir of an Italian American enclave in Rochester, New York. See *Mount Allegro: A Memoir of Italian-American Life* (New York: Columbia University Press, 1981).

15. The gender code of the immigrants (with its dismissal of the value of *any* education for females) placed formidable obstacles in the path of the potential or aspiring female writer (as opposed to the vernacular female storyteller). On the often ignored, but vital, contributions of women to the Italian American literary tradition, see Helen Barolini, *The Dream Book: An Anthology of Writings by Italian American Women* (New York: Schocken Books, 1987).

16. On Fasanella's work, see the illustrated volume by Patrick Watson, *Fasanella's City* (New York: Knopf, 1973).

Further Reading

Banfield, Edward C. *The Moral Basis of a Backward Society* (New York: Free Press, 1958). Banfield's controversial thesis that economic progress in southern Italy is obstructed by an ethos of "amoral familism" spurred intense debate and stimulated research.

Barzini, Luigi. *The Italians* (New York: Athenaeum, 1964). Still the best introduction to the mysteries of Italian national character.

Bell, Rudolph M. *Fate and Honor, Family and Village: Demographic and Cultural Change in Rural Italy Since 1800* (Chicago: University of Chicago Press, 1979). A careful scholarly study of four communities in rural Italy that shows profound insight into the traditional mentality of the peasantry.

Belmonte, Thomas. *The Broken Fountain.* 2d ed. (New York: Columbia University Press, 1989). One of the few firsthand ethnographic accounts of life and society in the back streets of Naples, Italy.

Blok, Anton. *The Mafia of a Sicilian Village, 1860–1960* (New York: Harper and Row, 1975). A detailed study of the origins of Mafia dominance in western Sicily.

Cornelisen, Ann. *Women of the Shadows* (Boston: Little Brown, 1976). A moving collection of narratives that reveals the crucial role of women in the maintenance of *contadino* society.

Gans, Herbert J. *The Urban Villagers* (New York: Free Press, 1962). A rigorous but highly readable sociological study of the Italians of Boston's West End.

Ianni, Francis A. J., with Elizabeth Reuss-Ianni. *A Family Business: Kinship and Social Control in Organized Crime* (New York: Russell Sage Foundation, 1972). A compelling study, based on firsthand research of an anonymous but powerful Mafia family.

Mangione, Jerre. *Mount Allegro: A Memoir of Italian-American Life* (New York: Columbia University Press, 1981). A much-acclaimed literary portrait of life within the Italian American community of Rochester, New York.

Orsi, Robert. *The Madonna of 115th Street: Faith and Community in Italian Harlem, 1880–1950* (New Haven: Yale University Press, 1985). A penetrating study of the role of Madonna worship as a bulwark against the cultural and intergenerational divisions that emerged in Italian Harlem.

Ross, E. A. *The Old World in the New* (New York: Century, 1914). Ross was one of the first sociological popularizers. He was regarded as anti-conservative, and his racist views tell much about the attitudes held by the "liberal" elite toward the immigrants.

Trebay, Guy. "Our Local Correspondents: The Giglio," *New Yorker* 66 (4 June 1990): 78–89. A beautiful evocation, by a journalist who knows what questions to ask, of the feast of the Giglio in Brooklyn.

Watson, Patrick. *Fasanella's City* (New York: Knopf, 1973). A visually striking biographical retrospective of the life and work of the painter Ralph Fasanella.

The Genealogy of Ice

Frank Lentricchia

Even you don't know what you meant by you.

—Raging Bull

Christmas season 1987, give or take a year. I can't remember exactly. Hillsborough, North Carolina. A kitchen. Three real people, who must not be called characters, though that's what they, along with all the other real people, must become. A woman, about seventy; her son, her son-the-author, late forties; his wife, late thirties. The older woman (the mother, the visiting mother-in-law) speaks, directing most of it to the non–Italian American daughter-in-law, but all the time keeping the son in view, occasionally shooting him a challenging glance or remark. Her mood is better than you think; her mood is better than she thinks. She speaks as if the conversation has been rolling for some time. In fact, her words inaugurate it:

"But what I want to know is why are we so involved, because they'll never change. Change? With us? Change my ass. I have to ask you something. What kind of a look do you call that on my son's face? He's just like his father. And his father is just like *his* father, that's where it all comes from, but my husband's father was the worst. He's the one who scared me. With their friends they're different, then they change in a hurry. My father-in-law was so cold you don't even know what I mean by 'cold.' I was ashamed to smoke, he never said a word and I was ashamed. You think I don't notice your husband when you smoke? I notice everything. And what are you looking at? What is he looking at? Naturally your husband is not as bad as my husband, but after all what do you expect me to say? With his friends I bet he's different, then all of a sudden they're warm, then they become warm, because their friends, the men especially, make them happy, let's face it, not us,

Reprinted from *The Edge of Night* by Frank Lentricchia (New York: Random House, 1994).

and not their kids. Don't look at me like that, you don't scare me. I changed your diapers. He looks at his mother and his wife with that face. *Che faccia brutta!* The Lentricchia men, they're all the same, believe me, except for one of my brother-in-laws who went to the other extreme. At least our husbands didn't do that, but maybe they should have, maybe they did that, too. Because let's face it, sex is another joke. What do you want me to say? *Why* are they like that around us? You went to college, you tell me. To be honest, I don't think even they know, and I don't care anymore, because in their own homes they don't want involvement, they go inside themselves. What are they doing in there? If they didn't want involvement, who told them to get married in the first place, if they didn't want involvement. What I want to know is how long are you going to kid yourself? If you have the answer, don't think I want to hear it, because I don't want to hear it, but if you have to, you can tell me."

I can't remember the words, I can't remember the context, maybe there wasn't one, because she doesn't need a context, but that's how I remember it now, five or six years later, my father in another room watching TV, my mother right in front of us, and I don't have to remind you who "us" is. She probably had a context; I just couldn't see it.

It should be mentioned that my mother is prone to opera. She talks in arias. Any and all disturbances presage apocalypse. Her enemies ought to croak, the bastards. All wounds are fatal, and anything can cause a wound, even nothing can cause a wound. It should also be mentioned that I've heard it said that I'm nothing like my father, who I'm not saying is what my mother says he is. According to him, I'm very like my mother. We're the same. "What do you expect? He exaggerates. He exaggerates everything. He gets it from his mother. He gets excited, don't you, Frank?" Arias without discernible context; emotions for which I can find no matching circumstances. Apocalypse twice a week. Wounds that cannot be healed, not even by affection. Affection, in fact, makes them much worse, opens them right up again.

About a year ago, in New York, an editor at a major publishing house said to me that I ought, up front, tell my readers who I am. Otherwise readers would have to crawl inside my head. She said "crawl inside." She felt that in order to understand the chunk she had just read, she would need to crawl inside my head, in order to find out who I am. When she told me that, I felt a strong urge to find out who she was. I wanted to open up her head. I should have said, "If I knew who the fuck I was, do you think I'd be writing this?" Or I should have said, "If I knew what the fuck I was doing, do you think I'd be writing this?" I was about to revise out "fuck," but if I did you might think that I was talking metaphorically

when I said I wanted to open up her head. In order to see what was under the skull, what was actually in there.

I was talking to the New York editor in my favorite Italian pastry shop, way over on the East Side, near the East Village, a place I liked to frequent because any time I went in there I saw an elegantly dressed elderly man, utterly manicured, a shave every four hours, a haircut every five days, who would occasionally walk outside to talk to youngish guys built like bulls in flowered shirts, with envelopes in their hands who kissed him on the cheek when they left. It was a movie, post–*Godfather*. They knew they were in a movie; they were enjoying themselves in the movie.

The elegantly dressed elderly man scared me. I had to look at him out of the corner of my eye, which I became very good at, because I didn't want to be in his movie in the wrong role. I've never seen a face that brutal when he thought no one was looking at the face. It was the best brutal face I'd ever seen. I liked to look at it. Maybe a plastic surgeon could give me a duplicate. They say anything can be arranged in New York.

It would have been nice to call him over, to introduce him to the New York editor at a major house. Then I could have said, "Now say the words 'crawl inside your head' to this man." If only she could have coffee with this man every day, if only she could, she would become more sensitive in her relations with writers, she would become a good woman. Because if she didn't, with his demitasse spoon, and his little pinky sticking way out, he'd eat what was under her skull. I don't like questions about who I am or what I'm doing. If you wish to know who I am, ask my parents; they know. Or my friends, with whom it is said I'm different.

I'll tell you what I like about writing. When I'm doing it, there's only the doing, the movement of my pen across the paper, the shaping of rhythms as I go, myself the rhythm, the surprises that jump up out of the words, from heaven, and I *am* doing this, and I am this doing, there is no other "I am" except for this doing across the paper, and I never existed except in this doing.

I'll tell you what I hate about writing. Finishing it. It comes to an end. You can't come forever. When I'm finished, I can't remember what it was like inside the doing. I can't remember. When I'm not writing, I want to become the man with the brutal face.

A sentence, a sentence, my family for a sentence.

This time it's only a few months back that I'm trying to remember, so I'm fairly confident about the words. A telephone call to my parents, for the purpose

of conducting research on a word famous in second-generation Italian American households, who get it from the first generation, and then pass it on to the third, where I am, dead end of tradition. Forget the fourth, where my kids are. I was writing about this word. Once I heard this word spoken by Robert De Niro in Martin Scorsese's *Mean Streets* (I like to write out those names) and felt secretly addressed, even thrilled, a member of a community. Its pronunciation varied startlingly in my family, according to affective context: *c*'s become *g*'s; final vowels could disappear. It all depended. The word was deeply rooted, yet flexible. It gave what was needed. A genial word, from the unprinted lexicon of Italian American. I pose the question of its meaning to my mother, who says immediately, "Pecker, your pecker." She's totally confident, so I don't mention that the interesting word takes the feminine definite article, because some part of me, maybe most of me, wants her to be right, with the feminine definite article, yes. My father only says, "Ann." That's all, you can hear him. My mother is not intimidated. She comes back: "I know that word." My father: "It's the woman's, *he* knows it's the woman's." He's totally confident. He tells her that I'm kidding around. He knows that, if asked, which I wasn't (because they don't do that), I'd side with him. After such phone calls, what knowledge?

I am an Italian American, one of whose favorite words bears his grandparents, his parents, his neighborhood, his favorite movie director, but not his children, not his colleagues, not where he lives now, and not most of his friends. I'm not telling you that I'm alienated from my ethnic background. I'm not alienated from it, and I'm not unalienated from it. It's an issue that doesn't much preoccupy me anymore.

This word dancing in my head cannot tell the difference between the man's and the woman's. The New York editor, who is an Italian American, thinks it important to tell you that I'm an Italian American. Are you glad to know that? Am I becoming clearer to you by the sentence? I know a word that means the man's and the woman's. Do you want to know my secret word? Shall we play with it together? You starting to crawl in?

I have a friend who lives in a good place, in South Carolina. His name is Leonard Cunningham. Leonard once said to me, in full knowledge that I am a married man: "You still a grumpy old bachelor?" One time I called the place where Leonard lives. The person at the other end, who was not Leonard, said something that I must have misheard, because I replied, "Am I Father Aelred?" I must have misheard. The person best in a position to know reminds me of a nightmare that I can't remember, king of the roof-rattlers, a full-

throated screamer. It seems that I looked into my wallet for my driver's license, found it, it was mine all right, definitely mine, but it bore someone else's name and picture. It was definitely mine all right. Feel free, don't worry about it. Crawl in.

 I said nothing when the New York editor said that I ought to tell my reader that I'm a literary scholar, a literary theorist, a professor of English, a critic, and I was rendered speechless when she whipped out a copy of the paperback edition of one of my books—bent and underlined—and quoted some sentences about my favorite philosopher, William James, which I didn't remember writing, then offered a commentary on those sentences (critic of a critic of a philosopher), which I couldn't understand, sipping my decaf cappuccino, then declared that *that* very passage, and others like it in my critical books, would help my readers to understand who I am. Tell them you're a literary critic.

 At which point, in a tone as dead flat as I could manage, I should have said, "I've concluded, after much consultation with experts in the field, and much reflection, that, in spite of all the obvious resemblances, I'm nothing at all like T.S. Eliot." That's what I should have told the New York editor when we were sitting there in that pastry shop way down on First Avenue. "For example," I should have said, "what are the chances that Eliot ever ate" (*academic, very dry, hands about the coffee cup*) "three cannoli in one sitting, even as I do now?" I can tell she needs to think I'm funny, rather than something else. She'd prefer not to think of me and something else. I'd prefer that she think of me and something else. I say, "You think I'm funny? What's so funny? You want to be edited?" She is trying to smile, but she cannot do it. I'm winning. At which point I call over the wonderful brutal face and say (*leaning in, with concern*), "Which one of us would you prefer to ride home with on the deserted subway at 1:00 A.M., to the end of the line in Brooklyn, just one of us and you in the car? Which one? Be careful, don't answer too fast, and don't say both because we're not kinky. Don't even suggest kinky. You got a gun? Which one? Choose, I'll count to five, then I'll tell him" (*broad winning grin*) "to do that thing with his demitasse spoon, which I imagined eight minutes ago, which I haven't told you about, because I want you to be surprised and tickled pink. You want to taste my cannoli? I'm Al Pacino in *Godfather II*. Who are you? All work and no play makes Frank a dull boy. Name that movie with Jack Nicholson!"

 I teach English in a distinguished university. In my distinguished department, which is like all English departments I have known or heard about, we have virtually nothing in common, not even literature.

For the last two years I've been writing about T.S. Eliot, I'd better say trying to write about him. All work and no play. He is a fascination and a crisis. Honey, I'm home. The job of the literary critic is to explain, whatever else he may do, but Eliot's poetry is beyond explanation, though it has been explained ad nauseam. I get nauseous. His poetry, and I say this with total admiration, is unreasonable. Not unreasonably difficult, just unreasonable, which is why I find it fascinating. I'm also drawn to his explanations of the writing process. He means the process of writing a poem. I mean the process of writing anything, including a letter, or this, maybe especially this. What is this? I hate that question. Make me happy and hate it too, hate it too.

Eliot is responding to a German writer, Gottfried Benn, Eliot is always responding to some other writer, building, ripping off, making something new. Theft and the individual talent. Eliot says that writing begins with an "obscure impulse" (in other words, you don't know what you're doing). Or, he says, you're haunted by a demon "with no face, no name, nothing" (in other words, you don't know who you are, you don't have a face). Benn says, says Eliot, that we start with an "inert embryo," a "creative germ." Plus the language. "He has something germinating in him for which he must find words, but he cannot know what words he wants until he has found the words." When you have found the right words (which you can't know are right in advance) then the thing for which the words have to be found disappears. You have a poem. Writing is a journey in and through language; writing is discovery. That's Benn. Here's Eliot's twist: the writer "is oppressed by a burden which he must bring to birth in order to obtain relief." Eventually, the writer gains "relief from acute discomfort" (sounds like an ad for something) and experiences "a moment of exhaustion, of appeasement, of absolution, and of something very near annihilation, which is in itself indescribable." Benn never mentioned acute discomfort; Benn maybe likes the process. Eliot feels labor pains, or maybe a sharp gas pain in the lower intestinal tract. The pain gives no pleasure. What gives pleasure is the end, when relief is obtained, and the poem is fully born. The last *t* has been crossed, *then* Eliot is satisfied.

Coleridge is better than either Benn or Eliot on the writing process. He says readers "should be carried forward, not merely or chiefly by the mechanical impulse of curiosity, or by a restless desire to arrive at the final solution" (we know who you are, you're under arrest), "but by the pleasurable activity of mind excited by the attractions of the journey itself." He's talking about readers who almost don't exist, who don't ask questions that make me unhappy, who do not seek the final solution. No reader could possibly experience what Coleridge wants readers to experience unless (Coleridge is not talking now, it's me) there were

writers who wanted to feel the same thing, "the pleasurable activity of the mind excited by the attractions of the journey itself." The meandering adventure through language (writing as drafting as revising as improvising), not the thing at the end but the unfolding process itself, the journey, the ride, every step of the way, never sure what's unfolding, never caring that much, happy to go off the track, screw the track. Outside the process, the demon has no name. The process names the demon and you are the demon, the demon *in* and *of* and *as* the process, and you like the demon. For once, you like yourself. The annihilation you experience is indescribably good, because it is the death of everything you were outside the process. The opaque burdens of your self-consciousness are lifted. When the process ends, you go back—the opacity, the weight, the stasis, and other things best not to mention, that's what you are. There you are, on the track.

When I'm doing this, whatever "this" is, and that's not my problem, that's your problem, if you want that problem, which you don't have to have because nobody is holding a gun to your head and demanding that you tell us what this is, when I'm doing this, I like taking walks, driving, riding in airplanes (I have an extra ticket, you want it free?), sitting in the waiting lounge, doing it there in public, when will my flight board? I can't wait. Motion like the motion of my pen. I can write in airplanes now. I become a dangerous driver, things come into my head when I drive and walk, writing as motion sickness, I better walk more. I *am* writing; *l'écriture, c'est moi.*

In a letter—on this one he didn't go public—Eliot had something to say about bad writing. Bad writing is writing that repeats what you've already written. To avoid it, you must "defecate" the self that produced it, if it is possible (which it isn't) to say a "self" produces the kind of writing that Eliot has in mind. Defecate the self *of* that writing, that's better, my graduate students might like that, or run the risk of writing feces. To avoid it, void it. Birth and defecation, labor pains and gas pains, life and crap. Does Eliot know the difference? Does anybody? Flesh of my flesh, shit of my shit. Shit of my death. I'm a literary critic.

It was in the place where Leonard lives that I first read these lines from Psalm 144:

> *No ruined wall, no exile,*
> *No sound of weeping in our streets.*

"Flesh of my flesh": Eliot's poem, his metaphorical child. I have two children, not metaphorical. We, I risk speaking for the three of us (I mean the two

kids and me, Eliot has no part in this), we feel unrelieved, unappeased, not absolved, annihilated in quite specific ways, the details of which I'm never going to tell you. We are certainly exhausted. "Annihilated" is heavy, but I'm using it anyway. Eliot used it, why can't I? I'm not giving you the details because this isn't *People* magazine. The domestic details are banal, anyway. They don't explain. The opium of the middle class. You know the soap opera, so don't ask.

One weekend, a long time ago, about fifteen years back, when they were about five and six and a half, they were visiting us. You know who "us" is and you know why they were "visiting." While she was cooking dinner (no, I won't tell you her name, you don't need to know that, either), we played a game involving the stairs to the second floor. Daddy, you stand at the bottom. Daughter Number 1 climbs to the third stair. Daddy says, Amy Amy Amy. She jumps into his arms. Daughter Number 2. Rachel Rachel Rachel. Jumps into his arms. Daddy, let's do it again. Lots of giggling. We do it for the fourth stair. We do the fifth. Giggling becoming intense, hysteria creeping in, the little bodies flying, love-missiles right on target. Daddy Daddy Daddy. Amy Amy Amy. Rachel Rachel Rachel. Crash. The sixth is painful, gravity is beginning to talk tough. Daddy was not ready. The kids want the seventh. Daddy braces, the seventh is accomplished. Higher! Let's go higher! We do the eighth, my God. We do the ninety-eighth; we do the four hundred and fifty-eighth stair. Flesh of my flesh. We open up each other's heads. "I'll get you through our kids, you son of a bitch." *I'll get the kids through you, you son of a bitch, I'll put the kids through you, you son of a bitch, I'll put the son of a bitch through the kids, you son of a bitch, I'll put the son of a bitch through the son of a bitch, with the full cooperation of the son of a bitch, you son of a bitch.* What do you expect? I'm middle-class. I like soap opera too.

We didn't have a name for the game we played. I think I was saving them. It was the game of I Saved the Kids. "He exaggerates. He exaggerates everything." Like my mother, I'm prone to it, prone to the real thing, where they go all the way, all the time the four hundred and fifty-eighth stair. The real thing is Italian opera. Can this shit live? Can this shit sing?

"You need to tell us where you're from."
"I'm one hundred percent from literature."
"No, seriously."
"Okay. I'm one hundred percent from the movies."

A conversation that never took place, with the New York editor or with anyone else. No real conversation about my first place. Good thing, it would have

been too hard to explain in conversation, to say just what I mean. The first place, my so-called origins, the Hydrogen Bomb of explanation. Then everything becomes clear. Then everything becomes dead. In conversation with strangers I tend to be sloppy and anxious, sometimes with intimates, too, what an experience that is. Conversation is too hard. Better to write. Forget the telephone, forget talking altogether. Except after long, enforced absences, talking is overrated.

Yeats said that he was always discovering places where he wanted to spend his whole life. One of the places where I want to spend my whole life is in Yeats. Like Yeats, I don't know exactly where I'm supposed to be. Long after I left, long after it seemed to have drifted out of my mind for good, Yeats helped me to recover my first place, my grandfather's house on 1303 Mary Street, Utica, New York, where we lived on the second floor until I was a senior in college. But "recover" is misleading, suggesting I got something back that I used to possess. I used to sleep and eat there, but I never possessed it, it never possessed me (that's better), I never actually lived there until I imagined myself all the way back through the medium of some of Yeats's poems about the great country houses of Ireland, specifically Lady Gregory's, Augusta Gregory's (she had just the right first name), in the west of Ireland, Coole Park, where Yeats was taken in every summer, nurtured and sustained and respected for who he was, a writer. Coole Park was the place where he wrote well and about which, much later, he would write better than well, he would write magnificently, out of his memory of loving sustenance and respect, poems about the place itself, writing when he had a bitter hunch, and he was right, that the place would be leveled, imagining its and his own not being there, and the vines and the saplings winning, forcing themselves up through the broken stone, the rubble. He wrote *magnificently* because he was haunted.

Absurd to think of my grandfather's house—my mother's father's house—and Coole Park in tandem, neck and neck in my imagination, absurd to say that I possessed it as if for the first time, not as if but actually, reading poems about an aristocratic mansion, where my grandfather would have been employed to "shovel shit," which is what he would say whenever I asked him to tell me what he did in the old country, when he was young. He shoveled it for *il padrone*, the landlord, which he said in his dialect: *u padron*. He was speaking literally, and he said *u padron* with a tone perfectly mixed with resentment, awe, and desire.

He, my mother's father, Tomaso was his name, could have been one of Lady Gregory's writers, because he was the best storyteller I ever heard. He had an endless supply featuring surprising savage ironies, beautiful twists of revenge, twists of revenge are always beautiful, those stories were wonderful because people got what they had coming to them, the bastards. And the supply must have been

endless because he told them every night and he never repeated himself except by special request. I never heard of any of them before or since. I believe he made them up, I hope he did, as we sat there around the kitchen table, spurring him on just by showing him how happy we were because he was telling us stories. He could see we hung on his words and gestures. We were helping him to make them up, that's what we were doing, though nobody could have known that, much less said it. We were imagining together, that's what I believe. Of course, we could never have done what he did, and he was not born to listen to stories.

After supper, after the espresso, the anisette, and the Stella d'Oro cookies, and several of us there waiting for him to start, he would turn it on without warning. We would sometimes ask for repetitions, a story he told last month, and he would oblige, but on occasion he would balk (briefly) and display a flare of irritation (briefly), when my father or I (the main requesters) would ask for a certain story too soon, like four days later (at which point we became the main aggravations). He would look at us, say oh my Jesus Christ, then deliver it as if for the first time, as if for a virgin audience, as if he himself had heard it for the first time six minutes ago, he himself laughing hard in the funny moments. Later, my father and I would say some of the key lines and words to each other, going back upstairs, as if we never heard them before, doing some of his gestures, going to bed with his voice jumping in our heads. If I could tell you how good he was, I mean so that you knew the way we knew, you'd miss him even though you never experienced him in the flesh.

One night, we got out of hand, my father and I. We asked for the one we liked best too soon, we asked the night after he told it, and then we became worse than an aggravation. Tomaso said nothing. He just got up, walked over to the refrigerator, looked in for about twelve seconds (which in a situation like that you can imagine what it felt like), took nothing out, even though he must have needed something bad, shut the door, came back to the table, then told it ferociously. His fury made it new. When he was finished, he got up and went to bed. It was barely dusk. I wish that I could remember that one, I'd tell it to you right now. But maybe that's what you get for abusing the storyteller, you lose your memory of the story. He withdrew that night, and now the story is withdrawn forever.

His sons and sons-in-law referred to him openly as the King of Mary Street, without irony, with pride. His depressions were rare but deep, and if he happened to be suffering one when they addressed him as the King of Mary Street, he'd come back with, I am the King of Pig Street. Or he'd say, the King of the Pricks, I am the Prick of Mary Street, I am the King of the Pigs. I wonder if Lady Gregory ever thought of herself as the Cunt of Coole Park? You can't tell about those

aristocrats. Like artists and peasants like Tomaso, they're capable of anything. They tend not to give a damn what people think.

One of my father's brothers came up with the one he liked best. The King of the Mushrooms (always with the definite articles), not because of the quantities he could put away, but because of the huge Santa Claus sacks full he would bring home every weekend, every autumn—he knew where they were in the damp and shady secret places in the hills around Utica, to which he'd walk, ten, twelve miles round-trip every weekend (one time I heard twenty-two miles), usually on a Sunday morning when Natalina, his wife, was at church. Even into his late sixties. At today's prices who knows the value. Maybe 300 pounds per autumn. Which my grandmother would put up, and her daughters and daughters-in-law would put up, a year's worth for the family, free.

On Thanksgiving he took everybody, about forty people, to an "American" restaurant, because if I want Italian food I'll stay home. But on most major holidays, we all ate at his table, two or three shifts, too many courses, the men falling asleep right there during coffee. I never saw one of the women fall asleep.

I never saw him reading. The only thing he ever wrote were the bills, with curses against the Blessed Virgin Mary. Lady Gregory listened to Irish peasants, then wrote it all down (who knows what she changed) and made books out of illiterate genius. If he had had a Lady Gregory, then you'd know. He was a Lady Gregory and he needed a Lady Gregory, but he couldn't be his own Lady Gregory.

I liked the wide black belt he wore with the huge buckle, I have one just like it, and I like to remember the way his belly, emphasized by the belt, spilled over it. My belly's starting to do the same thing, but he never did what I do. He never held it in; he just let it spill over; he let it cascade. If you could have asked him why he didn't hold it in (the question was culturally inconceivable), he'd reply in one of his favorite idioms. The crude English equivalent is: "Because I don't give a fuck." The crude Italian says: "Because it doesn't fuck me."

Without fail, every third summer, the sons and the sons-in-law painted his house. And every other summer, it bore fruit, that audacious thing he cultivated, that cherry tree—he and the sons and the sons-in-law mounting the longest extension ladder he could buy. He made that thing go beyond itself, "in nature's spite" (Yeats's phrase for a work of art, what we rear "in nature's spite"). He definitely reared that tree. It was thirty-five feet high when it was supposed to be only eighteen, and however wide a thirty-five-foot cherry tree would have to be, that's how wide it was. That cherry tree got too big and too old, so he reared it more, he got up under its ass with two-by-fours, bracing the big limbs that couldn't take it anymore. Then he made those long black belts, gargantuan versions of the one he

wore around his waist, he must have bred those tree belts, he must have pulled those tree belts right out of his own belt, and he stopped that tree from doing what it wanted to do, but it started to do it anyway, and the sap ran out of the gashes, so he poured stuff into the gashes that looked like actual concrete, which I think it was, and he stopped the gashes from getting worse, but later they got worse anyway.

And every other summer they climbed it, I was too young to be trusted on the extension ladder, with a great basket and a little hook attached to the great basket's handle, for the rungs, so you wouldn't have to hold the basket once you got up into it, and with a long stick, hooked at the end, it looked like a cane for a giant—I think he made it from an old cane of his, which he grafted an extension onto, which grew one-sixteenth of an inch every other summer—that cane was so the men could reach way out where no ladder could go, where only the goddamn robins could (and did) go, and where (naturally, damn the Virgin Mary) the best cherries were, but that cane at the end of a grown man's arm got out there all right and they pulled in those cherries in robins' spite, fuck those robins, because that's what Yeats was trying to put across, and they pulled in enough cherries for an army. And so they had to put them up, of course, Natalina, and the daughters, and the daughters-in-law.

It was family socialism, the men risking their necks, you could hardly see them up in there, up against that tree that sprawled way over into Louie Spina's yard, who was welcome to pick everything on his side, but he always asked before he did it, even though he knew the answer, and the women getting scalded in the kitchen, you think it didn't happen? It happened, more than once, and risking their sanity doing that tedious repetitive shit they have to do on an assembly line, without the adventure of the tree, being up in there when the tree belts might go at any minute, the wisecracks going back and forth between the guys on the ground and the guy in the tree. I heard some odd talk in the kitchen, those women let go because I was too young to be harmful, and I saw sullenness in that kitchen, like a pure thing. Those women were anxious to tear into somebody. I think they had a critique of socialism.

He commanded loyalty and energy, I don't know how. Nobody was afraid of him because there wasn't any big inheritance awaiting the best ass-kisser. Some ass-kissing, naturally, went on, because one or two thought there was a pile stashed away, but those one or two kissed his ass in vain. His personality was on the sweet side, and he was known to cry. Maybe it was the fig tree. If you can believe a fig tree at that latitude, which you have to because I'm telling you it was there, but I can't go into all that he did to rear it, it would take too long, and I haven't even

gotten to the other grandfather yet, you know, the one who was so cold you don't even know what I mean by cold. The grandfather who produced the son who produced me. The genealogy of ice, according to the leading soprano. ("He gets excited. He thinks he's the leading tenor, don't you, Frank?") Maybe it was the combination of the storytelling, the mushroom mountains he brought home, and the fig tree. Thomas the August. All I'll tell you is that if that cherry tree wanted to put out cherries the size of golf balls, then he gave that fig tree major hubris. There were maybe only seven figs per summer, but they pumped themselves up to the pear level, it's true. Maybe if your grandfather or your father or your father-in-law could do what he did for cherries and figs, you'd want to work for Tomaso, you might not be able to keep yourself from throwing in with him, no matter how irritated you might get sometimes, which you would definitely get because he couldn't or wouldn't drive, and you'd have to pull driving duty once a month, and drag your wife with you against her will, and your kids losing it in the backseat, once a month, on a Sunday, when maybe you were fed up with the extended family routine, who could blame you if you were fed up once a month? But just on that day when you were completely fed up you'd have to pull driving duty, take him up to his camp on Oneida Lake, "to the beach," *u beach.*

 He had two camps at Sylvan Beach, next to each other, and the big one, the size of a small hotel, burned to the ground and almost got the other one, too. They said "some bum" did it in the winter, but the crime was never solved, and he went into a depression almost as long as the one he went into after the near-lethal heart attack, a depression, according to my father, that lasted a year, he was mourning for his own death, but it turned out he outlived death by twenty-four years, no talking except for yes and no and an occasional because it doesn't fuck me. What I'm saying is that if this man is in your family, and I didn't screw up the tense just then, if this man is in your family, you want to be on his side, don't tell me you wouldn't. You wouldn't burn the camp. You wouldn't do something to the cherry tree in the middle of the night. No Italian would do a thing like that. Americans do that.

 I know what you're thinking. You're thinking, he's making a story out of that grandfather of his and that cherry tree. (I cannot tell a lie.) You just don't know my concept of truth, my conception (that's better), and I don't think you ought to worry about it either, which I'm not saying you're doing. Those kinds of worries are not worth it. The distinction between truth and fiction, that one gets tougher and tougher for me to get. I'm going to stop trying to get it, because it doesn't fuck me.

 The first place, 1303 Mary Street, technically doesn't qualify because the first four or five years of my life were spent a few doors east, up the block. East

was always "up"; west was always "down," because it led to downtown Utica. I begin with the basic fact, that the first place wasn't the first place (Yeats wasn't born in Coole Park either); I add to that another fact, that the so-called first place dropped out until I reread Yeats two years ago, just before traveling to Ireland, as I was starting this book, which I didn't know I was starting; then I add an assertion, which I want you to believe, though you might not: that I wouldn't go back, even if I could (and I can) because I don't feel any return-pain (no nostalgia, *that* you don't believe), because what I want from the first place I draw on freely. No, better to say it draws on me, like sucking, even now, sitting here writing. Yeats taught me that the first place was about writing. (No, not "about," "about" should be revised out.) Small second-floor spaces, first on Mary Street in the late forties and through the fifties, now here in Hillsborough, North Carolina, and a relationship to something made possible by those spaces. I am here in the first place.

"A relationship to something": I'm not sure of the name. Not a relationship *to*, no, as if the "something" were a person or geographical point. The relationship *is* the something, and the place is itself the relationship. The place is me-in-the-place, so if I'm not there, then the place is no longer the place, and I am no longer me. If you lose the first place, which almost everybody does, it's not a tragedy. The story still might turn out well.

So I am going to be drawn by these lines in Yeats, drained almost dry:

> *O may she live like some green laurel*
> *Rooted in one dear perpetual place*

Yeats, praying for his newborn daughter, and creating unnecessary pain for himself, and for me, by writing "perpetual." He should have forgotten "perpetual," he should have revised it out, because she's going to be rooted in a dear perpetual place that she'll lose, then, with luck (I have no idea how), she'll find a new perpetual place.

The "something" comes closer when I read this, concerning the pleasures of an ancestral house:

> *The pacing to and fro on polished floors*
> *Amid great chambers and long galleries, lined*
> *With famous portraits of our ancestors;* . . .

Tomaso had one in his dining room, a picture of his mother and father, which now hangs in mine, a portrait famous only in my family, and now among some few of

my friends. Yeats was describing the house of a rich man. But it's not the things of the house, it's never the things, no matter how lovely the things, because there are always lovelier. It's the looking and the pacing to and fro. My floors are polished, and I pace the hours between sentences, on my polished floors, looking for sentences, they're mine now, these polished floors. Yeats's poetic place, Tomaso's, where I am now, houses that look like they've been meditated upon, they have that kind of look, the look is there in the floors, and in the narrow stairs to the second floor, this is a house, this is, this is what truly is, and it looks like it has been looked at, this house of mine, with a yearning (Yeats gives me these words, they are his gift) with a yearning so great that the yearning drowns in its own excess:

> *Beloved books that famous hands have bound,*
> *Old marble heads, old pictures everywhere;*
> *Great rooms where travelled men and children found*
> *Content or joy; . . .*

He was there, at Coole Park, to write, that was his role, and to stroll magnificent grounds, and to approach the small lake at Coole, when the sun flares cruelly off the waters, and to gaze as if with lidless eyes into the glare as they climb the air, the swans mounting invisible through the sun-flare, just for him, honored guest of gazing. My role—I was the fussed-over grandson (a redundancy)—mine was to study, not to work like the men and the women, and to be sustained at 1303 Mary Street, for the leisure of my intellect, for my long apprenticeship in pure gazing. I, too, was an honored guest ("He gets good marks, he's smart in school").

When I was there, Tomaso was my Lady Gregory, the house on Mary Street my Coole Park. I was Tomaso's apprentice writer. He was the master, the writer who couldn't write, the talking writer. These lines from "Coole Park, 1929" suck me, too, deep into their vision:

> *They came like swallows and like swallows went,*
> *And yet a woman's powerful character*
> *Could keep a swallow to its first intent;*
> *And half a dozen in formation there,*
> *That seemed to whirl upon a compass-point, . . .*

Hard not to notice, it's a small poem, Yeats's saying "there" five times, a strategic incantation, bringing "there" here, making it thingy, and you stand in it, on it, take your stand there.

And because he, Tomaso, was "there," his powerful character holding us all in formation, I could stand there on the small second-floor back porch, a space five by five, the cherry tree at my right, at the twenty-foot level, at the level of the tips where only the robins and the giant cane could go, and the fig tree tucked in against the garage, at the back of the yard, the tomato plants next door on my left, looked at from above, and my grandfather's garden totally shaded by the cherry tree (he made it grow in sun's spite), and Louie Spina in his yard on my right, Louie invisible through the cherry tree, moving heavily about, who laid brick with arms like your thighs, thighs like your boy's waist, and me standing in the dusk after supper, I'd walk out there, drawn, belly full, no one moving now down there in the yards, legs becoming stone, it will take serious effort to leave (turn body, pick up feet), and the yard is quiet, leaning into the railing, automatic hands picking off the flaking paint (it's *next* summer the men must do that), the yard is calm, and the looker looks into quiet and calm more juicy than those huge cherries just hanging there, becomes part of another life, not his, he just drops into it, he goes in, sucked all the way into the juicy quiet and calm, full in his belly, twelve years old, just gazing there.

Okay, the other grandfather, my father's father. If I write down his first name, I'll secure a cheap irony, not to mention the melodrama of shocking coincidence. In melodrama, as in Italian opera, the writer makes deplorably excessive appeals to the emotions of the audience, he'll do anything, like tell you that the name of his father's father, the Patriarch of Ice, the Origin of Ice, is Augusto. Cheap.

It was said he baby-sat me in the early forties. Then, still in the early forties, he and my grandmother, Paolina, moved to Miami because the rich people, for whom he had strong left-wing contempt, like to go there in the winter, and they know the good places, and because he thought it would ease his arthritis, which it didn't. After they moved, I saw him a few times in the summer, when they came to visit, he always sending Paolina ahead, then coming himself two weeks later, and I saw him on two visits that I made to Florida. When he died in 1980, the last of the grandparents to go (I was forty then), his oldest daughter sent me a surprise, several volumes of poetry and notebooks, he had been writing all those years, teaching himself Dante, the poems all written in a consistently elegant hand, in large five-by-eight diary books, the volumes numbered, his picture the frontispiece of volume one, the entire set entitled *Le Memorie di Augusto Lentricchia*. Family pieces (picnics, birthdays, births, deaths, the day Paolina was breaking a box in the kitchen for firewood and the splinter by intention flew into

her eye, destroying her sight in that eye); public events (strikes, Sacco and Vanzetti, Hoover, the death of Lenin, especially strikes, laborers in hell); poems to Paolina. From denunciatory satire, to domestic commemorations, to the romantic lyric, 1,200 pages of work, spanning the years between 1920 and his death.

His sons and daughters knew he was writing all those years, but they never thought it important to mention this to me, the professor of English, of whom they were very proud, don't get me wrong. Every year he'd mail me a serious book: Michelangelo, Einstein, Thomas Paine, Walt Whitman. He was following my educational progress with pleasure, he said so in his letters. He wrote a poem about his grandson in graduate school at Duke University, but he never showed it to me. They said he was a champion baby-sitter, that's the phrase they used, they always said that. After his death, I quizzed his oldest daughter about it: "Because you would go to bed early, and you were a quiet kid, anyway. The grownups would go out and he'd take care of you so he wouldn't have to go out, so he could stay home and write, which he loved." I don't know why he took those thirty-hour train rides from Miami to Utica by himself. I'm guessing he wanted the private time for his writing. Not to mention the two weeks before, all by himself, which must have been wonderful.

He was a neat and a disciplined man. He ironed his own clothes, which always looked as if they'd been laundered and pressed only an hour ago. Calisthenics every morning. Mostly silent at the dinner table. His crew-cut silver hair looked like it was trimmed every five days, and no matter how hot and humid the day, he looked cool and contemplative. Perfect flat belly. When he spoke it was always like he was forcing the voice to come out; soft and cracked, broken up; the voice didn't want to speak; it wasn't used to it; the voice didn't want to go public. He was polite, even courtly in manner, especially with Paolina, but he wasn't interested in conversation. He was interested in reading and writing, and his kids weren't, and when he baby-sat me in the early forties we were a good team. The Patriarch of Ice and Baby Ice. Learning the ropes.

Of course, I've heard some stories, but I'll never tell them. First of all, I consider the sources: nonwriters. Second, I don't care. So what that he did a few things? Of course, my mother wasn't talking about a few things he did, she was talking about the tone of his presence, the quality of being, his and hers, when she had to be in the same room with the man. Am I supposed to believe that Pacino learned how to do *Godfather II* from him? Revenge is a meal best taken cold. Applies inside the family, too. She comes back to see the kids after the separation, you remember, Diane Keaton, who when she told him she was leaving him, when she was leaving him, remember he says "I'll change," with

that dead look on his face. How come Al didn't say, Diane, you change, because I'm not changing. And so she's standing there, just outside the threshold of the house in Vegas, saying good-bye to the kids, when he comes into view from another room, tanned and terrific looking, Al never looked better, and with the best pitiless look I've ever seen on that face of his that you can't take your eyes off of, and the look is delightful. (I must contact a very good plastic surgeon.) And he says nothing. Diane says, Hello, Michael. Al says nothing. He just closes the door in her face like death. Al didn't change. Later, in *Godfather III,* we see what happens. Diane changed. You changed, Diane, do you feel better now? Let them change, because we're not.

I don't want to contradict my mother, not because she's my mother, and there's nobody I'd rather sit and listen to, but because I believe that her feelings had grounds. All I'm saying is that I don't care. And I'm saying that I consider the source: a nonwriter, by which I don't mean bad. I mean nonwriter. My theory, which I haven't told my mother yet, is that her smoking wasn't the thing. He was aggravated because he couldn't get back to the writing, or because he was blocked, or because he was writing well and wanted to get back to it, or because he worked on the kitchen table, he had no choice, and how was he supposed to write with that loud mob (the family) in the house? The louder the mob the more he concentrated on that phrase in his head that he was going to write down tomorrow. That's just a theory of mine. Did he find intimacy on a daily basis too much work? The phrase he honed in his head, that was the thing, he liked that phrase.

Pacino and Paolina used to take walks every evening after supper, and they never invited anyone to go with them. What does that mean? I can believe that his family didn't have access, that they felt shut out, because he floated inside his own mind too much, because he wasn't one of those who constantly exude sympathy. You're there and he isn't, and you take it personally. They would think him cold. What else could they do? Assume that he was trying to be himself?

Every afternoon, Monday through Friday, she'd call him (I saw this in Florida) at 4:00 P.M., from the screened-in front porch where he sat with a book. So that they could watch a soap opera together. *The Edge of Night.* "Augu, *Edge'a Night.*" I'm not telling you they were lovers until the day she went into her final coma. He ignored something in her will, according to one of his sons. I have no idea about the nature of their relationship. Did he show her the poems, the ones about herself that she couldn't read? Did he read them to her? What if he didn't? What would that prove? The fact that a man who likes to write writes a tender poem to a woman doesn't necessarily mean what it is supposed to mean.

Maybe it means that he enjoyed writing the poem, period.

Paolina was the shyest person I've ever known, but when she said, "Augu, *Edge'a Night*," and he didn't hear because he was lost in that book of his on the screened-in porch, she said it again in a surprising tone. He came with a very small grin. He sat down; no talking; they watched the television intensely; no discussion during the commercials. After the episode was concluded, there was talk about plot details, getting it straight, preparing for tomorrow's intensity.

It's possible that marriage and kids were a mistake. It's possible he knew that. It's possible he was, at times, seething underneath because he knew that he shouldn't have gotten married, et cetera, because he did some things that could have been a lot worse, and he knew they could have, but he held back and had waking visions of himself doing the unspeakable, going way over the edge, getting himself onto the front page of the newspaper. It's possible. I have no knowledge of his nightmares; I'm only imagining.

Now I shall write out my desire for a dead man. This is what I want. That he, Augusto, could have been his, Tomaso's, Yeats. That in the warm months a little writing table would be placed for him out there on the second-floor back porch. That he would sleep out there when he wished. That in cold weather he be permitted into the finished part of the cellar, where he'd find a full kitchen and be given a key to the special cellar within the cellar, under lock and key except to Tomaso, Natalina, and now Augusto, a key to the inner cellar, lined with what to my eyes and his look like bookcases, where he shall find space to place his few books and his manuscripts, in between the canned goods, the cherries and peaches and pears, the mushrooms and sausage and caponata, and the tomatoes and peppers and beets, and on the floor against the coolest wall, Tomaso's cool homemade wine, as cool as himself. And when he wanted something to sweeten the day, he would only have to speak his desire, and she would bring him one of her homemade cannoli, stuffed only upon the voicing of desire. A pallet would be fit into the inner cellar and he would sleep in there, but only in the cold months. Then one fine day at midmorning in midsummer he would look up from his writing table on the porch (this is what I most want for him) and know the quiet like the pen in his hand and legal pad beneath, part of the lines he writes when he likes the lines, part of what he most wants to be and, in that moment, is, sensing himself inside a relationship more primordial than what it holds in relation. Then he knows, and is, what Yeats said about Homer:

> *. . . Homer had not sung*
> *Had he not found it certain beyond dreams*
> *That out of life's own self-delight had sprung*
> *The abounding glittering jet; . . .*

Life's, not Augusto's, self-delight, I want him to be lost in that, life's self, which was the world of Tomaso, and then from Augusto would spring, as it had sprung from Homer, the abounding glittering jet, expression pouring forth, piling high upon itself, the lines he would most like, lines that were part of the quiet and the self-delight of which he himself was only part.

And let it be his death room, the second-floor back porch, let it be detached and boarded up, and let him be buried in it between the fig tree and the cherry tree, and upon the grave let there be placed a sprig of cherry, one fig, and, each day, one mushroom, one for every time he could press back, almost without knowing he was pressing back, almost without pain, his urges for marriage and fatherhood. Let it all be.

Augu, *Edge'a Night.*

Italian Catholic in My Bones
A Conversation with Camille Paglia

Thomas J. Ferraro

Camille Paglia: I was born into an extremely religious Italian Catholic family, and for Italians, Catholicism is as much cultural as it is religious. Italian Catholicism is very analogous to Judaism in this respect. I have many intellectual friends who are Jews and who don't believe in God but who nevertheless adhere to Jewish practices and transmit them to their children, because Jewish history is the history of the religion. The religion is the history of their people. The same thing with Italian Catholicism: I have enormous respect for it; I feel Italian Catholic and will be Catholic until the day I die, because it is inextricable from my cultural identity as an Italian American. I think the strong ritualism of all Mediterranean Catholicisms, of Spanish Catholicism as well, goes back to the early Mediterranean cultures. I feel that there is a direct line between the heavy ritualism of Roman religion—and Etruscan before it—and modern Italian Catholicism. In this respect Roman religion was quite different from ancient Greek religion, which wasn't so ritualistic. Roman religion was more like Egyptian religion, which was ritual heavy. My Italian Catholicism has given me this sense of rapport with Egyptian culture since I was a tiny child. I feel I am Italian Catholic in my bones.

My earliest memories are of being in church—public occasions at St. Anthony of Padua parish in Endicott, New York, where I was born. It's in a mainly Italian, working-class neighborhood. The church is just this beautiful thing, under the grey skies of upstate New York. It's the snow belt up there, steel-grey skies—and this gorgeous church, in warm, orangey stucco, which is the color of architecture in the Mediterranean—all these stained-glass windows and incredible numbers of polychrome statues, all holding mystical signs and with cryptic symbols all over them. I've written in *Sexual Personae*

and elsewhere about the impact that these statues had on me. Number one, St. Sebastian, who was up near the altar: You were supposed to be thinking about Jesus in a Catholic church, but St. Sebastian's figure was just overwhelming. It was a semi-nude young man with a loincloth slipping off his hips, and the look on his face was one of mild pleasure, as opposed to the pain you'd expect if your body were penetrated by all those arrows. And so there was, I now feel, a kind of sadomasochistic or homoerotic sensuality about the image that completely derailed any feeling I had for the Jesus, Joseph, and Mary triad. I mean, I have absolutely no identification with that, because the images of the saints were so powerful to me. The other statues in that church were of St. Michael the Archangel—who remains my favorite saint to this day—in armor, trampling down the devil, and next to St. Michael was St. Lucy, holding out her eyeballs on a platter. This is extraordinary—this sort of horror-movie image that every child would see. And in a sacred context. The garishness, the grotesquerie is so different from the experience of someone who is Protestant. No Protestant person of my memory has ever had *that* in a sacred space. Seeing someone holding her eyeballs out to you on a platter—it's amazing! We've never fully analyzed what impact that has on someone's imagination.

So as the years passed, I began to realize that the elements in the Italian Catholic Church that I loved so much were the very things that Martin Luther threw out of the Renaissance Catholic Church because he regarded them as intrusions—foreign intrusions, pagan intrusions—into the purity of what we now call primitive Christianity, and I think Martin Luther was *right*. So this has led to my megatheory, which is that Italian Catholicism is this fantastically complex thing that is not merely Christian but is a unique fusion of Christianity with paganism—and that the things in Italian Catholicism that really formed my imagination were the pagan elements, in particular the saints. I was so excited when I eventually learned that Luther was especially opposed to this cult of the saints, who were late accretions and played very little part in the New Testament. And I realized that they are versions of the pagan gods; it's polytheism. In some cases this turned out to be literally true.

THOMAS FERRARO: Right.

CAMILLE PAGLIA: Let me say this about Catholicism in America. One of the things that I have not liked about the history of Catholicism in the last thirty years is its drift toward Protestantism. I began feeling this in the fifties already. The beautiful church that I remember so well, St. Anthony of Padua, was quite

unlike the churches that I was then attending with my parents when we moved to Syracuse, New York, which was a very Protestant city, and the churches were getting blander and blander. Whether they were building a new church or renovating and restoring an old one, there has been a tendency in this country to systematically remove all these polychrome statues. I call it a kind of airline-terminal effect. You get this kind of warehouse look: You go into these modernistic Catholic churches now, and there's hardly an image—there might be a modernistic image of Christ, something like that—and it's just appalling, the banality. Sometimes the altar's just a barbecue pit! How can these buildings ever develop the imagination and cultivate the aesthetic instincts of any child?

THOMAS FERRARO: Yes. The material matters: not just the marble and bronze and plaster of religious statuary, but the masonry of the church building, even the concrete of its foundation—that is, the business of getting your hands dirty. My mother's first cousin still operates a concrete firm owned by the family, in Astoria, New York.

CAMILLE PAGLIA: Well, I have constantly talked about concrete. The Romans, of course, were the first to really exploit concrete in their architecture, which was not like the cut stone used by the Athenians. There's a kind of engineering genius that Italians have that I think goes back to the great public-works projects, the sewers and the aqueducts of the Roman period. I have an uncle who could talk about concrete for twenty minutes. That was the subject of conversations. I mean, people would just stand around driveways or curbstones and talk about the errors made by a certain company in pouring that concrete.

THOMAS FERRARO: Yes. There's this testament paid to my maternal grandfather. He was a civic engineer who worked on the Lincoln Tunnel but later had a nervous breakdown and was employed by the family's concrete-making firm. The family still uses several of the formulas that he developed for the concrete; and they love to say so, too.

CAMILLE PAGLIA: Right! In Endicott, New York, to this day, there's a curbstone that my father helped to lay, when he was just helping out as a teen, and it's still in use. The attention paid in Italian culture to materials, the practicality of Italian culture, has been of enormous use to me, and that makes me very impatient with the effete wordsmiths of English departments, because they are totally divorced from the physical world. I hate the hoity-toity view of art which is pretentious, airy, and filled with moral meanings. Most critics and scholars have no direct contact with artists; they would be uncomfortable with them.

They pretend to talk about works of art, but in point of fact they are quite different from artists in personality. I have repeatedly said that the artist has more in common with the car mechanic—getting yourself dirty—which is why I have enormous rapport with artists. My career has essentially been at art schools—first at Bennington, and now here [in Philadelphia] for nine years at the University of the Arts. One of my ex-lovers had early on what I thought was one of the keenest perceptions about my work. She said, "You know what you're like? You're like a guy who yells out the window, 'Hey, Joe! Unload the cinderblocks from the truck. And when you're done, bring up the meatballs that are on the front seat!'" She wasn't Italian; she was Jewish, but she saw this kind of hands-on thing that we're talking about; it is so different from the Jewish tradition. She said it's a whole new kind of tone for talking about culture; it's a no-shit, cut-through-the-crap brute manipulation of materials. And that's what I feel is going on in Italian culture, with its artisans—I mean, the people who were brought over here in the late nineteenth century: the stonemasons, the Italian stonemasons—

THOMAS FERRARO: Who built Yale and Duke, for instance.

CAMILLE PAGLIA: Yeah, exactly. The stonemasons who did the universities. Whenever you go to visit mansions of the period—all those country estates and summer houses built by the industrial princes, the merchant princes, with the great new fortunes in America—when you go there and visit them, they always say, these parquet floors were laid by Italian carpenters, the stones were carved by Italian stonemasons, and so forth. There's just this artisanship, this craftsmanship. It was Italians who for the first time in the Renaissance, for the first time since the Greek period, had the idea of the artistry of the man who works with his hands—that Michelangelo could be called a genius even though he was filthy all the time. Traditionally there had always been this division between people who worked with their heads, the poets and the philosophers, and people who worked with their hands. The painter and the sculptor never had the prestige, except in ancient Greece for a brief period, of the poet and the philosopher. And it was no coincidence that it was the Italians in the Renaissance who made the painter and the sculptor equivalent in genius to the poet and the philosopher. I have often said that the Italian thing is like: A little old guy comes into your villa, or whatever, if you were in the late Renaissance, Baroque, or later period, and says, "You know, what you need, I'll give you—how about a thirteen-foot-by-six-foot painting here, and what about over here? I'll give you a statue. What do you want? A statue of Venus, you want a statue of Venus?

Okay, I'll give you a statue of Venus." Just a pragmatic way of talking about art, and yet an incredible feeling for beauty, that I think is so fabulous. That's one of the superiorities of Italian culture, the way aestheticism is combined with practicality.

THOMAS FERRARO: Almost a divine immanence in the material.

CAMILLE PAGLIA: When I was writing *Sexual Personae,* this sense of the material was crucial. I would be talking to my friends, other friends who are writers, I would often be giving this lecture; people have this mantra that I give them. They would get writer's block—many people have writer's block, but I never have writer's block of that kind—and I always say to them, "Hey, look! Just look at your materials; look at it like bricks and boards, bricks and boards, that's what it is"—okay, like that. "And you're just manipulating the bricks and the boards." And they say, "Where are you getting this view?"—and in a sense I don't have writer's block because I look at it in this practical Italian way.

THOMAS FERRARO: There's a sort of romantic modernist notion that it's a divine inspiration, and you have to wait around; whereas instead it's something you can perform, you can bring about.

CAMILLE PAGLIA: Yes, but there's also a kind of industriousness in Italian culture which is quite different from Jewish culture. I have some Jewish friends who are intellectuals and who still have the idea that working with your hands is demeaning—that that's what common laborers do, all right? One of the great virtues of my work is the whole plunging into the material that you're getting in *Sexual Personae,* the whole gung-ho attitude toward things, this heaping-up into this huge monument. When my mother and I visited Los Angeles, we visited Watts Towers, in Watts. People think it was made by a Black person, but it wasn't; it was made by an Italian. It's all this junk that was raised into huge Gothic towers. My mother said about it, "This was a man like my father"—like my grandfather, who worked in a shoe factory. There's this tradition in my family, on both sides really: An Italian can go to a junkyard and take a piece of junk and make something out of it, a contraption or whatever. It's unbelievable. Nothing is ever thrown away. All of my family, even the ones who have now been for several decades white-collar workers, they spend their time at home making fences, bending iron, polishing wood. There's a tremendous honor paid in my culture, in my family's history, to the person who makes things with his hands. It's considered enormous—people just stand around—and there's a lot of admiring. That's probably where I get a lot of my attitudes to-

ward art, because I'm just so used to, "Oh, look what Uncle Albert did!" And it would be just unbelievable! And they weren't taught. I mean, it's this sort of unbroken tradition of watching other people. Basketweaving. My grandfather in his spare time used to weave baskets, baskets that we still use for laundry. Or they would make grape arbors. When we moved into a house, a little Cape Cod house in Syracuse, and my father terraced the whole backyard—huge terraces—it was like the ziggurats of Babylonia. People were always laying pipes underneath the ground, to drain the water. I also have what I call a janitorial talent. It's embarrassing. I walk into a faculty meeting that's about to begin, everyone is sitting around, the shades are drawn for some reason, maybe slides have been shown in the room before, it's hot in there, people are saying, "Oh, it's so hot in here." I immediately walk into the room, and this Italian thing comes over me. I begin to rearrange the chairs—

THOMAS FERRARO: Yes, I know. Rearrange the chairs.

CAMILLE PAGLIA: I rearrange the chairs, I put up the blinds, I adjust the heat, I throw the garbage away, and I say, what is it? I cannot bear this kind of clutter and disorder in the physical realm. So there's a kind of constant monitoring of the physical realm. You also notice it in cities; you can always tell the Italian block, because you go suddenly from a filthy block to a totally swept block—a poor neighborhood—of apartment buildings, with geraniums out front. The minute you see a geranium in a poor neighborhood, you know it's an Italian who's living there! In fact, that's how I once chose a mechanic. I was having trouble with the transmission on my car in New Haven ten years ago, and transmissions are notorious because people can gouge you. I went from one transmission place to another, just looking at it from the outside, and finally, in the suburbs, I found a little transmission place with a whole row of geraniums out front. I said, "This is an Italian"—and I went there. And it was perfect, it was great, it was fabulous.

THOMAS FERRARO: I know what you mean. In Italian cooking, which is something I do, you work with textures. It's not just the food that you produce, but it's the efficiency, the beauty, its own physical beauty, of what you do in order to produce the food. There's an aesthetic of doing in the production of food, and then there's the opportunity for me to play my mother's role, to do the communion. I hate being in the room by myself doing the cooking, though. I'll call people up, if my son or my wife or a friend isn't around; if no one's around, I have to get people over to be there in the preparation, to be there in the eating, to be there after, to start talking about the next meal. All of this is very

Italian; it's also—it's always struck me as Catholic in form somehow or other.

CAMILLE PAGLIA: Well, it's the ceremonialism that I think is archaic; it's really tribal, the ceremonialism of food preparation, absolutely. I mean, it's Italian families. Everyone's in the kitchen, so it's a gigantic production. And that's why [Francis Ford] Coppola is a good movie director, because making a movie is like making an Italian meal, so this gigantic thing goes on all day long, while people are making polenta, or whatever it is, and just this milling around in the kitchen, and the kitchen is the center of the house, it's the center of life, the food preparation. Jewish culture is food-obsessed also but not quite in this grand way, this kind of grand-opera way, with a cast of thousands. In Italian culture, you talk about what you're going to eat, weeks in advance. First the anticipation, the mental anticipation of it. Then there's this tremendous to-do made about the preparation. Then while you're eating it, everyone's making a big deal about what you're eating. Then after the meal, you make a big deal about what you ate.

THOMAS FERRARO: You'd better believe it.

CAMILLE PAGLIA: Afterward, for weeks. So, for example, just now, for Easter, my mother asked me, two months in advance, should she make sauce for Easter?

THOMAS FERRARO: Two months in advance, absolutely.

CAMILLE PAGLIA: There's no other culture where your mother is asking you two months in advance, and where you're planning what you're going to eat, are you going to go to a restaurant for this meal or that and so on. It's just this entire thing. That is what separates me from so much of current feminism, which is obsessed with bulimia and anorexia right now, the food thing. My association with eating food has become a famous motif in my interviews, right from the first big interview that I had, the [4 March 1991] *New York Magazine* cover story: The reporter is always describing me eating an enormous amount of food with great relish, as I'm talking a million words a minute, et cetera, et cetera. My attitude toward food is like my attitude toward art: The consumption is pleasure. The sensory aspect to things, the multiple sensory aspect of the human body, is wonderfully dramatized in Italian food preparation. I do think there's a parallel between the Catholic Church Communion and what's going on at the Italian table—the ritualism of Italian culture—but in point of fact, one has to say that Italian food preparation predates Christianity.

THOMAS FERRARO: That's right.

Camille Paglia: It goes back thousands and thousands of years. This is true of all tribal cultures; the more tribal it is, the more centered it is around the fire, and around feasts, the idea of feasting, and everyone eating together. That's another thing in Italian culture, everyone eats together. It's just unheard of, this American thing of wandering in and out of the kitchen, grabbing a bite, never sitting down to the same table.

Thomas Ferraro: Talk about sacrilege.

Camille Paglia: Right, yeah. That's right. So this food thing is like a major thing. I'm surprised I'm not fat. I don't know why I'm not fat, because I'm so obsessed with food.

Thomas Ferraro: Because you *do*, as well as sit.

Camille Paglia: See, this is what I'm trying to bring back to feminism—this idea that food is life-affirming. The way that food has become symbolized in current feminist theory has to do with vomiting and starvation. And not just feminism—there's something really deeply deranged about academic theory right now. In French theory, all this abstraction, abstraction—

Thomas Ferraro: All this stuff about the body that's so abstractly rendered in language, right? There's no sensuality in the language itself.

Camille Paglia: All abstraction is body-denying. That is the sacrilege of abstraction. I believe in theory when theory is justified. I believe in the beauty of ideas; I admire Plato. But the minute you get language used as this kind of obscuring curtain, there's something really wrong. That's one of the things I have tried to restore to art criticism—the multiplicity of the senses. I'm always trying to evoke sensory effects from my writing. To me language is something spoken, not something on the page. That's why there's a repetitiveness to my language. As I revise, I'm reading it aloud, under my breath, so you're actually feeling the words in your mouth. There's a direct analogy between my obsession with food as an Italian and my writing abilities, or my writing style, my writing methods.

Thomas Ferraro: Let me ask you about the occasional pieces in *Sex, Art, and American Culture*. What's the relationship between being Italian Catholic and your position on date rape?

Camille Paglia: The connection would be the idea of personal responsibility. There's a principle of self-criticism that you get as a Catholic, because there's a whole self-examination leading to Confession. Madonna has commented on

this, too, that the Catholic has this power of self-analysis, of looking at yourself from the outside. You're trained to do that as a tiny child, to look at your life, to review your life, to assess it at certain intervals—originally, every week—and then to transfer that into verbal form. There is a kind of self-consciousness that Catholicism gives you, and also a sense of personal responsibility from childhood. You're expected to be responsible as a moral being from the age of six or seven, from your first Holy Communion on, right? And unfortunately in our culture there's a sliding of adulthood into your twenties now. A girl in college, eighteen or nineteen years old, gets drunk, dressed in a Madonna-style outfit, and ends up having an unpalatable sexual encounter at a fraternity house, and we're supposed to excuse her! "Oh, poor dear, oh my gosh, those bad boys, gee, we're going to punish them," and so on. This is not Catholic.

THOMAS FERRARO: It's blame culture; it's litigation culture; it's always somebody else's fault.

CAMILLE PAGLIA: Yes, yes. But also this endless prolonging of childhood into late teens and into your twenties. Anita Hill was twenty-six; she was a graduate of Yale Law School. And even if what she alleged Clarence Thomas said to her was true—now there's some doubt even about that—even if it *were* true, the man never laid a hand on her. He simply was joking about pornographic materials. Big deal. Ten years later, she's still talking about her passivity. Passivity seems to be predicated in our culture now, where something's being done *to* you.

THOMAS FERRARO: Right. Whine culture.

CAMILLE PAGLIA: Whining culture. I'm constantly talking about the problems with whining. You're expected as a Catholic not only to have examined yourself but to take action on the basis of your faults. And moral adulthood is expected of you very early. And I think that this is certainly behind my date-rape thing and my impatience with the childishness that is foisted on you in this culture, where everyone is all-forgiving. Well, everyone is not all-forgiving in Catholicism! Everything was very coded. You know, if you said this many Hail Marys, you could get a soul in Purgatory three years off or something. It was all worked out like that, and it's rather hilarious now. The catechism itself, which I loathed when I had to memorize it for Confirmation—I just hated it, having to memorize the questions and the answers to the *Baltimore Catechism*, but I've realized that that's behind a lot of my writing. I'm constantly posing rhetorical questions and then answering the questions. The rigor, the intellectual rigor of it.

THOMAS FERRARO: The aggressive formulations, which are both illuminating and

infuriating to your reader, are a corollary of the way Italian kids are raised, no?

CAMILLE PAGLIA: Oh yes.

THOMAS FERRARO: —Which is, that it produces both provocation and discipline at the same time.

CAMILLE PAGLIA: Yes, and I think the way Italian kids are raised is exactly right. That is, "no" *does* mean "no" in an Italian home. The liberal way that kids are raised in America produces whiners in adulthood. It's a problem with authority—this goes back to the hierarchical thing again, where the parents want to be the equal of the kids. Well, that's never the attitude in Italian families. It's just like in Chinese culture: The elders are to be respected.

THOMAS FERRARO: Oh, it's very much like the Chinese. Two of my sisters have married Chinese men, and I think that there's a similarity and difference in exactly the right proportions, it seems to me.

CAMILLE PAGLIA: It goes back, all the way back to the Roman ancestor cults, where you kept the ancestral masks in the atrium of the house and marched with them on one holiday every year. It goes back, in turn, to Etruscan culture.

One of my favorite moments is the scene in *La Dolce Vita* where there is this decadent Roman party at the end of the film. The aristocrats have been partying all night at their villa, and suddenly it's dawn. The matriarch, the mother, appears with their family priest on their way to the chapel for Mass. She abruptly summons these middle-aged aristocrats—"Come on, time to go to Mass"—and, boom, they suddenly leave the partygoers and fall in line behind the mother on their way to the chapel, and all the other partygoers are gaping, with their mouths hanging open. The aristocrats going from the orgy to the chapel are not going because they believe in God. The religion and the family culture are completely intertwined. You can see it there. There's a respect for the mother; respect for the family, that's your identity.

THOMAS FERRARO: Without a doubt. There's another one of those principles that we grew up with. My father always said that, when we wanted to have or do something, any appeal to the fact that our neighbors had or did that something was prima facie evidence that it wasn't a good idea.

CAMILLE PAGLIA: You mean as an Italian.

THOMAS FERRARO: Yes, as an Italian.

CAMILLE PAGLIA: Oh yes, there's a real xenophobia in Italian culture. That's where

my sociological abilities came from actually. My mother was born in Italy, and my father was born here, but all my grandparents were born there, and there's a definite sense of being an embattled ethnic group. I can remember my earliest memories are of my parents talking, constantly talking and discoursing on the differences between us and *them,* and the oddities of American culture that they disapproved of—it would concern cheerleaders, dating compulsions, gym classes, all kinds of things. And my parents had a sharply critical perspective on the surrounding culture; my earliest analytic powers came from that.

THOMAS FERRARO: I have some quite specific references that you may or may not want to respond to. I had been thinking about Vito Corleone as a persona, or Don Michael, or—

CAMILLE PAGLIA: Number one: Let me just say that people are always talking about defamation of this group or that, and they never talk about defamation of Italians. In other words, Jews are very sensitive to references to them, and Blacks to them, and you're hearing more now about Arabs, et cetera, but the kind of vulgar stereotypes of Italians that you see in films are just appalling. Yet *The Godfather* films, to me, are so wonderful. I *love* them. And I hate those films like *Moonstruck* and *Prizzi's Honor,* which have all these vulgar imitations of Italians. But the first two *Godfather* movies, I absolutely love them. Because they capture the ceremonialism of behavior. For example, the whole sequence where Robert De Niro is the young godfather. He's this quiet young man working in a grocery store. You see him just thinking, thinking, thinking—he's very soft-spoken—and he ends up killing the Black Hand guy after running over the roof; that whole thing is so well done. The attentiveness to the family! The young godfather shoots that guy in the face, practically, then goes down to the street and sits down on the stoop with his own wife and children, bobbing his infant son on his leg, and says, "Your father loves you very much." The Italian ability to get these emotional contrasts juxtaposed between murder and family love, tenderness and hatred—it seems to me that that is part of the Italian personality, our tolerance for violence. In fact, one of my favorite scenes about this is in *Broadway Danny Rose*—

THOMAS FERRARO: Oh, you like *Broadway Danny Rose*—

CAMILLE PAGLIA: I love it!

THOMAS FERRARO: See, I like *Broadway Danny Rose*. In fact, my wife, she's pregnant, and if we get a girl, we're going to call her Daniela Rose. Now Rose—Rosa is a family name; and Daniela—I've had two great students whose names

were Daniela, one in Switzerland and one here, so I have a positive reservoir; and it's biblical enough. But also—go ahead.

CAMILLE PAGLIA: Let me just say I despise, for example, Cher's performance in *Moonstruck*—she's trying to be Italian, she tries to imitate a Brooklyn accent; it's ridiculous. Whereas, oddly enough, Mia Farrow is able to capture very well this authentically Italian personality type; she is like a dead ringer for my cousin Wanda. It's amazing. It's a wonderful performance. My favorite scene is that one in the car where she's talking to Woody Allen about her ex-husband, and she says, "Yeah, well, they shot him between the eyes," and Woody Allen says, "Oh! That must have been very painful." "He's *dead*." And Woody Allen gulps, "Oh. Oh. That's right. I mean, my God, to be shot between the eyes means he would be dead." You can see this sort of like cringing—the Jewish ethical man with his great empathy for the victim. He imagines the victim suffering. But, meanwhile, Mia Farrow, who is the woman here—it's a reversal—is chewing gum, "Yeah, well"—

THOMAS FERRARO: "Don't forget the cannoli!"

CAMILLE PAGLIA: I've noticed that Italians have a kind of matter-of-factness about death and suffering. Death is something that is simply a practical event in life. One of the great virtues about being raised Italian is that there's no big bourgeois sanctimony about death. There's all this preparation for when you die—the funeral home, the cemetery, everything is prepared in advance. Again this descends from Etruscan culture—the way death is a ritual goes all the way back thousands of years. I remember from my earliest years the open casket. You always saw corpses.

THOMAS FERRARO: Always.

CAMILLE PAGLIA: And people are weeping. There's a big thing of weeping. And then people are talking, chatting and laughing, and standing all around the open casket. The morning of the funeral, there's a file that goes by the casket, and people kiss the corpse. Most people are horrified by that. The physical facts of death are accepted in Italian culture. Then you visit the graveyard and leave the flowers. In Italy people visit the graveyard every week and lay flowers. Death is something that is as concrete and material as anything else. That seems to me very commonsensical. And how interesting because it again relates to food. There's eating, and there's death; all the experiences of life are materialized, it seems to me, in this very healthy way. I think the Italian character is very healthy. So again, I've gotten into a lot of trouble in my life in colleges that

I've taught in, by my absolute matter-of-factness about someone having an accident or being killed. You know, dying. I mean, people go through these "Oh, no, oh my God, oh no," and so on, and as an Italian, I go, "Oh yeah? Well, *so?*" Like that. And I shock people constantly. People think that I'm simply uncaring, brutal, but in point of fact I can remember my relatives sitting around eating, and "Oh yeah, Old Man Signorelli dropped dead yesterday." "Oh, no kidding?" Like that. Then, "Pass the lasagna." Today there are all these verbal formulas in which you must telegraph your decorous empathy, something that you don't, in fact, feel. It's one of the things hanging over academe right now, where all the atrocities that have ever happened to anyone in history are trotted out, and you have to go "tsk, tsk." I refuse to do that about anything—about date rape, or battered women, or whatever it might be. My impatient "Yeah, well, deal with it" is an Italian thing: "*Deal* with it. Deal with it head on. Confront it. Don't expect pity." There's no self-pity in Italian culture unless it's theatricalized in the kind of Italian grandmother way, which has enormous strength, the mater dolorosa, the madonna thing, the suffering mother. It's definitely there, but it's there with strength—not with some kind of languishing need for protection.

THOMAS FERRARO: No, no. Mario Puzo's *The Fortunate Pilgrim* gives us that combination with a vengeance. Tell me—you were talking about defamation a minute ago, and then about getting in trouble for displaying sort of commonsense Italian attitudes toward the business of life. The culture of complaint notwithstanding, whine culture notwithstanding, can you say something about the academy and its sort of implicit anti-Catholicism and anti-Italianness? I think that it may be changing; the demographics are finally changing.

CAMILLE PAGLIA: Oh, no, I have said repeatedly, right from the start in the sixties, that the problem with American academe is that it's completely dominated by a WASP style; that in order to succeed in academe in America, you have to adopt a WASP manner, which is like very laid back, it's very low key, and so on, and this is why I am always attracted to Jews, because Jews were the only ones who could tolerate me.

THOMAS FERRARO: And the closest allies—and supporters, too. When they're in authority, something in us gets to come out?

CAMILLE PAGLIA: In Jewish culture there is great respect for dominant women, because the Jewish mother is extremely outspoken and harsh and loud in her manner. I began noticing early on in life that WASPs could not stand me, that I

was too much. I'm too loud, I'm too boisterous, I'm too everything. Whereas my parents, by the way, tried to assimilate. My parents are the generation that assimilated. So there is a sharp contrast between the way I behave and the way my parents behave. I'm not just someone who was raised in a certain way—

THOMAS FERRARO: You followed your grandparents, like I do.

CAMILLE PAGLIA: I followed my grandparents.

THOMAS FERRARO: The teacher in my family is my grandmother, my paternal grandmother—not my parents.

CAMILLE PAGLIA: Yes, I am part of the "ethnic pride" generation of the sixties, the search for ethnicity, where I identified with the working-class kind of style of my grandparents, not the middle-class style of my parents. And so my parents have always been criticizing me, my entire life, for how loud I'm being. "Why do you have to talk like that, why do you have to act like that?" My father—he died two years ago—was extremely well mannered, but his manners were quite different than mine, and I think in certain ways that's part of my revolutionary persona. I have never wanted to lose this authentic ethnicity, from early on. When I arrived at Yale graduate school in 1968, it was very WASP at that point, and Harold Bloom was quarrelling with the department. The reason I got along well with Bloom is because he has always refused to compromise his Jewishness, always. Even back in junior high school and high school and college, I was drawn to Jews because of their aggressive verbal style. Talmudic disputation is very like my manner, my verbal manner. And my idea for revolution as a sixties person before I ever arrived at Yale was to try to destroy the kind of WASP style that was necessary to rise anywhere in academe or corporate life. With my personality I was unhireable by any good college in this country; that's why I ended up in an arts school, where my personality is seen as normal. My energy level is the energy that you need to sing opera or to be an actor.

THOMAS FERRARO: Or to dance.

CAMILLE PAGLIA: Or to dance, to go out there and to dance.

THOMAS FERRARO: The irony about multiculturalism, right?

CAMILLE PAGLIA: Right. The way they solve any issue of multiculturalism or anything else is to add on some ghetto, some adjunct annex, where you can sweep all the unpalatable people and confine them there. That's why Black studies was stupid, right from the start. Instead of performing the true revolution—

THOMAS FERRARO: Which is African Americanizing the center.

CAMILLE PAGLIA: Yes. The true revolution was to destroy the English department and to create an interdisciplinary structure where all of the arts interrelate with each other. It has not been done. What *has* happened? Now they look for someone with a Black face or with a gay lifestyle or who is Asian, [and] they just add that person to a department to indicate that they are following a socially approved multicultural format here. But in point of fact, the WASP dynamic of American academic life is untouched. It's untouched.

THOMAS FERRARO: And what you're saying is that Theory with a capital "T" was a move against changing demographics. As more Jews and Catholics and African Americans—women especially, beginning in the late seventies—began to enter university echelons, theory itself—so verbally oriented, itself so logocentric!—became a way of resisting their different modes of knowing and doing.

CAMILLE PAGLIA: Right. What I have said, which really is a bombshell, is that French theory when it came in, in the seventies, was reactionary. It was a way to stop the pop cultural revolution of the sixties and the actual revolution that was ethnic. The people who were attracted to theory were all evading the emotional, the sensory; people whose experiences have been completely confined to the verbal realm and to academe, and who know nothing outside of the conference world. Foucault for them is an instrument of reaction, a form of control. As far as I'm concerned, for example, any gay theorist who uses Foucault is himself or herself homophobic, because if you need the abstractions of Foucault, the body-denying elements of Foucault, to think about your own homosexuality, you have a problem with it. Whenever I say that, by the way, in public lectures, people just cheer. Then there is the hypocrisy of Stephen Greenblatt, trying to tell us about the imperialism of the discovery of the New World and how Columbus, my ancestor, was a thug. How *dare* he, this man who never mentions the Holocaust, this man whose entire work and self are nothing but a creature of the WASP establishment, a fair-haired boy of the hierarchs of the English department at Yale, whose dissertation on Sir Walter Raleigh got the Porter Prize! The idea that he is now presenting himself as somehow a voice for multiculturalism—this man who was embarrassed by his own Jewishness—well, excuse me!

THOMAS FERRARO: I don't know. I was at Yale, too. But I did feel I had to, well, Protestantize my writing—when I was told not to use exclamation points and italics, not to "hymn" in my prose and all that, when I was being trained.

CAMILLE PAGLIA: That is a great point. That was one of the things that I wanted to

change: the absence of emotional emphasis and the absence of excitement in the kind of critical writing that we were expected to do. I probably use exclamation points more than anybody, any scholar, any living scholar—I use exclamation points more than anyone! It leads to this kind of wild, hyper sound; it makes people who think of themselves as serious dismiss me because of this, but I love exclamation points! When I write to my friends—you know, when we write to each other—we have exclamation points, sometimes ten of them. Ten of them! And everything <u>underlined</u>, and in BIG LETTERS, and so on and so on. And that seems to me part of the big revolution that I am bringing back also. Essentially, it's dynamics in music. It's like an opera, going from crescendo to diminuendo. You're experimenting with pace, with rhythm, with volume, with emotion.

THOMAS FERRARO: Right. And in my writing I had to work so hard to *sneak* that stuff in, to sneak those rhythms in, so that when reading me you have to have a very good ear to hear it, because I was deprived of the real color.

CAMILLE PAGLIA: And that is related to the terrible thing that has been done to the young, blanketing them with this passionless French theory, which is worse than New Criticism. My generation tried to get New Criticism out, with all of its WASP *pudeur*.

THOMAS FERRARO: New Criticism is good for producing concentration, and then—

CAMILLE PAGLIA: Well, I realized as the years went on that, in point of fact, I had been trained in New Criticism, and that it was a wonderful discipline. At the heart of my work I am a New Critic, but I've added to it everything else that I am, too, like my interest in sex and history. New Criticism has not been improved on. New Criticism in the classroom remains the best teaching tool, and it is also the best way to teach professors how to read, because right now we have people with Ph.D.'s who can't even handle a text—

THOMAS FERRARO: Amen.

CAMILLE PAGLIA: —who are totally tone-deaf to a text.

THOMAS FERRARO: I've got a question for you that occurred to me a few minutes ago when you were talking about your father. Did he die too soon to feel the effect of your book?

CAMILLE PAGLIA: Well, my father died having some sense about the celebrity. But

in certain ways it's freeing, that I don't have to worry about embarrassing him, or anything. My father was someone who was the only member of his large family to go to college—thanks to the G.I. Bill. We were poor. We began very poor. We didn't have a telephone or a television until I was twelve years old. He was a high school teacher first, then he went back to graduate school. People often make rude remarks about me: "Oh, she came from a privileged professor's home." What are they talking about? They are just ignorant—because by the time my father had a job as an instructor at Le Moyne College [in Syracuse, New York], I was twelve or thirteen, and that was hardly a privileged position. [Laughs]

THOMAS FERRARO: Yes, and he was trying to move quickly across class lines, without the sort of upper-middle-class security that's usually an entire generation's achievement.

CAMILLE PAGLIA: No, what I mean is that I sort of had the best of both worlds. My father was very studious and intellectual early on, but we were poor, so I never had any privileges, particularly, so that's why I had no problem enduring all the poverty and rejections of my mid-career, et cetera. But at any rate, this is what I hate about the outing phenomenon, because the problem with outing is that it assumes that you exist as a solipsistic individual, without any responsibilities to anyone else, without any ties to anyone else. One does not just make decisions based on oneself. One has these interconnections—like in Italian culture, you belong to a clan, you have responsibilities to the clan. So even though I was quite open about my sexual preferences while in graduate school and at my first job at Bennington, I wasn't going around trumpeting it to the world in general, because again, in Italian culture, embarrassment is very important. It's a shame culture, rather than a guilt culture.

THOMAS FERRARO: Right.

CAMILLE PAGLIA: In certain ways I probably wouldn't be this open about everything in my life if my father were still alive. It would be undignified, I think, but now I don't have to worry about that. After all, my work is a rebellion against what I was taught. My father could not possibly approve of all my beliefs, so the idea that he would agree with everything I'm saying, that's ridiculous! [Laughs]

THOMAS FERRARO: Right, but there would be forms of pride, and we're still waiting for the fullest impact of the book itself.

CAMILLE PAGLIA: Well, my father lived long enough to see that I had become world famous, but my media stardom came late, after he died, essentially. The first magazine cover that I was ever on came out at that moment, when he died. From then on I began talking about my own life, personal details, in ways that I would not have done if my father was still alive. I would not have been this autobiographical. It's not respectful. So again, that's why I feel that this outing thing is absolutely barbaric in many ways.

I think that outing is a good issue to be in the air, though, because from the moment I was famous, I felt that I had an *obligation* to be honest. For example, I feel Susan Sontag was utterly irresponsible in the way that she handled her interviews—in the *NewYork Times Magazine,* for example—after her recent novel came out. I thought it was absolutely contemptible, the way she handed out all these photographs of her childhood and her early marriage and talked about her son and all these other things, but then at the same time was totally silent about her open lesbianism or bisexuality that has been going on in New York for twenty-five years. It seems to me that any writer is justified in saying, "My life is confidential, and I exist only as a person who writes, or as an artist." But one cannot pick and choose. One cannot open oneself to the media, use the media for publicity, and say, "This part of my life I will give to you; that part is off limits." If I am receiving the reporter in this way, if I am allowing my personality to be written about now, apart from my writing, then I have an *obligation* to be frank, to be open. But outing has to be a matter of personal choice.

Throughout the eighties, I had given up thinking *Sexual Personae* was going to be published in my lifetime. I always had the sense that I was writing something for an audience that didn't yet exist, but I had great confidence in it—that the audience would exist for it later.

THOMAS FERRARO: This is vocational on your part. To emphasize the Catholic elements again, that expectant patience is a monkish sort of thing.

CAMILLE PAGLIA: Exactly. And what sustained me through all that was my sense of monastic vocation.

THOMAS FERRARO: You do this because it's going to really matter; it's going to matter after you don't; things don't end when you die; you give legacies.

CAMILLE PAGLIA: That's right. It's the idea of labor, the monastic tradition of isolated labor that you do for a greater cause, something that's greater than merely the contemporary, merely the present, and that you are the custodian of the inherited past.

THOMAS FERRARO: Custodian, yeah, what an amazing word that is.

CAMILLE PAGLIA: Yes, right, because it's the janitorial thing again. It was the monks who preserved so many of the Greek texts, just copying them over again. The idea of a scriptorium, the laborious copying over—I think of that all the time. I copy out things, and the muscular copying out is in some way an act of respect. So there's no doubt that my sense of vocation as a scholar was very much animated by the Italian Catholic past. My mother was born in the town of Ceccano, about twenty miles north of Monte Cassino, the great abbey where St. Thomas Aquinas was educated. This is our tradition. That's why I've been so contemptuous of the Ivy League. My attitude toward the Ivy League is totally disrespectful. Not because I'm a populist, because I'm not, as a scholar. I'm an elitist, as a scholar: I believe in the best and the greatest. Talent is something that is inborn, and I believe in the elitism of talent. But my sense of the tradition of scholarly work long predates Harvard or Yale. So that's why I just spit defiance at these full professors at Harvard or Yale. I delivered a lecture last year at Harvard—to 800 people crammed into their biggest theater—called "What's Wrong with Harvard?" And here's this person from this unknown school in Philadelphia, going up there and slamming them and slamming them and slamming them—by name. I was naming names of people on their faculty and slamming them, and the crowd was laughing and applauding and cheering. I thought, this is really something, because even Harvard itself knows that in some way it's become corrupt or bankrupt or whatever. I'm a reformer; I'm like Savonarola or my great role model, Teresa of Avila, who wasn't famous until she was in her forties. She went against the whole establishment. She fought the bishops and the pope. She singlehandedly started the reform of the Spanish convents. People said to me early on, "Oh, what can you do? One person can't do anything." And I said, "Excuse me, one person can move mountains."

Editor's Note

The interview was conducted by telephone on 27 May 1993. A small portion of this text was published in an earlier version focused on Catholicism in contemporary America. See Thomas J. Ferraro, "An Interview with Camille Paglia," *SAQ* 93 (Summer 1994): 727–746.

On Being an Italian American Woman

Mary Jo Bona

This article begins with a caveat: Those searching for a summary definition of being an Italian American woman will not find one in these pages. Being an Italian American woman is as complex as being an immigrant in the United States. Though we can locate shared experiences among both Italian American women and immigrants, their struggles are not unique to an inherent set of features within themselves, but are controlled by the economic circumstances and cultural values in their lives. Thus, to suggest that women of Italian American heritage possess unique attributes is problematic. Specific to each culture are folkways, culinary habits, and value systems that distinguish an ethnic group, such as Italian Americans, from other groups and yet reveal a commonality among their lived experiences. To assume that the Italian American woman has a "being" that she shares with other women from her cultural group dismisses the absolutely vital factors of generational difference, economic background, geographical provenance, and educational experience, and thereby limits her to a monolithic identity.

In order to embrace the complexity of the Italian American woman's experience, it is important first to correct the false images attached to being a woman from this ethnic group. She has been trivialized by the media and reduced to an "Italian mamma," dressed in black, lugubriously sorrowful, stirring the sauce. As Daniela Gioseffi writes in "Against Stereotyping," "we Italian women don't all have hair on our upper lips and stir spaghetti sauce as our main occupation" (Gioseffi 1992). In *Growing Up Italian,* a book of interviews with Italian Americans, Linda Brandi Cateura quotes Geraldine Ferraro, who describes her female ancestors as independent and changing human beings: "My mother lives alone because she wants to. She doesn't want to live with us. . . . Again, you have to understand my

Boldface terms are defined in the Cultural Lexicon which starts on p. 703.

mother is not an Italian stereotype, and neither was her mother. My grandmother never walked around in a black dress" (Cateura 1987, 261). The fact that Italian American women are regularly and perniciously depicted in perpetual mourning, doing domestic penance, allows them to be circumscribed by a comfortable, non-threatening image that needs no explanation. When psychotherapist Aileen Riotto Sirey asked Jewish women to write the qualities that came to mind when they thought of the Italian American woman, they responded by defining her by her role as a good wife, good mother, and good housekeeper, but they did not know much about her internal life or her personal desires (Cateura 1987, 116). Sirey takes this to mean that the Italian American woman has been invisible and self-effacing, a woman without a voice. Perhaps the problem lies in the fact that, as Italian Americans, we have too often allowed ourselves to be defined by other groups and by the dominant American culture, which has a tendency to limit all ethnic groups to a couple of stereotypic features, thus depriving them of their complexity.

The multifaceted nature of Italian American women begins with the grandmothers, the women most likely dressed in black, who made the transatlantic journey from Italy to America in the late nineteenth and early twentieth centuries. The legacy that they left their daughters and granddaughters was beautiful and painful, as attested by the second- and third-generation daughters, some of whom are referred to below. Finally, Italian American women themselves have written complex and multidimensional narratives of Italian American women's experience. Their depiction of their foremothers as hard working, persevering, and assertive in the face of atrocious working and living conditions speaks to the strength and determination to survive in a new world, one that often excoriated different cultural traditions and rewarded those who rapidly assimilated American ways. The daughters are writing their mothers' stories and privileging their gift of difference. As the mother in Octavia Waldo's (1961) novel *A Cup of the Sun* says to her children, "You live in a world that would deny you differences. Yet that is all your Mamma can give you." It is in these areas that we will discover the variety that makes up the Italian American woman.

In her unpublished poem "Lines to an Immigrant Grandmother," Helen Barolini writes, "You had no tongue here / but lived / stirring soup, looking out, wearing black / smelling strange, / no longer you / but only withered womb that once foresaw me. / Old woman were you happy?" The way in which Barolini depicts the grandmother seemingly reinforces the stereotype of Italian American women, but as historian Valentine Rossilli Winsey explained of first-generation Italian women, a simple black dress characterized the immigrant peasant woman

who came to New York at the turn of the twentieth century (Winsey 1975). What both Barolini and Winsey demonstrate is the fact that these women were neither one-dimensional stereotypes nor thoughtlessly devoted to their duties as wives and mothers.

After the 1880s, primarily southern Italian peasants immigrated to the United States; nearly 85 percent of all Italians who journeyed to America were from the *Mezzogiorno* (areas south and east of Rome). The Italian woman who immigrated to this country did so, as Barolini writes in *The Dream Book*, "as part of a family—as daughter, wife, sister; on 'consignment,' chosen, sometimes by picture, sometimes by hearsay, from an immigrant's hometown to be his wife. But always in the context of a family situation" (Barolini 1985, 6–7). According to historians of southern Italian culture, the family in the *Mezzogiorno* was the only institution that afforded comfort and could be trusted. Reasons for such strong emphasis on *l'ordine della famiglia* (the unwritten, but uncompromising code of duties and responsibilities to the family) (Gambino 1974, 3) stem from the geography of southern Italy and the historical pattern of invasion by a constant influx of foreigners. Beset by changing governments and natural disasters, the southern Italian had little else to depend on but the family and the close *comparaggio* or *comparatico* (godparentage) in their small villages. Inhabitants of small southern Italian villages typically spoke their own dialect and practiced their own traditions and rituals, thus contributing to the effect of *campanilismo* (village mindedness or provincialism) and its concomitant reinforcement of intense familial and communal loyalty. Within this structure, the Italian woman contributed economically, physically, and spiritually to the maintenance of her family. Experts on Italian culture describe the woman's role as embodying the ideal of *serietà* (seriousness) in her dedication to securing and nurturing family members, assuming control of the emotional realm, contributing to the physical well-being of her husband and children, and upholding the cultural, culinary, and spiritual traditions of the family (Gambino 1974). To do this job well meant self-sacrifice, perhaps even self-effacement, but severe impoverishment and political disempowerment which fueled her "heritage of fatalism," left her little choice (Winsey 1975, 200).

In the small Italian villages, then, the mother's "value was inviolate" (Barolini 1985, 12). In America the Italian immigrant woman was often perceived as unable to adjust to the American beliefs in change, mobility, and independence. Although she was valued in her role as the center of the family, the Italian immigrant woman (like most immigrants living in tenements) often suffered from lack of privacy and control once she came to the new land. Indeed, women in south-

ern Italian villages may have been part of a patriarchal, preindustrial society, but they nonetheless played life-sustaining roles within the domestic sphere. Winsey's interviews reveal the pained responses of first-generation immigrant women who deeply regret their lives in America, but who realize that they had no choice over their destinies: "I didn't want to marry. [But] in those days if you were married and you separated. . . ."; "I was only thirteen when I came. After three months I got married. . . . I got white hair when I was twenty-six. My life was finished"; "I would never have come here. I would never have made this life." Such rueful commentary reveals the internal voices of Italian American women. They were not silent, but because they had so little control over their own lives they learned to be resilient and patient, not passive and self-effacing. Perhaps historians are correct in asserting that the immigrant women's belief in **destino** (destiny) sustains them in the most compromising of marital, familial, and economic situations.

Defined through family affiliation, the Italian immigrant woman's role was potentially attenuated in America, especially when she was required by economic or legal necessity to send her children into a strange public world outside the home: the factory and the American school. Social historian Elizabeth Ewen believes that maternal authority over children was not weakened in America; rather, mother and children were intensively involved in adjusting to a new land. Like other first-generation immigrant women, the Italian American mother, Ewen writes, "had very little contact with the dominant value system of American life; her immediate context determined her energy, organization skills, and familial responsibility" (Ewen 1985, 96).

Because she was the center of the household, the Italian American mother transmitted to her children, especially to her daughters, whom she mentored, the values of cooperation, interdependence, hard work, and assertiveness. These values were learned, however, within the context of home life and in deference to familial well-being. Second- and third-generation daughters were given a conflicting legacy from their mothers. On the one hand, daughters were expected to follow in their mother's footsteps in serving the family; thus, they were encouraged not to change. On the other hand, daughters often became vital sustainers of the family income in their wage-earning capacity outside the home. Though they were expected (like their brothers) to turn over the pay envelope to the mother, they could not help but be influenced by America's love of independence, freedom, and individualism. Children who attended the public schools were equally influenced by its emphasis on the development of the self, outside of the context of the family. As one irate mother put it, when she was told that her fifteen-year-old son had to attend high school regularly, "*la legge è fatta contra la famiglia*" (the

law is made against the family) (Covello 1967, 295). For the daughters, work—at home or in the factory—was the preferred ideal, not school. As Ewen points out, "a pressing contradiction was involved. . . . free public education was one of the benefits of the New World, but economic circumstances made it difficult to take advantage of this, especially for the daughters" (Ewen 1985, 193). There's an Italian maxim, *fesso chi fa i figli meglio di lui,* which Leonard Covello translates as: Stupid and contemptible is he who makes his children better than himself. This **contadino** (peasant) fear was transported to America but not categorically maintained here. In fact, Covello records several firsthand responses from the daughters of Italian parents, who expressed their parents' desire to see them educated.

Second- and third-generation daughters recognize the legacy that they have been given from their mothers, including the often discharged prescription to go out into the world (the factory, the schoolroom, the workplace, the urban street) but not to change. As one Italian American woman put it: "You can grow out of this neighborhood, but I think it's always in you. I don't think you can ever leave it" (Maglione and Fiore 1989, 100). What the daughters of the Italian immigrant woman bring into new neighborhoods, sometimes thousands of miles away from their family of origin, are precisely those values from the old country: love of heritage; deep commitment to family unity; desire for education; respect for the dignity of work; practicality and assertiveness, especially in the face of adversity. Responding to the above characteristics, Janice A. Piccinini remarked to the American Committee on Italian Migration, "*that* was the Italian woman's gift to America's future. That was my grandmother Rosa's gift to me" (Maglione and Fiore 1989, 61). Writer Tina De Rosa recognizes the inherent contradiction of accepting the gift from her Italian ancestors: In accepting their gift of educating her and encouraging her growth, she concomitantly had to accept the burden of alienation, though she could never completely leave: "You are left with fierce and mixed feelings toward all the people who have made you who you are—toward your grandparents, toward all the aunts and cousins who formed you into a unique kind of woman, not quite Italian and not quite American. You are left loving and hating the family who gave you all that and then disappeared" (De Rosa 1980, 38).

The Italian American woman has unceasingly functioned as a role model for her daughters and granddaughters. In accepting the difficult legacy of coming from a culture that defines itself through affiliation with the family over and above the concerns of the individual, the Italian American woman has had to learn how to channel the values of passionate pride and dignity in one's culture into new areas of creativity. To do this, she has risked the censure of her own people. In particular, writers from the Italian American literary tradition begin with what

they know best—the family, its secrets and passions, its anguishes and desires. That the writer's family would react suspiciously, if not adversely, to narratives about family life is not unusual, given the centuries of misrule by educated despots and in southern Italy and Sicily.

Nonetheless, writers of Italian descent in America have not kept silent about their ancestors' painful journey to the new land; about resettling and restructuring a life in urban America; about the conflict between first- and second-generation Italian Americans, both of whom recognize the tension between Old World values and American ways; about being a woman in a family that privileges male experience and education over her own; about watching their grandparents die and, with them, the memories, however faulty, of the old land; about returning to Italy to rediscover partly who they are. Each of these themes shows up in varying degrees in novels written by Italian American writers. The women writers in the 1980s and 1990s have gone beyond sheer anger at recalling the pattern of discrimination that their ancestors endured. In a well-known Italian American poem by Maria Mazziotti Gillan, "Public School No. 18: Paterson, New Jersey," the speaker finds her voice, enraged by the realization that she and her family have been abused by the culture of the schoolroom: "Remember me, ladies, / the silent one? / I have found my voice / and my rage will blow / your house down" (Barolini 1985, 320–321). Women writers of Italian American descent are not writing defensively or narrowly about their heritage; rather, they use the passion of their voices, sometimes fueled by rage but often by love, to commemorate the voices of the past.

The way in which the woman is represented in the literature by Italian American women writers has little affinity with the stereotypical images outlined at the beginning of this essay; rather, female characters are neither silent nor mournful. Perhaps the quintessential novel of the Italian American family is Mari Tomasi's second novel, *Like Lesser Gods* (1949). In it Tomasi depicts a strong, capable, and complex Italian American mother, who has internalized the demands associated with *serietà*. Rearing her family in a working-class quarry town, Maria Dalli tries unsuccessfully to prevent her husband from leaving his job as a stonecutter, aware as she is of the deleterious effects of working in closed sheds. Maria's solicitude for her family's well-being assuredly makes her the center of the domestic sphere, but she is neither perfect nor always practical. The novel traces her growth into an older woman, one who accepts with the resilience of those ravaged by adversity, the illness and death of her beloved husband, Pietro. Her life as a widow continues in the same tradition: hard work and perseverance for the betterment of her children and grandchildren. Tomasi may very well have ide-

alistically represented the Italian American mother, but she neither stereotyped Maria Dalli nor made her incapable of growth and change. *Like Lesser Gods* successfully depicts the mother in the context of the family, wherein she defined herself and sustained the foundations of Italian culture.

In the 1990s, Italian American women writers such as Mary Bush, Rachel Guido de Vries, Dorothy Bryant, Susan Leonardi, Lynn Vannucci, and Anna Monardo (to name only a few) are involved in writing about their mother's and other women's lives. In their texts, the Italian American woman bears resemblance to the voices of those interviewed above: Some have led agonizingly painful lives, both physically and emotionally; some have led circumscribed lives—either in the household, the convent, or the factory—that have sometimes limited their intellectual and moral development. Depictions of first-generation immigrants tend to focus on the difficulty of survival, in a world in which reflection and leisure are luxuries unknown to them. Given educational opportunity and economic stability, later generations of Italian American women are more free to choose less conventional lives, and often remain single, get divorced, or choose female partners for their life companions. In each of these scenarios, however, what remains persistently evident is the Italian American woman's devotion to her **italianità** (things having the flavor of what is Italian). Thus, narratives are filled with family gatherings and culinary rituals, conversations in the kitchen and close bonds between siblings. The grandmother is regularly invoked as a high priestess of wisdom, her offerings of food a metaphor for her availability and love. As poet Rose Romano writes of the importance of Italian food: "everybody must know that we eat. Until we have a right to this place" (Romano 1990, 26).

The Italian American woman is claiming a right to this place—America—in her increasing visibility in the work force, in the political realm, in academia, and, yes, in the kitchen waiting for her children to come home. In each of these realms, she is talking and writing, being heard and getting published. Ann Cornelisen described the women in southern Italian villages as "women of the shadows." Italian American women deeply respect their foremothers, but they recognize the necessity of coming forward and showing their faces, speaking the truths of their Italian American identity.

Further Reading
Interviews of Italian American women include Valentine Rossilli Winsey, "The Italian Immigrant Women Who Arrived in the United States Before World War I," in *Studies in Italian American Social History: Essays in Honor of Leonard Covello*, ed. Francesco Cordasco. (Totowa, N.J.: Rowan and Littlefield 1975): 199–210; Linda Brandi Cateura, *Growing Up Italian: How Being Brought Up As an Italian-American*

Helped Shape the Lives and Fortunes of Twenty-Four Celebrated Americans (New York: William Morrow, 1987); and Connie A. Maglione and Carmen Anthony Fiore, *Voices of the Daughters* (Princeton, N.J.: Townhouse Publishing, 1989).

Good introductions to the Italian American family and the role of women include Leonard Covello, *The Social Background of the Italo-American School Child* (Leiden: E.J. Brill, 1967); Richard Gambino, *Blood of My Blood: The Dilemma of Italian-Americans* (New York: Doubleday, 1974); and Helen Barolini, "Introduction," in *The Dream Book: An Anthology of Writings by Italian American Women,* ed. Helen Barolini (New York: Schocken Books, 1985): 3–56.

For a well-known social history of immigrant women with a focus on Jewish and Italian ethnic groups, see Elizabeth Ewen, *Immigrant Women in the Land of Dollars: Life and Culture on the Lower East Side, 1890–1925* (New York: Monthly Review Press, 1985).

Journal articles include Daniella Gioseffi, "Against Stereotyping," *MS* (September/October 1992); Tina De Rosa, "An Italian-American Woman Speaks Out," *Attenzione* (May 1980); and Rose Romano, "That We Eat," *Vendetta* (1990).

Italian Americans, Today's Immigrants, Multiculturalism, and the Mark of Cain

Richard Gambino

In an article in the June 1993 issue of *Commentary,* the influential social commentator James Q. Wilson cites the southern Italian family system as an example of such systems that are socially and politically dysfunctional because they are "amoral" and, therefore, a model that Americans should avoid. Where such systems are found, America should erase them as fast as possible. In an exchange of letters in the August 1993 issue of the same journal, on the issue of modern immigration, Peter Brimelow cites, and Frances Fukuyama accepts, the theory that the "amoral familism" of certain non-WASP immigrant groups is the cause of past and present organized crime in the United States.

Brimelow explicitly adds "Iraqi Christians," Mexicans, and other modern-day non-European immigrants to the Italian immigrants of yesterday. Fukuyama writes that "it is probably appropriate to compare present-day Mexican immigrants to the several million southern Italians of peasant background who flooded into the United States," citing the theory of amoral familism as the point of comparison. The thesis of amoral familism comes from a 1958 book by Edward C. Banfield, *The Moral Basis of a Backward Society,* in which the author asserted that people in southern Italy had no community or social moralities, only loyalty to their families' short-term interests.

Two corollaries of the amoral familism thesis, the **Mafioso** and the **cafone** images, have branded Italian Americans with a contemporary American version of the mark of Cain.

Following such informal but powerful mass miseducation as in *The Godfather* films and their innumerable ilk, Italian Americans are blamed for America's

Boldface terms are defined in Cultural Lexicon located on p. 703.

organized crime, drug plague, political and business corruption, racism, sexism, and a host of other dark characteristics.

Yet if we use the only figure ever given by a federal agency—the 1967 *Report on Organized Crime* by the President's Commission on Law Enforcement— admittedly an old and controversial figure, there were 5,000 people involved in organized crime. Assuming all of them were Italian Americans, this is 0.0004 percent of the Italian American population according to the 1980 Census (the first Census that included all generations of ethnic groups instead of only the foreign born and their children) or 0.0003 percent of the Italian American population according to the 1990 Census.

As a matter of fact, there are several very damaging, widely held beliefs that are demonstrably false, one of which is the idea that organized crime in the United States is an offshoot or branch of the Mafia in Italy. Others are: (1) that Italian Americans started organized crime in the United States; (2) that Italian Americans have or had a lion's share of control over organized crime in the United States; (3) that a significant percentage of Italian Americans were or are involved in the Mafia or benefit from organized crime; (4) that a significant percentage of Italian Americans know or are related to criminals; and, most damaging of all, (5) that Italian American culture is somehow innately criminal or has crime as one of its major characteristics, or that Italian Americans have a propensity toward crime.

Parallel beliefs about some of today's immigrant groups, such as Mexicans, Colombians, Chinese, Koreans, and Jews from the former Soviet Union, are now extending the stigma to them, again with an intellectual veneer of "amoral familism" theories dressing up bigotries.

Investigative reporter Jack Newfield was right when, in the 4 February 1992 issue of the *New York Post,* he wrote:

> *Prejudice against Italian Americans is the most tolerated intolerance.*
> *I have been in rooms where you can get corrected if you use the word*
> *transvestite instead of "cross-dresser," then have the same politically correct*
> *moralist say a politician must have mob connections because he or she is of*
> *Italian heritage.*

Such, in my estimation, is the condition of Italian Americans in the 1990s vis-à-vis the social, political, and cultural winds that blow strong throughout the nation. The same winds are buffeting modern-day immigrants, 90 percent of whom are from the Third World, and the Italian American experience forms a caution-

ary story. Italian Americans have a confused and troubled identity. It is not informed by any literate education about the ethnic group but is dependent on ever more vague family tales around the dinner table and ever more grotesque caricatures and fictions in the mass media—such nightly standard fare on television as *The Untouchables,* known in the 1960s as "cops and wops," which Paramount has renewed in the 1990s, and the monumentally absurd 1993 TV movies *The Last Mafia Marriage* and *Vendetta 2: The New Mafia*. Schools amplify the distortion. One widely used textbook on the peoples of America makes but two mentions of Italian Americans. One is the violent anarchists of a hundred years ago, and the other is to Al Capone. To its credit, however, the text does have three chapters on American Indians.

The resulting imbroglio that is Italian American identity was caught in *Umbertina,* a 1979 novel by Helen Barolini about three generations of Italian American women. Tina, the daughter of an Italian father and an Italian American mother, encounters some Italian American tourists in Italy:

> *They were ruining her morning, Tina thought sourly. . . . She thought of herself in the States angrily explaining that she was not an Italian American. My father is Italian and my mother is a third generation (Italian) American who never heard Italian until she got to Italy to study; I am part Italian and part American,* <u>not</u> *Italian American. It was a splitting of hairs that convinced no one, not even Tina. But she felt obliged each time to put up her defense against being merged in that ethnic mess she saw and despised in the States. She thought of a bumper sticker that disgusted her:* "Mafia Staff Car, Keepa You Hands Off."

Melting-pot proponents of yesterday and today said and say to Italian Americans, Your culture is inferior, if not positively evil—"unassimilable," non-WASP, Mediterranean instead of "Nordic" or "Teutonic" or Anglo Saxon; it is Roman Catholic, incompatible with education, enlightenment, "Americanism," or democracy; it is vulgar, inherently criminal or at least crime-ridden, and responsible for introducing and maintaining gangsterism, drugs, and Mob violence in America. You'd do best by washing yourself clean of your heritage.

The major thrust of multiculturalism's message to Italian Americans also is: Your culture is inferior, if not positively evil, and you'd do best by washing yourself clean of it. In Yogi Berra's famous phrase, "It's déjà vu all over again." Except as made by multiculturalists, some of the specific indictments of Italian Americans have changed, while others remain the same. The ***italianità*** (Italianness) of

Italian Americans is now allegedly racist, sexist, reactionary, Eurocentric, Euroevil-imperialistic-oppressive-environmentally toxic (cf. the massive bashing of Columbus in 1992 on the 500th anniversary of his first voyage to the Western Hemisphere), blindly Catholic and dogmatically anti-abortion, blindly pro-American, vulgar in nonacceptable ways (unlike the vulgarities of the politically correct), and, in the only thing multiculturalists seem to share with melting potists, still inherently criminal or at least crime-ridden and responsible for introducing and maintaining gangsterism, drugs, and racketeers' violence in the United States.

Pop culture since the 1970s has also joined in giving the message to young Italian Americans that they would do best to abandon their heritage—an impossible task even if it were a desirable one. Individuals do not spring from nowhere like some modern Venus from the sea. For example, in the 1970s there began a spate of Hollywood films about non-Mafia Italian Americans that have clearly carried the message—among them, *Lovers and Other Strangers* (1970), *Mean Streets* (1973), *Rocky I* (1976), *Saturday Night Fever* (1977), and *Married to the Mob* (1988). Indeed, one feels relieved when a film like *Moonstruck* (1987) presents Italian Americans merely as a benign, operatically comic, and melodramatic group, or, in *My Cousin Vinny* (1992), when, after the most outrageous mockery of "Vincent La Guardia Gambini" and "Mona Lisa Vito" for almost the entire length of the film, these two absurd *cafoni* (Vincent even wears black undershirts and shorts) are shown at the end to have brains and character. Film critic Patrick Shanley was right when he wrote of Italian Americans in the 7 November 1988 issue of *Time* magazine, "They are the last ethnic group America can comfortably mock."

Italian American realities have never been understood by Americans, who regard the group as too "clannish." Scholars, reflecting this common misunderstanding of it, still see Italian American culture as amoral familism and now apply the tag to the cultures of many late-twenteith-century immigrant groups. Yet the family system of old south Italy was far from amoral, and so is its evolved form in the United States today. It was one of extended families linked beyond blood both by arranged marriages and by a system of **comparatico** (or **comparaggio**)—godparentage—to form a complicated network, or, if you will, a "community" system that Banfield incorrectly saw as lacking. In the United States, it was also enhanced by countless mutual-aid societies formed by the immigrants. This community did, in fact, function socially and demand and receive great, even legendary, individual sacrifices. It was compatible with a strong American patriotism that developed among Italian immigrants, as it did among Japanese immigrants who also had a strong family value system, even in supporting the United States against the country of origin in World War II. It was a system wherein one chose "god-

parents" for one's children not primarily, or even at all, on religious or ceremonial grounds, but in the interests of one's family network. These godparents became *compare* (male) and *comare* (female) to the child's parents, linking the adults *and their respective family networks* in a complicated system of mutual obligations and privileges. Far from being "amoral," it was moral, if not *moralistic,* to an extreme. In a typical conundrum created by the huge and fantasy-based Mafia sensationalism crowned by *The Godfather* novel and films (I have been unable to find the word used to mean a Mafia boss before the novel was published in 1969), even the word "godfather" brings "knowing" smirks from Americans who are, in fact, ignorant of its traditional meaning, as does the word "family" in an Italian American context.

Everyone understands the ordinary uses of the words "crime" and "family." But what precisely is a "crime family," now a standard journalistic phrase, except a code slur against Italian Americans? The members of the gangs the press refers to by using this phrase are not related by blood or family ties. Robert MacNeil, of public-television fame, has co-authored a book, *The Story of English* (New York: Viking, 1986), that notes the phenomenon of defaming Italian Americans by sheer use of language. MacNeil and his colleagues say of words like "godfather," "the family," "*capo,*" "racketeer," and "loan shark" that they "now come with Italian accents" more because of "the power of the media (than of) the Mafia."

It is also important to note that those modern-day immigrant groups who bring strong family-network moralities are having entrepreneurial success, as with Chinese-, Korean-, and Greek-owned businesses, and educational success, as with Asian Americans, *despite* bigotry, racism, and having to learn English and American ways. Family-network systems, and not crime, account for the survival and eventual upward mobility of Italian Americans in the past and of many immigrant groups today. They should be understood and encouraged, not stamped out as amoral breeding grounds for racketeering, anti–civic mindedness, and other "non-American" phenomena.

The explanation for organized crime in the United States lies not in the cultures of past immigrant groups, Irish, Jews, or Italians, or in today's immigrants, Mexicans, Colombians, Chinese, Koreans, Soviet Jews, or others now being smeared. Criminal racketeering bears the label *made in America* and is the result of the supply-and-demand dynamics of our all-too-human lust for morally taboo and illegal goods and services. Before the twentieth century, when those goods and services were chiefly brothel prostitution and illegal gambling houses, the demand for them was met by criminals from the ethnic groups that made up the U.S. population at the time. When later demands arose for illegal alcohol, then

drugs, criminals from the older groups were joined by those from newer arrivals, a process that continues. Throughout, perennial rackets like political and business corruption have been engaged in by crooks of all groups.

It is time to sort out the "ethnic mess" of Italian American images and identity. Solutions to it must be mainly on two fronts: (1) combating the Niagara of defamation that has become standard fodder in the entertainment businesses, the press, and publishing; and (2) including scholarly knowledge about Italy and about Italian Americans in the curricula of schools and in the textbooks used in them. Without these (and other) reforms, the multiculturalism will remain largely a biased, exclusionary, bizarre distortion of historical and present realities, and our debates about modern-day immigration, education, and the future of American society will suffer.

An Italian Journey
A Photographic Essay

Liana Miuccio

Photographer

Photographs copyright ©1998 by Liana Miuccio. All rights reserved.

This visual essay reproduces ten black-and-white photographs from a more comprehensive exhibition first mounted at the Ellis Island Immigration Museum in the summer of 1997. The exhibition was inspired by my great-uncle Giovanni, who led me on the visual journey recorded here to explore the roots of my Italian heritage. His sister Maria, my grandmother, left her ancient Sicilian hometown of Limina with my grandfather Filippo in the 1920s to create a new life in America. Their sacrifices represent the selfless determination of millions of Italian immigrants who helped to build this country. I dedicate *An Italian Journey* to my grandparents for giving me the rich gift of my Italian identity.

My paternal grandparents were among the over 4 million Italians who entered the United States through Ellis Island—the largest ethnic group to come through that immigrant station. They came from the small Sicilian hill town of Limina, in the province of Messina, and settled in the Bronx. My grandfather Filippo was a manual laborer and my grandmother Maria, a sewing machine operator. Their courage and hard work gave their children opportunities that would have been unavailable in southern Italy. Their son Alexander became a partner in a law firm and their daughter Frances, a college dean.

As a young man, Alexander, my father, visited his parents' native country, and met Giuliana, my mother, a Roman poet and teacher. They married in Rome and soon afterward settled in New York. My mother, always longing for her family and culture, returned twice to Italy with my father to give birth to me and my sister Deborah. My parents wanted to ensure that we were close to our Italian heritage so we returned to Italy every year and grew up speaking Italian.

In *An Italian Journey* I juxtapose photographs of relatives in Italy with photographs of family keeping its Italian culture alive in the United States. Through this exhibition I have learned that the bond between those who left and those who stayed not only remains, but can sometimes grow stronger.

In his introduction to the catalogue for the Ellis Island exhibit, Gay Talese has graciously provided an ideal framework for viewing the photographs:

Through her photography, Miuccio invites us to experience both cultures simultaneously. Although Miuccio's photographs achieve a highly personal form of photojournalism, they go beyond just one family's story. An Italian Journey *succeeds in reaching all of us who form this great nation of immigrants.*

My great-uncle Giovanni, Limina, Sicily, 1995

My father Alexander, Grand Central Station, 1996

The procession of St. Filippo, Limina's patron saint, Bronx, N.Y., 1996

Limina, Sicily, 1996

AN ITALIAN JOURNEY

The procession of St. Filippo, Limina, Sicily, 1996

St. Lucy's Church, Bronx, N.Y., 1996

LIANA MIUCCIO

My great-aunt Nunzia and great-uncle Giovanni, Limina, Sicily, 1996

My mother Giuliana and my sister Deborah, Manhattan, N.Y., 1996

apolide	*without a country*
una volta sola	one time only
terra madre	mother land
ti ho tradito	I betrayed you
lasciandoti	leaving
ogni istante	each instant
terra matrigna	foreign land
ti tradisco	I betray you
restando	staying

Giuliana Miuccio
Originally published in
Spazio / Space (1992)

My great-uncle Giovanni, Limina, Sicily, 1993

LIANA MIUCCIO

My sister Deborah, Manhattan, N.Y., 1996

Part II

Roots, Traditions, and the Italian American Life-World

The Italian American Traditional Life Cycle

Frances M. Malpezzi
William M. Clements

Among Italian Americans, many traditional beliefs and practices have clustered around transitional events in the individual's life. Called rites of passage by anthropologist Arnold Van Gennep, experiences such as birth, coming of age, marriage, and death amount to changes in personal identity. Van Gennep believed that these changes are universally regarded as perilous because, as one moves from one state of being to another, he or she may be especially vulnerable to supernatural attack. Thus, for those transitions that recur from generation to generation, people have developed practices to ensure that the passage from one identity to the next is safe.[1]

Another feature of these key transitional events is that they may erase social distinctions derived from wealth or education. According to Victor Turner, also an anthropologist, rites of passage remind people of their common humanity, their shared participation in a cycle of life that must be experienced regardless of the riches or status they may have acquired.[2]

In addition to these generally recognized transitions, many Italian Americans also stress the importance of such sacramental rites as baptism and christening, first communion, and confirmation. These three events—defined and carried out according to the directions of the Roman Catholic Church—have not produced an array of folk customs; however, birth, marriage, and death *do* provide settings for traditional beliefs and practices to coexist with the rituals and conventions prescribed by official religion, civil authority, and modern medicine.

Reprinted from *Italian-American Folklore* by Frances M. Malpezzi and William M. Clements (Little Rock: August House, 1992) by permission of August House. **Boldface** terms are defined in the Cultural Lexicon which starts on p. 703.

Birth

Traditions may begin to affect the Italian American child even before birth. Beliefs about conception, pregnancy, and childbirth have influenced his or her parents' behavior and contribute to matters directly affecting the child such as his or her birth date, number of siblings, and relationships with father and mother. Folk eugenics among Sicilians and some of their descendants in the New World suggest that the child inherits only the father's "blood." The mother's role during pregnancy is only as a vessel for the father's seed, which is the sole contributor to the child's genetic identity.[3] However, since the mother's "blood" was supposed to be mixed with the milk her child suckled, a woman could contribute to the child's inherent composition through the way in which she cared for it. In fact, the woman who nursed a child—whether its biological mother or a wet nurse—was supposed to have so close a relationship with the child that she experienced every pain that it felt. Some went so far as to aver that when a baby was bottle-fed it would assume bovine qualities and that the cow would feel all of its pains.[4]

Like many agricultural peoples, Italians counted children as a valued resource, and that attitude persisted among Italian immigrants, who ensured fecundity by carefully sustaining fertility-inducing practices at marriage. Though it certainly represents a point of view that most Italian Americans could now accept only with modification, the characterization of a commentator writing in 1928 does capture the viewpoint of many immigrant women: "To be childless is a terrible humiliation to an Italian woman. Children are the highest aspiration of her life; she would rather die than not have them."[5] Traditional ways to avoid childlessness included throwing **confetti** (candy-covered almonds) at weddings, having the mothers of the bride and groom prepare the bed for the wedding night, having a new bride avoid contact with salt, or—in seeming contradiction—sprinkling the bridal bed with salt.[6] Tradition also encouraged large families by warning about the dangers of sexual abstinence—uterine tumors for women and tuberculosis for men, according to southern Italian belief. A woman's use of any contraceptive agents was thought to cause her husband to become ill.[7]

But since certain days were especially inauspicious for birth, other days, scrupulously avoided by married couples, were regarded as dangerous for conception. For example, abstinence traditionally characterized the Feast of the Annunciation (25 March) when the Holy Spirit was supposed to have impregnated the Virgin Mary. Christmas falls nine months from that date, and a child born at the same hour as Jesus (midnight on Christmas Eve) was doomed to dire conse-

quences. If a girl, she would likely become a *strega* (witch), while infant boys would become werewolves. An alternative fear held that children born on Christmas would inevitably be deformed.[8] Conversely, some Italian Americans have believed that one born on Christmas Eve has healing powers, especially the ability to cure the effects of **malocchio** (the evil eye).[9] Couples had to make more complicated calendrical computations to avoid having a child born on the day of a quarter moon, which was regarded as unlucky.[10]

Some dates were regarded as especially favorable for birth. A child born at any time during the month of January may be immune from the effects of being "overlooked" (that is, becoming a victim of *malocchio*) and may have power over snakes, so prospective parents might pace themselves accordingly the preceding April. A child born on a Tuesday would always live under the protection of Saint Anthony, and one born on the thirteenth of any month would become the special ward of that saint and also of Saint Lucy.[11] A couple might also try to time conception according to the lunar cycle, since a child conceived during the full moon would be a girl, and one conceived during a quarter moon would be a boy. A boy would also result from conception on Sunday.[12]

Even though tradition may deny the mother's genetic contribution, what she does while pregnant can decidedly affect the child. A strong belief in prenatal marking has characterized Italian American pregnancy lore. Usually this belief has manifested itself in careful attention to the food cravings of pregnant women. While a woman is carrying a child, her dietary whims should be completely and immediately gratified. If they are not, the child will either bear a birthmark shaped like the desired food or be more generally disfigured. At the very least, throughout its life the child will crave the food (frequently strawberries) the mother did not get.[13] Accounts that validate the postnatal effects of unrequited prenatal craving abound in Italian American folklore. For example, a Calabrian-born woman who migrated to the United States at the age of twenty-one recalled a telling incident:

> *This woman went three doors next to where she livin'. She was all swell with baby. She smell fish fryin' in the pan, but the owner of the fish, she have no sense enough to offer the fish to the pregnant lady. My mother tell me, this pregnant woman, she good friend of my mother. She . . . say, "My God, I want the fish the lady fry so bad." She say she feel funny all over, she crave so bad and the baby want too. The lady rubbed her face and arms with her hands. . . . When the baby was born, the skin was all scales like a fish skin. . . . My mama say from now when you meet a pregnant lady, if it be bread or cherries from the country, whatever, you offer.*[14]

As in this account, a frequent component of prenatal marking is the woman's touching some part of her body when she comes into contact with the food she craves. The baby may be marked on its body at the spot where its mother had touched herself. A similar fate had befallen the storyteller herself while she was pregnant. She recalled:

> *Myself, I went to grocery store and I no have enough money to buy everything I want. It was Depression. So, I say I buy what I need is important first. I see black olives o[n] shelf. I keep look but I have no money for. I was pretty big with my Frankie. . . . So, I keep lookin'! . . . My back hurt, so I put my fingers on my back. When Frankie born, he had five olives on his back.*[15]

The necessity of gratifying the cravings of pregnant women inspired the taunt heard among Italian Americans in Greenwich Village during the 1920s and directed against the self-indulgent: "You're like a pregnant woman."[16]

While prenatal marking caused by unrequited cravings might be avoided, that which resulted from the expectant mother's being frightened often lay outside human control. The woman's only recourse was to lead as sheltered an existence as possible, remembering admonitory stories such as the one that Rose's mother offers in Jo Pagano's *Golden Wedding* ([1943] 1975), a novel about Campanian immigrants: "Remember Annie Masto I told you about in Denver? She was frightened by a cat while she was carrying her first boy, and when he was born he had a red mark just like a cat on his forehead."[17]

Specific kinds of frights could yield specific results. A pregnant woman's being frightened by a hare might produce a child with a harelip, and her seeing an automobile accident might result in an infant with serious physical deformities.[18] In *Blood of My Blood: The Dilemma of Italian Americans* (1974), Sicilian American Richard Gambino wrote of his grandmother's fury when she learned that her daughter had gone to see a horror movie while pregnant with Richard.[19] A woman, though, could protect her unborn child from prenatal markings from any source by eating a broiled kingfish "marked with cabalistic signs."[20] Once a child has been marked, the blemish was difficult to remove, though rubbing some afterbirth over the mark was sometimes thought to effect a remedy.[21]

Other proscriptions have applied to Italian American women and their husbands during pregnancy. For example, it has been considered dangerous for either one of them to work on Saint Aniello's Day (14 December). The consequences of violating this taboo may be a deformed child.[22] A pregnant woman should avoid lifting heavy weights since doing so will result in a premature birth,

and her gazing into a fire will prove fatal to her child.[23] At the same time, it is important that special preparations be made for an expected baby, since not to do so would make the child seem unappreciated. Social worker Dorothy Gladys Spicer discovered that some of her Italian American clients during the 1920s would often go to great expense to provide, for example, a new crib for a child when they had receptacles such as clothes baskets already available that would serve the same purpose.[24]

Although now virtually all births take place in hospitals under the care of physicians, traditional practice once designated a midwife as the principal attendant during a woman's labor. The midwife figures prominently in the remembered lore about birth among Italian Americans earlier in the century, and women such as the fictional Dame Katarina, characterized as "high priestess of ceremonials from cradle to grave" in Pietro di Donato's novel *Christ in Concrete* (1939), were held in high esteem.[25] Letitia Serpe, an immigrant from the Apulian city of Bari, described how a midwife officiated at the birth of her first child:

I got my midwife through my mother-in-law. The midwife and I got acquainted a month before I delivered. When it was time, my mother-in-law, the midwife, my aunt, and I were all together in the bedroom. The midwife was lovely—clean—she was like a she-doctor today—that's what she was.

I had a beautiful nine-pound baby and the midwife wrapped her in swaddling so her legs would grow long and straight.[26]

Midwives often practiced general folk medicine in addition to their role at births and might complement their mundane knowledge with magical practices such as placing salt at the four corners of the bed to ward off evil.[27] Di Donato's Dame Katarina began the birthing process by anointing the pregnant woman's forehead and stomach with holy water, and after the delivery "with spittle did benediction" upon the new mother's brow.[28]

A birth was heralded with celebration, at least by members of the immediate family. Spicer reported in the 1920s that Italian Americans saluted the birth of a boy by drinking three glasses of wine and of a girl by drinking two glasses, the lesser amount due to her being "born to suffering."[29] The celebration would be intensified if the baby had been born with a caul, for then he or she could look forward to being brilliant, talented, generous, healthy, lucky, and famous.[30] In some families, custom dictated that relatives who had come to visit the newborn be entertained with sweet drinks such as anisette and other cordials.[31] After a woman had given birth, she was allowed forty days of rest, during which time

she remained inside the house, was exempt from housework, and ate only chicken broth and soup.[32]

More general festivities accompanied christening and baptism, which occurred soon after a child's birth. It was a particular honor to serve as a child's godparent, and persons chosen for this role "were really kind of like the guest of honor other than the baby" at the baptism ceremony and subsequent reception.[33] The relationship of **compare** (godfather) and **comare** (godmother) with the child and with its parents has been one of the most important in Italian American life. As Jerre Mangione describes it in *Mount Allegro: A Memoir of Italian American Life* ([1943] 1981):

> *A* compare *occupies a special place in the hierarchy of Sicilian friends. No firmer relationship can exist between two men who are not related by blood than that of* compare. *Sometimes a relative would choose another relative to be his* compare *[that is, godfather to one of his children], but more often the honor was reserved for unrelated friends. It was a simple way of making them almost related.*[34]

Becoming a godparent was taken very seriously and might be subject to traditional taboos. A pregnant woman, for instance, could be discouraged from becoming a godmother, since doing so might cause bad luck for both her godchild and her unborn infant. To refuse a request to become a godparent amounted to a grave insult.[35] Though the official role of godparents emphasized their participation in a child's spiritual development, folk custom dictated that especially the godmother should involve herself in all phases of the child's rearing. For example, she was supposed to be the first to cut a child's hair and nails.[36]

Folk beliefs and practices governed the ways in which the mother and father attended to their offspring throughout infancy. For instance, babies often had pierced ears so that that they could wear gold earrings, since gold near the eyes was supposed to be beneficial to eyesight.[37] This custom might result in intergenerational disagreements, as Etta Ferraro Goodwin, a Campanian American from Peace Dale, Rhode Island, recalled in a 1991 interview:

> *And there was another thing I remember my mother relating to me as I grew older. . . . It was something that she never forgave my grandmother for. It was the custom in Italy that little girls when they were several days old—babies—have their ears pierced. They would have good eyesight for the rest of their lives. Well, in this country my mother learned that it was*

not a custom, and she didn't want her girls to have pierced ears. Because none of the other little American girls had pierced ears. And she wasn't going to have this.

Well, my grandmother wasn't going to have my mother have her way. So one day (I wasn't more than two weeks old), my mother relates to me, she had gone to the neighborhood butcher and left me with my grandmother baby-sitting me. And she had warned my grandmother. Every time my mother would say—relating to me—"Etta, I hated to leave you with Nonna because I was afraid she was going to pierce your ears. Well, I thought, well, she knew I didn't want it. She wouldn't do it. She hadn't done it in the two weeks. She probably wasn't going to do it. However, when I was walking up the path, I could hear this screaming, and you were screaming. I knew then. Nonna had pierced your ears. Lo and behold! I came in, and there you were in that little bed that she had for you especially, for all the little grandchildren when she baby-sat. There were little threads in your ears where she had pierced your ears. There was very little I could do. I could scream; I could holler. But you had done all the screaming for me. And I didn't win that round."

Until this day, not because my mother didn't want me to have earrings, I don't wear earrings, and everybody else is wearing.[38]

Some Italian Americans also believed that one should not weigh or measure a baby, since doing so would retard its growth.[39] If a baby was not growing as rapidly as traditional authority thought proper, its weight could be increased magically by cutting its clothes into twelve pieces and burning them at midnight at a crossroads.[40] Special baths and rubs might also be used on an ailing child or simply as a general health measure. Albina Malpezzi, interviewed in 1988, attributed the strength in her infant daughter's legs, which had been deformed at birth, to her Piedmontese-born mother's scrupulously massaging them with warm olive oil three times each day. In *A Dying Cadence* (1986), Sicilian American Joseph Napoli described his mother's weekly anointing of him with olive oil, and bathing a baby in wine has been supposed to give it strength.[41]

Specific ailments in young children might yield to specific remedies in the folk pharmacopeia, but magical practices could supplement these. An example, reported from Ligurian miners in California, required that a sick infant be rubbed with warm oil to which scorched bits of its father's clothing, especially the shirttail, had been added. As one passed a silver coin down the baby's back, one recited the following three times:

Monkey's blight,
She-goat's bane,
Halt thy ravage,
Cease thy pain,
Wither away
Like the pomegranate spray,
Holy Trinity,
Release this child
From its infirmity.

The whole procedure should be repeated on three consecutive days.[42]

Lullabies provided a less dramatic way of quieting a fretful child. An example in the Piedmontese dialect has been used to comfort children, grandchildren, and great-grandchildren in the United States:

Din-da-lon, Lucia,
Cioppa cul passarot.
Se tua mamma at cria
Disii cha lal Pinot.
(Rock-a-bye, Lucia,
Catch a little bird.
And if your mother scolds,
Blame it on Joe.)[43]

Another brief lullaby stanza comes from Sicilian tradition. Several second-generation members of the Gennuso family, whose parents immigrated to southern Louisiana, recall its use among their elders:

La pechalita mia,
Se brusha care;
Yo vogya par besada,
Su mamma more.
(My darling little baby,
My heart is breaking;
And when I want to kiss her,
Her mamma will scold me.)[44]

Italian American customs and beliefs associated with childbirth certainly

suggest that people recognized the importance and perils of this event for both the child and its parents. While protecting from supernatural and natural threats and reminding of the universality of much associated with this fundamental human experience, Italian American birthlore has also emphasized the involvement of the group, especially the family and its extensions, in ensuring a safe passage for newborn baby and new mother and father.

Weddings

Memories of growing up in Italian American households frequently emphasize the circumscribed existence of girls, whose principal life goal was in almost every case to be married as soon and as auspiciously as possible. A middle-aged Italian's description of the ideal behavior of the Italian girl growing up in Greenwich Village during the 1920s represents what was common, especially in families who had come from southern Italy: "Prior to her marriage she should not be permitted to go out unchaperoned even with other girls or to entertain men at her house."[45] A Sicilian American woman reared in New Orleans during the thirties and forties confirmed in a 1991 interview that this remained the ideal: "My father and mother were very, very strict with me. I could not go out without a chaperone. . . . I could not date. My husband was my first date." Even when she was named Miss New Orleans in the late forties, her protective mother insisted on accompanying her to all of the festivities associated with that office.[46]

While restrictions on girls and young women lessened with time and assimilation, as late as the 1960s sociologist Bartolomeo J. Palisi could write of Italian American family life in New York City: "Norms attached to their [Italian American women's] family role discourage extra-familial activities."[47] That the adjustment to the relative freedom accorded to American women was particularly difficult forms a theme for Sicilian American Clara Corica Grilla's recollections:

> *The most common problem of family adjustments that caused great trouble was the freedom given to females in the United States. Even coeducation was terrifying to the first immigrants. I personally have case histories of how girls were not allowed to attend English and/or citizenship classes. This problem was especially true among Sicilian families, whose conduct was subject to many taboos. Rules of courtship, marrying of people from other parts of Italy or from other nationality groups, from other religions, or from the lower social strata, all were (and still are) problems.*[48]

To ensure that daughters were not exposed to unapproved influences, they might not be "introduced" into extrafamilial society until the age of sixteen or seventeen, and then only under the auspices of an organization such as an Italian social club.[49] A proverb summarized the situation: *"Una ragazza per bene non lascia il petto paterno prima che si sposi"* (A good girl does not leave the parental nest before she is married).[50]

An ostensible motive for the sheltering of girls was to guarantee their suitability for marriage, an event that families hoped would occur before their daughters had become very old. Proverbial wisdom prescribed the ideal ages for bride and groom: *"L'uomo di ventotto; la donna diciotto"* (The man at twenty-eight; the woman at eighteen).[51] While the pressures of Americanization especially challenged traditions regarding this important rite of passage, many Italian American families tried to maintain practices that characterized marriage in Italy. The most notorious of these—and the one most directly opposed to conventional American custom—was marriage by family arrangement.

The custom may have been perpetuated in the New World, in part, because of the large number of single Italian men who had crossed the Atlantic and, having decided to remain in America, wanted Italian wives. They could obtain these only through arrangement with their families back in Italy since single Italian women were scarce in the United States. In Newark, New Jersey, for instance, the practice of a matchmaker's delivering a **masciata**, a message to the family of a prospective bride, persisted among single Italian immigrant men who wanted to marry someone from Italy.[52] The parents of Michelema Gaetano, who was only fifteen years old at the time, received such a message on behalf of her future husband, Vincent Profeta, who sent tickets for her and her father to come to America from Italy.[53] But the practice of arranged marriage sometimes occurred even when all parties were living in the United States. This had been the case with the Sicilian American parents of Joanne Terranella Burleson, who related their story in a 1990 interview:

> *They married in 1929, and years before that they started thinking about Raymond Terranella for Josephine Genaro. And he came from such a good family—hard working and everything. And he was so intelligent. Look at all the things he's done. So one person from the Terranellas came over to the Genaros' house and talked to them—talked to my grandfather Lawrence about marrying Mother. They never could go out together. They never had dates, and if they did, it was chaperoned.*[54]

Josephine Fastuca was able to go out on dates with her intended husband, but always with a chaperone. Their initial contact occurred through arrangement:

> When I got married, the way it came about was that my husband's brother went to my father's brother to tell him about his brother's intentions. And then my father's brother came to my father and told him that my husband would like to ask for my hand in marriage because he had seen me.[55]

To guarantee good luck in arranging a marriage, matchmakers might place a sheaf of wheat tied with pieces of jewelry as a centerpiece for the table where they were conducting their business.[56]

Even when such arrangements did not occur directly, families might exert subtle pressure on their offspring to select specific spouses or people from specific groups. Some Sicilians favored what anthropologists call "cross-cousin marriage"—that is, a young woman's marrying the son of her mother's brother.[57] Italian Americans from various regions generally encouraged marriage between *paesani*, immigrants from the same Italian community, or at least people from the same region. As a Sicilian put it, "Like takes like—chickpeas with chickpeas and broad beans with broad beans, to have a good crop."[58] Josephine Fastuca's husband believed it to be very important that their children "marry the same." He was bothered if their ancestors came from different *paesi*, if they were not of the same social class, or if their economic status differed. The prospective bride's and groom's families "had to match."[59]

In a case reported from Buffalo, New York, a woman's Sicilian-born parents had approved their daughter's marriage to a non-Sicilian, but on the eve of the wedding her protective brother wounded the prospective groom. Even though the parents had sanctioned the marriage, the brother could not bring himself to do so.[60] After *compaesani*, immigrants from the same community, next in order of preference were other Italians from different regions, though some northern Italians might assert a preference for non-Italians over despised Sicilians. Intermarriage outside the ethnic group and especially outside Roman Catholicism was informally, but decidedly, proscribed.

Despite restrictions that might seem to deprive marriage of the romance with which American custom invests it, Italian American girls devoted considerable attention to their marital prospects. Like girls from other traditions, they developed methods for predicting the identity of their future husbands. One procedure required that at midnight when the moon was full, a young girl sit alone in a room with a front door. The door should be locked, her eyes should be closed, and her mind should be blank. The door will suddenly jerk open to reveal a vision of her future husband.[61]

Another method required that on Saint John's Eve (23 June), a girl should put an egg white into a bottle of water. If this were left outdoors, the next morning the bottle would contain an image of her husband. Or two young women could bake an egg on Halloween. Each should eat half the yolk, then fill the empty cavity with salt, and eat all of that. If they walked backward to bed, they would dream of their future spouses bringing them glasses of water. Another method of prophesying marital prospects required that a girl make a bouquet of artichoke leaves, being sure to burn their tips. If the bouquet were still upright the next morning, she could expect to have a happy marriage, but if the leaves were wilted, her marriage would prove a failure.[62] There were also methods for ascertaining the nature of a hoped-for lover's intentions. If a girl's left eye itched, she could trust in his honor, but an itching right eye indicated infidelity.[63]

Anticipation of a possible wedding might affect not just the couple and their families. Once rumor had suggested that an engagement was in the planning stages, the couple might be subjected to not-so-subtle pressure to expedite the process. For instance, among Sicilian Americans dinners at which both were present might feature the pasta *mezzo-zittu*, which signaled that they were "half-engaged" and that a formal announcement of their intentions was in order. Once that announcement had been made, dinners for the couple would feature *zittu*, a pasta that symbolized their public declaration of marriage plans.[64]

Preparations for a wedding involved the prospective bride's assembling a trousseau, which might include not only household items and her own clothing, but clothing for her future husband as well. The custom of a family's providing each daughter with a dowry persisted from the old country, $300.00 or $400.00 being the amount specified among Sicilians in Columbus, Ohio, around the turn of the twentieth century.[65] Even after the dowry had ceased to exist formally, it remained the bride's responsibility to contribute the mattress to the newly married couple's domestic economy.[66]

While the actual marriage ceremony was shaped primarily by the dictates of the priest or civil authority who officiated, folk belief figured in such practices as the groom's carrying a piece of iron in his pocket to ward off the evil eye, a special threat at this time since his happy situation might provoke envy, and this ritual of transition might invite supernatural danger. According to some Italian Americans, the bride's wearing a veil was done for the same reason. Some brides considered it good luck to tear their wedding veil.[67] Church tradition forbade marriage during Lent and, until recently, Advent, but folklore also suggested that the month of May, reserved for veneration of the Virgin Mary, was unpropitious for marriages. Marrying in August invited sickness.[68] It was also considered bad

luck for a wedding ring ever to be removed. Once it had been put on during the ceremony, it should remain on the finger even after death.[69]

The celebrations associated with weddings remain highly anticipated events in Italian American life. Characterized as "the highest-level feast" and "the most celebrated and memorable" occasion in the life cycle,[70] the typical Italian wedding has provided the context for significant displays of festivity. The tone for such events is suggested by a description of the first Italian wedding observed in Newark, New Jersey, in 1877. The occasion was "celebrated with exceptional pomp and gaiety. Everybody was there." A local farmer

> *supplied the homeland delicacies of broccoli and pot-cheese which were spread lavishly on the tables. Alfonso Ilaria's tavern was emptied to furnish the endless bottles of wine which inspired the guests to dance to his sad mazzuccas and gay tarantella[s], in which he was accompanied on guitar by Alfonso Cervone, a baker.[71]*

Around the turn of the twentieth century in Thurber, Texas, a similar outpouring of celebratory expression characterized wedding observances:

> *Usually a band provided music the first day, and an accordion player was retained for the remainder of the observance. A special rice dish called rizzotto [sic] was served to wedding guests. For many Thurber weddings, the rice was cooked in a large washtub, into which were poured gallons of chicken broth, chicken giblets, tomato sauce, and grated cheese. Along with rizzotto was served a salad, a variety of meats, and barrels of wine.[72]*

The emphasis on food in this account reflects a common theme at Italian American weddings. Symbolic foods prepared for weddings included candy-covered almonds (**confetti**, jordan almonds, Italian wedding candy), which were deemed essential for the good fortune of the newly married couple. These were tied up in mesh bags and distributed to the guests, who might toss them at the newlyweds. Interviewed in Arkansas in 1990, Frances Gueri Byrd, a second-generation Italian American, remembered trays heaped with bags of *confetti* at the weddings she attended as a child.[73] Preparing these bags required considerable work, as did other foods especially associated with weddings, such as *wanda* (bow ties). Lucia Peek, whose maternal grandparents left a village near Naples early in the twentieth century, recalled in a 1991 interview that preparations for an aunt's wedding required several women to spend a day making these treats from strips of dough

that were folded, fried, and then powdered with sugar. The result was "bushel baskets" full.[74]

The sheer amount of food available at weddings marked them as particularly special events. Long tables at a church hall or Italian social club would be "loaded" with food.[75] An especially elaborate wedding feast appears in di Donato's *Christ in Concrete*. This novel treating the lives of immigrants from Abruzzi describes a multicourse meal that climaxes the nuptial festivities. Drinks appeared before the food was served: sweet liqueurs for the ladies and stronger alcoholic beverages for the men. The **antipasto** consisted of olives, pickled whiting and *calamari* (squid), salami, mortadella, pickled eggplant, and peppers. The soup course was chicken broth flavored with eggs, fennel, artichoke, and parmesan cheese. Boiled eels garnished with garlic and parsley were followed by fried squabs with mushrooms. An escarole salad dressed with wine vinegar and olive oil preceded the main course: a suckling pig on a bed of truffles and potatoes. Next came platters of snails and bread and then dandelion salad and boiled lobsters and clams. Dessert consisted of pastries, spumoni, gelati, and tortoni.[76]

Most Italian American families, of course, could not afford to entertain their wedding guests so lavishly, but food—special dishes as well as large quantities of familiar fare—defined the consummately festive nature of the wedding celebration. Moreover, many Italian American communities maintained their custom of **buste** (envelopes) to help a family defray wedding expenses. The bride would carry a satin bag, called **la borsa,** into which guests, recognizing that their hosts would reciprocate when another wedding occurred in the community, would place envelopes containing money.[77]

Before the bride and groom retired for the night, they often broke a vase or glass. The number of pieces into which it shattered represented how many years of happy marriage they might expect.[78] Their bed, prepared in advance by their mothers, might have a pair of scissors in the springs and be sprinkled with salt to ward off evil. Custom required that the groom's mother accompany them to their chambers and be the last to leave, extinguishing the lights as she departed.[79]

Death

Characterizations of southern Italian life often emphasize the importance of customs and beliefs associated with death: omens foreshadowing its occurrence, funeral and burial practices, and prescriptions and proscriptions regarding mourning. The culture's concern with such deathlore has been attributed to anxiety about

the soul's reluctance to forsake its earthly abode for life in the afterworld. Death rituals encourage the soul to begin its journey into the afterlife and protect survivors from its return, thus effecting a safe transition for all.[80]

While immigrants from southern Italy certainly brought such concepts with them, they modified their funeral observances in the New World. Improved economic conditions may have inspired former peasants to emulate the customs of the Old World elite. Elaborate floral decorations, funeral bands, and paid mourners used by Italian Americans early in the twentieth century paralleled practices of the *signori* (gentry), which peasants often could not afford.[81] Other influences, especially a general trend toward adopting mainstream American ways and the regulations of the Church, have also contributed toward the evolution of Italian American traditions regarding death.

The inevitability of death and the uncertainty of when it will happen have prompted Italian Americans—like people from most cultures—to develop ways of forecasting its occurrence. Traditional death omens include natural happenings such as howling dogs, chirping "death watch" crickets, and hooting owls as well as domestic accidents. Among the latter are breaking a mirror, spilling olive oil, or allowing a religious statue to fall. If one violates a customary taboo such as carrying out ashes on New Year's Day, that may mean that a death in the family will take place before the year is over. Dreams are regarded as having special prognosticative significance. A friend or family member will die soon if one dreams of raw meat, a priest, a dead person (particularly if that person seems to touch the dreamer), losing a tooth or having one pulled, or getting married. Mysterious, unexplained knocking or hearing footsteps when no one is there may mean that a death is imminent.[82]

When a death occurred earlier in the twentieth century, the funeral Mass took place only after the body of the deceased had been waked for a period of at least forty-eight hours.[83] Ideally this would have taken place at home, where the coffin was surrounded by palms, floral wreaths, and religious artifacts. A description of a "laying out" in the 1920s noted a silver cross on the wall above the body and pairs of candles in silver candlesticks at its head and feet.[84] Shades were drawn, mirrors were covered, and clocks were stopped at the time of death. Friends would visit to pay their respects and console the extended family, all of whom were expected to be in attendance and remain with the body around the clock.[85] The deceased would be dressed in his or her Communion garb if a child, while a woman might be laid out in her wedding dress.

Italian American wakes lacked the festive spirit associated with similar occasions in other ethnic groups, but plenty of food (especially meatless dishes) was

on hand. Minestrone soup might be provided to replace fluids lost in weeping. This was offered by friends and neighbors so that family members could devote themselves entirely to mourning. Visitors would first express their condolences to the bereaved, then offer prayers for the dead, and conclude their visit by sitting, gossiping, and enjoying some of the available food. In some cases, a "dinner of consolement," featuring veal to symbolize new life, would be prepared for the mourners.[86]

People often anticipated the expenses of a wake and funeral by joining a burial society, but in some cases the custom of **poste** (burial debt), provided financial aid. Accordingly, the bereaved family would set up a table, and those attending the wake would assist them with monetary contributions. Someone scrupulously recorded names and amounts, since the family viewed it as a point of honor to reciprocate when a donor needed funds for a similar purpose.[87] In Greenwich Village in the early 1950s, an Italian American family maintained a ledger listing those who paid their respects to their deceased father: 117 gave Mass cards, 33 made financial contributions, 26 sent flowers, and 19 extended sympathy messages. They kept this record "so that obligations could be properly discharged."[88] In an interview in 1991, Ray Ferraro, a second-generation Campanian American, characterized the way in which this custom has evolved:

A lot of families instead of giving flowers—they would have what they called a "place," or busta [sic]. And a member of the family, one of the older members would sit—most of these funerals were held at home. And it was an all-night deal. And a member of the family would be present there—greeted people as they came in. And the families would come in, and they would leave money. And this money was recorded in a little book. . . . Their names and how much was donated. And all that helped to defray the expenses of the funeral. Plus they brought food. Everyone always chipped in. There was always something to eat because you had to feed all these people that came from out of town. They weren't small families. They were all big families. So that was a big experience for us.

Now with this book with all the names I remember—I don't know whether it was my brother or my sister or my mother would say that would be our Bible because the first thing we did whenever we got the paper is look at the obituary notices to see who passed away. Or someone would call us. And we'd go to the book, and we'd look and see if they came to pay respects to us. If they did, we had to reciprocate. And that's how this tradition helped everyone.

> *Now today in this time and age it's done, but done in a different way. We do it now where we're trying to break off that tie. And if anyone that we know that had contributed to our family, we put it in memory of our parents. And in this way here, that ends part of that tradition.*[89]

Although funeral homes might be regarded as places too cold and impersonal to leave a dead relative's body, their use could be mitigated as long as a family member remained with the body at all times. Also, funeral homes frequently had a distinctly regional identity. For example, in the North End section of Boston, Italian Americans, according to William Foote Whyte, generally had "an undertaker of 'their own kind,' a man from the same part of Italy." In the 1930s this neighborhood boasted at least one undertaker for each region from which its residents had emigrated, and he maintained a highly influential profile among his *paesani*.[90] Even in communities where regional identities had given way to a more generalized Italian ethnicity, funeral homes catered to the traditional customs associated with death. In New Orleans, for instance, Italian-owned funeral homes remained open all night to allow mourners to stay with the body and provided doughnuts, other pastries, and coffee either around the clock or at designated times day and night.[91]

Floral arrangements in traditional designs remain an important decorative feature at a funeral home during a wake. Among the most popular have been a chair suggesting the throne awaiting the deceased in heaven, a pillar symbolizing the deceased's role as family support, and a clock with its hands stopped at the time of death.[92] It was once customary to place objects of special significance to the deceased in his or her casket, a practice that continues in modified form today. A reminiscence of a funeral held early in the twentieth century focused on what accompanied the body into the grave:

> *I recall that when grandfather died in 1915 at the age of eighty-eight, his wake was held in the home and the funeral begun there. He looked dignified in the vested suit which he made in the years when he had fashioned then-Governor Woodrow Wilson's clothes. Small change was placed in his pocket, as well as other mementos of the Knights of Columbus, Fourth Degree, the Sons of Italy, and other fraternal societies of which he had been a member.*[93]

Typically, jewelry, some change, and favorite articles of clothing would be interred with the body. Less common items left in caskets included *confetti* covering the

body of a dead child and a **bocce** ball.[94] Some Italian Americans still believe that any articles of clothing or jewelry placed with a body must be buried with it.[95] Quite recently at the funeral of a Piedmontese immigrant, a bottle of beer and a sprig of dried edelweiss, a native northern Italian flower, were placed with the body.

The fear that death had a contaminating effect caused southern Italians to avoid a direct route home after attending a wake or a funeral. The belief was that one should stop on the way home at a public place. Some believed that a purchase should be made before returning home, and, if that proved impossible, "you must walk around outdoors for a while before going to your home."[96]

Visiting someone when returning from a funeral or a wake might cause a person in that household to sicken. A young Italian American reported an incident from the 1950s demonstrating the persistence of this belief:

> *A few years ago, I had taken my grandmother to the funeral home to pay respects to a deceased friend. After leaving the funeral home, she said that she would like to visit another friend while we were in that section of town. I started for the residence of this person, but didn't get half way before she told me to stop. She said that she would like to go into the A and P and get something she needed. I waited outside while she went in to make the purchase. Five minutes later, she came out but had nothing in her hands. She said that they didn't have the article she wanted. It was not until later that I discovered why she went into the A and P store. She knew that she could not go directly to a friend's house and had to make a stop somewhere else first.*[97]

In the home, mirrors remained turned to the wall and covered with black for perhaps a week after a funeral. No cleaning was supposed to be done for the same period, and salt might be sprinkled as a prophylactic against the infection of death.[98] The emphasis on a lengthy period of mourning during which only black could be worn has virtually disappeared, as has the necessity for families to attend personally to the maintenance of most grave sites.

Imposing grave markers are still in use, but the practice of affixing a porcelain portrait of the deceased no longer occurs to any significant extent. On older tombstones, though, one notices the effect described by novelist Tina De Rosa in *Paper Fish* (1980): "Set into the stone are the small framed pictures of the dead; their faces are set so that they always look directly into the eyes of anyone who looks into theirs."[99] Yet Italian American graves still can be recognized on Palm

Sunday and for several weeks thereafter: They may be decorated with palms woven into fancy shapes or stapled to cardboard hearts or crosses.[100]

Traditions literally accompany Italian Americans from before the cradle until after the grave. Constantly evolving—a process accelerated by immigration, acculturation, and assimilation—folk beliefs and practices associated with birth, marriage, and death may no longer be interpreted in terms of Van Gennep's classic description of the purpose of a rite of passage. But they do continue to provide the assurances of support from a community that exists in both past and present during some of the most significant events in an individual's life.

Notes

1. Arnold van Gennep, *The Rites of Passage,* trans. Monika B. Vizedom and Gabrielle L. Caffee (Chicago: University of Chicago Press, 1960).

2. Victor W. Turner, *The Ritual Process: Structure and Anti-Structure* (Chicago: Aldine, 1969).

3. M. Estellie Smith, "Folk Medicine Among the Sicilian-Americans of Buffalo, New York," *Urban Anthropology* 1, no. 1 (1972): 104.

4. Robert Anthony Orsi, *The Madonna of 115th Street: Faith and Community in Italian Harlem, 1880–1950* (New Haven: Yale University Press, 1985): 82; and James R. Foster, "Brooklyn Folklore," *New York Folklore Quarterly* 13 (1957): 90.

5. Giuseppe Cautela, "Italian Funeral," *American Mercury* 15 (1928): 202.

6. Richard Gambino, *Blood of My Blood: The Dilemma of the Italian-Americans* (Garden City, N.Y.: Doubleday, 1974): 203; and Wayland D. Hand, Anna Casetta, and Sondra B. Thiederman, eds., *Popular Beliefs and Superstitions: A Compendium of American Folklore from the Ohio Collection of Newbell Niles Puckett* (Boston: G.K. Hall, 1981): 8 (items no. 188, 195), 10 (no. 252).

7. Hand, Casetta, and Thiederman, 12 (item no. 303); and Phyllis H. Williams, *South Italian Folkways in Europe and America: A Handbook for Social Workers, Visiting Nurses, School Teachers, and Physicians* (1938; reprint, New York: Russell and Russell, 1969): 177–178.

8. Catherine Harris Ainsworth, *Italian-American Folktales* (Buffalo: Clyde Press, 1977): 34–35; Carla Bianco, *The Two Rosetos* (Bloomington: Indiana University Press, 1974): 109; Michael Brunetti, "Italian Folklore Collected from Mrs. Stephanie Nappi," *New York Folklore Quarterly* 28 (1972): 259–260; Louis Jones, "Italian Werewolves," *New York Folklore Quarterly* 6 (1950): 133; and Bob Zappacosta, "Italian Beliefs," *West Virginia Folklore* 12, no. 2 (Winter 1962): 23.

9. Hand, Casetta, and Thiederman, 276 (item no. 6933), 1082 (no. 25728).

10. Ibid., 47 (item no. 1148).

11. Brunetti, 259; and Hand, Casetta, and Thiederman, 46 (item no. 1125), 51 (no. 1239).

12. Hand, Casetta, and Thiederman, 26 (items no. 688, 691, 703).

13. Bianco, 108; Brunetti, 259; Hand, Casetta, and Thiederman, 38 (item no. 953), 40 (nos. 993, 996, 997), 41 (nos. 1013, 1016, 1022, 1023); Dorothy Gladys Spicer, "The Immigrant Mother As Seen by a Social Worker," *Hygeia* 4, no. 6 (June 1926): 321; Caroline F. Ware, *Greenwich Village, 1920–1930: A Comment on American Civilization in the Post-War Years* (1935; reprint, New York: Harper and Row, 1965): 174; Williams, 87, 103; and Zappacosta, 23.

14. Barbara J. Taft McNaughton, "Calabrian Folklore from Giovanna," *Journal of the Ohio Folklore Society,* n.s., 3, no. 1 (Spring 1974): 26–27.

15. Ibid., 27.

16. Ware, 191. Through questionnaires Ware found that 54 percent of Italian Americans in Greenwich Village over the age of thirty-five believed in prenatal marking, while 31 percent of those younger than thirty-five subscribed to the belief.

17. Jo Pagano, *Golden Wedding* (1943; reprint, New York: Arno, 1975): 138–139.

18. Hand, Casetta, and Thiederman, 92 (items no. 2237, 2239), 94 (no. 2278).

19. Gambino, 203–204.

20. Idwal Jones, "Evviva San Francisco," *American Mercury* 12 (1927): 152.

21. Hand, Casetta, and Thiederman, 44 (no. 1092).

22. Gambino, 197; Hand, Casetta, and Thiederman, 94 (item no. 2293); and Williams, 35–36.

23. Marie Hall Ets, *Rosa: The Life of an Italian Immigrant* (Minneapolis: University of Minnesota Press, 1970): 181; and Hand, Casetta, and Thiederman, 155 (item no. 3752).

24. Dorothy Gladys Spicer, "Health Superstitions of the Italian Immigrant," *Hygeia* 4, no. 5 (May 1926): 269.

25. Pietro Di Donato, *Christ in Concrete* (Indianapolis: Bobbs-Merrill, 1939): 51

26. Elizabeth Ewen, *Immigrant Women in the Land of Dollars, Life and Culture on the Lower East Side 1890–1925* (New York: Monthly Review Press, 1985): 132

27. Hand, Casetta, and Thiederman, 22 (item no. 585).

28. Di Donato, 52, 58. *See also* Bianco, 110–111.

29. Spicer, "Health Superstitions," 269.

30. Hand, Casetta, and Thiederman, 76 (item no. 1848), 78 (no. 1880), 80 (no. 1938), 82 (no. 1999), 152 (no. 3693).

31. Lucas Longo, *The Family on Vendetta Street* (Garden City, N.Y.: Doubleday, 1968): 50.

32. Louis Guida, "The Rocconi-Fratesi Family: Italianata in the Arkansas Delta," in *Hogs in the Bottom, Family Folklore in Arkansas,* ed. Deirdre LaPin (Little Rock: August House, 1982): 94.

33. Interview with Mamie Jo DiMarco Chauvin (Sicilian, second generation), 19 March 1991, in Forrest City, Arkansas.

34. Jerre Mangione, *Mount Allegro: A Memoir of Italian American Life* (1943; reprint, New York: Columbia University Press, 1981): 167.

35. Hand, Casetta, and Thiederman, 52 (items no. 1272, 1273, 1275).

36. Ibid., 54 (item no. 1319), 62 (no. 1504).

37. Interview with Albina Malpezzi (Piedmontese, second generation), 25 November 1988, in Jonesboro, Arkansas; Ainsworth, 52; and Hand, Casetta, and Thiederman, 107 (item no. 2621).

38. Interview with Etta Ferraro Goodwin (Campanian, second generation), August 1991, in Peace Dale, Rhode Island (interviewed by Lucia Peek).

39. Williams, 104.

40. Ainsworth, 46–47.

41. Interview with Albina Malpezzi; Hand, Casetta, and Thiederman, 71 (item no. 1700); and Joseph Napoli, *A Dying Cadence: Memories of a Sicilian Childhood* (NP: NP, 1986): 5.

42. Jane Voiles, "Genoese Folkways in a California Mining Camp," *California Folklore Quarterly* 3 (1944): 215.

43. Interview with Pearl Malpezzi (Piedmontese; first generation), 19 July 1984, in Masontown, Pennsylvania. Malpezzi also provided the written transcription and translation of the song.

44. Interview with Sam Gennuso (Sicilian, second generation), 26 May 1989, in Jonesboro, Arkansas. Gennuso provided the written transcription and collaborated with his sisters, Louise Gennuso and Antoinette Giglio, in translating the song.

45. Ware, 174.

46. Interview with Mamie Jo DiMarco Chauvin.

47. Bartolomeo J. Palisi, "Patterns of Social Participation in a Four-Generation Sample of Italian-Americans," *Sociological Quarterly* 7 (1966): 176

48. Salvatore J. LaGumina, *The Immigrants Speak, Italian Americans Tell Their Story* (New York: Center for Migration Studies, 1979): 117–118 (from the memoir of Clara Corica Grilla).

49. Elizabeth Mathias and Richard Raspa, *Italian Folktales in America: The Verbal Art of an Immigrant Woman* (Detroit: Wayne State University Press, 1985): 281.

50. Virginia Yans-McLaughlin, *Family and Community: Italian Immigrants in Buffalo, 1880–1930* (1971; reprint, Chicago: University of Chicago Press, 1982): 93.

51. Yans-McLaughlin, 82.

52. Charles W. Churchill, *The Italians of Newark: A Community Study* (1942; reprint, New York: Arno, 1975): 79, 81.

53. Corinne Azen Krause, *Grandmothers, Mothers, and Daughters: Oral Histories of Three Generations of Ethnic American Women* (Boston: Twayne, 1991): 19.

54. Interview with Joanne Terranella Burleson (Sicilian, third generation), 14 March 1990, in Jonesboro, Arkansas.

55. Krause, 27.

56. Hand, Casetta, and Thiederman, 545 (item no. 13658).

57. Smith, 103.

58. Napoli, 59.

59. Krause, 30.

60. Yans-McLaughlin, 256.

61. Jerilyn Mankins, "More Italian Beliefs," *West Virginia Folklore* 12, no. 2 (Winter 1962): 29. See also Bianco, 111.

62. Hand, Casetta, and Thiederman, 518 (item no. 13069), 519 (no. 13083), 539 (no. 13517).

63. James R. Foster, "Brooklyn Folklore," *New York Folklore Quarterly* 13 (1957): 90.

64. Mangione, 134.

65. Grace Leonore Pitts, "The Italians of Columbus—a Study in Population," *Annals of the American Academy of Political and Social Science* 19 (1902): 157.

66. Orsi, 114; and Williams, 47–48, 86. See also Bianco, 113.

67. Hand, Casetta, and Thiederman, 590 (items no. 14648, 14649), 1078–1079 (nos. 25645, 25668).

68. Rocco Fumento, *Tree of Dark Reflection* (New York: Knopf, 1962): 86; and Hand, Casetta, and Thiederman, 268 (item no. 6743). For auspicious and inauspicious wedding days among Italian Americans, *see* Bianco, 113.

69. Marion Benasutti, *No Steady Job for Papa* (New York: Vanguard, 1966): 190.

70. Judith Goode, Janet Theophano, and Karen Curtis, "A Framework for the Analysis of Continuity and Change in Shared Sociocultural Rules for Food Use: The Italian-American Pattern," in *Ethnic and Regional Foodways in the United States: The Performance of Group Identity*, ed. Linda Keller Brown and Kay Mussell (Knoxville: University of Tennessee Press, 1984): 78; and Guida, 94.

71. Churchill, 34.

72. C. Richard King, "Old Thurber," in *Singers and Storytellers,* ed. Mody C. Boatright, Wilson M. Hudson, and Allen Maxwell (Dallas: Southern Methodist University Press, 1961): 110.

73. Interview with Frances Gueri Byrd (southern Italian, second generation), 23 May 1990, in Jonesboro, Arkansas; interview with Lucia Peek (Campanian, third generation), 19 January 1991, in Jonesboro, Arkansas; Hand, Casetta, and Thiederman, 610 (item no. 15049); Lorenzo Madalena, *Confetti for Gino* (Garden City, N.Y.: Doubleday, 1959): 86; Pagano, p. 87; and Williams, 100.

74. Interview with Lucia Peek; interview with Ray Ferraro (Campanian, second generation), August 1991, in Macomb, Illinois (interviewed by Lucia Peek).

75. Interview with Frances Byrd.

76. Pietro DiDonato, *Christ in Concrete* (Indianapolis: Bobbs-Merrill, 1939): 249–260.

77. Churchill, 35; Fred L. Gardaphe, ed., *Italian-American Ways* (New York: Harper and Row, 1989): 32; Longo, 135–136; Joe Vergara, *Love and Pasta: A Recollection* (New York: Harper and Row, 1968): 125–126; and Ware, 191.

78. Hand, Casetta, and Thiederman, 611 (items no. 15064, 15069).

79. Guida, 93; and Hand, Casetta, and Thiederman, 615 (item no. 15139), 1079 (no. 25684).

80. Interview with Mamie Jo DiMarco Chauvin; Bianco, 116–118; Elizabeth Mathias, "The Italian-American Funeral: Persistence Through Change," *Western Folklore* 33 (1974): 36–37; and Williams, 199–200.

81. Mathias, 49–50.

82. Hand, Casetta, and Thiederman, 1126 (item no. 26695), 1127 (no. 26712), 1129 (nos. 26748, 26749, 26759), 1132 (no. 26832), 1133 (nos. 26843, 26847, 26848), 1144 (nos. 27121, 27122, 27125), 1149 (no. 27250), 1154 (nos. 27355, 27356), 1157 (no. 27407), 1158 (nos. 27452, 27453), 1159 (nos. 27467, 27468), 1163 (no. 27559), 1170 (no. 27740), 1176 (nos. 27864, 27870), 1177 (nos. 27886, 27891, 27896), 1178 (nos. 27898, 27903), 1179 (no. 27915), 1190 (nos. 28162, 28163), 1191 (nos. 28167, 28186, 28187). *See also* DiDonato, 72; and Antonia Pola, *Who Can Buy the Stars?* (New York: Vantage, 1957): 184–185.

83. Dan G. Hoffman, "Stregas, Ghosts, and Werewolves," *New York Folklore Quarterly* 3 (1947): 327–328.

84. Cautela, 203.

85. Interview with Marie Marchese (Sicilian, second generation), 12 April 1991, in North Little Rock, Arkansas; Churchill, 36; and David Steven Cohen, *The Folklore and Folklife of New Jersey* (New Brunswick: Rutgers University Press, 1983): 199.

86. Cohen, 199.

87. Interview with Lucia Peek; Churchill, 36; and Rose Grieco, "They Who Mourn," *Commonweal,* 27 March 1953: 630.

88. Donald Tricarico, "The Restructuring of Ethnic Community: The Italian Neighborhood in Greenwich Village," *Journal of Ethnic Studies* 11, no. 2 (1983): 67.

89. Interview with Ray Ferraro.

90. William Foote Whyte, *Street Corner Society: The Social Structure of an Italian Slum,* 2nd edition (Chicago: University of Chicago Press, 1955): 201–202.

91. Interview with Mamie Jo DiMarco Chauvin.

92. Mathias, 50.

93. Daniel David Cowell, "Funerals, Family, and Forefathers: A View of Italian-American Funeral Practices," *Omega* 16, no. 1 (1985–86): 73.

94. Hand, Casetta, and Thiederman, 1224 (items no. 28913, 28915, 28917), 1225 (nos. 28942, 28946), 1226 (nos. 28963, 28970); Mathias, 37n; and Williams, 209.

95. Interview with Mamie Jo DiMarco Chauvin.

96. Cowell, 79.

97. Zappacosta, 23–24. *See also* Hand, Casetta, and Thiederman, 263 (item no. 6615), 1231 (nos. 29074, 29075).

98. Bianco, 119; Cowell, 80; Hand, Casetta, and Thiederman, 1215 (items no. 28718, 28722), 1217 (no. 28766), 1218 (nos. 28770, 28776); and Mathias, 50.

99. Tina DeRosa, *Paper Fish* (Chicago: Wine Press, 1980): 24.

100. Dorothy Noyes, *Uses of Tradition: Arts of Italian Americans in Philadelphia* (Philadelphia: Philadelphia Folklore Project, 1989): 60–65.

Further Reading

This article is an adaptation of Chapter Three, "Customs: The Life Cycle," in Frances M. Malpezzi and William M. Clements, *Italian-American Folklore* (Little Rock: August House, 1992): pp. 59–80. Important frameworks for the study of customs relating to the life cycle are Arnold Van Gennep, *The Rites of Passage,* trans. Monika B. Vizedom and Gabrielle L. Caffee (Chicago: University of Chicago Press, 1960); and Victor W. Turner, *The Ritual Process: Structure and Anti-Structure* (Chicago: Aldine, 1969). Works that deal with Italian American customs and folk beliefs include Carla Bianco, *The Two Rosetos* (Bloomington: Indiana University Press, 1974); Fred L. Gardaphe, ed., *Italian-American Ways* (New York: Harper and Row, 1989); and Phyllis H. Williams, *South Italian Folkways in Europe and America: A Handbook for Social Workers, Visiting Nurses, School Teachers, and Physicians* (1938; reprint, New York: Russell and Russell, 1969). Italian American folk beliefs also figure significantly in Wayland D. Hand, Anna Casetta, and Sondra B. Thiederman, eds., *Popular Beliefs and Superstitions: A Compendium of American Folklore from the Ohio Collection of Newbell Niles Puckett* (Boston: G.K. Hall, 1981). This work contains an index by ethnic provenance of particular beliefs. Works that focus specifically on Italian American birthlore include Karyl McIntosh, "Folk Obstetrics, Gynecology, and Pediatrics in Utica, New York," *New York Folklore* 4 (1978): 49–59; Barbara J. Taft McNaughton, "Calabrian Folklore from Giovanna," *Journal of the Ohio Folklore Society,* n.s., 3, no. 1 (Spring 1974): 20–28; and Dorothy Gladys Spicer, "The Immigrant Mother As Seen by a Social Worker," *Hygeia* 4, no. 6 (June 1926): 319–321. Italian American funeral practices are treated in Giuseppe Cautela, "Italian Funeral," *American Mercury* 15 (1928): 200–206; Daniel David Cowell, "Funerals, Family, and Forefathers: A View of Italian-American Funeral Practices," *Omega* 16, no. 1 (1985–1986): 69–85; and Elizabeth Mathias, "The Italian-American Funeral: Persistence Through Change," *Western Folklore* 33 (1974): 35–50.

Bread and Wine
in Italian American Folk Culture

Frances M. Malpezzi
William M. Clements

More than any other component of traditional cuisine, bread and wine have transcended the distinctive regional folkways that many Italian immigrants brought with them to the United States. **Campanilismo,** a picturesque term meaning a loyalty that extended no farther than the distance from which one could hear the sound of the village bells, characterized Italian life at the time of mass immigration between 1880 and 1910. After all, Italy had become a unified modern nation less than a generation before this mass immigration began. Italians often identified much more closely with a region (north or south), a province (for example, the Piedmont or Calabria), or even a specific local community (the *paese*) than they did with the new Italian nation. Immigrants were less Italians than they were Piedmontese, Calabrian, or Sicilian or natives of Monteu da Po, Maida, or Corleone.

Regionalism extended to foodways—pasta, in general terms, being the staple among southerners, while corn and rice dominated the diet of northerners, who might even be called *polentoni* because of the prevalence in their diet of *polenta*, a cornmeal dish whose name reflected its similarity in appearance to pollen. But bread and wine knew no regional limitations. Both figured prominently in nutrition throughout Italy and continued to do so among immigrants, no matter what their particular point of regional origin.

Centuries of tradition must have contributed to the importance of bread and wine in Italian American culinary tradition. Made from fruits of the native soil, both were "natural" foods. Moreover, both were available to families even when such nutritional luxuries as meat and fresh vegetables were not. Consequently, the ability to bake bread and to make wine represented important do-

Boldface terms are defined in the Cultural Lexicon which starts on p. 703.

mestic skills. A woman could not hope to be considered a worthy wife and mother unless she could provide her family with a regular supply of freshly baked bread. Likewise, a traditional male responsibility involved assuring that homemade wine was available to accompany every meal.

Even in the United States, particularly in small towns and rural areas, Italian women often had their husbands build outdoor ovens, whose primary purpose was for baking bread. In Lorenzo Madalena's novel *Confetti for Gino* (1959), Mamma DeMarino has one of these outdoor ovens in which she bakes not only bread, but rolls and holiday cookies as well.[1] Dome-shaped like beehives and made from brick or clay, outdoor ovens might yield as many as fifteen loaves of bread a week, depending on a family's size.[2] Bread baking would often be done on a large scale—as much as twenty-five pounds of flour going into a weekly batch of dough. Proportioning ingredients was a matter of experience, since the baker relied upon her sense of the dough's texture and appearance rather than upon precise measurements. The resulting bread was hearty and crusty, perfect for eating with olive oil or for dipping in wine and, as many Italian Americans noted, completely different from the bland, featureless bread of mainstream American culture. Bread appeared on the table at every meal and might constitute the main course at breakfast, where it was dipped in coffee or milk. In addition to large round and oblong loaves, Italian American bakers might prepare breadsticks for snacking or flat breads, which could be kept for weeks without spoilage. For special circumstances such as the Saint Joseph's altars, which Italian American families from the south of Italy prepared on the saint's feast day (19 March), bread might be baked in such festive shapes as chalices, stars, and the saint's beard.[3]

"*Un giorno senza vino e come un giorno senza sole*" (A day without wine is like a day without sunshine), according to a Sicilian proverb.[4] The role of wine in traditional Italian American cuisine contrasted sharply with how mainstream American culture has viewed alcoholic beverages. For wine was not an intoxicant but a food, enjoyed with virtually every meal even by the very young. As the characters in Raymond De Capite's *The Coming of Fabrizze* (1960) assert, wine warmed one during the winter and offered cooling relief during the hot summer months.[5] Wine enriched the blood (according to a Sicilian proverb, "*U vinu ti fa sangu*": Wine creates blood),[6] improved the complexion, assisted digestion, kept the teeth clean, and served as a strengthening tonic. Other examples of Italian American literature emphasize these qualities of wine.[7] The narrator of Marion Benasutti's *No Steady Job for Papa* (1966) describes her father's coming home from work to a revitalizing "egg soda," made of a whole egg beaten to a froth in a glass of wine. Marietta, a character in Antonia Pola's *Who Can Buy the Stars?* (1957), drinks wine

to settle her stomach during the rough sea voyage to America. The mother in *Golden Wedding* ([1943] 1975) by Jo Pagano drinks hot wine spiced with lemon to settle her nerves. To prohibit the distribution and consumption of wine, as occurred in some American communities—and throughout the United States during the 1920s—was to tradition-oriented Italian Americans as unthinkable as placing prohibitions on the use of bread. Drinking to the point of intoxication was not so much a moral issue as evidence of foolhardiness. Another Sicilian proverb suggested "*La biviri non misuratu fa l'uomo asinatu*" (Drinking too much turns a man into an ass).[8]

Some wines, though, were better than others, and the best of all was homemade. Wine making was a seasonal affair and might, in fact, be quite festive. Immigrants such as those depicted in *Christ in Concrete* (1939) by Pietro di Donato used the occasion to reminisce about life back in Italy and relate stories about their experiences in the United States.[9] In early autumn, Italian American men examined supplies of local grapes or shipments from the vineyards of California to select those that would produce the dark, heavy, often sharply acidic wine that came to be known to non-Italians as "Dago red." A preferred grape was zinfandel, since it yielded a beverage that approximated the Italian chianti. A gathering of family members or **paesani** might assemble to extract the juice from the grapes. Though the romantic image of barefooted peasants stomping vats of grapes is appealing, most traditional wine makers used a winepress, an implement that was as necessary to the domestic economy as the cook's pots and pans. Then the juice was placed in barrels, obtained perhaps secondhand from a distillery, and allowed to ferment. During fermentation, which might occasionally be hastened with added sugar, the wine maker's principal responsibility was to ensure that the barrels remained airtight, since leaks could turn the wine to vinegar.

Wine may be sampled at any time during the process, but often a traditional date (usually Saint Martin's Day, 11 November) would be designated as the official time to test the wine.[10] A panel of elders would each draw a glass from a barrel, hold it to the light to examine its color and clarity, carefully taste it, and render an opinion. Their favorable verdict on the wine's quality was essential for the family's honor as well as its diet during the rest of the year. Sometimes the new wine would be kept until Christmas before the whole family would begin to drink it.

In addition to their association with products of the native soil and with the labors of mother and father, bread and wine drew symbolic value from their use in Christian ritual. Consequently, prescriptions and proscriptions characterized their production and consumption.[11] Many Italian American women mark

each loaf of bread with a cross and do all of their baking on Mondays to guarantee a prosperous week. A loaf of bread should not be placed upside down—a lesson that both Jerre Mangione (in *Mount Allegro: A Memoir of Italian American Life*) and Gay Talese (in *Unto the Sons*) report having been taught by their parents. If a piece of bread falls to the floor, it should be kissed and blessed with the sign of the cross. Bread should not be wasted, nor should one pierce it with knife or fork. Bread should be one of the first items brought into a new home, and keeping at least a crust of this food staple in the cupboard warded off famine. Though less fraught with taboo than bread, wine also attracted its share of superstitions. Some wine makers noticed correspondences between the fermentation process and lunar phases. As the moon waxed, the process speeded up, and a waning moon paralleled a slowdown in fermentation. If tapped under an inappropriate sign of the moon, wine will turn to vinegar. Likewise, should a menstruating woman be involved in the wine-making process, the results will be disastrous.

Whether its ancestral origins were in the north or the south, members of **la famiglia,** the central institution in Italian American life, could expect to find bread and wine on the table every time they sat down to a meal, the occasion that represented a virtual sacrament since it symbolized the sense of being a part of that central institution. The sacramental character extended to the offering of bread and wine to guests, an act that offered them a place at the family table, which remained a focal point for Italian American life for several generations after immigration.

Notes

1. Lorenzo Madalena, *Confetti for Gino* (Garden City, N.Y.: Doubleday, 1959): 40.

2. C. Richard King, "Old Thurber," in *Singers and Storytellers,* ed. Mody C. Boatright, Wilson M. Hudson, and Allen Maxwell (Dallas: Southern Methodist University Press, 1961): 111; and Madalena, 40.

3. Charles Speroni, "The Observance of Saint Joseph's Day Among Sicilians of Southern California," *Southern Folklore Quarterly* 4 (1940): 135–139; and Kay Turner and Suzanne Seriff, "'Giving an Altar': The Ideology of Reproduction in a St. Joseph's Day Feast," *Journal of American Folklore* 100 (1987): 446–460.

4. Richard Gambino, *Blood of My Blood: The Dilemma of the Italian-Americans* (Garden City, N.Y.: Doubleday, 1974): 23; and Gene P. Veronesi, *Italian Americans and Their Communities of Cleveland* (Cleveland: Cleveland State University Press, 1977): 289.

5. Raymond De Capite, *The Coming of Fabrizze* (New York: David McKay, 1960): 86.

6. Jerre Mangione, *Mount Allegro: A Memoir of Italian American Life* (1943; reprint, New York: Columbia University Press, 1981): 24 (page citation is to reprint edition).

7. Marion Benasutti, *No Steady Job for Papa* (New York: Vanguard, 1966): 188; Jo Pagano, *Golden Wedding* (1943; reprint, New York: Arno, 1975): 57 (page citation is to reprint edition); and Antonia Pola, *Who Can Buy the Stars?* (New York: Vantage, 1957): 38.

8. Gambino, 136.

9. Pietro di Donato, *Christ in Concrete* (Indianapolis: Bobbs-Merrill, 1939): 243.

10. Catherine Harris Ainsworth, *Italian-American Folktales* (Buffalo: Clyde Press, 1977): 37; Rose Grieco, "Wine and Fig Trees," *Commonweal* (27 March 1954): 221–223; Wayland D. Hand, Anna Casetta, and Sondra B. Thiederman, eds., *Popular Beliefs and Superstitions: A Compendium of American Folklore from the Ohio Collection of Newbell Niles Puckett* (Boston: G.K. Hall, 1981): 629; and Joseph Napoli, *A Dying Cadence: Memories of a Sicilian Childhood* (N.p.: n.p., 1986): 39.

11. Interview with Joseph Capello (Piedmontese, second generation), 12 November 1982, in Jonesboro, Arkansas; Carla Bianco, *The Two Rosetos* (Bloomington: Indiana University Press, 1974): 99; William M. Clements, "Winemaking and Personal Cosmology: A Piedmontese-American Example," *New York Folklore* 16, nos. 1–2 (1990): 17–24; Hand, Casetta, and Thiederman, 630–631, 633, 635–636, 1031, 1396; Corinne Azen Krause, *Grandmothers, Mothers, and Daughters: Oral Histories of Three Generations of Ethnic American Women* (Boston: Twayne, 1991): 25; Mangione: 132–133; Napoli, 39, 54; Nat Scammacca, *Bye Bye America: Memories of a Sicilian-American* (New York: Cross-Cultural Communications, 1986): 26–27, and Gay Talese, *Unto the Sons* (New York: Knopf, 1992).

Further Reading

Most treatments of Italian American foodways deal at least in passing with the role of bread and wine. For example, see Helen Barolini, *Festa: Recipes and Recollections of Italian Holidays* (New York: Harcourt, Brace, Jovanovich, 1988); Linda Keller Brown and Kay Mussell, eds., *Ethnic and Regional Foodways in the United States: The Performance of Group Identity* (Knoxville: University of Tennessee Press, 1984), the relevant chapters being Judith Goode, Janet Theophano, and Karen Curtis, "A Framework for the Analysis of Continuity and Change in Shared Sociocultural Rules for Food Use: The Italian-American Pattern" (pp. 66–88), and Richard Raspa, "Exotic Foods Among Italian-Americans in Mormon Utah: Food As Nostalgic Enactment of Identity" (pp. 185–194); Toni F. Fratto, "Cooking in Red and White," *Pennsylvania Folklife* 19, no. 3 (1970): 2–15; Frances M. Malpezzi and William M. Clements, *Italian-American Folklore* (Little Rock: August House, 1992), particularly the chapter on foodways (pp. 221–245); and Joe Vergara, *Love and Pasta: A Recollection* (New York: Harper and Row, 1968).

Specific treatments of wine production and consumption include William M. Clements, "Winemaking and Personal Cosmology: A Piedmontese-American Example," *New York Folklore* 16, nos. 1–2 (1990): 17–24; Rose Grieco, "Wine and Fig Trees," *Commonweal* 4 June 1954: 221–223; Giorgio Lolli, Emidio Serianni, Grace M. Golder, and Pierpaolo Luzzatto-Fegiz, *Alcohol in Italian Culture: Food and Wine in Relation to Sobriety Among Italians and Italian-Americans* (Glencoe, Ill.: Free Press, 1958); and Ben James Simboli, "Acculturated Italian-American Drinking Behavior," in *The American Experience with Alcohol: Contrasting Cultural Perspectives,* ed. Linda A. Bennett and Genevieve M. Ames (New York: Plenum Press, 1985): 61–76.

Italian American Feste

Frances M. Malpezzi
William M. Clements

As depicted in Pietro di Donato's novel *Three Circles of Light* (1960), the scene is a festive fairyland.[1] Red, white, and green light bulbs and streamers festoon the main streets of the community. A bandstand in the shape of a fishing vessel, its "deck" gaily decorated with ribbons, has been erected alongside the parish church. People mill along the streets, speaking their regional dialects, Italian, or a transitional language that combines English vocabulary with Italian grammar and pronunciation. They stop to greet old friends, to gossip, and especially to select from the array of traditional foods that are hawked from sidewalk stands. That this is a *feast* day is obvious from the array of available foods: hot pizza made with mozzarella or with anchovies and mushrooms, crusty ceci peas baked in hot sandwiches, roasted chestnuts, pickled periwinkles, squid flavored with saffron, smoked eels, marinated octopus, lambs' brains, blood pie, kidneys wrapped in veal, tripe in red sauce, gelati, spumoni, tortoni—the list seems endless. Soon the apparent chaos of festivity will be interrupted by a grand procession. A statue of San Rocco, draped in blue-and-gold star-studded silk, with a diadem on its brow, precious rings slipped on its fingers, and a jeweled collar on the plaster dog at his feet, is carried by several strong men on a litter shaped like a rowboat. Following it on a circular route from the church through the community and then back to the church, worshipers walk four abreast carrying lighted candles. The band plays "Jubilata, San Rocco Nostrum, Jubilata," and devout onlookers rush up to the statue to pin gifts of money onto its robes.

Di Donato's description of the *festa* of San Rocco (16 August) represents what for many is the most typical expression of Italian American religiosity. As Italian immigrants became more and more a presence in American Catholicism,

Boldface terms are defined in the Cultural Lexicon which starts on p. 703.

they found their approach to piety at odds with that advocated by the Church hierarchy, which was predominantly Irish and German. Church leaders believed that they were confronting an "Italian problem,"[2] since the immigrants especially those from southern Italy, practiced a spirituality directed more toward local saints and the Blessed Virgin Mary than the patriarchal deity of the American Church. Italian immigrants, especially men, were less likely to attend Mass regularly and to provide financial support for maintaining the Church than their Irish American counterparts, and they were more likely to be overtly anticlerical and to engage in activities the Church hierarchy dismissed as "magic" or "superstition." For many Italian Americans, the Church figured into their religious lives only at such rites of passage as baptism, marriage, and death and at special holy days such as Christmas, Easter, and the festival honoring the patron saint of the community from which they or their ancestors had come to America.

American priests and bishops had little patience with the extravagance of *feste* during the early years of mass immigration from Italy. Consequently, Italian Americans often organized separate societies for their saints, organizations whose sole purpose was to plan and supervise the annual festival in the saint's honor. The society would devoutly maintain the statue of the saint until the date of the *festa* approached. Then they would robe the statue in rich garments, place it on a platform, and carry it in pious procession throughout the streets of the neighborhood, sometimes stopping at altars constructed in the saint's honor along the way. Very often a large Italian neighborhood might witness several *feste* during the course of a summer as immigrants from each region paid homage to their patron. For instance, in the Italian neighborhoods of New York City during the 1930s, Neapolitans celebrated the feast day of San Gennaro, Sicilians from Palermo honored Santa Rosalia, immigrants from the eastern coast of Sicily observed the *festa* of Santa Agatha, and descendants of residents of Nola paid annual homage to San Paolino. In smaller communities that might be dominated by immigrants from a particular Italian locality, the entire Italian population might participate in an annual *festa paesana* (country feast). Italians in Jessup, Pennsylvania, for example, have honored San Ubaldo on 15 May, while those in Aliquippa, Pennsylvania, celebrate the feast of San Rocco. The Virgin Mary has received special attention in numerous *feste,* many communities honoring her as Our Lady of Mount Carmel on 16 July, for example.

The decline of regional loyalties has produced *feste* with broader appeal, ones that reflect a sense of *Italian* as distinct from *regional* identity, and the forms of *festa* observance have adjusted to adapt to a twentieth-century American setting. Still, the *festa* remains the most distinctive of Italian American calendar cus-

toms, an annual opportunity for people to reaffirm the ethnicity that may have disappeared from their everyday lives.

Once scheduled on the saint's feast day, usually the purported anniversary of his or her birth or martyrdom, many *feste* have more recently reflected an Americanized sense of holiday by occurring on the weekend closest to the traditional date. Usually the whole weekend—Friday afternoon through late Sunday—is devoted to the *festa,* though in some cases the celebration may last for an entire week or even longer. The focus of activity is generally the grounds of the parish church (now that the Church hierarchy no longer feels threatened by this vestige of Italian religious behavior) or a public park. There parish organizations and community businesses will set up booths for the sale of foods ("traditional" Italian food such as sausage sandwiches and pizza as well as mainstream carnival cuisine such as corndogs and cotton candy) and religious objects. Other booths tempt celebrants with games of chance whose profits will offset some of the cost of the festival or augment the parish treasury. Music fills the air, especially on Friday night, when polka bands and rock groups may sometimes alternate with performers of folk and popular Italian music.

The central event in the *festa* remains the procession of the saint's statue. This may occur on Saturday morning. The statue leaves its normal place of repose and, carried on a platform by six or eight men, makes its way through the city streets, returning to the church. The clergy, representatives of parish organizations, and the festival queen follow the statue on its way. Anyone may join in at any point along the route. Formerly people walked barefoot in the procession as an act of penance, to fulfill a vow, or to induce the saint's intercessory efforts on their behalf. Now they are more likely to offer gifts of flowers and sometimes money, pinned to the statue's garments.

After the procession returns the statue to the church, the parish priest or a visiting cleric offers Mass, sometimes in Italian or an appropriate regional dialect. He summarizes the life of the saint and reminds his audience of its continuing relevance for them. Saturday afternoon marks a return to socializing. Festival organizers may stage talent and eating contests and tournaments in **bocce**, a bowling game, and **morra**, a game of finger manipulation. That evening fireworks and a dance bring the proceedings to a climax. Following Mass the next morning, booths reopen before the conclusion of the *festa* on Sunday afternoon.

While representative in general terms, this summary fails to capture the rich diversity that may characterize observances in honor of particular saints: dancing the **giglio**,[3] a structure six stories tall that represents the lilies with which his fellow villagers greeted San Paolino when he returned from captivity among

the Vandals in the fifth century (at the *festa* for the saint in Brooklyn); racing statues of three saints,[4] Ubaldo, Georgio, and Antonio, at the *festa* honoring the first saint in Jessup, Pennsylvania; baking *ciambelle* (in dialect *chiambelli*),[5] doughnut-shaped bread baked from a special recipe for San Rocco's feast day in Aliquippa, Pennsylvania; and preparing *capozzelli*,[6] sheep's head, for the festival of San Gennaro in New York City's Neapolitan community.

Though based on Old World sources, the *festa* has flourished with a special tenacity in the United States. That may be due to its multiple significance: It has served not only as an expression of spirituality, but, because of the original opposition of the American Church hierarchy, it came to stand for ethnic identity (originally regional, then pan-Italian). Formerly for a day and now often for a weekend or longer, the *festa* has allowed Italian Americans to convey who they are in a public, celebratory mode that displays their distinctive contribution to Christian ritual behavior. Many Italian Americans have shared the experience of the characters in Michael De Capite's novel *Maria* (1943).[7] For them the scene of the *festa* replicates the square of their native *paese*, filled by their selective memories with songs and laughter that temporarily obliterate the sometimes forbidding urban American environment during the sacred time of festival. *Festa* becomes the time and place for stressing the "Italian" in "Italian American."

Notes

1. Pietro di Donato, *Three Circles of Light* (New York: Julian Messner, 1960): 114–115.

2. "Religion of Lucky Pieces, Witches, and the Evil Eye," *World Outlook* 3 (October 1917): 24; Nicholas John Russo, "Three Generations of Italians in New York City: Their Religious Acculturation," *International Migration Review* 3, no. 2 (Spring 1969): 4–5; Rudolph J. Vecoli, "Cult and Occult in Italian-American Culture: The Persistence of a Religious Heritage," in *Immigrants and Religion in Urban America*, ed. Randall M. Miller and Thomas D. Marzik (Philadelphia: Temple University Press, 1977): 34–37; and Rudolph J. Vecoli, "Prelates and Peasants: Italian Immigrants and the Catholic Church," *Journal of Social History* 2 (Spring 1969): 217–268.

3. I. Sheldon Posen, "Storing Contexts: The Brooklyn Giglio As Folk Art," in *Folk Art and Art Worlds*, ed. John Michael Vlach and Simon J. Bronner (Ann Arbor, Mich.: UMI Research Press, 1986): 171–191; I. Sheldon Posen and Joseph Sciorra, "Brooklyn's Dancing Tower," *Natural History* 92 (June 1983): 30–37; and Joseph Sciorra, "'O Giglio e Paridiso': Celebration and Identity in an Urban Community," *Urban Resources* 5, no. 3 (1989): 15–20, 44–46.

4. Donald E. Byrne Jr., "The Race of the Saints: An Italian Religious Festival in Jessup, Pennsylvania," *Journal of Popular Culture* 19 (Winter 1985): 119–130.

5. Mildred Urick, "The San Rocco Festival at Aliquippa, Pennsylvania: A Transplanted Tradition," *Pennsylvania Folklife* 19, no. 1 (Autumn 1969): 14–22.

6. Joe Vergara, *Love and Pasta: A Recollection* (New York: Harper and Row, 1968): 16.

7. Michael De Capite, *Maria* (New York: John Day, 1943): 35.

Further Reading

An early account of *feste* in New York City is Jacob A. Riis, "Feast-Days in Little Italy," *Century* 58 (August 1899): 491–499. One might compare this to the more recent account in Joseph Sciorra, "Religious Processions in Italian Williamsburg," *Drama Review* 29 (Fall 1985): 65–81.

Three important books that focus on specific *feste* in urban Italian American communities are Bruce B. Giuliano, *Sacro o Profano? A Consideration of Four Italian-Canadian Religious Festivals,* Canadian Centre for Folk Culture Studies Paper No. 17 (Ottawa: National Museums of Canada, 1976); Robert Anthony Orsi, *The Madonna of 115th Street: Faith and Community in Italian Harlem, 1880–1950* (New Haven: Yale University Press, 1985); and Richard Swiderski, *Voices: An Anthropologist's Dialogue with an Italian-American Festival* (Bowling Green, Ohio: Popular Press, 1987).

In addition to those cited in the endnotes, good studies of particular *feste* include Donald E. Byrne Jr., "Maria Assunta: Berwick's Italian Religious Festival," *Pennsylvania Folklife* 30 (1981): 123–141 (on the Feast of the Assumption of the Virgin).

The *festa* is placed within the annual round of Italian American calendar customs in Frances M. Malpezzi and William M. Clements, *Italian-American Folklore* (Little Rock: August House, 1992), the relevant chapter being chapter four, "Customs: The Traditional Calendar" (pp. 81–111).

Il Caso della Casa

Stories of Houses in Italian America

Robert Viscusi

A word about the title. The "case of the house" means to suggest a crime, a pathology, something that demands investigation. Stories of houses in Italian America seems to promise that you will read about the seven-bedroom brick colonial that my cousin the doctor has just acquired in Westchester. And, I confess, I was sorely tempted to write about the house my grandmother almost bought after fifteen years of saving, but I didn't, because my grandfather got into a terrible bloody fight, and the lawyer and the judge took all of the money. But these stories, and some others that I would love to tell, will have to wait their moment. The case of the house, the function that it serves in Italian America, needs attention. We have, it seems to me, been pursuing and building houses—*case* in the medieval sense, in which house means family and family means house—for a hundred years and more in Italian America, and doing so with stunning passion. This passion is what requires our attention, and because it is passion our examination should be a little cool. So I will offer no stories of my own but will instead sketch in a theory that will allow us to examine some stories that other writers have told, in which the passion of the enterprise reveals itself most openly.

The theory is simple. Contrary to the testimony of maps, there is such a place as Italian America. It is to be found in Italian houses in America. In these places, the house is, in one of several possible senses, the old country itself. In this essay, I shall isolate and exemplify four ways that this can be so. The house may be a shrine, a villa, a ***palazzo***, or an embassy, and any house may be all four of these at the same time, for these nouns merely name purposes, and a house, as we know, can do many things at once.

Boldface terms are defined in the Cultural Lexicon, which starts on p. 703.

Shrine

Lares and *penates* are what make an American house Italian American, and we have innumerable examples to choose from because anything that bears the mark of Italy can become a household god in Italian America. This extends from such obvious artifacts as the statue of Santa Rosalia or the panorama of the Golfo di Napoli to the subtle but all-enveloping atmosphere of cookery—indeed, Mario Puzo goes so far as to identify house and family and food:

> *I had every desire to go wrong but I never had a chance. The Italian family structure was too formidable. I never came home to an empty house; there was always the smell of supper cooking. . . . Many years later as guest of a millionaire's club, I realized that our poor family on home relief ate better than some of the richest people in America. My mother would never dream of using anything but the finest imported olive oil, the best Italian cheeses.*

And so on: Puzo, like many other Italian American storytellers, employs as a standard trope the catalog of the items of **la cucina casalinga** (home-style cooking), the Italian equivalent of "soul food." And always, as here, the stress falls on the power, usually presented as a form of magic, that floats in the aromas of provolone and ragù.

What is the power? Certainly in the passage cited it has some of the features of guilt, and one thinks quickly enough of Freud's comparison of religion with obsessional neurosis. Reading Puzo, one often encounters the son who returns home precisely because he wished to go wrong—his returns, that is, assure him that his "faithlessness" to the family has been avoided, while at the same time the home to which he returns is saturated in the glamour of taboos violated. By seeming to give himself up to the strictures of the "family structure," the son can, in fact, luxuriate in an unbridled orgy of self-indulgent fantasy. It is not merely that the family table is a thieves' banquet, although Puzo paints his mother as a kind of self-righteous Fagin who regards her poverty as an excuse never to inquire too far into the provenance of those fine imported oils and cheeses. Not private property alone is violated here, but the very propriety of privates: about *The Fortunate Pilgrim* (1964), Puzo has written: "To my astonishment my mother took over the book and instead of revenge I got another comeuppance. But it is, I think, my best book." The touching collaboration of mother and son he describes

there is a version of the same fugitive fantasy of Oedipus victorious that informs the career of Michael Corleone in *The Godfather* (1969). Michael—who supplants the father that obligingly dies at the appropriate moment, who murders all rivals with the panache of a racing driver slipping on his French gloves—reaches apotheosis in the conclusion of the novel, when he fills the reveries of his mother and his bride as they kneel every morning in the church.

 These fantasies, delightful as they are, bear a heavy price. In Puzo's work, the price is nothing short of complete emptiness, a damnation deliberately chosen (see his early art-novel *The Dark Arena,* published in 1955) and resounding with all of the flatulence of a well-paid bad faith (see the interminable desert of his 1979 best-seller *Fools Die*). But Puzo, one hastens to add, has merely painted a picture, as it were, of the inside of a shrine that generally receives more veneration than accurate portrayal. Those who do give it genuine attention can scarcely ignore the crimes it commemorates. The guilty immigrant—he who left father and she who abandoned mother in Italy, as well as he who frees himself from the laws of life and property and she who frees herself from the laws of marriage in America—is the consecrator of this sanctuary. The immigrant wrestling with his or her guilt is the mortar not only of the shrine but also of the more complex purposes that may grow up around it.

The Villa

Aeneas, the successful immigrant, owed his prosperity to *pietas,* veneration for ancestors so profound that he left Troy actually carrying his father on his back. Here is an exorcism of guilt that really works. For the immigrant who has abandoned father and mother, there is still a symbolic path of Aeneas that lies open, and many have taken this road, choosing to build in America a home that can advertise itself, with whatever repression of absurdity, as *patriarchal*—**una villa padronale**, literally, a lord's or master's residence, a mansion. Stories of the *famiglia* that builds itself a house and so becomes a *casa* abound in Italian America. This is a narrative in mortar and stone as we encounter it glaring bleakly in the sunshine of Bensonhurst, Brooklyn, or south Philadelphia. Written, it appears most prominently in the promotional literature of the California wineries and on the back pages of menus in prosperous suburban *ristoranti*. Our novels, however, rarely content themselves with the pleasure of writing the family patronym over the door (or even on the title page), and the pure type of this tale, the feudal romance of capitalism, almost never appears. When it does show its face, in such works as

Guido D'Agostino's *Olives on the Apple Tree* (1940) or Raymond De Capite's *The Coming of Fabrizze* (1960), it wears, more likely than not, the frank colors of fantasy.

In the tradition of Italian American novels, the enterprise of the patriarch in Italian America cannot escape its own inappropriateness, and it founders in failure and desecration, the very things that it aims to repress. A typical failed patriarch in this line is the father of Henry Molise, the narrator of John Fante's *The Brotherhood of the Grape* (1977). Henry tells us:

> My old man had never wanted children. He had wanted apprentice bricklayers and stonemasons. He got a writer, a bank teller, a married daughter, and a railroad brakeman. In a sense, he tried to shape his sons into stonemasons the way he shaped stone, by whacking it. He failed, of course, for the more he hammered at us, the further he drove us from any love of the craft. When we were kids a great dream possessed Nick Molise, a glimpse of the glorious future lit up in his brain: MOLISE AND SONS, STONEMASONS. We sons had his brown eyes, his thick hands, his fireplug stature, and he assumed we were naturally blessed with the same devotion to stone, the same dedication to long hours of backbreaking toil. He envisioned a modest beginning in San Elmo, then expansion of operations to Sacramento, Stockton, and San Francisco.

Henry Molise, the narrator, tells us from the outset that this paternal empire did not materialize. The novel recounts one final attempt on the part of the old man to join with his son Henry, a Hollywood writer, in building something. Though his life's failure is already perfected when the novel opens, the father makes this parting gesture that Fante presents in the mode of tragic farce. The son humors the old man—whose problems include diabetes, heart trouble, and alcohol, complicated by raging satyriasis—and they erect the collaborative monument, which, as it happens, is nothing more grand than a stone smokehouse. They build it of alabaster quartz, a mineral, as Fante points out, that is ordinarily reserved for tombstones. Even this modest grandiosity is doomed. The old man, who was once a great builder, now is so drunk while he works that the building, almost the minute he finishes it, dissolves in the rain. One by one, the father's sins and weaknesses undo him; and when he dies, the only way his son can find to carry on for him is to make love to a grotesque old nurse that the father had lusted after while dying in the hospital.

Nick Molise, in a manner of speaking, dies into the house he fails to establish. The manner of speaking becomes a literal destiny in the story of Geremio in

Pietro di Donato's *Christ in Concrete* (1939). After twenty years of striving, the immigrant Geremio finally succeeds one Holy Thursday in making the down payment on a house. The next day, Good Friday, he literally becomes the house that he, too, at the last moment, has failed to establish:

> "Air! Air" screamed his lungs as he was completely sealed. Savagely he bit into the wooden form pressed upon his mouth. An eighth of an inch of its surface splintered off. Oh, if he could only hold out long enough to bite even the smallest hole through to air. . . . He had bitten halfway through when his teeth snapped off to the gums in the uneven conflict."

Such are the ironies that fate has prepared for the Italian American patriarchy that would plant itself in the New World with the same rock-like immobility it believes itself to have possessed in the Old. Di Donato's bricklayer father, like Henry Molise, fails in the ancestral role and reveals himself, finally, to be no more than an errant son—irresponsible, phallic, guilty, and doomed—who leaves to his son an empty role to fill, a dishonored satyr's grave that the son seeks forever to bless with some further desecration. Henry Molise's interlude with the ugly nurse only recalls rather mildly the hero of di Donato's *This Woman* (1959), who marries a widow and then insists upon making love to her on her husband's grave.

The Palazzo

To many an enlightened immigrant, then, it has seemed that it would not be enough for *family* to become *house* and for it to erect the paternal totem in the form of a rooftree. This would bear the marks of self-enclosure, even of self-damnation. House must also become *community*. The logic, perhaps, is the psychologic of the Communion supper: In consuming a corpse, one must spread the guilt. Instead of consecrating oneself alone to the magic of the relic of abandoned Italy—the murdered parent—and instead even of merely planting the corpse in order to grow a new paternal tree, call together assemblies of fellow criminals and share the guilty meal. And each guest at the table, offering the ritual *"Domine non sum dignus ut intres sub tectum meum"* (Lord, I am not worthy that you should come under my roof), can, clear in conscience, fall to with a will. Such is the solution, for example, adopted in *Christ in Concrete* after Geremio's death. Instead of moving into the *villa padronale* on whose altar the father had been immolated, the family thrived in a tenement (indeed, the central section of the book is called "Tenement")

and lived the life of the ***palazzo communale*** (apartment house), where most events in life are shared and the great building itself becomes a kind of ***paese***, a country. The subsequent life of the dead Geremio's family is rich with the features of this manner of existence; the housewives send each other gifts of cooked food, the children mate on the stoop, and every so often some great ritual meal takes place, and the families gather in their dozens to share food after a wedding or a funeral.

There is no doubt that this mode of living assuages some uncomfortable feelings and provides as well many of the advantages of community, but the idyll depends on failure.

There is another version of *palazzo* in Italian America that works quite differently. This one depends upon success. It occurs when a family owns the *palazzo* it occupies, renting apartments to others who inevitably assume positions of hierarchical subordination: Often a ***palazzo ducale***, a ducal or royal palace, wears the humble brick cloak of a three-family house in Bensonhurst or Astoria. We easily imagine how it pleases the once lowly ***contadino*** (peasant), who has become its proprietor and has found in its hallways the answer to Leporello's prayer, *"Voglio far il gentiluomo"* (I want to be a gentleman). Leporello, of course, changes his mind after he gets a close look at the fate of Don Giovanni. But the Italian American *servo padrone* (servant who would be master) at least in fiction, generally gets to try the role out for himself. He also gets to pay the price.

The best example is Gennaro Accuci, hero of Garibaldi Lapolla's *Grand Gennaro* (1935). The year is 1893. Gennaro, an illiterate Calabrese, has "without so much as a by-your-leave to the priest or mayor, to both of whom he owed money . . . slipped out of his mountain village and taken ship at Reggio for New York." His unpaid debt to the *galantuomini* (literally, gallant men; gentlemen) in Italy is the emblem of his career. He quickly gets rich in New York by stealing the business—a thriving concern—that belongs to a boyhood friend who, remembering old days in Calabria, helps Gennaro and then becomes his victim. Once he is rich, Gennaro buys a pretentious three-story brownstone that bears carved into its facade the operatic name Parterre. Himself occupying the *piano nobile* (first floor of a Renaissance palace), Gennaro installs two down-at-the-heels aristocratic *famiglie* in the upper floors. This constitutes a neat arrangement of the social pyramid to be seen inside any opera house in Italy, where the nobility occupy the *parterre*, and a Gennaro Accuci, if he is there at all, must make what he can of the

Note: The author is following the nomenclature used at the Metropolitan Opera House in New York City where the first tier of boxes is designated as the *parterre*.

spectacle below from somewhere up near the roof. Gennaro, truly realizing Leporello's fantasy, occupies not only the *parterre* of this opera house, but its stage as well. He is forever marching past its imposing stoop at the head of some parade, for he is, naturally, **un promininente** (a person of distinction) in the spectacular life of East Harlem. He lives out, too, a sentimental history that might have made even Metastasio, the most flagrant of melodramatists, hesitate and think "Do I dare?" Gennaro becomes the rival of his first-born son, then of the father of one of his aristocratic families, for the love of the daughter of the other aristocratic family; this girl, Carmela Dauri, a paragon of virtues and perfections such as one generally meets only in opera or in soap advertisements, at first loves Gennaro but at the end betrays him. The betrayal scene takes place—where else?—in the hallway of the *parterre*. Gennaro accidentally, and unnoticed, sees Carmela embrace his own second son!

The Grand Gennaro has its weaknesses, but it has its element of greatness as well, and I hope it will not seem mere paradox if I suggest that this extremely florid plot is one of the latter. For this plot accurately reflects the intricate doom of the *servo padrone,* whose whole life in America becomes a burnt offering on some ghostly Ara Pacis (Altar of Peace): He has broken the taboo of the great nobles of Reggio and Roma, and he must pay. Gennaro, with the inborn sense of theater that such a hero needs, after witnessing Carmela's betrayal, walks straight out of his *parterre* and into a trap he knows has been set by the old friend whose business he stole at the opening of the story.

One of the satisfactions this novel offers to us is that it is not only Gennaro whose comeuppance it records. As he must pay for his crimes—against mother-father Italy as well as against his friends—so must his aristocratic victims pay for their transgressions, and for Italy's transgressions, against Gennaro. For there remains this further twist in the guilt the Italian American house commemorates, enshrines, transplants, and glorifies: the sins of mother Italy herself—those sins that inspired the hatred, the abandonment, the murder that haunt the immigrants—still burden their victims. These sins of the old country, in fact, make necessary the emergence of a fourth type of Italian American *casa*.

The Embassy

Nothing will serve, finally, but that the breach be healed, that the hatreds give up their furies before the gentle forces of understanding and mutual absolution, the familial communion of love—for the sin, or at last the guilt, on both sides is great.

To allude to its magnitude is only to begin to suggest the limitless extravagance of lies, of monumental misconstructions and ignorant betrayals that rise up before the American Italian on that day when, moved by some irresistible anguish, he first turns back and looks toward home. There she rises, Italy the terrible, Italy the insatiable greedy granddaughter of Tiberius Caesar, the whip of King Bomba, the leer of his priest. To forgive all of this—even to look it squarely in the eye—will take whatever effort he can muster, all of his understanding, all of his woe.

I call this American Italian "he" because I first encountered him in the pages of Jerre Mangione's *Reunion in Sicily* (1950) and I met him again in the elaborate turnings of Robert Canzoneri's *A Highly Ramified Tree* (1976). But here I had better say "she," for I have read no account that so clearly displays the issues as it expresses itself in houses as does Helen Barolini's *Umbertina* (1979), a novel that could, indeed, have furnished examples for every part of this essay. This is a book about planting, about finding a house and a center that will hold. It has three central characters: Umbertina, the successful immigrant; Margherita, her granddaughter, who leaves country-club Italian America and lives in both cisatlantic and transatlantic literary worlds as the wife of the Venetian poet Alberto Morosini; and, finally, their daughter Tina, raised in both countries, who marries into the Jowers family, an old Cape Cod clan, while maintaining for herself a great degree of independence. Each of these women inhabits several houses, and all of them come to similar conclusions: Guilt and fear, like nostalgia, keep roots from sinking. Every house that lasts does so because it values itself where and as it stands.

Every such house is as I would put it, an embassy—that is, it refers freely to its own history; it achieves its stability by accepting its own impermanence, its own provisionality. Here is Tina, daughter of the restless Italian American Margherita and of the old Venetian Morosini, as she settles into her room in her new husband's family home:

> At the foot of the bed stood an old sea chest used by a Jowers sea captain on some trip to the ends of the earth. There were hooked and braided rugs on the floor and a child's Chippendale chair by the fireplace. . . . Everything was right. It was the equivalent of the fine Italian hand among the old families of the Veneto. Both were seafaring families; both had accumulated wealth and possessions and pride; but her father's family had been on the decline since the first World War and their possessions decimated, the style became faintly seedy. The Jowers family, however, were still enjoying their New World vigor. And yet, Tina thought, as she went to bed in that room, isn't it strange to realize that both places are doomed to vanish.

First Venice will disappear beneath the waters of the lagoon; and long after, but still inevitably, the Cape will erode and go back to its beginnings at the ocean floor.

Only a reading of the novel itself can make clear how dear a purchase is this wisdom of the young bride. I cannot justify it here, but it may not be entirely frivolous to point out that Tina's is the direction in which we shall all need, eventually, to travel.

For *la Casa italo-americana* must do more than offer shelf space to old Caruso records or a place in the garden to bury the fig tree in winter; it must do even more than impress our cousins. It must turn its face outward, as the embassy does, and must surely keep its inward gaze, reminding us of the astonishing doubling of our minds that makes us—American Italians, Italian Americans—what we are. And in the mutual recognitions of our doubled and redoubled selves, certain crimes and fears of crimes will be, if never quite forgotten, nonetheless remarkably transformed.

Stories and Storytelling, Italian and Italian American
A Storyteller's View

Gioia Timpanelli

The folktale in Italy, like all stories, comes from the art of language, from the art of the word, spoken and heard. In storytelling the teller and the listeners are together; it is this shared speaking and hearing that makes such an impression. The success of the communal evening depends on the storyteller's ability to tell the story so well that the listeners imagine the tale and, by their desire, attention, and responses, become part of it. When the imagination is awakened, the listeners become part of the moving experience of the story's creation and re-creation. The storyteller is the intermediary between listener and story, between past and present. Storytelling is by its nature communal, common and inclusive, uncommon and inclusive. No one in the place—old or young, rich or poor, female or male, ox or donkey, dark or light, ember or ashes, angel or human, cabbage or hunger, monster or beauty, tree or stone—is left out. In the beginning there are listeners and the storyteller; in the end there are the stories.

 The folktales can shine from within, be illuminated from without. In them no place, no creature, no plant, no being (be it male or female),[1] no person (female or male) need be excluded; when they are excluded we have distortion in our history and in our stories. Whoever or whatever is left out now needs to tell its story; when this is done and balance is achieved, the community sighs with the satisfaction of having survived a dangerous encounter. Although these old spoken stories come from the language, the culture, the place that held them, they travel, slowly or swiftly, finally belonging to everyone who has an ear for the words and a heart for the story. A story that stinks of decay, with bones that allow no life now, should be left alone. It does not need to be retold. But when one finds a story that makes one giddy with wonder, measured with poetry, then one can agree

Boldface terms are defined in the Cultural Lexicon, which starts on p. 703.

with the poet W.B. Yeats that art is made from hope and memory, two venerable parents of the art of storytelling.

This journey in stories and storytelling is always shared. My Sicilian family told stories; my Sicilian American family told stories. Everything in our life had story in it. My great grandmother, Angelina Milano, was a storyteller (*novellatrice*) from our Sicilian town. It was her songs and rhymes that I first learned from her son, my uncle 'Nzuliddu; her stories that I heard from my aunt Mariuzza; and her love of stories, from my father, who had received this love from her.

"*Na vota cc'era un ortu di cavuli.*[2] (Once there was a cabbage patch.) There are always lean years when everything is scarce. Two women who were best friends went out to find a little something to eat. One of them spied the cabbages. '*Cummari,*' she called out [Cummari means best friends, family or close pal], 'look at these beautiful cabbages.'" And so this Sicilian folk tale begins. Changes in the storyteller's voice, language, and gestures (a slowly turning opened hand, "there are always lean years . . .") make the events unfold leaf by leaf, make images appear, until in the end a young woman shares a beautiful garden of cabbages with her once hungry mother, and an entire world has been created. When there are surprises, and there will be surprises, they come in what happens in the story and not in the psychological description of the characters. Although the folktale is the source of our modern fiction, the events in these old stories are not to be confused with modern plots in fiction, which develop from the individual's particular journey rather than the communal events of the traditional narrative.

Folktales—along with myths, poetry, fables, medieval romances, local legends, teaching stories, anecdotes, and personal narratives—are part of the oral tradition.[3] People like stories. They see the pattern of life in them. Anthropologists assure us that humans have been telling stories at their camp fires, under great shade trees, everywhere they lived, even before ancient civilizations existed. They say we tell stories to amuse, instruct, enlighten, inspire. With its stories a culture reinforces its sense of itself and shows wonder and respect for the larger natural and spiritual universe as well. These old tales come from careful living in a specific place. The ancient storytellers, retelling vividly the stories in their keeping, were important guardians of the history of the place where they lived as well as keepers of their people's literature. This was a chain that went back from teller to teller, generation after generation.

The storytellers during historical times were, and in some places still are, the professional bards and the family storytellers. The home, village, neighborhood teller (*novellatrice* or novellatore) were considered to be born with the gift. It could be an elder telling stories to a gathering of family and neighbors, a mother

or grandfather telling stories to the children. In Tuscany families gather at a *veglia* (vigil) to hear *racconti* (stories).[4] In Sicily a neighbor asks an elder, "When are there going to be stories?" "Tonight is a good time" is the answer.

A grandson remembers storytelling evenings, eighty years before, at the home of his grandmother in Sicily: "Remembering **la nanna** stirs the emotional chords to an unimaginable degree. I loved her from my infancy with ever increasing admiration and appreciation. . . . She settled all disputes and incipient battles among us children with shrewd questions and compromises. She was among other things a teacher of manners and of the values upon which she wanted us to base our lives. *La nanna* held us often and I remember the warmth of her lap on cold winter evenings when she told marvelous tales we never tired of hearing."[5] She told the stories on winter evenings, and when the last chair was brought into the spacious sitting room, friends and neighbors appeared at the door; there were greetings all around as everyone found a seat; everyone was seated, ready to hear the *cunti* (tales). The grandmother, sitting in her favorite chair, a small charcoal warmer under her long silk skirts, would begin with one of the traditional openings, "*Si cunta e si arricunta*" (It is told and retold), thereby aligning herself and the listeners with the ancestors (her father who told her the story and his grandmother before him, and so on).[6]

Her stories, fables, fairy tales, and classical myths were artfully structured. No word in the old tale is wasted or extraneous, yet its sparseness admits the richest of images. These storytellers use literal and metaphoric language to tell about this human journey, with its lean years and fat optimism, its high winds and low grasses, its yearnings for love and immediate forgetfulness. And they use for their art words written in air, spoken language that is fleeting, immediate, incredibly alive in the moment, and forever changing—like life itself.

Heroic poetry like *The Odyssey, The Illiad, Beowulf, The Cid,* or *The Song of Roland* was probably based on stories from the oral tradition, shorter folktales and myths that were already known to the audiences and their grandparents before them. For centuries minstrels had created poetic forms in which to sing their story lyrics, poetic forms that were later used in long recitations. These long narrative poems were first chanted by bards who composed them, improvising the story for hours or even days to an attentive audience. This improvisation was based on studied poetic formulas—repetitions and perfectly placed epithets. But these epithets are varied beyond belief—and used precisely for their images, sounds, and placement in the spoken line. Just as in any other storytelling, repetitions are used for emphasis, clarity, and music. Like all old poetry the heroic recitations were beautiful to hear, the music and images touching the hearts

of the listeners as the rigorously trained bards chanted their poems.

Over many centuries the oral tradition coexisted with the written, literary stories. With writing, the spoken tradition changed, but it changed slowly over centuries. Great feats of memory were now not the only way to preserve a culture's literature. Written stories could travel far and be preserved in libraries (or be burned in them). This was story far away from the family or communal hearth, story that now had its own literary history. Stories that had become written texts now influenced the spoken stories, and they, in turn, influenced the next written texts.

It was unusual for anyone to read silently in antiquity.[7] For a long time, written texts were records of spoken words intended to be sounded aloud. Even in solitary reading, lips moved and sounds were made. For centuries this reading aloud linked the spoken and the written stories.

These ancient stories do not come from one source only. The diverse cultures around the Mediterranean basin and beyond influenced and added to the stories of Greek and Roman mythology. The Latin poet Ovid (Publius Ovidius Naso), born at Sulmo, northeast of Rome, in 43 B.C.E., wrote the *Metamorphoses,* a compilation of the major tales of classical mythology written in beautiful elegiac verse. He wrote stories of mythic transformations, from the beginning of time to his own era, linking the stories into an artistic whole by a number of devices, without breaking the sequence of connection. The stories had been told and written before in Homer, Hesiod, the Greek plays, and numerous other places, but still many of the tales would have been lost if not for Ovid. This is not a retelling of religious mythology but a book of literary stories, stories retold for their own sake, in Ovid's distinct, original voice. For the last 2,000 years writers, even if they used other classical texts, have used Ovid as their source for Greek and Roman mythology.

The most popular book of secular stories of the Middle Ages is the *Gesta Romanorum,* also known as *The Tales of the Monks.* Written in Latin and printed in the fifteenth century—probably compiled by monks centuries before—it is a collection of stories, each with an added teaching coda, that shows good morals and proper ethics so that virtue, both profane and religious, would be encouraged. The book was meant as a manual to be used in sermons. The stories in the *Gesta* were used, directly or indirectly, by Boccaccio, Chaucer, Shakespeare, and many other writers. Many of the stories had come from ancient Eastern tales, heard in Palestine and brought back to Europe, from Greek and Latin sources, and some from European folktales.[8] The oral material gathered or told in Italy came from the people, but it also came from the north, south, east, and west,

from Latin texts, Hebrew texts, Greek texts, Indian texts, from the Celt, Saracen, Norman, French, African, Spanish, and so on. The *Gesta Romanorum* became the most famous collection of stories of the Middle Ages, the stories used as the foundation block of later European fiction.

By the Middle Ages[9] the wandering minstrels, *giullari* (minstrels, strolling players), jongleurs, **cantastorie** (professional storytellers), ballad singers, and bards who sang and chanted their poems of love and legend in the marketplaces, streets, and baronial halls were also the keepers, creators, and repositories of the popular literature of Europe.[10] These incredible artists composed songs and recited their tales of ladies and knights, of Roland, Orlando, Charlemagne, of shepherds and shepherdesses, of love and the beloved, and they sang them in their own languages, in the color and spirit of their own dialects. They sang these stories from their poetic compositions and elaborately formed improvisations. This was story, song, poetry, and performance. To hear a great *cantastorie* was to be revisited by the characters of legend and history and to feel the story live.

These poets also sang and improvised their dramatic recitations in competitions. Everyone in the audience knew the incidents and the characters from the poetic epics. The characters became stock figures and soon were used by poets and storytellers throughout Europe. These wandering poets were well known and appreciated by their audiences in the marketplaces or at the courts. Word of mouth in the oral tradition goes farther than we in an electronic age imagine. Years ago I heard about a Sicilian *cantastorie* from a tourist who had been told about her from people everywhere he went. He described her as an imposing figure, holding a large staff that she used as an instrument for her metrical composition, chanting in a beautiful and powerful voice her long story poem, whose ending was greeted with a cesura of silence and then an explosion of applause and shouts of approval. "What was her name?" I asked. "I don't know her name. I never learned it."

Italy had caught the Provençal spirit of the mystical love poetry of the trouvères of northern France and the troubadours and trobairitz—female poets—of southern France, and made its own poetry from it.[11] Italy had made its own poetry. These Provençal poets wrote their songs in the eleventh century for courtly audiences, and their poems of love physical and mystical, of politics, of morals, and of religion profoundly influenced Western literature. It was Frederick II (1194–1250), born in Sicily, who gathered around him at his multicultural court in Palermo all of the brilliant minds of the time. Sicilian Giacomo da Lentini, one of the Sicilian and Italian poets at the court, created the modern sonnet, which was, in turn, based on one of the song forms of the oral poetry of the old *giullari*.

This close linking of arms of the spoken or sung poem with the written is almost always present in this literary history.

Also at the fountainhead of Italian literature are religious poems, hymns, and stories. The stories from the Bible inspired and informed life. Life was centered on the sacred stories, and they were the inspiration of art. In Italian painting there is a pictorial convention, the sacred conversation, in which the viewer seeing a holy image, inspired by the higher spiritual significance of the image, enters into an interior dialogue. One has only to look at the Italian art of the time to see how the sacred stories inspired art. Many legends of the saints and folktales of the Holy Family abound in Italy. At the beginning of Italian literature is the familiar and important collection of legends about St. Francis, *I fioretti di San Francesco* (The Little Flowers of St. Francis). Along with the secular stories, religious tales and legends weave a rich tapestry in Italian oral tradition. These stories, originally collected and written in Latin in 1345, were retold in the Tuscan tongue omitting the saintly lectures of the Latin and told simply and beautifully as stories about St. Francis and his followers, *"del glorioso messere santo Francisco, e de' suoi frati."* These tales so human and humble exhibit the same illuminations found in the saint himself. In one story St. Francis, who could not read or write, is traveling from Perugia to Assisi with one of his favorite followers, his amanuensis Brother Leo, when he receives a flash of divine inspiration. He cannot take out a paper and pen and go off to write it down nor can he wait until the evening. Instead, he shouts to his companion walking ahead of him, "Leo, Leo, little Lamb of God, take this down, take this down."[12]

Although the journey from Perugia to Assisi is relatively short, the account of it recorded in *I fioretti* is one of the first travel stories to be written in the vernacular. It announces, in its way, the genre of travel stories that formally begins with the account by the Venetian explorer and merchant Marco Polo (1254–1324) of his marvelous journey to China[13] and culminates in the travel journals of the great Renaissance explorers, above all, the logbook of Christopher Columbus's voyage to the land he thought to be Cathay. There is, of course, a vibrant tradition of imaginery voyages in Italian literature that extends from Dante's cosmic voyage to the Other World as set out in the *Divine Comedy* (1307–1324) through the globetrotting adventures of paladins and damsels, one of which involves an interplanetary voyage to the moon, that Ludovico Ariosto wove together in the Renaissance chivalric romance, the *Orlando furioso* (1516–1532), to the tale of shipwreck in the South Pacific (the year is 1643) intricately narrated by Umberto Eco in his 1995 bestseller, *The Island of the Day Before.*

Giovanni Boccaccio (1313–1375) was a scholar, humanist, poet, and nov-

elist. Although he wrote many other books, it is to the elegantly styled stories in *The Decameron* that Boccaccio owes his fame. The book is a collection of tales beautifully and masterfully written in the vernacular, the Tuscan language. The stories were told in the frame (*cornice*) of ten days, during which men and women fleeing the plague of Florence in 1348 decide to while away their time telling stories to one another. Many of Boccaccio's stories and the formal device of the frame were later adopted by authors like Chaucer and Shakespeare. Boccaccio's writing in *The Decameron* was so impressive that it immediately consolidated the prestige of the vernacular, which the "divine poet" Dante had first established for the Florentine tongue. *The Decameron* is considered one of the most influential books of fiction ever written. Based on stories Boccaccio collected and perhaps heard, the book was so popular that the tales were retold everywhere in Europe.

Boccaccio stood between two worlds: the medieval and the coming Renaissance. He used the medieval exemplum in his stories to show humans' virtues and vices; although he used the teaching story, he was chiefly concerned with how men and women fared in this world. Thought of as the elegant writer of lusty human dramas, he often loved moralizing about the human condition. Among the books he wrote in Latin is the first collection of women's biographies, *De Claris Mulieribus* (Concerning Famous Women), a book that tells of the lives of 104 women. He was also one of the first authors to write biography. It is interesting to note that these biographies came from the common teaching stories and moral texts of the Middle Ages.

Christine de Pizan, born in Venice (her father was Tommaso di Benvenuto da Pizzano), was a prolific French writer and poet whose works deal with the political life of France and the defense of women. *The Book of the City of Ladies,* written in 1405, tells the stories of women so that their great contributions to society can be reclaimed and their natures revealed and restored. This book of beautifully written stories and her other writings aim to restore the terrible imbalance to society when womankind is immorally maligned. With the help of reason, rectitude, and justice, she argues eloquently against many infamous writings that have slandered women. She argues her case point by point, using story as her illustration. She is considered the first woman to live by writing. It is valuable in the light of history to read these biographical stories about famous women by Christine de Pizan.

The old folktales, changing and traveling along with the people, continued to be told wherever traditional people existed, but, increasingly, oral tales were turned into literature. During the great Renaissance in Italy, a new flowering and thinking blossomed from old roots. While wandering minstrels contin-

ued to sing the long ballads in public places, poets used the material of the ballads to write famous epics for the courts. This literature was written by solitary individuals in the privacy of their own quiet places for nobles who paid and kept them. These poets would not become the *anonimi* (anonymous) composers of the heroic poetry or the *ignoti* (unknown) poets of fifteenth-century lyrics. Matteo Boiardo (ca. 1434–1494) wrote *Orlando Innamorato,* an epic based on the old Roland material but greatly transformed by the poet. The story, unfinished at Boiardo's death, was continued by Ludovico Ariosto (1474–1533) in his great epic *Orlando Furioso.*

This weaving of the spoken story and the literary story is especially true in Italy, where the first collections of stories were written down by *novellieri* (fiction writers). *Fiabe letterarie* (written fairy tales) have a long and interesting history in Italy. It is generally agreed that Italy has the first written collections. In Venice, in 1550, Giovan Francesco Straparola di Caravaggio published a collection of twenty-five tales, *Le Piacevoli Notti.* It was so successful that a second volume of forty-eight tales was published in 1553, and that was followed by many reprintings for an increasingly appreciative public. Straparola is known for his lively and popular style (two of the tales were written in the dialect of Bergamo) and for introducing fantastic fairy-tale motifs into the telling. The *fiabe* (fairy tales) and the *piacevolezze* (pleasantries or entertaining stories) were retold in thirteen nights by twelve women and two young men. Straparola used as his model the frame (*cornice*) that Boccaccio had successfully created in the *Decameron.* He also included some of the stories written in Latin by Gerolamo Morlini, a Neapolitan novelist who had collected twenty folk tales in his *Novellae* (1520), which contains the oral stories he heard in Naples and the Latin literary stories that had already been circulating in Italy for centuries.

But it is Giambattista Basile, Conte di Torrone and Conte Palatino, a scholar and man of letters who wrote the first European collection of folk tales.[14] Basile, *poeta e novelliere* (poet and story writer), was born in 1575 and died in Naples in 1632. His book *Il Pentamerone, Lo Cunto de li Cunte, overo Trattenemiento de li Peccerille* (The Pentameron, The Tale of Tales, or Entertainment for the Little Ones), written in sixteenth-century Neapolitan, is a baroque collection of tales, fifty stories told in five days by travelers stopping at an inn during **carnevale** (carnival). Although Basile's literary retelling uses ornate epithets and elaborate metaphors, his commentaries do not obscure the simple force of the original folk stories. His style is full of the lively writing conceits of the day: "She had a hundred wrinkles on her face but nothing to fill them with, and although her head was covered with silver, not a silver coin was in her pocket. . . ." *The Pentameron* is filled with real

woods and murky waters, vile acts and gruesome deeds. Here are the universal stories of love, adventure, greed, retribution, and sorrow told according to the manners and mores of the day. (And why not? Aren't some of the tales in *The Pentameron* as true today in English as they were in Naples in the sixteenth century?) While grounded in place and language, its genius rests in the universality of Basile's faithful telling of the tales.

The Pentameron includes the first European versions of Cinderella, Puss-in-Boots, the Babes in the Woods. Basile's book inspired later writers like Charles Perrault (1628–1703), who wrote elegant fairy tales for the French court and himself influenced a cabinet of new writers of elegant fairy tales like those of Madame D'Auloy. The book, reprinted often in its times in Neapolitan, was not read widely in Italy until 1924, when the great critic Benedetto Croce translated it from the difficult-to-read sixteenth-century dialect into Italian. Croce's version, published with many valuable notes, gave *Il Pentamerone* back to a large Italian audience. Two centuries after the first appearance of Basile's collection, William and Jacob Grimm acknowledge his importance in the notes to their famous *Household Tales* (1812–1814), which includes high praise for *The Pentameron* and a biography of its author.

The waning of the oral tradition took centuries.[15] Wherever people still lived communally, close to their old ways, the storytellers still told their tales. But with the rise of industrialism and the move away from the land, European society changed drastically. The Grimm Brothers were part of the great political and literary movement that swept Europe at the end of the eighteenth century. The Romantic movement brought with it admiration for the people who worked on the land and a respect for the vernacular language they spoke. It also brought a love of nature and its beneficence, of the indigenous, of the folk and their spoken stories.

The old ways were losing ground, and so it is no wonder that there was a great interest in collecting the old folktales before the oral tradition disappeared forever with the deaths of the last tellers. Although the collections of the first transcribers, like the Grimm Brothers, were scoffed at by the literary world of the time, and the tales derided as vulgar in the press, they were to have a lasting effect on literature and folklore. They were made by people who had themselves heard the stories and had been forever impressed by them. Previously the tales had been turned into literary retellings. Now men and women believed that the ancestors' simple tales were worthy to stand on the page starkly as they were told. For the first time, we had the words of the folk.

These collections were the beginning of the systematic discipline of folk-

lore. this meant that the stories were classified according to specific geography, history, cultures, and languages. In Italy the collections of tales were primarily collections of the regions. "*C'era una volta . . .*"(Once upon a time . . .) begins a folk tale in Tuscany. "*Cunta e s'arricunta . . .*" (It is told and retold . . .) begins the Sicilian storyteller. These tales are called *fiabe, novelle,* or *racconti* in Italian; the Calabresi and the Napolitani call them *cunti* as do the Siciliani from Palermo, Trapani, Siracusa, and Caltanissetta, while the people from Catania call them *favuli.* Tales are called *favole* or *contafavale* in Rome, *novelle* in Toscana, *foe* in Liguria, *fole* in Bologna, *storie* in the Piemonte, and *fiabe* in the Veneto. These are the names recorded by the great Sicilian folklorist Giuseppe Pitré in 1870. There were many fine collectors of these regional tales, like Angelo de Gubernatis in Siena, Domenico Comparetti in Pisa, Vittorio Imbriani in Florence, and the consummate folklore scholar—Giuseppe Pitré in Sicily.

Giuseppe Pitré (1841–1916) was a much loved and admired medical doctor who had a great passion for the folk stories of his childhood. He never forgot the woman who had told him folktales as a child. It was to this great teller, Agatuzza Messia, a quilt maker in Palermo, that he first went to collect Sicilian stories, discovering that her narration "had not lost one whit of its original purity, ease and grace." The founder of the folk tradition in Italy, Pitré devoted his entire life to his twenty-five-volume *Biblioteca delle tradizioni popolari siciliane* (1871–1916). Added to his work on folktales were volumes on *canzoni* (songs), *gli indovinelli* (riddles), *gli usi e le feste di Sicilia* (Sicilian customs and the feast days), and many other volumes describing and faithfully recording the folk life of the time. His aim was to reproduce the folk stories in exact and authentic language, respecting Sicilian regional differences in the language. Pitré so loved the tellers and the tales that he reproduced them scrupulously, setting rigorous standards for his friends, colleagues, and students whom he sent throughout Sicily to collect the tales. His methods were so thorough and exacting that at the end of each tale he added copious notes, including many versions, variants, and linguistic information on vernacular characteristics. At a time when there were a number of zealous collectors traveling all over Europe, such rigor was badly needed. Pitré, who was in contact with other world-famous folklorists, was always conscious of his professional responsibility. His methodical approach was backed by profound theory and great love. His knowledge, reading, and love for the story were so profound that he spoke from inside the story while keeping exact attention on the details of learning and scholarship.

Italian folklorists believe that the discipline of folktale collecting owes a great debt to Naples-born Giambattista Vico (1668–1744).[16] In Vico's *La Scienza*

Nuova (The New Science) can be found the theory that laid the foundation for the later sociological and anthropological methods. Using the new scientific methods of Francis Bacon, Vico studied the growth and decline of human societies and believed that they were created by living human forces. He studied primitive societies at a time when they were ignored, maintaining that their stories and myths were full of poetic and metaphoric fantasy that expresses the deepest foundation of a culture. Croce believed that by looking at different cultures scientifically, Vico created the comparative method in folklore.

One has only to read the amazing collection of tales researched and amassed by the folklore scholar Marian Roalfe Cox in her *Cinderella: Three Hundred and Forty-Five Variants of Cinderella, Catskin, and Cap o' Rushes, Abstracted and Tabulated, with a Discussion of Medieval Analogues and Notes* (London: Folklore society, 1893) to see that this famous folktale is specific to many places and yet seems also to have related elements that connect it in a more general way to like tales throughout the world.[17] To read and study the variety of Cinderella and Cinderland stories in this book is to see the comparative in folklore.

Because regional differences were so marked, there was no general collection of Italian folktales until the twentieth century. In 1956 the noted writer Italo Calvino published a substantial volume of tales culled and retold from previous collections. They were transcribed from the various dialects, translated into Italian, and published in 1956 under the title of *Fiabe italiane*. Calvino immersed himself for a time in Italian regional stories and then selected and rewrote tales and published them in a single Italian collection. The stories, divided into regional headings, present a striking collection of Italian folktales in one place. The stories have the sound of the old tellers in them, and, like all of the other great collectors/writers before him, it is Calvino's great style and sensibilities that made this possible. In 1980 the book was translated into English by George Martin and published as *Italian Folktales*, selected and retold by Calvino. For English readers it became the valuable source for reading Italian folktales. Finally Italian Americans and Americans had a source book in English for themselves and their children.

Living carefully in a specific place is the foundation of the traditional stories; we can feel the sun and smell the earth even when they are not mentioned. One story holds us among the many things of the world: this mountain, that bird, that skunk, the grasses, the coyote, March, the river that runs two ways. These stories know and show love for their place. In America, on Turtle Island, the Native Americans from every region and every people tell the profoundest myths, legends, and stories of life on this land. Like their stories, storytellers are also rooted with love and knowledge of the land.

Who can quote the accurate number of good family storytellers that left Italy to come to America? I have never heard of professional storytellers who came to America to tell the traditional Italian tales, but perhaps some did. Storytellers can be a hardy lot, and many family tellers did come. If a family had a good storyteller, she or he gathered the children around and told the old stories.

Anna R., 83: "My mother always told us stories. We sat on the floor, all the children around her. I remember Giufá; we always laughed when we heard what he did. Once, he didn't look nice—I thought my mother wanted us to be clean and neat—he was ragged and dirty. You know, I can still see Giufá's torn clothes and how his mother dressed him up. We were seven children and my mother made all our beautiful clothes. She bought material by the pound. Anyway, Giufá's mother made him a new pair of pants."

Alfred P., 70: "My mother would gather us children at her feet in the warm kitchen and she would begin to tell fairy tales. We loved them and would hear the same stories over and over. We were never tired of them. 'Tippiti, tappiti,' she would say, but I can't remember the next line. My sister remembered all the stories but she died of cancer twenty years ago, and I don't think my brothers remember them. I'm the next oldest and I don't remember any of the stories, but I remember every old saying my father taught us. I have never stopped using them. They are extremely wise sayings. My father was a philosopher."

John B., 36: "My father always told us stories in Sicilian. I speak Sicilian, too. My father learned the stories from my grandfather. He was a great storyteller, and he always told the old stories. Everyone remembers how at the most crucial place he would stop and light his pipe, taking time, taking a few puffs, and then he would tell the ending of the story."

By the time Italians came to America in numbers, preindustrial societies, where the storytelling traditions flourish, were disappearing. Even in Italy, where the culture was changing, the folktales were losing ground. Although the stories came with the parents and grandparents, there are many reasons why they did not become a tradition passed on to the children's children. To be able to tell the folktale meant that you had to tell the story to an audience who understood the old ways and the language in which it was told. Every word, with its many connotations, mattered. The stories themselves had to sit comfortably, appropriately, in the new American kitchen. There were radio programs, movies, theaters—all with American stories. There was a new language to learn and a new culture to understand. Stories also need the right place and time in which to be told. People now were separated; they no longer lived in villages where they knew all of the families; there was no longer the time or the occasion on a

cold winter's morning for a neighbor to ask, "Are there going to be stories soon?"

But Italians in America never stopped telling stories.[18,19] Now the question at the dinner table was: "What happened today?" After the first generation, most Italians stopped telling folktales but told personal stories and anecdotes about themselves and their families. There are plenty of stories in an Italian American household. If there were few tellers of Italian folktales in America (most of the stories told to me are about mothers telling to their children), the centuries of Italian storytelling were still evident in the exciting, dramatic, or funny way almost everyone at a table could tell her or his story. Everyone knows a good neighborhood or family storyteller who can bring meaning from the innuendo of a joke or delight from the retelling of an anecdote. At a table of people telling stories, there is always that one who can really tell them. These stories are being told for the listeners, the teller, and for the story itself. This is the oral tradition. Although the stories are personal, they are also wildly universal. We are not voyeurs listening to someone's private pains; even if terrible things happen in the story, some larger meaning is brought out. It shows something about life itself. Here is art, spoken and fleeting, once again told communally; here is art spoken with the ease of the ancient storyteller. This spoken story has made Italian American writers, poets, novelists, storytellers, television artists, and film makers, with more to come in this new generation. The story is living again in community.

In my family, in any year, there were three possible cyles of stories: the natural one, the work or school one, the religious one. Italian Americans who went to a church or temple followed this last cycle as well. The day had order, the week had order, the months, and the great year. It was within the orderly living of life that the extraordinary came. Each season of the Church calendar had its stories told always at that time: Advent, Christmas, Lent, Easter, Pentecost (and the wonderful, endless days of Ordinary Time). Each day was marked as dedicated to a number of saints, which led to more stories: legend or history.

And then there is the Italian American love of opera. The stories and music are also part of the great treasury of Italian American story life.

Paul G., 56: "When my sister got married outside of Chicago, my mother and I drove back to New York together. In those days, around 1955, it was a twenty-four-hour drive. My mother told me lots of stories about the family. Then to keep me awake she told me all the stories of the operas she could remember, with all their convoluted plots. She told them straightforward as though they had actually happened. It was so dramatic and engrossing that it worked. She kept me interested and awake! I have all her opera records and still listen to them."

I grew up a few miles from the ocean on beautiful land where you could always see the great sweep of ocean sky above and still walk on the earth instead of concrete. We lived in a Jewish neighborhood where our neighbors were our extended family. We shared the same basic social attitudes toward education, work, community. I heard stories in synagogue. Once, for Purim, I heard a great telling of the story of Esther that I shall never forget. I celebrated every Jewish feast day with my sister–best friend Phyllis, who is my *cummari*. (I was a witness at her wedding.) Every year at Purim we ate *hamantaschen,* a three-cornered cookie with prune filling, and *sfinci,* a round pocket pastry filled with ricotta, for the feast of St. Joseph, *festino di San Giuseppe,* on 19 March. The *sfinci* were made by my grandmother's dear friend and our neighbor Mrs. Guelfi, who was a great story-teller from Genoa. On the stoop, across the street, I listened quietly to the women telling the stories of life in the old country, about Poland, Lithuania, Russia, about pogroms and soldiers. Stories, while particular to the people who tell them, unite us in the larger story we all share and live together. Every person and every group has her or his or their story. I feel a great affinity for all people's stories; they come from the deepest layers of our souls.

Why have these old tales and storytelling surfaced again?[20] Perhaps it is the prodigious complexity of the stories and the delight in detail that move us now. Perhaps it is seeing the stories from the inside, as Jonah did. Perhaps it is the great interest not only in the old tales but also in the communal way they are told and heard that has brought storytelling back. Perhaps the success of this moment of storytelling is because people want to meet the teller face-to-face. It is hard to have a conversation or dialogue with a television set.

What happened in the story about the women and the kitchen garden? While one woman is picking cabbages, the other *cummari* sees a delicious mushroom, takes it in her hand to pick it, and finds that it is not a mushroom she is pulling but the ear of the Old Woman—bringing her up, up, up from the earth—bringing up the very One who has been waiting and listening in the garden. With turns and dreadful moments the story ends finally with the *cummari*'s daughter bringing great happiness to her mother.

Stories belong to the larger world, but how do we steer a course through this world, with this world, in this world? It is marvelous to see that the owner of the garden is not human; in some versions of this folk tale it is a dragon or ogress. There is a nobility in dread that faces and finds a way to get a golden gift from it. At the end there is even the gift of a story . . . and the daughter told her mother everything (. . . *e la figlia cci cunta tuttu*). From dread, gifts have been given all around. The story ends with the frame:

> Iddi arristaru filici e cuntenti
> E nuautri semu ca senza nenti.
> *(And they were left happy and content*
> *And here we are without a cent.)*

This is one of the traditional story endings from Sicily. It says that *they* were left happy and content, not we. They are inside the frame of the story; they are in *illo tempore* (that time, mythic time, story time), while we are *here* without anything—except the wisdom of the story.

These traditional stories, bare to the bone, do not shirk the human dilemma. They give a vivid sense of our living, our mortality, our troubles, our journeys, our loves, and our joys. But do traditional stories have a system of meaning? Certainly they have meaning, but which meaning? They have been considered fragments of ancient Indo-European myths, fragments of ancient solar myths, parts of an old totemic system, or they have been gathered together and studied by looking at their similar pieces or motifs. Anthropologists think of them as exhibiting incidents or episodes that show cultural beliefs. There are a number of spiritual interpretations of the stories. They are looked at for their formal aesthetic composition, as formulas for retelling. Scholars have spent entire lifetimes proving and defending their theories only to find the next generation unraveling them. The meaning psychology has brought to the fairy tales has added lively possibilities valuable to the modern audience. It has focused on the psyche's, or self's, journey. Since the mid-1970s, new interpretive methods have emerged from the psychoanalytic tradition, particularly the Jungian, that have placed an emphasis on the image and its profound role in determining audience response to archetypal stories. Traditional stories are art based on the reality we do know and on the mystery we do not know. In thirty years of telling them, I am not surprised when a new section of the story leaps out with meaning. The story we heard at age ten is not the same story we heard at twenty or hear at fifty.

But we who tell and listen can be thankful that the stories are not given to large statements on meaning; for like the heart to whom they constantly speak, they prefer experience to theory, discussion to inanities, silence to chatter, unity to separation. The old folktales, especially, have a tricky logic found in poetry, metaphor, and dreams. In them something can be seen by perception, experience, and intuition. Because of their structure everything in them has weight, even a cabbage leaf or a feather blowing here and there. It is in this simple structure that the old stories achieve greatness—and what could be simpler than a storyteller and listeners sitting in a place together, telling and hearing stories that are of the

greatest importance to their lives?[21] We find that so much modern literature has pieces and bits of these old tales written in them or entire stories inspired by them. But then haven't the old spoken stories and the old written ones walked arm in arm together for centuries in Italian story history—and so why not here in Italian American story history as well? We can hear and see the storyteller, we can read and hear the voice of the story. It is the story that makes such an impression.

Notes

1. This refers to the practice in ancient times of praising, asking permission, or asking blessings from the numen or numena, the spirit guardian of a place, saying as you crossed the threshold, ". . . *sive mas sive femina*" (if male or if female).

2. This story can be found in Sicilian, as "La vecchia di l'ortu," in Giuseppe Pitré, *Fiabe, novelle, e racconti populari siciliani*, vol. 4 of *Biblioteca delle tradizioni popolari siciliane* (Palermo: Pedone Lauriel, 1889): 183–190, with excellent linguistic notes on the exact Sicilian variant recorded, as well as many comparative notes on each story from many Italian and European and other variants. In English it can be found as "The Garden Witch," in Italo Calvino, *Italian Folktales*, trans. George Martin (New York: Pantheon Books, 1980): 650–653, which is the best English source for the Italian folktales. The stories, arranged by regions, are rewritten from regional collections and retold by Calvino with good notes.

3. All of this anthropological material comes from an unpublished article by Richard L. Currier, anthropology teacher.

4. For a complete view of the *veglia*, see Alessandro Falassi, *Folklore by the Fireside: Text and Context of the Tuscan Veglia* (London: Scolar Press, 1980).

5. This recollection is from Dr. Alphonse E. Timpanelli, *Memoirs of a Sicilian Childhood* (unpublished).

6. "*Si cunta and si arricunta*" is one of the many, many openings that, along with formal closings, frame the Italian folktale. It is usual and even imperative to begin and end with these formal frames.

7. For a good overview of this, see the "Introduction" and opening pages of M.B. Parkes, *Pause and Effect: An Introduction to the History of Punctuation in the West* (Berkeley and Los Angeles: University of California Press, 1993).

8. The medieval scholar Helen Waddell translated stories from Latin manuscripts for her little book *Beasts and Saints* (London: Constable, 1953).

9. For an excellent article on this, see Justin Vitiello "Sicilian Oral Poetry: Myths, Origins, and History" which was published in *Sicilia Parra*, 6, no. 1 (Spring 1994): 4–6. *Sicilia Parra* is the biannual newsletter of Arba Sicula, an international organization promoting the culture and language of Sicily (Prof. Gaetano Cipolla, Modern Foreign Language Department, St. John's University, Jamaica, N.Y. 11439).

10. The bards, who were important and powerful members of society, were often born into a family of tellers. St. Collum Cille (St. Columba) (521–597) born in Donegal, Ireland, was abbot of Iona. There is a famous story about the time he left his monastery to go to the mainland to defend the bards of Ireland, who were threatened with dissolution. He told the assembled:

"Humans of dust, you are no more than a story, how you got the clothes you are wearing is a story, how you came to be here is a story. I urge you to keep the bards among you, for it is better to pay for the enduring story, rather than the fleeting one."

11. Since these poems are lyrics and not story poems, I have only just mentioned the Sicilian School, *La Scuola Siciliana,* here. Many beautiful poems of Iacopo da Lentini, Pier Della Vigna, and Jacopo Mostacci can be found in Italian literature compilations of the thirteenth century.

12. The vignette described here comes from "Perfect Joy," story no. 8 in *The Little Flowers of St. Francis* (New York: Dutton, 1951).

13. See the amazing collection of autobiographical stories, *The Travels of Marco Polo* (New York: Dover Publications, 1993), which contains the precise observations and fantastic events and sights of Marco Polo's seventeen-year stay in China at the court of Kublai Khan.

14. Basile also launched arrows at social iniquities: "But in these times a purse full of gold is given willingly to parasitic spies rather than a coin to a worthy and needy soul. . . ."

15. The English Romantic poet William Wordsworth (1770–1850), in the Preface to the second edition of *The Lyrical Ballads* (1800), wrote that for his poems he chose incidents and situations from common life, telling them, where possible, in language really used by people—throwing over them a color of the imagination so that they would show the primary laws of our nature. It was this profound respect of the writers of the Romantic Movement that prepared the way for collections of folktales, transcribing more closely than before the words of the folk. *The Lyrical Ballads,* which included poems by Samuel Taylor Coleridge as well as Wordsworth, launched this movement in England.

16. Vico believed that societies develop through three constantly recurring cycles: the Age of Gods (theocracy), the Age of Heroes (aristocracy), and the Age of Mankind (democracy). His works influenced many writers, among them James Joyce, who used his principle of the recurring myth of society stemming from the collective, not from individual thinkers, in *Finnegan's Wake* (New York: Viking, 1939).

17. Because folklore scholars were amassing so much information, they decided that a system was needed to handle this situation. Antti Aarne began with a classification of the European folktale. Together with Aarne, the American scholar Stith Thompson published *The Types of the Folk-Tales* (Helsinki: F F Communications, 1928). However, when he discovered that this was fine for European tales but not for the other immense traditional narratives from around the world, Thompson created the six-volume *Motif-Index of Folk Literature* (Bloomington: Indiana University Press, 1932), which is used by folklore scholars to this day. In his "Introduction," Thompson wrote that the similarities in the world's folk literature exist not so much in complete tales but in single motifs, which he named. The tales could be classified now by these recurring motifs. One could, for example, now find by looking up the word "tower" all of the tales collected and recorded to date with that motif in them.

18. In 1979 two gifted artists, John la Barbera and Alessandra Belloni, formed the theater group I Giullari di Piazza to revive traditional music and theater from southern Italy and also to create new pieces. They collaborate with Native American, Brazilian, Nigerian, and flamenco artists to create exciting works of art. All of the personal accounts come from notes of conversations in my files.

19. Arba Sicula is an organization (and the title of their journal) dedicated to Sicilian folklore and literature (see note 9 above). There are Italians from other regions, such as Tuscany and Molise, and in Le Marche, who have formed folkloric associations in America.

22. Prof. Justin Vitiello of Temple University has written a book—*Studies in Oral History and Storytelling* (San Francisco: Mellen University Research Press, 1993)—on the subject of modern-day folktelling by way of personal story. In 1988 Vitiello recorded Trappetese storytellers who performed their sagas of emigration for him. In his book, he links these personal stories to the ancient feeling of stories from the oral tradition as real explanations of life that people reveal directly in the telling of the stories: "Seeing their lives as stories, or myths, raconteurs like my Trappetese informants grasp the significance of their particular experiences as real/symbolic journeys of life on which they assume identity as archetypes 'designed elsewhere.'"

21. In real storytelling there is no dichotomy between teller and listener, story and larger reality lived by way of the story; it does not matter one inch if the oral composer of the *Odyssey* (either the long poem or the short folk stories that precede it) knew the definitions of fable, saga, or folk tale but only whether the story is a work of art. If it is a work of art, it will come from the primary experience, fundamental inspiration, and knowledge that give any real art its validity. (All good thinking contains the other, secondary, separating knowledge; great teaching and criticism have inspiration in them as well.) The question here has to be something like the question asked the Greek citizens at the end of a performance, "Was Dionysus here?" What is in the informational bank of the storytelling artist is beside the point when the story is being told.

Further Reading

A good well-researched source of Italian women's stories from mythic times to the present. Cambria, Adele. *L'Italia segreta delle donne* (Rome: Newton Compton Editori, 1984) (in Italian).

De Pizan, Christine. *The Book of the City of Ladies,* trans. Earl Jeffrey Richards (New York: Persea Books, 1982.

A complete source book for the Greek myths. Graves, Robert. *The Greek Myths:* 2 Vols. (New York: Viking Penguin, 1986).

A brilliant and original inquiry into creativity and the gift-giving societies. Hyde, Lewis. *The Gift: Imagination and the Erotic Life of Property* (New York: Random House, 1983).

Part III

Writing As an Italian American

Italian American Literary History from the Discovery of America

Robert Viscusi

Italian American literary history has been slow to assume canonic form. Like Rome it has a destiny so deeply rooted, so widely branching, that no single gesture can shape it. It takes time, it needs the participation of many, to build for so large a tradition any clear figure against the indistinct haze of global retrospect.

Even the initial requirements for approaching this task of literary historiography are not few. Any survey of this subject, however primitive, must run far into a large set of meanings. Any historical imagination will find much to conjure with in the elements of the expression "Italian American." Most scholarly imaginations, strange to say, have proved themselves immune to the temptation to conjure. Indeed, professional studies of such themes as immigration and assimilation have popularized for the phrase "Italian American" meanings so narrow, so goal oriented, and so object centered that they suggest the preoccupations of the harbor police and of the market researcher rather than those of the literary historian.

Nonetheless, the words "Italy" and "Italian" present, even to superficial meditation, a notably extensive and resonant set of meanings. These words imply almost innumerable chronicles of past consideration. The words "America" and "American" have a similarly cosmic range of reference, extending into a permanent and abiding sense of an expanding future.

An understanding of Italian American literary history cannot begin without first making a survey of the range implied in each of its two component terms. Such a survey must be cultural in the largest sense, implying a recognition of intellectual, ideological, material, and political webs of influence and implication, along with the more familiar questions that enter the conversation from the halls of social demography, physical anthropology, and organizational psychology.

Boldface terms are defined in the Cultural Lexicon, which starts on p. 703.

When the immigration historian joins "Italian" together with "American," the two words diminish each other. The Italian American then appears an unfortunate sort of Italian who becomes a painfully struggling sort of American. This multiplication of fractional identities, given the iron laws of arithmetic, yields quotients that continually shrink in actual size.

When the literary historian joins "Italian" together with "American," however, the two words amplify each other's resonance. They create a world of possibilities, a theater of allusions, so vast that its exploration has only begun now, five centuries after its first authenticated texts appeared in those letters of Cristoforo Colombo and Amerigo Vespucci that came to galvanize the imaginations of peoples all over Eurasia, eventually to touch lives in terra firma everywhere. This world of possibilities is a territory more extensive than the Western landmass itself. To survey this theater of allusions means, first of all, to orient oneself upon a map that is global in spatial extension, one that infinitely reduplicates itself through the concentric spheres of time elapsed that it so demonstrably contains and embodies. This large landscape offers many clearly articulated points of reference. We begin the project of understanding Italian American literary history, then, with a survey of these points of reference, followed by a discussion of how this survey will assist the work of literary history.

Ten Points of Reference for Italian American Literary History

We can situate Italian American literary history by using the following points of reference. One may think of each of these points as if it were one of those old-fashioned drawers in a library catalog. Each drawer contains a few hundred cards that, as you slide them out of their confinement in the wooden cabinet, give off the faint perfume of aging paper that to the bookish scholar still calls forth the passion of inquiry. Upon each card is the title of a book. Twenty or a hundred books may be bundled under one heading. Each of the points of reference below resembles a bundle in one of these drawers of cards. The reader, beginning from these ten headings or points of reference, will be able to orient wide-ranging searches in the bibliography of Italian America as a literary subject.

First: Mercantile Adventure. Italian American writing begins with the European discovery of the lands in the Western Hemisphere. Cristoforo Colombo and Amerigo Vespucci, Italians by birth and by financial connections, invented the idea of the Western lands as the object of speculative commerce. Vespucci indeed invented America as a source of raw materials, a naked place full of naked people.

"Faciavamo di loro quello che volavamo" (We made of them whatever we liked), he writes. *"Gente disnuda e di poco anima"* (Naked people and of little spirit). America the land of raw matter (Nerlich, 1988; Colombo, 1930; Vespucci, 1992).

Second: The Roman Catholic Church. Italian American writing continues throughout the periods of settlement with the vast extension of Franciscan and Jesuit systems of education, administered from Italy, across most of the Americas, so that Propaganda Fidei looked out over Piazza di Spagna or inward at its maps of Canada, California, Colombia, and Rio de la Plata. The cultural and religious substrate of these Catholic countries permanently instituted a Roman civic ritual at the heart of ideological production, so that Italian immigrants tend to feel themselves soon enough quite comfortably at home in the great centers of Buenos Aires and Toronto. These places have cultural foundations at the same time recognizably Italian and recognizably *American* —in the Italian, or mercantile, sense of the word, referring to the nature of America as a source of raw materials and a site of speculative settlement. During this period the most important Italian American writings use the languages of the Spanish and the French vernaculars, though frequently they make use of Latin, still the international language of the Church for most of the last 500 years.

Third, Fourth, and Fifth: Music, Architecture, Law. During the period of the Enlightenment, the tradition of Italian American literature lay in its third, fourth, and fifth foundations (the musical, the architectural, and the political) with the importation of operatic and symphonic music, Palladian architecture, and Italian rationalist political science. These speech-act Renaissance art forms all aimed to change the world, and they worked very well in a theater of operations as plastic as the imaginary universe in which the planters and burgesses of the American Enlightenment created the Ciceronian outlines of their model republican institutions. Venetian constitutions and Vicentine palaces characterize this aspect of the foundations of Italian American literary history. Eloquent rationalists passed together many a theatrical evening in an operatic Rome where the baritones and choruses debated historical themes straight out of Senecan closet drama.

Sixth: Nation States. "Italy" and "America" both have many meanings, but the use of each of these terms to refer to a revolutionary nation-state has had a hegemonic character for a long time. "Italian American" refers to anything that has a joint relationship to two such revolutionary nation-states, when one is "Italy" and the other some American counterpart (Argentina, the United States of America, Bolivia). Such nation-state names are not neutral. Their use implies a large number of assumptions concerning revolutionary subjectivity (as set forward during the American Revolution or the Wars of Liberation or the Italian **Risorgimento**

[the movement for national unification]). "Italian American" implies rations of equality and inequality lined up on an axis whose two poles are the nation states Italy and an America counterpart (Anderson, 1991; Wolf, 1991).

The remaining foundations are specific to Italian American literary history in the United States. (In the remainder of this essay, I will restrict myself to using "Italian American" in this geographically restricted sense, except where otherwise indicated).

Seventh: Class. A large underclass of peasants migrated to the Americas. In many places, particularly the eastern and midwestern United States, they entered a class system that had already appropriated most of the Italian foundations of American culture to its own uses. Architecture, law, the symphony hall, the prestige of the nation-state, the very names Columbus and Vespucci all served the purposes of a dominant culture that assigned to the Italian immigrants a position at the very bottom of the totem pole, where they were encouraged to compete for starvation wages with the other groups who had received the same class assignment. Even the Roman Catholic Church, the Italian immigrants were to discover, in the United States had become a fiefdom that the numerous American Irish tightly held as an exclusive monopoly, paying the necessary vassalage to the feudal lords or Rome but not allowing any emigrants from the Roman peninsula to encroach upon their rich franchise.

Eighth: Race. Italian immigrants to the United States entered this country's racial caste system, which sorts people according to color and assigns them political-economic positions according to a simple standard that follows fairly closely in its prejudices the Protestant map of Europe, where the blond and blue-eyed rule in the north, regarding as progressively stranger and less to be esteemed the peoples that occur as one progresses toward the southern pole. Black Africans, most visibly Southern and Other, have passed most of their American epoch as slaves, escaping chattel status only at the end of the nineteenth century, and still at the end of the twentieth century in America laboring under a formidable burden of civil disabilities, economic disadvantages, inherited wounds, and limited prospects for improvement. The Italians entered this system as what Robert Orsi has properly named "inbetween people." These are persons who inhabit the American borderland between White and Black, Northern and Southern, European and African, enduring the many paradoxes and reversals of such a system (Orsi, 1992).

Ninth: Ethnicity. Not only have the Italians entered, along with African and other Mediterranean peoples, the color castes of American society, but they also have shared, along with the Irish and the Poles and the East European (Slav and Magyar) Jews, in the system of ethnic sorting that runs parallel with the color

system. In the ethnic system, differentiation thematizes culture rather than genetics, and here the Italian Americans have proved themselves virtuosi, transforming into a large-scale technicolor heraldry a set of extremely unlikely fetishes: their *cucina povera*, or diet of the poor (pasta with beans, weeds in salad, olive oil, a little cheese, a little meat), their utilitarian music (tarantellas were a ritual to test the strength of marriageable females), and their bailiffs (the rich kept the poor in line by employing the Mafia, crude bailiffs who carried sawed-off shotguns, a set of class traitors who in America acquired the sexual glamour of Satan and Beelzebub when the movies portrayed them as the demiurges Scarface Capone and Godfather Corleone). The ethnicity system gave the Italian Americans a quasi-folk tradition that allowed them to represent themselves in public through the dialect of the Mob and the pizzeria, much as the ethnicity system gave to European Jews a quasi-folk tradition that parodied Talmudic sages in the adenoidal carping, frequently obscene, that typifies some "Jewish comedians."

Tenth: Gender. Like other migrant peoples, Italian Americans have found the need to recode their gender practices as part of the traditional American preoccupation with experimental anthropology, or the construction of human types.

The American experiment has not confined its curiosities to political institutions. It has indeed, explored most arenas of human interaction, particularly that branch that the Renaissance, studying Rome, brought to a new pitch of perfection: interventionist anthropology, or the fashioning of humans according to patterns or in the interest of altering the breed. America concerns itself with the construction of human beings. Breeding practices and ideological machinery both work to produce new models of human being. Italian Americans have participated in this enterprise along with most other breeding stock brought to the Americas, and Italian American history is especially rich in self-transforming bodies like those of Charles Atlas, Sylvester Stallone, and Madonna Ciccone (Greenblatt, 1980; Bercovitch, 1975).

A Preliminary Survey of Italian American Literary History

Italian American literary history has at its disposal all of these sources of material, which, taken together, suggest the range of allusion available to this theater. How these work together is best suggested by a series of examples rather than by a set of theorems.

First: Mercantile Adventure. Italian American literary history begins in the difficult pages of Colombo and Vespucci. "Italian" in this context always carries

the fresh scent one associates with the passage of primitive capitalists through the forest shooting in all directions, offering bounties for the pelts of cave-dwelling mammals, collecting ostrich plumes in bales like cotton. Italian American writing again and again must face this brutal death-for-dollars aspect of capital exchange. The Italian place in the central creation myth of capitalism—the "discovery" of "America"—means that when Italian American writers address the cash nexus their imaginations resonate deeply in their historical archive. This long echo gives astonishing power to the novel beginning *"Amerigo Bonasera"* (Goodnight America) here offered as the name of an Italian American undertaker (Mario Puzo, *The Godfather* [1969]), or to Pietro di Donato's epic of exploited workers (*Christ in Concrete* [1939]). Both of these novels deal with the power of money to consume lives, as one deals with the construction (*Christ in Concrete*) and the other with the organization (*The Godfather*) of the complex historical face of America. In John Fante's *Ask the Dust* (1989), the Italian American hero meets a Mexican princess (as he imagines her) in a restaurant called the Columbia Buffet, an excellent sarcasm suggesting the persistence of reflection upon mercantile origins that runs through Italian American thought (di Donato, Fante, Puzo).

Second: The Roman Catholic Church. As in Italy itself, in Italian America a large encyclopedia of Roman Catholic myth and material culture forms the more or less universal backdrop to everyday life, and this ubiquity becomes the basis of a wide variety of literary strategies, from the use of Christian allegory in the keystone works of di Donato and Puzo to the use of papal baroque Rome as the theater of such works as Helen Barolini's *Umbertina* (1979). "Learning from Rome," moreover, informs the careers of many Italian American poets, scholars, composers, and architects who have put in time at the American Academy, that balcony over papal Rome. Many observers have commented upon the Italian American preference for Dante over such subtler craftsmen as Ariosto and Tasso, and this preference owes something to the need that Italian American literature has felt to establish its Catholic filiation at a point dramatically *prior* to the Irish version of the Roman religion. This filiation has a basic importance because it opens Italian American writing to such powerful meditations as Rocco Fumento's *Tree of Dark Reflection* (1954), which connects Italian American religion, via Roman Catholicism, to the primitive cavern cults of Campania (Barolini, 1979; Fumento, 1954).

Third, Fourth, and Fifth: Music, Architecture, and Law. Here the possibilities have the longest and widest reach. These arenas rest upon long and almost uninterrupted Italian dominance in Europe, where the influence of Italian innovators and codifiers has left its signature everywhere for centuries. These arts have proved irresistible to students of Italian culture all over the world, particularly in the

expansionist European nations of the sixteenth, seventeenth, and eighteenth centuries and in the American colonies, the artistic and legalistic cultures of which were founded on Italian paradigms. To remain within the United States alone, the dominance of Italian symphonic and operatic traditions in music remains substantial in ruling-class culture. The same can be said concerning the bucolic architecture of the Venetian nobility, which has inspired many of the official buildings in the capitals of the United States, which speak a Palladian dialect that the English learned in Vicenza and afterward have replicated everywhere from Whitehall to Columbus, Ohio. In the law, the Italian maintenance and revival of Roman traditions of jurisprudence has put Italian universities and legal philosophers at the center of the legal curriculum from the early Middle Ages down through the Enlightenment as embodied in the thought of Giambattista Vico and Cesare Beccaria (Braudel, 1991; Vance, 1989).

Italian transmission of patterns of thought and culture in these areas preceded the mass migration of Italians to the New World around the turn of the nineteenth century. This historical precondition perhaps best explains the relative ease with which such leaders as Arturo Toscanini in music, Robert Venturi in architecture, and Mario Cuomo in jurisprudence have risen to the top of their professions in the United States. These arenas of cultural production, relatively untainted by the complex stigmata of the migration, offer important foundations for the construction of cultural authority in Italian American discourse. Carole Maso's novels depend upon intricate musical analogies and repay an informed understanding of the Toscanini discography, referring as they do to the structures of Beethoven symphonies and the operas of Giuseppe Verdi. The architectural essays of Robert Venturi manage to concoct a semiotic that can translate Rome and Las Vegas into versions of one another. Similarly, the speeches and diaries of Mario Cuomo have a destiny in Italian American literary history equal with those of the letters of John and Abigail Adams in the literary history of New England (Maso, 1990; Venturi, Brown, and Izenour, 1991).

Sixth: Nation States. Emigrants from Italy left behind a culture that, even in its largest metropolitan centers, retained a medieval sense of restricted locality. People identified themselves by their *comuni* (towns, here meaning a local corporate entity). They called themselves such names as Castellammaresi (for Castellammare del Golfo, a town outside Palermo) or Sallesi (for Salle, a tiny town in the Appennines of Abruzzi). Arrived in New York, they began to identify themselves, within the immigrant community, by region of origin on the Italian peninsula. They became Sicilians and Calabresi. Their initiation into an American national identity accompanied their gradual acceptance of an Italian national identity. Such

labels, so much larger and more abstract in referent than their habitual categories of self-identification, posed for Italian Americans cultural problems and conundrums that have provided some of the more stunning works of cultural self-portraiture in the history of Italian American narrative, from Garibaldi Marti Lapolla's *The Grand Gennaro* (1935), an epic that shows Italianization and Americanization as parallel processes in the Italian Harlem of the 1890s, down to the poetry of Rose Romano (1991), which composes collage self-portraits using the fragments these large national identities have left behind them (Lapolla, 1935; Romano, 1991).

Seventh: Class. Since the Renaissance the word "Italy" has meant outside the Italian peninsula as much as, or more than, it meant inside that beautiful country studded with mountains and spectacular seascapes, that splendid storehouse of palaces and villas and fountains, that platonic timber room whither the young aristocrat or bourgeois has generally been free to travel from Scotland or Norway or Finland or Buenos Aires to make a grand tour among the Western world's largest illustrated book, wherein one may study the best models of elegance, elocution, and ecclesiastical polity. Italy, in this luxurious sense, belongs to the bourgeoisies of the world. No single fact has had a larger impact on the literary fortunes of Italian Americans. Italian intellectuals regularly over the decades visit darkest Bronx and Brooklyn to report back upon the grotesques and strangenesses they find in these backwoods settlements and urban slums, which they portray as sick bays where the old inmates are dying of nostalgia while the young ones carry machine guns under the chromium zippers of their leather jackets. What has been the result of this characterization of Italian American culture? It has given us portrayals on a scale that runs from the letters of Amerigo Vespucci to the films of Federico Fellini, showing an underbrush of lurid natives who file their teeth, with the result that Italian American culture has languished in the category defined by Antonio Gramsci as **cultura negata** (culture denied)—the expressive life of a people that has no right to represent itself in the forums of power. Until the current generation, Italian American culture has belonged to the social scientists, who gave it the loving condescension that oppressed people have learned to recognize as the best they can expect from welfare workers and public-health nurses. The departments of Italian culture—the literary and artistic and musical departments of American universities no less than those of universities in the old imperial capitals of London and Rome—have kept Italian American expressive culture waiting at the back door (Birnbaum, 1993; Viscusi, 1988).

Eighth: Race. Italian American narrative and confessional verse record a good deal of testimony from the subaltern side of the color line.

The autobiographical poetry of Maria Mazziotti Gillan stresses how the eldest child in an immigrant Italian family, while going through the public school system of an industrial city in New Jersey during the 1940s, repeatedly received the message that she belonged to the darker peoples on the American spectrum of acceptability. In this spectrum the socially acceptable—the desirable, the powerful, the authoritative—was coded in degrees of lightness. Gillan's poetic enterprise, while wide in range and varied in mode, strongly focuses upon the central act of taking back powers that the American racial rainbow system of human categories refused to grant her as a child. (See, above all, her 1983 poem, "Public School No. 18: Paterson, New Jersey," reprinted in Barolini, 1985.)

Gilbert Sorrentino's narrative *Aberration of Starlight* (1980) is a memoir of an unhappy marriage between an Italian American man and an Irish American woman, written largely from the point of view of their son: It records the many ways that the Irish American side of this marriage employed the racial code in the struggle against the Italian American side. These messages pass through the marriage—that is, they come from the many voices that enter the contrapuntal conversation that surrounds this attempted joining of two peoples. Sorrentino, a devoted student of modernist writing from Mallarmé through James Joyce and Alain Robbe-Grillet, uses the entire technical armamentarium at his disposal to show how the racial system encodes and enforces its hierarchy in this failed alliance across the color line. He does not conceal the degree to which the subaltern side of the marriage reinscribes its own status in the discursive practices of the Italian Americans (Gillan, 1985; Sorrentino, 1980).

Ninth: Ethnicity. Literary history has imported from social science the word "ethnicity," changing its meaning in the process. Social science uses the word to refer to marks of exclusion—signs of membership in a subaltern group that shares a common geographic, political, linguistic, or even genetic set of origins. But literary history uses the word "ethnicity" to mean not marks of exclusion but the conscious reproduction of marks of exclusion. In technical language, literary history can define ethnicity reinscription of self-conscious subaltern status. This self-conscious reproduction transvalues the marks of exclusion it reproduces.

This attempt at systematic transformation has received analysis in such well-known theoretical treatises as those of Werner Sollers, William Boelhower, Houston Baker, and Henry Louis Gates, and these concerns inform the discussions of **italianità** in Anthony Tamburri, Fred L. Gardaphe, and Paolo Giordano's landmark anthology *From the Margin: Writings in Italian Americana* (1991).

Many Italian American writers have played upon ethnicity, finding in it the standard configuration of a Gramscian *cultura negata,* a collective expressive life

only seeking authoritative permission to make itself noticed in the public forum. Pietro di Donato invented this formula for Italian American literary history in his 1939 novel *Christ in Concrete,* translating the oral discursive practices of immigrant **paesani** into acceptably stylish Book-of-the-Month-Club modernism, with equal doses of Emile Zola, William Shakespeare, Walter de la Mare, Gertrude Stein, Gabriele d'Annunzio, Ignazio Silone, Filippo Tommaso Marinetti, and James Joyce, among others, producing an amalgam not so stylishly demanding as that of, say, Ezra Pound, but more original and authoritative than that of Edna Ferber aiming at Joycean epic or Faulkner trying to write from inside the body of an African American. The second great virtuoso ethnic, Jerre Mangione, made of ethnicity the framework for an ontology of self every bit as peculiar as, though considerably more systematic than, one of Joseph Cornell's boxes that imagine a universe. The third, and perhaps last, master of this mode in prose fiction is Mario Puzo, whose *Fortunate Pilgrim* (1964) and *Godfather* performed for Italian American ethnicity in the 1960s what more theatrical modes of self-presentation accomplished in that same decade for African American ethnicity.

In the 1970s Italian American ethnicity, reformulated according to the proportions prescribed by Puzo, became the theme of triumphant commodification in the movies and the restaurant business, where *The Godfather* became a hot commercial trademark. Formulaic ethnicity (which is what literary history calls this sort of commodification) left a modest but firm signature upon education in the 1970s, with such treatises as those of the educational philosopher Richard Gambino and the literary historian Rose Basile Green, and with the foundation of various centers, journals, institutes, curricula, and associations devoted to Italian American studies, signs that this ethnicity had won some triumphs in the educational bureaucracy (Gambino, 1974; Green, 1974).

The concerns of the 1970s have been revived in new forms, in which writers in such groups as IAWA (Italian American Writers Association), BASIL (Bay Area Sicilian Italian Lesbians), and IAMUS (Italian Americans for a Multicultural United States) wear the old signs of ethnic modification as the badges of a new self-conscious reconstruction. Two writers who have particularly distinguished themselves as virtuosi at transvaluation of ethnic markers are Anthony Valerio, in his works of prose fiction *The Mediterranean Runs Through Brooklyn* (1982) and *Valentino and the Great Italians* (1994), and Rose Romano, in her memorable first book of poems, *Vendetta* (1991).

Tenth: Gender. Contemporary codes of gender differentiation have inspired a general critique in many languages, in many local, regional, and national cultures, and in many international communities of thought. Two particularly lively

branches of Italian American gender study have been the critique of machismo (Russo, 1986; Tricarico, 1984; Viscusi, 1988) and the study of gender artifice (Gilbert, 1979; Paglia, 1990).

Italian American writing has also focused upon gender construction as a central arena for transvaluation. Italian American ethnic commodification frequently performs its work of cultural negation through the construction of ethnic gender commodity forms. One sees this in all of those scenes from the Hollywood Corleone saga that work very well as imaginative inducements to dine in restaurants where they brew their own sauce (*The Godfather I*) or know how to play a tarantella (*The Godfather II*) or to fingerform their own gnocchi (*The Godfather III*). The epic spaghetti-advertisement effect has proved so dependable and attractive a language that by now one can trace a tradition that informs the entire filmographies of such Hollywood geniuses as Martin Scorsese, Sylvester Stallone, and Robert De Niro.

At a certain point, of course, things turn around. The critical intelligence starts dismantling the raging bulls and ragu mammas of ethnic gender commodification, replacing them with versions of themselves that often perform the same gestures but do so with a degree and intensity of self-reference that turns them into sites not only of deconstruction but of reconstruction as well. The first such works to make a large impact were Helen Barolini's novel *Umbertina* (1979) and the anthology she edited, *The Dream Book: An Anthology of Writings by Italian American Women* (1985), works that presented (in the first case) a complete anatomy and (in the second place) a complete history of the actual shape that the *cultura negata femminile italoamericana* (denied culture of Italian American women) has assumed within the varied worlds that Italian emigrant women and their descendants have inhabited in the Western Hemisphere.

Many other writers, from Daniela Gioseffi to Mary Jo Bona, have worked to construct alternative gender portfolios for self-fashioning Italian American women. An important development has been the project of Lucia Chiavola Birnbaum to outline a global prospect in which such self-fashioning could take place.

Questions for Italian American Literary History

If it remains impossible properly to write Italian American literary history, as many observers still believe, this is because two essential questions remain to be resolved: the question of language and the question of political identity. One might include these two among the points of reference, but not enough progress has been made

in either case to justify a heading so clearly formed as the ones I have set forth earlier in this essay. In considering the development of a critical literary history, then, at present one must lay out the forces at play in these fundamental and unresolved problematics, concluding by simply suggesting the lines of development that seem to offer the most plausible resolutions for this still emerging tradition of self-conscious historical reflection.

La questione della lingua (the language problem) has preoccupied the literary historiographers of Italy for centuries. How to find an appropriate literary language for the Italic peoples who speak and write a variety of local and interlocal dialects has produced a good deal of fertile instability in Italian literary production across the centuries (Dionisotti, 1987).

In Italian America the problems of literary Italian persist (Haller), but they also encounter the more substantial problems of an imperially triumphant Anglophone (Viscusi). How to construct a language comprehensible in the speech communities of the United States while at the same time maintaining access to the hugely remunerative Italian intertext remains an enigma that Italian American writing has not adequately resolved.

As to the problem of political identity, when we have adequate narratives of Italian American history, literary and cultural, they will address at every turn the unstable political ontology that has kept Italian America relatively silent, relatively self-enclosed, for so many decades. Not quite subjects of the king, not quite allies of fascism, not quite good postwar Americans, not quite ethnic separatists, not quite dual-passport citizens of Italy and the United States, Italian Americans have had to negotiate a bewildering succession of virtual political realities, without at any point in their history commanding well-constructed or stable political means of self-representation.

Every Italian American writer has had to answer the language question and the political question. Interesting responses to the language problem have appeared over the years in the poetry of Emanuele Carnevali, Joseph Tusiani, Peter Carravetta, and Rose Romano (see the essay on poetry by Stephen Sartarelli in this volume). The linguistic, for a poet, shades into the political, and the resulting enigmas have produced superb poetry in the works of Alfredo de Palchi and Paolo Valesio.

Italian Americans—Lawrence Ferlinghetti, Diane di Prima, Gregory Corso, Gilbert Sorrentino—were protagonists in the first great literary movement of the postwar years, the Beat revolution of the 1950s. In that period these writers attempted to give voice to the political imagination, the anarchic sense of freedom, that has characterized Italian America from the moment of its first appearance in

the fantasms of Amerigo Vespucci, a phantasm that reappears in the the great nineteenth-century Italian American guerilla general Giuseppe Garibaldi, who led the revolution in the south of Italy, and reappears again in the spirits of Nicola Sacco and Bartolomeo Vanzetti, martyred in the United States for their political imaginations in 1927. The Italian American Beats evoked all of that. Their voices opened the way for a new freedom of Italian American self-construction. This freedom characterizes Italian America in that place where the political imagination and its need for self-expression meet to produce its literary history.

Further Reading

Anderson, Benedict. *Imagined Communities: Reflections on the Origin and Spread of Nationalism,* rev. ed. (London: Verso, 1991).

Barolini, Helen. *Umbertina* (New York: Seaview, 1979).

———. *The Dream Book: An Anthology of Writings by Italian American Women* (New York: Schocken Books, 1985).

Bercovitch, Sacvan. *The Puritan Origins of the American Self* (New Haven: Yale University Press, 1975).

Birnbaum, Lucia Chiavola. *Black Madonnas: Feminism, Religion, and Politics in Italy* (Cambridge: Northeastern University Press, 1993).

Bona, Mary Jo. *The Voices We Carry: Recent Italian/American Women's Fiction* (Montreal: Guernica, 1993).

Braudel, Fernand. *Out of Italy, 1450–1650,* trans. Siân Reynolds. (Paris: Flammarion, 1991).

Colombo, Cristoforo. *Select Documents Illustrating the Four Voyages of Columbus,* ed. and trans. Cecil Jane. 2 vols. (London: Hakluyt Society, 1930).

Di Donato, Pietro. *Christ in Concrete* (Indianapolis: Bobbs Merrill, 1939).

Dionisotti, Carlo. *Geografia e storia letteraria* (Torino: Giulio Einaudi, 1987).

Fante, John. *Ask the Dust* (1939; reprint, Santa Barbara, Calif.: Black Sparrow, 1989).

Fumento, Rocco. *Tree of Dark Reflection* (New York: McGraw-Hill, 1954).

Gambino, Richard. *Blood of My Blood: The Dilemma of the Italian Americans* (Garden City, N.Y.: Doubleday, 1974).

Gilbert, Sandra and Susan Gubar. *The Madwoman in the Attic: The Woman Writer and the Nineteenth-Century Literary Imagination* (New Haven: Yale University Press, 1979).

Gillan, Maria Mazziotti. "Public School No. 18: Paterson, New Jersey." In *The Dream Book: An Anthology of Writings by Italian American Women* (New York: Schocken, 1985).

Green, Rose Basile. *The Italian American Novel: A Document of the Interaction of Two Cultures* (Rutherford, N.J.: Fairleigh Dickinson University Press, 1974).

Greenblatt, Stephen. *Renaissance Self-Fashioning: More to Shakespeare* (Chicago: University of Chicago Press, 1980).

Haller, Robert. *The Hidden Italy: A Bilingual Edition of Italian Dialect Poetry* (Detroit: Wayne State University Press, 1987).

Lapolla, Garibaldi Marti. *The Grand Gennaro* (New York: Viking, 1935).

Mangione, Jerre. *An Ethnic at Large: A Memoir of America in the Thirties and Forties* (New York: G.P. Putnam's Sons, 1978).

Maso, Carole. *The Art Lover* (San Francisco: North Point Press, 1990).

Nerlich, Michael. *The Ideology of Adventure*. 2 vols. (Minneapolis: University of Minnesota Press, 1988).

Orsi, Robert. "The Religious Boundaries of an Inbetween People: Street *Feste* and the Problem of the Dark-Skinned Other in Italian Harlem, 1920–1990." *American Quarterly* 44, no. 3 (September 1992): 313–347.

Paglia, Camille. *Sexual Personae: Art and Decadence from Nefertiti to Emily Dickinson* (New Haven: Yale University Press, 1990).

Puzo, Mario. *The Fortunate Pilgrim* (New York: Atheneum, 1964).

———. *The Godfather* (New York: G.P. Putnam's Sons, 1969).

Romano, Rose. *Vendetta*. (San Francisco: malafemmina press, 1991).

Russo, John Paul. "The Hidden Godfather: Plenitude and Absence in Francis Ford Coppola's *Godfather I and II*." In *Support and Struggle: Italians and Italian Americans in a Comparative Perspective*, ed. Joseph L. Tropea, James E. Miller, and Cheryl Beattie-Repetti (Staten Island, N.Y.: American Italian Historical Association, 1986).

Sorrentino, Gilbert. *Aberration of Starlight* (New York: Random House, 1980).

Tamburri, Anthony, Fred L. Gardaphe, and Paolo Giordano, eds. *From the Margin: Writings in Italian Americana* (West Lafayette, Ind.: Purdue University Press, 1991).

Tomasi, Silvano, ed. *The Religious Experience of Italian Americans* (Staten Island, N.Y.: American Italian Historical Association, 1975).

Tricarico, Richard. *Italians of Greenwich Village* (Staten Island, N.Y.: Center for Migration Studies, 1984).

Valerio, Anthony. *The Mediterranean Runs Through Brooklyn* (New York: H.B. Davis, 1982).

———. *Valentino and the Great Italians, According to Anthony Valerio*. 2d ed. (Toronto: Guernica Editions, 1994).

Vance, William L. *America's Rome*. 2 vols. (New Haven: Yale University Press, 1989).

Venturi, Robert, Denise Scott Brown, and Steven Izenour. *Learning from Las Vegas*. rev. ed. (Cambridge: MIT Press, 1991).

Vespucci, Amerigo. *Letters from a New World,* ed. Luciano Formisano, trans. David Jacobson (New York: Marsilio, 1992).

Viscusi, Robert. "Coining." *Differentia: Review of Italian Thought* 2 (1988): 7–42.

Wolf, Eric R., ed. *Religious Regimes and State-Formation: Perspectives from European Ethnology* (Albany: State University of New York Press, 1991).

Italian American Novelists

Fred L. Gardaphe

Introduction

On 14 March 1993 the *New York Times Book Review* published on page one an essay by Gay Talese entitled "Where Are the Italian-American Novelists?" The article, while more personal than scholarly, put forth a question that had never been proposed to such a large public audience at the national level. When the newspaper limited the number of published responses to Talese's attempt to answer the question to a single page of excerpts from letters a few weeks after the article appeared, Italian Americans turned to their own publications for a forum. A number of responses appeared in *Italian Americana*'s Fall 1993 and Spring 1994 issues. The question Talese so appropriately raised and so poorly answered is one that had led a number of American literary critics and scholars of Italian descent in search of the place of the novel in Italian American culture and the place of the Italian American novelist in American culture.

In the late 1940s Olga Peragallo, a graduate student at Columbia University, went in search of answers to the same question and documented her findings in *Italian-American Authors and Their Contribution to American Literature* (1949). Not long after, Rose Basile Green began work on a dissertation that would become the most important study of Italian American literature. Published in 1974 as *The Italian-American Novel: A Document of the Interaction of Two Cultures,* Green's study became a valuable guide for future scholars such as Robert Viscusi. In the late 1980s Mary Jo Bona produced a dissertation titled, "Claiming a Tradition: Italian American Women Writers" (University of Wisconsin, 1989) that picked up on the work of earlier critics and historians such as

Boldface terms are defined in the Cultural Lexicon, which starts on p. 703.

Helen Barolini and advocated the presence and importance of women writers.

Now that we have had nearly fifty years of steady scholarship in the area of Italian American literature, we can begin to identify the writers who have had a significant impact on American and Italian American cultures. For the most part, these writers have been ignored or overlooked by previous scholars and left out of most histories of American literature. As a corrective, this essay introduces a handful of these writers who, while having achieved relative success in their careers as writers, have yet to receive critical attention and historical recognition for their contributions.

Pietro di Donato

Born in Hoboken, New Jersey, in 1911 of Abruzzese parents, Pietro di Donato became a bricklayer, like his father, after his father's tragic death on Good Friday, 1923. Di Donato was one of a handful of Italian American writers to join the Communist Party, which he did at the age of sixteen on the night that Nicola Sacco and Bartolomeo Vanzetti were executed. He took up writing during a period in which he was out of work. His first story, "Christ in Concrete," which dramatized the early death of his father in a construction accident, was published in *Esquire* magazine in March 1937 and reprinted in Edward O'Brien's *Best Short Stories of 1938*.

The story grew into a novel of the same name, published in 1939, and became the main selection of the Book-of-the-Month Club, chosen over John Steinbeck's *Grapes of Wrath*. Di Donato had never intended to be a writer, but the novel's success placed him in a national spotlight.

Only since the 1980s have critics begun to realize the true revolutionary figure that di Donato was. Yet in spite of his absence in critical studies of American writers, di Donato is perhaps the most well known of the early Italian American writers because of the impact *Christ in Concrete* had, and continues to have on its readers. On many occasions he has been referred to as "the grandfather of Italian American literature." For many critics di Donato's first novel has become the prototypical Italian American novel, in spite of the fact that many were published long before his. One of the reasons for this comes from the fact that the signs of **italianità** (Italianness) are foregrounded in this novel as in no other writing yet produced by an Italian American. Di Donato's *italianità* becomes most obvious through the novel's diction; his word choice and word order, as has been pointed out in a number of articles, re-create the rhythms and sonority of the Italian language.

While other Italian American writers were portraying characters who struggled to fit into American life, Pietro di Donato was rejecting the American Dream by documenting, through a rewriting of the myth of Christ, the disintegration of the Italian family caused by American capitalism. Prior to his death in January 1992, he had completed a novel entitled *The American Gospels,* in which Christ, in the form of a Black woman, comes to Earth at the end of the world to cast judgment on key historical figures of contemporary America. This theme, of Christ as a woman, can be found in much of what di Donato has written, and it is a theme that is usually left in the shadow of the more obvious interpretation of the great Italian American myth he created in his first novel.

Di Donato's Catholicism has its roots in pre-Christian matriarchal worship. As di Donato himself admitted, "I'm a sensualist, and I respond to the sensuality of the Holy Roman Catholic Church, its art, its music, its fragrances, its colors, its architecture, and so forth—which is truly Italian. We Italians are really essentially pagans and realists" (von Huene-Greenberg, 36). Annunziata, the mother in *Christ in Concrete,* becomes the key figure in di Donato's rewriting of the Christian myth. She controls her son's reaction to the work-site "murders" of his father and godfather by calling on him to put his trust in Jesus, the son of Mary. This is a trust that has led immigrants to accept poverty as their fate and passivity as their means of survival in a world bent on using and then disposing of them. This trust is a myth that di Donato, through his protagonist Paul, refuses to accept. *Christ in Concrete* is perhaps the most mythical text of Italian American literature. As a myth it presents a heroic figure, Paul, who searches for God, in the form of Christ, whom he believes, as he was trained to believe, can save his family from the terrible injustices brought upon them through a heartless society.

The novel is divided into five parts: "Geremio," "Job," "Tenement," "Fiesta," and "Annunziata," each focusing on the key figures in the myth. In "Geremio" and "Job," di Donato presents Job as the antagonist that controls the Italian workers led by his father, Geremio, through the human forces of Mr. Murdin, the heartless foreman; the state bureaucracy that sides with the construction company during a hearing into Geremio's death; and the Catholic Church through an Irish priest who refuses to do more than offer the family a few table scraps from his rich dinner. Job, which never appears with expected articles such as "the," is depicted as a living thing that "loomed up damp, shivery gray. Its giant members waiting" (9). Job serves as the means by which "America beautiful will eat you and spit your bones into the earth's hole" (3), as one worker predicts. In "Tenement" young Paul comes to learn about the forces of good and evil in the world and that good comes only from the workers' community, which is portrayed in

"Fiesta." Paul's mother, Annunziata, pregnant at the opening of the novel, serves as the figure of the Madonna and represents the immigrants' faith in God, whom she invokes through prayers such as, "God of my fathers, God of my girlhood, God of my mating, God of my innocent children, upon your bosom I lay my voice: To this widow alone black-enshrouded, lend of your strength that she may live only to raise her children" (63). In the chapter devoted to her widowhood, Annunziata attempts to raise her children according to the Christian myth, but in the process her son Paul loses the faith she hopes to pass on to him through recollections of her husband's show of faith.

A heroic struggle occurs between man and God through the figures of Geremio and Job, through which Geremio believes he can gain the means to live and to eventually achieve the American Dream of a haven from Job, where "no boss in the world can then rob me of the joy of my home" (11). But the money saved for the house must be used to bury Geremio, who along with the workers become sacrificial victims to Job through the greed and insensitivity of the company. As Paul begins to take up the struggle where his father left off through death, he begins to see through the masked mechanism of this myth and realizes that the only way to beat Job is not to become a part of the system and to fight against it. This realization is vividly depicted by di Donato through one of Paul's dreams.

Toward the end of the novel Paul has a dream in which he is about to die as his father had. His godfather attempts to save him and is tossed off a scaffold by the foreman, who was threatening Paul. Paul fails to save his godfather but remembers who can save him: "it is our Lord Christ who will do it; he made us, he loves us and will not deny us; he is our friend and will help us in need! Bear, oh godfather, bear until I find Him" (285). Paul then takes off in search of Christ and runs into his father, who is on his way to work. The work site becomes a shrine for the workers who have now become saints; Mr. Murdin, the foreman, appears as a magician who "each time he revolves and shouts at Geremio and Paul he has on a suit and mask of a general, a mayor, a principal, a policeman" (288). Job falls apart, and Paul is the only one who tries to save himself. Paul sees himself in his father's crucified form. He is then carried off to "the Cripple," the hag who earlier in the story had conducted a seance for Paul and his mother. Paul sees his father hovering over "the Cripple," and, as they embrace, Geremio sighs, "Ahhh, not even the Death can free us, for we are . . . Christ in concrete" (290). Paul's dream quest ends here with the failure of Christ to save him and his family. Paul realizes that only he can save himself. This realization is dramatized in the last scene of the novel.

By the end of the novel Paul's faith is nearly destroyed as evidenced by his

crushing of a crucifix offered to him by his mother (296–297). However, the final image of the novel suggests that the matriarchal powers still reign. The image we are left with is an inversion of the *Pietà,* Michelangelo's famous sculpture of Christ being held by his mother, in which son is holding a mother who is crooning a death song–lullaby that hails her son as a new Christ, one that her children should follow (303). But this haunting image can also suggest that the mother has become the new Christ, who in witnessing what America has done to her son, dies and, through her death, frees her son from the burden of his Catholic past. This death is quite different from the death of his father, which leads Paul in search of Christ. His rejection of Christ as the means to survive in this world contributes to his mother's collapse. She then becomes the basis for a new faith, a faith in himself, a faith that his mother urges her children toward as she tells them to "love . . . love . . . love . . . love ever our Paul" (303). For di Donato, this figure of the dying mother replaces Christ as the figure through which man can redeem himself. There is no redemption through the father, for if Paul stays in the system, if he continues to interact with Job, he will share the same destiny as father, Geremio.

For di Donato the immigrant laborer may become a hero through martyrdom, but his life becomes not a model to emulate, but rather something to avoid. Through the father, America remains an immigrant's dream anchored in God and the belief that God will provide the means by which the immigrant will prevail. Geremio's hope that all of his children will be boys is tied into his perception of the American Dream: ". . . I tell you all my kids must be boys so that they someday will be big American builders. And then I'll help them to put the gold away in the basements!" (5). And so what is a dream for the immigrant becomes a nightmare for the child Paul, who, as witness to the tragedies that have befallen his immigrant family, must become not a new Christ, but more a St. John the Baptist figure who wanders through life preparing humanity for the revolution, seeking redemption through the women he encounters.

By directing his characters' rage at the employers who exploit immigrant laborers, Pietro di Donato argues for solidarity among American workers and requires that they look to one another to solve their problems. Just as it is the Italian community through the extended family that keeps Geremio's family together, it is the extended family of the workers that must watch out—and help—its own. Di Donato's revision of Christ points to the failure of American Catholicism to support the immigrants' struggle. He reveals Catholicism as a force that controls and subdues the immigrants' reactions to the injustices of the capitalist system that exploits as it maims and kills the Italian immigrant. His deconstruction

and remaking of the Christian myth forces us to reread his masterpiece as more revolutionary than it has been portrayed by past critics.

Di Donato's rewriting of the myth of Christ, while leading him away from organized Roman Catholicism, leads him toward the pagan. This return, while implicit in my reading of *Christ in Concrete,* becomes explicit in nearly all of his subsequent work. Di Donato's ability to see through the repression created by a Christianity that aligns itself with a capitalist power structure leads him toward socialism.

At the start of World War II, di Donato registered as a conscientious objector and worked in a government camp in Cooperstown, New York. In 1942 he was married to Helen Dean in a civil ceremony presided over by New York Mayor Fiorello H. La Guardia. In 1949 his *Christ in Concrete* was made into a film directed by Edward Dmytryk and adapted for the screen by Ben Barzman. The film, titled then *Give Us This Day,* won an award at the 1949 Venice Film Festival.

For di Donato salvation of his soul would come not in the form of an organized church, but rather through a spiritual quest for truth that would lead him back to a pre-Christian pagan (quasi-sadistic) sensualism that he would record in his next novel, *This Woman. This Woman,* di Donato's long-awaited sequel to *Christ in Concrete* appeared in 1958 and was greeted with many negative reviews. As a work of art the novel does not achieve the status of his first. However, for di Donato readers it is an incredibly important work. In the novel di Donato describes the path taken by the young Paolo after his rejection of both the American Dream and the traditional myth of Christ. The protagonist, Paolo di Alba, becomes "the boy who later felt the terrible exultation of pagan freedom when his mother died in his arms" (14). This freedom from the strictures of traditions Italian and American enables the protagonist to re-create himself through a new moral order built on a triad of masonry, sex, and soul: "The three-act drama of his mental theatre would revert first to the factual solidity of building construction, evolve to the mercury of sex, and then culminate with the spiritual judgement" (8).

The central story of the novel concerns Paolo's innumerable and incredible sexual encounters with women in a manner reminiscent of the Marquis de Sade and his faithful Italian disciple Gabriele D'Annunzio—di Donato often told the story of how his father was the illegitimate son of D'Annunzio. One of his conquests, Isa, short for Isis, is the widow of a German American hotel manager. Eventually his obsession with possessing this woman collides with his obsession with her husband's ghost. The novel dramatizes the classic madonna–whore complex through the figures of Paul's dead sister Ann and his lover Isa. In a particularly gruesome scene Paul rapes Isa, now his wife, on top of her former husband's

grave. Later Paul returns to the site and digs up the corpse so he can see the dead man who haunts him through the photos and personal effects Isa refuses to destroy. Paul does this believing he can exorcise the dead man's memory from his and his new wife's minds: "The unseen cannot die. The dead, viewed, remain truly dead without interruption" (193). He forces Isa back to the grave to see the mutilated corpse, and the experience drives her to a nervous breakdown. Later, and incredibly, this all ends happily as Isa and their son prance about the beach in a scene that becomes for Paul "a vaulting apocalypse," in which "his immediate pagan satyr mortal, and Catholic Soul eternal dashed into close secret embrace" (220).

Much of di Donato's later work continues to portray this conflict of the sacred and the profane. In *The Penitent* (1962) he recounts the story of Alessandro Serenelli, the man who killed the virgin Maria Goretti, who was later sainted by the Catholic Church. Di Donato attempts to understand the murder as a crime of nature-driven passion committed by a man who as a fisherman lived the pagan life of the sea (205). "Was purity more important than the denial of nature, the agony and loss of one life, the ruin of another and the sorrow of two families" (203)?

Di Donato's interest in the Catholic faith prompted him to investigate the life of the first American to be canonized as a saint, resulting in the biography *Immigrant Saint: The Life of Mother Cabrini* (1960). Di Donato then returned to the material of *Christ in Concrete* with a loosely woven novel entitled *Three Circles of Light* (1960). In 1970 he collected his selected writings and published them in *Naked Author*.

Di Donato's essays have been published in some of America's most prestigious magazines and journals. In 1978 he earned the Overseas Press Club Award for "Christ in Plastic," a story on Aldo Moro published in the October 1977 issue of *Penthouse* magazine. He also wrote plays and dramatic adaptations of his novels *Christ in Concrete* and *This Woman*. *The Love of Annunziata,* a one-act play, was published in *American Scenes* (1941).

After destroying the traditional myth of a Christianity corrupted by temporal powers, di Donato builds a new myth for his readers, that of man as surviving best within the naturally spiritual institution of family, which is constantly being threatened by a world corrupted by the artificial institutions created through a material-hungry capitalism. Di Donato's final novel is an attempt to resolve the sacred–profane dilemma presented in much of his earlier work. The redemption of the victims of capitalism through the final judgment of a female Christ becomes the matter of his *The American Gospels,* which, as of 1995, remains unpublished.

Through this novel, which should be read as his primal scream *out* of the world, just as *Christ in Concrete* was his cry *into* the world, di Donato takes his "revenge on society" by revealing "all the nonsense of authority and of Church" through what he calls a "conscious evaluation of myself" (von Huene-Greenberg, 33–34). To di Donato salvation for the world lies in man's ability to become his own god, to take responsibility and control of the world he has created, and to act for the good of all.

John Fante

John Fante was born in Denver, Colorado, on April 8, 1909, to a father who immigrated from Abruzzi, Italy, and a mother born in Chicago to immigrant parents from Potenza, Italy. He was one of four children raised in Boulder, where his father, a stonemason and bricklayer, found work in the building trades. At an early age he was encouraged by Catholic nuns to write. He attended Regis College and the University of Colorado at Denver. He left college to hitchhike out to California, where he took jobs in fish canneries and on shipping docks to help support his mother and siblings after his father left the family. From these experiences came his earliest writings, which he sent to H.L. Mencken, then editor of the *American Mercury*.

Fante dreamed of becoming a great writer. His early debut as a story writer at the age of 21 was aided by Mencken's desire to combat the Anglo-centric hegemony of New England literary establishment. By 1940, Fante had already published half of his lifetime production of short stories in national magazines such as the *American Mercury*, the *Atlantic Monthly*, *Harper's Bazaar*, and *Scribner's* magazine. He had also published two novels and a collection of his stories (*Dago Red* [1940]). Among the books published in the 1930s, James T. Farrell recognized Fante's 1938 *Bildungsroman* (novel of formation), *Wait Until Spring, Bandini*, and praised it. In spite of receiving such support and praise by two of the period's leading literary figures, Fante's writing has received little critical consideration, and his achievements have been left out of the many cultural histories of America.

Much of Fante's early writing concerns the development of the social and aesthetic consciousness of a child of Italian immigrants and the contribution of that consciousness to the child's fantasy of assimilation into mainstream American culture. Written in a deceptively simple style, and based in part on his own life experiences, Fante's work is characterized by a self-irony that results in a highly tragicomic presentation. The subject of much of his writing is the relationship between the individual and his family and community and the subsequent devel-

opment of a single protagonist's American identity that requires both an understanding and a rejection of the immigrant past that parental figures represent.

His four-book saga of Arturo Bandini,* of which *Wait Until Spring* is the first, follows a young Italian Catholic who lights out for California with the intent of escaping his family and its ethnicity by becoming a writer. *Wait Until Spring* deals primarily with the young man's parents and their struggles to establish themselves in a strange world, but more importantly it sets up the theme of assimilation into the American Dream. In *Ask the Dust* (1939), Fante's second novel, Bandini abandons his Italian American home and makes his way to California with plans of becoming a famous writer. In the process he denies the ethnicity that he questions in the first novel, by calling attention to the ethnicity of others, such as Camilla, the Mexican waitress with whom he falls in love and whom he continually calls a "greaser." *Full of Life* (1952) finds Bandini married to a non–Italian American. His wife is expecting their first child. Through his wife and her relationship with his father, Bandini reconciles his Italian heritage. In *Dreams from Bunker Hill* (1982) Fante returns to the Bandini days of *Ask the Dust* as Bandini tries to make his way in Hollywood.

Fante's works provide us with an insight into the process by which an American-born child of Italian immigrants fashions an American identity through the process of denying other immigrants and their children the same possibilities. For Arturo Bandini the development of this offensive behavior is a necessary defense, especially for one coming of age during the rise of Italian fascism, which makes life difficult for America's Italians during World War II. During the 1930s Fante was at work on his first novel, *The Road to Los Angeles,* which had been contracted, then rejected, by Alfred A. Knopf and was finally published in 1985 by Black Sparrow, two years after his death. He uses his protagonist's identity as a writer to separate Bandini from the working class, which reminds him of the past he is trying to escape. In this novel Fante sets up the myth of the alienated artist as hero in a society that has no need for what the writer produces. In *1933 Was a Bad Year* (1985) Fante shifts into the sports-figure-as-hero myth as he depicts a young boy's desperate struggle to assimilate into American culture. The protagonist, Dominick Molise, attempts to separate himself from his poverty and ethnicity and rise above the masses through baseball. Fante juxtaposes the experiences of

**The Saga of Arturo Bandini* comprises the following four novels arranged in terms of narrative sequence: *Wait Until Spring, Bandini* (1938, reprint 1983), *Ask the Dust* (1939, reprint 1980), *Full of Life* (1952), *Dreams from Bunker Hill* (1982). Fante, however, first introduced his alter ego, Arturo Bandini, in *The Road to Los Angeles*, his first novel which, although completed in 1936, was published posthumously in 1985 by Black Sparrow Press which lists it as part of the *Saga*. Ed.

Molise's dream of "making America" through sports with the reality of the life of leisure led by the protagonist's wealthy best friend. In all of these works, the protagonist is never successful in his attempts to transcend his social position.

While John Fante was one of the most prolific of Italian American novelists and story writers, he spent much of his life earning a living as a contract writer for Hollywood film studios. His greatest success was his adaptation of his novel *Full of Life*. The homonymous film version (1956) starred Judy Holiday and Richard Conte and was nominated for an Academy Award. Fante's screen credits include: *East of the River* (1940), *The Golden Fleecing* (1940), *Youth Runs Wild* (1944), *Jeanne Eagels* (1957), *The Reluctant Saint* (1962), *A Walk on the Wild Side* (1962), *Something for a Lonely Man* (1968), *My Six Loves* (1963), and *Maya* (1966). His Hollywood experience is the basis for his novella *My Dog Stupid,* published posthumously in *West of Rome* (1986).

His success as a screenwriter never satisfied his early yearnings to become a great writer, and so he continued writing novels. In 1977 he published *Brotherhood of the Grape,* a novel that focuses on a son's relationship to his father in the last year of the father's life. Fante's contribution to the Italian American tradition is his depiction of the myth of assimilation as a way of achieving the American Dream. The dream is achieved through "making America" as an artist, and it is the dream that guided many children of Italian immigrants away from their Italian heritage through materialism toward full membership in American culture. He creates this myth through his depiction of the Italian American family in *Wait Until Spring, Bandini* and their attempts to achieve the American Dream with dignity. In *Wait Until Spring* Fante depicts the father and mother as heroic figures who seem unconnected to any historical period. Fante's representation of *italianità* is encoded in three figures: the father, Svevo Bandini; the mother, Maria Toscana Bandini; and grandmother Dona Toscana. Against these figures he sets up the American identity through bankers, clerks, and the Widow Hildegarde. Caught somewhere between these two extremes of identity, the Italian and the American, are the children, Arturo, Federico, and August, who achieve a synthesis of Italian and American identity. In the preface to the 1983 republication of *Wait Until Spring, Bandini,* Fante pointed to it as the source of "all the people of my writing life, all my characters are to be found in this early work" (8). *Wait Until Spring* was made into a film in 1989, produced by Francis Ford Coppola, directed by Dominique Deruddere, and starring Joe Mantegna and Faye Dunaway.

In 1955 Fante was stricken with diabetes, which would bring on blindness in 1978—after which he continued producing novels by dictating to his wife, Joyce Smart Fante. In the late 1970s Black Sparrow Press rediscovered Fante through

the poet and novelist Charles Bukowski; since then it has published or republished all of Fante's writings. Fante died in 1983 at the age of 74.

Jerre Mangione

Jerre Mangione, who is better known for his autobiographical writings, produced two novels, which, while respected by critics, have rested on library shelves in relative anonymity. Both of these novels come out of Mangione's experience of the world in the 1930s and 1940s. In the course of this period of politicization he came to understand the terrible threat that European fascism presented to the world. As he worked to understand it better he befriended Carlo Tresca, an Italian antifascist and anarchist who came to America in the early 1900s to aid the exploited Italian immigrant laborers. His interactions with Tresca became the material upon which he would build his second novel, *Night Search* (1965). Based on the assassination of Tresca, *Night Search* dramatizes the experience of Michael Mallory, the illegitimate son of antifascist labor organizer and newspaper publisher Paolo Polizzi, a character based on Carlo Tresca, who, according to Mangione, was murdered while on his way to a book party celebrating the publication of Mangione's *Mount Allegro: A Memoir of Italian American Life*. *Night Search* follows Mallory as he searches for the murderer of his father. Mallory is an apolitical public-relations writer, inclined toward liberalism, who through his investigation of his father's death learns to take action and, in doing so, comes to an understanding of where he stands in relation to contemporary politics. Mallory very much resembles Stiano Argento, the protagonist in Mangione's earlier and more strongly antifascist novel, *The Ship and the Flame* (1948).

In the latter novel, based on his European experiences of the late 1930s, Mangione presents a more sophisticated overview of the effects of fascism by creating an allegory for the sorry state of political affairs in Europe prior to America's entry into World War II. The protagonist, Stiano Argento, is one of a number of characters fleeing fascist and Nazi powers. Argento, a professor of Italian history and literature in Sicily who is accused unjustly of antifascist activities, escapes the fascist authorities with the help of local Sicilian people and is smuggled aboard the Portuguese ship *Setubal*. Aboard the ship is the Austrian anti-Nazi writer Josef Renner and a number of refugees from other parts of Europe. The ship, run by a fascist-sympathizing captain, is headed for Mexico. On the way from Lisbon it is stopped by a Nazi submarine and three men are to be taken off, including Renner, who is wanted by the Nazis for his earlier anti-Nazi actions. Renner, a friend of

Argento since their college days, escapes but finds he is unable to further resist the Nazis and commits suicide. Among Renner's papers is a draft of a novel based on Argento's antifascist activities, which Argento burns after reading. Denied entry into Mexico, the *Setubal* heads for Nazi-controlled Casablanca, where, Argento believes, the captain will turn over his passengers. Argento, a liberal Catholic, realizes that the prayers his wife urges him to say won't be enough; he must act to save the passengers from the captain, a Mussolini-like figure who is determined to return his cargo to a place where many will face death or internment in concentration camps. Argento, inspired by Renner's death and his writing, takes control of the situation and is able to douse the flame of fascism that threatens to engulf the ship. His decision to act comes from the guilt he feels about having let the flame develop the power that virtually destroyed his Sicilian homeland. Through his actions and those of Renner's Polish mistress, Tereza Lenska, the entire group, except for Peter Sadona, a Yugoslavian accused of being a revolutionary, are allowed to enter the United States. Mangione, aware of the dilemma of the liberal and the fate of the revolutionary in the world, created a microcosm of the larger world of his time that, while suggesting that the struggle against fascism can be won through heroic action, reminds us that intolerance and persecution of those who think, and especially act, differently than those who enforce the order of other forms of government still remain.

Mario Puzo

Interpretations of the Italian American family take on new dimensions in Mario Puzo's novels. The image of the honest, hardworking Italian immigrant family portrayed in his earlier work is abandoned for the portrayal of the family able to gain the power through whatever means possible—legal or illegal—necessary to control their environment. This control is represented through the figure of the godfather (**compare** or **padrino**), a figure which belongs to the second-most-important category in the hierarchy of Italian family order, which Richard Gambino has described in *Blood of My Blood: The Dilemma of Italian-Americans* (1974), as consisting first of family members, followed by godparents—the *compari* and their feminine counterparts, **comari** (godmothers). Godparentage was, as Gambino explains, "a relationship that was by no means limited to those who were godparents in the Catholic religious rites . . . and which would better translate as 'intimate friends' and 'venerated elders'" (20). Third in the order, according to Gambino, were "**amici** or **amici di cappello** (friends to whom one tipped one's

hat or said 'hello'), meaning those whose family status demanded respect" (21), and finally "*stranieri* (strangers), a designation for all others" (21). These levels can be read as circles or buffers designed to protect the family. With the nuclear family in the center, surrounded by the extended family, then by the *compari* and *comari,* and then by *amici,* the order of the family works like walls around a castle. *Comparaggio* (godparenthood) ranks next to the family because a trust had been established between the two that is stronger than any other relationship an Italian can have. Traditionally, godparents would be chosen from the circle outside of the "blood" family for the purposes of cementing a family-like bond between those involved. Godparents would be selected on the basis of their ability to contribute to the protection and well-being of the family, and selection was often a strategic, political decision.

In America, especially during the Depression era, those who held power in the Italian American communities (even gangsters) would be besieged with requests to be godfathers or godmothers to those who lacked access to power. It is not uncommon for a single individual to be a godparent in dozens of families. In return for accepting the honor of being a godparent, the godfather's or godmother's first name often became the second name of the child at baptism or the third name of the child at confirmation. The godparent would be expected to assist the godchild throughout life and to act as a counselor and a mediator, especially during intrafamily disputes. If a parent died while the child was still a minor, the godparent would take over the child's upbringing. This then is the background of the serious and sacred relationship in Italian culture that would become distorted through some of the literary and media representations that captured America's attention during the 1970s.

In an essay entitled "The Making of *The Godfather,*" Mario Puzo writes: "The book got much better reviews than I expected. I wished like hell I'd written it better. I like the book. It has energy and I lucked out by creating a central character that was popularly accepted as genuinely mythic. But I wrote below my gifts in that book (41)." *The Godfather* was the third novel written by Puzo. His earlier novels were his attempts to fulfill a dream of becoming an artist and escaping the ghetto world in which he had been born. Like John Fante, Pietro di Donato, and Jerre Mangione, Puzo's early encounters with such writers as Dostoevsky in his local library strengthened his belief in art and enabled him to "understand what was really happening to me and the people around me" ("Choosing a Dream," 24). It would not be art but war that would enable Puzo to escape his environment "without guilt" (26). Out of his experiences in Europe during and after World War II he crafted his first novel, *The Dark Arena* (1955), and ten years later he re-

turned to his life experiences growing up in a New York "Little Italy" to create *The Fortunate Pilgrim* (1964), which is a classic of Italian American literature.

In *The Dark Arena,* the protagonist, Walter Mosca (in Italian, *mosca* means fly), returns home from serving in the American occupation army in Germany. Unable to take up where he left off before the war, Mosca returns to Germany as a civilian employee of the occupation government and resumes his life as a black marketeer. While the novel received some good reviews, Puzo was disappointed that it did not make much money ("The Making of *The Godfather*," 33). *The Fortunate Pilgrim* received similar notices and brought him even less of a financial reward. With such a poor earnings track record, no publisher would advance him the money he would need for a third novel. In debt to the tune of $20,000.00, he began to look for a way out. "I was forty-five years old," he writes, "and tired of being an artist" ("Making of *The Godfather*," 34). Puzo draws on his experience of anonymity prior to writing *The Godfather* in creating the character Merlyn in his novel *Fools Die* (1979, see especially pages 57–78).

With the publication of *The Godfather* in 1969, Mario Puzo was instantly promoted to celebrity status. Not since the publication of Pietro di Donato's *Christ in Concrete* had an American author of Italian descent been thrust into the national spotlight on such a grand scale. The timing of *The Godfather*'s publication had much to do with its rapid climb to Number One and its long stay (sixty-seven weeks) on the *New York Times* best-seller list. The novel came off the press in the middle of the ethnic-revival period of the 1960s. It also followed nationally televised congressional hearings on organized crime and the publication of Peter Maas's nonfiction best-seller, *The Valachi Papers* (1968), through which mobster-turned-informer Joe Valachi spilled his guts on his activities inside organized crime.

The Godfather has done more to create a national consciousness of the Italian American experience than any work of fiction or nonfiction prior to or since its publication. It certainly was the first novel that Italian Americans, as a group, reacted to either positively or negatively. It appeared during a time when Italian Americans were just beginning to emerge as an identifiable cultural and political entity. Even though this book was much more a work of fiction than any of the earlier, more autobiographical, novels written by Italian Americans, *The Godfather* created an identity crisis for Italian Americans throughout the nation. Antidefamation groups denounced Puzo for creating a bad image of Italians in America; young Italian American kids formed "Godfather" clubs; and real Mafiosi claimed Puzo knew what he was writing about. For a while Puzo wrote a number of essays on the subject of Italian America that appeared in major, national magazines. These essays, while often undermining the image of Italians that he

created in *The Godfather* and his later novel *The Sicilian* (1984), are also quite critical of the Italian American's behavior in American society.

The effect of *The Godfather* was tremendous; it was as though a man with an umbrella was given credit for shading an entire city. Since its publication, and especially since its film adaptations in the early 1970s, Italian American novelists have been writing in its shadow and Puzo has become a recluse writing the screenplays for such films as *Superman* (1978) and *The Godfather Part III* (1990) and two more novels, *Fools Die* (1978) and *The Fourth K* (1990). Though sociologists and literary scholars may forever debate the value of Puzo's work, it cannot be denied that he is one writer who has left a permanent imprint on the American cultural scene through his representation of *italianità* and his creation of a mythic filter through which Italian American culture would be read.

New Voices

There are many novelists who, while recognized in studies such as Rose Green's, have remained in relative cultural anonymity. Mari Tomasi, Julia Savarese, Michael and Raymond DeCapite, Charles Calitri, Joseph Papaleo, Dorothy Calvetti Bryant, and Ben Morreale are just a few of the many who have contributed significantly to the deployment of the Italian American novel. But in the 1970s one woman emerged whose critical and fiction writing had a major impact on the literary scene.

Helen Barolini

Helen Barolini, a granddaughter of Italian immigrants, wrote one of the earliest third-generation novels to reinvent ethnicity through representation of the immigrant experience. *Umbertina* (1979), came along after the American ethnic-revival period of the late 1960s and early 1970s—a time when generational sagas such as Alex Haley's *Roots* appeared. *Umbertina* tells the story of four generations of Italian American women focusing on the immigrant matriarchal grandmother, her granddaughter, and her great-granddaughter. Unlike many writers from other ethnic groups, Barolini does not spend much time recounting the story of the second-generation woman. *Umbertina* presented in fiction what most previous Italian American writers had given us only through autobiographical and episodic reportage.

Umbertina is a novel of self-discovery, a *Bildungsroman* (a novel of forma-

tion) that, while it spans four generations, can be read as the historical evolution of the Italian woman into the American woman, as the feminization of the Italian woman as she becomes the Italian American woman. The novel is divided chronologically into three parts, each focusing on a female character: Part One: Umbertina 1860–1940; Part Two: Marguerite, 1927–1973; and Part Three: Tina, 1950–. Significant is the absence of the second-generation female figure, Umbertina's daughter Carla, whose life is presented only through her relationship as the daughter of Umbertina and the mother of Marguerite. In each part, the female character is in search of what turns out to be her self.

The opening of *Umbertina* presents Marguerite, the granddaughter of the immigrant Umbertina, in a male psychiatrist's office recounting a dream. This Jungian analyst interprets her dream, saying that it reveals her ethnic anxiety as to "whether you are American, Italian, or Italo-American" (16). He suggests that she might begin her search for self by digging into her family's past. What is significant about this novel is the portrayal of the Italian American experience through four generations of women.

Giose Rimanelli

In 1935 a ten-year-old native of Molise, Italy, entered a Catholic seminary in Puglia with the intention of becoming a missionary. Five years later he left, but though he may have lost his reasons for being a missionary of God, Giose Rimanelli has in many ways become a missionary of literature. His first novel, *Tiro al piccione* (1953), is a fictionalized autobiographical account of his early years in Molise and his experiences during World War II. This novel was translated into English by Ben Johnson as *The Day of the Lion* and published by Random House in 1954. It received critical praise and became a best-seller in America. Reissued in 1992 in Italy, *Tiro* became an instant best-seller and reignited interest in Rimanelli's life's work.

In the late 1950s, after a few more books, Rimanelli came to America to give a lecture at the Library of Congress, after which he was invited to teach and travel throughout North and South America. He decided to remain in the United States, where he continued to write poetry and fiction, publishing all of his work, except for some academic work, in Italian. Rimanelli had keen insights into the plight of the Italian American long before he ever became one. The Italian living in North America served as a regular subject in his writing. In *Una posizione sociale* (1959), he recounts the life of the Italian living in New Orleans in the early 1900s and examines the lynching of thirteen Italians. In 1966 he collected, edited, and

introduced *Modern Canadian Stories. Tragica America* (1968) contains his reflections of his first years in the United States.

In 1976 he gave us a greater insight into the literature of Italy through *Italian Literature: Roots and Branches*. Since 1990 a professor emeritus of State University of New York at Albany, Rimanelli continues writing his fiction in Italian and publishing it primarily in Italy. Early in the 1970s he wrote his first novel in English, *Benedetta in Guysterland,* published two decades later by Guernica Editions in Montreal, Canada. The first question that comes to the reader is why this novel was not published until 1993. After all, when it was written Rimanelli was an internationally acclaimed writer who had published seven very successful books in Italy that had been translated into eight languages. He was already a well-known journalist and cultural critic. Since 1961 he had been a tenured professor in American universities such as Yale, promoted on the merits of his writing and not by virtue of his academic credentials. So why didn't he publish this novel right after it was written?

The answer lies in the fact that Rimanelli did not write it for publishing; he did not write it for money; he wrote it for love, for love of literature and for his American friends whose responses he has included in the Appendix. *Benedetta,* was his first response to the demands of starting over again, from scratch, as a writer with a new language, a man of the world with a new toy. Yet while the language was new, his knowledge of world literature and his knowledge of America were not. While the emphasis of most Italian American fiction has been the Italian American experience, most authors have been unable to reach a distance from the subject that would enable them to gain the perspectives necessary to renew the story of Italian life in America. What Mario Puzo romanticized in *The Godfather* (1969), what Gay Talese historicized in *Honor Thy Father* (1971), Giose Rimanelli has parodied in *Benedetta,* and through parody he has gone beyond the Italian American subject by, above all, writing a book about literature.

Benedetta's story incorporates America's obsessive fascination with the Mafia, sex, and violence. *Benedetta* tells the story of America's flirtatious relationship with Italy and debunks the traditional stereotype of the Italian American gangster, through the love story of Clara "Benedetta" Ashfield and the real-life Mafioso Joe Adonis. The result is a vital sociopolitical parody that shows that sex and violence are, in fact, displacements of each other.

Benedetta in Guysterland, written in Albany, New York, in 1970 and published twenty-three years later in Montreal, the birthplace of the author's mother, is a novel that reaches beyond its own time, regardless of its subject, and gives to Italian American culture a needed and long-awaited presence in American literature.

Perhaps this is why it earned a 1994 American Book Award by the Before Columbus Foundation.

Don DeLillo

Of the little that Don DeLillo has revealed about his personal life, we know that he was born in 1936 to Italian immigrants and left his working-class, Italian American home to attend college at Fordham, a Catholic university in New York. His early life was spent in the urban settings of the Bronx and Philadelphia, where he most likely experienced the type of neighborhoods he writes of in a few of his early stories. Of his entire body of published work, only two of his earliest stories ("Take the 'A' Train," 1962; "Spaghetti and Meatballs," 1965) are set in "Little Italy," and these are the only works which use Italian American subjects as protagonists.

The Italian American signs that do emerge in DeLillo's novels are almost always relegated to the margins of his narratives in the same way his characters are relegated (or relegate themselves) to the margins of their societies. Of the ten novels DeLillo has published to date (1995), seven contain characters that can be identified as Italian Americans. However, DeLillo's novels contain any number of ethnic characters who have traits DeLillo suppresses and at times even erases (or has characters who try to erase). Indeed there is almost always an obvious ethnic character in his narratives whose very presence undoes, or attempts to undo, the knot of American identity. A consistent thread that runs throughout DeLillo's work is the posing of the question, "what does it mean to be American?" It is often through the ethnic characters that DeLillo delivers his most biting social criticism. Frank Lentricchia is one of the few critics to read the ethnic signs in DeLillo's work. However, Lentricchia makes no reference to any of the Italian American traces in DeLillo's works. In his essay "*Libra* as Postmodern Critique" from *Introducing Don DeLillo,* Lentricchia perceptively points to DeLillo's characterization of Jack Ruby as "an escape hatch back to the earth of the robust ethnic life" (212). Ruby's private world remains "outside the subterranean world of power . . . whose only exit is blood" (213). Counter to Ruby's self, which is found in the private world of ethnicity, is Lee Harvey Oswald, whose historical self is lost in the public world of political action. America can make us all Librans, as Lentricchia suggests (210), because it enables us to constantly re-form ourselves. For DeLillo, ethnicity and a loyalty to it represent the maintenance of an autonomous selfhood; to maintain a strong ethnic identity is to remain in the ghetto, on the margins of society.

DeLillo is one of the most prolific of writers of Italian descent. Signs of *italianità* and references to identification with other cultures surface in some way in nearly all of DeLillo's work, more often than not through minor characters. In *Great Jones Street* (1973) are a writer named Carmela Bevilacqua and a character named Azarian, who is into soul music and the Black experience (a version of Norman Mailer's "white nigger"?). In *Ratner's Star* (1976) there are the characters Consagra; Lepro, who uses a word that means both "why" and "because" (which the Italian word *perchè* does); and Lo Quadro. In *Running Dog* (1978) are a cop named Del Bravo and the Talerico brothers, Paul and Vinny the Eye, who as members of organized crime belong to families, and "families know where they belong" (220). This identification of Italians with families and of the Central Intelligence Agency (CIA) with organization replicates the dilemma presented in *Americana* ([1971] 1989) of the system vs. the family. In *The Names* (1982) Volterra is an artist-filmmaker who serves as the protagonist's alter-ego. In *White Noise* (1985) are Alfonse "Fast Food" Stompanato, the head of a college's popular culture department; and Grappa, both of whom represent assimilated Italian Americans. In *Libra* (1988) there's the *Mafioso* Carmine Latta, and again DeLillo refers to the CIA as the company and to the Mafia as the family. DeLillo uses these minor characters, who often appear more as caricatures, as foils against which an identity is created for his protagonist. However, by the time we reach his latest novel, *Mao II* (1992), while the Italian American signs seem to have disappeared altogether he continues to present the struggle between the private and the public, the individual and collective life, as the great challenge that faces every American.

In much of his writing, DeLillo treats the breakdown of family and the subsequent cultural fragmentation that forces people to forge identities out of materials that are presented to them from outside the family. Without the family the Italian American is able to become a cultural chameleon, affiliating with whatever he or she chooses. In terms of Italian American culture, DeLillo's abandonment of the Italian American as a subject of his writing suggests the decline of a distinct *italianità* that has assimilated into the larger American culture that is in decay; it is a culture that leads nearly all of his protagonists to search for a better life in the margins of society. Though DeLillo has successfully left the Old World and the myths more traditional Italian American writers have created in the New World (as Lentricchia says, "Writers in DeLillo's tradition have too much ambition to stay home" [*AmericanWriter* 2]), his departure is guided, if not haunted, by proverbs such as *chi lascia la via vecchia sa quello che lascia ma non sa quello che trova* (Who leaves the old way for the new knows what is left behind but not what lies ahead), and he may belong more to the Old World than one might think, especially

when we recall some of the proverbs that guided public behavior in southern Italian culture: *A chi dici il tuo secreto, doni la tua libertà* (To whom you tell a secret, you give your freedom); *Di il fatto tuo, e lascia far il fatto tuo* (Tell everyone your business and the devil will do it); *Odi, vedi e taci se vuoi viver in pace* (Listen, watch and keep quiet if you wish to live in peace). When looked at in this light DeLillo's writing is perhaps more closely aligned with the traditional southern Italian idea of keeping one's personal life to one's self. Strategically DeLillo avoids breaking a personal and an ancestral *omertà* by employing the narrative strategy of speaking through the persona of the Other, by creating a masquerade in which his ethnicity can enter the mainstream without detection. Though DeLillo has successfully avoided being identified as an "ethnic writer," his work is quite possibly extending the literary tradition of Italian American culture into a postmodern world.*

Antoinette De Rosa

Born in Chicago's Taylor Street "Little Italy," Tina De Rosa started writing down stories of growing up at the urging of poet Michael Anania of the University of Illinois at Chicago, where she was working on an M.A. degree in English in the late 1970s. The work led to her first novel, *Paper Fish* (1980), which was nominated for a Carl Sandburg Award. The novel, in some of the most poetic prose to come from the hand of an Italian American, tells the story of a young girl growing up and out of a dying "Little Italy."

For De Rosa, the immigrant's story is one of the many myths the young learn as they interact with those of earlier generations. Her depictions of the old country do not come from research, travel, or reading, but from memory and imagination. *Paper Fish,* while centered on the lives of the members of the BellaCasa family, sounds a requiem for the death of one of Chicago's largest "Little Italies," in language that prompted Jerre Mangione to write for the book's back cover: "*Paper Fish* is an outstanding literary novel that breaks through the barriers of conventional fiction to achieve a dazzling union of narrative and poetry. Tina DeRosa writes of adults and

*The present essay was written before the publication in 1997 of Don DeLillo's momentous novel *Underworld* (New York: Scribner's) in which Italianness, including the linguistic dimension, figures prominently in the representation of the character Albert Bronzini, a retired science teacher and an urban saint of sorts. Although a novel of enormous scope, nothing less than the history of America from 1951 to 1992, its ethnic concerns will oblige a rethinking of the Italianness of DeLillo's writing, which Fred Gardaphe has so acutely diagnosed here through a symptomatic reading. Ed.

children with a captivating grace and sensitivity that make most contemporary novelists sound like clodhoppers. Hers is a delightfully fresh voice, filled with ancient wisdom yet new and probing, miraculously translating the most ineffable nuances of human existence in a language that is consistently beautiful and vital."

In examining reasons why Italian American fiction has not fared well in the commercial and critical arenas, author and critic Helen Barolini presented the following in a 1986 interview with Carol Bonomo Ahearn:

> *The greatest Italian American literary piece is still* Christ in Concrete. *And perhaps as a female counterpart to it Rosa Casserttari's story which was written down as oral history by Marie Hall Ets. Both those narratives are autobiographic, although di Donato's is couched in fictional form. But both leave the brute strength of experience and it is this experiential mode that denotes both our richness of material and our burden. It is as though style and linguistic daring are still being sacrificed to the white heat of telling our story. Only when our history—our story, if you will—has been transcended will we come into our own stylistically and be open to some greater experimentation of theme and style. (47)*

This idea of transcending the history in order to present the story is one that has been practiced and realized by the second and third generations of Italian American writers, the best of whom have met that challenge to experiment with technique and style and, in so doing, have carried *italianità* into new areas. Evidence of this stylistic innovation comes with De Rosa, who renders her narrative with poetic impressions:

> *Underneath, the street is brick, brick that is no longer whole and red, but chipped and gray like the faces of dead people trapped under lava. The street heaves up bricks, the guts of the street spit up brick. The face of the street cracks open and reveals its belly of brick, the gray faces. Squads of men in white t-shirts and hard hats with pickaxes in their hands chew into the street's cement face and the face cracks and there is no body under the bricks, only the cracked cement face. Then the street explodes, explodes in the faces of the men with pickaxes who come to take the streetcar line away.... (133).*

De Rosa at once creates and preserves the *italianità* of a Chicago neighborhood in imagistic language that was impossible for her ancestors to articulate.

Tony Ardizzone

One of the most successful of today's young Italian American writers is Tony Ardizzone. In 1975 he received his M.F.A. in writing from Bowling Green State University and, from 1979 to 1987, directed the writing program at Old Dominion University before accepting in 1987 an associate professorship at Indiana University, where he teaches in the creative writing program. In 1978 Tony Ardizzone published his first novel, *In the Name of the Father.* It tells the story of a young Jewish boy's passage into manhood through his search for a lost father. Though the novel failed to gain national support, it established Ardizzone as a writer with a bright future. Eight years later Ardizzone completed his second novel, *Heart of the Order,* establishing *italianità* as a major theme throughout this unarguably American work. *Heart* received national reviews, and portions of it earned him a National Endowment for the Arts Fellowship and a 1985 Virginia Prize for fiction. In the novel the protagonist, Danilo Bacigalupo, son of Italian immigrants, brother of many, grows up on Chicago's north side. In a game of alley baseball he hits a line drive that changes his life. Through a combination of realism and surrealism, Ardizzone displays the stylistic experimentation and sophistication that Helen Barolini hoped Italian American writers would someday achieve. By marrying the story of an Italo-American to America's favorite pastime, baseball, Ardizzone, transcended the realistic, parochial world of "Little Italies" and established a work that speaks to all of America and yet carries with it the religious and cultural peculiarities of *italianità*. The same year that *Heart* appeared, Ardizzone's first collection of short stories, *The Evening News,* was published by University of Georgia Press, which awarded the book its Flannery O'Connor Award for short fiction.

Kenny Marotta

Working with stories he heard while growing up, Kenny Marotta, a graduate of Harvard College and a Ph.D. from Johns Hopkins University in English literature in 1974, created *A Piece of Earth* (1985). The novel portrays the interaction of two Depression-era Italian American families. As Marotta's first novel, *A Piece* was well received by the critics. In it Marotta fights the myths and stereotypes that have been created and perpetuated by American popular media. One of those myths is that Italians who came to America wanted to retain their customs and wished to remain with their own kind, speaking the language of the old country.

Marotta dispels this myth in the following interior monologue of his character Antonia:

> It was a wise move, who can deny it? To have thought I could escape poverty, and come here, to find more. To melt, and to find days just as hot, not to mention winters that kill you with snow and ice. To have hoped I'd escape the words I heard every day—for I thought I'd go to a country where I'd never hear that speech by which my father badgered me, my children cried to me, and my neighbors came running with their "e' murtu, e' murtu." But here I've lived among more fools than I ever knew in my life before, and they all speak that language, though some so that you can hardly understand it (83).

This immigrant's lament is characteristic of Marotta's ability to defy the stereotype of Italian Americans as happy-go-lucky, clannish people and establish three-dimensional characters. Novels, such as Marotta's first, give dignity to Italian Americans, through depth, wit, and a generous as well as genuine representation of *italianità*.

Jay Parini

Gore Vidal and other critics have compared Jay Parini's novel, *The Patch Boys* (1986) to Mark Twain's *Huckleberry Finn* and John Knowles' *A Separate Peace*. What is it about Parini's writing that has enabled him to make his mark on American fiction using *italianità*? Parini had not read Fante, or di Donato, nor is he writing consciously in an Italo-American tradition. However, when reading Parini's *Patch Boys* we cannot help but be reminded of both the ironic humor of Fante and the social consciousness of di Donato. The novel is narrated by a young Sammy di Cantini and tells the story of a young man's coming of age during the summer of 1925. It is interesting to note that Parini, just as Ardizzone and Marotta, has chosen to set his work in the immigrant generation's time period. Di Cantini is a narrator who reminds us of John Fante's Arturo Bandini. This self-mocking, self-doubting storyteller struggles to come to terms with his relationships with his family, friends, and neighbors. The ironic tone of the writing rings once again of Fante's style. The narrator's political consciousness reminds us of di Donato's Paul of *Christ in Concrete*. The coal mine becomes for *The Patch Boys* what the construction site was in di Donato's novel: the backdrop for the conflict of capitalistic greed vs. family need. Slowly di Cantini falls victim to the corporate world. And as with di Donato's

Paul, we are left with the belief that Sammy's sensitivity and great awareness will enable him to transcend life in the Patch and make something of himself.

Carole Maso

In 1986 Carole Maso made a most impressive debut as a novelist. *Ghost Dance* tells the story of a third-generation ethnic who, unlike earlier generations, has the option of picking and choosing from the many traditions that make up American culture. What Italian characteristics the protagonist, Vanessa Turin, does not inherit directly through experiences with her grandparents, she imagines and reinvents to fulfill her needs. Few novels capture so well the effects of the fragmentation that occurs when solid cultural traditions are fractured. In *Ghost Dance* Maso reinvented an *italianità* through her recovery of the myths that made up her ancestral past. Her father's mother emigrated from Sicily; her father's father, from Genoa. Her mother is of German, English, and Armenian ancestry. Out of these diverse cultural roots, Maso has fashioned a unique perspective on life and art. Maso's second novel, *The Art Lover,* was published in 1990. In her 1993 novel, *Ava,* the experience of Italy greatly affects the protagonist, Ava Klein, a Jewish American professor who tells her story on the bridge between life and death. *Ava* represents a daring step into new forms of narrating a novel that marks Maso as a major American writer. The novel, composed of fragments of recollection, lacks traditional narrative threads that usually weave a coherent plot and requires the reader to construct a story out of the silences that constantly interrupt the voice. The result is that *Ava,* no matter how many times it is read, is able to generate new connections that create new meanings.

Conclusion

These authors represent only a fraction of the number of American writers of Italian descent who have made significant literary contributions to American culture. The novels of such writers as Josephine Gattuso Hendin, Anthony Giardina, Denise Giardina, Gilbert Sorrentino, Albert DiBartolomeo, Anna Monardo, and others document a variety of experiences found in Italian American life and will no doubt find their way into future discussion of the contributions of Italian American novelists and the deployment of the novel by American writers of Italian descent. Following the bibliographic resources cited below is a listing of novels that begins the work of establishing an Italian American canon.

Further Reading

Bibliographic Resources

Ahearn, Carol Bonomo. "Interview: Helen Barolini," *Fra Noi* 25 (September 1986): 47.

Bona, Mary Jo. "Claiming a Tradition: Italian American Women Writers" (Ph.D. diss., University of Wisconsin, 1989).

Gambino, Richard. *Blood of My Blood: The Dilemma of the Italian Americans* (New York: Doubleday, 1974).

Gardaphe, Fred L. *Italian Signs, American Streets: The Evolution of Italian American Narrative* (Durham: Duke University Press, 1996).

Green, Rose Basile. *The Italian-American Novel: A Document of the Interaction of Two Cultures.* (Cranbury, N.J.: Associated University Press, 1974).

Lentricchia, Frank, ed. *Introducing Don DeLillo* (Durham, N.C.: Duke University Press, 1991).

Peragallo, Olga. *Italian-American Authors and Their Contribution to American Literature* (New York: S.F. Vanni, 1949).

Puzo, Mario. "The Making of *The Godfather*." In *The Godfather Papers and Other Confessions* (New York: Fawcett Crest, 1972).

Tamburri, Anthony J., Paolo Giordano, and Fred L. Gardaphe, eds. *From the Margin: Writings in Italian Americana* (West Lafayette, Ind.: Purdue University Press, 1991).

von Huene-Greenberg, Dorothee. "Interview: Pietro di Donato." *MELUS* 14, nos. 3–4 (Fall–Winter 1987): 33–52.

Canon: Italian American Novelists (Selected Works)

—Compiled by Fred Gardaphe

Ardizzone, Tony. *In the Name of the Father* (New York: Doubleday, 1978).

———. *The Evening News* (Athens: University of Georgia Press, 1978).

———. *Heart of the Order* (New York: Henry Holt, 1986).

Arleo, Joseph. *The Grand Street Collector* (New York: Walker, 1970).

Barolini, Helen. *Umbertina* (New York: Seaview, 1979).

Bryant, Dorothy Calvetti. *Miss Giardino* (Berkeley, Calif.: Ata Books, 1978).

Calitri, Charles. *Rickey* (New York: Charles Scribner's Sons, 1952).

———. *Strike Heaven on the Face* (New York: Crown, 1958).

———. *Father* (New York: Crown, 1962).

Cavallo, Diana. *A Bridge of Leaves* (New York: Atheneum, 1961).

D'Agostino, Guido. *Olives on the Apple Tree* (New York: Doubleday, 1940).

De Capite, Michael. *Maria* (New York: John Day, 1943).

De Capite, Raymond. *The Coming of Fabrizze* (New York: David McKay, 1960).

DeLillo, Don. *Americana* (Boston: Houghton & Mifflin, 1971).

———. *End Zone* (Boston: Houghton & Mifflin, 1972).

———. *Great Jones Street* (Boston: Houghton & Mifflin, 1973).

———. *Ratner's Star* (New York: Knopf, 1976).

———. *Players* (New York: Knopf, 1977).

———. *Running Dog* (New York: Knopf, 1978).

———. *The Names* (New York: Knopf, 1982).

———. *White Noise* (New York: Viking, 1985).

———. *Libra* (New York: Viking Penguin, 1988).
———. *Mao II* (New York: Viking Penguin, 1992).
———. *Underworld* (New York: Scribner's, 1997).
De Rosa, Tina. *Paper Fish* (Chicago: Wine Press, 1980).
DiBartolomeo, Albert. *Blood Confessions* (New York: Dutton, 1992).
Di Donato, Pietro. *Christ in Concrete* (Indianapolis, Ind.: Bobbs-Merrill, 1939).
———. *The Love of Annunziata* (one-act play). In *American Scenes*, ed. Wiliam Kozlenko (New York: McGraw-Hill, 1941), 119–138
———. *This Woman* (New York: Ballantine, 1959).
———. *Three Circles of Light* (New York: Julian Messer, 1959).
———. *The Immigrant Saint: The Life of Mother Cabrini* (biography) (New York: McGraw-Hill, 1960).
———. *The Penitent* (biography) (New York: Hawthorne, 1962).
Fante, John. *Wait Until Spring, Bandini* (1938; reprint, Santa Barbara, Calif.: Black Sparrow, 1983).
———. *Ask the Dust* (1939; reprint, Santa Barbara, Calif.: Black Sparrow, 1980).
———. *Dago Red* (short stories) (New York: Viking, 1940).
———. *Full of Life* (1952; reprint, Santa Barbara, Calif.: Black Sparrow, 1988).
———. *The Brotherhood of the Grape* (1977; reprint, Santa Barbara, Calif.: Black Sparrow, 1988).
———. *Dreams from Bunker Hill* (Santa Barbara, Calif.: Black Sparrow, 1982).
———. *The Road to Los Angeles* (Santa Barbara, Calif.: Black Sparrow, 1985).
———. *1933 Was a Bad Year* (Santa Barbara, Calif.: Black Sparrow, 1985).
———. *The Wine of Youth: Selected Short Stories of John Fante* (Santa Barbara, Calif.: Black Sparrow, 1985).
———. *West of Rome* (Santa Barbara, Calif.: Black Sparrow, 1986).
Forgione, Louis. *The River Between* (New York: Dutton, 1924).
Fumento, Rocco. *Tree of Dark Reflection* (New York: Knopf, 1962).
Giardina, Anthony. *A Boy's Pretensions* (New York: Simon and Schuster, 1988).
Hendin, Josephine Gattuso. *The Right Thing to Do* (Boston: David Godine, 1988).
Lapolla, Garibaldi M. *The Fire in the Flesh* (New York: Vanguard Press, 1931).
———. *The Grand Gennaro* (New York: Vanguard Press, 1935).
LaPuma, Salvatore. *A Time for Wedding Cake* (New York: Norton, 1991).
Mangione, Jerre. *The Ship and the Flame* (New York: A. A. Wyn, 1948).
———. *Night Search* (New York: Crown, 1965).
Marotta, Kenny. *A Piece of Earth* (New York: William Morrow, 1985).
Maso, Carole. *Ghost Dance* (San Francisco: North Point Press, 1986).
———. *The Art Lover* (San Francisco: North Point Press, 1990).
———. *Ava* (Normal, Ill.: Dalkey Archive, 1993).
———. *The American Woman in the Chinese Hat* (Normal, Ill.: Dalkey Archive, 1994).
Monardo, Anna. *Courtyard of Dreams* (New York: Doubleday, 1994).
Morreale, Ben. *Monday Tuesday, Never Come Sunday* (Plattsburgh, N.Y.: Tundra Books, 1977).
Pagano, Joseph. *Golden Wedding* (New York: Random House, 1943).
Papaleo, Joseph. *Out of Place* (Boston: Little, Brown, 1970).
Parini, Jay. *The Patch Boys* (New York: Henry Holt, 1986).
Pola, Antonia. *Who Can Buy the Stars?* (New York: Vantage Press, 1957).
Pollini, Francis. *Night* (New York: G.P. Putnam's, 1961).

———. *Excursion* (New York: G.P. Putnam's, 1965).

———. *Glover* (New York: G.P. Putnam's, 1965).

———. *The Crown* (New York: G.P. Putnam's, 1967).

———. *Pretty Maids All in a Row* (New York: Delacorte, 1968).

Puzo, Mario. *The Dark Arena* (New York: Random House, 1955).

———. *The Fortunate Pilgrim* (New York: Atheneum, 1964).

———. *The Godfather* (New York: G.P. Putnam's Sons, 1969).

———. *Fools Die* (New York: New American Library, 1979).

———. *The Sicilian* (New York: Linden Press, 1984).

———. *The Fourth K* (Thorndike, Me.: Thorndike Press, 1991).

———. *The Last Don* (New York: Random House, 1996).

Rimanelli, Giose. *Tiro al piccione* (Milano: Mondadori, 1953).

———. *Original Sin* (New York: Random House, 1957).

———. *Day of the Lion* (New York: Random House, 1957).

———. *Una posizione sociale* (Firenze: Vallechi, 1959).

———. *Tragica America* (Isernia, Italy: Marinelli, 1968).

———. *Benedetta in Guysterland* (Montreal: Guernica, 1993).

Savarese, Julia. *The Weak and the Strong* (New York: G.P. Putnam's, 1952).

Sorrentino, Gilbert. *The Sky Changes* (New York: Hill & Wang, 1966).

———. *Mulligan Stew* (New York: Grove, 1969).

———. *Steelwork* (New York: Pantheon, 1970).

———. *Splendide-Hotel* (New York: New Directions, 1973).

———. *Aberration of Starlight* (New York: Random House, 1980).

———. *Crystal Vision* (San Francisco: North Point Press, 1981).

———. *Blue Pastoral* (San Francisco: North Point Press, 1983).

———. *Odd Number* (San Francisco: North Point Press, 1985).

———. *A Beehive Arranged on Humane Principles.* (New York: Grenfell Press, 1986).

———. *Rose Theatre* (Normal, Ill.: Dalkey Archive, 1987).

———. *Misterioso* (Normal, Ill.: Dalkey Archive, 1989).

———. *Under the Shadow* (Elmwood Oark, Ill.: Dalkey Archive, 1991).

Tomasi, Mari. *Like Lesser Gods* (Milwaukee: Bruce, 1949).

Valenti, Angelo. *Golden Gate* (New York: Viking, 1938).

Vivante, Arturo. *The Tales of Arturo Vivante* (short stories), ed. Mary Kinzle (Riverdale-on-Hudson, New York: Sheep Meadow Press, 1990).

Italian American Women Writers

Helen Barolini

When given an American Book Award in 1986, *The Dream Book: An Anthology of Writings by Italian American Women* (1985) was called a landmark in American letters for it collected, for the first time, Italian American women authors and presented them in various literary genres as a cohesive voice.

The anthology was intended not as an act of separatism, of setting a specific ethnic group apart from the main body of American literature, nor, indeed, Italian American women writers apart from their male counterparts, but rather as an act of inclusion and completion: restoring to the body of the national literature the names of women authors who had been overlooked even as men were being documented in literary histories and bibliographies and stood as the only examples of Italian American writing.

For when the past is not recognized, it is, in effect, denied. This was the case for Italian American women writers.

The question has always been: Why are Italian American women silent? It might well be instead: Why were they not heard?

Where is their written work, the testimony to their lives and experience? They have been dismissively referred to as "women of the shadows" from the title of Ann Cornelisen's book about a nonapplicable group, the village women of south Italy. In Alice Walker's words, "For years I have wanted to hear the voice(s) of the Italian American woman. Who is she? I have wondered. What is her view of life? Does she still exist?"

Yet the Italian American woman writer exists, and her experience is documented in a long literary record; if that voice seemed silent to the larger culture, it is because no critic or teacher amplified it. If the authors seemed women of

Boldface terms are defined in the Cultural Lexicon, which starts on p. 703.

the shadows, it was because the spotlight of attention never reached them.

There is an unsubstantiated but prevailing notion—as current as the misleading and negativist article by Gay Talese in the *New York Times Book Review* section, 14 March 1993—that there are no Italian American women writers as there are, so notably, Black, Jewish, and Asiatic women writers. Talese, in fact, alluding to some half-dozen male authors of Italian American background (and himself as novelist manqué) managed to write that misleading piece without mentioning a single Italian American woman novelist. They were referred to only in absentia by a question that spoke for Talese's uninformed view: "Were there no . . . Toni Morrisons, Mary McCarthys and Mary Gordons writing about their ethnic experiences?" An examination of college reading lists would have revealed to him that *Umbertina* (1979), as one example, my novel of the Italian American experience, has been listed in the company of Mary Gordon, Cynthia Ozick, Toni Morrison, Maxine Hong Kingston, Louise Erdrich, and others in American literature curricula on ethnicity and gender.

What Talese actually means is: Why aren't there any celebrities among Italian American women writers? Why aren't they talked about, written about, heard of? Where are their names on best-seller lists? But those questions beg others that he has never asked himself: What are the factors in the Italian American history and circumstances that have combined to keep valid writers of that background from being known? Why has the majority literature, in its cultural parochialism, ignored them?

Women, particularly, have been overlooked not only by the established majority, but also by feminist critics engaged in the recovery of women writers, and certainly by an inimicable publishing world. That does not in any way excise Italian American women writers from existence, precarious as that existence may be. They are the true "lost women writers," still to be recovered as their sister Black writers so notably have been.

In histories, sociological tracts, bibliographies, conferences, and articles, the names mentioned as Italian American writers have always been those of male authors, just as the achievers in other areas have been male; it is a near totality of male presence that effectively undercuts the importance and witness of women in the Italian American experience.

Exceptionally (an exception that proves the rule), it was in Andrew Rolle's *The Immigrant Upraised* (1968) that notice was given of Antonia Pola, an author who was silenced before she was formed. Her work, as far as is known, remains one book only, *Who Can Buy the Stars?* (1957), and that one tentative, unpolished, and yet so forceful in her woman's voice crying out for notice long before the

woman's movement opened a way. There are women even more lost than Pola, for she left a book while others remained unpublished, unrecorded.

The missing record of Italian American women's experience *as narrated by themselves* is one of the great lacunae in the national literature. To present a people from only one viewpoint—the male—is utterly to falsify a literary record and to cancel the important contributions of women writers.

Being Italian American, being female, and being a writer is being thrice an outsider, and why this is so is partly in the history and social background of the immigrant women who came to this country, partly in the literary mold of the country itself. The loneliness of seeming marginal is something well understood by an Italian American woman with literary aspirations, who seems to stand alone, unconnected to any body of literature or group of writers—an anomaly, a freak occurrence, a frequent nonrepeater, ephemeral.

After asking why Italian American women writers are isolated and few, a more difficult question to probe is: If grouped, do they form a cohesive identity and do they have, in fact, a specific resonance to their writing? I believe it to be so. The superabundant tradition from which they derive has given them a powerful identity; has bequeathed specific strengths and weaknesses, and has presented common problems as well as passions. The writing reveals the commonality. For no matter how oblique the themes or broad the views, overtones of who they are and how they feel, as formed by their values and history, show up in the work.

A base for Italian American women writers was the prior realization, as readers, that it was all but impossible to find writing in which to recognize the transcultural and transgenerational complexities of who we are, where we have come from, and what the journey has been.

Sandra M. Gilbert (née Mortola), who is well known under her nonidentifying married name as a literary theorist, feminist critic, and editor, but perhaps less known as a poet of strong, indeed passionate Italian American identity, stated the problem in a letter to me very precisely: "I am always struck by how few people have written about what it meant to be *us*!"

At the same time that there is a longing to validate one's identity, there are qualms about being too narrowly defined. Barbara Grizzuti Harrison once said in a panel discussion that she did not think of herself as an Italian American woman writer, but as an author who is all of that and more. We agree. It is not the qualifiers that are important, it is the writing. But it would be disingenuous to deny the influence of the ethnic factor, or the outsider position it has put us in. It was the aim of *The Dream Book* not only to create a record of literary achievement, but

also to help Italian American women find strength in solidarity and a means to greater visibility and voice.

In the end, each individual writer will transcend the limitations of qualifiers through the work itself. There is a great range among the Italian American women writers in their work and in their experience as writers. Some have a remote Italian connection, others were born in Italy. The degree of generational distance from Italy, or even the part of Italy one's people came from can have an influences on the writer. There are perceptible differences in style—from the older, wry, humorously cast family stories of Marie Chay or Rose Grieco to the more hidden allusions in the younger generation of writers like Agnes Rossi or Mary Caponegro. From the vivid realism of Julia Savarese or Marion Benasutti to the intense linguistic control of Ree Dragonette or the esoteric surrealism of Leslie Scalapino, great distances and changes are denoted. It indicates angles and complexity denied to the popular image of the Italian American woman.

There is an emerging Italian American woman whose newness of education and economic independence has, as in the best American tradition, advanced her from working to middle class, but the transition, tricky even for a Babbitt or a Gatsby, is even more vexed for someone who wants mobility upward together with the freedom to grow and change, but who also values the firmness of that early home base where the rituals, and food, and cultural traditions of her family and childhood reside.

Often, uncannily often, what the women write of, where they start, is with a grandmother, with those old women, most often illiterate or very little schooled, who had only their dreams, premonitions, and feelings to read for guidance. Going back beyond the Americanized generation of their parents, the writers feel an intense connection with the older generation and revere their iconoclasm, peculiarity, unconventionality, and strength.

Some of this wild oddness of the elders (before the homogenization into standard American) is recalled by Beverly Donofrio's piece "My Grandma Irene" in *The Village Voice,* 18 August 1987. The grandparent is a rich mine of the Italian American imagination—mythical, real, imagined, idealized, venerated, or feared. The grandparent embodies the tribe, the whole heritage for that—in overwhelmingly the most cases—is as far as a present-day Italian American can trace his or her descent.

After the immigrant grandparent, or, at most, great grandparent, there are only faceless hordes stretching back into the past—unknown, unvisualized, unnamed. Most Italian Americans embody the paradox of coming from very ancient roots of an ancient civilization but knowing their past only as far back as a grand-

parent. Most often there are no written records beyond the grandparent to tell us more of our ancestry; there are no Victorian photo albums in velvet covers. In our grandparents is incorporated all of the past, all of tradition and custom, and, we imagine, some archetypal wisdom and native intelligence. We start from the people who came here.

Rosemarie Caruso's vision of her grandmother walking down to her from the moon came in a dream—a benevolent vision in which the harsh reality never enters and which inspired Caruso's interesting exploration of tradition between mothers and daughters in a play called *Shadows of the Morning Moon*.

How often the grandmother figure turns up in dreams! From *The Dream Book*, Sandra M. Gilbert's poem "The Grandmother Dream" evokes the "Sicilian grandmother, whom I've never met / . . . sitting on the edge of my bed. . . ." Gigi Marino's poem "Angelina" memorializes a familiar and well-loved companion grandmother who dies and is often recalled:

> *I bless my dough each time*
> *I make bread—*
> *four hands punch it down:*
> *Mine, young and strong,*
> *and two old, skinny ones.*

In Michele Belluomini's poem "the dream" from *Sinister Wisdom*, she writes:

> *back in the old neighborhood*
> *cautiously picking my way among*
> *abandoned houses and broken sidewalks*
> *I am trying to follow my grandmother*
> *but clumsy, I fear I will fall*
>
> *she shouts encouragement to me in Italian*
> *she climbs a rope ladder to the attic*
> *words float from her mouth like water*

Diane di Prima's moving rededication of herself to the ideals of her grandfather is given stirring voice in her poem "April Fool Birthday Poem for Grandpa," published in *Revolutionary Letters* (1971).

Carole Maso's novel *Ghost Dance* (1986) includes unforgettable images of two Italian grandparents—one turned to the old ways of the past, the other fu-

ture-looking. And prize-winning fiction writer Jeanne Schinto has written of grandparents still haunted by their past in the story "The Disappearance" (*Shadow Bands*, 1988).

Other women writers have dealt with family themes by going back to explore strong ties with grandparents, as Diana Cavallo did in a *A Bridge of Leaves* (1961) and Tina De Rosa in *Paper Fish* (1980). *Umbertina* (1979) develops from the imagined image of a strong grandmother who will endow her descendants with her defiant courage.

The veneration, the awe, the wish for the strength of the grandparent is an enduring topos, ineluctable and omnipresent, a reference for almost every Italian American writer even when that writer is not writing specifically of a grandparent but of some other older ancestor, as in Mary Gordon's essay on her great-aunt, "Zi'Marietta." Mary Gordon an Italian American? How can that be? it might be asked. It can be because Gordon herself, at the beginning of her writing career entered a literary contest for young writers of Italian American background. Her mother's father was Italian; he had married an Irish woman who put the Irish Catholic stamp on their nine offspring so thoroughly that, in Gordon's own words, "the Irish drowned out, without a whimper, the Italians— a conquering nation meeting up with a docile colony it need only step over to rule." But it was not merely opportunism that led Gordon to identify herself as Italian for the sake of entering her essay "Zi'Marietta," in the UNICO literary contest. (It is of interest to note that while the 1976 winner of the UNICO national contest for young Italian American authors was a young man who has not been heard of since, the three young women who got honorable mention were Camille Paglia, Teodolinda Barolini, and Mary Gordon, all of whom have gone on to write notable works.) I think that the Italian connection for Gordon is an intense internal one, called upon subliminally, to correct the rigors of the Irish Catholic which she so often decries.

In her story, Gordon recalls the old woman's silver-backed brush and comb and her admonition: "Brush your hair five-hundred strokes a day and put olive oil on your hair after you wash it. American girls kill their hair. Your hair is alive; it is your glory as a woman." Left to her at Zi'Marietta's death, Gordon writes, "Now I have begun to use them, not often, but at those times when I most need to feel like a beautiful woman who has come from a line of beautiful women. When I most need that weight, Zi'Marietta's heavy silver comb and brush are there for me. . . . The silver comb and brush lie on the top of my dresser, heavy, archaic, ornate as history, singular as heritage." And, it may be added, symbolic of Italian stylishness and the aesthetic and sensual sense of self that is important to Gordon as a writer.

To all Italian American writers, it seems, the archetypal presence of an ancestor ("ornate as history, singular as heritage") is present.

Italian American women writers expose the signs and symbols, the auguries and directions of lives that were—and are—subject to great ambivalence, to dual pulls from opposing cultural influences, to dual vision.

The new writers assign meanings through their poetry, novels, stories, essays, and plays. Now in the written word—*their* written word, finally—can the instructions and directions for lives and futures be found. Their writings interpret the experiences of a collective past and bring into view what had been inexplicable, painful, dubious, conflicting. By writing their stories and reading each other, Italian American women come to know themselves.

The Historical and Social Context of Silence

The question to ask is not why Italian American women were silent so long, but: What were the women doing that impeded the act of writing? What were their lives like as they were transplanted from one culture to another?

The words of a cultural representative from Italy to the United States in the early 1980s seem emblematic of a long-engrained attitude of Italy toward Italian Americans. The mention of Italian American women writers was met with words of impatience and even a certain derision: Who *are* they? Why aren't they stronger? . . . more important? Who has heard of them or ever seen their books on racks at an airline terminal? How many people would any of them draw to a lecture? (Significantly, at the same time, in 1980, the Agnelli Foundation issued a monograph titled *The Italian Americans,* deciding it was time for the mother country "to revivify relations with the descendants of emigrants from our shores . . . that there be a rapprochement between the Italian American world and contemporary public opinion in Italy.")

In a time of hype when the prevailing standard is whether one has been interviewed on television for fifteen minutes of celebritydom, it was a dispiriting display of lack of critical judgment and historical understanding, and of a popularity-chart attitude that lingers in the mother culture and asks impatiently of its descendants abroad: Why aren't you better than you are?

The why is in their history.

It is not negative history, a litany of ineptness or missed opportunities. Quite the contrary: Given the adverse factors of extreme deprivation and provenance from areas that provided them with no practical preparation of language, civil or

political skills, schooling, or even basic literacy, the southern Italians who made up the bulk of the late-nineteenth-century or early-twentieth-century exodus did, in large part, translate their innate strengths and canniness into successful American terms. They did secure an economic foothold in their new environment and started the educational process that has turned their children to the professions and managerial positions.

At the same time, they also secured a sense of double alienation. The Italian immigration to the United States was preponderantly by people who were not wanted or valued in their land of origin, then found they were not wanted or valued in their new home country when they aspired to more than their exploitation as raw labor. Some of this discrimination still sticks in the Italian American memory, regardless of social advance.

That the literary arts lagged behind pragmatic ones in development is not hard to understand. A people without a written language and a literature (for Italian was as foreign to the great mass of immigrants as was English) had first to acquire not only the words and concepts of their new world but the very *notion* of words as vehicles of something beyond practical usage. In contrast, the ease and style of African American writers attests to the centuries of their exposure to, and absorption of, English. For Italian Americans, a realistic people for whom hard work and modest economic gains took precedence, the fact that literary writing does not immediately—or even usually—produce financial rewards meant it had to wait.

Italian Americans cannot be conveniently generalized; they are differentiated by a multitude of variables, including class, political activism, occupation, religion, education, the region of Italy from which their ancestors came and where they settled here, and to which generation in the United States they belong.

But, by and large, the women have a commonality.

They are women who, with rare exceptions, had never before been authorized to be authors (of themselves, of the word)—not by their external world, nor again by their internal one. A woman like Bella Visono Dodd (1904–1969), born in south Italy and brought to this country as a child, managed to become a highly educated college professor, later taking a law degree, and was known as a labor activist and public speaker on the rise in the Communist Party. But glory was transitory, and at high personal cost, as she relates in her ominously titled and curiously unrevealing autobiography, *School of Darkness* (1954). She defied the old ways for the sake of her successful career and remained childless, only to lose her marriage and her closeness to her family of origin and their ways, and to find herself finally cast out of the party to which she had given so many years of her

life. Her story ends with a desperate sense of loneliness and a return to the religious beliefs of her childhood. It is a stark and foreboding morality tale of the overachieving woman, one that could give little comfort to any mid-century Italian American woman looking for someone to emulate; it remains a testament of how even a supereducated Italian American woman was unable to transcend her background to write deeply of relationships and to evoke in vivid personal terms the depths of her internal turmoil.

The very thought of making one's life available to others through publication was alien to earlier Italian American women, and even Dodd, quite extraordinary in writing an autobiography, was not forthcoming concerning many areas of her life; she seems to have approached her written story as an act of contrition for past sins.

The women did not come from a tradition that considered it valuable to set down their lives as documents of instruction for future generations; they were not given to introspection and the writing of thoughts in diaries; they came from a male-dominated world where their ancillary role was rigidly, immutably restricted to home and family; they came as helpmates to their men, as mothers of their children, as bearers and tenders of the old culture. The creativity went elsewhere—into managing the homes, growing the gardens, making the bread, elegant needlework. Though they brought native strengths—sharp wits, tenaciousness, family loyalty, patience, and courage, which are skills for survival—they did not acquire until generations later the nascent writer's tools of education, confidence of language, the leisure to read, and the privacy for reflection.

When you don't read, you don't write. When your frame of reference is a deep distrust of education because it is an attribute of the very classes who have exploited you and your kind for as long as memory carries, then you do not encourage a reverence for books among your children. You teach them the practical arts, not the abstract ones.

Italians attach little value to exact meaning and the literalness of words. *Parole femmine,* they say in Italian: Words are feminine, words are for women, frivolous and volatile, a pastime in the marketplace. Deeds are masculine; men engage in action that is concrete, real. This is unlike the Jews, people of the Book, for whom the survival of race identity was closely tied to a constant reading and analysis of the Bible; and unlike Fundamentalist Christians, believers in the Word, who implicitly trust words and honor them as revealed truth. It is useless for disgruntled self-appointed critics to ask why there are no Norman Mailers or Eudora Weltys among Italian American writers, as if our writing could or *should* be homogenized into a WASP, or a Jewish, or any other framework. What has been

written authentically from the unique experience of being of Italian background in America may yet prove to be more valuable in the long run than all of the other writing being conformed to prevailing majority notions.

The long history of the Italian people has made them skeptical; it is as if, numbed by the rhetoric that continually whirls about them, inured to the conventional formulas of empty ***complimenti*** (compliments), they tend to lose all notion of words as conveyers of anything "real." What is real is life in the ***piazza*** (town square), church ceremonies from birth to death, the family at the table.

Words themselves are meant for fanciful approximations, polite artifice; they are relative and circumstantial, illusory and masking, but not for relying on. Even more distrustful of words are those who cannot read or write them—all of which creates distancing from that most abstract act with words, the writing of them into imaginative literature. It would take time—generations—before the habit of literature was widely rooted among Italian Americans.

The first survey of their literary activities was *Italian-American Authors and Their Contribution to American Literature*, a bibliography compiled by Olga Peragallo and published in 1949. She listed fifty-nine authors (with an amiable leniency that included Nicola Sacco and Bartolomeo Vanzetti), eleven of whom are women and, of those, only two whose names are known today: Frances Winwar and Mari Tomasi. In a preface to that work, the late Italian critic, author, and professor emeritus at Columbia University Giuseppe Prezzolini lent his keen and acerbic observations. He noted that at the time of Peragallo's compilation, there were, by Census count, 4,574,780 Italian Americans in the United States, of whom 3,766,820 still declared their mother tongue to be Italian. "This leaves," he wrote, "only 827,960 who spoke English at home; that is a very small minority from which one could expect writers to come forth. . . ." He also noted that, of the fifty-nine writers, "the amount and value of their literary output would certainly be greater if the members of the first generation had come to America endowed with a culture of their own and if they had been able to absorb also the culture of the United States. They found two barriers: the language and the social background. . . . Since these families were driven from Italy by poverty, the ghost of poverty followed them throughout their lives and influenced the education of their children."

Those children, including any hypothetical aspiring authors, were but one or two generations into the use of the English language in any way, let alone as a literary vehicle; they had to acquire the skill of becoming book readers. It was their American schooling that provided the beginnings of relating to literature, a literature not of their own world nor of their own experiences, but of Anglo-

American models that would, in turn, feed their sense of alienation.

And though, by the early years of this century, some men of Italian American background had begun to write and publish books, for the women it was to be a much longer, harder, and later development. Again, there are exceptions. Two notable women stand out as lone beacons rendering even deeper the dark void around them.

Sister Blandina Segale (1850–1941), a teaching nun of the Sisters of Charity, whose letters describing her mission to the Far West from 1872 until 1893 were published in book form as *At the End of the Santa Fe Trail* (1948), is the earliest known author among Italian American women. She was of northern Italian stock and arrived in this country in 1854 at a time when Italians were so few and far between that there was no developed prejudice against them as would later be the case. She was educated, bilingual, and her letters show a cultivated person who delighted in arranging a Mozart *Mass* for Christmas in a mining town, who made knowing allusions to the *Commedia* of Dante, and who taught a quartermaster's daughter Italian by reading *I promessi sposi* with her in the Santa Fe outpost where they were stationed. Sister Blandina became a civic influence in the Western territories and a social activist who was instrumental in ending the lynch law.

She wrote, as she says, in scraps of time, on scraps of paper, throwing the pieces into her desk drawer for a moment of leisure when she could enter them into her journal as a faithful record of the mission life and work of the nuns in Santa Fe under the authority of Bishop Lamy. In Sister Blandina's case, there is a tantalizing noncrossing of paths with another recorder of mission life, the novelist Willa Cather, who was to immortalize Lamy and other French-born Jesuits in her novel *Death Comes for the Archbishop* (1927). Regretfully, Cather minimized not only the work of the Italian Jesuits in the West, but certainly the achievements of the female religious in the Western territories.

Willa Cather's oversight remains symbolic of the displacement and neglect of Italian American women writers. From Sister Blandina on, her sister writers have been omitted from the record.

Sister Blandina was far more autonomous than other women of her day, and many generations ahead of the later-arriving southern Italian immigrants, among whom she would return to work in Cincinnati for the rest of her long life. Her memoirs leave no doubt of her enterprise, her adaptiveness, her self-reliance, and her deep satisfaction in her work. She is justifiably impatient with those who wonder how she could give up "everything" to be a nun.

Sister Blandina had the resourceful and adaptive qualities of the celebrated Anglo-American pioneer women. Yet her singular voice cannot alone fill the dearth

of personal written recollections from immigrant Italian women in the form of diaries, memoirs, or letters.

In 1961 a novel by Marie Chay called *Pilgrim's Pride,* pieced together from individual stories based on family lore and first appearing in a number of noteworthy journals, including the *Saturday Review,* documented the experience of her northern Italian immigrant grandparents in the same mining territory in which Sister Blandina had worked. Chay's novel is humorously written; it had to be to be publishable, for a skewed and stereotypical vision of Italian Americans made them acceptable on the margins of the national literature as easy-to-take, humorous ethnic types rather than substantial individuals fraught with the full range of human problems and emotions. Chay's dedication page carries an interesting disclaimer that indicates that there was more depth and darkness to her characters than was allowed into the book: "Thanks to the imagination and memory, the people are no longer what they once were, and the harsh, sad and tragic events they often went through are now something that even they might laugh about."

Sharing the stereotype of Italians as sunny, easy-going types is Camille Paglia, who flaunts as trademark "That's Italian!" whenever she requires an imprimatur for some of her dubious notions. She routinely overstates, as in this passage from her UNICO essay "Reflections on Being Italian in America": "The vivacity of our responses to the realm of the five senses makes it nearly impossible for us to suffer from that alienation which is the modern dilemma; the sense of absurdity and meaninglessness is a northern-European invention. Gothic gloom has never made much of an impact upon the sunniness of the Mediterranean temperament."[1] Already a Ph.D. from Yale University and in her fourth year of teaching literature at Bennington College when she wrote that, Paglia seems not to have heard of Pirandello, who invented the theater of the absurd, nor does she seem to have read the despairing and powerful novels of Verga or the poetry of Montale, or to know anything of the unsunniness of actual Italian American life. She has certainly no inkling of Professor Andrew Rolle's psychohistory of Italian Americans, *Troubled Roots* (1980). (Before Paglia, Rose Basile Green, in her comprehensive study *The Italian American Novel: A Document of the Interaction of Two Cultures* [1974] offered a similar notion of sunniness in the thesis that the basic optimism of Italian American writing will eventually win it success and a place in the American showcase of literature.) One has to look beneath the cliches of optimism and sunny temperament to discover other, shadowy, complicated layers of the Italian American temperament. A way to dismiss a people is to see them in simple terms, as the critics have, and not give recognition to the reality of their yearning, defensiveness, humiliation, and anguish as reflected in their plays, novels, and poetry.

The second notable exception, after Sister Blandina, to the late appearance of Italian American women in writing is Frances Winwar, born Francesca Vinciguerra in Taormina, Sicily, in 1908. She came to this country at a young age and was fortunate in having educated parents and a father who heaped a great deal of attention and encouragement on her. Going through American schools with precocious ease in acquiring English, she started writing poetry; her first publications were a series of poems in Max Eastman's *Masses* when she was only eighteen. As was the case with the later writer Mari Tomasi, Winwar had the inestimable good fortune to find a WASP mentor in the publishing world: Lawrence Stallings, the literary editor of the *New York World,* hired her as a book reviewer. She went on to become a successful, prolific writer, not unhelped by the anglicization of her name which, she has related, was a condition to the publication of her first book, *The Ardent Flame,* (1927), a study of Francesca da Rimini. Astutely, it now seems, she had consigned to the flames her first manuscript, an autobiographical novel, and thereafter was able to turn away from herself in order to concentrate on historical novels and the biographies of literary figures. This distancing from herself and her origins must be taken into account as part of the price paid for getting on in a publishing world not interested in Italian American material, regardless of the quality of writing, which in Winwar's case was of high enough level to win her the estimable and lucrative first *Atlantic Monthly* nonfiction award in 1933.

Winwar's nonidentification as an Italian American (paralleled these days by the very successful Evan Hunter, who was born Salvatore Lombino, or by women whose married names conveniently camouflage their origin) was reflected in the remarks of a curator of a large collection of books and manuscripts by American women. Asked if any Italian American women were represented, she said, "No, this collection represents *la crème de la crème.* For instance, if Christina Rossetti were American, not English, she'd be here." Then, asked about Frances Winwar, she said, "Oh, yes, of course she's here, but I never thought of her as Italian."

The historical and social context of literary silence, and the clues to the missing women writers can also be understood in Italian family mores. It is a story of conflicting cultures, alienation, unschooled parents' fear of the American school they sensed, rightly, was taking their children from their authority, the growing resentment of American children toward their Italian parents, the resulting split in loyalties and personalities, the passing of the old ways, and the painful rites of passage into the new.

Italian women who came to this country did so as part of a family—as daughter, wife, sister, or "on consignment," chosen, sometimes by picture or some-

times by hearsay, from an immigrant's hometown to be his wife. There was no pattern of the independent Italian woman emigrating alone to better her lot as there is, for instance, of Irish women who, advantaged by having the language, came over in droves to be hired as maidservants, many then living out their lives unmarried and alone. An uneducated Italian woman could not exist, economically or socially, outside the family institution that defined her life and gave it its whole meaning. She came, like an indentured servant, bonded to her traditional role. The oral history of Rosa Cassettari by Marie Hall Ets, published in 1970 as *Rosa: The Life of an Italian Immigrant* by the University of Minnesota Press, is that of a "picture bride" sent for in Lombardy to marry the man in Arkansas who had requested her. Rosa's story was recorded by a social worker at Hull House in Chicago and is the dramatic story of many such women.

The Italian woman had little choice but to put herself under the protection of a man. Women outside the family structure were scorned as deviants from the established order; they were either wicked or pitiful, but always considered abnormal. Unmarried or widowed women, who were thought, in their singleness, to be consumed with envy and full of spite toward women with men, were thus commonly held to be the chief casters of the evil eye. In Grazia Deledda's novel *La Madre* (1920; *The Mother*, 1923) filled with the intensity and superstitions of the harsh Sardinian world of a century past, a mother watches her son, a priest, fall under the spell of a woman who, being "rich, independent, alone, too much alone," was outside normality and thus a threat to all around her. In a patriarchal society, any female (save nuns) whose life was not defined by a man's would be suspect.

Rosemary Clement (a name truncated from Clemente during immigration processing) has Lena, a character in her play *Her Mother's Daughter* (1983) boast: "I'm a thinker—I thought myself right out of getting married." Eventually Lena's place in society is legitimized when she becomes a mother to her young orphaned niece and nephew, thus redeeming her womanhood and removing suspicion of egocentricity from her life. In Clement's *October Bloom* (1984), the psychological warfare between the old family and the new woman is still being fought as her mother opposes a young girl's desire to go away to college. Beverly Donofrio's vivid memoir, *Riding in Cars with Boys: Confessions of a Bad Girl Who Makes Good* (1990), also recounts her own desire for education being thwarted and how her reaction was played out in a wildness that could have left her life a permanent ruin.

As with Caruso and Clement, the Italian American playwrights Donna de Matteo and Michele Linfante have written works with deep connections to the mother–daughter bond—a connection much heightened in a culture that still

worships the ancient goddess as madonna—and to the wider world of women. The most dramatic analysis of mother and the link to daughter is in Angelyn Spignesi's exploration of the female psyche through her study of anorexia in *Starving Women: A Psychology of Anorexia Nervosa* (1983); the anorexic woman being the one "who explicitly enacts a war against aspects traditionally binding the female to the material earth—food, body, reproduction."

A model of the Old World Italian woman who was resourceful, strong, and able to live by her wits and hard labor when it was demanded of her (as it often was when her husband preceded her to America and was gone for years at a time without any word) appears in Lucinda LaBella Mays' 1979 novel *The Other Shore*. In Mays' book, the mother must pit herself against the elements, poverty, and outside hostility in order to survive. She keeps herself and her child alive by her unremitting sacrifice and strength until the long-awaited ticket to America arrives. The child, Gabriella, will find for herself that the long-dreamed-of street of gold is actually the American public school. She will liberate her life from her mother's through education and self-direction, thereby providing an elevating but historically uncommon ending.

For this much is certainly true of Italian women: They have resources of strength that are denied in the stereotype of them as merely submissive and servile creatures to their men. At the beginning of the twentieth century, Jacob Riis, who photographed and wrote of the immigrants in their tenement life on the Lower East Side of New York City, noted, "There is that about the Italian woman which suggests the capacity for better things."[2] Did he mean her tenaciousness, her endurance, her grace under pressure, her faith? Those are the qualities her granddaughters, in particular, cherish and have reintegrated into their lives, adjusted for new uses.

There are certain mindsets, however, brought over with the immigrants, that take longer to reshape. Self-denial was the psychological preparation among peasants for survival in regions where **la miseria** (wretchedness) was the norm of life and there was no chance of a better one: denial of aspirations; denial of any possibility of change; denial of education to children as being futile; denial of interest in anything beyond one's home walls; denial of goals as being unreachable and, therefore, an emotional drain and psychological impairment. Strength, psychic and physical, was conserved just for sheer life support. If they could not better themselves in the old country, what they could do, and did, was to leave. It was an act of enormous courage and faith, but inevitably there clung to them remnants of the old *miseria* mentality, for survival had once more to be secured, and this time in an alien land.

The ingrained suspicion of education used to be expressed in the saying, *Fesso è chi fa il figlio meglio di lui* (It's a stupid man who makes his son better than he is). In America, schools were not always regarded as the road to a better future; often they were seen as a threat to the family because they stressed assimilation into American ways and gave children a language their parents did not have. Reading was ridiculed as too private, too unproductive, too exclusive an enjoyment—free time should be spent with the family group, not on one's own. All the family wanted was cohesion and no threat of change; learning gave one ideas, made one different; and writing produced nothing. These were the criteria of a people involved completely in economic survival, and for their time and place they were right. Reading and writing are the rewards of a well-established class.

Here as in Italy (and, indeed, in all rural societies) the family was the chief fortress against the unknown. This commitment to family was placed solidly upon the shoulders of women, and, because of their service to it, it was they were who were most denied educational opportunities. Though the number of Italian Americans in college has doubled since mid-century, Italian American women still lag behind both Italian American men and women of other groups when it comes to higher education—and this despite the models of educated, achieving women like Ella Grasso, former governor of Connecticut; Geraldine Ferarro, Democratic candidate for the vice presidency of the United States in 1984; Eleanor Cutri Smeal, past president of the National Organization for Women, and Aileen Riotto Sirey, a successful psychotherapist in New York and founder of the National Organization of Italian American Women, a remarkably successful union of accomplished professional women who sponsor mentoring and other programs.

Nevertheless, studies show that Italian American students, in the main, (1) still demonstrate a predilection for pragmatic and vocational studies over the liberal arts, (2) are relatively disinterested in cultural activies, (3) do not get involved in extracurricular activities, and (4) in general feel alienated from faculty and other students at their colleges. A 1986–1987 study of Italian American college students at the City University of New York (CUNY) yielded the disquieting finding that "Italian American young people still have difficulty in establishing personal independence from their close, and in many cases, 'enmeshed' families."[3] More disturbing is the profile of the female student of Italian American background: extremely anxious, suffers from low self-esteem, is often depressed, and has an "irrational anxiety about appearance and other issues of self-worth." Her prime identity in family continues to operate against her involvement in the world outside.

At best women are getting a mixed message: Yes, better yourself through education, but don't get beyond your family; learn the wherewithal to gain eco-

nomically, but not how to develop an independent mind and spirit that might take you away from us. Still present is the concept of education as a practical tool to help one earn more money, not as the door to autonomy and lifelong self-development.

A film of 1970, *Lovers and Other Strangers,* reiterated the theme of not growing beyond the old style of doing things, as the father in an Italian American family confronts a son who is contemplating divorce: "What do you mean you're not compatible? What do you mean divorce? What are you—better than me? Look at me, do I have to be happy to be married! What makes you think *you* got to be happy? Why do you think we keep families together? For happiness? Nah! It's for *family!*"

Thus is the dialectic set up—there is resistance to change, but change is inevitable. In the very title of Louise A. DeSalvo's incisive essay "A Portrait of the *Puttana* as a Middle-Aged Woolf Scholar" is the recognition that an educated woman was (is) looked on with deep suspicion: The emancipation of the mind puts her outside familial control, beyond male authority, and that has to mean intolerable anarchy. The psychological warfare between the family and its progeny is still in fierce engagement.

Italian American writing is full of the dilemma of the individual on the road to selfhood who is caught in the anguish of what seems a betrayal to family. Breaking out of the family, or the neighborhood, is part of the transformation undergone in the search for one's autonomy.

The very solidity of the Italian American family, which is its success, makes it hard to break away from; and to be a writer means breaking away and taking distance from where one came in order to see it better, more truly. This puts the Italian American woman writer in a precarious position: Do you keep close to family, enjoying its emotional warmth and protectiveness, and lose your individualism; or do you opt for personal independence? Do you go against the grain of your culture to embrace the American concept of rugged individualism? Do you choose loneliness over denial of self to the family good?

This is an issue of separating, present in all human beings; the process by which one becomes himself or herself. The working out of independence–dependence factors is critical in the development of both men and women and for people of all backgrounds, but some cultures, in effect, demand too enormous a ransom to release the individual from benevolent captivity.

Human growth is toward individuation and the full development of the self. We begin in dependence upon our parents and work our way, sometimes only partially and often painfully, toward separation. This is a hard step for those of

the traditional, family-focused Italian American communities because removal often brings loneliness and new tensions along with independence, and creativity, and self-fulfillment. Strangely, the ways of the past have hung on in this country even as Italy has radically changed from what it was in the 1950s. An industrialized and transformed Italian society makes an Italian American community like Marianna De Marco Torgovnick's Bensonhurst (a neighborhood of Brooklyn), which tenaciously holds on to the old isolation, seem a remote backwater by comparison. Now a scholar, author, and professor of English at Duke University, she has written of her early background in "On Being White, Female, and Born in Bensonhurst" (*Partisan Review,* [Summer 1990]), noting, as she ponders the sea change she underwent, that a residue remains: "You can take the girl out of Bensonhurst (that much is clear); but you may not be able to take Bensonhurst out of the girl."

There is an irony here, for the Italian thrust and talent as a people was always toward individualism. The Renaissance was created of giant personalities. But none of that high culture touched the masses of people who would form the major immigrant population and who, in arriving in America, would find their rebirth here.

Sounding like an analyst pointing the way to group maturity, Jackob Burckhardt wrote of the Italian people in *The Civilization of the Renaissance in Italy* (1860): ". . . this it is which separates them from the other western people. . . . This keen eye for individuality belongs only to those who have emerged from the half-conscious life of the race and become themselves individuals."

The immigrants who left Italy took the first step toward lifting themselves from that "half-conscious life of the race" in the very act of taking passage to America. That act linked them and their descendants to the American ideal of the self-made person. And the paradox is that by becoming self-made in America, Italian Americans may finally be more authentically Italian than they ever could have been remaining submerged in the separated, old way in Italy.

In a sense, Italians transplanted to America were asked to mature immediately from a state of child-like dependence (on family or church or landlord) to a state of self-reliance that went against the grain of their very being and most deeply held convictions about life in order to be what America said they should be.

Mario Puzo, touching in *The Godfather Papers* (1972) on the enormous exodus of the poor from the south of Italy, says: ". . . they fled from sunny Italy, these peasants, as children in fairy tales flee into the dark forest from cruel stepparents."

It is interesting that he casts it that way. It seems a very apt simile: If they came as children, they had either to grow very quickly or to remain as vulner-

able as children, dependent on family and familiar surroundings, their impetus halted.

The Italian American woman comes out of a family-oriented, patriarchal view of the world in which women stayed at home or, at most, worked alongside their immediate male kin, but were always dependent upon a male—their father, brother, husband, and, eventually, if widowed, their sons. Family was the focal point of the Italian woman's duty and concern and, by the same token, the source of her strength and power, the means by which she measured her worth and was, in turn, measured, the reason for her being. Historically the woman's role as the central pivot of family life was crucial because of the importance of the family over any other institution: It was the only unit that protected its members from the abuses of others and helped them recover from natural disasters.

Within Italian culture, reinforcement of the woman's role and definition in the family was gained through the strong Italian cult of the madonna, the Holy Mother who prefigured all other mothers and symbolized them, the quintessential *mamma mia*. But as Andrew Rolle, who has made a unique contribution to the psychological understanding of Italian Americans, has observed: "The Madonna had been a mother but scarcely a wife."[4] So, too, the Italian woman reduced her sexual role as her husband's lover to take on the role of *mater dolorosa* (suffering mother).

This acute observation helps explain the often vexed sexuality of the Italian American woman and how, in contrast to other couples, she was in the past so little a companion and friend to her husband. What she was mainly was "Mother," the continuum of life to whom her children will be bound forever by the stringent strings of respect, weekly visits, confidences, obedience. Such restrictiveness may explain the performer Madonna's obsession with publicly acting out sex as she sings "Papa, don't preach": She is vehemently cutting loose from the childhood bonds of Catholic education and strict patriarchal family mores.

Becoming ourselves is why some of us write; the being is part of the writing. Pietro di Donato, who died in 1992, described *The American Gospels,* his work in progress, as his revenge, his answer to all the past constraints: "I am writing *[The American Gospels]* because I was . . . a true believer, and I outgrew that and have to replace it with Gods of my own creation. . . ." Or, as Marguerite in *Umbertina* puts it: "What world is there that's not beached first in ourselves?"

The caustic of the American experience has changed the old role to a new one at the cost of an enduring psychological split and a tension that has, in Italian American women writers, become the material of much of their work.

The women who are second- and third-generation Italian Americans know

and honor their special background, but they also question it, and they are deeply aware of hopelessly ambivalent feelings about family and about those bonds, both healing and constricting, that are suffered as the heavy cost of preserving tradition. Barbara Grizzuti Harrison in her 1974 essay "*Godfather II:* of Families and families" (republished in *Off Center*, 1980) has stated the dilemma: "I think of the strength of Italian women, of strength perverted and strength preserved. And I am painfully confused. I want all of these people to love me, to comprehend me; I want none of them to constrain or confine me. And I know that what I want is impossible."

In a harsh environment, woman was recognized as life sustaining by being the central pivot of the family in a way every bit as concrete as the Navajo's traditional hogan, which is built on four poles named after female deities so that the support of the home literally rested upon the female principle.

Richard Gambino's *Blood of My Blood: The Dilemma of the Italian-Americans* (1974) examines the background of the Italian American experience and its past dynamics. He has described well the positive qualities expected of the female who was to become wife and mother; she was socialized at an early age to be serious, active, sharp, and practical. In the chapter Gambino devotes to women, "*La Serietà:* The Ideal of Womanliness," his espousal of those qualities is, however, too idealized a male vision of woman's place. True, she was the center of life of the whole ethnic group; true, it was she who expressed the emotions of the men; true, she must be useful to her family, for her value is based on practical usefulness; but it is less true to women than to men like Gambino that this ideal of **serietà** was the end-all and be-all of a woman's life. Gambino finds women's traditional role pleasingly full of the dignity and gravity that would honor an ancient Roman matron. Contemporary women stuck with the role are less gratified with it than Gambino has ventured to imagine.

"I have it like heaven now," says the widowed Rosa Cassettari toward the end of her life, "no man to scold me and make me do this and stop me to do that. . . . I have it like Heaven—I'm my own boss. The peace I've got now it pays me for all the trouble I had in my life."[5] Even unlearned and unlettered women like Rosa, once they got to America, gained a sense of there being potentially something more to their lives than family service.

Why, if the **donna seria** is such a paragon of sturdy virtues, has the Italian American male, as he evolves educationally, professionally, and socially, fled her company so completely? As one member of Aileen Riotto Sirey's New York ethnotherapy group admitted, "I never wanted to marry an Italian girl; I wanted to marry a WASP, someone who was educated and could help me to get ahead."

One verifiable phenomenon of educated Italian American males, like Gambino himself, is that they marry outside their ethnic group. Fleeing the traditional woman and her feudal role, Italian American men find social mobility and better company in educated Jewish or WASP wives. Still, they want their mothers and sisters to keep the traditional ways to which they return on festive occasions, filled with nostalgia and sentiment for old ways that can safely be left behind when it is time to go.

That flight was given recognition in the popular 1977 film *Saturday Night Fever,* in which the woman protagonist, named Stephanie MacDonald, becomes the symbol for the Italian American hero, Tony Manero, of what is better, achieving, upward in life. Tony leaves his Italian American Brooklyn neighborhood (and the Italian girl who pines for him) to follow MacDonald by crossing the bridge into her realm, Manhattan, thus signifying his willingness to grow beyond his ethnic group.

The one thing, then, according to the men, that a woman must not do is change. Since everyone leaned on her for support, she must be permanently accessible and permanently unchanging, a linchpin of traditional values. She could not exist as an individual with her own needs and wishes, for that would have toppled the whole patriarchal order and undermined the common good of the family. That is a heavy price to pay for the pedestal and a Holy Mother image.

A very contemporary use of the self-nullifying theme in the Italian woman's life is the metaphor of Rosemarie Caruso's 1983 play *The Suffering Heart Salon,* in which the ritualization of women's sacrificial lives is played out in a New Jersey beauty salon and embodied in the line, "You don't like it?—do it anyway!" Caruso parallels women to the sanctified Communion host of the sacrificial Mass: They exist to be consumed by the officiating priesthood of men. In their sacrifice is their blessedness and specialness. Thus they are revered by those who consume them and they, themselves, are made to feel consecrated by their role. In contrast, their daughters assert a need for self-identity and want to free themselves from the past patterns. In their self-actualization they *must* react against their mothers, but, in denying the value of the mother's role by their rebellion against it, they lay upon themselves a terrible dilemma.

As early as the 1943 publication of Michael De Capite's novel *Maria,* a different kind of Italian woman from the submissive women portrayed in di Donato's *Three Circles of Light* (1960) or popularized as Mafia women in *The Godfather* (1972) and elsewhere was presented—one far beyond the stereotypes they had already become in the larger culture. *Maria* is a penetrating study of a woman in conflict with the role she is expected to fulfill while she yearns for something else.

Maria is depicted, first, as a young girl who submits to the marriage her

father arranges with a harsh, silent, and ultimately stupid man. She experiences divorce and abortion when both were not only unusual in American life, but also matters of extreme gravity in an Italian enclave. She befriends a Jewish woman; she expresses sexual interest in a man not her husband; she finds intense satisfaction in her comradeship with women at work. She knows the reality of life and achieves a sense of belonging in her city environment and at work. Only in her final action, when she rejects her second husband through feelings of guilt toward her eldest son, does something contrived enter into the novel. It is as if Maria, accepting the maternal role as more important, is made to act as the male author thinks she should. Still, it is a choice, not something forced upon an unformed person, as her first marriage was, and in the difficulty of the choice lies the seeming nobility of her self-sacrifice. Despite the novel ending on the traditional note of a mother's sacrifice, one feels the truth and depth of feeling of the character: Maria is beautifully realized and is resonant with an inner turmoil not normally accorded women who seem to act only as automatons of their tradition.

But such female characters have not fared well with critics, who are more comfortable with predictable stock figures, having certain assumptions about Italian Americans that they find hard to relinquish. Thus, Julia Savarese's novel *The Weak and the Strong* (1952) got a very harsh reception. Critics called her strong descriptions of poverty and the Depression era "bleak," "tough," "unrelenting" and—the ultimate pejorative—"humorless." Of course, for an established male writer, di Donato, say, or Jean Rhys, or Flannery O'Conner, that kind of unsentimentality would be **verismo** (realism) of the highest order.

Antonia Pola's fictional character Marietta in *Who Can Buy the Stars?* (1957), impatient with a weak husband, had the stamina to become a bootlegger as she tried in vain to buy happiness for her family and herself. Mari Tomasi also created women who acted independently of the notions of how they should act and suffered reviewers who misread her work as "Quaint . . . unpretentious . . . pastoral."

The women's voices, whether in literature or in the recorded interviews of Professor Valentine Rossilli Winsey,[6] in their poignant resignation or anger, strongly contradict the image of Gambino's ideal stoic matron, *la donna seria*. A chorus of female voices speak of unhappy marriages, no choices for their lives, and a kind of bewildered regret for what life had been. All that sustained them was that they did what was expected of them.

The Italian immigrant woman met her duties and responsibilities and showed again and again her strength, her resilience, and her timeworn patience. Indeed, her success in keeping the family together has earned her recognition and tributes from sociologists and other scholars.

But no barricade around the family unit is large enough or strong enough to keep out the winds of freedom wafted on the New World air. The minute their children set foot in the American school system, and imbibe the notions that in this land all is possible and each person has the right to be self-fulfilled and seek a personal happiness, something happens to the old bonds. They do not disappear, but they loosen. They allow for new thoughts, new arrangements.

It became apparent that in Anglo-American life (for that was the dominant ethnic pattern and became the standard by which American society judged all other ethnicities as up to par or not) the family had less importance than political or economic institutions, or even the school system. It was soon perceived that "Americans" rated self-sufficiency over family ties. Individual success and achievement were what counted, not sacrificing oneself for the family. As a result, the value of the Italian woman was diminished in the new land: She became old-fashioned, backward; she became the focus of well-meaning social workers who wanted to "save her" from what they viewed as an undemocratic patriarchal system without recognizing that in that very system she had found validation and had nothing, immediately, with which to replace it.

The psychological battering endured by the Italian American woman has been considerable. Professor Winsey quotes the poignant remark of a solitary old immigrant woman reflecting on her experience of life in America that keeps her children and grandchildren so busy running they have no time for her. "Bread rises," she said, "only when it's allowed to stand awhile. The soul, too, has its own yeast, but it cannot rise while it's running. It's certain that I got things here which in Italy I never could have gotten. But I had things in Italy which in America I still cannot find—yeast, yeast for the soul!"[7]

The Italian woman's soul was in her consecration as core of the family, upholder of its traditions and the transmitter of its values. In that role, her hardships and sacrifices were repaid, her value was inviolate, and this gave her a positive sense of her self and of her power—a power that was, however, often manipulative and always relative, confined as it was to the home environment and not used in the world at large. In America she was quickly dethroned from venerable matriarch into the image of the old woman in the kitchen stirring the sauce, heartwarming, maybe, but actually a figure of ridicule, a caricature. She and the stern values she stood for were no competition for the seduction of America, which beckoned her children away from stern duty, away from tacky self-sacrifice, away from the old way.

Not able to Americanize on the spot, the Italian immigrant woman suffered instant obsolescence (an American invention) and became an anachronism,

a displaced person, a relic of a remote rural village culture.

There is no doubt that family structure was an essential aid to the successful transplantation of Italians in America; it continues to provide stability and important verities and a specific Italian American identity. But now it is its tensions that are being explored by such works as Barbara Grizzuti Harrison's autobiographical *Visions of Glory: A History and a Memory of Jehovah's Witnesses* (1978), the novels *Miss Giardino* (1978) by Dorothy Calvetti Bryant, *Tender Warriors* (1986) by Rachel Guido deVries, *The Right Thing To Do* (1988) by Josephine Gattuso Hendin, and Anna Monardo's *The Courtyard of Dreams* (1993).

Contrary to folklore, humorous stereotypes, and appealing portraits of the traditional Italian woman as pillar of her family, Italian American literature abounds with portraits of other women who are harsh, frequently cruel, crushing, unfeeling. They are embittered and malevolent; given the strictures of their own lives, there is plenty of reason why.

There is a dark underside to the bright picture of the compact Italian American family life so extolled by sociologists and onlookers: There are undereducated men caught in low-paying, demeaning jobs who vent their frustration within the family; there are fathers who have deserted families to go West to seek the illusory fortune for which they left their native land; there is divorce or long, bitter marriages and the brutalization of their children and women by unhappy men. And there is the heritage of unworthiness turned into a sour self-hate that has cropped up anew in Gay Talese's denigrating remarks about Italian Americans given such prominence by a paper, the *New York Times*, that is itself often seen as having an anti-Italian bias.

Some mothers, as in Jennifer Lagier's poem "Second Class Citizen," in Marion Benasutti's fictionalized memoir, *No Steady Job for Papa* (1966), or in Rosemarie Caruso's plays, are portrayed with a humor that nonetheless still reveals layers of apprehension or bleak disappointment in their lives, an edge of rancor toward their lot. Other types include the angry mother in Jacquelyn Bonomo's poem "The Walk-In Closet" and the unsentimentalized portrait in Gigi Marino's "Angelina," who, pregnant again, throws herself down a flight of stairs. There are the haunting words of Janine Veto's poem "Naturally, Mother":

> *Freud aside, all our fathers*
> *do not matter*
> *A woman bleeds through her mother*[8]

But family in all its facets—not only the dark side, but also as benevolent warmth and support in Rose Grieco's stories and as compulsive nostalgia and life

ritual for Diane di Prima, who writes about shopping for eels for an Italian Christmas Eve in *Dinners and Nightmares* (1960); or as the pleasant surprise of Maryfrances Cusumano Wagner's poem "Preparations for an Italian Wedding," (1983) in which she finds, "You will be glad you followed tradition; / you will at last understand your mother"—is what gripped the imaginative powers of the first Italian American writers and, most forcibly, women, because their roles were so enmeshed in that powerful mark of their culture.

More than for men, the displacement from one culture to another has represented a real crisis of identity for the woman of the Italian family, and she has left a heritage of conflict to her children. They, unwilling to give themselves completely to the old ways she transmitted, may end up with burdens of shame and ambivalence, as shown in Gambino's above-mentioned CUNY report on Italian American students. The pernicious inheritance gets passed on; even third and fourth generations feel the remnants of conflict.

For the modern woman, it means that traditional power (based upon selflessness and sacrifice) has been transmuted into a more gratifying autonomy and self-awareness. If not power over her children in the old way, she has instead power of choice in her own life and the possibility of a democratic family style.

Yet there remain valid ties to the past, and feminists of Italian American background look for, and find strengths in, the old traditions, especially in those parts of the model of *serietà* that Gambino described as assertiveness, committment to work, activism, and practicality—qualities, it turns out, that are identified as normal expectations for *all male* Americans! Utilizing the Old World values of the ideal of Italian womanliness in the service of the contemporary quest for individuation, the evolving and maturing Italian American woman must learn to redistribute the focus of those qualities from the exclusive service to others to service to herself as well. That is the balance she explores in her writings. The pull back toward family is powerful; the push forward toward self-enhancement is ineluctable. How to arrive at an equilibrium is something that Louise DeSalvo's essay "A Portrait of the *Puttana* As a Middle-Aged Woolf Scholar" explores, not with the quaint self-deprecating humor of the past, but with pungent and sophisticated insights.

While their specific voice often discloses their ethnic identity, Italian American women writers speak for all women: Their emergence is that of all women who lived in the shadows of others.

The sociologists and other professional apologists who extol the Italian American family had better listen to the women and to their literature—to the voices of women writers who are telling it as it is. Home life was never as satisfy-

ing and untroubled as the men said it was; it was what it was for historic and social reasons that are now surpassed.

Put Italian American women in the context of their origin, their time and place, and the collective psyche that formed and held them, and it becomes comprehensible why they have taken long to test language and flaunt tradition as writers, and to give themselves the authority to be authors.

In his above-cited 1993 *New York Times* essay, Gay Talese wrote that, for all of his status as a best-selling author of nonfiction books of reportage, he was inhibited from writing an autobiographical novel about his family for fear of the shame it would bring them. His regret as a writer was that he had to distance himself from his innermost material and write "facts" about other people's lives.

His misperception, however, is that *his* failure of nerve has kept *all* Italian American novelists from writing about family (or whatever) whereas, in fact, the contrary is true: The family has proved their most cogent material. Through wilfullness or ignorance, Talese simply discounted past decades of Italian American writing. Nor is he presently aware that the old culture of shame, of not giving up secrets, has been replaced, one by one, by a new Italian American woman writer.

Single-handedly, Cris Mazza revokes shame by the deliberate shamelessness of images in her collection of stories titled *Animal Acts* (1988). There is nothing that she and her sister writers (Mary Caponegro, Anna Quindlen, Jeanne Schinto, Carole Maso) flinch from writing. For them there are no more shadows.

Seeds of Doubt: The Internal Blocks

In America, the newly arrived faced the cultural imperative of the dominant society: To "pass" you had to lose your distinguishing identity and somehow become a stranger in your own life. This part of Maria Mazziotti Gillan's poem "Public School No. 18: Paterson, New Jersey"[9] perfectly catches the story:

> *Miss Wilson's eyes, opaque*
> *as blue glass, fix on me:*
> *"We must speak English.*
> *We're in America now."*
> *I want to say, "I am American,"*
> *but the evidence is stacked against me.*

Author Evan Hunter (who, born Salvatore Lombino, made a nomenclatural leap into America's mainstream) explores in his 1974 novel *Streets of Gold* the transmutation of Ignazio di Palermo into Dwight Jamison and his attempt, in an anglicized persona, to attach himself to the American Dream. The realization of the futility of it all comes because, in his self-made WASPness, Dwight Jamison finds he does not exist, he is a figment of the American imagination.

It was the myth that failed—the myth that told us we could and should be equally American in the Anglo mold, but forgot to mention that to force people to become what they are not produces not equality but enmity, enmity with one's self. Here is Gillan again from "Public School No. 18":

> *Without words, they tell me*
> *to be ashamed.*
> *I am.*
> *I deny that booted country*
> *even from myself,*
> *want to be still*
> *and untouchable*
> *as those women*
> *who teach me to hate myself.*

Thus begins what is a major motif in Italian American writing: the sense of being out of line with one's surroundings, not of one's family and not of the world beyond the family—an outsider.

Schooling provided no texts by authors with Italian names, no expectation that people of Italian background had a rich literature. Rather, the illiteracy of the Italian immigrants was stressed without the counterbalance that illiterate people do have a culture outside of books and an operative social system. Now the counter view of James C. Raymond's *Literacy As a Human Problem* (1983) can be stated: Neither wealth nor literacy guarantees superior sensibility; either can engender a warped set of values, fashionable vulgarity, and callousness toward the disadvantaged. People who are highly literate, like people who are very rich, are tempted to regard literacy (like money) as the measure of human worth.

No mention of any Italian achievement in social or humanistic arts was ever provided to dispel the message that Italian Americans were somehow less than the Tom Sawyers and Becky Thatchers around them. This sense of being alien in America pervades other ethnic groups as well. Feminist writer Vivian Gornick decried what she says is the squashing of ideals present in earlier generations of

Jewish social activists and the overlaying of revolutionary goals with the whitewash of Protestant ethics in order to fabricate stereotypes of middle-class virtues. This is possible, Gornick pointed out in a radio broadcast, because of the overwhelmingly prevalent WASP models in American schools and colleges.[10]

Schools were aided in the task of imprinting minds with the need to anglicize, to grow up with the look of America, by movies that projected images of Shirley Temple and the Andy Hardy character. Italian American homes, gardens, names, and churches were embarrassing—too ornate, too foreign. It was the pristine, classic simplicity of the white New England church steeple on the village green to which taste was expected to conform, not to the rococo excesses of Catholic sanctuaries, much less the gaudy, overwrought paganized pageants of saints in some parishes with which Italian Americans annually annoyed their Irish clergy. Lines from a poem by Elaine Romaine (née Romagnano) state it succintly: "You were always irish, god / in a church where I confessed / to being Italian."[11]

The Catholicism the immigrants found here was a stern, puritanical, inhospitable version of what they had known as their religion. In America everything was tinged by the Protestant ethic: Worth was measured by material achievement, visible riches, and success, all of which is quite at odds with the Catholic harmony of everyone having worth in the sight of God and there being a divine plan in everything with hope eternal for salvation. The Protestant ethic stresses competitiveness, anxiety, struggle to succeed, to move up fast and visibly. The Catholic emphasis is on passive acceptance, resignation, and having an internal sense of worth and dignity without the external show of prosperity that indicates Calvinist grace. It is the difference between a tolerant, live-and-let-live orientation and a chiding, judgmental one.

In order to become American, one had to learn to be alone. One had to *value* being alone.

There is in this mandate the belief in individualism, which is the positive message of Protestantism, an insistence on maturity by facing the existential predicament of our essential aloneness and the need to form one's self outside of, and beyond, family.

But growing up is difficult and filled with the traps of self-consciousness about being different and finding reasons for shame in the taste and smells of Italian foods, in the look of grandparents, in the decor of home and garden.

Imagine Italians in a Currier & Ives world: sleighing up at Christmas to a cold and isolated farm on a forest's edge instead of strolling through a village where houses are all snuggled one against the other and you can mingle in a piazza thick with people and human exchange. It is a different image of the world. The Ameri-

can penchant for being off alone in nature, for being Thoreau, was not what Italian immigrants valued; it is part of the American mind. Henry Steele Commager's fortunately outdated *The American Mind: An Interpretation of American Thought and Character Since the 1880s* (1950) viewed that mind as one in which not a Jew, nor a Black, nor a Catholic had a presence nor, consequently, did their particular sensibilities and visions of what this country means.

Sister Blandina Segale foresaw in her journal that establishment history, as written by "Mr. Bancroft" (in his nineteenth-century work, the ten-volume *History of the United States*), would not give the whole picture as to what had been accomplished in American life by non-Anglos. Commenting on how the freedom-of-conscience edicts enacted by Catholic Lord Baltimore in Maryland were frequently overlooked, she charges: "Yet look at the stream of articles constantly given to the public about Plymouth Rock and the Pilgrim Fathers!"—just as those who decry the Mafia as an Italian import forget that the Ku Klux Klan is an Anglo-American invention.

In its presumption of rightness (which is the other side of provincialism) the Anglo-conformist society determined that every group but theirs was "ethnic." Thus the disingenuousness, for instance, of John Cheever, who referred to his mother as "an Englishwoman" but denied that his writing, though concentrated on a small world of Episcopal suburbanites of British descent, was ethnic. British Americans simply take it for granted that the customs, language, and school curricula of this country are Anglocentric; this, to them, isn't "ethnic," it's natural. That it is so is in part the American exigency of having to give a common frame of reference and unity to the many disparate peoples who make up this country. But its elitist and value-judgment overtones were something more: a slur against other ways and cultures that was, and continues to be, highly damaging to the peoples who felt its sting.

"The truth is," wrote Joseph Alsop in his biography of Franklin D. Roosevelt, "that the America Roosevelt was born into . . . and even the America of 1932 was entirely White Anglo-Saxon Protestant by any practical test. . . the presence . . . on the citizenship-rolls of so many people of other origins did not in any real way alter the fact that America in 1932 was still a WASP country in all significant respects . . . non-WASP Americans, however able, were excluded from the normal opportunities of any moderately fortunate WASP."[12]

The children of the immigrants escaped the embarrassment of that world by immersing themselves in the books the American schools provided, books that provided heroes and heroines who were unfamiliar in Italian American life and were not only intriguing, but also provided a sense of displacement and estrange-

ment—varying in degree by generational differences, but all reinforced through reading. The Italian American self-image was never in perfect focus: One could never find who one was—only who the larger society thought one should be.

It is a delicate question of balance. Italian Americans internalized English literary culture and were certainly enriched by it but, in the process were denied knowing that their tradition had, in fact, riches and glories of its own.

America passed through its period of isolationism and, since the second half of the twentieth century following World War II, has inevitably become part of the total world scene abroad and more accepting of multicultural differences at home.

Different origins presume differences in temperament and attitudes; it was psychologically impossible for Italian Americans of earlier generations to fit themselves into the Procrustean bed of Angloconformity without, in fact, maiming a part of themselves

Consider Medea: She, the barbarian princess, the foreigner, was the ultimate outsider to culturally correct Jason, the Greek insider, and her internalized rage was at his contempt for her being "Other." It is the rage that always informs the writing of all of those who are perceived as different. It is there in James Baldwin's *The Fire Next Time* (1963) as he grappled with the theme of American identity; over and over it appears in much multicultural writing; it is in women's writing; it is in *The Dream Book* as I question why Italian American writers, particularly women, have been left out of the national literature.

"As I grow older, I think more and more about my cultural background, which I unfortunately denied for many years," playwright Michele Linfante told me; she expresses the prevalence of those internal seeds of doubt, known to many ethnics, as to whom she was supposed to be.

Would it have been different if Frances Winwar, back in the late 1920s and 1930s, had opened the door to respect for Italian American writers by letting her highly successful books read "by Francesca Vinciguerra"? One can speculate; the verifiable fact is that a well-regarded writer I know who has felt slighted by lack of review notice in the *New York Times* has vowed to write from now on under another name—Jewish or WASP. Another, a professor of Italian, has taken a nickname and combined it with his Saint's Day name to coin the perfect passing authorial name: Harry Gabriel.

"I am really Sandra Mortola Gilbert," explained Sandra M. Gilbert, "and my mother's name was Caruso, so I always feel oddly falsified with this WASPish-sounding American name, which I adopted as a twenty-year-old bride who had never considered the implications of her actions!"[13]

Names are powerful signals, and an Italian American surname sets up barriers of preconception or even prejudice in those circles of American literature that are hard to scale under the best of circumstances. Italian names are analogous to the high visibility of Black writers—they immediately signal difference. The Italian American women who have written as Gilbert, Bush, Clement, Bryant, Bair, Fields, Smith, and so forth are not seen as being who they actually are, and that is to be regretted for it feeds the notion of the missing Italian American woman writer.

On the other hand, since the appearance of *The Dream Book,* some women who previously "passed" with a married name have reclaimed an Italian maiden name, as, for example, have Marianna DeMarco Torgovnick and Maria Mazziotti Gillan whose newest collection of poetry is called *Taking Back My Name* (1991).

In her review of *The Dream Book, New York Times* editorial columnist Anna Quindlen wrote: "I am Italian American, my father's surname belies my mother's background. Our literature should in part reflect our lives, and mine has not. There is a world that has not appeared very often in modern American literature, a world of insular families scorned by an English-speaking society, torn by the lure of assimilation and the sure disintegration of tradition that this would bring."[14]

Italian American women writers are left with questions: How to become writers out of the intercultural tensions of their lives? How to use their individual selves narratively to oppose and/or understand the Otherness of the dominant society? What are the strategies for restructuring the self to fit the society?

What I find is that we write ourselves to know ourselves; we write of our differences in order to embrace them. Yet it is hard for society and the literature to accept our differences. It has been said that the very essence of the creative is its novelty; hence we have no tried and tested standard by which to judge it. Substitute "different" for "creative," and the conclusion is the same.

Another difference from other woman writers has been the degree of isolation each Italian American felt, a degree that has seemed to distinguish them from any other group of women writers. WASPs, and Jews, and Blacks are part of established groups; many minority women have their own particularized networks. In *Black Women Writers at Work,* Toni Cade Bambara says: ". . . what determines the shape and content of my work is the community of writers. . . . writers have gotten their wagons in a circle, which gives us each something to lean against, push off against."[15]

Not so with Italian American woman writers; with few exceptions, each of those who appeared in *The Dream Book* thought herself unique as a writer of Italian American background. Very few knew of others. *The Dream Book* itself helped

change the isolation as writers became aware of one another, held joint readings, formed groups, began to appear in collections, and were asked to talk at colleges and for women's-history-month events. Finally, with Emelise Aleandri's 1987 staging of *The Dream Book Revue* at the CUNY Graduate Center in New York, many of the women whose written work had appeared in the anthology were visibly brought together for the first time as a collective presence and voice.

"What is the way out of this dilemma?" asks Sandra M. Gilbert in an essay on Sylvia Plath, as she considers the paradox of Plath's (or any creative woman's) life: that even as she longs for the freedom of flight, she fears the risks of freedom. Interestingly, Gilbert states that double bind in terms that might have been taken to describe the Italian American sensibility: "How does a woman reconcile the exigencies of the species—her desire for stasis, her sense of her ancestry, her devotion to the house in which she has lived—with the urgencies of her own self? I don't know the answer."[16]

The exploration of an answer will be a deeper probing of those seeds of doubt that in the past have kept the numbers of Italian American women few; it will be the stuff of literature.

Already some of the myths embedded in the culture about women have crumbled. Jean Baker Miller's *Toward a New Psychology of Women* (1976; 2d ed. 1986) identifies growth as the most dynamic quality of being human. Growth means change, and human growth equals psychological change; it means that personal creativity is a lifelong imperative for having a fulfilled life. Miller's cogent insights acutely question the "desire for stasis" that Gilbert posited as a female exigency.

The assumption about woman's traditional role as static bearer of the past must be rethought in terms of what reality shows: Women are involved through child care in witnessing and fostering constant change and growth, for child development is *the* text of change and growth. Women, raising children, have absorbed lessons for change, not fixity. By twisting reality and going against the grain of their nature and the very texture of their experience, women have been conditioned by society, representing the values of the dominant male, into the appearance of stasis; made into compliant upholders of traditions in which men have a major vested interest. That interest is premised on the maintenance of status quo. The whole idea of male and female roles is a cultural imposition that conveniently banishes the right to feel oneself a *person* regardless of gender. The price to women has been the thwarting of creative growth and change in themselves.

The mother, as the principle of life itself, stands for the passage from stasis to movement, from unborn to born. Can it be (what cultures have long denied) that women are more change oriented than men, more flexible and tolerant, have

always longed for the psychological excitement of growth and change rather than their statuary calm?

Since women's psyches have been carefully attuned to the principle that women exist to serve other people's needs, the response of one older woman who waited until her children were grown to do what she wanted—be a writer—is not surprising: "I see writing as a reward," she said, meaning that even now it can be indulged only after the needs of her grown children and grandchildren have been taken care of.

Italian American women have particularly projected their feelings of worth outward, making affiliation central to their lives. Waiting to be confirmed by others, they often have a woefully undeveloped central core of self. Women's nature has been defined for them by the other sex, and woman's graceful compliance to male authority (whether in home situations or in public institutions) has been made to seem the measure of their femininity.

Italian American women have lagged behind other women in the experience of self-realization by internalizing the myths of the "sacrificial mother" and "everyone else first before me." Other women however, like Tillie Olsen in her story "Tell Me a Riddle" (1996), give us a glimpse of the myth deflated; Cynthia Ozick observes, "You can't be the good citizen doing petitions and making chicken soup for your sick neighbor, and still be an artist." Ozick has the self-confidence to be the artist—Italian American women writers, according to which generation they belong to are still learning it or have never had the problem.

Also valuable to an Italian American's sense of herself is Iris Sangiuliano's *In Her Time* (1978), a work that defines the common life journeys of women and the crises that trigger growth. It is a false dilemma, Sangiuliano says, for women to think they have to choose between family and career, because they can have both. Life, she finds, unfolds not predictably, but in "great surges of billowing change; and it is the unpredictable which is the seminal female ingredient for change: conflicts + contradictions = change."

Philosopher Martha Nussbaum, in her essay review on "The Ideal of the Educated Woman,"[17] finds that past theorists of woman's role, from Plato, who imposed on women a male notion of the Good Life, forward, have always described a female life that lacked something. Solutions, Nussbaum says, are not to be found in the past philosophical tradition; rather, a new chapter remains to be written by both men and women trying to live fuller lives in a joint human experience. What she foresees is that we face a plurality of different lives, sometimes conflicting and sometimes enriching each other. In daily choices, we construct new and fuller meanings to the ideal of "the complete human life."

If this is a dilemma for all Italian Americans, it is more so for the writer, and utmost for the writer who is a woman. For it is the woman who, at the core of the family, is the transmitter of its traditions and upholder of its values. Can *she* defect from the one institution Italians believe in, the family? Can she at least redefine the ancient laws for her advantage?

This is the paradox: Italian American women are the core of their families, and they are the ones who have most subordinated themselves to the well-being of the total entity. Family above self. But, being at the heart of things, it is they who, breaking the silence imposed on them by family loyalty, are best suited to make literary use of the material implicit in family struggles. What provides the thematic material was, in the past, an obstacle to the writing. Now Italian American novelists make their lives public to help others articulate their own.

Emerging from the redoubt called family, Italian Americans are understandably reluctant to share with outsiders, to make their lives accessible and knowable; there is a strong cultural bias against looking too closely at "secrets." But writing is an act of public assertiveness, and Italian American writers from di Donato on have openly aired the family secrets. In fact, Italian Americans, male and female, in literature as in life, seem to have focused on family. It has been their theme more than such "American" ones as angst, personal ambition, spiritual struggle, or the hard working out of the sexual relationship. Italian American women writers, like all writers, use their personal material to go against the grain of secrecy by publishing. That the *New York Times* gave such prominence to Gay Talese's misperception that there are no Italian American novelists because they are bound by a code of silence not to reveal family secrets seems almost a willful decision to keep the stereotypes and negative appraisals of Italian Americans in place.

Instead, a contrary claim can be made: Given the past restrictiveness of their background, the deprivations of their history, and the closure of critical comment for their work, it is impressive and heartening to note the record of Italian American writing of the past and the continued outpouring of the present.

That Italian American women became writers at all is a triumph of assertion and faith over formidable obstacles. Italian American women were taught to keep out of public view. The traditional reserve that was valued in them ensured they would not put themselves forward. They come from a background of negative injunctions: Don't step out of line and be noticed; don't be the envy of others; don't attract the jealous fates, who will punish success. Italian American women were not brought up with the confidence that makes Jewish women such splendid social activists, such demanding wives and able promoters of themselves;

nor have they had the long experience of self-reliance and expressivity in the English language (oral as well as written) that Black women have had. They are not incited and brought together by ancient wrongs as are the Native Americans and Chicanos.

They were, instead, susceptible to the idea that excelling, drawing attention to oneself was not womanly, not good. This notion was prevalent in a society in which belief in **malocchio** (the evil eye) was present on all levels. One must not disconnect from one's immediate group, as a writer must in order to get perspective and unique vision; and one must not try to see too much either into oneself or into others; all such would bring upon oneself the curse of separation. The taboo is against being seen as excelling in anything, including in that close seeing that is self-knowledge. Those who see too far—Tiresias, Milton, Galileo—go blind or, like Cassandra, go unheeded.

Many Italian American women have had a hard time overcoming inner blocks to creative expression because they were not empowered, as female children, to be independent. Typical are women who have had to disengage themselves from internalized messages of unworthiness. Poet Kathy Freeperson (née Telesco) changed her name to indicate her changed perception of herself after leaving her father's tyrannical household. "Shut up—you're not a boy," was what she and her sisters heard growing up female. Many Italian American women have heard the same message: "What right have you got to think?" or, "Girls can't have opinions."

Other Italian American writers have undergone a de-ethnicizing influence in higher education and have rejected their own experience (too often portrayed in film and on television as backward and ignorant) in pursuit of so-called "universal" values that are, transparently, Anglo-American ones. It is, in fact, absurd to think that one can universalize only from Anglo-American models and not Italian American, African American, or whatever American ones. Jewish writing in America has disproved this.

There are other reasons, beyond the question of leisure time and education that Italian American women have taken long to become writers: They have not been used to intense self-inspection, to writing their thoughts in daily journals; they expressed themselves only in the condoned relief of the Confessional, in which a male figure exonerates and blesses them.

But now the phenomenon of rising expectations has reached everyone. Italian American women have a generation or more of higher education; economic independence has been reached; and many have moved in adulthood from the working class of their birth to the middle class of professionals.

It is the era of self-birthing, an experience well known to women of ethnic minorities, who, lacking models, have in fact made their own by creating themselves. Therefore, Tillie Olsen in her splendid book *Silences* says to all of the silent women: Create yourselves. There is much that is unwritten that needs to be written. Bring into literature what is not there now.

The words of Native American poet Joy Harjo are pertinent to us: "As I write I create myself again and again. . . . We have learned to only touch so much. That is why I write. I want to touch more . . . it frees me to believe in myself . . . to have voice, because I have to; it is my survival."[18]

Tina DeRosa, in a passionate statement of identity in the now defunct *Attenzione* magazine, expressed the dichotomy that many educated young women of her background are experiencing in the conflict between their past in the Italian family of origin and their future as educated American women. "I know now that where I belong is with myself, knowing that I don't really belong anywhere. That is the inheritance. . . . You say partially goodbye to one world, partially hello to another, some of the time you are silent . . . then you write about it. . . . Don't let anyone tell you who you are. You will know."[19]

Italian American women had long been denied the possibility of finding themselves in literature. How could they affirm an identity without becoming familiar with the models by which to perceive themselves? We are what we read, but in the case of Italian American women writers we could seldom read who we are. It is unfortunate that the Italian novelist Grazia Deledda (1871–1936), a strong, relevant, and highly pertinent model of an internationally significant writer embodying female values, someone for Italian Americans to emulate, is so little known in the United States.

Rather, as Mary Gordon has pointed out,[20] Simone de Beauvoir became the model for feminists; the myth of the tough dame took hold as women looked to those who seemed to have made it on their own terms. Aside from Camille Paglia, who champions Madonna as a feminist and says her own brand is the Hepburn type, women everywhere have been woefully deceived in the images of seemingly successful independent women like Simone de Beauvoir, Katherine Hepburn, and Lillian Hellman, who actually all have revealed in biographies that the man and his interests came first. As Gordon notes, de Beauvoir, "the mother of us all . . . died telling us she would have been nothing without the man she loved," the philosopher Jean-Paul Sartre, who demeaned her, betrayed her publically, used her as a procurer for his sexual adventures, expected her to drop her work to help him, and then at the end cruelly humiliated her by depriving her of all access to their joint papers and possessions by naming a young woman, his ex-mistress, as his executor.

Ironically, de Beauvoir's biographer is Deirdre Bair (a National Book Award winner for her biography of Samuel Beckett), who, despite a nonidentifying first name and married name, is of Italian American background, a fact never disclosed in personal accounts of herself.

De Beauvoir is no model: She betrayed the very words she wrote. She wanted other women to do as she said, not as she did. Are women left with disturbing questions about choices and no answers? But there is an answer, just as there is a proper model for women who would achieve selfhood and yet not deprive themselves of their full sexuality in love, childbearing, and the long companionship that is a fulfilled marriage.

Much more relevant as model woman and writer, especially to Italian American women, is Grazia Deledda. It is she who most captures the ideal of accomplishing her life's mission both in her art and in her personal life. She was a self-motivated achieving woman whose sense of her personal mission, movingly depicted in her autobiographical novel *Cosima* (1988) was not set aside for marriage and maternity but successfully combined with those womanly roles.

Born in the most backward and isolated part of Sardinia in 1871, Deledda received only three years of schooling but continued to teach herself and set herself the task of making her country live in literature. She not only produced a steady stream of literary work (thirty-three novels, eighteen collections of stories, and other writings) in the face of great odds, but she also saw her life's work honored with a Nobel Prize for Literature in 1926.

Not to be underestimated is the equal achievement of Deledda's having combined in her life, family and art. Grazia Deledda was not in the Anglo-American style of the childless great women writers like Jane Austen, George Eliot, Emily Dickinson, Willa Cather, Edith Wharton, and Virginia Woolf; she had the support of her northern Italian husband for her writing career. He and their sons, and family life as a whole, were the necessary sustenance to her art. She needed both.

Deledda fashioned her own destiny to become what she was told (by her family of origin and by society at large) was impossible: a great writer and a happily married mother, and she did it on her terms without denying herself her art or the family she created. She is an amazing figure of achievement, more generous and honest toward life and work than the deeply deceptive, coldly intellectual de Beauvoir.

The name and story of Grazia Deledda was not in schoolbooks as I was growing up, but that is hardly surprising; what *is,* is that even with the new surge

of interest in women writers and the resurrecting of old and forgotten authors, Deledda is still a forgotten woman.

Ellen Moers' *Literary Women* (1976) for instance, is a thick compendium of the great women writers, concentrating mainly on approximately sixty English, American, and French women of literature, with textual and bibliographic references to worldwide women authors. Grazia Deledda is omitted; the only Italian authors mentioned are in the back-of-the-book appendix: a line for Renaissance poet Vittoria Colonna, and two for contemporary novelist Natalia Ginzburg.

It is also disconcerting that the first book-length account of Deledda's life written in English, a fine study by Carolyn Balducci called *A Self-Made Woman* (1975), should carry on the book jacket the recommendation "for ages 12-up." By sidetracking this significant work into the graveyard of young adult books (as was Lucinda LaBella Mays' 1979 novel, *The Other Shore*), the publisher has, in effect, denied it the general distribution and recognition it deserves, making it more than likely that it has been, and will continue to be, overlooked.

Balducci writes of a recording that Grazia Deledda made shortly before her death from cancer in 1936 in which she said, "I have had all the things which a woman could ask of her destiny." Deledda did not, in fact, *ask* anything of destiny—she *took* her life into her own hands to make of it what she did.

That this striking figure should be so little known, so overlooked by publishers of feminist lines who are bent on rescuing so-called lost women writers from oblivion, so missing from the consciousness of Italian American women writers, who need precisely and desperately the kind of validation she gives, is just another of the instances of silence in which we have seemed to struggle alone without models, without inspiration.

Unlike Christina Rossetti, who wrote from an internal agony of renunciation and whose art was the bitter fruit of a masochistic abnegation, Deledda did not deny herself. She said she believed in only two things: the family and art for its own sake; these were the only beautiful and true things in life. It has a very Italian ring and a very sound psychological basis in the feminist theory of Jean Baker Miller as well as in that of the earlier, eminent psychologist Karen Horney, who identified the dubious splitting off in a woman of domestic vs. public life (a dichotomy de Beauvoir insisted on) as "the flight from womanhood."

Another Italian author not much heard of is Sibilla Aleramo (1876–1960), who wrote *Una donna* at the beginning of this century, anticipating feminism and women's liberation by many decades. It was, in fact, in this autobiographical novel that the word "feminism" was used for the first time, and the author's personal suffering was related to the condition of all women. *Una donna,* widely known in

Europe, has been translated into English (*A Woman*, [1980]). It is a gripping account of the psychological anguish of a creative woman's marriage to a small-minded and stultifying oppressor and her liberation at great personal expense. It is a story of courage in a time and place that made her action and subsequent book utterly remarkable. But Aleramo, too, is missing from the Italian American woman's reservoir of models.

Poet Jean Feraca is one of a growing number of Italian American women who have journeyed to Italy and brought to bear on the ancestral land the unique vision of the American Italian. Her collection *South from Rome: Il Mezzogiorno* (1976) is a strong evocation of an unromanticized, deeply felt archetypal Italy as veritable motherland, not a tourist pleasure land.

Even the relatively few literate and educated Italian women who immigrated to this country would have brought few models of women writers from their culture and few incentives to imitate them. This lack of a literary ancestry from the original culture has presented a significant problem to Italian American women. Whereas English and French women writers have always been strong within their national literatures, the tradition of women writers in Italy, noted by critic Sergio Pacifici in *A Guide to Contemporary Italian Literature* (1962), is relatively recent (notwithstanding those Renaissance exemplars who are often cited to prove that Italian women have long had voice and stature as authors but prove only that women writers in Italy were an isolated class phenomenon, not a national trend). The emergence of nationally known women authors coincided in the late nineteenth century with the unification of Italy as a nation and the limited social emancipation of women. The liberated postwar Italy of the late 1940s and the later feminist movement saw an increase of notable women writers. Says Pacifici: "Their increasing popularity with the public and the critics represents a significant cultural phenomenon, that may well herald a new era." Previously, relatively few women attained literary distinction, and this, Pacifici asserts, was not surprising in a country where the social order was shaped so exclusively by men. The lack of critical attention he ascribes "less to an objective question of artistic merit than to critical negligence or a pronounced prejudice against female talent."

This is true no longer in Italy, where some notable women have attained critical acclaim, but it is notoriously true of Italian American literary men, who not only do not accord any attention to women of their background who are writers, but also cannot even quote the names of these women.

The shadows into which Italian American women writers seem to have been cast come not only from the spotlight being thrown elsewhere by male critics who overlook women authors, but quite surprisingly also from feminist critics.

In Annis Pratt's introduction to her *Archetypal Patterns in Women's Fiction* (1981), she acknowledges having done, for that study, "close readings of more than three hundred women's novels." None of those novels is by an Italian American woman. Writing on the novel of development, Pratt notes that in women's fiction it is more often the story of women "growing down" rather than "growing up." Yet Italian American women are writing of rising expectations and the quest for self-realization. One of these is Dorothy Bryant whose novel, *Ella Price's Journal* (1972) is a classic example of the novel of growth—in this case, not of a young male, but of a middle-aged wife and mother.

Bryant's married name, under which she writes, cloaks her Italian American background; and her character Ella Price is an Anglo-Saxon Everywoman; but just as the outsider experience is heightened when told from the point of view of the double outsider (the Black or the Jew), so, too, the woman's experience of being stifled in a male world might have been made even more compelling if Bryant had used her own Italian American background from which to create the story of a woman's growth toward autonomy. The weight of her tradition makes the Italian American woman's experience in moving out of marriage toward autonomy even more dramatic than that of the more assertive Anglo-Saxon or Jewish woman. Did Bryant feel that her book would be given more consideration if she made her characters more "American"? That is a kind of self-censorship to which some Italian American writers are all too susceptible.

Diana Cavallo's sensitive and introspective novel *A Bridge of Leaves* (1961) is written in the first-person voice of a young man whose thoughts and memories record his inner journey from an early self-contained world to full immersion in the world of others that brings him to the crisis and resolution of his maturity. It is a true *Bildungsroman* (novel of formation), and yet the opportunity to narrate it in the female voice to reflect the experience of the Italian American woman was not taken.

Poet and novelist Daniela Gioseffi once said that she wrote "only rarely of her ethnic background, and dealt, mostly, with universal themes." That meant she had internalized the message that "universal themes" in this society cannot be ethnic, only mainstream, which usually means modeled on Anglo-American values but, in any case, made acceptable to a literary elite that decides what is right and what is not. It is little wonder with the prevailing canonization system that Gioseffi had learned to doubt the worth in wider human terms of her own experience and to term it, in a demeaning way, "ethnic."

Many non-WASP writers have come to the fore brilliantly. Jewish women writers, African American, Asian American, Native American, Chicano—all have

been collected, given critical attention, and, thereby, given presence. The Italian American woman writer seems to belong nowhere: Not minority, not mainstream as Jewish and Black writers now are, she remains without champions or advocates or interpreters. The Italian American woman writer seems to have been stranded in a no-woman's-land where there was small choice: Either follow the omnipresent models that do not speak to her own particular experience, or write of her experience and know that it will be treated as of no importance, too slight or "different" for critical attention.

It is a special problem: Until *The Dream Book* appeared in 1985, Italian American women had not had the critics or literary historians who would attempt to probe their background, unlock the reasons of past silence, and acknowledge that they are finally present.

Models are important inasmuch as they connect the present writer to her past and provide a continuity that makes a shared culture a valuable resource; one's own culture is important to the spirit of the writer and to the writing itself. Part of the intensity between Italian American mothers and daughters is somewhat explained by the lack of cultural models in the literature and young women having only immediate female family on which to base themselves. Being unable to follow the ways of their mother's generation, they try, instead, to make over the mother, to improve and uplift her, as in Rosemarie Caruso's play *The Suffering Heart Salon* (1983), so that the daughter will have a *worthier* model. It never works.

What might work, instead, is the reworking of the Demeter–Persephone myth, with its Sicilian locus, as the ultimate expression of the powerful mother–daughter bond. Harold Schecter, in a critical appraisal of Daniela Gioseffi's strong woman-focused poetry titled "The Return of Demeter," explores Gioseffi's celebration of the Good Mother and her insistence on the "revival of the archetypal female consciousness as giver of life, nurturer of living things, and maker of life-giving arts."[21]

The working out of mother–daughter relationships and the working out of understanding between the two generations as roles and expectations change is present in Michele Linfante's humorous and touching one-act play *Pizza* (1980). Drama has been a particularly strong genre for the expression of cross-generational conflict in families. Starting with Rose Grieco's plays *Anthony on Overtime* and *Daddy, Come Home,* staged at the Blackfriars Theater in New York in the early sixties, there has been a vigorous and notable burst of dramatic works by Italian American women playwrights, including Anne Paolucci, Rosemary Clement, Rosemarie Caruso, and Dorothy Gentile Fields. Karen Malpede is cofounder of the New Cycle Theater in Brooklyn, New York, and an editor of works on theat-

rical history as well a past teacher of drama. Nina Faso was coproducer of the spectacularly popular *Godspell* of the seventies. Filmmaker Christine Noschese has won grants to work on documentaries, and Helen DeMichiel in 1997 wrote and directed *Tarantella*, a feature film based on an Italian immigrant woman.

Donna de Matteo, a dramatist of talent, is a teacher of playwrighting at the HB Studio in New York. In her play *Rocky Road* (1981), de Matteo shows the way out for her protagonist Lynn, who having suffered a nervous breakdown, chooses to recover on her own and to find strength in herself, away from family. In *The Silver Fox* (1983), de Matteo depicts a successful self-made businesswoman who takes over the male role of head of the family until her daughter reverses the power position.

It is playwright Rosemarie Caruso's belief that the activity in drama by women of Italian American background is due to their grounding in the real and tangible—they like to see and hear what is going on between people; they like the clash of dialogue; they like the sheer relief of expressing their feelings *aloud*. After the silence, they want to be heard. Men, she says, present points of view and the rebuttals, but women want to explore and probe into feelings, and dramatizing them feels natural.

All is not family; it is a dominant theme but not the exclusive one in Italian American literature. Present also is the same theme of alienation in an uncomprehending society that has been so well used by Black and Jewish writers. Cultural dichotomy, divided loyalties, the problems between generations, intermarriage, and the problems between the sexes as men and women search for new roles, the tragic consequences of self-doubt and self-hate, placing honor before truth and instinctive "love" before understanding, the stress on "catching up" with America, the loss of Italianness—the Italian American experience has it all, and it all has to be told.

Italian American women who write are in the process of redefining themselves and family patterns; they are writing to create models that were never there for themselves; they are writing to know themselves. They write with positive affirmations. The personages they write about are afflated with hope, with the sense of change, with inspiration. They are not in the "deflation" style of many Anglo-American women writers who have documented a long period of emptiness and futility in the wispy, stylish voice of minimalism. Italian American women write from the passion of the outsider experience, as women whose time has come. They are emerging, not receding, writers.

In a very true sense, the Italian American woman writer has to be a self-made person; lacking a literary tradition, she works in isolation without models

and interpretive critics, struggling with an internal dialectic, a personal condition of inner doubts but also of outer odds of subtle discrimination and rejection; she struggles to become an author, sustained only by the need and impetus of what she is doing.

Why this is so has to do not only with the inner blocks of her tradition, but very much also with the external obstacles raised by the society and the barriers of prevailing literary hegemonies.

Literary Hegemonies and Oversights: The External Blocks

It becomes usual to accept that there are no Italian American writers of any value when established critics make it so by not noticing them; when professors of American literature say it in defense of why Italian American writing is not presented in course work; when an Italian American author of some prominence says it in the confidence of being the exception; and when readers believe it for the simple fact that except for Mario Puzo's *Godfather* (1969), they have heard of no other work: No author—no John Fante, no Diane di Prima, Ferlinghetti, Sorrentino, Innaurato—has been made familiar enough to them to come to mind. It is easy to dismiss what one does not know.

The spurious and circular reasoning is this: If there had been any first-rate Italian American authors, one would have heard of them. At one time that was said of women as a group, too; women writers and women's experience were, by definition, minor—the male experience was presented as the universal human one. Now we know more.

It is not that Italian Americans have not written work of value; it is that the dominant culture, working under its own rules and models, within a tight network of insiders—editors, agents, reviewers, critics—is not eager to recognize and include in its lists that which does not reflect its own style, taste, and sense of what is worthwhile, or, more vulgarly, the stereotypes that sell. After the *Godfather* phenomenon, Mafia themes proved profitable—therefore the rash of books like Gay Talese's *Honor Thy Father* (1973) on crime boss Joseph Bonanno, which, in turn, spawned the editorial decision to have wife Rosalie Bonanno "write" the book that became *Mafia Marriage* (1990). (*Prizzi's Honor* [1985], *Mafia Princess* [1986], and others belong to this dubious genre, which were then spun off into feature films and television mini-series.) Thus a skewed and stereotypical vision linked to market potential drives out those books that do not deal with the Italian American experience in pigeonholed ways. First having created a Mafia

market (which does not cater to an Italian American public but a general one), publishers then defend their rejection of serious Italian American material with the nonsense that there is no market for it.

Italian American novelists are not generically second-rate; they handle different material and handle it with the newness—perhaps rawness—and drive of the just-born and self-made writer. Literature is not only in the great and practiced writer. It is also in the new voices that, by enriching and extending the national library achievement, become of permanent value.

Italian Americans who accept uncritically the estimate of denigrators that they are unworthy of attention have let themselves be defined by those others in a way that other ethnic groups will no longer tolerate. Rather than examine an excluding system and question its premises, Gay Talese, for example, engaged in the negative exercise of blaming the victims of that arbitrary system for being victimized by it when he wrote in his previously mentioned 1993 article in the *New York Times* that Italian Americans don't read, therefore they don't buy books, therefore publishers are justified in not publishing Italian American writers because they maintain there is no market for their work. This is not reasoning; it is prejudice expressed as market research.

It is a fallacy that Italian Americans don't read or buy books, yet publishers use this worn out red herring to justify not publishing more Italian American authors, even though there is no such thing as a single market for books. Italian Americans are not writing only to be read by Italian Americans any more than African Americans only by African Americans, or West Indian Americans only by West Indian Americans. When Amy Tan's *Joy Luck Club* (1989) was published and became an enormous best-seller it was not because it was aimed at the Asian American market—everyone bought and read the book. It is inconceivable that the publishers of Richard Rodriguez or Sandra Cisneros were thinking only in terms of a restricted Hispanic market for them. The fact is that all of those writers are Americans, writing for the whole of American public and not just parts of it: That Gay Talese has accepted the editors' alibi about a missing "Italian American" market simply displays his own sense of unworthiness with his strangely (for a reporter) unexamined acceptance that the self-serving publishers who disparage Italian American writers must know best.

A subcategory called "ethnic writing" was created as the catchall for what didn't fit into the mainstream. This is itself a peculiar notion: A mainstream is not a body unto itself but exists by being fed from tributaries. That the writings of some American writers were considered marginal and not given entry to the cultural mainstream of the American literary world but existed, at best, in a back-

water of folklore and curiosities is an outdated attitude that is finally being addressed in the current success of multicultural writing. In 1992 the impressive outpouring of varied ethnic writing was officially recognized with the award to Derek Walcott, the Black writer from the West Indies, of the Nobel Prize in Literature for his "multicultural vision and commitment." With that the opening may at last have come for many writers who have been overlooked as ethnic or marginal, their minorization having been an inevitable by-product of the homogenizing tendency to represent a majority society of uniform values rather than the cultural pluralism that is the reality of American life.

Thus, John Fante's inspired production—*Wait Until Spring, Bandini!* (1938), *Ask the Dust* (1939), and *Dago Red* (1940)—or fine novels like Michael De Capite's *Maria* (1943) and Mari Tomasi's *Like Lesser Gods* (1949) got published but not really noticed or taken up in any way.

For it can be claimed, fairly, that Italian American writing did and does (in a limited way) get published, that there is no concerted effort to keep Italian American authors from being published. It can be said also that there is no concerted conspiracy of silence on the part of reviewers or literary critics to exclude mention of Italian American writing. How could there be? To maintain a conspiracy would imply recognition of a body of literature that is, instead, more conveniently emarginated by being ignored.

The Italian American novel, when written by an Italian American author, is all but invisible, while the use of that material by authors of other backgrounds does receive attention, as for instance, *The Immigrants* (1977) by Howard Fast; *The Little Conquerors* (1960) by Ann Abelson; *Principato* (1970) by Thomas McHale, *Household Saints* (1981) by Francine Prose, *Missed Connections* (1983) by Elaine Ford, Richard Condon's Prizzi books and the very successful theater and screenplays about Italian Americans by John Patrick Shanley, like *Moonstruck* (1987) and *Italian American Reconciliation* (1988).

In a country this size, composed of such rich and varied strains, there is room for all facets of literary expression, and there should be the opportunity to become familiar with them, but this is not the case. There are hierarchies and hegemonies that consciously or not, promote and decide what is literature and what is not. The facts of literary life are elementary: It is not simply publication, but what comes both before and after that count.

As Mary Gordon has said: ". . . reviews have a tremendous impact on book sales. . . . Books which are not reviewed are buried."[22] That is exactly what happens to the overwhelming majority of books that, unlike Gordon's, are published without special advocacy: If they are not signaled for attention by powerful names,

they die. The truth is that Italian American authors, with the exception of the celebrated token few, have no advocates.

The *New York Times*, which in its daily edition and *Sunday Book Review* section does more reviewing than any other publication in the country, mentions only about 8 percent of all books published in a given year. Even so, some books (all too predictable) get double reviews while the vast number go unnoticed. One answer to the all-embracing question concerning the Italian American woman who writes—"Why are we not known?"—can be answered in the four words: *The New York Times*.

Books that are not reviewed are not picked up elsewhere along the tightly linked chain of literary life. Literary achievement is gauged by appearance in required reading lists, literature-course outlines, textbooks, anthologies, critical appraisal, book reviews, bibliographies, and even jacket blurbs—all things that Italian American writers have been largely excluded from because they lacked the authority of a prominent name.

Strategies exist to exclude writings that are considered marginal. Jules Chametzky, a scholar of cultural pluralism as reflected in American literature, has shown how the publication of regional literature became, toward the end of the nineteenth century, "a strategy for ignoring or minimizing social issues of great significance."[23] Regional novels substituted for those dealing with race, class, the new money power, America's new ethnic composition, and the challenges to engrained social assumptions and mores. While such themes, which called for serious literary treatment but could upset notions of a unified national culture, were ignored, local-color and regional literature, which reinforced notions of a basically homogenous rather than a conflicted nation and culture, was accepted by the dominant public and leading editors.

Katherine Newman, an ethnic literary scholar and critic, has proposed discarding many of the old theories of American literature "since they were fitted to a specific body of literature: that of the Anglo-American seaboard culture."[24] Taking a wider view of the whole oeuvre, other characteristics can be discerned, and she sees one characteristic of American literature (particularly relevant from the ethnic perspective) being eccentricity in its exact meaning of being off center, assymetrical, irregular, uneven. That explains the uniqueness and marvelous strangeness of Pietro di Donato's powerful 1939 novel *Christ in Concrete*. That explains also other facets of Italian American fiction, with its "extraneous" material, distortions of character (Marietta in Antonia Pola's *Who Can Buy the Stars?* [1957] or the raging father in John Fante's *Brotherhood of the Grape* [1957]), eccentricity of style and language, and the often ambiguous attitude of the implied authors.

That is not to be wondered at; Newman quotes other studies to show that implied authors of ethnic novels tend to be schizoid—that is, in conflict between the values of their ethnic groups and those of the majority group.

This very "off-centeredness" (it is relevant here to note that Barbara Grizzuti Harrison's 1980 book of intelligent, perceptive essays is aptly entitled *Off Center*) of Italian American literature should be valuable in itself; ethnic literary scholarship stands for understanding material that before, in a policy of literary apartheid, was often excluded because it was measured by nonapplicable standards.

Like the feminists, ethnic literary scholars opt for a humanist criticism that transcends narrow views of what people are or should be: This should breach the walls that Mario Puzo set out to scale by writing *The Godfather*, for it was only when he made the deliberate effort to embrace condoned formulas of "American" writing and stereotypical characters that Puzo was admitted to the club of visible writers. Applauding him for playing the game was Rose Basile Green, who in a work called *The Italian-American Novel: A Document of the Interaction of Two Cultures* (1974) noted: "An Italian American novelist, Mario Puzo, has pried open the box that has secreted the sacred blackballs of the American literary club."

It is not the pandering to violent themes nor the deliberate commercialization of the story that relates Italian American fiction to the American mainstream. Rather, it is another characteristic of the American literature that Newman identified as deriving from the pressure of pluralism: "The chief preoccupation of our writers is choice-making. . . ."[25]

The necessity of choice—the old ways or the new? one's loyalty to family or to self—has always been implicit in the main thrust of Italian American writing. Italian Americans are laden with conflicted loyalties and roles, with contradictions within the tradition, with ambivalence in life. It is not always a cause for optimism—seeking resolution of conflict is painful—but it is affirmation; it is using one's native strength and wit, and that seems to be the direction toward which Italian American writing is propelled.

The women authors of Italian American background who dealt with their ethnic material have been the ephemerids of literature, fated to have a creative life span as brief as that of the mayfly. They were born, in a literary sense, already out of step by virtue of their themes. They were given no notice by reviewers, which meant they went out of print swiftly and receded into the silence from which they came without having made a ripple in the mainstream of American writing. It is a demoralizing and chastising experience. A writer must be given the opportunity to publish at least two or three books in order to have a substantial voice, a presence. Many Italian Americans never get beyond the first book

because the lack of response and attention makes a publisher unwilling to risk further. Frequently, a complete literary oeuvre remains unknown, unavailable. Italian American male authors have undoubtedly faced many of the same hardships, but the obstacles continue to remain more severe for women.

Literary history is falsified if it does not record all voices and give access to these voices by publishing, keeping in print, and making part of study courses those writers who are not merely the commercially prominent ones of the dominant tradition. As Newman says, the critical function is to examine works on their own aesthetic terms, to relate them to the entire corpus of American literature, and to overcome the internalized stereotypes and cultural myths that have caused critical myopia.

Publishers have been cool to the reception of Italian Americans outside of the safe stereotypes of a warm people with comical behavior (Mangione's *Mount Allegro*, Fante's *Brotherhood of the Grape*) or Mafia criminals and connections. They are cool to the complexities of human nature portrayed in minority or ethnic groups: They prefer racial tensions for Blacks, gangsterism and family solidarity for Italians, and complicated emotions or angst only in WASPS or Jews.

Genevieve Belfiglio, publisher of the magazine *Real Fiction*, explains that she founded that publication of short stories out of frustration, because her experience was that "major publishing firms attempt to mainstream fiction, at the expense not only of writers, but readers as well since only a narrow range of experience and style is acceptable."[26] This is confirmed by publishers who accept material that conforms to their notion of what the market wants; it fosters stereotypes, not literature.

Publishers say they cannot afford to be crusaders. But Black writer Zora Neale Hurston replied that she refused to be humbled by second place in a contest she never designed, and she identified what comes out of safe, marketable publishing as candidates for the American Museum of Unnatural History—that is, a weird collection of stereotypes, nondimensional figures that can be taken in at a glance, such as the expressionless American Indian, the shuffling Negro, the inarticulate Italian, and so on.[27]

My novel *Love in the Middle Ages* (1986) was rejected by one publisher because it didn't "seem right." In this case, the Italian American woman character was the achiever and her Jewish lover was not; it was said that this appeared anti-Semitic and it was suggested that the roles be reversed. Of course! Then the formula would have been observed—the same one that John Sayles used in his film, *Baby, It's You*, which is the story of two high school lovers: He is an Italian greaser who takes woodwork, and she is a Jewish princess who is the president of the

Drama Club and headed for Sarah Lawrence. She, it is understood, will get over her transitory sexual attraction to Sheik (his nickname derives from a condom) because she is going to be someone and he isn't. Hardly anyone of Italian American background has not encountered the use of that stereotype in real life, as when a teacher remarked to Dorothy Bryant (who was then Dorothy Calvetti and at the top of her class), "You can't be Italian; where were your people from?" "Near Turin," said Dorothy. "Then," said the teacher, relieved, "they could be of Germanic origin."

The exclusionary practices in the publishing world, where Italian Americans are not perceived as literary writers but, at best, writers of romance, suspense, or young adult books, seem to parallel the school's tracking ones: Italian Americans were routinely tracked into vocational courses rather than college-oriented ones. In her Bensonhurst essay, Marianna De Marco Torgovnick describes her high school experience: "Although my scores are superb, the guidance counselor has recommended the secretarial track; when I protested, the conference with my parents was arranged. . . . My father also prefers the secretarial track, but he wavers, half proud of my aberrantly high scores, half worried. I press the attack, saying that if I were Jewish I would have been placed without question, in the academic track. . . . I am allowed to insist on the change into the academic track."[28]

Italian American characters are not allowed to be individuals, to be complex, to be alive and contradictory, subject to the pulls of tensions and defeats of doubt, subject to losses, and gains, and changes. Instead, the cultural myth perceives them in very rigid, demeaning, stick-figure dimensions. Some Italian American authors get around this by changing the names of their characters to non-Italian ones.

That Italian American women writers have been underpublished is undeniable; just as exclusionary, however, is that the few who are published are not kept on record and made accessible, even bibliographically, in libraries and in study courses. Not only do Italian American women writing their own stories publish with great difficulty, but, once in print, they must confront an established cadre of criticism that seems totally devoid of the kind of insight that could relate to their work.

Italian American names are notably missing in essays such as the *New York Times*' "Women Playwrights: New Voice for the Theater," in which no mention is made of Donna de Matteo, Karen Malpede, or even Nina Faso producer of *Godspell*.[29] In the *Times* piece "Brooklyn, Borough of Writers" (8 May 1983, 1), a lot of names were dropped but not those of author Barbara Grizzuti Harrison or Daniela Gioseffi.

It is not only in reviews and essays, but also in feature articles and in letters it chooses not to print (as compared to what it does) that the *Times* can emarginate authors and practice a kind of censorship.[30]

Arguably, Gay Talese became an unwitting victim of bias when, on 14 March 1993, he was given the front page of the *New York Times Book Review* to tell the world Italian Americans don't read, write, think or evolve beyond family dependency and are incapable of the solitary stamina writing requires. Why were his negative views given such prominence when other, more substantial Italian American writers have not been allowed a chance to air their views? That choice of Talese's misperceptions to represent Italian Americans repeats an earlier one that seems to reinforce some subtle, unstated bias on the part of that paper in regard to Italian Americans. Camille Paglia appeared on the Op-Ed page in 1990, after the publication of *Sexual Personae: Art and Decadence from Nefertiti to Emily Dickinson* (1990), almost as a figure of fun. If the *Times* has a bias, featuring her would reinforce negative imaging: "See what Italian American intellectuals amount to," the editors can tell themselves, "here's one who calls Madonna a real feminist."[31] And now there is Gay Talese, who says Italian Americans can't write novels because they are afraid of their families.

Multiplied inexorably, year after year, author after author, and never redressed or even acknowledged, this kind of press adds to a general misperception and ostracism from reviews.

After the reviewer, it is the critic who takes the long view and decides what authors and titles become part of the canon, and that, Bernard DeVoto wrote in 1944, is the literary fallacy—believing that what the critics present and perpetuate as the national literature is the measure of a culture. What they actually do is present their temporary list of winners.

Next in the ring of exclusion, editors of collections and bibliographic tools, like the powerful H. W. Wilson Company, close admittance into their bibliographic-retrieval tools to those who have not been reviewed in the publications the Wilson Company chooses to scan. Among omissions from the *Book Review Digest*, for instance, are books by Mary Caponegro, Cris Mazza, Jeanne Schinto, and Mary-Ann Tirone Smith published between 1985 and 1992.

When teachers, editors, and compilers consult the Wilson volumes for, say, the names of authors who are writing about Italian Americans so they can be included in syllabi, presented at conferences, studied and commented on, they are naturally led to the conclusion that there are pitifully few Italian American authors, and of those few no women at all. Without entry in Wilson's *Short Story Index, Fiction Catalog, Book Review Digest, Standard Catalog for Public Libraries*, and the

like, the nonlisted author becomes a "lost" one—impossible for a teacher, a compiler, or a researcher to pick up except by hearsay.

By ignoring the multicultural literary reality of the second half of the twentieth century in the United States, the Wilson library tools have made themselves irrelevant to what is happening in American literature and cannot be consulted as a reliable guide to what fiction is being produced, published, and read in representation of various American ethnic groups.

William Vance, who produced the notable two-volume work *America's Rome* (1989), included only three Italian American writers (William Murray, John Ciardi, and Dana Gioia) in his examination of American fiction writers and poets in Rome, noting that their lack of visibility led him to conclude that possibly there were not many Italian American writers and that much remained to be explored.

The lack of visibility to which Vance referred is directly affected by exclusions from H. W. Wilson's *Fiction Catalog*. From the inception of subject listings in 1941 through the twelfth edition of 1991, plus the supplements covering 1992, there has been no listing under the subject heads "Italian Americans" or "Italians in the United States" for any Italian American woman writer, with the exception of Anna Quindlen, whose coming-of-age novel *Object Lessons* (1991) is listed in the 1991 supplement, but whose surname belies the Italian American connection and identifies only the Irish part of her, which—who knows?—may make her acceptable for listing in the Wilson Company's catalog.

Notre Dame law professor Thomas Shaffer happened to send me a reprint of an essay of his which mentions work of mine. In an accompanying note, he wrote: "I turned up *Umbertina* as soon as I began to do research on Italian Americans. I cannot remember who recommended it. . . . If I were asked today where to begin such an inquiry I would recommend *Umbertina* above all else."[32] Yet if he had tried to locate source material through reference guides such as the Wilson *Fiction Catalog*, he never would have found *Umbertina*.

Instead, he would have found Ann Beattie's story of the tangled personal relationships among three different couples, "Windy Day at the Reservoir," listed under "Italians in the United States," as well as Robert James Waller's 1992 romantic novel *Bridges of Madison County*—both listings based on the flimsy criterion that a female character in each piece of fiction was born in Italy. Yet in no way is that fact fundamental either to the development of the work or to any meaningful, insightful exploration of what it means to be Italian in America.

Authentic published writing about Italian women in the United States, including the original 1949 edition of Mari Tomasi's novel of the Italian granite workers in Vermont, *Like Lesser Gods*, which was named one of the ten outstanding

novels of that year, and its 1988 reprint has never been listed in the *Fiction Catalog*. The same holds true for Octavia Capuzzi's *A Cup of the Sun* (1961), Nancy Maniscalo's *Lesser Sins* (1979), Dorothy Bryant's *Miss Giardino* (1978), and Josephine Gattuso Hendin's *The Right Thing to Do* (1988)—in fact, for any other novel by an Italian American woman.

Indeed, one can say that there is deliberate misinformation and oversight—deliberate, because when the missing authors were brought to the attention of the Wilson Company by me in 1984, the complaint was dismissed as "patently unfair" and no rethinking of the company's exclusionary, outdated, and prejudicial selection process was effected.

The Wilson Company persists in demeaning the category "Italian Americans": Its longest-running entry (listed since 1957) is Max Shulman's satire of suburbia *Rally Round the Flag, Boys* (1957), which has long been out of print and even when available was entirely inappropriate as representative of Italian Americans, using them only as stereotypes along with the two other groups being lampooned: New England Yankees and New York commuters.

Almost equally equivocal is the listing under "Italians in the United States," which includes Jimmy Breslin, Bernard Malamud, Howard Fast, Mario Puzo, Mary Lee Settle, and Fred Mustard. One has to wonder why only one Italian American, Mario Puzo, was thought to have written meaningfully on Italian Americans, or why Mary Lee Settle's book about Italian coal miners in West Virginia is featured, but not Denise Giardina's well-received work on the same subject, *Storming Heaven: A Novel* (1987).

Is the Wilson Company's falsification of the record on Italian American writing duplicated for other ethnic groups? Such distortion of what comprises writing by and about ethnic groups as part of the national literature is a serious matter of literary apartheid. Wilson's *Book Review Digest* includes fiction that has been reviewed in at least four other journals on Wilson's approved list of approximately one hundred sources (previously only about sixty) as compared to the Gale Company's *Book Review Index*, which reports on any book reviewed, no matter how often and no matter where, from 422 sources. The Wilson Company effectively discriminates against ethnic, counterculture, and minority writers who are reviewed in journals outside conventional sources. In effect, the reviewing media, not the book itself, is being judged.

It is for Italian American women writers like never having been published at all except for that minute inner circle of friends who may have heard personally of the event—certainly such work is not "published" in the true sense of being made public and accessible. It is as if the writing of Italian American

women were some fastidiously secret pursuit, a distilling of a rare liqueur not to be shared.

There are other areas of bibliographic oversight in their regard: No Italian American novels are listed in the category of "family chronicles" in the bibliography of *American Historical Fiction* (4th ed., Scarecrow Press, 1981).

Through the fourth revision of the *Literary History of the United States* (Macmillan, 1974), which is still the current edition in library holdings, no mention is made of authors of Italian American background except for the eighteenth-century political writer Filippo Mazzei and Mozart's librettist, Lorenzo Da Ponte.

Contemporary Literary Critics (St. Martin's Press, 1977) lists 115 American and British critics. Missing, along with the eminent critic Bernard DeVoto, is any other Italian name.

In *The Ethnic American Woman* (1978), a collection of writings of ninety-five women authors from twenty-four ethnic groups, the Italian American group is represented by one entry, a writer of a scholarly paper, as compared to other groups amply represented by literary writers of novels and poetry.

The *Columbia Literary History of the United States* (Columbia University Press, 1988) is woefully inadequate citing two nineteenth-century authors of "ghetto" novels and then skipping entire generations of Italian American writers such as di Donato, Tomasi, Fante, et al. to arrive at the "new journalism" of the 1960s as practiced by Gay Talese.

American Women Writers (Ungar, 1979–1983) includes one Italian American woman writer, Frances Winwar. Lina Mainiero, of Italian background herself, was, as editor of Ungar's four-volume set, predisposed (she told me) to include Italian American women in that collection but said there were none that she could find; unless writers had been carried in anthologies or mentioned in literary criticism, or had won awards, there was no way to locate them. That justification is not quite credible: Mari Tomasi was named one of ten novelists of the year in 1940; *Buying Time: An Anthology Celebrating Twenty Years of the Literature Program of the National Endowment for the Arts* (Graywolf Press, 1985) lists these award recipients prior to the time of Mainiero's compilation: Helen Barolini, Diane di Prima, Joan Castagnoni Eades, and Leslie Scalapino. The UNICO national literary awards (which honored, among others, Camille Paglia and Mary Gordon in 1976) have been in operation since before the Ungar compilation. Perhaps the a priori expectation that there would be no Italian American women writers canceled out the motivation for a search.

American Women Poets (Chelsea House, 1986), of which Harold Bloom is the editor, and *Modern American Women Writers* (Scribner's, 1991), edited by Elaine

Showalter, both omit the most important counter-culture woman poet from the fifties on, Diane di Prima.

These items demonstrate the self-perpetuating myth on the part of readers, editors, and professors, and the demoralizing perception among Italian Americans themselves that Italian American literature is second-rate—because if it weren't it would be included in reference tools and collections; issued in paperback or series; anthologized, collected, selected, recommended, discussed, analyzed, and put in course offerings.

Exclusion leads Italian American writers to the Kafkaesque conviction that their writing is not worthy of being included. To emerge from this dismal swamp requires enlightenment of the denigrators; an end to stereotyping Italian Americans in the media and in publishing; a wide diffusion of the literary contributions made by Italian American writers; an increase in sensitivity on the part of reviewers and critics and their ability to explicate the particular experience and relate it to the dominant culture; and teachers who will promulgate the work because they need it and want it but who have to know it is there.

Among ethnic groups, Jews have become excellent critics, literary scholars, tastemakers. The officially recognized minority groups—Hispanic Americans, Asian Americans, African Americans, and Native Americans—have benefited by grants and the critical attention of liberals, set on righting the wrongs of racism, and are doing some of the most interesting work that is being published today. There is an abundance of anthologies and collections of multicultural writing done by minority authors. They have been championed by the Before Columbus Foundation, which has been giving out American Book Awards since 1978 that for the first time respect and honor excellence in American literature without restriction or bias.

In the wake of the feminist movement, the silenced women writers of the past were exhumed, explained, exhibited as lost treasures. They were reprinted by the feminist press, for example, and compiled in the volumes of *Notable American Women, 1607–1950: A Biographical Dictionary* and other sets. Examples of Anglo-American women predominated; one is left to ask why Sister Blandina Segale or Renata Brunorini, an actress and playwright of the beginning of the twentieth century, or Mari Tomasi, for example, are not entered when many more marginal women of Anglo-American background are. The feminist press has had a mission of recuperating women authors who were lost or neglected, remarkably without ever having found an Italian American author to reclaim and put back into print.

Editors and publishers have engaged in a great deal of "vertical" expansion with still more diaries and autobiographies of unknown "American housewives and writers," predominantly of Anglo-Saxon origin and always documenting the

same experiences; little attempt has been made to go horizontally into truly new areas to find other voices and to reach into experience that is not the conformist Anglo-American one.

Of the younger writers, Mary Bush and Cris Mazza received PEN/Nelson Algren awards for Fiction; Jeanne Schinto's story "Caddies' Day" was among the twenty published in *Best American Stories*, 1984, in which Mary Caponegro was listed in the honorable mentions; others have won awards since then from both the NEA and the American Book Awards of the Before Columbus Foundation. In 1991 Mary Caponegro won the American Academy's Prix de Rome; Agnes Rossi's first collection of short stories (1987) was awarded New York University's first fiction prize and publication by that press; Marianna De Marco Torgovnick's "On Being White, Female, and Born in Bensonhurst" was one of *The Best American Essays*, 1991 (Helen Barolini was listed as an honorable mention); and Anna Quindlen received a 1992 Pulitzer Prize for her commentary in her *New York Times* column, "Public and Private."

The difference between neglect and respect can be the network of support one has: in the academic world, in the publishing industry, with reviewers in the media; recommendations for writers' colonies, panel appearances, grants, and readings all count. It is new territory to Italian American women writers.

Affirmations

The exclusions have been great, the barriers formidable. Still, there is an answer. If others will not take the subject of Italian American writing seriously, the writers will, by also becoming the teachers and critics of their experience. That is what Black women writers have said and done, and that is what our own tradition counsels: In the Sicilian version of the Noah's Ark story, after God chose two of all of his creature to go aboard the ark, the fleas found they had been forgotten. So they slipped on by getting into Noah's beard. As the Sicilians say, "If God forgets us, we must use our own wits."

An answer also lies in time—time for Italian American women writers to become economically able to support their writing without having to write for hire, or as ghosts, and without having their work shunted off to the graveyard category of romance or young adult books; time to add depth to the habit of writing, to explore and experiment stylistically with the language, to retell old stories with new insights, to articulate in an authentic way in literature the Italian American experience.

The evidence shows that an Italian American literary record exists and that women are part of it. Yet that body of work remains unreprinted by publishers and unexamined by critics; it has still to be made known to a wide public and put into libraries and on reading lists. For Italian American women, it is a continuing "ordeal of the woman writer"—the words once used in a tape-recorded conversation in which Erica Jong, Marge Piercy, and Toni Morrison discussed the difficulties *they* faced in getting recognition. If those three prominent writers (all published and reviewed at the time) could speak of "ordeal," it makes all the more compelling by comparison the hurdles faced by disadvantaged Italian American women writers. Earlier, Virginia Woolf, though privileged by birth with connections to the English literary milieu and intellectual elite, had lamented the obstacles and self-doubt inherent in being a woman writer. How hollow those laments sound to the aspiring writer with the wrong name, with no contacts or associations within the publishing network, and with few or no literary antecedents! For Italian American women who have been struggling upward from distances of poor education, dependency, the burden of traditional roles, and prejudicial stereotyping in the publishing world, the obstacles to their acceptance as writers (when dealing with their own material) still are formidable.

A whole new form of literary criticism based on psychoanalyst Karen Horney's theories, and the new insights from ethnotherapy, could most appropriately be applied to Italian American writing. Horney had a comprehensive approach to experience, and proceeding from her studies of alienation, her work focused on the unblocking of neuroses that hindered the growth of personality and the full maturation of a person. Her concrete focus is extremely relevant to an analysis of realistic literature and applicable to the feelings of unworthiness, low expectations, and self-doubt experienced and revealed by Italian American women. Bernard Paris, who applied Horney's theories in *A Psychological Approach to Fiction* (1974), has identified a "Third Force" psychology that goes beyond Freudianism and behaviorism to recognize a third principle: the evolutionary and constructive force in human beings that represents the drive toward self-actualization. This seems extremely applicable to the growth-oriented direction of Italian American writing, which often proceeds from a sense of alienation to reach toward newly articulated self-awareness. Further, cultures themselves can be evaluated in terms of a universal norm of psychological health, for misguided values can also manifest in societies as a whole. As Paris states, "Those things are good in a culture which satisfy the basic needs of its members and foster their full human growth, those things are bad which frustrate the basic needs and induce self-alienation."[33] Some cultures, in effect, demand too enormous a ransom to release the individual from benevolent captivity.

Depth psychologist Angelyn Spignesi has done an exploration of the female unconscious in her *Lyrical-Analysis: The Unconscious Through Jane Eyre* (1990) by making applicable to all women the quest for self-awareness exemplified through Charlotte Bronte's character of Jane Eyre.

Spignesi had already set out on a bold new track in her first book, *Starving Women: A Psychology of Anorexia Nervosa* (1983), in which (perhaps influenced by her Italian American background) she identifies the anorexic, in wording that eerily evokes the Italian American woman, "to be the carrier of the starving woman in every person, the female starving to be nourished by the underworld from which she has been cut off for centuries," confined as she was to the world of matter *(mater)* and the literal kitchen and identified exclusively with aspects of emotion and nurturance, while men were free to scale the heights of intellectual soaring or descend to the imaginative night realm of the other "under" world.[34]

Spignesi's search for the female self is quite opposite of Camille Paglia's defense of a patriarchal vision of culture; in Spignesi's view, an artificial opposition between Mother and Father resulted in the male–female dichotomy that is at the bottom of Western civilization. The culture has been set up to perpetuate opposition—the separation between Father and Mother and all that it implies in right/wrong, good/bad.

Spignesi does not propose destroying Father to enthrone Mother, but, rather, reviewing the narrow domination of one psyche (the male) and its one "way-of-seeing" while more deeply exploring the female psyche. She suggests (in contrast to Paglia's contentious system of opposition between Apollonian male and Dionysian female) that we no longer imagine the female as opposite; by refusing to think in opposites, we can instead take "Mother and Father as continually in motion, without hierarchy, within one another yet with precise distinction and differentiation."[35]

Spignesi, more original and independent than Paglia, ventures into the new realm of women's unconscious rather than seconding what has been predetermined by previous *male* texts. Spignesi's work provides an incisive insight into the position of women vis-à-vis their mothers and is especially pertinent to Italian American women, who are less focused on by their mothers than are sons, first, and husbands, second—a finding reinforced by psychotherapist Aileen Riotto Sirey's work on ethnotherapy.

It is also a clear call to creative women: "an invitation to all of us 'hysterics' to begin to write on our own from the psyche which is our own and inherently that of woman. . . . It is time for women to enter the unfamiliar chasm of our own psychological terrain and to carry this up in aesthetic endeavour."[36]

Spignesi's emphasis on that goal is very much in the tradition of Freud and Jung, who articulated the bridge from the dream realm to literary imagination.

Among the theoretical questions that another scholar, Katherine Newman, poses for a critical framework by which to evaluate ethnic literature is this: What are the causes that bring about the production of literature by writers of an ethnic group?[37] Italian American women could answer: the need to know ourselves, to create our models, to write the stories that need telling, and to bring into being the works that are missing and that need to be read.

In the broadest sense, this is the function of literature. Literature gives us ourselves.

As a group, Italian American women have angles of vision and particular perceptions that are a needed part of the revitalizing multicultural factor in this country's national literature. Using the same strengths of their foremothers, but now for artistic rather than economic growth, Italian American women can authorize themselves to give their story to waiting readers.

Perhaps the first step is the keeping of journals, the writing of autobiography or memoirs. The volume *Women's Autobiography: Essays in Criticism,* ed. Estelle Jelinek (1980), contains a whole chapter entitled "In Search of the Black Self," affords much material by Anglo-American and Jewish women, but has not a single entry for an Italian American woman such as an excerpt from Sister Blandina's journal, Bella Visono Dodd's *School of Darkness* (1954), Barbara Grizzuti Harrison's memoir of growing up as a Jehovah's Witness, *Visions of Glory* (1978), or Beverly Donofrio's account of her life, *Riding in Cars with Boys* (1990).

A body of autobiographical work has still to be developed to illuminate points of contact with a common past as well as to reveal the inner lives of Italian American women. Black women have realized the importance of the personal voice as part of the long, united march toward recognition. Black autobiographies, they say, help rend the veil of White definitions that misrepresent a person to him- or herself and to the world. Creating a new identity can create a new literature.

In the past, the Italian American woman expressed herself orally. The oral-history narrators—beginning with Rosa Cassettari's riveting story of herself and Valentine Winsey's interviews—were natural poets as evident in the case of "Hands: A Love Poem" transcribed from his mother's spoken words by Ross Talarico.[38]

The great range of poetry by Italian American women extends from the oral tradition to today's stylistic sophistication. Italian American women are "making their bones" in poetry, from confessional feminist poets Daniela Gioseffi and Maria Mazziotti Gillan, to Sandra M. Gilbert's accomplished and warmly personal

family recollections in her collection *Blood Pressure* (1988); or the poet might be her own publisher ("Show respect! Subscribe!" she parodies on promotional literature), as is the waifish Rose Romano, who, like a stand-up comedian, stresses a blue-collar past and present, talks fast and smart, and presents herself defiantly in a collection from her malafemmina press called *Vendetta* (1990), in which she vaunts all of her differences ("I'm a Sicilian-Italian-American Lesbian / the scum of the scum of the scum").

An outstanding exception to all patterns is the brilliant Diane di Prima, who, having started on an academic route, dropped out to use her intelligence and drive in a highly original way and has become the most enduring of the fifties counterculture poets, a Zen teacher, an activist in social causes, and the founder of the San Francisco Institute of Magical and Healing Arts. At the stylistic end of the gamut is the linguistic transcendence of Ree Dragonette and Leslie Scalapino.

In their search for a self independent of the familial role thrust on them by tradition, many Italian American women writers have created fictional works that are strongly autobiographical: from Marion Benasutti's *No Steady Job for Papa* (1966) through Nancy Maniscalco's picaresque version of a Queens childhood in *Lesser Sins* (1979) and Rachel Guido deVries' novel *TenderWarriors* (1986) to Anna Monardo's novel *The Courtyard of Dreams* (1993), in which she uses her Italian background in the foreground and deals with the conflict still inherent in the American daughter of an Italian-born parent and the conflict of loyalty between the two cultures. Even when not specifically evoking an Italian American milieu, Diane di Prima's prodigious material has a rich thread of her Italian American background running through it—her preoccupation with the children, the meals, the ritual of the eels for Christmas Eve. It is the vein from which her wonderful, intense poetry flows, and it is in that kind of writing—the intimate revelation—that Italian American women seem most powerfully to express themselves.

In the genre of the immigrant saga, Italian American women have been depicted by writers of both genders and there is by now a whole gallery of literary portraits of the strong woman in characters such as Fortuna in Julia Savarese's *TheWeak and the Strong* (1952), Marietta in Antonia Pola's *Who Can Buy the Stars?* (1957), the title characters of Michael De Capite's *Maria* (1943) and my *Umbertina* (1979), Lucia Santa in Mario Puzo's *The Fortunate Pilgrim* (1964), and Annunziata in Ann Abelson's *The Little Conquerors*.

The Italian American woman is more confident now of her place in the world, and this is mirrored through the emergence of an educated and emancipated generation that is more given to looking out at a world greater than that encompassed in family. These are the young women who continue their educa-

tion, have careers, marry outside their group, and ecumenically fashion a mode of living from both traditions.

They signify a new school of young women writers of Italian American background who easily "pass" into the American mainstream of writing without overt ethnic tones in their material to marginalize them; some, despite Italian surnames, are only partially of Italian heritage as, for instance, Carole Maso, Leslie Scalapino, Mary Caponegro, Anna Quindlen, and Agnes Rossi. Intermarriage has bequeathed a new generation of writers who bring a differing viewpoint to their material. Carole Maso's acclaimed first novel, *Ghost Dance* (1986), introduced two Italian American grandparents portrayed with remarkable insight and understanding, who nonetheless remained free of the emotional overlay either of reverence or of bitterness with which an older generation of Italian American writers might have imbued them.

Mary Bush (originally Bucci) writes obliquely of the Italian American experience, but it can be intuited in her short fiction; there are certain nuances and overtones and working out of family ties that are strongly Italian American. "Bread" in her collection *A Place of Light* (1990) centers on a young girl's impressions as she recovers from an operation, not yet convinced she has survived; it is set against an easily recognizable Italian American background. Ole Papa in her story "Difficult Passage" has all of the resonance of the old Italian patriarch. Both stories are not Italian American per se, but the authenticity of tone identifies them. On the other hand, Bush's novel in progress will be explicitly of Italian immigrants in Arkansas, based on her grandmother's experience.

Jeanne Schinto (the spelling of whose surname, Scinto, was changed to help Americans pronounce it in the Italian way) is a fiction writer of great promise who moves easily between stories of an Italian American milieu, such as "The Boathouse" (UNICO Literary Award, 1982), "The Disappearance," and "Before Sewing, One Must Cut" from her collection *Shadow Bands* (1988), to those of the larger experience as exemplified in her novel *Children of Men* (1991) with its focus on a Black–White relationship.

Anna Quindlen, who deals with the strains of an Irish Italian heritage in *Object Lessons* (1991), seems a transition figure in the passage from the older storyteller to the younger writer. Quindlen's case is unusual in another respect. As with Mary Gordon, though her name masks it she is part Italian on her mother's side; she is also in a position of high visibility on the *New York Times*. She has unparalleled exposure and national name recognition through her syndicated column that appears on the *New York Times* Op-Ed page. In "I Am a Catholic," from a collection of her columns titled *Living Out Loud* (1988), Quindlen gives her history

thus: "I believe in my own past. . . . I could no more say I am not Catholic than say I am not Irish, not Italian."

All of these younger women are stylistically adept but curiously detached from narrative. Gone is the old robust vitality and passion of storytelling—of telling and retelling the story of the Italian exodus to the New World, what happened to displaced peasants in the great urban ghettoes, and what became of their dually conflicted children. Subject matter is wispier now; little moments are prolonged and evoked in a minimalist manner more attuned to Anglo-American writing. Mary Caponegro's "Sebastian," from her collection *The Star Café: Stories* (1990),[39] is a story of an Englishman and his disconcertions. The writing is certainly crafted and brilliant and was given attention in reviews; but it is also mannered and studied, and the sense of struggle that moved the earlier women to write is now absorbed into the writing itself. The themes of earlier novels—how to make one's place in a seemingly alien society; how to become educated and evolved enough to move into that society; how to combine work and family; how, in fact, to separate from family in order to hang onto one's self without losing everything—have almost been put aside in favor of internal moments told in polished prose.

Carole Maso writes with great literary mastery, deliberately eschewing the linear narrative mode (associated with male dominance of the novel form) for a more circular weaving and interlacing (female skills) of tempos and themes.

It was creativity itself that captured the imagination of Carole Maso in *Ghost Dance* (1986)—as it does in Mary Caponegro's story from *The Star Café* "Materia Prima," a finely written, well-conceived parable of the will to creative expression that brooks no constraints as it is related in the story of a young girl whose obsession for ornithology is the metaphor for any creative passion. Paralleling Spignesi's "starving woman," Caponegro's character, when sent away to boarding school by her parents in an attempt to curb her obsession, stops eating and finds with satisfaction that she has also stopped her menstrual cycle: She becomes anorexic and thus attains the control over herself that her parents had thwarted.

The allusions to birds intersperse the narrative with great acuity and design and early establish the importance of "learning to fly on one's own. . . . Then, when it is on its own, there are no confusions. The break is clean; independence is clarity."

Again as with Maso, the art form is strong in Caponegro. They both express the need for freedom that is realized in the service of self to art. Both are supreme stylists for whom the *materia prima* of background has indeed been transformed into a universal art with surrealistic and mysterious overlay. Curiously,

the title of Maso's novel *Ava* (1993) suggests in itself bird flight and freedom.

Some Italian American women writers have a specific Italian American frame of reference; for others it is so attenuated as to seem nonexistent except as a muted echo. For Agnes Rossi, the Italian American background is attenuated into accents of detail and character. Marie Russo, the character through whom Rossi's novella *The Quick* (1992) is narrated, is grounded in an Italian American family in which the father still rages against children who don't fulfill his expectations, but the larger story is one of loss and has resonances for all families.

The new younger writers have a commonality: a boldness of voice and sureness of style that signal a true liberation from whatever roles and stereotypes of Italian American women prevailed in the past. They write of a gritty reality in which women have faced the violence of today's life and survived, as in Jeanne Schinto's novel *Children of Men* (1991); or they write with a new humor that is not the self-parody, as in old stories that made comic characters out of Italian Americans who acted and talked funny, but is now a controlled and knowing irony, as in the accomplished autoerotic fantasy of Mary Caponegro's title story from *The Star Café*. The Italian American is no longer the object of humor but the distanced distiller of it, as what is nightmarish is filtered through an ironic eye.

In the imaginative storytelling of Cris Mazza's fictions, a story titled "From Hunger" features as heroine a striving artist who is so hungry for her art (and human attention) she literally eats the paint from her canvas—another starving woman. Mary-Ann Tirone Smith's characters are strikingly freewheeling young women who challenge the notions of prescribed conduct and one of whom, from *The Book of Phoebe* (1985), is named for Holden Caulfield's younger sister in the cult book of the fifties, J.D. Salinger's *Catcher in the Rye*.

The above-mentioned have mostly taken a stance away from ethnic identification, one that engages in free imaginative roaming. Indeed, in her letter to the *New York Times* in response to Gay Talese's 1993 essay "Where Are the Italian American Novelists?", Smith put it this way: "As an Italian American novelist, I haven't any interest in creating fiction centered on Sicilian goatherds and crowded ships poignantly pulling away from Neapolitan docks; or Ellis Island, or men carrying a statue of the Virgin through the streets of Little Italy, or the canonization of Joe DiMaggio. . . ." Rather, Smith states, what she explores is "the inevitable tragic consequences we must suffer when loyalty and honor are placed above truth. *That* is the Italian American experience."

Smith seems a touch too scornful and defensive about Italian American material, and she is only partly right in her statement about it; though she and others, like Caponegro, or Mazza, or Maso, have transcended their immediate

background to range imaginatively where they will, their other contemporaries, like Mary Bush, or Anna Monardo, or Rachel Guido deVries, still do deal with the Italian connection without disparaging it or dealing in the stereotypes of quaint and dated material. Smith's is too strenuous and too misleading a denial of what preceded her and gave first voice to the Italian American experience.

Italian American women have always been hard workers; in the past they worked at home—taking in lodgers, making artificial flowers, doing piecework and embroidery, cooking for others, and even, as the heroine of Antonia Pola's novel *Who Can Buy the Stars?* (1957), making bootleg whiskey. Why not, then, work at home as writers? To admit intellectual and artistic endeavor as "work" (especially since it seldom produces immediate income) would be a revolutionary change in attitude and advancement in class. "Nonproductive" work such as writing was once the activity of a leisured class who could afford the indulgence. But as Beverly Donofrio relates in her 1990 memoir, *Riding in Cars with Boys*, once she had willed herself an education, her life changed; she was empowered to consider writing, an intellectual endeavor, as a legitimate occupation, something that moved her from working class to middle class and enabled her to triumph over the *miseria* mentality that told her she would never make it out of welfare or a factory job.

To achieve balance between one's inherited culture and the culture into which one is born is a feat of what sociologists call "creative ethnicity"—that is, using one's ethnic heritage as the starting point upon which to build one's own identity in a selective and critical way, as opposed to total and unquestioning acceptance of tradition. There is anxiety in choice. The hardships now are not the primitive ones of survival, but the more complex ones of uncertainty of direction, too much choice, self-expression, and autonomy.

Professor Pellegrino D'Acierno has a positive evaluation of the two cultural forces implicated in being Italian American: "The maintenance of two identities, two cultures, two languages," he states, "should make us dissentious within ourselves, should make us into artists." He believes that in their zeal to take on a monolithic American identity, Italian Americans have let the prevailing culture deform their own life experiences; they have failed to make the most of their identity crisis and to use the experience as the crucible for artistic production.[40]

For cultural duality is not only ambivalence, it is also advantage: To draw upon two identities, cultures, and languages is to draw riches as well as dissentiousness once it is recognized in a positive way and so used. Aileen Riotto Sirey's findings in ethnotherapy confirm that those who identify as Italian American conceive of themselves as part of something dually glorious: the magnificent long heritage of Italy in all of its manifestations plus the unique promise of American

freedom to achieve one's best. It is a position reiterated by, and expressed in, the character of Tina in *Umbertina* (1979).[41]

Women are in a unique position of being able to use the dichotomy of two cultures as the crucible for artistic production. The Black women writers have been particularly fine at this: "Our alienation is our great strength," says Nikki Giovanni. This is what lies at the base of Italian American women writers using strong themes; they use the paradox of their lives, which has militated *against* expressivity, *in* expressivity. As Barbara Grizzuti Harrison said regarding her past submersion as a Jehovah's Witness, "Women are good at turning their desolation to their advantage." From waiting, from patience, comes intensity of focus, words straining to be heard, passion, conviction, an inner voice.

The opening words of *The Decameron* of Boccaccio are *"Umana cosa . . ."* (Something human). That encapsulates the Italian American woman writer's particular sensibility—very human, the stuff of life. She tilts toward life, bringing realism, vigor, specificity, humane understanding of the emotions, and respect for the human verities to her material.

Italian American women writers were late in coming to the fore of literary writing for historical, social, and personally inhibiting reasons having to do with the culture from which they came. As they give voice to that experience, it is not surprising that they have taken long, nor that their numbers are not greater; but it does remain surprising that external indifference to their recognition remains so entrenched.

And yet, like other American writers, the Italian American woman writer, while retaining her particular focus, transcends ethnic and gender groups, writing in the fullness of her exposure to, and experience of, a national literature that mirrors a many-cultured society. American literature is an ocean, says Black novelist Ishmael Reed, and it is large enough for all of the currents that run through it.

Marianna De Marco Torgovnick's "Being White, Female, and Born in Bensonhurst," included in *Best American Essays, 1991,* contains this reference to her book *Gone Primitive: Savage Intellects, Modern Lives* (1990): "Eventually I write the book I like best about primitive Others as they figure within Western obsessions, my identification with "the Other," my sense of being "Other," surfaces at last." Her sense of Otherness, of course, is that of being Italian American, and this is pertinent to the Italian American position in literature as Outsider. Though we seem to be forgotten in the national literature, we can turn that into the position of the Outsider, a powerful antidote to the blandness of conformism. We can challenge exclusion of our work, and we will inevitably remake the framework of what

has excluded us as we enter, more and more, into our places as participants and makers of the national literature.

As Torgovnick disclosed in her book, the civilized West's attraction to the primitive reflects a shiver of transcendental homelessness—a form of absolute alienation from the self, from society. It is easy to have those feelings growing up Italian American and, from the personal, to be able to project them more generally. Noting throughout *Going Primitive* how primitivism has been colored by being conceived and applied in our culture through the masculine view, Torgovnick also seeks to redress that imbalance (much as Spignesi does in identifying the feminine psyche through female material) by looking for the female mode and by making her work accessible.[42]

Again as in the manner of Spignesi (and contrary to Paglia), Torgovnick stresses the importance of alternative stories to the Western one; unlike Paglia, who is beholden to male mentors and has internalized their dominant, masculine values and attitudes, Torgovnick has a feminist and independent outlook. Her refuting the colonialist denial of the complexity of primitive societies can also be translated into a refutation of the dominant American culture's denial of minority culture as important.

Somewhat as happened with male writers of Italian American background where the best known—Puzo and Talese, say—are not necessarily the best, so with Italian American women writers it has happened that the most public attention has gone to the sensationalism of the provocative Camille Paglia. This is unfortunate, but also, probably, transitory. Unabashedly self-referential, a self-styled paragon of the Western world who takes on the whole of past Western culture and present-day popular culture as her subjects, Paglia extols the strengths of her Italian grandmothers and is openly proud and exaltant of her Italian background (through which she claims connection to Vergil's warrior queen Camilla of the Volscians). Notwithstanding Paglia's positive declaration of herself as Italian American (a refreshing switch from the cloaking or tacit nonidentification of that identity in other writers), her instant celebrity status is suspect since it displaces recognition of other arguably worthier models.

As Cynthia Ozick in an essay on feminism says: "Cultivation precedes fruition. It will take many practitioners of an art to produce one great artist."[43] The emergence of the Italian American woman as writer, scholar, intellectual is new, incredibly new, to the national literature and built on a base of all of the "lost" or unthought of writers who wrote without notice or encouragement.

A start is made, and then, like reverberations, one work will set off another: each new literary work responding to a previous one, provoked into being

by answering something left unsettled in the other work, and, in turn, provoking new responses to itself as each writer stands on the shoulders of another.

It has already happened that Italian American women see themselves as writers, not simply as upholders and transmitters of a patriarchal culture through their roles as wives and mothers. To evolve from that old and potent image has taken the whole of the twentieth century that began in the midst of the Great Migration from Italy.

Women are in the unique position of being able to use the dichotomy of their two cultures as the crucible for artistic production, to engage in aesthetic endeavor; from a long wait comes intensity of focus, words straining to be heard, passion, conviction, a firm inner voice.

What unites the women is that, at some point, they all derive from a common cultural context and tradition, one in which woman had a strongly defined role; it is important to see them whole and to hear in the cadence of their voices the echo of the larger group. That is not to isolate them to a separatist ethnic drawer in the bureau of American literature, but to identify them as an important source of American writing that has been overlooked.

Once the missing pieces have been fitted into the national literature, the unheard voices listened to, the contributions of a large group of American life attended to, the emphasis on ethnicity per se will have been transcended. Each Italian American woman writer is what she has always been: an American writer in her own right.

Notes

1. Camille Paglia, "Reflections on Being Italian in America," in *A New Day* (Bloomfield, N.J.: UNICO National, 1976).

2. Jacob Riis, *How the Other Half Lives: Studies Among the Tenements of New York* (New York: Charles Scribner's Sons, 1890).

3. Richard Gambino, *Italian American Studies and Italian Americans at the City University of New York: Report and Recommendations* (New York: John D. Calandra Italian American Institute, 1986–1987).

4. Andrew Rolle, *The Italian Americans: Troubled Roots* (New York: Free Press, 1980): 111.

5. Marie Hall Ets, *Rosa: The Life of an Italian Immigrant* (Minneapolis: University of Minnesota Press, 1970): 253.

6. Valentine Rossilli Winsey, "The Italian Immigrant Women Who Arrived in the United States Before World War I," in *Studies in Italian American Social History: Essays in Honor of Leonard Covello,* ed. Francesco Cordasco (Totowa, N.J.: Rowman & Littlefield, 1975).

7. Ibid, 210.

8. References are to works which appear in *The Dream Book: An Anthology of Writings by Italian American Women,* ed. Helen Barolini (New York: Shocken Books, 1985).

9. Maria Mazziotti Gillan. "Public School No. 18: Paterson, New Jersey," in Barolini, *The Dream Book:* 320–321.

10. Vivian Gornick in a radio broadcast on WBAI in New York City, 6 March, 1982.

11. Elaine Romaine, "you were always irish, god" in Barolini, *The Dream Book:* 306.

12. Joseph Alsop, *FDR: A Centenary Remembrance* (London: Thames and Hudson, 1982): 11–12.

13. Barolini, *The Dream Book,* 22.

14. Anna Quindlen, "Breaking Their Silence," *New York Times,* 29 December, 1985.

15. Claudia Tate, ed. *Black Women Writers at Work* (New York: Continuum, 1983): 29.

16. Sandra M. Gilbert, "A Fine, White Flying Myth," in *Shakespeare's Sisters,* ed. Sandra M. Gilbert and Susan Gubar (Bloomington: Indiana University Press, 1979): 260.

17. Martha Nussbaum, "The Ideal of the Educated Woman," *New York Review of Books,* 30 January 1986: 7–12.

18. Joy Harjo, "Bio-Poetics Sketch," *Greenfield Review,* 9, no. 3–4 (1981): 8–9.

19. Tina DeRosa, "An Italian American Woman Speaks Out," *Attenzione,* May 1980: 38–39.

20. Mary Gordon, "The Myth of the Tough Dame," *Mirabella,* November 1992: 102–108.

21. Harold Schecter, "The Return of Demeter: The Poetry of Daniela Gioseffi," *Psychocultural Review* (1976): 452–457.

22. *Authors' Guild Bulletin,* September–October 1982: 16.

23. Jules Chametzky, "Our Decentralized Literature," a paper presented at the John F. Kennedy–Institut fur Amerikastudien, Heidelburg, June 4, 1971, and published in their Proceedings.

24. Katherine Newman, "An Ethnic Literary Scholar Views American Literature," *MELUS* Spring, 1980: 6.

25. Ibid, 10.

26. Genevieve Belfiglio, "Introduction," *Real Fiction* 1 (November 1982) (unpaged).

27. Zora Neale Hurston, "What White Publishers Won't Print" in *I Love Myself* (New York: Feminist Press, 1979).

28. Marianna De Marco Torgovnick, "On Being White, Female, and Born in Bensonhurst," *Partisan Review,* Summer 1990: 462–463.

29. Mel Gussow, *The New York Times*, 1 May 1983: I, 2.

30. A special twenty-year anniversary insert of 68 New York Op-Ed pieces appeared 30 September 1990. Toni Morrison, Woody Allen, Henry Ford II, Salmon Rushdie, E.B. White, William Styron, Meir Kahane, Elridge Cleaver were all featured—and one token Italian American: Joseph Califano, who authored his piece when he was in President Johnson's administration, and so was a political choice. Why no Italian and Italian American writers or intellectuals?

31. Camille Paglia, "Madonna—Finally, a Real Feminist," *New York Times,* 14 December 1990: 39.

32. Thomas L. Shaffer, "Character and Community: *Rispetto* as a Virtue in the Tradition of Italian American Lawyers," *Notre Dame Law Review,* 64, no. 5 (1989).

33. Bernard Paris, "Third Force Psychology and the Study of Literature, Biography, Criticism, and Culture," *Literary Review* 24, no. 2 (Winter 1981): 221.

34. Angelyn Spignesi, *Starving Women: A Psychology of Anorexia Nervosa* (New York: Spring Publications, 1983): xi. An unwitting affirmation of Spignesi's starving-woman theory was offered by the novelist Kenny Marotta in a letter to me, dated 19 September 1986, that contained this observation of the female characters in *Umbertina:* "all those psychically malnourished, starving women, all women with a doomed wish for a nurturing mother, all with a painful vacuum they must mourn."

35. Ibid., 3.

36. Ibid., x.

37. Katherine Newman, "An Ethnic Literary Scholar Views American Literature," *MELUS,* Spring 1980: 5.

38. Rose Venturelli, "Hands: A Love Poem," in *Calling Home: Working Class Women Writing,* ed. Janet Zandy (New Brunswick, N.J.: Rutgers University Press, 1990): 208–210.

39. The title story from this collection was cited among "Other Distinguished Stories of the Year 1983" in *Best American Short Stories, 1984* (Boston: Houghton Mifflin, 1984).

40. From the transcript of the conference on "Contemporary Fiction Writing in Italy and America," held 14 October 1981 at Columbia University in New York City.

41. Helen Barolini, *Umbertina* (New York: Seaview, 1979): 422.

42. "In my future projects," Torgovnick wrote for her entry in *Contemporary Authors: New Revision Series* 15 (Detroit: Gale, 1985): 432, "I hope to reach not just a scholarly audience, but a more general one as well—something not always easy in an academic career, but very important, I think, for the state of our culture."

43. Cynthia Ozick, "Women and Creativity: The Demise of the Dancing Dog," in *Woman and Sexist Society,* ed. Vivian Gornick and Barbara K. Moran (New York: New American Library, 1971): 431–451.

Further Reading

Bibliographic Resources*

Aleramo, Sibilla. *A Woman,* trans. Rosalind Delmar (Berkeley: University of California Press, 1980).
Balducci, Carolyn. *A Self-Made Woman* (Boston: Houghton Mifflin, 1975).
Cornelisen, Ann. *Women of Shadows* (Boston: Little, Brown, 1976).
De Capite, Michael. *Maria* (New York: John Day, 1943).
Deledda, Grazia. *La madre,* (1920; reprint, Milano: Mondadori, 1982).
———. *The Mother* (1923, trans. Mary G. Steegman; reprint, Marietta, Georgia: Cherokee, 1982).
———. *Cosima,* trans. Martha King (New York: Italica Press, 1988).
Ets, Marie Hall. *Rosa: The Life of an Italian Immigrant* (Minneapolis: University of Minnesota Press, 1970).
Gambino, Richard. *Blood of My Blood: The Dilemma of the Italian-Americans* (New York: Doubleday, 1974).
James, Edward T., and Janet W. James, eds. *Notable American Women, 1607–1950: A Biographical Dictionary* (Cambridge: Harvard University Press, 1983).
Miller, Jean Baker. *Toward a New Psychology of Women,* 2d ed. (Boston: Beacon Press, 1986).
Olsen, Tillie. *Tell Me a Riddle* (New York: Dell, 1976).
———. *Silences* (New York: Delacorte, 1978).
Pacifici, Sergio. *A Guide to Contemporary Italian Literature* (New York: Meridian Books, 1962)
Paris, Bernard. *A Psychological Approach to Fiction* (Bloomington: Indiana University Press, 1974

* All of the primary works by Italian American women writers cited in Helen Barolini's essay are listed in the accompanying "Canon: Italian American Women Writers" (261–264). For bibliographic information pertaining to works by Italian American male writers mentioned in the essay, see the listings for di Donato, Fante, Tomasi, Mangione, et al. in "Canon: Italian American Novelists" (189–191). Ed.

Peragallo, Olga. *Italian-American Authors and Their Contribution to American Literature* (New York: S.F. Vanni, 1949).
Pratt, Annis. *Archetypal Patterns in Women's Fiction* (Bloomington: Indiana University Press, 1981).
Raymond, James C., ed. *Literacy As a Human Problem* (Tuscaloosa: University of Alabama Press, 1983).
Rolle, Andrew. *The Immigrant Upraised: Italian Adventurers and Colonists in an Expanding America* (Norman: University of Oklahoma Press, 1968).
———. *The Italian Americans: Troubled Roots* (New York: Free Press, 1980).
Sangiuliano, Iris. *In Her Time* (New York: Morrow, 1978).
Sirey, Eileen Riotto. *Ethnotherapy: An Exploration of Italian American Identity* (New York: National Institute for Psychotherapies, 1985).
Spignesi, Angelyn. *Starving Women: A Psychology of Anorexia Nervosa* (New York: Spring Publications, 1983).
———. *Lyrical Analysis: The Unconscious Through Jane Eyre* (New York: Chiron Press, 1990).
Talese, Gay. "Where Are the Italian-American Novelists?" *New York Times Book Review* (14 March 1993) 1.
Torgovnick, Marianna De Marco. *Gone Primitive: Savage Intellects, Modern Lives* (Chicago: University of Chicago Press, 1990).
———. "On Being White, Female, and Born in Bensonhurst." In *Crossing Ocean Parkway: Readings by an Italian American Daughter* (Chicago: University of Chicago Press, 1994).
Winsey, Valentine Rossilli. "The Italian Immigrant Women Who Arrived in the United States Before World War I." In *Studies in Italian American Social History: Essays in Honor of Leonard Covello,* ed. Francesco Cordasco (Totowa, N.J.: Rowman & Littlefield, 1975).

Canon: Italian American Women Writers (Selected Works)

—Compiled by Mary Jo Bona

Azpadu, Dodici. *Saturday Night in the Prime of Light* (Iowa City, Iowa.: Aunt Lute Book Co., 1983).
———. *Goat Song* (Iowa City, Iowa: Aunt Lute Book Co., 1984).
Barolini, Helen. *Umbertina* (New York: Seaview, 1979).
———, ed. *The Dream Book: An Anthology of Writings by Italian American Women* (New York: Schocken Books, 1985).
———. *Love in the Middle Ages* (New York: William Morrow, 1986).
———. *Festa: Recipes and Recollections* (nonfiction) (New York: Harcourt, 1988).
———. *Aldus and His Dream Book* (nonfiction) (New York: Italica, 1991).
Basile, Gloria Vitanza. *The Godson* (alternate title, *House of Lions*) (Los Angeles: Pinnacle Books, 1976).
———. *Appassionato* (Los Angeles: Pinnacle Books, 1978).
Benasutti, Marion. *No Steady Job for Papa* (New York: Vanguard, 1966).
Bernardi, Adria. *Houses with Names: The Italian Immigrants of Highwood* (nonfiction) (Urbana, Ill.: University of Illinois, 1990).
Bonomo, Jacquelyn. "Patience in the Endless Rain," "Hens," "The Ninth Life," "The Flashlight." In *The Dreambook: An Anthology of Writings by Italian American Women* (New York: Schocken, 1985).
Bryant, Dorothy Calvetti. *Ella Price's Journal* (Philadelphia: Lippincott, 1972).
———. *The Kin of Ata Are Waiting for You* (New York: Random House, 1976).
———. *Miss Giardino* (Berkeley, Calif.: Ata Books, 1978).
———. *Writing a Novel* (nonfiction) (Berkeley, Calif.: Ata Books, 1979).
———. *A Day in San Francisco* (Berkeley, Calif.: Ata Books, 1982).

———. *Confessions of Madame Psyche* (Berkeley, Calif.: Ata Books, 1986).

———. *The Test* (Berkeley, Calif.: Ata Books, 1991).

———. *Anita, Anita* (Berkeley, Calif.: Ata Books, 1993).

Bush, Mary (Bucci). *A Place of Light* (New York: William Morrow, 1990).

Calcagno, Anne. *Pray for Yourself and Other Stories* (Evanston, Ill.: Northwestern University Press, 1993).

Caponegro, Mary. *The Star Café: Stories* (New York: Scribner's, 1990).

Capuzzi, Octavia. (*See* Waldo, Octavia).

Caruso, Rosemary. *Shadows of the Morning Moon* (play)

———. *The Suffering Heart Salon* (play) (produced Los Angeles, 1983).

Cavallo, Diana. *A Bridge of Leaves* (New York: Atheneum, 1961).

———. *The Lower East Side: A Portrait in Time* (nonfiction) (New York: Crowell-Collier, 1971).

Chay, Marie. *Pilgrim's Pride* (Toronto: Dodd, 1961).

Ciresi, Rita. *Mother Rocket* (Athens, Ga: University of Georgia, 1993).

Clement, Rosemary Tarango. *Her Mother's Daughter* (play) (produced in New York City by *Il Teatro del Rinascimento*, 1983).

———. *October Bloom* (play) (produced in New York City by *Il Teatro del Rinascimento*, 1984).

de Matteo, Donna. *Rocky Road* (play) (produced in New York City at the Howard Bergoff Playwright Foundation, 1981).

———. *The Silver Fox* (play) (produced in New York City at the Howard Bergoff Playwright Foundation, 1983).

De Rosa, Tina. *Paper Fish* (Chicago: Wine Press, 1980).

———. *Bishop John Baptist Scalabrini: Father to the Migrants* (nonfiction) (Darien, Conn.: Insider Publications, 1987).

DeSalvo, Louise. "A Portrait of the *Puttana* As a Middle-Aged Woolf Scholar." In *Between Women: Biographers, Novelists, Critics, Teachers and Artists Write About Their Work on Women,* ed. Carol Ascher, Louise DeSalvo, and Sara Ruddick (Boston: Beacon, 1984).

———. *Casting Off: A Novel* (Brighton, U.K.: Harvester, 1987).

deVries, Rachel Guido. *Tender Warriors* (Ithaca, N.Y.: Firebrand, 1986).

di Prima, Diane. *Dinners and Nightmares* (New York: Corinth, 1960)

———. *Memoirs of a Beatnik* (1969; reprint, San Francisco: Last Gasp of San Francisco, 1988).

———. *Revolutionary Letters* (San Francisco: City Lights, 1971).

———. *Loba: Part 1* (Santa Barbara, Calif.: Capra Press, 1973).

———. *Selected Poems, 1956–1975* (Plainfield, Vt.: North Atlantic Books, 1975, enlarged edition, 1977).

———. *Pieces of a Song: Selected Poems* (San Francisco: City Lights, 1990).

Dodd, Bella Visono. *School of Darkness* (1954; reprint, Santa Cruz, Calif.: Devin Publications, 1963).

Donofrio, Beverly. *Riding in Cars with Boys: Confessions of a Bad Girl Who Makes Good* (New York: Viking Penguin, 1990).

Dragonette, Ree. *Parable of the Fixed Stars* (poems) (New York: Allograph, 1968).

———. *This Is the Way We Wash Our Hands* (poems) (New York: Calliope, 1977).

Ermelino, Louisa. *Joey Dee Gets Wise: A Novel of Little Italy* (New York: St. Martin's, 1991).

Feraca, Jean. *South from Rome: Il Mezzogiorno* (Monterey, Ky.: Larkspur, 1976).

———. *Crossing the Great Divide* (Madison: Wisconsin Academy of Sciences, Arts, and Letters, 1992).

Giardina, Denise. *Storming Heaven: A Novel* (New York: Norton, 1987).
Gilbert, Sandra Mortola. *In the Fourth World* (Tuscaloosa: University of Alabama Press, 1979).
———. *Emily's Bread: Poems* (New York: Norton, 1984).
———. *Blood Pressure: Poems* (New York: Norton, 1988).
Gilbert, Sandra Mortola, and Susan Gubar, *The Madwoman in the Attic: The Woman Writer and the Nineteenth-Century Literary Imagination* (nonfiction) (New Haven: Yale, 1979).
Gillan, Maria Mazziotti. *Flowers from the Tree of Night* (poems) (Seattle: Chantry, 1981).
———. *Winter Light* (poems) (Seattle: Chantry, 1985).
———. *The Weather of Old Seasons* (poems) (Merrick, N.Y.: Cross Cultural Communications, 1989).
———. *Taking Back My Name* (poems) (San Francisco: malafemmina press, 1991).
Gioseffi, Daniela. *The Great American Belly Dance* (Garden City, N.Y.: Doubleday, 1977).
———. *Eggs in the Lake* (Brockport, N.Y.: BOA Editions, 1979).
———. *Earth Dancing: Mother Nature's Oldest Rite* (nonfiction) (Harrisburg, Pa.: Stackpole, 1980).
———. *Woman on War: Essential Voices for the Nuclear Age* (nonfiction) (New York: Simon & Schuster, 1988).
———. *On Prejudice: A Global Perspective* (New York: Anchor, 1993).
———. *Word Wounds and Water Flowers* (West Lafayette, Ind.: Bordighera, 1995).
Gordon, Mary. "Zi' Marietta." In *A New Day* (Bloomfield, N.J.: UNICO National, 1976).
———. *Final Payments* (New York: Random House, 1978).
———. *The Company of Women* (New York: Random House, 1981).
———. *Good Boys and Dead Girls: And Other Essays* (New York: Viking Penguin, 1992).
Grieco, Rose. *The Queen of Mulberry Street* (Great Neck, N.Y.: Todd and Honeywell, 1989).
Harrison, Barbara Grizzuti. *Visions of Glory: A History and a Memory of a Jehovah's Witness* (nonfiction) (New York: Simon and Schuster, 1978).
———. *Off Center* (nonfiction) (New York: Dial, 1980).
———. *Foreign Bodies* (Garden City, N.Y.: Doubleday, 1984).
———. *Italian Days* (nonfiction) (New York: Weidenfeld and Nicolson, 1989).
———. *The Islands of Italy* (nonfiction) (New York: Ticknor & Fields, 1991).
Hendin, Josephine Gattuso. *The Right Thing to Do* (Boston: David Godine, 1988).
Linfante, Michele. *Pizza* (one-act play) (Berkeley, Calif.: West Coast Plays, 1980).
Manfredi, Renee. *Where Love Leaves Us* (Iowa City: University of Iowa Press, 1993).
Maniscalco, Nancy. *Lesser Sins* (New York: Avon, 1979).
Maso, Carole. *Ghost Dance* (San Francisco: North Point, 1986).
———. *The Art Lover* (San Francisco: North Point, 1990).
———. *Ava* (Normal, Ill.: Dalkey Archive, 1993).
———. *The American Woman in the Chinese Hat* (Normal, Ill.: Dalkey Archive, 1994).
Mays, Lucinda LaBella. *The Other Shore* (New York: Atheneum, 1979).
Mazza, Cris. *Animal Acts* (stories) (Boulder, Colo.: Fiction Collective, 1988).
———. *Is It Sexual Harassment Yet?* (stories) (Boulder, Colo.: Fiction Collective Two, 1991).
Monardo, Anna. *The Courtyard of Dreams* (New York: Doubleday, 1993).
Nocerino, Kathryn. *Death of the Plankton Bar & Grill* (St. Paul, Minn: New Rivers, 1987).
Paglia, Camille. *Sexual Personae: Art and Decadence from Nefertiti to Emily Dickinson* (New Haven: Yale University Press, 1990).
———. *Sex, Art, and American Culture: Essays* (New York: Vintage, 1992).

———. *Vamps and Tramps: New Essays* (New York: Vintage, 1994).

Paolucci, Anne (Attura). *Minions of the Race* (one-act play) (first produced in Kalamazoo, Mich., at Western Michigan University, 1972).

———. *Eight Short Stories* (Bergenfield, N.J.: Griffon House, 1977).

———. *Poems Written for Sbek's Mummies, Marie Menken, and Other Important Persons, Places and Things* (Bergenfield, N.J.: Griffon House, 1977).

———. *Riding the Mast Where It Swings* (poems) (Whitestone, N.Y.: Griffon House, 1980).

———. *Cipango!: A One-Act Play in Three Scenes About Christopher Columbus* (produced in New York City, 1987); (Whitestone, N.Y.: Griffon House, 1980).

———. *Sepia Tones: Seven Short Stories* (Whitestone, N.Y.: Rimu Publishing/Griffon House, 1986).

———. *Gorbachev in Concert and Other Poems* (Whitestone, N.Y.: Griffon House, 1991).

Pola, Antonia. *Who Can Buy the Stars?* (New York: Vantage, 1957).

Quindlen, Anna. *Living Out Loud* (New York: Random House, 1988).

———. *Object Lessons* (New York: Random House, 1991).

———. *The Tree that Came to Stay* (New York: Crown, 1992).

———. *Thinking Out Loud: On the Personal, the Political, the Public and the Private* (New York: Random House, 1993).

———. *One True Thing* (New York: Random House, 1994).

Raptosh, Diane. *Just West of Now* (Montreal: Guernica, 1992).

———. *Labor Songs* (Montreal: Guernica, 1997).

Romano, Rose. *Vendetta* (San Francisco: malafemmina press, 1990).

———. *The Wop Factor* (Brooklyn/Palermo: malafemmina press, 1994).

Rossi, Agnes. *Athletes and Artists: Stories* (New York: New York University Press, 1987).

———. *The Quick: A Novella and Stories* (New York: W.W. Norton, 1992).

———. *Split Skirt* (New York: Random House, 1994).

Ruffolo, Lisa. *Holidays* (St. Paul, Minn.: New Rivers Press, 1987).

Santini, Rosemarie. *The Secret Fire* (nonfiction) (Chicago: Playboy Press, 1977).

———. *Abracadabra* (Chicago: Playboy Press, 1978).

Savarese, Julia. *The Weak and the Strong* (New York: Putnam, 1952).

———. *Final Proof* (New York: Norton, 1971).

Scalapino, Leslie. *This Eating and Walking at the Same Time Is Associated All Right* (Bolinas, Calif.: Tombouctou, 1979).

———. *Considering How Exaggerated Music Is* (San Francisco: North Point, 1982).

———. *That They Were at the Beach—Aeolotropic Series* (San Francisco: North Point, 1985).

———. *Way* (San Francisco: North Point, 1988).

———. *How Phenomena Appear to Unfold* (essays) (Elmwood, Conn.: Potes & Poets Press, 1990).

———. *The Return of Painting, The Pearl, and Orion: A Trilogy* (San Francisco: North Point, 1991).

———. *Crowd and Not Evening or Light* (Los Angeles: Sun & Moon, 1992).

———. *Objects in the Terrifying Tense Longing from Taking Place* (New York: Segue, 1993).

———. *Defoe* (prose) (Los Angeles: Sun & Moon, 1994).

———. *Goya's L.A.* (drama) (Elmwood, Conn.: Potes & Poets Press, 1994).

Schinto, Jeanne. *Shadow Bands* (Princeton, N.J.: Ontario Review Press, 1988).

———. *Children of Men: A Novel* (New York: Persea Books, 1991).

Segale, Sister Blandina. *At the End of the Santa Fe Trail* (1912, reprint, Milwaukee: Bruce Publishers, 1948).

one thing, there clearly wasn't any emigration from the cafes of Florence and Milan into the New World. In other words, the predominantly southern, peasant background and economic hardship of the immigrants who first came to the United States hardly predisposed them to versifying on the docks or in the factories or mines where they worked, however familiar they may have been with popular poetic traditions. Moreover, at least until World War II, the American literary world was predominantly an academic and upper-crust affair, with nothing resembling the radical bohemian avant-garde of Europe of the 1910s and 1920s. Even modernist innovators such as William Carlos Williams and Ezra Pound had come from top-level academic backgrounds—of the sort that were out of reach to Italian Americans at the time—which afforded them the institutional cachet and visibility necessary to leave their marks on American letters. And though they had begun to form their own coteries outside the academy, still Pound and Gertrude Stein, among others, felt compelled to quit these shores for the greater openness and ferment of the European capitals, where, especially in Paris, the bohemian tradition was already of long standing and had itself become a kind of self-appointed institutional alternative to the various academies.

In fact when, in the wake of World War II, an American-style avant-garde unexpectedly burst upon the scene in such cities as New York and San Francisco, suddenly an unprecedented number of Italian Americans, along with Jews, African Americans and other minorities, figured among the poets spearheading such movements, together, of course, with those graced with "nonethnic" status. At the same time, as the prosperous "new" America of the postwar boom could now afford to open the doors of its educational institutions a little wider, we begin to find a greater ethnic range among the poets coming out of the academic milieu as well, which inevitably included a few Italian Americans. It was the beginning of the fragmentation of the great Anglo-Protestant citadel of American culture, a necessary process that continues apace today with many admirable results and as many lamentable mistakes, and which will in one way or another determine the modes and forms our culture will take in the future.

It is curious to note, however, that despite the nationwide prominence of a small handful of poets of Italian American origin who have emerged since World War II, the Italian American presence at the highest levels of poetic achievement and success remains relatively low, especially when compared with the group's overwhelming presence atop such cultural fields as film and musical composition. There is no easy explanation for this phenomenon, and it certainly does not lend itself quite so obviously to the socioeconomic interpretation given for the lack of poets among Italian Americans in the first half of the twentieth century. Part

of the explanation may in fact lie in a problem endemic to the entire, broad field of American poetry since the 1950s, a problem that continues to grow, paradoxically, with the greater openness of the discipline and the increasing proliferation of writing programs, small presses, "avant-gardes" and in-groups. The problem is that, with the "democratization" of poetic culture, with its growing detachment (even within academia) from criteria that, though certainly not devoid of ideological self-interest, were nevertheless time tested and usually transcended momentary or personal whims, and with the sudden, magmatic outpouring of poetry from a milieu generally unwilling to assess the whole vast picture and make specific judgments of value beyond the praise of cronies and comrades-in-arms, it has become difficult to determine which of our contemporary poets, if any, beyond a very small handful are of deep and lasting value beyond their resonance within a particular group at a particular time.

This, however, is a problem far exceeding the limited scope of our survey and affects the poets mentioned below only inasmuch as they are part of the broader American picture. Given this general problematic, then, let it be said that in this essay I discuss poets who happen to be of Italian origin, in full or in part, and whose work has had some resonance in American poetry and American culture in general. There is no well-delineated ethnic subgenre that one might call "Italian American poetry," since all of these poets speak above all as Americans and as members of the human race. Nor did the foregrounding of an "ethnic milieu" in the poets' work figure among my criteria for selection, although such evocations are inevitable in many cases and even of great interest when they manage to transcend the specificity of the milieu to unveil the universal humanity at its core. The poets covered in this survey belong, then, to the first substantial emergence of Italian Americans on the poetry scene, which runs roughly from the 1940s to the mid-1960s, and to the generation that has followed it and continues to produce work to this day.

The Poets: Born Before 1945

As if to give the lie to the image of the proletarian immigrant as good-hearted, hardworking, but essentially ignorant and indifferent to matters of the mind and tongue, anarchosocialist activists Carlo Tresca and Arturo Giovannitti, both Italian born, were also both poets. Giovannitti (1884–1964), however, was clearly the more accomplished poet of the two, and although his work never made any impact on American literary culture, it was read and appreciated by many social

activists and workers of his time. He published his poetry in workers' periodicals such as the publications of the International Ladies Garment Workers' Union and wrote essays in various socialist and union publications. Praised by Helen Keller as being truer and more powerful than the verse of the "ruling classes," Giovannitti's poetry is somewhat naif and archaic in tone, passionate and Romantic in its revolutionary sentiment, and often a bit long-winded in its exposition. He appears indifferent to the innovations of modernism, which he no doubt would have considered bourgeois parlor games. Nevertheless, Giovannitti often surprises with the simple power of his evocations, which though they may at times echo with a memory of his Italian past, always place the universal "common man" at the center of his universe. Here are the opening lines of his poem, "New York and I," written sometime in the 1930s:

City without history and without legends,
City without scaffolds and without monuments,
Ruinless, shrineless, gateless, open to all wayfarers,
To all the carriers of dreams, to all the burden bearers,
To all the seekers for bread and power and forbidden ken;
City of the Common Men
Who work and eat and breed, without any other ambitions,
O Incorruptible Force, O Reality without visions,
What is between you and me? (Giovannitti, *Collected Poems*, 5)

Giovannitti shows some skill at manipulating traditional forms, which he could do in French and Italian as well as in English, though always with his naively archaizing rhetoric. This dexterity is evident in the following poem, entitled "Atavism," in which he explores his twofold class background in fine, succinct fashion and with a touch of irony:

My mother's sires were men of solemn looks,
Long-haired, bewigged, lace-collared and rapiered,
Who served the king, obeyed the pope and feared
Nothing, save God and books.

My father's folks were of the common sap,
Poachers and court physicians, and such breed,
Who had nothing but princely veins to bleed
And royal game to trap.

> *And thus, entangled in such strange discords,*
> *In strange contrasts my twofold nature raves,*
> *And now it loves to kick and flog the slaves,*
> *And now to hang their lords.* (Giovannitti, *Collected Poems*, 94)

There was not much else of note published by Italian Americans in the 1930s, although perhaps worth mentioning are a book of formalistic, traditional poems by Italian-born Anna Maria Ascoli (born 1899), published under the false surname Armi by Random House, as well as three volumes published by Katherine Carasso (birth date unknown). In the late thirties, after some youthful work in a naif, formalist manner, the poet and painter Mary Fabilli (born 1914), a friend and associate of Robert Duncan in the "pre-renaissance" San Francisco of the 1930s and 1940s, began to write surrealist-influenced verse, which later gave way to more controlled, religiously inspired work.

Vincent (Venanzio) Ferrini (born 1913) published the first work of a long career in 1941. The son of a Christian anarchist father from central Italy and a mother from the south of the peninsula, Ferrini instills his early work with protest and rage against the inequities of industrial society. By the 1950s he found a simpler, more rarefied lyric style that begins to show the influence of Charles Olson. In his mature work of the 1960s and 1970s, he has found a more mythic voice that is perhaps most his own while remaining truly American. For the most part he has worked outside of any "schools of poetry" or specific milieus. He is perhaps best known in American literary history for being the object of an attack by Olson in the *Maximus* poems, which were begun as a series of letters to him when he was editor of *Four Winds,* and for his long friendship with Olson.

The Italian American poet who has found perhaps the most secure place in the American literary pantheon is John Ciardi (1916–1986). The story of Ciardi's career as poet, teacher, critic, and author of children's books is one of meteoric early success, excellence and national celebrity in his maturity, and decline in the later years. A truly natural poet and splendid versifier, Ciardi writes with great assurance of a great variety of subjects. Ever respectful of reality and of "his own profession, which is in praise / of the enlarging word," Ciardi has a great talent for ennobling common experience and raising it above the banal. His war poems, based on his experience as a gunner in a B-29 in the South Pacific, evoke an American mythos given more flesh and blood in a few words than in all the cliched movies on the subject. He wrote some of the finest love lyrics of the modern age, in which a Petrarchian idealism has donned the body of reality's throbbing, erotic presence:

My dear, darkened in sleep, turned from the moon
That riots on curtain-stir with every breeze
Leaping in moths of light across your back . . .
Far off, then soft and sudden as petals shower
Down from wired roses—silently, all at once—
You turn, abandoned and naked, all let down
In ferny streams of sleep and petaled thighs
Rippling into my flesh's buzzing garden.

(Ciardi, "To Judith Asleep" in *Live Another Day*
[1949]; reprinted in the *Collected Poems*, 65–66)

He also freely and readily evoked Italian themes in his poetry. Significantly, in both of his volumes of selected verse he chose to reproduce a sequence entitled "Tribal Poems," which touch upon his ethnic, familial, religious, and national (American) experiences with particular sensitivity to ritual and place. In Ciardi, "Italianness" is often a kind of universal condition, of which the poet, however, has a privileged, inside view. His evocations of the peasant superstitions embraced by the women of his family are full of hushed reverence, as when "Zia beat me with bay, / Fennel and barley to scourge the devil away," or when he alludes to a grandmother who "in *her* tribe's dark, kept herbs and spells / and studied signs and dreams," or especially when he pays tribute to his ever-present mother, whom he calls

. . . history's daughter
tall from her root of love, my comic source,
my radiant witch of first-made lunacies,
and priestess of the tongues before a man . . .

(Ciardi, "A Five-Year Step" in *Lives of X*, 79)

Ciardi saw himself as a "guardian of the language," and the resonance of his lines seems at times to span the centuries even while speaking to the moment. In recent years, his work has fallen somewhat out of favor in the American poetry community, due perhaps in part to the decline of his work in the latter part of his career, but perhaps above all to the latest wave of neo-experimentalism sweeping across certain sectors of the field, shifting tastes, even within academia, away from the values that inform Ciardi's poetry, which was very much of a piece with the traditionalist, New Criticism poetry of postwar America. The trends will pass, while the work remains.

Lawrence Ferlinghetti (born 1919) is perhaps the Italian name most familiar to readers of contemporary American poetry. (His *Coney Island of the Mind* [1958] was one of the best-selling poetry books of the twentieth century.) While his "Italianness" has been called into question, it would appear that he was sired by an Italian immigrant father, who had anglicized the name to Ferling and died before the poet was born. While he certainly did not grow up in an Italian American milieu, having been taken by his Franco-Portuguese Jewish mother back to France and then later adopted by an upper-class Anglo-Protestant family in the United States, Ferlinghetti nevertheless saw fit to reItalianize his name and has sought to embrace an "Italian" identity in other ways as well as in his verse.

Founder, in the early 1950s, with Peter D. Martin, of the San Francisco–based City Lights bookstore and City Lights Books, which have since become two of the most venerable institutions of "alternative" culture in America, Ferlinghetti is one of the finest talents to emerge from the Beat movement. He brings a broad knowledge of art and art history to his poetry, as well as a sensitivity to social issues and an ability to evoke the paradoxes and absurdities of contemporary American life. The poems bristle with an anarchist spirit that is at times complemented by a quest for spiritual transcendence, at times tempered with amorous sentiments. Perhaps their most salient feature is their irrepressible sense of humor. While his more recent work has failed to win as much acclaim as in the past, he remains true to his vision and continues his important editorial work.

Of Ferlinghetti's poems concerned with Italianness, the most unforgettable and the one most central to the Italian American poetic canon is "The Old Italians Dying" (1976), an elegy in the form of a city poem, that begins: "For years the old Italians have been dying/all over America." The poet laments the passing away of the generation of old immigrants who populate Washington Square in North Beach, San Francisco, and the other Little Italys; they feed pigeons as they await death. For the poet, the old Italian men, however picturesque in their foreignness and anachronistic in their attachments to the Old World, embody in their disappearance the demise of a world of traditional values and the loss of the experience connected to authentic dwelling in the world.

An interesting lesser-known poet of roughly the same age as Ferlinghetti, scholar and translator Felix Stefanile (born 1920) has cultivated a personal, original style that tends to formalism but also features a natural, unaffected free-verse manner as well. At his best he achieves a finely tuned rhetoric that settles fluidly into a clean, slightly ironic lyricism, as in the following quatrain inspired by a line by the German poet Rainer Maria Rilke ("When longing overcomes you, sing of great love"):

> *When longing overcomes me I hum to myself*
> *like any good workman, honest, hardly clever,*
> *bending the neck once more, tapping the delicate hammer,*
> *spilling a little ink as thick as blood.*
>
> (Stefanile, "When Longing Overcomes You,
> Sing of Great Love—Rilke")

Two other poets worthy of mention in this same general age group are Joseph Tusiani (born 1923) and John Tagliabue (born 1923). Tusiani, who was born in Italy and came to the United States in 1947, wrote his early works in Italian and has since had a successful career as a university professor. The multifaceted Tagliabue was born in Italy near Lake Como, came to the United States at age four and has been a teacher, a three-time Fulbright scholar, a travel writer, a playwright for puppet theater and an essayist on Asian art and theater. His poems are free in form and spirit and display a broad range of subject.

One of the truly important figures of the new nonacademic poetry of postwar America, Philip Lamantia (born 1927) emerged very young onto the San Francisco scene, showing an early natural talent for writing in the surrealist mode. Perhaps the first American to fully embrace the style and spirit of surrealism with successful results, Lamantia was hailed by chief French surrealist André Breton as "a voice that rises once in a hundred years." These early works, most of them written when the poet was in his late teens and early twenties, are aburst with gripping sequences of unlikely imagery and haunting cadences. At his best, the young Lamantia manages to infuse the usually more concrete English language with the same pure dream-like quality of the best French surrealists, André Breton, Paul Eluard, and Robert Desnos, as we can see in the following passage:

> *I drop the chiseled pear*
> *Standing in smoke-filled valleys*
> *(great domains of wingless flight*
> *and the angel's fleshy gun)*
> *I stamp the houses of withering wax*
> *Bells of siren-teeth (singing to our tomb*
> *refusal's last becoming)*
> *await the approach of the incendiary children*
> *lighting the moon-shaped beast*
>
> (Lamantia, "The Islands of Africa"
> in *Selected Poems: 1943–1966*, 18)

Or in this:

> *Through the ceiling I can see beggars*
> *walking on hands and knees*
> *to reach a pyramid flung into the storm*
> *where serpents drink champagne*
> *and wash their women with the blood of prophets.*
>
> (Lamantia, "The Enormous Window"
> in *Selected Poems: 1943–1966*, 22–24)

But Lamantia was soon to abandon this mode of writing, and then to give up writing altogether for a few years, after his experimentations with peyote among the Washo Indians of Nevada and the Cora Indians of Mexico. When he resumed writing in the late 1950s, it was in a Beat-influenced style that lacked the vitality and originality of his early work. Eventually, however, the piercing, dream-like quality that has always been his trademark returned to his work, though now it is more fully his own and less purely Surrealistic. In the mature poetry as exemplified by *MeadowlarkWest* (1986), his spiritual quest has become richly syncretic in its world-spanning embrace and is at times at its most poignant in moments of naturist mysticism:

> *Junco of the most elegant suit*
> *in a song of dynamic black and white*
> *alternate tones*
> *harmonic wholes*
> *alcohols of*
> *the secondary powers*
>
> (Lamantia, "America in the Age
> of Gold" in *MeadowlarkWest*, 22)

Often willfully fragmented, this later work displays a tremendous breadth of concern and reference, using syntactical disjunction and surreal juxtaposition to open vistas of conceptual surprise:

> *The glaciers of cities, pits, the abysmal mysteries of*
> *Baudelaire's labyrinth, one can say, breast of the city*
> *tufts of avian mystery in the sun's eye*
> *the old street gleaming with lizard paint*
> *to drink ecstatic*
> *as with ectoplasm*

the first sea-wash stain
with wind sonatas scratched from an old bore's heaven
 (Lamantia, "Invincible Birth" in *MeadowlarkWest*, 16)

Over the course of a career still in full swing in the mid-1990s, Lamantia has absorbed a vast range of influences to forge a style unique in American poetry.

A permanent fixture on the New York avant-garde scene, half-Irish Gilbert Sorrentino (born 1929) has never abandoned his experimental approach to literature during a long career as poet, novelist, essayist, editor, and publisher. His poetry is informed by a kind of gentle surrealism of sudden juxtapositions and shifts and occasional broken syntax, often employed to humorous and revelatory effect, and sometimes in a state of tension with fragments of traditional form. Not without a meditative side as well, Sorrentino's linguistic twists afford glimpses into realities beyond the merely logical and phenomenal, as do these oblique tercets about drinking in this untitled poem from *The Perfect Fiction* (1968):

A door that opens on
my world, a scene of ice, frozen
crisp, with gin:

a door closes, opens, the eye moves in-
voluntarily across the white
mirage, the harsh bright

fluid posts it, the tongue wants
this balm to move one from the haunt
grim in sunlight: reality
(A system edged with falsity,
reality is caught winds redolent
of juniper (All the drinkers went
 (Sorrentino, reprinted in *Selected Poems: 1958–1980*, 94)

Born on Bleeker Street in New York's Greenwich Village to Italian immigrant parents who abandoned him at a young age, Gregory Corso (born 1930) may well be the quintessential Beat poet. He survived a hard, turbulent childhood, menial jobs, and three years in prison for attempted robbery and somehow managed to become a poet. Completely self-taught (his core reading was done in prison), Corso writes passionate, humorous, word-sloppy,

street-smart, spontaneous poetry. Rescued from obscurity in 1955 by Allen Ginsberg, who once called him "probably the greatest poet living in America," Corso is perhaps the one Beat poet who has remained the most truly Beat. This may have kept him from ever fully maturing into a serious writer, but it has also preserved the sparks of rage and whimsy that have always animated his best work.

Winner of the first Frank O'Hara Award for Poetry, Joseph Ceravolo (1934–1988) made his living as a hydraulics engineer. A poet of original, unorthodox style, even in the context of the 1960s experimentalism that formed him, he associated with the poets of the New York School, winning their praise and admiration. At its best his poetry is simple yet highly indirect, approaching its subjects in oblique, fragmented language in an attempt to evoke experience through sound and implication instead of statement or description, as in these lines from "Drunken Winter":

> *Oak, oak! like like*
> *it then*
> * cold some wild paddle*
> *so sky then . . .*
> (Ceravolo, *The Green Lake Is Awake: Selected Poems*, 51)

At the exact opposite end of the aesthetic spectrum from Ceravolo, Lewis Turco (born 1934), a college professor, critic, playwright and novelist as well as poet, writes studied, descriptive, realistic, generally traditional verse. His best work seems to be a playful formalism almost devoid of meaning but delightful in tone and spirit, such as the "Pocoangelini" series.

A far cry in turn from Turco in spirit and substance, Diane di Prima (born 1934) is the preeminent woman poet to emerge from the 1960s counterculture in the United States. Coeditor with LeRoi Jones (Amiri Baraka) of the *Floating Bear* literary review and editor-publisher for many years of the Poets Press in New York, di Prima has had a rich, complex career that is far from over. If her early work now seems at times dated in its "hipness," its telegraphic style, and its casual obscenities, it nevertheless hints at the luminosity and mystical power of her finest mature work, as we see here in the early "Minor Arcana":

> *Body*
> *whose flesh*
> *has crossed my will?*

Which night
common or blest
shapes now
to walk the earth?

Body
whose hands
broke ground
for that thrusting head?
in the eyes
budding to sight
who will I read?
Body
secret in you
sprang this cry of flesh

Now tell the tale

(di Prima, *Pieces of a Song*, 16)

This mystical vein becomes gradually enriched by a vast array of experiences, often combining Eastern spiritualism, American Indian naturism, feminist sensualism and moral outrage to stunning effect, as in the "Wyoming Series," or the following "Prayer to the Mothers," in which the occasional high diction impressively modulates with colloquialism to share the weighty burden of the contents:

they say you lurk here still, perhaps
in the depths of the earth or on
some sacred mountain, they say
you walk (still) among men, writing signs
in the air, in the sand, warning warning weaving
the crooked shape of our deliverance, anxious
not hasty. Careful. You step among cups, step out of
crystal, heal with the holy glow of your
dark eyes, they say you unveil
a green face in the jungle, wear blue
in the snows, attend on
births, dance on our dead, croon, fuck, embrace
our weariness, you lurk here still, mutter

> *in caves, warn, warn & weave*
> *warp of our hope, link hands against*
> *the evil in the stars, O rain*
> *poison upon us, acid which eats clean*
> *wake us like children from a nightmare, give the slip*
> *to the devourers whom I cannot name*
> *the metal men who walk*
> *on all our substance, crushing flesh*
> *to swamp*
>
> (di Prima, *Pieces of a Song*, 91)

Still the turmoil of this righteous rage, as the poet continues to mature rewardingly, will yield to a poetry of greater texture, finer cadence, and richer modulation of tone and subject. As in the early work, it is in the mystical vein that she is at her best, at times achieving a gnostic brilliance with few equals in contemporary verse, as in these "Notes on *The Art of Memory*":

> for Thelonius Monk
> *The stars are a memory system*
> *for thru them*
> *we remember our origin*
> *Our home is behind the sun*
> *or a divine wind*
> *that fills us*
> *makes us think so.*
>
> (di Prima, *Pieces of a Song*, 147)

A far lesser countercultural figure than di Prima but one of some contemporary relevance nonetheless is John Giorno (born 1936), street poet, performance artist and sometime friend and lover of Andy Warhol. The self-declared originator of "performance poetry" and "audience-participation" poems, Giorno writes poetry with very short lines, a colloquial tone, and of little compositional interest other than the rapid exposition and and breathless voice.

A rather striking and original voice, on the other hand, is that of Sandra Mortola Gilbert (born 1936). A prominent feminist critic and university professor as well as a poet, Gilbert has forged a peculiarly personal, American brand of poetic surrealism, one based not so much on the texture of the language as on the use of shifting, oneiric imagery. Also keenly aware of her Italianness, Gilbert can strikingly evoke an imagined ancestral past without recourse to cliche and

can protest prejudice in a way that manages to be at once specific to her ethnicity and gender and universally applicable to all. In a style that ranges from the stark and brooding to the playfully humorous, Gilbert's poetry sharply evokes the absurdity in everyday life, the terror that lies in the interstices of waking existence, as in the following piece entitled "Spring":

> *why do my toes burn*
> *why do my toenails feel*
> *as though they want to fly away*
> *why are the pupils of my eyes dilating and*
> *fluttering like gills*
>
> *I pass through a long antechamber*
> *where flowers huddle in bunches*
> *whispering secret formulas*
>
> *my skin is flaking off in patches*
> *leaving green wounds!*
>
> *blood washes my ears*
> *air pours through my fingers*
> *I'm smaller than an oyster*
> *somebody's going to eat me whole*
>
> *I see that the appletree in the garden*
> *is wearing a necklace of feathers and*
> *I enter the warm house*
> *like a cell*
> *entering a royal lung*
>
> *why did I spend the whole winter*
> *hiding in doorways?*
>
> <div align="right">(Gilbert, In the Fourth World, 60)</div>

In a rather different vein of personalism, Maria Mazziotti Gillan (born 1940) combines simple realism, everyday experience, and a self-consciousness of poetry and its power to create a verse of sustained honesty and spiritual and social depth. For example, her much anthologized 1984 poem "Public School No. 18: Paterson, N.J." uses a string of life experiences to build a scathing indict-

ment of anti-Italian prejudice and climaxes with this simple, but brave and haunting affirmation:

> *I am proud of my mother,*
> *dressed all in black,*
> *proud of my father*
> *with his broken tongue,*
> *proud of the laughter*
> *and noise of our house.*
>
> *Remember me, ladies,*
> *the silent one?*
> *I have found my voice*
> *and my rage will blow*
> *your house down.*
>
> (Gillan, *Winter Light*; reprinted in *Where I Come From*, 12–13)

Professor and literary critic Paul Mariani (born 1940) also writes accomplished, quasi-formalist poetry that is learned as well as topical in subject and naturalistic in detail. Almost always colloquial and intelligent in tone, Mariani's work relies heavily on autobiography; even the frequent recourse to classical and mythological references usually serves only to confirm the universality of the quotidian. His more recent work as exemplified by his 1985 collection, *Prime Mover*, has been a little less formalistic and somewhat more turned to religious themes, though always in an everyday context.

Not to be forgotten among this age group are conceptualist poet and translator Charles Doria (born 1938); member of the conceptual-art Fluxus group, the prolific Richard Monaco (born 1942); the even more prolific professor, editor and poet James Bertolino (born 1942); prominent novelist and poet Daniela Gioseffi (born 1941); tireless avant-gardist Ray Di Palma (born 1943); and experimental erotic photographer–poet Gerard Malanga (born 1943).

Of perhaps more than passing interest is the poetry of the many-talented independent spirit John Brandi (born 1943), who is also an artist, bookmaker, painter, and teacher. His poetry is simple in presentation but wide open and sometimes complex in its free-verse form. He very often uses geographic locale as a source of inspiration (especially the American West and Southwest), and at his best he can combine a mystical sensitivity to nature with surreal juxtapositions of images to striking effect, as in "Home from Chilchinbito Wash":

Wet moonflower
under Buddha's nose, fire
floating above
 wick & tallow

Marigold
on seashell, monkey
in the moon

 All night, love
 All night, love

Saltbrine under fiddlehead fern
Dry lavender
on carnelian stone

This morning
planet light in the body's pores
Dry path of stars on leg

Mouth to mouth
in Milky Way

 You taste, love
 You taste of creation

 (Brandi, *That Back Road In*, 67)

Paul Violi (born 1944) has had a multifaceted career in journalism, publishing, and teaching as well as poetry. His verse style is colloquial, with free associations of experience in a kind of rambling verbal globe-trot through time, space, and imagined places. Generally loose in form, his poetry sometimes resorts to broken syntax and typographical irregularities. Influenced by the New York School, he has a keen sense for the surreal in contemporary life and a talent for humorous wordplay.

The Poets: Born 1945 and After

The generation of Italian American poets born after 1945 is a microcosm of that same literary generation nationwide: It is uneven in quality, as diverse as contem-

porary tastes themselves and immeasurably vast in quantity. This is not, of course, to say that there are not some serious talents among the younger Italian American writers; it is merely an indication of the critical complexity and breadth of the task of sorting them all out and an admission that this is not the proper place for such a selection.

Nevertheless, a few indications can be made on the basis of the more salient achievements of some of these writers who are now in mid-career. We have, for example, Professor Paul Vangelisti (born 1945), who in addition to writing postmodernist poetry has been active in translating and publishing modern and postmodern work from Italy. There is also the professor and critic David Citino (born 1947), who writes a direct, declarative poetry of basic, essential life experiences and has treated Catholic viewpoints with wit and irony in a long, many-part series of "Sister Mary Appassionata Poems." Professor, essayist, and translator W.S. Di Piero (born 1945) writes meditative poems in an American naturalist vein.

In the area of more experimental work, there is the Milanese-born composer, performance artist, and poet Marina de Bellagente La Palma (born 1949) and the increasingly acclaimed prose poet Leslie Scalapino (born 1948), who writes a very dry, hard-edged sort of poetry with a keen eye to sexual politics. Michael Gizzi (born 1949) writes playful, exuberant "avant-garde" poetry that explodes language and reference through fragmentation and juxtaposition but can also sometimes express a reticent tenderness. Gizzi, like his younger brother Peter, has also been active as a publisher and since 1993 has edited the art and literary review Lingo.

Poet, novelist, and critic Jay Parini (born 1948) writes poetry in the tradition of American realism. Richly descriptive and narrative in approach, his poetry's depth and complexity derive from acuteness of observation and precision in the rendering.

The most prominent and influential of the Italian American poets of his generation, Dana Gioia (born 1950) writes a finely honed, formalist poetry that often relies on a simplicity of idiom and reference for its effect. One of the standard-bearers for the "New Formalism" in poetry in the 1980s, Gioia has argued passionately for greater attention to metrics and music in poetic composition and champions clarity and directness over obscurity in style. An accomplished essayist and cultural critic whose opinions have elicited sometimes heated debate in the poetry world, Gioia has also been active as an editor and translator, bringing Italian poetry old and new to an American audience. At its best his poetry moves fluidly between traditional metrics and a more open line, negotiating the melancholy tension between experience and the other worlds experience may yield.

Further Reading

Bibliographic Resources

Alfonsi, Ferdinando. *Poeti Italo-Americani / Italo-American Poets: Antologia bilinque / A Bilingual Anthology* (Catanzaro, Italy: Antonio Carello Editore, 1985).

———. *Dictionary of Italian-American Poets* (New York: P. Lang, 1989).

Barolini, Helen, ed., *The Dream Book: An Anthology of Writings by Italian-American Women*, New York: Schocken Books, 1985.

Ellman, Richard, and Robert O'Clair, eds. *The Norton Anthology of Modern Poetry* (New York: Norton, 1973 and later).

Gioia, Dana. "What Is Italian-American Poetry?" *Voices in Italian Americana* 4, no. 2, (fall 1993): 61–64.

Hamilton, Ian, ed. *The Oxford Companion to Twentieth-Century Poetry* (Oxford/New York: Oxford University Press, 1994).

Messerli, Douglas, ed. *From the Other Side: A New American Poetry 1960–1990* (Los Angeles: Sun & Moon Press, 1994).

Nims, John Frederick, "John Ciardi: The Many Lives of Poetry." In *John Ciardi: Measure of the Man*, ed. Vince Clemente (Fayetteville: University of Arkansas Press, 1987).

Tamburri, Anthony Julian, Paolo A. Giordano, and Fred L. Gardaphe, eds. *From the Margin: Writings in Italian Americana* (West Lafayette, Ind.: Purdue University Press, 1991).

Canon: Italian American Poetry (Selected Works)

—Compiled by Pellegrino D'Acierno

Armi, Anna Maria (Anna Maria Ascoli). *Poems* (New York: Random House, 1941).

Bertolino, James. *Day of Change* (Milwaukee: Gunrunner Press, 1968).

———. *New and Selected Poems* (Pittsburgh: Carnegie Mellon University Press, 1978).

Brandi, John. *Poem Afternoon in a Square in Guadalajara* (San Francisco: Maya, 1970).

———. *Emptyplots: Poems from Venice and L.A.* (Bolinas, Calif.: Nail Press, 1971).

———. *A Partial Exploration of Paolo Flechado Canyon* (Bolinas, Calif.: Nail Press, 1973).

———. *San Francisco Lastday Homebound Hangover Highway Blues* (Bolinas, Calif.: Nail Press, 1973).

———. *The Phoenix Gas Slam* (Bolinas, Calif.: Nail Press, 1974).

———. *Diary from Baja California* (Bradentown, Fla.: Christopher Books, 1978).

———. *Diary from a Journey to the Middle of the World* (Great Barrington, Mass.: The Figures, 1978).

———. *Poems from the Four Corners* (Fort Kent, Maine: Great Raven, 1978).

———. *That Crow That Visited Was Flying Backwards* (Corrales: N.M.: Tooth of Time, 1982).

———. *Poems at the Edge of Day* (Buffalo, N.Y.: White Pine, 1984).

———. *That Back Road In: Selected Poems 1972-83* (Berkeley, Calif.: Wingbow Press, 1985).

———. *Hymn for a Night Feast: Poems 1979–1986* (Duluth, Minn.: Holy Cow, 1988).

———. *Shadow Play: Poems, 1987–1991* (Kenosha, Wis.: Membrane Press, 1992).

———. *Heartbeat Geography: Selected and Uncollected Poems* (Buffalo, N.Y.: White Pine, 1995).

Ceravalo, Joseph. *Fits of Dawn* (New York: "C" Press, 1965).

———. *Wild Flowers Out of Gas* (New York: Tibor De Nagy, 1967).

———. *Spring in the World of Poor Mutts* (New York: Columbia University Press, 1968).

———. *Transmigration Solo* (West Branch, Iowa: Toothpaste Press, 1979).

———. *Millenium Dust* (New York: Kulchur Foundation, 1982).

———. *The Green Lake Is Awake,* eds. Larry Fagin, Charles North, Ron Padgett, David Shapiro, and Pauk Violi (Minneapolis: Coffee House, 1994).

Ciardi, John. *Homeward to America* (New York: Holt, 1940).

———. *Other Skies* (Boston: Little Brown, 1947).

———. *Live Another Day: Poems* (New York: Twayne, 1949).

———. *From Time to Time* (New York: Twayne, 1951).

———. *As If: Poems New and Selected* (New Brunswick, N.J.: Rutgers University Press, 1958).

———. *39 Poems* (New Brunswick, N.J.: Rutgers University Press, 1959).

———. *In the Stoneworks* (New Brunswick, N.J.: Rutgers University Press, 1961).

———. *In Fact* (New Brunswick, N.J.: Rutgers University Press, 1962).

———. *Person to Person* (New Brunswick, N.J.: Rutgers University Press, 1964).

———. *The Strangest Everything* (New Brunswick, N.J.: Rutgers University Press, 1966).

———. *An Alphabestiary* (Philadelphia: Lippincott, 1967).

———. *A Genesis: Twenty-Six Poems* (New York: Touchstone, 1967).

———. *The Achievement of John Ciardi: A Comprehensive Selection of His Poems,* ed. Miller Williams (Chicago: Scott Foresman, 1969).

———. *Lives of X* (New Brunswick, N.J.: Rutgers University Press, 1972).

———. *The Little That Is All* (New Brunswick, N.J.: Rutgers University Press, 1974).

———. *For Instance* (New York: Norton, 1979).

———. *Selected Poems* (Fayetteville: University of Arkansas Press, 1984).

———. *The Birds of Pompei* (Fayetteville: University of Arkansas Press, 1985).

———. *Echoes: Poems Left Behind* (Fayetteville: University of Arkansas Press, 1989).

———. *Poems of Love and Marriage* (Fayetteville: University of Arkansas Press, 1989).

———. *The Collected Poems,* ed. Edward M. Cifelli (Fayetteville: University of Arkansas Press, 1997).

Citino, David. *Last Rites and Other Poems* (Columbus: Ohio State University Press, 1980).

———. *The Appassionata Doctrines* (Cleveland: Cleveland State Poetry Center, 1985).

———. *The Gift of Fire* (Fayetteville: University of Arkansas Press, 1986).

Corso, Gregory. *The Vestal Lady on Brattle and Other Poems* (Cambridge, Mass.: Richard Brukenfeld, 1955).

———. *Bomb* (San Francisco: City Lights, 1958).

———. *Gasoline* (San Francisco: City Lights, 1958).

———. *A Pulp Magazine for the Dead: Poems* (with Henk Marsman) (Paris: Dead Language, 1959).

———. *The Happy Birthday of Death* (New York: New Directions, 1960).

———. *Minutes to Go* (with William Burroughs, Brion Gysin, and Sinclair Beiles) (Paris: Two Cities, 1960).

———. *Long Live Man* (New York: New Directions, 1962).

———. *Selected Poems* (London: Eyre and Spottiswoode, 1962).

———. *Penguin Modern Poets 5* (with Lawrence Ferlinghetti and Allen Ginsberg) (London: Penguin, 1963).

———. *The Mutation of Spirit: A Shuffle Poem* (New York: Death Press, 1964).

———. *There Is Yet Time to Run Back Through Life and Expiate All That's Been Sadly Done* (New York: New Directions, 1965).

———. *10 Times a Poem: Collected at Random From 2 Suitcases Filled With Poems—The Gathering of 5 Years* (New York: Poets Press, 1967).

———. *Elegiac Feelings American* (New York: New Directions, 1970).
———. *Egyptian Cross* (New York: Phoenix Book Shop, 1971).
———. *The Night Last Night Was at Its Nightest* (New York: Phoenix Book Shop, 1972).
———. *Earth Egg* (New York: Unmuzzled Ox, 1974).
———. *The Japanese Notebook Ox* (New York: Unmuzzled Ox, 1974).
———. *Herald of the Autochthonic Spirit* (New York: New Directions, 1981).
———. *Mind field: New and Selected Poems* (Madras, India, and New York: Hanuman Books, 1989).
Di Palma, Ray. *Macaroons* (Bowling Green, Ohio: Doones Press, 1969).
———. *Observatory Gardens* (Berkeley, Calif.: Tuumba Press, 1979).
———. *Planh* (New York: Casement Books, 1979).
———. *Genesis* (Toronto: Underwhich Editions, 1980).
———. *Two Poems* (West Branch, Iowa: Toothpaste Press, 1983).
———. *January Zero* (Minneapolis: Coffee House, 1984).
———. *Raik* (New York: Segue, 1989).
———. *The Advance on Mesner* (Los Angeles: Sun & Moon Press, 1991).
———. *Mock Fandango* (Los Angeles: Sun & Moon Press, 1991).
———. *Numbers and Tempers: Selected Early Poems 1966–1986* (Los Angeles: Sun & Moon Press, 1993).
———. *Provocations* (Elmwood, Conn.: Potes & Poets, 1995).
Di Piero, W(illiam) S. *The Restorers* (Chicago: University of Chicago Press, 1991).
———. *Shadows Burning* (Evanston, Ill.: Northwestern University Press, 1995).
di Prima, Diane. *This Kind of Bird Flies Backward* (New York: Totem Press, 1958).
———. *The New Handbook of Heaven* (San Francisco: Auerhahan Press, 1963).
———. *Poems for Freddie* (New York: Poets Press, 1966).
———. *Earthsongs: Poems 1957–1959* (New York: Poets Press, 1968).
———. *Hotel Albert* (New York: Poets Press, 1968).
———. *Memoirs of a Beatnik* (1969; reprint, San Francisco: Last Gasp of San Francisco, 1988).
———. *Revolutionary Letters* (San Francisco: City Lights, 1971).
———. *Loba: Part 1* (Santa Barbara, Calif.: Capra Press, 1973).
———. *Loba As Eve* (New York: Phoenix Book Shop, 1975).
———. *Selected Poems, 1956–1975* (Plainfield, Vt.: North Atlantic Books, 1975, enlarged edition, 1977).
———. *Loba: Parts I–VIII* (Berkeley, Calif.: Wingbow Press, 1978).
———. *Pieces of a Song: Selected Poems* (San Francisco: City Lights, 1990).
Doria, Charles. *Selected Poems* (Barrytown, N.Y.: Left Hand Books, 1988).
———. *The Toy Palace: A Libretto for Animals, People, and Machines* (Barrytown, N.Y.: Left Hand Books, n.d.).
Fabilli, Mary: *Poems, 1976–1981* (Murry, Ky.: Inverno Press, 1983).
Ferlinghetti, Lawrence. *Pictures of the Gone World* (San Francisco: City Lights, 1955).
———. *Coney Island of the Mind* (New York: New Directions, 1958).
———. *Starting from San Francisco* (New York: New Directions, 1961).
———. *The Secret Meaning of Things* (New York: New Directions, 1969).
———. *Open Eye, Open Heart* (New York: New Directions, 1973).
———. *Who Are We Now?* (New York: New Directions, 1976).
———. *Northwest Ecologue* (San Francisco: City Lights, 1978).

———. *Landscapes of Living and Dying* (New York: New Directions, 1979).
———. *Endless Life: Selected Poems* (New York: New Directions, 1981).
———. *The Populist Manifestoes* (San Francisco: Grey Fox, 1981).
———. *Over All the Obscene Boundaries* (New York: New Directions, 1984).
Ferrini, Vincent. *No Smoke* (Portland, Maine: Falmouth, 1941).
Gilbert, Sandra Mortola. *In the Fourth World: Poems* (Tuscaloosa: University of Alabama Press, 1979).
———. *Emily's Bread: Poems* (New York: W.W. Norton, 1984).
———. *Blood Pressure: Poems* (New York: W.W. Norton, 1988).
Gillan, Maria Mazziotti. *Flowers from the Tree of Night* (Seattle: Chantry, 1981).
———. *Winter Light* (Seattle: Chantry, 1985).
———. *The Weather of Old Seasons* (Merrick, N.Y., Cross Cultural Communications, 1989).
———. *Taking Back My Name* (San Francisco: malafemmina press, 1991).
———. *Where I Come From: Selected and New Poems* (Toronto and New York: Guernica, 1995).
Gioia, Dana. *Daily Horoscope* (Saint Paul, Minn.: Greywolf, 1986).
———. *The Gods in Winter* (Saint Paul, Minn.: Greywolf, 1991).
———. *Can Poetry Matter? Essays on Poetry and American Culture* (St. Paul, Minn.: Greywolf, 1992).
Giorno, John. *Poems by John Giorno* (New York: Mother Press, 1967).
———. *Balling Buddha* (New York: Kulchur Foundation, 1970).
———. *Cum* (New York: Adventures in Poetry, 1971).
———. *Birds* (New York and San Francisco: Angel Hair Books, 1971).
———. *Cancer in My Left Ball* (Barton, Vt.: Something Else Press, 1973).
———. *Grasping at Emptiness* (New York: Kulchur Foundation, 1983).
———. *You Got to Burn to Shine: New and Selected Writings* (New York: High Risk Books/Serpent's Tail, 1994).
Giovannitti, Arturo. *Collected Poems* (Chicago: E. Clemente, 1962; reprint, New York: Arno, 1975).
Gizzi, Michael. *Avis or the Replete Airman* (Providence, R.I.: Burning Deck, 1979).
———. *Species of Intoxication* (Providence, R.I.: Burning Deck, 1983).
———. *Gyptian in Hortulus* (Providence, R.I.: Rhode Island Paradigm, 1990).
———. *Just Like a Real Italian Kid* (Great Barrington, Mass.: The Figures, 1990).
———. *Continental Harmony* (New York: Segue, 1991).
Greene, Rose Basile. *Primo Vino* (South Brunswick, N.J.: Barnes, 1974).
Lamantia, Philip. *Erotic Poems* (San Francisco: Bern Porter, 1946).
———. *Ekstasis* (San Francisco: Auerhahn, 1959).
———. *Narcotica* (San Francisco: Auerhahn, 1959).
———. *Destroyed Works: Hypodermic Light, Mantic Notebook, Still Poems, Spansule* (San Francisco: Auerhahn, 1962).
———. *Selected Poems: 1943–1966* (San Francisco: City Lights, 1967).
———. *Blood of the Air* (San Francisco: Four Seasons Foundation, 1974)
———. *Becoming Visible* (San Francisco: City Lights, 1981).
———. *Meadowlark West* (San Francisco: City Lights, 1986).
La Palma, Marina de Bellagente. *Casablanca Carousel* (Oakland, Calif.: H.B. Productions, 1976–1977).
———. *Grammar for Jess and 22 Cropped Sets* (Berkeley: Kelsey Street Press, 1981).
———. *Facial Index* (San Francisco: State One Press, 1983).
Mariani, Paul. *Timing Devices* (Boston: David R. Godine, 1979).

———. *Crossing Cocytus and Other Poems* (New York: Grove, 1982).

———. *Prime Mover* (New York: Grove, 1985).

———. *Dream Song* (New York: Marlowe, 1994).

Malanga, Gerard. *Chic Death* (Roslindale, Mass.: Pym-Randall, 1971).

———. *Rosebud* (Lincoln, Mass.: Penmaen Press, 1975).

———. *100 Years Have Passed: Prosepoems* (Los Angeles: Little Caesar Press, 1978).

———. *Equal Time* (Binghamton, N.Y.: Bellevue Press, 1979).

———. *Three Diamonds* (Santa Rosa, Calif.: Black Sparrow, 1991).

———. *Mythologies of the Heart* (Santa Rosa, Calif.: Black Sparrow, 1995).

Mazzaro, Jerome. *Changing the Windows* (Athens: University of Ohio Press, 1966).

Paolucci, Anne (Attura). *Poems Written for Sbek's Mummies, Marie Menken, and Other Important Persons, Places and Things* (Bergenfield, N.J.: Griffon House, 1977).

———. *Riding the Mast Where It Swings* (Bergenfield, N.J.: Griffon House, 1980).

———. *Tropic of the Gods* (Bergenfield, N.J.: Griffon House, 1980).

———. *Gorbachev in Concert and Other Poems* (Whitestone, N.Y.: Griffon House, 1991).

Parini, Jay. *Town Life: Poems* (New York: Henry Holt, 1988).

Piombino, Nick. *Poems* (Los Angeles: Sun & Moon, 1988).

———. *Boundary of Blur* (New York: Segue, 1993).

Scalapino, Leslie. *This Eating & Walking at the Same Time Is Associated All Right* (Bolinas, Calif.: Tombouctou, 1979).

———. *Considering How Exaggerated Music Is* (San Francisco: North Point, 1982).

———. *That They Were at the Beach—Aeolotropic Series* (San Francisco: North Point, 1985).

———. *Way* (San Francisco: North Point, 1988).

Sorrentino, Gilbert. *The Darkness Surrounds Us* (Highlands, N.C.: Jargon, 1960).

———. *Black and White* (New York: Totem, 1964).

———. *The Perfect Fiction* (New York: Norton, 1968).

———. *Corrosive Sublimate* (Los Angeles: Black Sparrow, 1971).

———. *A Dozen Oranges* (Santa Barbara, Calif.: Black Sparrow, 1976).

———. *White Sail* (Santa Barbara, Calif.: Black Sparrow, 1977).

———. *The Orangery* (Austin: University of Texas Press, 1978).

———. *Selected Poems: Nineteen Fifty-Eight to Nineteen Eighty* (Santa Rosa, Calif.: Black Sparrow, 1981).

Stefanile, Felix. *A Fig Tree in America* (New Rochelle, N.Y.: Elizabeth Press, 1970).

———. *East River Nocturne* (New Rochelle, N.Y.: Elizabeth Press, 1976).

———. *In That Far Country* (West Lafayette, Ind.: Sparrow Press, 1982).

———. *The Dance at St. Gabriel's* (Brownsville, Oregon: Story Line Press; Calstock, Cornwall: Peterloo Poets, 1995).

Tagliabue, John. *Poems, 1941–1957* (New York: Harper, 1959).

———. *The Buddha Uproar* (San Francisco: Kayak Press, 1967).

———. *A Japanese Journal* (San Francisco: Kayak Press, 1967).

———. *The Doorless Door* (New York: Grossman, 1970).

———. *Poems on the Winters Tale* (Ktaadn Poetry Press, 1973).

———. *The Great Day Poems* (Plainfield, Ind.: Alembic Press, 1984).

———. *New and Selected Poems: 1942-1997* (Orono, Me.: National Poetry Foundation, University of Maine, 1997).

Turco, Lewis. *First Poems* (Francestown, New Hampshire: Golden Quill Press, 1960).

———. *Awaken, Bells Falling* (Columbia: University of Missouri Press, 1968).

———. *Pocoangelini: A Fantography* (Northhampton, Mass.: Despa Press, 1971).

———. *American Still Lifes* (Oswego, N.Y.: Mathom Press, 1981).

———. *A Maze of Monsters* (Fayetteville: University of Arkansas, 1988).

Tusiani, Joseph. *Rind and All: Fifty Poems* (New York: Monastine Press, 1962).

———. *The Fifth Season* (New York: Obolensky, 1964).

———. *Gente Mia and Other Poems* (Stone Park, Ill.: Italian Cultural Center, 1978).

Vangelisti, Paul. *Communion* (Los Angeles: Red Hill, 1970).

———. *Air* (Los Angeles: Red Hill, 1973).

———. *Tender Continent* (Los Angeles: Chatterton's Bookstore, 1974).

———. *X-Ray* (Los Angeles: Red Hill, 1974).

———. *The Extravagant Room* (Los Angeles: Red Hill, 1976).

———. *Remembering the Movies* (Los Angeles: Red Hill, 1977).

———. *Two by Two* (Los Angeles: Red Hill, 1977).

———. *Abandoned Latitudes* (Los Angeles: Red Hill, 1983).

———. *Domain* (Los Angeles: Red Hill, 1983).

———. *Rime* (Los Angeles: Red Hill, 1983).

———. *Portfolio* (Los Angeles: Red Hill, 1989).

———. *Villa* (Los Angeles: Sun & Moon, 1991).

———. *Ribot, No. 2: A Subversion* (Los Angeles: Sun & Moon, 1994).

Violi, Paul. *Waterworks* (West Branch, Iowa: Toothpaste Press, 1972).

———. *In Baltic Circles* (New York: Kulchur Foundation, 1973).

———. *Splurge* (New York: Sun Press, 1981).

———. *Likewise* (Brooklyn, N.Y.: Hanging Loose Press, 1988).

———. *The Curious Builder* (Brooklyn, N.Y.: Hanging Loose, 1993).

———. *The Anamorphosis* (New York: Pataphysics Press, 1995).

The Evolution of Italian American Autobiography

Fred L. Gardaphe

Introduction

The writing of autobiographies by Italian Americans is a quite recent phenomenon in the scheme of American literary history. Louis Kaplan, in *A Bibliography of American Autobiographies* (1962), identified twenty-eight Italian Americans who are responsible for thirty entries out of more than 6,000 written prior to 1945. Patricia K. Addis, in *Through a Woman's I* (1983), identified fourteen Italian and Italian American women autobiographers out of more than 2,000 between the years 1946 and 1976. And while the number of Italian American autobiographies has increased significantly since the 1970s, critical study of only a few of those produced during this period is limited to a handful of articles, two dissertations, and one substantial book.[1]

To anyone familiar with the relationship of writing to Italian American culture, what is surprising about this literature is not how few autobiographies there are, especially in comparison to other major ethnic groups, but that any autobiographies have been produced at all. The small number of self-narratives can be attributed to a number of cultural obstacles within southern Italian culture, which most Americans of Italian descent have had to confront before they could first publicly speak and then write about the self. Identifying these cultural constraints and then examining how writers work either within or against them is important for understanding the self-fashioning that takes place in Italian American autobiography. In order to provide a sense of how and in what directions Italian American autobiography has evolved, we need to introduce a few characteristics of Italian American narrative. After this is done, we will take a brief look at some of the leading Italian American practitioners of autobiography.

Boldface terms are defined in the Cultural Lexicon, which starts on p. 703.

FRED L. GARDAPHE

Autobiography in Italian American Culture

The idea of speaking of one's self as independent of the community into which one was born is a recent development in Italian American culture. As Georges Gusdorf tells us in "Conditions and Limits of Autobiography":

> *The conscious awareness of the singularity of each individual life is the late product of a specific civilization. Throughout most of human history, the individual does not oppose himself to all others; he does not feel himself to exist outside of others, and still less against others, but very much with others in an interdependent existence that asserts its rhythms in the community (29).*

The available literature on Italian oral traditions supports Gusdorf's observations. Telling the story of self in public was not part of any cultural tradition that can be found south of Rome (the region from which more than 80 percent of the Italians who migrated to America came). In the Italian oral tradition, the self is suppressed and is not used as a subject in storytelling in the communal settings of Italy, where one function of such stories was to create a temporary respite from the harsh realities of everyday peasant life. Traditional stories served both to entertain and to inform the young, while reminding the old of traditions that have endured over the years. Personal information was expected to be kept to one's self.

The caution against speaking publicly of one's self becomes a strong warning against writing about the self. In southern Italian culture, there was a strong distrust of the written word—an Italian proverb warns: *Pensa molto, parla paco, e scrivi meno* (Think much, speak little, and write even less). The institutions of Italy—the Church as well as the State—maintained power over the peasant of southern Italy by controlling literacy. Hence came the immigrant's distrust of American cultural institutions, which represented the ruling classes. It is no wonder then that there was little or no parental encouragement of American-born children to pursue literary careers and great pressure on these children to earn money as soon as they were old enough to be employed. In her "Introduction" to *The Dream Book: An Anthology of Writings by Italian American Women* (1985), Helen Barolini offers an explanation of why few children of Italian immigrants wrote:

> *When you don't read, you don't write. When your frame of reference is a deep distrust of education because it is an attribute of the very classes who*

have exploited you and your kind for as long as memory carries, then you
do not encourage a reverence for books among your children. You teach
them the practical arts not the imaginative ones (4).

In spite of the low priority given to writing by Italian Americans on the whole, a number of authors have emerged who document their experiences as Italian Americans. These writers have created the basis for a distinctive literary tradition that emerges out of a strong oral tradition.[2] In this respect, Italian American writers have much in common with writers from Native American, Mexican American, and African American traditions. While more often than not the models for the structure of Italian American autobiographies come from the dominant Anglo-American culture, the content found in those structures is shaped by a home life steeped in a culture maintained by orality. Thus, the work produced by these writers should be read with an understanding of the inherited oral traditions as well as the American literary tradition, both of which contribute to their cultural formation.

The strong storytelling traditions that we find in Italian American oral culture are filled with tales that explain the reasons for traditional rituals and provide information about how to live one's life. American writers of Italian descent point to oral tales as the impetus for the creation of their own stories. In retrospect, many of these writers have realized that these stories provide the very keys to their self-identity. Much of Jerre Mangione's *Mount Allegro: A Memoir of Italian American Life* (1943) deals with the stories his family told; Diane di Prima recalls, in her autobiography-in-progress, that her grandfather told her stories that have stayed with her.[3] Gay Talese recounts quite a number of stories told by his family in *Unto the Sons* (1992).

Besides a strong connection to orality, Italian American narrative literature exhibits a number of characteristics reflective of behavior determined by social codes found in southern Italian culture. The act of writing in any culture is a means of connecting one's self to the society that surrounds the self, a means of bridging the public and the private. For any autobiographer, the initial society is the nuclear family; the extended family: grandparents, uncles, aunts, cousins, godparents; the neighborhood and the larger society outside the neighborhood. The unwritten rules that govern behavior within, between, and among these levels of interaction can be found manifested in Italian American autobiography.

Essentially, immigrant autobiographies document a remaking of the Italian self into an American self. The foreign-born "I" argues for acceptance as—and from—the "you" that represents the established American who serves as the

autobiographer's model reader. In immigrant autobiographies, we find the sources of an autobiographical tradition that contrasts Italian culture with American culture, creating a tension that drives the narrative.[4] This tension is found in the overriding theme of these immigrant narratives, which is the flight to a better world or a promised land, a theme found in many immigrant autobiographies and slave narratives.[5] Arrival in America brought the immigrant to a new system of codifying cultural signifiers, a system that often conflicted with a previous way of interpreting life. The resulting conflicts are most obvious in the early language encounters between Italian-speaking immigrants and English-speaking Americans.[6] Arrival in America also required that the immigrant develop a new sense of self in the context of the larger society. Many immigrant *cantastorie* (storytellers) shift from recounting traditional tales to telling personal narratives about the immigrant experience. This is the case with the earliest Italian American autobiographies of Constantine Panunzio, Pascal D'Angelo, and Rosa Cassettari.[7]

Those autobiographies of the children and grandchildren of immigrants, in opposition to immigrant autobiographies, document the remaking of the American self as Italian American. In these works, the more established and Americanized "I" explains, as it explores, the mystery of its difference from the "you" that is the model reader. Thus, for these Italian American writers, there exists the interesting option of identifying or not identifying with the American model reader. While it is important for the immigrant writer to be accepted as an American, this argument is one that is needed less as the Italian American assimilates into American mainstream culture. However, what does become more important to these later writers is the establishment of a connection with one's Italian ancestry. When reading Italian American writers, we need to observe the ways in which traditions both American and Italian, both oral and literary, function in their narrative constructions. The evidence used to locate and analyze what Michael M. J. Fischer has called "inter-references" will be found in the Italian and American signifiers produced in these texts.[8]

There are a number of social codes found in Italian American culture that generate the signs through which Italian American autobiography can be read. The two I will focus on in this discussion are **bella figura / brutta figura** (proper/improper public image) and *omertà* (silence).[9] The code of *bella figura* hails back to the writings of Machiavelli and Lorenzo the Magnificent through their use of the word *sprezzatura,* an oxymoron that signifies the concept of both appraising and not appraising something. *Sprezzatura* explains the ironic quality of Italian culture that has informed the writing of Italian Americans. Until now this irony, which plays a major role in the Italian American narrative, has never been exam-

ined through its Italian origins. It is a concept that forms the basis of public representation of the Italian self.[10] Understanding the code of *omertà* will heighten the reception of the writings of Italian Americans. *Omertà* is generated out of a perceived need to protect the family from outsiders who are capable of using information to harm the family's reputation, and thus their standing in the community. Southern Italian culture is replete with aphorisms and **proverbi** (proverbs) that advise against revealing information that can be used against the self or the family. *A chi dici il tuo secreto, doni la tua libertà* (To whom you tell a secret, you give your freedom); *Di il fatto tuo, e lascia far il fatto tuo* (Tell everyone your business and the devil will do it); *Odi, vedi e taci se vuoi viver in pace* (Listen, watch and keep quiet if you wish to live in peace).[11]

The act of writing creates a more permanent record than conversation and is capable of generating unintended interpretations. In this way, *omertà* is tied to *bella figura;* by keeping silent about personal subjects, one does not reveal one's true self and can continue to maintain a self-controlled presence that is less vulnerable to penetration by outsiders. Often, hyperbolic language and actions are used to simultaneously vent pent-up feelings and disguise the impact new knowledge has on one's self. Anyone who has observed a conversation between two Italians that seems to be going out of control—evidenced by intense screaming, threatening gestures, and the like—then dissipates into a hug or an arm-in-arm stroll toward a bar has witnessed *bella figura* in communication. Semblances of this behavior carry over into the writing of Italian Americans.

Jerre Mangione: At Home in America
Born in the United States in 1909 to Sicilian immigrants, Jerre Mangione is one of the most celebrated Italian American writers. In 1992 the Library of Congress honored his career with a special exhibit; among his many awards are a 1989 Pennsylvania Governor's Award for Excellence in the Arts; a Guggenheim (1946) and a Fulbright Fellowship (1965); two National Endowment for the Arts grants (1980 and 1984) and the prestigious Italian Empedocles Prize (1984). In 1971 Italy named Mangione *Commendatore* and awarded him the Star of Italian Solidarity. He has also received two honorary degrees: doctor of letters from the University of Pennsylvania (1980); doctor of humane letters from the State University of New York at Brockport (1986).

His first book, *Mount Allegro,* has remained in print most of the years since its first appearance in 1943, a feat that required six publishers to date (1995) and prompted Malcolm Cowley to write in a personal letter to Mangione: "*Mount Allegro* has had more lives than any other book of our time." *Mount Allegro* is the

first of four nonfictional books written by Mangione that can be read as autobiography. Each book represents a progressive stage of identity development, from Sicilian, to American and eventually to Sicilian American. The tension between the competing systems of the Old vs. the New World creates the dynamic by which the development of Mangione's writing occurs. The resolution of this tension culminates in the creation of a multicultural perspective and identity that Mangione achieves as he becomes at home in America.

Throughout *Mount Allegro,* we get the sense that the narrator is documenting the decline of a people, the end of an era, an era that becomes history the moment the narrator separates himself from his immigrant relatives. In fact, Mangione can write this book only after he has left his home. By leaving home, then, he begins the process by which he becomes Americanized. Even the structure of Mangione's first book reveals the duality experienced by the writer. First by leaving the family house in Mount Allegro and then by re-creating (or rebuilding) it in his writing, Mangione confronts his divided self and attempts to make a whole of the two halves. The residents of Mount Allegro are not part of the outside community; the interactions they have with the larger community are more often than not portrayed as confrontations that become the tales told at family gatherings. When Mangione announces his plans to leave Mount Allegro to attend college, his family expects that he will do so only to return in a position of power. The family expects him to become a doctor or a lawyer. When they realize he has the talent or temperament for neither career, a wise uncle suggests a compromise: that Gerlando (the Gerry in the book) become a pharmacist. Mangione chooses instead to become a writer; this choice signals a total break from the Old World, for there is no real need in the Sicilian American oral-based community for a writer; to become a writer was to elect to become an outsider.

What accelerates the building of Mangione's American identity is a 1936 trip to Italy, recounted at the end of *Mount Allegro.* Mangione leaves America for Italy with the caution that he not travel far from American consulates, for his relatives fear that, as the son of immigrants, he might be kidnapped and forced to serve in Mussolini's army. In Sicily, Mangione is identified as the *Americano* (American). He speaks an older dialect of Sicilian and uses words that are part of a creole invented out of necessity as Sicilians imposed their native language on the American experiences that had no Sicilian equivalent. He immediately recognizes his Sicilian relatives as versions of those back in America, physically and especially temperamentally. These similarities enable him to realize that it was futile ". . . for anyone to believe that Sicilians could become conventional Americans in the course of a single lifetime" (265). However, he also becomes aware of a great difference

between Sicilians and Sicilian Americans, especially in a time of fascism: the former still had a fear of ". . . speaking out of turn. It lay on their hearts and minds like a heavy poison. But Sicilians had to talk, for it was in their nature. Some talked to me because I was an American relative and would not give them away" (266). Mangione can see this fear, and recognize the limitations it forces the Sicilian to live with, only because he has come to understand and exercise a more "Americanized" notion of freedom and self-reliance.

The guiding principle of Mangione's style and a dominant theme in his work is that one can challenge destiny and take control of his or her own destiny. He writes out of a need to explain the people who have affected his notions of self; he also writes in order to bridge the gap between the Italian immigrant and the American. He knows the sophistication and the wit these illiterate immigrants are capable of communicating to each other, but not to outsiders, who mistakenly equate the immigrants' struggle for self-expression in a foreign language with ignorance. The solution to the Sicilian vs. American identity conflict dramatized in *Mount Allegro* would be pursued in Mangione's second book, *Reunion in Sicily* (1950).

Reunion in Sicily documents the second of Mangione's many trips to Sicily. These trips become odysseys that reverse the typical journey paradigm found in the immigrant autobiography. The reunion that he experiences in Sicily goes beyond the strengthening of ties between families in two worlds; it is more a reunion of a divided self. The book reveals the important process of a reintegration of self. Mangione comes to realize that he is neither American nor Italian, but a synthesis of the two, which creates an Italian American. Structured as a personal travelogue and political report, *Reunion in Sicily* opens with a confession that in spite of receiving a Guggenheim Fellowship, Mangione is in no mood to go to Sicily. Ten years after his first visit, Mangione tells us that the goal of this project is to look at postwar life in Italy and to document the transition from dictatorship to self-government. Among the dangers he anticipates encountering is the trap of marriage. At thirty-seven years of age, Mangione is plagued by his relatives' disappointment with his bachelor state. They hope he will return from this trip to Sicily married to a good Sicilian woman. *Reunion in Sicily,* like its predecessor, includes anecdotes concerning his experiences with his Sicilian relatives. Through his discussions with them and other Sicilians, he is able to document the effects that World War II had on the Italians. Many experienced American bombing of their villages; some witnessed the brutality of Allied soldiers, brutality not normally equated with the liberation of Italy.

It is a different Sicily that Mangione experiences in this trip. Political ar-

guments may be heard in public. Fathers who believed in fascism's ability to impose order and enable progress now have sons whose hopes for a brighter future are planted in the growing Communist and Socialist parties that are quickly gaining strength in the more impoverished regions of southern Italy and Sicily. Rather then merely report the situation as a touring journalist, Mangione employs a more novelistic approach as he threads his narrative with dialogue, allowing Italians to speak of their experiences for themselves. As Mangione gathers the impressions from Italians and Sicilians from all walks of life and from different classes, he begins to understand the way they view America and the "typical American" stereotype they have constructed based on their interactions with Americans. Though much of what he is fits their notion of the stereotypical American, there are qualities that Mangione has that do not conform to their image of "the American." By challenging their monolithic notions of what the typical American is, Mangione becomes the exception, a reminder that stereotypes are artificial constructions. Through this sometimes intense scrutiny of his parents' homeland, Mangione comes to learn about a Sicily his parents had not made him aware of. The result of this learning is the establishment of an identity that crosses both American and Italian cultural boundaries. Mangione can be an American in Italy and an Italian in America.

Mangione's achievement of a true bicultural perspective, created by his newly developed ability to now experience Italy and America as both outsider and insider, comes when he realizes that he cannot possibly be a pure product of either culture. *Reunion in Sicily,* the result of Mangione's Guggenheim-sponsored trip to Italy in 1947, reveals the writer's growing interest in the human community of the world. In his proposal to the Guggenheim committee, he mentioned that what was happening in postwar and postfascist Sicily "should concern all who realize that the military liberation of a people sickened with dictatorship and war is one thing; its convalescence into a healthy, self-governing body is quite another" (3). It is Mangione's sense of the need to develop a concept of world community that motivates him to return to Sicily for a third time, close to twenty years after his second trip. This third trip is recounted in his next book.

A Passion for Sicilians: The World Around Danilo Dolci (1968) is a social history written in the first person, and as such it serves as an ethnography of a neglected region's fight for progress against the Mafia and a stubborn, slow-moving Italian government. Mangione chooses to step back and record his observations of the work of Italian social activist Danilo Dolci, often called the "Ghandi of Sicily," whose goal was to assist Sicilians in taking control over their own lives. In *A Passion for Sicilians,* Mangione, now considered an "unofficial" representative of

America on a Fulbright Fellowship, describes the conditions of poverty that continue to plague Sicily, despite the economic growth that Italy is experiencing. Once again, Mangione depends on the people he knows best, his family, to recount the Sicilian postwar experience. With a solid knowledge of Sicily's past, discovered and documented in both of his earlier books, Mangione is most concerned, as is Dolci, with Sicily's future. It is a changing Sicily that Mangione sees this time around, a land in which Sicilians are learning to take destiny into their own hands by informing on the Mafia, protesting against government neglect, and building community centers that will train tomorrow's leaders. But the establishment of a new democracy in Italy presents many challenges to the traditional patriarchal structure of the family, a structure that was mirrored in the earlier fascist regime. Mangione records the struggle in one young woman's words: "How can we ever have democracy in our society if we don't have it in the family" (260)?

In a sense, Mangione shows with this book that he has become not only a citizen of both countries, but also an ambassador of sorts to both countries, each to the other. In it he presents a sense of being finally at home in both worlds. Now comfortable in this ambassadorial position, Mangione is prepared to write *An Ethnic at Large: A Memoir of the Thirties and Forties* (1978), which contains the type of material that we most expect to find in a traditional "success story" autobiography. In it we follow the son of immigrants out of the neighborhood and into the world. Early portions of the book involve a retelling of the experiences in Mount Allegro, but now these events appear from an even greater distance both in time and space. Mangione, at age sixty-nine, reexamines his life from childhood through age thirty-five. The result is that he now (re)presents the past in a much more Americanized context. He is much more confident in his abilities to mediate among cultures, and he reexamines his past from a unique multicultural dimension that enables him to view events from a variety of perspectives.

His main interest becomes examining social injustices from a nonpartisan point of view. His multicultural perspective requires that he reach beyond partisan politics for solutions to social injustices, beyond the politics of difference that divide immigrants from natives, rich from poor, Black from White. It is from this suprapolitical stance that Mangione presents not only his story, but also the history of the America he has experienced. Structured chronologically, *An Ethnic at Large* charts the development of Mangione's career as a writer and civil servant and dramatizes the cross-cultural experiences he encounters in America. The writing becomes an account of the narrator's coming of age during America's Roaring Twenties, the Great Depression, World War II (including visits to the White House) and the McCarthy era.

An Ethnic at Large begins with Mangione recounting his sense of alienation as he peers through the picket fence that separates the inner world of his Sicilian home from the outside American world. Unlike the persona of *Mount Allegro,* who viewed a self composed of two lives, divided between Sicilian and American, the protagonist in *An Ethnic at Large* speaks of a third life, "the one I lived with myself, which gradually was to dictate the secret resolve to break away from my relatives" (13). This became a fantasy life, nurtured by daydreams and books "read clandestinely in the bathroom or under the bed" because his mother "believed that too much reading could drive a person insane" (14). College life marks the beginning of Mangione's conscious movement away from a Sicilian identity. He even escapes an Italian fraternity in order to separate himself from those who had created "a miniature ghetto" by banding together "to fortify themselves against the fear of being surrounded by a hostile people" (36).

From college, Mangione follows a distinctly American path. His earlier encounters with mainstream American writers had strengthened his belief in the possibility of realizing his dream of becoming a writer. Upon graduation, he lands a job in Manhattan with *Time* magazine; much to his dismay, it is in the Business and Finance Department, in which he has scant knowledge and no interest. After he quits the job in 1931, perhaps the worst year of the Great Depression, he takes on odd clerical jobs, reviews books for the *New Republic,* works in the Library of Cooper Union Institute and eventually lands work with a New York publishing firm. All this time, he is also trying to keep his literary aspirations alive. His interest in writing and his encounters with American avant-garde artists lead him to dismiss the "art-for-art's-sake" cult and to realize that "no writer worth his salt could turn his back on social injustice" (49). For a brief time, he attends meetings of the New York John Reed Club, whose motto was "art is a class weapon." Though uncomfortable with party-line politics, Mangione contributes to the cause by writing articles and reviews for such left-wing publications as *New Masses,* the *Partisan Review,* and the *Daily Worker,* most of which he published under the pen name Mario Michele and his baptismal name, Gerlando. Most of his writing during the thirties, primarily book reviews, was done for the *New Republic.* In 1937 he left New York to work for the New Deal. In the course of this period of politicization, Mangione comes to understand the terrible threat that rising European fascism presents to the world. As he works to understand it better he befriends Carlo Tresca, an Italian antifascist and anarchist who came to America in the early 1900s to aid the exploited Italian immigrant laborers.

During this same period, Mangione also reads Sicilian writers, interviews Luigi Pirandello, and convinces the publishing firm that employs him to accept

the work of Italian antifascist writer Ignazio Silone. Later his left-wing publications and his friendship with Tresca proved to haunt his first trip to Italy, during which his mail was censored and his movements monitored by fascist authorities. Upon his return from Italy, Mangione (by now fiercely antifascist) quits his publishing job in New York and goes to Washington to join the New Deal as an "information specialist" with the United States Resettlement Administration, which later became the Farm Security Administration. Because of his previous experience in the publishing field, Mangione was offered a job in the Federal Writers' Project as national coordinating editor, an experience he documents in his social history entitled *The Dream and the Deal: The Federal Writers' Project, 1935–1943* (1972).

Shortly before the United States entered World War II, Mangione was invited to join the public relations staff of the U.S. Department of Justice to help publicize the national registration of aliens of enemy nations; he was appointed special assistant to the U.S. commissioner of immigration and naturalization, in which post he became the custodian agent for a program of selective internment of aliens of enemy nationality, a program sponsored by the Department of Justice, which interned 10,000 aliens, only 250 of whom were Italians. In that position, he traveled to a number of detention centers gathering firsthand information about the conditions he observed. Mangione's sensitivity to his own ethnicity enabled him to see things from a multicultural perspective, and thus, he was able to identify with the Japanese, German, and Italian Americans who were kept, some of them merely on grounds of suspicion, in America's version of concentration camps. Mangione refers to the experience as a reminder that "we were engaged in a war of hopelessly conflicting wills . . . that had thrust us into the shameful position of locking up people for their beliefs" (352).

Later, during the McCarthy era, his "foreignness," in spite of his years of dedicated public service, would come back to haunt him. A neighbor reported to Mangione that two government men had been questioning her and had asked if she had seen any foreign-looking people around Mangione's apartment, to which she had replied, "Yes, his parents." During the same period, Mangione was called to testify before an executive session of the House Un-American Activities Committee, as well as its Senate counterpart, headed by the notorious Joseph McCarthy. Never having been a member of the Communist Party, Mangione was of no further use to either committee and never heard from them again. In the final chapter of *An Ethnic at Large,* Mangione reveals the resolution he has come to regarding his recurring identity crisis. Unlike those who would spend a lifetime harboring an anger generated by experiences of prejudice, or those whose identities suffered conflicting self-images throughout their entire lives, Mangione found

a compromise by "becoming an ethnic at large, with one foot in my Sicilian heritage, the other in the American mainstream. By this cultural gymnastic stance, I could derive strength from my past and a feeling of hope for my present" (369–370).

With *An Ethnic at Large,* Mangione has found a way to write himself home. Through it, he clearly established himself as an accomplished writer whose major works illuminate the Italian American experience while providing insights into the complexities of ethnic American culture. Over the years since the publication of *An Ethnic at Large,* Mangione has continued to serve as an ambassador and interpreter of Italian American culture. He reviews books, presents talks, encourages younger writers, and continues to examine and chronicle the Italian American experience. His *La Storia: Five Centuries of the Italian American Experience* (1992), cowritten with Ben Morreale, is a monumental social history of Italian Americans that establishes Jerre Mangione as a true diplomat of Italian American culture, at home in America.

Carl Marzani: A Reluctant Radical

Carl Marzani has spent his life fighting against injustice through his writing. At the age of ten, he published parodies of fascist songs. From the 1920s through the mid-1990s, he has written six books, dozens of pamphlets, and film documentaries. In each case, his goal has been to make America a better place to live. In 1992 at the age of eighty, the writer, whom Italo Calvino called "the only man truthfully and completely in love with the United States" (preface to *Roman Childhood,* xi), began to recount the story of his life. *Roman Childhood* (1992) is the first in a series of a proposed five or six small books through which Marzani recalls and re-creates the eight decades of his education as a reluctant radical. *Roman Childhood* covers Marzani's life from his 1912 birth in Rome through his immigration to America in 1924. Marzani is proud of his Roman heritage, which he can trace back through twenty-seven generations. The book opens with an "Appreciation" of Marzani by Calvino, who met Marzani during a 1960 visit to the United States. What follows is a depiction of his childhood; Marzani contrasts his life with that of his best friend, who later became a staunch fascist and then a corporate businessman. Both joined the Youth Catholic Explorers, a Boy Scout-like group whose members often found themselves battling the Balillas, a fascist youth organization.

Roman Childhood is an immigrant story unlike any other written by an Italian American. Marzani's personal style always avoids the temptation to be obviously literary. He includes family photos, proverbs, and song lyrics, and the combination creates a document that is charming, historically important, politically

· 300 ·

vital, and never dull. Marzani's firsthand experience of fascism enabled him to recognize it approaching the United States. "The key to an understanding of fascism," he writes, "is its destruction of 'existing' democratic institutions" (137). Marzani saw the 1947 loyalty oaths for public servants, ordered by President Harry Truman, and the American Cold War policies as the first steps toward fascism in America. Remembering his father's lament that the Italians should have fought fascism in Italy, Marzani dedicated his life to combating it in America.

Growing Up American (1993), the second installment of Marzani's memoirs, captures the transformation of Marzani from Italian American greenhorn to Oxford scholar. As in *Roman Childhood,* Marzani recounts the major events of his life and comments on contemporary American life. This combination of historical recollection and cultural criticism separates Marzani's memoirs from most immigrant autobiographies. Beginning with his adolescence in Peckville, Pennsylvania, where he was a thirteen-year-old first-grader, Marzani brilliantly recalls his education and social indoctrination into American life. Within six years, he went from grammar school through high school and earned a scholarship to the prestigious Williams College. This volume features the teachers who both supported and thwarted his attempts to succeed in America. At Williams, Marzani revived the school's literary publication and was elected "Most Brilliant" and "Biggest Drag with the Faculty," nosing out Richard Helms, who would become Director of the Central Intelligence Agency (CIA). There he met the antifascist historian Gaetano Salvemini, whose *Beneath the Axe of Fascism* (1936) he helped edit.

Besides formal schooling, Marzani supplemented his education with a cross-country hitchhiking trip during the height of the Depression. "The trip," he writes, "made me a citizen inside; what I had achieved was more than a rite of passage—a testament to personal stamina and ingenuity. . . . This was now my land, my patrimony, bestowed by previous generations of immigrants, freely and generously, on one Carl Aldo Marzani—newly minted American" (39). His exploits as a young adult experimenting with the new freedoms afforded by American democracy feature sexual and travel adventures that never give way to braggadocio. Marzani, the elder dean of true-blue American radicalism, reminds us that you don't have to be a Republican to be a patriot, or a "self-reliant" WASP to be an American. In typical Italian American fashion, he does not separate his accomplishments from his family: "The family had been my fortress; from its keep and redoubt I had sallied forth unafraid, because I knew I could always scuttle back to security. My heart was full of love for them and their pride in my success—it was a vindication of Father's choice of America as a place of exile" (151). *Growing Up American* ends with Marzani on his way to England to study on an Oxford schol-

arship awarded to him by the president of Williams College, who had overruled a faculty committee's objection to Marzani's candidacy.

In *Spain, Munich, and Dying Empires* (1994), Marzani recalls his student days in 1936 at Oxford University. Out of curiosity and strong antifascist beliefs, the young scholar visits Spain and finds himself fighting fascism alongside the anarchists in the Spanish Civil War. While his stay was brief, his insights into the battle are those of a seasoned veteran. The experience is one in which his "life was altered forever" (36). When he returns to Oxford, he meets up with actress Edith Eisner—a member of the American Communist Party and the woman he would marry. Because of her he reluctantly joined the Communist Party, an action to which he did not give much thought at the time. "[I]t never crossed my mind that joining the party might embarrass or harm me by jeopardizing my future or making me an outlaw in American society. Given Spain and the Congress of Industrial Organizations (CIO), most Communists and Communist sympathizers were accepted and even respected" (49–50).

While those actions would later become the foundation for Marzani's persecution, the bulk of this installment is devoted to an incredible honeymoon hitchhiking tour of Nazi-controlled Germany, Eastern Europe, Syria, India, Laos, China, and Japan in which Marzani and his bride meet Ghandi, Nehru, Chinese generals, and Japanese secret police. The trip begins in Oxford in August 1938 and ends with the couple's arrival in San Francisco in April 1939. Marzani's penchant for keeping track of even the tiniest detail enables him to figure out that the trip cost a little over a penny per mile, or 67 cents per day.

Self As Italian American Woman

What we often find in the autobiographical work of Italian Americans who are children and grandchildren of the immigrants is an intense politicization of the self. Frequently, this politicized expression emerges in combative voices, representative of the intense struggle that Italian American women especially have waged in forging free selves in a patriarchal system.[12] If creating an American identity was difficult for Italian American men, the process for Italian American women would prove even more difficult. As Helen Barolini explains:

> [T]he displacement from one culture to another has represented a real crisis of identity for the Italian woman, and she has left a heritage of conflict to her children. They, unwilling to give themselves completely

to the old ways she transmitted, end up, in their assimilationist hurry, with shame and ambivalence in their behavior and values ("Introduction," The Dream Book, *13).*

This shame and ambivalence often become the very building blocks of Italian American women's writing. As an illustration, we will turn to Helen Barolini's autobiographical essays and Diane di Prima's autobiographical memoirs and her autobiography-in-progress.

Helen Barolini: Autobiography As Piecework
The writings of Helen Barolini, novelist, essayist, and critic, provide us with an understanding of how hard it was for Italian American women to write within considerable sociocultural constraints, often producing self-narratives in a fashion that resembles the "piecework" they took on in their own homes. In one of her many autobiographical essays, Barolini encourages women to reconsider this "work at home" tradition in terms of creating literature:

> *A revolutionary concept could be based on the fact that Italian American women, by preference or not, have traditionally worked at home—taking in lodgers, making artificial flowers, doing piecework and embroidery, cooking for others. . . .Why not, then, work at home as writers? This would be revolutionary in admitting intellectual and artistic endeavors as "work," especially since they seldom produce immediate income. But the* miseria *mentality would finally have been overcome ("Becoming," 31).*

Though Barolini has not written an autobiography per se, she has provided us with a sense of one in progress through her various essays, critical writings, and two novels and with *Festa: Recipes and Recollections* (1988). Her writings reveal the plight of the woman in the immigrant home and create a sense of how traditions both survived and died in the experience of succeeding generations.[13]

Barolini knows the importance that creating and reading literature plays in one's self-development. "Literature," she says, "gives us ourselves" ("Introduction," *The Dream Book,* 51). Without experiencing models created by Italian American women, Barolini says, we cannot expect Italian American women to pursue literary careers. She believes that Italian American women can contribute to a revitalization of American literature, which might begin with writing about the self in the manner of keeping journals and writing memoirs and autobiographies:

> . . . *quite missing, as yet, are the honest and revealing stories of women's inner lives. . . . Redefining the self not as mirrored by society's expectations but in one's own authentic terms is essential for an integrated literary expression. Autobiography, when it is honest and not a camouflage, can be a powerful declaration of selfhood and a positive step toward establishing an incontrovertible voice* ("Introduction," The Dream Book, 51–52).

Unlike Jerre Mangione, the house in Syracuse, New York, that Barolini grew up in was not a shrine to the old country; yet in spite of her parents' attempts to turn their back on their Italian heritage, there were experiences that raised questions of identity in the young granddaughter of immigrants:

> *I knew very little of my Italian background because it had always been played down. There had been the early confusion in grade school when I didn't know what to fill in on the form when nationality was asked: was I Italian because my name sounded strange, or was I American because I was born here? By the time I was in high school, it was simply a matter of embarrassment to be identified with a people who were the dupes of that great buffoon, Mussolini, and the war intensified our feelings of alienation from Italy and the efforts to be thoroughly American. We didn't want to be identified with the backward Italian families who lived on the North Side and did their shopping in grocery stores that smelled of strong cheese and salamis. Neither the ethnic nor the gourmet age had yet dawned in the states; it was still the time of the stewing melting poet and of being popular by being what everyone else was or thought we should be* ("Circular," 111).

However much the young girl wanted to disassociate herself from her Italian identity, there was always the female figure in black, her immigrant grandmother Nicoletta, "who didn't speak English and had strange, un-American ways of dressing and wearing her hair" ("Circular," 111), reminding her of her family's Italian origins. However, in leaving home to attend college, Barolini did not run away from, but right into, an Italian identity. It was at Wells College, in a Latin course, that she was "first awakened . . . to unsuspected and deep longings for the classical Mediterranean world, and for an Italy from which after all I had my descent" ("Circular," 111).

Later, on a 1948 trip to Italy, Barolini met the man she would marry, Italian poet and journalist Antonio Barolini. At first, the marriage upset her parents, "who felt that in marrying an Italian I had regressed in contrast to my brothers,

who had married Irish" ("Circular," 112). After settling into an Italian life, the couple soon found themselves back in New York, where Antonio was employed as Italian consul general for one year. Antonio's career required frequent relocation between America and Italy. While the frequent travel to Italy of writers such as Mangione served to develop and strengthen an American identity, the opposite experience was Barolini's, whose life in Italy served to re-create and nurture her Italian identity, as she explains in her "Introduction" to *The Dream Book: An Anthology of Writings by Italian American Women* (1985): "I had to make the long journey to Italy, to see where and what I came from, to gain an ultimate understanding and acceptance of being American with particular shadings of ***italianità*** (Italianness). To say that was at odds with the dominant American culture is an understatement. It is the essence of lifelong psychological conflict" (269).

This conflict surfaced in her first novel, *Umbertina* (1979), an American saga that dramatizes the lives of three generations of Italian American women. Because the first generation turns its back on the past and looks only forward, it influences the second generation to do the same; the third generation looks back into the past for keys to its identity. The opening of *Umbertina,* appropriately enough, finds the granddaughter of the immigrant Umbertina in a psychiatrist's office recounting a dream. The psychiatrist analyzes the dream and suggests that she might begin her search for self by digging into her family's past. This fiction then parallels Barolini's own experiences of the third generation's return to the past and recovery of an *italianità* that establishes a historical context for her present-day self. This odyssey in search of self takes Barolini back and forth from Italy to America. By turning these experiences into writing, Barolini historicizes the Italian American woman, an act that John M. Reilly, in "Literary Versions of Ethnic History from Upstate New York," says revolutionizes our way of reading: "Giving voice to the women who have usually been given minor roles in realistic fiction and setting them in the center of interwoven narratives so that their experiences and thoughts form the substance of the novel is to define the women as historical actors and to modify our understand of other texts in which the women were not subjects (193).

Barolini's search for self through her own writing, and the creation of her American identity through the creation of literature—once established—enabled her to go in search of her sister authors. The results of that search are found in *The Dream Book*. As Barolini's own work reveals, for Italian American women writing became not only a means of discovering an American identity, but also a means of discovering and creating a human identity. It is this dual requirement that makes writing into extremely challenging work for Italian American women as they at-

tempt to reconcile past and present, Old World and New: In the houses of Italian America were women writers, who, until Barolini gave them *The Dream Book,* had no sense of a developing tradition since they were often isolated both from the Anglo-American literary tradition as well as the beginnings of a male-dominated Italian American tradition. Barolini's comments on the desires of second- and third-generation Italian Americans to emulate and adapt a more "American" way of life can tell us much about the conflict the women experienced: "We wanted the look of tweed and tartan and not the embroideries of our grandmother's Italian bed linens; we wanted a Cape Cod cottage for our dream house, not some stuccoed *villino* with arches and tomatoes in the back yard" ("Introduction," *The Dream Book,* 20). Italian immigrant families, in spite of embracing the freedoms America provided that Italy did not, kept up the traditional male–female double standard. Women were not expected to go on to college; when they did go, it was often with the parents' hopes that they would find husbands. Faced with such restrictive barriers erected by family and tradition, the Italian American woman who would be a writer could become one only by directly challenging the forces that tied her down.[14]

A great part of that challenge would require fighting the image that the larger society had created for her to emulate. Barolini took it upon herself to recast the public image of the Italian American woman in her own likeness. In doing so, she proved not only that an Italian American woman could write, but also that any consideration of Italian American culture would be incomplete if the literary works produced by women were ignored. In 1988 Barolini took on a risky challenge, destroying the stereotype of the Italian woman posed, wooden spoon in hand, slaving over a stove full of pots and pans. In *Festa: Recipes and Recollections,* Barolini turns the woman's room, the family kitchen, into an embassy of cultural tradition. Though the Italian's relationship to food has been trivialized and reduced to the point of absurd media stereotyping, cooking and eating are important identity-creating acts. Barolini reminds us that cultural traditions are reinforced and transmitted in Italian American kitchens and at their dinner tables. "Starting in her kitchen, my mother found her way back to her heritage, and this, I suspect, happened for many Italian American families who were rescued from lives of denial by the ethnic explosion of the sixties" (*Festa,* 520). In *Festa,* Barolini examines the traditional relationship between Italians and food. She presents, in the form of a personal month-by-month calendar, the traditional Italian and Italian American celebrations and the foods that are part of those festive occasions.

"Italy is as close to me as appetite," she says in the first sentence (*Festa,* 1). Her writing is a combination of memoir and research that demonstrates how food's

history and preparation are inseparably bound. To Barolini, the instruments of cooking, the ingredients, whether seen in the wild or on a grocer's shelf, the aroma of a spice, a ragu or a sweet bite of a pastry have the power to evoke endless streams of memories: "*Mangiando, ricordo* [By eating I remember]. My memory seems more and more tied to the table, to a full table of good food and festivity; to the place of food and ritual and celebration in life. Yes, I believe in good food and in festivity. Food is the medium of my remembrance—of my memory of Italy and family and of children at my table" (*Festa,* 13). By establishing the social and historical contexts for her recipes, Barolini does more than give us another cookbook; she relates personal history to group history and describes how the habits and work of women have been formed in, and through, the Italian family. With *Festa,* Barolini takes us into the private world of the Italian American woman, sharing, what is often quite secretive, authentic family recipes. By presenting her version of cooking as the perfect art, complete with historical references, proper means of preparation, and manners of serving and consumption, Barolini has given her readers vital sustenance, not only for the body, as the caricature of *mamma mia* has been restricted to providing, but for the mind and the soul. She has also presented us with a new way of reading the role of the woman in the kitchen. Barolini's version of the Italian American house encompasses many rooms, but the heart of what she has to offer lies in the kitchen and the stories that, for more than a hundred years, women have shared as they worked together to whip up family banquets. In *Festa,* as in Barolini's many autobiographical essays, we find the stories that the men would never hear, stories passed down to daughters, nieces, and granddaughters who would one day turn them into literature.[15]

Diane di Prima: Autobiography As Self (Ex)Tension

> *Italian American women writers have explored the vital connection between being a woman and being ethnic in a world (America) which traditionally has valued neither.*
> —Mary Jo Bona, "Broken Images, Broken Lives"

The driving force behind the poetry and prose of Diane di Prima is a gender- and culture-based tension created between men and women and between Italian and American culture. In *Memoirs of a Beatnik* (1969), the first major autobiography by an Italian American woman, di Prima opens her narrative with the violation of two traditional taboos based on the two proffered codes: she *talks* about *sex* in

public. *Memoirs,* which begins with di Prima recounting the loss of her virginity and closes with her first pregnancy, represents the definitive fracturing of *omertà* that (as Helen Barolini best explains in her "Introduction" to *The Dream Book*) has been the cultural force behind the public silence of Italian American women. While *Memoirs* does not constitute a traditional autobiography, it should be considered as a precedent, against which we might better read the sexual personae of Italian American women like Madonna and Camille Paglia.

In one of the few articles that examines di Prima's connection to her ethnicity, Blossom S. Kirschenbaum, in a 1987 article titled "For Diane di Prima, the Beat Goes On," points out that much of di Prima's poetry defies and yet extends the traditional notion of **la famiglia**: "Poems flaunt defiance of familial convention, but at the same time enlarge the circle of quasi-family. . . . Even as she distances her parents, she carries forward an understanding of her grandfather's legacy. In revolt, therefore, di Prima still seeks precedents in her own cultural history" (38). Kirschenbaum examines the Italian content of di Prima's writing and the poet's behavior, which rebels against the traditional expectations Italian men have of their women; she sees di Prima as fracturing the centuries-old code of silence that men have employed in their attempts to control women:

> *By rejecting self-sacrifice, and by sexualizing (even bestializing) the female goddess, di Prima has moved away from traditional Italian values and content. . . . By direct challenge of the concept of legitimacy, by revising the index of who really counts, and by using non-English verse forms . . . di Prima has been rewriting history and, by implication, genealogy. She widens the concept of common ancestry and common progeny. . . . She defines her own usable past to include the Italian heritage that does not however limit her. She insists on her own definitions of history, country, and self. Confidence in that self sustains her openness to the world of other selves. This is her legacy to her children and grandchildren—and to her readers (38).*

This legacy is the result of her gaining control of language, which enables di Prima to break away from the traditional holds that have kept Italian women silent. By re-creating her life through her art, she gives voice to the selves that were kept silent in the past and, in effect, gains control over her self and how that self is presented to society.

In her autobiography-in-progress entitled *Recollections of My Life As a Woman,* from which she has been publishing pieces in publications such as *Mamma Bears*

News and Notes (out of San Francisco and in which excerpts appear regularly from Volume 6 on), *Voices in Italian Americana* and *Mother Jones,* she returns to the troubled times before she left home (when *Memoirs* begins) and struggles to uncover and process the family secrets that have haunted her. To date (1995) she has completed five chapters of *Recollections,* which I have had the opportunity to read. While it would be premature to judge the work before it is completed, I would like to point to some stylistic characteristics and themes that emerge in these early chapters.

As many other Italian American women writers, di Prima uses the figure of the grandmother as a symbolic source from which she draws her ethnic identity.[16] She opens her autobiography by establishing a connection to her grandmother: "My earliest sense of what it means to be a woman was learned from my grandmother, Antoinette Mallozzi, and at her knee" (33). In contrast to her grandmother's fatalistic sense of realism, di Prima presents her grandfather's idealism. Di Prima recounts that it was through her grandmother that she learned "about the specialness and the relative uselessness of men" (34). Through her grandmother, she learns, at an early age, the Italian sense of irony that enables seemingly diverse opposites such as Catholics and Communists to be united: "To my child's senses, already sharpened to conflict, there was no conflict in that house. He was an atheist, she a devout Catholic, and for all intents and purposes they were one" (35).

She includes in her narrative letters to her therapist and to her family members, accounts of dreams, quotes from other writers, poetry, stories told by her grandfather, and a variety of forms that interrupt the narrative flow and remind us that memory comes in pieces. Through such a structure, we get a sense of the many selves that di Prima has fashioned during her life and how they continue to interact in her mind. While she presents a variety of "selves" throughout the years that she recounts, she does it all through the singular sound of a voice that clearly belongs to a woman looking back on her life, and, in this respect, hers reflects a more modernist approach to writing her life story.

Unlike her mother, who kept silent about her own "breakdown" until shortly before her death, di Prima is able to talk about her weaknesses as well as her strengths. However, she delves deep into her past in this autobiography only after the deaths of her parents. When she confronts her siblings about their perceptions of the past, she is met with silence. In a letter to her brothers after she has told them that a former husband of hers has died of AIDS, she refers to the family's *omertà:* "Now recently I have been looking at issues of support and lack of support in my life, and all that silence is looming as a biggie. Silence from Frank. Silence from Richard" (*Recollections*, 66). And as she continues to investigate and

reimagine her past, she begins to form the idea that all that silence is covering childhood abuse both physical and psychological:

> *Disappointment and silence marked the women too. But there, the silence lay deeper. No tales were told. They did not turn from one career to another, 'take up the law,' but buried the work of their hearts in the basement, burned their poems and stories, lost the thread of their dreams"(110).*

For di Prima, writing has always been instrumental in healing the psychic traumas of life. Through the first few chapters, she confronts a number of them, which she describes then reflects upon. One insight she comes to in *Recollections* is that she has inherited what she calls, "immigrant fear":

> *Assault was the model of the world, the world around me. The world as my parents understood it. Anything could happen to you anytime, and mostly it wouldn't be good. Hence my mother's real hysteria if we were late, if my father came late from the office. A kind of immigrant fear I carry to this day. Will I wake at night and hear them outside my door, arresting, killing my returning love? (86)*

This is a fear similar to the one that Rosa Cassattari spoke of in *Rosa: The Life of an Italian Immigrant* (1970), her as-told-to autobiography written by Marie Hall-Ets. While Rosa's fear stemmed from class divisions in the old country, di Prima's fear extends from the family into the societal strata of her life in the form of travel timetables and insurance claim forms and manifests itself in her "not opening the door to the census taker" (87). Such fear affects even the way her family dealt with sickness:

> *Disease as assault, invasion, medicine as invasion. And health as return to the unspeakable. The horror of daily life. I prayed that 'quarantine' would never end. The methods of the oppressors (Ellis Island) adapted by the oppressed and used against their children"(89).*

It is this fear, this remnant of the sense of **destino** that ruled life back in Italy, that di Prima reveals as she confronts, and by so doing voices and comes to terms with, another weakness.

Di Prima begins to take control of her public image only when she is presented with the opportunity of going off to high school; it is the first time she is

able to shape her life outside her family's reach, to "reinvent" herself. Later, by going away to college and living on her own, she is able to completely break away from the domination of her parents; yet her parent's attitudes continue to haunt her.

> *I remember the week that I was leaving for college, my father turned to me, somber, to deliver his deepest message. Summation of the truths of his life, what he had learned. Held me by the shoulder, or with his eyes:"Now don't expect too much. I want you to always remember that you're Italian."*
>
> *Not that we weren't as good, but however good we were, we would be held down. Or back. An underclass. (unpublished manuscript)*

While di Prima has overcome the fatalistic sense of destiny communicated by her father, her autobiography reveals the success of an American woman of Italian descent to both overcome and understand elements of the Italian culture that helped to shape her life. In her struggle against the hegemony of the patriarchal Italian American culture, she learns to identify with those oppressed by American culture. Her autobiography, as much of her poetry, is an attempt to redefine the idea of woman through Italian American eyes. Unlike most earlier Italian American autobiographies, she speaks for herself and, in the act of speaking, breaks the traditional code of *omertà* in a manner that, according to traditional expectations of female behavior, would be *brutta* or *mala figura*. She uses the tensions of her life to extend her "self" beyond the traditional constraints that have silenced earlier generations of Italian American women.

Self As Italian American Man

Gay Talese: Self As a Journalist's Subject
Since the 1960s, the writing of Gay Talese (1932–) has been a mirror of American life, and, while he might have been the one holding the mirror for parts of American society, his own participation was often reflected. However, whether the subject was the *New York Times* in *The Kingdom and the Power* (1970) the Mafia in *Honor Thy Father* (1971) or sexuality and the First Amendment in *Thy Neighbor's Wife* (1980) Gay Talese's best-selling books have primarily reflected other people's experiences. In *Unto the Sons* (1992), Talese has turned the mirror onto himself, and, in the process, he also captures images of the forces of history that have shaped modern Italy and America and those who have contributed to the making of the man named Gay Talese. *Unto the Sons* represents the biggest risk Talese has taken

yet in his career as one of America's most successful and innovative journalists. That risk comes in the form of an intense investigation of his Italian American experience. In many ways, Talese has spent an entire life preparing for this book. And its success is a result of applying the skills he honed on his earlier works to a most personal subject. What is remarkable about Talese's presentation of the Italian American experience is the skillful and imaginative way he uses his own life as a stepping stone into a past that has shaped two nations.

Ten years of research and writing have enabled him to weave the fabric of his book with threads of oral tradition as recalled personally and through interviews, history, myth, and autobiography. The result is a style that breaks down the wall between fiction and nonfiction. His retelling of ancient myths, of St. Paola di Francesco's miracles and accounts of the evil eye, are combined with excerpts taken right out of his Uncle Antonio Cristiani's diary, interviews of living relatives and research from a number of written sources. What Talese did not experience himself, he reconstructs using the techniques of fiction writing so that what we have in this book is fictional autobiography. This is a far more challenging project than the usual autobiographical fiction that has been the staple fare offered by Italian American writers.

Unto the Sons is a chronicle of a man struggling to understand his Italian American identity. In the process of learning his past, he rediscovers the "old country" of his parents and grandparents and reclaims an identity with Italian culture. The early chapters focus on Talese's youth as an "olive-skinned" kid in a "freckled-face" Ocean City, New Jersey, during World War II. This section introduces the conflict that second-generation Italian Americans know all too well: "There were many times when I wished that I had been born into a different family, a plain and simple family of impeccable American credentials—a no-secrets, nonwhispering, no-enemy-soldiers family that never received mail from POW camps, or prayed to a painting of an ugly monk, or ate Italian bread with pungent cheese" (51). From there, he moves into telling his father's story of life in Maida, a village in the toe of the Italian boot, and his father's immigration to America. He then shifts back to the lives of his great-grandparents. Toward the end of this volume, Talese becomes a character, like the others in his own book. The book ends by circling back to the opening, a move that is perhaps preparing readers for a sequel that will follow his personal history from college through his career as a journalist.

Unto the Sons opens in a first-person point of view, as a traditional autobiography, then shifts almost imperceptibly into third person, where it stays even through the author's own birth and childhood. By remaining in this point of view, Talese reminds us that we are not who or what we were in our past. He also re-

minds us that our representation of that past is, in fact, a "fiction" in the true sense of the word: a conscious construction, susceptible to interpretation and revision. Throughout *Unto the Sons* there are profiles of historical figures such as Garibaldi, Napoleon, and Mussolini that, while connecting his family's stories to the larger fabric of history, serve as vehicles for exploring and criticizing the Italian character. Talese's interpretation destroys the stereotypes of the cowardly Italian soldier and explains why Italians, "individualistic in the extreme," never organized into a strong sociopolitical force in America. He explores Old World notions of Fatalism and then re-creates the lives of those immigrants who defied *destino* (destiny) to renew their lives in America.

Here and there, Talese injects the history of Italy, from pre-Christian times, through various foreign invasions and occupations by the Spanish—an experience that led to the creation of the phrase *"non ti spagnare"* (don't be afraid)—the French and the English. All of these invasions forced upon native Italians the fear of outsiders that exists even to this day. Talese presents the evolution of independent city-states, the rise of the republic through the **Risorgimento** (1796–1870), Italy's entrance into the modern world, and the modern world's entrance into the "Sleepy Hollow" world of Maida. Like the various autobiographical writings of Jerre Mangione, Talese's story transcends his self to create a group biography. But groups, as we know, are made up of individuals, and individuals' lives are affected by others. That is why we have so many characters in this book. Each character, in his or her own way, has contributed to the identity of the man we know as Gay Talese. Through his recounting the pasts of these many characters, Talese shows us how we are created out of the stories we are told and re-created by the stories that we tell.

Frank Lentricchia: Autobiography As Autofiction

> *The man who tries to explain his age instead of himself is doomed to destruction.*
>
> —*Ezra Pound*

Until recently, Frank Lentricchia was more likely to speak than write about being Italian American. In one interview he tells of thinking about writing an autobiographical essay but holding back, "because I fear this goddamn sentimentality about it" (Salusinszky, 183). In tune with postmodern sounds, his book *The Edge of Night* (1994) walks a tightrope over sentimentality by defying the more traditional approaches found in the autobiographies of his Italian American contem-

poraries such as Diane di Prima, Robert Viscusi, Mario Cuomo, Lee Iacocca and Geraldine Ferraro. Lentricchia's imaginative autobiographical narrative, which focuses on a period covering a little over a year of his life, refuses to speak for an entire culture and concentrates on his own personal struggle to form an identity composed of a working-class childhood and a middle-class adulthood. What makes Lentricchia's autobiographical narrative significant is the way he both adheres to and betrays an Italian American tradition.

Lentricchia plays with *bella figura* and its counterpart *brutta figura* throughout the work. His use of hyperbolic language and swear words creates a spectacle (like a Martin Scorsese film, the narrative maintains an "in your face" attitude). Communication and criticism by indirection, and echoes of oral tradition, all work to enable him to simultaneously maintain and break the code of *omertà*. Lentricchia's narrator comes to us in a number of voices: There is the literary and cultural critic that we have come to know through his earlier writings; there is the son of two working-class Italian American children of immigrants who sees himself as at the "dead end of tradition" (7):

> *I am an Italian-American, one of whose favorite words bears his grandparents, his parents, his neighborhood, his favorite movie director, but not his children, not his colleagues, not where he lives now, and not most of his friends. I'm not telling you that I'm alienated from my ethnic background. I'm not alienated from it, and I'm not unalienated from it. (8)*

And then there is a new voice, one that is extremely critical of its own participation in the activity of the literary academy—a place he refers to as "the Imperial Palace of Explanation," where live "those-who-always-already-know" (125). Lentricchia never privileges one voice over the other, and so the reader can never point to the "real" Frank Lentricchia; in fact, we get a sense that the real Frank Lentricchia exists in the writing and not in the written.

In this work, with a title taken from a 1950s television soap opera, Lentricchia combines meditations on Yeats and Eliot, subjects of much of his earlier writing, with accounts of his past and imaginative flights into the absurd. The opening epigraph from Pirandello points to the plurality of the individual who is the subject of writing: "A character really has his own life, marked with his own characteristics, by virtue of which he is always some one. Whereas a man . . . *a man* can be no one." Connected to this is another epigraph, taken from Martin Scorsese's *Raging Bull* (1980), which opens the first section: "Even you don't know what you meant by you." Anyone looking for the "real" Lentricchia as did a *New*

York Times reviewer (John Sutherland 6 Feb. 1994, VII:24), will no doubt be frustrated in this work. The "I" in Lentricchia's text is plural; it floats upon wave after wave of memory-made fiction and fiction-made memory. Like the poets of the Italian crepuscular tradition, Lentricchia parodies high culture through popular culture. Through this work, he bridges diverse influences of his life; Yeats and Eliot become equals to his grandparents.

In the first chapter, Lentricchia presents a version of his self that tells the reader the narrator is unreliable. His mother, "prone to opera" (4), tells his wife: "He exaggerates. He exaggerates everything. He gets it from his mother" (4). Yet he is also like his grandfathers: Tomaso Iacovelli, the storyteller and keeper of the oral tradition, and Augusto Lentricchia, the frustrated writer who produced a manuscript that came into his grandson Frank's possession only after Augusto's death; entitled *Le memorie di Augusto Lentricchia,* the work is 1,200 pages of recorded memories and poems covering the years 1920–1980.

Lentricchia admits that his interest lies more in the process of writing than the resulting product. "I never existed except in this doing" (6), he writes, but that "I" cannot be pinned down. For once the process stops, the I stops being. Each section of this autofiction finds a new "I" emerging to encounter experiences that create a new sense of self. In "Part One, To the Monastery (May 1991–September 1991)" one Frank Lentricchia goes off to Mepkin Abbey, reads Thomas Merton and gains a new sense of religion. In the second chapter, a different Frank Lentricchia takes off for Ireland, the homeland of his literary self and one of his cultural grandfathers—Yeats. He goes in search of the ghosts of the writers he has read and about whom he has written (68). On this trip, he transports a new self that he has begun creating through his latest writing project, which is unlike anything he has previously written; he is paranoid about losing that self—an extremely fragile self that is newly created on paper. These two selves—the newly literary and the critical Franks—come together in a fanciful encounter between Don DeLillo and William B. Yeats at Dominick's Restaurant in the Bronx, New York. He returns to this trip toward the end and learns that the name Frank does not exist in Irish (83). In the third chapter, we witness a transition from which the literary critic becomes the self-critic; in essence, the end of literary criticism becomes the beginning of self-criticism. Entitled "My Kinsman, T.S. Eliot," this section explores the social consequences of achieving literacy (104) through an intellectual version of Nathaniel Hawthorne's short story "My Kinsman, Major Molineaux" (90).[17]

Throughout the rest of the work, Lentricchia delves deep into both his historical past and his imagination; he begins not only to fantasize, but also to criti-

cize his past, as in this example in which the narrator takes on the perspective of his daughter:

> You know, when it suits you, you come on like a wop right off the boat. You're proud of this, to put it mildly. It's like a weapon, like a knife, your ethnicity. Why did you take relish in teaching us those words when we were young? Wop, greaseball, dago, guinea, spaghetti bender. You like those words, but they just bore us. We don't care. (144)

Lentricchia knows that the price of social mobility is the creation of alternative selves that adapt to new situations one encounters on the trip away from the family and into society:

> The more I went to school the more I became the stranger in the house. Which, of course, was the point. Which is what we all wanted, a gulf, the gulf made by their love, though we would never have thought to say it that way. My son the college teacher, etc. (151)

When Lentricchia returns to his Italian American past to dig up the bodies of those who have shaped him, he carries with him every Italian American who has ever left home and succeeded in a mainstream environment. Unlike many others, his is a triumphant return; in the writing, he maintains control over the ghosts that have haunted him and has created a way to haunt them back.

Conclusion

The cultural conditioning that takes place within American families of Italian descent figures strongly in the way the personal saga is presented in public, whether in print or in conversation. Many, if not most, of the earlier (especially immigrant) autobiographies served as arguments for the acceptance of the Italian as an American; they featured individuals taking on a spokesperson's role as a representative of the immigrant community. Contemporary writers working in the self-narrative mode refuse such responsibility while maintaining a strong connection to that community.

Notes

1. See William Boelhower's *Immigrant Autobiography: Four Versions of the Italian American Self* and "The Making of Ethnic Autobiography in the United States"; Sam Patti's "Autobiography: The

Root of the Italian-American Narrative"; Maria Parrino's dissertation (recycled as *Italian American Autobiographies*), "Il luogo della memoria e il luogo dell' identità: narrazioni autobiografiche di donne dell'immigrazaione italo-americana," and her *Italian American Autobiographies;* James Craig Holte's "Benjamin Franklin and Italian-American Narratives"; and my dissertation, "Italian Signs, American Streets: Cultural Representation in Italian/American Narrative Literature" and my articles: "My House Is Not Yours: Jerre Mangione and Italian/American Autobiography," and "Autobiography As Piecework: The Writings of Helen Barolini."

2. Barolini points out that as late as 1949, the date of the first published survey of Italian American writers (Olga Peragallo, *Italian-American Authors*), the U.S. Census counted a little over 4.5 million Italian Americans, fewer than a million of whom spoke English, a small number to expect many writers to come from.

3. See "Chapter One" of di Prima's *Recollections of My Life As a Woman,* which was published in *VIA* 1, no. 2 (fall 1990).

4. For a survey of the Italian American movement from an oral- to literate-based culture, see Fred L. Gardaphe, "From Oral Tradition to Written Word: Toward an Ethnographically Based Literary Criticism," in *From the Margin: Writings in Italian Americana.*

5. William Boelhower, in *Immigrant Autobiography: Four Versions of the Italian American Self,* presents the most thorough analysis to date (1995) on the subject of Italian American autobiography. Rose Basile Green's pioneer study *The Italian-American Novel* presents some of the earliest Italian American writing and examines autobiographical aspects of Italian American fiction. In *The Ethnic I: A Sourcebook for Ethnic American Autobiography,* James Craig Holte provides valuable information on the autobiographies of Frank Capra, Edward Corsi, Leonard Covello, Lee Iacocca, and Jerre Mangione.

6. Pascal D'Angelo's early attempts to read American signifiers, described in *Son of Italy,* provide a good example of this confusion. "I began to notice that there were signs at the corners of the streets with 'Ave.! Ave.! Ave.!.' How religious a place this must be that expresses its devotion at every crossing, I mused. Still, they did not put the 'Ave.' before the holy word, as in 'Ave Maria,' but rather after" (70). For an interesting account of the Italian and English language encounters see Robert Viscusi, "Circles of the Cyclopes: Schemes of Recognition in Italian American Discourse."

7. I discuss these autobiographies in more detail in "My House Is Not Yours."

8. Understanding how ethnicity is reinvented by each generation is accomplished by reading what Fischer, in "Ethnicity and the Post-Modern Arts of Memory," calls a narrative's "inter-references between two or more cultural traditions," which "create reservoirs for renewing humane values" (201). By identifying and reading these inter-references we will be able to see that, as Fischer concludes, "ethnic memory is . . . or ought to be future, not past oriented" (201).

9. Any theorizing about Italian American autobiography requires a basic understanding of these social codes produced within Italian culture and an awareness of how these codes figure in the development of an American identity.

10. The most popularized example of this concept in America is the Colombo character played by Peter Falk in the television series of the same name. Application of this code to the self-narratives of Jerre Mangione, Angelo Pelligrini, Carl Marzani, Helen Barolini, Diane di Prima, and Gay Talese and to the autobiographical elements in the cultural criticism of Sandra Gilbert, Frank Lentricchia, and Camille Paglia will create new readings of these important contributions to U.S. literature.

11. This tendency to keep to one's self has often been misinterpreted by other American groups, who see this characteristic silence or *omertà* as un-American. In America *omertà* is often pointed to as an attribute of Mafia members, who hold their tongues under fear of death. Unfortunately, the Mafia, as represented in American popular culture, has become the filter through which characteristics of Italian American life have primarily been perceived.

12. Though discussing the African American writer, Stephen Butterfield, in *Black Autobiography*, accurately describes the experience of Italian American women writers: "Every writer must struggle to discover who and what he is; but if you are never able to take who you are for granted, and the social order around you seems deliberately designed to rub you out, stuff your head with little cartoon symbols of what it wants or fears you to be, and mock you with parodies of your highest hopes, then discovering who you really are takes on the dimensions of an epic battle with the social order. Autobiography then becomes both an arsenal and a battle ground" (284).

13. An excellent article pointing to sources for study of the experiences of the Italian woman in America is Betty Boyd Caroli, "Italian Women in America: Sources for Study," *Italian Americana* 2, no. 2 (Spring 1976): 242–251. See also Connie A. Maglione and Carmen Anthony Fiore, *Voices of the Daughters,* a compilation of responses to questionnaires, face-to-face interviews, phone interviews, and oral histories of Italian American women collected by the authors between 1984 and 1989.

14. One moving account of how going to college affected an Italian American woman is Tina De Rosa, "An Italian-American Woman Speaks Out," *Attenzione* (May 1980): 38–39.

15. See Susan Leonardi, "Recipes for Reading: Summer Pasta, Lobster a la Riseholme, and Key Lime Pie," *PMLA* 104, no. 3, (May 1989:340–347) for a reading of recipes as embedded and gendered discourse.

16. In this respect, di Prima, like many Italian American writers, participates in what Ernest Jones and Karl Abraham have identified as "the grandfather complex," which allows the "fantasy" of being "the parents of their own parents . . . to be acted out symbolically" (Sollors 1986: 230–231). The key to reading the literature produced by third-generation Italian American writers is observing the role that the grandparent plays in connecting the writer to his or her ancestral past. A significant difference between second- and third-generation writers, then, is this presence of the grandparent figure, who serves to reconnect the protagonist to a past out of which the protagonist fashions an ethnic identity.

17. This chapter first appeared in *Raritan* 2, no. 4 (Spring 1992). Perhaps more importantly, Lentricchia presented a dramatic reading of this chapter at the 1991 annual conference of the American Association of Italian Studies. Hawthorne's story tells of a young country man who has gone off in search for the one relative who has made a name for himself. When the young man finally meets the relative, the relative is tarred and feathered and being chased out of town.

Further Reading

Bibliographic Resources

Addis, Patricia K. *Through a Woman's I* (Metuchen, N.J.: Scarecrow Press, 1983).
Ahearn, Carol Bonomo. "Interview: Helen Barolini." *Fra Noi* (25 September 1986): 47.
Boelhower, William. *Immigrant Autobiography in the United States* (Verona, Italy: Essedue Edizioni, 1982).

———. "The Making of Ethnic Autobiography in the United States." In *American Autobiography: Retrospect and Prospect,* ed. Paul John Eakin (Madison: University of Wisconsin Press, 1991): 123–141.

Bona, Mary Jo. "Broken Images, Broken Lives: Carmolina's Journey in Tina De Rosa's *Paper Fish*." Melus 14, nos. 3–4 (1987): 87–106.

Butterfield, Stephen. *Black Autobiography* (Amherst: University of Massachusetts Press, 1974).

Calvino, Italo. *Fiabe italiane.* 2 vols. (Milan: Einaudi, 1956).

Cordasco, Francesco, and Salvatore LaGumina. *Italians in the United States: A Bibliography of Reports, Texts, Critical Studies, and Related Materials* (New York: Oriole Editions, 1972).

Fischer, Michael M. J. "Ethnicity and the Post-Modern Arts of Memory." In *Writing Culture: The Poetics and Politics of Ethnography,* ed. James Clifford and George E. Marcus (Berkeley: University of California Press, 1986): 194–233.

Gardaphe, Fred L. "Autobiography As Piecework: The Writings of Helen Barolini." In *Italian Americans Celebrate Life: The Arts and Popular Culture* (Staten Island, N.Y.: American Italian Historical Association, 1990): 19–27.

———. "From Oral Tradition to Written Word: Toward an Ethnographically Based Literary Criticism." In *From the Margin: Writings in Italian Americana,* ed. Anthony Julian Tamburri, Paul Giordano, and Fred L. Gardaphe (West Lafayette, Ind.: Purdue University Press, 1991): 294–306.

———. "My House Is Not Your House: Jerre Mangione and Italian/American Autobiography." In *American Lives*, ed. James Robert Payne (Knoxville: University of Tennessee Press, 1992): 139–177.

———. "Italian Signs, American Streets: Cultural Representation in Italian/American Narrative Literature" (Ph.D. diss., University of Illinois at Chicago, 1993).

Gusdorf, Georges. "Conditions and Limits of Autobiography." In *Autobiography: Essays Theoretical and Critical,* ed. James Olney (Princeton, N.J.: Princeton University Press, 1980): 28–48.

Holte, James Craig. "Benjamin Franklin and Italian-American Narratives." *MELUS* 5, no. 4 (1978): 99–102.

———. "The Representative Voice: Autobiography and the Ethnic Experience." *MELUS* 9, no. 2 (1982): 25–46.

———. *The Ethnic I: A Sourcebook for Ethnic American Autobiography* (New York: Greenwood Press, 1988).

Kaplan, Louis, comp. *A Bibliography of American Autobiographies* (Madison: University of Wisconsin Press, 1962).

Kirschenbaum, Blossom S. "For Diane di Prima, the Beats Go On." *Fra Noi* (March 1987): 37+.

Krause, Corrine Azen. *Grandmothers, Mothers, and Daughters: Oral Histories of Three Generations of Ethnic American Women* (Boston: Twayne, 1991).

Maglione, Connie A., and Carmen Fiore. *Voices of the Daughters* (Princeton, N.J.: Townhouse Publishing, 1989).

Malpezzi, Frances, and William Clements. *Italian-American Folklore* (Little Rock: August House, 1992).

Mathias, Elizabeth, and Richard Raspa. *Italian Folktales in America: The Verbal Art of an Immigrant Woman* (Detroit: Wayne State University Press, 1985).

Morreale, Ben. "Jerre Mangione: The Sicilian Sources." *Italian Americana* 7, no. 1. (May 1982): 5–18.

Mulas, Franco. "A *MELUS* Interview: Jerre Mangione." *MELUS* 12, no. 4 (Winter 1985): 73–83.

Parrino, Maria, ed. *Italian American Autobiographies* (Providence, R.I.: Italian Americana Publications, 1993).

Patti, Samuel J. "Autobiography: The Roots of the Italian-American Narrative." *Annali d'Italianistica* 4 (1986): 243–248.

Peragallo, Olga. *Italian-American Authors and Their Contribution to American Literature* (New York: S.F. Vanni, 1949).

Reilly, John M. "Literary Versions of Ethnic History from Upstate New York." In *Upstate Literature: Essays in Memory of Thomas F. O'Donnell*, ed. Frank Bergmann (Syracuse, N.Y.: Syracuse University Press, 1985): 183–200.

Salamone, Frank. "An Interview with Jerre Mangione." *Voices in Italian Americana* 4, no. 2 (Fall 1993): 19–29.

Salusinsky, Imre. "Frank Lentricchia." In *Criticism and Society* (New York: Methuen, 1987): 177–206.

Sollors, Werner. *Beyond Ethnicity: Consent and Descent in American Culture* (New York: Oxford University Press, 1986).

Talese, Gay. *The Kingdom and the Power* (New York: World, 1969).

———. *Honor Thy Father* (New York: World, 1971).

———. *Thy Neighbor's Wife* (Garden City, N.Y.: Doubleday, 1980).

Tamburri, Anthony Julian, Paul Giordano, and Fred L. Gardaphe, eds. *From the Margin: Writings in Italian Americana* (West Lafayette, Ind.: Purdue University Press, 1990).

Viscusi, Robert. "Circles of the Cyclopes: Schemes of Recognition in Italian American Discourse." *Italian Americans: New Perspectives in Italian Immigration and Ethnicity*, ed. Lydio F. Tomasi (New York: Center for Migration Studies, 1985): 209–219.

Weisberger, Bernard. "Jerre Mangione: The Man and His Work." *VIA: Voices in Italian Americana* 4, no. 2 (Fall 1993): 5–17.

Canon: Italian American Autobiographers (Selected Works)

—Compiled by Fred L. Gardaphe

Arrighi, Antonio A. *The Story of Antonio, the Galley Slave* (New York: F.H. Revell, 1911).

Barolini, Helen. "The Finer Things in Life." *Arizona Quarterly* 29, no. 1 (1973): 26–36.

——— "A Circular Journey." *Texas Quarterly* 21, no. 2 (1978): 109–126.

———. *Umbertina* (New York: Seaview, 1979).

———, ed. *The Dream Book: An Anthology of Writings by Italian American Women* (New York: Schocken Books, 1985).

———. "Becoming a Literary Person Out of Context." *Massachusetts Review* 27, no. 2 (1986): 262–274.

———. *Festa: Recipes and Recollections* (New York: Harcourt, 1988).

Corsi, Edoardo. *In the Shadow of Liberty* (New York: Macmillan, 1935).

Covello, Leonard, and Guido D'Agostino. *The Heart Is the Teacher* (New York: McGraw-Hill, 1958).

Cuomo, Mario M. *Diaries of Mario M. Cuomo* (New York: Random House, 1984).

D'Angelo, Pascal. *Son of Italy* (New York: Macmillan, 1924).

di Prima, Diane. *Memoirs of a Beatnik* (1969; reprint, San Francisco: Last Gasp Press, 1988).

———. "Chapter One" of *Recollections of My Life As a Woman. VIA: Voices in Italian Americana* 1, no. 2 (Fall 1990): 33–47.

———. "Behind the Smile." *Mother Jones* 17, no. 2 (March–April 1992): 60–62.

Ets, Marie Hall. *Rosa: The Life of an Italian Immigrant* (Minneapolis: University of Minnesota Press, 1970).

Lentricchia, Frank. *The Edge of Night* (New York: Random House, 1994).

Mangione, Jerre. *Mount Allegro: A Member of Italian American Life* (1943; reprint, New York: Harper and Row, 1989) (page citations are to reprint edition).

———. *Reunion in Sicily* (New York: Houghton, 1950; 2d ed., with Introduction by Deidre Bair, Columbia University Press, 1984) (page citations are to reprint edition).

———. *A Passion for Sicilians: The World around Danilo Dolci* (New York: Morrow, 1968; 2d ed., with Introduction by Alfred McClung Lee, published as *The World around Danilo Dolci*, Harper, 1972; 3d ed., with new concluding chapter by the author, published under original title, Transaction Books, 1985) (page citations are to 1985 edition).

———. *America Is Also Italian.* (New York: Putnam, 1969).

———. *The Dream and the Deal: The Federal Writers' Project, 1935–1943* (Boston: Little, Brown, 1972; 2d ed., Avon, 1974; 3d ed., University of Pennsylvania Press, 1983).

———. *Mussolini's March on Rome* (New York: Franklin Watts, 1975).

———. *An Ethnic at Large: A Memoir of the Thirties and Forties.* (New York: Putnam, 1978; 2d ed., with an Introduction by Bernard Weisberger, University of Pennsylvania Press, 1983) (page citations are to reprint edition).

———. *La Storia: Five Centuries of the Italian American Experience* (with Ben Morreale) (New York: HarperCollins, 1992).

Marzani, Carl. *The Education of a Reluctant Radical.* Book 1, *Roman Childhood* (New York: Topical Books, 1992).

———. *The Education of a Reluctant Radical.* Book 2, *Growing Up American* (New York: Topical Books, 1993).

———. *The Education of a Reluctant Radical.* Book 3, *Spain, Munich, and Dying Empires* (New York: Topical Books, 1994).

Mazzuchelli, Samuel. *The Memories of Father Samuel Mazzuchelli, O.P.* (Chicago: Priory Press, 1967).

Napoli, Joseph. *A Dying Cadence: Memories of a Sicilian Childhood* (West Bethesda, Md.: Marna Press, 1986).

Panella, Vincent. *The Other Side: Growing Up Italian in America* (Garden City, N.Y.: Doubleday, 1979).

Panunzio, Constantine. *The Soul of an Immigrant* (New York: Macmillan, 1921).

Pellegrini, Angelo. *Americans by Choice* (New York: Macmillan, 1956).

Scammaca, Nat. *Due Mondi.* (Trapani, Italy: Editrice Antigruppo Siciliano; New York: Cross-Cultural Communications, 1979).

———. *Bye Bye America: Memories of a Sicilian American* (New York: Cross-Cultural Communications, 1986).

———. *Sikano L'Amerikano! Italian Stories* (Trapani, Italy: Editrice Antigruppo Siciliano; New York: Cross-Cultural Communications, 1989).

Segale, Sister Blandina. *At the End of the Santa Fe Trail* (1912; reprint, Milwaukee: Bruce Publishers, 1948).

Talese, Gay. *Unto the Sons* (New York: Alfred A. Knopf, 1992).

Ventresca, Francesco. *Personal Reminiscences of a Naturalized American* (New York: Daniel Ryerson, 1937).

The Italian American Coming-of-Age Novel

Mary Jo Bona

Toward the conclusion of Tina De Rosa's novel *Paper Fish* (1980), the paternal grandmother, Grandma Doria, requests that her granddaughter, Carmolina, dress in a bride's gown, though she is not, strictly speaking, getting married. Because the grandmother is dying and will never live to see her granddaughter marry, the ceremony takes place with all of the accoutrements of a wedding, *sans* groom. Carmolina dons a specially made wedding dress and a string of baby pearls and watches her ailing grandmother being lifted in a chair in front of a procession of family attendants and observers from the neighborhood. When Grandma Doria is placed in front of Carmolina, the symbolic ritual begins, for it is during this scene that the grandmother gives her granddaughter a future legacy: an identity distinct to herself, not completely divorced from her family antecedents, but nonetheless separate from her ill sister and from her dying grandmother. De Rosa demonstrates the development of Carmolina's identity, or coming of age by using a metaphor of the mirror in which Carmolina sees for the first time her own face in the glass, autonomous now but never utterly free from the impediments of her bittersweet past. At first sight, De Rosa's *Paper Fish* little resembles the traditional definition of the coming-of-age novel, or, more technically termed, the *Bildungsroman* (novel of formation or development). The generic definition of the *Bildungsroman* and *Erziehungsroman* (novel of education) originates in eighteenth-century Germany and refers to a genre derived from the quintessential German novel of formation, Goethe's *Wilhelm Meister's Apprenticeship.* Goethe's male protagonist develops and realizes the intellectual, physical, moral, and spiritual capacities within himself (Abel, Hirsch, and Langland 1983, 5). The subject of this novel and others like it is the development of the protagonist's mind and char-

Boldface terms are defined in the Cultural Lexicon, which starts on p. 703.

acter as he moves from childhood through various difficulties (often spiritual in nature) to adulthood and the recognition of his identity and role in the world (Abrams, 1988). Central to his complete maturation is the hero's acceptance of his role in a social context, which aids him on his journey from youth and ignorance to wisdom and experience.

The traditional *Bildungsroman* thus features a male protagonist, who often moves from the country to the city, encountering people and problems that will eventually lead to his maturation. Specific generic features of the *Bildungsroman* typically include the following, each of which is important in discussing the Italian American version of the developmental novel: belief in a coherent self; faith in the possibility of development; insistence on a time span in which development occurs; emphasis on a social context, however adverse; and focus on the protagonist's integration into the community (Abel, Hirsch, and Langland 1983, 14; Fuderer 1990, 4). Critics of the genre have been quick to point out that even the most generous definitions of the *Bildungsroman* prohibit women from being central because, as Elizabeth Abel notes, "their social options are so narrow that they preclude explorations of [their] milieu" (Abel, Hirsch, and Langland 1983, 7). The same might be said for Italian American novels that choose ethnicity as their topic. After the transatlantic crossing, immigrant groups often settled in urban neighborhoods and stayed there. Consequently, these novels focus not solely on a particular individual coming of age, but rather on the complications involved in the family itself as it develops an Italian American identity.

The contemporary feminist movement has been instrumental in identifying what Susan Fraiman calls a "renovated paradigm"—that is, a revised genre featuring the development of a female protagonist (Fraiman 1993, 137). The ways in which novelists have revised the traditional genre to meet the needs of marginalized people in America attests to the resiliency of the genre itself and the necessity of allowing a genre, as critic Carol Lazzaro Weis puts it, "to expand and/or challenge its formal and thematic limits" (Weis 1990, 17). Novels of female development expand the formal and thematic limits of the genre in such a way that they provide an important gloss on what I term the ethnic *Bildungsroman*, specifically those texts written by Italian American novelists since the late 1930s. Understanding the ways in which gender influences literary representations of women's development offers a reading of another equally restricted group—those "hyphenated" persons of diverse racial or ethnic background. Critics often observe that women have experienced prohibitions to developing individually and have found the society inimical to their desire to join it. As Laura Sue Fuderer points out, "obstacles are greatly compounded when [the] protagonist faces ra-

cial prejudice in addition to restrictive gender roles" (Fuderer 1990, 4).

Understanding some of the typical thematic features of the female *Bildungsroman* thus offers another lens by which to view the Italian American coming-of-age novel. Like all *Bildungsromane,* Italian American novels share features of the traditional genre while at the same time evincing a reinterpretation and a revisioning of its major themes. It is no wonder that disenfranchised people—women, people of color, ethnic Americans—would produce a new *Bildungsroman,* for they come to the genre with different values about family, about individuality and about autonomy.

With regard to theme, the woman's developmental novel problematizes the fundamental emphasis of the traditional *Bildungsroman* on the individual's relationship to society. As Elizabeth Abel suggests, critics have formerly assumed that society constrains men and women equally (Abel, Hirsch, and Langland 1983, 6). What literary representations of women and ethnics have shown to the contrary, is that society often proscribes and thwarts individual development for marginalized people, thus making their growth into adulthood impossible and/or filled with untenable pain. Because their social options are often limited, both male and female characters from the Italian American literary tradition struggle to achieve an identity amenable both to their cultural traditions and to the American society at large. One can immediately cite the following texts as illustrating the tension between Old World and New World values: Pietro di Donato's *Christ in Concrete* (1939); John Fante's *Wait Until Spring, Bandini* (1938) and "The Odyssey of a Wop" (1940); Mari Tomasi's *Like Lesser Gods* (1949); Josephine Gattuso Hendin's *The Right Thing to Do* (1988); and Anna Monardo's *The Courtyard of Dreams* (1993).

In Octavia Waldo's (Capuzzi Locke) 1961 novel, *A Cup of the Sun* the female protagonist struggles heroically to voice her aspirations and to achieve a level of autonomy unknown to her mother. The pain that she feels has to do with her confusing and sometimes debilitating relationship to her family and most intensively to her older brother. Though the novel hints at a double *Bildungsroman* for brother and sister, it makes it clear that the brother, Andrea, fails to develop because of the Old World proscriptions of an inflexible father *and* the pressures to conform to the image of an American male during World War II. The failure to develop chronicled in such novels as Waldo's reveals an incapacity on the character's part to resolve the conflict he feels about his Italian American ethnicity as it intersects with American ways. Andrea's sister, Niobe, achieves a level of freedom without succumbing to madness, like her brother. Waldo's text makes it amply evident that complete withdrawal to the inner life (a pattern of behavior often seen in women's novels of development) stops growth and prohibits healthy

development. For the sister to develop a coherent self (the primary assumption undergirding the genre), she must accept the duality of her identity as an Italian American. However much her familial culture or the American milieu tries to impose a restrictive definition on who she is as a woman from a small Italian American community, she will go into the world formulating her own self-definitions, both nurtured and complicated by her culture of heritage.

Central to the traditional *Bildungsroman* plot is the protagonist's eventual entrance into society after an extended confinement to the inner life. While this may work well for male protagonists, as it does in Diana Cavallo's developmental novel, *A Bridge of Leaves* (1961), such inner concentration often leads to illness and eventually to death for female characters. Charlotte Perkins Gilman's by-now famous madness narrative "The Yellow Wallpaper" (*New England Magazine*, January 1892), a story of failed development, excruciatingly details the effects of enforced isolation upon the female protagonist. Critic Annis Pratt suggests that such a process stems from the most conservative branch of the female *Bildungsroman*, in which the genre "pursues the opposite of its generic intent—it provides models for 'growing down' rather than for 'growing up'" (Pratt 1981, 14). Interestingly enough, it is the male protagonist's return to, and embracing of, his culture of heritage that saves him from certain madness in Cavallo's *Bridge of Leaves*. David cannot remain isolated from his past or his future; by invoking and confronting his cultural past, he saves himself from irreversible madness. According to Elizabeth Abel, however enriching isolation may be, it "threatens a loss of public activity; it enforces an isolation that may culminate in death," especially for women (Abel, Hirsch, and Langland 1983, 8).

As the novels of female development, the protagonists of the Italian American coming-of-age novel often replace inner concentration with outer activity in their realization that some form of accommodation to the dominant society is necessary for survival. The characters in Mario Puzo's *The Fortunate Pilgrim* (1964) and Helen Barolini's *Umbertina* (1979) actively strive to assimilate American ways even though they know that the terrain they are stepping upon is a "sadder wilderness, where the language was strange, where their children became members of a different race. It was a price that must be paid" (Puzo 1964, 12).

Aware of the fact that there is something always lost in the process of accommodating another value system, Italian American *Bildungsromane* do not slavishly adhere to American ways, even when those ways have been privileged and rewarded. For example, like female novels of development, the Italian American coming-of-age text unwaveringly values the family home and its concomitant emphasis on relatedness and communality over and above the traditionally Anglo and Anglo-American markers of maturity: separation and autonomy. Earlier critics

of George Eliot's *Mill on the Floss,* for example, interpreted Maggie Tulliver's strong affinity to the family home as a developmental failure, ascribing Maggie's tragedy to "heredity weakness" rather than to the destructive effects of being a girl in such a circumscribed society (Abel, Hirsch, and Langland 1983, 9). Critic Susan Fraiman suggests that readers of Eliot's novel shift their focus to a "recuperated 'female' register," one that values "inner over outer growth, return to origins over separation from family" (Fraiman 1993, 137).

Italian American novels of development similarly require a shift to what may be called an "ethnic" register. In novels such as Marion Benasutti's *No Steady Job For Papa* (1966) and Rachel Guido deVries' *Tender Warriors* (1986), traditional features of the *Bildungsroman* (belief in a coherent self, the necessity of undergoing some process of alienation in order to achieve self-consciousness) are immediately called into question by the novels' redefinition of what it means to become an adult in the United States. While an emphasis on mobility and individualism is apparent in all novels of formation, for Italian American texts such movement takes place typically within the community and is aided by the social ministrations of ethnic mentor figures, godparents, or **compare/comare** (godfather, godmother, sponsor, or companion). Both Tomasi's *Like Lesser Gods* and di Donato's *Christ in Concrete,* for example, emphasize the importance of godparent figures who mentor young protagonists and help them make the right choices about their status as Americans of Italian descent. Often the godparent figure serves to mediate two cultures for the frightened and confused inheritors of Italian and American value systems. Separation from the family is often equated in the Italian American mindset with spiritual death and is *not* typically subscribed to in these novels. Hendin's *Bildungsroman, The Right Thing To Do,* depicts a female protagonist who comes to realize that physically leaving the parental home will not necessarily aid in her development. She must return in order to restore a sense of coherency to her Italian American identity. Returning home is met with the stamp of approval; it is not perceived as a failure of adulthood, but rather is interpreted as an example of mature willingness to confront the difficulty of family.

Home life for Italian American protagonists is not always succoring and is never without its impingements and losses. What the protagonist in the Italian American coming-of-age novel does, however, is revalue the primacy of family and community, aware of the fact that to be without origins, without a sense of place, is to live a life without identity. In *Paper Fish,* Carmolina's brief separation from her family (she runs away and cannot be found for days) reveals all the more poignantly the ineluctable bonds connecting her to her family, especially to her mentor, her grandmother. Her return is as irresistible as her ethnicity, guiding

her into an adulthood that will make her life difficult but rewarding. For many Italian American writers, casting off ethnic values and denying the influence of origins causes permanent emotional damage that cannot be remedied with American medicine. Thus the Italian American version of the *Bildungsroman* expands traditional limits in several ways: by often focusing on the family unit itself as it comes of age in America; by accepting that an individual protagonist may never fully achieve a coherent self because of the dual and conflicting legacies of two contradictory cultures; by examining the crucial influence of Italian American mentors, who help ease the protagonist's transition into adulthood; by maintaining the supremacy of relatedness and communality over separation and autonomy as equally prosperous roads to maturity, however differently, if not narrowly, perceived by those outside the culture; and, finally, by recognizing that a woman's participation in this generic enterprise is more complicated by the family's imposition of restrictions on her behavior because of her gender.

The category of ethnicity modifies literary representations of development in the Italian American tradition. Achieving a healthy adulthood is always fraught with impediments and complications. Italian American novels offer another version of the *Bildungsroman,* one that typically takes the family as its focus, thus compelling a reconsideration of what it means to attain the freedom of mobility and the coherency of individuality in America. Michael Palma's poem "Coming of Age" describes the speaker's entrance into adulthood as a process of recognizing both of these imperatives (mobility and individuality) through the lens of his Italianness: "Old men in dirty caps and cotton shirts / Were all around me, inside me, when I was twenty." Even though the speaker has entered the business world and has been educated, his Italian forebears remind him of who he is: "They dressed up and sang at weddings, they pinched my cheeks. / Alone in the parking lot in a new suit of clothes / I grunted spontaneously in time with the band" (*VIA,* 4, no. 1 [1993], 179). Coming of age for Italian Americans often means achieving a coherency in adulthood as a result of embracing the responsibilities, complications, and joys of the parental home.

Further Reading

BIBLIOGRAPHIC RESOURCES

Abel, Elizabeth, Marianne Hirsch, and Elizabeth Langland. "Introduction." In *The Voyage In: Fictions of Female Development* (Hanover, N.H.: University Press of New England, 1983): 3–19.

Abrams, M.H. *A Glossary of Literary Terms,* 5th ed. (New York: Holt, Rinehart, and Winston, 1988): 119–120.

Buckley, Jerome. *Seasons of Youth: The Bildungsroman from Dickens to Golding* (Cambridge: Harvard University Press, 1974).

Fraiman, Susan. "*The Mill on the Floss,* the Critics, and the *Bildungsroman.*" *PMLA* 108, no. 1, (January 1993): 136–150.

Fuderer, Laura Sue. *The Female Bildungsroman in English: An Annotated Bibliography of Criticism* (New York: Modern Language Association of America, 1990).

Moretti, Franco. *The Way of the World: The Bildungsroman in European Culture* (London: Verso, 1987).

Pratt, Annis. *Archetypal Patterns in Women's Fiction* (Bloomington: Indiana University Press, 1981).

Puzo, Mario. *The Fortunate Pilgrim* (New York: Atheneum, 1964).

Sammons, Jeffrey L. "The Mystery of the Missing *Bildungsroman;* or, What Happened to Wilhelm Meister's Legacy?" *Genre* 14 (1981): 229–246.

Swales, Martin. *The German Bildungsroman from Wieland to Hesse* (Princeton, N.J.: Princeton University Press, 1978).

Weis, Carol Lazzaro. "The Female *Bildungsroman:* Calling It into Question." *NWSA Journal* 2, no. 1 (Winter 1990): 16–31.

Canon: Italian American Coming-Of-Age Novelists (Selected Works)

—Compiled by Mary Jo Bona

Ardizzone, Tony. *Heart of the Order* (New York: Henry Holt, 1986).

Barolini, Helen. *Umbertina* (New York: Seaview, 1979).

Benasutti, Marion. *No Steady Job for Papa* (New York: Vanguard, 1966).

Bryant, Dorothy Calvetti. *Ella Price's Journal* (Philadelphia: Lippincott, 1972).

———. *Miss Giardino* (Berkeley, Calif.: Ata Books, 1978).

Cavallo, Diana. *A Bridge of Leaves* (New York: Atheneum, 1961).

De Rosa, Tina. *Paper Fish* (Chicago: Wine Press, 1980).

deVries, Rachel Guido. *Tender Warriors* (Ithaca, N.Y.: Firebrand, 1986).

di Donato, Pietro. *Christ in Concrete* (Indianapolis: Bobbs-Merrill, 1939).

Fante, John. *Wait Until Spring, Bandini* (1938; reprint Santa Barbara, Calif.: Black Sparrow, 1983).

———. "Odyssey of a Wop." In *Dago Red* (New York: Viking, 1940).

Giardina, Anthony. *A Boy's Pretensions* (New York: Simon and Schuster, 1988).

Hendin, Josephine Gattuso. *The Right Thing to Do* (Boston: David Godine, 1988).

Marrotta, Kenny. *A Piece of Earth* (New York: William Morrow, 1985).

Maso, Carole. *Ghost Dance* (San Francisco: North Point Press, 1986).

Monardo, Anna. *Courtyard of Dreams* (New York: Doubleday, 1993).

Parini, Jay. *The Patch Boys* (New York: Henry Holt, 1986).

Tomasi, Mari. *Like Lesser Gods* (Milwaukee: Bruce, 1949).

Waldo, Octavia (Capuzzi Locke). *A Cup of the Sun* (New York: Harcourt, Brace, and World, 1961).

Part IV

Italian American Presence in the Arts

Catholic Ethnicity and Modern American Arts

Thomas J. Ferraro

Mary Gordon, a luminous novelist and essayist, nonetheless exemplifies what is taken for granted about the impact of Catholics and their faith on U.S. literature and art. In *Good Boys and Dead Girls and Other Essays* (1991), she laments that Catholics in the United States—"and even ex-Catholics"—have been "scandalously underrepresented" in the creative arena, literature especially: "There has been such a silence, such an absence of the Catholic voice, in America." What she is speaking of is overtly religious fiction—doctrinally interested and institutionally focused—in the mid-twentieth-century European tradition of François Mauriac, George Bernanos, and Graham Greene. Her honor roll of American Catholic creative writers is therefore very short: Flannery O'Connor, J.F. Powers, possibly Maureen Howard or Elizabeth Cullinan, possibly David Plante or Walker Percy, and herself, all of whom are northern European (mostly Irish) in origin.

Although the number of officially recognized Catholic writers and artists is tiny, a latent Catholic sensibility is deeply implicated in the American imagination. Much of what we have taken to be mainstream is at the same time significantly or even profoundly Catholic; in the received accounts, the Catholicity of this art has, with certain minor and unassimilated exceptions, been "left out." In the United States as well as across its borderlands, writers and artists have worked off of Catholic culture (occasionally consciously, more often not), observed that culture in action (its dissolution in some cases, its dissemination more often), and struggled to make it or break it through the symbolic action of writing itself. This deep interplay between the twentieth-century American imagination and the cultural logic of Roman Catholicism presents a significant opportunity for revisionist interpretation and scholarship that will move us beyond impasses now

Boldface terms are defined in the Cultural Lexicon, which starts on p. 703.

persisting between consensus-era American studies and beyond-national-boundaries multiculturalism while greatly profiting from both.

The postwar politesse of identifying "religion in literature" with self-consciously doctrinal themes is coming to an end. I want to challenge not so much classically trained "religion in literature" scholars, whose work has been strong but also tightly circumscribed, as those in the New Historicism and cultural-studies movements, whose insights into the oppressions of gender, race, and class have been won by ignoring the politically disquieting matter of religious affiliations and origins.

An important step in reconstructing literary and artistic history is to deemphasize orthodox (that is to say, catechistic) expectations of what is Catholic in American arts and letters—the search for explicit and explicitly sympathetic discursions on the Church, on questions of theology and humankind, on living the saintly life today—in favor of what for lack of a better term we might call "cultural practices": identifying, then investigating, less-official versions of Catholic self-understanding than piety and Thomism, less-self-conscious forms of Catholic creativity than inspirational verse or doctrinal narrative. It involves identifying and investigating writerly intuitions that originate in Catholic childhoods, that contrast sharply with the dictates of American Protestantism-turned-Emersonian individualism, and that persist however unrecognized and uninvited into literary maturity. And it may well mean crediting and assessing the investments of non-Catholics in Catholic ways of being and knowing, in contradistinction to the long-standing exclusionist course of preemptively dismissing non-Catholic representations of Catholicism as prejudicial, sensationalistic, or worse.

What are these U.S. Catholic cultures, the ways in which U.S. Catholics have moved and had their being? I am thinking, in part, of the belief that transubstantiation and the resurrection redeem rather than abnegate the flesh; of the deep taste for ritual and icon coupled to a knowing conviction that the Bible is subversive business; and of the immersion in incantatory prayer rhythms in which it is the diverse materiality of sound that communicates rather than the significations of writing. I refer as well to the dependence on figures of mediation (the priest, the Virgin, the saints) and structures of mediation (the institutional Church, secular authorities, patronage networks), even when all too human. I refer to the model of intercourse between human destiny and personal culpability and to the orchestration of public and private that obtain in the doctrine of original sin, in the regimens of the sacraments, and in the assurance of common prayer. And I refer to the sanctification of the father-dominated, mother-centered, procreation-obsessed extended family; to the concomitant establishment of monkish and cloistered

single-sex communities, officially celibate, of the especially devout and especially service-minded; and to the incongruities of power and eros within the theater of worship, the Mass (wherein an inviolate feminized male is attended to by boy-apprentices and a disciplined coven of women). More generally, there remains the antirelativist, antihistoricist, antisocial-constructionist conviction that human beings are everywhere and at all times pretty much alike and that things neither progress nor decline as radically as philosophers (both elite and popular) would have us believe.

This litany is a partial accounting only, necessarily tentative and provisional. It is a heuristic guide to be qualified and amplified by research and close textual analysis. Its justification lies as much in historical accuracy as in religious partisanship, as much in broadening perspective as in ethnic self-promotion: the expectation that a great deal of what has been taken as major American aesthetic practice will be reseen for its residually or incipiently Catholic meanings. At the same time, when the pull of Mediterranean Catholicism is finally recognized as constitutive of rather than ancillary to national mythologies, Italian American arts and letters will be largely reconceived not as a minor, but as a major participant in the arena of cultural history.

Within religious and medieval studies, "Mediterranean Catholicism" refers to the semipagan emphases within Catholicism (putative survivals and resurgences of Greco-Roman and other fertility cults) that distinguish Catholicism in part from its Judaic ancestry and in whole from its Protestant correctives: image and icon superseding language as the vessel of mystery (a celebration of visual rather than verbal materiality), Mary the Virgin-as-Mother commanding the miracle-making communion of saints and thus jeopardizing the all-male Trinity, and the body of Christ cannibalized as an intimate, cathartic, and mystical incorporation of the incommensurable. Christ of the bleeding heart, the *Pietà* of the madonna, and the martyrdom of St. Sebastian: a triptych of icons constituting a supplementary, at times alternative, Mediterranean Catholic Trinity.

I wish also to extend the term "Mediterranean Catholicism" beyond well-established meanings, in order to invoke both the Latin presumption that sacred institutions can be terribly imperfect and the Latin penchant for sanctifying institutions that modernity construes as nonreligious. On the one hand, pious peasants from Italy to Mexico regard the Vatican and its representatives, often down to the level of the parish priest, with a certain distrust, an attitude reductively labeled "anticlericalism." Conversely, I think there is a little-recognized peasant Catholic aptitude for reproducing the Church's social gestalt in putatively secular spheres—a *genius* for organizing the home and one's livelihood, if not the state,

on the model of the Church's chains of command and divisions of responsibility, its forms of motivation and its rechanneling of resistance. I do not mean to underestimate either the pagan dimensions of Catholicism as practiced in northern Europe and its diaspora or the movements toward Protestantism as enacted after Vatican II in Latin cultures: My use of the term aspires to be nonsectarian, for Mediterranean Catholic is not Catholic without that will to all-inclusiveness, that dream of catholicity with the lowercase "c."

The Mediterranean tag indicates that my interest has roots in ethnic spirituality, and it does; to a certain extent, what I am proposing is ethnocentric recovery work along the lines of Robert Orsi's *The Madonna of 115th Street: Faith and Community in Italian Harlem, 1880–1950* (1985) and my own interest reflects the appeal of Catholic offspring for a Church dimly remembered from youth. But I do not intend to be as sectarian (or softly pluralistic, or nostalgic) as that. It is my working hypothesis that the semipagan Marianism of the Mediterranean represents the popular core of traditional Catholicism because it incarnates its religio-aesthetic genius. In its aesthetics, or rather in its aesthetic embodiment of the metaphysical and the ethical and even the sociophilosophical, Catholicism since the Reformation has continued to capture the imaginations of many more than its own nominal offspring. Given its reflection of the popular will, Mediterranean devotionalism will not go away, even when the Vatican outlaws or discourages it, but will continue to reemerge: in Catholicism proper, in alternative nominally Protestant worship, and in provinces heretofore deemed intrinsically profane— in spheres, that is, where we hardly expect it.

There are three roughly distinguishable coteries of writers in the canon of modern American literature whose work cries out for revisionist attention: first, that of high modernism in the technical sense, written by Anglo-Celtic Catholics who identified themselves as such and who advocated the aesthetic deployment of overtly pious practices; second, that of the mainstream novel of upward mobility and self-making, scripted by lapsed Catholics whose restoration of the problematics of transformative passion belied the surface Emersonianism of American-Dream discourse; and third, by non-Catholic fellow travelers, who relied upon Catholicism both to deconstruct the "Puritanism equals America" equation of official U.S. history and to countervail against the isolation, evacuated materialism, and therapy culture of the post-Calvinist suburbs.

We have long understood that the rise of the institutional study of English (from Matthew Arnold forward) substitutes for religious morality in the modern secular age, and we have long recognized that there are Christian energies at work in "high modernism," the experimental literature of alienation from mo-

dernity. But what Christian energies exactly? Consider the three high modernists whose formal and thematic innovations changed the shape of fiction, poetry, and drama in the English-speaking world, particularly in North America. I mean James Joyce, T.S. Eliot, and Eugene O'Neill, who are, respectively, Irish Catholic, Anglo-Catholic by expatriation and conversion, and Irish American Catholic.

The close relation between symbolist mythic method and the aesthetics of Roman Catholic ritual prompts us to think beyond Joyce and reconsider, for instance, leading Catholic theoreticians of the New Criticism, such as Allen Tate and W.K. Wimsatt. The modernist lyric and the prose epiphany derived from it function as forms of what Thomas Merton called "contemplative prayer," prompting reexamination not only of Eliot and Merton, but also of Robert Lowell, Frank O'Hara, Robert Duncan, Gilbert Sorrentino, and other Catholic contributors to the second wave of poetic high modernism. Finally, the Catholic construction of the Oedipal family drama differs from the account assumed to be modernity's definitive, that of Sigmund Freud, an Austrian Jew, prompting us to trace the problem of "insufficient influence" from O'Neill to subsequent immigrant writers, many of whom (like O'Neill's devotee Henry Roth) were not Catholics.

In *Love and Death in the American Novel* (1960), Leslie A. Fiedler argued that the premier post-Reformation vehicle of the Western imagination—the European novel of adultery—was made untenable in the United States because its Puritan brand of Protestantism was so successful in vanquishing the Virgin, thereby purging Christianity of its gynocentric compromise with pagan antiquity: In the wildly popular sentimental novels of the nineteenth century, composed by women (Susan Rowson, Susan Warner, Harriet Beecher Stowe, among others), the middle-class Protestant home was purified of eros, whereas in the self-consciously serious fiction written by men (James Fenimore Cooper, Herman Melville, Mark Twain, and the like), rugged masculine "individualists" took to rafts, whaling vessels, and the frontier with other men in overtly antidomestic and implicitly homoerotic flight. Fiedler's version of the religious-literary matrix, which he adapted from Denis de Rougement's *Love in the Western World* (1940), is overdue for theoretical recuperation, but his historiography holds only to a point. By the end of the nineteenth century, for instance, American literary culture did in fact reclaim the adultery novel from its repressed European past—just at the moment, of course, that its writers were personally invested in, and not just curious about, Marian Catholicism.

There were two crucial stages. The 1890s witnessed Harold Frederic's *The Damnation of Theron Ware* (1896) and Kate Chopin's *The Awakening* (1899), then ushered in the new century with Theodore Dreiser's *Sister Carrie* (1900). Frederic's

Theron Ware is a conflicted but dramatically legible Catholicization of Nathaniel Hawthorne's *The Scarlet Letter* (the obvious nineteenth-century exception to Fiedler's thesis, which upon closer examination actually reaffirms it); an astounding novel of Catholic ideation and social forecast, *Theron Ware* features, among other things: a convent-trained Irish aesthete whose collection of madonna-and-child prototypes epitomizes what she herself calls Catholic "paganism" (Celia Madden is the first coming of Camille Paglia); a priest-aristocrat (Celia's bisexual confessor and possible intimate) who warns that the twentieth century in America will be, increasingly, a Roman Catholic century; and a prostitute–con women turned debt-raiser for the Methodist Church whose climactic salvaging of the novel's title character insinuates a Marian basis to new-style Protestant pragmatism. In *The Awakening*, the breakthrough novel of first-wave feminism, Chopin adopts a Presbyterian protagonist in order to dramatize adulterous rebellion from bourgeois motherhood, but does so against the backdrop of drenchingly Catholic New Orleans and with a vocabulary of redemptive corporeality and spiritual quest derived from her own, putatively rejected, Creole Catholic background.

The American adultery narrative had arrived. During the early years of the modernist experiment, it was the Anglican Church leanings of Henry James (*The Wings of the Dove* [1920], *The Golden Bowl* [1904]) and Edith Wharton (*The Age of Innocence* [1920]) that helped underwrite an Americanized version of European adulterous manners: an Episcopalianism with southern European temptations yet ultimately Jansenist reservations. It yielded, at the height of the experiment, to the force of Roman Catholicism proper.

In 1925 and 1926, a trinity of Catholically invested narratives were published and almost instantaneously canonized: Each was moderately modernist in form, yet brazenly thirteenth century in certain of its key social themes and underlying religious inflections, which followed in the Catharist heretical tradition of troubadour court poetry. In 1925 F. Scott Fitzgerald took a short story he had tellingly entitled "Absolution"—concerning a midwestern boy and his German American confessor who prod each other into distinguishing between casuistry and sacramentalism—and produced from it *The Great Gatsby*, which the British arbiter-critic Tony Tanner has put forth (in the "Introduction" to the 1990 Penguin paperback) as the most accomplished prose fiction ever written by an American. Keeping in mind that Fitzgerald was trained at Catholic prep school and aspired then to becoming a priest, we are able to account for the disparate Catholic energies of *The Great Gatsby:* the testimony to the human spirit Fitzgerald generates by making Gatsby a Christologic hero, the resignation he expresses concerning the ultimate efficacy of his characters' related challenges to their gender–class

inscriptions, and the foregrounding of passional incarnation he achieves by dramatizing Gatsby's incommensurable love for Daisy.

I take it as a measure of the presumed innocuousness of Catholic encodings that "cultural reproduction" and "intergroup conflict" can be discussed these days not only in Fitzgerald but in the two other significant adultery novels of the mid-1920s—Willa Cather's *The Professor's House* (1925) and Ernest Hemingway's *The Sun Also Rises* (1926)—without even mentioning their saturation in Catholic settings, characters, and problematics. Hemingway's Jake Barnes, arguably after Huckleberry Finn the most distinctive and recognizable voice in American literature, is a lax Catholic pondering his lapses; the novel is structured as a pilgrimage from France's secular capital to a religious fiesta in the Spanish Pyrenees; and its central dilemma is the tension between a Marianist devotion to a sexually independent woman and the monkish, arguably homosocial enthusiasms of overdetermined celibacy. So too, *The Professor's House* is composed around the tension between the Judeo-Protestant jeremiad that the title character has devoted his career to writing and the Catholic strategy of iconographic representation that increasingly attracts him, a lapsed Catholic whom Cather names "Professor St. Peter" and who in middle age is taken up in Platonic adoration of his best male student. As Cather teaches us, and not Cather alone, it is the Church's structuring of desire around the iconicity of gender difference that St. Peter—and Jake, and even Fitzgerald's Nick Carraway—come increasingly to internalize and that in the end enables, rather than disallows, the energies of homosexual desire.

It is a well-known fact of social history that consumer culture targeted women as its primary vehicle (from the beginning, advertisers have referred to the generic consumer as "her"). But the profound tacit utility of Catholicism for American novelists struggling to comprehend and evaluate the emergence of female consumerism has gone virtually unnoticed. Fitzgerald, who supported himself by writing short stories for women's magazines, and especially Dreiser, who worked with an ever-changing coterie of women in editing such magazines, revealed the stakes for women in the heterosexual theater of spectacle consumption—a matter not of status per se, but of domestic and public power (what Lily Bart, in her own Old New York way, discovers in the *tableau vivant* scene in Wharton's 1905 *House of Mirth*). At the same time, Dreiser (in *Sister Carrie* but also in that other classic of 1925, *An American Tragedy*) as well as Fitzgerald found cause to celebrate the sensuous materiality of the consumer goods themselves (Carrie's shoes, Gatsby's shirts, Clyde's suits)—embodying the sacramental promise of transubstantiation—in marked contrast to the preemptive disdain characterizing both genteel humanists and Western Marxists.

Whereas writers with Catholic backgrounds mostly shied away from acknowledging their own residually Catholic temperaments or even depicting Catholics as such, the period's most influential Protestant novelists—not only Hemingway and Cather, but also William Faulkner, the one American writer of modernist fiction of truly *global* significance—freely admitted the temptations of Catholicism while representing its adherents explicitly. In Faulkner's *Absalom, Absalom!* (1936), for instance, it is the Catholic humanist decadence of French New Orleans that produces Charles Bon's tragic self-awareness (as at once aristocrat and chattel), knowledge that, in turn, drives Bon to devastate Sutpen's ambition for a plantation dynasty. I wonder then, too, whether it is just his "gothic narrative technique" that has made Faulkner the patron saint of the extraordinary contemporary boom in Latin American fiction, a literature that necessarily wrestles with a colonizing yet immensely attractive, because Mediterranean and Marianist and partly pagan, Catholic heritage?

Despite the superior aesthetics of high modernism, the genre of nineteenth-century realism, which depicted "the other half" and their struggle to succeed, did not fade in the United States and Canada, in large measure because the blue-collar classes have, since the late nineteenth century, become more and more Catholic. It is not a coincidence that social-work treatises of the twenties and thirties, the postwar interrogation into "the culture of poverty," and the new social history of the seventies and eighties all focused heavily on Catholic emigrant populations—from Ireland, Poland, Quebec, Mexico, Puerto Rico, and, especially, from southern Italy. During the same fifty years, major contributions to late realism, naturalism, and local color were the dozens of autobiographical works by emigrants from Catholic countries and their offspring: from María Cristina Mena, John Fante, and Carlos Bulosan to James T. Farrell, Jerre Mangione, Edward Rivera, and Mary Gordon. One of the still undervalued subgenres of American literature is the representation, in whatever mode, of immigration, cultural persistence and mobility, and ethnic interaction.

How have Catholics fared, as Catholics, in America? Via fiction, immigrants and their descendants have responded, not always in dissent, to the long-standing charge of sociologists that the Catholic poor are poor *because* they are Catholic: because they are fatalistic, obsessively familial, deaf to the virtues of the Protestant work ethic, anti-intellectual by nature, and, above all, because they are female-dominated, mother-centered, or unrelentingly reproductive. To read Jim Tully's *Shanty Irish* (1928), Mary Doyle Curran's *The Parish and the Hill* (1949), and David Plante's *The Family* (1978) alongside Garibaldi Marto Lapolla's *The Grand Gennaro* (1935), Piri Thomas' *Down These Mean Streets* (1964), and Ernesto Galarza's

Barrio Boy (1971) is to be struck by certain convergences in immigrant Catholic conditions and immigrant Catholic compensatory strategies.

Acts of anti-institutional populism have been both strenuously imaginative and forcefully feminizing: dedication of cults to Mary (most extravagantly, Mexico's Virgin of Guadalupe, but also Italian East Harlem's Madonna of 115th Street, now attended to by Haitian immigrants); increasing conversion, especially by women of color, to evangelical Protestantism; and renewal of fading folk elements (be they from pre-Christian Europe, Indo-America, the Philippines, or West Africa), many of them gynomythic. The 1992 anthology *Catholic Girls*, edited by Amber Coverdale Sumrall and Patrice Vecchione, with fifty-three contributors ranging from Audre Lorde and Louise Erdrich to Francine Prose and Barbara Hoffmann, gives a fabulous sense of how multicultural the Catholic diaspora actually is and how integrative its feminizing can be. In contrast, the strategy of many of the upwardly mobile, at least traditionally and east of the Mississippi especially, has been to work within mainstream American Catholicism in the name of Catholicism's universalist vision: a reconfiguration that has characteristically conceded much of women's remarkable consecration in Marianist culture but with it, less regrettably, the concomitant burdens of decidedly Old World "superwomen."

Despite the burgeoning work on Hispanic and Afro-Caribbean peoples of color, and despite the inclusion of Bachiller Luis Lazo de Vega's history of the Virgin of Guadalupe in the *D.C. Heath Anthology of American Literature* (1990), there is little Catholically inflected scholarship on postcolonial arts and letters in North America. The working assumption is that the various and markedly strong piety among ordinary folk represents, ipso facto, the ongoing colonization of their hearts and minds, anticlericalism notwithstanding. Whereas historians such as Ramón Gutiérrez and social scientists such as Peter Skerry have begun complicating the terms of inquiry, literary criticism continues to take its main cues from African Americanists committed to Afrocentrism, who have repudiated or sidestepped Christianity as the opiate of the people. Yet many of the strongest texts in the emergent literatures of the Mexican and Canadian borderlands as well as the larger Caribbean Rim identify the persistence of pre-Columbian forms of spirituality in Indo-Hispanic and Afro-Hispanic Catholicism in less antithetical terms: Gloria Anzaldúa's 1987 *Borderlands/La Frontera* and Rudolfo Anaya's 1972 *Bless Me, Ultima* (which attempt, respectively, lesbian-feminist and masculine reproductions of female shamans within Hispanic Catholicism); Judith Ortiz Cofer's 1990 *Silent Dancing*, Edward Rivera's 1982 *Family Installments*, and Sandra Cisneros' 1989 *The House on Mango Street* (childhoods in parochial-school Puerto Rico, Nuevo York,

and Chicano Chicago, respectively); José Antonio Villarreal's 1959 *Pocho* and Richard Rodriguez's 1982 *Hunger of Memory* (autobiographics separated from each other not so much by ideology as by Vatican II, which the latter brilliantly illuminates); as well as Oscar Hijuelos' 1989 *The Mambo Kings Play Songs of Love* and Dany LaFerrière's 1987 *How to Make Love to a Negro* (which together read like a brief for Michael P. Carroll's take on cults of the Virgin). The cosigned anthropological thriller of Louise Erdrich and Michael Dorris, *The Crown of Columbus* (1992), contributed festively to the defeat of the anniversary hoopla, in large part by not forcing its mixed-blood, lapsed-Catholic heroine (whose wonderful, self-knowing voice dominates the novel) to exorcise completely the Christianity within her.

Who put the "magic" in magical realism, their indigenous ancestors or those Mediterranean missionaries?—a query first raised in the mid-1920s by William Carlos Williams in his *In the American Grain* (1925) (which assaults Puritanism as viciously as any text in American literature, on the way to assessing the impact of Columbus, Cortez, de Léon, de Soto, de Champlain, and Père Sebastian Rasles) and by Willa Cather in her masterwork, *Death Comes for the Archbishop* (1927), in which the European Catholic aestheticism of its title character is partially transformed and partially defeated by the mestizo culture and desert landscape of the Southwest. Also from a retrospective viewpoint, it is happily pan-Latin that Italian Americans, actresses and divas especially, were major attractions in the early days of U.S. Hispanic theater, as Nicolás Kanellos has taught us (see *Hispanic-American Almanac*, 1992)—and the converse is surely also true.

Whereas Protestantism and to a large extent Judaism emphasize verbal mystery, Mediterranean Catholic ritual celebrates visual materiality. Mary Gordon has noted how much regular attendance at Mass can contribute to the "training" of an aspiring novelist like herself, yet it is in terms of the tangible and especially visible manifestations of the sacred that Catholic ritual has made its most concerted impact on the American imagination.

I am interested in how deeply populist aspects of Catholicism have resurfaced in the postmodern mass culture, which, after the end of the Cold War, has become America's most successful export: the object, literally, of global desire. What do transubstantiation and the sacrifice of the Mass have to do, in the wake of the changes of the Second Vatican Council, with the consumer arts—advertising, videos, pop music, and spectator sports? Since the 1970s, rock icons such as Van Morrison, The Grateful Dead, the late Richie Valens, U2, Madonna Ciccone, and Mamma Zirilli's boy, Bruce Springsteen (not to mention such newcomers as Gloria Estefan, Los Lobos, and African American rappers P.M. Dawn) have renewed Roman Catholic ritual in secularized forms: its mystery, its catharsis, its

bodily communion. If Catholics have been among the most effective producers of postmodern mass culture, they have also been, perhaps more dramatically still, among its most devastating interrogators: from the markedly religious Catholic Beats (Jack Kerouac, Tom Dooley, Lawrence Ferlinghetti, Diane di Prima, and Richard Fariña (who constituted the final romantic stage of what James T. Fisher calls the "Catholic Counterculture in America"), to the less obviously Catholic postwar novelists (including Mario Puzo, Donald Barthelme, and Don DeLillo), to the auteur film directors whose Catholic conceits range from the overt (Martin Scorsese, Francis Ford Coppola, Michael Curtiz) to the implicit (Frank Capra, John Ford, Robert Altman, Brian DePalma).

"Where Are the Italian-American Novelists?" asked the distinguished literary journalist Gay Talese in a 14 March 1993 essay on the front page of the *New York Times Book Review*. "There is no widely recognized body of work in American literature that deals with [the Italian immigrant experience]." Italian American literature, especially Italian American literature that is not contemporary, remains little known and nearly unstudied—grotesquely so, given the donning of the mantle of social representation in American literary studies. In five of the six major American literary anthologies published in the late 1980s and early 1990s, each of them claiming a multicultural sweep, there is not a single selection by a writer of Italian origin, with the exception, in a couple of the more revisionist anthologies, of Christopher Columbus, who was possibly Jewish by origin and Spanish by trade.

The state of the anthologies is a brutal fact: It reflects in part the past, that Italian Americans did not produce either a professional or an amateur readership supportive of these books when they were first written, or capable since then of keeping them in the public eye, although that failure, as Puzo once explained, is also a blessing, since Italian Americans, unlike Jews, Blacks, Asians, and Chicanos, have never had to pass a board policing ethnic political correctness (a problem that goes back at least to the 1920s). The state of the anthologies reflects the timing of the emergence of Italian American intellectuals, coming of age at last, as readers both inside and outside the academy, only *after* the torch of economic marginality in the United States has been passed on to peoples of color. To reclaim the Italian American literary heritage, we must talk about the religious sensibility of southern Italian peasants—who worshipped Mary and the communion of saints, trusted the image while remaining wary of the word, and embraced the family (what Robert Orsi calls "the domus") as if it were the Church.

The version of Catholicism that Italian Americans have come to represent,

put into play, and contest is the superstition-tinged familial Marianism of the Italian laity, pious even when it is (as it is so often) anticlerical and aesthetic to the bones. Art critic Camille Paglia has coined a useful term, "Italian pagan Catholicism," to distinguish the Gentile populism constituting both the culturally transcendent wellspring of Western art and the culturally specific legacy of Italian Americans. The southern Italians themselves have always been willing, perhaps even too willing, to confess this penchant, these survivals: *"Siamo primo pagani, dopo cristiani"*(We are pagans first, Christians second), which Carlo Levi once underscored by his famous title, *Christ Stopped at Eboli* (1947), meaning that we in the mountains where Christ did not arrive are still pagans. "Much as the Vatican may deplore it," Ann Cornelisen reiterates in *Women of the Shadows* (1976), "in the South, Christ is on the altar, but the people pray to and worship the Virgin Mary."

To engage Catholically interested, Catholically produced art across ethnic lines is to be confronted, full force, with reproduction in the New World of the Old World's inexorable divisions: between the semi-Protestantism of the Jansenist north (where Christ is Vindicator-King, In the Beginning was the Word, and sexuality takes to the underground) and the semiheathenism of the Mediterranean south (where Mary is the Virgin Intercessor, image and icon supersede language, and the body is vessel to the spirit). The fact that the Irish won control of the American Church in the nineteenth century (along with the Germans and, later, the Poles in the Midwest), reversing the European hierarchy, is of determinative significance. Partaking of a less sanctioned American Catholic sensibility have been not only the Italians, but also the East Coast Portuguese, the Southwestern and otherwise diasporic Latinos, Californian Filipinos and Chinese, the Cajuns and Creoles of Louisiana, as well as the Afro- and Indo-Hispanics of the Caribbean. For Catholics with a Mediterranean bent, facing Irish American authority has meant either renewing the anti-institutionalism characteristic of peasant Catholicism outside of northern Europe (by means of national-origin parishes and Pentecostal conversion) or else assimilating to mainstream American Catholicism—itself on the way, after Vatican II especially, to increasingly Protestant form.

One of the better-kept secrets in U.S. literature is the first period of considerable achievements by Italian Americans in fiction. During the late 1930s and early 1940s, the offspring of Italian immigrants—Garibaldi Marto Lapolla, Jerre Mangione, Pietro di Donato, John Fante, Michael De Capite, Jo Pagano, George Panetta, Guido D'Agostino, and, after the war, Mari Tomasi—created a corpus of works that outstripped the production of any other immigrant group up to that time, except (as always) the prodigious Russian Jews, and even the Russian Jews were challenged in terms of quality. These narratives were more or less autobio-

graphical; all of them were focused on entrenched or rising working-class families; and most of them were hugely peasant Catholic.

Three novels, in particular, are highlights of this Italian American *risorgimento* (resurgence): di Donato's *Christ in Concrete* (1939), which Signet Classics brought back into print in 1993; plus De Capite's *Maria* (1943), the obscure of the obscure; and Mari Tomasi's *Like Lesser Gods* (1949), reprinted in 1988 as a regionalist novel by a tiny Vermont press. The titles of these three texts speak for themselves. Each of them explores the creation among the immigrants and their offspring of a distinctively Italian American Catholicism: an everyday piety in which the Passion Play informs the fight for survival and the quest for dignity, in which the elevation of Mary feminizes but also sexualizes the intercessions of the Holy Spirit, and in which the religion of **la famiglia** is transformed from a rationale of insularity (**la miseria** vanquished at last) into a mandate for interethnic empathy and alliance.

The Italian American Catholic writers have not only investigated, but also *enacted,* forms both of resistant preservation and conciliatory change. In Tomasi's *Like Lesser Gods,* for example, Piedmontese immigrants in Vermont are seen to achieve blue-collar security and incorporation into the Yankee community of Granitetown, but only at the cost of Marian bloodletting: Maria of the *Pietà* transformed into a celibate male nursemaid who fancies himself a guardian angel, Christ of the bleeding heart turned into a solid, yet cold and colorless, tombstone of granite. This Catholic self-transformation is performed (at least in part) by Tomasi herself, without the compensatory development of modern feminist consciousness but with an insistence on preserving the dignity of labor, on allaying ethnic tensions, and on instituting companionate child-centered marriage.

The persistence of Marianist Catholicism has been made especially manifest in Italian American and Italian Canadian fiction, by and large male authored, whose near-obsessive subject (unrecognized despite its obviousness) has been the representation of *"mamma mia":* the Blessed Virgin incarnated as the immigrant matriarch, struggling to make it on behalf of her progeny in North America. Four filially scripted, maternally focused autobiographical novels—De Capite's *Maria* (1943) and Puzo's minor masterpiece, *The Fortunate Pilgrim* (1964), as well as F.G. Paci's *Black Madonna* (Ottawa, 1982) and Nino Ricci's *Lives of the Saints* (Ontario, 1990)—are distinguishable from each other on many grounds. But they share a sense that to have to engage Catholicism in general and Italian Catholicism in particular means a certain trajectory of double-minority consciousness—Catholic in a Protestant nation, Mediterranean Catholic within a Jansenist Catholic subculture—whichever side of the U.S.–Canadian border they have landed. In

particular, all four novels converge around a larger-than-life woman who, for all of her nurturing of her favored son, is not so all-forgiving and not so all-protective after all, neither so Blessed nor (and this is at the heart of the matter) so Virginal. We are prompted then to inquire whether the Marianism in these texts is paradoxically that of filial resentment at the mother's effort, failed or succeeding, to implement her own agenda. Underneath the son's charge of maternal inadequacy (if not, in the case of Puzo and possibly Ricci, betrayal) lies enabling mother-worship: In turning to write penetratingly about their mothers, De Capite, Puzo, Paci, and Ricci, each in his own way, was able to recover how her nascent, including sexual, self-determination (as well as that of her female allies: her daughters) both fomented and sanctioned his own.

The best of the Irish immigrant literature of the thirties and forties—Farrell's *Young Manhood of Studs Lonigan* (1934), O'Neill's *Long Day's Journey into Night* (1940), and Doyle Curran's *The Parish and the Hill* (1948)—foreground aptitudes for daily living, **omertà**-enforced hermeticisms, and attitudes toward human destiny that rival the notorious forms of the **Mezzogiorno,** prompting us to rethink what is generally Catholic and what is distinctly ethnic in the putative hallmarks of southern ***italianità.*** Placed side by side, Irish American and Italian American narratives illustrate the emotional overinvestment of Catholic mothers and sons. Whereas the Irish seem to recriminate themselves for the maternal bond to the point of pleasure, an erotics of guilt, the Italians seem to embrace filial intimacy to the point of indecency, an eros to please the devil.

Feminist scrutinizing of literary history reveals Diane di Prima as the strongest of the female Beats, arguably the strongest and certainly the most salient female Italian American creative writer to date (1995). Focusing on the crucial figure of Jack Kerouac, cultural historian James T. Fisher has shown that the utopian mysticism of the Beats, long identified with Allen Ginsberg and the Kaballah, included a meditative dimension drawn from the Franco-Jansenist conscience as well as from the Franciscan tradition of ascetic monasticism. Concentration on di Prima, as on Ferlinghetti or Fariña, throws Beat religiosity into a yet more Mediterranean light. Her poetry happily manifests the late medieval–early Renaissance sensibility identified by the brilliant scholarship of Carol Walker Bynum and Sarah Beckwith, and it dovetails markedly with that of fellow San Franciscan Robert Duncan, whose work is more archival in imagery while also more committed to the potential paganism in Eliot's modernist legacy. Di Prima's *Memoirs of a Beatnik* (1969) envisions participation in the between-men orgy as a festive (that is, non-demonic) spiritual rite—with a lightly penned graphicness that puts the proudly sensationalistic "zipless fuck" of Erica Jong's *Fear of Flying* (1973) to shame,

and with an awareness of the mystical possibilities and disappointments of gender-bending sexuality that puts the antibiologism of certain academic feminisms to doubt. The largish and dynamic Italian American lesbian arts community identified by *SinisterWisdom* (Summer/Fall 1990), gathered mainly in the Berkeley area, surely owes a debt to di Prima, yet for all her experimentation (literary as well as personal), di Prima's original spiritual headquarters was across the bay, in the Beat/Gay Haight she helped to create with Duncan and others.

In *The Dream Book: An Anthology of Writings by Italian American Women* (1985), Helen Barolini has gathered a passel of women writers with some degree of Italian ancestry, several of whom are known to us importantly under other aspects (Mary Gordon, travel writer Barbara Grizzuti Harrison, feminist English critic Sandra M. Gilbert), and most of the rest of whom are more valuable as historical witnesses than creative writers. On the other hand, the energies that went into Barolini's own *Umbertina* (1979) produced a fascinating tension. In the penultimate climax of the novel, a young woman's decision to undergo an abortion is portrayed as a victory for feminist self-determination over the patriarchal hypocrisies of the Church establishment. But that decision puts into check as well the Italian peasant imperative to reproduce, an imperative not only inherited from the great grandmother, who is the title character, but also embodied in the form of the novel itself, which is determinedly multigenerational. Barolini thereby unselfconsciously echoes the stunning abortion in Michael De Capite's *Maria* and the equally instinctively feminist disavowal of children (by Octavia) in Puzo's *The Fortunate Pilgrim*—while also anticipating the feminist regimens of celibacy, sterility, and barrenness that dominate contemporary ethnic North American autobiographical fiction (especially by women of Asian descent, including Maxine Hong Kingston, Joy Kogawa, Amy Tan, and Sky Lee).

It has been argued, most saliently by Daniel Aaron, that in his writing Don DeLillo betrays nary a sign of his Bronx Italian American background. Yet DeLillo's stinging appreciation of the contemporary America family, *White Noise* (1985), which became a collegiate sensation, investigates the rituals of postmodernity from a quietly Catholic perspective that is intriguingly fractured between populist empathy and traditionalist longing. The novel insinuates a heady identification with consumer culture, with the simulacra of the advertising-information media, and with no-blame, no-guilt divorce—which are shown to feed upon the sacramental needs of American individualists and to yield for them, somewhat miraculously, a sanctifying sense of membership in larger (often much larger) wholes.

In *American Catholic Arts and Fictions: Culture, Ideology, Aesthetics* (1992), the impressive first tome on the subject of this essay, Paul Giles designates the icono-

graphic tradition as especially crucial to residually Catholic art, and he introduces seminal discussions of film directors John Ford, Robert Altman, and Alfred Hitchcock through an analysis of the work of painter Andy Warhol (who attended Mass three times a week and recast Catholic icons of high art into "postmodernist aesthetic kitsch") and photographer Robert Mapplethorpe (who often worked with images of Christ and the devil). No wonder, then, that Italian America has produced so many masters of the visual arts, pure and applied, from futurism (Joseph Stella) and abstract impressionism (Frank Stella) to postmodern architecture (Robert Venturi), the commercial arts (Jerry della Femina), and the auteur film directors (from Frank Capra onward); not to mention the myriad set designers, lighting technicians, and animators whose otherwise unknown Italian surnames roll each time the credits do—or the corresponding designers, draftsmen, and illustrators in the fashion and advertising industries.

By almost any reckoning, the first great Italian American artist was the painter Joseph Stella, a son of Naples whose possession of an importantly large body in the old southern Italian way, with a persona to match, helped turn him into an icon of the modernist years. His work, first highlighted in the epoch-making *Armory Show,* was simply major, including the kaleidoscopic *Coney Island, Battle of Lights* (ca. 1913) and the five-part tableau on the Brooklyn Bridge, *New York Interpreted (The Voice of the City)* (1920–1922). While his penchant for abstracted representations of industrial modernization—the amusement park and the bridge, but also steel factories, skyscrapers, cigarette advertisements, and the like—earned him the tag of futurist, he deliberately schooled himself in the Italian Renaissance. To an amateur eye taking in the greatest paintings (including the fabulous 1917 gouache, *Telegraph Pole*), no influence seems more obvious than the stained glass of European cathedrals and Greenwich Village churches. Marianist leanings are evident throughout his career, with a quiet literalism in the monotone *Immigrant Madonna* and *The Virgin,* both from 1922, and with an effective revisionism in several celebrations of the independent American "new woman," among them *The Birth of Venus* (1922) and *Torso* (1929). Toward the end of his career, he contributed twelve devotional works to the 1934 *Second International Exhibition of Sacred Art,* most of them within medieval genres, including *Head of Christ, The Holy Manger,* and a remarkable altar piece, *Saint John,* all executed in 1933.

In 1972 the paintings of a fifty-eight-year-old gas-station attendant, Ralph Fasanella, were "discovered" by the New York art world; a one-man show, a *New York* magazine cover story, and high praise by world-class art arbiter John Berger followed. Often poster-size or larger, Fasanella's putatively primitive oils characteristically cast clusters of small, working-class figures—Lower East Side deni-

zens on market day or feast days, crowds at political rallies or funerals, sandlot or schoolyard ballplayers—against an imposing fusion of cityscape with Church: the end of a darkened alleyway transmuted (or is it "transubstantiated"?) into a redeeming Gothic facade, or the chancel of a downtown parish transmogrified-mortified into the portals of an urban hell. *Iceman Crucified (#1)* of 1948 and *Iceman Crucified (#4)* of 1958 are veritable microcosms of the gestalt of di Donato's *Christ in Concrete*. Although his works are not to be found in galleries and are therefore almost impossible to view, there is one good overview in book form, Patrick Watson's *Fasanella's City* (1973), which contains extensive interviews with Fasanella. In addition, reproductions of *San Gennaro Festival* (1957) and *Family Supper* (1972) grace the paper covers of Robert Orsi's *The Madonna of 115th Street* (1985) and the anthology *From the Margin:Writings in Italian Americana* (1991), edited by Anthony Julian Tamburri, Paolo A. Giordano, and Fred L. Gardaphe.

The great crooners, jazz artists, and early rockers of the postwar period—the epochal Frank Sinatra, Tony Bennett, and Louis Prima, but also Dean Martin, Al Martino, and Vic Damone, then Bobby Darin, Franki Valli, and Dion—were in sensibility very, even hugely, Italian, but only vaguely, very vaguely, Catholic. For instance, the torch songs of the saloon singers might be taken as a kind of Mediterranean blues, repressed belief in **destino** reemerging as "White soul," but that kind of interpretation is stretching the notion of residual Catholicism to the breaking point. On the other hand, two contemporary rock icons—the 1970s' most electrifying poet-performer and the 1980s' most ubiquitous pop songstress—made their draws, no doubt about it, from childhoods and youths saturated in Roman Catholicism.

The idiom in which Bruce Springsteen operates—the language and imagery of his oeuvre, the ethos of his shows, and the very shape of his career—is that of a renegade priest turned prophet to the East Coast working classes, women included (no male star since Elvis Presley has had as female an audience). In his songs, he describes last-ditch efforts to salvage broken American dreams—"redemption," he calls it—that he himself offers, in turn, in relentless stage shows, alternatively evocative of homosocial street camaraderie and heterosexual romance yet intuitively modeled in its larger rhythms on the High Masses of feast days. For those in the audience, the experience is, as they always report, that of religious transport, the cleanest of ecstasies yielding the most good-willed and least self-indulgent of rock 'n' roll crowds, and this effect is no surprise: Listen to the contrasting messages and styles of the first three performances on *Bruce Springsteen Live, 1975–85,* and you will hear secularized versions of the gathering, the Confiteor-Kyrie, and the Gloria, distinctly articulated and in the correct order.

As the decades proceeded, Springsteen himself moved from small-scale cult following to stadium megastar to a persisting but scaled-down middle age, with a typically Catholic self-reflexiveness regarding the life cycle: The Boss has been aging less like the eternally rebellious Mick Jagger or the precociously wise Billie Holiday and more like, not coincidentally, the Chairman of the Board: In the early 1990s, a father of two, he began sporting crosses as more than a fashion statement, recorded children's ballads, and offered varying testimonies to his "leaps of faith."

Madonna's mesmerizing videos have already captured the imagination of a generation of critics, who embrace the debunking of the Catholic family drama in *Oh, Father* (1989) and the inscription of Black Protestant fundamentalism in *Like a Prayer* (1989). But, like Springsteen, the live performances should not be underestimated. By the time of the Blonde Ambition Tour in the late 1980s, she knew what she was doing sufficiently to have her brother, Christopher Ciccone, design the rock stage of the decade: a stylized Italian Gothic chancel, featuring a monstrous stained glass window, framed by Gothic columns, and fronted by an altar on which she performed most of the songs she wrote herself. No more than with Springsteen can the domestic scale of television capture the crowd communions of arena rock, recalling the cathedral, and of stadium rock, recalling outdoor Easter celebrations at the Vatican. *Truth or Dare* (1991) Madonna's movie exposé of the tour, credited the banning of the show in parts of Italy to obscenity, with an insipidity typical of the voice-over of the film. In Italian cities, ordinary corner newsstands sell pornography that is contraband in the United States, so it was not the sexuality per se that the Italian authorities feared, it was the blasphemy. And they were right.

In "The Sacraments of Genre: Coppola, DePalma, Scorsese," a wonderful essay from the mid-1980s, Leo Braudy argues that the Catholic way of knowing is profoundly a way of seeing, such that Italian Americans working in putatively secular arts nonetheless betray "an almost priestly urge" to reeducate their audiences "in the timelessness of ritual stories" and to reawaken in them sensitivity to "the transcendental potential within the visual world." For major artists such as the movie directors occasioning Braudy's essay—Francis Ford Coppola, Brian DePalma, and Martin Scorsese—visual style is "a mode of moral explanation," not its handmaiden: a reintroduction of sacred significance into profane realms despite the fact, and at times because, the artist is guiltily aware of the discrepancy "between secular metaphors of ritual, sainthood, authority, and their religious counterparts."

Scorsese graduated by the flagship Catholic high school of New York City, theologically tutored as well as philosophical by inclination, has produced a cor-

pus of films that interrogate in evolving ways the relation of sanctity to violence. For critic Robert Casillo, Scorsese's obsessive subject is the tension between Christ's pacifistic rejection of pagan scapegoating, which Scorsese wants to take as an ethical mandate, and the mesmerizing repaganizing purgation of the mortification of the flesh entailed by Christ's dying on the cross. Scorsese's films wonderfully host the play of literary philosophy, such as the mytho-scriptural analysis of René Girard that Casillo deploys, yet in no way permit the disembodied abstraction that plagues so much contemporary "theorizing" of the body. From *Mean Streets* (1973) and *Taxi Driver* (1976) to *Raging Bull* (1980) and *Goodfellas* (1990), Scorsese puts his audience through sensual hell: We feel as deep assault to ourselves and as deep allure for ourselves the purgative violence of his protagonists, viscerally repellant and repellently seductive. Journalists and academics alike have remained wary of *The Last Temptation of Christ* (1988), indicating that overtly religious thematics continue to embarrass, and arguments for the significance of his remake of the 1961 Universal thriller *Cape Fear* (1992) are still in the making. Yet there is increasingly critical accord that in the New York City street dramas (including the 1980s seriocomedies *King of Comedy* [1983] and *After Hours* [1985]), Scorsese has created a topos for Catholic reflections on modernity that are as powerful and as smart as any in the twentieth-century Catholic literary canon, American or European.

It was novelist Mario Puzo, never sufficiently credited, who created the mythic characters and primal narrative conceits that made Francis Ford Coppola's incomparable *Godfather* films possible. Puzo's *The Godfather* (1969) is centered upon a nearly omnipotent patriarch, a Mafia don, who has abrogated to himself the roles both of the righteous Vindicator of Hebrew Scripture and the Marian Intercessor of Mediterranean Catholicism; in a plot performative of this iconography, Puzo places his Chosen People in double jeopardy (as criminal entrepreneurs, as a Sicilian American family) only to imagine a double salvation, via the sacrificial yet victorious return to the fold of the prodigal son. In the aura that halos the novel and *The Godfather I* (1972), the Mafia emerges as a shadow version of the Church Triumphant, with the latter's City of God ethos turned ethnic solidarity in a seeming effort to redeem capitalism from American individualism. In *The Godfather II* (1974), the Corleone enterprise expands successfully into international racketeering, but only at the cost (as John Paul Russo has shown) of rendering wholly illegitimate—a fratricide, an abortion, a forced suicide—the ascendent don's claim to be protecting his extended family and serving the Faith. In the willful but rushed *The Godfather III* (released Christmas Day, 1990), it is not the invisible Mafia that is a version of the visible Church, but the Church that is a version of the Mafia:

the Borgias updated as viciously corrupt multinational financiers, also known as the Vatican Bank. If Puzo's cinematic technique as a novelist (which predates *The Godfather*) supports the claim that the pagan Catholic imagination is inherently visual, Coppola's studied invocation of Italian Renaissance painting (as well as his sacramental glossing of Puzo's darker ironies) can be credited with giving Puzo's designedly populist melodrama a gloriously evocative screen realization.

If there is as much Catholic energy in twentieth-century U.S. arts and letters as proposed here, it is also true that there has been relatively little critical inquiry to account for and assess it. In writing of contemporary Italian American filmmakers, Leo Braudy spoke of the priestly urge felt by artists to reeducate. It is an urge that motivates, not coincidentally, the work of the first two major American critic-scholars of Italian extraction: the ascetic virtuoso of high modernist poetry and philosophy, Frank Lentricchia, and the cultic priestess of the visual and popular arts, Camille Paglia. As distinct as they are from each other, Lentricchia (in the autobiographical *The Edge of Night* [1994] and the literary history *Modernist Quartet* [1995]) and Paglia (in *Sexual Personae* [1990] and the less-occasional pieces of *Sex, Art, and American Culture* [1992]) nonetheless share a commitment to rearticulating, with revivifying wisdom, the transcendent dimensions of Western creativity. Each manifests a specifically Italian enthusiasm for hierarchies of value, and each brings to critical exegesis a generally Catholic aptitude for ritual theatricality, more liturgical in the case of Lentricchia and more iconographic in the case of Paglia. For these two *pezzonovanti* (critics to be reckoned with), the struggle against the aesthetic relativism of multiculturalism has turned out, ironically enough, to be a matter of ethnic, even religious, imperative.

Further Reading

Braudy, Leo. "The Sacraments of Genre: Coppola, DePalma, Scorsese." In *Native Informant: Essays on Film, Fiction, and Popular Culture* (New York: Oxford University Press, 1991). First published in *Film Quarterly* 39 (1986): 17–31.

Casillo, Robert. "School for Skandalon: Scorsese and Girard at Cape Fear." *Italian Americana* 12, no. 2 (summer 1994): 205–21.

de Rougement, Denis. *Love in the Western World* (New York: Harcourt, Brace, 1940).

Fiedler, Leslie. *Love an Death in the American Novel* (New York: Dell, 1960).

Fisher, James Terence. *The Catholic Counterculture in America, 1933–1962* (Chapel Hill: University of North Carolina Press, 1989).

Giles, Paul. *American Catholic Arts and Fictions: Culture, Ideology, Aesthetics* (New York: Cambridge University Press, 1992).

Gordon, Mary. *Good Boys and Dead Girls and Other Essays* (New York: Viking, 1991).

Lears, T. J. Jackson. *No Place of Grace: Antimodernism and the Transformation of American Culture, 1880–1920* (New York: Pantheon, 1981).

Lentricchia, Frank, ed. *New Essays on "White Noise"* (New York: Cambridge University Press, 1991).

———. *The Edge of Night* (New York: Random House, 1994).

Lourdeaux, Lee. *Italian and Irish Filmmakers in America: Ford, Coppola, and Scorsese* (Philadelphia: Temple University Press, 1990).

Orsi, Robert. *The Madonna of 115th Street: Faith and Community in Italian Harlem, 1880–1950* (New Haven: Yale University Press, 1985).

Paglia, Camille. *Sexual Personae: Art and Decadence from Nefertiti to Emily Dickinson* (New Haven: Yale University Press, 1990).

Rodriguez, Richard. *Days of Obligation: An Argument with My Mexican Father* (New York: Viking, 1991).

Russo, John Paul. "The Hidden Godfather." In *Support and Struggle: Italians and Italian Americans in a Comparative Perspective,* ed. Joseph L. Tropea, James E. Miller, and Cheryl Beattie-Repetti (Staten Island: American Italian Historical Association, 1986).

SAQ 93 (summer 1994) (Special Issue: *Catholic Lives/Contemporary America,* ed. Thomas J. Ferraro).

Tamburri, Anthony Julian, Paolo A. Giordano, and Fred L. Gardaphe, eds. *From the Margin: Writings in Italian Americana* (West Lafayette, Ind.: Purdue University Press, 1991).

Watson, Patrick. *Fasanella's City* (New York: Alfred A. Knopf, 1973).

Wyatt, David. "Bruce Springsteen." In *Out of the Sixties: Storytelling and the Vietnam Generation* (New York: Cambridge University Press, 1993).

Zilczer, Judith. *Joseph Stella* (Washington, D.C.: Hirshhorn Museum and Sculpture Garden, Smithsonian Institution, 1983).

Sacraments

Italian American Theatrical Culture and the Dramatization of Everyday Life

Jo Ann Tedesco

Introduction

Italian Americans entered the literary realm of drama earlier and with far more ease than they did the area of fiction. Their affinity for theater can be attributed, in part, to the rich traditions—regional as well as national, popular as well as erudite—of Italian theatrical expression, many of which traveled to America with the immigrants. But as anyone who has been to Italy or remained stateside and read Luigi Barzini in *The Italians* (1964) on gesture knows, the art of performance and the theatrical impulse inform the practice of everyday life. Similarly, in an intrinsically scenographic culture like the Italian American, in which everyone assumes the role of actor in the family scenario, where all of the characters are "in search of an author," it is inevitable, as in the celebrated play by Luigi Pirandello, that these living "characters" should find their playwright. Drama, along with opera and film, has thus proved to be the most natural form of expression for the still aptly described "sanguine" (rather than the choleric, melancholic, or phlegmatic) temperament and the strongly held code of behavior of most Italian Americans. These unwritten laws of full self-expression and intense family loyalty are the very basis of any dramatic or melodramatic confrontation.

Modern American society's adoption of relativism and the ensuing superficial relationships such a worldview engenders are in direct contrast to the intensely formed and maintained relationships of the Italian American. Hence Hollywood's infatuation with things Italianate. One can only wish that the cast of characters populating Hollywood movies was broader, and the palette from which the characters are painted were wider. However, even the caricatured Italian seems

Boldface terms are defined in the Cultural Lexicon, which starts on p. 703.

to strike the fancy of most Americans and to harken back to even older forms of stock characters.

People in the latter half of the twentieth century crave the very things they discarded in their lemming-like quest for the American Dream, and Italians for the most part have maintained many of them. The pit-bull tenacity necessary to accomplish such a feat is a double-edged sword often leading to a characteristic parochialism. *Ma che ci vuoi?* (But what do you expect?), especially when the lesser of the two evils is so colorful and satisfying. Family ritual, close relationships, and large doses of the "us–them" complex are a refreshing antidote to the disenfranchisement, alienation, and rootlessness of many Americans.

What better schooling and raw material for dramatic interaction and characterization is there than the intensely passionate and rigid framework of an Italian American family? Italian Americans maintain one of the most pragmatic and conventional lifestyles of any of the great immigration ethnic groups. Many women stay at home as career homemakers. They raise their own children, cook their own meals, and, when finances allow, fight the maids to clean their own houses. Italian American families spend "quantity time" together rather than just "quality time." Relatives actually enjoy one another's constant companionship, resent unnecessary absences, and even time spent reading in the same room might be construed as "tuning out" in some gregarious households.

The more pressure exerted upon the individual to conform to the family-generated identity, the more muscle required to escape. Artists and intellectuals are usually discouraged, often histrionically, from following their natural bents, and only the fittest survive the journey out of the family. Such pursuits are usually considered dangerous voyages into uncharted territory, fraught with obstacles and even enemies—non-Italians, strangers, and various unknown dragons. The mater-paterfamilias reiterate this theme. Family ties are sacred, are they not, so why should anyone want to go "away to school" or for that matter spend so much time with friends? It is enough that one's interests may deviate from acceptable family group activity, but to actually want to enter unfamiliar terrain—maybe even, God forbid, assimilate a bit more than anticipated—that is unwise behavior.

In cooler, more detached families such behavior is easily detected and circumvented, but in the Italian American family such manuevering is accompanied by large dollops of genuine love and concern. You are kept within the fold for what is perceived to be the greater good—saving you from unpromising, ungainful employment and deep disappointment in the big world.

This is the stuff of which drama is made. The classic "rite of passage" from the small world of family and neighborhood into the great outside world becomes

fraught with dramatic possibilities. Any thinker, writer, or artist who makes it out of such a turbulent and often turgid world has more than proven his or her mettle. Having been made painfully aware of the personal differences that make them family anomalies, those brave pilgrim souls cross their Rubicon at a very early age.

Ever since Gay Talese dropped his bombshell in the form of a cover story for the *New York Times Book Review*—"Where Are the Italian-American Novelists? (14 May 1993)—an acrid public debate has raged in Italian America not only in response to Talese's big question (the supposed lack of Italian American novelists) but to his devastating explanatory hypothesis, namely that Italian Americans have failed to constitute themselves into a reading public that would support Italian American literary production. But Talese's indictment strikes even further, zeroing in on the supposed lack of serious literary culture even in middle-class Italian American homes. Even if such a generalization holds for previous generations who were concerned with the pragmatics of moving out of the blue-collar class rather than with making their children into literati, it would seem that reading habits, or lack of them, are more adequately explained in terms of class-formation and educational level rather than as ethnic characteristics.

Whatever lack of literary exposure there may have been in the traditional Italian American home, there was in no way a lack of artists. Artistry is a quality of the soul and will find its proper mode of expression not in spite of all obstacles, but rather because of them. The irritation of the grain of sand in the heart of the oyster is the very element that creates the pearl. The novel has just not been the predominant genre of choice, that's all.

With the auditory and visual senses more than indulged and opera and movies in abundance, many potential novelists pursue the theater, opera, and film. All three forms are primarily dramatic and spectacular. Those same operas and films serve to familiarize aspiring writers with plot structure, while everyday life provides colorful characterizations and conflict as well as rich dialogue.

Italian Theater

The roots of this affinity for the dramatic form are actually quite ancient and predate the Roman comedies of Terence and Plautus. Prior to the borrowing of the Greek form of drama, there existed three native comic traditions in the Neopolitan district, which were passed down to the earliest Italian American immigrants almost entirely intact. They were the *fescennia locatio* (improvised and lascivious

exchanges sung by clowns); the Greek phylax plays of colonized southern Italy, which were travesties of mythologies and burlesques of daily life; and the *fabula atellana* (farces, parodies, and political satires that introduced stock characters). (See Fellini's *Satyricon,* a 1969 film directed by Federico Fellini, that perfectly reproduces almost all of these ancient forms, capturing their visceral impact and body language.)

Romanized Greek drama was introduced in 240 B.C. by Livius Andronicus, an actor turned playwright, who was also responsible for an innovation that developed into a new form of entertainment called *pantomime*. This occurred, most fortuitously, when his voice gave out during a performance requiring him to recite, sing, and dance. He merely assigned the dialogue to a speaker, which freed him to dance and pantomime his role. Given the Italian propensity for grand and exaggerated gesture, the pantomime is but a logical extension of that aptly named "sanguine" nature.

After tragedy, the new comedy of Greece was imitated in form by Plautus and Terence, who adapted the content to suit the tastes and customs of Rome. Add to this stew the spectacle of the circuses and Roman games, and we have a hint of the theater of the times. Pantomime alone remains the sole original contribution the Romans made to the Greek dramatic form. These ancient Roman elements have survived in part to the present day.

Although never achieving the greatness of Greek tragedy, the Romans kept theater alive, influencing succeeding generations and forms. The degenerate improvisational performances were no more than vulgar burlesques so overtly sexual and bloody that they offended both barbarians and Christians alike and to such a degree that they were prohibited—not too successfully, however, for the shreds of theatrical tradition were preserved by the popular traveling minstrels, mimes, acrobats, jugglers, dancers, storytellers, and wrestlers who wandered throughout Europe until the folk plays and mummers' plays displaced them in the Middle Ages.

The liturgical dramas of medieval times merged with the secular, Dionysian form of drama during the Renaissance. Mystery and morality plays were moved outdoors and became more secular until they were merely spectacles heralding the entrance to a town by monarchs and other notable figures. The series of stops and pantomimed pomp were known as *tableau vivant* (living pictures). They remained rough versions of the traditional virtue–vice conflict until classical themes were revived in the face of flagging Church power. *Intermezzi* (pantomimes that included song and dance) led to one in particular that actually became the first opera. This *intermezzo,* titled *The Harmony of the Spheres,* was produced in the sophisticated Medici court of Florence in 1589.

Rudimentary forms of all of these dramatic forms survived and even prospered in the Italian American theatrical ventures of even the earliest immigrants. The first recorded Italian American example of such a continuation of its ancient predecessors is a *commedia-ballata* (comedy-ballet) performed by Guglielmo Ricciardi in 1765 and mentioned in his memoirs.

Italian American Theater

The Immigrant: 1870–1920

Because of the paucity of immigrants prior to 1870, such ventures were sparse and mostly unrecorded, but by the final decades of the nineteenth century the formation of a vital theater for the Italian American community was well under way. The turn of the century saw virtually hundreds of Italian theaters in operation. The problems Italy was enduring during those same years, such as cholera, famine, drought, and the political tensions of a struggling, newly unified Italian nation, provided the ever-expanding immigrant community with a practical incentive for the production of popular theatrical entertainments. Social, political, and theatrical Italian American organizations rallied to the homeland's many needs by staging benefit productions as fund-raising ventures.

Newspapers of the day reported innumerable productions of this sort, and from that time to the present we see an unbroken line of Italian American theatrical activity. Productions emerged from almost all social clubs for the aforementioned reasons, but only one purely dramatic organization surfaced in the last two decades of the nineteenth century and was consistently listed as a producing and performing organization: the Società Filodrammatica Italiana di New York, better known as Il Circolo Filodramatico Italo-Americano. The first recorded performance of an Italian American repertory group is their production of *Maria Giovanno Ossia Le Due Madri (Maria Giovanna or The Two Mothers)* at Dramatic Hall on Houston Street on 17 October 1880. This organization showed the greatest activity and longevity of any company of this period, performing regularly from 1878 to at least 1894, when *Il Progresso* newspaper records were interrupted. The *Brooklyn Eagle Almanac* continues listing them as a functioning organization through 1902, and we can reasonably assume they produced throughout those years as well.

Budgetary records for many of the theatrical organizations of the period reveal the expenses, profits, and beneficiaries of the proceeds. The Christopher Columbus monument, erected in Columbus Circle in 1892, was partly funded by the drama groups of the period.

The productions of this era were quite varied. Besides the main production, which ranged from high melodrama to drama and verse drama, from farce and comedy to children's theater, there also appeared on the same bill a potpourri of accompanying events: music, recitations, grand marches, prize fighting, poetry readings, and the usual assortment of variety acts. A more traditional theatrical company of the nineteenth century was La Compagnia Comico-Dramatica Italiana A. Maiori e P. Rapone, named for its two founders. Founded around 1892, it survived longer than any of its major predecessors and is significant for the professional quality of its performance and its introduction of Shakespeare and other European classics to Italian American audiences.

Alongside the actual theater companies of this period, another popular form of entertainment developed—an immigrant equivalent of vaudeville, which since its development has been treated superficially and often erroneously by social historians. It is important to point out that the definitive study of the Italian American immigrant theater is that of Dr. Emelise Aleandri, actress, producer, and cohost of television's *Italics*. The following discussion is indebted to her comprehensive dissertation (1983) and conversations with her.

In various *Café Chantants* (café's that offered music) located in Manhattan, Brooklyn, and Hoboken, New Jersey, there sprang up the social phenomenon called the **caffé-concerto,** which mixed strolling musicians and other variety performers to provide the only relaxation for the hardworking immigrants. Two performers who emerged from the café scene were Guglielmo Ricciardi (1871–195?), who went on to American theater and films, and Italian-born Eduardo Migliaccio (1880–1946), who started the Italian theaters of the Bowery in New York City. The primary entertainment provided by performers was the singing of Neapolitan folk songs and the enactment of Neapolitan **macchiette,** or character sketches, literally, a character "daub." More intricate than the typical vaudevillian routine, in which the comedian merely rattled off a series of mostly unconnected "stories with punch lines," the *macchiette* were akin to the more fully developed comic monologues of such later comedians as Mike Nichols and Elaine May, Bob Newhart, Shelly Berman, Pat Cooper, Dom Deluise, and Richard Pryor, all of whom developed actual personae and placed them in specific situations. If well executed, the character with his peculiar traits is recognized immediately upon the comedian's appearance on stage. The *macchiette* are written mostly in verse interspersed with spoken passages of prose and dialogue. These verses were put to music.

Migliaccio's fame rests on his development of a variation based on the immigrant experience in America called the *macchietta coloniale,* which Arthur

Livingston, professor of Italian at Columbia University, described as being "constructed on rigorous canons of 'ingenuity': there must be a literal meaning, accompanied by a double sense, which, in the nature of the tradition, inclines to be pornographic." I take issue with Livingston's use of the term "pornographic" in that earthiness and double entendre do not arouse the sexual appetite as much as they tickle the funnybone.

Photographs of Migliaccio in the garb of some of his various characterizations confirm the fact that these sketches were in keeping with the highest tradition of social satire and seem to have served the audiences as good satire should: to awaken them to their own folly, as in the case of the ersatz military parading done by patriotic but untrained immigrants posturing as soldiers. After Migliaccio's mercilessly accurate lampooning of the practice, it was immediately dropped by the immigrant community of New York.

Furthermore, his performances were not limited to merely one sketch per evening. They included a whole series of sketches requiring him to assume male and female roles and to impersonate characters from various walks of life, very like the sociological studies of Andy Kaufman, Tracy Ullman, and Lily Tomlin of the late twentieth century.

For nearly a generation, the *macchiette* were the mainstay of the immigrant theater, and this reflects a little-understood dramatic truth; Plot is secondary to character in the dramatic form. A fully rounded character reveals both his interior and his exterior life as well. One can well imagine the joyous reception of those immigrants who witnessed the very first portrayal of their own strife at adjusting to a foreign culture.

The expansion of professional Italian American theater in the opening decades of the twentieth century was a direct result of the growing number of immigrants. Among the best-known individuals and groups were the Donna Vicenza Company and the Gennaro Cardenia Company. Lesser known were the Filodrammatica Racalmuto, Circulo Filodrammatica Polimnia of Attilio Carbone, the Circulo Filodrammatic Novelli, the Teatro Garibaldi Gennaro Ragazzino, the Clemente Giglio Players, the Teatro D'Arte Company of Giuseppe Sterni, and various other companies headed by such impresarios as Giovanni di Rosalia, Silvio Miniciotti, Francesco di Ceasare, Paola Cremonesi, Alberto Campobasso, and Enzo dell'Orefice.

Such ventures developed in "Little Italys" all over the country, but New York, naturally, yielded up the most. Eastern industrial cities followed suit, and even San Francisco produced a few theaters, operas, and theatrical stars. The immigrant audience was especially receptive to simple comedy acts called *zarzuella*, a

vaudevillian form of Italian farce in the direct tradition of **commedia dell'arte** (comedy of art), a type of comedy developed in Italy in the sixteenth century, characterized by improvisations from a plot outline and by the use of stock characters. The actors worked improvisationally and without scenery.

Such fare became the stock of smaller theaters called nickelodeons, where a poor immigrant could be revived with some inexpensive comedy for a mere nickel or dime. These establishments became very popular and one of them, the Bijou, became famous for its presentation of *Stentorello* (the simpleton), a Tuscan stock character. As a continuation of the previously mentioned ancient characters, each area of Italy had developed its own favorite characters who appeared in local dramas and festivals. *Stentorello,* the darling of the Florentines, was a ***cafone,*** (a simple, country bumpkin), who at various times appeared as the gluttonous servant, the crafty fruit vendor, the shiftless drunkard, and the noble menial. Besides appearing in his own productions, he could also turn up in a Shakespearean tragedy or any other such serious drama in order to comment in his vulgar manner and provoke unexpected laughter with his coarse interruptions and commentary.

The peak years of immigrant theater in San Francisco were 1907 to 1914, when the community supported the previously mentioned vaudevillian-styled acts as well as a great number of serious original plays and the ever-present operas. In addition to the serious works of such writers as Dumas, Goethe, Sudermann, Sardou, and Jules Verne, there were new plays by the unknown actors themselves.

Another commedia dell'arte character, the Neapolitan **Pulcinella** (the vulgar but charming, good-for-nothing trickster) was introduced concurrently on the East Coast, in the traditional fashion, but in the novel and in the decidedly Italian American form of the character of *Farfariello* (literally, Little Butterfly, with the additional connotation of an irritating Little Devil), who was created and performed by the previously mentioned New Yorker Eduardo Migliaccio, a genuine comic genius, according to the critics. His *Farfariello* was the archetypal southern Italian immigrant who appeared in the all-too-familiar guises of the fruit vendor, the ragpicker, the laborer, and the iceman, as well as parodies of the famous.

Having as a child heard several of my grandfather's recordings of the innovator, I recall vividly his depiction of the immigrant in uniquely American situations. A family favorite was one entitled *The Irish Wife.* It began with his theme song being whistled rather poorly by the obviously intoxicated protagonist. The whistling gradually developed into drunken humming and singing, the gist of which was "Mo me beviamo, beviamo, beviamo . . . Hic!" This little ditty was followed by his muttering about leaving his marital problems behind. Next, the strident "American" voice of an Army recruitment officer is heard barking orders. It is

established that Farfariello in his stupor has decided to escape it all by enlisting. His opening line to the officer is a definite "Me wanna be 'soldier!'" However his mispronunciation of the word "soldier" is clearly the Neopolitan word for rat. He is unable to "Stand-a straight!" to establish his sobriety, and it all goes downhill from there until he is sent home, only to be greeted by his aloof Irish American wife. The perfect prototype for Alice of *The Honeymooners,* she then proceeds to fuel his disappointment by behaving as the perfect "American" cultural stereotype. She does not have any dinner ready because she was having her hair done at the "beauty parlor." She is, however, more than willing to open any number of canned goods for her husband. She answers the phone, speaks with a friend and then— offense of all offenses—she actually smokes! The clichéd punch line of so many Italian American jokes "Ma questa fume pura!" (But this one smokes, too!)—may have actually originated here. The immigrant husband answers his wife in broken English but speaks dialect when muttering to himself and to the listening audience. One of Richard Pryor's early routines was almost identical and, incidentally, as hysterical in its perfect depiction of inebriation.

Migliaccio's talent was greater than mere acting talent in that he wrote more than 150 such character sketches. Some of the more memorable were *The Barese Iceman, Cafone Furbo* (The Shrewd Boor), *The Italian American Banker, The Midwife, Cresy Gherl,* and *The School Gherl.* He also parodied such notables as Caruso and Luisa Tetrazzini. As evidenced by his titles, he used dialect, broken English, and the peculiarly new form of Italo-Americanese that used English words as a root and added Italian endings and cadences. Examples from his song "Iammo a Cunailando" (Let's Go to Coney Island) are *baschetta* for basket, *stretto* for street, *sciu'mecca* for shoemaker, *Bruklino* for Brooklyn, and *scioppa* for shop. New immigrants couldn't even begin to comprehend this lingo, but for the habituated audiences of the *macchietta coloniale* this was mother's milk.

Such seemingly improvisational (they were, in fact, carefully written) material of the *macchiette coloniali* provided perceptive, satiric commentary on the class structures of both cultures. The painful process of assimilation was explored and amplified through irony and humor, aiding the transplanted immigrants to endure their hardships.

The Next Generations: After the 1920s
Such were the theatrical exploits that sprung up all over the country during those turbulent years of the Great Immigration (1880–1920), and so our progenitors continued their time-honored, ancient means of dramatic expression. No wonder future generations of Italian Americans found it so comfortable to express

themselves through the collective enterprise of drama. When these generations were exposed to higher learning in American colleges and universities, their proclivity to "express" surfaced, and teaching became the natural extension for those attempting to comprehend their environment and culture. The stuffy halls of academia and the Siberia of esoteric publications were invaded and invigorated by the ebullient Italian American.

These same second and third generations were getting their artistic feet wet in the "real" worlds of theater and film as well. Actors such as Valentino, Henry Armetta, Tullio Carminetti, Eduardo Ciannelli, Jimmy Durante, Frank Sinatra, Don Ameche, Dane Clark, Ben Gazzara, Anthony Franciosa, Vincent Gardenia, Anne Bancroft, and others cut an early path for Tony Musante, James Farrentino, Al Pacino, Robert De Niro, James Coco, John Capodicci, Frank Biancamano, Patricia Elliot, Susan Sarandon, Rose Gregorio, Bernadette Peters, Concetta Tommei, Marisa Tommei, Rosemary De Angelis, Marcia Savella, Judy Scarpone, Emelise Aleandri, Anne De Salvo, John Travolta, Sylvester Stallone, Armand Assante, Talia Shire, Nicholas Cage, John Cazale, John Turturro, Michael Badalucca, Ray Serra, Paul Sorvino, the Dannys DeVito and Aiello, and countless others.

While acting seems to be the natural milieu for Italian Americans, others such as Frank Capra and Vincent Minnelli were endowed with the cinematic storytelling gene, which is an even more specialized dramatic talent. They were the forerunners of Brian De Palma, Chris Columbo, Gary Marshall, Penny Marshall, Nancy Savoca, John Lewis Carlino, Francis Ford Coppola, and Martin Scorsese. Most of these directors are also known as actors' directors, those with a special aptitude for eliciting especially sensitive portrayals from well-cast, talented actors. Growing up in families in which everyone expresses their desires, disappointments, and physical states as easily as they breathe can only be the perfect training ground for that sort of director.

Theatrical directors are legion as well—Frank Corsaro, Dino Narrizano, Michael Bennet, Tony Giordano, Bob Nigro, Vincent Gugliotti, Joe Brancato, Frank Biancamano, Joe Janetti, Julie Boyd, Don Scardillo, Carmen Capalbo, and John Vaccaro, to name but a few. Their styles are as diverse as the dramatic range itself and cover everything from the experimental (Vacarro, a founding father and namer of the theater of the ridiculous) to the commercial Broadway theater (Bennet of *The Chorus Line* fame) to the multipurpose (Corsaro, for example, who has alternated between straight theater and the opera, bringing the experiments of the avant-garde theater to the staging of traditional operas). The conclusion to be drawn is clear: drama is a comfortable milieu and the natural habitat for the Italian American.

The gap to be crossed between the mindset required by the performance of drama, a secondary interpretive art form, and that of the primary playwright is narrower than supposed. What better way to understand an art form than from the inside? Many if not most, of the world's leading dramatists have begun as actors, some beginning with Shakespeare, and Italian Americans who pursued such a goal were not totally ostracized by kith and kin. The theatrical vocation, however, was next to impossible for a budding thespian of the second generation—that is, unless one was born into one of the theatrical families (such as Vincent Gardenia's) that actually supported themselves for generations by their artistic ventures. Any other would-be actor would be thought foolhardy to sacrifice a regular, albeit meager, salary for the high gamble of the arts. All the more applause for those few brave souls who ventured forth from the safety of the immediate family.

The 1950s and 1960s
Among those of the second generation who found their way into the theater during the 1950s was an actor named Michael Gazzo (1923–1995), one of the first Italian American playwrights to gain wide recognition. What began as a series of improvisations at the New York's Actors Studio by Gazzo, Shelley Winters, and Anthony Franciosa was the genesis of Gazzo's first and most significant play, *A Hatful of Rain,* which opened at the Lyceum Theater on November 9, 1955, and ran for 390 performances. Directed by Frank Corsaro and starring Ben Gazzara, Shelley Winters, and Anthony Franciosa, the realistic melodrama, set in a tenement apartment on New York's Lower East Side, established Gazzo as a master of brutal dialogue and of the mean-streets theater that subsequent Italian American playwrights would make into their primary genre. Introducing the controversial and then taboo subject of drug addiction into the kitchen-sink drama of the fifties, Gazzo produced a gripping portrait of a decent young man and former GI, Johnny Pope (Ben Gazzara), struggling to break a drug addiction he had acquired in a hospital. The play initially revolves around Johnny's attempt to conceal his secret life of addiction from his wife Celia (Shelley Winters) and his father. Once that secret is disclosed and Johnny is forced to go cold turkey, the drama turns into an agony of recognitions that break through the system of denials maintained by Johnny and his family, including his faithful brother Polo (Anthony Franciosa).

From the Italian American perspective the play is archetypal in its focus on the familial space of the home, a space intruded upon by a vicious pair of dope-dealing gangsters and, at the very end of the play, opened up by the wife's call to the police to report her husband as a drug addict. In 1957 the movie director Fred Zinneman, on the basis of a screenplay by Gazzo and Alfred Hayes, adapted *A Hatful*

of Rain into a critically praised film starring Eva Marie Saint, Don Murray, and Anthony Franciosa. Gazzo also wrote the play *Night Circus,* which opened on Broadway in 1958. In his long career as an actor, the gravel-voiced Gazzo moved from Off-Broadway roles in the fifties to stints as a Hollywood character actor, his most memorable performance being that of Frankie Pentangeli in *Godfather Part II* (1974), for which he received an Oscar nomination.

Another notable dramatist, Lewis John Carlino (1932–) began his career in the late-1950s. His first play, *The Brick and the Rose: A Collage for Voices,* was produced in Los Angeles in 1957. He erupted onto the New York scene in the early sixties, establishing himself as one of the most promising of the new generation of American playwrights. Between June 1963 and May 1964, four one-act plays and the full-length *Telemachus Clay: A Collage for Voices* (1963) were produced Off Broadway. His remarkable year began with the production of *Cages* at York Playhouse (14 June), a bill comprising two one-act plays: *Snowangel* and *Epiphany,* both of which were anatomies of sexually obsessive behavior. In *Snowangel,* a man pays a not-always-submissive prostitute to enact with him the scenario of a long-lost moment of love. *Epiphany,* the more daring of the two plays, unfolds as a weird parable—Kafkaesque in the metamorphosis it describes—about gender politics and marital warfare in which an ornithologist discovered by his wife in a homosexual act turns into a rooster who lays eggs. The success of *Cages* led to the production of the earlier-written *Telemachus Clay* (16 November at the Writers Stage Theater) which, as announced by the subtitle *A Collage for Voices,* was a formal experiment in which eleven actors, seated on high stools placed on a bare stage, addressed the audience, not each other. Although the story was the conventional "portrait of the artist as a young man" (a young man of twenty escapes his abusive family and, as a latter-day Telemachus, sets off to Hollywood in quest of his dream of becoming a writer), the presentation was innovative, approximating the structural freedom of cinema. The actors occupied multiple roles (ninety different characters were represented) and spoke in fragmented and nonlinear voices, producing a compelling montage of dreams, interior monologues, flashbacks, memories, and reported conversations. Often compared to Dylan Thomas' *Under Milkwood* and Edgar Lee Masters' *Spoon River Anthology, Telemachus Clay,* together with *Cages,* established Carlino as an American playwright to be reckoned with. He concluded his memorable 1963–1964 season with another bill of two one-act plays, *Double Talk* (5 May, 1964 at the Theater de Lys): *Sarah and the Sax,* which presented the chance encounter of an old Jewish lady with a jive-talking black musician, and *The Dirty Old Man,* which presented another chance encounter, this time between a virgin and an aged poet.

Although he would write one more play, *The Exercise* (1968), Carlino turned toward the cinema where he immediately gained notice as the screenwriter of *Seconds* (1966) and *The Brotherhood* (1968), for which he received an Oscar nomination for best original screenplay. Starring Kirk Douglas as the senior member of a Mafia family in the grips of transition, *The Brotherhood* is a significant Italian American cultural text in that it portrays the conflict between the old and the new (American) way of conducting "family business" in terms of the generational struggle between an older, tradition-bound brother and a younger, college-educated brother who rejects the traditional ways. It thus can be seen as a prefiguration of Francis Ford Coppola's *The Godfather* (1972). Carlino would go on to have even greater success as the screenwriter of such films as *The Sailor Who Fell from Grace with the Sea* (1976) and *Resurrection* (1980) starring Ellen Burstyn and Sam Shepard, and as the director-screenwriter of *The Great Santini* (1979) starring Robert Duval and Blythe Danner.

The theater of the late 1950s would produce the first Italian American female playwright, Julie Bovasso (1930–1991), the distinguished actress of stage, screen, and television. She directed her own theater company called the Tempo Playhouse (1953–56) and had the unique distinction of introducing, in 1963, the French playwright Jean Genet and the Theater of the Absurd to America, when she produced, directed, and starred in *The Maids*. She wrote, directed, and acted in *The Moon Dreamers: A Play in Two Acts with Music* (first produced Off Broadway at La Mamma Experimental Theatre Club, 1968), and then, *Gloria and Esperanza: A Play in Two Acts* (first produced Off Broadway at La Mamma Experimental Theatre Club, 1969; produced on Broadway at ANTA Theatre, 1970) for which she received a triple Obie award. She wrote several more full-length plays among which were *Schubert's Last Serenade* (first produced, with *Monday on the Way to Mercury Islands,* Off Broadway at La Mama Experimental Theatre Club, 1971), and *Down by the River Where Waterlilies are Disfigured Every Day* (first produced in Providence, R.I., by Trinity Square Repertory Co., at Bridgham Street Theater, December 20, 1971; produced in New York City by Circle Repertory Co., 1975). An award-winning actress, she is most recognized as John Travolta's mother in *Saturday Night Fever* (1977) and as Cher's aunt in *Moonstruck* (1987). Bovasso was part of the very beginning of the last artistic renaissance of American theater: the birth of the phenomenon of Off-Off Broadway in the 1960s. As a result, plays that would not have necessarily found audiences in the traditional theater were very successfully produced in such out of the way places as the Café au Go Go, Café Cino, and Café La Mama.

Among the many playwrights who started out in the avant-garde theater

of the 1960s and then moved to commercial theater were a number of Italian Americans. The most notable of these "downtown" writers was Leonard Melfi (1935–). His gripping *Birdbath* was produced at Theatre Genesis in 1965 and was later made into a television drama starring Patty Duke and James Farrentino. It dealt with the poignant meeting of two wounded "birds": a waitress, appropriately named Velma Sparrow, and a passionate, aspiring writer Frankie Basta. Their romantic encounter winds through the dark, labyrinthine caverns of the human psyche, but Melfi's male protagonist is far from the stereotypical Italian American. Frankie is probably the first unselfconsciously intellectual Italian American male in drama. Melfi was initially a naturalistic writer, but much of his later work has a surreal, poetic quality sometimes evocative of such French dramatists as Jean Giraudoux and Jean Anouilh. He (along with Sam Shepard) is the perfect embodiment of the American avant-garde artist in that he combines outrageousness with almost equal doses of tenderness and toughness. Melfi also has the distinction of having written the only collection of plays, *Encounters: Six One-Act Plays* (1967), ever to make the best-seller list. He continues to write for Broadway and Off Broadway, and his plays are performed worldwide.

After having had a number of plays produced in Italy beginning in 1958, the Italian-born playwright Mario Fratti (1927–) came to New York in 1963 to serve as the drama critic for an Italian newspaper. He soon joined the ranks of American playwrights; the first New York City production of his plays was at the Theatre de Lys in 1963, a double bill featuring *The Academy* and *The Cage*. Since then more than 300 of his plays have been staged on both sides of the Atlantic, and Fratti is still writing. Becoming an American citizen in 1974, Fratti occupies a unique position as a New York City–based European playwright whose dramatic identity is bilingual and bicultural. Although he has continued to maintain a high profile in Europe, having had most of his plays produced in both English and Italian versions, he has transformed himself into a writer who operates equally well in English and Italian, and his plays written in English exhibit an ear attuned to American dialogue. As a corollary to his appropriation of an American linguistic identity, he has staged a polemical encounter with American reality. Beginning with *The Refrigerators* (1965), a zany critique of contemporary American life and technology, Fratti has increasingly dramatized in the American grain, exploring racism and prejudice with *The Chinese Friend* (1969) and taking such problematic figures as Patty Hearst (*Patty Hearst,* 1975) and Henry Kissinger (*Kissinger,* 1976) as dramatic subjects. His increasing concern with American themes has made him a translational figure who writes from the intersection between American and European culture. Most of his work is cerebral as is the case in European drama:

the Pirandellian exploration of life as theater and the human condition as a trap to be escaped by adopting a mask are constant themes in his plays. *The Academy* stands alone as a universally humorous treatment of the Italian view of Americans. Set in postwar Italy, it represents the adventures of aspiring gigolos who attend special classes in European charm in order to secure the attentions of rich American "patronesses." Fratti is also responsible for the adaption of Fellini's *8½* into the hit Broadway musical *Nine* (1982) for which he won several awards. His daughter, Valentina, now heads her own successful Off Broadway group, the Miranda Theater Company.

At this time, the La Mama Plexis also produced a playwright named Greg Antonacci (1948–), who, in 1975, graduated from the downtown scene to Broadway with the "free-fall-back-into-the-'50s musical," *Dance With Me,* a *Grease* "soundalike" which Antonacci created and starred in for its year's run at the Mayfair Theater. He then left for the more lucrative field of television where he starred as girl-chasing taxi driver Vinnie Mordabito in *Busting Loose,* a 1977 television series on CBS for which he also served as staff writer. He is representative of many others of his generation who used the theater only as a launching pad into television and who are thereby lost to the theatrical historian.

The 1970s
The 1970s continued to yield Italian American playwrights in such profusion that a cursory glance at the catalogues of either French's or the Dramatists Play Service produces an impressive list of names ending with vowels. Hailing from all parts of America, most of these writers were never produced in New York City, even non-commercially. Like it or not, American theater has come to mean plays produced and reviewed in New York City.

Although most of the new breed of ethnic and regional playwrights who made it to New York created their theatrical magic downtown and uptown (Harlem was experiencing a second renaissance as well), Broadway did see a number of productions by Italian American playwrights. Leonard Melfi moved on Broadway with *Morning, Noon, and Night* (1967); *Jack and Jill,* which was produced as part of *Oh! Calcutta!* (1969); and *Taxi Tales* (five short plays, 1978). The Off-Off Broadway veteran from Hoboken, N.J., Lewis LaRusso II (1935–), also scored a number of successes on Broadway: *Lamppost Reunion* (produced at the Little Theater, 1975), *Wheelbarrow Closers* (produced at the Bijou Theater, 1976), and *Knockout* (1979). A playwright who works in the "old semi-realistic and tough school," as the reviewer Clive Barnes put it (*New York Times,* 12 October 1976), LaRusso set out his universe of thematic concerns in *Lamppost Reunion,* which

treated a reunion in a nasty dive in Hoboken where a singer named Fred Santora (obviously, a cipher for Frank Sinatra, a figure intrinsic to Hoboken mythology) returns to his old haunt after a triumphant concert in New York. What ensues is a booze-filled night of reminiscences and recriminations, expressed in the raw, alcohol-edged language that is LaRusso's trademark, in which the singer, now a world-renowned celebrity, encounters his cronies of twenty years ago, who remain confined to the small world of the "Lamppost Bar." Joseph Bologna (1936–) and his wife and collaborator Renee Taylor wrote and starred in *Lovers and Other Strangers* (first produced on Broadway at Brooks Atkinson Theatre, 1968), a delightful comedy treating the wedding of a young Italian American to an Irish-Catholic girl. The couple's typically "modern" (late-sixties, post-sexual revolution) courtship and wedding ceremony precipitates marital crises in both their families. The play was successfully converted into an equally charming and hilarious film by the same name in 1970. Bologna and Taylor subsequentally collaborated on *It Had to Be You,* which was produced Off Broadway and made into a film in 1971. After writing the screenplay for the Italian-Jewish love story *Made for Each Other* (1971), they turned to television collaborating on a number of teleplays including the Emmy-winning *The Acts of Love and Other Comedies* (1973).

These incursions into Broadway would set the stage for two young Italian American playwrights who would achieve major mainstream successes in the course of the 1970s: Michael Cristofer (born Michael Procaccino in White Horse, New Jersey, in 1945) and Albert Innaurato (born in Philadelphia in 1948). Both of these playwrights vaulted onto the New York scene in the mid-seventies in a way that matched Carlino's triumphant entrance in the 1963–1964 season. Although Cristofer, himself a gifted actor, had demonstrated his theatrical sense in such earlier works as *The Mandala* (1968), *Plot Counter Plot* (1971), and *Americomedia* (1973), it was *The Shadow Box* (produced in Los Angeles, 1975; New York, 1977) that would establish him as a master of dramatic language and of the scenographic language of theater. Both of these dimensions are already at work in his play's suggestive title, itself an elaborate word play announcing the "shadow boxing" with death. To describe the play as a contrapuntal representation of three terminally ill cancer patients living out their final days in a hospice does not adequately express the being toward death and the intensification of life the three protagonists experience. The three, although visited by figures from their personal life, are never allowed to meet. Only at the play's closure do they emerge as a chorus, pronouncing, in turn and in the face of death, the "Yes" of affirmation and the last words, "This moment." *The Shadow Box* was awarded the Pulitzer Prize and Tony Award.

Albert Innaurato, a Yale Drama School graduate, after his award-winning Off-Broadway play *The Transfiguration of Benno Blimpie* (produced in New Haven, Conn., 1973; New York, 1975), wrote the long-running hit *Gemini*, which was first produced Off-Off Broadway at Playwrights' Horizon, 1976; then Off Broadway at Circle Theatre, 1977; and finally on Broadway at the Little Theatre, 1977. Both plays deal with the same subject matter: the sub-cultural world of south Philly Italian Americans who express their frustration, hopelessness, and helplessness in what Innaurato calls "bizarre behavior." These ghettoized Italian Americans are so brutalized by the harsh realities of poverty and emotional deprivation that they in turn brutalize those with whom they come into contact. Both plays are written from what might be construed as an anti-Italian perspective since Innaurato's characters range from cartoonish at worst to gargoyles at best. Although *Gemini* received the wider notice and acclaim, *Benno Blimpie* is the more powerful work of art by virtue of Innaurato's exaggeration of his portraits of intrinsically unappealing, rather despicable characters to such a degree that they become grotesques, at once ludicrous and monstrous, shocking and illuminating.

The growing number of New York City–based Italian American dramatists led to the formation of the Forum of Italian American Playwrights, an organization dedicated to the creation of a truer ethnic image by bringing together and fostering the talents of playwrights and theatrical artists of Italian American heritage. The preliminary meeting was held on 17 September 1975 at Ken Eulo's Courtyard Playhouse on Grove Street in Greenwich Village. Attending were Mel Arrighi, Philip LoGiudice, Ted Pezullo, Frank Biancamano, Fred Freda, Anthony Inneo, Mario Fratti, and Leonard Melfi. The organization was chartered as a not-for-profit corporation in March 1977 with Ken Eulo acting as the first president and Mario Fratti as vice president. The remaining charter members made up the board of directors, with the addition of Julie Bovasso and Louis LaRusso. Three years later, Jo Ann Tedesco was added to the board and introduced Donna de Matteo as an eventual replacement for Julie Bovasso.

Playwright Ken Eulo, who founded the Courtyard Playhouse, has since retired from the theater to write mystery novels. Mel Arrighi (1933–1986) was one of those rare writers who was equally at home in fiction and in drama. Given the luxury of prose with which to describe and to motivate characters, novelists rarely are able to distill such information into its essence—a play. A true dramatist must create a sense of place with dialogue alone, scenery not excepted. Having had twelve novels, including *Turkish White* (New York: Harcourt, 1977), published by major publishing houses and well received by the critics, Arrighi also saw three of his plays produced on and Off Broadway: *An Ordinary Man* (Cherry

Lane Theater, 1968), *The Castro Complex* (Stairway Theater, 1970), and *Unicorn in Captivity* (Impossible Ragtime Theatre, 1978). Unfortunately, he died an untimely death after such a prodigious start. One marvels at his exclusion from lists of Italian American writers—I wonder how many others like Arrighi have slipped through the holes in the literary record.

Indeed, a number of playwrights and theatrical artists are not perceived as being Italian American, an ethnic group whose public identification is primarily determined by a vowel-marked surname. For example, the Pulitzer Prize–winning playwright Michael Cristofer (Michael Procaccino) has chosen to work under a pseudonym. Others who have married (Julie Boyd, born Julie Mamanna) or who are half-Italian genetically, but almost completely Italian American culturally, tend to disappear from the tally by virtue of "foreign" surnames. Mark Blickley, a perfect example of the latter, was raised by the maternal "Mirabella" side of his family and writes from a decidedly New York ethnic sensibility in such plays as *The Milkman's Sister* (in development) and *The World's Greatest Saxophone Player* (produced in New York City at the Actors Theater of America, 1985). There are even those who are Italian but for one paternal grandfather, such as the Steve McQueen look-alike, actor Gary Swanson, who rightly claims to be more Italian than Robert De Niro. But who would ever know? And who knows how many "closet Italian" playwrights have "passed" in like manner?

The Forum was designed, in fact, to define the identity of contemporary Italian American theater and to serve as a support system. One of the most positive developments of the seventies and eighties has been what Helen Barolini has described as the "vigorous and notable burst of dramatic works from young Italian American women playwrights, some of which have been presented by companies like New York City's Forum of Italian American Playwrights and Il Teatro del Rinascimento" (Barolini, 1985). Emerging on the New York scene in the 1970s were a number of woman playwrights who bonded at the Forum and who would remain active through the 1990s. Donna de Matteo (1941–), for example, initiated her career with *The Barbecue Pit* (produced Off Broadway at Theatre East, 1969), a family drama in which the parents of a blind son come to grips with their personal tragedy by learning to let their son live as himself. Since the early 1970s, she has taught playwriting at the Herbert Bergoff Playwright Foundation where many of her plays have been produced: *The Ex-Expatriot* (1972), *The Paradise Kid* (1974), *Almost on a Runway* (1976), *The Animal Lovers* (1977), *Rocky Road* (1981), *The Silver Fox* (1983), and *The Flip Side* (1993). *Dear Mr. Giordano* was produced Off Broadway at Roundabout Theater in 1975. A writer in the Neil Simon school of playwriting and often compared to him, she treats, in a number of her plays,

the unexpected "at-home" life of the *Mafioso* and his family. Her domestic comedies as a rule portray women within the wider context of family life. *Rocky Road*, for example, tells the story of a middle-aged surburban housewife, Lynn, who suffers a nervous breakdown after her huband falls in love with a younger woman but who eventually emerges as a strong women, exiting the family to become a stand-up comic. The title refers to the ice cream flavor, and the play begins with Lynn's disastrous attempt to free, at her children's behest, a pint of Rocky Road frozen to the refrigerator—disastrous in that in wresting it free, she experiences a bone-breaking fall from the kitchen window. Throughout much of the play, she remains confined to a head-to-toe cast, her physical condition a comic metaphor for her fractured marriage and the psychic "casting off" she must undertake to stand free. A number of de Matteo plays, however, are woman-centered. For example, *Silver Fox* examines the interaction—a power struggle—among four generations of Italian American women, as presided over by the great-grandmother, a former abortionist. The theme of abortion returns in *There She Is, Ms. America* (in development in 1995), a play about four women who enter a hospital in New York to have abortions. Everything goes awry in the inefficient—almost screwball—hospital, and one of the woman, instead of having an abortion, winds up having a baby. This turn of events produces all sorts of internal and external conflicts among the other patients, who represent a cross section of American women.

As a Forum playwright I am also concerned with dramatizing the everyday life of Italian Americans. My plays include: *Sacraments: A Not-So-Divine Human Comedy* (produced at the Public Theater, 1978; Harold Clurman Theater, 1984); the double bill, *On the Rocks* and *The Wearing of the Green* (Thirteenth Street Theater, 1980); *I Thought You Had the Goddamn Blues* (Courtyard Theater, 1981) *There Will Be No Intermission* (Thirteenth Street Theater), and *Perfidia* (California State Theater, Sacramento, 1995). *Perfidia* treats a little-known episode in *la storia,* one that is shared with the Japanese American community: the internment of non-naturalized Italian Americans in a camp in Elmira, New York, during World War II. *Of Penguins and Peacocks,* starring Liliane Montevecchi as Sarah Bernhardt and Taina Elg as Eleonora Duse and directed by Tom O'Horgan, was in development in 1995.

In the early 1970s, Marisa Gioffre, another Forum playwright, had her play *Bread and Roses,* a historical documentary of the feminist movement, produced at Riverside Church in New York City and at colleges throughout the country. The play, a series of vignettes and speech excerpts interspersed with songs, sets out an overview of feminism that extends from the attacks on Susan B. Anthony and Elizabeth Cady Stanton to the 1969 Abortion Hearings. Rosemary De Angelis,

an Obie-winning actress who joined the Forum as a poet, staged dramatizations of John Fante's fiction and completed her first screenplay in collaboration with her sister Aggie Garret. There are also a number of other promising woman playwrights who operate outside New York City. Among them are two West Coast writers: the Los Angeles–based Rosemarie Caruso whose award-winning *The Suffering Heart Salon* was produced in Los Angeles in 1983; the San Francisco–based Michele Linfante whose one-act play *Pizza* was published by West Coast Plays, Berkeley, California in 1980.

An account of the theater of the 1970s would be incomplete without mention of street theater. The work of Peter Copani (1942–), who was hailed by the *New York Times* (19 August 1973) as the "leading playwright of the streets," is an interesting fusion of ancient Roman-Italian public spectacle and urban theater. A native of Syracuse, New York, he was a trailblazer in New York City street theater with his one-act musical *Street Jesus,* which was produced by Union Betterment People's Performing Company in July, 1973. Dubbed the "Bard of the Streets" by the media, Copani expressed his artistic vision in a form that was most natural to him. A former junkie who had lived on the streets, he confronted, in generating *Street Jesus,* the warring Italian and Puerto Rican gangs of Park Slope, Brooklyn. Copani courageously sought to show the aggressive neighborhood youths how to siphon off their hostilities through dramatic expression and to transform their factionalism into theatrical collaboration. Copani explained his strategy in some detail in an interview for *Contemporary Authors,* 89–92 (1980):

> *My working procedure involves going into a community, working with the people to discover their feelings, anxieties and aspirations, and then writing a musical dealing with those people in a way that articulates and expresses their emotions. This process contributes to their level of consciousness, to their understanding of their own lives. It takes me one year to do the research of working with the people of a given community, to write up the musical, to do a neighborhood production, and then to formulate a final draft of the show.*

This groundbreaking, social approach to theater culminated in the powerful and eloquent *Street Jesus* and in an oeuvre that includes such public performances as *The Blind Junkie* (produced in New York City at Lincoln Center Festival, 1971), *Power* (produced in New York City by People's Performing Company, 1973), *The Great American Soccer Family* (a one-act musical produced Off-Off Broadway at Provincetown Playhouse, 1975), and *The New York City Street Show* (produced in

New York City at Greenwich House, 1977). In 1975 Copani was awarded a City of New York Certificate of Appreciation by Mayor Abe Beame.

Among the strongest and most language-oriented of the Italian American dramatists is the experimental playwright Frank Gagliano who was born in Brooklyn, New York, in 1931. Writing in *Contemporary Dramatists* (1988), the drama historian A. Richard Sogliuzzo has called Gagliano "one of the most daring, imaginative, and poetic playwrights in the American theatre." Gagliano's plays include *Conerico Was Here to Stay* (1966), *In the Voodoo Parlour of Marie Laveau* (1973; a revised version produced in New York City, 1983), *The Private Eye of Hiram Bodoni* (produced in New York City, 1978), and *The Total Immersion of Madeleine Favorini* (Las Vegas, Nevada, 1981). Gagliano's first notable New York production was *City Scene,* a double bill comprising *Conerico Was Here To Stay* and *Paradise Gardens East* (produced Off-Broadway at the Fortune Theater, 1969), two excursions into urban life New York City–style. *Conerico* is set on a subway platform, deserted but replete with graffiti. Having mysteriously lost his hat, a young man who, as the audience eventually learns, is suffering from amnesia brought on by his younger brother's suicide, awakens from sleep on a bench to witness a series of surreal scenes involving disassociated characters: a blind man thrashing wildly with his cane, a girl with a cello pursued by men who will eventually rape her, a mysterious stanger named Jesus and the like—the phantasmagoria of urban life with all its violence and abrasiveness. In *The Total Immersion of Madeleine Favorini,* a play central to the Italian American canon, Gagliano has his woman protagonist Madeleine Favorini, a repressed librarian locked in the stirrups of a gynecological examining table, take a mental—hallucinatory—voyage to Sicily, her ancestral home, where she encounters the various forms and spirits of the place, metamorphosizing into a variety of identities. The actress playing Madeleine and the other two members of the cast portray twenty characters. This theatrical device of role changing underscores the psychic metamorphosis that Madeleine undergoes as she journeys from the despair of her American self to a Dionysian encounter with her motherland where she herself is transformed into an earth mother and initiated into the mysteries of Sicily. What Gagliano is staging here is nothing less than the psychodrama of the Sicilian American self as it confronts its personal and collective past. Only after Madeleine has been initiated into the archaic mysteries of Sicily is she able to liberate herself from her demons and to become as weightless as language. As she puts it in her affirmative last words, "Yes! Yes! I know what I want. I know what I mean! I want to become—language! Language!"

Also deserving of mention are two playwrights who made brief appearances in the 1970s and then vanished from the scene: Henry Salerno, a Forum

Member, whose tendentious political play about the ongoing racist treatment of the American Indian by the American government, *The Only Good Indian* (co-authored by Mario Fratti) was produced in New York City at the Theatre for the New City in 1975; and Jasper Oddo whose *A Barber Shop in Pittsburgh* was produced in New York City at the State Maximus at the the Changing Space in 1977. At the close of the decade, Dan Lauria, nationally known as the father on television's *Wonder Years,* wrote his first play *Game Plan* which was produced at Theater Four in New York City. Gene Ruffini, a journalist-screenwriter with a score of Off-Off-Broadway workshops and productions to his credit, founded his own Italian American Repertory Theater. His plays performed in New York City include *The Choice* (produced at the Double Image Theater, 1976), *Angelis* (produced at American Theater for Actors, 1978), and *A Grave Encounter* (produced at the Double Image Theater, 1988).

The 1980s and 1990s

The 1980s saw the continuing production of such senior playwrights as Melfi, Fratti, and Gagliano, all of whom were born either just before or during the thirties. The younger generation, as epitomized by Cristofer and Innaurato, continued to consolidate and extend their work while a number of new voices emerged.

Although born in 1930, Joe Pintauro, a former Roman Catholic priest, made his first appearance as a playwright in 1977 with the production of *Cacciatore I, II, III,* (three one-act plays first produced in New York City at the Actors Repertory Theater). A successful poet and novelist before his turn to drama, the New York–born Pintauro established himself as a strong playwright in the eighties, beginning as a dramatist of the Italian American experience and then moving on to explore other worlds, with sexuality and all its heterosexual and gay permutations. Among his plays, many of which were originally produced by the Circle Repertory Company in New York City (where Pintauro is a playwright-in-residence), are the following: *Snow Orchid* (Circle Repertory, 1980), *The Orchid Man and the Black Swan* (Circle Repertory, 1982), *The Hunt of the Unicorn* (Circle Repertory), *Wild Blue* (Perry Street Theater, 1987), *On the Wing* (Barrow Group, 1987), *Beside Herself* (Circle Repertory, 1989), *Moving Targets* (Vineyard Theater, 1990), *The Raft of the Medusa* (Minetta Lane Theatre, 1991), and *Men's Lives* (Bogstreet Theater in Sag Harbor, New York, 1992).

Often compared to Alberto Innaurato whose grotesque and operatic mode of writing he often approaches, Pintauro is one of the central playwrights in the Italian American canon. A number of his plays (and novels) quite accurately reflect Italian American life and sensibilities either when he takes *la famiglia* as a

theme as in *Cacciatore* and *The Snow Orchid* or when he introduces a single character who serves as the bearer of the Italian American worldview as in *Men's Lives* (1994), a drama about fishermen. In *Cacciatore,* for example, he explores the Italian American milieu in three dissonant melodramas of domestic confrontation. In *Cacciatore I,* two brothers, Vito and Charlie DiGiovanni, meet in a room of the house they both share and reminisce fondly about their beloved dead brother only to discover that they are talking about their own relationship. As the heated and resentful conversation explodes into a moment of violence, Vito and Charlie recognize that the positive image they each project onto their dead brother is a mirror of what each finds lacking in the other. *New York Times* drama critic Thomas Lask pointed out, in his review of *Cacciatore* (10 May 1977), that Pintauro's two great strengths as a dramatist lie in "an ability to write pungent, idiomatic urban speech, and a willingness to let human passions overflow on the stage." (By the way, the title refers to chicken *cacciatore,* chicken hunter-style, its pervasive aroma symbolizing the Italian American household.) Pintauro continued his exploration of the passionate tensions and operatic dynamics of the Italian American family in *Snow Orchid,* a portrayal of a Brooklyn family breaking free from fears of the past.

Pintauro is a prolific writer of short plays and brief sketches that take up provocative issues, sometimes bluntly (*Wild Blue* comprises eight one-act plays, two of which are concerned, respectively, with homosexual incest and the "outing" of a gay Roman Catholic priest), sometimes absurdly (*On the Wing,* for example, is a series of playlets treating the subject of birds and flying, one of which *[Butterball]* is about four turkeys eating a human, a perverse commentary on American consumerism). His work culminated in the critically acclaimed *The Raft of the Medusa* (Minetta Lane Theater, 1991), a one-act drama about an AIDS support group whose members are patients of a gay shrink. Taking his title from Theodore Gericault's haunting 1819 painting of shipwreck survivors clinging to a raft in rough seas, Pintauro portrays the sometimes banal, sometimes heated interactions among twelve characters, representing a broad cross section of AIDS victims—straight as well as gay—whose bantering group talk explodes into a terrifying moment of truth when one of the group's members is discovered to be an impostor (a reporter in search of a story).

Throughout the 1990s, Pintauro has been riding a wave of success. Four of his plays, including *Snow Orchid* and *The Raft of the Medusa,* have traveled to London where they were produced by the Royale Court Theatre and received critical acclaim. In December 1995, the entire cycle of his twenty-six one-act plays was produced in Chicago by the Dolphin Back Theater under the title *American Divine.* The attention he has received is, in part, the result of his bold treatment,

typically described as "raw" and "strident," of controversial issues—many of which relate to the American sexual persona in the age of AIDS. In turn, criticized for making melodramatic what is tragic and praised for the operatic and direct forcefulness of his melodramatic scenarios, he remains one of the primary dramatists of the Italian American culture of scenes, situating the various eruptions of what has been repressed (the past, resentment, violence, sexuality, homosexuality) within the sanctum of the house, the family, the church, and, as in *The Raft of the Medusa,* the support group. Pintauro himself is the embodiment of the articulate, highly educated, and cultured writer that one usually associates with the more sophisticated European man of letters, and thus his persona presents a sharp contrast to the harsh realities he depicts in his art. Despite—or perhaps because of—his success, Pintauro is an acute diagnostician of the seldom addressed pitfalls awaiting the Italian American writer.

Of the new playwrights, perhaps the most noteable—and definitely the most controversial, given his plays' concern with sexual conflicts—is William Mastrosimone (1948–). Born in Trenton, New Jersey, this dramatist has had a string of successful national and international productions: *The Woolgatherer* (New Brunswick, N.J., 1979; New York City, 1980; London, 1985), *Extremities* (New Brunswick, N.J.,1980; New York City, 1982; London, 1984), *A Tantalizing* (Louisville, 1985), *Shivaree* (Seattle, 1983), *The Undoing* (Louisville, 1984), *Nanawatai* (produced in Norwegian, Bergen, Norway, 1984; produced in English, Los Angeles, 1985), *Tamer of Horses* (New Brunswick, N.J., 1985; revised version produced in Los Angeles, 1986; revised version produced, Seattle, 1987), *Cat's-Paw* (Seattle, 1987), *The Understanding* (Seattle, 1987). In *Extremities,* his most well-known play, Raul, an intruder and would-be rapist, is stymied when his intended victim Marjorie temporarily blinds him with bug spray and then proceeds to turn into the torturer. When Marjorie's two woman roommates return home and come to witness her escalating violence toward her victim(izer), a number of mind games ensue among the four protagonists in which gender and personal allegiances are violated and social questions regarding America's culture of violence are probed. Mastrosimone adapted his play for the 1986 movie *Extremities* starring Farrah Fawcett. In *The Undoing,* a latter-day version of Tennessee Williams's *Rose Tattoo,* Mastrosimone employs Italian American characters, including Lorraine Tempesta, a widowed mother who runs a chicken market of sorts and whose mothering of her daughter is oppressively Italian; and a chorus of two old Italian women. One of his most beautiful plays, *The Stone Carver,* published in his *Collected Plays* (1994), deals directly with the problems of an assimilating second-generation son in conflict with his first-generation father. A morally courageous explo-

ration of the "Second Generation Syndrome," the play has been produced by Joe Brancato only outside New York, but a New York City production is in the planning stage (as of 1995).

The versatile Richard Vetere (1952–), whose first book of poetry *Dream of Angels* was published in 1984 by Northwood Press, had his play *Rockaway Boulevard* produced at Actors Studio in 1978 and has continued to find success as a playwright: *The Engagement* was produced in 1991 at the George Street Theater in Princeton, New Jersey; *The Marriage Fool* in 1994 at the Penguin Repertory Theater in New York City; and *Gangster Apparel* in 1995 by Igloo at Here in New York City. His one-act "Hale (Nathan) the Hero" was produced by General Motors' Playwrights' Theater on the Arts and Entertainment (A&E) television network in 1992. *Vigilante,* for which he wrote the screenplay, was the twentieth highest grossing film of 1983, and more of his screenplays are slated for production.

Also to be mentioned is the actor Chazz Palminteri who wrote and performed the hit one-man play *A Bronx Tale* (1989), which began its life in Dan Lauria's dramatic workshop in Los Angeles and was then moved to Playhouse 91 in New York City. Based on the New York–born actor's experience of growing up in the street-corner world of the Bronx in the 1960s, the ninety-minute monologue recounts the story of Palminteri's own childhood and adolescence when he was taken under the wing of the neighborhood gangster named Little Johnny. Palminteri's young man narrator is caught between the conflicting mentorships of the street-smart Little Johnny (his credo: "The working man is a sucker") and his father, a hard-working bus driver who embodies the values of the straight world. Interspersed with musical snippets by Dion and the Belmonts, the monologue is a rich evocation of blue-collar Italian American life in the Bronx enclave (187th Street and Belmont Avenue), replete with the time-honored tests of street loyalty and the usual suspects: Eddie Mush, Frankie Coffee Cake, and Gigi the Whale. Somewhat unforeseen, however, is the climatic moment of this coming of age narrative which involves, among other things, a border-crossing first romance with an African American girl. Optioned by Robert De Niro to be his directorial debut, the play was aptly developed, in 1993, into a very beautiful and very successful film, in which De Niro and Palminteri both starred.

Another darker and distressingly nihilistic view of the Italian American subculture was presented by Frank Pugliese (1974–) in *Aven'U Boys,* the title a marker of the subliteracy of the trio of Italian American teenagers who are the protagonists. Produced Off-Broadway in 1993, the fragmented play unfolds as a series of violent racial and sexual vignettes set in Brooklyn, New York. Whereas *A Bronx Tale* is a kind of extended rock 'n' roll ballad dedicated nostagically to the

small world of the Italian American enclave and the law of the street informing it, the *Aven'U Boys* is an apocalyptic rock video that terrifyingly documents that small world gone bad in the 1990s. The law of the street degenerates into lawlessness; the masculine code is reduced to brutal macho displays and sado-masochistic rites; the gentle interracial romance becomes a passionate encounter between one of the "boys," the most sensitive of the trio, and a black woman, a union that is doomed from the very start in this world—the smallest of all possible worlds—of racial hatred and aggravated territorialism. The chaos of this urban world in which nothing connects is brilliantly rendered by Pugliese through the disassociating use of flashbacks and the violent litany of subliterate verbal exchanges.

To end our survey of the 1990s on a campier note, I mention the Obie-winning Gerald Alessandrini's wildly successful Off-Broadway revue, *Forbidden Broadway 1993*, the twelfth installment of his wicked spoof of Broadway and its narcissistic superstars, such as the two Italian American divas Patti LuPone and Liza Minnelli.

Ethnicity and Personal History

Whereas the writer Gay Talese has bemoaned the reluctance of Italian American novelists to write of their ethnic experiences and to betray family secrets, Italian American playwrights seem to revel in their ethnicity and personal history, as evidenced by this selective chronicling. Most of the aforementioned playwrights deal with, or at least portray, their ethnicity in their work and write plays that confront the great mystery of the Italian American family, whether implicitly or explicitly. Those clannish, possessive Italian families seem to have been accepting of dramatic expression while discouraging the reading and writing of books. Theater was in no way foreign or threatening to them. In fact, theatrical expression has been an integral aspect of Italian American cultural life: Sicilians brought their puppets and puppet theater across the ocean, as Agrippino Manteo's *Papa Manteo's Life-Sized Marionettes* (established in New York City in 1919) so beautifully exemplify. Early Neapolitan immigrants brought their traditional forms of theater and even the theater companies themselves to the New World, as mentioned previously. One can find a depiction of one of these early theaters that catered to the entertainment needs of the immigrants in *The Godfather Part II* (1974).

This was precisely the type of company in which the late Vincent Gardenia (Cardenia) worked as a young child and which thrived into the 1960s. It was his

father, Gennaro Cardenia, who carried on the family's theater company, a prime example of the "Little Italy" theaters. Emelise Aleandri, the authoritative source on Italian American theater through 1920, discovered that Vincent Cardenia's father's company shared theaters and even the costumes of the Yiddish theater during those early days on the Lower East Side. Her research yielded a notice crediting Luther Adler for costumes. Although the love of theater was mutual, the Jews translated plays they would see uptown into Yiddish, while the Italians performed only old Italian chestnuts and their own improvised comedy spoofs, many of which were recorded at Coney Island. The Jews were learning the ways of the New World early in their immigration, while the Italians preferred the comfort of the old and the familiar.

For better or for worse, the bulk of the Italian American population preferred—and still does—familiarity and the insular protection of tradition. It is entirely predictable that the Italian American immigrants would cling to their usual entertainments even in the New World. The uniquely Neapolitan tradition of the *macchiette* and other satirical routines enacted by broad-styled actors is but the continuation of an ancient tradition. Bearing in mind Luigi Barzini's eloquent description of the Italian inventive and expressive use of gesture, it is not surprising that it creeps into its drama. Indeed, the immigrant theater, along with oral storytelling, and the opera, was the primary means by which tradition was handed down. From firsthand experience, I personally wrote my obligatory autobiographical play, so that my children would know their deceased grandmother and great-grandmother.

The spectacle inherent in the southern Italians' religious rituals, parades even their decorating and clothes, filtered down into their earliest American theatrical ventures and provided a cultural comfort zone for the alienated immigrant. The progeny of those same most noble of pilgrims have found a new home, a new language, and a new theater. The dilemma of the Italian American playwright would seem to be that of finding a theatrical language that expresses the drama of ethnic identity while operating within the theater of the primary American culture, but that is not the case. A real artist absorbs from and fuses whatever language he hears into one of his own that is elevated and yet the same. The hack writer only parrots back while the real writer synthesizes—and it shouldn't be just one language or vocabulary that he uses. Just as a real actor can assume different personae, so the real writer must be able to write different voices. Some do.

On a personal note, I mention my own somewhat isolated attempt to explain the central role played by the Catholic Church in the Italian American experience. In theater and film to date (1995), Catholicism has been used pri-

marily as a backdrop rather than as an intrinsic or structuring element of the work. My play *Sacraments* stages the rite of passage to Americanization of a second-generation female in terms of Italian American Catholicism as marked by the family celebrations of the seven sacraments of the pre–Vatican II period. The varying degrees of the actual profession of the faith are fleshed out in the various characters, and the viewer witnesses the discrepancy between the beauty of principles lived and the compromise of principles merely affirmed or given lip service. The constant juxtaposition of the sacred and the profane, the sublime and the ridiculous is part of an attempt to articulate the contradictions through which Italian Americans have collectively lived out their ethnic lives. Written before the trivialized representations of family life epitomized by *Moonstruck,* the play depicts the cultural straddling many intellectuals faced in the journey to assimilation.

Looking Ahead

What does the future hold for the Italian American theater? Although Italian American playwrights appear more frequently, they have not had the mainstream impact, especially with respect to their representation of ethnic experience, that third-generation filmmakers have had. They seem more comparable to Eduardo De Filippo, the wonderful Neapolitan actor-playwright, who toiled in the Neapolitan theater unknown to the world until Vittorio De Sica among others made his small works of true art into internationally applauded films. Italian American playwrights also seem to create smaller, more personal works that seem almost made for the screen. They have yet to exploit their own experience so as to produce dramas that enter the American imagination in the way that Arthur Miller's *View from the Bridge* (1955) or Tennessee Williams' *Rose Tattoo* (1951) do. (Then again, what plays since these have?) Neither have they altered the course of twentieth-century theater as the great Italian modernist Luigi Pirandello did and as the postmodernist Dario Fo continues to do. What the second and third generations of Italian American playwrights have accomplished is to begin to forge an authentic voice that is faithful to their own dramas of assimilation and to the "sacraments" of everyday life.

I end with a statement so intrinsically Italian American that it exemplifies precisely the kind of attitude that stops those Italian Americans intellectually competent and artistically gifted from making that final push: ***Pazienza!*** (an Italian invocation that means patience is called for in a given situation but also suggests that one must adapt oneself to the way the world works). For those giants in the

theater—Pirandello, Williams, Miller, Fo—we must wait patiently. There are never too many of them in a generation. How many Broadway or uptown playwrights are even remembered after their arrival on the theatrical scene? However, I must admit to a little warm spot in my heart when another one of "us" gets his or her wings.

Pazienza!

Further Reading

Bibliographic Resources

The basic work on early Italian American theater is Emelise Aleandri's *A History of Italian American Theatre in New York City* (Ph.D. diss., City University of New York, 1983). An actress, director, and co-host-producer of *Italics: The Italian American Magazine,* a nationally aired television program, Aleandri has recently produced a videodocumentary titled *Teatro: The Legacy of Italian-American Theatre* (a co-production of City University Television and the John D. Calandra Italian American Institute/CUNY, 1995). A history of contemporary Italian American theatrical culture from the 1950s to the present remains to be written. Short but comprehensive surveys of the work of Julie Bovasso, John Carlino, Mario Fratti, Frank Gagliano, Albert Innaurato, William Mastrosimone, and Leonard Melfi may be found in *Contemporary Dramatists* (Chicago and London: St. James Press, 1988).

Aleandri, Emelise. "Women in the Italian American Theatre of the Nineteenth Century." In *The Italian Immigrant Woman in North America,* eds. B. Caroli, R. Harney, and L. Tomasi (Toronto: Multicultural History Society of Ontario, 1978).

―――. "Italian-American Theater." In *Ethnic Theater in the United States,* ed. Maxine Schwartz Seller (Westport, Conn.: Greenwood Press, 1983): 237–258.

Barolini, Helen, ed. *The Dream Book: An Anthology of Writings by Italian American Women* (New York: Schocken Books, 1985): 269–296.

Barzini, Luigi. *The Italians* (New York: Atheneum, 1964).

Bonim, Jane F. *Mario Fratti* (Boston: Twayne, 1982).

Di Scipio, Giuseppe C. "Italian-American Playwrights on the Rise." *Journal of Popular Culture* 19, no. 3, 1985: 103–108.

Fratti, Mario. "Italian-American Playwrights." *La parola del popolo* (September–October, 1976): 281–283.

Livingston, Arthur. "La Merica Sanemagogna." *Romanic Review* 9, no. 2 (April–June, 1918): 206–225.

Singer, Mark. "Manteo's Marionettes." In *The Big Book of Italian American Culture,* ed. Lawrence DeStasi (New York: Harper, 1990): 67–68.

Canon: Italian American Dramatists (Selected Works)

—Compiled by Pellegrino D'Acierno

Arrighi, Mel. *An Ordinary Man* (first produced Off Broadway in New York City at Cherry Lane Theater, 9 September 1968); New York: Dramatists Play Service, 1969.

―――. *The Castro Complex,* (first produced in New York City at Stairway Theatre, 18 November 1970); New York: Dramatists Play Service, 1971.

———. *The Unicorn in Captivity* (first produced in New York City at Impossible Ragtime Theatre, 3 November 1978).

Blickly, Mark. *The World's Greatest Saxophone Player* (first produced in New York City at the Actors Theater of America, 1985).

Bologna, Joseph (with Renee Taylor). *Lovers and Other Strangers* (first produced on Broadway at Brooks Atkinson Theatre, 18 September 1968); New York: Samuel French, 1968.

Bovasso, Julie. *The Moon Dreamers: A Play in Two Acts* (first produced Off Broadway at La Mama Experimental Theatre Club, 1968; new version produced Off-Broadway at Ellen Stewart Theater, 8 December 1969); New York: Samuel French, 1969.

———. *Gloria and Esperanza: A Play in Two Acts* (first produced Off Broadway at La Mama Experimental Theatre Club, 1969; produced on Broadway at ANTA Theatre, 1970); New York: Samuel French, 1969.

———. *Monday on the Way to Mercury Island* (first produced, with *Schubert's Last Serenade*, Off Broadway at La Mama Experimental Theatre Club, 1971).

———. *Schubert's Last Serenade* (first produced, with *Monday on the Way to Mercury Island*, Off Broadway at La Mama Experimental Theatre Club, 1971; produced, with *Final Analysis* and *Supper Lover*, Off Broadway at La Mama Experimental Theatre Club, 1975); published in *Spontaneous Combustion: Eight New American Plays*, ed. Rochelle Owens (New York: Winter House, 1972).

———. *Down by the River Where Waterlilies Are Disfigured Every Day* (first produced in Providence, R.I., by Trinity Square Repertory Co., at Bridgham Street Theater, 20 December 1971; produced in New York City by Circle Repertory Co., March 1975).

———. *The Final Analysis* (first produced, with *Schubert's Last Serenade* and *Super Lover*, Off Broadway at La Mama Experimental Theatre Club, 1975).

———. *The Nothing Kid* (first produced, with *Standard Safety*, Off Broadway at La Mama Experimental Theatre Club, 1975.

———. *Standard Safety* (first produced, with *The Nothing Kid*, Off Broadway at La Mama Experimental Theatre Club, 1975).

Carlino, John. *The Brick and the Rose: A Collage for Voices* (produced in Los Angeles, 1957; New York, 1974; London, 1985); New York: Dramatists Play Service, 1959.

———. *Junk Yard* (one-act). New York: Dramatists Play Service, 1959.

———. *Used Car for Sale* (one-act). New York: Dramatists Play Service, 1959).

———. *Objective Case* (produced in Westport, Conn., and New York City, 1962); With *Mr. Flannery's Ocean*. New York: Dramatists Play Service, 1961.

———. *Mr. Flannery's Ocean* (includes *Piece and Precise*) (produced Westport, Conn., 1972); With *Objective Case*. New York: Dramatists Play Service, 1961.

———. *Two Short Plays: Sarah and the Sax, and High Sign* (New York: Dramatists Play Service, 1962).

———. *The Beach People* (first produced in Madison, Ohio, 1962).

———. *Postlude and Snowangel* (first produced in New York City, 1962).

———. *Cages: Snowangel and Epiphany* (two one-act plays) (first produced Off Broadway at York Playhouse, 14 June 1963); New York: Random House, 1964.

———. *Telemachus Clay: A Collage for Voices* (first produced Off Broadway, at the Writers Stage Theater, 16 November 1963); New York: Random House, 1964.

———. *The Dirty Old Man* (first produced Off Broadway, 1963). New York: Dramatists Service, 1964.

———. *Doubletalk: Sarah and the Sax and The Dirty Old Man* (two one-act plays) (first produced Off-Broadway at the Theater de Lys, 5 May 1964); New York: Random House, 1964.

———. *The Exercise* (first produced in Stockbridge, Mass., 1967; produced on Broadway, 1968); New York: Dramatists Play Service, 1968.

Screenplays: *Seconds,* 1966; *The Fox,* with Howard Koch, 1967; *The Brotherhood,* 1968; *Reflection of Fear,* with Edward Hume, 1971; *The Mechanic,* 1972; *Crazy Joe,* 1973; *The Sailor Who Fell from Grace with the Sea,* 1976; *I Never Promised You a Rose Garden,* with Gavin Lambert, 1977; *The Great Santini* (also director), 1979; *Resurrection,* 1981.

Copani, Peter. *The Blind Junkie* (produced in New York City at Lincoln Center Festival, 23 August 1971).

———. *Power* (produced in New York City by People's Performing Co., 7 June 1973 and at Lincoln Center Community Theater Festival, 30 August 1973).

———. *Street Jesus* (one-act musical) (produced in New York City by Union Betterment People's Performing Co., July, 1973).

———. *The Great American Soccer Family* (produced Off-Off Broadway at Provincetown Playhouse, summer, 1975).

———. *The New York City Street Show* (produced in New York City at Greenwich House, 1977).

Cristofer, Michael (Michael Procaccino). *The Mandala* (produced in Philadelphia, 1968).

———. *Plot Counter Plot* (produced in New York City, 1971).

———. *Americomedia* (produced in New York City, 1973).

———. *The Shadow Box* (first produced at the Mark Taper Forum in Los Angeles in 1977; produced on Broadway in 1977 and in London, 1979); New York: Drama Book Specialists, 1977.

———. *C.C. Pyle and the Bunyon Berby* (produced in Gambier, Ohio, 1978).

———. *The Lady and the Clarinet* (produced in Los Angeles, 1980; New York City, 1983); New York: Dramatists Play Service, 1985.

Screenplays: *Falling in Love,* 1985; *The Witches of Eastwick,* 1987.

de Matteo, Donna. *The Barbecue Pit* (produced Off Broadway at Theatre East, 1969).

———. *The Ex-Expatriot* (produced in New York City at HB Playwrights Foundation, 1972).

———. *The Paradise Kid* (produced in New York City at HB Playwrights Foundation, 1974).

———. *Dear Mr. Giordano* (produced Off Broadway at Roundabout Theater, 1975).

———. *Almost on a Runway* (produced in New York City at HB Playwrights Foundation, 1976)

———. *The Animal Lovers* (produced in New York City at HB Playwrights Foundation, 1977).

———. *Rocky Road* (produced in New York City at HB Playwrights Foundation, 1981).

———. *The Flip Side* (produced in New York City at HB Playwrights Foundation, 1993).

———. *The Silver Fox* (produced in New York City at HB Playwrights Foundation, 1983).

Fratti, Mario. *Il Campanello* (produced in Milan, 1958; produced in New York City as *The Doorbell,* 1970); published in *Ohio University Review* (Athens), 1971.

———. *The Academy* (produced in New York, 1963); published in *The Cage, The Academy, The Refrigerators* (New York: French, 1977).

———. *La Gabbia* (produced in Milan, 1963; produced in New York as *The Cage,* 1966); published in *The Cage, The Academy, The Refrigerators* (New York: French, 1977).

———. *I Frigoriferi* (produced in Pistoia, Italy, 1965; produced in New York as *The Refrigerators,* 1971); published in *The Cage, The Academy, The Refrigerators* (New York: French, 1977).

———. *Eleonora Duse* (produced in Sarasota, Fla., 1967; New York, 1980); New York: Breakthrough Press, 1972.

———. *The Victim* (produced in Sacramento, Calif., 1968; New York, 1973); published in *Eleonora Duse, The Victim, Originality* (New York: French, 1980).

———. *The Chinese Friend* (produced in Italy, 1969; produced in New York City, 1972); published in *Enact* (New Delhi), October, 1972.

———. *Four Plays* (includes *The Coffin, The Gift, The Friday Bench,* and *The Wish*) (Houston: Edgemoor, 1972).

———. *Races: Six Short Plays* (includes *Rapes, Fire, Dialogue with a Negro, The Refusal, The Other One*) (Newark, Del.: Proscenium Press, 1972).

———. *New York: A Tryptych* (produced in New York City, 1974).

———. *Patty Hearst;* published in *Enact* (New Delhi, 1975).

———. *Kissinger* (produced in California, 1976); published in *Enact* (New Delhi, 1976).

———. *Six Passionate Women.* Published in *Enact* (New Delhi, 1978).

———. *Nine,* book by Arthur Kopit, music and lyrics by Maury Yeston, adaptation of the screenplay *8 1/2* by Federico Fellini (produced Waterford, Conn., 1981; New York, 1982); New York: French, 1983.

Note: For a complete bibliography of Fratti's extensive output, see *Contemporary Dramatists,* ed. D.L. Kirpatrick (Chicago and London: St. James, 1988): 163–166.

Gagliano, Frank (Joseph). *Conerico Was Here to Stay* (first produced in New York, 1965). Included in *The City Scene,* 1966.

———. *Night of the Dunce* (produced in New York City, 1966); New York: Dramatists Play Service, 1967.

———. *The City Scene* (includes *Paradise Gardens East* and *Conerico Was Here to Stay*) (produced in New York at the Fortune Theater, 1969); New York: French, 1966.

———. *The Prince of Peasantmania (Inny),* music by James Reichart (produced in Waterford, Conn., 1968; revised version produced Milwaukee, 1970).

———. *In the Voodoo Parlour of Marie Laveau: Gris-Gris, and The Comedia World of Byron B* (produced Waterford, Conn., 1973); as *Gris-Gris, and The Comedia World of Lafcadio Beau* (produced in New York City, 1974) revised version, as *Voodoo Trilogy* (produced in New York City, 1977); revised version, as *In the Voodoo Parlour of Marie Laveau* (produced in New York City, 1983).

———. *The Private Eye of Hiram Bodoni* (produced New York, 1978).

———. *The Total Immersion of Madeleine Favorini* (produced Las Vegas, Nevada, 1981).

Gazzo, Michael. *A Hatful of Rain* (produced in New York City at the Lyceum Theater, 1955); New York: Samuel French, 1956.

———. *Night Circus* (produced on Broadway, 1958).

Grieco, Rose. *Anthony on Overtime* (produced at the Blackfriars Theater in New York City, 1961).

———. *Daddy, Come Home* (produced at the Blackfriars Theater in New York, 1962).

Innaurato, Albert. *Urlicht* (produced New Haven, Conn., 1971; New York City, 1974); Included in *Bizarre Behavior,* 1980.

———. *I Don't Generally Like Poetry But Have You Read "Trees"?* with Christopher Durang (produced New Haven, Conn., 1972; New York City, 1973).

———. *The Life Story of Mitzi Gaynor; or, Gyp,* with Christopher Durang (produced New Haven, Conn., 1973).

———. *The Transfiguration of Benno Blimpie* (New Haven, Conn., 1973; New York City, 1975; London, 1978); New Haven: *Yale/Theatre,* 1976.

———. *Earth Worms* (produced Waterford, Conn., 1974; New York City, 1977); Included in *Bizarre Behavior*, 1981.

———. *Gemini* (produced in New York City, 1976); New York: Dramatists Play Service, 1977.

———. *Ulysses in Traction* (produced in New York City, 1977); New York: Dramatists Play Service, 1978.

———. *Bizarre Behavior: Six Plays* (includes *Gemini, The Transfiguration of Benno Blimpie, Ulysses in Traction, Earth Worms, Ulricht, Wisdom Amok*) (New York: Avon, 1980).

———. *Passione* (also director; produced in New York City, 1980); New York: Dramatists Play Service, 1981.

———. *Coming of Age in SoHo* (also director; produced Seattle and New York 1984; revised version produced New York, 1985); New York: Dramatists Play Service, 1985.

La Russo II, Louis. *Lamppost Reunion* (produced in New York City at the Little Theater, 1975).

———. *Wheelbarrow Closers* (produced in New York City at the Bijou Theater, 1976).

———. *Knockout* (produced in New York City at the Helen Hayes Theater, 1979).

Mastrosimone, William. *The Woolgatherer* (produced in New Brunswick, N.J., 1979; in New York City at the Circle Repertory Theater, 1980; London, 1985). New York: French, 1981.

———. *Extremities* (produced in New Brunswick, N.J., 1980; in New York City at the Westside Arts Center, 1982; London, 1984); New York: French, 1984.

———. *A Tantalizing* (produced in Louisville, 1982); New York: French, 1985.

———. *Shivaree* (produced in Seattle, 1983); New York: French, 1984.

———. *The Undoing* (produced in Louisville, 1984).

———. *Nanawatai* (first produced in Norwegian, Bergen, Norway, 1984; produced in English, Los Angeles, 1985); New York: French, 1986.

———. *Tamer of Horses* (produced in New Brunswick, N.J., 1985; revised version produced in Los Angeles, 1986; revised version produced in Seattle. 1986); New York: French, 1985.

———. *Cat's-Paw* (produced in Seattle, 1987); New York: French, 1987.

———. *The Understanding* (produced in Seattle, 1987).

———. *William Mastrosimone: Collected Plays* (Lyme, N.H.: Smith and Kraus, 1994).

Screenplay: *Extremities*, 1986.

Melfi, Leonard. *Lazy Baby Susan* (produced in New York City at Café La Mama, 1965).

———. *Birdbath* (produced in New York City at Theater Genesis, 1965; Edinburgh, 1967; London, 1969); Included in *Encounters*, 1967.

———. *Encounters: Six One-Act Plays* (New York: French, 1967).

———. *Morning, Noon, and Night* (produced New York City, 1968); New York: Random House, 1967.

———. *Jack and Jill* (first produced in New York City, 1968; revised version, produced as part of *Oh! Calcutta!*, New York City, 1969; London, 1970); New York: Grove Press, 1969.

———. *Porno Stars at Home* (produced in New York City, 1976).

———. *Taxi Tales* (five plays; produced in New York City, 1978); Included in *Latter Encounters*, 1980.

———. *Latter Encounters: Seven One-Act Plays* (includes *Taxi Tales—Taffy's Taxi, Tripper's Taxi, Toddy's Taxi, The Teaser's Taxi, Mr. Tucker's Taxi—Rusty and Rico, Lena and Louie*) (New York: French, 1980).

———. *Lily Lake* (produced in Binghamton, New York, 1986).

Palminteri, Chazz. *A Bronx Tale* (produced in New York City at Playhouse 91, 1989).

Pintauro, Joseph. *Cacciatore I, II, and III* (three one-act plays) (first produced at the Actors Repertory Theater in New York, 1977); New York: Dramatists Play Service, 1981.

———. *Snow Orchid* (first produced in New York City at Circle Repertory Workshop, 1980).

———. *The Orchid Man and the Black Swan* (three-act play) (first produced in New York City at Circle Repertory Workshop, 1982).

———. *The Hunt of the Unicorn* (first produced at Circle Repertory Workshop in New York City).

———. *On the Wing* (produced in New York City by the Barrow Group, 1987).

———. *Wild Blue* (produced in New York City at Perry Street Theater, 1987).

———. *Beside Herself* (produced in New York City at the Circle Repertory Company, 1989).

———. *Moving Targets* (produced in New York City at the Vineyard Theater, 1990).

———. *The Raft of the Medusa* (produced in New York, City at the Minetta Lane Theatre, 1991); New York: Dramatists Play Service, 1992.

———. *Men's Lives* (produced in Sag Harbor, New York at the Bogstreet Theater, 1992); New York: Dramatists Play Service, 1994.

———. *American Divine* (cycle of twenty-six one-act plays) (produced in Chicago at the Dolphin Back Theater Company, 1995); New York: Smith and Krause, 1996).

Ruffini, Gene. *The Choice* (produced in New York City at the Double Image Theater, 1976).

———. *Angelis* (produced in New York City at the American Theater for Actors, 1978).

———. *A Grave Encounter* (produced in New York City at the Double Image Theater, 1988).

Tedesco, Jo Ann. *Sacraments: A Not-So-Divine Human Comedy* (produced in New York City at the Public Theater, 1978; Harold Clurman Theater, 1984).

———. *On the Rocks* and *The Wearing of the Green* (a double bill first produced in New York City at the Thirteenth Street Theater, 1980).

———. *I Thought You Had the Blues* (produced in New York City at the Courtyard Theater, 1981).

———. *Perfidia* (produced in Sacramento at the California State Theater, 1995).

Vetere, Richard. *Rockaway Boulevard* (produced in New York City at the Actors Studio, 1978).

———. *The Engagement* (produced in Princeton, N.J., at the George Street Theater, 1991).

———. *Hale (Nathan) the Hero* (produced by General Motors' Playwrights' Theater on A&E, 1992).

———. *Gangster Apparel* (produced in London at the Old Lion, 1993; produced in New York City by Igloo at Here, 1995).

———. *The Marriage Fool* (produced in New York City at the Penguin Repertory Theater, 1994).

Screenplay: *Vigilante* (1982).

Italian American Musical Culture and Its Contribution to American Music

Robert Connolly
Pellegrino D'Acierno

In the Lobby

Music has always been and continues to be one of the primary forms of Italian American expression and the area of perhaps its strongest contribution to the common culture because it involves the spheres of classical as well as popular music. This essay deals with the adventures of Italian American musical culture: the traveling of the Italian musical heritage—high and low—to America; the translation of Italian conventions and techniques into American terms; the various bordercrossings and hybridizations that have produced the Italian American musical identity. Following are the main sections and subsections of this article:

I. Opera and the Melodramatic Lifestyle
II. Arturo Toscanini: Maestro dei Maestri
III. Between the "Grand Tradition" and the New Americanism: Italian American Composers from Menotti to Corigliano
 1. The First Constellation: The Generation of Menotti and Piston
 2. The Second Constellation: From Martirano to Corigliano
IV. The Long Goodbye to *Bel Canto:* Popular Music from Russ Columbo to Frank Zappa
 1. Dark and Handsome and Baritone: The Crooner As Archetype of the Second Generation
 2. Vaudeville and Broadway: From Durante to Liza Minnelli
 3. Roll Over Rossini: Italian American Rock 'n' Roll

Boldface terms are defined in the Cultural Lexicon, which starts on p. 703.

4. After the Long Good-bye: From Frank Zappa to Bruce Springsteen and Madonna
V. Bordercrossings: Italian Americans in Jazz
VI. "'O Sole Mio": The Italian American Songbook
VII. Dance and the Italian American Body Image: Between the Tarantella and Ballet
 1. The Tarantella and the Dionysian Body
 2. Ballet and the Apollian Body
 3. The Italian Presence in American Ballet
 4. The Italian American Presence in American Ballet
 5. Dancers in Exotic and Popular Styles
 6. The Italian American Body Image

Opera and the Melodramatic Lifestyle

People in Italy probably do not realize it, but their country's most popular cultural export to the world (excluding pizza) is opera. Verdi and Puccini are the most-performed operatic composers the world over, and Luciano Pavarotti is undoubtedly the best-known Italian in the world today. Italians take opera for granted: It has always been there, and even the smallest city has its opera house, government subsidized. For most of the rest of us, however, it is a rare and precious commodity.

Italy was the logical country to develop opera—a Latin country, speaking the most musical of languages, where the pomp and splendor of the Catholic Church was an inherent part of life, where pleasure-loving royal courts had the means to present spectacles of music and dance, where this new art form, notwithstanding its aristocratic origins in the court, would establish itself as the dominant and most popular form of cultural expression, cutting across class distinctions to become for Italians the language of the soul. Opera dealt with the things most important in their own lives—honor, betrayal, filial loyalty, cuckoldry, religious piety, mother love, woman dishonored, enslavement by malevolent foreign rulers. In Luchino Visconti's film *Senso* (1954), which takes place in the 1870s, the characters' lives have been so shaped by opera, specifically Verdi, that they no longer seem to know the difference between life on stage and off. They even speak in the melodramatic style of a libretto by Arrigo Boito (1842–1918), poet and composer famous for his librettos for Verdi.

Italian opera does in fact reflect the character of the people. Italians are

extroverted, their gestures are broad, and they are more overtly emotional than Anglo-Saxons. They dress beautifully, with style and taste, and have no desire to pass unnoticed. In the nineteenth-century opera house, the box often offered only a partial view of the stage, but it was like a jewel box that set off its occupants, who could be seen by everyone and could in turn have an unobstructed view of the other boxes and their glittering spectators. Even today the Italian point of view is that the opera is a ***spettacolo*** (spectacle) and that you in the audience are a part of that *spettacolo*. The intervals often last forty-five minutes, and the foyers are filled with mirrors and grand staircases, which one can descend in spectacular fashion and be seen and admired by one and all, or merely watch the others descend. Just walk through an Italian ***piazza*** and observe the life surging through it: It *is* a theater. Italians are fond of the grand gesture and do not hide their emotions. (When Caruso died in Naples, his young wife, the American socialite Dorothy Benjamin, was unable to cry; the women of Naples never forgave her for this.) Understatement is a concept totally foreign to most Italians; there is no word for it in Italian. There is no understatement in Verdi or Puccini. I once told a Neapolitan friend that he could never understand the British way of life or their sense of humor without understanding understatement, and I gave him several examples. He looked at me and said, *"Ho capito: gente fredda"*(I get it: cold people). American audiences may have trouble relating to the passionate and violent characters in Mascagni's *Cavalleria rusticana* and Leoncavallo's *I pagliacci;* the audiences in Naples and Palermo (and probably in Bensonhurst, Brooklyn) can recognize them instantly. Not for them Noel Coward's epigram in *Private Lives:* "Emotion is so *very* untidy." American composer Ned Rorem observed in his memoirs (*The Paris Diary,* 1966) that Italians will never understand camp, "because they *are* camp"—which perhaps means that they are not afraid of strong emotions and strong sensations. It has been said, for example, that Verdi produced music of genius because he was not afraid to go to the very brink of bad taste, without ever precipitating into it, whereas French composers have always been careful to remain within the bounds of exquisite good taste, and never quite creating works of genius. Italy is a world of strong colors, and so is Italian opera.

The earliest operas in Italy were court entertainments in Florence, in which the then fashionable pastoral dramas were enacted, with the texts sung by soloists and a chorus, with a vocal ornamentation that with the years became increasingly elaborate. In 1637 the first public opera house was built in Venice, and within a few decades such theaters had sprung up throughout Italy.

The first two centuries in America were hardly a fertile period for the arts. In Boston in the early 1700s a group of young men decided to put on a perfor-

mance of Thomas Otway's play *The Orphan*. A law was immediately passed forbidding all theatricals that "tended to increase immorality, impiety and a contempt of religion," imposing fines on all concerned, playgoers included. Religious music was permitted, however, and by the end of the eighteenth century the larger Eastern cities had societies that performed oratorios and other sacred works. Opera, however, reflecting as it did the opulence of European court life and the elaborate ritual of the Catholic Church, had no place in the lives of the settlers of the New World.

Italian opera officially arrived in America on 7 November 1825, when the fiery Manuel García, celebrated Spanish tenor, composer, and operatic manager, together with his children, his wife, and a motley group of Italian singers, arrived in New York harbor after a thirty-seven-day voyage from Liverpool, in hopes of establishing a center of Italian opera in the New World. García had three immensely gifted children: His son, Manuel Patricio García (1805–1906), an excellent baritone, became a great teacher of voice, numbering Jenny Lind among his pupils, and died in London at the age of 101 in 1906; Maria Felicia García (1808–1836), mezzo-soprano, would become, as Maria Malibran, the most celebrated singer and the most famous woman in the world after Queen Victoria; Pauline García (1821–1910) would become Pauline Viardot, the outstanding mezzo-soprano, friend of famous writers and composers, and constant companion of the novelist Ivan Turgenev. They took over the Park Theatre and began rehearsals of Rossini's *Il barbiere di Siviglia* (The Barber of Seville). García set about getting an orchestra and chorus together, not an easy task.

New Yorkers' curiosity grew; a few people had seen Italian opera in Europe, but most had no idea of what to expect. Newspaper articles appeared on Italian music, and on how to behave at the opera, and what to wear. One article assured its readers that ". . . there will be no dancing—nothing that the most fastidious delicacy can take offense at. . . ." Little was known of seventeen-year-old Maria Felicia, but when one paper quoted the high fees she had gotten at the York festival in England, the public decided that if she cost that much, she must be good.

A large and distinguished audience, described by one paper as "the most fashionable ever brought together in an American theater" and including Joseph Bonaparte (the former king of Spain), the young James Fenimore Cooper and his friend the poet Fitz-Greene Halleck, was present at the Park Theatre on 29 November 1825 for the first performance in the New World of Italian opera in Italian. García sang Almaviva; Maria was Rosina; Manuel Patricio was Figaro; and Joaquina, García's mistress, sang the small part of the servant Berta. The audience was highly enthusiastic. They realized that García and his daughter were exceptional artists, but they were too inexperienced to be bothered by the inad-

equate chorus and orchestra. New York fell in love instantly with Maria Felicia. Shortly afterward she wrote to her friend (albeit rival) the celebrated soprano Giuditta Pasta in Italy: "Here they are half mad about Italian opera, and I, as you can imagine, am the heroine!!! How lovely to be in a country where they don't understand anything!!!"

It is often assumed that the legendary poet and librettist Lorenzo Da Ponte was influential in arranging García's engagement in America. A colleague of Mozart and Salieri, he was certainly the most well-informed person on Italian opera in this country. Da Ponte, however, makes no claim whatsoever to this accomplishment in his memoirs, and he was hardly a modest man. Furthermore, at this point, he was seventy-six years old, down on his luck, and considerably less well known than he had been in Europe. Apparently, however, shortly after García's arrival in New York, Da Ponte did go to his lodgings and introduce himself as the librettist of Mozart's *Don Giovanni*. García impulsively grabbed the old man and danced around the room with him, singing the drinking song from the opera all the while. It is certain, however, that Da Ponte, whose mission was to disseminate a knowledge of the Italian language and culture in the New World, assisted García in his undertaking and in arousing American interest in Italian opera.

On 23 May 1826 at the Park Theatre, García presented the first U.S. performance of *Don Giovanni*. It was a great success, the audience deeming Mozart even more enjoyable than Rossini, and the work was repeated ten times that season. Furthermore, for the first time Americans began to realize just who this eccentric old man living in their midst really was and accorded him new respect, to Da Ponte's immense joy.

García's season continued with Rossini's *Tancredi* and *Otello* and Zingarelli's *Giulietta e Romeo*. After four months of two performances a week, however, attendance began to decline. A small band of enthusiasts attended regularly, but New York, with a population of 18,000 was still simply too small and too provincial to support a permanent opera company. (And—hard to believe—at that time there were no more than 2,000 Italians in all of America.) García then decided to try his luck in Mexico, where he could at least speak his native Spanish. In the fall of 1826, he and his family and a few other singers sailed for Vera Cruz. Maria, who had married a middle-aged French businessman, Eugene Malibran, primarily to get away from her despotic father, remained behind in New York. She went on to sing English comic operas *(The Devil's Bride* and *Love in a Village),* as well as religious music, to enormous acclaim. She sailed for Paris in 1827 and reigned as the most celebrated singer in the world until her tragic death at the age of twenty-eight after a fall from a horse in England. García remained in Mexico for three

years. As he was about to embark on a ship in Vera Cruz to return to Europe, bandits robbed him of his *forziere* (strongbox) containing more than a thousand ounces of gold, the entire fruits of his labors in the New World.

The French tenor and impresario Giacomo Montresor presented a season of Italian opera at the Richmond Hill Theater in New York in 1832, giving fifty performances of Rossini's *La Cenerentola* and *L'Italiana in Algeri*, Bellini's *Il pirata* and Mercadante's *Elisa e Claudio*. The season was not a financial success, but did serve to bring a number of excellent (and sorely needed) European orchestral musicians to New York, many of whom chose to remain in the city.

Da Ponte, whose hopes of seeing operatic activity flourishing in New York had been dashed by García's departure for Mexico, never stopped trying. He somehow managed to persuade a group of wealthy New Yorkers to build a real opera house at Church and Leonard Streets. And so on 18 November 1833, the Italian Opera House, a faithful replica of an opulent European theater, opened its doors, under the management of Da Ponte and Vicenzo Rivafinoli, a Milanese impresario, with Rossini's *La gazza ladra*. The season of sixty-eight performances was a great artistic and social success, but a financial disaster, with receipts of $50,000 and expenses of $80,000. The theater burned down two years later.

The English ballad operas, rowdy satires of the stately operas of Handel that dealt with highwaymen and tavern wenches instead of gods and goddesses, interspersed the popular songs of the day, and had been popular in America in the eighteenth century, were beginning to fall out of favor; what audiences liked most were productions of Italian, French, and German operas sung in English. Opera in Italian, consequently, went into a ten-year exile that would end in 1854.

Concert life in New York was thriving, however, and a surprising number of the most celebrated European artists were beginning to appear there—in addition, many of them spending two years or more traveling the length and breadth of America. Why did they come? Americans, after all, were considered barbarians incapable of appreciating European culture. The money? Curiosity about the New World? Even with the new steamboats, the voyage must have been arduous indeed. In any case, this meant that even in those early decades, Americans were able to hear singers such as Malibran, Adelina Patti, the British baritone John Braham, Jenny Lind, and the French soprano Laure Cinti-Damoreau—the world's finest. Thus, even in America it was possible for a music lover to acquire the beginnings of real musical taste and discernment.

A gigantic step forward was taken with the opening of the Academy of Music at Fourteenth Street and Irving Place on 2 October 1854 with a performance of Bellini's *Norma*, starring two of the world's most celebrated singers: the

Italian tenor Giovanni Mario and his wife, Giulia Grisi. Opera on the highest level would continue to be presented there until 1886. It cost $335,000 to build and had the largest stage in the world. Its sumptuous boxes were occupied by New York's first families—the Belmonts, the Lorillards, the Cuttings, the Van Nests, the Van Hoffmans, the Schuylers, and the Astors—the aristocracy of old wealth. The rest of New York gazed upon them with envy.

The Academy of Music, under impresarios (they changed frequently) Max Maretzek, Maurice and Max Strakosch, and J.H. Mapleson, introduced New York to Verdi's *Rigoletto* (1855), *Il trovatore* (1855), *La traviata* (1856), Meyerbeer's *L'Africaine* (1856) and Gounod's *Romeo et Juliette* (1867), all sung in Italian, as well as to European stars such as Henriette Sontag, Christine Nillson, Lilli Lehmann, Marietta Alboni, Italo Campanini and Americans Lillian Nordica (Norton), Clara Louise Kellogg, Minnie Hauk, and Annie Louise Cary.

Three decades later, New York had a younger generation of powerful families—the Roosevelts, the Goulds, the Whitneys, the Morgans, and the Vanderbilts—even richer (and more powerful) than the Belmonts et al. but considered by them hopelessly nouveau riche and socially inferior. These families aspired to social acceptance and refinement. They wanted a place in which they, too, could display their wealth. They coveted the boxes at the Academy, which they were unable to obtain. So, in true American fashion, they decided to build their own theater, the original Metropolitan Opera House. Sixty-six individuals put up $10,000.00 apiece, which entitled each of them to his own private box and 100 shares of stock. There was one Italian name among them, Egisto P. Fabbri, member of an old shipping firm and one of J.P. Morgan's partners: He served as a treasurer. (For the record, in the mid-1990s there are no Italian names.) On 22 October 1883, the Metropolitan Opera House, on Broadway and Thirty-ninth Street, opened its doors with an all-star production of Gounod's *Faust*. Having transcended its original purpose as a social gesture, it is still with us, in its new location at Lincoln Center, one of the world's major opera houses.

The first year, under the management of Henry Abbey, a well-known theatrical producer with little operatic experience, all operas were sung in Italian. The season was an artistic success but lost $500,000.00. The following year, the new director, Leopold Damrosch, offered only works sung in German. This season proved successful. For the next seven years, the Met was a German house, with an impressive roster of German singers, an emphasis on the Wagner operas, and everything—even *Carmen* and *Aida*—sung in German. Remember, in 1880 there were 44,000 native-born Italians in the United States, and two million native-born Germans.

Wagner held the world in thrall. Musical culture in this country was basically German. Many of the music conservatories had been established by Germans. They made it clear to the world that their music was on an infinitely higher artistic and philosophical level than any other. Attending a performance of *Parsifal* was considered a religious experience. If a work was lengthy, solemn, and morally uplifting, it was good for you. This was a viewpoint that would naturally appeal to a nation that was still largely Puritan. After hearing Wagner's towering orchestrations, the musical establishment asked how could anyone take seriously the (deceptively) simple and tuneful ones of Bellini and Donizetti? The eminent critic Eric Bentley once said in a lecture on European drama at Columbia: "Two hundred years ago, Goethe and Schiller and Lessing told the German people that culture could civilize them; they are still trying." It is interesting to note that the Germans have created many works of undeniably great art, but which are often deliberately harsh, dissonant, ugly, and painful: the silent films *Dr. Caligari* and *Nosferatu,* Alban Berg's operas *Wozzeck* and *Lulu,* much of Kurt Weill, Bertolt Brecht, and George Grosz, to cite works of German Expressionism, the modernist movement in which the tradition of angst culminates. The Italians virtually never have; for them, art means beauty. One is hard pressed to decide whether this is a virtue or a limitation.

By 1895 the society millionaires were beginning to tire of so much Wagner; they demanded operas that required all-star casts—and they got them, a decade of the most incredible ensembles that any house has ever had: Jean de Reszke, the elegant Polish tenor, and his basso brother, Edouard; the legendary Australian soprano Nellie Melba; the suave French bass Pol Plancon and the baritone Victor Maurel, Verdi's first Iago and Falstaff; the American divas Emma Eames and Lillian Nordica. Audiences got used to hearing five or six of the aforementioned on the same night, in *Don Giovanni, Faust,* or *Les Hugenots.* Where, you may ask, were the Italians? There were, of course, a few, including the tenors Italo Campanini and Francesco Tamagno, both close to retirement. Melba and the others mentioned above were all supreme vocalists and polished musicians, but as a whole they could be described as singularly devoid of emotion. They were probably giving WASPified productions of Italian operas—which is no doubt what the audience preferred, being for the most part Anglo-American Protestants of Puritan origins for whom displays of passion and emotion would have been unseemly.

Opera and theater still bore a slight taint of dubious respectability among the upper classes in Boston and New York. Even in Italy, there had been objections to *La bohème* (1896) by Puccini and *La traviata,* inasmuch as both heroines were of easy virtue, and the fact that these stories took place in contemporary

times somehow made them seem even less acceptable; if all of this debauchery had been taking place in the 1600s, somehow it would have been less offensive. Furthermore, the Met boxholders *were* parvenus, as they had been called, extremely insecure, and anxious to observe the proprieties; they could not afford to take any liberties. Thus, when Emma Eames, Louise Homer, and Nellie Melba—well-brought up, no-nonsense, God-fearing girls all—came out to sing Mimi and Violetta, their wholesomeness instantly removed any taint of sin or sensuality from their roles as morally compromised heroines, and the audience could sit back and relax, secure in the knowledge that everything was *comme il faut*. The Neapolitan tenor Fernando De Lucia, one of the finest singers who ever lived and more popular in Italy than Caruso, was brought to the Met in 1893 and was not a great success. His voice and style seemed to perplex both audience and critics. He was the possessor of a pronounced *vibrato,* a rapid vibration or throbbing of the voice, common among Italian singers of an earlier generation. It is a quality that Latin audiences like and that is considered an expressive device that adds color and emotion to the voice, but to British, German, and American vocal teachers it has always been the unforgivable sin. De Lucia returned to Italy the following year.

 Americans had trouble accepting the full-bodied, all-stops-out, passionate Italian style of singing: "Emotion is so *very* untidy," to cite Noel Coward once again. Things began to change on the night of 23 November 1903, when another young tenor from Naples, Enrico Caruso, made his Met debut, in *Rigoletto*. Most critics realized that here was no run-of-the-mill tenor, although one complained of "tiresome Italian mannerisms" in his singing, and another of his "bourgeois air, and little distinction of bearing," which was understandable considering that they were used to the Duke of his predecessor, the suave and handsome Jean de Reszke, who was of noble lineage. But Caruso learned, and they learned, and by the end of the season he had won them all over. He also had the good fortune to arrive in the United States along with hundreds of thousands of other Neapolitans and Sicilians, in the midst of the first huge wave of Italian immigrants. In a sense, he had brought his own audience along with him.

 Within a year or so, Caruso had become the most famous opera singer in the world. His personal warmth, generosity, and Neapolitan **comunicativa** (expressiveness) made him the most beloved artist of his time, and the Metropolitan was his home. Because of Caruso, Italian immigrants could feel proud of their own origins; they could hold their heads up to the world. The world's greatest tenor was not only their **compatriota** (countryman), but also their **concittadino** (fellow townsman). Not only was Caruso Italian, he was from the **disprezzato**

(scorned) south—a *scugnizzo* (Neapolitan street urchin) from a poverty-stricken *quartiere* (neighborhood) of Naples.

Virtually everyone who ever heard Caruso sing, including a handful of vocal enthusiasts who are still with us, declared that his was the greatest voice they ever heard. So there is little room for discussion there. The sheer size alone of the voice when heard live in the theater made an unforgettable impact on the listener. This is something that even today cannot be captured on a record.

On recordings the voice often seems to be more of a baritone than a tenor; this, however, was a deliberate choice. At the beginning of his career in Italy, Caruso sang the *bel canto* roles of the early nineteenth century, requiring a light, agile voice and sweetness and delicacy of tone. But he sensed that this type of singing was in decline with the arrival of **verismo**, and that the new operas of Puccini, Mascagni, Giordano, and Leoncavallo demanded a bigger, darker, more virile, and more dramatic sound. He gradually dropped the *bel canto* operas from his repertoire (except for Donizetti's *L'elisir d'amore*) and soon became the world's foremost *verismo* tenor.

It is also significant that Caruso's beginnings coincided with those of the recording industry. On an April afternoon in 1902, in a hotel room in Milan, he recorded ten arias for the Gramophone Company of London, for which he was paid 100 pounds. In 1904 he signed a contract with Victor Records, for whom he would record hundreds of arias and songs. He brought prestige and respectability to the fledgling recording industry at a time when many prominent artists thought that singing into a horn was beneath their dignity. The industry, in return, rewarded him millions of dollars, world fame, and immortality.

Caruso made headlines in 1906 when a Mrs. Hannah Graham accused him of pinching her derriere at the monkey house of the Central Park Zoo. He was fined $10.00 and let go, and the incident was forgotten. It may have been a trumped-up charge; if not, it may have been that the lady simply did not understand the ebullient tenor's Neapolitan sense of gallantry.

It is said that an entire generation of young tenors ruined their voices trying to sound like Caruso. The beauty, volume, and emotional impact of his voice were God-given. He was unique.

From 1903 until his death in 1921, he sang 622 performances of thirty-seven roles at the Met, opening every season except one (1906), and performed in other opera houses and concert halls all over the world. He probably sang too much and gave too much. Some said that he was overly fond of money. He paid the price. Prematurely aged he died at the age of forty-eight in Naples, of pleurisy stemming from a lung infection. At his funeral on 4 August 1921, at the Church

of San Francesco di Paola, hitherto reserved for members of the royal family, his old rival, tenor Fernando De Lucia, sang the "Pietà, Signore," and Naples wept.

In 1908 Giulio Gatti-Casazza, the director of La Scala in Rome, became general manager of the Met, bringing with him Arturo Toscanini as his principal conductor. The great singers began to arrive from Italy, and they triumphed: Antonio Scotti, Lina Cavalieri, Beniamino Gigli, Claudio Muzio, Ezio Pinza, Giovanni Martinelli, Amelita Galli-Curci, Luisa Tetrazzini, Titta Ruffo, Mario Del Monaco, Ettore Bastianini, Renata Tebaldi, Franco Corelli, Magda Olivero. They are still arriving; today in Italy, even if a singer performs regularly at La Scala, he is not considered a true *divo* (superstar) unless he has sung at the Met.

Italian opera forms the basic repertoire of virtually every company in America, and Puccini is the most performed composer. Puccini visited New York in the early 1900s and went to see two popular Broadway melodramas, *Madame Butterfly* and *Girl of the Golden West*. The composer, who had a flair for the "exotic," was enchanted by their star, Blanche Bates, and by the spectacular stagings of David Belasco. He based two of his most popular operas on them, and the second one *(La fanciulla del West)* was given its world premiere at the Met in 1910.

Italian opera is the most popular throughout the world because the emotions are expressed through the melody, which is universal. When you hear Rossini's Figaro sing his "Largo al factotum," you know instantly all there is to know about him, even though you may not understand a word. In German opera, in particular, the texts are usually on a higher literary level, more complex and often more important in conveying the meaning of the drama than the music (the music often subordinate to the text), which can create a problem for non-German speakers. In Italian opera, on the other hand, the words are subordinate to the music and to the force of the spectacle and its emotional excess.

Americans tend to think of opera primarily as music; our knowledge of it has been obtained mainly through radio and records. To Italians it is primarily theater; their knowledge of it has been gained through live performances in theaters. Thus, America has produced many great *singers*, who sing the music beautifully, but few or no great singing actors. In the performance of *verismo* operas (realistic dramas composed from 1890 to 1910, treating the violence and passion of contemporary lower-class life), such as Mascagni's *Cavalleria rusticana,* Leoncavallo's *I pagliacci* and *Zaza,* Cilea's *Adriana Lecouvreur,* and Puccini's *La fanciulla del West),* singers would scream and shout and make deliberately harsh and unmusical sounds, in the interest of dramatic effectiveness. In the theater, in Italy at least, this can be wonderfully exciting. To many Anglo-Saxon audiences and critics, who may not be familiar with the plot of the opera or the language, this kind of singing

can seem vulgar, offensive, and disconcerting. To voice teachers, it is the quickest way to vocal ruin. To Italians, most American singers—or, better, most non-Latin singers—are simply bland, unexciting, and devoid of temperament. Also, the opera audience in Italy is not precisely the same one that goes to symphony chamber music and concerts. It is somewhat more on the level of the American audience for musical comedy. In Italy, opera often has the air of an athletic contest, and the audience likes it that way. If Franco Corelli or Mario Del Monaco hangs on to a high note three times longer than the score indicates, the audience in Rome or Parma goes wild with delight, whereas the New York critics would accuse him of being tasteless, unmusical, and unfaithful to the composer.

The young American conservatory graduate has the equivalent of a good university education. Italian singers generally come from a different social and educational background. They often do not study other languages and other countries' music; they don't have to. They are not the finished musicians that the Americans are, but they are singing in their own language music written for Italian voices, and are capable of bringing a kind of raw, animal excitement to their work, in addition to possessing the world's most beautiful natural voices.

Opera houses throughout the world today are filled with American singers, who are apparently the best trained, most versatile, and hardest working in the business. Having no national repertoire of their own to fall back on, they have had to study all of them and be prepared to sing anything, in any language, at a moment's notice. They lack the warmly beautiful sound and the flamboyant larger-than-life presence of the best Italian singers, but, knowing this, many of them—Beverly Sills, Marilyn Horne, Chris Merritt, Rockwell Blake, Samuel Ramey (*he has a beautiful voice; American baritones do*), Joan Sutherland (Australian), and Maria Callas even—have compensated by trying harder, developing extraordinary techniques that enable them to perform phenomenally difficult music (the *bel canto* roles of Bellini and Rossini in particular) and that are beyond the capabilities of most other singers, in this way achieving international stardom.

We asked Luigi Veccia, a baritone from Rome who teaches voice in New York City, whether he could tell instantly whether a young singer was Italian or Italian American, given that a young American whose parents were born in Italy presumably inherits vocal organs identical to theirs. Veccia replied: "Yes. Americans don't open their mouths when they speak. They speak from the back of the throat, and vowels are slurred over. And they sing that way, too." Italian speech is more open and is brighter and more "forward"—that is, articulated at the very front of the mouth. So, according to Veccia, the Italian American could sound like a native Italian only if he grew up speaking Italian. We know that many Italian

American children were encouraged by their parents to speak only English in order to assimilate as quickly as possible. Veccia could think of three exceptions: Rosa Ponselle and Lina Pagliughi, both of whom *did* speak Italian at home, and Mario Lanza, who, coming from south Philadelphia, probably did.

Italian Americans, not surprisingly, have contributed a fair share of opera singers to the world. One of the first and greatest was Rosa Ponselle (1897–1982), born Rosa Ponzillo to Neapolitan parents in Meriden, Connecticut. Possessor of perhaps the most beautiful soprano voice of the century, she and her younger sister Carmela were touring in their vaudeville act when Caruso happened to hear her in 1917. One year later, with virtually no operatic training, she made a triumphant Met debut opposite him in *La forza del destino*. Philadelphia-born Dusolina Giannini (1902–1986), a dramatic soprano of exceptional temperament—whose tenor father, Ferruccio, had been making commercial cylinders as far back as 1895 and whose brother Vittorio was a famous contemporary composer—was a favorite of Toscanini's and had a major career both in America and in Europe. Lina Pagliughi (1910–1980), a coloratura soprano who was born in San Francisco to Italian immigrants, was taken back to Italy at an early age by Luisa Tetrazzini (1871–1940), one of the finest coloratura sopranos of her time, and, as Gilda in a production of *Rigoletto* staged by the Teatro Nazionale in Milan, made her operatic debut at the age of seventeen. She was 4 feet, 10 inches tall and almost as wide, and Italian audiences, who usually overlook such things, simply could not accept her as the ethereal little heroines to which she was vocally suited. Thus, she hardly ever sang in the major Italian theaters, but she enjoyed enormous success on the radio, on records, and in the smaller provincial houses. She was also the voice of Snow White in the dubbed Italian version of the Disney film. Two other prominent singers were Jessica Dragonette (1910–1980) of New York, who was half Italian and who trained for opera but went into radio in 1926 and for more than twenty years was voted radio's most popular soprano; and Louise Caselotti, a mezzo-soprano born in New York in 1910, who was the heroine in the first Italian sound film ever made, *Sei tu l'amore?* (which was filmed in Hollywood in 1930, inasmuch as Italy did not yet have the necessary equipment). She sang hundreds of Carmens all over the country, and in 1946 an unknown and discouraged young soprano named Maria Callas, just returned from Greece, came to be coached by her in New York. After a year of coaching, Caselotti introduced her to Giovanni Zenatello, director of the Arena of Verona, who needed a Gioconda (for Ponchiellis's *La Gioconda*). He agreed to give Callas a try, and the two ladies left for Italy together. Louise's sister, Adriana, a *coloratura* soprano, was the voice of Snow White for Walt Disney's in 1937 classic. She was nineteen years old, and Disney paid her a few hundred dollars.

Fifty years later, when the studio wanted to touch up the sound track for rerelease, they called her back again, her voice virtually intact. She appeared on major radio programs, but the Disney Company insisted that she be identified only as Snow White, and thus she never received prominence on her own.

Singing leading roles at the Met in the late 1930s and early 1940s were lyric sopranos Rosemarie Brancato, Norina Greco (the sister of the famous dancer José), and Josephine Tuminia, who achieved a kind of immortality by recording a jazzed-up version of the "Blue Danube" with the Jimmy Dorsey Orchestra on a 12-inch Decca 78 rpm. Soprano Franca Somigli went to Italy, where she had an important career. When World War II broke out, Mussolini called most of the Met's Italian singers back to Italy, with the exception of Licia Albanese, who was still relatively less famous than the others and who had married an Italian American. That was a break for her, and for American audiences, for she had the Italian wing all to herself during the war, and Americans had at least one Italian soprano to show us how *Madama Butterfly* and *La traviata* were supposed to be sung. Vivian Della Chiesa (1915–), a handsome soprano from Chicago and a favorite of Toscanini, starred in radio, opera, and supper clubs. Frank Guarrera, a robust baritone from Philadelphia, joined the Met in 1949 and remained for many years.

Another gift from south Philadelphia, a promising young opera and concert tenor whose name was Arnaldo Alfredo Cocozza before it was changed to the more euphonious Mario Lanza, was discovered singing at the Hollywood Bowl in 1947 by Ida Koverman, Louis B. Mayer's opera-loving secretary, and you know the rest. Lanza's voice was the most gorgeous ever given to an American tenor. (The only one, actually—there are not even any runners up. We are not a country of great tenors; neither is England. Baritones, yes.) It sounded more Italian than most Italians—warm, passionate, generous, sensual. Even in Italy, only Giuseppe Di Stefano could compete for sheer beauty of sound.

Lanza (1921–1959) was young, handsome, sexy, a star of movies, radio and television, and a pop singer, too—a combination that no operatic tenor, not even Caruso, had ever offered. All of this, plus the publicity machines of MGM, RCA, and CBS, made his name known to audiences of every level the world over. His was the classic case of too much too soon. For a little-known concert singer with two years of professional experience and just one operatic performance under his belt (*Madama Butterfly* in New Orleans in 1948) to find himself a major Hollywood star and the most sought after tenor in the world would be reason enough to turn the head of any young artist, including an Italian kid from the streets of south Philly. In 1949, when his film *The Great Caruso* was playing all over the world, Lanza said to the press: "Caruso was thirty-three when he made his Met debut.

I'm only twenty-seven; that gives me six more years." He never got there, however. Lack of discipline, an outsize ego (perhaps masking a basic insecurity), excesses of every sort, immense fame and earnings, and doubtless (as with many other singers with operatic voices who become screen stars) a fear of having to compete, live, without a microphone, with his own image on the sound track resulted in a tragically brief career. Lanza died in a Rome hospital in 1959, officially of an embolism but under circumstances that have never been clearly explained.

Lanza's influence, however, was widespread and longlasting, his artistry having been preserved on film and recordings. Luciano Pavarotti, Placido Domingo, and Jose Carreras have all stated that one of the most indelible experiences of their youth was seeing *The Great Caruso* and knowing right then that that was what they, too, wanted to do. Millions of teenagers went to his movies and bought RCA Victor Red Seal recordings of Italian operatic arias and songs. Since most of his career was spent on Hollywood sound stages and in recording studios, Lanza knew how to use the microphone. He delivered his arias in a warm, caressing fashion, almost in the manner of a pop singer, making this music accessible to even the average listener. The combination of his sensuous sound, impeccable and unaffected diction and savvy use of the microphone was irresistible. Lanza's records continue to sell by the millions. He proved that an American tenor can, on occasion, produce a more beautiful and Italianate sound than most native Italians, upsetting many theories and giving hope to countless young American singers.

Another tenor from Philadelphia was the underappreciated David Poleri (1921–1965), a handsome and charismatic artist with an exceptionally beautiful voice (one of the very few besides Lanza that had a truly Italian sound), who starred in the original production of Menotti's *The Saint of Bleeker Street* (1954) and who possessed, if anything, too much temperament. In 1953, during a performance with the New York City Opera of *Carmen* in Chicago, fed up with the rapid tempi of conductor Joseph Rosenstock, he yelled at him, "Finish the opera yourself, dammit!" and stalked off the stage, leaving poor Carmen (Gloria Lane) to die of heart failure—an act that virtually put an end to Poleri's U.S. career. He went to Italy, where he sang in major theaters, and he died in a helicopter crash in Hawaii in 1965. Soprano Herva Nelli, who was born in 1909 in Italy and raised in Philadelphia, gained prominence in 1947 when she was chosen by Toscanini for his NBC Symphony broadcast of Verdi operas and went on to sing leading roles at the Met for five seasons. Born in 1922 in San Francisco, Fiorenza Quartararo sang on the Bing Crosby show as Florence Aba in the mid-1940s, then joined the Met, where she met basso Italo Tajo, married him, and retired young. Marguerite Piazza (1926–) sang *Fledermaus* at the Met, and then had a lucrative career on television and in

nightclubs. In the 1950s and 1960s, basso Giorgio Tozzi, sopranos Mary Costa and Anna Moffo, and mezzo-soprano Joann Grillo began successful Met careers. In the 1960s, a handsome and personable young tenor at the New York City Opera named Frank Porretta (1930–) sang Mozart with Beverly Sills, *Lakme* with Joan Sutherland, *The Desert Song* with Ann Blyth, and Weill's *Mahagonny* Off Broadway. Bass Ezio Flagello (1931–) made his Met debut in 1957. A versatile artist whose technique permitted him to sing Bellini, Verdi, and Wagner, he is best remembered for his Leporello in *Don Giovanni*. He retired in 1987.

In the 1990s, young Italian Americans singing at the Met and elsewhere include sopranos Catherine Malfitano, Diana Soviero, Mark Spacagna, D'Anna Fortunato, Gianna Rolandi, Rosemary Musoleno, and Lella Cuberli (Italian by marriage), who has an important career in Italy singing the florid *bel canto* roles that few others can cope with; and tenors Jerry Hadley (Italian Irish), Franco Farina, Ronald Naldi, Arthur Spinetti, and Anthony Laciura.

Italy and most other European countries have always subsidized the arts, in the belief that their country's cultural patrimony must be kept alive and realizing that opera, symphony orchestras, theater, and ballet, as well as certain forms of film and literature, can never pay for themselves. America does allot some funds for the arts—a minuscule amount—but the general feeling has always been that this is not democratic, that we have no native Beethovens or Verdis to keep up and why should we pay to maintain someone else's tradition, and that the arts, like baseball, should pay for themselves. As a result, American opera houses, which are too big and whose tickets are too expensive, are obliged to present a severely limited repertoire of the best-known, most popular works, year after year. A half-empty house is a risk they cannot afford, which means that there are hundreds of wonderful works that the American public will never be able to hear.

Over the years, however, there have been a number of smaller opera companies, whose directors, all Italian or Italian American, have staged a number of these neglected works, because they loved them and felt that they should be heard, often featuring important artists never before heard in the United States. In the 1960s, the Philadelphia Lyric Opera, under Aurelio Fabiani, gave us Donizetti's *Lucrezia Borgia,* with Montserrat Caballe, and Bellini's *I Capuleti e i Montecchi;* Frank Pandolfi's Connecticut Grand Opera presented Cilea's *Adriana Lecouvreur,* with Magda Olivero, and Bellini's *I puritani;* the Neapolitan maestro Pasquale Riggio presented Mascagni's *Iris* and Catalani's *Lorelei* at the Casa Italiana of Columbia University; the venerable Amato Opera Company in the Bowery has enabled us to hear Verdi's *La battaglia di Legnano* and Giordano's *La cena delle beffe;* and Maestro Alfredo Silipigni's New Jersey State Opera has presented Verdi's *Attila,* with

the Turkish soprano Leyla Gencer, Giordano's *Fedora,* and Boito's *Mefistofele,* both with Olivero, Mascagni's *Zanetto,* Leoncavallo's *Zaza,* and Puccini's *Le villi.*

In the summer of 1994, Cleveland-born Maestro Vincent La Selva and his New York Grand Opera embarked on the heroic task, never before attempted in any country, of performing all twenty-eight of Verdi's operas, in chronological order, over a seven-year period, in free outdoor performances in New York's Central Park, with one unit set and a small band of intrepid impassioned singers. Usually operating on a shoestring, these men have enabled us to hear these rarely performed works when they could have played it safe and presented another *La bohème,* with infinitely less work, and been assured of a full house. They deserve our eternal gratitude.

The operatic pride and joy of Italian Americans since the late 1960s is, of course, Italy's gift to *bel canto,* tenor Luciano Pavarotti. Since his 1968 Metropolitan debut in *La bohème,* his uniquely beautiful, silvery voice, superb diction, ebullient personality, and the ability to make listeners feel that he is singing directly to them, have made him the most celebrated and best-loved tenor of his time. The most difficult tickets to obtain at the Metropolitan are those for his performances, even though he gives the Met more of his time than any other theater. European houses in the 1990s pay much more, but the Met does its casting several years in advance, which singers like; it apparently gives them a sense of security. When he sings at Covent Garden in London, ticket prices are doubled, and one sees, several months in advance, ads in London papers for Pavarotti concerts to be held in northern England or central France, offering airfare, hotel, and ticket at a special rate.

There were some superb tenors in the generation preceding Pavarotti's, but they had all developed serious vocal problems by the time they were thirty-five years old. Pavarotti has been singing superbly for more than three decades—the voice has become a bit darker, which is natural—and can continue for years to come, if he chooses. Pavarotti's tenor predecessors were often difficult and temperamental. Being a tenor is not a normal state of affairs; nature made most men baritones. The ability to sing the high C's (and D's and F's) with which Italian opera scores are replete is given to a precious few. Part of the excitement for the audience is the sense of danger involved: Is he going to make the high note and, if he does, how beautifully? A singer's instrument is his body; it has its good days and bad. Thus, many tenors are understandably on edge: Am I in voice tonight? Is the high C there? Unlike his tenor colleagues, however, Pavarotti appears to be remarkably *equilibrato* (well-balanced, in equilibrium), both on stage and off. He has evidently found a vocal technique he can count on, which assures him that the high notes are there and that he doesn't have to worry. As a person he

seems relaxed, affable, and gregarious. The Met has a rule that a singer is allowed to have twelve visitors to his or her dressing room after a performance. Pavarotti said, "No, I want all my fans to be able to come back and see me." So they put him in "the green room," where hundreds of people can troop backstage and where for hours on end he signs photographs and records, slapping his fans on the back and kissing the ladies. He seems to enjoy this ritual, and his fans adore it. He is also the first tenor in recent memory with a sense of humor, a trait not often found in the breed. He delighted in telling jokes—awful ones, in his rudimentary English—on the *Tonight Show* with Johnny Carson. His many years as a top star, his dozens of recordings, and his prudent investments, combined with canny—some would say excessive—exploitation by his managers and publicists, have made him the best-known and richest opera star in the world. Like Caruso and Lanza before him, he is one of those rare artists whose name is known to the person on the street, who knows nothing else about opera. Record stores that sell only pop music often have a section marked "Pavarotti."

He has been accused, to some extent justifiably, of lowering his artistic stature by appearing at sports stadiums, gigantic auditoriums, television galas, and in such unlikely places as Atlantic City and Las Vegas. At a free, open-air concert in Central Park on 26 June 1993, he drew more than half a million spectators, including an enormous number of young people of every color, race, and economic level—the very audience that is virtually never seen in a concert hall—all cheering him wildly. And while the concert, with its worldwide TV and recording rights, undoubtedly netted him still more millions, he has done incalculable good by introducing these vast audiences to the beauties of opera.

In 1991, Pavarotti appeared at the Met in two relatively unfamiliar operas—*Idomeneo* and *Der Rosenkavalier*. One can only wonder how many people, who no doubt would have preferred hearing *Rigoletto*, got their first taste of Mozart and Richard Strauss because of his name in the cast. Unfortunately, for reasons that are not clear, as of the mid-1990s there seem to be no first-rate young tenors on the international horizon with the potential to one day step into Pavarotti's shoes. Let us hope this changes and that soon the long-awaited young Orpheus will appear.

We have traced the history of the way in which America appropriated Italian opera and made it one of the primary texts of its elite culture (for a historically accurate representation of the social role played by opera in the aristocratic circles of Old New York, see Martin Scorsese's 1993 film *The Age of Innocence*, based on the novel by Edith Wharton) and described the role played by the *divo* and *diva* as ethnic signifiers. We would be remiss, however, to leave our discussion of op-

era without addressing its role as an Italian cultural text. For those first- and second-generation Italians of the Great Immigration (1880–1920), the opera was, along with religion, the primary institutional, or public, means of maintaining a link with the old country and of accessing anew the Italian worldview. ***La famiglia,*** of course, remained the private medium for transmitting the tradition—***la via vecchia***—but that family had originally been formed in the crucible of Risorgimento Italy (1850 to 1870, approximately), an Italy in the grips of establishing itself as a modern political and institutional entity, an Italy struggling to pass from a cultural system still informed by religion to one that was secularized and ideological in nature. That Great Immigration family, especially its southern Italian and usually economically underprivileged and politically subaltern version, drew its belief system from popular religion and highly local and parochial customs. Its culture was folkloric—with all of the archaic residues that term suggests—and thus its conception of the world was highly fragmented and disjointed. The family's own counterinstitutional psychology was the product of a historical failure of Italian institutions to elaborate a secular culture that was "national-popular" (that is, "democratic") in character, to use Antonio Gramsci's category. The culture of the immigrant family was, in great part, the minority expression of the territorialized language of local dialects and the conception of the world inscribed within them. As the Marxist cultural critic Gramsci repeatedly pointed out, Italian intellectuals had failed to produce a literary culture that was national-popular, one that was capable of constituting a common cultural identity—based on language and shared narratives—or a readership upon which such an identity would rest. On the other hand, opera approached the form of a national-popular expression, despite Gramsci's protestations that Italian opera was cosmopolitan and European, rather than national, owing to the universality of music. To the contrary, we would argue that opera is the primary national-poular expression of nineteenth- and early-twentieth-century Italian culture, its reception cutting across class lines and serving as a means of constructing the subjectivity of its audience.

This can be seen by the immigrants'—regardless of their class orientation—passionate attachment to it as a signifier of their distanced Italianness and their integration of its melodramatic conception of the world into their passional and psychic identities. (A quick perusal of old photographs of turn-of-the-century "Little Italys" supports this: One sees a plethora of posters announcing performances of *La traviata* and the other standbys at ramshackle opera companies, not just the Met.) For the immigrants, strangers to themselves, it was the one Italian text that remained accessible to them in the New World, where it had been appropriated as an aristocratic and cosmopolitan text; for them it remained a liv-

ing and to-be-lived text—an immigrant equivalent of the role baseball once played in the American psyche—serving to reflect their own imaginary world and style of emotional excess in a nonalien way; it was a total spectacle of signs and codes in which all of Italy remained suspended and through which the Italian experience could be repeated. Of course, over the course of generations, Italian Americans have become somewhat estranged from opera, its role as lived cultural text having been displaced by the American mass media, its canonization as an aristocratic text obliging them to approach it and reappropriate it from the outside, from an elite position, as "strangers" to their most internally persuasive and most natural form of cultural expression. It is interesting to consider the following appreciation of opera written in 1993 by Wayne Koestenbaum from a highly sophisticated and nonethnic position:

> *Opera has the power to warn you that you have wasted your life. You haven't acted on your desires. You've suffered a stunted, vicarious existence. You've silenced your passions. The volume, height, depth, lushness, and excess of operatic utterance reveal, by contrast, how small your gestures have been until now, how impoverished your physicality; you have used only a fraction of your bodily endowment and your throat is closed.* (46)

This passage conveys perfectly what is at stake in Italian opera, and however remote its tone may be from the immigrant's voice, it captures the sense of opera that the Italian Americans of the Great Immigration knew by heart: opera experienced in the new land as a means of overcoming their interior foreignness; opera as equipment for living, as an artistic register that one lives socially and inwardly.

Arturo Toscanini: Maestro dei Maestri

In 1908, five years after Caruso's arrival at the Metropolitan, another Italian arrived who would bring enormous pride to the Italian American community, and whose name would be known even to those who had never set foot in an opera house or concert hall. In that year Arturo Toscanini (1867–1957) left his post as artistic director of La Scala to assume the same function at the Met at the invitation of his friend and colleague Giulio Gatti-Casazza, who had been appointed manager. For the seven years of his tenure, Met audiences were treated to performances of an overall level unknown until then.

A charismatic figure of extraordinary energy and concentration, intolerant of the shortcomings of his musicians as well as his own, he demanded more from his musicians than they believed themselves capable of, and got it. His fits of rage were legendary, and his curses always delivered in Italian. He knew every note of a score as written, as a defense in his constant war against the liberties taken by singers—interpolated high notes and such—that had become almost traditional and slovenly orchestral playing common in many houses of his day. He coached the singers, even the *comprimari* (those singing small roles), phrase by phrase. A man of compelling personal magnetism, he was able to impart his vision of a score to others. Under his direction, many merely competent singers were able to give inspired performances.

He resigned from the Metropolitan in 1915 in a dispute over his ideas and what the management would allow. His Olympian standards could not be sustained in a theater that was obliged to put on a performance every night of the week. As he put it, "Is no discipline; with me, yes, but with others, no." He returned to La Scala but soon became an outspoken opponent of Mussolini and fascism. Most artists are not political; they just want to perform. Many Italian singers had already left the Met, refusing to take the salary cuts that the Depression had made necessary, and most of the rest were called back by Mussolini in 1939 at the outbreak of war. Beniamino Gigli, the famous tenor, said simply, "I am Italian; my loyalty is to my country." Toscanini, however, who was not only a great musician but a man of moral stature, could not compromise, and as an antifascist, he returned to the United States in 1936. Even after the war, he chose to remain here, in his home on the Hudson River in Riverdale, New York.

In his ceaseless striving for musical perfection, he was influential in raising the standards of orchestral playing in this country and making his listeners more knowledgeable and exigent. He insisted that his La Scala audiences become better acquainted with Wagner and Gluck, and in America he programmed the works of lesser-known Italian composers such as Martucci, Respighi, and Castelnuovo-Tedesco, who were his friends. With his radio and television appearances, he became the most important figure on the American musical scene, regarded by many as the world's greatest conductor.

From 1928 to 1936, he directed the New York Philharmonic Orchestra, achieving performances of a clarity and precision hitherto unknown. At La Scala he had the houselights lowered during the performance (previously they had not been), and at Carnegie Hall his performances began precisely on time, and audiences had to be in their seats for the drop of his baton.

Shortly afterward, NBC made him an offer he could not refuse: an orchestra

of his own, made up of the world's finest instrumentalists. In December 1937, he conducted the first historic broadcast of the NBC Symphony, which for seventeen years would bring great music into millions of American homes. He oversaw every detail of the broadcasts: The programs for the audience in Studio 8H in Radio City were even printed on rattleproof paper.

In 1954 he suffered a momentary memory lapse in the midst of a broadcast. Few listeners even noticed it, but from that day on he never again performed in public. He died in 1957, almost ninety. When his coffin was placed in the family tomb in Milan, the combined choruses of La Scala, the RAI (Radio Audizioni Italiane), and the Conservatory sang the "V*a, pensiero*" from *Nabucco,* the same piece Toscanini had conducted in that spot fifty-six years earlier, in tribute to Verdi.

Joseph Horowitz's book *Understanding Toscanini* (1987) is a rather grim account of how, in his opinion, the Toscanini myth in America was carefully constructed by RCA, NBC, and impresario Arthur Judson. In 1944 Toscanini appeared at a wartime Red Cross benefit at Madison Square Garden, where Mayor La Guardia auctioned off one of his batons for $11,000. This cinched his image as the ardent patriot and American hero. On the orchestra's cross-country tour in 1950, he played "Dixie" in Richmond, Virginia, and was photographed riding the ski lift at Sun Valley. *Life* magazine showed us the new, Americanized Toscanini at home with his family. In the early 1950s, RCA gave his LP recordings the most single-minded promotion in the company's history. Radio announcers informed us that Toscanini was "the greatest musical interpreter of our time—perhaps of all time." The existence of other great conductors, such as Wilhelm Furtwangler, the conductor of the Berlin Philharmonic, was carefully downplayed. The American public, Horowitz declares, accepted it all, and the Toscanini mystique was complete.

Horowitz was born in 1948 and thus does not belong to the Toscanini generation. The pendulum has admittedly swung a bit in the other direction. The idea now is that in being so fanatically faithful to his composers' scores, Toscanini was not actually being faithful to them and to their intentions. Certain liberties are now permitted. The composers themselves were not that rigid. Singers often added unwritten high notes to an aria in order to please an audience—and to show off. Many of these bits have become traditional, some of them even sanctioned by Verdi and Puccini. Generally, if the audiences cheered, the composers were more than happy to leave the bits in.

Anyway, why single out Toscanini? America is, and always has been, the land of hype. Since Jenny Lind, every artist has been subject to it. There are no publicity machines in Europe even faintly approaching the grand scale of our own (and

probably no artists pulling down so much money). There has always been the idea in America that culture has to be sold to the public, as palatably and profitably as possible. But maybe it works: In the 1990s, classical recordings are bought in the United States on a scale undreamed of forty years ago. When they told us that Toscanini was the world's greatest conductor, maybe they were right.

Also, if anyone sought the spotlight, it was Leopold Stokowski, who was a real publicity hound, with his beautiful hair and poetic hands and the other elements of his carefully orchestrated mystique—Garbo and Gloria Vanderbilt, and *Fantasia*. Toscanini was aloof; he did nothing to court the public. He never lowered his standards or lost his dignity. Toscanini had the mystique naturally. The public relations men just helped it along.

Toscanini was a man of energy, rigor, and occasional tyrannical violence. His perfectionist insistence on fidelity to the score was revolutionary in his day—and the first step toward the modern spirit of respecting the composer's intentions. He is by the far the most influential conductor of the twentieth century.

Between the "Grand Tradition" and the New Americanism:
Italian American Composers from Menotti to Corigliano

There is no question that a canon of twentieth-century Italian American composers can be delineated, one that would include a significant number of musicians who are also central to the American canon. The question remains, however, of whether the line of composers extending from Walter Piston and Gian Carlo Menotti to David Del Tredici and John Corigliano defines itself in terms different enough to constitute a specific Italian American tradition of art music. In other words, are we merely dealing with American Italian music and a group of eclectic composers who either adhere to a modernist version of international style or play out an endgame with Verdi and Puccini? Or are we, in fact, dealing with composers who stage an encounter between Italian musical culture and the American "tradition of the new," as do Aaron Copeland and George Gershwin? The Italian American composer, particularly the operatic, is almost automatically placed in the role of custodian (*custodianship,* with the piety toward tradition and craftsmanship it entails, is a quintessential Italian vocation) of the European "grand tradition" and the Italian contribution to it. This custodial project—one that musicians share with their counterparts in the visual arts and the various artisinal traditions—is nowhere better embodied than in the figure of Toscanini, the "transatlantic connection" who transmits the Old World music to the New World from

the pragmatic—"custodial"—perspective of the working musician. This custodianship and craft-consciousness can also be seen to inform the central role played by Italian Americans in musical pedagogy: for example, Piston at Harvard University and Vincent Persichetti at the Juilliard School, both of whom wrote definitive textbooks on twentieth-century techniques.

From this point of view, a neoclassical composer like Piston, who is described in the *New Grove Dictionary of American Music* as the "most consistently loyal [of the major composers] to the 'grand tradition,' both stylistically and formally," might serve as an example of the Italian American musician who defines himself in a cosmopolitan way. On the other hand, if there is such a thing as a paradigmatic Italian American composer, one who embodies the hybridism of straddling two musical cultures, Menotti would be the more indicative choice. While working within the tradition—"updating Puccini," as the ritual formula goes—Menotti has been one of the central forces in the democratization and "Americanization" of opera and in translating it into the new media, first radio and then television. Moreover, in *The Saint of Bleeker Street* (1954), set in the Italian quarter of New York City, Menotti creates an opera, at once lyrical and realistic, that represents the Catholicism of the Italian American world in terms of a psychodrama that pits the mysticism of the saint (Annina) against the agnosticism of her brother (Michele).

What follows is a series of brief sketches of the major Italian American composers—whether emigres like Menotti and Vittorio Rieti or second-generation like Piston and Norman Dello Joio—organized in terms of two trans-generational constellations: The first Janus-faced constellation comprises composers born between the turn of the twentieth century and 1930, who define themselves primarily in terms of the European tradition; the second Janus-faced constellation comprises the more forward-looking and experimental composers born around or after 1930, who define themselves primarily in terms of the American tradition and who move toward postmodernist stylistic identities.

The First Constellation: The Generation of Menotti and Piston
The most famous, most successful, and most loved of Italian American composers is Gian Carlo Menotti (1911–), who, though born in Italy, came to the United States to study music at the Curtis Institute in Philadelphia (1927–1933), and chose to stay. Among his fellow students at Curtis were Samuel Barber (1911–1980), who would become his lifelong friend and colleague, and an Italian child prodigy, Nino Rota (1911–1979), who composed numerous operas and orchestral works but who achieved his greatest fame for his unforgettable film scores

for Federico Fellini *(La Strada, La Dolce Vita, 8 1/2)*, Luchino Visconti *(Senso, Rocco and His Brothers, The Leopard)*, and Francis Ford Coppola *(The Godfather Part I and Part II)*. Menotti has written more than twenty operas, including *Amelia Goes to the Ball*, which premiered at the Metropolitan in 1936; *The Medium* (1946) and *The Telephone* (1947), which are usually double-billed; *The Consul* (1950), in which Maria Callas would have made her La Scala debut, but for a last-minute contretemps; and *The Saint of Bleeker Street* (1954), all of which enjoyed impressive runs on Broadway, and *Amahl and the Night Visitors* (1951), the first American opera to be commissioned for television and one of the most frequently performed operas of all time. These were his greatest triumphs. His succeeding works for some reason have met with less success. Menotti is probably the most conservative of contemporary operatic composers, his style unashamedly rooted in the tradition of late-nineteenth-century *verismo*. His strong sense of theater, his accessible style of vocal writing, and his exceptional melodic gift have endeared him to a vast public, if not to his more avant-garde colleagues. In 1958 he organized the Spoleto Festival in Italy, a canny blend of culture and *vita mondana* (society life) presenting a stimulating mixture of Italian and American music, theater, and dance groups. In 1977 he created its American equivalent in Charleston, South Carolina, where it continues to flourish. In 1986 his opera *Goya* premiered at the Kennedy Center in Washington, D.C. A multifaceted, multitalented, and colorful figure who has also written ballets, concertos, and chamber works, Menotti has been criticized by some for, Bernstein-like, attempting too much and spreading his talents too thin.

Within the Italian American context, Walter Piston (Pistone) (1894–1976) can be regarded as the instrumental counterpart of Menotti in that, by mid-century, he was considered among the major contemporary composers, having gained a fairly wide public success with music that, in Kenneth McLeish's apt description, is "fluent and characterful and uses the techniques of modernism without ever becoming unapproachable: when people say 'he makes us hear C major as if he'd just invented it,' this is the sort of music they have in mind." Piston's personal history narrates a conversion to music and ultimately to musical life in academia: Growing up in a nonmusical home, he taught himself the violin and piano after his family moved from Maine to Boston in 1905, and he earned pocket money playing in concert halls and restaurants. During World War I, he enlisted in the Navy Band, learning to play the saxophone by ear in several days. He enrolled at Harvard in 1919, studying counterpoint under Archibald T. Davison, whose assistant he became; after graduating summa cum laude in 1924, he went to study with Nadia Boulanger in Paris, where he encountered the new music. Upon his return in 1926, he took up a position at Harvard, where he would teach

until 1960, assuming the Naumburg Professorship and mentoring such students as Elliott Carter, Leonard Bernstein, and Irving Fine, all of whom would become notable composers. His influence extended far beyond the Harvard sphere, in part because his lucid textbooks on harmony, counterpoint, and orchestration were widely used throughout the world. Primarily a composer of orchestral music, he is much admired for his meticulously wrought and civilized works—elegance, control, and craftsmanship are the terms usually applied to his neoclassical formalism. His best-known work is the jazzy ballet-suite *The Incredible Flutist* (1938), a work that, according to Elliott Carter, marks the transition from Piston's initial attempt to integrate and assimilate modernist techniques to his later search for directness and simplicity. Although he establishes no specific musical intertextuality with the Italian tradition, his musicianship is "Italian" in its working-musician's concern with performance (many of his symphonies were commissioned for the sound of a specific orchestra and the sound of a specific hall) and his aristocratic and accessible moderation in music: "Piston's music is sane and unneurotic," Klaus Roy has written; "he does not hand on to us his problems, but his solutions." The position of "inbetweenness"—not to be confused with the pejorative "middle of the road"—is perhaps the primary discursive position, as this volume attempts to demonstrate, from which Italian Americans compose, write, and perform. Piston was awarded the Pulitzer Prize for Music in 1946 and 1961 for his Third and Seventh Symphonies, respectively.

The elegant and worldly Vittorio Rieti, literally a figure from another age, was looked upon with awe in cultural circles as the last of the Diaghilev circle. Born in Alexandria, Egypt, of Italian parentage in 1898, he studied composition in Rome with Ottorino Respighi and Alfredo Casella and is remembered for his scores for Diaghilev's Ballets Russes in the 1920s, such as *Barabau* (1925) and *Le Bal* (1929), scores as controlled and sophisticated as the composer himself. He emigrated to the United States in 1940, and became an American citizen in 1944. In 1946 he wrote *Night Shadow* (later known as *La Sonnambula*), using themes by Vincenzo Bellini; George Balanchine choreographed the haunting work for the New York City Ballet, which has kept it in its repertoire. In 1990 Rieti's *Ninth Symphony* premiered in New York City. Extremely prolific, Rieti wrote chamber music, choral works, short operas, and music for the company of the distinguished French actor Louis Jouvet. He was visiting professor at the Peabody School of Music in Baltimore from 1948 to 1950, at the Chicago College of Music from 1950 to 1953, at Queens College, New York, from 1956 to 1960, and at the New York College of Music from 1960 to 1964. America had little or no influence on his composing style, which remained virtually the same for seventy years, that of

the quintessential citizen of the world, who, it has been said, might have stepped from the pages of a novel by Henry James. He died in New York in 1994.

Vittorio Giannini (1903–1966), in addition to symphonic works, wrote a number of operas in a relatively traditional Italianate style, including *The Scarlet Letter* (1938), *The Taming of the Shrew* (1953), his most popular work (and which Maria Callas agreed to appear in if he would write a bravura aria for her; he did not, possibly in error), *The Harvest* (1961), and *The Servant of Two Masters* (1966). His assets were considered to be his melodic facility—a mixture of Puccinian *verismo* and Wagnerian chromatism—and his sound theatrical instincts. In the early 1930s he won three consecutive Rome Prizes at the American Academy in Rome. He had a distinguished teaching career at the Juilliard School, the Manhattan School of Music, and the Curtis Institute. In 1964 he helped found the North Carolina School of the Arts, and he served as its director until his death. His father, Ferruccio, a famous tenor, was one of the very first classical artists to record, having made numerous cylinders for Vittorio Bettini in New York as early as 1895, and his sister Dusolina (1903–1986) was an internationally renowned dramatic soprano.

Norman Dello Joio (1931–) claims that his earliest influences were Italian opera, the music of the Catholic Church, and the pop music and jazz of the 1920s and 1930s. His music, however, unfolds under the sign of Hindemith, who was his principal teacher. As Richard F. Goldman observes: "If Dello Joio's music is less angular and has more obvious warmth than his master, that is perhaps a reflection of his Italian heritage." While on the mark, this comment indicates the way in which Italian American musicians are perceived. Dello Joio's Italianness is more correctly recuperated by examining the intertextuality he establishes with the tradition—for example, his deployment of traditional liturgical music, the Puccinian allusions in his two-act opera *The Triumph of St. Joan* (1958), and his reworking of a theme by Vincenzo Albrici (1631–1696) and the antiphonal music of the early Italian Church composers in *Antiphonal Fantasy on a Theme of Vincenzo Albrici*. The Italian American experience is thematized in the fourth section ("Little Italy") of the suite *New York Profiles* (1949), which consists of a spirited Italian dance such as might be witnessed in the streets of New York's Italian neighborhoods. His output has been enormous. He was awarded the Pulitzer Prize in 1957 for his *Meditations on Ecclesiastes* for string orchestra. Martha Graham utilized music from his *Serenade* for her *Diversion of Angels* (1948) and from his opera *The Triumph of St. Joan* for her *Seraphic Dialogue* (1955). Dello Joio has taught at Sarah Lawrence College from 1945 to 1950 and the Mannes College of Music in New York City from 1956 to 1972; he has been at Boston University since 1972.

Vincent Persichetti (1915–1987) taught at the Philadelphia Conservatory and at The Juilliard School for many years and composed hundreds of symphonic and chamber works. His music features "non-consecutive pitches over long musical spans and outer-voice structures," but, as Hugo Weisgall has pointed out in the *Dictionary of Contemporary Music* (1971), "He has always written in whatever manner suits his particular conception at the time, from freely tonal through quasi-serial music, all with an equally sure hand." A master technician, he believed that the musician's challenge is to create a compositional style utilizing the wealth of material placed at his disposal by the expansion of musical grammar over the last century. His works, written in an astonishing variety of musical idioms, have been criticized by some for revealing a cold and detached technical virtuosity rather than a distinctive quality of their own. Persichetti's piano works are considered particularly significant, offering a microcosm of his entire musical output. He also set to music texts by Whitman, Dickinson, Joyce, Cummings and Sandburg. Persichetti was honored with a medal from the Italian government in 1958.

Peter Mennin (Mennini) (1923–1983) was president of Juilliard from 1962 until his death. He is remembered for his nine large-scale symphonies, notable for their characteristic American nervous energy as well as for the influence of certain northern European symphonic composers.

Dominick Argento (1927–) has been professor of music at the University of Minnesota since 1958. He prefers to work in relative isolation in the upper Midwest. He studied with Luigi Dallapiccola in Florence on a Fulbright grant in 1951–1952, and again in Italy in 1958 as a Guggenheim Fellow. Primarily a composer for the voice, he has a fondness for small-scale vocal works and one-act operas. His opera *A Postcard from Morocco* (1971) has been frequently performed; his song cycle *From the Diary of Virgina Woolf* won the Pulitzer Prize in 1975; and his opera *Miss Havisham's Fire,* based on Dickens' *Great Expectations,* was premiered by the New York City Opera in 1979. "The voice is our representation of humanity" is his credo. His music is romantic without being derivative, and he is popular with critics and audiences alike. His opera *The Dream of Valentino,* based on the life of the legendary actor, was premiered by the Washington Opera in 1994.

Nicholas Flagello (1928–1994) began composing at the age of eight, performing publicly as a pianist before the age of ten. While a child, he began a long and intensive apprenticeship with Vittorio Giannini, who imbued him with the enduring values and principles of the European tradition. He graduated from the Manhattan School of Music (B.M., 1949; M.M., 1950) and immediately joined the faculty, remaining there until 1977. In addition to composing, he was active as a conductor, making numerous recordings that spanned a wide repertoire. In

1985 a deteriorating illness brought his musical career to an end prematurely. As a composer, Flagello rejected the fashionable academic modernism of his time, maintaining a view of music as a vehicle for personal emotional and spiritual expression, using traditional forms and principles derived from Romantic usage. His music is characterized by a brooding intensity, with rich melodies and explosive climaxes. His catalog numbers seventy-five works, including six operas, two symphonies, eight concertos, and numerous orchestral, choral, chamber, and vocal works.

(This assessment of Flagello's career was graciously prepared by Walter Simmons, his biographer.)

The Second Constellation: From Martirano to Corigliano
Salvatore Martirano (1927–1995), former professor at the University of Illinois at Urbana, is known for his avant-garde works. While he was a fellow at the American Academy in Rome from 1956 to 1959, his work was primarily dodecaphonic (twelve-tone); later he began to incorporate elements of jazz and rock. In this vein is *O O O O That Shakespeherian Rag* (1958), a collage work that juxtaposes jazz, night club music, and serialism. *L.'s G.A. (Lincoln's Gettysburg Address),* a computer-aided work (1968), was a success at the Electronic Circus in 1969 and has come to be regarded as a multimedia classic. An anti-war piece, it features a "gas-masked politico" (played by an actor who uses helium to produce a shrill, high-pitched voice) who squeals the Gettysburg Address while film images flash by of a man masturbating and a toy tank driving over a woman's naked torso. Other images of war follow, accompanied by near-deafening prerecorded sounds—the total effect of this sonic and visual barrage is to deconstruct Lincoln's monumental address. During the 1970s and 1980s, Martirano experimented with a wide variety of styles and media, including electronic tape. In 1971 he developed the Sal-Mar Construction, an instrument that permits the simultaneous creation and performance of improvisatory compositions.

Donald Martino (1931–), who has taught at Princeton, Yale, and Harvard Universities and the New England Conservatory, and is professor of music at Brandeis University, won the Pulitzer Prize in 1974 for his *Notturno*. He studied in Florence as a Fulbright scholar from 1954 to 1956 with Roger Sessions and Milton Babbitt, as well as with Luigi Dallapiccola, and followed the twelve-tone school of composition. He has developed an extremely complex, quasi-mathematical style, "using arithmetical permutations of rhythmic and tonal elements as a means to connect nonconsecutive pitches over long musical lines," to use Max Harrison's precise description in *Contemporary Composers* (1992). His most specific

encounter with Italian culture involves his work on *Dante, Paradiso's Choruses* (1974) for twelve soloists, two choruses, tape, and orchestra.

David Del Tredici (1937–), professor of music at Harvard, Boston University, and since 1984 the City College of New York, abandoned the serialism in which he was trained for an outright return to tonality and has achieved enormous popular success. Since 1968 most of his work has been based on Lewis Carroll's *Alice* stories. *Final Alice* (1974) is considered his finest work; its *finale* unfolds as a thirteenfold repetition of his own surname, a musical pun on *tredici,* the Italian word for "thirteen." His subsequent works have managed to be complex and yet accessible and even enjoyable to the audience at the same time. His *Child Alice* (1977–1981) has been highly acclaimed and frequently performed, and *In Memory of a Summer's Day* (1980) was awarded a Pulitzer Prize.

John Corigliano (1938–) is the son of John Corigliano (1901–1977), concertmaster of the New York Philharmonic and the San Antonio Symphony. Corigliano thinks of his music as having an American, "clean-lined" sound, closer to Copland, Roy Harris, and Bernstein than to Schoenberg. He makes no hard and fast distinction between serious and popular music, saying that it should all be serious and all popular. In 1970 he used the Moog synthesizer in a rock transcription of *Carmen, the Naked Carmen,* an "electric rock opera." In 1976 his *Dylan Thomas Trilogy* for voice and orchestra was acclaimed, as was his *Clarinet Concerto* the following year. His score for Ken Russell's film *Altered States* (1980), notable for its virtual rejection of conventional harmony, was nominated for an Academy Award. His postmodernist opera, *The Ghosts of Versailles,* the first part of a trilogy reexamining Beaumarchais' *Figaro* rather than Mozart's, was cheered by the audience at its world premiere at the Metropolitan in 1991, a rare phenomenon indeed for a contemporary opera, and played to sold-out houses. It returned to the Met for the 1994–1995 season, an even rarer phenomenon and a real tribute to its composer. Corigliano's *Symphony Number One: The AIDS Symphony,* premiered in 1992 and has been performed often since then.

Thomas Pasatieri (1945–) studied with Vittorio Giannini and Vincent Persichetti at Juilliard. He has composed more than sixteen operas, including *The Trial of Mary Lincoln* (1972), *The Seagull* (1974), *Washington Square* (1976), and *Maria Elena* (1983), several of which were premiered on television and are performed frequently, as well as several hundred songs and film music for Hollywood. Pasatieri has endeared himself to both audiences and singers by writing in a frankly traditional, Italianate vein. Since he strives to write music that is grateful for the voice, his operas have often attracted first-rate singers, a number of whom have commissioned works for him.

Has this survey revealed any features that would serve to define Italian American art music as a specific entity? The long fidelity to opera has characterized the oeuvres of many of its major composers. Consider, for example, their contributions to the American opera of the late 1980s and early 1990s: Menotti's *Goya* (1986), Pasatieri's *Three Sisters* (1986), Argento's *The Aspern Papers* (1986), and Corigliano's *The Ghosts of Versailles* (1991). Although these operas display a variety of musical and theatrical styles, they can probably be subsumed under the broad category of traditional lyricism, regardless of however that designation may be inflected by more actual terms such as neotraditionalism (Argento) and postmodernism (Corigliano). Here again we have a situation in which Italian American artists occupy the position of "inbetweenness," the integrated as opposed to the apocalyptic position, as Umberto Eco would say. Such a position is certainly at odds with the situation in Italy that has produced such "apocalyptics" as Luigi Dallapiccola, Luciano Berio, and Giacinto Scelsi, the latter perhaps the most eccentric of modern composers whose concept of one-note music anticipated minimalism. However, to regard Italian American composers as guardians of tonality or, at most, prisoners of middle-period Stravinsky, or to take Del Tredici's "reinvention" of tonality as an allegory of the Italian American tradition—all are gross essentializations that fail to take into account the differential identities of these composers and to interrogate the position of inbetweenness and the lyricism and elegant craftsmanship it entails.

The Long Good-bye to Bel Canto: *Popular Music from Russ Columbo to Frank Zappa*

There can be no doubt that Italian Americans have contributed more than their share to our country's popular music and jazz, and, despite the previous comments about Italian American operatic voices being somewhat less sumptuous than those of their native Italian colleagues, it can be safely said that where pop voices are concerned, those of the Italian Americans are on the average richer, warmer, and more romantic than those of their competitors.

The genealogy of Italian American pop singers as it extends from Russ Columbo and Frank Sinatra into the rock era can be seen to execute a long goodbye to *bel canto,* with *bel canto* understood informally and in its twentieth-century application as an attempt to emit the most beautiful sounds possible, using the microphone as a means of so doing. It was through the figure of the dark and handsome crooner, a musical persona the second-generation virtuosi would define, that the Italian American singers would exert a certain hegemony over American popular

singing from the 1930s to the early 1960s. This can be seen by the following constellation of "crooners," which might be organized into two contrasting stylistic camps: the introspective–involved vs. the extroverted–distanced balladeer (or the "hard" vs. the "soft" crooner, to use the distinction made by Charlie Gillet *The Sound of the City: The Rise of Rock and Roll*), although the singers often cross over.

The "hard" style was that of the crooner with an edge, introspective as well as erotic, to his vocal style, as prefigured by Columbo and typified by the mature Sinatra's "angular-toned, 'hard,' involved style," as Gillett puts it, suited to render the "Other-ache" of the torchsong. The "hard" style is definitive of the Sinatra school: from the smooth romanticism of Vic Damone to the more extroverted styles of Tony Bennett and Julius La Rosa. The "soft" style was smooth, emotionally relaxed, and, as Gillett specifies, more "suited to sing-along novelty songs and sentimental ballads." It is best epitomized by Perry Como and such effortless stylists as Dean Martin and Al Martino. In categories of their own would be the singers: Mario Lanza, the American Caruso and crossover phenomenon who also knew how to drive a pop ballad; Louis Prima, the heir of Jimmy Durante and the Italian American equivalent of Louis Armstrong; and Frankie Laine, a belter who dominated the charts of the late 1940s and early 1950s with his big-voiced ballads, some of which were country-and-western influenced. Also to be mentioned are such vocal groups as the Four Aces and the Ames Brothers and such woman crooners as Fran Warren and Toni Arden.

The crooners who, after the revolution of rock 'n' roll, would be relegated to the mainstream as guardians of the prerock canon were succeeded in the late 1950s by the teen idols (Frankie Avalon, Fabian Forte, Bobby Rydell, Bobby Darin, and their female counterparts, Connie Francis and Annette Funicello) and the Italian doo-wop groups (the most important lead singers of which were Dion DiMucci of the Belmonts and Frankie Valli of the Four Seasons), and in the late 1960s by such rockers as Felix Cavaliere and Mitch Ryder and, in the 1970s and 1980s, by the Italian Irish Bruce Springsteen. Although most of the rock performers remain signifiers of ethnicity and of specific urban contexts, their musical identities come to be constructed more and more in terms of the subculture of rock 'n' roll. This is especially true of the post-1960s generation, which—unlike the crooners, many of whom were able to sing in Italian or at least to incorporate English versions of Italian songs into their repertoire—operates without reference to the Italian musical tradition.

The role of the crooner-balladeers was congenial to the lyricism of their musical heritage and to the expression of their sexual personae, as well as to what might be called their cultural persona: the Italian performing self, which, how-

ever it may be identified with self-display (vocal virtuosity and the protocols of *divismo* [superstar behavior]) and the emotional exorbitance of the extreme situations of operatic singing, has many registers. Therefore, to attribute the musicality of Italian American singers, as musicologists tend to do, to "innate Italian lyricism" or "folkish tunefulness" is to reproduce a slightly more sophisticated version of the great stereotype of musical solarity: mandolins—"O sole mio"—$^6/_8$ or $^2/_4$ rhythms. The point to be recognized is that the *canzone popolare napoletana* (Neapolitan popular song), in its evolution from the early nineteenth century to the 1950s, is a variegated music that deploys many registers, not just the solar—the syncopated rhythms, the tarantellas and cabalettas of the sun—but also those of the "dark sun" of melancholy and of the nuanced and introverted voice that captures the pain of the amorous catastrophe. There is also a sophisticated register involving sexual banter as typified in such songs as *"E spingule francese"* (French Pin), *"Io ti do una cosa"* (I'll give you something) and *"La pansè"* (The Pansy), the titles of which immediately suggest the double entendre. (The Neapolitans, of course, are aware of the solar register and the melodic and verbal hyperbole it brings into play. As the lyrics of the quintessential song of the *posteggiatori* [Neapolitan street singers], *"Dduie Paravise"* [Two Paradises] make clear, Neapolitans think of Naples as an earthly paradise where *"musica e passione"* have combined to produce "a never-ending repertory": "Carmela," "O sole mio," "Maria Mari!"—three legendary songs that epitomize the solar mode of excess.)

Furthermore, the *bel canto*, within the Italian cultural context, is a mode of performance, flagrant in self-display but also other-directed, designed to produce a violent catharsis in the listener who belongs to an ear-intense culture in which the voice itself is a sonic spectacle. Here we speak of *bel canto* not just as codified by Bellini, Donizetti, and Company, but as a living practice that also informs Italian popular music well into the twentieth century, especially the Neapolitan tradition, the *point d'appui* (point of reference) for the second-generation Italian American singers. Although it derives from the opera style of the early nineteenth century, the Neapolitan tradition of modern popular song is equaled only by the new American music that displaces it in the 1930s and eclipses it in the 1950s, when African American music comes to dominate the world music scene. Italian singing as performance involves the vocal and gestural (including the gaze) manifestation of passion, and as such unfolds as a seduction by which the desire of the singer and the desire of the listener are joined. The "soft violence" of the vocal performance with all of its passional excess diverts the excess of violence always at work in the Italian real.

It is this sense of singing as exhibitionism and seduction that forms the

background to the Italian American episode in American popular music. Although the melting pot has long been discredited as a metaphor for Americanization, it certainly remains in effect as a description of the formation of American popular music, in which musicians, singers, and songwriters have constructed their musical identities in terms of hybridizations and bordercrossings involving classical music, jazz, pop, and rock—not all of them mandated by the commercial demands of Tin Pan Alley. This is particularly true of the Italian American singers who, typecast into the role of "dark and handsome" crooner, would construct their singing styles as hybrids borrowing from the African American jazz singers and the American mainstream, grafting these influences onto their own sense, however intuitive, of the *bel canto*—their applied Carusoism—elaborating a new art of performance, at once erotic and intimate, that would, as in the case of Columbo and Sinatra, involve the audience in a delirious response that had been previously reserved only for movie stars such as Valentino. Indeed, it would be Sinatra who would precipitate the now legendary 1944 Columbus Day riot, when 30,000 fans stormed the Paramount Theater in New York City, an event that announced the new way in which pop music would be received: The image of the performer would become central to the vocal performance, the distinction between the meaning of a singer's music and the meaning of his or her projected persona having collapsed.

Dark and Handsome and Baritone: The Crooner As Archetype of the Second Generation
Before the appearance of the electric microphone in the early 1920s, popular singing as we know it today did not—could not—exist. If you sang popular music in the theater and wanted to be heard in the uppermost balcony, you had to have the rudiments of a legitimate vocal technique—that is, the kind that opera singers had. So you sang in an impersonal kind of John McCormack Irish-tenor sound that carried well, hoping that the words were at least intelligible to the audience. Or, if nature had given you lungs of steel, like Al Jolson's, you belted the song across. It is no accident that the most popular performer of the pre-mike period was Jolson, whose larger-than-life voice and personality could project to every seat in the house. The singer with the orchestra in those days was generally faceless and anonymous; he or she was merely there to deliver the lyrics of the song. Record labels of the 1920s often merely said: "with vocal refrain." With the advent of the microphone, a new type of singing came into being, called, disparagingly at first, crooning. Crooning was damned from the pulpit and the editorial pages as unhealthy, unmanly, and another sign that America was going to the dogs. Crooning was simply singing softly, intimately, and possibly romantically with as pleasing a tone as possible, without having to worry about sheer volume. Since

no one had ever sung that way before, old-timers instantly denounced it as effete and not really singing at all.

One of the very first of this new breed was Nick Lucas, "The Singing Troubadour," born Dominic Anthony Lucanese in Newark, New Jersey, in 1897. Already a virtuoso guitarist in his teens, he toured in vaudeville and is credited with making the guitar more popular than the banjo. After the World War I Armistice in 1918, he toured the Continent, appearing at the Cafe de Paris in London, where the Prince of Wales brought the Queen of Spain to hear him play. Returning to the United States, he joined Ted Fio Rito's Orchestra at the Edgewater Beach Hotel in Chicago. He began to sing as well as play on their radio broadcasts and was signed to a recording contract in 1925. In 1929 he appeared in Warner Brothers' early talkie *Gold Diggers of Broadway*, singing "Tip-Toe Thru the Tulips," a song that would be forever associated with him. At Tiny Tim's request, he sang it at Tim's wedding in 1969, before the largest audience in the history of the *Tonight Show*. He was one of the highest-paid stars of vaudeville and radio in the 1930s, and the Nick Lucas guitar, introduced in 1925, earned him royalties for decades. Lucas was still making occasional recordings and appearing in clubs such as Harrah's in Reno, Nevada, until shortly before his death in 1982. Gene Austin, who was not Italian, sneaked in there for a couple of years as real competition with his husky, sweet-voiced renditions of "My Blue Heaven," which sold twelve million copies for Victor Records—back then—and "Ramona" in 1927–1928.

Although these two were among the earliest stars of the microphone era, and their singing could be called intimate, Lucas' style was basically upbeat and cheerful, and Austin's, though somewhat more romantic, could hardly be considered erotic. That had to wait for the arrival on the scene of Russ Columbo. Ruggiero Eugenio de Rodolfo Columbo, born in Philadelphia in 1908, was a child prodigy who sang and played the violin on stage from the age of four. For a time, he considered a career in opera. Bandleader, composer, and singer, he made his radio debut in 1930; he was twenty-two years old, a handsome liquid-eyed crooner, usually in tails, who could have been Valentino's younger brother. He may well have been the first Italian American heartthrob. Caruso hardly fit that description, and Valentino was considered by many a bit too bizarre for comfort.

Columbo was a baritone; most of his predecessors were tenors. There was an overt sensuality to his persona and in his singing: he was definitely not the boy next door. He sang in an impassioned, throbbing style, with the second chorus of every song a silken, wordless obbligato in the manner of a violin, which his fans found irresistible. And he sang love songs almost exclusively; his big hits were "Paradise," "Temptation," and "Prisoner of Love." By 1932 the "Big Three" of radio

crooners were Columbo, Bing Crosby, and Rudy Vallee, the latter one of those inexplicable phenomena of show business. Crosby and Columbo carried on a well-publicized radio feud that year, "The Battle of the Baritones," Bing on CBS and Russ on NBC. By 1934 Columbo seemed to have it all—three Hollywood films to his credit, stardom on radio and records, and a romantic involvement with Carole Lombard—when, on 7 September of that year, a Civil War–era pistol that he was examining at the home of a friend in Hollywood went off accidently and killed him. He was twenty-six years old. The story goes that his mother, who had a serious heart condition and later lost her sight, was never told of his death. Her family would read her letters supposedly written by Russ, constantly on tour throughout the world, until her death ten years later. Some believe that she had guessed the truth, but went along with the charade.

So for the rest of the decade, Bing Crosby had the field all to himself. His reign was absolutely unchallenged. Crosby created casual. He was, we liked to think, the ordinary American guy, not too good-looking, a bit broad in the beam, dressed in slapdash fashion (the sure sign of someone you could trust), a good family man (apparently), and father of four sons, who simply opened his mouth and sang, effortlessly and beautifully, and without affectation—the way we imagined we sounded when we sang in the shower. On the radio, he seemed to be ad-libbing rather than following a script, and if he flubbed a word in a song, it simply endeared him to the audience all the more. Every young male singer in the country copied him; Dean Martin's entire act in his later days was a kind of parody of Crosby. He was the most loved personality in the country for a good fifteen years: He was the Great American Guy.

Bing had no real competition until one of his imitators, a skinny, hollow-cheeked kid from Hoboken, New Jersey, named Frank Sinatra (1915–1998) became an overnight sensation at the Paramount Theater in New York, the site of his first solo engagement, on 3 December 1942, and his return engagement that precipitated the Columbus Day riot in 1944. Actually, the overnight sensation had been carefully honing his craft for several years as vocalist with the orchestras of Harry James and Tommy Dorsey. His explosion onto the scene had been painstakingly orchestrated by his manager, George Evans—nurses in attendance with smelling salts, ambulance parked outside the theater. As is rarely the case in such instances, Sinatra deserved the orphic reception; he really was good, far better than those hordes of teenage girls would realize. If you examine the photographs of the era of the thousands of screaming bobby-soxers in the audience, most of them seem to be Italian American. Frankie was one of their own and, whether they sensed it or not, destined to become the American Orpheus for the next fifty

years, the definitive pop stylist of his generation and, subsequently, as the *Rolling Stone Encyclopedia of Rock & Roll* puts it, "the model and envy of rockers from the beginning."

He sang beautifully, and he sang *more* than Crosby. As Sinatra wrote in "Me and My Music," an article that appeared in *Life,* 23 April 1965: "Instead of singing only two bars or four bars of music at a time—like most of the other guys around—I was able to sing six bars, and in some songs eight bars, without taking a visible or audible breath. This gave the melody a flowing, unbroken quality, and that—if anything—was what made me sound different." In other words, Sinatra did not want it to sound like Everyman in the shower; he wanted it to sound gorgeous. He had listened to Caruso and Crosby and Jascha Heifetz's violin and Tommy Dorsey's trombone, learning the secrets of breath control and how to spin out a long, unbroken legato. However intuitively grasped, he had a sense of Italian *bel canto*—producing the most beautiful sound possible, with polished and expressive phrasing.

As Sinatra himself observed, in the oft-cited 1965 article for *Life*: "It occurred to me that maybe the world didn't need another Crosby. What I finally hit upon was the *bel canto* Italian school of singing, without making a point of it. That meant I had to stay in better shape because I had to sing more. It was more difficult than Crosby's style, much more difficult." Both Henry Pleasants and John Rockwell in their definitive studies of Sinatra's vocal style have stressed this intuitive appropriation of the Italian tradition. Pleasants emphasizes the instinctive musicianship that brought Sinatra "closer to the art of the classical singer than any other popular singer has come," reading his technique through the lens of Pier Francesco Tosi, who had codified the *bel canto* style in the first part of the eighteenth century. From this perspective, Sinatra's style is a hybrid construction in which the Italian idiom fuses with Crosby's engaging approach and the various elements of the new Americanism as mediated by Tin Pan Alley, especially the influence of the jazz singer Billie Holiday and the cabaret singer-diseuse Mabel Mercer. "It was Billie Holiday," Sinatra wrote in *Ebony* magazine in 1958, "whom I first heard in Fifty-second Street clubs in the early thirties, who was and still remains the single greatest influence on me." He learned phrasing from Holiday, and the art of the lyric from Mabel Mercer.

An aspect of Sinatra's art that is seldom mentioned is the fact that, along with all of the forgettable jukebox stuff he was obliged to do, almost from the beginning he also was recording songs more often encountered in the concert hall ("None but the Lonely Heart," "Without a Song," "Somewhere a Voice Is Calling") and in the upper echelons of American popular song ("The Song Is You,"

"It Never Entered My Mind," "I Concentrate on You")—songs that Mabel Mercer might sing in an East Side supper club, songs written for sophisticated Broadway audiences and considered over the heads of the American public, songs that other popular singers, Crosby included, rarely performed.

This impeccable selection of songs—Wilfred Sheed calls him "The Man Who Saved the Standards"—does not explain the way in which Sinatra appropriates these songs, makes them his own by personalizing and eroticizing them, especially those involving the amorous catastrophe, infusing them with the Sinatran *tenebroso,* an urban and mass-media version of that dark sound that comes from what the poet Federico Garcia Lorca calls the *duende* (mysterious power). Although Sinatra constantly describes himself as a saloon singer, an omnibus category for a singer who can turn a booze ballad or bounce a song and even belt an anthem like "New York, New York," he is unique as a torch singer, as a voice that articulates the drama of erotic crisis and the solitude of amorous loss. This is, of course, not to overlook the tender celebrations of young love characteristic of his work in the 1940s, in which the whole world would be suspended in the balance of a single kiss; or his postcrooner swinging come-fly-with-me mode, the sophisticated detachment of which might be seen as a defense against the romantic *tenebroso;* or the bittersweet ballads of experience of his mature style; or the aggressive vocals of his middle and old age from the hit single "My Way" (1969) to the "husky murmur" of the collection *Duets* (1993), his ultimate comeback. Indeed, the trajectory of his oeuvre provides a complete anatomy of romantic love as it passes from spring to winter. Within that trajectory are inscribed two histories: the physical history of his voice as it passes from the tenderness of the youthful tenor (technically speaking, he is high baritone) whose velvety crooning approached a whisper to the raspiness of old age; and his autobiography as an amorous subject as registered in love songs deliberately chosen to correspond to his personal history and inner experience. This autobiography of the vicissitudes of love, the voice, and The Voice is unique in the ephemeral realm of American pop music, and, because it is a work of time—the life of a man registered in music—a defiant exception to F. Scott Fitzgerald's "law": "There are no second acts to American lives." Indeed, it is the passage from the second to the third act that provides Sinatra, who turned eighty in 1995, with his consummate moment as a singer: the cycle of dark songs of exacerbated and unfulfilled desire that enact, in the anatomy of love, the melancholy passage from late summer to autumn. Recorded in the mid- and late-1950s when Sinatra was in his forties and on the rebound from his marriage to Ava Gardner, the songs of this cycle, interpersed with swing tunes, would serve as aphrodisiacs, initiating the late-1950s American audience into the rites

of neo-romantic love. This cycle comprises the following LPs done for Capitol Records under the orchestration of Nelson Riddle: *Songs for Young Lovers* (1954), *In the Wee Small Hours* (1955), *Close to You* (1957), *Where Are You?* (1957), *Only the Lonely* (1958), and *No One Cares* (1959).

Music critic for the *New York Times* Stephen Holden, in a celebratory review (31 October 1993) of the "pop patriarch's" hit album *Frank Sinatra Duets* (1993), featuring compiled duets with thirteen other pop superstars including Bono of U2 and Luther Vandross, has emphasized the intergenerational dialogue at work in the album, seeing it as a demonstration of Sinatra's influence on younger singers (some of whom belong to the generation that rejected his kind of music in the late 1960s and the 1970s) "as a symbolic healing of that generational gap in pop taste, as a final, reconciliatory swan song." With the album, Sinatra has come full circle, reasserting his transgenerational significance as "the patriarch of naked pop self-expression."

No one has served more completely as an ethnic signifier than Sinatra, his image coming to mirror the contradictions of second-generation identity. Through him the "ethnic thing"—the ethnic self with all its vulnerabilty and rage, its strengths and weaknesses—undergoes a tremendous magnification, a universalization of sorts resulting in a mass-media version of the American imperial self constructed in Italian American terms. Whereas baseball player Joe DiMaggio, his predecessor as cultural hero, embodied the performing self governed by **sprezzatura** (nonchalance, a Renaissance concept that suggests, among other qualities, what Ernest Hemingway, a great admirer of DiMaggio, termed "grace under pressure") as manifested in the "Streak," that unique record in which the **bella figura** (cutting a fine figure) and the work ethic coincide, Sinatra is a more complex figure who constantly introduces the negative into the construction (and maintenance) of his image. Like that other cunning Mediterranean hero of the (im)proper name, Odysseus (literally, to be the bane of many people's existence), Sinatra (Swoonatra, the Lean Lark, the Voice that Thrills Millions, the Voice, Ol' Blue Eyes, the Chairman of the Board, and the "name ending in a vowel" that he would defend in his 1972 appearance before the House Select Committee on Crime, which he described as a "forum for gutter hearsay") is a man of many turns but always a technique for troubling others. Sinatra is, in a characteristically Italian way, a man who "makes the scene" by making scenes, but who also makes the private public and thus always puts at risk what Erving Goffman calls "the territories of the self." It is here, with the notion of a territorial self, that we begin to zero in on Sinatra's Italianness, which traditionally has been read, as in Gay Talese's essay for *Esquire* in 1966, as a discrepant but simultaneous occupation of two

different worlds: the cosmopolitan one populated by show-business people in which he assumes the role of the swinger, and the traditional one populated by his inner circle of *paisanos*, as Talese puts it, in which he assumes the role of **Il Padrone** (the Boss) or, as Talese qualifies, an **uomo rispettato** (respect-worthy man). Intrinsic to this notion of the man of respect is exaggerated personalism, the display of absolute generosity and fidelity toward the special circle of friends on the condition of reciprocal loyalty: "All the Way"; "All or Nothing at All." The territorial self draws the line in the sand. Of course, when Sinatra presses territorial demands on such wider spheres as the media or congressional committess or even the presidency, he opens the way to territorial violations—what he sees as encroachments on his sphere, and what the public sees as violations on his part.

Of all American performers, Sinatra has been the one most involved in the aggressive performance of the grandiose self. Whereas Arnold Shaw, in *Sinatra: The Twentieth-Century Romantic* (1968), has acutely described Sinatra as embodying a "constant counterpoint between toughness and tenderness," that counterpoint is more fully understood when it is situated within the dynamics of the Italian American territorial self. Having struck the Faustian bargain with the media from the outset, Citizen Sinatra has waged a steady agon with the press and other intruders to reterritorialize his preserve—privacy, artistic privilege, and the taste culture (the ideal of "classiness") he upholds, "respect," the Italian American subculture—that preserve being the very thing that was forfeited as his part of the bargain. Through its identification with Sinatra's confrontational self, the American public has come to engage in the career brinkmanship of his repeated comebacks, above all, the first comeback as negotiated by his role as Maggio in *From Here to Eternity;* to appear at the "wrong door" with DiMaggio, our two Italian heroes in search of the American obscure object of desire, whether blonde and breathless or brunette and barefoot; to play the phallocentric game of musical beds with "broads" and starlets in search of the forever lost object of desire; to charm widows, even Humphrey Bogart's, in the name of the mutually lost object; and to slug the *paparazzo* who referred to Judy Garland as a "broad." These and other such amorous scenes—we are still in the 1950s—would provide the subtext that would reverberate in the extended torch song Sinatra would deliver to America throughout his singing career. As he matured, the "amorous errantry"—to move from love to love is itself musical, as Roland Barthes points out in *A Lover's Discourse* (1978)— would harden into the sexual persona he would codify, in the 1960s, as "Swinger." The amorous system would change into a power game as announced by the infantile hipsterism of the Rat Pack, the Clan. Engaged by a new set of scenes and personae (the Rat Pack leader of the 1960s, the Chairman of the Board of the

1970s, the Ol' Blue Eyes of the 1980s, and the pop patriarch—the Legend—of the 1990s), the American public would play out a thirty-five-year-long board game called "My Way" which connected presidents to *Mafiosi*, madonna to *puttane*, Hollywood to Hoboken via Las Vegas, the *bella figura* to the *brutta figura*. Can all this—not to mention the dilettantish political turn from liberalism to Reaganism—be understood in Italian American terms as an attempt to overcome the marginalized and slighted ethnic self by constructing a grandiose self, defiant and hobnobbing, one that involves the vulnerable young Sinatra hardening over the years, into the all-attitude tough guy, the Chairman of the Board?

Can the meaning of Sinatra's music be distinguished from the meaning of Sinatra? The question of Sinatra's persona is much more complex than that of, say, Elvis Presley or the Beatles, the two other musical phenomena that have had similar impacts on popular music. Sinatra is like one of those multistable figures studied in Gestalt psychology that turns from beautiful maiden to old hag depending on what is focused on. What Italian Americans, especially of his generation, see in addition to "the greatest singer in the history of American popular music" (Rockwell's assessment) is the following: the man who tries "to do it all in one generation, fighting under his own name, defending underdogs, terrorizing top dogs"; the man who throws a punch at a musician who said something anti-Semitic and who snarls at a Red-baiting columnist, "If being a Commie means sticking up for the litte guy, I'm Red through and through"; the man who espouses the African American cause two decades before it is fashionable and does not allow Black friends like Sammy Davis Jr. to be treated with any less respect than he demands for himself; the man who serves as a "kind of one-man, Anti-Defamation League for Italians in America." (Some of the above examples are taken from the 1966 *Esquire* essay by Talese, who views Sinatra from an Italian American perspective.) What others, especially the younger generations, see besides the "greatest singer in the history of American popular music" is: a man whose "My Way" routine had become a self-parody long before Sid Vicious; a man who is "obviously proud to be close to notorious hoodlums," to use the words of William Safire of the *New York Times;* the man who "Bogarts" (bullies) everyone, including Speaker of the House Sam Rayburn of Texas, who, after placing his hand on Sinatra's sleeve and requesting him to sing "The Yellow Rose of Texas," received a bit of Hoboken stichomythia: "Get your hand off the suit, creep!"; the man who when honored with the President's Medal of Freedom Award and an honorary doctorate from Stevens Institute of Technology in Hoboken is ridiculed by the "Doonesbury" cartoonist Gary Trudeau in a series of six strips for flaunting his mobster pals and for the *brutta figura* with the woman dealer in Atlantic City. What is symptomatic

about the negative perception of Sinatra is that it demonstrates three laws regarding the stereotyping of Italian Americans within the American imaginary network: They are always already stigmatized by the generic Mafia taint; they are always regarded as politically incorrect, regardless of whether they are on the Left or Right, the Ferraro/D'Amato syndrome; they are not allowed to manufacture negative experience, even in defense of their own defamation, without that aggressiveness being read as a displaced expression of *Mafiosità* (Mafia behavior or mentality). In other words, *"Sinatraism,"* understood as a generic second-generation self-affirming aggressive sensibility, as a type of Italian American "Bogartism," is perceived by the majority culture as "Little Caesarism": "Doing it my way" is deemed a dangerous way of organizing the signs of one's personality because it rejects the Other-induced self, the self authorized by the dominant culture, which, in the Italian American case, is the benign, conformist "Pinocchio-self," the self that accommodates itself to the other's negative fantasy by constructing itself according to an equally fantastic positive formula. This is not to absolve Sinatra from not distancing himself ethically from stigmatizing associations, nor is it to propose the famous Freudian loophole: The bow of Philoctetes comes with the festering wound; artistic genius comes with a neurosis or demons not necessarily of one's own choosing. It is simply to indicate that Sinatra's position is symptomatic of the Italian position in the culture at large, and that as the voice of Italian America he has problematized his identity in such a way as to be one of the few Italian Americans to impose the famous *"Che vuoi?"* onto the majority culture: "What do Italian Americans want?"

Let us return to our history of the crooner. By 1945 every record company and radio network was scrambling for an attractive young baritone of its own (tenors having gone out of fashion)—and if he were Italian American, all the better for, at a time when a singer's image was becoming all-important, Italian Americans fulfilled the conventional dark-and-handsome stereotype of the American romantic hero. They found a lot of them. One of the best and longest lasting was Perry (Pierino) Como (1912–), who left his job as a barber in Canonsburg, Pennsylvania, to become the male vocalist with the Ted Weems Orchestra in 1936 and whose soothing, almost sleepy style of singing found a wide audience. As previously mentioned, Como, as the embodiment of the "soft" crooner, can be viewed as the stylistic counterpoint to Sinatra. Temperamentally as well, he is the antithesis of Sinatra, his private and professional life seemingly having run a smooth and untroubled course for decades.

It was exactly his art of nonchalance that endeared him to the postwar public for whom he served as "the Eisenhower of the baritones, a gentle father

figure" who dominated the charts from 1944 through 1958 with forty-two Top Ten hits, ranging from "Long Ago and Far Away" to "Catch a Falling Star" and "Magic Moments," both of the latter from 1958. It was television that best captured his calm-cool-collected personality, and he became an American icon by mastering the intricacies of the new medium, in which he was billed as the "low-pressure king of a high-pressure realm." His image as a country-club Italian can be seen as a mainstream corrective to the threatening *divismo* of Columbo and Sinatra, a nonconfrontational persona constructed in terms of being **simpatico** (likable) and maintaining the *bella figura* as if performance were a golf game.

Como sang a number of Italian and Italian American songs, but mostly in English. If you wanted songs in Italian, you bought the records of Carlo Buti, the honey-voiced tenor who was Italy's most popular singer in the 1930s and 1940s, and who often appeared in America. Buti was—surprise!—*not* Neapolitan and did not not sing Neapolitan songs. He was Florentine. There were, after all, some lovely songs produced in the northern half of Italy, and it was those that he sang, in his impeccable Tuscan.

A number of the Italian American singers of the middle and late 1940s sang in both languages. Louis Prima (1911–1978), a Sicilian American born in New Orleans, began as a talented jazz trumpeter and was later accused of selling out when he became a singing comedian and leader of an orchestra that combined jazz, dixie, pop, and swing. His recording of "Oh, Marie" ("Maria, Marì!" by Eduardo Di Capua) was a big hit, as were his comedy songs "Josephina, Please No Leana on the Bell," "Felicia No Capicia," "Bacce Galuppe (Makes Love on the Stoop)," "Angelina (the Waitress at the Pizzeria)," "Pleasa No Squeeza the Banana," and other gems of an era that never heard of political correctness. These songs in dialect or with phrases in dialect are authentic Italian American texts—however vulgar in their carnivalization of courtship—in that they are double-voiced, addressed at once to the Italian American listener privy to the obscenities coded in the dialect and the American listener who regards those expressions as "greenhorn" folklore. Prima's girl vocalist, Lily Ann Carol (Greco) was an excellent singer and a real Italian beauty.

In 1946 Phil Brito (Phil Colabritto) recorded an album *Phil Brito Sings Songs of Italy,* which kept in circulation the standard repertory and served as a model for Dean Martin and others who would record similar anthologies. Typical was Brito's version of "Mamma" by Cesare Bixio, which was made famous by Beniamino Gigli and is sometimes called the unofficial Italian national anthem. Carl Ravazza sang *"Vieni su,"* which was apparently not authentically Italian. Alan Dale sang many Italian songs. His father, Aristide Sigismondi, was a famous Ital-

ian comedian, and as a child Dale sang and acted, in Italian, in his father's shows. He sang with the George Paxton orchestra in the mid-1940s before going out on his own as a single and made many records in English and Italian, including an interesting LP of American standards —"Laura," "Over the Rainbow," "Stardust")— sung in Italian. Jerry Vale and Jimmy Roselli both had hit records of *"Malafemmena"* (written by Antonio de Curtis, the great Neapolitan comic better known as "Totò"), Roselli's sung in a particularly flavorful Neapolitan dialect, not the one heard in Naples but the one that evolved in Brooklyn. What is significant about this use of Italian, which persisted even until the early years of rock 'n' roll, is that many of the second-generation singers maintained bilingual singing identities addressed to the Italian audience even as they were assimilated by the demands of mainstream performance.

It is in the guise of the crooner qua balladeer that the Italian American male singers would dominate the postwar and 1950s musical scene. Falling between the two prototypes, Sinatra and Como, such singers as Vic Damone, Al Martino, Tony Bennett, Jerry Vale, Frankie Laine, Alan Dale, Don Cornell, Dean Martin, and Johnny Desmond would all play a role in the Italianization of American pop. Vic Damone (Vito Farinola), born in 1928, had one of his first big hits in 1949 with "You're Breaking My Heart ('Cause You're Leaving Me)," Leoncavallo's *"Mattinata."* The movie-star-handsome Damone had the most beautiful voice of the lot; even Sinatra said, "This kid has the best set of pipes in the business!" He chose high-quality songs and sang them tastefully, although he lacked whatever that indefinable spark is. Tender and wistful like the young Sinatra, Damone's voice has held up remarkably well, and in the mid-1990s he is still a major name on the saloon circuit.

Frankie Laine (Frank Paul LoVecchio), born in Chicago in 1913, the son of Sicilian immigrants, first sang in a church choir and was later celebrated as the crooner "with steel lungs." He had more hits on the jukebox in the late 1940s and early 1950s than any other singer: "That's My Desire" (1947), "Mule Train" (1949), "Jezebel" (1951), "That Lucky Old Sun" (1952), "Rawhide" (1952), "High Noon" (1952), and "I Believe" (1953). Laine, who affirms, "I'm not a crooner. I'm a singer who shouts," was the premier exponent of the style called "belting." His big, lusty baritone and driving, histrionic style found their proper expression in a series of "melodramatic epics of love and fury," which made him a challenger to Sinatra. Good-looking Johnny Desmond (Giovanni Alfredo De Simone), from Detroit (1920–1985), sang with the Glenn Miller Army Air Force Band, becoming known as the "G.I. Sinatra," then went out on his own, having a big hit with "Just Say I Love Her" ("Dicitencello vuje" by Rodolfo Falvo). Jerry Colonna wanted to be

an opera singer but became famous as Bob Hope's comic sidekick. A holdover from an earlier age was the personable tenor Frank Parker, who sang opera, light classics, and pop, appearing on the *Jack Benny Show* in the 1930s and with Arthur Godfrey throughout the 1950s. Everybody thinks Tony Martin was Italian; he had Italianate good looks, a rich, sensuous voice with an Italianate throb in it, and he sang "There's No Tomorrow" ("O Sole Mio"), but he was Jewish.

Three singers who sometimes work in the Sinatra mode are Tony Bennett, Al Martino, and Julius La Rosa. Of them, Bennett (Anthony Dominick Benedetto), who was born in Astoria, Queens, in 1926, has had the most significant career, approaching Sinatra in his ability to go the distance, evolving from the purveyor of jukebox hits like "Because of You" to a jazz-oriented saloon singer, the elder statesman of the classic ballad who keeps on finding new audiences, as his 1990s success on the MTV cable network attests. As Stephen Holden has written: "Among those still living who are custodians of the pre-rock canon, Mr. Bennett now ranks just under Frank Sinatra and Ella Fitzgerald in reputation (*New York Times*, 21 October 1993, C15)." He, too, has served as an ethnic signifier in a way that goes beyond the "ingrained machismo" and "operatic impulse" he shares, according to Holden, with Sinatra, because his versions of such songs as "From Rags to Riches," "Stranger in Paradise," "I Wanna Be Around" have become ethnic anthems, capturing in a big-city-neighborhood voice the hysterical search for the American Dream. In 1989 he recorded an album, *Astoria*, dedicated to his old neighborhood.

Al Martino (Alfred Cini), born in Philadelphia in 1927, was discovered by Arthur Godfrey in 1952 and had his first hit record that year, "Here in My Heart." He works in what has been described in the "nice Italian ballad style a la Vic Damone," his signature song being the 1965 hit "Spanish Eyes," also known as "Moon over Naples." He claims to have had career problems since playing the part of the singer Johnny Fontane (a thinly disguised Frank Sinatra) in Francis Ford Coppola's *Godfather* (1974), he performs principally in Europe. Another Godfrey discovery is Julius La Rosa (1930–), who was memorably fired by him on 4 October 1953 in front of a stunned studio audience: "And that was Julie's swan song . . . ," decreed the autocratic Godfrey, who claimed that La Rosa had lost his humility. He had a big hit in 1953 with an infectious old Sicilian song, *"Eh, compari,"* a kind of "Old MacDonald Had a Farm" with instruments instead of animals. An underrated artist who still sings beautifully—Gene Lees has described him as "the most brilliant member of the Sinatra school"—La Rosa had the guts and good sense not to change his name, which some people felt had a comic ring to it. In those days, you changed your name to something more show-bizzy like Dick Capri, or

neutral like Don Cornell, also an Italian American, who left Sammy Kay's band to enter the crooner sweepstakes, and who had big hits with "It Isn't Fair" (1950) and "I'm Yours" (1952).

Closer to Como in style and the embodiment of the stereotype of the dark and handsome Italian American singer is Dean Martin (Dino Crocetti), who was born in Steubenville, Ohio, in 1917 and died in 1995. Martin was for years considered little more than a straight man for Jerry Lewis, and when the team broke up it was assumed that it was all over for him. Instead he surprised everyone by quickly becoming a megastar eclipsing even Lewis. He became one of the highest-paid entertainers at the poshest Las Vegas hotels and on television from 1965 to 1974, where his laid-back style and self-spoof as a boozer-swinger both captivated and offended the public. He was a charter member of Sinatra's Rat Pack and, along with Sinatra, came to embody the sensibility of the "booze culture" of his generation. He turned out a string of films (mostly undistinguished), including those with the Rat Pack and the Matt Helm movies of the late 1960s—his most creditable performances were in *Some Came Running* and *Rio Bravo*—and recorded hundreds of songs that the public liked, which made him a millionaire. His biographer, Nick Tosches (*Dino: Living High in the Dirty Business of Dreams* [1992]), believes that Martin's dominant trait was his Italian **menefreghismo**, which translates roughly as an "I don't give a damn" attitude. Tosches' book is a compelling exercise in the art of pop biography—usually either hagiographic or dirt-dishing—not simply because it serves as an exposé of Martin's fast-lane adventures in *l'America* and "its funhouse of troubled dreams," but also because it expresses Martin's worldview from an inner point of view and in the no-holds-barred language of the Italian American subculture. What emerges is a portrait of Martin as a "mob-culture Renaissance man," a *menefreghista* who negotiates the dirty business of dreams by maintaining an absolute emotional distance from everyone, including himself, erecting a "wall of *lontananza* (distance) between the self and the world." This distance also informs Martin's singing, according to Tosches: "Underneath the feeling in his voice, underneath the weaving of those colors, there was always *lontananza*."

However Martin may have constructed himself, consciously or not, as a handsome screen over a void, as a personality missing the person, somehow his combination of arrogance, cool, charm, and an air of not taking himself or anyone else seriously struck a responsive chord in the hearts of the great American public. They could identify themselves with him perhaps because he was a cipher—albeit an extremely sexy one—whose accomplished singing, as displayed in such records as "That's Amore," "Memories Are Made of This," and his theme song,

"Everybody Loves Somebody," placed no emotional demands on them. One could, of course, describe his appeal to the White mass-cult audience of the 1950s and 1960s in terms of vicarious appeal: Here was a guy who lived the way they had always wanted to—gambling, boozing, womanizing, throwing money around, laughing at life, telling the world to go to hell. Tosches, in his inimitable ethnic-ese, gets at the mystique of both Sinatra and Martin by focusing on the audience they attracted to the Sands in Las Vegas: "It was not just the dirty-rich *giovanastri* (punks) and *padroni* who were drawn to them, to their glamour, to the appeal of darkness made respectable. The world was full, it seemed, of would-be wops and woplings who lived vicariously through them, to whom the imitation of cool took on the religiosity of the Renaissance ideal of *imitatio Christi*." In other words, the crooners were, for the mass public, good "bad objects," sublimated versions of that (id)entity always attributed to the Italian American male who had codified their threateningness into the romantic protocols of the balladeer.

Here we approach the ethnic subtext of the mainstream images of second-generation singers who served as acceptable—White but temperamentally and erotically dark—objects of desire and models of "cool"—that it was "dago cool" was part of the return of the repressed always brought into play by the performer as ethnic signifier. Given the subsequent history of American popular music, two aspects of its Italian American, or Sinatran, phase are of cultural interest. First, it is significant that as pop grew more and more into a question of music articulated through the image of a performer, the industry would turn to Italian Americans, the urban group in the "Old America" of the prerock era most concerned with the self as spectacle, to manufacture the first installments of the pop personality. Second, unlike the succeeding waves of performers who would come from Black musical culture and the White youth subculture, Italian Americans did not present themselves in opposition to the mainstream. The musical ideology of their tradition, together with their body image and their gestural codes, translated seamlessly into the romanticism of the common culture. The second generation were thus part of a commodification of the ethnic self by which their working-class origins and subcultural traits were sublimated. Therefore, the superficial and patronizing assessment by Arnold Shaw ("Considering the preponderance of *paisanos,* is it any wonder that mainstream pop, until the advent of rock 'n' roll, was a *pasta* of Neapolitan, *bel canto,* pseudo-operatic singing?") ignores the way in which the second-generation singers eroticized and personalized the technically proficient but bland pop crooning tradition, using their musical personae to introduce a tenderness full of desire but edged with sexual threat—that is, with something that is hidden. It is naive to maintain that we identify ourselves

with pop singers sheerly on the basis of glamourous traits. Singers, especially ethnically or racially different ones, bring into play that which is hidden, the repressed subtext of their difference by which they enter into the frame of the majority culture's fantasy.

Mention should also be made of Italian American woman vocalists contemporary to the crooners. Fran Warren, a very hip and talented singer from the Bronx, sang with the bands of Charlie Barnet and Art Mooney and won acclaim in the mid-1940s for her recording of "A Sunday Kind of Love" with the Claude Thornhill Orchestra; later, as a single, she made a number of hit records for RCA Victor. Joni James (Joan Carmela Babbo), the Connie Francis of the 1940s, had a steady stream of hits from the late forties through most of the fifties, one of her biggest successes being "Why Don't You Believe Me?" Her repertoire included a large number of Italian songs. Toni Arden (Antoinette Ardizzone) received operatic training from her father, who had sung at La Scala in Rome and at the Metropolitan in New York City. She chose the pop field, however, and recorded an impressive string of hits, in English and in fluent Italian, for Decca Records in the 1950s. Into the 1990s, she still performs occasionally at Italian clubs and restaurants in New Jersey. The Junoesque Morgana King (1930–), of Sicilian origin, also had operatic training and also chose pop and jazz, in which areas she nonetheless makes exquisite use of her incredible vocal range and expert breath control to produce a dramatic style all her own. Remembered for her performance as Signora Corleone in *The Godfather Part I* and *Part II*, she still makes appearances at jazz clubs in Manhattan.

Two other cabaret singers who have had cult followings are David Allyn and Buddy Greco. The legendary and shamefully neglected David Allyn (David DiLello), born in Hartford, Connecticut, in 1923, started out as the male vocalist with Boyd Raeburn's band in the mid-1940s ("Forgetful," "I Only Have Eyes for You"), went out on his own, made a small number of records for obscure labels that are treasured today by jazz fans and vocal connoisseurs, but never really made it. It is the same old story: When you sing with that much taste and musicianship, you risk going over the heads of the mass public and winding up a cult figure. Allyn appeared at Michael's Pub in New York City in the late-1980s, singing as beautifully as ever, but the crowd, self-absorbed and trendy, did not give him the reception due to a musician whose work is admired by the likes of Alec Wilder and Frank Sinatra. His personal life has been rocky; so many of the really great ones have been self-destructive. He shows up from time to time at the New York City nightclub Red Blazer Too, one of those singers who gets even better as he gets older. Buddy Greco (Armando Greco), born in south Philly in 1926, grew

up speaking Italian and English. As a child he played small parts in Italian-language dramas on local radio stations. His father tried to encourage his interest in opera, but jazz won out. Into the 1990s, he remains one of the most musically interesting singer-pianists in the business. In the same category is Joe Derise, another highly talented and underrated jazz singer-pianist. Apparently being jazz-oriented limits a performer's popularity but helps to ensure professional longevity.

Then there were the handsome operatic tenors from Italy, the late Sergio Franchi from Cremona, Enzo Stuarti from Rome (and Newark), and Aldo Monaco from Pozzuoli (Sophia Loren's birthplace). All three, possessed of exceptionally beautiful voices, quickly learned that singing in Las Vegas was far more profitable than singing in opera.

Vaudeville and Broadway: From Durante to Liza Minnelli

Now we shall turn our attention briefly to vaudeville and Broadway. It is important to begin by pointing out that Italy had its own tradition of vaudeville *(varietà)*, recorded with nostalgic irony by Fellini in several of his films, and that the immigrant theater of the first part of the twentieth century was an Italian American version of vaudeville. Of the mainstream performers, none was more important than Jimmy Durante, who served as an ethnic signifier although his performing self was strictly ragtime, quite removed from that of his Italian-born counterpart, Eduardo Migliaccio.

If someone with a sandpaper voice and a four-note range can be called a singer, then it can be said that no singer has ever been so well loved for so many years as the one and only Jimmy Durante (1893–1980). He was not much to look at, he was virtually voiceless, his English was Bowery basic, his piano playing nothing special, and his songs less than deathless (though his allegro con brio version of "As Time Goes By" was recycled as the theme song of the 1993 film *Sleepless in Seattle*). Yet, somehow it did not matter: The Great Schnozzola was irresistible. "The Song Gotta Come from Da Heart," as one of his signature songs put it, and it did.

For more than sixty years, in clubs, vaudeville, Broadway legit reviews, radio, movies, and television, his act was pretty much the same. He would sit down at the piano, push back his battered hat, talk-sing nonsensical numbers like "Ink-A-Dink-A-Doo" and "Umbriago," interrupting the songs with his roguish asides, and (literally) pound the piano to pieces. Born on New York's Lower East Side in 1893 to Mr. and Mrs. Bartolomeo Durante from Salerno, the bambino Schnozz was greeted, as Durante often recalled as part of his "nose-ography," by the midwife's alarm, "Dis ain't da baby—it's da stork!" He was perpetually teased as a child about his outsize nose. "I would run home and cry," he recalled. "I made

up my mind then that I would never say or do nuthin' to hurt nobody, no matter what." He originally thought about becoming a concert pianist, but by the time he was a teenager he was playing ragtime piano in Coney Island and Bowery saloons. According to an anecdote retold by Frank Capra, Durante said to his supportive father who hoped he would make it to Carnegie Hall, "Pop. Imagine what dey'd do if I came out in Carnegie Hall and dey see dis nose. Dey'd laugh at me, Pop, no matter how good I played." After a pause, Bartolomeo said, "God works in inscrutable ways. He'll take care of you. Go ahead. Go to Coney Island." Teaming up with hoofer Lou Clayton and singer Eddie Jackson, he moved rapidly from nightclubs to vaudeville to Ziegfeld's *Show Girl* on Broadway in 1929, and a year later to Hollywood and the movies. He went on to become one of America's most beloved entertainers. Indeed, whenever MGM realized that a new musical was in trouble, they would remedy things by writing in a part for him.

Durante shared two attributes with other great entertainers such as Jolson, Sophie Tucker, Fanny Brice, W.C. Fields, Judy Garland: an enormous energy and, at the same time, an air of being totally relaxed and at home on the stage. He, and they, had merely to walk out on stage to have the audience immediately in the palm of their hand—what Italians, who particularly prize it, call *la comunicativa,* the ability to communicate one's personality to an audience, an art obviously acquired painstakingly from years of performing in all kinds of places and to all kinds of live audiences (it cannot be acquired in a recording studio). The director Frank Capra, who considered making a movie of Durante's life at the suggestion of Frank Sinatra, wrote in 1981 a moving profile, "The Unforgettable Durante" (*Reader's Digest*, November 1981), in which he described the comedian's personality: "Jimmy was a compassionate clown: He let you know he was bothered by the same things you were, but that if you couldn't change them, you might as well laugh at them. As he often said, 'Dem's da conditions dat prevail.'" Durante has the makings of a genuine Italian American folk hero, even though his act was not particularly marked by Italianness. All of the stereotypes aimed at immigrant Italians of his generation—the Italian body as stigmatized by the nose, fractured English as proof of illiteracy, the accommodating optimism and Pinocchioism of the second generation, bad taste—converge in him, but, rather than being repressed as part of a typical second-generation rejection of one's background, they are all foregrounded, rendered into an elaborate burlesque by which the ridiculous becomes the sublime. This involves more than his capitalizing upon his nose. Consider, for example, the burlesque at work in his lyric, "Toscanini, Tchaikovsky, and Me . . . we are definitely da Big Three!" in which his routine of hobnobbing with the long hairs sends up the immigrant ("low brow")

aesthetic that is dominated, as it always is, by the dream of "high art." Or the whole fracturing of English at work in his act or his catastrophic misreading of radio scripts—"corpsuckles" for "corpuscles," "nonfriction" for "nonfiction," "casamclysmic" for "cataclysmic"—the burlesque of illiteracy: For Durante, the dees, dem, and dose, it seems, were de linguistic conditions dat prevail, and, as foolosopher of dat broken-English universe, he was the carnivalizer of the immigrant's linguistic identity. Or the so-called national mystery: the "Goodnight, Mrs. Calabash, wherever you are" finale, the Schnozz's burlesque of the melancholy Cyrano. (Mrs. Calabash was the *senhal,* or poetic pseudonym, for his deceased wife, as Durante finally disclosed in 1966.)

Another comedian who emerged from vaudeville is Louis Francis Castillo (1906–1957), the son of an Italian immigrant father and better known as the Lou Costello of the beloved comedy team Abbott and Costello.

The most popular leading man in Broadway musicals for four decades was the baritone Alfred Drake (Alfred Capurro), who was born in New York in 1914. He starred in *Babes in Arms* (1943), *Oklahoma!* (1943), *Kiss Me Kate* (1948), *Kismet* (1953), and *Gigi* (1973). Singer-comedian Kaye Ballard (Catherine Gloria Ballotta, from Cleveland) first attracted attention in the Off Broadway musical *The Golden Apple* in 1954. Bernadette Peters (Bernadette Lazzara) of Ozone Park, Queens, singer, dancer, actress, and comedian, has been Broadway's most **simpatica** (likable) musical leading lady since the 1970s, from *Dames at Sea* and *George M.* (1968) to *Mack and Mabel* (1974) and Sondheim's *Sunday in the Park with George* (1984) and *Into the Woods* (1987). Patti Lu Pone starred in *Evita* (1979), *Anything Goes* (1987), and the London production of Andrew Lloyd Webber's *Sunset Boulevard* (1993). Superstar Liza Minnelli manages to juggle Broadway, Hollywood, Las Vegas, television, and worldwide touring with Frank Sinatra. She ranks as the last of the old-school Broadway belters.

Roll Over, Rossini: Italian American Rock 'n' Roll
The Italian American impact on popular singing continued well into the rock era, that is, well after the "death of the crooner," or, what amounted to the same thing, the institutionalization of the crooner—no longer perceived as having a dangerous edge—within the pop mainstream, Las Vegas, and television.

The second-generation singers would be replaced, in the late 1950s, by two new musical types. The first type was the "teen idol" as epitomized by the south Philadelphia "dreamboats," Frankie Avalon, Bobby Rydell, Fabian Forte, a fabricated role in which a group of teenage Italians who had absorbed the ethos of rock 'n' roll were typecast by the industry, "as music left the streets and moved

into the studios," as heartthrobs to capitalize on their good looks—clean-cut and nondangerous versions of the dark other—and to produce a rock 'n' roll consumable by the teeny-bopper audience targeted by American Bandstand. The second type was the White "doo-wop group," a role into which inner-city Italians naturally placed themselves, living out the "Street Corner Symphony"—the singing a capella on the Lexington Avenue IRT is in no way apocryphal—and through which they expressed their own urban anguish and "mean streets" desire: "There's a Moon Out Tonight." The Italian American doo-wop groups (Dion and the Belmonts, Johnny Maestro and the Crests and later the Brooklyn Bridge, Tony Canzano and the Duprees, Frankie Valli and the Four Seasons, the Regents, Vito Picone and the Elegants, and so forth) represent a genuine bordercrossing between urban-Black and Italian musical cultures. As John Javna, a doo-wop enthusiast, observes: "Unlike previous white artists who had made their fortunes by 'covering' (read: 'stealing') black groups' tunes, the new white doo-woppers learned their art on America's street-corners. They developed their own styles [the 'Italian style' exemplified by the Elegants' "Little Star"] and wrote their own songs."

Sociologically, it is interesting that the crucibles for both phenomena were big-city Italian neighborhoods. The teen idols were drawn from the south Philly subculture, which was relocated in the television studio where it became a model for mass-mediated teen culture of the late fifties and sixties. The doo-wops crystallized in the boroughs of New York City and the metropolitan area: the Crests in Brooklyn, the Belmonts in the south Bronx, the Capris in Queens, the Four Seasons in Newark. But there was a tremendous difference in the packaging of the two types. Self-styled impresario Bob Marcucci, whose exploits are recounted in the 1980 film *The Idolmaker,* picked the best-looking kids from the area, regardless of their vocal attributes or lack of the same, and set about making them stars. The formula produced Frankie Avalon (Francis Thomas Avallone) and the "Tiger Man" Fabian (Fabio Forte), both of whom, together with Bobby Rydell (Robert Ridarelli), defined the Philadelphia sound. Of the three, Rydell, with his sweeping pompadour, was probably the most accomplished musician, and between 1959 and 1964 he scored nineteen Top Thirty smashes, including "Kissin' Time," "Volare," a rocking version of the Domenico Modugno tune, "Swingin' School," "Wild One" and "Forget Him." From a sociological point of view, the teen-idol phenomenon is interesting because it packages these good-looking teenagers of moderate talent as simulacra of the Italian American identity, as ethnic signifiers without ethnic or musical substance. As such, they served as images by which the ethnic look is rendered a spectacle suitable for the fantasy consumption of White American adolescent girls.

On the other hand, the doo-wops, whether Black or Italian, were part of the New York City street-corner scene and did not receive the benefit of the star-manufacturing machinery in place in Philadelphia. With the exception of Dion and the Belmonts and Frankie Valli and the Four Seasons, most of the Italian American doo-wop groups produced one or two hits and then faded from view, only to be recycled on the rock 'n' roll revival circuit. In any case the era of Italian American rock 'n' roll is embodied most authentically in the genealogy of street-corner vocal-harmony groups that extends from Johnny Maestro and the Crests and Dion and the Belmonts to Frankie Valli and the Four Seasons and Joey Dee and the Starlighters. Their songs—"Sixteen Candles," "I Wonder Why," "Teenager in Love," "Where or When," "The Wanderer," "Barbara Ann" (the Regents), "Little Star" (the Elegants), "Sherry," "Big Girls Don't Cry"—embody the street-corner ethos of the 1950s and the pre-Beatles 1960s. (For an account of the way in which Italian Americans bought into rock 'n' roll culture, see Ed Ward's "Italo-American Rock" in Miller's *Rolling Stone Illustrated History of Rock & Roll* [1980]. The article begins: "In my hometown, Eastchester, New York, there was only one ethnic group that knew anything about rock and roll. They liked loud, flashy colors, and they seemed to have a natural sense of rhythm and an inborn musical ability. They excelled in the school band, and at dances they cut everybody." Here Ward is deliberately projecting the standard Black stereotype onto Italians, as the remainder of the piece makes clear [132].)

The female counterparts of the teen idols were Annette Funicello, born in 1942, and Connie Francis (Concetta Franconero), born in 1938. Annette, a Hollywood and specifically Walt Disney construction—"the winsome Mouseketeer whose developing bustline had been measured daily by every young male eye in the country," as Greg Shaw comments—was the embodiment of adolescent and then teen innocence, a cross between Cinderella and "Italianette," the title of one of her albums. As she passed from Mouseketeer to teen idol—her little voice, although manufactured, recorded eight hits, including "Tall Paul"—to Frankie Avalon's wedding-ring-demanding inamorata in the mindless beach-party flicks of the mid-1960s, to Skippy peanut butter commercials, she has maintained her wholesome girl-next-door/girl-in-the-modest-one-piece-bathing-suit image. She has been perceived from the start as an ethnic signifier, her name suggesting, as Karal Marling notes (*New York Times Book Review,* 5 June 1994: 1), "just a hint of garlic and grandmas in black dresses," her fascination lying in "a demur innocence coupled with a touch of something foreign and different, somehow, from the prevailing norms of blue-eyed middle-class all-Americanism." As such she is part of the process by which Italian Americans were rendered "normals," a counterpart

to the "dreamboatization" of Avalon, Fabian, and Rydell by which clean-cut Italians came to personify male niceness. Although also emerging from the teen scene, Connie Francis, who is said to have more hit records than any female singer in history, established her career as a mainstream pop singer. One of the few female soloists of early rock 'n' roll, her big, strong contralto has adapted itself to a wide range of vocal styles, from rockers like "Stupid Cupid" and "Lipstick on Your Collar," to romantic ballads like "My Happiness" "Who's Sorry Now" and other revivals like "Everybody's Somebody's Fool," to albums of country and Italian songs.

The list of Italian American teen idols is extensive: Freddie Canon (Frederick Picciarello), Terry Randazzo, James Darren, Johnny Restivo, Sal Mineo, the actor who also sang, and the like. Of these, the most important was Bobby Darin (Robert Walden Cassotto), who was born in 1936 in a "mean streets" section of New York City's east Harlem. As the story goes, he took his name from a broken neon sign on a Chinese restaurant that was missing the first three letters of the word "Mandarin." He came on the scene as a rock singer in 1958, quickly becoming an idol of the teenage crowd. He won two Grammy Awards in 1960 for his recording of "Mack the Knife" and made a dozen films. By 1967 he had sold thirty-five million records. Ambitious and talented, he had won over an adult audience and was being taken seriously as an artist of stature—Sinatra-influenced—when he died of a heart ailment at the age of thirty-seven.

After the Long Good-bye: From Frank Zappa to Bruce Springsteen and Madonna
As the great divide between taste cultures—adult and teenager—grew more absolute, the second-generation crooners became the staples—caught in the time warp of television and Las Vegas—of the pop mainstream tradition, where they were joined by younger crossover singers like Bobby Darin, occasionally producing an anthem like Tony Bennett's "I Left My Heart in San Francisco" (1962). Their hegemony over popular singing was no longer in effect, and their attempt to translate the *bel canto* into American terms had long since run its course. Their successors, the teen idols, were history by the mid-1960s, and the doo-wop groups, with the notable exception of the Four Seasons, did not survive the invasion of the Beatles. Of course, Sinatra, who had called rock 'n' roll that "rancid, putrid aphrodisiac," continued to defy the laws of pop entropy, surviving his own institutionalization.

After 1965 three Italian American groups would remain dominant: Frankie Valli and the Four Seasons; Felix Cavaliere and the Young Rascals (later the Rascals), a recycled version of Joey Dee's Starlighters, a "blue-eyed soul" quartet formed in 1965 in New York City featuring, along with Cavaliere, Eddie Brigati,

Gene Cornish, and Dino Danieli; and Mitch Ryder (William Levise) and the Detroit Wheels, a White soul-rock group. Also deserving of mention is Jim Croce (1943–1973), a singer, guitarist, and songwriter whose breakthrough hits "You Don't Mess Around with Jim" (1972) and "Operator" (1972) were followed by his classical character-song "Bad Bad Leroy Brown" (1973) and the posthumously released "Time in a Bottle" (1973). He was clearly headed for the top of the rock world when he was killed in a plane crash while nearing the end of a tour.

Three Italian American performers play definitive roles in the musical culture of the 1970s and 1980s: Frank Zappa (1940–1993), whose band the Mothers of Invention had already become a fixture of the counterculture of the 1960s, the exponents of a free-form mixture that would come to define acid, or psychedelic, rock; the Italian Irish Bruce Springsteen (1949–), whose mother's name is Adele Zerilli; and Madonna Ciccone (1958–). All three define their musical identities primarily in American terms and without specific reference to the Italian musical tradition. They do, however, elaborate complex personae in keeping with their status as postmodern performance artists. The emphasis is on "postmodern" because all three fashion their musical and personal identities ironically in terms of pastiche and recycling. Unlike their predecessors—from Sinatra and the other balladeers, to such doo-woppers as Dion Di Mucci and Frankie Valli, and other rockers like Felix Cavaliere and Mitch Ryder (the latter two would be points of reference for Springsteen)—who defined themselves in terms of the Italian American subculture and constructed themselves as strong Italian American hybrids (the "blue-eyed soul" of the Young Rascals, none of whom had blue eyes, designates this hybridization, the "blue eyes" alluding to Sinatra as well), these three construct their identities as "texts," as collage constructions in which rock 'n' roll (not ethnicity) serves as the primary subculture. Although the figure of Italianness, especially as mediated through Catholicism (see the chapters by Thomas J. Ferraro and Fosca D'Acierno in this section) does come into play in their performances of the self, it does so as a trace among other traces. This is especially true of Madonna, the last ethnic and the first postethnic diva, who fashions her persona by perpetually deconstructing it. From this perspective, all three can be seen as meta- and postethnic artists as Italian Americans.

The zaniness of Frank Zappa, who physically resembled an **Arlecchino** (Harlequin figure), his mustachioed face and dangling-man body already a total mask, and whose countercultural craziness and will to improvisation were embodied in the notorious "freakouts" of his group, can, without stretching it too much, be compared with the zaniness of a *commedia dell'arte* player—more cerebral, of course, but his "weirdness" is just as antic, with Suzy Creamcheese playing his

Isabella. Zappa was a rebellious figure who emerged from the 1960s counterculture and who epitomized hippiedom. His posture as a California trickster—a cross between a serious avant-gardist whose experimentation was central to the development of art rock and a universal satirist who, in the name of "Mothermania," constructed a three-decade-long sick joke on the pathology of American popular culture, constantly lapsing into scatology (the Mothers of Invention was itself a euphemism for the censor-offending the Mothers), occasionally lapsing into good taste—involved a serious, albeit improvised, attempt at the politics of artistic identity. The most formal aspect of Zappa's politics of protest was his work as a spokesperson against the attempt by the Parents' Music Resource Center in Washington, D.C., to establish a rating system for records. Zappa, in a statement to Congress on 19 September 1985, argued that such a move would open "the door to an endless parade of Moral Quality Control Programs based on 'Things Certain Christians Don't Like.'" Zappa's defense of artistic freedom was in keeping with his attempt to serve as the agent provocateur of rock culture and to practice a musical politics, as first announced in "Who Are the Brain Police?" in the 1966 album *Freak Out!* (For a tribute to Zappa's activism, see Vaclav Havel's article titled "Revolutionary" in the *New Yorker* [20 December 1993: 114–117].)

From the ethnic perspective, Zappa-ism—"zapping" the establishment and subverting all formulas, especially the conventions by which rock stars construct the subjectivity of their audience—represents a radical rejection of the second-generation's uncritical assimilation by the system. Sinatra's politics—his media game of patronage, the old ward politics of Hoboken writ large, and his cynical conversion from the liberal Left to the Reagan Right, which can be read as an allegory of Italian American political assimilation—are extra-musical: Musical performance is reduced to an instrument of political fund-raising, and ethnic rage is derailed into the punctilio of mouth-to-mouth warfare with the press. Zappa's politics, instead, are embedded within his music and his antagonistic notion—dadaist-mammaist—of performance (he used to tell his audience, "You wouldn't know good music if it bit you on the ass!").

Unlike Bob Dylan's politics of messianic protest, rooted in the figure of the Old Testament prophet speaking through the idiom of American folk, Zappa's protest, at least when it did not take the form of superficial social commentary as in those songs concerned with ethnic or Valley-girl stereotyping, involved a sophisticated politics of forms, a "freaking out" of rock conventions. This can be seen in the collision of musical styles defining the collage aesthetics of the Mothers of Invention: social satire, parody of rock 'n' roll, classical references—Varese and Stravinsky—and avant-garde jazz improvisations, as John Rockwell points out

in his 1976 essay "Art Rock." To undertand the deconstructive thrust of Zappa's music, his art of "decomposition" about which he theorizes in *The Real Frank Zappa Book* (1989), describing music as "perturbations" and offering an instruction kit for putting humor into music, one is obliged to consider his specific strategies. For example, in describing *Cruisin' with Ruben & the Jets* (1968), ostensibly an album designed to persuade the buyer that the record was sung by a real 1958 New York doo-wop group, he asserts that he "conceived that album along the same lines as the compositions in Stravinsky's neoclassical period. If he could take the forms and cliches of the classical era and pervert *them,* why not do the same with the rules and regulations that applied to doo-wop in the Fifties?" After describing his techniques for musical subversion (deviation from standard chord progression, superimposition of the opening to Stravinsky's *Rites of Spring,* and so forth), he then goes on, in typical Zappa fashion, to identify his musical satire as part of a larger subversive gesture attacking what he called the "sub-mongoloid" love lyrics of the 1950s: "*I detest 'love lyrics.'* I think one of the causes of bad mental health in the United States is that people have been raised on 'love lyrics.'" He then proceeds to put rock 'n' roll (sexual intercourse) back into rock 'n' roll: "Cheap Thrills (In the Back of My Car)."

So with Zappa, we are dealing with a serious postmodernist musical composer-performer, one who constructs what Umberto Eco has described as the double-coded text intended to elicit an ironic response from a sophisticated audience hip to classical as well as rock intertextuality. To rework Eco's famous postmodernist exemplum ("As Barbara Cartland has said, I love you"), Zappa's music declares: "As rock 'n' roll has said, let's go fill-in-the-blank." In other words, Zappa's ironic music is all bracketed. The same thing probably could be said about his ethnic identity: bracketed, rather than hyphenated. It is interesting to search his "autobiography," *The Real Frank Zappa Book,* for signs of an awareness not so much of his Italianness—he asserts this clearly from the start in the section titled "The Boring Basic Stuff"—but of the role that his Italianness has played in his own self-construction as a collage text. The nearest he comes is in "A Chapter for My Dad," in which he explains how his father had wanted to write a *History of the World*—with Sicily as the hub. He then proceeds to write a history of the world with rock 'n' roll as the focal point.

The second Italian American influencing the musical culture of the 1970s, 1980s, and beyond is the singer, songwriter, guitarist, and band leader Bruce Springsteen, the New Jersey–born son of an Italian mother and a predominantly Irish father. Because he is not marked nomenclaturally—his family name is, in fact, Dutch—and also because his musical persona is an all-American rock 'n'

roll construction, his Italianness is encrypted, vaguely glimpsed through physiognomy and body image and, even more vaguely, through his pulsiveness. Thomas J. Ferraro, in the essay that opens this section, quite convincingly recuperates Springsteen's Italianness through the figure of blue-collar rock 'n' roll Catholicism. It is thus no accident that Springsteen's musical persona involves a recycling of Presley and Dylan through the filter of an urban-Catholic—"It's Hard to Be a Saint in the City"—sensibility incubated by the New Jersey shore scene. It is interesting, however, that John Landau, in a May 1974 piece for the *Real Paper* that had the effect of a shot heard round the rock 'n' roll world ("I saw rock 'n' roll future last night and its name was Bruce Springsteen!"), would describe him as "a rock 'n' roll punk, a Latin street poet, a ballet dancer, a joker, a bar band leader. . . ." Here in this mix are the traces of a postmodern ethnic—"Latin"—identity that has reconstructed itself in terms of the subculture of rock 'n' roll. But there is much more to Springsteen than a jukebox identity. By way of experimenting with our perception of ethnicity, consider what would happen if he were named matrilinearly Bruce Zerilli. Would the name change alter substantially our response to him? Would it oblige us to read him as an ethnic signifier in the way Sinatra and Madonna are securely read? This is no easy exercise, for it raises the question of the way in which, in postethnic America, identity is formed as a hybrid construction in which ethnicity—especially third- or fourth-generation ethnicity, which, as in Zerilli-Springsteen's case, is compounded by intermarriage (the typical destiny of Italian Americans, a group that tends to intermarry)—is just one element in a complex system of traces by which identity is rendered a transitional category. Furthermore, with a rock star like Springsteen, who is jockeying to find a position in the rock genealogy that extends from Elvis through Dylan and Hendrix, we are dealing with the construction of an image that involves the organization of the signs of a performer's personality, of which ethnicity is no longer the determining sign.

That Springsteen, however, is sometimes mistaken for being Jewish, is symptomatic of the fact that his image is generically ethnic, vaguely Other. That Otherness is elaborated in the explicit class terms of a blue-collar, "street" Catholicism in the Scorsese mold as thematized in the lyrics of Springsteen's songs and then expanded into the archetypal rock persona of the outlaw qua "renegade priest." Springsteen does acknowledge his Italianness, attributing his art of storytelling to his grandfather Zerilli and treating in his songs the blue-collar Oedipalism of his family life: "There ain't a note I play on stage that can't be traced directly back to my mother and father (Lynch 1984)." If the figure of Italianness were applied to his work, it would both bring into focus and distort aspects of

his persona: his bravado as the Boss, his attempt to "naturalize" rock 'n' roll (the great Italian American stereotype of the "natural," the instinctive White artist who brings into play pulsive rhythms), and, above all, the whole contradictory ethnic search for the American Dream, displaced into the no less contradictory search for the authentic voice of rock 'n' roll.

Unlike Springsteen's encrypted Italianness, Madonna's identity as a performer is both nomenclaturally determined and consciously constructed in Italian American terms, as the chapter devoted to her in this section will make abundantly clear. The way in which she is perceived as an ethnic signifier is illustrated, for example, by Norman Mailer's masculinist assessment of her in his August 1994 piece for *Esquire:* "She is either among us for extraordinary reasons or is a pint-size Italian American with a heart she hopes is built out of the cast-iron balls of the *paisans* in generations before her." Although the controlling element of her persona is Italianness, she is a "translational" figure who systematically appropriates and recycles various cultural identities and styles: She is the ultimate bordercrosser, which can be seen as an aggressive—perhaps transgressive—version of the traditional "inbetweenness" of the Italian American. She has radically redefined the parameters of Italian American womanhood in ways that go far beyond her aesthetics of shock as typified by her 31 March 1994 appearance on *The Late Show with David Letterman* when she said the F-word thirteen times. The "extraordinary reasons" of which Mailer speaks certainly involve the strength to play out the dangerous game of the ethnic and sexual persona to its limit, producing on the way a fascinating body of work, at the center of which lie her music videos, the quintessential postmodern art form through which she demonstrates her strength as a performance artist and dominatrix of the simulacrum.

Occupying opposite ends of the contemporary pop musical spectrum are two other major Italian American singers, Jon Bon Jovi and Ani DiFranco, both of whom have become iconic figures in their genres: mainstream hard rock and metal; independent urban-folk. Jon Bon Jovi (John Francis Bongiovi, Jr.) was born, like his role model Bruce Springsteen, in New Jersey in 1959 to a working-class family. His New Jersey–based group, Bon Jovi, assembled in 1983, made four albums for Mercury during the 1980s—*Bon Jovi* (1984), *7800 Degrees* (1985), *Slippery When Wet* (1986), *New Jersey* (1988)—that have come to epitomize the era of pop-metal. Of these, their third, *Slippery When Wet*, elevated them to the status of major concert headliners. Although Bon Jovi has achieved and maintained enormous popularity—he has sold more than seventy-five million albums—his work has sometimes been reduced to the formula of "good looks, good hooks," the looks referring to his mop of curls and telegenic smile; the hooks to his appealing toned-

down heavy metal sound and his production of music in keeping with the taste of his targeted audience. He generated *Slippery When Wet* by submitting thirty songs to an audience of New York and New Jersey teenagers and then making his final selections on the basis of their responses. But his group has been one of the few pop-metal bands to endure and continue to evolve in the 1990s as evidenced by their mature work: *Keep the Faith* (1994), *Cross Road* (1994), and *These Days* (1995). Like Springsteen, he has constructed his persona with reference to rock and roll mythology and to working-class experience as reflected in such anthems as "Livin' on a Prayer" (1986) and "Keep the Faith" (1992). In 1990, after writing the sound track to the Western *Young Guns II* (in which he had a bit part), he turned toward acting, appearing in *Moonlight and Valentino* (1995) and five other films, all of which will be released in 1998.

Ani DiFranco, guitarist, singer, songwriter, and record producer, was born in 1970 in Buffalo, New York, where she began her career at the age of nine. She left home at fifteen, and produced her first album, *Ani DiFranco* (1989), on her own label, Righteous Babe, at twenty. Her fierce independence is reflected in her attempt to function outside the system, which has led her to refuse lucrative offers from major record labels (all twelve of her albums have been distributed through the Righteous Babe label) and to forge an iconoclastic image, which she has described as "stompy-booted, butch folk-singer chick" (*Rolling Stone*, 13 November 1997), the early punkish version of which involved shaved head, tattoos, and body piercings. More important, her music, informed by feminist concerns, has embodied this against-the-grainness, oscillating between a highly intimate, confessional mode and a polemical, angry-young-woman's voice that addresses such issues as abortion, rape, gender inequities. Her albums include *Not So Soft* (1991), *Imperfectly* (1992), *Puddle Dive* (1993), *Out of Range* (1994), *Like I Said* (1994), *Not a Pretty Girl* (1995), *More Joy Less Shame* (1996), *Dilate* (1996), and *Living in Clip* (1997). However different they may be, both Ani DiFranco, a folk-punk diva of the musical underground, and Jon Bon Jovi, a pop divo of the mainstream, define their musical personae without explicit reference to Italianness and thus are emblematic of the passage from weak ethnicity to post-ethnicity characteristic of the 1990s at large.

Bordercrossings: Italian Americans in Jazz

Italian Americans have contributed more than their fair share to the world of jazz. A glance at the jazz and swing bands of the 1930s and 1940s reveals a large num-

ber of Italian names. It is intriguing to note that children raised in the Italian-speaking families of recently arrived immigrants, and even children who had been born in Italy, could nonetheless grow up with an instinctive feeling for jazz, whereas young musicians in Europe in the late twentieth century have an absolute passion for jazz but are simply unable to play it as well; it is something that cannot be taught.

Italian Americans' affinity for jazz is perhaps best explained as the result of their specific intersection—territorial and temperamental—with African America. Their involvement in jazz has been an extraordinary instance of bordercrossing through which a dialogue with Black musical culture has been maintained, and reciprocated by the strong interest African American singers—sopranos, above all—have had in opera. There is a long history of the intersection between the two cultures. (See Robert Orsi's "The Religious Boundaries of an Inbetween People: Street *Feste* and the Problem of the Dark-Skinned Other in Italian Harlem, 1920–1990" in the September 1992 *American Quarterly*.) Indeed, as the darkest and most "polyrhythmic"—the "hottest"—of the White ethnics, Americans of southern Italian ancestry were traditionally regarded as doubles of African Americans. Nonetheless, the charge of "bleaching" and intellectualizing jazz has also been leveled at Italian American musicians—ironic, at least from an Italian American point of view, for their own musical culture had been forged in the crucible of Naples, the original melting pot in which European, Arabian, and African music had all inextricably intermixed for centuries. Furthermore, their music was fundamentally Dionysian, a music of *passione* (the Italian equivalent of "soul") and exacerbated *melancolia* (the Italian equivalent of "blues"), and, as such, distinctly at odds with the "bleaching" it, too, receives in its caricature: simply metronomic and "eupeptic jauntiness." Moreover, Neapolitan popular music was an expression of the culture of poverty, a music of the subaltern. (The best metaphor of this can be found in the film *Carosello napoletanto,* the greatest of the Italian musicals, which documents the history of Neapolitan musical culture: The narrator is a homeless Neapolitan song vendor, who, together with his family and their hurdy-gurdy, traverses the centuries of Neapolitan history in search of a home—indeed, their hearth and only true possession is the *canzone* [song], their means of survival.)

In any case, the Italian American encounter with jazz has been ongoing ever since the first intersection that occurred at the turn of the twentieth century, in New Orleans, another melting pot of musical cultures. It should be pointed out that the Italian American immigrants to Louisiana were the other group subjected to lynchings, some of them motivated by their friendliness toward Blacks, and to discrimination, their children being denied access to White schools. (For a his-

torical account, see the chapter titled "New Orleans: Wops, Crime, and Lynchings" in *La Storia* [1992], by Jerre Mangione and Ben Morreale.) As a musical bordercrossing, it represents the first of many—for example, the previously discussed adventures of the doo-wops in the late 1950s and, in the 1980s, the phenomenon known as "Goatee Rock," which, in Orsi's description, "represented the fusion of Black rock-and-roll and blues idioms with the romantic melodies of southern Italy."

If, as the story goes, Jelly Roll Morton, the king of early new Orleans jazz, was fond of playing his ragtime version of the "Miserere" from *Il trovatore*, Nick LaRocca was fascinated by ragtime and jazz as played in New Orleans by the great Black virtuosi, and he would establish the Original Dixieland Jazz Band, the White counterpart to King Oliver's jazz band. Although the question of whether LaRocca "took the tiger out" or put passion in (or perhaps just distilled it with Sousa) is still a question of acrid historical debate, it is certain that he was instrumental in the dissemination of New Orleans music, for his was the first recorded jazz ensemble.

Nick LaRocca (1889–1961), born Dominick James LaRocca in New Orleans, the son of Sicilian immigrants, was a left-handed cornet player. In 1908 he gathered together a group of New Orleans boys, who, since they could not read music, improvised as they went along, and thus the first White jazz band came into being. By 1916 they were playing in Chicago, advertised as "the Famous Original Dixieland Jazz Band"; they arrived in New York the following year. LaRocca, who was self-taught, played the cornet and the trumpet, composed jazz standards such as "Tiger Rag," "At the Jazz Band Ball," and "Clarinet Marmalade," and made numerous Victor records. He claimed that swing music originated when Glen Gray's Casa Loma Band listened to their records and picked up from them some of the rudiments of jazz. As a youth, the legendary Bix Beiderbecke adopted LaRocca's style of cornet playing. After his band disbanded in 1938, LaRocca returned to New Orleans, where he went into business, rarely performing in public.

Eddie Lang (1902–1933), born Salvatore Massaro in south Philadelphia, was the first of the twentieth century's guitar heroes and was said by one critic to play "with the soul of an Italian artist and the drive of an American jazzman." He began playing the violin, then went on to study banjo and guitar. In 1925 he teamed up with the violinist Joe Venuti, with whom he recorded a series of legendary jazz duets in the early 1930s. In 1930 he appeared with the Paul Whiteman Orchestra in the film *King of Jazz*. Bing Crosby said that Lang was the first guitarist to do much single-string work; previously the guitar had been strictly a rhythm instrument. He became Crosby's staff accompanist in 1932. Because Lang was troubled

by chronic throat problems, Crosby persuaded him to have his tonsils out. He died of an embolism under the anesthetic. Lang invented a solo vocabulary for the guitar; he was called the finest guitarist of his generation and is still considered by many the greatest who ever lived.

Joe Venuti, the legendary left-handed violinist, was born Giuseppe Venuti in 1903—some sources give 1898—on a ship carrying his parents to the United States, where they settled in Philadelphia. The first, and probably the best, of the jazz violinists, he played with many of the leading bands of the 1920s, eventually joining Paul Whiteman's orchestra (which also featured the virtuoso banjoist Mike Pingatore). Later he appeared as a soloist in nightclubs and on Broadway, and in 1944 he moved to Hollywood, where he became a member of the MGM Studio Orchestra. Venuti was even more famous for his outrageous behavior than for his musical skill. Stories circulated of his eating Whiteman's violin, of playing stark naked for a group of madams in a Philadelphia brothel, of pouring liquid Jell-O into a sleeping Bix Beiderbecke's bath; and of arranging a plate of salad greens around his penis to serve at Mildred Bailey's dinner party. *New Yorker* jazz critic Whitney Balliett described him as "a great, stout, square, bustling haystack of a man with a tombstone of a voice and a huge Roman head (cited in Sudhalter, 1979)."

During the 1950s Venuti was a regular on the radio with Bing Crosby. After almost two decades of relative obscurity in Washington state, during which he had become an alcoholic, he was "rediscovered" after a memorable performance at the 1969 Newport Jazz Festival. He performed in concerts and made numerous recordings with younger musicians, who gasped at his phenomenal technique. Despite doctors' warnings, he refused to take things easy, and in 1978, just as he was to open at the Holiday Inn in Chicago, he died.

The prodigious talent of Adrian Rollini (1904–1956)—at the age of four he played a Chopin recital at the Waldorf-Astoria in New York City—may have been obscured by his passion for such "novelty" instruments as the goofus, the hot fountain pen, the vibraphone, and the bass saxophone. He took up the latter instrument at the age of eighteen and soon became the envy of black saxophonists like Coleman Hawkins and Budd Johnson, who tried in vain to emulate his big sound. In the early 1920s, he played with the California Ramblers and made hundreds of records. He opened his own club, Adrian's Tap Room, at the President Hotel in New York City in 1934, and for the next two decades he led small groups in hotels throughout the country. He is best remembered for his improvised solos on his records with Bix Beiderbecke. Rollini moved to Florida in the 1950s, and died there in 1956 under circumstances that have never been clarified.

Toots Mondello, born Nuncio Mondello in Boston in 1912, played lead

alto sax in the 1930s with Benny Goodman, Joe Haymes, Ray Noble, and his own band. He recorded with Bunny Berigan, Miff Mole, Larry Clinton, Claude Thornhill, Teddy Wilson, Louis Armstrong, Lionel Hampton, Billie Holiday, Sarah Vaughan, and Artie Shaw.

Flip Phillips, born Joseph Edward Phillips in Brooklyn in 1915 and Italian American despite his name, played tenor sax in the 1940s with Benny Goodman, Wingy Manone, Red Norvo, and Woody Herman. For the next ten years, he toured annually with Jazz at the Philharmonic; he then moved to Florida, where for fifteen years he led his own quartet. In the 1940s, Phillips was a great crowd pleaser, playing in a Southwestern, shouting-honking style. After his 1975 comeback, however, his playing became more restrained.

Hank D'Amico (1915–1965), swing-era clarinetist and saxophonist, played with the bands of Paul Specht, Red Norvo, Bob Crosby, Tommy Dorsey, and Jack Teagarden. Stylistically he was strongly influenced by Benny Goodman. In the 1960s he worked with small groups, and in 1964 he appeared at the New York World's Fair.

Charlie Ventura, born in Philadelphia in 1916, played tenor and baritone sax with Gene Krupa from 1942 to 1960, and from 1946 to 1951 he had his own big band, which was billed as "bop for the people" and featured clever arrangements in which voices and instruments performed bop themes in unison. He managed a nightclub in the early 1950s, and later settled in Springfield, Massachusetts, where he led a swinging quartet.

Johnny Guarnieri (1917–1985), from New York, pianist, harpsichordist, and composer, began studying classical piano, but at fifteen, after hearing Fats Waller, he turned to jazz, joining the George Hall Band two years later. In 1939 he played with Benny Goodman, and in 1940 he joined Artie Shaw's orchestra, making with Shaw's Gramercy Five what have been called the only significant jazz harpsichord records. He later played with Tommy Dorsey and Cozy Cole and sat in on many jazz recording sessions. Considered a master of stride piano and capable of bravura playing in any style, he worked as a solo pianist in California. In 1970 he recorded an album of $5/4$ originals and premiered a $5/4$ piano concerto in Los Angeles, and later in the 1970s he toured Europe.

Lennie Tristano (1919–1978), blind from childhood, was playing the piano at the age of four and later studied saxophone, clarinet, and cello. He received a B.M. from the American Conservatory in Chicago, and in 1946 he moved to New York, where he formed his own trio, and later a sextet, with saxophonists Lee Konitz and Warne Marsh. In 1949 he recorded two of his own compositions for Capitol Records, "Intuition" and "Digression," the first "free" improvisations

to be recorded, in which each member of the sextet improvised, in any key he chose, with the result somehow being neither aimless nor chaotic. Capitol had little faith in the records and released them reluctantly only after pressure from Tristano's supporters. Modern musicians were spellbound; the uninitiated were merely baffled. This marked the beginning of "third stream" jazz, which was to influence many European musicians. Tristano began formal teaching in 1951, after which his nightclub appearances became infrequent. He appeared at the Berlin Festival in 1965 and at the Harrowgate Festival in 1968.

The Tristano controversy still rages. He aspired to a pure, dispassionate piano sound; his "Requiem" was recorded at half-speed, so that when it was played back it would have an otherworldly aura to it. To some he could do no wrong; to others he was a bloodless technician whose music was overformalized and devoid of warmth and feeling.

Jimmy Giuffre, born in Dallas in 1921, clarinetist, saxophonist, and composer, played with Boyd Raeburn, Jimmy Dorsey, Buddy Rich, and Woody Herman and was an important figure in avant-garde jazz in the late 1950s and early 1960s. He wrote the classic "Four Brothers" for Woody Herman in 1947, as well as a clarinet quintet and several pieces for string orchestra. In 1978 he joined the faculty of the New England Conservatory of Music.

Charlie Mariano, born Carmine Ugo Mariano in Boston in 1923, played alto sax in the 1940s with Shorty Sherock, Larry Clinton, and Nat Pierce and in the 1950s with Chubby Jackson, Stan Kenton, and Shelly Manne. In 1958 he returned to Boston, where he taught at the Berklee College of Music. He met the Japanese jazz pianist Toshiko Akioshi, who was a student there, and married her in 1959. They formed a quartet and spent two years in Japan. Returning to the United States in 1965, he taught at Berklee for six more years, during which time he traveled to Japan three times with Astrud Gilberto and was sent to Malaysia on a U.S. government grant to coach the Radio Malaysia Orchestra. There he learned to play the nadaswaram, a south Indian wind instrument made of wood. From 1974 to 1981, he lived and worked in Europe. He has always sought to play music that is contemporary—to keep up with the times. He has said that his interest in other countries' musical cultures has broadened his vision, so that his best work has been done after the age of fifty.

Buddy DeFranco, born Boniface Ferdinando Leonardo in Camden, New Jersey, in 1923, played clarinet with the bands of Gene Krupa, Charlie Barnet, and Tommy Dorsey and toured Europe with Billie Holiday in 1954. In the late 1950s, he conducted jazz workshops in schools in California. From 1966 to 1974, he led the reconstituted Glenn Miller Orchestra, then resumed teaching and play-

ing in nightspots. Since 1981, DeFranco has led a quartet with Terry Gibbs. Whitney Balliett has written the definitive statement on DeFranco's place in the history of jazz: "DeFranco, unbearably challenged by Charlie Parker, attacked bebop head-on and mastered it. He developed such fluency and invention and speed that he was considered the supreme jazz clarinetist (Balliett 1989)."

Conte Candoli, born in Mishawaka, Indiana, in 1927, played trumpet with Woody Herman, Chubby Jackson, Stan Kenton, Charlie Ventura, Charlie Barnet, and Gerry Mulligan. From 1968 he played with the Doc Severinsen Band on *The Tonight Show.* In 1973 he and his brother Pete organized a band in Monterey, California, with which they continue to perform. He is also active as a teacher.

Pete Candoli, born in Mishawaka, Indiana, in 1932, a jazz trumpeter like his brother Conte and famed for his high notes, played with the bands of Sonny Dunham, Will Bradley, Ray McKinley, Tommy Dorsey, Teddy Powell, Woody Herman, Tex Beneke, Les Brown, and Stan Kenton. In 1972 he created a nightclub act with his wife, the singer and actress Edie Adams, in which he sang, danced, played, and led the orchestra. He appeared at the Aurex Jazz Festival in Tokyo in 1981 and continues to work with his brother.

Joe Morello, born in Springfield, Massachusetts, in 1928 and partially blind from childhood, played drums for Woody Herman, Johnny Smith, Stan Kenton, and Dave Brubeck. It has been said that he was the first drummer to make the Brubeck group sound like a jazz band. In the 1990s, he performs less frequently, his appearances being mainly of an educational nature or in promotional activities for drum manufacturers.

Scott LaFaro (1936–1961), double-bass player, studied at the Ithaca, New York, conservatory and in Syracuse, New York, he played with Buddy Morrow, Chet Baker, Barney Kessel, Benny Goodman, Bill Evans, and Stan Getz. His 1960–1961 records with Evans and Ornette Coleman are considered innovative in that, besides merely keeping time, he would interweave countermelodies into his accompaniments, assuming a kind of parity with the pianist, thus expanding the role of the bass in trios far beyond the then accepted norm. He played with Stan Getz at the 1961 Newport Festival immediately before his death in an automobile accident.

Chuck Mangione, born in Rochester, New York, in 1940, trumpeter, fluegelhorn player, and composer, studied at the Eastman School. From 1960 to 1965, he and his brother Gap (Gaspare, born 1938) led a hard-bop group, the Jazz Brothers. He then played with the bands of Woody Herman, Maynard Ferguson, and Art Blakey, and in 1968 he formed a quartet. In 1970 he recorded *Friends and Love,* an album blending jazz, rock, folk, and classical elements, that

was highly acclaimed; his album *Feels So Good* in 1970 sold more than two million copies. His Latin-tinged score for the film *Children of Sanchez* in 1978 was equally successful. Mangione's later uncomplicated, melodic style has made jazz accessible to a wide, unspecialized audience, and he has been influential in increasing the use of the fluegelhorn in jazz. He has taught at the Eastman School. Two of Mangione's works bear directly on his Italian American identity: *Bellavia* (his mother's maiden name which means beautiful way), a 1974 album that celebrates his mother and father and the "warm everybody-feel-good environment" they established in their home; *Tarantella*, a 1981 recording of a benefit for Italian earthquake victims.

Chick Corea (Armando Anthony Corea), the son of Armando John Corea and Anna (Zaccone) Corea, was born in Chelsea, Massachusetts, in 1941 into a musical family. At the age of four, he began playing the piano at home, learning the fundamentals of music from his father, a trumpet player and bandleader, who would write out arrangements of popular tunes he played with his own band but at a level suited to teach his young son notation and the language of music. Corea then studied classical piano in Boston with Salvatore Suolo, who trained him in traditional piano technique. His father also exposed him to be-bop jazz at an early age and even incorporated the young Corea into his band.

In 1959 Corea moved to New York City where he attended Columbia University for a month and then the Juilliard School, but dropped out: "I only lasted a month or so. I became terribly bored with the formality of it all." He stayed in New York determined to become a jazz musician. His first professional engagements were with the Latin bands of Mongo Santamaria and Willie Bobo, in 1962–1963, during which he developed what would become a lifelong love for Latin music. Working as a sideman for Blue Mitchell, Stan Getz (for two years), Herbie Mann, and Sarah Vaughn, his apprenticeship culminated in his first recordings: *Tones for Joan's Bones* (1966) and *Now He Sings, Now He Sobs* (1968). Corea joined Miles Davis' groundbreaking *Bitches Brew* group in 1968, playing keyboards and, at the urging of Davis, moving from the acoustic piano to the world of electronic instruments. After leaving Davis' group in 1970, he formed the band *Circle* with Dave Holland, Barry Altschul, and later Anthony Braxton, a group that was very influential on the avant-garde jazz scene. The free-form style of the Corea of the late-sixties is best represented in the album *Circling In* (1970). In 1970 he converted to the Church of Scientology, which he calls the "second greatest discovery of my life," music, of course, being the first.

During the 1970s Corea established himself as one of the most popular jazz crossover artists on the American scene (he won nine best keyboardist polls be-

tween 1973 and 1979), playing an important role, along with other Miles Davis alumni, in the codification of "jazz fusion into a commercially successful format, featuring complicated riffs and flashy virtuoso," to cite *The Rolling Stone Encyclopedia of Rock & Roll*. Most of his work from 1972 through 1976 with Return to Forever, a group he first formed in 1972 and which was subsequently reconstituted as it evolved from a mainly acoustic, Latin-spiced group to a high-voltage rock band—its strongest constellation included drummer Lenny White and the guitarists Al Di Meola and Bill Connors. Return to Forever, which merged jazz and rock in an intriguing way and announced Corea's larger hybrid aesthetics that involves the mixing of Latin and classical and other musical elements, recorded eight albums: *Return to Forever* (1972), which featured songs written by Corea for the Brazilian vocalist Flora Purim and the mixing of Latin-inflected rhythms with sonata structures; *Light As a Feather* (1973), in which Al Di Meola made his first appearance with the group; *Hymn of the Seventh-Galaxy* (1973), which marked the group's transition from melodious pop jazz to heavy-duty jazz-rock; *Where Have I Known You Before?* (1974); *No Mystery* (1975), winner of the 1975 Grammy for best jazz performance; *Romantic Warrior: Musicmagic* (1977); and *Return to Forever Live!* (1977), the latter two were complications of a 1977 New York City concert. This period also produced the solo album *The Leprechaun* (1976), regarded as one of Corea's masterpieces, and *My Spanish Heart* (1976), with Gayle Moran, his second wife, as vocalist.

Throughout the 1980s and the 1990s the versatile Corea has continued to perform and to record regularly in a wide variety of jazz and fusion settings. Of note was his successful excursion into classical music in the early 1980s which involved his playing Mozart with the New Japan Orchestra in Tokyo in 1985 and his Mozart-influenced composition, *Septet for Winds, Strings, and Piano* which was given its first New York performance by the Chamber Music Society of Lincoln Center in 1983. Corea, who regards the jazz and classical distinctions as academic, explained his turn to classical music in an interview with the *New York Times* (2 January 1983: II, 15): "Musicians don't care if a given composition is jazz, pop or classical music. All they care about is whether it is good music—whether it is challenging and exciting."

Corea as a composer and arranger has globalized the notion of "fusion" in his work to encompass jazz, rock, and classical music. Consequently, the question of whether Corea can be seen to elaborate an Italian American musical persona is problematic and requires a different set of categories than those that apply to Buddy DeFranco or, say, Scott LoFaro, who revolutionized bass playing by developing a multifingered technique akin to that of a classical guitarist. Both

DeFranco and LoFaro can be read as straightforward hybrids who apply classical technique seamlessly to the improvisatory flows of jazz. The result is a kind of *sprezzatura* that conceals difficulty and, in DeFranco's case, is symbolized by his stance—straight and motionless, clarinet pointed at the floor and never raised upwards for gestural effect. Whitney Balliet gets at this in his description of DeFranco's playing as "constant motion" (Balliet 1989). He writes "DeFranco doesn't appear to use notes," a perfect definition of musical *sprezzatura*. As embodied in Corea's crossing-over and straddling, the Italian American musical persona has also undergone a fusion, African Americanized (the experience with Miles Davis was definitive), Latinized (if that is not a contradiction in terms: Corea is perceived as being Hispanic), Scientologized (for a description of the role Scientology has played in his music, see his statements in *Current Biography*, 1988); Mozartized and Europeanized (Bartok, Milhaud, Faure, Scriabin have all influenced his work). Does the Italian musical identity manifest itself in his work other than as the site of innumerable crossovers and crossings out? It is perhaps encrypted and generalized in Corea's search for lyricism, unintentionally detected and unnamed in such typical labelings of his music as "soft and Romantic and elusive" and in the telegraphic words of the entry in the *Penguin Encyclopedia of Modern Popular Music:* "[Corea] puts tension into Romanticism; object of beauty often attained."

Al DiMeola, born in New Jersey in 1954, studied the drum until age nine, when he heard the Beatles and switched to the guitar. At fifteen he was playing country music when he heard the Miles Davis Band with Chick Corea and knew that that was the sound he was looking for. In the 1970s, after studying at the Berklee College of Music, Boston, he played acoustic guitar in concert halls throughout the world with John McLaughlin and Paco De Lucia. In the mid-1980s he formed his own group, the Al DiMeola Project, and toured the United States with it. He has said that his playing has been influenced by classical guitarists Julian Bream and Larry Coryell. DiMeola is a virtuoso on both acoustic and electric guitars.

Bucky Pizzarelli, guitarist, born John Pizzarelli in Paterson, New Jersey, in 1926, became a studio musician for NBC in 1954, toured extensively with the Vaughn Monroe Orchestra, and moved to ABC in 1966, where he played on *The Dick Cavett Show*. In the 1970s, as his fame as a jazzman began to grow, he toured with Benny Goodman, formed a duo with George Barnes, and became a well-known figure at recording sessions and concerts. Pizarelli plays a seven-string guitar; the extra string allows him to play a bass line to his own solos. He is known not only for his virtuoso solo performances, but also for his skill as a classical guitarist.

John Pizzarelli Jr., born in 1960, Bucky's son and also a talented and versatile guitarist, seems headed for major stardom. This is because he also sings. If

you can sing, the nightclub customers will stop talking and listen to you. If you merely play an instrument, you could be Vladimir Horowitz and they wouldn't be quiet; they assume you are background music and behave accordingly, and so you remain a good sideman. Attractive, *simpatico,* with a quick wit and an unassuming manner, as well as the leader of a big band of his own (and an RCA recording contract), he returned from a 1994 whirlwind tour of Germany in which he and his band opened for Frank Sinatra. One cannot help comparing him to Harry Connick Jr. Both are young and attractive, both lead 1940s-style big bands and sing 1940s standard songs in the style of the 1940s pop-jazz vocalists, for which both have taken a lot of flack, their critics pointing out that this is not the 1940s. As jazz-oriented musicians, and men of taste, however, they prefer this music to today's rock—a rare phenomenon among musicians of their generation. Pizzarelli does not possess quite the overwhelming "big star" presence of Connick, but he is considered by his peers the better musician.

Mike Renzi (1941–), a jazz pianist from Providence, Rhode Island, plays in smart nightspots, accompanying singers of the caliber of Mel Torme and Sylvia Syms, and just the fact that they choose him says it all. His playing is so inventive, so tasteful, and so beautiful that the listener, spellbound, has a hard time concentrating on the star.

Worthy of mention is New York's "jazz dentist," Ron Odrich, born Rinaldo Basilio Orefice in 1931 in New York City, who manages to be both a superb jazz clarinetist and a prestigious Park Avenue periodontist, in whose office one is soothed by the coolest of cool sounds, rather than the standard elevator music. Odrich's patients include, not suprisingly, a good number of jazz notables, as well as upscale Italians, who squeeze in appointments on their trips to New York.

"'O Sole Mio": The Italian American Songbook

One component of their culture that Italian Americans did not fail to bring with them to America was their wealth of popular songs, particularly those from Naples. Listening to and singing these songs, so redolent of the sights and sounds of their homeland, must have been of enormous comfort to those uprooted people during their first, difficult years. Italian songs are unrivaled for their warmth, melodiousness, and sheer *cantabilità* (singability). They are also incredibly adaptable. The classic Neapolitan songs, for example, can be sung with equal effect by operatic tenors, sopranos, and baritones, pop vocalists, *posteggiatori* (the strolling musicians—usually elderly—who stop at your table in the tourist restaurants in Naples and regale

you with a voiceless but undeniably authentic version of "Torna a Surriento," in return for a bit of your *spiccioli* or small change), American crooners, and rock stars.

The best-known and best-loved Neapolitan song throughout the world must surely be "'O Sole Mio" (Oh, My Sun), written in 1898 by Eduardo Di Capua. It has been recorded by everyone from Enrico Caruso in his native dialect in 1916 (surprisingly late) to Tony Martin, who sang it as "There's No Tomorrow," and Elvis Presley, whose fans know it as "It's Now or Never." Anyone interested in the Neapolitan song would be advised to seek out the *Antologia della canzone napoletana* (Durium 1963), a set of twelve compact discs (CDs) or cassettes—the CDs are better because they provide extensive notes and texts—presenting a history of the Neapolitan song from 1200 to the 1980s, sung by Naples' finest exponent of the genre, Roberto Murolo. Murolo is not an operatic singer (his is but a thread of a voice); he is rather the melancholy Neapolitan with a guitar. His artistry is matchless, and only a native of the city can do justice to the dialect. Murolo is concerned not with producing a golden tone, but with making the words come alive. He himself says, *"Io non canto con la voce; canto col cuore."* (I do not sing with my voice; I sing with my heart). Even if you do not understand a word of Neapolitan, it is a joy to hear this warmest and most sensuous of dialects sung so beautifully.

In the early 1930s, numerous lovely, melodious, and quintessentially Italian songs were written, before the influence of American popular music began to make itself felt. Two that found favor in the United States, and both written by C.A. Bixio, were *"Parlami d'amore, Mariù,"* first sung in a 1932 film by the young Vittorio De Sica and known in English as "Tell Me That You Love Me Tonight," and the languorous *"Violono tzigano,"* which became "Serenade in the Night."

In 1934 the soprano Grace Moore, her operatic career sagging, accepted a role in a low-budget film at a minor Hollywood studio (Columbia) about a young American girl who goes to Italy hoping for a career in opera. The film was *One Night of Love,* and the entire world was enchanted by the scene in which Moore gets up in a colorful, picturesque Milanese trattoria (complete with the requisite checked tablecloths and candles) and sings, with enormous verve, an old Italian song, *"Ciribiribin,"* written in 1889 by Alberto Pestalozza. The next year, Moore was the most in-demand and highly paid singer in the world of opera. Toscanini said to her, "As long as you can make audiences happy with that little song, never stop singing it." She took his advice. Her record of *"Ciribiribin"* sold well, but Harry James' swing version in 1939, with his virtuoso trumpet solo, sold even better.

One of the biggest hits of 1935 in the United States was the fondly remembered "Isle of Capri," which was recorded by Bing Crosby, Gracie Fields, Xavier Cugat, and practically everyone else. The song is not Italian, however. It is offi-

cially listed as British; its author, one Will Grosz. Other countries are always writing romantic songs about Italy, after all. The song seems to be little known in Italy, although if you buy one of those lovely music boxes of inlaid wood on Capri, that is what it is going to play: They know what their customers want. The Capresi can thank their lucky stars for this song, which has made their already famous island even more famous and has undoubtedly done wonders for tourism. Even today, the British or American tourist will inevitably say, "Yes, and we visited the isle of Capri"—and for the rest of time the world will apparently mispronounce the name of the island because of this nostalgic song, which, for musical reasons, puts the accent incorrectly on the second syllable.

The big Continental hit of 1937 in America was the lively *"Vieni, Vieni,"* as sung by Rudy Vallee and sundry others. Although half of its lyrics are in Italian, its composer was a Frenchman, Vincent Scotto, of Corsican origin, making him, like his name and his song, half French and half Italian.

In 1940–1941, the Andrews Sisters, who were not in the least Italian, had three big hits on Decca Records with popular Italian tunes a lot of people still remember—"The Ferryboat Serenade" (*"O bella piccinina"* by E. Di Lazzaro), "Oh Ma-Ma" (*"C'è la luna mezzo mare"* by Paolo Citorello), and "The Woodpecker's Song" (*"Reginella campagnola"* also by Di Lazzaro). Musetta's waltz from Puccini's *La bohème* used to pop up every few years with a different English title and lyrics, and one of Frank Sinatra's first records with the Tommy Dorsey Orchestra was "Hear My Song, Violetta," which was practically note for note the Prelude to Act IV of Verdi's *La Traviata*. Most of the Italian American crooners of the mid-1940s took a crack at "Oh, Marie" (*"Maria, Marì!"* by Di Capua), both in Italian and in English. Louis Prima's exuberant version was the most popular.

After World War II, Americans (re)discovered Italy and returned enthusiastic about its food, fashions, films, and music. The song "Three Coins in the Fountain" was written in America, but it, and the 1954 film of the same name, with its wide-screen Technicolor views of the scenic beauties of Rome, made millions of Americans more eager than ever to visit that magical land. More Italian songs found their way to the United States. Rosemary Clooney became famous overnight with a catchy, if inane, novelty number, "Botch-A-Me," ("Ba-ba-baciami, piccina" by R. Morbelli), which had been sung in a 1941 film by Alberto Rabagliati. Clooney considered the song beneath her, but the new head of the Columbia Records pop division, Mitch Miller, had learned that that kind of thing grabbed the most nickels in the jukeboxes.

The 1893 Neapolitan classic *"'O marenariello"* (by S. Gambardella) became "I Have but One Heart" and was recorded by Phil Brito, Vic Damone, Dean Mar-

tin, Sinatra, and Johnny Desmond. Eddie Fisher sold a lot of copies of the lovely "*Anema e core,*" which kept its Italian title, as did "*Luna rossa*" and the immensely popular "*Arrivederci Roma.*" Maybe we were becoming more sophisticated. Dean Martin sang "*C'è la luna mezzo mare,*" "On an Evening in Rome" ("*Sotto er celo de Roma*"), as well as lots of pseudo-Italian stuff that is best forgotten. Robert Goulet had a hit with "*Amore, scusami.*" Nat Cole recorded "*Non dimenticar*" in 1958 (and sang it in phonetic Italian). Mario Lanza sang "*Come prima*" in his last film, *For the First Time* (1959). Domenico Modugno's original Italian versions of "Volare" ("Nel blu dipinto di blu") and "Ciao, ciao, bambina" became best-sellers in this country—an almost unheard-of phenomenon.

Then, around 1958, American rock 'n' roll invaded the Italian air waves, and it was all over. Almost overnight, Italians, in their eagerness to be *aggiornato* (up to date), stopped writing and performing the kind of melodic, sentimental songs that were their specialty and, like most of the rest of Europe, set about trying to imitate the American models, which, of course, they did badly. A young boy from Milan, Adriano Celentano, grabbed a guitar and gyrated all over the stage (he has a scene in Fellini's *La Dolce Vita*), in an attempt to become the Italian Elvis Presley. It is interesting to note, however, that neither he nor any of the other European Elvis imitators could ever bring themselves to wear the outrageous costumes that Elvis sported in his later years; they drew the line at that. Celentano wised up, dropped his Elvis imitation, and is still in the 1990s a popular figure on the Italian music scene. In any case, through the mid-1990s, Modugno and "*Ciao, ciao, bambina*" in the late 1950s remain the last Italian popular singer and song to be widely known in America. Remembering that, in the period 1952–1953 alone, Italy produced such memorable songs as "*Luna rossa,*" "*Anema e core,*" "*Scalinatella,*" and "*Scapricciatiello,*" we can only lament the decline of Italian popular music, which on the whole has become Americanized and derivative, adopting the international koine of contemporary rock, abandoning its traditions, and thus in danger of losing its difference. It is also lamentable that much of Italy's most creative work from the 1970s onward has not traveled to America—or, if it has, it has been to the enclave audience of recently arrived Italians. There was an extraordinary moment of musical expression in the 1970s involving the emergence of the *cantautori,* singer-songwriters such as Fabrizio De André and Paolo Conte who operated in a mode that mixed Bob Dylan–like angry-young-man auteurism with ironic cabaret styles. Since the 1980s, Pino Daniele, a phenomenal musician who sometimes sings in a strange hybrid of Neapolitan dialect and English, has come to dominate the Italian scene. Their work remains little known in America.

The two most important Italian American contributors to the songbook are Harry Warren and Henry Mancini. One of the best, certainly the most prolific, and one of the least known of American songwriters was Harry Warren. The man who won three Academy Awards, had forty-two songs on the hit parade (Irving Berlin had thirty-one), and whose songs have sold more than fifty million copies of sheet music was born in Brooklyn in 1893, the youngest of eleven children, to Italian-born Antonio and Rachel Guaragna and christened Salvatore. His father changed the family name to Warren to ease the Americanization of his children, and Salvatore became Harry.

As a young man, Warren tried writing songs but with little success, and so he went to work as a song plugger for the Remick Music Publishing House. When sound came in, Warner Brothers bought up Remick, and Warren was invited to Hollywood in 1930. His luck changed in 1933, when he wrote the score for *42nd Street*, whose big hit was "Shuffle Off to Buffalo." He quickly became Warner Brothers Number One songwriter, turning out, together with lyricist Al Dubin, the scores from the now classic Busby Berkeley extravaganzas and introducing songs like "I Only Have Eyes for You," "Lulu's Back in Town," "September in the Rain," "You Must Have Been a Beautiful Baby," and "Jeepers Creepers."

After a decade at Warner Brothers, Warren moved to Twentieth-Century Fox for five years, where he wrote scores for the Alice Faye and Betty Grable musicals, then to MGM for Fred Astaire, Judy Garland, and Esther Williams films, followed by seven years at Paramount, for Bing Crosby and Dean Martin.

All in all, Warren wrote the songs for more than seventy-five pictures, winning Academy Awards for "Lullaby of Broadway" (*Gold Diggers of Broadway*, [1935]), "You'll Never Know" (*Hello Frisco Hello* [1943]), and "On the Atchison, Topeka, and the Santa Fe" (*The Harvey Girls* [1946]). Other hits included "Chatanooga Choo-choo," "No Love, No Nothin," "I Had the Craziest Dream," "I've Got a Gal in Kalamazoo," "There Will Never Be Another You," "The More I See You," and "That's Amore."

Of Warren's fifty-year exile in Hollywood, Wilfrid Sheed, in a 20 December 1993 profile in the *New Yorker*, wrote: "He must surely have been the only songwriter out there who learned his music singing Bach and Palestrina in a church choir, and who thought Puccini was God." Warren often claimed that Puccini was his favorite composer and the strongest influence on his musical ideas.

Why, then, given these impressive accomplishments, is Warren's name not better known? For one thing, he had a strong penchant for privacy; his songs, fondly remembered as many of them are, are not quite on the exalted level of the best of Cole Porter or George Gershwin and he composed for the movies,

not for Broadway. When we hear *Showboat,* we automatically think Jerome Kern; *Kiss Me Kate,* Porter; and *Oklahoma!,* Rodgers and Hammerstein.

Who wrote the songs for *Meet Me in St. Louis? Snow White? The Wizard of Oz,* even? Who knows Jule Styne, Sinatra's favorite film composer? or Ralph Rainger and Leo Robin, who wrote wonderful songs for Bing Crosby's Paramount films in the 1930s? Film composers of Warren's era never received much publicity. If their names appeared at all on record jackets, they were in small print. However, given the sums they earned, they probably didn't brood too much over the situation.

Harry Warren's songs may not have been deathless masterpieces, but they reflected wonderfully the mood of their times. And he had the satisfaction of knowing that his songs, sung by the likes of Dick Powell, Alice Faye, Betty Grable, and Judy Garland were heard in movie theaters all over the country—the world, actually—by an audience infinitely more vast than that of any Broadway composer.

One of the most influential and original creators of contemporary film scores was Henry Mancini. The celebrated composer, arranger, conductor, and pianist was born in Cleveland in 1924, the son of Italian immigrants, Quinto and Anna Pece Mancini. Shortly afterward, his father, a steelworker, moved the family to Aliquippa, Pennsylvania, another steel town, where Mancini grew up. The elder Mancini played the flute and encouraged his son to study music. Mancini recalled being taken as a boy to see Cecil B. DeMille's 1935 epic, *The Crusades,* and being particularly impressed by the film's musical score. Having mastered the flute, piccolo, and piano, he was soon playing the flute alongside his father in the local Sons of Italy Band.

In 1942, upon graduation from high school, he enrolled at the Juilliard School of Music in New York, where his studies were soon interrupted by military service. After the war, he spent three years with the Glenn Miller Band, reorganized by Tex Beneke. He also studied privately with composers Ernst Krenek and Mario Castelnuovo-Tedesco. In 1952 he joined Universal-International Studios in Hollywood as a staff composer, remaining there for six years and writing scores for more than 100 films, from *Abbott and Costello Meet Dr. Jekyll and Mr. Hyde* to *The Glenn Miller Story, The Benny Goodman Story,* and Orson Welles' *Touch of Evil.*

He brought a new approach to film music, moving away from the lush, symphonic scores of composers like Korngold, Steiner, and Rozsa, using instead lighter, jazz-influenced motifs. In 1958 his friend director Blake Edwards asked him to write the background music for a new television series, *Peter Gunn.* Mancini decided that what was most appropriate for this kind of "hip" show was a sophisticated, cool, jazz-oriented score using a small group of musicians, with basically

a guitar and a piano playing in unison. He created what he described as "a sinister effect with some frightened saxophones and some shouting brass." The show's theme music became wildly popular, particularly with high school marching bands and rock groups, and made Mancini famous.

In all, his music was heard in nearly 250 films. He won Academy Awards for the scores of *Breakfast at Tiffany's* (1961) and *Victor/Victoria* (1982), as well as for the songs "Moon River" and "Days of Wine and Roses."

Whereas much background music could be used interchangeably for any number of films, Mancini's was notable for its relevance to the story, underlining and enhancing the mood of each individual scene. He never began work on a score until the film was finished. He would view it repeatedly, and then the ideas would begin to come.

Mancini made eighty-five albums of his own orchestral and choral compositions and received twenty Grammy Awards for his recording work. He frequently performed as guest conductor and piano soloist with major symphony orchestras. He endowed a chair in film composition at the University of California at Los Angeles, as well as a fellowship at The Juilliard School. He was the author of *Sounds and Scores* (1962), a guide to professional orchestration.

At his death in 1994, he was putting finishing touches on an adaptation for Broadway of *Victor/Victoria,* for which he had written twenty-five new songs. Mancini was, and is, a key figure in the international pantheon of composers for film that includes the Italians Nino Rota, Ennio Morricone, and Giorgio Moroder.

Dance and the Italian American Body Image: Between the Tarantella and Ballet

> [In Italy] everybody enjoys everybody else's beauty—it belongs to everyone who sees it; they enjoy it all their life over and over with the same pleasure. One could guess that they had invented ballet. They know how to lift the waist imperceptibly as they turn half in profile, how to show a back, hold the head, raise an arm, point a foot, or extend a hand; they love doing it and seeing it.
>
> —*Edwin Denby*

The art forms through which the Italian body has been traditionally codified in movement and in *contraposto*—the tense moment just after or before motion—are: (1) the opera, which produces the monumental and statuesque body of melodramatic declamation; (2) the *commedia dell'arte,* which transposes the agile and

cunning body of street life into a choreography of improvisation; (3) the ballet, an invention of the Italian court that, as the supreme European codification of the animal body, constitutes the Italian body in its most etherealized form as typified by Taglioni's leap (Marie Taglioni—Marie *pleine de graces* (full of graces), as she was called—was the supreme Italian ballerina); and (4) the folk dance, which expresses the sexualized and carnivalized body of courtship and the festa, as typified in the **tarantella,** a lively, whirling Italian folk dance that when danced by couples is characterized by light, quick steps and flirtation between the partners; although its provenance is the *Mezzogiorno,* it has become the Italian national dance. And this is to say nothing of everyday practices such as walking and lolling which are controlled by the pragmatized aesthetics of the *bella figura* by which the everyday body is rendered into an aesthetic object. Edwin Denby, America's foremost dance critic, was particularly responsive to the informal "ballet" performed by Italians in their everyday lives. Commenting on the way the liveliness and skill of their movements recall ballet, he observed that the foreign ballet fan upon witnessing these ad hoc performances realizes "what it means that ballet was originally an Italian dance, and he becomes aware of the lively sociability of its spirit and its forms." Since body codes and gesture are social acquisitions, the question of the way in which the "Italian body" travels to America and is, over the generations, rewritten in American terms, takes us into the area where culture is seen to operate in its most corporeal way, a problematic area for the Italian Americans who have been stereotyped, both positively and negatively, as the "people of the body."

The Tarantella and the Dionysian Body

> Tarantella . . . Who plays it softly that she dances? And there in the cobbler's shop with shoes slung on shoulder is the boy Geremio smiling to her and telling the cobbler he will marry the little girl with braids who swings sweetly barefoot. She is twelve and as she does Tarantell with the children Geremio's dark eyes travel through the villagers' music to tell her "You shall be mine, Tarantell-Tarantell!" It plays as they are engaged in Aunt Seraphina's big stone room where the giant-muscled Luigi happily follows with Jew's harp in mouth. Tarantell-Tarantell it mischievously calls during wedding's solemn rite in huge chamber of Saint Michael . . . Tarantell-on-Tarantell it waves wildly gay with matrimonial feast under ancient home's thick rafters out into luna-laved vineyards and beneath olive trees and Tarantell! in fierce loveliness on virgin couch!

> *Now it sails her to the America where Geremio's children visit from out of her to become her darling brood. Tarantell—NewWorld—Tarantell her young motherhood in the English-tongued America so hard so ungracious— Tarantell gray striving Tarantell in Tenement America in and about polyglot worker poor as they laugh and scream and moan and weep their cheated fragment selves.*

We begin with this rather long excerpt from the conclusion of Pietro di Donato's novel *Christ in Concrete* (1939), which reproduces in high-speed writing the frenetic movement of the *tarantella,* because it demonstrates the importance of the dance to first- and second-generation Italian American identity. It is the moment of the death of Annunziata, the dancer in this passage and the widow of the deceased laborer Geremio: She recapitulates—dances—in this interior monologue the story of her life in terms of the *tarantella:* her courtship and wedding in Italy, her passage to America, and now the hour of her death. She does so instinctively, almost as a sonic defense mechanism against the fragmentation of "Tenement America," for the *tarantella* is the most instinctive dance of southern Italy, its rhythms carrying all from infancy when it is sung as a cradle song into the adult world of courtship and sexuality, embodying the rhythms of the carnivalized body of the fiesta and thus a suitable weapon against the approaching silence of death.

The *tarantella*—lifeline, deathline of identity—is a dominant topos in Italian American culture: It is danced at Connie Corleone's wedding in *The Godfather;* it is the dance that Frankie Pentangeli tries to coax out of the Americanized band at Anthony Corleone's First Communion party in Nevada at the beginning of *The Godfather Part II,* eliciting instead "Pop Goes the Weasel"; it is rendered into jazz by Chuck Mangione in his album *Tarantella;* as transposed into ballet by George Balanchine in *Tarantella,* it provides Edward Villella with one of his greatest roles; and, of course, it remains an official ethnic marker at the weddings of third- and fourth-generation Italian Americans who have lost the codes of this manic dance of love and death. (For an explanation of the semiotics of sexual seduction it brings into play as a courtship dance, see Richard Gambino's *Blood of My Blood* and Curt Sach's *World History of the Dance* [1937].) It derives its name from the town of Taranto in Apulia, but a more picturesque etymology traces its origins to tarantism, an epidemic that appeared in fifteenth- through seventeenth-century Italy: The bite of a venomous spider called the "tarantula" (a name also derived from Taranto) could be cured only by purging the body—"sweating the poison out"—by dancing the *tarantella*. Often used in art music, especially by foreign composers such as Chopin, Liszt, and Richard Strauss, and a literary topos for such travelers to

Italy as Goethe and Rilke, the dance, with all of its frenzied energy, has come to epitomize the body image of Italians and Italian Americans. As Gambino has pointed out: "It is characteristically Southern Italian in that it calls for individual improvisation within set patterns." We would go further by describing it as a dance that is at once Apollonian and Dionysian: the top half of the body held in Apollonian restraint; the legs and arms released into a frenzy; the face the meeting place of both registers.

Rilke, who was particularly attuned to its Dionysian elements, once exclaimed: "What a dance, as though invented by nymphs and satyrs, old as though rediscovered and rising up anew, wrapped in primeval memories—cunning and wildness and wine and men with goat's hooves again and girls from the train of Artemis." (If you have only heard the "bracketed" version of the *tarantella*, the bastardized Americanized version, the one that, for example, Milton Berle copyrighted, as Robert Viscusi has pointed out to us, we relay you to the film *Carosello Napoletano* (1952) for a more authentic version of this dance of danger, perennially subjected to the most vulgar of folklorizations. Also to be experienced is a performance of Auguste Bournonville's full-length ballet *Napoli,* which is the most spectacular use of the *tarantella* in the annals of dance. Created in 1842 for the Royal Danish Ballet, it remains a fixture in the company's repertoire.)

Ballet and the Apollonian Body
We know what the dances of the ancient Greeks looked like; thousands of surviving friezes show us. The dancers basically glide across the floor. The Italians took those dances and added a jump (*il salto*) creating the *saltarello,* a lively dance involving much vigorous arm movement, which is still performed and which Italian dance scholars call the quintessential Italian dance. The peasants from each region created their own folk dances—the *rotta,* the *piva,* the *tripola,* the *brando,* and, from the region of Taranto, the *tarantella*. The higher classes developed their own dances—the *gagliarda,* the *pavana,* the *passamezzo,* the *volta,* and the *bergamasca*—which were somewhat more decorous and suited to the heavier clothing and shoes they wore. With time, certain foreign folk dances—the polka, the mazurka, the gigue, the sarabande, the czardas, the polonaise, and the rigaudon—crept in. (Many of our classic ballets—*Sleeping Beauty, Swan Lake,* the Bournonville ballets from Denmark—include as a divertissement a series of dances inspired by the various nationalities.)

The first celebrated European dance master was Domenico da Piacenza (born in the late 1300s and died after 1462), who worked at the d'Este court in Ferrara and published his theories in *De arte saltandi et choreas ducenci*. He and his

equally renowned student Gugliemo Ebreo (born before 1440) taught social dancing at various Italian courts and produced the festivities for the wedding of Costanzo Forza and Camilla d'Aragon in Pesaro in 1475. By the time of the high Renaissance, the dance had assumed a role of primary importance in the education of young people. Where did these dance masters get the steps for the dances they created? From the folk dances. They simply borrowed the steps from the popular dances of the lower and higher classes and the foreign interlopers, adding more formal invention of their own. By the late fifteenth century, each Renaissance court in Italy had its own dancing master, who tried to outdo the others in arranging elaborate banquet-fetes for special occasions, marriages, betrothals, and royal visits. According to the entry titled "Ballet" in the *New Encyclopaedia Britannica,* one such spectacle, produced in Tortona, may be regarded as the first actual ballet, but the authors are quick to point out that historians also cite as the first ballet the *Ballet Comique de la Reine,* a spectacle in celebration of a royal bethrothal presented, in 1581, in the Louvre for 10,000 titled guests of the court of Catherine de Médicis (who was herself an excellent dancer, and Italian). Depicting scenes from the legend of Circe and costing the French treasury a staggering sum, it was an attempt by the French academicians to reestablish the relationship between poetry, music, and dance as found in the classical Greek theater. It was staged by Balthasar de Beaujoyeaux, alias Baldassaro de Belgioso, an Italian, and was a success. It was the French who created the first dance academies, codified the steps of the new art and gave it its name, "*ballet,*" from the Italian *balletto,* (little dance). The French have long made it a point to disseminate their culture, and thus it is not surprising that it was they who first brought formal dance to the New World.

The Italian Presence in American Ballet
Although in this essay it is impossible to set out the intricate history by which ballet was imported to America, it is important to stress that Italian dancers and dance masters played key roles in this process. For example, in 1774 two Italian dancing teachers, Pietro Sodi and Signor Titoli, established schools in Philadelphia, and in 1832 Signor Papanti, an Italian musician and dancer, founded a dancing school on Tremont Row in Boston; he later was appointed master of deportment and dancing at West Point. In her writings, Agnes DeMille mentions that Ronzi and Charles Vestris, members of the famed Florentine family of dancers, presented a one-year engagement of ballet at the Bowery Street Theater in New York City in 1828.

These early forays set the stage for the appearance in 1839 of Paul (Paolo)

Taglioni, the premier *danseur* of the Berlin Royal Opera and member of the celebrated Taglioni family. His sister Marie Taglioni, considered the greatest ballerina of her age, had danced *La Sylphide* (choreographed by her father, Filippo Taglioni) at the Paris Opera in 1832, the ballet that ushered in what has been called "the Golden Age of Ballet." After Paul and his wife, Amelie, had triumphed in the great theaters of Europe, he became obsessed with the idea of taking a steamboat to America and trying his luck in the United States. The directors of the Park Theater in New York City were looking for celebrated European dancers and instantly engaged Taglioni and his wife. Arriving in New York, which they found delightful, they decided to make their debut in *La Sylphide,* not an easy matter since the work demands a large, well-trained *corps de ballet,* which simply was not to be found in New York. Undaunted, Paul Taglioni whipped the poor girls that he was able to recruit into some kind of shape. *La Sylphide* and the Taglionis took New York by storm—Paul, in particular, since America had never seen a male dancer remotely of his caliber, capable of performing such bravura leaps and pirouettes. *The Spirit of the Times* wrote of him: "Taglioni is Italian in appearance, wondrously well-formed—limbs clean and sinewy like those of a race horse." The Taglionis performed a wide variety of European works throughout the United States. The local dancers must have been dumbfounded. After four months, they returned to Berlin, covered with glory and leaving American audiences with a new respect for male dancers.

The next important chapter in the adventures of Italian ballet in America belongs to Domenico Ronzani. In 1857 the manager of the Philadelphia Academy of Music was looking for a suitable attraction to open the city's beautiful new opera house. Ronzani (1800–1868), a famous Italian mime and choreographer at La Scala who had the imposing title of *Primo ballerino mimico assoluto,* was asked to bring over a ballet company from Italy. On 15 September 1857, the Ronzani Ballet made its debut at the opulent new theater with a lavish ballet version of *Faust*. The troupe was composed of highly accomplished dancers, including the Cecchetti family and their seven-year-old son Enrico. (Enrico, 1850–1928, who spent a year in America, would go on to become one of the greatest dancers of his time and, later, ballet master at the Imperial Theater in St. Petersburg, Russia, where he taught, among others, Pavlova, Karsavina, and Nijinsky. He returned to the United States in 1913, nearly sixty years later, as a member of Pavlova's touring company. He is generally considered to be the greatest ballet teacher in history.) It was an ill-timed debut, however. A severe financial panic was sweeping the country, and America's interest in ballet was beginning to ebb. Ronzani brought over an exceptional prima ballerina, Anetta Galletti, from Italy, and the

company toured. Financial difficulties forced the company to disband, and Ronzani set about forming a new troupe of mostly American dancers, including the extraordinary George Washington Smith, then at the height of his powers. The company toured for several years, presenting first-rate, handsome productions of works such as *La Bayadere, Esmerelda,* and *The Corsair* in Philadelphia, New York, and Boston, but, dogged by bad luck, it was dissolved in 1859. Ronzani remained in the United States doing odd jobs in the theater until his death in New York in 1868—an abject ending for a man who had been a star at La Scala for thirty years.

The next episode in our history involves the adventures of a trio of distinguished ballerinas: Marie Bonfanti, Rita Sangalli, and Giuseppina Morlacchi. In 1866 two New York theatrical managers had planned to present a distinguished group of European ballet dancers at the Academy of Music. They had purchased dazzling scenery and costumes in London. When the academy burned down (an all-too-common occurrence in those days), they sold the contracts and scenery to William Wheatley, proprietor of the famous Niblo's Gardens in New York City. Wheatley combined them with the script of a third-rate melodrama by Charles M. Barras called *The Black Crook* and presented the ignoble pastiche to the public on 12 September of that year. It was an instant sensation and ran on and off for forty years; Christopher Morley and Agnes De Mille collaborated on a lavish and historically accurate revival in Hoboken, New Jersey, in 1929. Despite the caliber of the original, it was, nonetheless, a legitimate forerunner of the American musical comedy and served to introduce ballet to the general public. The elaborate second-act finale revealed a golden lakeside grotto, against which the shapely members of the *corps de ballet,* in the diaphanous raiment of sylvan nymphs, frolicked. Lovers of the higher things came back night after night to feast upon the joys of ballet, as well as upon all those uncovered female limbs, still a rarity on American stages.

The prima ballerina, the tiny, dark-haired Marie (Marietta) Bonfanti (1847–1921), a leading dancer at La Scala, became an instant favorite with the American public. She eventually married George Huffman, son of a socially prominent New York family. She was the prima ballerina at the Metropolitan Opera from 1888 to 1894, and in 1896 she opened a dancing school, which she ran for ten years.

Her coballerina in *The Black Crook* was another gifted Italian dancer, Rita Sangalli (1850–1909), from La Scala, who returned to Europe in 1870 to become prima ballerina at the Paris Opera, coming to be regarded as one of the great beauties of the Belle Époque (1890–1914).

The diminutive and lovely Giuseppina Morlacchi (1843–1886) arrived in

1867. As a child in Milan, she studied at the ballet school of La Scala, where the prima ballerina was a girl from Philadelphia, Augusta Maywood. Morlacchi made her New York debut in *The Devil's Auction,* a ballet spectacle intended as a rival attraction to *The Black Crook.* She became particularly popular in Boston, where in 1868 she introduced a dance called the "French Can-Can." The "original Morlacchi can-can" soon brought fame and fortune to its creator. She was a dainty creature, with delicate features, which left the spectator unprepared for the Latin fire of her dancing. She married a handsome, reckless, and famous Indian scout known as Texas Jack and toured with him and Buffalo Bill in Western extravaganzas. He raced to Leadville, Colorado, when gold was discovered and died there of pneumonia in 1880. She returned east and retired with her sister near Lowell, Massachussetts, where she taught ballet to the local factory girls. When she died at the early age of forty-three, the whole town went into mourning.

These three women, artists of the highest caliber, through their work in both classical and popular fields, must have opened the eyes of at least a portion of their audiences to the beauties of ballet.

After the opening of the Transcontinental Railway in 1869, a good many dancers, including Bonfanti, Sangalli, and Morlacchi, ventured into the South and West to places hitherto inaccessible. They played towns that had no theaters and no hotels. They had to recruit most of their musicians and dancers locally. In some instances, they actually had to go to brothels to find women willing to appear on the stage in tights. The miners were nonplussed, however, and almost pathetically grateful to have a little beauty brought into their lives. Unfamiliar with the custom of showering dancers with bouquets, the miners showered them with gold nuggets. They surely deserved them, however, for the constant dangers and hardships they had to put up with, and for the incredible feat of managing to seem like the embodiment of ethereal grace and beauty once they stepped on those makeshift stages.

After these Wild West excursions, our history comes to be focused on the Met. When the Metropolitan Opera opened its doors in New York City in 1883, it naturally included a ballet company. It did not have the importance of the ballet companies attached to European opera houses, where opera and ballet are given on alternate nights, but at least it was a ballet company, and for decades it remained the only permanent dance company in the United States. Most of its prima ballerinas have been Italian, celebrated in their day but most of them now forgotten. The Met probably chose so many Italians because the dancer in an opera ballet, such as *Carmen* or *Aida,* has to be an actor as well, and Italian dancers are trained in mime, whereas for many American schools of dance, which are not state

supported, this is a luxury they cannot afford. The fact that the Met soon became a virtually Italian house did not hurt, either.

The Met's first prima ballerina was Malvina Cavallazzi (c. 1852–1924) from the La Scala ballet. When the Met presented Auber's *Masaniello,* also known as *La Muette de Portici,* in its second season, she appeared as Fenella, the dumb girl, whose role is mimed, rather than sung. The *New York Herald* commented that "she discovered herself an actress of a great emotional power and deep intelligence." In 1884 three leading dancers arrived from Italy—Lucia Cormani, Adele Fallio, and Isolina Torri—all La Scala trained.

Two of the star dancers in 1885 were Bettina De Sortis, from La Scala, and Marie Bonfanti, a New York favorite since her days in *The Black Crook,* twenty years earlier. The first Met ballet master, Giovanni Ambrogio, was succeeded in 1890 by Augusto Francioli, and there were two new prima ballerinas from La Scala, Edea Santori and Fiordilice Strocchetti. The Met finally acquired a first-rate male dancer in 1895 with the arrival of Luigi Albertieri, a protégé of the great teacher Enrico Cecchetti, who made his debut in the skating scene of Meyerbeer's *Le Prophete,* partnered by Maria Giuri, also from La Scala. A year later, he became ballet master at the Metropolitan. In 1915 he opened a dance school in New York, training his dancers in the demanding method of his master, Cecchetti. One of his pupils was Fred Astaire. Giuseppe Bonfiglio was the company's principal dancer from 1905 to 1935. When Giulio Gatti-Casazza became general manager of the Met in 1908, he brought with him from Italy, in addition to Toscanini, a ballerina, Gina Torriani, and a choreographer, Lodovico Saracco. In 1909 Rita Sacchetto, celebrated for her pantomime dances, was engaged; she later became a star of silent films. In 1909 the Metropolitan Opera Ballet School was created, and Malvina Cavallazzi, the company's first prima ballerina in 1883, was brought back from England to direct it. Her work proved so successful that by 1914 it was no longer necessary to import dancers for the ensemble.

Cia (Lucia) Fornaroli (1888–1954) was the Met's prima ballerina from 1910 to 1914. *Prima ballerina assoluta* at La Scala from 1921 to 1923, she was considered the finest Italian dancer of her generation. In 1929 she succeeded Cecchetti as director of the La Scala school. Due to fascist attacks against her husband, Dr. Walter Toscanini (son of Arturo), in 1933 they returned to New York, where she conducted her own school of classical dance, using the Cecchetti method.

In 1913 the Met hired a lovely sixteen-year-old Italian ballerina who had been a sensation at the Chicago Opera, Rosina Galli (1896–1940). Her spectacular technique won her equal praise from the Metropolitan audience. "The sensation of the evening was the brilliant dancing of Rosina Galli, whose performance

literally swept the vast audience off its feet," wrote the *New York American* of a 1914 performance of *Carmen* that starred Geraldine Farrar and Giovanni Martinelli. The *Brooklyn Eagle,* reviewing her 1918 performance in *Le Prophete,* said: "First and foremost, praise must go to little Rosina Galli and her partner Bonfiglio, who in their dancing . . . transcended every one of the singing principals" (who, by the way, included Caruso, Claudia Muzio, and Margarete Matzenauer). She was ballet mistress of the Metropolitan from 1919 to 1935, and in 1930 she married Giulio Gatti-Casazza, general manager of the house.

The Italian American Presence in American Ballet
Although the Italian presence would continue to be felt throughout the twentieth century, culminating in the triumphant reception granted Carla Fracci (see below), the Italian American community began producing a number of distinguished American-trained dancers, two of whom, Edward Villella and Gerald Arpino, would become major figures in America ballet.

The most prominent first- and second-generation ballerinas are Maria Gambarelli, Gisella Caccialanza, and Eleanor D'Antuono. Maria Gambarelli (1901–1990) came to America when she was seven years old and began studying at the Metropolitan Opera Ballet School. At thirteen she became the understudy to Rosina Galli, and she was prima ballerina from 1937 to 1941. She made several films, and in 1942 was named prima ballerina at the Capitol Theater in New York City. In those days, virtually the only large ballet companies to be found in the United States outside of the opera houses were in large vaudeville theaters such as the Capitol, the Roxy, and Radio City Music Hall. To some it may have seemed a comedown, and the dancers had to do several shows a day, but they danced for enormous audiences who came to know and love them—and the pay was excellent. Personable and attractive, Gambarelli was known to everyone as "Gamby." Gisella Caccialanza, who was born in San Diego in 1914, studied with Cecchetti, danced with the Ballet Caravan, the Ballet Society, and the San Francisco Ballet. She created roles in several Balanchine ballets of the 1930s and 1940s. Eleanor D'Antuono, born in Cambridge, Massachussetts, in 1939, was for many years a versatile and gifted leading dancer with the Ballet Russe de Montecarlo, the Joffrey Ballet, and the American Ballet Theater.

Also to be mentioned are the modern dancers Terese Capucilli and Kathy Buccellato, both of whom in the 1990s are leading dancers with the Martha Graham Dance Company, Capucilli having taken over many of the roles that Graham created for herself.

The Italian Americans, however, have yet to produce a ballerina of the

magnitude of Carla Fracci, the first Italian dancer of the twentieth century to achieve international fame. Fracci, who was born in 1936, the daughter of a Milanese streetcar conductor, began her career in the 1950s, when dance in Italy was at a low ebb. By the 1960s, she had become Italy's leading diva, more prominent even than any opera star and singlehandedly responsible for the rebirth of ballet in that country. She had a similar effect on the American Ballet Theater in the late 1960s and early 1970s. Her Giselle and Sylphide were unforgettable. She conveyed the essence of the nineteenth-century romantic spirit: She seemed to be a lithograph of Marie Taglioni come to life. (There are American dancers who are technically stronger than Fracci, but they inevitably have trouble identifying emotionally with these romantic heroines; the same is true in opera as well.) When the Russian ballerina Natalia Markova arrived at the American Ballet Theater, Fracci returned to La Scala, where her reign was unchallenged and where, in the mid-1990s, she is still its leading ballerina.

On the other hand, Villella and Arpino, the Italian American heirs of Cecchetti, have come to embody bravura in American terms, although Arpino's contribution is primarily as a choreographer. Born in 1937, Edward Villella, the son of Sicilians from Long Island and a former gymnast, thrilled New York City Ballet audiences in the 1950s and 1960s with his virile and electrifying performances. Never before had we seen dancing on such a level from an American male dancer. He performed feats of technical virtuosity that we thought only Russians were capable of. He was capable not only of keeping up with the most dazzling of the Balanchine ballerinas, but often of surpassing them. Since 1985 the director of the Miami City Ballet, Villella ranks as the finest male ballet dancer America has produced. In *Afterimages* (1977), Arlene Croce, also Italian American and arguably the late-twentieth-century's most perceptive authority on dance, offered this definitive statement on Villella, whom she regards as "the most physically exciting man in the American theater": "Villella at his best in his greatest roles *(Rubies, Tarantella, Harlequinade, Oberon in A Midsummer Night's Dream)* has been supremely wholesome, tough, exuberant, and cocky. At less than his best, he throbs like a sexy steam cabinet. If [Luis] Fuente is the Anthony Quinn of the ballet, Villella is its Kirk Douglas." His accessible image as a regular, beer-drinking guy—a sort of dancing Al Pacino, to rework Croce's comparison—and his ability to communicate verbally the inner secrets of ballet have helped Villella redefine the general public's stereotype of the male ballet dancer.

No name is better known in the world of contemporary American dance in the 1990s than that of Gerald Arpino, artistic director and leading choreographer of the Joffrey Ballet. Born Gennaro Pietro Arpino on Staten Island in 1925,

he began his sudy of ballet at the age of seventeen at the Ivan Novikoff studio in Seattle, where he became friends with another student, Robert Joffrey. In 1944 they both switched to the school of Mary Ann Wells (also in Seattle), one of the most respected teachers on the West Coast, where they remained for four years, Arpino serving with the U.S. Coast Guard at the same time. He returned to New York to study ballet at the School of American Ballet and modern dance at the Martha Graham School. He danced on Broadway in *Annie Get Your Gun* in 1948 and *Bless You All* in 1950 and in 1952 he toured South America with the Ballet Russes concert company. The following year, he and Joffrey opened their own school, the American Ballet Center, in New York City. In 1956 they cofounded the Robert Joffrey Theatre Dancers, later to become the Joffrey Ballet, which crisscrossed America, playing in more than 400 small towns and cities.

A versatile and engaging performer, at home in both the classic and modern repertories, Arpino soon became the company's principal male dancer. He was also premier *danseur* with the New York City Opera Company from 1955 to 1961. He began to choreograph in 1961, presenting his first two ballets, *Partita* and *Ropes,* at a concert given with John Wilson and Company. His first ballet choreographed for the Joffrey, which would subsequently produce much of his repertory, was *Sea Shadow* (1962), "a dream-like pas de deux for a mortal man who encounters a sea nymph beneath the ocean." The remainder of the description by Sasha Anawat is worth considering for it underscores those elements that will charaterize his style: "Their lovemaking in this imaginary fluid environment gave Arpino license to push the limits of his dancers' extensions, making a choreographic feature out of the suppleness of their limbs and spines. His aesthetic, as it evolved thereafter, often spotlighted 180-degree penchee arabesques and ballerinas balanced prone on their pubic bones with arms and legs 'swimming' behind them. Overt sexuality combined with a strong spiritual strain (particularly Christian) became one of Arpino's trademarks." After suffering a back injury in the spring of 1962, which would end his career as a dancer, he devoted himself to full-time choreography, establishing himself as the Joffrey's house choreographer and creating ballets that are among America's most popular.

The Joffrey's aim was to commission new works by the best contemporary choreographers and to revive neglected twentieth-century masterworks. The company introduced the modern-dance works of Alvin Ailey, Anna Sokolov, and Twyla Tharp to ballet audiences and revived historically important works by Balanchine and Massine not seen since the early 1930s. It presented an evening in which Rudolf Nureyev danced Nijinsky's roles. At the heart of the Joffrey's attempt to define ballet (and a ballet company) in contemporary terms was Arpino's

effort to create new ballets for popular consumption and, therefore, to introduce into the elitist regime of ballet a postmodernist aesthetics that collapsed the distinction between "high" and "low." Of course, elitist critics, particularly the Olympian Arlene Croce, who is an Arpino-basher, were highly critical of this attempt at pop ballet and of the trendiness of the Joffrey's agenda in general: "The whole point," Croce writes in *Afterimages,* "is that the Joffrey is the hippest, youngest, most 'relevant' company around and don't you forget it." On the whole, Arpino's work mixes classical ballet with modern dance, with a generous dose of sensuality and theatricality. But such a generalization does not get at the hybridism informing his ballets, particularly his appropriation of rock music and rock dancing, which, in postmodernist fashion, are transcoded into the language of ballet and thus "bracketed," marked as doubly coded texts that introduce a contamination between popular and elite dance. In our view, dance critics have all too often removed the "bracketing" and responded to his works without modifying their dance aesthetics. Croce, for example, responds to his work in terms of "seemliness," which is tantamount to describing a Roy Lichtenstein painting in terms appropriate for a Piero della Francesca. This is not to say that Lichtenstein's *Artist's Studio: The Dance* (1974) or Arpino's *Trinity* (1969), to cite comparable works that are rooted in post–1968 popular culture, are immune from judgments of quality, but rather that the criteria for those judgments must be historically grounded. Thus, for Croce, who admits that Arpino's ballets "exhibit impressive powers," to criticize him on the grounds that his ballets "translate" other ballets is to miss the point completely: Artistic texts are always necessarily made from other texts, and the postmodernist aesthetics of appropriation simply foregrounds this role by its exacerbation of intertexuality. When Lichtenstein inserts a cartoon replica of one of Matisse's heroic dances into the comic-strip world of *Artist's Studio* or when Arpino rewrites Martha Graham in *Olympics* (1966), and speeds up in *Kettentanz* (1971) a solo that appears to come from *Giselle,* and "upgrades"—from a postmodernist view, "downgrades"—rock dancing into the syntax of classical ballet as in *Trinity* or *Billboards*—all are comparable gestures of bracketing. A ballet that apparently lends itself to popular and facile consumption ought not be summarily dismissed as catering to the taste of an uninformed public, but rather should be examined for its elements of hybridization and recycling, which are strategies of the dominant contemporary aesthetic.

Arpino, however, scored a great critical as well as popular success with his *VivaVivaldi* (1965), with its hybridization of fiery Spanish dance, led by the riveting Luis Fuente, with the relatively stately music of the eighteenth-century Italian master. Arpino's greatest success is *Trinity* (1969), which the company would

perform for eight years and which eventually became its signature work. Inspired by the anti–Vietnam War peace marches that Arpino had witnessed while at the University of California in Berkeley, the rock ballet both thematically and formally is an expression of the 1968 counterculture: "youths alienated from their families," "love-ins," flower carrying and offering, a live rock band in the pit—in other words, the whole scenography of the counterculture, which is made to culminate in the dancers' depositing of peace candles on the stage as they leave. The choreography itself was generated from the dancers' "natural" response to the rock music: They danced as if at a club and not a rehearsal; their gyrations and pulsations were then formalized by Arpino. Given this celebration of the American counterculture, it is no accident that the audience at the Berekely premiere responded with shouts of "Peace! Peace!" and that the Russian audience attending its Moscow debut in 1974 called for forty-two curtain calls. As Sasha Anawalt, a critic sympathetic to Arpino's populist approach to dance, states: "Audiences didn't expect electronic music at the ballet. And it made them realize that young dancers are no different from young people. The elitist barrier between artist and ordinary citizen broke down further with *Trinity,* compounding the Joffrey's popular image as a vibrant, energetic troupe alive to its times."

Things went well throughout the 1970s: there was a ballet boom, and the Joffrey, now a renowned company with superb virtuosi, toured the country in triumph. In the 1980s, the boom ended. It had begun with the sudden appearance of extraordinary artists such as Fracci, Nureyev, Baryshnikov, Makarova, and Gelsey Kirkland, and when they left the scene, or better, when their great days were over, it ended. Into the mid-1990s, their successors have yet to appear. Joffrey died in 1988, and Arpino was appointed to succeed him. Arpino is a practical man and devotes most of his time to keeping the company afloat and together during this uncertain period for the arts. Since the end of the 1980s, the company has had to cancel appearances in New York City, which apparently garner more prestige than profit. Doubtless with this in mind, in 1993 the Joffrey presented *Billboards,* the first full-length American rock ballet. Conceived, produced, and directed—but not choreographed—by Arpino, it was set to the music of the musician known formerly as Prince. The work was given its premiere at the University of Iowa in Iowa City, which had sponsored it, and was an instant and much-needed hit. Before bringing it to New York City, the company performed *Billboards* throughout middle America for a year, packing theaters in the most unlikely cities and having to schedule extra performances for the the hordes of rockers who had never heard of Joffrey but who loved Prince.

What they got was a company of handsome young dancers mixing ballet

and modern dance with street rock, which was obviously second nature to them, with dazzling lighting, exhilarating street figures refined into grand jeté, "Purple Rain" sensuality, same-sex pas de deux, and, of course, that deafening electronic score. The ballet is hardly deathless art; but once again Arpino has succeeded in introducing throngs of young people to the world of dance and in taking his choreography of hybridization one step further, as evidenced by the response of the audience, which reacted pulsively to the ballet as if at a rock concert.

In addition to Arpino, there have been a number of other Italian American dancers who went on to become either directors of companies or choreographers for more mainstream productions. One of the first and best known was Vincente Minnelli (1910–1986), who began dancing with the Minnelli Brothers Tent Show at the age of three. As a young man, he went into set and costume design, and from 1935 to 1940 he directed several successful Broadway musicals. Invited to Hollywood by MGM, he began by staging musical numbers and was soon directing films, among which were *Meet Me in St. Louis* (1944), *An American in Paris* (1951), and *The Band Wagon* (1953). Fred Danieli, who was born in 1917, danced with the Mordkin Ballet, Ballet Caravan, the American Ballet Theater, and the Chicago Civic Opera. He has appeared on Broadway and on television, and in 1949 he established the Garden State Ballet School in Newark, New Jersey. He is now director of the Garden State Ballet Company, also in Newark. Peter Gennaro, born Falco Gennaro in 1924, began as a dancer in ballet and on Broadway, and became Jerome Robbins' assistant on *West Side Story*. He has since gone on to become one of America's top choreographers for Broadway, television, and Radio City Music Hall. Michael Bennett (1943–1987), born in Buffalo to Mr. and Mrs. Salvatore di Figlia, danced in Broadway musicals, choreographed *Promises, Promises* (1969); codirected *Follies* (1971); wrote, directed, and choreographed *A Chorus Line* (1973), the quintessential Broadway mythologization of the dance vocation and his greatest success, and *Dreamgirls* (1981). The handsome and charismatic Louis Falco, whose looks bespoke his Neapolitan origin, was born in Brooklyn in 1942 and made his debut with the Jose Limon Company in 1960. He began to choreograph in 1976 and since 1968 he had his own company, which regularly toured in the United States and Europe. He died in 1993. Gus Giordano, born in 1928, dancer, choreographer, and director, has toured the world with the Gus Giordano Jazz Dance Company since 1958 and directs a school of jazz dance in Chicago.

One other pure dancer deserves mention: Robert Maiorano, who was born in Brooklyn in 1947. He joined the New York City Ballet in 1962 and soon became an audience favorite with his elegant bearing, technical skill, and dark-eyed Italian good looks. Appointed soloist in 1969, he created roles in a num-

ber of major works by Balanchine and Jerome Robbins. He teaches ballet in Saratoga, New York.

Dancers in Exotic and Popular Styles
Chief among the dancers in exotic styles is the suave and elegant José Greco, whose Spanish dance company has been world famous for more than forty years, and who has been acclaimed in films and on television. Many assume his name to be Spanish. In reality, however, he was born in Italy (Montorio nei Fretani, in the mountains of Abruzzi) in 1919 and raised in Brooklyn. Bursting onto the dance scene in the mid-1940s as the partner of the great Spanish dancer Argentinita, he was the most virile dancer Americans had seen up to that point—and offstage as well, if his autobiography, *The Gypsy in My Soul* (1977), is to be believed. Greco is still touring, and his son José II is also an exceptional dancer.

On a more popular level is Tony De Marco (1900–1965), who was the most famous of the exhibition ballroom dancers. Temperamental and flamboyant, he danced to the strains of Gershwin and Chopin in the country's most elegant hotels, tossing on high a series of glamorous partners, including Nina in the 1920s, Renee in the 1930s, and Sally in the 1940s and 1950s. He danced with Joan Crawford in MGM's *The Shining Hour* in 1938 and married a number of his partners.

In another branch of the terpsichorean profession were those performers who were blissfully unaware of the Cecchetti method, but who were far better known, had more fans, and were certainly better paid than their more highbrow colleagues—the beauties glorified by the Minsky Brothers in the 1930s and 1940s, and who were worshiped by lovers of the female form divine. Journalist H.L. Mencken coined the highfalutin term "ecdysiast" for them, a euphemism that is deprecatory in effect and, as a patriarchal coinage, totally forgetful of the Mediterranean origins of the "striptease" as a sacred dance, linked to temple prostitution. When Mayor La Guardia, in one of his periodic cleanup campaigns, banned their appearance in New York City, their fans simply followed them across the river to New Jersey, where their artistry was welcomed and appreciated. The most gorgeous, highest-paid, and most enduring of these ladies was the raven-haired, voluptuous young Italian woman from Hartford, Connecticut, Anne Corio. Her birth date is given in the reference books as "circa 1920," but she was already a headliner in 1930; she returned to Broadway in 1962 as the star of the revue *This Was Burlesque,* which toured the country for years, and appeared in New York in 1979 in a production called *Big Bad Burlesque.* She may have been called "the Girl with the Epic Epidermis," and her act, "How to Undress with Finesse," but like her rival, Gypsy Rose Lee, she was also an author and a film star (Corio starred

in five films for PRC and Monogram—known as the Poverty Row studios—between 1941 and 1944, including *Swamp Woman* and *Jungle Siren*). She also cultivated an interest in art and literature, although she confessed that she did not share Gypsy's enthusiasm for E.E. Cummings. When her mother finally saw her daughter's act, she said approvingly, "It's all right. They look, but no touch." Only slightly less famous was her Italian American colleague, Rose La Rose (1913–1972), born Rose Dapelle in Brooklyn. In those days, each big star had a gimmick of her own. La Rose's was the reverse strip. She came out on stage wearing practically nothing and ended her act fully clothed. Whatever the motives Corio and La Rose may have had for bucking the conventions of *la via vecchia* (the old way), they both would certainly find their champion in Camille Paglia, who, in the October 1994 issue of *Penthouse,* has written a defense of erotic dancing as an art form and a display of beauty through which women are not victimized but express their power over men.

The Italian American Body Image

> *Touch my body, move in time.*
> —*Madonna*

From the Renaissance onward, perhaps no culture has been more obsessed with the aesthetics and protocols of the body image than the Italian. This is manifested, for example, in the idealization of the human body undertaken under the sign of Neoplatonism by Renaissance visual culture, the painting and sculptures of Michelangelo, Leonardo, and Titian being its high points; in Baldassare Castiglione's *The Book of the Courtier* (1528) the first treatise on the art of image management; and in the everyday art of *la bella figura* which, as previously mentioned, infuses the practices of everday life with an aesthetic quality.

That traditional body image has undergone a sea change with immigration and has been redefined over the generations in American terms, including the negative figure of the Italian body that was projected onto the first immigrants. (For a historical account of the stereotyping of the foreigner's or greenhorn's body, see Salvatore LaGumina's *Wop!: A Documentary History of Anti-Italian Discrimination in the United States* [1973]). As a rule, the Italian Americans have been perceived as the "people of the body" (see the chapter on the cinema in this section), and thus the image of the Italian body as crystallized in proper names—the graceful bodies of Valentino, DiMaggio, Villella, and Madonna; the "ordinary" bodies of LaGuardia, Geraldine Ferraro, and Mario Cuomo; the corpulent bodies of Caruso and the

painter Joseph Stella as caught (Borsallino, guitar, and all) by Man Ray in his iconic photograph; the thin bodies of Sinatra and Pacino; the "evil bodies" of Lucky Luciano and John Gotti, the "media don"; the stereotypically perceived immigrant bodies of the organ-grinding Henry Armetta and the comic Lou Costello, who, in Italy, was affectionately known as Pinotto, or "Little Pig"; the eccentric bodies of the "fooloso-phers" Yogi Berra and Jimmy Durante, who is reduced to the signature of his nose; the agile bodies of the quarterbacks (Angelo Bertelli, Paul Governali, Vito "Babe" Parilli, Ralph Gugliemi, Daryl Lamonica, Joe Montana, Dan Marino, Vinny Testaverde), and so on—can be seen as installments in either the history or the counterhistory of the general process of stereotyping. The immigrant's body, always regarded as an abject object, was a particular site of vicious stigmatization, often of a racialist stripe and always classist, given that Italy itself was regarded as the site of the aristocratic body whereas its immigrants, especially those of the south around whom the body stereotype crystallized, were perceived as the refuse of the *Lazaronitum*, barbarians—Darwinian *cafoni* (peasants or clods) unsuitable for Americanization and genteelization. This negative textualization of the immigrant's body took the form of a moralization of physical difference: "The tall Scot, and the dwarfed Sardinian owe their respective sizes to race and not to oatmeal or olive oil," to cite a typical passage written by an Anglo-Saxon suprematicist, or "Mindful of these darting eyes and hands, one does not wonder that the Sicilian will stab his best friend in a sudden quarrel over a game of cards." (For the provenance of these two statements, see La Gumina (1973): 196 and 140, respectively.) That body, the one that brought the Italian fleas to America—not ballet or opera, the Italian opera providing a theater and mirror for upper-class behavior, as so acutely documented in Scorsese's *Age of Innocence* (1993), while the immigrant's body was simultaneously being subjected to systematic degradation—received treatment similar to that of Jews and Blacks, the other "dark-skinned Others." Futhermore, there was a certain division between the "good" Italian: the hardworking laborer; and the "bad" Italian: the organ-grinder Peppo Skinnolino as caricatured in a cartoon from 1904, the beggar, and, above all, the criminal who would provide the basis for the "great Italian American stereotype."

Four elements in the history of the metamorphosis of the Italian body into an American one are symptomatic of the process of assimilation. The first involves the expansiveness of the American body, its tendency to occupy a larger space when moving, what Italian Italians perceive as a grossification of sorts. The dance critic Edwin Denby defined the difference in terms of walking and lolling: "Italians on the street, boys and girls, both have an extraordinary sense of the space they really occupy, and of filling that space harmoniously as they rest or move; Americans occupy a much larger space than their actual bodies do; I mean to fol-

low the harmony of their lolling you have to include a much larger area in space than they are actually occupying. . . . In Italy I have watched American sailors, soldiers and tourists, all with the same expansive instinct in their movements and repose, looking like people from another planet among Italians with their self-contained and traditionally centered movements." So by and large, the spatial practices of Italian Americans, like those of other ethnic groups, have been progressively altered by the expansiveness of American space, the tight and controlled body exhibited in the *passeggiata* (walk) in the piazza being exchanged for a more Whitmanesque, more open, body.

The second involves the loss over generations of the Italian gestural code, Italian gesticulation being an object of ridicule and deprecation within the majority culture, the marker of foreignness and lower-classness, and thus a trait to be eliminated by successive generations. Gesturing, again transcoded into a moral key, was taken as a mark of "emotional instability," of a pervasive hysteria—that is, it was extricated from the function of *la comunicativa*. In a trait-mongering article written in July 1914 for *Century Magazine*, the sociologist Edward Ross asserts that "southern Italians lie more easily than Northern Europeans" and implies that their furtive code of gestures and glances goes against the American ideal of "squareness," body language being perceived as a mode of lying rather than of telling the truth, which it, in fact, is. The article continues: "They gesticulate much, and usually tears stand in their eyes. When two witnesses are being examined, both talk at once, and their hands will be moving all the time. Their glances flit quickly from one questioner to another, and their eyes are the restless, uncomprehending eyes of the desert Bedouin between walls." This gestural code, of course, is linked inextricably to the speaking of Italian: It is impossible to speak Italian without recourse to gesticulation, which serves both the supplemental or metadiscursive function of commenting upon oral speech—often with the effect of an aside that emits information contradicting the spoken word—and the anaphoric or diacritical function of accentuating and punctuating what is spoken. Gesturing is an instance of the Italian art of performance and remains part of the general aesthetics of the speech act, regardless of the class of the speaker.

With the loss of Italian and bilingual identity, Italian Americans have tended to lose the marvelous language of the gestural body and the understanding of it as a part of the art of *la comunicativa*. Indeed, the dominant culture regards gesticulation as a stigmatizing action and still adopts it as a vulgar form of parodying Italianness—to wit, the proliferation of "Godfathering" imitations of Marlon Brando.

This notion of the gesturing body leads us to the more comprehensive notion of the ceremonial self and of Italians as people who make scenes and who

make the performance of the self into a scenographic event. In the notion of self-display, of rendering the body into a spectacle, there converges what might be called the narcissism of self-display and the everday aesthetics of the *bella figura,* the exhibiting of a beautiful choreography for the gaze of the other. Both (healthy) narcissism and voyeurism are sanctioned by the eye-intensive Italian culture. An example of the gap between Italian and American cultural performance can be found in the dance world. When the La Scala Ballet Company performed at the Metropolitan Opera House in 1981, it was a shock for New York audiences. The Met's Balanchine favored dancers who were tall and slim, with long necks, small heads, and small features—wonderful, impersonal automatons of enormous technical skill, willing to let the choreography be the star. They were like the notes on the musical score come to life. The Italians, on the other hand, proved to be shorter, broader, and livelier, and not so concerned about synchronizing their movements perfectly with the others. They bounded out, smiling, exuberant, and sensual, each one seeming to say, "Look at *me!* Not bad, eh?" and each one projecting a distinct personality. However the American experience may have distanced Italian Americans from the decorum of self-display, it nevertheless manifests itself in Italian American performance, whether in the blue-collar exorbitance of John Travolta's dancing in *Saturday Night Fever,* in Madonna's aesthetics of shock, or, more ascetically, in the performance pieces of Vito Acconci, in which the artist's body becomes a cynosure. The notion of self-display naturally leads to the vestimentary code and once again to the schizophrenic perception of Italian and Italian American taste cultures: the great sartorial divide between Armani and John Gotti, between Marcello Mastroianni's impeccable double-vented blue suit worn in *La Dolce Vita* and John Travolta's snow-blinding white suit worn in *Saturday Night Fever,* between Adrienne Vittadini's couture frocks and the standard-issue black dress of the immigrant past.

 The third element in the transformation of the body involves the penchant for the nickname. For the body-centered Italians, the body is an entity to be nicknamed and thus familiarized and deprived of menace. Consider the endless stream of physiognomic nicknames that circulate through di Donato's *Christ in Concrete*— Saint Pimple-legs, Orange-peel Face, Head-of-Pig, Snoutnose, Black Mike, Nazone, Yellow-Fever Giuseppe—as opposed to the designations of the non-Italian workers, Frank the Scotchman, Barney the Irishman, Tommy the Englishman, Hans the German, and Grogan the "real" American, who, in not being nicknamed in terms of the body, remain totally distant. The ritual of nicknaming is also represented in Robert De Niro's film *A Bronx Tale,* which is set in the 1950s and features the voiceover of the young Calogero introducing the viewer to the habitués

of the local bar through their nicknames: Tony Toupee, Eddie Mush, Jojo the Whale, Frankie Coffee Cake, Jimmy Whispers, Danny K.O., and Bobby Bars.

The fourth transformation involves the relationship between the body and food, the culinary tradition being the primary "language" through which Italian Americans have maintained the link with the old country, as symbolized by the prominently displayed can of imported Sasso-brand olive oil depicted by Ralph Fasanella in *Family Supper* and the *spaghettata* (an improvised meal of spaghetti) celebrated in *Christ in Concrete,* when the men cook for the women: "Man needs spaghetti. . . . We'll conjure a spaghetti that will surpass even that of the house of Savoi!" The Italian concern for food has lead to a negative stereotyping of the Italian American body, involving a metonymization by which love for food has been displaced by overeating. Nowhere is the stereotypical association more fully represented than in Alfred Innaurato's memory play *The Transfiguration of Benno Blimpie* (1977), a grosteque dramatization of the 500-pound Benno's attempt to eat himself to death, a compensatory gesture motivated by his dysfunctional family life and a traumatic homosexual encounter. The play is structured around bulemic imagery, which extends to Benno's sexuality, his symbolic self-cannibalism—"the supper of the self"—and his attempt to paint, a sublimatory activity through which he compensates for his unfulfilled desire and seeks to ingest, bulimically, his Italian heritage: ". . . I want, I want, want, want, Brunelleschi, Botticelli, Raffaello, Michaelangelo, Bellini, Pico Della Mirandola, Donatello, Giotto, Cimabue. I want, please, please, please, I want—wantwantwantwantwantwant! Give me . . . give me. . . ." Given the pervasiveness of the eating stereotype from the vulgar Alka Seltzer meatball commercial and the mass-media iconography of overnurturing, overweight mammas to the endless number of cinematic representations of Italian Americans at table, the Clemenzas' recipe for "gravy" in *The Godfather,* and Innaurato's pathological hunger artist, it is important to point out that—counter to the stereotype—food has a sacramental importance in Italian life (see the chapter on bread and wine elsewhere in this volume), that eating is done communally as part of family life, and that, therefore, compensatory eating (the solitary eating of the hunger artist whether bulimic or anorexic) is strongly discouraged: Eating is regarded as a complement to and facilitator of family interaction (see the interview with Camille Paglia in this volume for a description of how food becomes a subject of discourse).

It can be argued that cuisine is one of the central cultural contributions to the common culture, the Italian style of eating and cooking having become, in many areas, the American way of relating to food: Into the 1990s, pasta—not spaghetti—seems to be the American national dish. It should also be pointed out

that, along with the metamorphosis of the body image, the image of Italian food has undergone a radical transformation in the American mind, having passed from its humble origins as immigrant soul food—such bastardized staples of the early cuisine as veal cutlet parmigiana and even spaghetti and meatballs do not exist in Italy—to a full spectrum of imported styles ranging from *nuova* and *alta cucina* to *trattoria* cooking. Furthermore, the upgrading of Italian cuisine in the American perception began in the 1960s, if not earlier, with the generic splitting of the culinary turf into southern and northern cuisine (coded expressions by which restaurants declare their culinary ideology and price range: northern Italian cuisine, more or less, designating an interregional, universalized, and more sophisticated Italian cuisine; southern cuisine referring to the traditional Italian American style of cooking institutionalized in the restaurants of "Little Italys") and has culminated in the late-twentieth-century phenomenon of what might be called "Tuscanization," in which a great variety of authentic regional cuisines have traveled to America, of which the rigorously straightforward Tuscan style has become the most pervasive. Whereas the metamorphosis of the body image can be symbolized by the passage from Valentino to Travolta, from Rosa Ponselle to Madonna, the metamorphosis of the culinary image might be emblematized by the passage from ordinary pizza to the 1990s craze for "boutique pizza," individual-sized, extremely thin crusted, artfully topped with designer ingredients and cooked in wood ovens—that is, made in the Italian, not the Italian American, manner. Pizza, made in whatever manner and more than pasta, is the most universal culinary signifier of Italiannesss. For the Italian American, it is an evocation of the Mediterranean, such ingredients as tomato, olive oil, fresh mozzarella, and sardines being talismans of the Mediterranean world. For Americans, who have appropriated it as their most substantial species of junk food, it serves as a "eucharist" of Italian culture. Consider, for example, the role played by pizza in Spike Lee's movie *Do the Right Thing* (1989), in which it serves as the tangible link that binds the Black and Italian cultural worlds—linguistically and otherwise at odds. In a more general sense, it also projects the image of Italianness: As the Italian writer Lietta Tornabuoni has pointed out in *Bianco, Rosso e Verde* (1993), it conveys at once a poor image and a hedonistic image, its ingredients combine minimum preparation with maximum taste, minimum cost with maximum pleasure, thus expressing what has historically been a special Italian talent: making the most out of the least. She writes: "Image of joy, image of lightness: Easy to cook and easy to eat, fast, natural, and good, pizza has become for the world the emblem of a way of life that is free and gay, informal, casual, of an attitude that gives to eating the carelessness of a game and the importance of pleasure."

With this, we conclude our account of the body image, which has taken us from the *tarantella* to pizza, from the recklessness of the dancing body to the joyous consumption of the Italian American "eucharist."

Further Reading

Opera

Clement, Catherine. *Opera, or the Undoing of Women* (Minneapolis: University of Minnesota Press, 1988). A groundbreaking analysis of opera from a feminist perspective.

Dizikes, John. *Opera in America: A Cultural History* (New Haven: Yale University Press, 1993). An entertaining, informative, well-illustrated, and recommended work.

Gramsci, Antonio. "The Operatic Conception of Life." In *Antonio Gramsci: Selections from Cultural Writings,* eds. David Forgacs and Geoffrey Nowell-Smith (Cambridge: Harvard University Press, 1985).

Kimbell, David. *Italian Opera* (Cambridge: Cambridge University Press, 1991). A musicologist at the University of Edinburgh examines the "Italianness" of Italian opera in a scholarly yet readable fashion.

Koestenbaum, Wayne. *The Queen's Throat: Opera, Homosexuality, and the Mystery of Desire* (New York: Vintage, 1993). A passionate reading of opera from the perspective of a self-identified "opera queen."

Kolodin, Irvine. *The Metropolitan Opera, 1883–1966* (New York: Alfred A. Knopf, 1966). All of the essential facts and dates, recounted with style and humor.

Krembiel, Henry Edward. *Opera in New York from Its Earliest Days* (1908; reprint, New York: Da Capo, 1980). Distinguished critic of the *New York Tribune* reports first hand on the Met's "Golden Age."

Sadie, Stanley, ed. *The New Grove Dictionary of Opera.* 4 vols. (London: Macmillan, 1992). Comprehensive and definitive, this reference work contains musicians' biographies and articles on all aspects of opera, including an essential treatment of Italian opera.

Schiavo, Giovanni. *Italian-American History* (1947; reprint, New York: Arno, 1975). Most of the book, despite the title, is concerned with the activities of musicians, particularly Italian musicians in the United States in the eighteenth and nineteenth centuries. There are brief biographies of important Italian artists of the period that are not to be found elsewhere.

Toscanini

Horowitz, Joseph. *Understanding Toscanini: How He Became an American Culture-God and Helped Create a New Audience for Old Music* (New York: Alfred A. Knopf, 1987). An important cultural history of America using the Toscanini cult as an example of how Great Music was linked to a Great Public—"a new, democratized arts constituency."

Liebrecht, Norman. *The Maestro Myth: Great Conductors in Search of Power* (London: Carol Publishing Group, 1993). A lively, caustic, scrupulously researched work on the nature of the conductor written by a critic for the *London Sunday Times.*

Italian American Composers

Goldman, Richard Frank. "American Music in the United States." In *The New Oxford History of Music: The Modern Age, 1890–1960* (London: Oxford University Press, 1974).

Harrison, Max. "Donald Martino." In *Contemporary Composers* (Chicago: St. James, 1992): 617–618.

Hitchcock, H. Wiley, and Stanley Sadie, eds. *The New Grove Dictionary of American Music.* 4 vols. (London/New York: Macmillan, 1986). Covers artists and aspects of American music, classical and popular.

McLeish, Kenneth. "Walter Piston." In *The Listener's Guide to Classical Music: An Introduction to the Great Classical Composers and Their Works* (New York: Macmillan, 1991).

Roy, Klaus G. "Walter Piston." *Stereo Review* 24, no. 4 (1970): 57.

Popular Music

Larkin, Colin, ed. *The Guinness Book of Popular Music.* 4 vols. (Middlesex/Chester, Conn.: New England Publishing Associates, 1992). Probably the most comprehensive reference work on the subject.

Frank Sinatra and the Other Crooners

Friedwald, Will. *Sinatra! The Song Is You: A Singer's Art* (New York: Scribner's, 1985).

Lahr, John. *The Artist and the Man* (New York: Random House, 1997).

Mustazza, Leonard. *Ol' Blue Eyes: The Encyclopedia of Frank Sinatra* (Westport, Conn.: Greenwood, 1998).

Petkov, Steven and Leonard Mustazza, eds. *The Frank Sinatra Reader* (New York: Oxford University Press, 1995).

Pleasants, Henry. *The Great American Popular Singers* (New York: Simon and Schuster, 1974). Contains an essay on Sinatra that first discussed his relationship to *bel canto*.

Rockwell, John. *Sinatra: An American Classic* (New York: Random House/Rolling Stone, 1984). The most definitive monographic treatment of Sinatra and his musical style.

Shaw, Arnold. *Sinatra: Twentieth-Century Romantic* (New York: Holt, Rhinehart and Winston, 1968).

Sheed, Wilfred. Album Notes for *Frank Sinatra: The Voice, the Columbia Years, 1943–1952* (Columbia, 1986).

Talese, Gay. "Frank Sinatra Has a Cold." *Esquire,* April 1966; reprinted in *Fame and Obscurity* (New York: Dell, 1981).

Tosches, Nick. *Dino: Living High in the Dirty Business of Dreams* (New York: Dell, 1992). One of the most exhaustive and insightful biographies of an American pop-culture figure (Dean Martin) and itself a significant performance in writing as an Italian American.

Rock 'n' Roll

Gillet, Charlie. *The Sound of the City: The Rise of Rock and Roll* (New York: Pantheon Books, 1983).

Javna, John. *The Doo-Wop Sing-Along Songbook* (New York: St. Martin's, 1986).

Lynch, Kate. *Springsteen: No Surrender* (New York: Proteus, 1984).

Miller, Jim. *The Rolling Stone Illustrated History of Rock & Roll* (New York: Random House/Rolling Stone, 1980). A collection of essays by leading rock writers on individual performers and larger phenomena, including an essay by Ed Ward on "Italo-American Rock."

Pareles, Jon, and Patricia Romanowski, eds. *The Rolling Stone Encyclopedia of Rock & Roll* (New York: Rolling Stone/Summit Books, 1983). The definitive work on rock 'n' roll, which elaborated a musicological language with which to treat rock.

Rockwell, John. "Art Rock." In *The Rolling Stone Illustrated History of Rock & Roll,* ed. Jim Miller (New York: Random House/Rolling Stone, 1980).

Shaw, Arnold. *The Rockin' 50s* (1974; reprint, New York: Da Capo, 1987).

Shaw, Greg. "Teen Idols." In *The Rolling Stone Illustrated History of Rock & Roll,* ed. Jim Miller (New York: Random House/Rolling Stone, 1980).

Zappa, Frank, with P. Occhiogrosso. *The Real Frank Zappa Book* (New York: Poseidon Press, 1989).

Jazz

Balliett, Whitney. "Buddy DeFranco." In *Barney, Bradley, and Max: Sixteen Portraits in Jazz* (New York and Oxford: Oxford University Press, 1989): 190–201.

Kernfeld, Barry, ed. *The New Grove Dictionary of Jazz.* 2 vols. (London/New York: Macmillan, 1988).

Sudhalter, Richard. "Joe Venuti." In *The Best of the Music Makers,* ed. George T. Simon (Garden City, N.Y.: Doubleday, 1979): 587–588.

Dance

Anawalt, Sasha. "Gerald Arpino." In *International Dictionary of Ballet.* 2 vols. (Detroit: St. James Press, 1993): 46–49.

Bremser, Martha, ed. *International Dictionary of Ballet.* 2 vols. (Detroit: St. James Press, 1993).

Cohen-Stratyner, Barbara. *Biographical Dictionary of Dance* (New York: Schirmer Books, 1982). Entertainingly written short profiles of personalities in all fields of dance.

Croce, Arlene. *Afterimages* (New York: Alfred A. Knopf, 1977). A collection of the writings of one of America's most important dance critics; particularly recommended are her treatments of Edward Villella.

DeMille, Agnes. *America Dances* (New York: Macmillan, 1980). In her deftly witty style, DeMille tells of the Italian dancers who braved the rigors of touring the Far West in the nineteenth century.

Denby, Edwin. *Dance Writings* (New York: Alfred A. Knopf, 1986). The collected reviews and essays of America's foremost dance critic (1903–1983) and a master of simple, elegant prose. He was able to convey through words to the reader just what had taken place on stage. His observations on the body movements of ordinary Italians in the streets and the piazzas and how much they reveal of the national character are both perceptive and amusing.

Gambino, Richard. *Blood of My Blood* (Garden City, N.Y.: Doubleday, 1975): 154–155.

Moore, Lillian. *Echoes of American Ballet* (New York: Dance Horizons, 1976). Contains detailed accounts of the careers of celebrated, now-forgotten Italian dancers and choreographers in America in the eighteenth and nineteenth centuries.

Sachs, Curt. *World History of the Dance* (New York: Norton, 1937).

Canon: Italian American Jazz Musicians

—Compiled by the musicologist and jazz critic Gene Lees

Mike Abene (1942–) Pianist, composer

Joe Albany (Joseph Albani, 1924–1988) Pianist, arranger, and composer

Tony Aless (Anthony Allessandrini, 1921–) Pianist and bandleader

Gene Allen (Eugene Sufana, 1928–) Baritone saxophonist, bass clarinetist
David Allyn (David DiLello, 1923–) Singer
Danny Alvin (Daniel Alvin Viniello, 1902–1958) Drummer
Ray Anthony (Raymond Antonini, 1922–) Trumpeter and bandleader
Frank Assunto (1932–1974) Trumpeter and bandleader
Johnny Audino (1927–1989) Trumpeter
Gary Barone (1941–) Trumpeter and flügelhornist
Mike Barone (1936–) Trombonist, composer, and arranger
Gianni Basso (born in Asti, Italy, 1931–) Clarinetist and soprano/tenor saxophonist
Louie Bellson (Louis Paul Balassoni, 1924–) Drummer, bandleader, composer
Tony Bennett (Anthony Dominick Benedetto, 1926–) Singer
Gene Bertoncini (1937–) Guitarist
Gus Bivona (1915–) Clarinetist, alto saxophonist, and flutist
Sharkey Bonano (Joseph Bonano, 1904–1972) Trumpeter and singer
Mike Brignola (1957–) Clarinetist, flutist, and saxophonist
Nick Brignola (1936–) Baritone saxophonist and flutist
Vinnie Burke (Vincent J. Bucci, Jr., 1921–) Double bass player
Conte Candoli, (Secondo Conte Candoli, 1927–) Trumpeter
Pete Candoli (Walter Joseph Candoli, 1923–) Trumpeter
Johnny Carisi (1922–) Composer and trumpeter
Nick Ceroli (1939–1985) Drummer
Bill Chase (Bill Chiessa, 1935–1974) Trumpeter and bandleader
Gene Cherico (1935–) Double bass player
Rocky Cole (Rocky Coluccio, 1920–) Pianist and orchestrator
Chick Corea (Armando Anthony Corea. 1941–) Pianist, jazz/rock/fusion keyboardist, and composer
Eddie Costa (1930–1962) Pianist and vibraphonist
Hank D'Amico (1915–1965) Clarinetist and saxophonist
Vic Damone (Vito Rocco Farinola, 1928–) Singer
Bobby Darin (Walden Robert Cassoto, 1936–1973) Singer, songwriter
Vinnie Deane (Vincent DiVittorio, 1929) Saxophonist
Buddy DeFranco (Boniface Ferdinando Leonardo De Franco, 1923–) Clarinetist
Don DeMichael (1928–1982) Editor of *Down Beat, Jazz Record Review*
William Dennis (William DeBerardinis, 1926–) Trombonist
Joe Derise (1925–) Pianist
Al Di Meola (1954–) Guitarist, bandleader, and composer
Gene DiNovi (1926–) Pianist
Joe Diorio (1936–) Guitarist and composer
Michael Di Pasqua (1953–) Drummer and percussionist
Dottie Dodgion (née Dorothy Giaimo, 1929–) Drummer
Chuck Domanico (1944–) Double bass player
Michael Donato (1942–) Canadian double bass player
Joe Farrell (Joseph Carl Firrantello, 1937–1986) Tenor saxophonist, flutist, and multi-instrumentalist
Nick Fatool (1915–) Drummer

Carl Fontana (1928–) Trombonist
Tony Fruscella (1927–) Trumpeter
Jimmy Giuffre (1922–) Clarinetist, saxophonist, composer, and teacher
Conrad Gozzo (1922–) Trumpeter
Jerry Granelli (1940–) Drummer, vibraphonist, and pianist
Jerry Gray (Generoso Graziano, 1915–) Composer, arranger, and bandleader
Buddy Greco (Armando Greco, 1926) Pianist, arranger, composer, and singer
Vince Guaraldi (1928–) Pianist and composer
Johnny Guarnieri (1917–1985) Pianist, harpsichordist, and composer
Tony Inzalaco (1938–) Drummer and vibraphonist
Frank Isola (1925–) Drummer
Pete Jolly (Peter A. Ceragioli, 1932–) Pianist and accordionist
Morgana King (Morgana Massina, 1930–) Singer and actress
Pat LaBarbera (1944–) Tenor saxophonist and clarinetist
Joe LaBarbera (1948–) Drummer
John LaBarbera (1945–) Trumpeter and arranger
Scott LaFaro (1926–1961) Double bass player
Frankie Laine (Frankie Paul LoVecchio, 1913–) Singer
Ralph Lalama (1951–) Saxophonist
Nappy Lamare (Hilton Napoleon LaMare, 1910–1988) Guitarist, banjoist, composer, and singer
Eddie Lang (Salvatore Massaro, 1902–1933) Guitarist
John LaPorta (1920–) Saxophonist, clarinetist, composer, and teacher
David Larocca (1949–) String bass and electric bass player
Nick LaRocca (Dominic James LaRocca, 1889–1961) Trumpeter, cornetist, bandleader, and composer
Julius La Rosa (1930–) Singer
Eliot Lawrence (Elliot Lawrence Broza, 1925–) Bandleader, composer, pianist
Clyde Lombardi (Claudio Lombardi, 1922–) Double bass player
Mike Longo (1939–) Pianist, keyboardist, and composer
Pat Longo (1929–) Alto saxophonist and clarinetist
Joe Lovano (1952–) Tenor saxophonist
Henry Mancini (1924–1994) Composer and conductor
Chuck Mangione (Charles Frank Mangione, 1940–) Trumpeter, flügelhorn player, composer, and bandleader
Gap Mangione (Gaspare Charles Mangione, 1938–) Pianist and composer
Mike Manieri (1938–) Vibraphonist, keyboardist, arranger, and composer
Wingy Manone (Joseph Matthews Manone, 1900–1982) Trumpeter, singer, and bandleader
Charlie Mariano (Carmine Ugo Mariano, 1923–) Alto saxophonist, flutist, and nadaswaram player
Dodo Marmarosa (Michael Marmarosa, 1925–) Pianist
Joe Marsala (1907–1978) Clarinetist and bandleader
Marty Marsala (Mario Salvatore Marsala, 1909–1975) Trumpeter and drummer
Pat Martino (1944–) Electric guitarist and composer
Carmen Mastren (Carmine Nicolo Mastandrea, 1913–1981) Acoustic guitarist and arranger
Don Menza (1936–) Tenor saxophonist and composer

Jay Migliori (1936–) Tenor saxophonist and composer
Toots Mondello (Nuncio W. Mondello, 1912–) Alto saxophonist
Joe Morello (1928–) Drummer
Boots Musilli (Henry Musilli, 1917–1967) Alto/baritone saxophonist
Vido Musso (born 1913 in Carrini, Sicily–1982) Tenor saxophonist
Phil Napoleon (Filippo Napoli, 1901–1990) Trumpeter and bandleader
Martin Napoleon (Martin Napoli, 1921–) Pianist
Teddy Napoleon (George Napoli, 1914–1964) Pianist
Sammy Nestico (Sal Nistico, 1924–) Trombonist and arranger
Bert Niosi (Bartolo Niosi, born 1909 in London, Canada–1987) Clarinetist, alto saxophonist, and bandleader
Sal Nistico (Salvatore Nistico, 1940–) Tenor saxophonist
Sam Noto (1930–) Trumpeter and flügelhorn player
Ron Odrich (Rinaldo Basilio Orefice, 1931–) Clarinetist
Remo Palmier(i) (1923–) Guitarist
Tony Parenti (1900–1972) Clarinetist and saxophonist
Joe Pass (Joseph Anthony Passalaqua, 1929–) Guitarist
Tony Pastor (Antonio Pestritto, 1907–1969) Bandleader, singer, tenor saxophonist
Santo Pecora [Mr. Tailgate] (Santo Pecoraro, 1902–1984) Trombonist
Flip Phillips (Joseph Edward Phillips. 1915–) Tenor saxophonist
Bucky Pizzarelli (John Pizarelli Sr., 1926–) Guitarist and bandleader
John Pizzarelli Jr. (1960–) Electric guitarist and singer
Ray Pizzi [Pizza Man] (1943–) Tenor and soprano saxophonist, bassoonist, and flutist
Al Porcino (1925–) Trumpeter
Joe Puma (1927–) Electric guitarist
Mike Renzi (1941–) Pianist
Paul Ricci (1914–) Clarinetist and saxophonist
Adrian Rollini (1904–1956) Bass saxophonist; also vibes, goofus, hot fountain pen, etc.
Art Rollini [Mousie, Schneeze] (1912–) Tenor saxophonist
Joe Romano (1932–) Tenor alto saxophonist, clarinetist, and flutist
Leon Roppolo (1902–1943) Clarinetist and composer
Frank Rosolino (1926–1978) Trombonist and singer
Peter Rugolo (born in San Piero, Sicily, 1915–) Arranger, composer
Bill Russo (William Joseph Russo, 1928–) Composer, arranger
Sonny Russo (Santo Russo, 1929–) Trombonist
Sal Salvaldor (Salvatore Salvatore, 1925–) Guitarist
Tony Scott (Anthony Sciacca, 1921–) Clarinetist
Frank Signorelli (1901–1975) Pianist and composer
Frank Sinatra (1915–) Singer and actor
Frank Strazzeri (1930–) Piano, composer, multi-instrumentalist
Joe Tarto (Vincent Tortoriello, 1902–1986) Tuba and double bass player and arranger
Frank Tiberi (1928–) Tenor saxophonist, bassoonist, flutist, and clarinetist
Nick Travis (Nick Travascio, 1925–1964) Trumpeter
Lennie Tristano (1919–1978) Pianist and teacher
Phil Urso (1925–) Tenor saxophonist

Charlie Ventura (1916–1992) Tenor saxophonist and other reeds
Joe Venuti (Giuseppe Venuti, 1903–1978) Jazz violinist and legendary practical joker
Al Viola (Alfonso Viola, 1919–) Guitarist
Frances Wayne (Chiarina Bertucci, 1924–) Singer
Ronnie Zito (1939–) Drummer
Torrie Zito (1933–) Pianist

Madonna
The Postmodern Diva As Maculate Conception

Fosca D'Acierno

So much has been written about Madonna—the queen of pop music and clever dominatrix of mass-mediated scandal—but rather little has been said about Madonna's "Italianness." Madonna herself, at the beginning of her Torino concert, which was filmed for a widely distributed videotape, *The Ciao Italia Tour* (1988), says: *"Sono fiera di essere Italiana"* (I am proud to be Italian). Later in her career, we see her once again referring to her "Italianness" when her "Blonde Ambition Tour" (1990) is banned in Italy by the Pope. This time, however, she announces to the Italian press that she is proud of her Italian heritage but identifies herself as an Italian American; she rather pointedly inserts "American" because in America it is her artistic right to perform what she wishes. These are not, of course, the only examples of Madonna's perpetual references to her "Italianness." How can we, for example, forget the use of Venice as a location in one of Madonna's earlier hit videos, *Like a Virgin* (1984)? When discussing her choice to shoot this video in Venice, Madonna said: "We just felt that Venice symbolized so many things—like virginity. And I'm Madonna and I'm Italian."

What is it though about Madonna that truly affirms her position as an Italian American woman and allows her to be something of a vehicle for the expression of many of the qualities that are exclusive not only to Italians in this country but even more so to Italian American women? The question of Madonna's Italianness is threefold. The first and most important aspect of Madonna's position as an Italian is her name and the "game of the name" she plays out between her sacred name and her profane personae. For Italians, identity is nomenclatured: There is, with any ethnicity, always a certain amount of visual ambiguity regarding physical features, but, for Italians, names and their telltale vowels, especially at the end, are primary signifiers.

Boldface terms are defined in the Cultural Lexicon, which starts on p. 703.

Madonna Veronica Louise Ciccone chose to retain her true name (reducing her surname, however, to her given name). "Madonna" is by no means a typical name; it is, in fact, somewhat unusual as a given name—it is a displacement of the common, ubiquitous "Maria." "Madonna" is charged with cultural connotations—Catholic as well as Italian—some of which operate at an unconscious level that is activated by the "improper" name hidden beneath the proper name. "Madonna" designates the Virgin Mary but, when uncapitalized, it serves as an honorific addressed to a woman, especially a married one, who is deemed worthy of respect: *ma* (my) *donna* (lady), which is derived from the Latin *domina* (the female head of the home), the feminine of *dominus* (lord), and consequently translates as "my mistress" or "my domain," with all of the chivalric associations these terms suggest. As the Italians put it: *essere donna e madonna* (to be absolute mistress). It is precisely this slippage between sacred name ("Madonna") and hidden name ("dominatrix") that Madonna enacts, however unconsciously, in the performance of her sexual persona and the construction of her cultic identity. She is at once an auratic object of adoration who gives herself, in the spectacle, to the gaze of the audience, and a subject in power who consciously controls both the spectacle and those who are captivated by it. From this point of view, her name becomes a site of subversion, a self-willed misnomer that signals the intersection of the sacred and the profane codes that inform her performance of the self.

But it is *her name,* improperly proper. It is primarily through her name that Madonna's Italianness is continually reaffirmed and her status as postmodern **Diva** proclaimed. Unlike other "pop queens" such as Gloria Estefan, who constantly reaffirms her Cubanness by performing songs either in Spanish or with a decidedly Latin influence, or African American rap artists like Queen Latifah, who empower Black vernacular, or the queen of soul Aretha Franklin, who brings gospel into the mainstream, Madonna does not ever affirm her cultural background and identity by singing in Italian. In fact, the one time Madonna does perform in a language other than English, it is Spanish in the song "La Isla Bonita" (1986). Madonna makes references to neither the operatic tradition nor the Italian folk song. Other Italian American singers (such as Dean Martin and Frank Zappa) did, in fact, sing in either Italian, Italian dialects, or the interesting mélange of English and dialect that within Italian American communities is referred to as "Brooklynese." The only way in which Madonna refers to her tradition is by adopting the role of the prima donna—the diva—and by always expanding on the idea of the ***spettacolo*** (spectacle).

Thus we by no means see Madonna's Italianness through her music. In fact, on many occasions she has cited her style as being born of the sound of Latinos

and urban African Americans. In her *succés de scandale*, the aluminum-clad book *Sex* (1992). Madonna adopts the name Dita Parlo as her "alter ego." Although the name renders itself, in loosely translated Italian, as "I speak in fingers," it actually has no significance at all, but it is nonetheless a blatantly "Italianized identity." However, in her movie roles, Madonna is always somehow de-Italianized: She is stripped of her name—in everything but the credits—and thus of her true identity in most all of her Hollywood ventures. Consider, for example, the following roles in which she "passes": She is Susan in *Desperately Seeking Susan,* Breathless Mahoney in *Dick Tracy,* and Nikki Finn in *Who's That Girl?* But when Madonna is in charge of the construction of her personae in her videos and movies, her Italianness is often a dominant presence. For example, in the video *Papa Don't Preach* (1986), in which she portrays a young pregnant girl in Queens, New York, she dons an "Italians Do It Better" T-shirt; in *Like a Virgin,* she decides to become *deflorata* (deflowered) while cruising through the canals of Venice in a gondola; in the documentary *Truth or Dare* (1991), she is "allegedly" herself; and in *Sex,* as mentioned above, she "becomes" Dita Parlo. Thus Madonna is always, in the identities and names of her choice, most definitely Italian. Even when she attempts to efface all of the visual signs of her Italianness—particularly through her platinum blonde hair and her appropriation of the persona of Marilyn Monroe ("Marilyn," by the way, is a diminutive of "Mary")—she still remains visually (according to Camille Paglia in "Madonna II: Venus of the Radio Waves": "Madonna has introduced ravishing beauty and a lush Mediterranean sensuality" [Paglia 1992, 13]), and in name, Italian.

However, it is more than just that name that frequently brings into play her Italianness: It is also her obsession with her Catholic upbringing. Madonna's continual grappling with her religion brings us to the second point in our understanding of her Italianness. Madonna has exploited the significance of her name. Because in Italy the true "Madonna" holds the most powerful position in the society along with her earthly double, "la mamma," Madonna's name, in its profane application as a rock star's sobriquet, would seem to suggest some sort of blasphemy not only to Italian Catholics but to all Catholics. On the contrary, Madonna is constantly "playing with" her own religious identity and her doubts; she is simultaneously fascinated with, and oppressed by, her Catholic background. She is a "lay" theologian, to allude to the duality of her sacred and profane identities. As for most Italian Americans, Madonna's religion is an inextricable part of her self: It is her identity, even when she transgresses it by acting out the dialectic between madonna and **puttana** (whore). (It is important to note here that long before Freud codified the mother–whore complex in such essays as "A Special Type of Object Choice Made by Men" and "The Most Prevalent Form of Degradation in

Erotic Life," it was a linguistic commonplace in those locutions that, in Italian, are called **bestemmie** (blasphemies). Such profanities, which involve the juxtaposition of a sacred name with its opposite, often involve the name of the Madonna: **Madonna–puttana,** (Madonna–whore) being the most typical. Her Catholicism always surfaces in her songs and in her videos because it, like her name, is the key to her cultural identity. Interestingly enough, Madonna goes so far as to dedicate her greatest-hits album *The Immaculate Collection* (1990) ". . . to The Pope, my divine inspiration. . . ."

Thus Madonna fully plays out the *Madonna–puttana* (and its darker variation, Madonna–dominatrix) identities and her own internal division between sacred and profane: When she is good she is very bad, and when she is bad she is very good. Madonna best represents these two seemingly contradictory personae in three different pieces: the two videos *Like a Virgin* (1984) and *Like a Prayer* (1989) and the documentary *Truth or Dare* (1991). In the first two videos, we see Madonna as the embodiment of the sacred and the profane. This seemingly blatant contradiction is epitomized in *Like a Virgin* when Madonna, who seems anything but virgin-like, appears in a modified, lingerie-style, white wedding dress. She is at her best in this video, flaunting her sexuality, while her adolescent-sounding voice belts out the anything-but-innocent-sounding lyrics. It is interesting to note that, in her more recent performances of the song "Like a Virgin," Madonna simulates masturbation on stage; it is this less than holy act that prompted the Pope to ban Madonna's 1990 tour in Italy. Similar to the *Like a Virgin* video, *Like a Prayer* shows that Madonna is still concerned about flirting with the holy and the blasphemous. In the video, she (again clad in lingerie-style clothing) enters a church, where a series of strange, fantasy-like, spiritually charged events transpire. The Madonna–puttana kisses a statue of a saint and makes love to a Black priest, while Saint Madonna receives the stigmata, the signs of religious ecstasy. This video seems to be the paradigmatic example of Madonna's duality and the way in which she constantly engages both her name and her personae in a dangerous dance with that which our society considers taboo.

In a less obvious manner, Madonna acts out the *Madonna–puttana* dialectic in the documentary *Truth or Dare*. This film is meant to show us the "difference" between Madonna onstage and Madonna offstage. What happens, in fact, is the continual breaching of the boundary between role and person: Performance is all, and her performance involves the breaking of all frames. The film attempts to distinguish between Madonna's two existences (and thus, we would assume her self and her personae) by using black-and-white footage to bracket the scenes that are "offstage" (private) and color footage to bracket the onstage (public) perfor-

mances. What we come to see, despite the technical manipulation, is that Madonna is virgin and whore in both the public and the private spheres. Madonna, both onstage and off, often assumes the role of the protective mother, especially with regard to her often troubled dancers. When she goes to visit her own mother's grave she is filled with the melancholy innocence of a child, and when her father comes to see her performance she, with child-like awkwardness, attempts to please and pacify him. We do see Madonna acting the saintly part again in her live performances of musical numbers such as "Like a Virgin" and "Like a Prayer," among others. It is during these performances that Madonna assumes the fictitious role of the madonna–puttana. Her execution of this role is far more interesting, however, when it comes to be seen in black and white, when it is "reality." Madonna is equally at ease performing fellatio on a bottle and mothering the wounded. She slips as quickly into the role of controlling and commanding bitch (with everybody) as she does into the role of mourning daughter. Madonna is comfortable with her seemingly schizophrenic identities, and she is always playing one against the other. It is all either black or white with Madonna: There is no in-between, no grey area, and virtually no difference between the fictive and the real. Why then, is it so difficult for society to understand that this is just the way in which she continually chooses to present (invent) herself for her audiences?

So many critics seem to love to discuss Madonna's obsession with religion: Is it possible that so many of them—except perhaps Camille Paglia—have missed the whole point? The prevalent theory is that Madonna "performs" these outrageously profane acts because of her need to "shock the public." (For further discussion about "Like a Prayer," see "Like a Catholic: Madonna's Challenge to Her Church" by Greeley in *Desperately Seeking Madonna* (Sexton 1993); and, in *The Madonna Connection* (Schwichtenberg 1993), these two articles: "Madonna T/Races: Music Videos Through the Prism of Color" by Nakayama and Peñaloza, and "Images of Race and Religion in Madonna's Video *Like a Prayer:* Prayer and Praise" by Scott.) On the contrary, it would seem that her "stage" Catholicism and her devotion to rituals are, in fact, expressions of Italian American–style Catholicism. Her provocative Catholicism, like her name, is the key to our understanding of Madonna. Catholicism, for Madonna, is all about contradictions, much like the clash between her name and her various personae. Madonna speaks frequently about religion—how could she avoid it?—and has some interesting theories concerning why she is so committed to continually representing herself in relation to her religious identity. In an interview in *Newsweek* (2 November 1992), Madonna discussed her views on the connection between sadomasochism (S/M) and Catholicism: "When I was growing up, there were certain things people did for

penance; I know people that slept on coat hangers or kneeled on uncooked rice on the floor and prayed for hours. There was some ecstasy involved in that. I mean there's a lot of pain-equals-pleasure in the Catholic Church. And that is also associated with bondage and S/M." Thus Madonna does not use Catholicism merely as a means to shock her public; rather it is a mode through which she comes to ritualize her own contradictions and to dramatize the complex interplay of her personae.

The above discussion about how Madonna continually fertilizes her identity as an Italian American through the "game of the name" and through her manipulation of her religiosity leads us to the third and final point regarding Madonna's Italianness, which can be found in her penchant for the spectacle, her obsession with voyeurism, and the idea of seeing and being seen. We have noted that in *Truth or Dare* it is almost impossible to distinguish the "public" Madonna from the "private" Madonna; interestingly enough, in the Italian language there is no word for privacy; Italians use the English: "la privacy." The absence of this word is a great indicator of the cultural life of Italians. Italians hate to be alone, and much of the social life revolves around being with people in the public sphere: The **piazza** (square) takes on the role of the stage; it is not only where Italians meet, it is where they see and are seen. Italians are rather exhibitionistic and voyeuristic by nature, and much of the culture is based upon aesthetics: Italians gauge everything in terms of **bello** (beautiful or good) and *brutto* (ugly or bad). It is often in the *piazza*—beneath the watchful and ever-present public eye—that Italians enact this game of seeing, and their courtships as well. In modern-day Italy, one often witnesses the **passeggiata,** the evening walk in which all of the residents of a small town (it occurs in a modified version in larger cities) put on their best clothing to parade through the town in order to be seen and to look at others.

We see Madonna performing a similar practice in *Truth or Dare;* we also see her obsession with the visual, with the aesthetic, and with voyeurism in several of her other works. The theme of the video *Open Your Heart* (1986) is a peep show; the video *Vogue* (1990) is based upon a dance of "posing" born from the New York club scene (seen); and in her book *Sex,* Madonna is often seen posing naked in public places (pizza parlors, highways) in the middle of Miami. So very much of Madonna's visual code seems to stem from her Italianness, her incessant need to participate in this practice of looking and being looked at. Madonna creates so much controversy in order to be constantly in the visual field of the public's gaze. Just like many Italian (American) women, Madonna establishes the rules of the game of "you can look, but you can't touch"; Madonna can maintain this distance because she is a performer. The spectator may watch her play the dangerous lover

on stage and appear in Miami naked but can never quite touch her; with Madonna, everything is visual, and everything centers on the gaze.

On 14 October 1996 Madonna gave birth to Lourdes Maria Ciccone Leon, the "game of the (Christian) name" being passed on to Lourdes, who was conceived with trainer Carlos Leon. (Actually a place name, Lourdes is a small pilgrimage town in southwestern France where St. Bernadette as a child experienced her visions of the Virgin Mary and, since 1862, is consecrated to the cult of Our Lady of Lourdes; the given name, another trace of Madonna's Catholicism, opens up a vast play on the miraculous child and the mysteries of motherhood.) While filming Alan Parker's megaproduction of *Evita* (1996), Madonna had unexpectedly found herself pregnant: "I feel like a 14-year-old who is trying to hide the fact that she is pregnant from her parents. . . . What will the press do when they find out?" True to form, she managed—willy-nilly—to have a scandalous pregnancy like her namesake and to maintain that scandal by opting for a marriageless—and, it has become clear, husbandless—motherhood. She documented the vicissitudes of her pregnancy along with those of her other provocative birth—the gestation of her performance as Eva Perón, her most challenging film role to date—in the cagily written "Private Diaries," "a sketchbook of feelings, ideas, and dreams," that appeared in *Vanity Fair* (November 1996: 174-188, 223-232). In the "Diaries"—"private" in the oxymoronic sense that Madonna has made her own: the more she discloses of herself, the more she conceals—she oscillates between a daily record, on- and off-set, of the making of *Evita* as the company moves from Buenos Aires to Budapest and a more "private" account of her internal life, mentioning—but not really describing—the "too many trips to the ugly side of my unconscious" that awaken her from sleep. Madonna is not Freud, and perhaps the most telling dream she relates—a visit to the house of Sharon Stone, who is taking a bath in a red dress, that is interrupted by a gun-toting Courtney Love who threatens to shoot them only to burst out laughing, saying it was only a joke (187)—is left for the reader to interpret. Again the fascinating but calculating Madonna: confession "without confession" and in the form of a press release; self-representation that turns into damage control ("I am writing today as therapy. As damage control. To keep from crying out or destroying something. Women who are educated, women who call themselves feminists, women who are gay have the nerve to attack me in the press and say that my choice to have a baby and not be married is contributing to the destruction of the nuclear family [230]."); self-disclosure without analysis and in the form of "advertisements for myself."

As she passed from "Material Girl" (1984) through "Blond Ambition"(1990), to the "Dita Parlo" of *Sex* (1992) and its accompanying album *Erotica* (1992) to

become "Goddess of the '90s," Madonna occupied a gamut of fantasy-scenarios in which the media occupied the role of the Other and in which she mirrored our culture's own fantasy of celebrity. She presented herself through a breathtaking succession of sexual personae and women's roles, dressing for her masquerade in looks and poses appropriated from the pop-culture canon. For Madonna, the quick change artist, the self is a spectacle that expresses itself in material externality and through a self-fashioning that is intimately linked to self-deconstruction. The Madonna of the mid-1990s seems to have reached a level of artistic maturity as evidenced by her performance, however problematic, in *Evita* and her CD *Ray of Light* (1998). Will Madonna ever become herself? Will we be able to speak of a post-Lourdes Madonna? Or will the public side of her motherhood be one more installment in her Immaculate Collection of women's roles? It is easy to submit her metamorphoses—insofar as they hide an eternal return of the same—to a quick psychoanalytic explanation. Her mother, Madonna Fortin Ciccone (the game of the name begins here), died of breast cancer in 1963 when Madonna was five, a traumatic event that, as Madonna has repeatedly remarked, has haunted her. As Ingrid Sischy has pointed out in her piece, "Madonna and Child," for *Vanity Fair* (March 1998: 204–212, 266–270), the theme of atonement for her mother's traumatic death runs through her work from the visit to her mother's grave in *Truth or Dare* through such songs as "Inside of Me" and "Promise to Try" to the song in *Ray of Light* in which she becomes "Mer Girl" ("'Mer' refers to mermaid and is French for the sea," as Sischy points out, but more to the point, it suggests mother and mother's girl.). If there is a series of Madonna's metamorphoses that take place in (and against) the name of the Father ("Papa Don't Preach") and the Italian Catholic notion of woman as Madonna; there is also a series that take place in (and for) the name of the Mother. "(Madonna) Deconstructing Madonna" or "(Madonna) Desperately Seeking Madonna"—which will serve as the more appropriate name for the movie of her life?

Further Reading

Bego, Mark. *Madonna: Blonde Ambition* (New York: Harmony Books, 1992). An introductory yet comprehensive biography tracing the evolution of Madonna.

Paglia, Camille. *Sex, Art, and American Culture* (New York: Vintage Books, 1992). An interesting collection of essays on popular culture that contains two controversial pieces specifically concerning Madonna as feminist.

Schwichtenberg, Cathy, ed. *The Madonna Connection: Representational Politics, Subcultural Identities, and Cultural Theory* (Boulder, Colo.: Westview Press, 1993). A highly academic collection of essays about Madonna.

Sexton, Adam, ed. *Desperately Seeking Madonna* (New York: Delta, 1993). An anthology of academic, journalistic, and cultural criticism.

From Stella to Stella
Italian American Visual Culture and Its Contribution to the Arts in America

Pellegrino D'Acierno

The Traveling of Italian Visual Culture

In the room the women come and go
Talking of Michelangelo.

—T.S. Eliot

The Italian presence in American art is long-standing, extending as far back as 1621, when a small group of Italian glassmakers were active in Jamestown, and then proceeding to the signal year of 1760, the date marking the beginning of Philadelphia painter Benjamin West's four-year sojourn in Italy, the first of innumerable journeys by American artists (from John Singleton Copley and John Singer Sargent to Paul Cadmus and Cy Twombly) who, as William Vance points out in *America's Rome* (1989), would make "artifacts of their own national culture from what they saw and experienced in Italy." But, as the first volume of a two-volume groundbreaking collection of essays edited by Irma Jaffe, *The Italian Presence in American Art: 1760–1860* (1989), makes clear, the migration worked in both directions, involving, for example, the contributions of the painter Constantino Brumidi and other Italian emigres to the U.S. Capitol (Brumidi, the Michelangelo of the Capitol, painted the murals of the Rotunda's dome and frieze); the nineteenth-century appropriation of Leonardo da Vinci as a model for American art; and the various American installments of Palladianism, most notably the architectural works executed by Thomas Jefferson, whose political thought was also Italian influenced.

For present purposes, it would be impossible to trace fully the history of the intricate dialogue between the two visual cultures and to document the way in which the Italian classical tradition has served as a model for American

artists, sculptors, and architects. This tradition, as it originates in Greek and Roman art, is then retrieved and canonized by Italian Renaissance art and is ultimately academized by neoclassicism, is the primary means by which Italy has perennially exercised its role as world educator in the arts. It was the authority and fascination of the classical tradition that led generation after generation of American artists to Italy in an attempt to insert themselves within that tradition. As the art historian Charles Eliot Norton wrote in 1869 in a letter to his friend John Ruskin, "Italy is the country where the American, exile in his own land from the past record of his race, finds most of the most delightful part of the record." Since this chapter will focus primarily on twentieth-century Italian American visual culture, readers are directed to the following texts that document the role Italy has played in the formation of American artists: In addition to the previously mentioned volume edited by Irma Jaffe, see also its sequel, *The Italian Presence in American Art: 1860–1920,* the second in a projected three-volume study, the last volume of which will treat the decades 1920–1990; Theodore Stebbins' *The Lure of Italy: American Artists and the Italian Experience, 1760–1914* (1992); and William Vance's two-volume *America's Rome* (1989). Volume 1 is titled *Classical Rome;* Volume 2, *Catholic and Contemporary Rome,* a definitive cultural history of the literary and artistic exchanges between America and Italy as mediated by Rome; this highly recommended work is itself one of the great American literary encounters with Italy.

Locating Italian American Visual Culture

How are we to locate Italian American visual culture given, on one hand, the cosmopolitan pervasiveness of traditional and contemporary Italian art and, on the other hand, the conditions of the production of art in the twentieth century when national traditions are displaced by transnational movements and abstract art makes problematic the very notion of ethnic art, which is linked to the figural? As twentieth-century art becomes more conceptual, more art about art, can we still speak of a visual art that directly registers ethnic experience that is bound to the American social text and therefore to the "referent"—that is, to exteriority and materiality? If the postmodern, as Mario Perniola maintains (*Artforum* [Summer, 1991]), is "an ethnocentricity that eliminates multiplicity and the differences of cultures by throwing all artifacts into a melting pot that erases their old boundaries and definitions," can we still speak of an "art of difference" or must we adopt categorically the universalizing formula of postethnic, postnationalist art?

To establish an absolute division between Italian artists and Italian American artists, whether first, second, or third generation, takes us only so far because a number of Italian artists have exerted great influence on the American art scene, whereas their Italian American counterparts may or, just as often, may not maintain an Italian connection. Furthermore, to define Italian American art as an enclave or a self-conscious tradition that possesses its own genealogy and set of thematic and stylistic concerns and that defines itself in opposition to the American context would be to construct a historical fiction. There is no coalescence into a movement such as the Harlem Renaissance of the 1920s, or any shared ideological program to represent Italian Americans in a positive way. So to locate Italian American visual culture, it is necessary to raise the larger question of the way visual culture has traveled in the twentieth century as well as to articulate precisely the cultural spaces and contexts from which artistic works and theories issue.

For example, to describe the "Italian connection," it is necessary to make the following distinctions: (1) those works, styles, and movements (after all, the twentieth century is a century of movements) that are "made in Italy" by Italian artists and exported to America and other cultures by the various networks—institutional and economic as well as interpersonal—of cultural transmission; (2) those works "made in Italy" by American or Italian American artists who consciously attempt to affiliate themselves with Italian culture and to adopt an Italian artistic or intellectual persona (for example, the painting of Cy Twombly or the illustrious roster of artists and architects who have worked at the American Academy in Rome); (3) those works "made in America" by Italian artists who have immigrated here, however temporally, and whose art bears the traces of an encounter with America (for example, the post-1987 films of Bernardo Bertolucci or the work of such bicultural artists as Lucio Pozzi and the members of the *Transavanguardia* [Transavant-garde], Sandro Chia and Francesco Clemente, all of whom have worked out of Soho in New York City but who also migrate between the two cultures); (4) those works "made in America" by Italian Americans who confront the Italian American experience directly in their work, such as Joseph Stella and Ralph Fasanella, or who, in occupying postethnic and cosmopolitan positions, forge an Italian connection, such as Frank Stella, whose *Shards* (1982–1983) are exercises in the neo-baroque conducted under the sign of Caravaggio, and the postmodernist architect Robert Venturi, who, as evidenced by his book *Complexity and Contradiction in Architecture* (1966), has learned just as much from Rome as from Las Vegas.

On the other hand, there are those third- and fourth-generation artists who define themselves exclusively in American terms, such as the pop artist Allan D'Arcangelo, and therefore must be factored into the equation primarily on the

basis of descent. Such assimilated artists, as we shall see, may occupy positions of either "weak ethnicity" or negated ethnicity.

In describing the "Italian connection" (and from the Italian point of view, the "American connection"), we are addressing enunciative positions that involve deterritorialization and reterritorialization on the part of the artist, and thus the question of exile—voluntary or involuntary—and the way in which it affects stylistic identity is a crucial matter. For example, Joseph Stella's migration between the two cultures is a contradictory expression of the will to (voluntary) exile and (involuntary) estrangement, an untenable attempt to reverse immigration that confirms his permanent doubleness and makes him the exemplary first-generation artist of inbetweenness. On the other hand, there is the multiplication of cultural personae and artistic styles that informs the voluntary migrancy of Francesco Clemente, who maintains studio-residences in Rome, Madras, and New York City and who thus practices an ethnopluralism that is characteristic of the weak ethnicity of the postmodern artist. Perhaps the most interesting of these migrations is that of the involuntary exile of Alberto Burri (1915–), who was born in Città di Castello, Umbria, and who, after taking his degree in medicine in 1940, served as a medical officer in the Italian army during World War II. Burri would eventually become, along with Lucio Fontana, the chief Italian practitioner of Art Informel (Art Without Form, a movement in European painting, beginning around 1945, that ran parallel to Abstract Expressionism in America), winning international fame for his work, especially his *Sacks* (1952). So much has been made of his genesis as a painter that his story of forced deterritorialization is worth repeating for anecdote's sake alone. Here is Daniel Wheeler's perceptive version of it, from his *Art Since Mid-Century: 1945 to the Present* (1991):

> Burri, a medical doctor in the Italian army, began spontaneously to paint in 1944, despite his lack of artistic training, while held a prisoner of war in Texas. With this, he revived an old but long-suppressed interest, doing so in twelve-hour marathons that soon made him [as] desperate for art supplies as he had been for something to fill the void of his captive existence. Thus when canvas and white paint could not be obtained, Burri seized whatever makeshift substitute—burlap bags, toothpaste—lay at hand. Such necessity left him with a permanent taste for sensuously tactile surfaces and unconventional, cast-off materials.

It was upon this necessary encounter with found and degraded material that Burri would base his radical experiments in collage painting that began in the

1950s. Using rough burlap and, subsequently, charred wood, iron, and, plastic, he undertook a defiant recycling of waste and trash that resulted in a resacralization of the detritus of industrial society, a conversion of trash into objects of beauty. Thus the artistic revolution he initiated represented, on one hand, the negation of the entire tradition of painting and, on the other, a radically new exploration of material by which material itself became the protagonist of painting. This "matter painting," his collaged paintings made of materials rescued from the scrap heap of industrial society, made him the best-known Italian artist of the postwar period in America, and his work influenced such American artists as Robert Raushenberg and Conrad Marca-Relli and later the practitioners of Junk Art and in Italy the *Arte Povera* (Poor Art) group. It all began in Texas: his physical deterritorialization leading him to a deterritorialization of the language of traditional art.

<center>*The Italian Tradition of the New*</center>

Before beginning to establish a canon of Italian American artists, it is necessary first to give a brief overview of the adventures of twentieth-century Italian art, many episodes of which have had repercussions on the American scene and on Italian American artists such as Joseph Stella and Conrad Marca-Relli, who forge transatlantic links with the Italian "tradition of the new." As evidenced by the displacement of Paris by New York City as the art capital of the world, the twentieth century, the so-called American Century, has seen American visual culture, high and low, exert a hegemony over world culture, especially in the post–World War II, or postmodern period. As Camille Paglia puts it in *Sexual Personae: Art and Decadence from Nerfertiti to Emily Dickinson* (1990), "The twentieth century is not the Age of Anxiety but the Age of Hollywood." But it can be argued, as Pontus Hulten has, that, at least with respect to visual culture, the twentieth is also an Italian century.

The adventures of Italian modernism begin with the big bang of the *Futurist Manifesto* (published in *Le Figaro* on 20 February 1909), the shot heard round the world of the first machine age. The manifesto, written by F. T. Marinetti, the militant theorist–propagandist of the futurist movement's down-with-the-past ideologies and the high-priest-qua-technician of its "new religion–morality of speed," proclaimed:

> We say that the world's magnificence has been enriched by a new beauty: the beauty of speed. A racing car whose hood is adorned with great pipes,

like serpents of explosive breath—a roaring car that seems to ride on grapeshot—is more beautiful than the Victory of Samothrace.

Here Marinetti, in performing one of those destructive gestures intrinsic to the modernist avant-garde and its aesthetics of shock, junks the static ideal of classical beauty as epitomized in the early-second-century Greek sculpture, the *Victory of Samothrace,* thereby calling for the "death of art" in the traditional sense. Instead, he proposes as a model for modern art the "mechanical splendor" of a racing car, a mass-produced object that embodies the idea of speed and technological beauty definitive of modern life. In addition to containing the first, and perhaps most effective, advertisement for the automobile yet devised—one immediately imagines a Bugatti, the precursor of the red Ferrari that will find its way into the permanent collection of MOMA (Museum of Modern Art) in New York City—the *Futurist Manifesto* establishes the agenda for Italian avant-garde art throughout the century: (1) *to make it new at all costs,* to create a radically modern and antitraditional art that incorporates, in its language and structure, the dynamic values of the technological universe and that is dedicated to an ideology of permanent and programmed innovation; (2) *to destroy and deface the past at all costs,* "to murder the moonlight," as Marinetti declared in one of those apocalyptic slogans that were his trademark, to destroy the traditional work of art and its autonomous status by breaking down the boundaries between "world" and "text" (a program encapsulated in Marinetti's rallying cries: "Art = Life"; "Art = Action"); (3) *to break the hold of the past and its fossilized traditions on Italy* and thus to free it from the "smelly gangrene of professors, archaeologists, ciceroni, and antiquarians . . . and from the numberless museums that cover her like so many graveyards."

Although Marinetti would fatally misread fascism as essentially another modernist movement dedicated to the modernization of art and society, he does draw up the lines of battle that will determine the unfolding of Italian art in the twentieth century: avant-garde vs. passéism, namely revivalism and academicism; "making it new" and destroying the past vs. traditionalism and maintaining the presence of the past; politicized art vs. formalist and autonomous art. Marinetti's invention of the futurist movement would serve as the model—at times an antithetical one—for the other modernist avant-gardes that would succeed it, from dadaism to surrealism. As such, futurism was Italy's first great artistic export of the century, generating futurisms in Russia, Germany, France, England (vorticism), and even in Mexico and Japan, influencing artists as diverse as Marcel Duchamp, John Cage, and the Italian American Joseph Stella, who will figure prominently

in the adventures of Italian American art. Indeed, as the title of this chapter suggests, those adventures can be seen to begin with him and to culminate in the ongoing work of Frank Stella (no relation to Joseph Stella), the two Stellas being the two strongest Italian American painters in the American constellation.

The Italian "tradition of the new" extends from the first wave of futurism to the *Transavanguardia* (a term coined in the late-1970s by Achille Bonita Oliva to describe the Italian wing of what would subsequently be called neo-expressionism) and other postmodernist developments. In that time, four distinct periods are distinguishable.

The early period (1900–1920) is dominated by futurism and the metaphysical school, founded by Giorgio de Chirico (1888–1978), who is perhaps the strongest and most influential Italian painter of the century. His enigmatic paintings of this metaphysical period, with their disconcerting empty spaces and jarring juxtapositioning of objects that evoke a disquieting melancholy, served as the immediate precursors of surrealism, and his neoclassical paintings, executed after 1920 as part of a return to the Renaissance tradition, became points of reference for the postmodern "returns" of the 1980s.

The fascist period (1922–1945) is characterized by a general reaction against avant-garde experimentalism as evidenced by the long good-bye to the international avant-garde executed by "second futurism" as it came to be co-opted by the regime and by the formation in 1926 of the Novecento, a reactionary movement dedicated to a return to the Italian tradition and to a rather affected neoclassicism, a Milan-based movement whose provincialism would be countered, in turn, by the Roman school, founded in 1930 by Mafai and Scipione, and, more vehemently, by the Corrente group, founded in Milan in 1938, which would pave the way to abstraction.

The postwar period (1945–1968) witnesses an enormous creative explosion in Italian visual culture: Italian cinema, in its evolution from neo-realism to the auteur cinema of its great modernist masters (Visconti, Fellini, Antonioni), emerges as a viable aesthetic alternative to Hollywood cinema, while Italian design and architecture come to exert a worldwide influence. So, too, does painting, which, in moving toward an internationalism of style, becomes the site of a postwar debate involving a struggle between realism and abstraction, a struggle from which emerges the dominant movement of the 1950s, *Informalismo* (Art Informel), an Italian and European version of abstract expressionism. As defined by Maurizio Calvesi ("*Informel* and Abstraction: In *Italian Art of the Fifties*" in Braun, 289): "Informel is dominated by the direct communication of the sign, the artist's gesture; it is an instant immersion in reality itself. The gesture is the direct trace

of the living presence of the artist; the material does not evolve into form, but remains pure action, a sign of reality in ferment." From that follows conceptual art and the various neo-avant-gardes of the 1960s.

The postmodern period (1968–) is dominated first by *Arte Povera*, which advocates the use of everyday materials, and then by the *Transavanguardia*, a postmodernist formulation of an avant-garde position in neo-expressionist terms that has been defined as "traditional in format, apolitical, and, above all else, eclectic involving the appropriation of images from history, popular culture and non-Western art." The canon of twentieth-century Italian masters extends from Boccioni and the other futurists (Balla, Carrà, and Severini) to de Chirico and Modigliani, from Morandi and Marini to Burri and Lucio Fontana, from Merz, Paolini, and Pistoletto to the three C's: Chia, Clemente, and Cucchi, all of whom were packaged under the Transavanguardia label. All of these artists, most of whom have traveled to America either literally or through their works, belong to the overall process of the internationalization of art that has come to characterize modern and postmodern art.

Throughout this volume Italian American culture in general has been perceived to stand to Italian culture as a supplement, in the Derridean double sense of being both an appendix or optional extra to the main text of Italian culture and something that completes that text and therefore is an integral part of it. This notion of supplementarity will be useful to our search to locate Italian American visual culture, especially with respect to the first- and second-generation painters who attempt to confront the immigrant experience—that experience in and of itself being an instance of supplementarity.

Immigrant art, the art of the (often involuntary) exile, of the artist caught between traditional and new iconographies, between the old landscape and the new urban environment (New York City was and continues to be the center of Italian American and American Italian art) is a conflictual expression of deterritorialization and territorialization, most fully demonstrated by Joseph Stella's double identity as the first American Italian and the first Italian American painter. Stella's position, in some respects unique to him, involves a constant migration between the two visual cultures. The "inbetweenness" of his position can be regarded as the paradigmatic site of the Italian American artist, one that obliges us to read his work as an American supplement to Italian art. On the other hand, the generation of painters that follows Stella, typifed by the blue-collar folk artist Ralph Fasanella and O. Louis Guglielmi, who infuses his surrealism with social commentary, is embedded in the politics of immigrant and working-class identity as incubated in the Great Depression; therefore, its supplementarity is estab-

lished with respect to American modernism—for example, Fasanella's primitivism (regressive with respect to modernism) is the classical expression of the minor art of ethnicity. However, the work of those figures who operate on the postmodern terrain such as the Princeton-educated Frank Stella and Robert Venturi, who are distanced generationally and by class from the immigrant experience, can be seen as "dangerous supplements" to Italian art in the way that they position themselves with respect to the tradition: Stella's use of Caravaggio and the Italian baroque as a revisionary ratio applied to the course of American abstract art and the position of his own painting within it; Venturi's rethinking of Las Vegas in terms of Rome and vice versa.

From (Joseph) Stella to (Frank) Stella: The Canon of Italian American Painters

My paintings smell of oil and garlic and salami and some people just don't smell anything.
—Ralph Fasanella

[Italian immigrants] are very quick to learn, have a deftness of hand which adapts them to trades requiring manual skill, and their artistic sense is always developed, though it sometimes does violence to the esthetic color sense of hyper-critical Americans.
—Allan McLaughlin, 1904

The Italian American contribution to American visual culture has been substantial, especially if we factor into the equation the recent contributions to American cinema by Martin Scorsese, Francis Ford Coppola, Michael Cimino, Brian DePalma, and others (see the chapter on the cinema in this section) and to architecture by Venturi, Paolo Soleri, Romaldo Giurgola, and others. The question remains, however, of whether the body of paintings produced by Italian American artists can be defined by using the category of ethnic art—that is, a visual art that expresses the Italian American experience directly or at least confronts the question of cultural identity and issues from an enunciative site that is marginal, proletarian, or immigrant—or whether these works are more properly understood with respect to the schools and movements from which they emerge, as traditionally has been the case.

In fact, a canon of Italian American painters, to our knowledge, has never been established, and what follows is a somewhat provisional attempt to suggest

what such a canon might be. A caveat: It is important to recognize that the figure of ethnicity as it is applied to reading an artist's work must be deployed in a critical and flexible way. Ethnicity manifests itself in a myriad of ways, unconscious as well as conscious, in the construction of a stylistic identity, including the denial of ethnicity itself. Consequently, we shall employ a nontotalizing view of ethnicity that accounts for a full range of positions: from the "strong ethnicity" exhibited in the comment by Fasanella cited above to the "weak ethnicity" of artists whose "Italian connection" is nonbinding or whose work calls into question the notion of ethnic or national or collective consciousness. Furthermore, "weak ethnicity" is in no way intended as a pejorative: On the contrary, it may be used to describe strong artists who transcend ethnic determination on some level and who attempt to engage the common experience and the problems of mankind from a universal perspective. On the other hand, "strong ethnicity" is intended to describe those artists who see ethnicity and its attendant marginalization as the universal human condition.

As a counterpoint to the folk artist Fasanella's affirmation of the Italianness of his painting, consider what Lucio Pozzi, an artist adept at drifting between stylistic and cultural identities, told me: In response to a London exhibition of his cubist paintings, the reviewer described his diagonals and fractals as looking like "slices of pizza." Here we have an instance of the most vulgar application of the grid of ethnicity (spaghetti, tomato sauce, and accordians). On the other hand, ethnicity as a lived experience (as opposed to the conscious attempt to enter a visual tradition or to take ethnic or immigrant experience as a theme) is determinative of the artist's sensibility: the shape of bread, the way a grandfather may smoke a *Toscano* (a black Italian cigar), the color of one's father's clothes or the gestural code and facial expressions of one's mother as they counterpoint a representation of the madonna by Raffaello hanging in the living room—all may operate as traces in the formation of artistic identity, even that of the most abstract painter.

Joseph Stella: The First American Italian and Italian American Painter

> *And when in 1912 I came back to New York I was thrilled to find America so rich with so many new motives to be translated into a new art. Steel and electricity had created a new world. A new drama had surged from the unmerciful violation of darkness at night, by the violent blaze of electricity and a new polyphony was ringing all around with the scintillating, highly colored lights. The steel had leaped to hyperbolic*

> *altitudes and expanded to vast latitudes with the skyscrapers and with the bridges made for the conjunction of worlds. A new architecture was created, a new perspective.*
>
> —Joseph Stella

> *Italy is my only true inspiration. The Artist is like a tree growing older, bent by the weight of its fruit, it presses always closer to the maternal womb that gave it birth. Despite everything, thirty years and more of America have succeeded only in making more solid and firm the Latin structure of my nature.*
>
> —Joseph Stella

The question of locating Italian American visual culture crops up from the very start, with the Italian-born Joseph Stella (1877–1946), the first painter of the Italian American experience. Stella is the quintessential "translational" figure in that his work maintains a dialogue with both the Italian masters and the modernists (the Italian Futurists) while also constructing an American (Whitmanesque) stylistic identity. Furthermore, his work addresses the immigrant experience as part of a more total (modernist and thus cosmopolitan) encounter with twentieth-century-America reality: the (in)human metropolis as embodied in the New York City of the Great Immigration with its skyscrapers and tenements, and the universe of machine-age labor as typified by the 1907 mine disaster at Monongah, West Virginia, and the lives of steelworkers in Pittsburgh, which Stella carefully and sympathetically documented in his early work as an illustrator for progessive magazines. As Stella recognized, "To my mind at present America offers more than any country a wealth of material to the true modern artist, because nowhere else what we call modern civilization reaches the same climax." He is thus a figure who constitutes his artistic and personal identity in terms of the double consciousness typical of the displaced immigrant self. In a passage that is constantly invoked by art historians to explain Stella's status as an outsider, Antonio Aniante, an Italian journalist, wrote in 1932:

> "Two instincts clash in him; two homelands crowd his creative thought.... Having left as a young man with a Latin soul immersed in classical studies, he returns to the old country as an American painter. Two-sided, alienated, he views the greatness of America with the eyes of a European, and the gentleness of the Neapolitan sea with the eyes of a stranger." (cited in Jaffe, 1970, 2)

However useful this assessment may be, it only begins to get at the larger contradictions at work in Stella's self-construction as a hybrid artist: his constant migration between American and European visual cultures, his transitions from one stylistic identity to another, his perpetual slippage between his status as an American Italian and an Italian American painter. In this respect, Irma Jaffe's struggle at the end of her monograph *Joseph Stella* (1970) to weigh the Italian and American elements of his artistic identity, only to claim him as an American artist, is both exemplary and inconclusive. We would suggest that Stella is the quintessential hybrid, a painter who from the position of permanent exile constructs his work in terms of a number of dialogues: between the tradition of the old (the Italian and European masters) and the tradition of the new (international modernism), between the immigrant experience and cosmopolitanism; between Italian visual culture (not only the "great tradition" but also the local or vernacular tradition of his Neapolitan roots) and American visual culture. All of these dialogues might be summed up in the opposition between the Virgin and the Brooklyn Bridge, to ring a variation on Henry Adam's emblem of the Virgin and the Dynamo, or collapsed into the figure of *The Madonna of Coney Island* (1914) the title of one of Stella's futurist paintings. These oppositions are given visual form in the autobiographical abstract paintings *Tree of My Life* (1919), an extraordinary psychological self-portrait expressed in terms of antithetical symbolic landscapes, in which, as Joann Moser points out, "Stella explored his dual allegiance to America and Italy, his urban and rural environments, industry and tradition, past and future."

On the basis of the avant-garde work he executed from 1913 to 1922, Stella has been booked into the history of modern art as America's first and foremost futurist artist and, more generally, as America's "European connection," that is, the most talented of those early modernists who absorbed the lessons of cubism, futurism, and fauvism and imported pre–World War I European modernism to New York. Let us take a closer look at Stella's work, especially in light of the 1994 retrospective at New York's Whitney Museum of American Art, which emphasized the immigrant experience and imposes a rethinking of his post-1922 output, in which he turns away from modernist experimentation and toward a more traditional figuralism, informed by a flagrant use of color. (See the comprehensive monograph *Joseph Stella* [1994] by Barbara Haskell, the curator of the 1994 exhibition, a sequel to the first Whitney retrospective in 1963.)

Born and raised in the medieval mountain village Muro Lucano, near Naples, Stella did not immigrate to America until 1896, at the age of eighteen, but between 1910 and 1912 he sojourned in Europe, returning to Italy to enact an Italian American version of the "voyage to Italy" and coming into contact with

avant-garde circles in Paris. Upon his return to America in 1912, he initiated his translation of Italian futurism into an American idiom, finding in the depiction of movement, lights, and modern urban and industrial architecture his great theme: the polyphony of the metropolis. He came to be celebrated for his futurist-inspired dynamic renderings of Coney Island, the Brooklyn Bridge, New York skyscrapers, the lights of Broadway, and such industrial objects as the gas tank. Beginning with the initial success of his 1919–1920 painting *Brooklyn Bridge*, which was immediately accorded the status of an icon of American modernism, Stella would be forever identified with his paintings of the Brooklyn Bridge, the most sublime of futurist objects and a motif that would form the basis of his mythologization of New York City as the capital of the twentieth century. In his masterpiece *New York Interpreted (The Voice of the City)*, 1920–1922, it was the subject of the fifth panel titled *The Bridge (Brooklyn Bridge)*, and he would return to it in such later paintings as *American Landscape* (1929) and *The Brooklyn Bridge: Variations on an Old Theme* (1939).

The danger, of course, with the futurist label is that his diverse output is often reduced to one anthology painting, usually the 1919–1920 *Brooklyn Bridge*, and his American version (Whitmanesque) of futurism is deprived of its complexity as a cross-cultural encounter by being reduced to an eccentric (romanticized) and homegrown version of the real thing. ("There is," as Werner Haftmann wrote, "a lack of restraint and a spaciousness which may justly be called American.") In other words, Stella's futurism tended to be regarded as some sort of supplement to Italian futurism when it was, in fact, a "dangerous supplement," producing one of the great modernist encounters with New York City. "Stella's New York is a theorem about the city and about art," Peter Conrad has acutely observed. The visual poetry and power of this encounter place him squarely at the center of the New York genealogy—Whitman, Stella, Hart Crane, who requested Stella's permission to use *The Bridge* (1920–1922) as the frontispiece to the first edition of his 1928 poem *The Bridge*. Stella's writings—prose poems, in effect—about New York City convey the wild rhapsody of incongruities he inscribed within his paintings: "New York . . . monstrous dream, chimeric reality, oriental delight, Shakespearian nightmare, unheard of riches, frightful poverty. Gigantic jaw of irregular teeth, shiny black like a bulldozer, funereal gray, white and brilliant like a minaret in the sunlight, dull, cavernous black like Wall Street after dark."

Although Stella's view of New York—Dantesque in that it renders the infernal, purgatorial, and paradisiacal registers of its immense, incessant, ephemeral machinery—is modernist and cosmopolitan, it is profoundly Italian and in a way that it is more specific than the comparison to Dante suggests. Stella's paint-

ings of, and writings on, New York map out the social space of the "immense kaleidoscope" in terms of a metaphorics of urban space—euphoric and dysphoric or "infernal," a term that constantly recurs—that is informed by a cosmic dialectic between the sacred and the profane. New York's skyscrapers are cathedrals whose Gothic thrusts are repeated in the verticals of the paintings and fragmented in the stained-glass prisms of his cubo-futurist geometries; the Brooklyn Bridge is the gothic shrine, the Manhattan transfer where heaven and Earth meet, the sacred American site where all of the forces of the new civilization converge in an apotheosis. Therefore, inscribed within the futurist vision and its techniques is the archaeology of the Italian religious self that responds to the great spectacle of the metropolis "as if on the threshold of a new religion or in the presence of a new Divinity."[1] This archaeology of the self is always at work in the joy of Stella's paintings. Two examples from the futurist phase will serve to suggest the Mediterranean mysticism and residual Italian Catholicism at work in Stella's painting, in which color itself is charged with a pantheism expressed through synesthesia—the "clamour of lights," "the polychromatic riot of a new polyphony." The first is *Battle of Lights, Coney Island, Mardi Gras* (1913–1914), the most strictly Italian futurist of his paintings in its visual language, which is directly influenced by the work of Gino Severini. But in Stella's dynamic rendering of the force field of Coney Island, the "battle of lights" at play in the famous amusement park, there is also the visual presence of the Italian American *festa* and, at the formal level, the dynamics of carnivalization: the formal techniques of futurism are carnivalized in the name of the *festa,* the joy of Stella's polyrhythmic painting. The second example is provided by Stella's greatest work, variously called *New York Interpreted* or *The Voice of the City* (1920–1922). Here we will confine ourselves to one formal detail: the five big panels *(The Port, The White Way I, The Skyscrapers, The White Way II, The Bridge)* are organized to resemble the traditional polyptych altarpieces of Italian medieval and Renaissance churches, including the predella or pedestal, decorated by a frieze of small scenes, as both Jaffe (1970) and Haskell, and Stella himself, have pointed out. In other words, Stella has translated the sacred structure of the Italian altarpiece into a modernist shrine framing his rendering of the profane transcendence of the metropolis. "The flux of the metropolitan life," Stella wrote, "continually flows as the blood in arteries, through the subways and the tubes used for the predella of my composition, and from arcs and oval darts the stained glass fulgency of a cathedral."

Although we have been irresistibly drawn to focus on the central period of Stella's work, it is important to point out that his American apprenticeship began with his chronicling of the immigrant experience. After his classical education in

Italy (Stella came from a fairly well-off middle-class family; his elder brother, Dr. Antonio Stella, a physician and activist in the Italian American community who had preceded him to America, subsidized his early career), he studied art briefly at the Art Students League in New York City and then at the New York School of Art. His traditionalist teacher there, William Merritt Chase, admonished him to study the paintings of the old masters. He took as his first subjects the immigrants and denizens of the Lower East Side, drawing their portraits in the realist style of "the great tradition." He described his project as a "going to curious types, revealing, with the unrestrained eloquence of their masks, the crude story of their life. The forceful, penetrating characterizations of Mantegna's engravings and the powerful dramas depicted for eternity by Giotto and Massaccio, so much admired in the mother country, were ever present in front of me, urging me to search for tragic scenes." His illustrations of immigrants—Americans in the rough—were published in progressive journals, and his first impact was as "America's most authentic painter of the melting pot." His early career as an illustrator led him into the world of industrial labor. He documented for the magazine *Charities and the Commons* the mining disaster at Monongah, West Virginia, in 1907 and then was sent to Pittsburgh as part of *The Pittsburgh Survey*, a study for which he executed a series of individual portrait drawings of steelworkers and other laborers, detailed and psychologically penetrating. Stella's portraits of immigrants and workers as they extend from *The Head of an Old Man* (1905) through the Pittsburgh series as epitomized in the *Italian Leader* and *Four Miners* (both from 1908) to *Self-Portrait: Faces in the Crowd* (1944) constitute the origins of a specifically Italian American form of visual expression in that they employ the tradition of the old masters to represent the immigrant experience. His preoccupation with drawings of old men, in particular, reveals a Leonardo-like anatomization of immigrant and peasant profiles and is typical of the *pietas* (piety or respect) he maintains in rendering the immigrant experience from within, eschewing all signs of the folkloristic and picturesque.

These drawings of the immigrant experience reveal the Stella who is a painter of strong ethnicity as do, in a different way, his futurist works, which stand as among the most significant Italian American visual texts because they resonate with the effects of a hybrid aesthetics. His paintings executed after 1922 constitute a complete break with the modernist work executed under the sign of Italian futurism. Although these figural and highly symbolic, even alchemical, works, comparable in their way to de Chirico's "return" to the tradition, can retrospectively be retrieved as prefigurations of postmodernism, they led to a certain eclipse of Stella's reputation. Critics read him as a lapsed modernist and failed to grasp what was at stake in his "unusual union of classical figuration, occult symbolism,

and stylized decoration," to use Haskell's precise description. Furthermore, the subtext of Italianness was completely deleted so that Stella's late work was transcoded into tropical kitsch and straight—not ironic—primitivism instead of being properly placed within the context of Neapolitan devotional imagery and folk art and, at the intellectual level, the symbolist's magical world of correspondences. At the heart of the late Stella is the encounter with the Eternal Feminine: the Sacred Venus as depicted in the series of madonnas executed from 1926 to 1928; the Profane Venus as depicted in the Udines, Ledas, Sirens, and Venuses; the Blonde Venus as represented in the portait of Kathleen Millay superimposed upon the background image of Capri in *Amazon*, her profile a cross between a Piero della Francesca madonna and the actress Alexis Smith; and an entire floral universe of feminine forms in which the Great Goddess is occulted and fetishized. Stella orchestrates a magical universe in which color is a feminine element and in which painting becomes a "serenade," an analogue to music by which the synesthesia of colors produces a wild rhapsody. Thus the postfuturist Stella can also be seen to be an expression of strong ethnicity—the return to the vernacular tradition of Neapolitan primitivism and its magical realism.

For all of these reasons, Stella may be regarded as the first and most definitive painter of the Italian American experience. And in his polyphonic self, we find at work the three criteria that will serve us in defining *positively* the Italian American artist: (1) dialogism with the Italian tradition; (2) direct registration of immigrant or ethnic experience either thematically or formally, the deployment of Catholic iconography—however secularized—being essential to Italian American visual culture; and (3) the hybridization of artistic identity, which may or may not involve an explicit politics of Italian American identity. In the latter case, we move to those Italian American artists for whom national and ethnic identity is a question of traces that may not be consciously deployed to organize a stylistic identity. Here we approach the question of "weak ethnicity" and those artists of Italian American descent who regard ethnicity as a transitional category and who either define themselves primarily in terms of American (visual) culture or who adopt postmodern (postethnic) positions in which individual ethnic, cultural, and artistic textual bodies are reconstituted in the name of pluralism. This superceded, bracketed, pluralized, and sometimes deliberately negated ethnicity becomes the "normal" position of third- and fourth-generation artists, nevertheless, as is always the case with that which is sublated or repressed, a position infiltrated by the play of traces. "Weak ethnicity" is a palimpsest—never a sealed tomb that keeps the repressed or omitted from returning.

The following are representative artists of the generation that follows

Joseph Stella: Rico Lebrun (1900–1964), a Neapolitan-born painter, sculptor, printmaker, and animator who was instrumental in the production of Disney's *Bambi* (1942); Luigi Lucioni (1900–1986), a traditional realist; Jon Corbino (1905–1964), a romantic realist; O. Louis Guglielmi (1906–1956), a New York surrealist and the other Italian American painter of the Brooklyn Bridge who often took New York City as the site for his spatial deformations; Enrico Donati (1909–) and Angelo Savelli (1911–1995), both Italian-born modernists, the latter an Italian expatriate who came to New York in 1954 at the age of forty-two; and the urban folk artist Ralph Fasanella (1914–1997), who was born in Greenwich Village in New York City on Labor Day, an auspicious birthday given the artist's eventual concern with American working-class experience. Each artist, all Italian or foreign born with the exception of Fasanella, takes a different path dictated in part by the conditions and time of his arrival in America; each represents a different degree of Americanization and expatriation.

Luigi Lucioni, for example, came to America at the age of ten and was trained as an American painter in New York City at Cooper Union and the National Academy of Design. His assimilation is emblematized by his being named painter laureate of Vermont by *Life* magazine for his works depicting that state. A craft-conscious traditionalist, he is appreciated for his exquisitely detailed and intriguingly arranged still lifes and for the deliberate formalism of his landscapes. He is a custodian of traditional technique, influenced by painters as diverse as Botticelli and Cezanne. This is another way of saying that his Italianness is not thematized in his painting.

Rico Lebrun, on the other hand, was trained in Italy at the National Technical Institute and the Naples Academy of Fine Arts and began his career in Italy as a designer in a stained-glass factory, moving to the United States in 1924 at the age of twenty-four to work in the American branch of the factory in Springfield, Illinois. He soon moved to New York City, where he established himself as an advertising artist. Like Stella, he shuttled between the two visual cultures, returning to Italy for an extended stay (1930–1933) to study fresco techniques and the Renaissance and baroque masters. Upon his return, he undertook two mural projects: the first for the Fogg Art Museum, Harvard University, on the basis of which he won a Guggenheim Fellowship; the second, *River Flood,* for the Pennsylvania Station Post Office Annex, New York, a Federal Arts Project on which he briefly collaborated. He moved to Los Angeles in 1938, and, despite frequent travels to Mexico and elsewhere to teach and paint, Southern California would remain his primary base until his death in 1964. It was there that he would teach at various institutions, including Walt Disney Studios, where he taught animation

and collaborated on *Bambi* (cinema would exert a strong influence on his subsequent painting), and execute, from 1950 to 1961, his most ambitious work, *Genesis,* a large mural commissioned by Pomona College, Claremont, California. He exerted a particular influence on figurative artists in Southern California and Mexico, and in 1967 the Los Angeles County Museum of Art held a retrospective exhibition of his work.

Deeply influenced by Neapolitan baroque culture, his "agonized, expressionistic style" has been traditionally read through the lenses of the baroque—"baroque frightfulness" reminiscent of Goya—and of "metaphysical humanism," to use a category devised by Barry Schwartz, who, in *The New Humanism* (1974), described Lebrun as the "most influential metaphysical Humanist of the century." By metaphysical humanism, Schwartz intends a modern art that registers the crisis of contemporary humans and fixes the image of "human concern" through the traditional means of the human figure, however disfigured and grotesque. Lebrun's expressionistic figuralism, a hybrid of baroque realism and modernist (German) expressionism, might be regarded as an exercise in the grotesque. (It is no accident that Paul Klee would define the grotesque in terms of the haunting impressions he gained at the Naples aquarium: Naples is a perennial locus of the grotesque.) Lebrun's preoccupation with the grotesque informs his Goyaesque paintings of cripples, beggars, and harlequins from the late 1930s; his series of farm implements that turn into human skeletons and of images dedicated to slaughterhouses done in the aftermath of World War II; his 1953–1958 Holocaust series based on the atrocities of Buchenwald and Dachau; and his prints and illustrations based on Dante's *Inferno,* Brecht's *Three-Penny Opera,* and one of Grunewald's Crucifixions, all sources that lead to the macabre. Also to be mentioned is Lebrun's other major work, the monumental, basically monochromatic *Crucifixion Tryptych* (Syracuse University, 1950), which is structured as a series of cinematic "frames," an interesting counterpointing of a modernist device (cinematic montage) with scenes that are organized as convulsive baroque dramas. The *Tryptych* as a formal experiment might be seen as the inverse of Stella's deployment of the polyptych in *New York Interpreted*. Although the emphasis here has been on the grotesque aspects of Lebrun's art—it is important to stress that his vision is an uncompromising anatomization of the human condition in keeping with his designation as a "metaphysical humanist" and the admonition he directed at contemporary artists who refused to "look things in the face."

Lebrun's Italianness was translated by American critics into two of the aesthetic categories—the baroque and humanism, specifically the residual humanism still fixated on the human figure—that are internal to Italian culture. A strict

modernist position such as that of Enrico Donati, a member of the surrealist group in New York City who passed from automatism in the late 1940s through a constructivist phase and then to matterism, refuses to be read in such terms. Donati, a sculptor as well as a painter, was born in Milan and migrated to the United States in 1934 at the age of twenty-three, becoming an American citizen in 1945. He studied in New York City at the New School for Social Research and the Art Students League and taught at Yale University in New Haven, Connecticut, in the early 1960s. His friendship with Marcel Duchamp gave him a privileged position among the surrealists in exile in New York during the 1940s. He collaborated with Duchamp on two projects: the window display for Brentano's bookshop on Fifth Avenue (1945) announcing the publication of André Breton's *Le Surréalisme et la Peinture* and featuring a pair of boots by Donati, a materialization of the famous painting by Magritte that was reproduced on the cover of Breton's book; and the notorious "Please Touch" three-dimensional cover for the catalog *Le Surréalisme en 1947,* upon which was pasted a readymade that consisted of a pink foam-rubber breast. Duchamp also wrote an autograph note for the catalog of Donati's one-man exhibition in Paris in 1946 that cryptically begins: "UNE NNNNNNNNNNNN de reciFs OSCILL . . ." Donati was also celebrated by Breton, who dedicated a piece to him in the 1944 edition of *Le Surréalisme et la Peinture,* mentioned above. Breton locates Donati within the context of the then raging controversy regarding surrealism's split into two rival systems of figuration (direct contact with the outer world vs. abstractionism), interpreting Donati's painting *Said Giovanni di Paola* (1944) as a work that maintains an equilibrium between the two rival worlds, a "balm for the wound that has lacerated surrealism." Breton concludes, "I love the paintings of Enrico Donati as I love a night in May." Breton canonized this painting—of clouds, open sky, and light in metamorphosis, of vortexes and a "nebula that spins within nests," and of a woman's body in a violin case that vanishes like a flame—because, even though it frees itself from the real, it remains antithetical to abstraction by rendering the texture of the things it caresses. Of course, what is in play is the technique of automatism perfectly applied by Donati to represent the fluidity of celestial phenomena and to embody chance encounters between brush and pigment. Although the automatism at work in Breton's prose invokes the code of Italianness in its description of Donati's work—the luminesence of Neapolitan mornings, Cremona violins—Breton does not remark about the title, an allusion to the Sienese painter Giovanni di Paolo (1403?–1483). This allusion is astute from an art-historical perspective: Within the Renaissance tradition, Giovanni di Paolo is the Sienese foil to Masaccio, his Florentine contemporary, by virtue of his mystically hovering and destabilized

figures that are completely antithetical to Masaccio's solid and grounded paintings. *Said Giovanni di Paola* (the sky did open!) and the surrealist destabilization of the universe it enacts are thus linked by Donati to the Italian tradition, marking the painting as a dangerous supplement. Donati would continue in the surrealist mode painting, in the early 1940s, such works as *Le Philtre, Nocturne, Baptism of the Birch-Tree, Conception of Venus,* and *The Evil Eye,* the latter another surrealist allusion to Italian culture. In the late 1940s he turned away from surrealism and toward interrogating the materiality of painting, becoming a member of the *Movimento spaziale* (spatialism) founded by Fontana in 1947. Donati remained, by and large, a permant exile and therefore permanently Italian and European, a citizen of the surrealist colony in the magnetic field of New York. Unlike O. Louis Guglielmi, who, as we shall see, will use surrealism—a homegrown socialist version of it, that is—to represent urban reality, Donati does not problematize his Americanness.

Angelo Savelli, who was born in the fishing village of Pizzo in Calabria and whose career spans five decades, provides an interesting study in expatriation. Active in the art scene of Rome in the late 1940s and then, after a revelatory stay in Paris in 1948, estranged from the Italian context ("I realized," he recounts, "that I needed to liberate myself from the divine Italian tradition and find something to contribute to the historical continuum"), he embarked, together with his American wife, for New York City in 1954 at the age of forty-two. Although already an established painter within the Italian context, his encounter with the New York art scene as epitomized by the Tenth Street Art Club and later such artists as de Kooning, Motherwell, Reinhardt, and Newman would lead him to commit to an American conversion to abstract expressionism, even if it meant that he would have to start from scratch. As he wrote, "I saw a fire burning all over and I knew I had to be there." His "Manhattan transfer" would lead him in 1957 to follow the "Great White Way," which has nothing to do with Stella's dynamic rendering of the lights of Broadway. It refers to Savelli's turn to the color white, a breakthough that would inform his white-on-white experiments in painting, collage, and other media, including the process of white relief lithography for which he is best known.

Savelli provides us with the emblem for these obsessive exercises—Mallarmean explorations of what he called "inner space" but ultimately Dantean—in whiteness: "I see with inner white eyes / I see with white eyes." I say Dantean because this experimentation would culminate in a series of works titled *Dante's Inferno* (1964–1968), a title Barnett Newman suggested offhandedly on a visit to Savelli's studio. These "white, box-like scuptures which contained, as the central image, a taut, heavy rope, also painted white," each piece symbolizing a character and scene from the *Inferno,* to cite the catalog description prepared by the Corcoran

Gallery in Washington, D.C., which exhibited them in 1969, together with their sequel, *Paradise* (1969), a set of rectangular and triangular rooms—white spaces punctuated by white paintings—from which the spectator is denied access. One wonders if Savelli's itinerary through whiteness can be read as an allegory of deterritorialization, as a kind of homeless dwelling in the pure land of silence and light. Be that as it may, the following passages from a 1978 catalog statement (Max Hutchinson Gallery) will serve to suggest the telepathy between the artist and his white muse:

> "1 p.m., January 17, 1978. Communicated with Leon Battista Alberti. These are his words: 'Nothing pleases God more than white. . . . January 30. The birds are singing. There's grass on the ground and Kasimir Malevich is in my room. The conversation is likely to begin when Duchamp knocked at the door. . . .'"

Whereas both Donati and Savelli produce sophisticated modernist stylistic identities in terms of the New York experience, Corbino, Guglielmi, and Fasanella are painters of the Italian American experience. Born in Vittoria, Sicily, and brought to New York City in 1913, Jon Corbino received an art scholarship to the Ethical Culture School in New York City and then studied at the Art Students League in New York City, eventually serving as an instructor there for eighteen years. His work, mainly in oils, pastels, and color drawings, is basically representational, and he is regarded as an antitraditionalist whose work "energized the transitional period between realism and abstract expressionism." Unlike the cosmopolitan Stella, who encountered directly the Italian tradition of the new, Corbino's Italianness involves the translation of the myths and memories of his childhood in Sicily into an American idiom as evidenced by the evil eyes and red moons lurking ominously in the backgrounds of his paintings of turbulent catastrophes, flying horses, and ritualistic dancers. Like Stella, Corbino took as his first subjects workers who earned their living through physical labor. The iconography of the immigrant experience can be seen in his transplantation of the bodies of Sicilian peasants into the blue-collar laborers who people his socially conscious paintings executed during the 1920s and, in a different way, in the figures caught up in the maelstrom of his catastrophe paintings—earthquakes, hurricanes, and floods—of the 1930s, which recall childhood memories of the people he had seen struggling against the natural forces of the universe, particularly the traumatic experience of an earthquake he had witnessed in Sicily.

Two of his most acclaimed and widely reproduced paintings illustrating his

imagination of disaster are *Earthquake* (1936) and *Flood Refugees* (1938). A work that epitomizes the Italian American experience is the oil painting *Wedding Party / Sunday Picnic* (1939), which represents a Sicilian peasant wedding transplanted to an American park bench. Charged with energy and raw emotion, it disposes a whole gallery of animated guests sitting and standing *al fresco* around a table covered by a white tablecloth. At the head of the table stand the bride and a woman attendant, both in white, while the seated groom, dressed in a red shirt, encroaches upon the women's space. These figures are enclosed within a makeshift canopy that separates the genre scene from the background of the sea and the somewhat ominous sky. As "good Italian American painter," Corbino would finally take the Crucifixion as a theme, painting a series of them from 1949 onward. Another instance of his imagination of disaster, his Christ figure was depicted "as an existential symbol of alienation, looming above mourners in a compressed space or lowered from the cross in an expansive scene of pageantry," to use the words of the catalog for a 1987 retrospective exhibition at the Museum of Fine Arts in St. Petersburg, Florida.

Turning away from his apocalyptic paintings of cosmic catastrophe, which some critics have seen as a reflection of his traumatic uprooting as an eight-year-old child from pastoral Sicily and the immersion of his once prosperous family in the hard immigrant life of the Lower East Side, he began to paint circus riders and ballet dancers leaping and whirling through metaphysical space. In 1960 he moved to Sarasota, Florida, where he often painted the performers of the Ringling Brothers, Barnum & Bailey Circus during the winter. He received many distinctions, including a Guggenheim Fellowship; and in his 1964 obituary he was described as "one of the pioneers of American modernism."

Iceman Crucified: Ralph Fasanella As the Blue-Collar Primitive

> *We got caught in the money culture. We became Americanized and we forgot our own guys. You know, we had a lot of great people in Italy and we didn't hang our hats on them. Of course there are historical reasons—we're talking about a group of people who came here from southern Italy. They talked about Michelangelo and da Vinci and the greatness of Italy, but I don't think they knew how to read or write, and I think if they saw the da Vinci thing or any part of the Italian culture they wouldn't know what the fuck it was anyway.*
>
> —*Ralph Fasanella*

"This man pumps gas in the Bronx for a living. He may also be the best primitive painter since Grandma Moses." So read the headline of the 1972 article in *New York* magazine (30 October, 37) that first brought the painting of the entirely self-taught, then fifty-eight-year-old gas jockey to the attention of all of New York, the city whose neigborhoods and working life Ralph Fasanella (1914–1997) had lovingly celebrated since the 1940s. It is highly appropriate that his enormous, detailed, 9-foot-long mural *New York City* (1957) hangs in City Hall, on permanent loan from the artist. Like Joseph Stella, Fasanella is a poet of city life, but his New York City is not perceived through the lens of modernism. It is a city miniaturized and territorialized in terms of neighborhoods and recurrent sites (Catholic churches, baseball diamonds, gas stations, "Little Italys," and tituli—his paintings are filled with written words and signs). The geography of his New York is a fictitious composite, as in *New York City,* in which elements of City Hall and Union Square are superimposed onto Columbus Circle. Fasanella's New York is thus a heterotopia where various neighborhoods and zones are set into dialogue. Sometimes the spatial dialogue is drawn up along class lines, as in *Park Avenue* (1946), in which luxury buildings confront brick tenements.

His discovery is a New York story, one of the happy ones and quite the opposite of his father's, the neighborhood iceman who suffered the blue-collar "crucifixion" of hard work and self-sacrifice to the family. He would memorialize his father's agon in a pair of icons: *Iceman Crucified #1* and *Iceman Crucified #4*, painted in 1948 and 1958, respectively. In the first, his father is nailed to the cross with ice picks, and his head is pierced by a gigantic, scale-rupturing pair of ice tongs, his crown of thorns. Calvary is thrust inside to the hallway of a tenement house. A rough attempt at perspective in keeping with Fasanella's primitivism is achieved by receding lines of mailboxes and a series of frames: the outer frame of the brick tenement facade, and another frame within the lobby that holds the cross. The top half of the painting displays three vertical rows of windows of the indented brick tenement, weighing on the iceman and effecting his entombment. It is a brick version of Pietro di Donato's *Christ in Concrete* (1939), a suitable icon for the workingman as immigrant Christ. A second, and less tortured, version portrays his father as a younger man with his right arm draped around the cross and shouldering a huge bucket of ice held in place by his left hand. The ice tongs—again huge—no longer are affixed to his head but are made to support a box-like cabinet that holds the immigrant's sustenance: bread, wine, fruit, a newspaper that reads, "RUTH HITS 2," the implication being that baseball is also the immigrant's bread and wine. This wooden structure—an opened cabinet on one side, a closed door with a welcome mat before it on the other side—forms a back-

drop to the cross, another frame within the frame. On the left arm of the cross are placed a cup of morning *espresso* and an alarm clock; in place of INRI, near the top of the cross an inscription reads: "LEST WE FORGET." These elements suggest that the workingman suffers a slow crucifixion at the hands of the everyday grind. But since the crucifixion is set within a vital cityscape, the iceman's victimage can be seen to be integral to and generative of community life. Furthermore, the emptiness of the middle-class surburban community (to the right of the cross) provides a stark contrast to the vitality of the urban *communitas* linked to the crucifixion and of the populated stoop that grants access to the cross.

Fasanella is thus the great working-class painter of the Italian American immigrant experience as lived out in the "Little Italys" of New York City. His background is political: He drove a truck in the Spanish Civil War, and he was a labor organizer until his conversion to painting at the age of thirty. He embodies the progressive ethos of Fiorello La Guardia and, above all, Vito Marcantonio, to whom he dedicated two paintings, *Marcantonio for Mayor* (1955) and *Death of a Leader* (1954). His chronicling of working and political life in America is informed by working-class politics. (He is a cracker-barrel philosopher whose views on American politics and, as in his blunt statement cited in the above epigraph, the Italian American identity are lovingly recorded by Patrick Watson in *Fasanella's City* [1973], a richly illustrated presentation of his paintings and life story.) His is a blue-collar primitivism not to be confused with the Hallmark-card variety. As the curator Andrew Connors has commented:

> *A lot of people in the art world do not realize how integrated Fasanella's work is with the labor community. His paintings about labor and injustice portray the stuggle of powerless people to change their situations. His work shows a deep understanding of contemporary social issues (cited in Carroll, 1993).*

And here we must interrogate the political implications of primitive, or "folk," art as the discursive position for a minor-minority art. Fasanella takes politics as a primary theme, as evidenced by the Marcantonio paintings; *The McCarthy Period* (1963) and *Gray Day* (1963), the latter dedicated to Julius and Ethel Rosenberg, both paintings attacking the witch-hunting and Red-baiting of the early 1950s; *American Tragedy* (1964), a polemical response to the 1963 assassination of President John F. Kennedy originally called *The Tunnel of Lies;* and his eighteen canvases (begun in 1975) chronicling the "Bread and Roses" textile strike in Lawrence, Massachussetts, in 1912. The historian Peter Carroll has described this series "as a veritable history of the American immigrant labor experience, told with the

accuracy and detail of a historian." So in the postmodern period, when avant-garde art has been desperately seeking to maintain its oppositional function by practicing a politics of artistic forms, Fasanella, the blue-collar "natural," has succeeded in politicizing his paintings not only at the level of content, but also at the formal level for he has used the superceded—"regressive"—position of the primitive artist to produce a "minor" art, to paint otherwise, and therefore to go against the grain of the dominant artistic language of his time.

His masterwork, *Family Supper* (1972), at once a moving reminiscence of, and eulogy for, Fasanella's early family life, might serve as an emblem of Italian American painting. It stages the family history of the immigrant as a quotidian liturgy enacted within the *domus* (house), the tenement apartment being represented as a displaced Catholic church. As Stella employed the polyptych altarpieces of traditional Italian churches as a model for *New York Interpreted,* Fasanella structures his painting of the family at table as an altarpiece, framed by brick tenements. The three walls of the kitchen-dining room form a proscenium that displays to the viewer the daily sacrament of the family supper—the present course is dessert, as indicated by the cups of ***espresso*** and the pastry tray holding *cannoli*. The supper is administered by the solemn, dark-haired mother, who sits at the head of the table surrounded by equally solemn children and a grandmother. The figure of the mother is enlarged as in medieval painting to indicate her significance. The iceman father is not physically present. The room as sanctuary is framed on all four sides by the red bricks of the tenements: The ceiling projects out as a canopy topped with an oval line of red bricks and is superimposed over New York tenements replete with cisterns; the two sides are lined with thin strips of tenement windows that show occupants and that resemble the rows of medallions often placed on the sides of altars; the whole construction rests on a miniaturized row of Italian food stores.

The family scene is scaled at least five times larger than the framing elements to show the importance of the *domus* for Italian American life. Within the sanctuary of the home are two consecrated areas. On the back wall superimposed over the seated mother's head is a figure of what might be called the "madonna of the clothesline," for her aura is traced by the lines of clothes draped around and through her arms. This figure of a housewife Madonna, flanked by a coin-operated electric meter and a gramophone, is obviously an idealized double of the mother who sits at the table. On the right wall hangs a version of the previously discussed *Iceman Crucified,* which has a calendar appended to it. These two icons represent Fasanella's mother and father as household saints: They are blue-collar devotional images.

The Madonna figure, who comforts two children standing on green chairs, is portrayed as the Misericordia (the Virgin of Mercy). Her domain is the *domus,* which she keeps in immaculate order in the Italian fashion. The flatness of her portrayal suggests a painted icon, but since she stands atop a dresser her figure also suggests a living statue, an altarpiece or shrine set within the larger altarpiece of the painting itself. She is superimposed upon a cross and a larger field of bricks, while the neighboring tenement's wall is made visible through the room's mostly transparent back wall. The intrusive neighbors are thus made privy to the family scene. In other words, we are dealing with a complex and sophisticated set of mirror constructions that brings us to the heart of Fasanella's art of miniaturization. The altarpiece on the back wall, dedicated to the "Madonna of the clothesline," is a mirror construction of the larger scene depicting the supper, as is the image of the *Iceman Crucified* calendar hanging from the side wall. In this version of the *Iceman,* the cross is actually placed on an ice bucket resting on a church altar, where it is flanked by two chalices. That the absent father is made present to the family through a calendar is both a commemorative image recording the workingman's Passion at the hands of the hard time of work and a sign that the liturgy of everyday life is to be enacted in terms of the absent father.

What is being represented here? The painting was originally named the *Last Supper,* and it contains two tituli: "In Memory of My Father Joe: The Poor Bastard Died Broke and to All 'Joes' Who Will Die Same—Broke." is inscribed on an ice bucket in the foreground, and the omnipresent motto—LEST WE FORGET—is affixed to the red-brick canopy at the top of the painting. Fasanella has represented in this autobiographical scene an immigrant version of the American Tragedy in terms of the traditional Catholic codes by which the immigrants brooked the suffering of blue-collar existence. It is all a question of the *domus:* the present mother as Madonna of the *domus,* as strong keeper of the family; the absent father as martyr for, and of, the family, as blue-collar Christ of sixteen-hours-a-day work, now appropriately enshrined in a wall calendar. The painting conceived as an altarpiece sided with brick is both a commemoration of *la sacra famiglia* (the Holy Family) and a pro memoria for the daily sacrifices at the heart of immigrant life. It is fitting that the painting should rest in the Ellis Island museum, where Fasanella, upon presenting it in 1991 to the American people, said, "I became an immigrant again."

O. Louis Guglielmi, Italian American Surrealist; Conrad Marca-Relli,
Italian American Abstract Expressionist

Another painter who comes out of the immigrant experience is Osvaldo Louis Guglielmi (1906–1956), a surrealist who, along with Jospeh Stella and Fasanella

(the filmmaker Martin Scorsese might also be included), is one of America's canonical artists of city life. His New York City, however, is not the dynamic, polyrhythmic metropolis celebrated by Stella or the congested, canny "big neighborhood" miniaturized by Fasanella. His is the city abstracted, emptied, silenced, excavated, defamiliarized in the manner of de Chirico but with desolation replacing the melancholy of the metaphysical painter. Born in Egypt of Italian parents, Guglielmi moved with his family to New York City in 1914 when he was eight years old after a peripatetic existence in Europe, the result of his father's touring as a concert violinist and violist. He grew up within the poor ghetto of Italian East Harlem, an experience that would permanently mark his work and outlook. His work emerges from the political matrix of the Depression, when he worked on the Work Projects Administration's (WPA) Federal Arts Project in the 1930s, and he would establish himself in the late 1930s as a leading figure in the social surrealist movement, attributing his genesis as a socially conscious artist to the critical spirit of those times. His paintings are critical commentaries on the "age of anxiety" as it extends from the Great Depression through the war years, and although he sometimes directly represents the economic problems of the underclass, as in *The Relief Blues* (1938), he is primarily concerned with rendering the alienation of individuals caught up in the inhuman metropolis, as in *The Tenements* (1939), which depicts caskets strewn in the streets. Although his work from the mid-1930s to the early 1940s is indebted to precisionism (also known as cubist realism), it is as a surrealist that he makes his mark. He came to his surrealism primarily through the Italian connection—the metaphysical school of Carrà and and de Chirico—although the work of René Magritte also exerted a strong influence. Guglielmi's surrealism, however, was not concerned with generating a hermetic dream world of private symbols; rather, it was a political means of interrogating the reality of the capitalist city and of reproducing its tragedies of isolation through surrealist techniques of estrangement. Two early paintings, *The Church of St. Vincent de Paul* (1930) and *Nocturne* (1931) are infiltrated by absences. In the first, as Peter Conrad points out in *The Art of the City: Views and Versions of New York* (1984) "the Gothic quirks of the spire on West 23rd Street are partly obliterated by the bare rectangle of an office block. The shrine is stamped out by an empty box." In the second and more politically charged canvas, the intrepid navigator on his column in Columbus Circle gazes blankly at the anonymous, equally blank General Motors Headquarters, an acute diagnosis of immigrant alienation if the statue of Columbus is read as an ethnic figure and a prefiguration of the failure of communication that will dominate his later paintings.

Of these, *Terror in Brooklyn* (1941) is his most famous image. It represents a desolate suburban street with three terror-struck figures in black imprisoned within a bell jar; their howl, perhaps caused by the sight of the bones of a human pelvis suspended by bright ribbons across a blank wall, is also trapped within their glass prison, forever muffled. The empty street recedes to infinity, in the manner of those unending surrealist alleys. On one of the buildings lining it, a sign reading "Real Estate" appears. The painting is an urban version of the Lamentation, with the victims and the Victim (Christ) caught in a drama in which nothing connects. The viewer's senses are estranged by being forced to "see" the strangled howl that reaches no one outside the bell jar. Conrad, the most sensitive interpreter of Guglielmi's city art, maintains that this silencing is also at work in his paintings of the Brooklyn Bridge, the very same bridge on whose cables Stella and Hart Crane had played their rhapsodies: "[Guglielmi] whose father was a violinist, finds the bridge catatonic, and its muteness is a sonic symptom of the death abstraction brings to the city" (245). Of his paintings that treat the Brooklyn Bridge, none are more demythologizing of the great "altar and harp" (Hart Crane) than *The Bridge* (1942) and *Mental Geography* (1938).

Unlike Stella, who views the bridge anthropomorphically, placing his viewer-pedestrian within its central passageway, as if it were the nave of a Gothic cathedral, Guglielmi in *The Bridge* represents the structure, reduced to a single tower with its cut-off span extending beyond the painting's frame, from below and from a side angle, a warped viewpoint that emphasizes its inaccessibility, which is the theme of the painting. Suspended from the tower is a damaged, dampening violin mute, a surrealist visual pun on the "bridge" of a musical instrument. In the scene unfolding below, a human figure metamorphoses into a violin and extends his hand to embrace like Orpheus the inaccessible object of desire looming above, forever eluding his possession. To the violin man's right, underneath the span and in its shadow, stand two workmen who view the bridge in the pragmatic terms of repair, as indicated by a twisted ribbon-like sash sagging from the span. To their right is a strange wood structure from which another, much smaller mute dangles.

Can Guglielmi's surrealist scenarios of estrangement, as typified in *Terror in Brooklyn* and *The Bridge,* be read as allegories of immigrant estrangement? Certainly a painting like *The Bridge,* which introduces the paternal emblem of the violin and construes the great American icon as a musical apparatus that refuses to be played, may be seen in such terms. Perhaps more indicative, though, is Guglielmi's turn to abstraction—albeit the abstraction of surrealism, which still holds to the referent—to represent the alienation of Depression and wartime urban experience, for by occupying the enunciative position of an "officially" mi-

nor artistic language (the minor-minority position of the modernist avant-gardes is staked out within and against the domain of major art and, despite its protests to the contrary, remains a function of "major" Western art, as evidenced by its almost immediate canonization and consumption by the art world), Guglielmi inscribes his own ethnic marginalization within the codified language of surrealist estrangement. Thus, unlike Stella and Fasanella, who paint explicitly as Italian Americans, Guglielmi may be regarded as a strong painter of weak ethnicity.

A different way of painting as an Italian American is embodied in the work of Conrad (Corrado) Marca-Relli (1913–), a mainstream modernist. Born in Boston of Italian parents, he studied briefly at Cooper Union in New York City, but is mostly self-taught. Since 1930 he has lived and worked in New York City, where he was influenced by DeKooning and Pollack. His mature work can be seen to unfold within the ambit of the New York school of abstract expressionism although, as Arnason points out, his highly personal style—more figural than abstract, more classical than expressionist—makes his inclusion somewhat anomalous. His Italian connection, which resulted from his numerous trips to Italy, is perhaps most evident in his early mature works of the 1940s, which represent circus life and Italian Renaissance architectural motifs in the manner of the metaphysical school of de Chirico, Carrà, and Morandi. In the late 1940s, Marca-Relli turned to collage and has since become one of the American masters in this medium. Harold Osborne, an authority on modern art, has given this account of his career:

> *He came to prominence in the 1950s as one of the second wave Abstract Expressionists, developing a highly original and dramatic technique of collage painting. Cutout shapes of painted canvas were attached to a canvas ground in expressive combination with a black glue which served to outline their forms. During the 1960's he experimented with novel forms of relief painting and constructions which had much in common with the more objective and reserved manner of Post-Painterly abstraction. (353)*

Multiple A B C D (1969) is a good example of such constructions, especially in its more sculptural collage achieved by the use of materials strapped together, the holes of the joints emphasizing their status as reliefs. The influence of Burri's collage technique can be seen in the use of simulated wood and remnant fabric. Marca-Relli's Italianness, then, is primarily reflected in the dialogism he maintains with the Italian "tradition of the new"—especially de Chirico, whose mannequins influenced Marca-Relli's collage painting of the 1950s—and his bridging of American abstract expressionism and its Italian counterpart.

Frank Stella: Abstraction Blooded

> *What gives Mondrian and Pollack the power they have is the strong link through Manet to Caravaggio. Mondrian and Pollack have "real" pictoriality; they acknowledge the spatial fecundity and compelling image manipulation with which Caravaggio began modern picture making. This acknowledgement gave the painterliness, color, and surface manipulation that Mondrian and Pollack had inherited that added dimensions needed to make these effects useful to abstraction. It is the legacy of Caravaggio's space and Caravaggio's illusionism that tipped the scales decisively in favor of abstraction by the middle of the twentieth century.*
> —Frank Stella, Working Space, 1986

Frank Stella, born in 1936 in Malden, Massachusetts, and educated at Phillips Academy and Princeton University, is the greatest of the Italian American painters and, as chief exponent of minimalist painting and its attempt to go beyond abstract expressionism, one of the dominant figures in contemporary American art, destined to enter history as the "paradigmatic post-painterly painter," to use Irving Sandler's formula. He exploded onto the New York scene in 1959 when he exhibited at MOMA (the Museum of Modern Art), as a member of the Sixteen Americans show, his notorious quartet of black pinstripe paintings. These black paintings represent a reduction of painting almost to a zero degree in order, as Stella explained, to "eliminate illusionist space" and to demonstrate that painting is "a flat surface with paint on it—nothing more." Stella's famous "what-you-see-is-what-you-see" statement is worth considering, for it illuminates the literalness he aimed for:

> *I always have arguments with people who want to retain the "old values" in painting—the "humanistic" values that they always find on the canvas. If you pin them down, they always end up asserting that there is something there besides the paint on the canvas. My painting is based on the fact that only what can be seen is there. . . . If the painting were lean enough, accurate enough or right enough, you would just be able to look at it. All I want anyone to get out of my paintings, and all I ever get out of them, is the fact that you can see the whole idea without any confusion. . . . What you see is what you see.*
> ("Questions to Stella and Judd," Art News, September 1966: 58–59)

Beginning with the black paintings, he goes on to make a series of incredibly bold moves: the series of aluminum and copper paintings and other "shaped

canvases," those L's, T's, U's, and the various geometric figures through which the traditional rectangular form of painting was deconstructed, then the extraordinary explosion of color in the Protractor series (1967–1968), and finally the overall transition from minimalism to maximalism as seen in the Polish Village series (1971–1973) and the exuberant *Shards*. All of these moves are in keeping with his conception of the strong painter's persona: "The idea of being a painter is to declare an identity. Not just an identity, an identity for me, but an identity big enough for everyone to share in." Concerning the Italian connection: In the Charles Eliot Norton Lectures he delivered at Harvard in 1983–1984 (published in 1986 as *Working Space*), Stella, inspired by his recent experience in Italy, undertook an extraordinary reading—at once retrospective and prospective—of the history of Italian Renaissance and baroque art. In the crisis of late-sixteenth-century Italian art—how are the belated artists of the baroque to go beyond their great high-Renaissance precursors?—and in Caravaggio's resolution of that crisis through the construction of a more "real" space, Stella finds a pertinent model for contemporary abstract artists, who, faced as they are by the "anxiety of influence" caused by having to work in the wake of the great late-modern abstractionists, must find a way of constructing a new pictorial space. And Stella's series of *Shards*, begun in 1983, is clearly an attempt to demonstrate this thesis: "learning from Caravaggio," as it were. In other words, those painters working as late-modernist abstractionists need to "make painting real"—like the baroque painting that flourished in sixteenth-century Italy.

Stella's appropriative Caravaggian trope is a postmodern version of the more staightforward dialogism of Joseph Stella and Marca-Relli and, in some sense, comparable to the ironic dialogue with the Italian tradition established by the architect Robert Venturi, who as "the father of postmodernism" occupies a position within the discipline of architecture similar to that of Stella's within painting. Whether we can go further by applying the category of weak ethnicity to his complex nonfigurative work and his persona as strong and self-celebratory artist is questionable. Charles Altieri in his essay, "Frank Stella and Jacques Derrida: Toward a Postmodern Ethics of Singularity" (1994), has provided us with the most rigorous reading of Stella's project and its implications for a politics of identity. His conclusions are worth considering:

> . . . *Stella establishes a rich deconstructive tension making visible and irreducible the competing claims on the artist of the high-cultural traditions and of populist resistance to those traditions. His insistence on house paint, on machine-made forms, and on refusing all decorum flaunts any*

> *model of sensibility and of judgment based on cultivated taste. Yet this takes place with such insistently inventive and excessive abstraction that Stella's project cannot be thematized in politically correct terms: Stella's is a populist individualism wary of all group identifications, because with the group come external principles of judgment and authorized allegories to which the arts are expected to conform.* (182–183)

In some sense, the missing subtext to this description is that of Italianness: What you see is what you get (to rephrase) is the credo of the pragmatic Italian *bricoleur* who, despite the supreme fiction of abstraction, is concerned with the materiality of painting, and Frank Stella's notion of the strong artist is the ultimate installment of that artistic disaffiliation initiated by Joseph Stella, who refused group alignment, and more generally an expression of the anarchic and exorbitant cultural self that this volume seeks to anatomize. To introduce such a subtext, however, would be to impose a politics of identity upon an artist who is concerned with articulating an empowering and affirmative view of art that is grounded in our "postmodern condition" and thus incorporates within it the destabilization and deterritorialization of identity.

Differential Identities: Postmodern or Weak Ethnicity and Allegories of Italianness
The third and fourth generations (counting from Joseph Stella) of Italian American artists features, in addition to Frank Stella, a number of interesting figures who come onto the scene in the 1960s and 1970s and who define themselves primarily in American terms. Among the most significant in the genealogy are the following: Robert De Niro Sr. (1922–1993), a student of Hans Hoffman who practices an improvisational and passionate approach to painting (De Niro is the father of the famous actor); pop artist Allan D'Arcangelo (1930–); Californian John Baldessari (1931–), a conceptual artist and exponent of Story Art, notorious for his Duchampian gesture of 1970 in which he destroyed thirteen years of his own accumulated work and had the remains cremated in a mortuary, an artistic auto-da-fé he imposed on himself as a radical refusal of the "aesthetics of boredom"; abstract photographer Paul Caponigro (1932–), the Italian-born but now SoHo-based pluralist Lucio Pozzi (1935–); performance artist Vito Acconci (1940–); New Imagist Nicholas Africano (1948–); and Robert Longo (1953–) whose art has been described by H.H. Arnason, in *History of Modern Art* (3d ed., 1986), as "'apocalyptic Pop,' huge 'salon machines,' made of over-lifesize imagery appropriated from or inspired by film, television, comic books, and advertisements, a secondhand world of kitsch and high culture mixed and matched to provoke voy-

euristic responses to such elementary, interrelated themes as love, death, violence."

I have deliberately played out the facile game of labeling artists according to stylistic affiliations to suggest the way in which these postmodern artists are integrated into the American art scene. Allan D'Arcangelo's pop art, which takes the great American highway as its primary subject, is perhaps the most emblematic of the postethnic positions taken by most of these contemporary Italian American artists. D'Arcangelo, born in Buffalo, New York, had his first exhibition in New York City in 1963, by which time pop art was firmly established. He executed a series of hard-edge, boldly colored paintings fixated on highway and faster-than-a-speeding-automobile imagery, billboards, and route and speed-limit markers. The technique of repetition with variation governs a good part of his oeuvre in keeping with pop aesthetics, but it also is employed as a formal device in specific series of highwayscapes in which variations are employed cinematically to create an impression of a changing roadscape as perceived by an advancing driver. For example, in the four-frame *June Moon* (1963), D'Arcangelo takes the white-lined highway as his theme, showing how the road sign appears as a driver moves across the country; the moon is gradually usurped by a Gulf sign in a way Marinetti would have applauded. Critics saw these experiments as important extensions of pop iconography—his experiments with the pop architectural landscape and road signs would influence Robert Venturi—but because these works often placed the spectator in the position of the driver and imposed the question of tridimensionality, they were perceived as violations of pop two-dimensionality. Nicolas Callas, the art critic most attuned to D'Arcangelo's pop experimentation with perspective, explains how D'Arcangelo "makes of the vanishing point the polar star of the speeding driver" and how he ultimately "breaks the hold of perpective by a strict adherence to the driver's code."

The success of the highway formula proved a mixed blessing to D'Arcangelo, trapping him in his pop-artist identity of the 1960s when his work is more varied than that. One need only consider the political content of his work executed around 1968, which involves protest for civil rights and against the war in Vietnam, as well as his later work, which is concerned with the relationship between reality and appearance as presented by the American industrial landscape. An example of his protest work is the 24-foot caricature of President Lyndon B. Johnson that D'Arcangelo attached to the Bad Humor Poets' Truck, which, as part of the Angry Arts Festival of 1967, was stationed around New York City in order "to harangue the populace." Although his political concerns place him in the genealogy leading from Stella through Fasanella and Guglielmi to the sculptor Mark di Suvero, his painting does not disclose Italianness

and remains rooted in the pop adventures of the great American open road.

Of these later-generation artists, the two most interesting with respect to Italianness are Lucio Pozzi and Vito Acconci, both of whom are provocateurs. Pozzi was born in Milan in 1935 and has lived in New York City since 1962. Notwithstanding his American citizenship, he remains profoundly bicultural in his artistic identity—or perhaps, given his commitment to diversity and his dislike of rigid polarizations, a citizen of the inbetween, permanently deterritorialized and always in search of difference. He is celebrated for his lectures in Patchameena, his imaginary (nonsense) language, and for his day-long performance piece, *Paper Swim*, in which, dressed as a Duchampian diver, he navigates under a sea of paper, emerging at calculated intervals to mark blank paper with cryptic black signs. Pozzi defines his art as research that uses his understanding of painting as the means of exploration. This is perhaps another way of saying that he is a strong conceptual artist who remains profoundly dedicated to pure painting. "Painting has been my passion," Pozzi avers, "so I have used painting as a matrix to explore many ways of existence and various questions about communication in the modern world."[2]

Pozzi's intellectual formation is essentially Italian, and he traces his method of thinking to the Italian theoretical tradition: Lucretius, Giordano Bruno, whose cosmic view with authoritative openings is a model for Pozzi's relativism, and Vico. His ideological formation is indebted specifically to Antonio Gramsci, the Italian Marxist and revolutionary, as well as the Italian anarchist tradition, and he often directly introduces political content into his works. For example, his photographic installation *Pink Eye* (1976) consists of a photograph of a spectator, a man with hands in his pocket and whose eye Pozzi has painted pink, watching policemen beating a man who raises his hands to fend off the blows. (The unidentified photograph documented an event that had actually taken place in Soweto, South Africa.) The photograph is "witnessed" by portraits of pacifist and political leaders, such as Gandhi, Marx, and Rosa Luxemburg, whose eyes have been cut out and and relocated on an adjacent wall from which they gaze at the portraits. The viewer's gaze is relayed into "eyewitnessing" the piece through this system of blind spots, gazes of faceless eyes, and the pink eye of the spectator in the photograph. This installation works as an elaborate apparatus to politicize the act of spectatorship. The Italian philosophical tradition as delineated above provides the theoretical ground for Pozzi's "pluralism," to use a term that is in some ways inadequate to describe the nomadism of his thinking, which is at once concerned with the artistic process ("I, for one, am inclined to think that the shifts of the mind, and not the forms, techniques, and subject matters, might turn out to be the prime substance of art in our time") and cut with American pragmatism. He

also acknowledges the importance of Italian painting, especially futurism, for his figurative painting. Pozzi's "pluralism," a term that can also serve to describe his identity politics and his endless drifting between European and American personae, involves constant bordercrossings. As he puts it, "The linkage of incompatible data has guided me in all my activities, from theatre to painting (how much to stress the theatrical in painting or the painterly in theatre?) to writing and to every other possible field I've tried to approach."

Pozzi's stylistic nomadism is always undertaken in the name of "research"—a term he uses to displace "avant-garde," a position he regards as having been institutionalized as an "academy of transgression"—and to stake out his own attempt at the regeneration of art that goes against the grain of both the "academy of conservatism" and the "academy of the avant-garde." This nomadism has led him into many areas: from paintings on canvas to constructions, watercolors, collages, videos, installations, performances, and a vibrant series of *Rag Rug* paintings. The latter testify to an extraordinary encounter between a sophisticated postmodern artist and the most "homemade" of traditions. Tiffany Bell has written of them:

> The Rag Rugs *are non-representational paintings which Pozzi began making in 1988 as almost incidental works. Named for rugs woven from scraps of material, they were originally made from the paint that was left on Pozzi's palette at the end of each day. Whatever the colors, they were applied with a palette knife in sections of thin rows. The result is a textured patchwork of many colors that blend together in a shallow space. (Lucio Pozzi [1990: 12, 16])*

Pozzi regards these works as a metaphor for his entire working process since they literally recycle the remnants of his previous paintings into a new whole. For an artist who maintains that his paintings cannot be distinguished as "abstract" or "realistic" because they are not linked by these kinds of formulas, it was only natural that he would elaborate a philosophy of simultaneous composition that would account for the practice by which certain artists, including himself, pursued different and contradictory styles at the same time and even worked on two or more stylistically different paintings simultaneously. Borrowing a term from computer jargon, he has called this practice "concurrency," thereby giving definitive form to the pluralism that had characterized his work from the start.

Vito Acconci, born in the Bronx in 1940, began his career as a conceptual artist as an innovative poet who was concerned with the notion of the page as a material space to be traveled over by the writer and, in turn, by the reader. For example, his *Book Four* (1968), self-published in photocopies, begins with a page

· 533 ·

that reads at its upper left: "(It stopped back.)," followed by a blank space that leads to an inscription at the lower right: "(This page is not part / of the four books / and is at the top)." He then shifted his focus from page ground to actual space, the occupation and traversal of which constituted a kind of writing with the body's movement. This concern with spatial writing—the questions: Why am I moving? Why am I in real space?—led him to his first performance pieces, executed in the late 1960s. Typical of them is *Following Piece* (1969), a performance played out on the streets of New York City. Acconci would follow, or "tail," a person chosen at random for various periods of time. Once decisions of time and space were thus abrogated, the artist would be dragged along and even be abducted by the stranger. In the early 1970s, his work again shifted, becoming focused on his physical person. Acconci describes these self-concentration pieces in this way: "How do I show people that I've concentrated on myself? One obvious way is to do something physical to myself, to create some stress that my body has to adapt to, react to." At the heart of these self-attack pieces was an attempt to short circuit the conventional art *transaction*—"from the doer through art object to art receiver"—by establishing direct and immediate contact with the viewer. *Untitled Project for Pier 17* (1971), a piece enacted in an abandoned warehouse pier in downtown New York City, is representative of Acconci's attempt to call into question the conventional roles of artist and viewer. When the artist encountered a person on the pier, he divulged secret information about himself, giving his "spectator" material for blackmail. He would then seek to barter for silence, establishing a bargain between himself and the spectator—a trans-action. This scenario can be construed as a sinister version of the confessional exchange. Also in this vein is *Claim* (1971), another person-to-person, face-to-face piece that raises the question of territoriality. The blindfolded artist, seated in a chair in a basement and armed with a crowbar, talks to himself, staking claims to his territorial solitude. The viewer qua performer, upon entering on street level, is confronted by a video projecting the artist's minatory performance and must decide whether to descend and to risk encroaching upon the artist's space, which is defended with real violence.

 The most scandalous of these confrontational pieces that seek to implicate the audience in deranging scenarios is *Seedbed,* which mixes installation with performance and was first presented at the Sonnabend Gallery in New York City in 1971. The visitor entered the gallery only to find an empty space, punctuated only by a stereo speaker: The action was clearly elsewhere, in the "other scene" being enacted furtively by the artist who lay hidden under the hardwood floor. Midway through the room, the floor became a ramp inviting the visitors to walk up it,

thereby performing the public part of the scenario. The tracery of their footsteps became the psychological triggers of the desire of the artist who, hidden under the ramp, committed the most private of acts (masturbation) while broadcasting through a microphone hooked up to the speaker the sexual fantasies he was constructing on the basis of visitors' movement. This is the most dangerous of performances not simply because of its shock effect, but also because it involves a radical psychic rewiring of public and private space, of the real and the imaginary. Of course, critics are correct in reading it as a transgressive act linked to his Catholic formation Jesuit-style in a tough New York City Catholic high school. As a staging of Onan's scenario, it is reminiscent of the illicit and unrepeatable anecdote with which the great filmmaker Buñuel characterized the "spiritual exercises" of autoeroticicm. Moreover, Richard Kostelanetz in his *Dictionary of the Avant-Gardes* (1993) is on the mark in interpreting Acconci's overall project as the making of a "Catholic art concerned with abnegation and spiritual athleticism." On the other hand, all of the themes associated with Italianness throughout this volume seem to come into play in Acconci's art, albeit forced to an avant-garde extreme: the body—maculate and immaculate—territoriality; performance as self-display; the confounding of public and private; violence, be it profane or sacred; and exorbitance.

Seedbed is clearly a limit-work, and Acconci would soon begin to excise himself systematically from his work, turning to pieces that were viewer activated—no longer neurosis inducing—and ultimately to public art, where his transgressiveness is transformed into playful subversiveness. By way of concluding and of activating the great Italian American topos—the *domus*—I focus here on Acconci's relatively recent pieces involving houses. In *Instant House* (1980), the "inhabitant" activates the house by sitting on a swing: The weight forces the four panels that form the floor and depict an American flag to rise up to become the walls of the "instant house," the outside walls depicting a Soviet flag. *House of Cars* (1983) is an apartment complex made of used cars that have been gutted and welded together. *Bad Dream House* (1984), a house made up of three upside-down houses, carries forward the interrogation of architectural dwelling begun in *House of Cars* by subverting and quite literally "overturning" the conventions attached to our notion of a home, producing, in effect, a schizo house. This disruption of the American fantasy network is also at play in a more recent taboo-breaking work, his *Adjustable Wall Bra* (1990–1991), an installation comprising four huge plaster, canvas, and steel-cable-reinforced structures. Once again an intimate and unmentionable object is exposed and expanded into a monumetal public spectacle. In a review for *Artforum* (Summer, 1981), A.M. Homes has noted how this installa-

tion combines Acconci's concerns with the body and with the home, creating, in effect, a "home for the body." Here we are iconographically far away from Fasanella's "Madonna of the clothesline," but still within the fantasy—adjustable—of the Madonna of the *domus*.

The Daughters of the Daughters of the Daughters of Artemisia Gentileschi:
Italian American Woman Artists
This mention of the madonna of the domus and the problem it conceals—the role of woman as image or model rather than artist—leads us to the question of Italian American woman artists who are in the process of emerging and establishing their own forms of self-representation. In searching standard surveys such as Charlotte Rubinstein's *American Women from Early Indian Times to the Present* (1982) and *Making Their Mark: Women Artists Move into the Mainstream, 1970–85* (1985) the catalog of an exhibition curated by Randy Rosen, I have found only two women of Italian descent who figure prominently: the sculptor Concetta Scaravaglione (1900–1975), the child of poor Italian immigrants from Calabria who rose from the culture of poverty to carry out important public commissions and to win critical acclaim for her *Girl with Gazelle* (1936); and Linda Montano (1942–), a performance artist.

Scaravaglione's career is indicative of the obstacles confronting second-generation woman artists. Her immigrant family at first opposed her desire to go to art school, thinking a career as a stenographer to be a more viable choice. Eventually they relented, but she had to interrupt her education to take a job in a perfume factory to earn money to pay for her tuition. On the other hand, her persistence enabled her to fulfill the American Dream, and Charlotte Rubenstein regards her career as a reflection of "the new opportunities opening up to people of all ethnic backgrounds in the United States." She was extremely proud of her Italian origins and even attributed her feeling for the human form to her early experience in the crowded ghetto: "My eyes were feasted all day. I sincerely believe that this constant rubbing of elbows with a moving army of people gave me a knowledge of the figure and the movements of the body."

Montano, two generations removed from Scaravaglione, occupies positions typical of her generation's search for a "woman-centered aesthetic"—feminist art, performance, and body art. Exemplary are her performances—private rituals of sorts—in which she commemorates and exorcizes her grief over the early death of her husband, Mitchell Payne. She regards these performances as "mourning, not art." In his essay in *Making Their Mark* (1985), Thomas McEvilley sees her introduction of autobiographical and personal elements into performance art as

"subverting the male emphasis on pure form and transcendence of personality."

A generation of promising artists emerged in the 1970s and 1980s, in the midst of the women's movement. Among them are Natalie Mariono D'Alessio, Joy D'Andrea, Elisa D'Arrigo, Donna De Palma, Lenore Papaleo-Vitrone, Linda Salerno, and Roseanne Sassano. An account of their work remains to be written. Perhaps one or more of them will attain the status of Artemisia Gentileschi (1593–1652), an important Renaissance painter and a portrayer of powerful and active women.

The Sons of the Sons of the Sons of Michelangelo: Italian American Sculptors

> *I have nobody to help me out. I was a poor man. Had to do a little at a time. Nobody helped me. I think if I hire a man he don't know what to do. A million times I don't know what to do. A million times I don't know what to do myself. I never had a single helper. Some of the people think I was crazy and some people said I was going to do something.*
>
> *I wanted to do something in the United States because I was raised here, you understand? I wanted to do something for the United States because there are nice people in this country.*
>
> —Sam Rodia

The history of the Italian contribution to American sculpture extends from the sculpture created for the U.S. Capitol Rotunda by the emigrees Enrico Causici, Antonio Capellano, and Luigi Persico between 1825 and 1844 to the contemporary work of Mark di Suvero (1933–), who is considered one of America's foremost monumental sculptors. It extends from the anonymous and poor "sculpture" executed by the generations of stonemasons and bricklayers who peopled the American building trades—those "Christs in concrete" celebrated by di Donato in his 1939 novel dedicated to immigrant laborers—to the signature styles of the Italian-trained sculptors Attilio Piccirilli (1888–1945), whose patrons included John D. Rockefeller and the Harrimans, Constantino Nivola (1911–), who studied under Marino Marini, and the American-trained Beniamino Bufano (1898–1970), Concetta Scaravaglione, Peter Agostini (1913–), and Harry Bertoia (1915–1978). It extends from the neoclassicism of the Capitol sculptors, who applied that style to represent themes of American popular mythology, and the traditionalism of Piccirilli and Bufano to the abstract work of Nuvola, Agostini, and Bertoia and such experimental works as the store-window mannequins of the hyper-realist sculptor John De Andrea (1944–). It extends from the primitive assemblages of Sam Rodia (Simon Rodilla, 1879–1965; his name also appears as Sabato Rodia, and both "Sam"

and "Simon" may be anglicizations of "Sabato"), the immigrant tile setter who single-handedly constructed the Watts Towers in Los Angeles, to the sophisticated monumental assemblages executed in the 1960s by di Suvero, who used beams, tires, chairs, chains, and other scrap from demolished buildings and junkyards, contributing to the adventures of Junk Art. It extends from the naive earthwork of Baldassare Forestiere, the "human mole," who created what has been described as "a ten-acre subterranean maze of curving passageways, rooms, courtyards, patios, and grottoes" beneath his property in Fresno, California, to the ironic and conceptually informed site sculptures and earthworks of Walter De Maria (1935–).

Most of these sculptors have produced works—monumental and antimonumental—that have deeply affected American public space: for example, Piccirilli's *Fireman's Memorial Monument* (1912) on Riverside Drive in New York City and his glass panel, *Youth Leading Industry* (1936), for the International Building in Rockefeller Center; Bufano's monumental work located in San Francisco (the controversial cast granite statue of St. Francis, located in Fisherman's Wharf, and his *Sun Yat-Sen* [1939], located in St. Mary's Plaza); Bertoia's sculpture screen (1956) for the U.S. Department of State and his fountain sculpture (1967) for the Philadelphia Civic Center; Nivola's mural for the Olivetti showroom in New York City and his thirty-five sculptures for the Saarinen dormitories at Yale University; di Suvero's series of outdoor, environmental sculptures for the five New York City boroughs; and De Maria's famous Dia-sponsored permanent installations, *Broken Kilometer* (1979) on West Broadway and *The New York Earth Room* (1977) stashed away in a loft in SoHo.

Some of them have elaborate political histories. The pacifist Bufano, as the story goes, cut off his finger and sent it to President Woodrow Wilson in protest of World War I. Nivola left his native Sardinia in 1939 to escape to the fascist regime. Piccirilli's reliefs for the Palazzo D'Italia, the south wing of the International Building on Fifth Avenue in New York City, were removed in 1940 when the United States was on the brink of war with Italy and anti-Italian sentiment was rampant. Di Suvero, a political activist who built the Tower of Peace, a 60-foot pylon, in Los Angeles in 1966 (Frank Stella, along with 400 artists, also contributed to this antiwar monument), exiled himself in Venice to protest America's involvement in the Vietnam War.

Two of the sculptors have the makings of genuine Italian American folk heroes: Bufano and Rodia. Bufano, who was born near Rome and whose family immigrated to New York when he was three, is the embodiment of the eccentric, work-consumed artist, indifferent to personal appearance and social conventions but deeply committed to the cause of permanent peace. His life and work have

been documented by Randolph Falk in a well-illustrated monograph (1975), the photographs in which capture the physical expressiveness of the at-work, at-rest artist, who was the model, as the story goes (Bufano was a great teller of Bufano stories, as Falk makes clear) for the Indian on the front of the buffalo nickel, designed by his teacher, John Fraser. Bufano moved to California in 1915, settling in San Francisco, an appropriate place given the Franciscan spirit that pervades his art and life. Indeed, St. Francis was a recurrent subject of his monumental sculpture, and he dreamed of covering Yosemite's El Capitan with a mosaic of St. Francis. His Franciscanism is at work in his small-scale figures of gentle animals; in his pacifism, which is thematized in such works as *Hand of Peace* (1967) and the *Monument to Peace* (1969) at Timber Cove Inn, 90 miles north of San Francisco; and in his embrace of poverty. His antimaterialism is the subject of his mosaic *Dollarocracy* (1965), depicting a bloated Pluto, and a leitmotif of his life: Bufano's money consisted of his sculptures, which he bartered for essential services and his modest needs. Bufano was found dead in his San Francisco studio, as the story goes, with $12.75 in his pockets.

The untutored Rodia is the embodiment of the Italian American naif, a blue-collar, ghetto version of the great Spanish architect Gaudi, who attempted to build a cathedral in Barcelona single-handedly. Susan Sontag has used Gaudi's one-man attempt to define "camp," but that category cannot be applied to Rodia's thirty-three-year-long attempt to construct the Watts Towers. He is "the junk man triumphant," an immigrant *bricoleur* who has transformed the shards of urban culture—broken dishes and colored glass, pieces of green Seven-Up, blue milk of magnesia, and other bottles, fragments of mirror, and so on—and the materials of ordinary construction—cement reinforced with steel rods and wire—into wondrously intricate and colorful towers, three spires as flamboyant as the Gothic architecture they recall ascending from a labyrinth of other structures. The irony in all of this is that Rodia, working in all innocence of the modernist tradition of assemblage, has produced a masterpiece of assemblage that, as his post-1960 recuperation by art historians attests, comments on that sophisticated tradition.

In the novel *Underworld* (1997), Don DeLillo, in a beautifully written passage, provides a profound comprehension of Rodia's "jazz cathedral," both as an artistic and an existential construction in the form of a gift:

> *Whatever the cast-off nature of the materials, the seeming off-handedness, and whatever the dominance of pure intuition, the man was surely a master builder. There was a structural unity to the place, a sense of repeated themes and deft engineering. And his initials here and there, SR, Sabato*

> Rodia, if this was in fact his correct name—SR carved in archways like the gang graffiti in the streets outside. . . . When he finished the tower Sabato Rodia gave away the land and all the art that was on it. He left Watts and went away, he said, to die. The work he did is a kind of swirling free-souled noise, a jazz cathedral. . . . (277)

The *bricoleur* and the mason are the typically "poor" artistic positions, which Italians and Italian Americans occupy almost congenitally, given their traditional respect for ordinary materials and their pragmatic aesthetics of making the most out of the least. The two great celebrations of the dignity of workers in cement are di Donato's novel *Christ in Concrete* and the 1992 film by John Turturro, *Mac*, the credits of which are written in wet cement. Whereas Bufano maintained a studio in Italy in order to have access to Carrara marble, sculpting there and shipping the finished pieces back to America, Constantino Nivola, who came from a family of masons in Sardinia and worked as a mason until he was sixteen, brought the mason aesthetics with him to America, applying it to his modernist works. "My sculptures," he wrote, "are made of ordinary materials: bricks, cement blocks, lime, stucco; and natural elements: sun, water and sand. It is the mason's technique." Furthermore, his sculptures, which are cast in cement from negative molds, are often reminiscent of the shapes and objects of Sardinian folklore and sometimes contain, as in the memorial to the masons of Orani, his hometown, specific allusions to *nuraghi*, the prehistoric monuments of Sardinia.

This rapport with materials, particularly those that are totems of the old country, recurs repeatedly in Italian American first-generation art. For example, the ropes that Savelli employs are souvenirs of his fishing village. Bricolage is another recurrent technique whether spontaneously "invented," as in Rodia's case, or ironically employed, as for example, in Italo Scanga's mixed-media installations, which include found objects.

Scanga, who was born in Italy in 1932 and settled in America in 1947, is credited with "creating a new kind of provocative folklore" that involves the ironic recycling of the iconography of everyday Italian life. The *New York Art Review* (1988) gives this composite description of his work: "Room-sized presentations display religious kitsch sprinkled with red paint, hung near the floor. Urns containing grains or spices, like chili powder, are to be smelled or tasted as the viewer kneels to see a painting of Christ or the Madonna. Menacing farm implements often lean against the wall, and dried herbs are hung from the ceiling. Thus a kind of parodical shrine is created using the imagery of martyrdom typical to poor households in Italy." Here we are at once in the same world of Fasanella's *Iceman Crucified* and

expelled from its sacramental economy by the ironic force of the bricolage, which obliges the viewer to adopt a critical stance toward self-martyrdom in the name of the *domus*.

The Sons of the Sons of the Sons of Brunelleschi: Italian American Architects
The twentieth-century dialogue between Italian and American architectural cultures has been extremely rich, particularly because through it the relationship between modernism and classicism has been repeatedly redefined. Even though modernism is centered elsewhere—Paris, Berlin, New York—Italy has remained an art mecca throughout the twentieth century, with Rome the contradictory site where the traditions of the old and the new problematically converge. Stanford White's Italianization from the 1880s onward is in some respects the culminating chapter in the premodernist encounters with the classical-Renaissance tradition that began with the American Palladianism of the late-colonial period. It can also be regarded as the prologue to the Roman adventures of Louis Kahn, Robert Venturi, and Michael Graves, all of whom will have formative encounters with Italian architectural culture. Indeed, both Venturi and Graves will be important contributors to the discourse on postmodernist architecture that is initiated with Venturi's *Complexity and Contradiction in Architecture* (1966). The institutional conduit for much of this dialogue has been the American Academy in Rome, which was founded in 1894 by the American architects William R. Mead and Charles F. McKim, the partners of White. Originally intended as "a school of contact and research, not of original design," it has evolved over the years, as evidenced by the stays of Venturi and Graves, into a cross-cultural laboratory dedicated to both archaeological and experimental work.

Learning from the Campidoglio / Learning from Las Vegas
The twentieth century's American–Italian architectural dialogue unfolds in four periods: (1) 1895–1910, the period beginning with the founding of the American Academy and involving the emergence of American architects as strong partners in international architectural debates on classical form and urbanism, including McKim and John Russell Pope, who turn to Rome—ancient and modern—as a model for America's new vision of itself as an imperial power; (2) 1910–1925, the moment of the architectural avant-gardes—the architectural wing of Italian futurism as embodied in the influential but unrealized projects of Sant'Elia—and the emergence of the international movement; (3) 1925–1940, the fascist period and the ambivalently received lessons in monumentality; (4) 1944–1968 into the 1990s, the period that begins with postwar reconstruction and culminates with

the global village of the 1960s, followed by the adventures of postmodernism, which involve the internalization of architectural debate.

Emblems of the American–Italian dialogue can be found in the traveling of Frank Lloyd Wright to Italy via Bruno Zevi (the Roman architectural theorist) in the postwar period and in the traveling of Italian rationalism as embodied in Aldo Rossi, perhaps Italy's master architect of the contemporary period, to America in the 1970s and 1980s. Rome became the most active center of postwar Europe, the capital of the Italian "society of the spectacle." It was to this Rome that Kahn, Venturi, and Graves would come. Indeed, for American architectural culture in general, Rome would become the good postmodern city. This can be seen in the various Rome models that are elaborated not only in Venturi's theoretical work but also in Graves' *Roma interotta* (1978) and in Colin Rowe and Fred Koetter's *Collage City* (1978). One of the great symptoms of contemporary American architecture is its "piazza envy," as evidenced by Venturi's search for an American equivalent and Charles Moore's Piazza d'Italia in New Orleans. (The reader is directed to the forthcoming acta of a 1994 symposium, "Rome As a Generating Image in American Architecture, 1895–1965," held at the American Academy in Rome under the directorship of Robin Middleton and Neil Levine, which has begun the difficult task of delineating the terms of this American–Italian dialogue. The above discussion is indebted to the sessions.)

The Italian American contribution to American architecture is epitomized by the crisscrossing of the trajectories of two of its most significant contemporary architects: the Italian adventures of the American-born Venturi, who was the recipient of a Rome Prize Fellowship at the American Academy in Rome for the years 1954–1956 and then architect in residence there in 1966; and the American adventures of the Italian-born Paolo Soleri, who has worked in the United States since 1947. Born in Philadelphia in 1925 and educated at Princeton University (B.A. 1947, M.F.A. 1950), Venturi has been canonized as "the father of architectural postmodernism" on the basis of a two-pronged critique leveled at the modern movement and the orthodoxy of its "puritanically moral language." Operating first under the sign of "complexity and contradiction" and then "ugly and ordinary," Venturi would attempt to dethrone that language as it had come to be codified in the American functionalism of the late 1950s—established as an authoritative and monological discourse based on the categorical rejection of the past and, in its attempt to establish a universal language of absolute forms, blind to its own symbolism and historical status as the architectural language of the industrial society. Based on the recognition of the symbolism intrinsic to architectural language—its connotative or semiotic valences—Venturi's practice and

theorization of a postmodern architecture involved the "dialogization" of architecture, to use Mikhail Bakhtin's term: a dialogue with the past—the immediate modernist past as well as the classical tradition—but in a way that would eschew antimodernist and neoclassicist "takes" and establish a "past-present"; a dialogue with the larger urban context and the surrounding built environment; and a dialogue with pop culture by which architecture would be hybridized in terms of the vernacular of everydayness—the billboard, light signs, large-scale lettering, and other commercial motifs.

The first installment of his critique took the polemical form of what Venturi called a "gentle manifesto," *Complexity and Contradiction in Architecture* (1966), a text that in its call for a "nonstraightforward" architecture would exert an enormous influence on architectural culture, one that perhaps would be matched only by the impact of Aldo Rossi's *The Architecture of the City* (1966). By "nonstraightforward" Venturi intended an architecture that exhibits "complexity and contradiction" and therefore foregrounds the linguistic impurity and hybridism at work in both traditional and modern architecture: architecture as a site of semiosis, the communicativeness of "more is more," not the white silences of "less is more." The second—and more inflammatory—installment of his critique was set out in *Learning from Las Vegas: The Forgotten Symbolism of Architectural Form* (1972), coauthored by his wife and collaborator, Denise Scott Brown, and Steven Izenour.

Indeed, if one were to speak of a paradigm shift that marks the passage from modernist to postmodernist architecture, it might be situated in Venturi's *Complexity and Contradiction,* although the artistic revolution he theorized was, in fact, an evolutionary way of seeing architecture: "The modern movement was almost right," as he would put it later on. His integrating position can already be seen in his labeling of his text a "gentle manifesto," a clear rejection of the apocalyptic position usually occupied by avant-gardists in their manifestos that call for a complete break from the past in the name of the new. Throughout this discussion, I shall emphasize Venturi's writing and reading practices, for in some sense his theorization of architecture involves an application of techniques of close reading appropriated from literary criticism (from T.S. Eliot to William Empson, the eminent English critic) to the pragmatic analysis of architectural texts. If his overall project can be seen to culminate in the textualization of the architectural work, that textualization involves a constant interchange between reading architecture and making architecture—his own making of an architecture that can be read for its complexity and contradiction and subsequently an architecture encoded as a "double text" and thus intended for an ironic reception. This interchange between reading and "doing" architecture informs the very structure of *Complexity and*

Contradiction, which begins with ten sections in which Venturi establishes his topical method and assembles examples of architectural complexity and contradiction, then concludes with a section dedicated to his own work. This rotation of a reading position into a "making" position and vice versa is at the heart of his articulation of the postmodernist project. Similarly, that the architect occupies the position of the critic or "reader" of architecture is emblematic of the hybridism that he calls for in the name of postmodernist aesthetics. It can also be seen to be at work in the trope that he and Denise Scott Brown perpetually employ: "Learning from. . . ," with "Learning from Las Vegas" its most memorable formulation. But this formulation can certainly be used retrospectively to describe Venturi's overall relationship to the architectural text: *Complexity and Contradiction* might just as well be rewritten as "Learning from T.S. Eliot" or "Learning from Italy," or, to use another Venturian formula, "Learning from the Campidoglio."

It is this project of "Learning from Italy" that situates Venturi at the heart of our argument regarding weak ethnicity—that is, the way in which Italianness is established through the intellectual appropriation of the Italian cultural text as opposed to direct involvement in the Italian American social text, as is the case with Fasanella or the filmmaker Martin Scorsese. This does not mean that Venturi does not encounter the American social text, but rather that he does so from the disciplinary position of architecture and the cosmopolitan position of a postmodern intellectual. He will deploy the text of Italian architectural tradition as one of the means of generating his own projects and as a lens through which to read the American context. As such, his dialogism must be expanded to include the historicizing dialogue he maintains with Italy and the figure of the hybrid—architect and critic, classicism and pop (or, to use his formula, "Scarlatti and the Beatles"), irony and the vernacular—that runs through his work. From this perspective, his stylistic identity may be understood as a construction of weak ethnicity.

In any case, the encounter with Italy is fundamental for Venturi. It is at work from the very start: His first published article, in 1953, "The Campidoglio: A Case Study," an excerpt from his M.F.A. thesis at Princeton and reprinted in *A View from the Campidoglio* (1984), is a sharp critique of the disastrous effects modern interventions have had on the Campidoglio. His background in architectural history, as H.H. Arnason observes, "prepared him to see in Rome, while there during 1954 as a Prix de Rome winner, not a collection of great monuments but, instead, an urban environment characterized by human scale, sociable *piazzas,* and an intricate weave of the grand and the common." This encounter with Italian architecture and the Rome model would form the ground for *Complexity and Contradiction,* in which he established the categories of his new typology—the master categories

of complexity and contradiction, supplemented by such variations as outside and inside and the "difficult whole"—and then found suitable illustrations in both traditional and modernist architecture.

Italian mannerist and baroque architecture were both particularly privileged as instances of complexity and contradiction, with the mannerists Michelangelo and Palladio and the baroque masters Bernini and Borromini given special prominence. However, his was essentially a topical method governed by juxtaposition of past and recent examples, employing in his theoretical writing the same techniques of juxtaposition and of establishing perspectives through incongruity he practiced in his architectural work. He did not establish a genealogy of architects into which he inserted himself, nor did he draw a historical parallel between postmodernism and mannerism-baroque as styles of "postness," nor did he search the past for architectural precedent in the manner of a literal neoclassicist. On the contrary, he searched the tradition as a practicing architect attempting to renew it and to translate it into postmodern terms.

He did, not surprisingly, remark the presence of the honky tonk: "The consistent spatial order of the Piazza San Marco, for example, is not without its violent contradictions in scale, rhythm, and textures, not to mention the varying heights and styles of the surrounding buildings. Is there not a similar validity to the vitality of Times Square?" It is here the turn to pop and "learning from Las Vegas" is announced. In *Learning from Las Vegas,* he would again refer to the Rome model: "Las Vegas is to the Strip what Rome is to the Piazza." He goes further, establishing many parallels between the two cities, which he takes as archetypes, "exaggerated example[s] from which to derive lessons for the typical."

Although we have focused on Venturi's theoretical work rather than his architecture, there are two other elements of his architecture that return us to the problem of ethnicity. The first is his call for an architecture of diversity that is "appropriate for a plurality of tastes and sensitive to qualities of heritage and place. . . . Today the world is at once smaller and diverse, more interdependent yet more nationalistic; even small communities seriously maintain ethnic identities and carefully record local history. People are now aware of the differences among themselves yet more tolerant of their differences." Here we again approach the American social text. The second element is the question of the house he built for his mother in Chestnut Hill, Philadelphia, the official frontal photograph of which shows his mother seated on the threshold. Can the Vanna Venturi house be regarded as an Italian American cultural text? Of course. We have previously seen the centrality of the house to the visual tradition, and it is clear that this house, the second of his designs to be built, is important to Venturi, for he writes about

it on two occasions—in *Complexity and Contradiction,* where he emphasizes its mannerist elements, and in his postscript to his 1982 Walter Gropius Lecture at Harvard, in which he emphasizes its classsical qualities, using it to demonstrate his own status as "an architect who adheres to the classical tradition of Western architecture." What is interesting is that the house is not simply the site of an elaborate intertextual game Venturi plays with Palladio, but rather the means of translating the "essence of Classicism" into contemporary American terms of a small and "ordinary" suburban house. It is this deeply historicist translation defined by the proper name of the mother that leads us to the perennial Italian *pietas*— pop mediated by mom—toward the tradition.

Raising Arizona, or The Desert Theorems of Paolo Soleri
Of Venturi's generation, but far removed from his irony and his celebration of the urban sprawl of Las Vegas, is Paolo Soleri, a visionary architect in the Buckminster Fuller mold, whose utopian projections of an alternative urban environment have made him a central figure in contemporary urbanism. Although much of his work is projective (his architectural drawings are considered to be self-contained works of art, while his sketchbooks are particularly prized as latter-day versions of Leonardo's notebooks), he is not simply a paper architect. Indeed, of his five projects that have gone into construction as of the mid-1990s, the culminating one, Arcosanti, the building of which began in 1970, is the equivalent of a city and, as an architectural labor authored by an individual artist, dwarfs Gaudi's construction of *La Sagrada Famiglia,* the architectural gesture that most resembles Soleri's. Arcosanti is an experimental habitat, designed for 5,000 people, in the form of a megastructure that will rise twenty-five stories and cover thirteen acres of an 860-acre land preserve when completed. Situated on a mesa located at Cordes Junction, 80 miles north of Scottsdale, Arizona, Arcosanti is the embodiment of his revolutionary philosophy of urbanism, what he calls arcology (from architecture and ecology, a derivation that indicates the perfect balance between nature and culture he wishes to maintain in his new organization of urban space). Arcology as an architectural ideology is focused on the construction of highly integrated three-dimensional complexes, called "arcologies," that deploy solar energy and are oriented toward pedestrians. Although he bears the same interest as Frank Lloyd Wright, his mentor, in establishing a synthesis of city and country dwelling, his utopianism is far removed from that of Wright's plan for the never-realized Broadacre City, for it is based on the apotheosis of the vertical city, not the suburb, as three-dimensional space: "Everyman" ought to have a "usonian" (one- to five-car) house. Arcology as a humanist philosophy defines itself as an "instru-

ment for cultural intensification and social integration while meeting the private needs of the individual." In other words, Soleri is aware of the way in which cities construct human subjectivities.

There is, of course, a long physical and mental journey that precedes Soleri's ultimate territorialization in the Arizona desert. The voyage to the desert and the American Southwest is an allegory of both architecture (Frank Lloyd Wright had already gone to Phoenix to construct Taliesin West) and voluntary immigration—the good European as American pioneer (D.H. Lawrence and others had gone earlier to Taos, New Mexico, in search of the archaic). But Soleri's position finally is that of the prophet-outsider who goes into the desert—away from the metropolis, especially his Italian urban past—to realize his vision of the promised city.

Soleri was born in Torino in 1919, received his training in architecture at the Torino Politecnico, and came to America in 1947 to take up an apprenticeship with Wright at Taliesin West. (For an account of his indebtedness to, and his moving away from, Wright, see Donald Wall's *Visionary Cities: The Arcology of Paolo Soleri* [1970].) In 1946 he hand-constructed, along with Mark Mills, a remarkable underground desert house for his mother-in-law at Cave Creek, Arizona, which was covered by a split revolving dome for sun control. Soleri's itinerary involves a perpetual dialectic between the gigantic (his mega-environments) and the miniature (his design of craft objects and ceramics). He returned to Torino with his wife to pursue the artisanal life, settling in southern Italy in 1951 to do ceramics. There, at Vietri-sul-mare, a fishing village on the Amalfi coast near Salerno, he designed his first major building: the Solimene ceramics factory, which, however derivative of Gaudi in its (appropriate) use of glazed pots for the exterior sheathing and reminiscent of Wright's Guggenheim, remains an original solution to the harmonizing of building and cliffscape. Dennis Sharp (1987) has described it "as an early experiment in the strict use of locally available materials, handcraft and engineering, all of which were to become important features of Soleri's later work in Arizona."

In 1955 Soleri and his wife returned to the Arizona desert, settling in Scottsdale. There he built Cosanti (an Italian neologism meaning "before things"), his residence and offices, both a laboratory from which he would theorize his arcologies and a laboratory work itself in that its own construction involved the invention of the structural procedures and forms that would be deployed later in Arcosanti, such as the concrete forms cut from the ground employed in the Earth House and other experiments in concrete casting. Cosanti also served as both the headquarters of the Cosanti Foundation, described by Soleri as a "not-for-profit organization pursuing the research and development of an alternative urban en-

vironment," and the workshop that would provide the economic base for the construction of Arcosanti by making ceramic wind bells for sale.

If thinkers are either single-minded hedgehogs or multivalent foxes, as Isaiah Berlin maintains, Soleri is certainly a hedgehog, for all of his projects culminate in the big idea of arcology (architecture plus ecology, but also the science of the ark that shelters and the arch that bridges). But Soleri is himself a large cultural construction, a hybrid who bridges the futurism and high technology of America and the archaeology and humanism of Italy: Arcologies are to be realizations of what he calls "the City in the Image of Man," a phrase that harkens back to Renaissance humanism. His first arcological sketches were received as 2001-type space colonies, but they are at the same time, as J. McFayden has pointed out, highly reminiscent of Italian hill towns, those ancient equilibriums of architecture plus ecology. As Mega-Soleri, he is the embodiment of the Promethean artist who designs a whole city while, at the same time, he establishes a collective of thousands of short- and long-term workers—students and professionals of all ages, races, and backgrounds—who by participating in the building of the new city become a community.

All of the contradictions at work in the Italian American artistic identity, the composite portrait of which I have endeavored to draw in this chapter, may be seen to converge in Soleri: mysticism (Soleri's, like Mario Cuomo's, is influenced by Pierre Teilhard de Chardin) and pragmatism, utopianism and territoriality; abstraction (the "abstract" labor of the sketchbooks and the project) and materiality (the love of specific materials—concrete, earthwork, and so forth); theory (the "big idea," Mega-Soleri) and practice (craftsmanship, hand- and body-work); engineering and sculpture (Soleri's arcologies are ultimately sculptural entities obsessed with the imagery of the new city).

By way of closing, I want to return to the notion of the status of Italian American artistic texts as "dangerous supplements" to the Italian tradition. As we have seen, this supplementarity is activated by the applied Palladianism at work in Venturi's house for his mother, in which the classicism of the villas in the Veneto is grafted upon an "ordinary" suburban American house, commenting in its way on the earlier Jeffersonian adventures of monumental Palladianism in America. Similarly, Soleri's Arcosanti also functions as a dangerous supplement to an Italian culture that has long since erected all of its great cities and whose status as an extended *centro storico* (historical center) confines its architects to limited interventions, usually in the peripheries, or to tasks of historically conditioned renewal. Of course, for visionary architects there always remain the mesas, foothills, and deserts of the white page. The migration of Soleri's "City in the Image of Man" to

the mesas of the American Southwest is a supplementary installment—no less humanistic—of the Renaiassance's search for the ideal city and, more specifically, a belated realization of the "City of Sun" projected by Tommaso Campanella (1568–1639), Italy's greatest utopian thinker, who oriented his city in terms of the metaphorics of the sun. If the Americanness of Soleri lies in the technological and ecological aspects of vision, his Italianness lies in his sense of the city as a work of art, the city as "the most relevant aesthetic phenomenon on this earth."

Notes

1. All citations of Joseph Stella are from his *Selected Writings,* an appendix in Barbara Haskell, Joseph Stella (New York: Whitney Museum of American Art, 1994): 201–224.

2. Unless otherwise indicated all subsequent statements by Lucio Pozzi and Vito Acconci are excerpted from texts they prepared for a forthcoming volume under my editorship, *The Adventure of the Avant-Garde: From Dandyism to Postmodernism.* Ed.

Further Reading

Although there is a vast literature on the Italian influence on American art, including the various journeys to Italy by American artists, there is, to my knowledge, no systematic treatment of Italian American visual culture nor has there been a concerted attempt to establish a canon of Italian American painters. In 1992 the Hofstra Museum, Hofstra University, Hempstead, New York, took an initial step by organizing a small exhibition, *The Italian Contribution to the Arts,* the catalog of which contains a preliminary version of this article. More recently, Hunter College of the City University of New York mounted a a more extensive exhibition, "Italian-American Artists, 1945—1968: A Limited Survey, Works on Paper," that ran from 9 November 1994 to 14 January 1995. Curated by Anthony Panzera and Lisa Panzera, the exhibition included 37 Italian American artists. In addition to the core group discussed above in my treatment of the post–Joseph Stella, pre–Frank Stella generation (Jon Corbino, Enrico Donati, O. Louis Guglielmi, Luigi Luccioni, Constantino Nivola, and Angelo Savelli), the following artists were treated: Peter Agostini, Peter Busa, Lawrence Calcagno, Nicolas Carone, Edmond Casarella, Giorgio Cavallon, Carmen Cicero, Stefano Cusumano, Sideo Frombolutti, Edward Giobbi, John Grillo, Peter Grippe, Salvatore Grippi, Angelo Ippolito, Vincent Longo, Bruno Lucchesi, Nicholas Marsicano, August Mosca, Philip Pavia, Vincent Pepi, Gregorio Prestopini, Salvatore Romano, James Rosati, Felix Ruvolo, Attilio Salemme, Salvatore Scarpitta, Sal Sirugo, George Spaventa, Joseph Stefanelli, and two women artists, Clare Romano and Lucia Autorino Salemme. In her introduction, "Rediscoveries: Italian American Artists, 1945–68," to the exhibition catalog (New York: Hunter College Publications, 1994: 4–6), Lisa Panzera Melchor groups the artists primarily into two stylistic camps: realism and abstraction. Although the question of Italianness is broached, albeit cautiously, and affiliations with twentieth-century Italian artists are traced, Melchor concludes: "Ultimately, rather than illustrating stylistic influence, or some common element deriving from their ethnic bond, these Italian-American artists emphasize their Americanness in their distance from tradition and their involment with the American context." However one wishes to categorize these artists individually in terms of a spectrum that runs from "minor major" to "major minor" to "minor," the output of the generation operating in the post–World War II period is substantial and deserving of a more comprehensive study conducted from the Italian American perspective.

Individual artists, on the other hand, have received substantial attention (see the monographic studies listed below). *The Big Book of Italian American Culture,* edited by Lawrence DiStasi (New York: Harper and Row, 1989), contains lively essays on Paolo Soleri, Sam Rodia, Ralph Fasanella, Beniamino Bufano, and Frank Frazetta, a science-fiction cartoonist, illustrator, and poster designer. Considering the number of artist-immigrants treated in the present survey, it is distressing to find that the exhibition held at the Hirshhorn Museum, Washington D.C., in 1976, *The Golden Door: Artist-Immigrants of America, 1876–1976,* included only two Italian Americans, Joseph Stella and Giorgio Cavallon, a symptom perhaps of a general art-historical failure to regard Italian American visual culture as a specific entity. In addition to the works listed below, I am indebted to the texts prepared by Lucio Pozzi and Vito Acconci for a book under my editorship, *The Adventures of the Avant-Garde: From Dandyism to Postmodernism* (forthcoming).

The Italian Presence in American Art

Jaffe, Irma B., ed. *The Italian Presence in American Art.* 2 vols. (New York: Fordham University Press, 1989). The first volume covers the period 1760–1860; the second, 1860–1920.

Stebbins, Theodore, ed. *The Lure of Italy: American Artists and the Italian Experience, 1760–1914* (Boston: Museum of Fine Arts, 1992).

Vance, William L. *America's Rome.* 2 vols. (New Haven: Yale University Press, 1989). The first volume focuses on the influence of classical Rome; the second, on that of Catholic and contemporary Rome.

General Histories of Modern Italian Art

Braun, Emily, ed., *Italian Art in the Twentieth Century: Painting and Sculpture, 1900–1988* (Munich: Prestel-Verlag, 1989).

Hulten, Pontus. "An Italian Century?" In *Italian Art: 1900–1945* (Milano: Bompiani, 1989). The enormous catalog of a 1989 exhibition organized by Pontus Hulten and Germano Celant at the Palazzo Grassi in Venice. Containing twenty-five essays by leading specialists, it provides a comprehensive overview of the history of all aspects of Italian visual culture in the first half of the twentieth century.

General Histories and Dictionaries of Modern Art

Arnason, H.H. *History of Modern Art.* 3d ed. (New York: Harry N. Abrams, 1986).

Haftmann, Werner. *Painting in the Twentieth Century* (New York: Praeger, 1965).

Kranz, Les, ed. *The New York Art Review: An Illustrated Survey of the City's Museums, Galleries, and Leading Artists* (Chicago: American References, Inc., 1982).

Osborne, Harold, ed. *The Oxford Companion to Twentieth-Century Art* (Oxford: Oxford University Press, 1988).

Wheeler, Daniel. *Art Since Mid-century: 1945 to the Present* (New York: Vendome Press, 1991).

Individual Artists

Vito Acconci

Acconci, Vito. *Making Public: The Writing of Reading of Public Space* (The Hague: Stroom, 1993).

Shearer, Linda. *Vito Acconci: Public Places* (New York: The Museum of Modern Art, 1988).

Beniamino Bufano
Falk, Randolph. *Bufano* (Millbrae, Calif.: Celestial Arts, 1975).

Allan D'Arcangelo
Callas, Nicolas. *Art in the Age of Risk* (New York: E.P. Dutton, 1968).

Enrico Donati
Breton, André. *Surrealism and Painting* (New York: Harper and Row, 1972).

Ralph Fasanella
Carroll, Peter. "Ralph Fasanella Limns the Story of the Workingman." *Smithsonian* 24 (August, 1993): 58–69.

Watson, Patrick. *Fasanella's City* (New York: Alfred A. Knopf, 1973). This book reproduces in color all of Fasanella's paintings executed through 1973 and provides a detailed visual analysis, interspersed with telling comments by Fasanella on the Italian American condition as experienced by his generation.

O. Louis Guglielmi
Conrad, Peter. *The Art of the City: Views and Versions of New York* (New York: Oxford University Press, 1984). Conrad also treats Joseph Stella in this definitive work on city art.

Lucio Pozzi
Galleria Peccolo. *Lucio Pozzi: The Rag Rug Paintings.* (Livorno: Edizioni Roberto Peccolo, 1991). Livorno, January, 1991. This exhibition catalog contains a comprehensive essay on Pozzi's oeuvre written by Tiffany Bell.

Grace Borgenicht Gallery. *Concurrencies.* (New York: Becker Graphics, 1993). New York, 10 December–9 January 1993. This is the catalog of an exhibition curated by Pozzi and organized to illustrate his theory of "concurrencies" as set out by the artist in his introductory statement, the text of which is suitably printed in multiple typefaces.

Sam Rodia
DeLillo, Don. *Underworld* (New York: Scribner's, 1997): 276–277.

Seitz, William. *The Art of Assemblage* (New York: Museum of Modern Art, 1961).

Angelo Savelli
Harithas, James. *Savelli: Inner Space* (Washington, D.C.: Corcoran Gallery of Art, 1969).

Padaglione d'Arte Contemporanea. *Angelo Savelli.* (Milan: Edizioni Nava, 1984). Milan, 26 October–25 November 1984. This catalog contains an excellent essay by Ned Rifkin that reviews Savelli's five decades of work as well as an anthology of critical writings on Savelli.

Max Hutchinson Gallery, Sculpture Now, and Parsons-Dreyfuss. *Angelo Savelli* (New York: Max Hutchinson, 1978). New York, March, 1978.

Paolo Soleri

McFayden, Tevere. "The Abbot of Arcosanti." In *The Big Book of Italian American Culture,* ed. Lawrence DiStasi (New York: HarperCollins, 1990).

Sharp, Dennis. "Paolo Soleri." In *Contemporary Architects,* eds. Ann L. Morgan and Colin Naylor (Chicago: St. James, 1987).

Soleri, Paolo. *The Sketchbooks of Paolo Soleri* (Cambridge: MIT Press, 1971).

Wall, Donald. *Visionary Cities: The Arcology of Paolo Soleri* (New York: Praeger, 1970).

Frank Stella

Altieri, Charles. "Frank Stella and Jacques Derrida: Toward a Postmodern Ethics of Singularity." In *Deconstruction in the Visual Arts,* eds. Peter Brunette and David Wills (Cambridge: Cambridge University Press, 1994).

Rubin, William. *Frank Stella, 1970–1987* (New York: Museum of Modern Art, 1987).

Stella, Frank. *Working Space* (Cambridge: Harvard University Press, 1986).

Joseph Stella

Haskell, Barbara. *Joseph Stella* (New York: Whitney Museum of American Art, 1994). This definitive study of Stella includes a selection of his writings translated into English for the first time as well as a comprehensive bibliography.

Jaffe, Irma. *Joseph Stella* (Cambridge: Harvard University Press, 1970).

———. *Joseph Stella's Symbolism* (San Francisco: Pomegranate Artbooks, 1994).

Moser, Joann. *Visual Poetry: The Drawings of Joseph Stella* (Washington, D.C.: Smithsonian Institution Press, 1990).

Robert Venturi

Venturi, Robert. *Complexity and Contradiction in Architecture* (New York: Museum of Modern Art, 1966).

Venturi, Robert, and Denise Scott Brown. *A View from the Campidoglio: Selected Essays, 1953–1984* (New York: Harper and Row, 1984).

Venturi, Robert, Denise Scott Brown, and Steven Izenour. *Learning from Las Vegas: The Forgotten Symbolism of Architectural Form* (Cambridge: MIT Press, 1972).

The Italian American Culture of Scenes
Everyday Life As Spectacle—A Visual Essay

Pellegrino D'Acierno

*In memoriam Ralph Fasanella (1914–1997),
consummate painter and celebrator of the Italian American experience;
visual historian and advocate of the working class*

The following visual essay comprises eight paintings by three of the painters most central to the representation of the Italian American experience: Joseph Stella (1877–1946), Ralph Fasanella (1914–1997), and O. Louis Guglielmi (1906–1956). The paintings have been chosen to illustrate various dimensions of the culture of spectacle as it is embedded in everyday life and mixes elements of the sacred and the profane. Furthermore, the eight paintings have been arranged into pairings according to the page headings.

The essay begins with two paintings by Ralph Fasanella, *Family Supper* (1972) and the *Iceman Crucified #4* (1958), both of which are archetypal representations of Italian American immigrant family life. They memorialize in turn the two scenes at the core of the domus-centered society: the *scena madre* (the "mother scene") and the *scena padre* (the "father scene"). Reminiscences of Fasanella's early family life, they employ traditional Catholic imagery to sacralize his working-class mother and father who are elevated into blue-collar household saints. The second grouping compares two Madonna paintings by the Italian-born Joseph Stella: *The Virgin* (1926) and *The Madonna of Coney Island* (1914). Although both are early-twentieth-century attempts to reconfigure the Madonna in modernist terms, *The Virgin*, which represents the Madonna as both a fertility goddess and a Catholic deity, is the more traditional, a result of Stella's return to sacred Italian iconography as well as to the popular devotional imagery of southern Italy, namely the Neapolitan tradition of his roots. Painted twelve years earlier, *The Madonna of Coney Island* is informed by Stella's futurist vision and enthrones an abstract version of the Virgin at the center of the profane playland of Coney Island, which she sacralizes and instresses.

Both paintings as modernist icons bear witness to the Marian devotion at the heart of the Italian American imagination.

Italian American cultural creation has been inextricably bound up with the urban experience, and thus the second part of this essay is concerned with city art and the representation of two scenes—the street feast and the Brooklyn Bridge—that are definitive of the Italian American urban imaginary. The Italian American contribution to American painting and the other arts has been expressed primarily through its urban vision: Its central musical work is Giancarlo Menotti's opera *The Saint of Bleecker Street* (1954); its canonical novels ranging from Pietro DiDonato's *Christ in Concrete* (1939) to Don DeLillo's *Underworld* (1997) have been city-novels; its most original contribution to American cinema has been the "mean streets" subgenre.

The third pairing compares two quite different artistic approaches to the representation of the street feast: Fasanella's *Festa* (1957) and Stella's *Battle of Lights, Coney Island, Mardi Gras* (1913–1914), the latter applying the imagery of the feast to the artificial paradise of Coney Island. The *festa* is the primary scene through which Italian American spectacle culture has imprinted itself upon the American common consciousness. It has been repeatedly represented by painters and filmmakers, including Francis Ford Coppola and Martin Scorsese. The festival is the primary expression of what Robert Orsi has called "religion in the streets." Although Fasanella and Stella approach its representation from completely different stylistic registers—the miniaturization and teeming vision of Fasanella's urban folk realism; the dynamism and kaleidoscopic quality of Stella's futurism—they both convey the joyous energy of the feast.

The fourth pairing involves two antithetical representations of the Brooklyn Bridge: Stella's *The Bridge* (Brooklyn Bridge), one of the five panels in Stella's masterpiece, *New York Interpreted (The Voice of the City)* painted from 1920 to 1922, and O. Louis Guglielmi's *The Bridge* (1942). The most recognizable image to have been painted by an Italian American artist, Stella's *Brooklyn Bridge* represents the bridge as a sacred object, the machine age's equivalent of a gothic cathedral whose architecture of cables and coils vibrates like a musical instrument. His spatial representation of the bridge as altar and harp is transposed by the vibrations of his color scheme into a musical composition, thereby rendering the immanence of the bridge, which Stella experienced in mystical terms, like being "on the threshold of a new religion or in the presence of a new Divinity." By contrast Guglielmi's *The Bridge* (1942), a surrealist deconstruction of the Brooklyn Bridge, represents the abstract apparatus of the bridge as a disenchanted and alienating object. For Guglielmi, who is clearly working against Stella, the bridge stands as a symbol of the inhuman metropolis, a broken and mute instrument no longer capable of intoning the symphony of the city.

The Domus: The "Scena Madre"

Ralph Fasanella: Family Supper, *1972*
Oil on canvas, 50 by 72 inches
Ellis Island Immigration Museum—permanent exhibit

The Domus: The "Scena Padre"

Ralph Fasanella: Iceman Crucified #4, *1958*
Oil on canvas, 25 by 36 inches
Courtesy of Marc Fasanella

THE SACRED SCENE: THE TRADITIONAL AND MODERNIST MADONNA

Joseph Stella: The Virgin, *1926*
Oil on canvas, 39 9/16 by 38 3/4 inches
The Brooklyn Museum, New York
Gift of Adolph Lewisohn

THE SACRED SCENE: THE TRADITIONAL AND MODERNIST MADONNA

Joseph Stella: The Madonna of Coney Island, *1914*
Oil on canvas, 41 ³/₄ inches in diameter
The Metropolitan Museum of Art, New York
George A. Hearn Fund, 1963 (63.69)

LA FESTA OR STEALING EVERYDAY FROM SUNDAY

Joseph Stella: Battle of Lights, Coney Island, Mardi Gras, *1913–1914*
Oil on canvas, 76 by 84 inches
Yale University Art Gallery; bequest of Dorothea Dreier
to the Collection Societe Anonyme

LA FESTA OR, STEALING EVERYDAY FROM SUNDAY

Ralph Fasanella: Festa, *1957*
Oil on canvas, 40 by 36 inches
Courtesy Gina Mostrando

Joseph Stella: New York Interpreted (The Voice of the City) The Bridge
(Brooklyn Bridge), 1920–1922
Oil and tempera on canvas, 88 $^1/_2$ x 54 inches
The Newark Museum, Newark, New Jersey; purchase 1937 Felix Fuld Bequest Fund
Photo © Art Resource, N.Y.

THE CITY: THE ITALIAN AMERICAN URBAN IMAGINARY

O. Louis Guglielmi: The Bridge, 1942
Oil on canvas, 81 by 35"
Museum of Contemporary Art, Chicago
Gift of the Mary and Earle Ludgin Collection

Cinema Paradiso

The Italian American Presence in American Cinema

Pellegrino D'Acierno

We are the sons of the sons of the sons of the sons of Michelangelo and Leonardo. Whose son are you?

—Good Morning, Babylon

Johnny Fontane will never get that movie. I don't care how many dago, guinea, wop, greaseball goombahs come out of the wood work.

—*Jack Woltz to Tom Hagen,* The Godfather Part I*

From Huck Finn's Puppet Theater to Cinema Paradiso

It is impossible to speak of contemporary cinema and in particular of the New American Cinema—the "critical cinema" created in the 1970s and 1980s by the generation of film-school-trained directors, the so-called movie brats, who conceived themselves as author-directors, not functionaries of the studio system, and attempted to structure "art films" into movies intended for popular consumption—without reference to the dominant role played in its formation by such Italian American filmmakers as Francis Ford Coppola (1938–), Martin Scorsese (1942–), Brian De Palma (1940–), and Michael Cimino (1943–), to name only the most conspicuous of the "sons" of Frank Capra. That these second- and third-generation Italian Americans have entered the pantheon of the New Hollywood

Boldface terms are defined in the Cultural Lexicon, which starts on p. 703.

*In *The Godfather* trilogy, the first movie, which was released in 1972, is titled *The Godfather*. However, in order to avoid any possible confusion, it is referred to as *The Godfather Part I* throughout this chapter.

as a result of the artistic and commercial success of such films as *The Godfather* trilogy, *Raging Bull, GoodFellas, The Untouchables, Scarface,* and *The Deer Hunter* (to mention films that involve the problem of representing ethnicity in general, however mediated that representation may be by the genre format) might be regarded as another triumphant version of the American success story as scripted in the Hollywood "melting pot." The story becomes even more triumphant if one considers the extensive presence of actors and actresses of Italian descent on the 1990s Hollywood scene, from Robert De Niro to Madonna, from Al Pacino to Mary Elizabeth Mastrantonio, from Joe Pesci to Marisa Tomei, from Joe Mantegna to Annabella Sciorra. Furthermore, many of these actors—De Niro, Danny DeVito, Sylvester Stallone, Alan Alda, Penny Marshall, John Turturro, and Gary Sinise—have done significant work as directors. It would seem that not only did Johnny Fontane get the part, but he got to direct the film as well.

Beyond demonstrating that the American Dream is alive and well, such stories typically confirm the myth of ethnic succession to the means of artistic and cultural production and the generational law according to which the third generation "makes it" by maintaining strong cultural selves—that is, acculturated selves that do not betray their ethnic identity and resist the process of assimilation (deculturation). But as with all stories emerging from the dream factory, especially those pertaining to "celluloid ethnicity," the triumph of the mainstreamed individual artist—the ethnic director as superstar—tells only part of the story. The fuller form of the question to be posed must address the issue of whether Hollywood Italians have, in fact, used the cinema to assert their own identity and to narrate their own history in a critical way, one that corrects the misrepresentations to which their tribal identity has been traditionally subjected. This is no small task given that Italians, as Michael Novak has pointed out, have been "symbolic villains in the American imagination ever since the puppet shows that Huck Finn went to see: those swarthy characters in black puppet capes, with thin mustaches, so threatening to milk-white maidens."

Hollywood and the mainstream media in general confer the power to narrate but at the same time impose their own master narrative—a mythological narrative based on stereotypes that results, at best, in a symbolic or weak version of ethnicity—and, as a rule, tend to block the emergence of narratives that are charged with difference. By "difference" I intend the endowing of ethnic protagonists with an authentic inner life: All cinematic representations that fail in this respect remain instances of the stereotyping discourse that has been institutionalized within Hollywood. All stereotypes—negative, positive, neutral—are by definition negative because they kill subjectivity in the name of the same. So the

rise of the ethnic director to representational power in the New Hollywood is a contradictory phenomenon, at once a testimony to the capacity of the ethnic artist to appropriate the means by which the common culture is produced and a cautionary tale illustrative of the appropriative power of the culture industry: To function within the Hollywood system is already to be assimilated—that is, to consent to the ideology and the languages of the dominant cinema and thus to run the risk of narrating the story of one's difference in the narrative form of the "same," the Hollywood master narrative.

This essay will explore the adventures of those predominantly third-generation directors who have rejected their roles in Huck Finn's puppet theater and attempted to take possession of the theater itself or, to be exact, its twentieth-century incarnation, Cinema Paradiso. Just as the naive apparatus of the puppet theater has been displaced by the artificial paradise of cinema—the stereotypical representation of the Italian American has, however, remained more or less unchanged—we may need to find a new and more disenchanted metaphor for the current state of affairs. The one that immediately comes to mind is the logo of *The Godfather Part I:* the hand of the invisible puppeteer who, in attempting to control all of the strings, comes to discover that the puppets and the apparatus of power itself are in control. It should be pointed out that Coppola takes the emblem of the invisible hand from the Sicilian puppet theater, a form of representation linked to Italy's feudal past. And thereby hangs a tale of tradition and modernization that will inform the Italian American quest for self-representation through, and against, its own status as a subculture that reproduces itself through traditions—archetypes and codes; above all, the archaic code of honor—that are fragmentary residues, decontextualized souvenirs of their original Italian setting.

As we shall see, the individual cinemas of this postmodern generation of ethnic directors are complex sites of cultural production. As a rule, these directors neither function as spokespersons for ethnicity nor build minority political agendas into their films. Theirs is not a politically correct cinema; rather, it is "cinematically correct" in the sense that they function as strong directors determined to wrest a personal cinema from the dominant cinema. Whereas the cinema produced by the first and second generations of Italian American filmmakers (Frank Capra, Gregory La Cava, and Vincente Minnelli), who worked from within the system, involved a certain suppression of ethnicity, these younger directors, freed by the auteur theory and working within the cultural context of the New Ethnicity, were able to gain control—however tactically—over the trope of ethnicity as it had come to be institutionalized by Hollywood. Although it would be simplistic

to reduce their heterogeneous work to ethnic projects, each occupies, at least in part of their work, the position of the outsider as expressed in their attempts to either reterritorialize or deterritorialize the genres and the conventional language of the dominant cinema, whether in the name of a personal cinema or, as in the case of Coppola and Scorsese, an ethnic cinema. Each has a conflictual and vicissitudinous relationship with Hollywood, perhaps with the exception of the New York City–based Scorsese, who has maintained a certain distance from the dream factory: the director to whom the system came, as Steven Spielberg has put it. As they passed from film school and independent filmmaking to positions of power within the system, their great triumphs would be matched by their great disasters: Coppola's failed attempt to construct Zoetrope Studios as a director-friendly alternative to the Hollywood studio and his problematic exercises in forging a Wellesian persona that expanded into the big-budget cinema of megalomania—successful in *Apocalypse Now,* disastrous in *One from the Heart,* which forced him to file for bankruptcy; the Academy Award–winning Cimino's fiasco *Heaven's Gate,* which forced United Artists out of business; and DePalma's "bomb-fire," *The Bonfire of the Vanities.* Both of these failed films became symbols of the out-of-control director goaded by the "devil's candy" of the New-Old Hollywood.

At the heart of each of their artistic outputs lies a different version of the struggle to come to grips with their split cultural heritage—even when the problem of ethnicity is suppressed, for that suppression or omission, is a symptom of ethnicity. Their individual cinemas are rooted squarely in the American film tradition, regardless of whatever influence Italian neorealism and the great auteur styles of Fellini, Antonioni, and Visconti that emerge from the neorealist context may have exerted on them. Although, for example, Coppola's *The Conversation* and De Palma's *Blow Out* are specific reworkings of Antonioni's *Blow Up,* and Scorsese's "mean streets" cinema can be regarded as an extension of neorealism, they define their cinematic identities primarily in the terms of American mainstream cinema. Indeed, whether these four directors, along with the other "sons and daughters of Capra" working on the American scene, can be regarded as an ensemble that collectively constructs an Italian American or minority cinema within Hollywood or mainstream cinema is highly problematic. Of the four, only Coppola and Scorsese treat the thematics of Italianness in a sustained and significant way. On the other hand, they all share certain thematic and scenographic concerns, particularly those stemming from the Catholic matrix—theirs is a cinema of rituals and profane theology. More important, they hold in common certain stylistic traits: the language of cinematic violence; a stylistic exorbitance that might be termed "neobaroque," to use an aesthetic category internal to Italian culture it-

self; a definitive attitude toward the visual world and its spectacles; and, above all, a subversive and confrontational approach toward genre, by which they deterritorialize the canonic Hollywood formats. Here looms the problem that will obsess us: Can an ethnic cinema be defined in terms of the politics of representation—that is, the resistance to the language of dominant cinema, especially the genre formula? Or does a cinema, to be authentically "ethnic," need to practice a politics of identity by which a minority view of the world is represented?

So our primary task is to examine the cinema of these four directors together with the large group of Italian Americans currently active on the Hollywood scene, including such actor-directors as Sylvester Stallone and Danny DeVito as well as Abel Ferrara and Quentin Tarrantino, who belong to the Scorsese "school," to search for ethnic manifestations and markings. As author-directors, they each adopt a distinct strategy for dealing with their "doubleness" as hyphenated-American directors. These strategies can be reduced to the following three: (1) adopting the paradigmatic Hollywood directorial position of "passing": the outsider as insider, the Capra position; (2) maintaining an intermediate position that involves the appropriation of traditional genres for the purposes of ethnic representation, as is the case with Coppola in *The Godfather* trilogy; (3) occupying the strict position of the ethnic cinema: the cinema of "divided consciousness" in which the "cursed part"—the secret wound of ethnicity—is displayed, and the figure of the outsider is both treated as a theme and inscribed within cinematic language itself, as is the case with Scorsese. This essay also works toward defining an Italian American film canon. This task requires us to rethink the criteria by which ethnic canons have been traditionally determined (for example, films by directors of Italian descent that treat the theme of Italian Americanness from an inner point of view and for the purposes of authentic self-representation) and to forge a definition of ethnic cinema that accounts for the contradictory and mediated ways in which ethnicity expresses itself through mainstream cinema and its masks of genre.

As a corollary to these cinematic concerns, we—out of necessity—address the problem of cultural stereotyping with respect to both cinema and the majority culture at large. As we shall see, the Italian American identity has been fabricated and institutionalized as a constellation of cultural stereotypes inscribed within a master discourse upon ***la famiglia*** (the family), itself split into two antithetical but always contaminating narratives: those of the "good family" (the normal, assimilated, and assimilating family) and the "bad family" (the stigmatized and stigmatizing "crime family"). This essay then is written in two contrasting vocal registers: the recitative of cinematic history and the aria of denounced stereo-

types—passionate, as arias must be, to the point of being polemical. I adopt this musical strategy of counterpointing as a way of orchestrating within my own narrative the figure of opera, which along with the Mafia, has been the dominant mode through which Italianness has been configured in the American imagination.

I begin this narrative with *The Godfather* phenomenon as comprised by the best-selling novel by Mario Puzo published in 1969 and the trilogy of films (1972, 1974, 1990) directed by Francis Ford Coppola, who, in collaboration with Puzo, also wrote the screenplays. *The Godfather Part I* is the work that signals the arrival of the New Ethnicity in Hollywood and marks the moment in which Italian American artists assume, for the first time, the position of holding the "language" of the mass media in their own hands. Therefore, our narrative begins back in the period 1969–1972; right in the middle of a movie-made history, whose prehistory extends from 1915 (Thomas Ince's *The Italian*) to Valentino's meteoric career in the silents, but which officially begins in the early 1930s with *Little Caesar* and *Scarface*, the gangster films that established once and for all the (im)proper place of the figure of the Italian American in the American imaginary.

Overture of Archetypes and Stereotypes: Italian Americans As Phantoms of the Opera

I feel that the Mafia is an incredible metaphor for this country.
—Francis Ford Coppola

Id in opera never learns to fear the superego; libido never acknowledges the repressive rule of society. This is a realm of emotional atavism. Morally, of course, these characters are a reprehensible crew. Music bypasses the rational quibbles of language to plead on their behalf, and persuades us to envy such lack of inhibition and such maniacal consistency.

—Peter Conrad, A Song of Love and Death

Francis Ford Coppola's *Godfather* trilogy is the most mythical representation of the Italian American experience to have emerged from the domain of American mass culture in the twentieth century. It is, by consensus, the greatest gangster film of all time, the gangster movie raised to the level of art film. As one of the chief money-makers of all time, it has had enormous economic reverberations upon the Hollywood system: *The Godfather Part I* is traditionally held respon-

sible for initiating the megahit syndrome that still governs the mind-set of the New Hollywood. Apart from its role within the internal history of Hollywood and its sociological importance as a cult film that initiates the "Mafia craze," it stands as the paradigm of mainstream ethnic cinema because it is the site where two fantasy histories intersect: the fantasy history that the majority culture projects upon the Italian American (the Mafia stereotype) and the fantasy history that Italian American culture projects upon itself (the *myth* of the "strong family" engaged in Hobbesian warfare: all-in-the-family against All). Because it operates at the level of cultural and cinematic (Hollywood) myths, and thus in terms of distortions and deformations, *The Godfather* trilogy remains the most symptomatic, if not the most central, cultural text of the Italian American experience. I say symptomatic, for the trilogy attests to the conditions in place in the majority culture that govern the visibility—the representation, dissemination, consumption—of the figure of Italian Americanness. That *The Godfather* trilogy allows us to see through the dark glass of the gangster film the most canonical representation we have in the mass media of the ethos of *la famiglia* is in no way accidental. Nor is Coppola's attempt to transform and thus deny the conventional narrative of the rise and fall of the "gangster as tragic hero" by rewriting it, in the key of family history, as a transgenerational and collective narrative of the family's tragedy of isolation: the American tragedy of Italian assimilation of, and by, the American Dream. At the mythical level, the trilogy narrates the impossible quest for the American Dream, which, like all obscure objects of desire, recedes the more it is grasped. This impossible attempt at seizure is enacted in the familial drama of "going straight," a process of stripping away the stigmatizing elements of the immigrant experience, which took crime as its initial mode of "Americanization," and then of transforming the family business into a good capitalist enterprise, a task whose emptiness is exposed the further we move into the trilogy by the discovery that the good system is a mirror-image of the Mafia.

The saga of the Corleone family as it negotiates its passage from traumatic immigration through the conflictual stages of acculturation to assimilation within American capitalism by dint of individual qua familial enterprise is the generic history of the Italian American family and its accession to the American Dream. (This economic incorporation is repeated at the personal level by Michael Corleone's intermarriage with Kay, the all-American girl.) The only problem, of course, is that it is the history of the wrong family—the "bad family," the crime family that has caused the "good family" to be stigmatized within the eyes of the majority culture. Furthermore, what appears as history, as a factual system, is a mythic narration. But this, as Roland Barthes tells us in *Mythologies* (1972), is the

way in which myth operates. According to the laws governing the American imaginary, the narrative of *la famiglia* becomes representable only in the displaced and distorted form of the myth of the stigmatized family, the "other family," the demonic and criminal version of *la famiglia*. I should point out that there are no other generational narratives of the Italian American experience in the Hollywood canon—no *Roots,* no *America, America,* and with respect to antidiscrimination, no *Gentleman's Agreement*—but that should come as no surprise. Italian Americans, as a rule, are the objects of a mythical discourse that links their representation to the interchangeable symbolic economies of the two families: the "good family" (the normal family, the "powerless" one that is appropriated by the American Dream as it eats DeCecco pasta) and the "bad family" (the "crime family," the one that imports the olive oil for that pasta—you will remember that Genco Importing is the "legit" side of the Corleone family business—and appropriates the American Dream in its own terms: "familial amoralism" and the violent exercise of power).

This "doubling" of the family, of course, is an old story: The Mafia from the start organized itself in terms of the metaphorics of the family (see Francis Ianni's *A Family Business: Kinship and Social Control in Organized Crime*), and the status of Italian Americans in the mass media as discredited and discreditable people can be regarded as the revenge of the Mafia against its own tribe. It is also a new "old story," given events in Italy in the 1990s that have disclosed the Mafia-ization of the government as summed up in the recently coined term *Tangentopoli* (Kickback City). As the oldest story in the world, an Italian version of Cain and Abel, it always takes the form of the return of the repressed: the vendetta of the Sicilian Mafia against Sicily for its weak history as a colonially ruled territory that produced the Mafia as a subculture and an invasive way of life, and, more comprehensively, the vendetta of the Sicilian Mafia—and in a certain sense the **Mezzogiorno** (southern Italy)—against the Italy that has rendered them subaltern; against *la storia* (history) that has criminalized them or allowed them to criminalize themselves; against Italian America; against America; against Hollywood; and even against Coppola and Puzo, who, by choosing to embed family history within the stigmatized form of the gangster film, at once manipulate, and are manipulated by, mythical discourse—the most dangerous game in town. Indeed, the charge of exploiting the dark side of the Italian American experience for commercial gain is constantly leveled at the two cofounders of the "Godfather industry": the cashing in on the great Italian American failure to pay for individual artistic success, to employ the blood-money equation in which the charges are ritually couched.

Such "ethnically correct" charges completely miss the point: *The Godfather*

trilogy is highly ambivalent in its treatment of the Corleones, vacillating between a heroization of *la via vecchia* (the old, or traditional, way) as embodied in Don Vito (Marlon Brando) and a critique of *la via nuova* (the new, or modern, way) as embodied in his son Michael (Al Pacino). The trilogy is no less ambivalent toward the American system and, in *The Godfather Part III,* global capitalism, both of which are viewed as mirrors of Mafia business practices. Furthermore, it should be stressed that this is not a film about gangsters but about *Mafiosi* and the subculture they represent. Don Vito Corleone is not a Scarface or a Little Caesar; he is an **uomo d'onore** (a man of honor), an **uomo di rispetto** (a man who exacts respect by a glance, a gesture, or word) who operates according to protocols that are the product of a specific cultural experience—Sicilian and Sicilian American. You, reader, from your position of legitimacy, will no doubt object: What are Coppola's Mafiosi if not glorified gangsters, gangsters with a family life and a sociologically sketched out code of behavior? But this is again to miss the point. Coppola is representing Mafioso behavior, a behavior that both informs and contaminates the entire subculture from which it issues. This behavior centers on power that is exercised in social relationships outside a bureaucratic framework. The real question to raise is the manner in which the Mafia way of life is represented in cinematic terms.

What has happened in American culture at large, however, is that the great divide between the two families is perpetually collapsed, and the "bad family," the aberrational one, has usurped the place of the "good family" in the fantasy network of the American imaginary. It is precisely this fantasy network that Coppola wishes to disturb. This is most evident in his attempt to apply the metaphor of the Mafia to America, thereby inverting the stereotype, but this does not account for the specific ways in which *The Godfather* operates as a myth. *The Godfather* trilogy, in effect, presents the Corleone family as the "good family," that is, as the family that respects codes—"business" codes, violence codes (violence for violence's sake is the attribute of the rival families, the "bad families"; violence is sanctioned only when it involves making a reputation or avenging oneself). Above all, the Corleones accept family codes that can be summed up in the protocol *l'ordine della famiglia* (literally, "the order of the family"). It is "the unwritten but all-demanding and complex system of rules governing one's relations within, and responsibility to, his own family, and his posture toward those outside the family," to use Richard Gambino's definition as set out in *Blood of My Blood* (1974). What the film orchestrates in the spectator is the absolute conversion to the inner point of view of the family, including its code of **onore** (honor) and the desire for vendetta against those who violate it. This "godfathering" of the spectator

is achieved by an elaborate set of narrative traps and cinematic devices by which we are made to identify ourselves with the family scenario and to share its secrets. These are most effective in *The Godfather Part I,* in which our specular identification with Don Vito Corleone is absolute even as his power—in cinematic terms, the power of the Don's gaze and the spectator's power to assume the position of that gaze—is transferred to Michael Corleone, his third-born son. This occurs dynastically by an intricate process of familial succession as biblical as it is oedipal, for it involves a transfer of power to the youngest son, the son most suited to maintain the "law of the father." This process is repeated in cinematic terms with Michael assuming the power of the Godfather's gaze after his death. As the trilogy progresses, however, the spectator is gradually distanced from Michael and made to watch his tragedy of isolation from the outside and in critical terms.

The question of spectatorship brings us to the heart of the way ethnicity is encoded in mainstream cinema. *The Godfather* trilogy is double voiced, addressed at once to the naive viewer, the myth consumer, who will read the film as a factual system—that is, overlook the fact that the "good family" is a fabrication, that, for example, Don Corleone's refusal to deal drugs is a narrative trap set by Coppola, a part of the Mafia's own fantasy history, having nothing to do with the actual business practices of organized crime, which Coppola uses to reverse the traditional stereotype—and to the sophisticated viewer who will read the myth as myth and the gangster film as art film. At another level, the trilogy's double voice is addressed at once to the nonethnic outsider and the Italian American spectator who will respond to the thick description of *la famiglia* in a plenary way, finding in the Corleone family history fragments of his or her own. This is in no way to suggest that the ideal viewer is a *Mafioso* who will model his persona on the film. (For a typical life-imitates-the-movies reading, see the article by Alessandra Stanley titled "Real-Life Tough Guys and Silver Screen Gangsters," *New York Times,* 21 February 1992.) For example, the "reading" by Vincent Teresa, one of the highest-ranking crime figures ever to turn state's evidence, faults the film for its factual inaccuracies regarding Mafia operations. This is the most naive response to the film possible for it mistakes a mythical narrative for a factual one, leading him—ironically, to say the least—to voice a high-toned critique of the American moviegoing public, sadists at heart: "The audience was actually cheering at times. That shocked me. You'd think that Don Corleone was the Lone Ranger and the other mob were the bad guys. . . . Didn't they understand that *all* the mobsters in the movies were vicious?" Of course, this transvaluation is exactly the response that the film intends: the myth of the "good family" replacing the myth of the "bad family." On the other hand, the WASP reading that sees the film

in all its epicness as the Italian American *Gone with the Wind* is almost as naive, if it were not so patronizing. Equally naive but well intentioned is the movie buff's reading that reduces the film to "the greatest gangster movie of all time." The most reductive response to the film, at least from the Italian American perspective, is that of the *Godfather*-bashers who see the film as a betrayal of the Italian American experience, a knee-jerk reading that is absolutely deaf to the double-voicedness at work in it—as expressed in this letter published in the *New York Times* (1 August 1972):

> *In* The Godfather, *the exploitation of Catholic rituals and Italian customs—in the wedding and funeral scenes as well as the Baptism—is part of the biggest cultural ripoff that any commercial promoters have gotten away with in years.* The Godfather *stereotypes Italian Americans as gangsters or as the half-admiring, half-fearful pawns of gangsters. The authentic details of how a bride receives money gifts at a wedding or how spaghetti is made only give credibility to the central lie about Italian Americans.*

On the other hand, Arthur Schlesinger's reading (*Vogue,* May 1972: 54), which expresses the sophisticated but nonethnic viewing position, is closer to the point:

> *The film shrewdly touches contemporary nerves. Our society is pervaded by a conviction of powerlessness.* The Godfather *makes it possible for all of us, in the darkness of the movie house, to become powerful. It plays upon our inner fantasies, not only the criminal inside each of us but our secret admiration for men who get what they want, whose propositions no one dares turn down.*

I would state this even more forcefully: The film as film makes you "an offer you can't refuse"—it imposes upon the empirical spectator membership in the family. Not only does it trap the spectator in an imaginary identification with the outlaw, as is always the case in gangster films, but it affiliates the spectator in such a way that he or she is entrapped within the very network of **comparaggio** or **comparatico** (godparentage) that is at work in the film. The "power trip" turns into a "family trip," as it were. In other words, the dichotomous mechanism by which culture in general is organized—inner point of view vs. outer point of view; the normal "we" vs. the abnormal "they"; the lawful vs. the criminal—is reversed. The criminal family becomes the site of regulated and hypercoded behavior, and we the spectator are privileged by the risk-free involvement conferred by cinema to enter the family circle and to adopt its archaic system of honor. This process of

conversion is most clearly demonstrated by the scene, in *The Godfather Part II,* in which Michael dismisses Kay for having had an abortion, the ultimate moment of taking sides. The audience—at least in the Upper East Side moviehouse where I viewed the film—in total identification with Michael, broke out into heated applause. Similarly, this "godfathering" of the viewer informs the following comments by Roger Ebert, the critic-as-everyman:

> *Both Don Corleone and Don Michael Corleone could have been great men. But they lacked the final shred of character that would have allowed them to break free from their own pasts. Or perhaps their tragedies were dictated by circumstances. Perhaps they were simply born into the wrong family* (Ebert, 1993).

Of course, this "godfathering" of the spectator is rendered much more problematic for an Italian American spectator whose own identity has been established in terms of *comparaggio*. The trilogy traps the Italian American spectator in a wicked mirror-game: to identify or not to identify; to affiliate or to disaffiliate. This is a staging of *la storia* in the grand style of Hollywood, but it is enacted by the wrong family (the Corleones, not the Cuomos) and on the wrong stage (the crime scene). The power of the film, from the perspective of ethnic cinema, resides in its power to place the Italian American viewer in a "double bind" situation: damned if you do identify yourself with the negative stereotype, for that is to be an accomplice to those who have caused your tribe to be stigmatized; damned if you don't, for that cultural stereotype is the only one through which the "grandiose self" is displayed. As we shall see, this "double bind" situation is the normal condition—dilemmatic, to say the least—of the Italian American within the majority culture.

This brings us to the question of ethnic authorship and the role *The Godfather* trilogy plays in the history of Italian American self-representation. *The Godfather Part I* represents the moment when Italian American artists (not only Coppola and Puzo but also an ensemble of actors and technicians) come to occupy the position of language (novelistic and cinematic) in mainstream culture and thus to control, to a certain degree, their self-representation. They produced a magnificent but disturbing hybrid: a family saga—a home movie, to use Coppola's term—spliced into a gangster movie, a popular work executed as an auteur work, a dialogical text in which the family-ethnic register and the Hollywood register contaminate each other, a double-voiced text both literally (a good part of the film is spoken in Sicilian dialect accompanied by subtitles, and the English dialogue is peppered with Italianisms, especially proverbs, and the "spaghetti Italian" concocted

by the Italian Americans, such as "Sweet tonado!") and figuratively (the film constantly presents rituals and cultural material that privilege an ethnic viewing). This doubleness is, of course, the hallmark of the ethnic cinema, but here ethnic representation is won at a price and always by the compromising strategy of reterritorializing the gangster genre for the purposes of presenting *la storia*.

But let us take a closer look at *The Godfather* trilogy to examine the specifics of its treatment of the Italian American identity. The trilogy begins on the wedding day of Don Vito Corleone's daughter on the last Saturday in August 1945 and concludes with the natural death of Michael Corleone, the son of Vito and successor to his Donship, in Sicily in 1979. The wedding celebration is held at the Corleone family compound in Long Beach on Long Island, an upper-class enclave (Valentino had a house there, as did Lucky Luciano) that indicates the distance the upwardly mobile Corleones have established from "Little Italy," their original immigrant home and still the site of "family business." *The Godfather* epic begins *in medias res*, as classical epics do: The Donship is about to be passed from the patriarch Don Vito, the exponent of *la via vecchia*, to Michael, a college-educated war hero who represents the generation of the sons and who will embody the struggle between old and new, acculturation and assimilation: the law of the father vs. the law of the son, who will not always be able to act in the name of the father.

So we begin in the middle of the history of the generational narrative: the death of the first-generation father and the ascendancy of the son. The story of young Don Corleone's escape from the ur-vendetta that forces him to emigrate from Sicily and his subsequent rise to power in America will be recounted only in *The Godfather Part II* through a series of flashbacks. Since Italian identity is primarily nomenclatural, it is important to point out that Vito Corleone's childhood rite of passage from Sicily to America is marked by a traumatic name change by which an Ellis Island official substitutes the name of his birthplace (Corleone, a place name that signifies Mafia country) for his surname (Andolini). So the family narrative, recorded under the place name of the father, goes from Sicily to America to the return to Sicily, fulfilling the formula of the epic quest (separation, initiation, return) in ethnic and familial terms (immigration, Americanization, homecoming to, and death in, Italy). The return to Sicily reverses the original figure of immigration as does *The Godfather Part III* in its entirety, for it is concerned with acquiring International Immobiliare, the Vatican-owned conglomerate.

Incipit *Godfather Part I:* the dark screen with the voice-over of the supplicant Bonasera who is attempting to get the ear of the omnipotent Don Vito on the wedding day of his daughter. Bonasera has come into the inner sanctum of the Corleone home to request justice from the Godfather because the American

system of courts has failed to punish the young men who have broken the jaw of his daughter for resisting their advances. It is straight out of the opera: the violated daughter who, although Americanized, has maintained her honor; the failure of the American system in which Bonasera, an undertaker by profession, has placed his trust; the call for vendetta and the relapse into the tribal justice it represents; the ear of the Godfather into which Bonasera will whisper what the audience is kept from hearing: ***soddisfazione*** (ritual satisfaction) in the form of death for those who have violated the honor of the family. Cross-cut into the "scene of the father," in which the spectator is made to occupy the Godfather's gaze, is the ***scena madre*** (literally, "mother scene" but roughly equivalent to what in English is called the "big scene": A play on both senses is intended) of the wedding celebration itself. Elaborately staged ***al fresco*** (outdoors) in the Italian manner, the wedding reception is ethnologically accurate as evidenced by the ***tarantella***, the manic dance performed at festive occasions; the bawdy song *("La Luna Mezzu O Mari");* the ***borsa***, the bridal purse into which the envelopes containing money are placed; and so forth. The celebration is in honor of the marriage of Don Vito's only daughter, Connie (played by Coppola's sister, Talia Shire), to Russo, a small-time operator who will be given a minor role in the family operations. Marked as an outsider because he has no "family" connections, Russo will eventually beat up Connie and betray the family. (The jaw is always the target of violence: Bonasera's daughter, Connie, and Michael all receive blows to the face, linking that violence and its revenge to the figurehead of the Godfather, whose prominent jaw is his dominant physical characteristic: jaw for jaw, blood for blood, the Italian American equivalent of an eye for an eye.) Connie, in turn, will enact the violated-daughter scenario with her brother Sonny (James Caan), the oldest son, who will act in the place of the father. All of this is opera, the melodrama of the family romance embedded within the gangster film.

 The opening sequence of the film is a powerful exercise in chiaroscuro created by cross-cutting the "light" scenes of the public wedding celebration against the "dark" scenes of the private rituals executed within the shadowy recesses of the home. In these rituals, Don Corleone, attended by his retinue of "vassals," assumes his feudal and tribal role of ***compare*** (godfather) according to the symbolic protocols of the gift: The symbolic gift of honor is bestowed upon the Don by the supplicant, usually by the deferential kiss of the hand accompanied by the spoken honorific ***bacio le mani*** (literally, "I kiss your hands"), or by the utterance of the honorific "Godfather" (Bonasera fails to make a proper show of ***rispetto*** or respect at first); in turn, the Godfather will dispense the counter-gift, the favor requested by the supplicant, who may or may not be eventually asked to

reciprocate. This ritual, based on the system of *comparaggio* and extended kinship, is intensified on the wedding day, the maximum moment of exchanges, as indicated by the ultimate protocol of the gift: "No Sicilian can refuse any request on his daughter's wedding day." In this *scena padre* ("father scene"), the elaborate system of affiliation and filiation by which *la famiglia* operates in a universe that it regards as hostile is presented. The sequence of supplicants is particularly significant for it reveals the process by which outsiders are rendered insiders: Bonasera, who is already affiliated because the Don's wife is the **comare** (godmother) of his daughter and must activate the kinship tie and establish the correct tone of **amicizia** (friendship); Johnny Fontane (Al Martino), the down-on-his-luck singer (the Frank Sinatra figure), who is a godson in the technical sense and therefore entitled to the "gift" (the part in the movie that will resurrect his career); Enzo the baker, who asks for help in keeping his future son-in-law from being deported (a straightforward instance of patronage involving the exchange of *favori*, or favors); Luca Brasi, the henchman, who must perform the rite of loyalty, presenting a generous wedding gift of money directly to the Godfather accompanied by his well-rehearsed but awkwardly delivered speech to demonstrate his loyalty as a "family member." It is important to point out that Bonasera commits a series of gaffes. He completely misconstrues the symbolic economy of the gift by offering to pay the Don for his services, something that raises the hackles of the Don. Then he inappropriately calls for murder, a request that cannot be granted for it violates the Don's sense of justice: eye for eye, jaw for jaw.

What is being communicated to the spectator here is the semiotics of the Italian American (the Sicilian) family: a family that operates in terms of highly regulated codes and rituals involving reciprocal services and symbolic debts. The performance of these codes is governed by an economy of honor and respect in which the Godfather embodies the law of the father, the law of the extended family, and ritual relations: generosity in the name of the father to those who honor and observe the order of the family; reciprocal violence in the name of the father to those who violate it, including those within the family circle (Rizzo, Fredo, the second-oldest son, and even Connie), and to those who refuse the economy of the gift (Jack Woltz, the Hollywood producer, who refuses to grant the part to Johnny Fontane even after the Don has offered him *amicizia*). "Gift for gift": This archaic ritual economy, the archaeology of the Sicilian family and its feudal past, will collide throughout the trilogy with the demands of the capitalist economy of modern America. The generational site of this collision will be the conflicted Donship of Michael Corleone, who will attempt to Americanize the family business. The most obvious mirror of this clash, as it materializes in *The Godfather Part II*,

is Frankie Five Angels, the old-style Don who reluctantly eats canapes and attempts to get the band to play a *tarantella* at the Communion celebrated *all'Americana* in Tahoe, gestures symbolic of his inability to adjust to the new way of doing business. More important, however, is the linkage of this economy of honor with the sacramental economy of ritual violence: the cosmic passion play that will enact itself in gangster terms. The opening sequence, as we shall see in a moment, also sets into play a number of other scenarios.

The Godfather trilogy culminates on the Saturday evening before Easter 1979 at the Teatro Massimo, the neoclassical opera house in Palermo, Sicily. The spectator has traveled a long way to arrive here, a good part of the journey mediated by violent montage, the cinematic instrument of violence that Coppola uses to enact the vendetta within the sacred context of familial religious rites. Each of the three films begins with a celebration (Connie's wedding party, the Communion of Michael's son Tony in the new family compound at Tahoe—like good American pioneers the Corleones go west—and the ceremony in which Michael receives papal honors), but each beginning is structured as a double scene that introduces a narrative violence that can only be resolved by the teleological law of the vendetta and its cinematic equivalent: violent montage and the deus ex machina of vendetta. *The Godfather Part I* ends with the funeral of Don Vito and the passage of power to Michael as finalized in the climactic scene of the Baptism of Connie's son, in which Don Michael becomes the "godfather" both literally, by sponsoring the infant in the church, and figuratively, by orchestrating the "other ceremony," the Extreme Unction of the vendetta, the profane sacrament that he administers to the rivals and traitors, including Rizzo (Michael's brother-in-law and the father of the child he has sponsored), who was a conspirator in the hit on Sonny. *The Godfather Part II* narrates the parallel stories of father and son by inserting, within the continuing ("present tense") narrative of Michael Corleone's consolidation of power through the casino operation in Las Vegas and his attempt to "go legit," flashbacks of Don Vito Corleone's immigration to America and his rise to power. These flashbacks are triggered by homologous moments in the lives of the father and son and thus serve as ironic comments on the rift between *la via vecchia* and *la via nuova*. It all culminates with the public and "dishonoring" trial of Michael by the House Un-American Activities Committee and the subsequent vendetta against the traitors, including his brother Fredo and his wife, Kay, who is **scomunicata** (excommunicated from the family circle). With respect to the "godfathering of spectatorship," the viewer's conversion to the law of vendetta—however mediated by the developing monstrosity of Michael—involves the dismissal of Kay. Her WASP mentality and the "weak" vendetta (the abortion of her own

child) she enacts mark her as *donna non seria,* as a woman who has not internalized the economy of the family and its system of dark sacraments. She has remained an outsider, and the spectator's disidentification with her is a litmus test of our cinematic affiliation with the Corleone family: a sign that we have internalized its cultural clash as embodied in the figure of Kay as well as in its will to vendetta.

Meanwhile, back at the opera house: Tony, the son of Michael and Kay, is making his debut in the role of Turridu in Mascagni's *Cavalleria rusticana* (Rustic Chivalry), a "Greek-style tragedy enacted by peasants." The opera, as its name indicates, represents the way in which Sicilian peasants enact the protocols of the vendetta, in this case, the revenge of Alfio, a carter, against Turiddu, who has committed adultery with his wife. Here it is important to note that Coppola is using *Cavalleria rusticana* as a mirroring device for the events in the film, as an operatic encoding of "love and death" Sicilian-style that mirrors and comments on filmic events. At another level, he is deploying the opera house itself as a signifier of Italian elite culture, the house of culture from which their ancestors were excluded and to which the Corleones have gained access. Indeed, Tony's debut represents the greatest triumph of the Corleones in the legitimate world, greater than the fabricated triumph of Michael's papal honoring with which this film begins, the triumph of the artistic side of the family that has heretofore been repressed by business and the will to power.

While Tony performs his role on the stage to the rapt attention of his family seated in the royal box, the "real" opera—the gangster opera, *cavalleria Mafiosa*—takes place in the opera house itself, where the intricate strands of a double vendetta unfold. For present purposes, I cannot go into all of the details. Suffice it to say that this cosmic vendetta is articulated, once again, by montage: the plot orchestrated by Don Altobello to assassinate Michael in his box; the countervendetta orchestrated by the Corleones, which unfolds both within the opera house—Connie's gift of the poisoned cannoli to Don Altobello, the opera-loving, treacherous Don—and throughout Italy, where, by means of cross-cutting, the violent murders of the three figures who have blocked the Immobiliare deal are graphically displayed. (It should be mentioned that Don Altobello's vendetta involves the poisoning of the newly anointed pope, an ally of the Corleones, in this baroque fantasy!) Deferred by a machinery worthy of Alfred Hitchcock, the assassination of Michael finally takes place after the performance has ended and on the grand stage provided by the steps of the opera house. The assassin, dressed as a priest, succeeds in only wounding Michael but kills his daughter Mary (played by Coppola's daughter, Sophia). Mary must be eliminated because her adherence to the code of the family and the overevaluation of kinship it entails

have led to their logical consequences: an incestuous love affair with her cousin Vincent, which, according to the law of symbolic exchanges governing the familial narrative, must be paid for with her life.

All of this business is straight out of the opera; as Michael informs his ex-wife, "It's Sicily, Kay; everything is opera." What becomes explicit here at the end of *The Godfather Part III* through the use of *Cavalleria rusticana* as a mirroring device has been implicitly at work throughout the trilogy. Coppola has transposed the gangster film into the key of opera. He has set into dialogue two opposing cultural texts: the cultural text of the Hollywood gangster movie through which the Italian American has been traditionally reduced to the cultural stereotype of the outlaw, and the cultural text of Italian opera, the spectacle through which Italians have mythologized themselves and produced their own system of archetypes. Stereotypes are archetypes that have been degraded, and Coppola, as the genre director par excellence, has set into collision these two mythologies of identity, thereby creating a disturbance in the network of stereotypes. Coppola has orchestrated *The Godfather* trilogy according to the dramaturgy of the opera, imposing upon his characters roles in the family romance in which they enact the operatic codes of melodramatic excess and "emotional atavism." Even Michael's brooding silence and need to control are studies in exorbitance: an operatic King Lear, the Shakespearean figure that Coppola has taken as the model for Michael's disintegration. The Italians are, above all, a people of scenes, of *scene madri*. This will also explain the importance of music to the film. Music, whether that of the soundtrack by Nino Rota or the diegetic music of the various musical performances built into the narrative (from Johnny Fontane's two songs to *Cavalleria rusticana*), determines the dynamics of the image-track. The entire trilogy is structured to unfold like an opera, unlike the standard use of opera as a set piece in, for example, *Capone* and *The Untouchables*, in which opera is reduced to a signifier of Italianness.

So if we are to speak of a politics of representation at work in *The Godfather* trilogy, it must be determined in terms of the hybridization of these two cultural myths: the myth of the opera and the myth of the Mafia, for they are the primary modes in which Italian-Americanness and Italianness in general are represented. As previously stated, *The Godfather* acts at the level of mythic representation and the specific intersection between American and Italian myths. It is important to remember that, as Roland Barthes has pointed out, "myth is stolen language." Coppola, indeed, has stolen the language of opera. But his theft is far more inclusive, involving the wholesale appropriation of elements from the general cultural text of the Italian American experience: the whole life-world of *la*

famiglia—its customs that mark the life cycle (if we substitute Anthony's Communion for Confirmation, all seven of the sacraments can be seen to be represented), its foodways, its folk arts, the language of the tribe, even its folk medicine (the woman folk healer who treats the pneumonia of the infant Fredo). Furthermore, the trilogy undertakes a wholesale borrowing of the body language and gestures of Italians, not only as they have been formalized in the opera but also from everyday experience. With respect to the body image projected in opera, Coppola's specific use of *Cavalleria rusticana* is not merely confined to the grand finale. At the beginning of *The Godfather Part III,* for example, Vincent, the illegitimate son of Sonny who will become the third "godfather," bites his rival Joey Zasa on the ear. This is the Sicilian protocol for signaling a duel. It is the same gesture that Tony will later repeat in his role as Turridu, to the delighted recognition of Vincent in the audience. This gesture is an aggressive version of the Judas kisses that traverse the trilogy, including the crucial one by which Michael signals the death of Fredo. The same stealing of gestures can be seen at work in the representation of the Old Mustachio Pete, Don Fanucci, who in his white-suited swaggering is the embodiment of the figure of the *guappo,* the cock-of-the-walk street king of Neapolitan ancestry. He performs the gangster version of **la bella figura** (cutting a fine figure), as does his postmodern counterpart, Joey Zasa, the media Don. A similar theft applies to the liturgical gestures of Catholicism that are desecrated. Consider, for example, the double theft at work in the finale: Coppola steals from *Cavalleria rusticana* the Crucifixion scene, already stolen by Mascagni, to set up a counterpart to the profane ritual—business-murders, the Corleones' version of the Last Judgment. A similar theft takes place with respect to the Sicilian **teatro dei pupi,** the puppet theater in which the old chivalric stories of *donne e cavalieri* ("damsels and paladins") are replayed as scenes of personal revenge and violence in which the heroes are bullies who kill on the stage. In both *The Godfather Part II* and *Part III,* the puppet theater is made to serve as a mirroring device that prefigures violence: the deaths of Don Fanucci and Mary Corleone. (For a sociological discussion of the links between the puppet theater and the Mafia way, see Gaia Servadio's *Mafioso: A History of the Mafia from Its Origins to the Present* [1976].) Likewise, Coppola, in *The Godfather Part II,* represents a typical vignette from the immigrant theater in which an immigrant son laments the death of his mother in Naples by singing an aria of mother love. Even more spectacular is the stealing of the **festa** (feast) in "Little Italy," which becomes the setting for the murders of both Don Fanuzzi and his postmodern avatar, Joey Zasa, by which the young Don Vito and his illegitimate grandson, Vincent, establish themselves, in turn, as men of respect.

All of these cultural thefts will be registered by the Italian American spectator as thefts of identity. On the other hand, Coppola has stolen from the text of American culture: In fact, he has stolen the entire genre of the gangster film and used it to inscribe within it the myth he has stolen from the history of his tribe. Furthermore, he has stolen the myth of the American Dream, turning the tables on it, seeing it mirrored in the Mafia Dream. So *The Godfather* trilogy is never simply a text of Italian self-hatred. Its politics of representation and self-representation involve a troubling of the order of stereotypes.

Let us, for a moment, begin again. The mythical encoding of the family spectacle in terms of the archetypes and stereotypes of opera now becomes apparent: the *scena madre* of the wedding party—the chorus of wedding guests and those who, led by Mamma Corleone, do turns at singing the obscene song and dancing the *tarantella;* the tight-lipped aria of Michael Corleone delivered to Kay, "That is my family, not me"; the rehearsal song in the staccato of the heavy Luca Brasi; the appearance of the tenor Johnny Fontane, in the form of Dionysian crooner; the erotic interlude of the satyr play performed by Sonny and the bridesmaid, and so forth—counterpointed by the *scena padre,* the series of muffled duets and asides performed in *recitativo,* broken by *sotto voce,* by Don Corleone and the supplicants with the attendants as the chorus. Don Corleone never performs alone: He is always "a with."

The orchestration of family life as spectacle: It is all so stereotypically Italian American. But within the spectacle, another—aggressive—scenario is taking place, one that involves territorialization and the establishing of strict boundaries between the private and the public. According to this scenario, the participants are strictly zoned in terms of family hierarchy and their status as ritual relatives: (1) the realm of the absolute outsiders, the fenced-out FBI agents who take down license plate numbers in the driveway along with the intrusive photographers; (2) the middle zone of the wedding celebration in which are mixed members of the immediate family (those who will be included in the family photograph), members of the family extended by *comparaggio,* members of the Corleone "crime family" (business associates such as Clemenza and Luca Brasi), and members of the rival crime families deemed worthy of respect, such as Don Barzini (all of these are in some way affiliated with the family and thus have full access to the family spectacle); (3) the zone of the clients-supplicants who have special business to conduct with Don Corleone behind closed doors; and (4) the category of strangers, some of whom can be assimilated into the family circle, as is the case with Tom Hagen, and others who will remain strangers even though bound by marriage, such as Kay. All of these people are bound to a fatal law of allegiance to

l'ordine della famiglia. All, including members of the immediate family (blood of my blood), can be recategorized according to their degree of estrangement from, or embrace of, *la famiglia.* Crucial to this process is the betrayal of the family by family members: Fredo betrays the family and thus becomes a "stranger" whom Don Michael must eliminate—of course, only after Mamma Corleone dies in order to spare her grief; Rizzo, who has passed to the inner circle by marrying Connie, betrays the family and must also be eliminated; Connie, who becomes temporarily estranged from the family by neglecting her role as mother and running through a series of lovers is *scomunicata* because she no longer comports herself as a **donna seria**. She eventually returns to the fold. (The intricacies of the dynastic succession will be discussed below.) The same law applies to business associates.

What is being played out within the family spectacle is a severe territorial rite by which is established a boundary line that cannot be crossed: "Don't ever take sides with anyone against the family again," as Michael informs Fredo. Furthermore, this rite is conducted through carefully scripted strips of behavior, to use the terminology of sociologist Erving Goffman, which require the adoption of masks. Both Don Vito and Don Michael Corleone are "masked men": They control their personae, their masks. For them, character lies in the masks they carve: The mask is destiny. The only time they may drop the mask to reveal the face is within the context of the family. Indeed, so much attention is paid to honor because that honor is a tribute to the mask: what is being saved is the mask, not the face. Furthermore, the personal tragedy of Michael lies in the way his mask comes to usurp his face, as evidenced in particular by his systematic lying to Kay. On the other hand, the hot-headed Sonny is a man who reveals his face in bargaining with Tartaglia ("Never tell anybody outside the family what you're thinking again," as Don Vito chastises him) and therefore is unsuited to hold the Donship even though as the oldest brother it is his by right of succession. His macho recklessness, in fact, leads him to his death. With this notion of persona, we go to the heart of the Italian (southern Italian, to be precise) conception of manliness and how it operates within the context of what might be called a mask culture.

The Seventeen Pantomimes

> *You know Sicilians are great liars, the best in the world. I'm Sicilian. My father was the world-heavy-weight champion of Sicilian liars. From growing up with him, I learned the pantomimes. There are seventeen different*

> things a guy can do when he lies to give himself away: the guy's got seventeen pantomimes, a woman's got twenty—the guy's got seventeen. But if you know them like you know your own face, they beat lie-detectors all to hell. You're telling me everything; showing me nothing.
>
> —Don Vincenzo, True Romance

In this passage from the film *True Romance* (1993), written by Quentin Tarantino, Don Vincenzo (Christopher Walken), in a pause in the intimidating game of Q and A in which he is engaged, discloses the rules of the game: In face-to-face interaction, visual respect ought to be shown; in mask-to-mask interaction, respect has to be shown to the rules of the game itself, and thus those players—(whether in the position of sender or receiver of the "pantomime") who control the game (whether by masking the face or reading through the masked performance) are the winners. The Don, who is interrogating a non-Italian who does not know the rules of the game and who will eventually violate the game absolutely by insulting the Don's Sicilian heritage in the name of "historical" fact, plays another and amateurish version of the game—an ***americanata,*** a pejorative for something done American style (that is, without ***garbo,*** an untranslatable word that suggests a discreet and gracious tactic, a protocol that respects the rules of the game by showing that one is seriously involved in the performance however illusory it may be).

The Godfather is the first mainstream film to initiate the American viewer into the dynamics of the culture of masks. However the "game" may be distorted and reduced to a gangsterized version, it is the Great Italian Game (subspecies Mafia). The "godfathering of the spectator" is achieved, therefore, not simply by vicarious ethnic identification with the family but by implicating the "straight" audience in the elaborate game of the masks—the ultimate game of power—being played out, staking the spectatorship with its secret. This "godfathering of the spectator" involves a virtual process of affiliation, one by which the mass audience is "Italianized," and, however unconsciously, made a "subcultural" insider, an accomplice of the stereotype. Here we can speak of Coppola's revenge against the stereotype and the obligatory language it imposes on producers of the majority culture: If the interaction between (Hollywood) cinema and audience is a stereotype-to-stereotype interaction, Coppola has won the game of stereotypes by masking the stereotype as an archetype, by disturbing and troping the stereotype imposed by the culture industry thus making it a means, however preliminary, of voicing a silent history, of turning Hollywood language toward a countermythology, a metahistory whose distortions and fabrications are offered to those

ethnic consumers who cannot trace their own history on the screen where the production of the Other—of the common culture—enshrines the stereotype. So with *The Godfather*, we are never simply dealing with the glamourization of the Mafia and the mass consumption of ethnicity. To gain some perspective on Coppola's strategy of the "compromise formation," consider the hypocritical prologue of Howard Hawks' *Scarface* (1932), which denounces the violence of gangsterism as embodied in the psychopathic universalized ethnic while making violence the very aesthetic principle of the film:

> *This picture is an indictment of gang rule in America and of the callous indifference of the government to this constantly increasing menace to our safety and our liberty. Every incident in this picture is the reproduction of an actual occurrence, and the purpose of this picture is to demand of the government: "What are you going to do about it?"*

It is left to the reader to decide how far or short a distance *la storia* and, with it, the common culture have come.

Italian American Cinema and the Age of Hollywood: The Italian American Self between the Culture of Silence and the Society of the Spectacle

> *The twentieth century is not the Age of Anxiety but the Age of Hollywood.*
> —Camille Paglia

As previously mentioned, Coppola's *Godfather Part I* marks the moment when Italian Americans come to occupy the position of language, initiating a period in which third-generation filmmakers assume a certain ascendancy in mainstream culture. Brian De Palma, the quintessential assimilated postmodern director, provides an unintended parable of this mainstreaming with his 1983 remake of *Scarface* (1932), the film that, along with *Little Caesar* (1931), had initiated the stereotyping process by which the image of the Italian American has been institutionalized as the antisocial gangster. De Palma transforms the original version by Howard Hawks, which depicted the rise and fall of Tony Camonte (played by Paul Muni, the all-purpose ethnic), the first in the long line of Hollywood portraits of Al Capone, into the key of new ethnic crime with Castro-exiled Cubans occupying the gangster positions previously held by Italians. Chicago becomes Miami; bootlegging becomes cocaine-trafficking; Scarface remains Scarface, albeit neobaroque, still

marked by an oedipal fixation upon his sister and desire for the blonde consort of his boss; the American Dream remains the American Dream ("The World Is Yours," the neon sign on the Goodyear blimp reads). What is indicative is that De Palma displaces the ethnicity of the original characters while casting Italian American actors (Al Pacino, Robert Loggia, Mary Elizabeth Mastrantonio) in the leading roles. In other words, within the system, the Italian American director is in a position to control the figure of ethnicity (this displacement also occurs in three of Michael Cimino's films; the politics of representation involved in this will be discussed below), and Italian American actors can be typecast in Latino roles according to the same skewed logic of ethnicity that permitted Muni and Edward G. Robinson to be cast as Italians. How different is the New Hollywood from the Old?

That the "language" of Italian American mainstreaming should be cinematic rather than literary is highly significant, as is the fact that their verbalism should express itself primarily through the screenplay (Coppola is a distinguished screenwriter as are the others) and in the realistic and more improvisatory form of movie dialogue as opposed to the novel. This is not to overlook Puzo's role in the *Godfather* phenomenon, but the novel itself was in effect a screenplay, and it is no accident that Puzo has established himself as a leading Hollywood screenwriter. Cinema can be regarded as the Italian American vernacular, in part because of its links to oral language and to other everyday languages, including the tough-guy dialogue at which these directors excel. For Italian American filmmakers, movies are the contemporary equivalent of those traditional popular forms—opera and **commedia dell'arte** (literally, "comedy of art," the highly improvisatory comic theater created in Renaissance Italy)—through which their ancestors expressed themselves. These historically earlier systems would form the basis for the Italian cinema that, from neorealism to the emergence of the great auteur films of Fellini, Antonioni, Visconti, Pasolini, and Bertolucci, was the most viable alternative to Hollywood cinema. This sense of cinema as a vernacular is most clearly demonstrated in the films of Scorsese, who, notwithstanding his film-school pedigree, created a street cinema that captured the visceral rhythms of urban existence in "Little Italy" and converted the blue-collar film into an art form.

There is a long cultural history that explains why cinematic language should serve Italian Americans as their paradigmatic form of expression. Italians, like the Jews, are people of the book or, to be exact, two books: The Bible and Virgil's *Aeneid,* the first narrative of Italian emigration (from Italy to Troy and then, after the burning of Troy, the return to Italy, the Promised Land). Here the *Aeneid* is used to epitomize the general text of Roman and pagan culture. These two books were rewritten and conflated by Dante, at the end of the medieval period, in the

Divine Comedy, the first literary text of "modern" (secularizing late-medieval) Italy, "the first great book," as Philippe Sollers maintains in *Writing and the Experience of Limits* (1983), "thought and acted integrally, as *book,* by its author."

As a literary Bible written in the Tuscan dialect, Dante's *Divine Comedy* would provide the basis for the modern Italian language as well as the point of departure for an extraordinarily rich literary tradition that extends from Petrarch and Boccaccio to such postmodernist writers as Italo Calvino and Umberto Eco. This literary tradition was (and remains) elite, and Italian intellectuals have been faulted for the failure to produce a literary culture that was "national and popular." The traditional places where the divide between high culture and low culture collapsed were the *commedia dell'arte* and the opera, which despite its aristocratic origins in the court developed in the nineteenth century into the dominant national-popular cultural expression. It is only in the twentieth century that opera becomes appropriated by high culture as museum art.

In addition to their elite culture of the book—Dante's text was a literary Bible without the canonic and disciplinary force of the earlier sacred texts—the Italians have produced an extraordinary visual and scenographic culture, much of it religious in nature and thus in service of the Roman Catholic Church. Indeed, the overall orientation of Italian culture has been toward the image as opposed to the word, with opera considered on the side of the image because its music deletes the effect of the sung word as do its scenographic effects. Furthermore, with respect to the word, the Italian linguistic identity was fragmented into the official language, the cosmopolitan culture of writing, and a great variety of dialects oriented toward oral performance and embodying the worldview of a multitude of subcultural universes. The standard Italian was considered hierarchically higher than the dialects, the jargon of tribal identities.

What does all of this have to do with the immigrant experience? The **contadini** (peasants) of the Great Immigration (1880–1920) emigrated from a culture of poverty (primarily agrarian) to a culture of poverty (primarily urban). These *contadini,* who came primarily from the *Mezzogiorno,* the "place where Christ stopped," the place that Marx and Engels had called the *Lazaronitum* (from the Italian *lazzarone,* Neapolitan beggar, and thus a pejorative designating the wretchedness of the southern subproletariat and its supposed laziness and dishonesty), were disenfranchised from official Italian civilization. Theirs was the archaic culture of the family, and the class culture of the subaltern, the **morti di fame** (literally, those dying of hunger). It was a culture of silence. They were estranged from the mother tongue, the standard Tuscan-based language, the language of the **signori** (masters), of bourgeois domination, and the system that marginalized them. They spoke

a local dialect, although some of them were bilingual. Their linguistic identities were thus constituted in terms of the subcultural language of difference. The dialect was the visceral language of the skin, of blood: the deep language in which they broke their silence, in which they lived out the family scenario, made love, established bonds of solidarity or excommunication, expressed their passions, raised their voices and cursed, and even enacted the vendetta. Their culture was not oriented toward writing (the text) or the word—official, bourgeois, the law. They in fact systematized the exclusion from, and refusal of, the official world by the practice of **omertà** (the primary meaning of which is the code of silence and dissimulation observed by criminals when interrogated by the law and by which they maintain a conspiratorial network of group protection; the term has the secondary meaning of the wall of silence erected by a subculture or subaltern class to mask the secrets of its inner life from the intrusiveness of the Other).

These people were not oriented toward the book or book learning. They worked the land; the land was the text they elaborated. The only cultural text was the family itself, the lived text of family codes and dramaturgies, of superstitions and folklore, and of a paganized Catholicism. This lived text was in its way extremely rich, maintaining the traditions that had held together the social fabric for millennia. On the other hand, civil and legal society were regarded as instruments of the Other. *La famiglia* was the only functioning institution and was the primary disciplinary mechanism in creating "personal" identity. This is reflected in the linguistic usage still at work in Italian: **educazione** (education) designates the learning instilled by the family; **istruzione** (instruction) designates education in the English sense, formal learning presided over by institutions, book learning.

To understand this prologue in the *Mezzogiorno* is thus to understand the alienation from language suffered by the immigrants to America. Their original estrangement from standard Italian was compounded by a second linguistic estrangement: the exile within their new mother tongue, English. To wit, the Italian Americans are the ethnic group that lost its language: They are the ones who, as a rule, discouraged their children from speaking Italian at home so as to expedite assimilation. Moreover, their suspicion toward institutions and their concern with the pragmatics of survival made them anti-instructional, in the above sense. Although the second generation began the long passage from immigrant status (the immigrant, by definition is he or she who labors), it is only with the third and fourth generations that we see a plenary embrace of education and the creation of a body of intellectuals capable of representing and explaining to Italian Americans their own history of cultural exclusion, of articulating their paradoxical status as members of what Gramsci called a **cultura negata**, a denied and self-

denying culture as evidenced by the estrangement from the mother tongue, the most musical, if not the most beautiful, of all languages.

In a general way, this cultural experience explains why the first mainstream group of Italian American intellectuals would turn to cinema as a way of representing their ethnicity and thereby overcoming their cultural silence. Italian American writers as an ensemble have failed to use their immigrant experience to produce a major literature, one strong enough to contest the dominant language (American English) so as to subvert that language from within and to introduce difference into it: to use the established literature to tear an *Other's* (a stranger's, an immigrant's, a silent one's) voice from it. The ritual explanation is to resort to the *omertà* formula, thereby supplying a rationale based on the Italian American's reluctance to betray the innerness required by the novel and lyric poetry. This, however, is more of an apology than an explanation. I would attribute it to the double exile from language itself and the difficult generational process of forging a writing self and, to be more pragmatic, a reading audience. The body of writing produced so far (mid-1990s) by Italian American writers can best be described as a minority and minor literature, with "minor" intended in a nonpejorative sense, for the discursive site of the minor is one of the places from which an ethnic subjectivity can be voiced with a minimum of distortion.

Consider, for example, the production of three of its most exemplary novelists. Pietro di Donato's *Christ in Concrete* (1939) is a masterpiece of a minor literature in the above sense, and regardless of its value as a text of the immigrant working-class identity and a linguistic experiment that reproduces the grain of the immigrant's voice, it remains confined to the margins of the twentieth-century literary canon. Mario Puzo's *Godfather* (1969) is a blatant attempt to mainstream and commodify the Italian American experience by rewriting it in the commercial form of a (Mafia) best-seller, the most degraded narrative form of the major literature, and as such is at best a travesty of the still-to-be-written "great Italian American novel," whereas his *Fortunate Pilgrim* stands as a "little masterpiece" of ethnic literature. Don DeLillo's work, at least prior to *Underworld* (1977), eschews ethnicity as a defining thematic, and his prominent status within the postmodern canon is determined without specific reference to ethnicity.

On the other hand, Italian Americans, throughout the twentieth century, have made major contributions to American visual and architectural culture, the disciplines in which Italians have always excelled. The architects Robert Venturi, "the father of postmodernism," and the visionary Paolo Soleri; the painters Joseph Stella and Frank Stella; the sculptor Mark di Suvero and the maker of public art Vito Acconci have all been major players on the American scene.

It is cinema, above all, that has served Italian Americans, whether as directors, actors, producers, or technicians, as their primary medium of artistic and intellectual expression, granting them access to the means of mainstream cultural expression and conferring upon them the celebrity that accompanies the Faustian pact required by Hollywood for participation in the "dream factory." It is perhaps unnecessary to point out that Hollywood "dream work" is in good part a function of genre and narrative formulas that involve a vast system of ethnic and racial stereotyping, one that works against authentic self-representation on the part of ethnic directors: To function within the system is already to be assimilated, as previously mentioned. On the other hand, participation in the system, that regime of stereotypes and mythologizations of the ethnic Other, provides an opportunity to appropriate and to manipulate those stereotypes, as the previously discussed case of Coppola demonstrates.

But before we attempt to define the specifics of the Italian American cinema and its relationship to the ethnic tendency in American cinema, it is necessary to explore the Italian American presence on the Hollywood scene. As we shall see, the "movie-made" identity of the Italian American is fraught with contradictions and, even when it is represented by such masters as Coppola and Scorsese, remains conditioned by the stereotyping discourse of Hollywood and the majority culture at large. It should be pointed out that Hollywood has dedicated one genre, the gangster film, almost exclusively to the representation of the Italian American, and, as a corollary (not a corrective), has traditionally cast the Italian American in the role of the detective or policeman, quite often as an ambivalent figure who straddles the borderline between law and criminality. *Serpico* is the exception that proves the rule. Violence—particularly violence that expresses itself through rituals and codes—is the great cinematic prerogative of the Italian American male, who is particularly prominent in the "masculine genres." This can be seen especially in the history of the boxing film as it extends from *Golden Boy,* a mythological account of a young second-generation fighter caught in a culture clash between the fight game and violin playing (American violence vs. Italian musicalness), to such film biographies as *Somebody up There Likes Me* and *Raging Bull,* based on the lives of Rocky Graziano and Jake LaMotta, respectively, to the *Rocky* series, which Sylvester Stallone initially modeled on the Ali-Wepner fight. It also manifests itself in the street film, in which the Italian American was traditionally cast as the dead-end kid, the gang member or punk determined by the male-bonding rites of the street-corner, and, more recently, as the greaser and his postmodern avatar, the *Guido,* who exhibit urban-style machismo: The composite image is that of the neighborhood boy as protogangster caught up in the

protocols of mean-street behavior and the a capella of the street corner. Robert De Niro's *A Bronx Tale* (1993), based on an autobiographical screenplay by Chazz Palminteri, is the culminating, and by far the most humanizing, film in this tradition. It recounts the adolescent passage of a man-child caught between the conflicting worldviews of his law-abiding father and a surrogate father, the neighborhood Mafioso, who in his way serves as a mentor in the "paideia" of the streets.

Another genre in which the Italian American is consistently cast is the family melodrama in which generational conflict is represented in terms of the cultural conflict between family values and the American way of life. These household scenarios are often represented in the coded form of oedipal conflict: authoritarian Old World fathers vs. sons and daughters enacting their dramas of assimilation and defamilialization; overprotective and nurturing mothers vs. sons and daughters attempting to assert their autonomy in American terms. The paradigms of the mother-centered films are *Marty* (mother–son) and *The Rose Tattoo* (mother–daughter). The paradigmatic father-centered film is, of course, *The Godfather* trilogy, the Italian American Oedipus. A subgenre of this cinema of the Italian American family romance is the "wedding picture," ranging from such 1960s films as *Love with the Proper Stranger* and *Lovers and Other Strangers* to such 1980s and 1990s installments as *Moonstruck, True Love,* and *Betsy's Wedding.* The latter, along with *Lovers and Other Strangers,* represents a culture-clashing marriage to a non-Italian. Such movies typecast Italian Americans in their role as exponents of a family-determined identity that expresses itself through such rituals as Baptism, the wedding, the funeral, and the periodical explosion into the *festa*. In other words, Italian American family life is represented as a spectacle, as a mode of emotional, culinary, and melodramatic excess. *La famiglia* is represented as the strong family—the hypercoded family—that at once requires a degree of fidelity and provides an order of pleasure that are both alien to the economy of the typical WASP family. *La famiglia,* always pictured as a regressive depository of tradition and arbiter of gendered sexuality, is the primary unit of the stereotyping, negative as well as positive, of the Italian American identity.

These preliminary observations are borne out by the four films dedicated to the Italian American experience that have won Oscars as Best Pictures: *Marty* (1955), a blue-collar family drama that narrates the passage of a thirty-three-year-old mama's boy from the family circle and the ancillary net of male-bonding with neighborhood friends toward a relationship with an unlikely woman (a wallflower middle-class teacher who is Catholic but not Italian); *The Godfather Part I and Part II* (1972 and 1974), previously discussed; *Rocky* (1976), a fight film in which Sylvester Stallone plays the role of every-White-man as ethnic underdog, enact-

ing the blue-collar version of the American Dream by going the distance with Apollo Creed, the Ali figure.

These four films, regardless of their tremendous discrepancies at the artistic level, are a faithful index of the ways in which the Italian American identity has been represented in mainstream cinema: blue-collar or criminal males in the role of visceral or authoritarian heroes who express themselves through violence (Marty excepted, but he, too, is a prisoner of the body; he is a "dog," as he puts it); overevaluation of kinship as seen in the castrating domesticity of Marty, the stereotypical nice guy, and in the familism of the Corleones; recessive women confined to the kitchen or the shadows but whose force is expressed within the **domus**; and, most tellingly, males who have difficulty with language. Examples of the latter include the inarticulate Marty, who is confined to the litany, "I dunno, Angie. What do you wanna do?" until he is liberated into speech by his love interest; the Godfather himself, the Italian American Zeus, who speaks physically throttled jaw speech, together with the larger cast of English-murdering characters who speak in undeleted expletives or ejaculations ("bada bing"); and Rocky, the self-described "great White dope," a troglodyte who has to practice his dumb jokes before he delivers them to his beloved Adrian and who is so imprisoned within language that his most expressive speech act is "Yo."

"What's the story?" as the equally "articulate" father (Richard Castellano) queries in *Lovers and Other Strangers*. The story is that the proclivity to linguistic disfiguration is an ironclad rule governing the stereotyping of the Italian American. Italian American characters are barred from language or at best prisoners of language. Consequently, they are never placed in the position of struggling with their class image, of which language is the inevitable mirror. Furthermore, they are repeatedly portrayed as eating as opposed to speaking, with eating taken as a territorializing gesture, a substitute speech act that activates their stereotyped status as people of the body. Thus the composite portrait presented by these four films is certainly drawn up along class lines: Only one of the major protagonists is college-educated, Michael Corleone (Dartmouth), but he must unlearn his "college-boy" behavior to perform the primary "speech acts" of the Italian American: violence. There are practically no portrayals of middle- or upper-middle-class Italian Americans in the mass media.

In terms of the mythological economy of Hollywood, which is about winning and losing, about realizing the American Dream by transcending class origins, we have the following tally: Marty, a butcher who aspires to owning his own shop, begins as a loser and ends as a small winner having moved toward a relationship with a more genteel (assimilated) Other (the relationship is never con-

summated); Rocky wins it all by going from a club fighter and small-time enforcer to the Italian Stallion, enacting the American Dream in the most mythological and simplistic way possible; Michael Corleone loses by winning. Only in *The Godfather* trilogy do we get a complex version of the drama of upward mobility—albeit in stigmatizing terms.

Against this composite portrait of the Italian American that emerges from these four Oscar-winning films, we must consider the substantial success that Italian American artists have gained in Hollywood, especially in the New Hollywood of the 1970s and 1980s. Consider the fact that, from its inception in 1927 to 1995, the Academy of Motion Picture Arts and Sciences has conferred upon Italian Americans 30 Oscars in the six basic categories (from 1927 to 1935, only two awards for acting were conferred; the present format, which recognizes Best supporting Actor and Actress, was introduced in 1936). This represents approximately 15 percent of the awards. According to Hollywood (that is, those directors receiving Oscar awards or at least Oscar nominations), the pantheon of Italian American directors comprises the following: Frank Capra (1895–1991), the Sicilian-born immigrant who ranks along with John Ford and Howard Hawkes as master director in the Old Hollywood of the studio system; Gregory La Cava (1892–1952), nominated as Best Director in 1936 for *My Man Godfrey* and in 1937 for *Stage Door;* Vincente Minnelli (1910–1986), who won the award for Best Picture in 1951 for *An American in Paris* and for Best Picture and Best Director in 1958 for *Gigi;* Francis Ford Coppola and Martin Scorsese, the two acknowledged masters of the New Hollywood, although Scorsese, as of 1997 had yet to win the Oscar for Best Director; and Michael Cimino, who won the award for Best Picture and Best Director in 1978 for *The Deer Hunter.* To this list should be added the names of Brian De Palma and Sylvester Stallone, who was the authorial force behind the Oscar-winning *Rocky* and who directed several of its sequels. Although Bernardo Bertolucci (1940–) won an Oscar in 1988 for Best Director and Best Picture for *The Last Emperor,* he belongs to the Italian national tradition as it intersects with the new economy of international cinema. Of the new generation of filmmakers, most of whom are independents, so far only director/screenwriter Quentin Tarantino has been anointed, winning, together with his collaborator, Roger Avery, the award for Original Screenplay for *Pulp Fiction* in 1994. Of all of these directors, only Coppola and Scorsese address the question of Italianness in a direct and sustained way. The implications of this will be discussed below.

The pantheon of Oscar-winning Italian American and Italian actors and actresses comprises the following: Frank Sinatra, Best Supporting Actor in 1953 for his role as Maggio in *From Here to Eternity;* Ernest Borgnine, Best Actor in 1955

for his role as Marty in the film of the same title; Anna Magnani, a leading Italian actress who had a significant Hollywood career playing Italian Americans, Best Actress in 1955 for her role as Serafina delle Rose in *The Rose Tattoo;* Sophia Loren, another Italian actress who had a significant Hollywood career, Best Actress in 1961 for her role as the mother in the Italian-language film *Two Women;* Anne Bancroft (Anna Maria Italiano), Best Actress in 1962 for her role as Annie Sullivan in *The Miracle Worker;* Liza Minnelli, Best Actress in 1972 for her performance as the chanteuse Sally Bowles in Bob Fosse's *Cabaret;* Robert De Niro, Best Actor in 1974 for his role as the young Vito Corleone in *The Godfather Part II* and again for his role as Jake LaMotta in *Raging Bull;* Don Ameche, Best Supporting Actor in 1985 for his role in *Cocoon;* Joe Pesci, Best Supporting Actor in 1990 for his role as Tommy DeVito in *GoodFellas;* Al Pacino, Best Actor in 1992 for his role as the ex-Army colonel in *The Scent of a Woman,* a reworking of an Italian film titled *Profumo di Donna;* and Marisa Tomei, Best Actress in 1992 for her role as Mona Lisa Vito in *My Cousin Vinny.* The strongest showing was in 1995 when three actors of Italian descent won awards: Nicolas Cage winning the Best Actor Award for his portrait of a hopeless alcoholic in *Leaving Las Vegas;* Susan Sarandon winning the Best Actress for her role as Sister Helen Prejean in *Dead Man Walking;* and Mira Sorvino winning Best Supporting Actress for her performance in the title role in *Mighty Aphrodite.* This partial sweep can stand as an index for the mainstreaming of actors of Italian American descent that has occurred in the nineties, something that is also confirmed by the six nominations received between 1990 and 1996 by five other Italian American actors; Leonardo DiCaprio for *What's Eating Gilbert Grape* (1990), Susan Sarandon for both *Lorenzo's Oil* (1992) and *The Client* (1994), John Travolta for *Pulp Fiction* (1994), Chazz Palminteri for *Bullets over Broadway* (1994), and Gary Sinise for *Forrest Gump* (1994). It is interesting to consider the implications of the near sweep in 1995, especially since all three actors did not play Italians and also because both Cage (Nicholas Kim Coppola) and Sarandon (Susan Abigail Tomalin, Welsh-Italian in descent and Catholic in upbringing; her mother's maiden name was Criscione) are not nomenclaturally marked. On one hand, their casting indicates that Italian American actors are no longer confined to ethnic typecasting. On the other hand, their roles are clearly marked by otherness: Sorvino's quirkiness as the prostitute with the heart of gold and the mighty accent and high-pitched voice, Sarandon's eccentricity as the iconoclastic nun, and Cage's edginess as the alcoholic determined to drink himself to death in the arms of a prostitute. Cage's and Sarandon's performances, in particular, are typical of the atypical status of Italian American actors who, in this period of multiculturalism, consistently embody white Otherness, with that Otherness only vaguely referenced to ethnicity,

unlike the dangerous Otherness embodied by the *Godfather* generation of actors, namely the manicness of De Niro and Pacino. Nonetheless, both Cage and his nearest female counterpart, Linda Fiorentino, most notably in *The Last Seduction* (1994) and *Jade* (1995), have succeeded in infusing their screen personae with a dangerous edge that, however implicitly, signifies their Italianness.

What is surprising about this list of Oscar winners is that eight of the fifteen roles involve ethnically correct typecasting. Also indicative is that all of the award-winning performances date from the 1950s onward, with the majority coming from 1972 through 1995 when ethnicity was "in." This attests to a certain invisibility of the Italian American in the Old Hollywood, in part a result of the usurpation of ethnic roles by non-Italian actors—the Edward G. Robinson syndrome. My three favorite figures of this invisibility are the following: the ludicrous Italian gigolo played in popinjay fashion by Eric Rhodes in *Top Hat*, a glorious Art Deco film in which Hollywood constructed a fantasy version of Venice, a role he reprised in *The Gay Divorcee:* what better revenge, Hollywood-style, against the dangerous Valentino cult than to cast a sissy in the role of the gigolo Tonetti ("Your wife is safe with Tonetti, he prefers spaghetti")?; the voice of Snow White (Adriana Casselotti's), so clearly that of a classically trained soprano, in Disney's animated film *Snow White and the Seven Dwarfs;* the narrow-chested Edmund Purdom, in *The Student Prince,* lip-syncing the songs sung by Mario Lanza, who was not regarded as suitable to play the role of leading man.

This (mis)casting of non-Italian actors in key roles that were definitive in the construction of the Italian American image was, in effect, an ironclad rule governing the casting practices of Hollywood throughout the so-called Golden Years (1930s–1940s). These practices can be attributed in part to the system and its deployment of bankable (ethnic but non-Italian) stars in Italian roles according to a law of interchangeable ethnicity (ethnicity is thus construed as Hollywood's mark of Cain, determining the typecasting of actors, so marked, into transethnic roles) and its elevation of character actors into leading roles (character actors "pass" more easily as ethnic types). The result—profoundly ideological for "impersonation" and "transethnic" passing are essentially colonialist practices: the system determines who will represent you, who will construct your stereotype—was to produce an unconnectedness between the character and its projector, precisely because the actor approached his or her role from the outside and in terms of the "method" of impersonation. For example, along with Robinson, who defined the stereotype of the Italian American as gangster and street Bonaparte (Rico Bandello in *Little Caesar,* the fight manager Nick Donato in *Kid Galahad,* "Little John Sarto" in *Brother Orchid,* and Johnny Rocco in *Key Largo*), George Raft, the "second

Valentino," begloved and bespatted and so smooth an operator that he erased all markings of actual ethnicity, impersonated Italian American operators, some smooth, some not so smooth. Among them were the coin-flipping Rinaldo, Tony Camonte's strongarm and rival for his sister's attention in *Scarface;* the Italian immigrant maneuvering for political power in New York City as well as the affections of the upper-class Rosalind Russell in the comedy *It Had To Happen;* and, most significantly, Joe Fabrini in the cult classic *They Drive by Night,* directed by Raoul Walsh, in which Raft and Humphrey Bogart play truck-driving brothers trying to strike out on their own, the myth of ethnic "mobility" literalized in the formula of the road movie. Similarly, but usually in a comic and even bathetic mode, J. Carrol Naish (of Irish descent) made a career of impersonating Italian Americans (the father of Mario Lanza in *That Midnight Kiss,* the police detective Louis Lorelli in *Black Hand,* Uncle Vince in *Clash by Night,* and Luigi in both the radio and the television versions of *Life with Luigi,* a role that crystallized the stereotype of the servile and comically human Italian, Amos and Andy rolled up into one character, the sentimentalization of the Henry Armetta stereotype).

Martin Scorsese, cavalierly rather than critically, has commented on the behavioral inauthenticity that such casting practices produced:

> *Before* The Godfather *and* Mean Streets *came along, there were only a few Hollywood films about Italians that made sense.* House of Strangers *[1948] was accurate in terms of emotions—particularly in the character of the son played by Luther Adler. Richard Conte was great in that too. As for Edward G. Robinson, I love him as an actor, but there was a little too much of the old "Mustache Pete" Italian in his performance. Hawk's* Scarface *is a great film, but it's marred by that "Mama Mia!" school of Italian acting. Paul Muni was a great actor, but his performance in it is dated. George Raft and Ann Dvorak on the other hand were so good, so natural. Muni's with his mother were embarrassing. No one talks that way.*

This ersatz quality characterizes the majority of screen impersonations of Italians until the 1950s, when Frank Sinatra was cast as Maggio, a role originally slated for Eli Wallach, in *From Here to Eternity,* a scandalous instance of the politics of casting that gave rise to the innuendo of the Mafia's rigging of the part; Ernest Borgnine as Marty (by the way, as a demonstration of the skewed logic governing typecasting, Borgnine was cast in *From Here to Eternity* as Sergeant "Fatso" Judson, the "wop"-hating redneck), and Anna Magnani and the ingenue Marisa Pavan (both Italian born) as the Sicilian mother and daughter in *The Rose Tattoo.* Although one

can only imagine the inappropriateness of Wallach delivering Maggio's aggressive quip, "Only my friends call me wop," Sinatra's ethnic reactiveness as Maggio, a foil to the self-containment exhibited by Montgomery Clift's Prewitt, who is able to absorb "the treatment," was perceived as "behaving, rather than acting," as playing it "straight from Little Italy" according to *Time,* a rather naive response given that Sinatra's performance was an allegory of ethnic persona that involved a complex contamination among person, role, and character.

Such (mis)casting practices and the assimilationist ideology they conceal, of course, still persist, the casting of Nick Nolte as Augusto Odone in *Lorenzo's Oil* (1993) being a case in point, one that is troubling in that Odone is one of the few representations of an educated, middle-class Italian in mainstream media. What is even more problematic from a historical point of view is that this discrepant casting determines the actor-character formulas of the handful of films from the 1930s through the 1950s that are crucial to the representation of the Italian American experience. What resulted was not merely a folklorization of the Italian identity but, as its underside and as an instrument of the "weak racism" to which the "other" (non-Black, non-Jewish) minorities are subjected, the systematization of an inferiority complex based on the assumption that the ethnic subject is not suited to perform his own role. For example, *Winterset* (1936), Alfred Santell's adaptation of Maxwell Anderson's play, which was based loosely on the Sacco and Vanzetti case, features Burgess Meredith in the role of Mio, the main protagonist, while Eduardo Ciannelli is cast as the villainous Trock Estrella. Since three members of the cast—Meredith, Margo, and Ciannelli—had played in the stage production, an argument can be made for the "naturalness" of Burgess being cast, however implausibly, in the role he had so well defined on stage. On the other hand, the casting of Ciannelli, the only Italian player, as the evil-eyed second lead is emblematic of the system of casting then in place: Italians are allowed to play Italians provided they are supporting characters or supernumeraries; non-Italians are allowed to play Italians on the basis of craft and regardless of faked typecasting.

If there is an Edward G. Robinson syndrome at work in the Old Hollywood, there is, as its corollary, an Eduardo Ciannelli syndrome: the typecasting of Italian actors into the role of heavies or villains, usually according to physiognomic criteria as subtle as those of the criminologist Lombroso. The careers of Ciannelli (1887–1969), Hollywood's most recurrent evil menace, Jack LaRue (Gaspare Biondolillo; 1902–1984), Anthony Caruso (1915–), and Ted DeCorsia (1904–1973) are salient demonstrations of the typecasting of Italians as aggressive and sadistic villains. With the exception of such actors as Don Ameche (1908–1993) and Robert Alda

(1914–1986), who pass for debonair normals (for example, Alexander Bell and George Gershwin) and Richard Conte (1914–1975), an actor who was consistently cast as the generic Italian American, the visibility of Italian Hollywood actors was gained primarily in the guise of the supporting character actor—that is, the actor as "supplement" whose ethnically stigmatized body and inflected speech conform to the law of ethnic typing. Another corollary might be called the Anna Magnani syndrome, the importing of Italian actors and actresses to assume Hollywood roles based on the screen identities established in their European performances. This Hollywood exchange, which becomes a dominant practice as the cinema becomes more international, often involves a translation of their original personae into glamourized and cultish poses, more in keeping with Tinsel Town's aesthetics of the celebrity. And finally there remains the game of the name: those closet Italians who alter their names as a strategy of passing or, more pragmatically, to fit on the marquee: Anne Bancroft (Anna Maria Louise Italiano), Bernadette Peters (Bernadette Lazzara), the actress-director Penny Marshall (Penny Marscharelli), John Saxon (Carmen Orrico), and Nicolas Cage (Nicholas Kim Coppola). Cage, the nephew of director Francis Ford Coppola, and the grandson of the late Carmine Coppola, who played flute under Toscanini, changed his name as a means of constructing an identity in his own terms. On the other hand, there are a number of actors who have adopted Italianate names to produce an exotic cachet: Pola Negri (Barbara Appollonia Chalupic), Theda Bara (Theodosia Goodman), Yvonne DeCarlo (Peggy Yvonne Middleton). There are also a number of actors and actresses who have a parent of Italian descent but who are not nomenclaturally marked as Italians: among these masked Italians, the most astonishing to find is Jack Nicholson, who is perceived as being culturally Irish Catholic, but whose biological father, according to his biographer Patrick McGilligan, was a professional dancer and singer Don Furcillo-Rose: Furcillo was his surname; the "Rose" was professional (McGilligan 1994: 42). In addition to the previously mentioned Susan Sarandon, this group also includes Burt Reynolds, whose mother is of Italian origin, and Ashley Judd, the daughter of Naomi Judd and an Italian American father.

The discrepancy in actor-role formula traverses the history of classical Hollywood cinema, and, regardless of how the system fluctuated between dream factory and reality factory, Hollywood produced a conception of the world based on studio typology and concomitant actor-role formulas that conferred ersatz visibility by denying self-presentation. This discrepancy, for example, is at work in the three cinematic adaptations of Sidney Howard's prize play, *They Knew What They Wanted,* the archetypal story of the aging Californian fruit grower Tony Patucci,

whose courtship by mail of a San Francisco waitress leads not only to their marrying but also to her affair with his younger and handsomer foreman, whose photograph Tony had sent to win her heart. Her betrayal on the wedding night produces a child, which Tony then agrees to raise as his own. As its three adaptations and its subsequent conversion into a Broadway musical indicate, Howard's play is a central text in the folklorization of the Italian American as "the most happy fellow," as **cornuto e contento** (cuckolded and contented) open to heart-saving if not face-saving compromise, what Italians would call *sistemazione* (see below for a fuller explanation of these two terms). As Tony Patucci is made to put it in the third adaptation: "Peoples dey know whata dey want, but peoples no usa da head. We usa da head." In the first adaptation, *The Secret Hour* (1928), the Danish actor Jean Hersholt plays Luigi (the names keep changing as do the occupations: from bootlegger in the play to the more respectable orange grower to grape grower) and Pola Negri plays Annie (Waitress No. 7); in the second adaptation, *A Lady to Love* (1930), Edward G. Robinson and Wilma Banky occupy the main roles; in the third adaptation *They Knew What They Wanted* (1940), Charles Laughton, replete with a Charlie Chan mustache and oily black hair, and Carole Lombard play the leads. Laughton's performance was described by critic Bosley Crowther as "little more than an actor's expansive imitation of a big dummy with a thick Italian accent."

Similar violations and ethnic verisimilitude in actor-role formula are systemwide: George Jessel, the Jewish comedian, in the role of the Italian American concertina player in *Love, Live and Laugh* (1929); Dolores Costello as the boarding school girl who discovers that her mother is a madam in the *Madonna of Avenue A* (1929); William Holden as the musically gifted prizefighter in *Golden Boy* (1939) who comes to generational grips with his traditionalist father, played by Lee J. Cobb, who, it would appear from his caricatural performance, belongs to the Henry Armetta school of acting; and so on. Even *Give Us This Day* (1949, by the British producer J. Arthur Rank), the film version of the first chapter of di Donato's 1939 *Christ in Concrete,* the central literary text of the Italian American experience, featured Sam Wanamaker in the leading role of the immigrant bricklayer, with the Italian actress Lea Padovani, however, playing his wife. In *Black Hand* (1950), loosely based on the adventures of Joseph Petrosino, head of the New York Police Department's Italian squad at the turn of the twentieth century and first Italian American "good guy," Gene Kelly plays the featured role of the crusading young Italian American cop determined to remove "Little Italy" from the grip of Black Hand extortion. He is supported by J. Carrol Naish as Louis Lorelli, his crime-busting ally.

This brings us to the question of leading men and leading ladies. The Italian-born Rodolfo Valentino (Rodolfo Guglielmi), the greatest *divo* of the silent films, was the only Italian American to establish himself as a leading man in the Old Hollywood. His screen persona marked him as an exotic, as the dangerous lover and threat to American masculinity. The notorious incident involving the "pink powderpuff" epithet hurled at him by the *Chicago Tribune* in 1926 (however justified by the last part of his career) can be read as a response to his threatening masculine Otherness—the seductive game of the gaze, a particular sign of Italian masculinity—which could be brooked only by the Hog Capital's charge of effeminacy. But his Italianness was, to a certain degree, erased by his generic status as Latin Lover, the gigolo of every woman's dreams. He played only one Italian role, in fact, that of the immigrant nobleman in *Cobra* (1925). The true heirs of Valentino were supplied by Italy in the form of Marcello Mastroianni and the Hollywood-fabricated Latin Lover, Rossano Brazzi. On the other hand, Robert De Niro and Al Pacino, the two most riveting actors of the contemporary period, are the heirs of Brando and Clift. They establish themselves at the level of serious cinematic acting and, to a certain degree, transcend their status as ethnic actors, although they have constructed their screen personae in terms of playing Italian American roles.

There are a number of leading men who have primarily functioned in terms of sexual persona. Of these, the two most representative are the singers-turned-actors Frank Sinatra and Dean Martin (Dino Crocetti) who personify the temperament and body image of the second generation. Martin is the embodiment of the culturally defined type that Italians designate as **simpatico,** the person who is easy to like and nonconfrontational. (See Nick Tosches' incisive 1992 biography of Martin: *Dino: Living High in the Dirty Business of Dreams.* Written from an Italian American point of view, it gives an exhaustive account of Martin's **menefreghismo,** or "I-don't-give-a-damn-ism," while presenting an anatomy of the dark side of the American Dream factory.) Sinatra, on the other hand, exchanges personae, vacillating between the *simpatico* and the *antipatico.*

In the wake of Sinatra and Martin, there have been a series of Italian American actors who have succeeded as leading men. However unreliable the status of leading man may be as an index of ethnic representation or representability, it is an important marker of the dynamics of assimilation, for, when the actor maintains the markers of his ethnicity, the question of ethnic sexual persona is introduced and the previously stigmatized ethnic body becomes an object of desire. Of those actors who have established themselves in terms of sexual persona, the following should be mentioned:

Sylvester Stallone and John Travolta, whose careers will be discussed below, Frank Langella, Nicolas Cage, Armand Assante, Joe Mantegna, Anthony La Paglia, Gary Sinise, and Chazz Palminteri, the latter four often alternating between leading man and character-actor roles. Also to be mentioned is Alan Alda who, as both actor and director, has been described as defining the role of the tolerant, good-natured, intelligent, middle-class, middle-aged male for the 1980s and '90s—in other words, the actor least marked by his Italian Americanness. At the other end of the spectrum is John Turturro who was typecast as a sleazy Italian American early in his career and has gone on to do brilliant work as an untypical leading man, appearing in almost thirty films since 1984. Of the younger generation, the most prominent is the "world's biggest heartthrob," Leonardo DiCaprio, who received an Oscar nomination for his performance in *What's Eating Gilbert Grape* (1993) when he was just nineteen and, in 1997, assumed his first role as leading man in *Titanic*. Another heart throb is the singer Jon Bon Jovi (John Francis Bongiovi Jr.) who made his debut in *Moonlight and Valentino* (1995) and has subsequently starred in five films to be released in 1998.

With respect to actresses and beyond the international careers of such actresses as Magnani, Loren, and Gina Lollabrigida, who, each in her own way, defined the archetype of Italian womanliness for the moviegoing public (passionate, earthy, and self-assertive—that is, eternally feminine but not feminist), Anne Bancroft (1931–) is the one Italian American of her generation to establish herself as a leading lady. Because she established herself early on as a serious actress— that is, in terms of interiority—she has resisted being marked in ethnic terms. Of the *Godfather* generation of actors, Susan Sarandon (1946–), whose first notable performance was as the wholesome Ohio bride in the cult classic *The Rocky Horror Picture Show* (1975), has been the strongest and the most durable actress. Since the 1980s there has been a tremendous proliferation of second- and third-generation actresses, all of whom pass and, although they are frequently cast in the role of Italian Americans, escape typecasting because of their universal beauty, their acting skills and professional assertiveness, and the new ethnic friendly climate in Hollywood: René Russo, Mary Elizabeth Mastrantonio, Annabella Sciorra, Lorraine Bracco, Elizabeth Bracco, Marisa Tomei, Laura San Giacomo, Linda Fiorentino, Mira Sorvino, Isabella Rossellini (Italian born), Greta Scacchi (Italian born), and Valeria Golino. It is certain that the vulgar "mamma mia" image is dead, but the problem remains of whether a postmodern version of the *donna seria* will emerge—perhaps the traditional ideal of the *donna seria* will pass into professionalism and with it the notion of the actor able to serve as an ostensive sign of ethnicity. In this age of assimilation, when, paradoxically, marginality has become

universal, Italians as the last of the old ethnics have become the first of the postethnic ethnic actors. It is only Madonna who has succeeded in constructing a sexual persona in terms of ethnicity: She remains the pop madonna, the mistress–master of the twenty pantomimes and the culture of masks turned into vogueing, the last actress to function as an ostensive sign of Italianness. Her only link to the *donna seria* is her constant transgression of it and the seriousness of her masquerade as the material girl: the black dress exchanged for a bustier. Having appeared in fifteen films since 1985, Madonna has served a real apprenticeship as an actress, and her performance in the title role in *Evita* (1996), which was awarded the Golden Globe for best actress, has moved her acting onto a new level. With the birth of her daughter Lourdes, in 1996, Madonna has had to reinvent herself one more time: Who knows to what returns and revisions her maternity will lead?

Whereas the visibility granted by the New Hollywood to Italian American directors and actors is more than a sign of mainstreaming and assimilation, of "making it," the question remains of whether Italian Americans have made an "empire of their own," to use the term Neil Gabler applies to the Jews' invention of Hollywood: "Ultimately, American values came to be *defined* [Gabler's emphasis] largely by the movies the Jews made. Ultimately, by creating their idealized America on the screen, the Jews reinvented the country in the image of their fiction." Of course, the conditions that permitted Jewish Americans, primarily, to construct the old studio system and to maintain such a hegemony over the means of cultural production are no longer in effect. It should be recalled that the director Frank Capra was among the first to attempt to break with the system and to set up an independent production company, Liberty Films (1946–1948). After producing *It's a Wonderful Life* (1946), Capra was soon obliged to abandon his attempt at autonomy, which he had first called for in the article "Breaking Hollywood's 'Pattern of Sameness'" (*New York Times,* 5 May 1946). The sociological question needs to be raised regarding the impact of Italian Americans on the contemporary system. Other than Coppola's attempt to construct Zoetrope Studios, De Niro's ongoing TriBeCa project, and those of various individual producers such as Albert Broccoli (the producer of the "James Bond" films) and the relocated Dino DeLaurentis, the hegemony Italians have exerted (and continue to exert) has been through Hollywood as a patronage system, and their primary managerial role has been exercised through the directorial position. Coppola, Scorsese, De Palma, and Cimino all worked with actors on an exchangeable basis establishing an ensemble of mostly Italian American actors. Both Coppola and Scorsese practiced a type of "godfathering" of family members as well as the ex-

tended family of enclave actors, thereby executing an *italianata,* something, for better or worse, all-too-Italian. This led to Coppola's assigning key roles to family members in the production of his films: his sister Talia Shire; his conductor father, Carmine; his nephew Nicolas Cage; and ultimately his daughter Sofia as Maria Corleone in *The Godfather Part III.* The casting of a rank amateur such as Sofia in a key role opened Coppola to severe criticism. From the Italian perspective, however, such a familial gesture—a *sistemazione*—makes perfect sense, for it validates the notion of the "family movie" and, besides, why should not the director inscribe within a film about "godfathering" the very gesture of (god)fathership?

Why should the film serve Italian Americans as their primary form of artistic expression? And why is cinema the site through which their cultural history becomes readable? To account for their ascendancy in cinema, we must resort to playing the risky game of "the pertinent and impertinent stereotype"—that is, to explain creativity in certain artistic or cultural fields by resorting to the formula of national or ethnic character. Italian culture possesses a strong visual and scenographic component and has traditionally been stereotyped—pertinently—as a "culture of the spectacle," as an extroverted and eye-intensive culture given over to self-display and to the everyday aesthetics of the *bella figura,* the equivalent of the English "to cut a fine figure" but, in fact, a term designating a more comprehensive worldview based on the projection of style and grace, the ultimate art of image management. The sites where the spectacle is traditionally played out are the ***piazza*** (the town square), where the daily rite of the evening ***passeggiata*** (stroll) is enacted; the church, where the drama of the Eucharist is enacted against the backdrop of gorgeous fresco cycles, the prototypes of cinema in the arrangement of framed sequences; the opera house, where the audience–performance line breaks down, with the audience performing its own narcissistic scenarios. Even that most solemn of German philosophers Immanuel Kant played the game of the (im)pertinent stereotype when he divided European national identities according to whether they have a feeling for the sublime or the beautiful. Naturally, Kant placed the Italians as aesthetes on the side of the beautiful, their genius seen to express itself in "music, painting, sculpture, and architecture." (Given the extraordinary national cinema that Italy has produced in the twentieth century, Kant would not object to the updating of his list to include cinema.) Kant, however, is guilty here of coining an impertinent stereotype, for he ignores the significance of the strong Italian literary and philosophical culture, emphasizing Italians' attachment to the visual, the play of surfaces, at the expense of the *logos* and the interiority that language confers. Consider his comments written in *Anthropology* (1798):

> As the French prevail in their gusto for conversation, the Italians prevail in their gusto for the arts. The French prefer the private celebration, the Italians public celebration: the pomp of the parade, processions, carnivals, the splendour of public edifices, paintings, mosaics, Roman antiquities in the noble style. They like to see and be seen within a numerous company.

Here we nevertheless approach the pertinent stereotype that sees Italians as the people of the magnificent spectacle, and the Italian world, including the world of everyday practices, as a work of total art: the image of Italy as the site of a global aestheticization and theatricalization of reality. At this point, we are not far from the Italy described by Luigi Barzini in *The Italians* (1964). Barzini has long been the foremost purveyor of impertinent stereotypes—that is, cultural stereotypes that, at least in Barzini's case, are symptomatic of the ways in which Italians stereotype themselves and thus are useful as instances of self-understanding. Consider his description of the everyday performance of the self as a spectacle:

> *What exactly are those* cose all'italiana? *They are things in which we reflect ourselves as in mirrors: a gratuitous* beau geste, *a shabby subterfuge, an ingenious deception, a brilliant improvisation, an inarticulate stratagem, a particular act of bravery or villainy, a spectacular performance*. . . .

This comprehensive cultural stereotype of Italians as extroverted and gregarious people of the pagan spectacle has come to serve as a grid for reading the Italian American identity. It is important to understand that in the overall mapping of cultural stereotypes, Italian Americans stand to Italians as degraded copies, as simulacra that are poor imitations of the real thing. This is reflected in the degradation of the stereotype itself, for it comes to be attached to Italian Americans with stigmatizing force: Italian Americans are perpetually characterized as the primitive people of the body who have no linguistic identity. Their proper language is body language: the language of gesture and the self-display of the spectacle. The positive stereotype of Italy as the supreme visual culture is translated into the stereotype of bad taste, of the spectacle as kitsch. The concept of the *bella figura* is translated into that of the **brutta figura** or vulgarized as "Dago cool"— for example, the *bella figura* cut by the character played by Chazz Palminteri in *A Bronx Tale* as he nonchalantly drives his Cadillac convertible in reverse through the Bronx labyrinth. Here we return to the scenario set out at the beginning of this section: the double linguistic exile suffered by the immigrants by which they become strangers to themselves. This problematic relationship has led to the sys-

tematic stereotyping of the Italian American as one who is barred from speech, who "breaks" English and is broken by English.

This brief version of the game of the (im)pertinent stereotypes positions us to understand the formulaic explanation of Italian Americans' excellence in the visual arts as opposed to the written word. Gay Talese, the journalist and author of *Unto the Sons* (1992), put into circulation a version of the impertinent stereotype in his provocative piece, "Where Are the Italian American Novelists?" (*New York Times Book Review*, 14 March 1993). Talese explains the success of Italian American filmmakers such as Scorsese and Coppola in terms of the failure of their novelist counterparts, resorting once again to the great divide between the culture of the image and the culture of the word, or, to be exact, the culture of silence, of *omertà*, of the repressed word, of the unwritten great novel. Talese explains why Italian Americans gravitate toward the collective art of filmmaking rather than the solitary act of writing: "The writer's life is a solitary one, and I believe solitude is a most unnatural condition for the village-dwelling people that the Italians essentially are, and the crowd-pleasing performers they strive to become whenever the least bit of attention is paid." What we have here is a version of Kant's impertinent stereotype supplemented by a paranoid view of writing that sees it as a way of exposing oneself to the scrutiny of authoritarian forces: "The word is dangerous," Talese writes. "It is traceable to a single source." Whatever the explanatory power of this formula may be, it deprecates both the literary production of Italian Americans (so carefully documented in this volume) and the cinema as a total art form: verbal as well as visual and musical. Furthermore, it overlooks the status of cinema as the most powerful "linguistic" and narrative form of the twentieth century. Cinema is the great polyglot and, as such, is the medium most accessible to those still caught between two languages and locked into the realm of silence. (The estrangement from language, especially from literary language, is lifted only by the educational process as it extends over generations, the very process from which the original immigrants and their generational successors were alienated.)

A much more pertinent stereotype is proposed by Leo Braudy (1986) in his essay, "The Sacraments of Genre: Coppola, De Palma, Scorsese." He sees these directors as exponents of "a Catholic way of regarding the visible world.... Unlike the Protestant (and often Jewish) denigration of visual materiality in favor of verbal mystery, such directors mine the transcendental potential within the material world." Here the Kantian stereotype is moved onto a new ground, and the force of the visual acknowledged. But why not grant cinema the status of a speech genre or of writing itself—writing with movements, with bodies—for then its power

as an instrument for ethnic representation becomes clear as does its specific power to represent blue-collar reality and the subcultural world of mean streets.

*The Cinema of the Fathers / The Cinema of the Sons and Daughters:
Toward the Formation of an Italian American Film Canon*

In the *Sight and Sound* Top Ten poll conducted among directors in 1992, Coppola and Scorsese were ranked fourth and fifth, not far behind Federico Fellini (1920–1993) and Orson Welles (1915–1985), both of whom can be regarded as precursors of the auteur cinema (the cinema of the strong author-director who imposes his personality and visual style upon a given film and ultimately upon an entire oeuvre) in which both Coppola and Scorsese work. Welles and Fellini can stand as alternative models of the way in which authorship traditionally expresses itself in American and European film. Although Welles' films have come to be read retrospectively as attempts to impose a European sensibility upon American cinema, his work is more properly understood as the definitive example of authorship expressing itself both within and against the language of dominant (Hollywood) cinema. His strategy, most evident in *Citizen Kane,* is to convert genre film into an art film by introducing disturbances into the traditional Hollywood narrative, by foregrounding stylistic devices, and by mixing genres. Fellini, the master of the European art film as it evolves out of neorealism, works within an Italian tradition that, by privileging the personal film and stylistic excess, has allowed him to project his persona directly onto the film, thereby using cinema as an instrument of autobiographical construction and self-psychoanalysis. Both Welles and Fellini can be regarded as master practitioners of national cinemas.

On the other hand, the cinematic identities of Coppola and Scorsese are more problematic, in part because they belong to the postmodern generation of film-school-trained directors for whom the distinction between the American and the European models has collapsed and who construct their directorial identities in terms of an elaborate intertextual play with genres, precursor films, and other directorial and period styles. Furthermore, their relationships to the Hollywood system are conflicted: Coppola has constructed his Wellesian persona in terms of an elaborate agon with Hollywood attempting, at one point, to establish an alternative studio (Zoetrope) and rollercoasting between enormous blockbusters and bombs; Scorsese, as a New York director has instead maintained a certain distance from Hollywood. More fundamentally, their identities as American filmmakers are complicated by their status as practitioners of ethnic cinema. Their work, or

at least a central part of it, is concerned with the thematics of Italianness and informed by that double consciousness—the "divided consciousness"—characteristic of ethnic art. This "doubleness" also informs their cinematic language, manifesting itself through a dialogic cinema that refuses the monolingualism of Hollywood and its targeting of audiences.

It is important to point out that in the *Sight and Sound* poll, a more reliable index of canonization on an international scale than the Oscars, which are more appropriately regarded as signs of mainstreaming, the three films singled out as all-time bests were, in fact, those dedicated to the representation of the Italian American experience: Scorsese's *Raging Bull,* usually regarded as the definitive film of the 1980s, ranked fourth, while Coppola's *Godfather Part I* and *Part II* ranked seventh and ninth, respectively. The elevation of these three films, which belong at once to the Hollywood and the Italian American canon, raises a number of thorny questions regarding the ways in which ethnicity expresses itself in American mainstream cinema. Can one speak of an Italian American cinema in the strict sense of a separate cinema concerned with representing the "Otherness" and "difference" of the Italian American experience in a "different" (counter-Hollywood) and essentially critical way—that is, in a way that would constitute an oppositional or alternative cinema in ethnic terms? Here we arrive at the heart of the matter that will concern us throughout the remainder of this essay: Do these and the other third-generation Italian American filmmakers practice a politics of identity in their cinema? By "politics of identity," to use an all-too-fashionable term, I mean a deployment of cinema that contests and disturbs the stereotyping discourse that since the 1930s (and even further back) has constructed and institutionalized the image of the Italian American as a cultural stereotype.

Let me immediately question this question. First of all, both Coppola and Scorsese have produced heterogeneous bodies of work, of which only a part treats ethnic matters directly: *The Godfather* trilogy and Scorsese's "mean-streets" series, *Who's That Knocking at My Door?, Mean Streets, Raging Bull,* and *GoodFellas* (*Taxi Driver* also belongs to this mode). To reduce them to the status of ethnic directors in a narrow sense is to distort the complexity of their work and to misunderstand their struggle with their split cultural identities. That their oeuvres are traversed by a fault line dividing their ethnic films from their other work is already a marker of this complexity. Furthermore, even their ethnic production—early Scorsese excepted—is mediated by the genre format: They are, as De Palma and perhaps Cimino also are, directors who deconstruct and reconstruct genres. *The Godfather* trilogy and *GoodFellas* and *Raging Bull* are critical revisions of those masculine genres—the gangster and boxing films—in which Italian Americans were tradi-

tionally typed as part of Hollywood's master script of American ethnicity. So, in a certain sense, in their commercial films Coppola and Scorsese are representing the same thing—the generic cinema of stereotypes—but in a different way and for the purposes of critical self-representation. To speak of a politics of identity, then, requires us to immediately address the politics of representation, the ideological and aesthetic implications of genre filmmaking. However their films may belong to the cinema of ethnicity, they also remain expressions of the already old New American Cinema—the postmodern cinema of the 1970s and 1980s that emerged in the wake of the breakdown of the old studio system and in which the ethnic director as auteur, as "superstar," is the norm. From the postmodern perspective, insofar as its retroaesthetics involves recycling and nostalgia trips, the films of Coppola, Scorsese, and Company can be regarded as retrospective exercises in which they act out the endgame of ethnicity in cinematic terms. For example, both *The Godfather* trilogy and *Raging Bull* are critical reworkings of the old ethnicity from a distance and through the lens of the New (mediated) Ethnicity of cinema: the rise and fall of an old immigrant crime family and the rise and fall of Jake LaMotta, the Othello of the Bronx, in the brutal fight game of the 1940s and 1950s. Both crime and athletics were the primary means of immigrant upward mobility.

Having put into play all of these caveats, how then are we to determine an Italian American film canon? How, in particular, are we to understand the transition from the "cinema of the fathers" (Capra, La Cava, Minnelli, and even the actress Ida Lupino, the only Italian American woman filmmaker of the Old Hollywood) to the "cinema of the sons and daughters" (Coppola, Scorsese, De Palma, Cimino, Stallone, and Abel Ferrara and Quentin Tarantino, who work in the "meanstreets" tradition of Scorsese; Joe Dante of *Gremlin* fame; such women filmmakers as Penny Marshall, Nancy Savoca, Vicky Stallone, and even Madonna, who can be considered as an authorial force in her videos; and such actors-turned-directors as Alan Alda, Danny DeVito, John Turturro, and Robert De Niro)?

The cinema of the fathers did not address the problem of Italianness in a direct way. For example, Frank Capra constructed his cinema in the careerist terms of studio and professional advancement, becoming the great vehicle of populist cinema and the dominant ideologue of the New Deal. As the paradigm of the assimilated director, he embodied in his career the realization of the American Dream Old-Hollywood style. His overt mentions of Italianness were confined to the vignette of the Italian American Mamma-Pappa family in *It's a Wonderful Life* and the minimal ethnicity of *A Hole in the Head*. However, to dismiss summarily directors such as Capra and Minnelli—and Capra's assimilated heirs such as De

Palma and in a certain sense Cimino—from the Italian American canon on the grounds that an ethnic cinema must be defined in terms of themes as well as descent is to impose an essentialist view upon ethnic cinema. Ethnic cinema, by definition, always involves the inscription of the doubleness of its author. That doubleness need not take the direct form of a narration of ethnic protagonists who, by occupying the role of the outsider, enact either the tragedy of their marginality or the comedy of their assimilation. To the contrary, ethnicity is "spoken" through a series of repressions, negations, displacements, distortions, and, above all, through the strategy of "passing" itself, which involves the use of genre as a mask. Whereas the cinema of the fathers enacted the murder of their own ethnicity whether decreed by the system or the genre format, the traces of the crime remain evident in the omissions and displacements at work in the cinematic text. The signs of ethnicity express themselves as *symptoms* that can be recovered by a symptomatic reading.

For example, Capra's cinema is traditionally regarded as an expression of a first-generation denial of ethnic identity and the buying into the American ideology of success through assimilation. In fact, Capra's films bear the imprint of ethnicity; only it is manifested through the mask of symptoms. For example, in *You Can't Take It with You,* there is a telling juxtaposition of two family systems: the stuffy upper-class WASP family, and its anarchic counterpoint, the Vanderhofs, whose family dynamics are clearly those of the Italian American family, the family as spectacle, as three-ring circus, that fosters eccentricity and whose rhythm expresses itself in scenes. Something similar applies to Vincente Minnelli's cinema, in which the Italianness can be recovered by a symptomatic reading that translates his will to style and to musicalness back into the Italian cultural matrix. A similar reading could be applied to his melodramas in which his representations of the family romance can be seen as displaced versions—"soft operas," as it were—of the Italian American mode of melodramatic excess. This is clearly not the place in which to develop such symptomatic readings in detail. It is important, however, to indicate that such symptoms also inform the work of contemporary Italian American filmmakers.

An example of this is provided in films by Cimino, the pessimistic populist heir of Capra who is concerned with the American Dream gone bad. In both *The Deer Hunter* and *Heaven's Gate,* he displaces his own ethnicity onto protagonists of other ethnicities: Slavs in a small Pennsylvania steel community in the first; immigrant settlers caught up in the 1892 Johnson County wars in Wyoming in the second. This attempt at an ethnic keying is symptomatic in the above sense, as is his similar displacement of organized crime onto the Chinese syndicates in *The*

Year of the Dragon, accompanied by a territorial shift from "Little Italy" to Chinatown. On the other hand, his one attempt to confront his roots directly in *The Sicilian,* based on Mario Puzo's novel of the same name, is a flawed exercise. The fact that Cimino cannot encounter his ethnicity other than by employing the Hollywood formula and without the understanding of the Italian context exhibited by the Neapolitan director Francesco Rosi, whose earlier film *Salvatore Giuliano* treated the life of the Sicilian bandit in a much more culturally grounded way, is symptomatic. All fiascos are symptomatic.

Brian De Palma's cinema lends itself even more to such a reading. De Palma treats Italianness tangentially, using, for example, the Church of San Miniato and Florence as settings for *Obsession,* a definite reworking of Dante's encounter with Beatrice in the key of Hitchcockian suspense. His only substantial encounter with Italianness comes in the retroversion of *The Untouchables,* in which he orchestrates De Niro's attempt to out-method Rod Steiger's earlier version of Al Capone. His postmodern reworking of *The Untouchables* can be viewed as a neobaroque exercise in neogangsterism, replete with the traditional allusions to Capone's love of opera—*I pagliacci,* of all operas!—and the telling contrast between two ethnic lifestyles: the tight-lipped WASP Eliot Ness (Kevin Costner), who is represented as a subdued and work-ethic-driven family man, versus the grandiose self of Capone, the crowd-pleasing, cigar-smoking, libidinal gangster as businessman who resides in a palatial hotel that belies his penchant for violence. The question to put: When the stereotype is so exaggerated, does the stereotype break? Much more indicative at a thematic level are De Palma's attempts to critique the "way of the WASP": the extraordinary send-up of the aspic-and-alcohol-embalmed WASP family and their doily priorities in the independent film *The Wedding Party,* a playfully grotesque view of the repressed American upper-class (white-bread canape) family shot from an ethnic perspective; and the similar but aborted critique of the WASP as "master of the universe" attempted in *The Bonfire of the Vanities.* Even more to the point is De Palma's attempt to establish his cinematic sonship with respect to Alfred Hitchcock rather than his ethnic fathership, the ramifications of which will be discussed in a moment.

So the traditional criteria of theme and descent, of a *cinema by and for* a given ethnic group, needs to be radically rethought if they are to be made to account for the contradictory and mediated ways in which ethnicity expresses itself through mainstream cinema. As we have just seen, the *cinema by* is problematic even when applied to Italian American directors, many of whom display their ethnicity despite themselves. Moreover, to define a film simply in terms of the descent of the director is to eliminate the fact that a nonethnic Other may have access to a genuine

understanding of a given ethnic group. This is a problem that has come to the surface with the directorial politics surrounding the making of Spike Lee's 1992 film *Malcolm X*. In the case of *Malcolm X,* it was important, from the perspective of identity politics, that an African American direct the film. On the other hand, the film itself departed little from the traditional mythological formulas of dominant cinema, using the cinema of the same to represent something different. But that is the point: Although the political message of *Malcolm X* may be muffled by the cinema of the spectacle, the real political effect is to be determined with respect to appropriating the mass media to produce a popular film addressed specifically to a Black spectatorship.

This exclusionary principle of *authorship by* ought not, and does not, hold as a rule. For example, it would mitigate against the making of a film such as Gilo Pontecorvo's *The Battle of Algiers* (1965), perhaps the greatest example in world cinema of entering the Other's worldview. In the case of the Italian American cinema, it would eliminate such films by non-Italian directors and screenwriters as *A View from the Bridge* (1962) and *The Rose Tattoo* (1955), both of which are valid representations of the Italian American experience, although the latter takes the form of a fantasy projection by Tennessee Williams, the screenwriter, which nevertheless permits Anna Magnani to perform an ethnically articulated role. Such a criterion would automatically privilege a film like Nancy Savoca's *True Love,* somewhat of a *tarantella* of clichés, while excluding John Sayles' *Baby It's You*, which gives a more layered portrait of the *Guido* universe, to which both films are dedicated.

Likewise, the litmus test of the *cinema for* must also be called into question, especially for an assimilated Italian American spectatorship that resists, unlike the African American and Latino audiences, targeting along racial or linguistic lines and is dispersed within the silent majority. However, this does not mean that Italian American spectatorship does not come into play. The obvious instance is the Edward G. Robinson syndrome: The Italian American will detect the discrepant typecasting imposed upon them by the system. For example, they will read the performances by Cher and Olympia Dukakis in *Moonstruck,* both Academy Award–winning performances, as inauthenthic by virtue of a tissue of nuances that go against the grain of their sense of Italianness. More to the point, Italian American spectators will bring to bear at every moment of a film their own ethnically determined aesthetics. This aesthetics is determined by the cosmic distinction between those who make either a *bella figura* (to amplify our previous definition: to behave in an aesthetically correct manner that displays that one understands the rules of the game by which an image is projected) or its unpardonable opposite, a *brutta figura*. This everyday aesthetics is a product of family disci-

pline, and those who violate its protocols reflect negatively on the family. As a corollary to these categories is the figure of the **cafone** (peasant or boor, literally, but, in fact, an intense pejorative used to dismiss those who lack style and whose anti-aesthetic behavior indicates that they have failed to internalize family and group aesthetics). These categories are held by all classes and are "tribal" aesthetic categories (like the Thai distinction between the "rough" and the "smooth"), not merely bourgeois style markers; they are applied globally and especially to everyday experience. They always come into play in films in which Italians are represented and particularly when they are self-represented by Italian actors. For example, in *Moonstruck*, Danny Aiello's performance will be regarded as an exercise in **cafoneria** (*cafone*-ness), a *cafone* playing the role of a *cafone*; Vincent Gardenia's performance will be regarded as that of skilled actor playing the part of a *cafone* and thus an actor who makes a *bella figura;* and Nicolas Cage's performance will be regarded as that of a skilled actor who fails to give off the signs that he is playing a *cafone* and thus makes a *brutta figura* in this role.

At a more complex level, certain films of Italian American directors, above all, Scorsese and Coppola, are specifically designed to address the ethnic outsider and insider in different ways. I have already spoken of the double-voicedness at work in *The Godfather* trilogy. This double-encoding is perhaps the fundamental characteristic of ethnic cinema, strictly defined. My favorite example occurs in Scorsese's *GoodFellas,* when Tommy (Joe Pesci) and the boys visit his mother (played by Scorsese's mother), who naturally invites them to eat despite the lateness of the hour. As they sit around the kitchen table engaging in small talk (outside in the trunk of their car is the not-so-dead body of the made-man they are on their way to bury; the scene is an excruciating instance of black humor), they are made to listen to a story told in English by the mother, who, after it is finished, says it would be better told in Italian. She invites Tommy to supply the translation: The man in the story was a *cornuto contento*, a contented cuckold, but it is almost impossible to give the resonances of this idiomatic expression in English, for it contains a whole worldview. To begin with, being made a **cornuto** is absolutely the most damaging occurrence that can befall an Italian male, for it means that he has been, among other things, made a fool of and thus has lost face. (Anglo-American culture shares neither of these obsessions: cuckoldry and being gulled.) However, to be a *cornuto* that is *contento,* one who accepts this indignity complacently, is to be a double fool, too foolish even to recognize that he has been made a fool of by his wife and her lover. This is a perfect example of the way in which double-voicedness works in cinema: the inside joke addressed to the Italian American spectator as it is embedded within the larger joke (the presumed-dead body bang-

ing to get out of the trunk while the "good fellas" visit with Mamma as a pretext for picking up a shovel) to which both spectatorships respond.

The notion of a double-voiced cinema brings us back to our basic definition of ethnic cinema as a cinema of doubleness—of divided consciousness—that may manifest itself indirectly through suppression or negations or directly at both the thematic and the formal level. Its fullest expression can be found in *The Godfather* trilogy and in Scorsese's "mean-streets" series, for in these films ethnicity becomes problematized at the thematic level as does cinematic language itself. Coppola and Scorsese embed their split cultural identities within cinematic textuality itself. Whereas the cinema of the fathers placed ethnicity under erasure, the cinema of the sons risks the commodification of ethnicity.

The oeuvres of Coppola and Scorsese and Company are complex sites of cultural production in which their Italian American identities are often in conflict with the directorial personae and the cinematic culture from which they generate their work. In some sense, the postmodern (multicultural and perhaps postethnic) cinema in which they work displaces descent from ethnic into cinematic terms: The cinema of the sons is a cinema generated from previous cinema and is characterized by a recycling of previous styles, by the hybridization of genres and narrative modes, by fragmented citations and the general strategy of intertextuality. Thus cinematic identity is established by an agon waged with cinematic ancestors and the cultural patrimony of cinema itself. For example, that Brian De Palma should establish his cinematic identity by rewriting, in postmodernist fashion, the films of Alfred Hitchcock—that is, by waging an oedipal struggle with his cinematic rather than his "ethnic" father—is representative of the way in which cinematic and cultural identity are at odds. Whereas Stallone and Travolta embody the myth of success through assimilation, Coppola and Scorsese, the primary exponents of the Italian American cinema, and, to a lesser degree, De Palma and Cimino, who practice a cinema of "weak ethnicity," occupy authorial positions that are informed by a tension between acculturation and assimilation, between allegiance to the Italian American subculture and consent to majority culture, between ethnic filiation and cinematic affiliation, between resistance against, and consent to, Hollywood, both as a mind-set and as a dominating model of cinema that imposes a set of narrative and formal conventions. From this point of view, their conflicted cinematic position mirrors the predicament that confronts Italian Americans at large in the waning years of the twentieth century: the generational conflict that has resulted from the passage from an identity that was "family made" to one that is increasingly movie made and media determined.

Having set out in a general way the problem of determining an ethnic film canon, we must now undertake two more specific tasks. The first is to examine in a critical way the body of mainstream American films—from *Little Caesar* and *Scarface* to *Marty* and *The Rose Tattoo*, from *Love with the Proper Stranger* and *Lovers and Other Strangers* to *Rocky* and *Saturday Night Fever*, from *Moonstruck* and *Prizzi's Honor* to *Married to the Mob* to *My Cousin Vinny*—through which the cinematic image of the Italian American has been constructed and institutionalized as a cultural stereotype or, to be more precise, as a constellation of stereotypes clustered around the master-stereotype of *la famiglia*. The second task is to extricate from this extensive body of films (see the Filmography at the end of this chapter) a "countercanon" of films primarily by Italian American directors that call into question this stereotypical image, whether by deconstructing and reconstructing it or, as more often is the case, by appropriating it for the purpose of self-representation, of creating a more complex and authentic representation of who and what Italian Americans are as individuals and a group. This "countercanon" will provide us with the means of determining an authentic canon, one whose films resist and disrupt the hegemony of stereotypes. After doing this, we can describe the set of themes and stylistic features these films share in common. Before so doing, however, we must play another round of the game of (im)pertinent stereotypes.

The Game of (Im)Pertinent Stereotypes: "Wops Do Not Use Maple Syrup" (Ezra Pound)

Artistic, Impulsive, Passionate.
—*stereotypes projected upon Italians in a 1965 survey conducted at Princeton University*

the Mafia; pizza and other food; hard hats; blue collar; emotional, jealous people; dusky, sexy girls; overweight mamas; frightening, rough, tough men; pop singers; law and order; pastel-colored houses; racists; nice, quiet people.
—*stereotypes projected upon Italian Americans, according to Richard Gambino in* Blood of My Blood *(1974)*

Italy, the mother of the arts and the father of Western civilization, has always been the savage source of stereotypes. You may well recall the notorious one—impertinent to the point of being pertinent—delivered by Orson Welles in the Machiavellian role of Harry Lime in *The Third Man*:

In Italy for thirty years under the Borgias they had warfare, terror, murder, bloodshed, but they produced Michelangelo, Leonardo DaVinci, and the Renaissance. In Switzerland they had brotherly love and they had 500 years of democracy and peace and what did that produce—the cuckoo clock.

The canonical stereotype of Italy as a site of political and moral disorder that nevertheless manages to produce virtuosi like Leonardo and Michelangelo has a long career, going back to Chaucer and Shakespeare. The history of post-Renaissance Italy is traditionally booked in terms of the failure of the public sphere and the triumph of individuals—the implication being, as in the *The Third Man* citation, that Italy is a place of deviancy, of exorbitance: Its artists (Leonardo and Michelangelo) and its criminals (the Borgias), its saints and its sinners, are opposite instances of the same law of deviancy. For Europeans on the grand tour and subsequently for those Americans—"innocents abroad"—who went in search of its "fatal gift," Italy was perceived as the dangerous Other, the part of Europe that was the most oriental, the most southern (most African, most Arabian), and, by extension, the most pagan despite the presence of the Church or perhaps because of it: Roman Catholicism is, at least from a Protestant point of view, sublimated paganism, an extroverted Christianity performed as a spectacle in which Pulcinella plays Christ. Italy always was and still remains the labyrinth of labyrinths: the most civilized, the most pious, the most traditional, the most exalted, and, on the other side of the coin, the most uncanny, the most irregular, the most sophisticated in a Machiavellian way, the most violent—even its beauty is violent. Even mass tourists are subjected to the most benign symptoms of its fatal gift: Roman fever, the Daisy Miller syndrome and its late-twentieth-century installment, the so-called Stendahl syndrome, the melancholy caused by the overwhelming effect of too much beauty.

A vast body of writings—many by foreigners, Italophiles and Italophobes alike, for labyrinths rule out the possibility of neutrality—have been dedicated to the mapping out of the Italian labyrinth and its equally labyrinthine history. In lieu of an Ariadne's thread, these writers have traditionally proceeded by reducing that cultural history to a series of pertinent and impertinent stereotypes, usually descriptive of the Italian national character. I say "impertinent" for as Giulio Bollati, in an essay on the history of the Italian identity, has pointed out: "The 'Italian' does not exist, only 'Italians' exist." Of course, Bollati's is itself a most pertinent cultural stereotype, for it quite correctly exposes the lack of an organic and psychological Italian national identity and the historical reasons of such a lack: (1) Italy's lateness in consolidating itself as a nation; (2) its linguistic fragmentation;

(3) its ***campanilismo*** (excessive allegiance to one's local or regional identity and, specifically, to one's native town as emblematized in the *campanile* or bell tower), which is mirrored in introductions in which, after the exchange of names, the 64,000-dollar question is posed: "Di dove sei?" (Where are you from?); and (4) its status as a "heterotopia"—that is, its 3,000-year tradition as a culture of mixture, eclecticism, graftings. Thus, to speak of an integrated Italian identity is a hazardous business—perhaps best reserved to travel writers, novelists, and Hollywood filmmakers concerned with maintaining the myth of Italian solarity ("passionate, artistic, impulsive") and its underside, the black sun that explodes into dangerous sexuality and violence.

But what does Italy—especially that supreme fiction, the "Italy of the mind"—have to do with the Italian American experience? The *contadini* who partook in the Great Immigration were already, in some sense, strangers in their own homeland, class exiles and language exiles, long before they entered their new exile—class and linguistic, once again—within the promised land of America. There may be no such thing as an "Italian identity" because Italians parse their identities into turfs: Tuscans decline themselves into Florentines, Sienese, Pisans, Lucans, and so forth, and those Florentines, in turn, decline themselves according to whether their parish is either Santa Croce or Santa Maria Novella, and so on; the same applies for Venetians or Sicilians: microidentities established by territorial declension. This produces an incredibly rich tapestry of cultural differences—linguistic, alimentary, artistic—and, at the personal level, engenders the triumph of an individualism that expresses itself in the following extreme forms: the (artistic) virtuoso (all Italians comport themselves as *divi*) and the anarchistic self (all Italians are nonconforming monads—symbolic political parties or "countries"—unto themselves).

On the other hand, overriding this process is what might be called the "great divide": the distinction between northerner and southerner, with the onus falling on the southerner, as is always the case with geopolitics. This apparatus of the "two Italys" is the mechanism for stereotyping internal to Italian culture itself, assuming the proportions, in the twentieth century, of a permanent political and cultural battle. It is reflected in the everyday language of insult by which northerners refer to southerners as ***terroni*** (peasants linked aboriginally to the earth), and southerners refer to northerners as ***polentoni*** (polenta-eaters," thereby indicating their preference for cornmeal as opposed to pasta, the culinary emblem of the south).

Although the immigrants came from all of the regions, the majority come from the *Mezzogiorno,* and it was the generic southerner (Neapolitan, Sicilian,

Calabrian, Abruzzian, Apulian) who would generate the image of Italian Americanness in the American perception and who would stand as the object of gross stereotyping. Moreover, the very category of Italian American—as epitomized in the catchword **paesano** (countryman)—is a fabrication imposed by immigration and the resulting diaspora within urban America that conferred upon the immigrants a collective (national) identity, which their own homeland had fragmented into a tribal one. The north–south dichotomy is the fundamental predicament of Italian culture determining the nation's mind-set; one need only think of its constant presence in Italian films ranging from Visconti's *Rocco and his Brothers,* the most profound representation of internal migration (south–north) in the Italian cinema, to Pietro Germi's and Lina Wertmüller's comedies satirizing the southerner. In fact, regionalism and the great divide inform the Italian mentality, permeating all aspects of the life-world. For example, its sense of humor is linked to the dialect: Italians find humorous a comedian who, in performing in dialect, parodies the linguistic universe that by virtue of the dialect is already a canny caricature.

Campanilismo traveled to this country with the immigrants, producing in its way the microcosms of regional and even village identities that constitute the various "Little Italies": these "Little Italies" were informally zoned in terms of the original local birthplace, producing a crazy quilt of contrasts and symbolic rivalries. Over the years, *campanilismo* has progressively become muted by the generic Italian American identification. One of the few American films to treat it is *The Brotherhood,* a film about the Mafia based on a screenplay by John Carlino that sharply distinguishes between Sicilian and Neapolitan characteristics as reflected in the rival systems of regional criminality: the Mafia versus the *Camorra*. Can the generational stripping away of *campanilismo,* the Italian principle of "rugged individualism," explain why the anarchic individualism of the Italians has translated into the assimilationist conformity of the Italian Americans?

In some sense, the great divide has been displaced into the opposition between Italy and Italian America: The Italian American is perceived by the majority culture as a degraded copy of the Italian—the real thing—and hence there issues the stereotype that Italian Americans are stereotypes.

Things can be *typically Italian,* but only *stereotypically Italian American*. Consider the great divide between the commodity rubrics "made in Italy," that great boutique of international capitalism, the capital of designer style and mecca of tourism, and "made in Little Italy," the home of the Ravenite Club and cannoli. The great divide, which has become internalized by Italian Americans as a double bind, is reflected, for example, in the mental map that New Yorkers hold of their city: Bulgari, Gucci, Buccellati, Ferragamo, and the other repositories of chic lining

Fifth Avenue; Versace, Missoni, Pratese, Cenci (the Italian Brooks Brothers), San Ambroeus, the American branch of the Milanese *pasticceria* (pastry shop) that specializes in *gelato* (Italian-style ice cream), and other boutiques of even more refined chic on Madison Avenue; "Little Italy," the place of the San Gennaro Festival and Umberto's Clam House and Roma Furniture, specializers in Bronx Renaissance decor, a "Little Italy" now depleted by the egress of the third generation to the suburbs and the encroachment of the Chinese (nevertheless still the village of a "thousand eyes" and thus of little crime); Greenwich Village, still the meeting place of the tolerant old Italian neighborhood and bohemia but now upgraded—the yuppies in search of take-out *alta cucina* (high cuisine) at Balducci's providing a stark contrast to the time-worn rituals of Tiro A Segno, the old eating club for those of the earlier generation who had "made it" in America; the Mount Carmel neighborhood of Italian Harlem, the district of Vito Marcantonio and the spiritual center of Italian America, now bereft of pilgrims; Bensonhurst and Bay Ridge, stigmatized as enclaves of bigotry; SoHo, the capital of postmodernism and the adopted home of internationally renowned Italian avant-garde artists who eat their *carpaccio* (raw steak) and *tiramisù* (a trendy dessert, literally, "pick-me-up") at Mezzogiorno, a toney neo-Tuscan restaurant; and, of course, Joey Buttafuoco, arch-*Guido* and product of Matzoh-Pizza (Massapequa) cruising into the Long Island sunrise.

Where is the proper place of the contemporary Italian American? Why, after more than a century of territorialization in America, do they remain without a definite consciousness of themselves. Unlike Jewish and African Americans, who exist in oppositional relationship to the majority culture, they belong to majorities (White, Christian, Catholic, middle class) for which they represent the Other: the "darkest" White man (the double of the stereotype that has afflicted the African American: those who sing and have rhythm, have "Saturday Night Fever," engage in self-display and violence, and possess sexual prowess); the Christians of the grand opera rite: Our-Lady-of-Mt. Carmel-style Catholics, not St. Patrick style; the most blue collar of the middle class, having come late to the educational process. They are thus constituted as the Other who is not an Other. As such, the majority culture has reduced them to **Cosa Nostra** ("our thing"): the user-friendly stereotype, the ethnic group that consents to stereotyping—"unmeltable" but certainly malleable; the group without an operative antidefamation league and that does not effectively control its media image. When it does protest, it does so in such a way as to confirm the stereotype. (For a send-up of the attempt to found such an organization, Americans of Italian Descent, in the late 1960s, see Nicholas Pileggi's "How We Italians Discovered America and Kept It Clean and Pure While

Giving It Lots of Singers, Judges, and Other Swell People" in *Esquire,* June, 1968.)

Furthermore, perceived as atavistic Whites—people of the (blue-collar) body, the last White ethnics, what the playwright Albert Innaurato calls "nigger-Italians"—they function as "floating signifiers" for the majority culture, which voices its discontents through the mouthpiece of their stereotypes, all of those things that it has repressed in the name of political correctness. The most vulgar mass-media example of this is Sylvester Stallone, who as Rocky functions as the signifier of the White (blue-collar) hope and as Rambo functions as the John Wayne of the silent majority, the emblem of Reagan's America and exponent of supply-side violence.

On the other hand, the minorities perceive the Italian American as the "first White man," the one who defends turf and still has not lost his body to embourgeoisement, the Latin who is not a Latino. The best cinematic example of this can be found in Spike Lee's *Do the Right Thing,* in which an Italian pizza-parlor owner is perceived as the capitalist oppressor—not the functionary and duped brother of the system itself—and as the enforcer of cultural separatism (pizza-pie colonialism) as evidenced by his refusal to include photographs of Blacks in his portrait gallery of Italian American cultural heroes. Italian Americans are in the middle, and hence overdetermined with respect to both the majority and the other minorities.

What is it about the Italian American identity and the cultural experience through which that identity has been formed that makes Italian Americans so susceptible not only to the process of vulgar stereotyping that, for better or worse, is the price an ethnic group must pay for Americanization, but also to the vicious underside of that process: the internalization of, and colonization by, the system of stereotypes imposed by the dominant culture? Why has *la famiglia* been so vulnerable to this process of stereotyping? How is one to explain the tremendous gap between the types the Italian family, whether in its original immigrant form or its more acculturated generational transformations, is designed to produce: the **uomo di pazienza** (the "man of patience" who practices control and reserve in all things) and the *donna seria* (the "woman of seriousness" who practices a similar ethos and who inculcates in her children a code of decorum and rectitude) and the stereotypes projected upon them by a majority society that sees them either as **buffoni** (clowns) given over to emotional, alimentary, and libidinal excess or as gangsters, as criminal specters who haunt the American Dream and who are intrinsically cinematic because their gangsterism, as opposed to that of other groups, is so flagrant, so spectacular.

The most benign stereotyping of the "good family" by the Old Hollywood can be found in the 1936 film *Poor Little Rich Girl,* which stars Shirley Temple in

the title role. Lost in the city, she stumbles into Tony the organ grinder, played by the character actor Henry Armetta, the "house" organ grinder, an Italian American equivalent of Stepin Fetchit. Tony—pot-bellied, Sicilian-nosed, English-breaking, and dressed in a tattered sweater, poor but still the "most happy fella"—takes her into his hovel, where she is soon immersed in the family love feast, a communal dinner administered by Tony, who dishes out spaghetti to his meatball-shaped wife and his unwashed brood from a pot that occupies the center of the table. This loving-family scenario does not go unappreciated by the little rich girl who is "poor" (motherless and the apple of the eye of her tycoon father, who is perennially at work) because in her mansion she is subjected to the surveillance of a governess who obliges her to eat spinach and, whenever she sneezes, sends her immediately to bed and calls the doctor. Tony, on the other hand, greets her sneeze (her way of testing people's reaction to her) with a loving embrace, an accepting "salute," and another helping of pasta: the discipline of the WASP family versus the anarchy of the poor-but-rich immigrant family.

This stereotype of *la famiglia* at table has evolved and hardened into what amounts to little more than a blue-collar version of *commedia dell'arte*, with the authoritarian papa at the head of the table and the subservient mamma in the role of the madonna of the kitchen sink—"Woik on your meatballs," as Charlie Partana (Jack Nicholson) says in *Prizzi's Honor*, instructing Angelica in the niceties of domestic etiquette. A telling example of the stereotype is to be found in the dysfunctional blue-collar family portrayed in *Saturday Night Fever*. There the Maneros assemble for dinner assuming their typical roles in the family war: the Father, a recently laid-off construction worker whose position as provider is threatened and who takes out his frustrations by belittling his son Tony (played by John Travolta); the Mother, who dotes on her good but absent son, a priest, making the sign of the cross whenever mentioning his name, while also belittling the no-account Tony; the Son, Tony the Disco King, with a nowhere job and a family-inculcated inferiority complex that is only assuaged when he struts his stuff at 2001.

The setting: All eat porkchops and pasta; the only virtue of Signora Manero's cooking is that the "sauce don't drip"; nevertheless Tony, as one reviewer remarked, protects his polyester disco garb by a "prophylactic" of a tablecloth. The scenario: The Family "dumps" on Tony, including Little Sister, who incites the row by accusing Tony of being jealous of his brother; Father hits Son for back-talking, disturbing Tony's carefully arranged coiffure; Mother hits Father; Father hits Mother, who, in turn, hits Little Sister; **Nonna** (grandmother) watches all with distress and then, hitting the table, issues the call for peace: "Basta! Mangia!" After a momentary truce, the argument flairs up again: Father hits Son and so forth,

as in a game of *morra* (Italian game played with fingers). Then all returns to patriarchal normalcy, Mother and Daughter clean the table (Father, in a subsequent dinner, will prevent Tony from helping); Son heads for the disco palace, his only form of expression, his generational crisis precipitated, as we shall see in a moment.

We have gone from the stigmatized immigrant body of Henry Armetta's organ grinder to the disco-grinding body of John Travolta; from the old "Mustache Pete" as represented by Don Fanucci in *The Godfather* to Joey Zasa, the "media Don": this is, for all intents and purposes, the genealogy of the Italian American stereotype. How is one to explain the steady state of the stereotyping, which, despite slight variations, has conditioned the media image of the Italian Americans even now that they have assumed quite visible roles as bearers of the American Dream. Here I am thinking specifically of the stocktaking piece by Stephen Hall featured in *New York Times Magazine* of 15 May 1983. Titled "Italian Americans: Coming into Their Own," the article lists such Italian Americans who have become managers of the American superstructure: Mario Cuomo, then governor of New York; Salvatore Luria, Nobel Prize winner for medicine; Eleanor Cutri Smeal, former president of the National Organization for Women (NOW); Lee Iacocca, chairman of Chrysler; Joseph Vittoria, president of Avis; Geraldine Ferraro, then a U.S. Congresswoman from New York; Robert Venturi, architect; Cardinal Joseph Bernadin, archbishop of Chicago; A. Bartlett Giamatti, then president of Yale and soon-to-be commissioner of baseball; U.S. Senator Pete Domenici of New Mexico; and U.S. Senator Alfonse D'Amato of New York. What is interesting is that the great visibility of these cultural heroes has done little to alter the mass-mediated image of the Italian American.

For example, in her national race for the vice presidency and in the Democratic primary for governorship of New York, Geraldine Ferraro was dogged by charges relating to her husband's conduct of the family business, charges that, however founded or unfounded, were given credibility because they activated the tribal stigma of Italian Americans as discreditable people. On the other hand, the Republican Alfonse D'Amato, also known as Senator Pot Hole and Senator Sleaze, was branded a "fascist" by his Democratic challenger, Robert Abrams, in the 1994 senatorial race, a strategy that backfired. More indicative is that even Mario Cuomo is not immune from stigmatization as evidenced by his reluctance to run for the U.S. presidency, which fueled rumors of "family" skeletons in the closet. With such a toxic charge, we pass beyond the realm of "weak racism" usually associated with ethnicity to out-and-out racism. Similarly, neither have the verbal performances of Cuomo and the late A. Bartlett Giamatti (who died in 1989), two of the most articulate public men in recent American history, done much to dispel the image

of Italian Americans as blue-collar prisoners of language ("Sylvester Stallone for President!" as the joke goes), as verbal "mooks," to allude to the notorious line in Scorsese's *Mean Streets*. This is exquisitely ironic on two counts. First, given that Italian Renaissance humanists relayed the ancient Greek and Roman rhetorical traditions to the modern world, and that modern Italian culture, profoundly rhetorical in its orientation, has privileged verbal performance in both the public and the private spheres, Cuomo and Giamatti can be seen to belong to a transplanted civic tradition that goes back to humanism (a secular and legalistic tradition unlike the more prophetic tradition of African American oratory). Second, their exemplarity as public speakers has not served as a model for the Italian American speech community despite the general shoddiness of current American political discourse.

The question remains of why these stereotypes continue in place now that Italian Americans have exited from their ethnic ghettos and the culture of poverty and have assumed their roles as "normals," as key functionaries of civil society. The first explanation, from Antonio Gramsci, the most influential Italian thinker of the twentieth century, is that the Italian American subculture has only recently produced a body of intellectuals, including the filmmakers discussed herein, capable of criticizing their group's status within majority culture and of pointing the way to an identity that is self-induced and not Other-imposed. A second and more psychological explanation would address the intricacies of the Italian American culture of masks and the deeply ingrained attitude of *menefreghismo* (literally, "don't-give-a-damn-ism" or indifference) or its more aristocratic equivalent, **sprezzatura** (studied disdain or nonchalance). According to such a mindset, Italian Americans practice image control in their own way: Take my mask, project stereotypes upon my persona, but you do not penetrate my face; your projections display to me the limitations of your fantasy and your culture conditioning; my mask is a fiction that anticipates and deflects your fiction, hopelessly naive for it does not take into account the play of masks.

The process of cultural stereotyping is linked to the Italian American family, which, because it constitutes itself as a "strong family," serves as a foil to the American (defamilized or "weak") family. For example, a writer commenting on the public television series *An American Family,* which documented the breakdown of the Loud family, a typically 1970s California nuclear family, noted: "Maybe it's better to be a Corleone than a Loud, better to be tribal and ethnocentric than urbane and adrift." Because *la famiglia* dramatizes itself according to certain ritual scriptings of behavior and expresses itself in "scenes," it stands as the Other family—the exaggerated, hypercoded, ever-affiliating archfamily—especially in the context

of the late-twentieth-century breakdown of family values in America. To answer a previous question: The proper place of the Italian American is the family, and, as a corollary, his or her assigned position within the representational order of dominant culture is the discursive site of the stereotype. The Italian American—the assimilated species, those who have been stripped of their masks—constructs his or her identity for and as the Same: *for* the stereotype that has been projected upon him and therefore *as* a stereotype. The discourse upon the Italian American has been constructed in terms of a master narrative of *la famiglia* that splits into two antithetical strains: the narrative of the "good family," whose economy is love, and of the "bad family," whose economy is violence and whose primary embodiment is the "crime family." The good family, the one that Mario Cuomo has proposed as the model for his inclusionary politics, the one that Leo Buscaglia rhapsodizes, is the one that instills a loyalty to itself as well as to the American Dream: the one that uses maple syrup. As Richard Brookhiser quite correctly observes in *The Way of the WASP* (1991):

> Yet this intense—and in the WASP world, inordinate—family loyalty, except when it turned to crime, had no negative social effects (except, it may be, on Italians themselves). The Italians who settled down here lived peaceably with non-Italian neighbors: Jews and Chinese in New York, blacks in New Orleans. Howard Beach and Bensonhurst were headlines in the eighties, but they are historical anomalies. Italians have shown only moderate skill in running ethnic political machines, and scant interest in home country politics. The Italians' intense involvement in their families violated the imperative of civic-mindedness, but it permitted a passive conformity with other WASP ways.

On the other hand, it is precisely the "bad family" that has in gangster fashion usurped the place of the accommodating "normal" family in the mass media and in majority culture. Since we have already discussed the dynamics of this with respect to *The Godfather*, let us turn to the history of the representation of the "good family" as it extends from the 1950s into the 1990s.

The Fantasy History of the Italian Americans: Family Movies

The Year 1955 is a signal year in the history of the cinematic representation of the Italian American; that year two films narrating the conflict between first- and sec-

ond-generation families came to the attention of the mass audience: the Oscar-winning *Marty* (an adaptation of a television play by Paddy Chayefsky directed by Delbert Mann), a small-budget black-and-white film that managed to ring true, and *The Rose Tattoo* (based on Tennessee Williams' play and directed by Daniel Mann), which featured an Oscar-winning performance by Anna Magnani in the role of a Sicilian-immigrant widow. However implicated in the stereotyping discourse of the media culture of the 1950s they may be, both films produce sociologically and psychologically accurate portraits of Italian American family life that are complex, authentic dramas of assimilation. The litmus test of the stereotype is whether or not a representation confers upon a character interiority and therefore a certain subjectivity. Both films present "typical" protagonists: *Marty* is informed by a slice-of-life blue-collar naturalism in keeping with the "kitchen-sink" or "clothesline" drama of Chayefsky; *The Rose Tattoo,* on the other hand, is infiltrated by the poetic realism of Williams to the point of being overweighted by the sexual symbolism of the rose and the artificial poetry of folklorism. Both are, on the whole, negative portraits of the stifling effects of *l'ordine della famiglia* as it is imposed by two quite different versions of the overprotective mamma. In both the father is deceased, and in *The Rose Tattoo* Serafina Delle Rose (Anna Magnini) observes the Sicilian mourning ritual for her passionately adored husband, a trucker whose smuggling activities lead to his death at the outset of the film. Both are dramas of the house: of the mother's control over the threshold, over who is permitted to enter and to leave the *domus*. As dramas of the threshold, they represent the hazardous rites of passage that the mother and son and mother and daughter must undergo. The Petragalli home is a run-down working-class-family house located in the Bronx, into which Marty will invite the wallflower teacher he meets at a dance hall. The dance hall provides a counterspace to the protective home, for there the unattractive middle-aged Marty must risk repeated rejection in his quest for a partner. The Delle Rose home is a shabby cottage situated on the Gulf Coast between Mobile and New Orleans, a transplanted Sicilian village replete with a group of peasant women who act as a chorus. Serafina will retire into the home to mourn the death of her husband, who unbeknownst to her has betrayed her with another woman. Its threshold will be violated successively by her husband's mistress, who commissions Serafina, a seamstress by trade, to make a rose-colored silk shirt for him, by the school teacher, by the boyfriend of her daughter Rosa, and by a suitor, Alvaro Mangiacavallo (Burt Lancaster), a buffoonesque version of her husband who will lead her out of her mourning. Her role as guardian of the threshold is announced at the beginning of the film when *la strega* (the witch), an evil omen, appears in her yard to claim an escaping goat.

Serafina attributes to her the **malocchio** (evil eye) and orders her daughter to retire immediately into the safety of the house. The discrepancy between the folkloric superstitions of Serafina and the common sense of her Americanized daughter comes to the surface in the ensuing dialogue:

> Rosa: She has a cataract, Mama, and her fingers are crooked because she has rheumatism!
>
> Serafina: Malocchio, the evil eye, that's what she's got! And her fingers are crooked because she shook hands with the devil. Go in the house and wash your face with salt water and throw the salt water away! Go in! Quick! She's coming!

She then makes the **mano cornuta** (the sign of the horn made with the hand), the gesture used to ward off the effects of the *malocchio*, especially when one is without the protection of those horn-shaped amulets called **corna** traditionally made from coral or gold. These protective talismans have evolved into those bright red plastic good-luck charms shaped like chili pepper that abound in America's "Little Italies" and are worn on a chain around the neck as ethnic markers—a standard feature of *Guido* dress. With Serafina's gesture, we enter into the fatalistic worldview of the southern Italian peasant for whom belief in the evil eye is a symptom of the precariousness of one's position's in a zero-sum universe in which good fortune brings the **invidia** of others (envy, from the Latin *invidere,* to look at with malice, and hence the role of the "bad eye" that projects calamity). As Frances M. Malpezzi and William M. Clements write: "To prosper, according to this worldview, is to invite envy. And envy generates ill feelings that may result in harm befalling its target. *Mal'occhio* makes concrete the abstract envy that pervades a universe defined by only a limited amount of good." (For another definitive account, see Lawrence Di Stasi's *Mal Occhio: The Underside of Vision.*) It is precisely this primordial belief in impending calamity, borne out by the death of her husband, that places Serafina in the role of the overvigilant good mother, the mother with the good eye, who guards the threshold and who seeks to exercise control over those forces that may harm her daughter Rosa (the rose is a symbol of her daughter's virginity, to be guarded at all costs), including the Americanization represented by school ("How high is the high school? . . . Scuola maledetta!" [a cursed school]) and the American-style courtship pursued by Rosa's boyfriend ("You don't look Catholic to me—a wild thing in the house.") Of course, the belief in the evil eye has become a standard feature in the cinematic treatment of Italian Americans. Reduced to urbanistic folklore or expanded into the larger mythology of the un-

lucky or lucky person and thus deprived of its archaic and uncanny associations with the "return of repressed," it can be seen at play in *Moonstruck* in the unluckiness of Loretta Castorini (Cher), whose not marrying in church "curses" her first marriage, and in the luckiness of the protagonists of *29th Street* and *Down by Law*.

Marty's elderly mother also smothers him—*simpatico* but *brutto*—in the name of the *domus,* the implication being that the family both demands and supplies too much and thus infantilizes the son. There are two dramas at work: Marty's deferred rite of separation from *la mamma*, something that will require him to distance himself from the family circle and from his fast-aging pals, whose "babe aesthetics" he will violate by courting a "dog"; and his mother's loss of her role as nurturer (to have no one to cook for, the ultimate Italian tragedy of the *domus*) and her passage into old age. Although the film privileges Marty's drama, the ethnic spectator will fill in the missing text of the prop-mother's drama: the fact that in the usually large Italian family one member—usually the spinster daughter—is called upon to serve as custodian of the aging parents. Here Marty's mother's crisis of aging is precipitated by her agreeing to take into her home her sister, who has been expelled from her son's home for meddling. This crisis is intensified when Marty brings home the teacher (Catholic but not Italian) for the moment of truth: the culture-clashing encounter with his mother, who regards her with suspicion—a stranger not to be incorporated into the *domus* in part because her Americanness renders her unsympathetic to the tragedy of displaced mothers. In *The Rose Tattoo*, a similar fate awaits Rosa's boyfriend (Catholic but not Italian), whom Serafina obliges to get down on his knees and swear to her that he will not violate the honor of her daughter.

Both films represent *la famiglia* as a strong grid; both underscore its control of sexuality and depict a generational clash that expresses itself through conflict but not defiant rebellion. At the level of stereotypes, *The Rose Tattoo* codifies for the American audience of the 1950s the Earth-mother myth of the southern Italian woman—at once fiercely maternal and fiercely erotic (the archetype of *la lupa,* the she-wolf)—which Magnani and Sophia Loren would come to embody throughout their careers. On the other hand, the character of Marty, a man *negato* (not suited) for sexuality, is somewhat anomalous within the canon of male stereotypes, who are more typically represented by the phallicism of Serafina's dead husband, Rosario Delle Rose (Rosario of the Roses), and even the vulgar sexuality of the suitor-*cafone* Alvaro Mangiacavallo, whose surname, "Horse Eater," is a deliberate contrast to the peasant aristocraticness suggested by the name of Serafina's husband. Another version of the mama's boy may be found in *Moonstruck*. The concept of the "mama's boy" is, in fact, a blind spot in Italian culture,

for in some sense all sons are quite naturally and unabashedly "mama's boys"; for what is a more compelling demonstration of *caritas* than the love a mother bears for her son. After all, was not Jesus a "mama's boy" in this de-oedipalized sense, as the countless *Pietàs* and madonnas-with-child adorning Italian churches reiterate. This blindness is reflected in the absence of a critical term for **mammismo** (literally, "mom-ism" or mother worship) in Italian. It is also at work in the perpetual resort to the interjection *"Mamma mia!"* when things go awry, an unbearable regression, in the eyes of American culture, on the part of an adult male but, for Italians, a declaration of the maternal love that binds the universe into a canny order. In Italian the expressions *figlio di papà* (daddy's boy) and the less frequently used *figlio di mamma* denote an overprivileged child who has been spoiled by parents, usually rich ones. While the overpossessed son is the norm(al), the Italian variant of the oedipal complex can be seen to split into two masculine typologies, perhaps pathologies: the Latin Lover as traditionally (and negatively) represented by the figures of Casanova and Don Giovanni, those seducers who have their way with a multitude of women but find difficulty with the individual woman, and those "mamma's-men" who enact the **Madonna-puttana** (mother–whore) complex, which Freud diagnosed in universal terms. The most psychologically sophisticated cinematic rendering of this complex can be found in the work of Fellini, especially in *8 1/2*, which unfolds as a psychoanalysis of the Italian male as well as of Italian madonna-centric culture. In American movies, it can be seen in its most vulgar form in the dichotomy that informs the sexual universe of the *Guido* (for example, the great divide between virgins and tramps observed by Tony Manero in *Saturday Night Fever*). As we shall see, Scorsese sets out a more Catholic-grounded and more complex version in his early films, with *Who's That Knocking at My Door?* providing the fullest anatomy of it.

The representation of the Italian American family continues throughout the 1950s and 1960s, usually in the formulaic form of dramas of assimilation and generational conflict, with particular focus on the role of the father or father figure: *Full of Life* (1957), the comedy of an Old World father who disrupts the New World marriage of his son; *A View from the Bridge* (1962), an immigrant drama of incestuous passion; *Love with the Proper Stranger* (1963), a charming vignette of the gentle rebellion of a second-generation daughter (played by Natalie Wood) against the patriarchal order represented by her brothers, who require the "stranger" (an Italian American jazz musician played by Steve McQueen, who has gotten her pregnant as a result of a one-night stand—purely exploratory on her part; casual on his) to marry her, a *sistemazione* (a way of ordering a situation) that she initially refuses given his pro forma compliance with her brothers' remedy; and *The Brotherhood*

(1969), a film about the Mafia that represents the generational conflict between an older and a younger brother in familial terms and that is regarded as a direct precursor of *The Godfather Part I and Part II.*

The perennial concern with masculinity and masculine violence will explode in the cinema of the 1970s and 1980s: *The Godfather,* the Italian American equivalent of the Oedipus trilogy; Scorsese's "mean-streets" series *(Who's That Knocking at My Door?, Mean Streets, Raging Bull,* and *GoodFellas);* Stallone's *Rocky* (1976) and its four sequels; and John Badham's *Saturday Night Fever (1977),* which can be regarded as an updated version of *Marty.* All of these films, perhaps with the exception of the epic *Godfather* trilogy, belong to a blue-collar cinema that represents the violence—sexual and verbal violence as well as physical—produced by the closed world of the Italian American neighborhood. Two further examples are *Bloodbrothers* (1978), in which the members of a family of hard hats try to coerce a younger brother (played by Richard Gere) into a construction job, while he seeks to pursue his "soft" and true vocation as a child counselor; and John Sayles' *City of Hope* (1991), a tale of urban corruption situated in Jersey City in which the "good father," the owner of a successful construction company, attempts a *sistemazione* of his son's life by offering him a "no-show" job on a construction site, a paternal gesture with disastrous consequences to both father and son.

As a subgenre of this blue-collar cinema is what might be called the cinema of the *Guido* or, even more vulgar, **cugine** (dialect for cousin), the dominant mass-media stereotype since the 1970s, which is crystallized in *Saturday Night Fever. Guido* is a pejorative term applied to lower-class, macho, gold-amulet-wearing, self-displaying neighborhood boys, supposedly derived either from the typical Italian first name ("Guido") or from the Italian *guidare* (to drive), a reference to their penchant for cruising in hot cars, those "id-mobiles" that serve as the *Guido's* boudoir. **Guidette** is their gum-chewing, big-haired, air-headed female counterpart. Belonging to this subgenre are such movies as *The Lords of Flatbush* (1974), *The Wanderers* (1979), *True Love* (1989), which represents the wedding of a *Guidette* and a *Guido,* the groom wanting to go out with the boys on his wedding night, *Baby It's You* (1983), and *My Cousin Vinny* (1992). Although this subgenre involves a vulgar process of stereotyping, a "dumbing down" of the Italian, the last two are the most interesting, for they ring variations on the *Guido's* resistance to formal education. *Baby It's You* narrates the high-school romance between Jill (Rosanna Arquette), a college-bound middle-class Jewish girl, and the Sheik (Vincent Spano), the quintessential *Guido:* darkly handsome, flashily dressed, school defiant, headed toward crime, but true loving. Sayles uses the Sheik as a foil for the smarter and class-privileged Jill. His sympathetic but critical portrayal of the

Guido's "nowhere-ism," despite the perpetual cruising, focuses on the Sheik's lack of any cultural connection, except for his role model, Frank Sinatra, whose songs he will lip-sync in a nightclub act he develops after dropping out of high school. His worldview is set out in the following dialogue:

> The Sheik: The way I figure it, there's only three people in the world that matter: Jesus Christ, Frank Sinatra, and me.
> Jill: Frank Sinatra?
> The Sheik: The man knows what he wants and gets it: best clothes, best cars, best women. Do you listen to Sinatra?
> Jill: My parents do.
> The Sheik: They got taste!

My Cousin Vinny instead represents a *Guido* as a lawyer, Vinny Gambini (Joe Pesci), a Brooklynite who goes to Alabama to defend his cousin, an innocent college student who has been charged with the murder of a convenience-store owner. The untutored—he wears a black leather jacket and gold chain to court—and completely inexperienced Vinny—he passed the bar on his sixth attempt—manages to take on a hanging judge and the rest of the redneck establishment by dint of his street smarts and the help of his girlfriend, Mona Lisa Vito (Marisa Tomei), who proves to be the deciding expert witness on automobiles, *Guido* high tech: "I come from an entire family of mechanics." What is interesting about the film is that the *Guido* and the *Guidette* in Dixie do, in fact, triumph, a triumph of New York motor-mouthed ethnic stereotypes over redneck drawling stereotypes. Needless to say, this comedy offers one of the all too few "white-collar" (black leather) representations of an Italian American in contemporary movies: the premise of professional incompetence redeemed by street smarts situates us in another mythological key, that of the Italian American as the natural, as wise fool.

Whereas *The Godfather* trilogy provides a critique of the American Dream of success and its negative effects on *la famiglia*, *Rocky* and *Saturday Night Fever*, two blockbuster movies of the 1970s, endorse—in Italian American terms—the conventional myth of "ethnic rags to mainstream riches," of working-class accession to the American Dream. Both protagonists belong to the *Guido* typology. In the first, a down-and-out palooka, Rocky (Sylvester Stallone), who makes a living strong-arming deadbeats for a loan shark, enacts the blue-collar version of the American Dream by going the distance with the champ. This requires him to submit to the discipline imposed by his manager (discipline = success) and to

compensate for his limitations as a boxer with heart and courage (to take punishment = to win). In the second, Tony Manero (John Travolta), the disco king of 2001, a *Guido* caught up in the Bay Ridge scene—"a cliché, a nobody going nowhere," as he is critically appraised by his dance partner, Stephanie Mangano, herself an upwardly mobile ex-*Guidette* who has made the move to Manhattan—enacts a rite of passage that requires him to reject his "roots" as represented by his dysfunctional family and the neighborhood subculture. The only way out of the trap of his stultifying working-class existence (he works as salesboy in a paint store) is to cross the bridge (the Brooklyn Bridge) that leads to the brave, new world of Manhattan and assimilation. His only means of self-expression is disco, greaser's ballet, and in a certain sense the movie is a portrait of the blue-collar performance artist as young *Guido*.

Both of these films represent the Italian American as bearers of the American Dream through the mythological narrative of Hollywood, infiltrated by details of neighborhood life and punctuated by an incredibly disfigured use of language. Once again the Italian American is barred from speech: "All the characters seemed to have crawled from under the stones," as one critic described the Travolta film. Whereas the rise of Rocky from underdog to champion is a fantasy narrative, *Saturday Night Fever* can be regarded as a coming-of-age movie that involves Tony's rejection of his ethnically determined identity and a move toward a new class identity, one that is mentored by Stephanie and his brother, a priest in crisis. His ritual of dressing for Saturday night reveals the superficiality of his cultural identity; stripped to black bikinis, he poses before his bedroom mirror, witnessed by the posters of his cultural icons: Bruce Lee, whom he mimes, Farrah Fawcett, and Sylvester Stallone. His superficial Catholicism, perhaps a reaction to his favored brother's priesthood, is signified by his girding himself with religious medals; his Italianness, by the gold amulets—the ubiquitous *corni*—he also drapes around his neck. All of this is to prepare for the only ritual that counts in his universe: Saturday night—not, as in *Marty,* Sunday morning Mass—and its liturgy of narcissistic self-display by which he overcomes his lack of self-esteem and becomes an object of adoration—male as well as female. Of course, disco paradise is a subcultural trap and, in the course of the film, he must outgrow it. This process of education can be seen in two specific gestures by which he rejects *Guido* ideology: the restoration of the trophy he and Stephanie had won in the dance contest to the Puerto Rican couple he felt deserved to win, a rejection of the ethnocentrism his *Guido* friends exhibit; and his ultimate acceptance of Stephanie as a platonic friend, an accommodation that requires him to junk the *Madonna–puttana* divide, the great psychosexual baggage of the *Guido*'s identity.

While these two movies embody made-in-Hollywood assimilationist fantasies, they also serve as allegories of Italian American accession to media power in the 1970s: They catapult both Stallone and Travolta into overnight mass-media stardom in terms of animal magnetism, of body image. In the case of Stallone, hyped as the new Brando, the body "speaks" through violence and not language. And when he speaks, it is in the captions of a comic-book hero. His is the hard body designed for the mute poster, and when in performance he is already the statue of Rocky erected before the Philadelphia Museum, a phallic statue that only comes alive when it jabs or smells the blood of a kill. I say this despite the endearing touches of humanity that are calculatedly built into the role. Stallone is a body-machine, a blank upon which will be projected, especially in his Rambo mode, all of the masculinist fantasies and depoliticized discontents of the silent majority. Rocky's American success is always to be won, and then lost, and then won again, in part because that success is conceived in material terms, in part because it is a function of male rituals.

Travolta also is a prisoner of the (class) body, a greaser version of Valentino. However, unlike the exotic Valentino, whose profile and gaze caused suicides, Travolta is a "bodythrob" for adolescent girls, a cherubic *Guido* whose erotic power is a function of body style, the self-display and sublimated machismo of the narcissistic body, the ethnic body as spectacle. In both of their media images, the distinction between stereotype and self-stereotype collapses. From this point of view, Stallone and Travolta, underdogs as mass-media stars, Hollywood-conquering American Dreamers, are the New Ethnic installments of the traditional process of stereotyping and self-stereotyping by which Italian Americans have been defined and have defined themselves as people of the body: (1) the corporate body of the holy family; (2) the laboring body, the body of the immigrant and his blue-collar sons (the immigrant by definition is the one who works); (3) the familiar body of the mother-house, the *casalinga* (home-style) body of the auratic *mamma*, who, dressed in black or in an apron, cuts the grind of domesticity by singing spaghetti arias; (4) the devouring body that enacts the Italian American cogito: "I eat, therefore I am"; (5) the heterosexualized body that territorializes the world in terms of the *Madonna–puttana* complex; (6) the violent body of the gangster that expropriates the American Dream machine-gun style rather than *lupara* style (***lupara***, the Italian shotgun); (7) the crooning body that plies the blonde, blue-eyed American Venus with an "olive-oil" voice (the metaphor is borrowed from *The Godfather Part I*); (8) the carnivalized body that carries the statue of the Madonna in the procession of the *festa;* and so on. All converge in the mass-mediated bodies of Stallone and Travolta, the body silenced by, and emptied of, interi-

ority by the eternal return of stereotypes, the ethnic body as commodity that is at once desired and stigmatized.

It is interesting to note that Travolta, after experiencing a complete loss of cinematic identity in the 1980s, was reconstituted by his performance as the heroin-addicted hit-man Vincent Vega in Quentin Tarantino's *Pulp Fiction* (1994). The effect of his performance in *Pulp Fiction* depends, to a certain degree, on the spectator's awareness that Travolta is "playing it again," that is, recycling, transforming, and extending his earlier screen persona as fixated in the role of Tony Manero. The supreme moment of this double awareness comes in Jackrabbit Slim's when the pop icon Travolta playing the anonymous Vega appears among the other icons (Marilyn Monroe, Buddy Holly, Elvis Presley) and proceeds to dance a twist not with the flash of Tony Manero but with the restrained competency of Vincent Vega. Nonetheless, in *Pulp Fiction* and his subsequent performances from *Get Shorty* (1995) to *Primary Colors* (1998), in which he plays a Clintonesque president of the United States, Travolta evolves into a serious and multi-dimensioned actor, escaping his imprisonment within the ethnic stereotype. The same cannot be said for Stallone despite his consistent attempts to refashion his screen persona.

In the 1980s, *la famiglia* becomes a cinematic topos or standard situation, a genre unto itself in which the same cast of characters seem to rotate from film to film. Once again the "good family" vs. "bad family" distinction remains in effect, but the criminal family undergoes a process by which it is stripped of its menacing force and translated into a comic mode. This process is reflected in such Mafia comedies as *Married to the Mob, Things Change, Spike of Bensonhurst* (all released in 1988), *The Freshman* (1990), and *Oscar* (1991), a gangster farce featuring Stallone in his comic mode. It is also at work in such movies as Alan Alda's *Betsy's Wedding* (1990) and George Gallo's *29th Street* (1991), in which the stereotypes of the good and the bad families interact. The masterpiece of the Mafioso comedy is John Houston's *Prizzi's Honor* (1985), which, among other things, introduces a feminist theme into the patriarchal universe of the mob in the form of a hit-woman who becomes the wife of Charlie Partana (Jack Nicholson), who will eventually have "to ice" her to affirm the ever-weakening law of the father. These films signify that the Mafia stereotypes had become so well established in the collective mind that they could be played off. In a certain sense, Scorsese's brilliant black comedy, *GoodFellas,* can be seen to fall within this tradition, but he operates at a different and much more dangerous level than parody. As we shall see, *GoodFellas* is, in effect, a Nietzschean exercise in the transvaluation of values by which the euphoria of the Mafia lifestyle is portrayed as more than living dangerously but as being beyond good and evil.

During the 1980s, the stereotype of the "good family" remains alive and well, receiving its fullest treatment since *Marty* and *The Rose Tattoo* in the huge box-office success *Moonstruck,* directed by Norman Jewison and scripted by John Patrick Shanley. The movie, an ethnic fairy tale set in Italian American New York (the neighborhood is an artificial construction, an amalgam of Brooklyn and Manhattan locales), enchanted audiences and critics alike, receiving an Oscar nomination for Best Picture in 1987. Its popularity can be attributed in part to the strength of its ensemble acting, which featured Oscar-winning performances by Cher (Best Actress for the role of the daughter) and Olympia Dukakis (Best Supporting Actress for the role of the mother) along with a number of supporting performances by Italian American actors: Vincent Gardenia, who received a nomination for Best Supporting Actor, Nicolas Cage, Julie Bovasso, and Danny Aiello, all of whom imparted to the movie an "Italian effect." *Moonstruck* is, in fact, a fantasy construction of *la famiglia*—lower middle class; the father is a plumbing contractor—that puts into play all of the exhausted all-in-the-family cliches and reduces ethnic life to urban folklore. These cliches are announced by the title "moonstruck" (those pixilated Italians at it once again: *pane, amore, e fantasia,* "bread, love, and fantasy") and immediately introduced on the soundtrack by Dean Martin's version of the tritest of all love-and-mandolin songs, "That's Amore." We move to the tried-and-true cast of characters that produce the magical quality of the Italian family—all are *simpatico,* even when they are *antipatico;* all are fools of love, but, in rather patronizing fashion, this family is allotted a dose of wise foolishness, especially as epitomized in the sage *nonno* (grandfather), who understands the amorous workings of the moon, and the stable *mamma,* who in her wisdom pardons her husband's long-standing affair with a bimbo of sorts. By the way, *mamma*—moon-proof—is in no way tempted to stray into a liaison with the middle-aged NYU professor who finds her mature womanliness a welcome change from the young coeds he makes a practice of seducing: The old double standard is alive and well in the time warp of the Italian American family. And, of course, there is the Cinderella of Brooklyn: Loretta (Cher), a thirty-eight-year-old widow who goes, at her fiancé's request, to a bakery to invite his estranged younger brother Ronny Camerini (Nicholas Cage) to their wedding. At the bakery ovens, she finds the enraged brother, dressed in Stanley Kowalski's undershirt, making Italian bread and fueling his hatred for his brother, who "once upon a time" had distracted him, causing him to lose his hand in a bread slicer—and his *primo amore* (first love), who found him repellent. Loretta and Ronny are both unlucky in love, for she, too, had lost her husband in an accident. The theme of bad luck and the *malocchio* are once again in play, but the moon will change all of that, for love is lovelier the

second time around, to allude to a Frank Sinatra tune that is somehow absent from the soundtrack. The moon strikes twice: first, in a night of passionate lovemaking with Ronny that awakens our Sleeping Beauty from the sexual sleep of her courtship with the boring Johnny Camerini (Danny Aeillo), a hopeless mama's boy (her onetime way of healing the grudge between the brothers); and then once again the following night when she grants Ronny his wish of taking her to the Met, where, after a Cinderella-like transformation, she is at once transfixed by *La bohème's* songs of love and death and dismayed at discovering her philandering father sharing his night at the opera with his mistress, duplicating her own illicit night. All is resolved, of course, at the family table the following morning: the family *triumphans* (Loretta and Ronny to be married, father and mother reconciled, and so forth), reconfirming the fundamental law of the abiding Italian American stereotype: all's well that ends with the well-made family—stereotype *triumphans*. What the spectator celebrates throughout *Moonstruck* is the family reunion of stereotypes, the fantasy projection of the American imaginary that employs all of the clichés in the cinematic encyclopedia: the Italian American as *déjà vu*.

Italianness According to Scorsese: Christ in Celluloid

Show yourself now Jesu! Now is the time! Save me!
Why don't you come! Are you there! . . . "
—Pietro di Donato, Christ in Concrete

St. Francis was not a numbers runner.
—Martin Scorsese, Mean Streets

It is Martin Scorsese, arguably the strongest filmmaker at work on the American scene in the late twentieth century, who takes full control over the narrative of Italian Americanness, defining it for the first time as the "Other" narrative, as an outsider's narrative marked with class and cultural difference. His cinema is the first to show Italian Americans—the mean-streets species, that is—as they are and to construct a personal narrative, based on his own autobiographical experience of growing up in "Little Italy," that presents the Italian American psyche from an inner point of view and in a cinematic language that reproduces the violent rhythms of everyday life in the New York *Lazaronitum*. Although this attempt to elaborate a personal narrative informs all of his films, including his more commercial exercises in genre filmmaking, it is most in force in his films concerned

ence and according to a masculine law of self-punishment that the bourgeois spectator can never fully fathom—all of this becomes ours. The violence of the ring extends into the *domus* itself, taking the form of soul-battering agons: LaMotta versus his wife, LaMotta versus his brother, both fifteen rounders ending in TKOs. However, to countervail this visceral process of identification (heartbeat, punchbeat), Scorsese introduces distancing devices such as those provided by the scenes in which we see the bloated LaMotta—ex-champ, ex-husband, ex-brother, ex-bull—delivering punch lines in his nightclub routine. This alternating current of identification and disidentification culminates in the code-switching citation from St. John's Gospel that serves as the epilogue to the film: "All I know is this: Once I was blind and now I can see," the implication being that LaMotta has undergone a redemption. Here we enter into the heart of the narrative economy of Scorsese's cinema: We witness these abject narratives of self-destruction, these psychodramas of masculine outsiders barred from redemption, self-banished from love, as if they were legends of sinner saints recorded by a blue-collar Dostoevsky.

Manliness According to Coppola and Scorsese

A man who doesn't spend time with his family can never be a real man.
—Vito Corleone to Johnny Fontane, The Godfather Part I

Scorsese's is the primary expression of the cinema of sons. Unlike in Coppola's *Godfather* trilogy, in which the patriarchal order remains in effect and elements of *la via vecchia* are passed from generation to generation (albeit in distorted form), thereby maintaining the supreme fiction of the strong family, in Scorsese's universe the sons have lost their actual fathers, their places having been usurped by father surrogates, the neighborhood "godfathers" who are at best weak fathers. Scorsese narrates the breakdown of the third-generation Italian American family and the failure of its traditional culture, particularly the Church, to maintain its integrative function. This obsoleteness is conveyed by the sexual crisis of J.R. in *Who's That Knocking*, a film that takes place within and against the context of the sexual revolution of the 1960s. He is saddled with a traditional (archaic) and duplicitous morality that sees women either as virgins or "broads," one that inhibits him from sleeping with the woman (a blonde and innocent-looking American who resembles, not accidently, the statues of the Madonna kept by his mother) he loves and intends to marry and, on the other hand, obliges him to reject her when she tells him that she has been raped. It is even more in effect in *Mean Streets,* in which

with the Italian American experience: the two realized installments of the projected "mean streets" trilogy (Scorsese's first feature, *Who's That Knocking at My Door?*, which was independently produced, begun in 1963 as a graduate film for NYU and completed in 1969, the fragmented shooting—including the addition of a nude scene to satisfy the distributor—actually serving to accentuate the film's disjointedness, and *Mean Streets* (1973), the film that established Scorsese as a comer); *Raging Bull* (1980) and *GoodFellas* (1990), an adaptation of Nicholas Pileggi's book *Wiseguy*. These four films, which constitute what might be called the "mean cinema," are supplemented by *Italianamerican* (1974), a short documentary of an interview with Scorsese's parents, quite literally a home movie in that it explores the *domus* in search of family history. Like Coppola, Scorsese also "godfathers" his family of actors, as evidenced by his casting of his mother in cameos.

Both *Who's That Knocking* and *Mean Streets* are autobiographical films centered on male protagonists—J.R. and Charlie, respectively, both played by Harvey Keitel—who serve as personae upon which Scorsese projects the psychosexual residues of his Catholic upbringing: J.R.'s *Madonna–puttana* complex and Charlie's punk Catholicism, his St. Francis complex, which expresses itself in the liturgies he performs as street priest in pool halls and bars ("Are thou the King of Jews?" asks his friend, Tony the bartender, to which Charlie replies, "Do you say this of yourself or have others told you?") and in his attempt to act as his brother's keeper to Johnny Boy (Robert De Niro), the ultimate lost soul. Both films situate the spectator inside the psyches of the protagonists by means of point-of view-shots: whereas *Who's That Knocking* is, in effect, a first-person narrative, *Mean Streets* is more complex, distributing subjectivity to the other three characters as well (Johnny Boy, Tony, and Mike), all of whom form the team whose collective and interactive behavior the film presents. Nevertheless, it is Charlie who is the dominant focus of the film, and we are constantly given access to his inner world, such as when, for example, we are made to witness his soliloquy with God before the altar or to enter the vertigo of his drunkenness by means of a wide-angle lens. On the other hand, the techniques of identification and distantiation are even more complex in *Raging Bull* and *GoodFellas;* the latter is accompanied by a voice-over presenting alternately the points of view of Henry Hill (Ray Liotta) and his wife (Lorraine Bracco). This voice-over gives the spectator direct access to their inner world—an easy familiarity that is perpetually contradicted by the estranging violence in which they are engaged. Nowhere is our identification with a character and his gaze more enforced than in the scenes of Jake LaMotta (Robert De Niro) fighting in the ring. There his violence becomes ours: his explosive body, his gaze, the bodies he annihilates, his body that welcomes punishment as a proof of exist-

Charlie walks the tightrope between the two superseded systems: that of confessional-style Catholicism, which has failed to sustain his priestly vocation (his disenchantment is conveyed by the story of his being duped by a priest's morality tale when on a retreat), and that of the old-style Mafia, whose code of honor is embodied in the behavior of his courtly Uncle Giovanni, who takes Charlie under his wing, grooming him old-boy style to operate a restaurant. But it is precisely the authority of Zio Giovanni that he constantly violates by following the call of the streets as epitomized in his involvement with the street-crazy Johnny Boy and his epileptic cousin Teresa, also a persona non grata, with whom he is having a surreptitious affair. The mean-street boys thus live in the generation gap: The code of honor has degenerated into a free-for-all of insults, ripoffs, and dodging of loan sharks ("If you're stupid enough to lend me money," Johnny Boy tells Michael, "you don't deserve to get paid"); religion is reduced to street sacraments and Charlie's punk imitation of Christ: "You don't make up for your sins in church. You do it in the streets. You do it at home. The rest is all bullshit and you know it." This is not to imply that Charlie's religiosity is not authentic, but that it is inadequate: "another false saint," as Scorsese describes him, he is unable to mediate the chain of reciprocal violence in which all are caught.

In *The Godfather* trilogy, *la famiglia* was seen as the repository of archaic but viable traditions; here the family is in ruins, shattered by ghetto life and its accommodation with the brutality of urban life. Nevertheless, Scorsese endows his underground men—punks, toughs, hoods, street fighters, including the one who becomes middleweight champion, "Mafiosi manqués" (never "made-men"): all permanent borderliners incapable of deterritorializing, of deghettoizing—with an interiority by which their exercises in self-destruction and (self-)violence are portrayed as part of a visceral street nihilism, a punk existentialism that renders them at once menacing figures and clowns ("goodfellas"). They are solitaries without solitude, for they are imprisoned within the network of street-corner society and its economy of vigorish and stolen goods, and, as such, they are marginals, excluded once and for all from "bourgeois" or even working-class identities. They work the streets; but they are nowhere, permanently displaced persons. They are all tactics and no strategy: They hold to a constant pattern of evasion; they are permanently on the make. They are rebels not only without a cause but without a form of rebellion other than a cosmic rage that expresses itself through violent gestures of territorialization. The best example of this is provided by Johnny Boy in *Mean Streets*, when he shoots at the Empire State Building from a tenement rooftop in "Little Italy": rebellion without rebellion; the ultimate gratuitous act, the wildness that stems from being nowhere and everywhere a prisoner.

These "mean streets" characters are what Italians themselves would call *morti di fame* (literally, "those dying from hunger" but, in fact, a derogative term without any connotations of pity that is applied contemptuously to "losers," those who have not mastered the system and internalized the law of the family). Scorsese does not mythologize them, nor does he view them with ironic detachment from the superior position of the bourgeois author. Rather, he becomes one with them, using cinematic language to establish a cultural, psychological, and linguistic equality with them and their milieu—the culture of violence, Scorsese's own culture before it was mediated by cinematic culture. In fact, the mean streeters' primary access to culture is the movies, which they ritually attend—and, I should immediately add, rock 'n' roll music. If Scorsese's characters can be seen to undergo a cultural clash, it is most clearly represented in the soundtracks of his film, in which rock 'n' roll is constantly made to collide with traditional Italian songs or familiar songs by Italian American crooners. His films are structured throughout to create a sort of jukebox effect, and the most stunning instance of counterpointing comes in *Mean Streets*, when the old-time Italian band plays "The Star Spangled Banner" at the San Gennaro street festival. Here we return to our argument regarding the "double-voiced" cinema.

Unlike Coppola, whose *Godfather* trilogy is a compromise formation with respect to Hollywood narrative by which his protagonists are heroized and held at a distance from the spectator, Scorsese creates a visceral film language that, by using point of view and other subjectivizing devices, forces the spectator to enter into the skin of his characters—notwithstanding their negativity—and to inhabit their life-world. Scorsese's use of film to construct a personal narrative has important ramifications for the ethnic cinema, for its leads him to create a countergenre—the "mean-streets" film—that not only narrates the dramas of outsiders but inscribes that outsiderness within film form itself. This produces an authentic ethnic cinema, one that operates, at least initially, as an expression of a minority or marginal point of view and as a "minor" discourse in that it refuses the "major" language of Hollywood. Scorsese, in effect, constructs a "minor" cinema—a tough cinema: Italian American, New York, blue collar—within the dominant cinema. He begins by defining this countergenre in his early independently produced work concerned with "Little Italy" *(Who's That Knocking at My Door?* and *Mean Streets)*, then expands it, in *Taxi Driver*, into commercial form, and then uses it as the basis for the deterritorialization of traditional Hollywood genres in his subsequent work.

The two most significant examples of his expropriation of Hollywood genres in the name of the "mean cinema" are to be found in *Raging Bull* and

GoodFellas, in which Scorsese deconstructs, in turn, the conventional rise-to-the-top boxing film and the gangster-crime film, transcoding the conventional moralistic formula of the "gangster as tragic hero" punished for, and by, the American Dream into a euphoric narrative of the "high life" of the wise guys, in which they organize the reality principle in terms of the pleasure principle and the libidinal exercise of violence—up to a point that is, for they, too, will have to do time. It is "wise-guy" style, of course, for they organize prison life—*sistemazione* at work once again—into the easy time of special treatment and little feasts. In the end they, too, must fall: Tommy's dream of becoming a made-man results in his being "whacked"; and our hero, Henry Hill, as he passes from the gangster high to the cocaine high, winds up in the federal witness protection program, a gentle fall that requires him to do the easy time of the straight life. This does not mean that the spectators completely suspend moral judgment; rather, they are made to enter into the gangster surrealism that informs the everyday practices of the goodfellas.

In short, Scorsese succeeds in articulating a personal narrative of Italianness—a counternarrative with respect to Hollywood's mythological one, *(Prizzi's Honor* and *Moonstruck)*—that reproduces the way in which mean-street Italian Americans experience the world, confronting head on the most central and unacceptable elements of the cultural identities imposed upon them by their various "Little Italys." There is no attempt to ameliorate ghetto life by romanticizing it or by locating in it the traces of the American Dream, as in *Saturday Night Fever.* There is no exit: Even the dream-realizing champ, Jake LaMotta, remains a self-destructive prisoner of the culture of violence and its law of territorialization. *Territory is all,* and the raging bull enacts its law not only in the savage rites performed in the symbolic neighborhood of the ring but, even more self-destructively, in his pathological jealousy—his territorial possessiveness—of his wife, who plays a Bronx-blonde Desdemona to his split performance in which he assumes at once the roles of Othello and of Iago, accusing even his brother of making him a *cornuto.* Here again we return to the Italian masculine mind-set, for which cuckoldry is the major obsession because it involves the question of honor, of loss of face, and the failure to respect. Once again it is a question of boundaries and their violation, of a sense of self expressed in territorial terms. For example, this territorial self can be seen to express itself in the turf-establishing gestures with which the dramatis personae of *Mean Streets* are first introduced to the spectator: Charlie's territorial dialogue with God in the church; Tony's expulsion of a drug user from his bar; Mike's trafficking in hot goods in the marginal zone of the Lower West Side, where the towers of Wall Street and the legitimate economy loom up in the background; Johnny Boy's blowing up a mailbox.

Scorsese's cinema of cruelty does not resort to any sociological glosses (critics wanted him to explain LaMotta's rage by supplying a biographical account of his childhood in an orphanage,) nor is their any attempt to build into his films a political agenda such as Spike Lee does in his consciousness-raising parables dealing with ghetto life. Scorsese's characters are subpolitical: they are *morti di fame* in the Gramscian sense of the term, members of a parasitic underclass that has no political or even class identity, marginals without a history and doomed to permanent underdevelopment. As we shall see, they exist in a cultural vacuum from which the laws of the father and the mother have receded.

This is not to say that his films are without political effects. It is to say, however, that he avoids the trap—always depoliticizing—of playing identity politics in the terms of commercial cinema. His politics are those of deterritorializing cinematic language, in making cinema, even commercial cinema, speak the language of the Italian American ghetto. At the most obvious level, this means he reproduces the everyday speech of the *Lazaronitum*—its blasphemies, its remnants of Italian, its sublime vulgarities, the idiolect of "Little Italy" and its brutal tribal way—politically incorrect, to say the least—of dividing up the world. His inarticulate characters are all prisoners of language, but here language is an instrument of survival, a means of gaining an edge and of deferring the inevitable—violence. Consider the fast-talking language games played out by Charlie and Johnny Boy in *Mean Streets* to defer Mike's collection of Johnny Boy's debt. On mean streets, it is always either the violence of language or the language of violence itself. Exemplary in this respect is the **passatella** (the male game of ritual insult, what in English is called "scoring"), in which violence is transformed into the key of play. Or consider those moments when language breaks down and violence breaks out: the "What's a mook?" routine in *Mean Streets*.

But let us briefly examine the four films concerned with the Italian American experience as cultural narratives. Although Scorsese's work belongs to the cinema of the sons, it is marked by the conspicuous absence of birth fathers, their place occupied by godfather-type surrogates: Zio Giovanni, in *Mean Streets,* an old-style *Mafioso* who is mentoring his nephew Charlie in *la via vechia:* "A man is known by the company he keeps"; the neighborhood godfather, in *Raging Bull,* whose sponsorship is initially rejected by LaMotta, who must eventually affiliate in order to get a shot at the championship, a symbolic sonship that requires him to take a dive; and the more assimilated godfather Paulie, in *GoodFellas,* who along with the other wise guys grooms Henry Hill from childhood to assume a place in the mob, estranging him early on both from school and from his family: his Sicilian mother, who is shocked when he appears dressed as a pubescent gangster, and,

especially, his Irish father, whom the child Hill outearns as errand boy for the goodfellas. These godfathers act at a certain distance with respect to their "sons," more or less as figures of surveillance. The vacuum is filled by the other sons, the male-bonding network of the street-corner society or, in *Raging Bull,* by the rivalry between LaMotta and his brother.

Mothers are present through absence, in the residual form of the mother–whore complex, the product of the sons' Catholic upbringing, which they project onto their lovers and wives. This is the subject of *Who's That Knocking at My Door?* In fact, the film begins with a *scena madre* in which the mother prepares a **calzone** (a large, deep-fried pocket of dough filled with ricotta), ritually apportioning it to her children in her role as domestic madonna.

Coppola's is a cinema of the father; Scorsese's is a cinema of the sons. In *The Godfather* trilogy, the traditional ideal of manliness as expressed in the concept of the *uomo di pazienza* remains in effect. Masculine restraint determines the dynastic passage of the donship from Don Vito to Don Michael to Don Vincent, although for the daring trigger-happy Vincent it remains an ideal to be more completely mastered, perhaps in an inevitable sequel. In Scorsese's universe of normlessness, it is an ideal that has receded, artificially maintained by the surrogate fathers, an encumbrance for the sons, for whom the old control game of the masks has been replaced by the pulsive hazarding of the face.

The Italian American Cinema from 1990 to 1997:
The Tarantino Situation and Other Exercises in Cinematic Attitude

The adventures of Italian American cinema can be seen to undergo an extraordinarily rich—but nonetheless problematic—evolution in the years extending from 1990 through 1997, a period characterized in general by two major transformations in Hollywood cinema: the incorporation of the ideology of multiculturalism by which a new generation of minority (particularly black but also Asian and Latino), women, and gay filmmakers are admitted into the mainstream; the opening of a new space for the independent film.

The Italian American cinema of the 1990s is characterized by the following developments: (1) an incredible escalation in the mainstream presence of Italian American actors and actresses, culminating in the annus mirabilis of 1995 in which Nicolas Cage, Susan Sarandon, and Mira Sorvino achieved a near sweep of Oscars in the acting categories (see earlier discussion of this as an index of assimilation);

a number of high-profile actors make the turn to directorial and productorial tasks: De Niro with *A Bronx Tale*, John Turturro with *Mac*, Steve Buscemi with *Trees Lounge*, Al Pacino with *Looking for Richard*; Danny DeVito establishes Jersey Films, and produces *Pulp Fiction*; (2) the continued strong filmmaking by the "movie brats" as they enter the mature phases of their careers: Martin Scorsese consolidates his position as the most accomplished and cinema-obsessed film director of his generation; the other two masters Coppola (see below) and DePalma confine themselves to well-executed genre films, the resurgent DePalma scoring commercial and artistic successes with *Raising Cain* (1992), *Carlito's Way* (1993), and *Mission Impossible* (1996); Cimino, after making *Desperate Hours* in 1990, disappears from the radar screen only to surface in 1996 with *Sunchaser*, an idiosyncratic psychological thriller; (3) a decisive changing of the guard occurs as epitomized by the meteoric rise of Quentin Tarantino (b. 1963) and the emergence of Abel Ferrara (b. 1952): Tarantino, also a character actor, establishes himself as perhaps the most accomplished director and screenwriter of his generation, primarily on the basis of *Reservoir Dogs* (1992) and *Pulp Fiction* (1994), but who solidifies his standing with *Jackie Brown* (1997); the prolific Ferrara, who makes seven films between 1990 and 1997, comes to the forefront with *King of New York* (1990), *Bad Lieutenant* (1992), *The Funeral* (1996); (4) as part of this changing of the guard, a number of promising independent film directors initiate their careers: Michael Corrente with *Federal Hill* (1995) and *American Buffalo* (1996); Tom DiCillo with *Johnny Suede* (1992), *Living in Oblivion* (1995), *Box Full of Moonlight* (1997); Greg Mottola with *Daytrippers* (1996); Salvatore Stabile with *Gravesend* (1997); (5) the emergence of a new presence by women filmmakers as exemplified by the commercial success of Penny Marshall, who, with *Big* (1988), *Awakenings* (1990), *A League of Their Own* (1992), *Renaissance Man* (1994), and *The Preacher's Wife* (1996), establishes her credentials as an A-list Hollywood director; by the continued small-scale work of Nancy Savoca, whose *Household Saints* (1993) is an original contribution to Italian American cinema in its exploration of the small world of *la famiglia* as reflected in the destinies and daily lives of three generations of women—grandmother, mother, daughter—in a working-class family; and by the omnipresence of Madonna who has become a leading actress, having appeared in fifteen films, including Alan Parker's megaproduction of *Evita* (1996) in which she starred. During the 1990s, the Italian American presence in mainstream commercial cinema continues to be decisive, revitalized by the explosive work of the independents Tarantino and Ferrara who cross over into the mainstream. But it is important not to overlook the significant creativity that has manifested itself at the level of the independent or small-budgeted film. Exploring a range of themes from within the

Italian American perspective, such films as Turturro's *Mac*, Buscemi's *Trees Lounge*, Savoca's *Household Saints*, and Tucci's *Big Night* have extended the boundaries of Italian-themed films and moved the Italian American cinema into new territory.

"Fascinating Gangsterism," or
Why Italian American Filmmakers Continue to Make Crime Movies

> PULP (pulp) n. 1. A soft, moist, shapeless mass of matter.
> 2. A magazine or book containing lurid subject matter and being characteristically printed on rough, unfinished paper.
> —American Heritage Dictionary, *New College Edition*
> (*the epigraph to Quentin Tarantino's* Pulp Fiction)

These positive developments are accompanied by what might be called an "involution," an adherence to the status quo in that a good part of the production of Italian American filmmakers, minor as well as major, remains fixated on the gangster/crime film, which continues to serve as the primary vehicle with which to represent Italianness in mainstream commercial cinema. This "involution" is a highly contradictory phenomenon. On one hand, it keeps the Italian American image imprisoned within the gangster genre and thus automatically reinforces the negative—guilty by cinematic association—stereotyping to which Italian Americans have been traditionally subjected. On the other hand, such gender-driven and gender-twisting filmmakers as Scorsese, Tarantino, and Ferrara elevate the gangster drama as art to a new level of self-consciousness and introversion, deploying the genre to produce gripping but highly distorted identity narratives that explore the visceral nihilism and amoral excesses of a new band of outsiders who bear very little resemblance to Coppola's canonic "band of insiders," who were determined by the laws and discipline of the crime family and the clannish loyalty and conservative moral stability it imposed.

For the contemporary history of the gangster film, the year 1990 is pivotal: while Coppola's *Godfather Part III* provides a valediction to the old-fashioned Little Italy Don, Scorsese's *GoodFellas* anounces the arrival of the post-*Godfather* gangster film whose development can be seen to take place under the sign of "pulp," in the two senses of the term invoked by Tarantino in the above-cited epigraph to *Pulp Fiction*. However defined, "pulp cinema" always reduces itself to the one common denominator: the flesh made pulp; the body in pain—bloodied, pulverized, and lacerated by violence—made spectacle. So as we begin to explore the com-

plex reasons for the continued obsession with the crime film and, specifically, its pulp mode, it is important to point out that pulp is the ultimate installment of the master narrative of the body and violence that has always been at the center of Italian American cinema. Although the primary practitioners of pulp are Tarantino, Ferrara, and the Scorsese of *GoodFellas*, *Cape Fear*, and *Casino* (the "pulp Scorsese" is already prefigured by the body-work of *Raging Bull*), not to be forgotten is De Palma whose *Carlito's Way* extends the pulpish concerns announced in *Scarface* (1983) which, in its depiction of the out-of-control and ultraviolent "Miami gangster," has, to a certain degree, displaced *The Godfather* trilogy as the model for the neogangster movie.

Like the traditional Depression-generated gangster movies, these neo-gangster films are essentially allegories of the American Dream gone bad, but they operate on the ambiguous moral landscape of late-capitalist America and its urban culture of ultraviolence. For example, Scorsese's *GoodFellas*, which chronicles the underworld of New York City in the sixties, and *Casino*, which chronicles the glitzy overworld of Las Vegas in the seventies, rewrite the master narrative of the American Dream as disfigured and travestied by a new breed of gangster. These neo-Mafiosi are driven by a mean streets hedonism and acquisitiveness that mirror the values of the consumer society at large, inverting its "fun morality" into visciousness for fun. Scorsese brings the Mafioso into the postmodern era, transposing the selfish, atomistic individualism of the traditional gangster into the key of narcissism and the ecstasy/obscenity of a "gangster high." But these neogangster films are also allegories of cinema by dint of their subversion of the gangster genre from within and their radically transgressive re-creations that push the genre to its limits, exacerbating its traditional self-referentiality and, at times, rendering the gangster's film metaphysical. Although they have often been grouped under the rubric of ultraviolent movies (for an overview, see Laurent Bouzereau's *Ultraviolent Movies: From Sam Peckinpah to Quentin Tarantino*, 1996), these neo-ganster films are never simply mindless exercises in blood-splattering violence but, rather, effective interrogations of the figure of the mythic big-screen gangster that call into question the cinematic fantasy that the American spectatorship has fetishistically attached to such figures.

To get at the contradictions informing this "involution," this renewed insistence on the gangster film, it is useful to make the following distinction: (1) those derivative films that constitute an "involution" in the strict sense of a regressive repetition of the formulaic gangster movie without substantially disturbing its representational laws and iconography. The Italian American gangster film, of course, had been stabilized by Coppola in the seventies with the first two install-

ments of *The Godfather* and then seemingly exhausted by two generations of parodies. Nonetheless, the Mafia exploitation film remains an omnipresent fixture in the mainstream media of the nineties as evidenced by the made-for-television feature, *Gotti: The Rise and Fall of a Real Life Mafia Don* (1996) and two primetime mini-series, *The Last Don* (1997) and *Bella Mafia* (1997). Although based on Mario Puzo's 1996 novel by the same name, *The Last Don* is little more than a recycling of the stereotypical situations derived from the preceding cinematic tradition accompanied by the mandatory bromides of Sicilian folk-wisdom: for example, "The world is what it is, and you are what you are"; "one man's tragedy can be another man's opportunity." Nonetheless, it managed to capture over 36 million television-viewing households, something that caused David Letterman to supply his own bromide, "It was so convincing, all its viewers said, 'I didn't see nothing!'"; (2) those more artistically realized films that effect an "involution" in the sense of rendering generic material more complex, of raising it to a higher power, of dismantling and re-creating the genre by citation or by deliberately exhausting its codes and stylistic registers.

Here one is dealing with a wide range of films that may fall anywhere between mainstream and art-film narratives. At the mainstream end of the spectrum is a film such as *Donnie Brasco* (1997), which troubles the conventions of the Mafia film sufficiently enough to qualify as an authentic identity narrative. Based on Joseph Pistone's memoir and scripted by Paul Attanasio, the film explores the process of psychic doubling and bonding that takes place between an FBI undercover agent, Donnie Brasco (Johnny Depp), who infiltrates a New York City–based crime family for no less than six years, and a low-level hood, played by Al Pacino, who is completely and anachronistically loyal to the Mafia conception of the world and its hierarchy. Brilliantly scripted by Attanasio who has emerged as a significant screenwriter, the film renders the linguistic universe of the mafioso with great verve; the celebrated scene in which Donnie Brasco parses the various nuances of the expression "Fuggeddabowdit!" for the benefit of his fellow FBI agents as they attempt to decipher a surveillance tape is a crash course in mob-speak, one that indicates the dangerous way in which the Mafioso lifestyle has infiltrated Brasco's own behavior. At the art-film end of the spectrum are Tarantino's *Reservoir Dogs* and *Pulp Fiction* and Ferrara's *Bad Lieutenant* and *The Funeral*, quintessential independent films—regardless of their mainstreaming and cult-status—that deliberately deconstruct the generic, aesthetic, and ideological conventions of the crime film, the dismantling and reinstatement of the laws of genre becoming the true subject of these self-conscious texts. Occupying the middleground are "mainstream independent" films like De Niro's *Bronx Tale* or small-budgeted films like

Michael Corrente's *Federal Hill* and Salvatore Stabile's *Gravesend*. These three Little Italy films ring interesting and original variations on the "mean streets" register and use the format to explore the ghetto-determined lives of young Italian American males at risk in a street universe whose male-pack violence contaminates them and comes to be introjected as self-destructive behavior. Something that, for example, the more mainstream *Sleepers* (1996), which covers similar ground, fails to do. *A Bronx Tale* and *Federal Hill* are interesting because both of their conflicted male protagonists are caught between two worlds, the no-exit world of mean streets violence and the legitimate overworld. *A Bronx Tale* narrates the adolescent passage of Calogero, who is trapped between the mentorship of his father (Robert De Niro), a law-abiding, hard-working bus driver who has internalized the blue-collar work ethic and the ethos of *la famiglia*, and his "street father," the flashy local Don (Chazz Palminteri) who, in direct opposition to the real father, initiates him into the tactics—the ghetto Machiavellism—necessary for survival. As indicated by its title, *Federal Hill* is set in the Little Italy of Providence, Rhode Island, and focuses on Nicky (Anthony DeSando), a handsome *Guido* who is caught between his infatuation for a Brown University archaeology student and his attachment to his trigger-tempered turf buddy, Ralphie (Nicholas Turturro), who compels him toward a mean streets destiny.

Within a category of their own are, of course, Scorsese's Mafia movies, *GoodFellas* and *Casino*, both of which adopt the strategy of involution by raising the representational stakes of the mean streets subgenre to a higher level. From the Italian American perspective, these are the most problematic of the neogangster films not only because they stress Italian American cultural imagery but more important, because they are so ambivalent in their representations of "fascinating gangsterism," inviting the spectator to enter into and traverse the gangster fantasy from the inside while simultaneously being made aware of and distanced from the horror and violence that the fantasy obfuscates. This contradictory invocation and exorcism of the gangster as fantasy figure produces a split in the spectator, one that cannot be totally explained by the functional dictum: "The better the gangster, the better the movie," to rephrase Alfred Hitchcock. Scorsese, in his documentary *A Personal Journey with Martin Scorsese through American Movies* (1996), has observed in describing the dangerous appeal of a screen gangster such as Scarface: "[Their world] was almost attractive because of its irresponsibility, and that was disturbing."

Big-screen gangsters have, of course, always been represented as fantasy figures in the guise of immigrant or ghetto-bound small-time hoods who enact in spectacular and dramatic fashion (Aristotelian in the rise-and-fall of the "gang-

ster as tragic hero") the American Dream of rapid social mobility. Throughout its long history, the crime film has served as a critical means of exploring the American Dream as it has been internalized in the psyche of the deterritorialized criminal, usually the ethnic outsider, who by definition is confined to the "underworld," the gangland that exists just under the surface of ordinary life. To make himself seen, the gangster must "cheat" the American Dream by substituting violence for the work ethic while displaying in flagrant fashion all the lineaments of instant success—"the Look" (sharp clothes and the agressively postured body), fast cars, fast women, loose money—and exercising power over others in a spectacular way. (For a brilliant analysis of the importance of "the Look" in gangster films, see Stella Bruzzi's *Undressing Cinema: Clothing and Identity in the Movies*, 1997.) Scorsese has himself confessed the fascination real-life Mafiosi exerted upon him: "When you're a kid you look and see these guys and they're very interesting people. To a kid they are beautifully and elegantly dressed, and they command a great deal of respect in your small world" (Scorsese 1990: 21). At the surface level, *GoodFellas*, for example, is about the gangster culture of spectacle: its protocols of self-display, conspicuous violence (violence as spectacle), conspicuous consumption, conspicuous expenditure (money is to squander), and conspicuous bad taste, which culminates in the extreme garishness of both Henry Hill's home and the love-nest he provides for his mistress. Here we are far removed from the conservative taste culture of the Corleones and plunged into the tacky world of vulgar consumerism, the gangster as arriviste, the *cafone* on a roll.

But to understand how Scorsese attempts to deconstruct the representation of the mythic gangster, it is necessary to go beneath the gangster spectacle and its flagrant travesty of American conspicuous consumption and to see how these scenarios of self-display are expressions of gangsters who are themselves caught up in their own gangster fantasy and thus whose cinematic status as fantasy figures is bracketed and critically exposed as such by Scorsese. To get at the complexity of Scorsese's representation of the neogangster's identity, one need only consider the opening of *GoodFellas*, which begins with the brutal murder of a wiseguy in a car trunk, the termination of a scene that initiates much later in the film, and then moves to a voice-over by Henry Hill (Ray Liotta) as an adult:

> Hill (voice over): *As far back as I can remember, I always wanted to be a gangster. (soundtrack: Tony Bennet's "Rags to Riches")*
> Film title: **GoodFellas**

> Hill (voice-over): *To me, being a gangster was better than being president of the United States.*
>
> *(Henry as a child looks out his bedroom window.) Even before I wandered into the cab stand for an after-school job, I knew I wanted to be a part of them. It was there that I knew I belonged, and to me it meant being somebody in a neighborhood that was full of nobodies.*

As Hill declares being a gangster is a way of establishing an identity by incorporation into a group (the gangster fantasy is intersubjective, requiring the approval of the Other: the crew, the boss Paulie Cicero [Paul Sorvino], and, ultimately, the big Other constituted by the law of the Mob) and of making oneself seen (being a somebody). The adult Hill's voice-over is superimposed over a primal scene of sorts in which Hill as a child comes to be inscribed within the gangster fantasy-scenario. The spectator, positioned in a point-of-view shot that initiates with the child Hill looking out of his window into the street, enters Hill's scene of seeing in which he is captivated by the flashy signifiers of the gangster lifestyle: Cadillacs, diamond pinkie rings, flashy sharkskin suits, sharp shoes, and the bonhomie of the hoods who ritually exchange greetings and playfully engage in mock violence, which is terminated by the appearance of Paulie, the local boss and authority figure. The remainder of the film is about Hill's entrapment within this fantasy-scenario and the horror it conceals from him. Scorsese does not, however, simply position his spectator within Hill's gangster high and the idolization of the gangster lifestyle it entails. From the very start, the director indicates his intention to deglamourize the figure of the gangster by counter-positioning the spectator to see through the fantasy-scenario: before Hill begins his voice-over, we see the scene of horror—the brutal murder in the trunk, the first of many such scenes—which the fantasy conceals and at the same creates; we then hear Tony Bennett's "From Rags to Riches," an anthem that, in introducing the most succinct formulation of the American Dream possible, serves to ironically comment on the goodfellas' aspiration to social mobility, the bottom line of which is conspicuous consumption. Money is the proof of power, but the power of money, like power itself, needs to be constantly expended.

It is clear that Scorsese's intention is to deromanticize and demystify the figure of the Mafioso, an intention made explicit at the narrative level by the terminal breakdowns experienced by the three primary members of Paulie Cicero's crew at the film's conclusion: Hill, whose gangster high has become a cocaine high, turns stoolie to save himself, ingloriously entering a Witness Protection Program to live the rest of his life as a "schnook"; the out-of-control Tommy Devito (Joe Pesci), whose gangster high expresses itself routinely in psychopathic blasts of

violence and cruel displays of power, goes so far over the edge that the mob has to exterminate him, precisely at the moment he believes he is going to realize his fantasy of becoming a "made man"; Jimmy Conway (Robert De Niro), "the kind of guy," as Hill's voice-over indicates, "who rooted for bad guys in the movies," winds up enclosed in a total paranoia, devastated by the mob's whacking of Tommy through whom he had vicariously lived out the fantasy of becoming "made" (the gangster high that was forever out of his reach because he was not Italian), and scheming to eliminate Hill, no longer a "good" goodfella. Although these humiliating resolutions, rewritings of the classic gangster film by which its rise-and-fall narrative is collapsed, position the viewer in a lawful spectatorship, the most satisfying parts of the film are those scenes in which the spectator is made to enter the gangster high: the rush of Hill's palm-greasing entry into the Copacabana through the back door with his future wife (Lorraine Bracco) and his securing a prime table, his wiseguy power eroticized and confirmed by her seduction; the exhilaration with which the goodfellas perform their deeds as a kind of transgressive activity, including Pesci's monstrous hazings, which are staged by Scorsese with a grotesque mixture of comedy and terror, and so on. All of these scenes culminate in the final image, Tommy's firing of a gun at the camera, accompanied by Sid Viscious's rendition of "My Way." This posthumous appearance of Tommy is an emblem of the spectator's fantasy inscription within the gangster film: it is the classical moment of the apotheosis of the gangster, the teleological moment in the traditional gangster narrative when, as Bruzzi (1997: 83) points out, the gangster becomes immortal and then dies. But it is exactly this moment that Scorsese has excised from the narrative and repositioned to enact the return of the repressed and to serve as an icon of the gangster film. As we proceed, we shall have to come to grips with a new iconography of the Italian American gangster and a new constellation of dangerous but compelling characters, loose cannons in the American Dream. With respect to them, it would not be incorrect to speak of an Italian American Gothic.

Under the Sign of "Pulp": Mapping Contemporary Italian American Cinema

The nineties, to use all-too-familiar coordinates, can be defined with reference to Coppola and Scorsese, both of whom complete their crime trilogies during this time: Coppola in 1990 closes out the *Godfather* series—at least for the time being—with *Godfather Part III*; Scorsese extends the anatomy of street crime in Little Italy he had begun in 1972 with *Mean Streets* with two more complex por-

traits, *GoodFellas* (1990) and *Casino* (1994). Coppola then passes to well-executed genre films directing *Bram Stoker's Dracula* in 1992, *Jack* in 1996, and *The Rainmaker* in 1997, a legal thriller based on John Grisham's homonymous novel. Always an impresario, he interspersed his cinematic work whether as director or producer with a series of entrepreneurial ventures, using the profits from Bram Stoker's *Dracula* to found the Niebaum-Coppola Winery in California's Nappa Valley and launching in January 1997 a literary magazine, *Zoetrope Short Stories*, as a means of generating film properties. On 21 March 1997, he celebrated the twenty-fifth anniversary of *The Godfather*, with a national rerelease of the film. Besides this commemorative gesture, Coppola has essentially distanced himself from the ethnic thing, and it is interesting to note that he passed on making a film based on Mario Puzo's *Last Don* (1996), a weak version of *The Godfather* which, as previously mentioned, found its more appropriate medium as a prime time television mini-series.

The nineties, however shadowed by the legacy of *The Godfather*, are more meaningfully defined with reference to Scorsese, whose "mean streets" cinema has served as a model for much of the work produced by the new wave of Italian American filmmakers, especially the "cinema of attitude" practiced by the two bad boys, Quentin Tarantino and Abel Ferrara. Although celebrated primarily for his Italian America films and his seven-film collaboration with Robert De Niro, Scorsese moves in a number of new directions which, nonetheless, forward the master narrative informing his oeuvre—the meditation on violence—by transposing it into new social and class contexts. For example, *The Age of Innocence*, his sumptuous 1993 adaptation of Edith Wharton's Pulitzer Prize–winning novel, written in 1920, of "old New York," marks a passage from the "closed world" of Little Italy to the perhaps even more "closed world" of nineteenth-century New York City aristocracy. The film is a stunning amalgam of two cultural sensibilities: the aristocratic American novel of manners as embodied by Wharton and the aristocratic Italian scenographic tradition as embodied by Luchino Visconti, whose cinema served Scorsese as a guide to filming the world of the patrician Other, whose stolen glances and gloved touches have a violence all their own. The social distance between the uptown residence of Mrs. Manson Mingott and Mulberry Street is most easily traversed through cinema.

Leaving behind his image as precocious movie brat, Scorsese has become a prime spokesman for cinematic preservation and a film instructor at large to America as evidenced by his compelling documentary, *A Personal Journey with Martin Scorsese through American Movies*, written and directed with Michael Henry Wilson in 1996. The complex trajectory of his brilliant oeuvre illustrates at once the evo-

lution and "involution" characteristic of Italian American filmmaking during the 1990s. Scorsese, on one hand, breaks new thematic ground not only with *The Age of Innocence* but with *Kundun* (1997), an explicitly political film that chronicles the life of the Dalai Lama, the spiritual and political leader of Chinese-occupied Tibet. On the other hand, he directs a studio movie, *Cape Fear* (1991), a demonic reworking of the original directed by J. Lee Thompson in 1962 and his most deliberately commercial film to date, one that positioned him to undertake more personal projects. More significant for our discussion is his reoccupation of the old territory of the gangster film with *Casino*, his 1995 reworking of *GoodFellas* in the larger key of a critical history of the American culture of gambling as centered in the Las Vegas of 1973–1983. *Casino* is Scorsese's biggest and flashiest film, an extravaganza in the line of *Citizen Kane* and *La Dolce Vita* which, like those two anatomies of earlier installments of the society of the spectacle, not only exposes the laws of that money-driven spectacle as reified in the machinery of the gambling palace but reproduces the machinery of the spectacle in its own excessive, neo-Baroque visual style, thereby making *Casino* at once a critique and an accomplice of the society of spectacle.

Las Vegas, it should be pointed out, has been a primary locus in the Italian American imaginary ever since the 1960s when Frank Sinatra's Rat Pack took center stage at the Sands Hotel and used it to define the sharkskin protocols of a sixties "cool" intended for mass cultural consumption. Rat Pack cool involved, among other things, speaking a Vegas-inflected hipster lingo which, in one of its most felicitous turns of phrase, referred to death as "the big casino." Following Sinatra's lead, especially as set out in *Ocean's Eleven* (1960), a lightweight heist movie featuring the Rat Pack, which targeted the casino and its surveillance mechanisms as a cinematic subject, Italian American filmmakers and other artists have produced a psychogeographic mapping of Italian America in terms of the New York (Little Italy)–Las Vegas axis, with significant detours to Los Angeles/Hollywood. Crucial to this mapping, of course, has been the mythologization of Las Vegas's mobster history in which the Mafia is represented as colonizer of its casino gambling and entertainment industry, a mythology first set out by Coppola and Puzo in *The Godfather Part II*. But Vegas as locus of power and money is a constant point of reference in Puzo's other work (for example, *K* and *The Last Don*) and receives perhaps its most demystifying treatment in Nicholas Pileggi's nonfiction work, *Casino: Love and Honor in Las Vegas* (1995), which would form the basis for the screenplay of Scorsese's film. Reconstructing material gathered from interviews, Pileggi recounts in semidocumentary fashion an exposé of Las Vegas, producing, in effect, a "Las Vegas confidential" that describes the final installment

of the mob's ownership of Vegas as exemplified in the real-life story of Frank "Lefty" Rosenthal and Anthony "Tony the Ant" Spilotro, the mob's "last" two men in "the neon capital of the world." But the Italian American mapping out of Las Vegas, however, has many other dimensions: the architect Robert Venturi's postmodernist exploration of the strip in *Learning from Las Vegas* (1977); Coppola's 1982 romantic comedy *One from the Heart* which, in its replication of Vegas as a set, is the most stunning visual portrait we have of Vegas as an expression of the postmodernist sublime; and the actor Nicolas Cage's Oscar-winning performance as an alcoholic in *Leaving Las Vegas* (1995), in which love, death, and self-indulgence converge in Las Vegas. Cage stamped the film with a number of signature expressions, for example, "the Kling Klang King of the Rim Ram Room," an allusion to a Sinatra song. Even Liberace, the ultimate icon of Italian American kitsch, managed to be enshrined there in a museum dedicated to him. This other mythologization of Vegas confronts its status as the American capital of the society of spectacle, as the postmodernist city of the hyperreal, that elsewhere/nowhere constituted by ephemeral flows—cash, sex, booze, neon, and sleaze—where the American Dream is realized by being gambled away.

Scorsese's *Casino*, based on a screenplay cowritten with Pileggi in which the real figures Rosenthal and Spilotro become "Ace" Rothstein (Robert De Niro) and Nicky Santoro (Joe Pesci), intersects with both these profane mythologies: Mean Streets meets Glitter Gulch, Gangland meets Playland, which is another way of saying Italian America's fantasy history meets the common culture's fantasy history. Furthermore, these two mythologies converge with a third, the profane mythology of cinema itself for *Casino* is essentially about movies—the rules of their game—and about moviemaking as a form of gaming. Here I am not just referring to the metacinematic elements of *Casino*: its recirculation of elements from Scorsese's previous films (i.e., the numerous auto-citations in *Casino* as well as its overall recycling of *GoodFellas*); and the elaborate game (previously described) Scorsese plays with the gangster genre and the grafting of other genres onto it. *Casino*, his biggest-budgeted film to date, is a high-roller of a movie in its extravagance of representation, its stylistic excess. This is to say, its central themes—the ecstasy and obscenity of gambling; money as spectacle; the power of money to reduce all human exchanges to the monetary level—are embedded within and mirrored by its own spectacular economy, which is an expression of the power of movies. Its hyperactive camera movements and free-floating scenes parallel the circulation and movement of money. As Jean Baudrillard writes: "Gaming is wonderful, because it is at the same time the locus of the ecstasy of value and that of its disappearance. . . . In gaming money is neither produced nor destroyed; it dis-

appears as value and rises again as appearance" (Baudrillard 1990: 53). *Casino*'s aesthetic of appearances is thus like gaming in that it, too, deprives the cinematic spectacle of depth and value, metamorphosing it "into pure circulation, pure fascination." *Casino* constantly superimposes the economies of two spectacles whose seductiveness and obscenity mirror each other: money as spectacle; the movies as spectacle. So the Vegas-style of *Casino* is intrinsic to Scorsese's multileveled critique of the American money culture and the void that its materialism hides.

Furthermore, the three protagonists are caught up with the need to present and maintain the self as spectacle, a project that has dire results. Neither "Ace," whose concern with "the Look" is manifested by the fifty-two color-coordinated outfits he sports, nor the out-of-control Nicky can maintain the invisibility that is requisite for their operations. When Ace, after being denied a license to operate the casino, becomes a talk-show host, Tommy tells him in disgust that he is making a spectacle of himself. This applies as well to himself and to Ginger McKenna (Sharon Stone), the femme fatale whom Ace has attempted to convert into a wife and mother. Tommy's violence becomes too visible, requiring the mob to "rub him out." Ginger, a beautiful all-purpose hustler who operates the casino in terms of seductive self-display, capivates Ace's gaze by the dazzling show she improvises one evening at the tables, and the remainder of their love story—their marriage and its breakdown, including her betrayal of Ace with Tommy—is conducted in terms of Ace's attempt to stage her presence as masquerade, as sheer money-bought "look." Ginger, on the other hand, increasingly refuses the masquerade and consistently enacts bad scenes, making a spectacle of herself in a rebellion that takes the form of self-destruction. Therefore, *Casino* is about the self as spectacle—the fascinating "look," male and female masquerade, narcissism that requires visibility—and, as its corollary, the cinema as spectacle.

The geographical and spatial coordinates of *Casino* are also highly significant: set primarily in Las Vegas, that "apotheosis of a desert town," as Venturi put it in *Learning from Las Vegas*, the film's action is centered in the artificial paradise of the strip with the fictional Tangiers Casino (actually, Rosenthal ran the Star Dust; the Tangiers is a composite of four actual casinos: the Stardust, the Hacienda the Frontier, and the Marina) as the primary location. But two other off-the-strip spaces are determinative: the empty space of the desert, the burial ground where, as Ace points out in a voice-over, "lots of the town's problems are solved," and the Midwest gangland, usually contracted to the urban back-rooms from which the mobsters call the shots, whether in Chicago, their home base, or in Kansas City, the place to which the money skimmed from the casino operation is funneled. Each month the bosses come from all over the Midwest to collect tribute,

convening in the back room of the San Marino Italian Grocery in Kansas City. Central to Scorsese's demystification of the mob is his use of the old chestnut: the gangster parody that depicts the all-powerful bosses as a motley crew of septuagenerian bosses, old chestnuts themselves, who gather around a table—Last-Supper style—in the grocery to eat macaroni and drink red wine from old jelly glasses. As Nicky explains in a voice-over: "Now, these old greaseballs might not look it, but believe me, these are the guys who secretly controlled Las Vegas."

As is usually the case in gangster films, territorialization is all, and here the Tangiers Casino, built by a loan floated by the mob-controlled Teamster's Union and directed by the innocuous Phil Green, a front-man for the mob, is a monument to the ingenious territorializing skills of the Chicago-based mob, which, although banned from Las Vegas, does manage to infiltrate utopia through the casino operation. The mob sends out its two emissaries: first Ace Rothstein, a gambler's gambler, a "fixer," the brain who meticulously runs the casino operations; and subsequently Nicky Santoro, a mobster's mobster and enforcer, the muscle who protects the casino and eventually takes over street operations. What ensues is the self-destructing narrative of the ascent to power of these two "goodfellas," ethnic doubles and psychic opposites (the Jewish American Rothstein, and the Italian American Santoro). As in *Raging Bull*, Scorsese centers his film around the mythological theme of enemy or rival "brothers," who eventually find themselves locked in an erotic triangle with Ginger.

The film's first hour unfolds as a demystifying case study of the casino operation, which is anatomized to documentary effect—but in a flagrant cinematic style that is only "documentary" in the sense that it duplicates the flows—cash, neon, glitter, desire—of the casino apparatus. Not only are the laws of the casino operation exposed as statistically rigged in favor of the house ("It's all been arranged just for us to get *your* money."; "The longer they play, the more they lose. In the end, we get it all.") and the intricacies of the mob's skimming detailed, but Las Vegas and the casino are described in sacred terms: "For guys like me," Ace says in a voice-over, "Las Vegas washes away your sins. It's like a morality car wash. It does for us what Lourdes does for humpbacks and cripples." The rite celebrated in this pilgrimage site, the Cathedral of American late capitalism, is the psychic value of money and the dollar as the Almighty. Presiding over this rite is Rothstein, the quintessential fixer and control freak, the calculating and calculable individual except in his dealings with the two figures of chaos, Ginger and Nicky.

The narrative is focused on the reterritorializations of the two protagonists, as they transplant themselves from the underworld of Chicago to the glitzy "overworld" of Las Vegas. Unlike Michael Corleone who is able to cross over,

Rothstein and Santoro are ultimately unable to reterritorialize themselves, although Rothstein makes a much better show. As he puts it in a voice-over: "Who could resist? Anywhere else in the country, I was a bookie, a gambler, alway's lookin' over my shoulder, hassled by cops, day and night. But here, I'm 'Mr. Sam Rothstein.' I'm not only legitimate, but running a casino. And that's like selling dreams for cash." He succeeds in territorializing the space of the Tangiers; his obsessive surveillance of every detail of the gambling operations is rendered cinematically by the all-seeing gaze of the camera that conveys his point of view. That panoptic gaze and the constant voice-overs spoken, in turn, by the major protagonists, with Nicky even allowed to speak posthumously toward the end of the film, are dominant stylistic features of the film. They impart a certain omniscience to the characters that contradicts the blind spots which distort their self-understanding. Ace's controlling gaze is convulsively derailed when he first spies Ginger and is then obsessively focused on Ginger whom Ace maintains as fascinating spectacle, as fetishized object of sheer visibility, with Ace showering her with gorgeous clothes and jewels from Bulgari. She is a pure simulacrum, the scene that money buys, and thus, according to Scorsese's parable on American materialism, doomed to turn obscene. Similarly, the panoptic gaze that originally embodies the power of Ace as director and Nicky as enforcer/torturer is inverted, turned back upon them as they come to be objects of a total surveillance imposed by the "Feds"—and, more determinative, by the brutal surveillance of the all-seeing mob, which cannot countenance their violations of invisibility.

Whereas Rothstein, at least initially, is able to distance himself from mean streets behavior and assimilate himself into the country-club set and WASP respectability, Santoro brings mean streets with him; despite his facade as a family man, he is incorrigible, unwilling to pass, incapable of relinquishing his primordial ghetto identity. As he informs Ace, "I'm what's real out here. Not your country clubs and your TV show." From the perspective of the ethnic cinema, *Casino* can be regarded as a complex allegory of failed assimilation, doomed from the start, obviously, because it is mob-sponsored and, more important, because its usual ethnic suspects are governed by vulgar materialism and the compulsion to repeat mean streets behavior. Although Rothstein is portrayed in the "respectable" terms of a victim of his own hubris and money-complex, it is the sociopath Santoro, played by Joe Pesci to manic effect, who is particulary distressing as a figure of Italianness, an intensification of cinematic Little Caesarism filled out with all the unsavory elements of the ghetto worldview. Pesci's hyperaggressive persona as developed in his three performances for Scorsese has been indelibly stamped on common consciousness by *Saturday Night Live* whose "visciousness for

fun" parody of him as a talk show host has become a fixture in its repertory.

Like *GoodFellas*, *Casino* is an attempt to demystify and deglamourize the figure of the gangster. Although this demystification is clearly focused on Santoro, the gangster as untragic hero, a player in a spectacle whose primary function is to convert violence into one more spectacle, and on the troop of dumb-downed old gangsters who call the shots from the outside and who represent the economic parasitism of the mob, the film operates in the danger zone where the lines between the underworld and overworld, between "fascinating gangsterism" and its critique, often become blurred. More than a gangster movie, more than a Vegas picture, *Casino* is an incisive and large-scale interrogation of the American society of spectacle as it came to realize itself in the dream-inducing, money-making machinery of the old Las Vegas, that is, Vegas before it was taken over by the big corporations and made into a Disneyland. As indicated by the pulsive flows of its image-track and sound-track and by the hyperrealism of its Vegas look, *Casino* is a film in which the spectacle of money and the spectacle of movies mirror each other. Its insistence on representing the ecstatic form of value tells us that the old Vegas was already a Disneyland for gangsters.

The most definitive event of this period is the explosive impact of the work of writer-director-actor Quentin Tarantino who, in his first two films, *Reservoir Dogs* and *Pulp Fiction*, plays out the end game of the gangster film, the most hypercoded of all the Hollywood genres, with astonishing results, producing a fundamental and powerful redescription of the genre by which it is transposed into the key of the Tarantino universe, a "world apart" governed by the law of violent surprises and whose primary ontological reference is the fictional world constituted by cinema itself. Although focused on the crime film, this end game, conducted from the aesthetic position of the independent filmmaker and cineaste, expands into a more comprehensive movie game by which the classical Hollywood movie, with its commitment to the action image framed by intelligent and hard-hitting dialogue, is redefined and resurrected as a vehicle with which to do cinema in a contemporary mode.

Tarantino first burst onto the scene in 1992 with his debut film *Reservoir Dogs*, a heist film, which does not show the lethally bungled robbery of a jewelry store but, instead, focuses on the post-heist rendezvous of the band of thieves who assume the role of detectives to determine the traitor in their midst. This structuring of the film around a blacked-out scene, which is then partially reconstructed through retrospective dialogue and flashbacks, derails the plan-and-execution mechanism of the traditional caper movie and shifts attention onto the process of vital testing and self-testing by which the character, loyalty and, ultimately, pro-

fessionalism of each team member is fathomed. *Reservoir Dogs*, a Godardian subversion in the guise of a modest but flashily stylized genre movie, is replete with those cinematic citations and "intertertextual archetypes" (for example, the Mexican stand-off, borrowed from Sergio Leone's 1966 spaghetti Western, *The Good, the Bad and the Ugly*, with which it ends and which will also be repeated as the closure of *Pulp Fiction*), the magic of which slated it for immediate canonization as a cult film. But it was the shocking scene of ultraviolence—a ten-minute torture scene featuring the severing of an ear—that provoked the split between celebration and vilification that would continue to characterize the reception of Tarantino's work, including his screenplays for *True Romance* (1993) and *Natural Born Killers* (1994), which were singled out as "nightmares of depravity" by former senator Robert Dole, who clearly had not bothered to see the films in question. Nonetheless, the rather fierce polemic surrounding his depiction of violence has led to the branding of his cinema as "ultraviolent" and "neobrutalist." For the present writer, this reading is impossibly naive and thoroughly misplaced, given the ironic way in which Tarantino constantly double-codes the scenes of violence in his films, making it virtually impossible for even the most innocent of spectators not to consciously and with a certain sense of distressing amusement play out Tarantino's game of irony. For example, the business of the previously mentioned torture scene is conducted by a deranged character who goes into a macabre song-and-dance routine to the radio accompaniment of "Stuck in the Middle with You." It is impossible to take such a scene at face value, that is, as anything other than "pulp fictional," a calculated reflex provoked by Tarantino's cinema of shocks and designed to trap the viewer in a transgressive spectatorship that calls into question the spectator's terminal inscription within the cinematic culture of violence. An even more "pulpish" example can be found in *Pulp Fiction* itself: the gory scene in which the two hitmen, Vincent Vega (John Travolta) and Jules Winnfield (Samuel F. Jackson), are obliged to clean up the blood-spattered car in which Vega has inadvertently blown out someone's brains. The cleanup, orchestrated by the professional fixer, Winston Wolf, aka "The Wolf" (Harvey Keitel), whom they have summoned to dispose of the car, and pressured by the time frame of the "Bonnie situation" (the impending return home of the wife of Jules's friend Jimmie, played by Tarantino, who reluctantly helps them in their moment of crisis), is represented in the most matter-of-fact and banal way as if violence and the erasure of its bloody traces were an everyday, almost domestic, chore. This routinization of violence, along with Tarantino's normalizing representations of gangsters who are configured, notwithstanding their aspirations to absolute "cool," as ordinary everymen (ordinary sociopaths, as it were), no longer the mythic gang-

ster, either as "tragic hero" or psychopath, is certainly Tarantino's way of commenting on the new culture of violence in anything but a mindless way. The scene of the cleanup with all its forced incongruities marks itself as a distinct fabrication. As for Scorsese, violence is a central textual strategy for Tarantino; that violence—the "bad violence" of criminal or sadistic acts as well as the mediated violence of language—is clearly foregrounded and bracketed as cinematic violence, part of a rhetoric of violence designed to position the viewer in an ironic spectatorship by which the "bad violence" of fictional actions and the mediated (foregrounded, ritualized, spectacularized) violence of cinematic textuality are made to constantly exchange places.

Expanding the genre-bound concerns of *Reservoir Dogs* into a more comprehensive and disturbing vision of movie-made America, Tarantino realized, in 1994, his strongest film to date, *Pulp Fiction*, a transgressive and cinematically self-conscious crime film set in the seamy Los Angeles underworld. *Pulp Fiction* stands to the 1990s as Scorsese's *Raging Bull* and David Lynch's *Blue Velvet* did to the 1980s. As one of the culminating exercises in the mean streets cinema initiated by Scorsese and as perhaps the ultimate manifesto of cinematic postmodernism, *Pulp Fiction* can serve as a rearview mirror through which to read the history of the Italian American cinema that I have attempted to trace throughout this piece. It, together with *Reservoir Dogs*, undertakes a radical deconstruction of the classical crime film from within the genre by which, through a constant process of citation, recycling, mixing of other genres, especially action and blaxploitation films, the conventions of the crime film are foregrounded and made into the subject of the film. In Tarantino's cinematic universe, his protagonists exist outside the moral law, but within the representational law of cinematic genre, a law which they reaffirm by constantly breaking or surprising. So such designations as "coffee house action films"—and the whole misplaced debate regarding his citational style, i.e., his "ripping off" of other directors—only get at the surface of his films, which are concerned with interrogating the law of genre and with exploring the contingency that informs the happening of events in cinema, that is to say, the taking place of cinema itself.

From the perspective of the Italian American cinema, it is Tarantino's reworking of the gangster figure that is most germane. As epitomized in his junkie hit man, Vincent Vega (John Travolta), Tarantino's gangsters are no longer represented as "wise guys" or Mafiosi; they are dislodged from the ethnically and sociologically defined universe of the *The Godfather* trilogy and of Scorsese's Mafia films. His low-life existentialists in the form of hit men/escape artists who are continually entrapped in lethal no-exit situations, operate in what appears to

be the underworld of contemporary Los Angeles, the capital of the postmodern culture of nihilism. But that world, at once hardboiled and hyperreal, is, in fact, a self-referential cinematic universe modeled on the American pulp fiction tradition: The "cheap"—popular and lurid—magazines of the twenties and thirties, printed on cheap paper and sandwiched between cheaply illustrated covers, that prefigured the paperback; they featured the "disposable" crime fiction produced by such now-indispensable American writers as Dashiell Hammett and Raymond Chandler and generated a treasury of material perfectly suited for cinematic adaptation, especially for B-movies. Tarantino's pulp universe is a heterotopia of film citations and grafts, references to popular culture, and situations and characters derived from a repertory of works falling under the sign of pulp fiction; a postmodernist microcosm of the world in fragments and of fragments. His outlaws have no allegiances other than to the ad hoc codes of professionalism and masculine loyalty and to the protocols of being cool or hip. They have no family history; as configurations of cinematic references and fragments of popular culture, their identities are purely cinematic, purely "pulp fictional," a question of family resemblance to the screen gangsters fathered by De Palma, Scorsese, Kubrick, Godard, John Woo, and so on—the list is infinitely expandable in keeping with Tarantino's own personal history as a self-described "film geek," an autodidactic clerk in a video store who absorbs all the lessons of movie-making and cinema history by way of passionate and cultish spectatorship. As Tarantino is fond of saying: "I didn't go to film school, I went to the movies."

As part of Tarantino's conscious dismantling of the traditional crime film, he marks his gangsters as cinematic constructions, surrounding their "look," gestures, speech, and behavior with quotation marks. Like Godard and unlike Scorsese or Coppola, he thus draws the spectator's attention to their status as fictional gangsters who do not copy the real gangster but rather signify him. Keyings and rekeyings of fabricated behavior are constantly in play: "Let's get into character," as Jules tells Vincent Vega as they break off their discussion of the cosmic significance of foot massages and switch to their intimidating gangster routine. Tarantino's gangsters, thus, are metacinematic figures who constantly declare their fictionality just as his narratives, with their disruptive breaks and gaps, their titled subsections, and their continual jamming of the action by recording the talk-fests of their garrulous characters, signal their cinematicness.

Tarantino renders the gangster contemporary, post-modernizing and de-ethnicizing the traditional figure of the gangster. This de-ethnicization can be seen most explicitly in the game of the name Tarantino plays in *Reservoir Dogs*, where the erased surnames of the color-designated characters render the Italianness of

some of the characters into a subtext, hinted at, either by the actors' actual ethnic identities (Mr. Pink is played by Steve Buscemi, Mr. Brown by Tarantino himself), or by their previous screen identities as celluloid Italians (Harvey Keitel as Mr. White). The exception to this erasure of names is Mr. Blonde, played by Michael Madsen, who is clearly identified as "Toothpick Vic" Vega, appropriately so, for he embodies the old gangster ethos—he has maintained *omertà* by taking the fall and doing time for the gang—and is, at least before he goes psychotic, bound by loyalty to the father and son who run the operation. In *Pulp Fiction*, on the other hand, Vincent Vega is only Italian by nomenclatural marking, his ethnicity vaguely suggested by a generic street cool and his white boy hipsterism, his at-large "attitude" signified by the gold earing he wears in his right ear, his queued long hair, and his minimalist gangster look—black suit, white shirt, black tie. But he eats Big Macs and Douglas Sirk steaks; he belongs to a universe far removed from that of Scorsese's Italian-food-obsessed gangsters and such traditional gangsters as Johnny Rocco (Edward G. Robinson) in *Key Largo* (1948) who craves pompano and champagne as emblems of the high life to which he aspires. Although he has been to Europe and fancies himself a connoisseur of the "little differences," his cultural references are purely American pop-cultural. His Italianness is a subtext imparted by Travolta and by Tarantino's resurrection of his career by transforming his screen persona from post-adolescent *Guido* to pop-gangster, a resurrection that is even figured at the narrative level by Vega's posthumous appearance. Furthermore, in keeping with the multiculturalism of the contemporary gangster film and his own primary concern with race matters, Tarantino pairs Vincent Vega with an African American hit man, Jules (Samuel L. Jackson), having both of them work for a black crime boss named Marsellus Wallace, the modified Roman name indicating, among other things, the displacement of Italian by black gangsters. Interracial dynamics are central to the film as evidenced by the positive interaction between Vince and Jules who, nothwithstanding their affinities as psychological and linguistic doubles, embody divergent worldviews. Two of the couples—Marsellus and Mia, Jimmie and Bonnie—are interracial. Unlike the closed territorial world of Scorsese's gangland (Italian, Jewish, Irish), Tarantino's world is hybrid, criss-crossed by white and black identities. (For two exemplary readings of the film from the African American perspective, see Stanley Crouch's "Eggplant Blues: The Miscegenated Cinema of Quentin Tarantino" [in Crouch, 1995] and bell hooks's "Cool Cynicism: *Pulp Fiction*" [in hooks, 1996].)

As part of this dismantling of the conventional gangster iconography, Tarantino makes the gangster into an incessant talker, breaking the traditional codes of reticence and inarticulateness. Although his gangsters speak in a tough-guy lingo

constantly peppered by the F-word and all its variations, it is a hybrid and cross-cultural idiom: L.A. mean streets patois, pervaded by African American ghetto speech, including the provocative N-word, mixed with Valley Boy speech. His films are structured in terms of a "talk, talk, bang, bang" rhythm creating a friction—at times blackly humorous—between the stop-time of talk and the violence of imminent action. His word-parsing, back-talking characters are locked into the idiom of a street existentialism that, despite its constant resort to expletives, is no less rigorous in its arguments than those of a professional philosopher.

Before discussing further the cinematic implications of *Pulp Fiction*, it is important to raise the question of Tarantino's Italianness. Born in Knoxville, Tennessee, in 1963, he was raised in a fairly affluent area of Los Angeles known as The South Bay by his mother Connie, who is half-Cherokee, half-Irish. She was only briefly married to his biological father, the twenty-two-year-old Tony Tarantino, a law student and part-time actor, described by one biographer as a "matinée idol lookalike" (Clarkson 1995: 7), who would play absolutely no role in his son's upbringing, other than marking him biologically and nomenclaturally as Italian. In an interview in *Playboy* (November, 1994), Tarantino explained his somewhat distanced and movie-mediated view of Italianness:

> *There really is no such thing as a Los Angeles Italian. In New York there are Italian neighborhoods. In Los Angeles there aren't. There's no ethnicity here. You just are who you are. Of course, most of that Italian stuff is learned from movies like* Mean Streets *anyway. It's that whole attitude, that "Hey! Yo, yo, yo, mah friend. I'm feelin' fine." You know, that classic Italian car-coat-cigarette-Bogarting thing. But can I tell the genuine-article Italian from the poseur Italian? No. (Laughs) To me they all seem like poseurs.*

Although essentially a self-constructed hybrid and not culturally Italian in a strict sense, Tarantino has forged a cinematic persona that is profoundly Italian. Although his cinematic formation is heteroclite, it has been profoundly influenced by Scorsese, his chief role model; De Palma whose *Blow Out* (1981) is ranked second on Tarantino's "coolest movies of all time list"; Coppola; Ferrara, his accomplice in the ultraviolent crime film; Sergio Leone, the director of spaghetti Westerns; and the whole repertory of directors of Italian exploitation films, the so-called *gialli* (murder movies)—the Italian equivalent of pulp—which range from Dario Argento's horror movies to the Fernando Di Leo's Mafia movies. More important, Tarantino occupies the discursive position of the Italian American filmmaker. This involves more than deploying the gangster film and its mean streets,

tough-guy ethos; more than observing the "sacraments of genre"; more than employing the rhetoric of violence. As I have repeatedly insisted, that position is best defined as "inbetween," as a third space interstitial to both majority and minority cultures. Like Scorsese, even in his present state of canonization, and Ferrara, he is a dangerous hybrid who constantly crosses over: from independent to mainstream filmmaking, from high to popular culture, from Godard to blaxploitation, and from mean streets culture to black culture. It is thus no accident that his films constantly bring up the Italian thing: his protagonists Vic and Vincent Vega are remainders of the hegemony of the Italian gangster; *Reservoir Dogs* begins with an extended deconstruction of Madonna's song, "Like a Virgin"; in the previously discussed pantomime speech in *True Romance*, the tortured Clifford (Dennis Hopper) deliberately antagonizes Don Vincenzo (Christopher Walken), who had been boasting about his ancestry, into killing him by assaulting the Sicilian identity, pointing out that, as a result of the Moorish invasion and the sexual pillaging of Sicily, "Sicilians were spawned by niggers." All of these elements can be summed up in his adherence to the "cinema of attitude," his on-the-edge and over-the-top confrontational style, which he shares with both Scorsese and Ferrara.

From this perspective, *Pulp Fiction*, which is at once rooted in both the American tradition of "pulp" and post-fifties popular culture, is clearly a central work in the Italian American canon, one that distances itself from the old ethnicity of *The Godfather* and its pious narration of family history and relocates mean streets within the multicultural and interracial universe of the 1990s. Whatever fetishisms have attached themselves to its totemistic objects—The Royale with Cheese, foot massages, the glowing suitcase opened by the combination 666, the Band-Aid on the back of Marsellus Wallace's neck, and the like—it is much more than a cult film celebrating ultraviolence. Like Scorsese's and Ferrara's films, but without the Catholic matrix, it is an exercise in street theology and specifically a meditation on divine intervention—the miraculous God trick by which the bullets fired at the two hit men are diverted. This miracle leads Jules to a religious conversion and mires Vincent, further, in his cool skepticism. But the God trick is the most external aspect of a thornier and more fundamental problem, the question of contingency: of how things happen in the world; of how things happen in cinema; of how cinema happens; of how cinema takes place in time. Although this is not the place to discuss these issues at length and to describe the complex jigsaw structure of the film by which the "three short stories . . . about one story" are made to intersect or, more exactly, to collide, it is possible to hazard a comment on Tarantino's God trick. Ostensibly, the film is centered on the miracle of divine intervention and its surprising of the dynamic duo either into belief or dis-

belief. How is the spectator to take the miracle? Straight, that is, innocently? Or ironically, that is, as "pulp theology," one more instance of double-coding? Throughout the film, things have happened according to the same principle of miraculous surprise and chance: Vincent's resurrection of Mia from her overdose by the thrust of an adrenalin needle into her heart, the miraculous survival of the gold watch, Vincent's accidental killing of the black kid in the car, Butch's killing of Vincent as he exits from the bathroom, and so on. In positing the God trick, Tarantino is commenting on the way in which cinema—and he himself as director—effects its own miraculous interventions. Whether the God trick and the cinematic trick belong to the same or different order of contingency—that is the question. The most powerful cinematic miracle occurs in the final episode of the film: Vincent Vega who has already been killed is resurrected by Tarantino's God trick to eat a big stack of pancakes and sausages and to refuse to bear witness to Jules's "moment of clarity."

Like Tarantino, Abel Ferrara is an exponent of "pulp cinema" (minus Tarantino's ironic bracketing) who operates in the same world of ultraviolence. His cinematic passage from independent to mainstream director, however, has proved more problematic than Tarantino's as a result of his, at times, chaotic intellectualism and the off-beat quality of his experiments, which bear, to allude to a figure that recurs in Ferrara's work, a vampirish relationship to genre and precursor films. Tarantino has expressed admiration for his work (Woods 1996: 75):

> *As far as I am concerned,* King of New York *is better than* GoodFellas. *That is about as pure a vision as you're going to imagine. I mean, that's exactly what Abel Ferrara wanted to do his entire career. It has the polish and the artistry of a pure vision and, at the same time, it's just* full on out *action.*

What Tarantino is getting at here is Ferrara's ability to embed a personal and highly idiosyncratic vision of the world within an action film or, to put it another way, to concretize the film of ideas in the spectacular form of popular entertainment.

Born in the Bronx in 1951, Ferrara, the son of an immigrant from Salerno, near Naples, who changed the original family name from Esposito (originally a Neapolitan designation for a foundling or someone born out of wedlock that evolved into a surname) to the aristocratic-sounding Ferrara after the Renaissance city in Northern Italy, is profoundly Italian American and Italian Catholic in his cultural formation and cinematic vision. Beginning with his 1979 debut film, *The Driller Killer*, a slasher film, he has passed through a gamut of genres to emerge as

an authentic auteur with his own set of dark obsessions, including the movies. He has Johnny, a character in *The Funeral* (1996) and one of Ferrara's perverse hybrids, Communist in ideology, hoodlum in practice, an Italian American gangster with an intellectual conscience, declare upon viewing *The Petrified Forest* (1936): "I would say life is pretty meaningless without the movies." Ferrara has been prolific in the nineties following the acclaimed *King of New York* (1990), with *Cat Chaser* (1990), *Bad Lieutenant* (1993), *Dangerous Game* (1993), *Body Snatchers* (1993), *The Addiction* (1995), and *The Funeral* (1996). Along with his 1987 film *China Girl*, an ethnic reworking of *Romeo and Juliet* set in New York's Littly Italy and Chinatown, three of these corrosive films are central to the Italian American canon: *Bad Lieutenant*, *Dangerous Game*, and *The Funeral*. They each represent the spiritual crisis of self-destructive borderline characters—lapsed Catholics or lost souls drifting in the abyss between belief and disbelief. These lacerated and self-lacerating characters are in the grips of the same desperate search for redemption played out with reference to a visceral Catholicism that the more it is denied, the more it asserts itself. Played by Harvey Keitle with the rawness of an open wound, the Bad Lieutenant, the proverbial bad cop, more criminal than the criminal, a casualty of mean streets New York, remains unnamed in the film, and that lack of a proper name is a declaration of the lack that consumes him. He is a walking abyss, the locus of every possible unsatisfiable addiction—drugs, booze (to counter the drug high), sex (whether paid for or coerced), gambling, corruption. He is a bad object to himself and in the eyes of the world; from the very beginning of the film, he is a man already suicided by his bad conscience. Although he lacks a proper name, his ethnicity is pointed to by a number of cues: the little old Italian lady, perhaps his mother-in-law, who inhabits his house; his lapsed Catholicism (he calls the Church a racket, but identifies himself as a Catholic at two points); and his typical ethnic family life, which is slipping away from him. The possibility of redemption comes to him in the most unforeseen way: The sexual violation of a nun, who is first brutally deflowered with a crucifix and then raped by two neighborhood boys, in a church, which they also desecrate. The Bad Lieutenant is charged with investigating the case, and he, too, violates her privacy, voyeuristically gazing upon her naked body when she is being examined at the hospital and then eavesdropping on her confession in which she reveals to the priest her awareness of the identity of her attackers. The nun refuses, however, to identify her violators and thus pardons them. She serves as the model for his *imitatio Christi*; at the end of the film, he, too, redeems them and possibly himself by paying for their lives, however coincidentally, with his own. This is street Catholicism at its most elemental and primal level, and it is the *metanoia*, the conversion of the Bad Lieutenant from his

degraded state into a Christ figure, that makes the film so corrosive, so disturbingly orthodox and blasphemous at once. The film is saturated with Catholic imagery, from kitsch icons of the Madonna to a visionary appearance of Christ, and, along with Scorsese's *Mean Streets*, represents the essence of popular Italian Catholicism—with the Bad Lieutenant as its most tortured cinematic martyr, a pulp "saint" whose iconography mixes drug paraphernalia with rosary beads.

The technical religious term *metanoia* actually occurs in *Dangerous Game*, an intricately structured film about making a film that features a stunningly visceral performance by Harvey Keitel in the role of a film director (the surrogate for Ferrara himself) who attempts to motivate, with an insistence that borders on mania, his two actors, played by James Russo and Madonna, into method-driven performances that have the force of emotional truth. *Dangerous Game*, originally called *Snake Eyes*, a title that suggests the problem of the gaze and mirroring at the heart of the film, thus involves the interaction among three protagonists—the actor, the actress, and the director—who, as they observe each other's on-set behavior, exchange roles. The film within the film (the movie Keitel is directing) is a violent marital psychodrama that casts Russo and Madonna in the roles of a middle-class suburban couple in the grips of a marital break-up. As it applies to the film within the film, the "dangerous game" is the couple's stripping away of all the masks and pretenses, all the necessary fictions, that protect their marriage. The marital agon is conducted over Catholicism and in terms of the psychosexual hang-ups it instills. The husband's sexuality, in typical Italian American fashion, is determined by the *Madonna–whore complex*. He rants at his wife for what he calls her "metanoia," her recent religious conversion, which has drastically altered the nature of their sexual relationship, estranging her from the transgressive promiscuity of their original swingers lifestyle and its requisite dangerous sex games, including the graphic videotaping of their encounter with another couple. The husband, who remains addicted to dangerous sexuality and cocaine highs, is totally alienated by her newfound purity and sadistically attempts to undermine her conversion. It is no accident that Madonna is cast in this role, given her own construction of a sexual persona in terms of the *Madonna–puttana* antithesis.

At another level, the "dangerous game" applies to the Stanislavskian game of truth the actors must play and constantly replay under the gaze of the director (and under their own as they view the rushes) as they search to motivate and find the "emotion memory" and "through line" by which their performances become the real thing. This search for the "emotion memory" even prompts Madonna and Russo to have "real" (off-the-set) sex to motivate their on-the-set performances. And finally, with respect to the mirror structure of Ferrara's movie, the "danger-

ous game" describes the contamination between the "actors" within the "film within the film" and the characters within the film itself. They exchange roles, Keitel becoming the actress's lover, their liaison prompting the break-up of his marriage. But the ultimate installment of the "dangerous game" is played out by Ferrara himself, who works through the painful break-up of his own marriage by mirroring it onto the film, doubling himself in the figure of the director.

The Funeral, a retrogangster film, set in the New York of the 1930s, sometime during Franklin Roosevelt's second term, is a cerebral dismantling of the Mafia movie and the myth of the Italian American strong family. As such it belongs to the same general deconstruction of the classical gangster genre undertaken from within Italian American cinema by Scorsese and Tarantino and informed by the same visceral aesthetic. But unlike the strategies employed by these two directors—Scorsese's deromanticization and demystification of the gangster lifestyle; Tarantino's pulping of the mythic gangster into a delirious contemporary figure in whom the normal and pathological coincide, a postmodernist hybrid strung out between the gangster's hardboiled past and a pop-ecstatic present—Ferrara takes a different tack, going to the jugular of *la famiglia*, redescribing it as a dysfunctional and repressive structure, a crucible of estrangement and violence. The Tempio family, Sicilian in origins, consists of three brothers, Johnny (Vincent Gallo), a gangster with a commitment to Communism, whom we first see as a corpse set out for viewing in the family home, his story, including his shooting, will be told in flashbacks; Ray (Christopher Walken), as eldest, the head of the family business, a combinatiion saloon and protection racket; and Chez (Chris Penn), the middle and most volatile who works the bar; and the two long-suffering wives of the latter two, Jeanette (Annabella Sciorra) and Clara (Isabella Rossellini). However problematic the Corleone family may be in its inner workings, it maintains the *via vecchia* and functions with cohesiveness and a degree of *pietas* and even love. The Tempio family is an anti-family, a disintegrated and deranged version of the enmeshed and enmeshing Italian family in which the celebrated hypercommunicativeness of *la famiglia* has turned into a systematic failure of communication. That breakdown is constantly made to counterpoint their hyberbolic and obsessive displays of love and grief before their brother's embalmed cadaver. As Ferrara explains in an interview (*Sight and Sound*, April 1997, 8): "They didn't understand each other. Did they really love each other? Sure, Ray would kill for his brother, but he wouldn't listen to him. He had no idea where the kid was coming from. The other brother, Chez, can't even talk to them." By way of motivating this breakdown of communication, Ferrara stages a gangster version of the primal scene. In a flashback, the father brings the three brothers as chil-

live. Ferrara's skewing of *la famiglia*, and, its cinematic corollary, the skewing of the classical gangster film make *The Funeral* into a contemporary paradigm of the Italian American cinema. Its savage representation of *la famiglia* in disintegration mark it as one of the rare films that break through the *cordon sanitaire* of stereotypes surrounding the Holy Italian American Family.

<div style="text-align:center">

*Between Cinema Paradiso and Checkpoint Pasta, or
One More Round in the Game of (Im)Pertinent Stereotypes*

</div>

As the slow apocalypse of the twentieth century draws to its close, the long and not always forward-moving journey from Huck Finn's puppet theater to Cinema Paradiso seems to be culminating in one of those patented Hollywood endings. If Italians can be said to have found a bit of paradise in America, it would certainly be the artificial paradise of cinema. Of course, the price of admission was paid for by a wicked process—still ongoing—of stereotyping and self-stereotyping. Cinema is the most determinative of contemporary art forms for the imaginary mirror it holds up to the spectator is constitutive of identities. Ethnic and minority spectators are particularly susceptible to its power for their identities are constituted in terms of a culturally induced lack. Therefore, stereotypes—even negative ones—provide the ethnic spectator with an imaginary representation that guarantees his or her place in the symbolic network of the dominant culture. With respect to the Italian American image, one wonders how a group so obsessed with everyday aesthetics—*la bella figura*—has been systematically cast in the role of the *cafone*, the figure who casts the *brutta figura*. (The *Guido* is, by the way, the postmodern avatar of the *cafone*.) Consider, for example, the character of Nick Apollo Forte (Lou Canova), the nightclub singer in Woody Allen's *Broadway Danny Rose* (1984) and quintessential middle-aged *Guido* who sings the pasta-curdling song, "Agita" (***Agita*** is spaghetti Italian for stomach upset, and one of the few Italianisms to have entered current common parlance). Although it is true that Woody Allen casts himself as Danny Rose, Appollo's foil, and that the pair replicates, in its way, the original Jewish/Italian odd couple, Jerry Lewis and Dean Martin, and that there is no comedy without ethnic stereotypes, and that Italians themselves laugh at the *cafone* as Jews laugh at the *schlemiel*, the problem remains of how to respond to vulgar stereotypes such as this in which one's own dis-identification is immediate but which confirm the image that the majority culture projects upon one's tribe. It is foolish to experience *agita* over Woody Allen's film, which is an extended ethnic joke (Jewish as well as Italian) addressed

dren together to participate in a murder of an enemy of the family as a way of instilling solidarity: The father has the youngster Ray shoot, execution-style, the bound victim. This traumatizing primal scene—part object lesson: kill your enemy or be killed by him; part rite of passage into gangsterhood—goes a long way in explaining the psychological genesis of the dysfunctional family.

But Ferrara is also getting at other dimensions of *la famiglia*. Johnny's intellectual flirtation with communism is totally inconceivable to his brother Ray who cannot think beyond strict private interest, namely money. Ferrara, in the previously cited interview, illustrates this self-interest with an Italian proverb his father had used to admonish him: "The only friend you got is the money in your pocket." He then goes on to explain the disconnection between Ray and Johnny in the bar scene:

> *That's the contradiction between Walken and Gallo in the bar. Walken thinks it's a joke [for a Sicilian to be a communist]. "We're guineas right? We exploit situations. We don't believe." But Gallo does. You got to get outside yourself, you can't just walk round thinking, "The only thing that counts is me." You got to think about something other than yourself.*

Ferrara's endowing of Ray with an altruistic consciousness, which translates into a rebellion against the family, is aimed at two targets: the traditional and generic Italian concern with strictly private interest (for the classical treatment of this concept, see the chapter, "Realism and Guicciardini," in Luigi Barzini's *The Italians* [1964]: 157–175); and the hardening of this concern into the selfish, atomized individualism that epitomizes the gangster mentality. But the insertion of a gangster with a political conscience, a communist hoodlum and intellectual rebel, is not the only monkey wrench Ferrara thows into the classic gangster film. No less disruptive are a series of figures who skew the film: the college-educated Jeanette, the long-suffering wife of Ray, who laments her lost intellectual life and claims that being a gangster is not romantic; Clara, the equally long-suffering wife of the manic Chez, a *mater dolorosa* who vigilantly awaits and then buffers his outbursts; Gaspare Spoglia (Benicio Del Toro), the slickly attired *guappo* figure who flamboyantly struts his gangster stuff and appears to be extracted from a gangster film of the 1930s, Ferrara's homage to the mythic gangster and a sharp counterpoint to the angst-ridden Tempio brothers who are far removed from the world of "fascinating gangsterism"; the family's priest (Robert Castle, a real priest) who, in a somewhat inappropriate exchange with Jean, condemns the family's sham Catholicism that masks the state of "practical atheism" in which the Tempios

in particular to an interethnic New York spectatorship that understands the rules of ethnic laughter, which has long been their primary means of communicating with each other. The question: Is one then to laugh at or with the stereotype, given that the stereotype always has the last laugh?

Another more recent variation on the image is what might be called the Giulianization of the stereotype, after the Mayor of New York City, Rudy Giuliani. The new stereotype depicts Italian Americans, the heirs of the radicals Sacco and Vanzetti, as politically incorrect (read: racist) in part because they are (mis)perceived as having betrayed their traditional minority politics for majority politics. This stereotype can be seen most clearly in Spike Lee's *Do the Right Thing* and *Jungle Fever* in which the African American director explores the question of interracial conflict focused on the concept of disrespect. Lee's portraits of Italian Americans are split into "good" or "bad" Italians according to whether they do or do not overcome the racism that is attributed—however incorrectly—to them as a norm. What is problematic, from an Italian perspective, about Lee's well-intentioned representations, which involve collaborations by Italian American actors (John Turturro, Annabella Sciorra, Danny Aiello) is that his minority cinema reproduces the stereotypes of the majority culture despite his attempts to endow his Italian characters with complexity. Consider, for example, the interracial dynamics at work in *Jungle Fever*: an upwardly mobile Buppie architect Flipper Purefloy (Wesley Snipes) and an Italian American secretary Angie Tucci (Annabella Sciorra) enter into a sexual relationship motivated by little else than taboo-breaking jungle fever. The superficial depiction of Angie, who is defying the blue-collar racism of her father and brothers, is insufficiently motivated to stand either as an assertion of her autonomy as a woman or as a self-defining expression of sexual politics. But perhaps this drift of white and black stereotypes into the grip of "jungle fever"—the eros of stereotypes—is what Lee intends, for he frames it with a more authentic interracial courtship, involving the sensitive Paulie Carbone, Angie's ex, played by John Turturro, who reverses his earlier role as racist in *Do the Right Thing*. The collaboration between Lee and Turturro is a model for the new ethnic cinema. However outraged Lee may have been by the notorious remark spoken by one of the dons in *The Godfather Part I*, he has managed to forge a cinema of borderlines where, at least with respect to the Italian American ghetto, an exchange of respect can take place. One would like to read the solidarity between the African American construction worker and his Italian American counterparts in John Turturro's brilliant first film *Mac*, as an intercinematic exchange between Lee and Turturro, a gesture toward a new cinema of respect.

The mention of *Mac*, an autobiographical account of Turturro's relation-

ship with his laborer father, situates us at the heart of contemporary Italian American cinema. It is the culmination of the Italian working-class cinema as it extends from *Marty* through *Saturday Night Fever*, but even more important, it harkens back to Di Donato's *Christ in Concrete* for it is informed by the spirit of dignity of manual labor and will-to-workmanship, as imparted from laborer father to laborer son (played by Turturro himself), that is the essence of the Italian American work ethic, although only the eldest of the three brothers will remain faithful to the law of the father regarding work: "There are two ways of doing things: the right way and my way, and they are both the same." This small-budgeted film is an exemplary instance of an ethnic cinema that refuses the dominant narrative and establishes its own voice, literally in that it employs unsubtitled Italian and introduces authentic folk music into the soundtrack. There is one stunning effect that needs to be mentioned: in this film about laborers-become-contractors who construct houses in Queens for the love of building, the mother remains permanently off-screen, a presence informing the family house only through her disembodied voice and its lamentations.

And here the problem of woman's self-representation in cinema crops up. Of the Italian American women filmmakers currently at work such as Penny Marshall and Vicky Stallone, it is Nancy Savoca (1960–) who has done the most significant work from the point of view of ethnic cinema. Born in the Bronx, New York to immigrants from Sicily and Argentina, Savoca, a graduate of New York University film school, made her debut in 1989 with *True Love*, a romance-puncturing comedy of courtship and marriage Italian American–style focused on the gender politics brought into play by the wedding of a Bronx couple. The immature groom, an arch-*Guido*, maintains his right to hang out with his friends on the wedding night, something that precipitates a rebellion on the part of his much more sensitive and sensible bride. After making *Dogfight* in 1991, Savoca returned to the Italian American experience with her 1993 feature, *Household Saints*, which spans three generations in two working-class Italian American families, the Santangelos and the Falconettis, who live in New York City's Little Italy and whose destinies come to be united through a marriage that takes place in 1949. As in *True Love*, the film's narrative is essentially women-centered, despite the roles played by a domineering father and a less-domineering husband, and thus domus-centered. It is important to point out that the film's main story is framed, narrated by the grandparents of a contemporary Italian American family gathered together for a meal *al fresco* who pass on to their grown-up daughters and grandchildren the fantastic events of a story that began over forty years ago in their former neighborhood of Little Italy and belongs to its local folkore. So the story

the film will narrate belongs to the oral tradition, and it is appropriate that it is retold by the elders, begun by the grandmother and then formally resumed by the grandfather: "It happened by the grace of God that Joseph Santangelo won his wife in a pinochle game." This incipit sets the tone for the magical realism with which Savoca will relate the strange and marvelous story of a saint's life, Little Italy–style.

The first part of the story involves the marriage of the ungainly Catherine Falconetti (Tracey Ullman), who lives with her father and brother and appears slated for spinsterhood, to a virile-looking butcher, Joseph Santangelo (Vincent D'Onofrio), who wins the right to marry her in a pinochle game with her drunken father who has wagered her as a stake. As a result of Catherine's inept cooking, the first encounter between the two families proves disastrous with Joseph's superstitious immigrant mother taking her culinary lapses (uncooked meat, dirty escarole, hair in the tomatoes) as bad omens—to say nothing of Catherine's "Falconetti look." Despite the mother's disapproval and the unlikeliness of the match, the marriage is consummated and proves to be a success as Joseph awakens his bride to an ecstatic sexuality. The marriage flourishes despite the malign presence of Joseph's mother who lives with them and constantly horrifies the pregnant Catherine with witch-like pronouncements and old wives' tales that detail the inadvertent actions that will cause miscarriages or the birth of monsters. "Your child will be a chicken," she warns Catherine who has witnessed Joseph kill a turkey in his butcher shop. This belief in prenatal marking is part and parcel of the folkloristic conception of religion the old woman has brought with her from the Old Country and which she expresses in worship at a home altar and before the devotional images arrayed throughout the apartment. Whatever the cause, Catherine's first pregnancy results in a stillbirth. The intergenerational conflict between the two women ends when the mother-in-law dies, and, as an exorcism not only of her mother-in-law's malign presence but of the entire folkloristic religious conception of the world held by the first generation, Catherine completely redoes the house removing all of the kitsch icons while reading aloud from a book that exposes old wives' tales to be nothing more than ignorant superstitions.

Her second pregnancy results in the birth of a beautiful daughter, Teresa (Lili Taylor), an angelic child who proves, nonetheless, to be "monstrous" in a way totally unforeseen by her superstitious grandmother and totally incomprehensible to her Americanized and secularized parents. She is a saint or, at least, she aspires to be a saint. Educated by nuns in a Catholic grammar school, she develops early on a fascination with Saint Bernadette and initiates her own set of spiritual exer-

cises. She restores her grandmother's devotional images to their original prominence, a gesture that symbolizes the return of the repressed: the religiosity, however folkloristic, of her grandmother that Teresa will cultivate in a more orthodox but no less eccentric way. After receiving from her Catholic high school a copy of *Story of a Soul* as a prize for writing an essay, she develops a specific devotion to her namesake, Teresa of Liusieux, known as the Little Flower or St. Thérèse of the Child Jesus. She models herself on the saint following the "little way" that, according to the Little Flower, opens sainthood to the ordinary person by the doing of small things and performing daily duties in a perfected spirit of love for God. When she announces her intention to become a Carmelite nun, her father squelches her vocation, angrily informing her, among other things, that "nuns are sick women."

She goes on to college and establishes a relationship with a young man, Leonard Villanova who explains his Life Plan to her: "First, I get the St. John's law degree. Then I want a Lincoln Continental. I want a family, and a town house on the upper East side, and I want membership in all those clubs . . . that always turned up their noses at Italian Americans." This is a pragmatic vision that Teresa cannot share, but, nonetheless, she does accept his persuasive argument that the "little way" can be achieved through the domesticity of marriage. Eventually yielding her virginity to him in an out-of-the-body way, she moves in with him, remaining a soul apart. While ironing Leonard's red-check shirt, the miracle of miracles occurs. She is finally granted her long-awaited vision: Jesus, her mystical groom, appears to her wearing his shroud which she offers to wash and iron for him; the vision—or is it just a hallucination?—expresses itself in the endless multiplication of red-checked shirts, appropriately so for a household saint for whom the sacred is expressed through household chores. Diagnosed as suffering from an acute hallucinatory psychosis precipitated by obsessional religious feeling, she is confined to an asylum where, during a visit by her parents, she claims to have played a four-handed pinochle game with God, Jesus, and the Virgin (boys against girls, with God cheating!). Whether vision or madness, the celestial card game, like a dream, replays in displaced form the original game that led to her birth and all the ordinary little miracles that have occurred as part of the family history. She mysteriously dies, and at her funeral the mourners recognize her as a saint through whose intervention, as the Little Italy legend goes, all their petitions were granted.

How is the spectator to take all of this? As a genuine saint's story or as the psychobiography of the gentle madness of a hunger artist who cannot find spiritual sustenance in a disenchanted and materialistic world, the bottom line of which

is "sausages and pinochle," as old-man Falconetti is fond of putting it? The individual spectator will have to decide, given that Savoca recounts the story with sustained humor and respect for the eccentricity that informs Teresa's quest to become a latter-day holy fool. What is certain is that *Household Saints* unfolds in a magical way the transgenerational history of the small world of the Italian American domus and the place and displacement of women within it. Whereas Teresa's "little way" can be seen as a parody of the traditional subordination of Italian American women to the domesticity imposed by the domus-centered society, it is more properly understood as saint's work, as an expression of what she regards as womanhood. Since the film is so attentive to the folkloristic dimensions of Italian American experience, not to be overlooked is its visual dimension, its kitsch and kitchen visuals that reproduce the world of popular Catholic imagery, especially those hallucinatory and ectastic scenes that express the interiority of women through the intensified imagery of the domus.

Another work that covers similar ground, including the mother and daughter intergenerational conflict, is *Tarantella* (1997), directed by the independent filmmaker Helen DeMichiel. But in *Tarantella* the mother dies at the outset, and her estranged daughter, a young Manhattan-based photographer (Mira Sorvino), who has returned to her childhood home in an outer-borough Italian American neighborhood, must confront the silence that had always characterized her relationship with her mother but has now been rendered absolute by death. With the help of the next-door neighbor, an elderly woman played by Rose Gregorio, the daughter will break that silence and extract from it the suppressed family history and the heroic roles played by her mother and grandmother in it.

That family history has been recorded in a dream book compiled by the immigrant mother and written in Italian. Here DeMichiel is indebted to Helen Barolini who ha explored the significance of dream books—manuals used to interpret dreams and to read one's destiny—for immigrant Italian women. Barolini, in fact, regards these dream books as instances of "immigrant 'literature,'" naming her classic anthology of writings by Italian American women, *The Dream Book* (1985), after them. But in *Tarantella*, the mother has actually written her life story in the form of a beautifully fashioned dream book. The neighbor, who is herself on the verge of dying, translates the Italian in the dream book for the daughter, initiating her into the secrets the dream book holds and ultimately leading her to an atonement with her dead mother and an acceptance of her own Italianness. That secret history belongs to the grandmother's troubled Sicilian past (a loveless marriage, an abusive spouse, a murder dictated by a dream, flight, and exile in America) and is narrated in the film through the use of Sicilian puppets and

masks. Similarly, the daughter's troubled childhood is represented by black-and-white flashbacks, and her divided consciousness as an American and an Italian young girl is symbolized by *tableaux vivants* in which she appears, in folk dress, in scenes representing the conflict between the *via vecchia* and *via nuova*. These various levels of dream and reality make *Tarantella* itself into a dream book.

Also crucial is the role that Madonna has played in altering the image of the Italian American woman, endowing *la donna* with an autonomous sexual persona that has been traditionally suppressed by her maternal role. Madonna's videos are important cinematic statements in that they raise the question of feminine desire as mediated through the cinematic gaze. It is in the area of women's filmmaking that the next leap forward will take place. Italian American cinema has not yet found its Lina Wertmüller.

Both Turturro's and Savoca's recent films belong to the minor cinema in the sense that we have tried to develop throughout this essay. It is from this position that a group of new Italian American filmmakers have produced a number of identity narratives that, in going against the grain of the mainstream version of Italianness, have produced alternative images. Of these independent films, three are particularly noteworthy in that they set out strategies for a new ethnic cinema that consciously plays out the game of the (im)pertinent stereotypes, playing off and subverting the stereotypes inherited from the mainstream.

Tony Vitale's *Kiss Me, Guido* (1997), for example, is a highly amusing version of the game for it stages a collision between the two most antithetical and perhaps most open to caricature of all male figures: the *Guido*, the stereotype of Italian American stereotypes, and the homosexual, here represented as generically West Village. Bronx is Bronx; Greenwich Village is Greenwich Village, but, in this screwball comedy, the twain meet with farcical results. It all begins in a pizza parlour in the Bronx—where else?—where the hunkish Frankie Zito (Nick Scotti), a gentler and kinder version of the conventional *Guido*, works and intermittently breaks into imitations of De Niro and Pesci as practice for his acting class. Having arranged a rendezvous with his girlfriend whom he plans to surprise with an engagement ring, he comes home to discover himself in the process of being cuckolded by his maximally *Guido* brother, Pino (Anthony DeSando), who is super-macho, gold-chained, Cadillac-driving, and endowed with an Arthur Avenue accent in which "pawn" and "porn" are indistinguishable. As a result of this betrayal, he resolves to move out of the family home in the Bronx and, misreading a *Village Voice* ad (he thinks GWM means "Guy with Money" rather than "Gay White Male"!), finds himself the roommate of Warren (Anthony Barrile), a gay actor who has also been disappointed in love. From this initial premise, Vitale

works out all sorts of odd-couple variations on the straight versus gay encounter in which, to deliciously comic effect, the characters remain stereotypically true to their initial sexual and cultural identities. For example, consider the following collision of straight and gay taste-cultures: on the first night of their arrangement, the roommates watch together *A Sound of Music*, a quintessential "queer text." Frankie, ever the Bronx naive, asks about Julie Andrews: "She did that before *Pretty Woman*, right?" So the film is not really about consciousness raising, although Frankie does evolve and does move beyond his initial homophobia: rather than breaking stereotypes, Vitale is more concerned with testing their comic possibilities and with remedying them with laughter. The great carnival of stereotypes occurs at the end of the film when Frankie makes his acting debut in the role of a gay character in a two-man play. Having "gone down to da city" from the Bronx, his family and friends witness, with varying degrees of shock and incomprehension, the ultimate test for Frankie as both an actor and an unreconstituted *Guido*: the homoerotic kiss.

In his 1996 directorial debut, *Trees Lounge*, the character actor Steve Buscemi takes a different tack, one that explores, in slice-of-life fashion, the stereotypical identities of working-class Italian Americans who populate the nowheresville of a "wonder bread" town in Long Island, New York. Buscemi's suburbanized Italian Americans, one generation or so removed from Little Italy, have been marginalized and impoverished by the transfer. They have lost their cultural identity, and although they embody and at times parody Italian Americanness, it remains infrequently expressed, traced, for example, in the once-heard toast, "*Salute*!" (Good Health!). The film revolves around the grungy bar-fly scene at the neighborhood dive that gives the film its title. The central character, Tommy, played by Buscemi himself, is a chronic screw-up, a thirty-one-year-old unemployed automobile mechanic whose car is perpetually on the blink and a full-time barfly who cannot get his life together. Within the constellation of Italian American male screen types, Tommy is an oddity, not simply because he is an alcoholic but because he is not *sistemato*. Indeed, his alcholism and failure to work out a *sistemazione* (a life arrangement) are inextricably linked. (For a fuller definition of *sistemare*/*sistemazione*, see the lexicon.) Although he is situated in a suburban version of the *Guido* universe, he is not really part of it, existing, rather, in parasitic relationship to it. Estranged even from his family, which regards him as a sponge, he is essentially nowhere, as symbolized by his immersion in the futile camaraderie of the bar scene and the temporary job he finds as the driver of a Good Humor truck, the daily arrival of which is one of the few social rites in the community.

In American terms, he could be described as a loser; his life unfolds

according to Murphy's Law. In Italian American terms, he could be described as a cross between a *morto di fame* and a *disgraziato*. He is essentially a displaced person having lost his girlfriend of seven years to a more conventional *Guido*-type Rob (Anthony LaPaglia), his former friend and ex-employer. She is pregnant possibly by him, and the film is really about his inability to relinquish his attachment to her, even though she has moved on to a new life. Not without a certain sleazy charm stemming, in part, from his lack of machismo, he is nonetheless a loser in love. His failed attempt to seduce a *Guidette* at Trees Lounge ends with his getting her so drunk that she goes to sleep in one of the booths. One of the film's best lines comes when he encounters at a funeral a *Guidette* whom he cannot quite place; she explains that her hair is smaller than it used to be. But his ultimate failed seduction involves the seventeen-year-old niece of his former girlfriend. Estranged from her family, she spends the night with him. This leads to the expected catastrophe, with the father, a brutish disciplinarian and middle-aged *Guido*, physically assaulting him and demolishing his Good Humor truck. *Trees Lounge* is a small and unpretentious work that captures the feel and idiom of suburban working-class existence; in its small and unpretentious way, it disturbs the universe of Italian American stereotypes by portraying a nowhere man in crisis whose existential skid removes him from the armored and unquestioning masculinity of the *Guido* universe.

It is Stanley Tucci's *Big Night* (1996), codirected with Campbell Scott and cowritten with his cousin, Joseph Tropiano, that moves Italian American cinema in a new direction, even though it nostalgically revisits the fifties when America went crazy for everything Italian—or for what it thought was Italian. It provides one of the most sensitive and insightful portrayals of Italian Americanness in contemporary cinema precisely because it directly addresses the process and pitfalls of Americanization from the point of view of recent immigrants. Set on the New Jersey shore in the 1950s, the film narrates the story of two Italian-born and Italian-speaking brothers, Primo (Tony Shalhoub) and Secondo, played by Tucci himself, who are trying to make a success of their restaurant, the Paradise. The three main male characters represent varying degrees of assimilation: Primo, the most bound to his Italian identity, the most resistant to assimilation, is a virtuoso chef who regards the Italian culinary tradition as an art-form and observes an unswerving fidelity to it; at the other end of the spectrum is the completely assimilated Pascal (Ian Holm), a fellow restaurateur who runs a rival and much more successful enterprise, a garishly deluxe establishment that caters indiscriminately to American taste and is run strictly as a business; in the middle is Secondo, maître-d', sous-chef, and would-be businessman, who respects his brother's artistry but who

also recognizes the pragmatic issues involved in running a business, especially one that is in danger of failing as is the understated Paradise.

Big Night is thus an identity narrative structured in terms of two conflicting food ideologies: Primo's commitment to authentic Italian *alta cucina* as represented by his insistence on *risotto* and other difficult-to-make preparations versus Pascal's calculated exploitation of all the clichés of Italian American cuisine, spaghetti and meatballs, veal cutlet parmigiana, and so on. Consequently, Secondo finds himself caught in a double-bind situation: damned if he does not maintain his allegiance to his brother and to his own Italian identity; damned if he does buy into the American Dream as embodied by Pascal and the total assimilation it represents. His dilemma is set out in the opening scene of the movie when he is obliged to explain the intricacies of Italian cuisine to a couple of disgruntled Jersey patrons, a husband and wife who are imprisoned within their outsider notion of Italian food. Secondo explains to her the nuances of Primo's signature dish, seafood *risotto*, a specialty the brothers have brought with them from Italy. The cigarette-smoking wife, however, is convinced that the *risotto* should come with a side order of spaghetti and meatballs, which Americans regard as the Italian emblem food par excellence. (Actually, Italians eat meatballs only as a separate course; spaghetti and meatballs is an Italian American creation, one determined by the American penchant for combining everything into a single dish.) The Paradise is committed to serving authentic insider food, not emblem dishes. As Secondo politely informs the couple in a memorable quip, "Sometimes spaghetti prefers to be alone." Nonetheless, he retreats to the kitchen and, on the premise that the customer is always right, asks Primo to prepare a side of spaghetti *sans* meatballs to accompany the *risotto*. Primo is justifiably outraged at this violation of the syntax of Italian gastronomy: the coupling of two starch dishes is an absolute no-no. "Shall I make her mashed potatoes as well?" he retorts in contempt. There then ensues the first installment of the wrangle that will be waged by the two brothers throughout the film. "If you give people time, they learn," says Primo, defending his culinary mission. "This is a restaurant," Secondo counters, "not a fucking school."

But much more is involved in their conflict than the demands of art versus those of commerce. Theirs is the archetypal problem of fraternal conflict itself, one that goes back as far as Cain and Abel and Romulus and Remus. Removed from the framework of the family, their strife is played out in terms of the American Dream, which simultaneously draws them together and drives them apart, precisely because they cannot desire it in the same way. The dignified and introverted Primo, who is anything but the temperamental chef, confines himself to the kitchen and to perfecting his art. He does not drive; he socializes with his

paesano, a barber, his friend and confidant, with whom he speaks Italian; he is, at least initially, too shy to court his American love interest, a florist who supplies the restaurant with flowers. Furthermore, he remains tied to Italy and to the idea of returning home to a more humane existence. The extroverted Secondo, on the other hand, is caught up in a number of complex and intersecting relationships that draw him into assimilation. At the amorous level, he is torn between his love for an American woman to whom he cannot fully commit and his adulterous liaison with Pascal's wife (Isabella Rossellini) who is Italian. But it is his relationship with Pascal, his mentor in the American Dream, that is so disruptive because Pascal functions as a third and rival "brother" who threatens the affectionate relationship between Primo and Secondo. Pascal, played by Ian Holm who effects an ersatz Italian accent, is a parody of a parody Italian. He is an absolute but shrewd *cafone* as reflected in his credo: "You must bite into the ass of life; drag it to you!" Although he recognizes and respects the artistry of Primo, he involves Secondo in a scheme that will doom the Paradise and bring the brothers into physical conflict.

Accepting at face value Pascal's promise to bring his friend Louis Prima and his band to the restaurant to supply the instant PR necessary to save the Paradise, Secondo decides to stake everything on the one "big night," the feast in honor of the Italian American jazz icon whose kitsch versions of Neapolitan classics are constantly heard on the soundtrack. The film's exploration of the discrepancy between Italian and Italian American food cultures is repeated at the level of the soundtrack, which juxtaposes emblematic Italian American songs like Rosemary Clooney's "Mambo Italiano" with more authentic songs such as "La strada del bosco," originally made famous by Beniamino Gigli but here performed by Claudio Villa. The film appears to climax in the celebration of the "big night," but the sumptuous and seemingly endless feast prepared by the two brothers and joyously consumed by their friends and acquaintances turns catastrophically anticlimactic when Prima fails to appear and Pascal's hoax is exposed. Nonetheless, the feast remains the most triumphant celebration of Italian food aesthetics and its accompanying ethos of hospitality in the history of American cinema. Perfectly embodying the Italian conception of food as spectacle, the feast is orchestrated into an elaborate sequence of courses that mixes preparations emblematic of *alta cucina* with true insider foods. Indeed, the centerpiece of the feast is the Calabrian regional dish called a *timpano* ("drum" in Italian), an enormous drum-shaped torte containing a salmagundi of ingredients, including pasta within the pasta, that expresses the excess proper to the feast. As Primo explains to his American girlfriend, "And inside are all the most important things in the world."

After the "big night" is consummated, hospitality turns into hostility, creat-

ing the sort of unhappy and complex ending that the film's original distributors wanted to delete. But it is precisely the problematic ending that makes the film so troubling, particularly to a food-obsessed Italian American spectatorship conditioned to regard the feast as a ritual solution to real existential strife. The long-suppressed conflict between the brothers explodes into truth-telling accompanied by physical combat. Who is carrying whom? Where has the American Dream taken them? It has lead them to a desolate beach in the promised land where, at the very end of night, they enact the breakdown of their solidarity: "This country is eating us alive," Primo shouts to Secondo. Like the "big night," the American Dream has turned out to be a flawed feast. The disconsolate Secondo returns to the kitchen where he is soon joined by the equally disconsolate Primo to whom he offers some of the omelette he has just prepared. The film ends with Secondo tentatively placing his arm around Primo's shoulders, a rapprochement of sorts that announces the big day ahead of them during which they must reconstruct their intimacy.

Having observed, in this section, the representation and self-representation of Italianness in films made in the 1990s from a position concerned with critically monitoring Italian American images and themes, a position that might be called "Check-Point Pasta," I want to conclude with an appeal for a more oppositional form of spectatorship on the part of the Italian American viewer.

Postscript Written with Reference to the Twenty-fifth Anniversary of The Godfather

> The Godfather *is my favorite movie. I watched the movie back in the 70s and probably it helped me a lot, in a lot of the plans that we put together for how to dismantle the five families in New York.*
> —Rudolph W. Giuliani, Mayor of New York City

If history is a nightmare from which one attempts to awake, the history of contemporary Italian American cinema unfolds as an attempt to awaken from the nightmare Francis Ford Coppola imposed upon it when he attempted to recover the repressed history of Italian America through the compromised and stigmatizing vehicle of the Hollywood gangster film. Coppola and Scorsese have given Italian American cinema its two primary "genres": the epic or large-scale gangster film as art, and its gritty, more obsessive and visceral street-bound variant, the "mean streets" film, both of which are expressions and codifications of the Italian American urban experience and the gangsterism—real and imaginary, small-time and corporate—it produced as its primary mythology. Tarantino and Ferrara have

provided another and more contemporary paradigm by extending the mean streets film into pulp form, pushing its visceral aesthetic and rhetoric of violence to the limit. As initially confronted by Coppola and Scorsese, the dilemma remains whether Italian American filmmakers can change the mainstream narrative of their own history and speak directly of the Italian American experience without resorting to the crime film. As I have argued throughout this article, the gangster/crime film is too complex a register to reduce categorically to a bad object and, at least in the hands of its most accomplished exponents—Coppola, Scorsese, De Palma, Tarantino, Ferrara—is not simply an exercise in self-abasement or identification with the ideological fantasies by which the dominant culture defines legitimacy. For Italian American directors, especially those who have followed Scorsese's lead, the mean streets cinema has served as a vehicle with which to appropriate and subvert the mainstream narrative of Italianness by redescribing the underworld/overworld from an Italian American perspective and in terms of a corrosive street nihilism. Nonetheless, the crime film is far too stigmatizing a form to serve as a site from which to wage an identity politics. And here we approach the central paradox at the heart of Italian American cinema: Unlike other ethnic or minority cinemas, it has, with few exceptions, never been concerned with constructing "positive" images and with building liberating or consciousness-raising political agendas into its Italian-specific narratives. This has been its greatest strength and its greatest weakness. At the generic level, it has operated primarily from the danger zone of the gangster/crime film. But more important, its most representative filmmakers have occupied a discursive space that lies somewhere in between popular commercial cinema and the art film. Its three strongest contemporary directors—Scorsese, Tarantino, and Ferrara—operate from a third space, oscillating between mainstream and independent aesthetics. Although it has become a canonized genre within the mainstream, a model of a cinema with an edge, with an attitude, for a generation of younger filmmakers, the "mean streets" film with all of its dark, disruptive force is essentially a cinema of the third space. Although it is ostensibly concerned with territoriality, its real concern is with the complete uprooting of its marginalized male protagonists from the very possibility of a zone of experience. As such, it has served contemporary Italian American male filmmakers as a compensatory cinematic zone, a halfway and liminal genre with which to accomodate the uprootedness of the ghetto-bound protagonists that constellate the body of Little Italy films extending from *Mean Streets* itself to *A Bronx Tale*, *Federal Hill*, and *Gravesend*, the latter by the twenty-two-year-old Stabile taking the poverty of experience to a horrendous dead end.

The real problem presented by the continued commercial and aesthetic

viability of the crime film is that it precludes the treatment of a wide range of Italian American themes. At the time of this writing, there is essentially no film record of Italian American political and social history, particularly its radical political tradition. Whereas there exists a whole subgenre of films dedicated to Al Capone and Lucky Luciano, there is, for example, no record of Vito Marcantonio, the leftist New York Congressman, or even a major film by an Italian American revisiting the Sacco and Vanzetti case. Although there exists a tradition of blue collar films (*Marty*, *Bloodbrothers*, *Mac*, *Wait until Spring, Bandini*), there is no record of Italian American unionism as expressed, for example, in the Great Strike in Lawrence, Massachusetts, 1912, or in a figure like the anti-mob activist Peter Panto, who was the unacknowledged model for the longshoreman Terry Molloy (Marlon Brando) in *On the Waterfront*. There is essentially no biographical record of important Italian American public figures, other than show business personalities. Although, quite predictably, Hollywood has slated for production major films dedicated to the lives of Frank Sinatra, Bobby Darin, and Dean Martin, there is no guarantee that these pop hagiographies will explore the Italianness of these figures, that is, with the exception of the Martin biography, which will be directed by Scorsese. Few representations of middle-class and upper-class Italian American life exist, continuing the class ghettoization that has characterized the Italian American presence in Hollywood cinema from the outset. Other than the films by Savoca and DeMichiel mentioned above, there exists no feminist project within the Italian American cinema, and its most important mainstream woman director, Penny Marshall, has taken the standard escape route of genre filmmaking. With the exception of Puzo and a few other writers (for example, Di Donato whose *Christ in Concrete* was adapted by Edward Dmytryk as *Give Us This Day* [1949]), the canonic novels of the Italian American tradition have not been adapted. For example, Helen Barolini's *Umbertina* remains unfilmed, and no works by Don DeLillo, who has been mentioned as a potential Nobel Prize winner, have found their way into film. There have been few representations of the Italian American encounter with Italy, that cultural encounter being primarily reserved for Daisy Miller and her Hollywood avatars in films ranging from *Summertime* to *Only You*. The nearest approximations of *Roots* are the various gangster-relief homecomings to Sicily in *The Godfather* trilogy. And here our initial question—why the gangster film?—turns into a more fundamental one: Why have so many dimensions of the Italian American experience resisted representation?

As we have seen, a number of independent filmmakers born in the 1950s or thereafter—Turturro, Savoca, Tucci, Buscemi, Vitale—have begun to address this issue. They have begun to explore new dimensions of the Italian American

experience, making actor-driven, character-centered films concerned with endowing Italian American male and female protagonists with a genuine subjectivity. From the position of the independent film, they have transformed the discursive status of the Italian American filmmaker and developed new cinematic forms of self-representation and self-understanding. Their work with its "chamber" aesthetics supplements the work carried out in the mainstream by those Italian American filmmakers who have come to occupy key roles in Hollywood cinema where access to self-representation does not automatically produce a cinema of authentic difference.

Although the major directors—Coppola, Scorsese, De Palma, Cimino, Tarantino, Ferrara—have in various ways changed the discursive status of the Italian American in the dominant cinema, those changes must be reckoned in terms of individual films and the resistance these films offer to the hegemonic discourse of Hollywood. Nonetheless, the dominant representation of Italian Americans in mainstream narrative has remained ineluctably bound to the underworld and to their archetypal role as fixtures in crime movies, as bearers of subcultural violence now transformed into the new ultraviolence. It would be, however, hopelessly simplistic to denounce the crime film as a cinematic register on the grounds that it either glamourizes gangsters and exploits celluloid violence or demonizes Italian Americans and, given the recent escalation of multicultural crime in movies, other ghetto-determined ethnicities as well. It is more instructive to ask why the most gifted of Italian American filmmakers have turned to the gangster/crime film in order to relate their graphic, highly personalized stories of outlaws, Mafiosi, hit men, and bad detectives. These figures are outsiders, whether professionally or psychopathologically so, and all are aggressive individuals who fix themselves upon an image, typically a grandiose and destructive self-image constructed with reference to a distorted version of the American Dream, that alienates themselves from themselves. Therefore, it is no accident that ethnic filmmakers are drawn, whether consciously or unconsciously, to the gangster genre, the one Hollywood genre whose codification of Otherness mirrors and is symptomatic of their own outsiderness, of their own inscription within and estrangement from the American Dream.

This rather pat and consolatory explanation of the gangster film as a cinematic symptom of the Italian American condition takes us only so far into the nightmare of history. Other readings would lead us in completely different directions. The sociological reading, for example, would see the Mafia film as a critical rewriting of the master narrative of American capitalism—the immigrant success story—that exposes its false promises and provocatively celebrates

the monsters it produces in the name of economic success. Such a critique, as Coppola has often indicated, is certainly one of the governing intentions of *The Godfather* trilogy. It also informs Scorsese's *GoodFellas* and *Casino* and their dissections of parvenu—all cash, flash, and bash—Mafiosi. It is also at the heart of the economic critique of *la famiglia* in Ferrara's *The Funeral*, epitomized in the older Tempio brother's recognition: "We should be taking over the Ford motor company and not shooting each other." Another reading, perversely religious in its take, would see the crime film as an essentially "moral" form, one defined by an eschatological narrative that corresponds with the Italian Catholic ur-narrative—damnation and redemption, sacred violence, the body as cynosure.

The most problematic reading by far, the one advanced earlier on, would seek to account for "fascinating gangsterism" by turning the gangster film back upon the spectator and would question those mechanisms that entrap the viewer's desire and narcissism into an identification with the film gangster as fantasy figure. In this regard, it is interesting to note that Mayor Giuliani chose to kick off the celebrations for the inauguration of his second term with a screening of *The Godfather Part I*. As he claimed in the above-cited quotation, the film served him both as an inspiration to fight the Mafia and as a model for busting the five families. Giuliani's instrumentalized reading of *The Godfather* is clearly based on disavowal, the repression of the element of "fascinating gangsterism." But, according to the *NewYorkTimes* (1 January 1998, B1, B5), the Mayor does a mean imitation of Don Corleone as played by Marlon Brando, even having employed his raspy-voiced routine when addressing his staff at a meeting. If Mayor Giuliani probed more deeply the film's hold over him, all sorts of suppressed material might emerge, including the fantasy of enhanced personal and public power the film builds into its processing by the spectator. Ironically, Mayor Giuliani's self-protective reading leaves the contradictions at work in *The Godfather* intact and fails to access the film from the position of an Italian American viewer whose ethnic identity is put into deep crisis by the film.

It is time for the Italian American spectatorship to adopt a more critical and oppositional stance in decoding films that represent Italianness, especially those made by Italian American directors. It is time, for example, to recognize the crime film as a fatal strategy, one that represent Italianness by negating it. On the other hand, if the spectator subjects the films of Coppola, Scorsese, and company to a critical interrogation, he or she will find that these directors have clearly exposed and problematized the fatality of that strategy in the film itself even as they have followed that strategy to its fascinating conclusion. The critical spectator needs to follow their cues and read against the grain and not merely consume

their films in a mindless way, like those real-life mobsters who watch *The Godfather* in search of "the Look" and the archaic protocols of a subculture they have long since lost. It is not just the Mafia film and the gangsterized version of Italianness it reproduces that must be confronted through an oppositional gaze, but the larger system of stereotypes imposed by the mainstream. For example, the flattering portrait of Italianness projected by the character played by Meryl Streep in *Bridges of Madison County* (1995) must be recognized as spurious, as cameo Italianness referenced to a mythic domesticity and its tender discontents. But, above all, it is the films of Italian American directors that must be submitted to a critical interrogation on the part of the Italian American spectatorship, the litmus test being whether a film contests and disarticulates the generic codes for representing Italianness by endowing its characters with complexity and contradiction, whether the film articulates a difference through which the spectator can recognize himself or herself in a way that does not confirm the status quo; and ultimately whether the film destabilizes the order of stereotypes and transforms the representational status of the Italian American in the name of difference.

Filmography: The Italian American Presence in American Cinema, 1972–1997

The following filmography lists American films concerned with representing Italian Americans and the Italian American experience that were made during the twenty-five-year period that extends from 1972 to 1997. This period can be defined with reference to Francis Ford Coppola who first released his epochal film *The Godfather Part I* on 21 March 1972 and who celebrated, in 1997, the twenty-fifth anniversary of the film with a nationwide rerelease. This filmography, which indicates (D)irector and (G)enre, is an attempt to extend and update the annotated filmography compiled by Mirella Jona Affron in 1976, which covers the first fifty years or so of the history of the cinematic representation of the Italian American as it extends from the silent comedy *My Cousin* (1918) to *The Gang That Couldn't Shoot Straight* and *Made for Each Other* (both from 1971). See Mirella J. Affron, "The Italian-American in American Films, 1918–1971," *Italian-Americana*, 3 (fall 1976), 233–255.

1972

Across 110th Street D: Barry Shear G: Crime
The Godfather Part I D: Francis Ford Coppola G: Crime/Mafia

1973

Mean Streets D: Martin Scorsese G: Crime/"Mean Streets"
Serpico D: Sidney Lumet G: Crime/Biography (police officer Frank Serpico) 1974
The Godfather Part II D: Francis Ford Coppola G: Crime/Mafia
Italianamerican D: Martin Scorsese G: Documentary
The Lords of Flatbush D: Stephen F. Verona G: Drama/Street Gang
A Woman under the Influence D: John Cassavetes G: Drama

1974

Italianamerican D: Martin Scorsese G: Documentary

1976

Rocky D: John G. Avildsen G: Boxing

1977

Saturday Night Fever D: John Badham G: Drama

1978

Bloodbrothers D: Robert Mulligan G: Drama/Blue Collar
Paradise Alley D: Sylvester Stallone G: Drama

1979

Breaking Away D: Peter Yates G: Comedy/Sports
Rocky II D: Sylvester Stallone G: Boxing
The Wanderers D: Philip Kaufman G: Drama/Street Gang

1980

The Idolmaker D: Taylor Hackford G: Drama (Fictionalized biography of the rock producer Bob Marcucci)
Raging Bull D: Martin Scorsese G: Boxing/Biography (Jake LaMotta)

1981

The Godfather: The Complete Epic, 1902–1958 D: Francis Ford Coppola G: Crime/Mafia (a chronological ordering of the first two installments of *The Godfather*, supplemented by 15 minutes of footage cut from the theatrical releases, that was originally prepared for television, where it aired as *The Godfather Saga*)

1983

Baby, It's You D: John Sayles G: Drama
Rocky III D: Sylvester Stallone G: Boxing

1984

Broadway Danny Rose D: Woody Allen G: Comedy

1985

Prizzi's Honor D: John Huston G: Romance/Comedy/Crime
Rocky IV D: Sylvester Stallone G: Boxing
The Pope of Greenwich Village D: Stuart Rosenberg G: Drama
Wise Guys D: Brian De Palma G: Comedy/Crime

1986

Down by Law D: Jim Jarmusch G: Comedy

1987

China Girl D: Abel Ferrara G: Romance (ethnic bordercrossing)
Moonstruck D: Norman Jewison G: Romance/Comedy
Matawan D: John Sayles G: Drama
The Sicilian D: Michael Cimino G: Crime
The Untouchables D: Brian DePalma G: Crime

1988

Dominick and Eugene D: Robert M. Young G: Drama
Married to the Mob D: Jonathan Demme G: Comedy/Crime
Prince of the City D: Sidney Lumet G: Crime
Spike of Bensonhurst D: Paul Morrissey G: Comedy/Crime
Things Change D: David Mamet G: Comedy/Crime

1989

Do the Right Thing D: Spike Lee G: Drama (interethnic conflict)
Men of Respect D: William Reilly G: Crime
Queen of Hearts D: Jon Amiel G: Comedy/Romance
True Love D: Nancy Savoca G: Comedy/Wedding

1990

Betsy's Wedding D: Alan Alda G: Comedy/Wedding

The Godfather Part III D: Francis Ford Coppola G: Crime/Mafia
GoodFellas D: Martin Scorsese G: Comedy/Drama/"Mean Streets"
Rocky V D: John G. Avildsen G: Boxing
The Freshman D: Andrew Bergman G: Comedy/Crime

1991
City of Hope D: John Sayles G: Drama
Jungle Fever D: Spike Lee G: Drama/Romance (ethnic bordercrossing)
29th Street D: George Gallo G: Comedy
Oscar D: John Landis G: Comedy/Gangster
Wait until Spring, Bandini D: Dominique Durredere G: Drama/Blue Collar
 (adaptation of John Fante's novel)

1992
My Cousin Vinny D: Jonathan Lynn G: Comedy
Reservoir Dogs D: Quentin Tarantino G: Crime

1993
A Bronx Tale D: Robert De Niro G: "Mean Streets"/Coming of Age
Bad Lieutenant D: Abel Ferrara G: Crime/"Mean Streets"
Dangerous Game D: Abel Ferrara G: Drama/Film about Film
Household Saints D: Nancy Savoca G: Drama/Little Italy
Lorenzo's Oil D: George Miller G: Drama
Mac D: John Turturro G: Drama/Blue Collar
True Romance D: Tony Scott G: Crime
Used People D: Beeban Kidron G: Romantic Comedy

1994
Angie D: Martha Coolidge G: Romantic Comedy
Bullets over Broadway (1994) D: Woody Allen G: Comedy
Federal Hill (1994) D: Michael Corrente G: Drama/"Mean Streets"
Only You (1994) D: Norman Jewison G: Romance
Pulp Fiction D: Quentin Tarantino G: Crime/"Mean Streets"
Romeo Is Bleeding D: Peter Medak G: Crime

1995
Bridges of Madison County D: Clint Eastwood G: Romance
Casino D. Martin Scorsese G: Crime

Living in Oblivion D: Tom De Cillo G: Comedy/Film about Film
To Die For D: Van Dan G: Black Comedy
Two Bits D: James Foley G: Drama/Coming of Age

1996

Big Night D: Stanley Tucci and G: Drama
Sleepers D: Barry Levinson G: Drama/"Mean Streets"
Sweet Nothing D: Gary Winnick G: Drama
The Funeral D: Abel Ferrara G: Crime/"Mean Streets"
Trees Lounge D: Steve Buscemi G: Drama

1997

Donnie Brasco D: Mike Newell G: Mafia
Gotti: The Real Life of a Mafia Don D: Robert Harmon G: Mafia
Gravesend D: Salvatore Stabile G: "Mean Streets"
Kiss Me, Guido D: Tony Vitale G: Comedy
Tarantella D: Helen DeMichiel G: Drama

Further Reading
I. GENERAL WORKS

Baudrillard, Jean. *Fatal Strategies* (New York: Semiotext(e), 1990).
Bliss, Michael. *Martin Scorsese and Michael Cimino* (Metuchen, N.J.: Scarecrow Press, 1985).
Bollati, Giulio. *L'Italiano: Il carattere nazionale come storia e come invenzione* (Torino: Einaudi, 1983), 44.
Bouzereau, Laurent. *Ultraviolent Movies: From Sam Peckinpah to Quentin Tarantino* (Secaucus, N.J.: Citadel, 1996).
Braudy, Leo. "The Sacraments of Genre: Coppola, De Palma, Scorsese" in *Film Quarterly* 39 (1986): 17–31.
Bruzzi, Stella. *Undressing Cinema: Clothing and Identity in the Movies* (London and New York: Routledge, 1997), 67–94.
Cassillo, Robert. "Moments in Italian-American Cinema: From *Little Caesar* to Coppola and Scorsese," in *From the Margins: Writings in Italian America*, ed. A. Tamburri, P. Giordano, and F. Gardaphe (West Lafayette, Ind.: Purdue University Press).
Di Stasi, Lawrence. *Mal Occhio: The Underside of Vision* (San Francisco: North Point Press, 1981).
Friedman, Lester D., editor. *Unspeakable Images: Ethnicity and the American Cinema* (Urbana: University of Illinois, 1991).
Golden, Daniel Sembroff. "The Fate of La Famiglia: Italian Images in American Film" in *The Kaleidoscopic Lens: How Hollywood Views Ethnic Groups*, edited by Randall M. Miller (Jerome S. Ozer, Publisher, 1980).
Kolker, Robert Philip. *A Cinema of Loneliness: Penn, Kubrick, Coppola, Scorsese, Altman* (New York: Oxford University Press, 1980).
Lourdeaux, Lee. *Italian and Irish Filmmakers in America: Ford, Capra, Coppola, and Scorsese* (Philadelphia: Temple University Press).

Malpezzi, Frances and William Clements. *Italian-American Folklore* (Little Rock: August House Publishers, 1992).

McGilligan, Patrick. *Jack's Life: A Biography of Jack Nicholson* (New York: Norton, 1994).

II. Individual Directors

Frank Capra

Capra, Frank. *The Name above the Title: An Autobiography* (New York: The Macmillan Company, 1971).

Carney, Raymond. *American Vision: The Films of Frank Capra* (Cambridge: Cambridge University Press, 1986).

McBride, Frank. *Frank Capra: The Catastrophe of Success* (New York: Simon & Schuster, 1992).

Michael Cimino

Bach, Steven. *Final Cut: Dreams and Disasters in the Making of* Heaven's Gate. (New York: William Morrow, 1985).

Lawton, Ben. "America through Italian/American Eyes: Dream or Nightmare?" in *From the Margins: Writings in Italian America*, ed. A. Tamburri, P. Giordano, and F. Gardaphe (West Lafayette, Ind.: Purdue University Press).

Francis Ford Coppola

Coppola, Eleanor. *Notes: Eleanor Coppola* (New York: Simon & Schuster, 1979).

Cowie, Peter. *Coppola: A Biography* (New York: Charles Scribner's Sons, 1989).

Ferraro, Thomas, *Ethnic Passages: Literary Immigrants in Twentieth-Century America* (Chicago: University of Chicago Press, 1993), 18–52.

Johnson, Robert K. *Francis Ford Coppola* (Boston: Twayne Publishers, 1977).

Lebo, Harlan. *The Godfather Legacy* (New York: Simon & Schuster, 1997).

Zucker, Joel S. *Francis Ford Coppola: A Guide to References and Resources* (Boston: G.K. Hall, 1984).

Brian DePalma

Bliss, Michael. *Brian De Palma* (Metuchen, N.J.: Scarecrow Press, 1985).

Bouzereau, Laurent. *The DePalma Cut* (New York: Dembner Books, 1988).

Dworkin, Susan. *Double De Palma: A Film Study with Brian De Palma* (New York: Newmarket, 1984).

Salamon, Julie. *The Devil's Candy: "The Bonfire of Vanities" Goes to Hollywood* (Boston: Houghton Mifflin, 1991).

Vincent Minnelli

Naremore, James. *The Films of Vincente Minnelli* (Cambridge: Cambridge University Press, 1993).

Martin Scorsese

Ehrenstein, David. *The Scorsese Picture: The Art and Life of Martin Scorsese* (New York: Carol Publishing Group, 1992).

Kelly, Mary Pat. *Martin Scorsese: A Journey* (New York: Thunder's Mouth Press, 1991).

Keyser, Les. *Martin Scorsese* (New York: Twayne Publishers, 1992).

Thompson, David and Ian Christie, eds. *Scorsese on Scorsese* (London: Faber and Faber, 1989).

Scorsese, Martin. Interviewed in *Cinema Papers* 81, December 1990.

Stern, Lesley. *The Scorsese Connection* (Bloomington: Indiana University Press, 1995).

Weiss, Marion. *Martin Scorsese: A Guide to References and Resources* (Boston: G. K. Hall, 1987).

Quentin Tarantino

Bernard, Jami. *Quentin Tarantino: The Man and His Movies* (New York: HarperCollins, 1995).

Clarkson, Wensley. *Quentin Tarantino: Shooting from the Hip* (Woodstock, N.Y.: The Overlook Press, 1995).

Crouch, Stanely. *The All-American Skin Game, or The Decoy of Race* (New York: Vintage, 1997), 227–236.

Dawson, Jeff. *Quentin Tarantino: The Cinema of Cool* (New York: Applause Books, 1995).

hooks, bell. *Reel to Reel: Race, Sex, and Class at the Movies* (New York: Routledge, 1996), 47–51.

Woods, Paul A. *King Pulp: The Wild World of Quentin Tarantino* (New York: Thunder's Mouth Press, 1996).

APPENDIX I

The Italian American Experience, 1492–1998

COMPILED BY STANISLAO G. PUGLIESE

1492: On 12 October Cristoforo Colombo of Genoa, sailing under the patronage of Ferdinand and Isabella of Spain, lands in the Western Hemisphere. He makes three more voyages, in 1493, 1498, and 1502.

1497: John Cabot (Giovanni Caboto) sails for King Henry VII of England and reaches North America. Amerigo Vespucci, in the employ of the de'Medici family, is sent to Spain to assist in Colombo's third voyage. Vespucci himself undertakes four expeditions to the New World, two for Spain (1497 and 1499) and two for Portugal (1501 and 1503). On the basis of his observations and data, a German cartographer proposes naming the new land after Amerigo. During the Age of Exploration, Italians explore every part of the New World. These include: Giovanni Verrazzano (1524), humanist from Florence; Antonio Pigafetta, who sails with Magellan (1519); Marco Da Nizza in the southwest territories (1539); Francesco Bressani, first European to describe Niagara Falls (1644); Henri de Tonti, explorer of the Mississippi River (1682); and Alessandro Malaspina, scientific explorer of the Pacific Coast from Alaska to Mexico (1791).

1610: Italian wine makers come to America with Captain John Smith.

1621: A group of artisans (glassmakers) from Venice settles in Jamestown, Virginia.

1639: Historical archives in Kings County, New York, describe Peter Caesar Alberto as "the Italian," the first Italian to live in Brooklyn.

1657: The first large group of Italians—150 Italian Protestants (Waldensians)—land in New Amsterdam (later to be called New York) and Delaware, fleeing from the persecutions of the Counter-Reformation and the Inquisition.

1702: Father Eusebio Francesco Chino, Catholic missionary and historian, explores the California territory, building more than thirty churches and baptizing more than 4,500 persons.

1736: Onorio Razzolini is appointed Armourer and Keeper of the Stores of Maryland; regarded as the first Italian to hold public office in America.

1753: Philadelphia College (later the University of Pennsylvania), founded by Benjamin Franklin, offers courses in Italian.

1764: Cesare Beccaria, Italian representative of the eighteenth-century Enlightenment, publishes *Of Crime and Punishment*, affecting American conceptions of jurisprudence; John Adams quotes directly from the work in his defense of the British soldiers involved in the Boston Massacre of 1770.

1773: Filippo Mazzei arrives in Virginia and quickly establishes strong ties with Thomas Jefferson based on their political convictions concerning individual liberty and democracy. Mazzei's idea that "all men are by nature equally free and independent. This quality is essential to the formation of a liberal government. . . . A truly republican form of government cannot exist except where all men—from the very rich to the very poor—are perfectly equal in rights" was to have an important impact on American political ideals. Some scholars believe that Jefferson's phrase "all men are created equal" in the Declaration of Independence was derived from Mazzei, who also influenced Benjamin Franklin and Thomas Paine. Mazzei also experimented with various types of plants, fruits, and vegetables in America. Other Italian revolutionaries include: Francesco Vigo, the first Italian to become an American citizen; William Paca, a signer of the Declaration of Indendence; and fifty Italians who fought for the Continental Army, along with two regiments of volunteers from Italy.

1783–1871: From the founding of the American Republic to the unification of Italy, approximately 25,000 Italians immigrate to the United States. Between 1830 and 1860, many of these are political refugees, forced into exile because of their participation in the Risorgimento (the movement for national unification). Included in this group are Giuseppe Mazzini and Giuseppe Garibaldi (see 1831, 1850, and 1861 below).

1790: Pergolesi's *La serva padrona* is the first Italian opera performed in the United States.

1800: Paolo Busti from Milan arrives to manage the Holland Land Company, which develops five million acres of land into villages, towns, and cities;

later he is acknowledged as "the father of Buffalo, New York."

1805: Thomas Jefferson asks fourteen musicians from Italy to form the nucleus of the United States Marine Band.

1812: Italian Americans fight in the War of 1812 against the British.

1825: Lorenzo Da Ponte—Catholic priest, linguist, musician, and librettist for Mozart—becomes the first professor of Italian language and literature, at Columbia College in New York City.

1831: Revolution breaks out in central Italy; Giuseppe Mazzini forms the Young Italy Society to fight for unification and independence from Austria. When the revolution is put down, many flee to America.

1837: John Phinizy (Finizzi) is the first Italian American to serve as mayor of an American city—Augusta, Georgia.

1847: The Astor Place Opera House, built especially for Italian opera, opens in New York City.

1849: *L'Eco d'Italia,* the first Italian-language weekly in the United States, begins publication.

1850: Giuseppe Garibaldi arrives in New York as a political refugee after the fall of the Roman Republic. He settles on Staten Island with Antonio Meucci, said to be the true inventor of the telephone.

1851: Santa Clara College is founded in California by Father Giovanni Nobili, an Italian Jesuit; other academics include: John Grassi, first president of Georgetown University (1815); Charles Botta, who wrote the first history of the American Revolution (1819); Samuel Mazzichelli, educator and philologist; Gaetano Lanza, who established the Massachusetts Institute of Technology (MIT) in Cambridge, Massachusetts (1861); Joseph Cataldo, founder of Gonzaga University in Spokane Washington (1887); Giovanni Schiavo, writer; Leonard Covello, educator; Peter Sammartino, founder and president of Farleigh Dickinson University in Rutherford, New Jersey.

1855: Constantino Brumidi, "the Michelangelo of the United States Capitol," begins work in Washington, D.C. For the next twenty-five years, Brumidi decorates many of the most important buildings in the nation's capital.

1860: Italy is unified as a nation-state under a constitutional monarchy. Ironically, social and economic conditions begin to worsen for many of the landless peasants in the south, especially after 1870, when protectionist

measures are passed to protect nascent industries in the north. A devastating pattern is set: the north becoming more prosperous, and the south becoming more destitute. These conditions would lead to the mass emigration between 1880 and 1920.

1861: Giuseppe Garibaldi is offered a commission as major general in the Union Army by President Abraham Lincoln, but declines. A Garibaldi Brigade does fight for the Union in the Civil War. Five hundred Italian Americans fight for the South in the European Brigade. Luigi Palma Di Cesnola serves in the Union Army during the American Civil War. Later, as an archeologist, he is appointed the first director of the Metropolitan Museum of Art in New York City.

1870: Italian immigrants in American cities: New York: 2,794; San Francisco: 1,622; New Orleans: 1,571; Chicago: 552; Philadelphia: 516; Boston: 264.

1871–1880: Approximately 56,000 Italians arrive in America.

1880: The first Italian-lanquage daily newspaper in the United States, *Il Progresso*, is founded in New York City by Charles Barsotti, editor.

1880s: Italian Americans develop the wine industry in Northern California. Utilizing new methods of production and distribution, Italians revolutionize the wine-making process. The wine industry comes to be dominated by a handful of Italian families: Rossi, Guasti, Petri, Cribari—the most successful were Ernest and Julio Gallo. In addition to wineries, Italians make the land of California flourish with fruit and vegetable farms, literally transforming the landscape.

1880–1920: Millions of Italians arrive in America. Most of these are from the *Mezzogiorno* (literally, "land of the midday sun," southern Italy). Overwhelmingly rural and agricultural, the *Mezzogiorno* continues to suffer from poverty, illiteracy, famine, and the economic policies of the country. Social and economic conditions, especially the land-tenure system, as well as a particular configuration of class, status, and local power, act as catalysts for the Great Immigration to America. Nearly 30 percent are from Sicily, 28 percent from the Naples area, and 13 percent from Calabria. Parliament orders inquiries into the causes of emigration; some see it as a safety valve to alleviate conditions in the south and control the population. As emigration increases, intellectuals and political leaders come to recognize these various problems as the "Southern Question."

1883: The Metropolitan Opera House opens in New York City. Fifty musicians from the Teatro Venezia in Venice and fifteen others from the Teatro San Carlo in Naples are in the orchestra.

1884–1887: A cholera epidemic in Italy kills thousands and forces many to immigrate to America.

1889: Frances Xavier Cabrini arrives in New York City to assist Italian immigrants; in 1892 she opens Columbia Hospital; later hospitals are founded in Chicago, Seattle, Colorado, and Southern California. In 1946 she is canonized the first American saint by Pope Pius XII.

1890: The Dante Alighieri Society is established in Boston to promote Italian literature, language, and culture in the United States. Italian immigrants in American cities: New York: 39,951; San Francisco: 5,212; New Orleans: 3,622; Philadelphia: 6,799; Chicago: 5,685; Boston: 4,718.

1890s: The discovery of sulfur in Texas destroys the sulfur-mining industry in Sicily, forcing further emigration. In New York, only 1 percent of the Italian population is involved in agriculture, compared with 34 percent in California and 43 percent in Louisiana. Some 1.7 percent of the Italian population are professionals in New York, compared with 1.4 percent in California and 0.6 percent in Lousiana. Ninety percent of the New York City Department of Public Works is composed of Italian American workers.

1891: On 14 March in New Orleans, eleven Italian immigrants are killed by a lynch mob of more than 6,000 after a court finds them not guilty in the murder of a police superintendent. The mob is further incited when it is learned that blacks are allowed to patronize Italian shops and were politely addressed as "Mister." It is the worst mass lynching in American history. Italians are killed in other parts of America, but most of the murders (in the form of lynchings) occur in the South, where the Ku Klux Klan begins a campaign of terror against Italians. Academics and social scientists set out to "prove" that Italians are violent, corrupt, lazy, and untrustworthy by nature. Italian stereotypes stimulate the spread of American nativism.

1892: On 1 January, Ellis Island, called *L'isola delle lacrime* (Island of Tears) by the Italians, opens and begins processing millions of immigrants.

1894: Dr. Maria Montessori is the first woman in Italy to receive a medical degree; her theories on the education of children are influential in America.

1899: Guglielmo Marconi, "the father of the radio," arrives in America.

1900: On 29 July, Gaetano Bresci, an anarchist from Paterson, New Jersey, assassinates King Umberto I of Italy after the Italian government kills hundreds of workers gathered for peaceful demonstrations in Milan. From about 1880 until World War I, anarchism is a popular political force in Italy. Many Italian communities in America become centers for anarchist groups. Often misunderstood, most anarchists did not advocate the use of indiscriminate violence; yet in the American popular consciousness, the Italian immigrant came to be seen as a dangerous political subversive—bomb in one hand and dagger in the other.

1901: In an effort to stem the flood of emigration, the Italian government establishes requirements for those wishing to leave for America.

1903: Enrico Caruso makes his American debut on November 23 at the Metropolitan Opera House in New York City.

1904: Amadeo Giannini founds the Bank of Italy in California; later it will be called the Bank of America.

1908: On 16 November, Arturo Toscanini opens the 1908 season at the Metroplitan Opera House. Meanwhile, in the same city, 270 Italian families are charged with violation of the Compulsory Education Law (compared to 66 Russian, 56 German, 55 Irish, and 7 English families).

1909: On 12 March, Joseph Petrosino, an NYPD (New York Police Department) detective investigating organized crime, is shot and killed in Palermo, Sicily.

1910: A Chicago strike led by A.D. Marimpietri, Emilio Grandinetti, and Giuseppe Bertelli leads to the formation of the Amalgamated Clothing Workers of America. Italian immigrants in American cities: New York: 340,765; San Francisco: 16,918; New Orleans: 8,066; Chicago: 45,169; Philadelphia: 45,308; Boston: 31,308.

1911: A fire on 25 March at the Triangle Shirtwaist Factory in New York City kills 145 women workers, 75 of whom are Italian American. The tragedy forces the country to pass legislation to improve working conditions.

1913: Rudolph Valentino arrives in the United States, becoming a film star in Hollywood.

1914: On the eve of World War I, nearly 25 percent of Italy's population has emigrated.

1915: *Il Caroccio*, (1915–1935) a monthly bilingual cultural magazine dealing with the Italian immigrant experience, begins publication in New York City.

1917: America enters World War I; 12 percent of the U.S. Army is composed of Italian immigrants or Italian Americans. A literacy test becomes part of the immigration law in an attempt to stem the flow of immigrants from southern and eastern Europe.

1919: Roughly 20 percent of the population of California is Italian American.

1920: Nicola Sacco and Bartolomeo Vanzetti, two anarchists, are arrested in Massachusetts for armed robbery and murder. With Attorney General A. Mitchell Palmer fanning the first "Red Scare" in American history, a fair trial is impossible. Both are found guilty. At the trial, Vanzetti declares before the court: "The taking of our lives—that is our triumph." Along with the trial of Julius and Ethel Rosenberg in the 1950s, the Sacco and Vanzetti trial is one of the most disputed in American jurisprudence.

There are approximately 200 Italian newspapers being printed in the United States. Previous annual figures: 1884: 7; 1890: 11; 1900: 35; 1910: 73; 1915: 96.

1923: Gaetano Merola establishes the San Francisco Opera House.

1924: Benito Mussolini, fascist dictator of Italy since 1922, orders the creation of a Fascist League of North America. Mussolini and his fascist regime meet with the general approval of the American government, the American people, and the Italian Americans. A few Italians voice warnings that are ignored.

1926: The Casa Italiana, a center for the study of Italian literature and culture, is completed at Columbia University in New York City.

1927: After seven years on Death Row, Sacco and Vanzetti are executed. Their tragedy is immortalized in Ben Shahn's painting. Fifty years later, officials of the state of Massachusetts move to vindicate the two anarchists, declaring 23 August 1978 a memorial day for the two men.

1933: Gaetano Salvemini, one of the most famous of Italian antifascist exiles, is appointed professor of history at Harvard University. Italo Balbo, minister of aviation in fascist Italy and implicated in the death of the antifascist priest Giovanni Minzoni, completes a flight from Italy to Chicago, crossing the Atlantic before a squadron of twenty-four planes. This is the fourth such Atlantic crossing for Balbo and a great propaganda coup for Mussolini's regime. Italian Americans cheer as he passes over New York

City and Chicago. Balbo enters the ranks of Charles Lindberg, Amelia Earhart, and Antoine de St. Exupéry.

1935: Italian Americans send wedding rings and other gold to Italy in support of the invasion of Ethiopia. Throughout the 1920s and 1930s, the Italian American community is divided over fascism: Some look with pride on the new government as resurrecting the glory of ancient Rome and putting Italy on the world stage; others see fascism as a repudiation of the Italian traditions of humanism and tolerance. Generoso Pope's influential newspaper *Il Progresso* supports Mussolini and fascism, leading the way for the general approval of the Italian American community. When World War II begins, though, almost all Italian Americans repudiate Mussolini.

1937: Toscanini begins his association with the NBC Symphony Orchestra, conducting until 1954.

1938: Enrico Fermi wins the Nobel Prize in Physics. After the award ceremony in Stockholm, Sweden, Fermi and his wife (who was Jewish) refuse to return to Italy where the fascist regime has just passed anti-Semitic legislation. Instead, they move to New York City, where Fermi accepts a post at Columbia University. Between 1941 and 1945, he is involved in work on the first atomic bomb. On 2 December 1940, he supervises the first nuclear chain reaction; President Franklin D. Roosevelt is told: "The Italian navigator has just landed in the New World." Other distinguished Italian Americans in science and medicine include: Emilio Segre (Nobel Prize in physics for the discovery of the antiproton, 1959); Salvatore Luria (Nobel Prize in medicine for pioneer work in molecular biology, 1969); Renato Delbucco (Nobel Prize in medicine for work on DNA, 1975); Franco Modigliani (Nobel Prize in economics, 1985); and Rita Levi-Montalcini (Nobel Prize in medicine, 1986).

1939: Pietro di Donato publishes his first novel, *Christ in Concrete,* written in a stream-of-consciousness style that records the tragic reality of the immigrant experience.

1940: Census reveals 4,574,780 Italians in America. The Mazzini Society is formed in New York City by Italian antifascist exiles in the United States led by Count Carlo Sforza and Max Ascoli.

1941: America enters World War II; 500,000 Italian Americans serve, with more than a dozen soldiers receiving the Congressional Medal of Honor. Joe DiMaggio of the New York Yankees hits in fifty-six straight games.

1973: Martin Scorsese directs *Mean Streets*.

1974: Average family income (in 1974 dollars) of Italian American Catholics is $11,748, compared to $8,693 for Baptists, $10,345 for British Protestants, $11,032 for Episcopalians, $12,426 for Irish Catholics, and $13,340 for Jewish families.

1978: A. Bartlett Giamatti, scholar of Renaissance literature, becomes president of Yale University; he is later named commissioner of major league baseball.

1980: The U.S. Census reveals that 23 million Americans are of Italian descent. The number of Italian American students in college doubles since 1945.

1982: Mario Cuomo is elected governor of New York; his election, along with the Democratic Party's nomination in 1984 of Geraldine Ferraro as vice president (the first woman and the first Italian American on a national ticket), represents the culmination of a century of political struggle: Democrat Francis Spinola (of New York) was the first Italian American congressman (1887); Charles Bonaparte was the first Italian American attorney general of the United States and founder of the FBI (1908); Fiorello LaGuardia was elected to United States House of Representatives (1916), then mayor of New York City (1933); Vito Marcantonio of the American Labor Party served as congressman (1934–1948); John Pastore of Rhode Island was the first Italian American senator (1950); the 1950 mayoral race in New York City was contested by four Italians; Congressman Peter Rodino of New Jersey succeeded in making Columbus Day a national holiday (1967); Rodino, as chairman of the U.S. House Judiciary Committee, conducted impeachment proceedings against President Richard Nixon (1974); Judge John Sirica presided over the judicial inquiry (1974); Eleanor Curti Smeal was elected president of the National Organization for Women (1977); Antonin Scalia was named an associate justice of the U.S. Supreme Court (1986); Jim Florio was elected governor of New Jersey (1989); Rudy Giuliani was elected mayor of New York City (1993).

1982: Joseph Bernadin of Chicago is appointed the first Italian American cardinal, by Pope John Paul II. Italian Americans are taking a more active leadership role in the American Catholic Church, supplanting the dominant position held by the Irish for more than a century.

1985: *The Dream Book: An Anthology of Writings by Italian-American Women Writers*, edited by Helen Barolini, is published; it is the first attempt to establish a canon of Italian American women writers.

1942: In February the American government forces thousands of Italian Americans living in California into internment camps. In separate circumstances, four elderly men, declared enemy aliens, commit suicide. Ironically, some of those interned had sons fighting in the U.S. armed forces. The government eventually abandons the program when it becomes politically and economically unfeasible. On Columbus Day, President Franklin D. Roosevelt declares that Italians in America are no longer to be classified as enemy aliens.

1943: The anarchist Carlo Tresca is murdered in New York City.

1951: The American Committee on Italian Migration is formed in New York City to develop a program to loosen restrictions on immigration. Eventually, Congress passes the Immigration and Nationality Amendments (1965), which provide for the gradual elimination of immigration restrictions.

1952: Rocky Marciano wins the heavyweight boxing championship.

1953: Lawrence Ferlinghetti opens City Lights Bookstore in San Francisco.

1954: Gian Carlo Menotti, composer, wins the Pulitzer Prize for the *Saint of Bleecker Street*.

1960: Eighty percent of Italian Americans born after 1960 are married to non-Italians.

1965: The Center for Migration Studies opens on Staten Island, New York, to study and document the immigrant experience in America.

1969: Mario Puzo publishes *The Godfather*.

1970: On 29 June, thousands pour into Columbus Circle in New York City to celebrate the first Italian American Unity Day and to protest against negative images of Italian Americans in popular culture; ironically, the organizer of the rally is Joseph Columbo Sr., reputed mob boss and founder of the Italian American Civil Rights League.

1972: Francis Ford Coppola directs *The Godfather*, first of a trilogy, reopening national debate on the stereotyping of Italians as criminals. Puzo and Coppola defend their work as a depiction of the American Dream turned tragic nightmare.

1972: Architect Robert Venturi publishes *Learning from Las Vegas*, planting the seeds for the postmodernism of the 1980s. John P. Diggins publishes *Mussolini and Fascism: The View from America*, detailing how American officials, citizens, and Italian Americans perceived Mussolini's regime.

1986: John Ciardi, poet, critic, and translator of Dante, dies.

1991: The Italian government donates $17.5 million to Columbia University to transform the Casa Italiana into the Italian Academy for Advanced Studies.

1992: Al Pacino wins the Academy Award for Best Actor for his portrayal of a blind man in *Scent of a Woman,* based on the Italian film *Profumo di Donna.*

1993: Frank Zappa, hailed by some as the most creative and adventurous American composer of his generation, dies. A study reveals that Italians are one of the largest groups of immigrants to enter New York; unlike the emigration of a century ago, these immigrants are highly educated professionals. Like their predecessors, they are unable to make a living in changing economic circumstances.

1994: Leon Edward Panetta is appointed White House chief of staff by President Bill Clinton. Panetta had formerly been director of the Office of Management and Budget and U.S. representative from California.

1995: In a near sweep, three actors of Italian descent win Oscars: Nicolas Cage winning the Best Actor Award for his portrait of a hopeless alcoholic in *Leaving Las Vegas;* Susan Sarandon winning the Best Actress Award for her role as a nun in *Dead Man Walking;* and Mira Sorvino winning Best Supporting Actress for her performance in the title role in *Mighty Aphrodite.*

1996: Susan Molinari, the youngest member of Congress when she was elected in 1990, delivers the keynote address at the 1996 Republican convention.

1997: Don DeLillo publishes the novel *Underworld*, which is immediately recognized as a masterpiece of contemporary American fiction.

1997: Rudolph Giuliani is reelected mayor of New York City.

1997: Ralph Fasanella, political activist, self-taught folk painter, and chief visual chronicler of the Italian American urban and political experience, dies. A tribute to his egalitarian vision is appropriately placed in the subway station at Fifth Avenue and 53rd Street where his oil painting, *Subway Riders* (1950) has been on permanent view since 1996.

1997: Charles O. Rossotti is confirmed by the U.S. Senate as the 45th commissioner of the Internal Revenue Service. Mr. Rossotti, the founder and chief executive of American Management Systems, a computer consulting company, was chosen to change the culture and modernize the technology of the much criticized IRS. His selection is emblematic of the new pres-

ence of Italian American executives in both the public and the private sector. The emergence of an Italian American managerial class is evidenced by the following high-profile figures: Richard A. Grasso, chairman and CEO (chief executive officer) of the New York Stock Exchange; Frank Mancuso, chairman and CEO of Metro-Goldwyn-Mayer (MGM); Tony Mottola, the president of Sony Music Entertainment; publisher Lucio A. Noto, chairman of the board and CEO of Random House; Len Reggio, chairman and CEO of Barnes and Noble, the world's largest bookseller; Paul Tagliabue, president of the National Football League.

1997: NORC (National Opinion Research Center) at the University of Chicago reports that the average Italian American has at least one year of college education and an average family income of $33,000. NORC also finds that Italian Americans are evenly split along the political spectrum: 35 percent consider themselves Republicans; 32 percent Democrats; and 33 percent Independent. Italian Americans tend to support liberal causes: 89 percent say they would vote for a woman president; 55 percent are pro-choice; over 60 percent feel that the government should spend more money on education, health-care, and the poor.

1997–1998: The works of A. G. Rizzoli (1896–1981), "Architect of Magnificent Visions" and son of immigrants, begins a two-year tour of the United States.

1998: Maestra Joann Falletta, hailed by the New York Times as ". . . one of the finest conductors of her generation," is appointed Music Director of the Buffalo Philharmonic Orchestra, making her one of two American women conductors currently at the helm of major symphony orchestras.

Further Reading

Amfitheatrof, Erk. *The Children of Columbus* (Boston: Little, Brown, 1973).
Cavaioli, Frank J., and Salvatore J. LaGumina. *The Peripheral Americans*. (Malabar, Fl.: Krieger, 1984).
Di Franco, Philip. *The Italian-American Experience* (New York: RGA, 1988).
Gallo, Patrick J. *Old Bread, New Wine: A Portrait of the Italian-Americans* (Chicago: Nelson-Hall, 1981).
Gans, Herbert. *The Urban Villagers* (New York: Free Press, 1982).
Iorizzo, Luciano, and Salvatore Mondello. *The Italian-Americans* (Boston: Twayne, 1982).
Mangione, Jerre, and Ben Morreale. *La Storia: Five Centuries of the Italian-American Experience* (New York: HarperCollins, 1992).
Rolle, Andrew. *The Italian-Americans: Troubled Roots* (New York: Free Press, 1980).
Schoener, Allon. *The Italian-Americans* (New York: Macmillan, 1987).
Tommasi, Lydio. *Italian-Americans: A New Perspective in Italian Immigration and Ethnicity* (Staten Island, N.Y.: Center for Migration Studies, 1985).

APPENDIX II

Cultural Lexicon

Italian American Key Terms

Compiled by Pellegrino D'Acierno

This lexicon contains definitions of those Italian terms that can be regarded as central to or exemplary of the Italian American experience. These key words and phrases occur—often repeatedly—in the main body of this volume where their first appearance in each chapter is marked by boldface type. The terms appear boldface throughout the lexicon for cross-referencing. Although our contributors have given their own particular definitions of these terms in their individual essays, this lexicon is intended to give more extensive definitions and to serve the reader as a guide to the Italian American lexical universe and its translation of certain Italian terms into the American context. Although a few of the words included are technical terms from the artistic domains, the majority are terms deployed by Italian Americans in everyday linguistic transactions, and thus they can be regarded as equipment for living and as indexes of the Italian American worldview. Some of these words have been coupled with their antonyms to suggest the oppositions at work in the Italian American linguistic realm. Whenever appropriate, the reader is referred to a source in which the meaning of a given term is more fully explored. This lexicon contains only those Italian terms, rich in semantic connotations and cultural implications, that require extended definitions. The other Italian terms—usually of a technical nature—that appear in italicized form throughout this volume are translated or defined at their first appearance in each chapter. Although Italian words and phrases in the main body of this volume are sometimes preceded by the definite article (*il, la, l'* and their plural forms), they are listed in this lexicon without the definite article for easier access.

acida or **agida** n. (from *acido* or acid): literally, acid in the stomach; an upset stomach but often used to indicate aggravation and anxiety. *Agida* (in its Italian American pronunciation) is used as a noun (that fellow gives me *acida* or *agida*)

and typically accompanied by a gesturing to the stomach. It is not to be confused with *agitato* (agitated, distressed, a more total and more extroverted version of emotional turmoil). *Agida* is listed here as an example of those Italian Americanisms that have passed into American usage since 1972, the year in which Francis Ford Coppola's *Godfather* popularized a repertoire of terms from the Italian American subculture ranging from traditional usages (*infamia, famiglia, vendetta*) and proverbs to primal words (such interjections as *mannaggia!* [dammit!] and *marrona!* [Sicilian for *Madonna!*]) to "technical" words from the criminal underworld (*caporegime, consigliere*). Cinema, particularly the street films of Martin Scorsese, has played a significant role in disseminating the Italian American "jargon of the real" within the common culture. Although the 1970s and 1980s have seen a great influx of loan words from standard Italian, a small number of Italian Amercanisms have gained currency: For example, *Guido* (see entry below); *agida*, which was adopted by a number of newscasters on NBC in New York City in the 1980s; certain all-purpose curses (see the discussion of *sfaccim'* in the introduction to this volume); *gonzo* (simpleton); and *bimbo*, a word derived from *bambino* (baby) that resurfaced in the 1980s after a long history of various uses. Its current pejorative usage to designate an airheaded woman (all ambition and no talent), with the residual meaning of "babe" or "doll" goes back to the immigrant experience. *Bimbo* was commonly used as the name of a monkey or a monkey doll that accompanied Italian organ-grinders. The currency of *agida*, a visceral term for angst linked to the belly, is symptomatic in that the word activates—however unconsciously—the pervasive stereotype of Italian Americans as people of the body. As confirmation of this, see Nick Apollo Forte's performance of his "belly song" in Woody Allen's *Broadway Danny Rose* (1984).

al fresco adv., adj.: outdoors, literally "in the cool," meaning fresh air; an Italian phrase now used in English as in the expression "dining *al fresco*," whereas Italians tend to use *all'aperto*. Conflating the idea that Italian cuisine is admirably suited to be eaten in the open air and the image of the mediterranean climate, *al fresco* has become a signifier of the pleasurable way in which Italian life is conducted. It is listed here to exemplify a number of fashionable loan words currently used by English speakers as signifiers of trendiness or of Italianness: For example, the pervasive use of *ciao*, perhaps Italy's most successful recent linguistic export, and *al dente* (firm in the cooking, underdone, literally "to the tooth"). Both expressions have been slightly altered by the sea change: *Ciao*, an informal greeting and farewell, has lost the subtlety it has for Italian speakers whose linguistic realm is sharply divided between informal (second-person) and formal or polite (third-person) forms of address. As opposed to the formal ways of saying goodbye (*arriverderci/*

arrivederla), *ciao* is used as a familiar addressed to friends and peers. When it is addressed to a person one is only on polite terms with, all sorts of code-switching ensues. When used by an English speaker, *al dente* often implies the subtext, "I am a pasta connoisseur; I understand pasta the way Italians do." Many of the current loan words are derived from the culinary realm and the design and artistic registers, including cinema. Federico Fellini, for example, is responsible for the dissemination of a number of terms around which the image of the Italy of the "economic miracle" (1958–1968) crystallized: *vitelloni* (loafers, lay-abouts), *la dolce vita* (the sweet life), *paparazzo* (intrusive photographer, derived from the character named Paparazzo in *La Dolce Vita*). Fellini also boosted the popularity of *ciao* which was made into a cult-word by the "Ciao, Marcello" that Anita Ekberg addressed to Marcello Mastroianni in *La Dolce Vita*. Fellini himself has become one of the prevalent signifiers of Italianness: *Fellini-esque,* as William Ward has pointed out, has become "a stock description for anyone, particularly women, or anything that is lurid, overdressed or overweight." But Fellini-esque has come to mean much more to the American awareness as demonstrated by the 1995 television commericial for the Green Point Bank, a send up of a whole series of Fellinian magical moments. As Ward has pointed out, there are also a number of terms used by the media or in elite circles that have become focalizers of the contemporary Italian condition: *l'arte dell'arrangiarsi* (the art of taking care of number one), *la commedia dell'arte* (constantly applied to Italian politics), *braggadoccio* (swaggering, actually an English coinage), *con brio* (with energy), and *bravura* (brilliant technique or style in musical performance; a showy manner or display), the latter two applied to almost anything done contemporary Italian-style. Similarly, *gusto* (vigorous enjoyment; zest) and *con gusto* summon into play the passion for life associated with Italians. The cachet of Italian words is demonstrated by the names of two rock groups: the British *Scritti politi* (a deliberate truncation of *scritti politici* or political writings) and the New York City–based Japanese *Cibo Matto* (food madness).

William Ward. *Getting It Right in Italy: A Manual for the 1990s* (London: Bloomsbury, 1990): xiv.

all'italiana / all'americana adv. phr.: in the Italian style, in the Italian manner and in the American style, in the American manner. In *The Italians,* Luigi Barzini has given a repertoire of *cose all'italiana* (things done Italian style): "What exactly are these *cose all'italiana?* They are things in which we reflect ourselves as if in a mirror: a gratuitous *beau geste,* a shabby subterfuge, an ingenious deception, a brilliant improvisation, an intricate strategem, a particular act of bravery or villany, a spectacular performance. . . . Such *cose* may not be statistically prominent, but they can only happen in Italy." In the Italian American context, these terms are

used to indicate the speaker's alignment with or distance from one of the two contrasting cultures.

americanata n. (pl. *americanate*): something done American-style or embodying the American way of life, often used perjoratively. In the Italian American context a typical usage is: "What [the immigrants] learned of this strange country often repelled them. From their perspective the *Mericani* [Americans] appeared a foolish people, without a sense of humor, respect, or proper behavior. Ideas of youthful freedom, women's rights, conspicuous consumption, they dismissed as *Americannate* [dialect form]."

amicizia n.: friendship. Italian speakers inhabit a linguistic universe in which friendship or intimacy is indicated by the familiar form of address, the second person singular *tu* (thou or you). The expression *dare del tu* (to give someone the *tu* form) describes the interpersonal rite by which one passes from a polite relationship to friendship. At the linguistic level, consequently, friendship is not immediately given. On the other hand, Italians tend to greet strangers far more than Americans do as a sign of ritual respect; they also observe an etiquette of physical greeting: To shake hands is obligatory, and the social kiss (on both cheeks) is normal.

Within the first- and second-generation Italian American context, friendship has a particular meaning. As Richard Gambino explains, "'Friends,' is a preferred word to 'guest' and 'good manners' is a term used more than 'hospitality.' This derives from [the immigrants'] use of *buon costume* and *amici*, the latter a term that means more than 'guests' to the *contadini* but considerably less than 'friends' in any intimate sense. For one was truly intimate only with the family."

Gambino, Richard. *Blood of My Blood: The Dilemma of the Italian-Americans* (Garden City, N.Y.: Doubleday, 1974): 20.

amico/straniero n. (pl. **amici/stranieri**): friend/stranger. In the Ptolemaic universe of the *contadino* family, these polarized terms designated the great divide between insiderness and outsiderness. The *l'ordine della famiglia* was structured in terms of five concentric circles of persons: 1. the inner circle of family members, "blood of my blood"; 2. the inner circle extended to include affines or *parenti* (those related by marriage); 3. the inner circle extended further by *comparaggio* (ritual kinship) to include those regarded as symbolic members of the family; 4. an intermediate zone comprising, in Richard Gambino's words, "*amici* (friends) or *amici di cappello* (friends to whom one tipped one's hat or 'said hello'), meaning those whose family status demanded respect"; 5. the outer circle comprising *stranieri* (strangers), a designation, as Gambino specifies, "for all others,

including people one may speak to every day." The inward passage from *straniero* to *amico* was marked, in Gambino's words, "by the rite of sharing a meal (or just coffee), a symbolic entering into the ceremony of family communion." In Mafia-speak, *gli amici* or *gli amici degli amici* (the friends of friends) refers to those who are members of the criminal association.

Gambino, Richard. *Blood of My Blood: The Dilemma of the Italian-Americans* (Garden City, New York: Doubleday, 1974): 20–21.

antipasto n. (pl. *antipasti*): "an Italian appetizer consisting of an assortment of smoked meats, fish, olives, tomatoes, hot peppers and other ingredients served with oil and vinegar," as defined by *American Heritage Dictionary* (1969). This definition is old-fashioned and does not account for the extraordinary diversity of *antipasti* which range from *prosciutto e melone* (Italian air-dried ham and melon) to *fritti misti* (mixed fries either of vegetables or fish) to *carpaccio* (raw beef). *Antipasto* literally means "before *pasto* (food)," and thus indicates the organization of the Italian meal into a series of courses: *Antipasti* (the "first" first course), *primi piatti* (first courses such as pasta), *secondi piatti* (main courses of meat or fish, accompanied by *contorni* or side dishes), followed by *insalata* (salad is eaten always after the main course), followed by cheese and/or dessert. At home, dessert is primarily fruit; in a restaurant or on a special occasion, *dolci* (sweets). These courses are carefully choreographed, designed to unfold as gustatory events that comment upon each other.

Arlecchino n.: a conventional buffoon of the *commedia dell'arte*, traditionally presented in a mask and parti-colored tights, and known to English speakers as Harlequin. He is the archetypal trickster figure in Italian popular culture. See *commedia dell'arte*.

bacio le mani! ph.: literally, "I kiss your hands," a ritually polite expression of salutation used in Sicily. See *complimento*.

bel canto n. ph.: literally, "beautiful singing"; a style of operatic singing characterized by rich tonal lyricism and brilliant display of vocal technique. It has come to be used as a generic term to describe the art of singing in the Italian style. In its precise historical application, *bel canto* refers to the florid, elegant style of singing that flourished in the first three decades of the nineteenth century. In this restricted sense, it is exemplified by the singing called for by such operas as Bellini's *I puritani* and *La sonambula* and Donizetti's *Lucia di Lammermoor*.

bella figura/brutta figura n. ph.: literally, "a beautiful figure" and "an ugly figure"; usually used in the phrase *far(e) bella figura* (to cut a fine figure, to show

to advantage, to look very impressive) or its negative equivalent *far(e) brutta figura*. The notion of *bella figura/brutta figura* takes us to the heart of Italian and Italian American public behavior and the aesthetic decorum that governs it. The category can be seen to operate on two levels: At the level of social interaction, it designates proper or improper public behavior and thus activates all those protocols that pertain to maintaining and augmenting "face." To give an anecdotal example: A relatively poor family sets out its best crystal to honor the presence of a respected guest (the most trivial example of the *bella figura*); after the toast, the guest inadvertently topples his wine-filled glass, breaking it (a *brutta figura*); the family minimizes what has happened, and the hostess goes to the cabinet and retrieves a matching glass, filling it with wine and presenting it to the guest with the words: "Break this one, too, it brings good luck!" (a more complex instance of the *bella figura* in that the gesture saves the face of the guest and augments the face of the family). At the second level, *la bella figura* represents the aesthetic principle governing the presentation of self—looking one's best at all times and coming off well in whatever situation. Here we are speaking of image management that is, in effect, a mode of self-fashioning, one that is governed by aesthetic considerations that are for Italians and Italian Americans in no way superficial: The *figura* is the woman or the man. Although the concept of cutting a *bella figura* is a function of one's public persona and thus can be related to what might be called the Italian culture of masks, it involves much more than maintaining or choreographing appearances. It is essentially a formula of self-respect and respect for others in that it requires one's best effort. All three of its nearest English equivalents, "making a good show," "keeping up appearances," "saving face," do not convey its intricacies.

bello adj. (fem., **bella**): beautiful. It is used alone or in the phrase **che bello!** or **che bella!** (how pretty!) as a kind of pervasive and visceral response to the beautiful aspects of the world and to register approval of anything eye-catching or interesting. As such, it is an expression of Italian everyday aesthetics and a marker of the eye-intensiveness of Italian and Italian American culture. It is said that Italians raise their children to react to the world in terms of *bello* and *brutto* (ugly), whereas other less aesthetically oriented cultures impose the distinction between good and bad.

bestemmia n. (plural, **bestemmie**): blasphemy, oath, curse word, which often take the form of a coupling of a sacred name with a negative term: For example, *porco Dio* (God pig), *Dio cane* (God dog), or *Dio boia* (God executioner, hangman), the latter a Tuscan locution roughly equivalent to the English *Goddam! Goddam it!*

The *bestemmia* is to be distinguished from the *parolaccia* (literally, bad word; dirty word; obscenity). The verbal juxtaposition of the sacred and profane at work in the typical *bestemmia* is an instance of the Italian carnivalesque. See *carnevale/quaresima*.

bocce n.: an Italian traditional game resembling bowling and Italian America's most popular folk game. For a detailed description of its intricacies, see Frances M. Malpezzi and William M. Clements, *Italian-American Folklore* (Little Rock: August House Publishers, 1992): 151–156.

borsa n.: the bride's purse into which wedding guests place their gifts in the form of *buste* (envelopes filled with money). This rite was memorialized by Francis Ford Coppola in *The Godfather* (1972).

bracciante n. (pl. **braccianti**): landless agricultural laborers, who were not fixed wage earners but were hired by the day according to the work to be done. The term belongs to the traditionally oppressive agricultural system, still in place in southern Italy in the late nineteenth century, that condemned the southern peasantry to a marginal existence. Emigration was the means of escape. See *gabellotti, latifondo*.

brutta figura, far(e) phr.: to cut a bad figure, to look silly, to lose face. See *bella figura/brutta figura*.

buffone n. (pl., *buffoni*): buffoon or fool. In a culture like the Italian and the Italian American governed by the ethos of *serietà* and the everyday aesthetics of *la bella figura,* the *buffone,* like the *fesso,* is an object of supreme contempt. Consequently, it is perverse that Italian Americans have often been negatively stereotyped by the mass media as *pagliacci* of all stripes—from the immigrant actor Henry Armetta (cast in caricatural roles similar to those of Stepin Fetchit) through the Luigi portrayed by J. Carrol Naish (Amos and Andy rolled into one) in the radio and then television comedy series "Life with Luigi" to the Guido qua lawyer played by Joe Pesci in *My Cousin Vinny* (1992). The colonizing power of this stereotype led to the self-stereotyping and the self-hatred practiced by some second- and third-generation Italian Americans, a number of whom abandoned their surnames to assume colonized nomenclatural identities. In the novel *Umbertina,* Helen Barolini illustrates this process of self-stereotyping:

> *Marguerite learned that it was not nice to look too Italian and to speak bad English the way Uncle Nunzio did. Italians were not a serious people, her father would say—look at Jimmy Durante and Al Capone; Sacco and Vanzetti. Italians were buffoons, anarchists and gangsters, womanizers.*

*"What are we, Dad, aren't we Italian?" she would ask. "We're Americans,"
he'd say firmly, making her wonder about all the people in the shadows
who came before him. Grandma Umbertina was exempt, even though she
didn't speak English, because she had made good.*

Barolini, Helen. *Umbertina* (New York: Seaview, 1979): 150.

busta n. (pl. *buste*): envelope and, in the Italian American context, those envelopes filled with money that are placed in the bride's *borsa* as wedding gifts. This rite was memorialized by Francis Ford Coppola in *The Godfather* (1972).

caffè n.: the term designates coffee as well as a café or coffeehouse. In Italy and, above all, in Naples, the great love of coffee has produced an elaborate culture dedicated to the preparation of coffee and its delectation. Italian coffee culture is manifested in the exquisite devices (*macchine* or machines) devised by Italians for making *caffè espresso* and in the precise vocabulary for defining types of coffee: *Caffè espresso, caffè ristretto, caffè basso* (all three referring to very strong black coffee—*ristrettissimo* amounts to a thimble-full); *caffè americano, caffè lungo, caffè alto* (American-style or weak coffee); *caffè nero* (without milk, pure), *caffè latte* (half milk, half coffee), *caffè macchiato* ("stained" with a little bit of milk), *cappuccino* (coffee "capped" with foam; the name derives from its resemblance to the light-brown hooded robes worn by the Capuchin friars), *caffè corretto* (coffee "corrected" or spiked with liquor) and so on. The immigrants brought with them many elements of the coffee culture: *Espresso* and *la napoletana* (the traditional flip-flop coffee pot or *macchinetta* devised by the Neapolitans) and *la moka* (the beveled and more modern version) have long been signifiers of Italianness. The wholesale importation of Italian coffee culture, however, is a recent phenomenon, prompted by mass tourism to Italy in the 1960s and after and the current vogue for *cose italiane* (things Italian). Although Italian coffee culture has traveled to America, its cardinal rule is not necessarily observed: Never take anything but *espresso* after the evening meal; to take *cappuccino,* a quintessential morning or afternoon drink, is to make a *brutta figura.*

The two primary public places where coffee is taken are the *bar* (no resemblance to the American bar) where it is quickly downed while standing at a counter and the *caffè* where it is lingered over interminably while sitting. Italy, like other European countries, has a highly developed culture of the *caffè*—coffeehouses that usually extend outdoors and that are perfectly suited for people watching and for conversation, the two great art-forms of the *caffè*. Nowhere does the discrepancy between the Italian and American sense of time manifest itself more acutely than in the lingering and "learned leisure" sanctioned by the rite of

the *caffè*. Italian Americans recapitulated the *caffè* scene in the United States: Coffeehouses were foci of immigrant social life of the 1890s, giving rise to the *caffè-concerto* (see below). The Villa Emanuale III in Little Italy and the Villa di Sorrento at 109th Street and First Avenue were among the most popular of the New York City *caffè-concertos*. Such coffeehouses as Caffè Reggio, the oldest café in America, and Caffè Borgia, both in Greenwich Village, and Café Eldorado (24 Spring Street), Ferrara's on Grand Street, and many others in Little Italy became important fixtures in New York City social and intellectual life, serving as gathering places for artists and writers. In the 1950s *espresso* itself became an emblem of Beatnik counter-culture. See *espresso; caffè-concerto.*

caffè-concerto n. (pl. *caffè-concerti*): the Italian equivalent of the French, *café chantant,* or cafes in which singing and other forms of performance took place. The *caffè-concerti* were an institution of early immigrant life, proliferating in Little Italy and other areas of the New York metropolitan area during the period 1895 to 1903. The most popular of these cafés was the Villa Vittorio Emanuele III, located on Mulberry Street near Canal Street, and named for the reigning king of Italy. Emelise Aleandri has explained their social importance: "A *café-chantant* was a coffee house or café-bar where, as in Italy, alcoholic beverages were served in addition to *caffè* (coffee) and where working-class Italian immigrants convened, usually on Sunday, their only leisure time. Like the theatre, the *café-chantant* proved to be a social affair and sociological phenomenon. Friends, refreshments, and a singer performing favorite Italian folk songs and romantic ballads served to lessen the traumas of big-city living in a strange country." Two important entertainers emerged from the *caffè-concerto,* Gugliemo Ricciardi and Eduardo Migliaccio.

<small>Aleandri, Emelise. "Italian-American Theater." In *Ethnic Theater in the United States,* ed. Maxine Schwartz Seller (Westport, Conn.: Greenwood Press, 1983): 237–58.</small>

cafone n. (S. Ital., Rom. Campagna) peasant; (fig.) boor, ill-mannered person; would be elegant individual whose manners are insolent and boorish. *Cafone* is one of the key terms in Italian American social language, marking the great divide between those Italians who know and those who do not know their own cultural codes. It is generally used as a pejorative applied to indicate those who behave in a barbaric and anti-aesthetic manner, similar to the English word *yahoo*. Robert Orsi has defined its more culturally specific application to someone who disregards the values of the *domus:* "The word was not used in reference to non-Italians: it was used only to describe people within the *domus*-centered society from whom more could have been expected. It described a deep failure of human qual-

ity: *Cafoni* were selfish, uncaring, crude. They had no respect for the *domus,* and as a result they had no respect for anything else." Orsi cites an informant who had given this precise definition:

> [A cafone is] *rough, ill-mannered. He showed no respect for the customs and the traditions of the family and society. when he could get away with it he did not consider the rights of or feelings of other people. He had no ideal to rise to. He was an unfeeling clod, too dull to think of the finer things in life. Nothing was sacred to him. A man with no soul.*

Cafone was and is still used by Italian Americans of all classes and is not in any way a bourgeois category. It is a term expressive of everyday aesthetics and, as a negative used within *contadino* culture, an index of the aristocraticness of the peasantry and the immigrant. See *bella figura/brutta figura; educazione.*

Orsi, Robert. *The Madonna of 115th Street: Faith and Community in Italian Harlem, 1880–1950* (New Haven: Yale University Press, 1985): 87.

cafoneria (or *cafonaggine*) n.: boorish action; ill-mannered behavior.

campanilismo n.: excessive attachment to one's native town or village; chauvinism on a local level; parochialism. Derived from *campanile* (church bell tower), it indicates that the primary space of Italian public identity was the parish and, by extension, the village, a space demarcated by the sound of church bells. It is interesting to note that Italian dictionaries, whose ideology is that of the national or public standard, use the implicitly pejorative description "excessive attachment" as opposed to "love" for one's town which is closer to the passionate attachment Italians traditionally have felt (and continue to feel) toward their native town and, by extension, their region. Frances M. Malpezzi and William M. Clements describe some of the demographic and psychological implications of *campanilismo:* "Stemming from the isolating topography of most of Italy, lack of mobility, and linguistic and cultural diversity, *campanilismo* represents a marked tendency to move and act in very narrow circles. It also results in a sense of closeness with fellow villagers (*paesani*) and an abiding distrust of anyone else (*forestieri, stranieri*), even those from the village just five miles away, but especially those who might speak a completely different dialect." It should be pointed out that the Italy that spawned the Great Immigration (1880–1920) had not imposed a coherent national and linguistic identity on its people. The Italian immigrants brought their territorial identities to the New World where they tended to group with fellow immigrants from the same region or village and to recapitulate their small worlds in the Little Italys of America which were themselves zoned as Little Naples, Little

Sicilys, Little Genoas, and, even, in terms of the micro-identities of villages or neighborhhoods. Whatever the limits of *campanilismo* may have been (localism and provincialism), it did guarantee that first- and second-generation Italian Americans maintained their differential identities. The novelist Pietro di Donato epitomized the typical first-generation response to the lack of individualism exhibited by American citizens in his unflattering caricature of the mass population as "gasoline drinkers without culture, who spoke with a vocabulary limited to repetitive four-lettered words; listened to caterwauling, imbecilic music; and all looked more or less alike." However this portrait may be an expression of immigrant rage, it also documents the Italian obsession with individuated identities: "There was no confusing one *paisano* for another," di Donato added, "and no two resembled each other in any respect." Malpezzi and Clements, who also cite di Donato, have emphasized the ongoing importance of *campanilismo* to the Italian American experience: "This diversity among Italian Americans is evident in a vital folklore which continues to reflect *campanilismo* and to emphasize the centrality of *la famiglia*, even while forging an emergent pan-Italian consciousness that identifies and unites those whose ancestors immigrated from culturally distinct *paesi*."

Malpezzi, Frances M. and William Clements. *Italian-American Folklore* (Little Rock: August House, 1992): 29–42.

cantastorie: a professional storyteller, literally a singer of history who sings or recites stories in verse in the piazza, usually on a feast or market day. Richard Gambino has explained the role of the *cantastorie* as tribal historians who linked the immigrants to their oral traditions: "The stories of the *cantastorie* and the plays of the marionette theater were attended by adults as well as children. Among a largely illiterate population these two media kept alive traditional tales and folklore going back to medieval times. The stories told and the dramas and comedies presented emphasized the ideals of *pazienza, l'ordine della famiglia,* and other important patterns of life. . . ."

Gambino, Richard. *Blood of My Blood: The Dilemma of the Italian-Americans* (Garden City, New York: Doubleday, 1974): 155.

carnevale/quaresima: Carnival and Lent. Carnival in Italy is a time of merrymaking and revelry before Lent (usually the period from 7 January to *martedì grasso* or Shrove Tuesday). The polarity between Carnival and Lent (often thematized in paintings as the battle between forces personified as life and death) is a reminder that the traditional Italian calendar was structured and lived out psychologically in terms of the liturgical year. A number of Italian cities have developed carnival cultures, the Italian equivalent of Mardi gras. Venice, whose

social life has traditionally involved the mask and masquerade, has maintained a *carnevale* tradition based on the masquerade. In the period of its decline in the eighteenth century, it extended its carnival season into what amounted to a steady state. In the 1970s Venice resurrected its *carnevale* in the debased form of a tourist attraction. Most of the other Italian cities have lost the *carnevale* tradition. Rome, for example, has lost the thread of its vital eighteenth-century carnival tradition. Except for a few residual masked balls, the public aspect of the Roman carnival so carefully observed by Goethe in his *Italian Journey: 1786–1788*, has disappeared. Naples, perhaps the most carnivalesque of Italian cities as reflected in the Neapolitans' convulsive displays of fireworks, has built its carnival culture around San Gennaro instead. For a ritual people like the Italians, who mediate death and mourning with calibrated rites, the Carnival and the feast day have been integral expressions of popular religion and death-defying scenarios for rupturing the laws of everyday life and the hierarchical ordering of social life. The Italian Americans brought with them this love of the feast but *carnevale*, at least in the Venetian sense, was left behind.

It is important to point out that the carnivalesque is a defining characteristic of the Italian sensibility, and here the carnivalesque signifies the mixing and inversion of the sacred and profane. From Boccaccio and Ariosto through the nineteenth-century Roman poet Giuseppe Gioachino Belli to the filmmaker Fellini, the carnivalesque has defined the Italian sense of humor. Italian American culture preserved the carnivalesque in its art of the *festa* which contaminates the sacred and the profane in what Robert Orsi has called "religion in the streets." As a register in Italian American art, the carnivalesque can be found at work in the *macchiette coloniali* of Eduardo Migliaccio; in Joseph Stella's futurist *festa* depicted in *Battle of Lights, Coney Island, Mardi Gras* (1913–1914); in the renderings of urban life by the painter Ralph Fasanella; in the grotesque plays of Albert Innaurato; in the street Catholicism of Martin Scorsese's early films and later, in its blackest form, in *Good Fellas* (1990), where the brutalities of Mafia life are carnivalized to the maximum degree; and, in its fourth-generation form, in the work of Quentin Tarantino whose *Pulp Fiction* (1994)—in its perverse way the ultimate theological exercise in street religion—carnivalizes the iconography and lexicon of American popular culture.

casa/palazzo n.: house and palace. In Italian and Italian American life, *la casa* is intimately linked to the idea of the family. Robert Orsi has used the term *domus* to describe the unit comprised by the family and home (the physical building), calling the *domus* the "religion of Italian Americans." In recognition of the formative power of the *domus* in shaping the self and in constructing personhood as a "self-in-connection," Orsi has described first-generation Italian America as "the

domus-centered society." He writes: "The self that took shape in the *domus,* nurtured and formed most fundamentally by its values, was also revealed there. This is where people declared who they were, where they identified themselves. The *domus* in Italian Harlem was a theater of self-revelation: on this stage, a person showed the world his or her worth and integrity, responsibility, and devotion, the respect they gave and were due."

Robert Viscusi, in chapter nine of this volume, has explored the various psycho-physical dimensions and class implications of *la casa* which may range from an *appartamento* (flat) to a *palazzo,* which may be applied to a palace or any imposing building (*palazzo ducale*), but generally indicates a simple apartment building (*palazzo comunale*), to a *villa con giardino* (a house with a garden).

Orsi, Robert. *The Madonna of 115th Street: Faith and Community in Italian Harlem, 1880–1950* (New Haven: Yale University Press, 1985): 75–106.

comare n.: godmother, literally co-mother; the function and status of godmother, the bond of spiritual parentage that obtains between godmother and godchild. This privileged guardianship is indicated by the alternative expression *madre spirituale* (spiritual mother). See *comparaggio.*

commedia dell'arte n. ph.: the name usually given to the popular Italian improvised comedy common in Italy in the sixteenth and following centuries, in which the plot and the stock characters (*maschere* or masks) only were provided, the dialogue being improvised by the actors. The term means roughly "comedy of professional players" (*dell'arte* or of the profession, indicating that the actors were trained professionals). Along with opera, in many ways its formal opposite, *commedia dell'arte* was one of the primary forms of Italian theatrical and popular expression. It is the essential manifestation of the Italian play spirit, and its *zanni* (servants of all kind who were full of clever ideas and always ready to ridicule, intrigue, or quarrel) were all embodiments of the trickster. It is important to stress that the actors spoke in dialect and that the use of masks directed attention away from the face and toward the body. These two features foregrounded the subversive and carnivalizing effect of the improvised scenarios. A number of its stock characters such as *Arlecchino* and *Pulcinella* have become archetypes in the world's imaginary, and the Italian American immigrants often incorporated them into their theater and puppet shows.

comparaggio (or **comparatico**) n.: godparenthood; the important custom by which the clan was extended by incorporating carefully selected outsiders who became to a significant (but incomplete) extent members of the family, to paraphrase Richard Gambino. Frances Ianni defines the nomenclature and protocols

of *comparaggio* by which the kin-centered network of cognates (blood relatives) and affines (relatives by marriage) is extended:

> *[*Comparaggio *is] the practice of establishing fictitious kin roles in conjunction with rites of passage. At baptism each child is given two sponsors, whom he calls* madrina *(little mother) and* padrino *(little father), and who in turn use the complemetary terms* figlioccia *(little daughter) or* figlioccio *(little son) towards the godchild. The parents of the child and the godparents become* comare *(co-mother) and* compare *(co-father) to one another, and all adult members of both families partake of the relationship. Similar relationships are established at confirmation, and among newly married couples and their ceremonial sponsors. The* comare*–*compare *relationship is also established informally between good friends of the same sex. All these relationships are blessed by San Giovanni, the patron saint of* comparaggio. *They are products of ritual kinship, but the mutual rights and obligations established are real and binding."*

In addition to their use as technical terms for godparents, *comari* and *compari* are often applied to men and women who are treated with special respect and affection by members of the family. As Robert Orsi points out: "*Comari* and *compari* may have served as godparents for the children of the family or they may have been old friends or *paesani* of the family. But the designation of a man or woman as *compare* or *compari* was quite flexible.

Gambino, Richard. *Blood of My Blood: The Dilemma of the Italian-Americans* (Garden City, New York: Doubleday, 1974): 3.

Orsi, Robert. *The Madonna of 115th Street: Faith and Community in Italian Harlem, 1880–1950* (New Haven: Yale University Press, 1985): 90.

Ianni, Francis A. J., with Elizabeth Reuss-Ianni. *A Family Business: Kinship and Social Control in Organized Crime* (New York: Russell Sage Foundation, 1972): 18–19.

compare n.: godfather, literally co-father. The word has entered American slang as *goombah* (from Sicilian dialect) which has come to signify: 1. a friend, companion, old pal, trusted associate; 2. an organized-crime figure; *Mafioso*. See *comare; comparaggio*.

compatriota n.: compatriot; fellow-countryman.

complimento n. (pl. *complimenti*): compliment, salutation. It should be stressed that Italian and Italian American culture is Asian-like in its ceremoniousness and its formal displays of *rispetto* (respect). The rhetoric of *complimenti* (or flattery) is particularly in play in everyday greetings where a person is usually designated by

a specific title (*Avvocato* or Lawyer; *Ingegnere* or Engineer; *Ragioniere* or Accountant and so on). *Dottore* (Doctor) is applied to anyone with a degree, or, as William Ward points out, "anyone who looks as though he's got one." And *Maestro* (Master) is the supreme honorific. These and other deferential protocols are intrinsic to the Italian sense of *cortesia* (courtesy, politeness, generosity) which is mediated through the *domus*. The guest–host relationship is particularly sacred, going back to ancient Roman traditions which honored the guest for the guest or stranger could very well be a god. In daily transactions, reciprocal *cortesia* is the rule: Often a rite of what might be called "escalating courtesies" ensues by which an initial act of generosity is reciprocated by a counter-act of generosity, by which a *bella figura* is returned by a *bella figura* that ups the ante and so on.
See *rispetto*.

comunicativa: gift of establishing contact with or "getting across" to an audience. The best example of the art of *la comunicativa* remains the singing of Enrico Caruso. In Italian and Italian American everyday life, it can be seen at work in body-languge and the gestural code. See *gesto*.

concittadino adj., n.: fellow-citizen.

confetti n. (pl. of *confetto*): candy-covered almonds thrown at weddings to secure good fortune for the married couple. They are not the English confetti (small pieces of paper scattered around on festive occasions) although the English word derives from the Italian. Obviously, the custom of throwing *confetti* is analogous to the American custom of throwing rice.

contadino n. (pl. **contadini**): peasant farmworkers, but, in the Italian American context, the lower class of southern Italians, whether agrarian or urban, which produced the majority of immigrants during the Great Immigration (1880–1920) and whose ethos shaped the American experience of first-, second-, and even third-generation Italian Americans. As Richard Gambino writes: "Italian immigrants were overwhelmingly of the *contadino* class—peasant farmers—but also fishermen, artisans, and unskilled urban poor whose ways were *contadino* from such cities as Naples, Palermo, Bari, Messina, Catania, Reggio di Calabria, Salerno, Cosenza, Cantanzaro, Enna, Ragusa, and Agrigento. In the *contadino* tradition shared by these people, there was only one social reality, the peculiar mores of family life."
See *cultura negata; famiglia*.

Gambino, Richard. *Blood of My Blood: The Dilemma of the Italian-Americans* (Garden City, New York: Doubleday, 1974): 3.

APPENDIX II

corno n.: horn; the amulet shaped like a horn that some Italian Americans have worn for protection against the *malocchio* (the evil eye). As Frances M. Malpezzi and William M. Clements explain, "The *corno* may be worn on a necklace or keychain, hung from an automobile mirror, or pinned to clothing. The meaning of this symbol has expanded to include good luck in general or simply Italian-American identity."

Malpezzi, Frances M. and William M. Clements. *Italian-American Folklore* (Little Rock: August House Publishers, Inc., 1992): 113–132.

corna n. (pl. of *corno*): horns; "the horns" are the symbol in Italy of cuckoldry. It is used in the expressions *fare* or *mettere le corna a qualcuno* (to put the horns on someone, to cuckold someone) and *portare le corna* (to wear the horns, to be a cuckold). Though traditionally it is the man who wears *le corna,* modern usage does not restrict subject and object by gender.

cornutismo/gallismo n.: at the other extreme from the mythology of the cuckold (*cornutismo*) is *gallismo* (a neologism that can be roughly translated as cock-of-the-walk behavior or "roosterism"). It designates the impudent and almost aggressive behavior of those men who believe themselves to be conquerors of women. In current Italian usage, it designates a debased and highly disenchanted version of Casanova-ism, devoid of the art of seduction and concerned with anonymous sexual relations—"scoring," to use American masculinist slang.

cornuto adj., n. (from *corna,* horn): when used as an adjective, it means horned or cuckolded; as a noun, it means cuckold. It is traditionally applied to a man whose wife has been unfaithful to him and thus has given him the horns of a cuckold. The *cornuto* is regarded as an object of contempt not only because his honor, masculinity, and virility have all been violated but also because he, as usually the last one to know, is too stupid to realize his wife has been betraying him with another man. In a shame culture such as the Italian and particularly the southern Italian, the masculine concern with cuckoldry has amounted to a national obsession, for the wife's betrayal is a comment on the husband's sexual performance, a deadly insult in a country where excessive sexuality is taken as the masculine norm. In Italy prior to the sexual liberation of the 1960s, the *cornuto* often avenged himself through physical violence, one of the most notorious vendettas against the offending male being that enacted by the husband in Mascagni's opera *Cavalleria rusticana.* Contemporay cultural anthropologists have explained the psychological implications of cuckoldry for southern Italian culture by focusing on how the "horns" are given collectively to the ghenos or clan and on why a physical response to betrayal is demanded because *le corna*

derive from an excess of sexuality. An enormous folklore has been built up over the centuries around cuckoldry that has been focused on the use of the gesture *mano cornuta* (the vertical horn-sign; see entry on *gesto*). Since its late-medieval treatment by Boccaccio in the *Decameron,* cuckoldry has also been a central topos in both comic and tragic literature.

Morris, Desmond, Peter Collett, Peter Marsh, and Marie O'Shaughnessy. *Gestures* (New York: Stein and Day, 1979): 119–134.

cornuto e contento phrase: literally, "horned and happy"; said of a man who knows his wife is cheating on him yet accepts the situation with equanimity. It is a term of derision and opprobrium.

Cosa Nostra ph.: literally, Our Thing; a generic term for organized crime. The term was set into circulation by the criminal Joseph Valachi when he testified in 1963 before the Permanent Subcommittee on Investigation of the Committee on Government Operation (the McClellan committee) of the United States Senate. Francis Ianni qualifies its usage: "After Valachi testified, *Mafia* and *Cosa Nostra* began to be used interchangeably as terms for organized crime. It should be pointed out that they are not the same. *Cosa Nostra,* if it exists, is native to America; a nationwide *Mafia* organization, if it exists, is an American adaptation of a form of organization that originated in Sicily."

Ianni, Francis A.J., with Elizabeth Reuss-Ianni. *A Family Business: Kinship and Social Control in Organized Crime* (New York: Russell Sage Foundation, 1972): 4.

cucina n: Cuisine or cooking; a covering term for Italian American foodways. The Italian Americans have maintained a great fidelity to their culinary traditions. In this volume, *la cucina* appears in three modified phrases which are organized hierachically: *cucina povera* (peasants' cooking); *cucina casalinga* (good, plain home-cooking); and *alta cucina* (the Italian equivalent of *haute cuisine,* restaurant cooking). On the other hand, as Marcella Hazan points out:

> There is no such thing as Italian haute cuisine *because there are no high and low roads in Italian cooking. All roads lead to the home,* la cucina casareccia—home cooking, which is the only good cooking—la buona cucina. . . . *The family table, worshipfully called* il sacro desco, *was an inviolable place, the one still spot in a turning world to which parents, children and kin could safely cling. The food put on such a table did not strain for effect, was not meant to dazzle, did not need to be elaborate. It only had to be good. This is still the essential character of* la buona cucina, *of good Italian cooking. Good is good enough.*

It should be pointed out that most of the Italian words used in contemporary American English are derived from the culinary realm and are often used by non-Italians as signifiers of trendiness. The dominance of Italian food culture has resulted in a class schism between the old Italian American cooking and the new Italian cuisine. From a sociological point of view, it is interesting to note that Italian restaurants in America (now properly identified as *trattorie* or *ristoranti*) were, in the years around 1900, pejoratively designated as "spaghetti joints" and, in the 1920s, as "red-ink spots" or "joints" (referring to cheap wine, the Dago Red memorialized by John Fante in his 1940 story by the same name).

As Americans have become more familiar with Italian cuisine, a number of food or product cults have developed. Both the Italian *gelato* (ice cream) and *espresso* cultures were imported to America in the 1970s and 1980s while such talismans of Italian cuisine as olive oil (*extravergine* or made from the first pressing), balsamic vinegar, and *risotto* (rice, particularly the type known as *arborio*) have become cult items. Within the proliferation of specialized cookbooks, Helen Barolini's *Festa: Recipes and Recollections of Italian Holidays* (New York: Harcourt Brace Jovanovich, 1988) stands as the most insightful rendering of the relationship between food and celebration intrinsic to the Italian way.

Hazan, Marcella. *More Classic Italian Cooking* (New York: Knopf, 1978): 3–4.

cucina casalinga n. ph.(or *cucina casareccia*): good, plain home-cooking, the Italian equivalent of soul-food.

cucina povera n. ph.: literally poor cuisine; peasants' cooking. Although the term designates the poor subsistence diet of the *contadino* underclass, it also applies to the hearty, peasant cooking that forms the basis of Italian American cooking.

cugino/cugina n. (pl. *cugini/cugine*): male and female cousin. Italian Americans have much more to do with cousins than their American counterparts. In the world of the enmeshed and enmeshing Italian American family, cousins (second cousins and cousins once or twice removed are all considered *cugini*) play integral roles. In the Italian American youth subculture, *cugine* (dialect for *cugino*) is a synonym for *Guido* (see entry). In mob-speak, *cugine* is a young tough guy "looking to be made," that is, aspiring to official recognition as a *Mafioso* or "made man."

cultura negata n. phr.: a "negated" or denied culture. Throughout this volume, the term has been used to describe the culture of the Italian peasantry (essentially, the *contadino* culture of southern Italy that contributed the majority of immigrants to the diaspora of 1880–1920) and, by extension, the first installments of Italian American culture. The political philosopher and the most influential Ital-

ian thinker of the twentieth century, Antonio Gramsci (1891–1937) elaborated the concept to describe the cultural (de)formation of subaltern classes in general, that is, politically and economically subordinated classes that either are excluded from participation in the hegemony of the dominant classes or passively consent to it. According to Gramsci, such classes are not merely politically and economically oppressed but, more important, culturally dominated. In the broadest sense, this means that the conception of the world of such classes is imposed from without (and above) by the hegemonic apparatus at work in civil society. The hegemonic apparatus (a series of directive and consent-inducing institutions and practices) exerts its influence in indirect and culturally mediated ways. Although the worldview, attitudes, beliefs, linguistic, and everday practices of a subaltern class may appear to be its own cultural creations (spontaneously and autonomously produced), they are in fact constructed by the dominant culture and by the historical process itself. Subaltern culture expresses itself, according to Gramsci, through popular religion and a folkloristic conception of the world that are in fact sedimentations of past historical epochs, traces of a history of subordination to dominant groups of the past. Such dominated and internally colonized classes are thus made to occupy a negative or passive position both with respect to politics (a subaltern class lacks autonomy and is unable to establish its own hegemonic position) and to history (a subaltern class is unable to create actively its own history and thus is constituted negatively as the subject of the history made by the ruling classes). It should be pointed out that Gramsci was a Marxist revolutionary and that his analysis of the subaltern class—the potential revolutionary class—was motivated by an attempt to understand what would permit the popular masses to emancipate themselves politically and culturally.

Born in Sardinia, the son of a Neapolitan father, and thus a southern Italian both territorially and genealogically, Gramsci elaborated a critical history of the *Risorgimento* (the movement for national unification; see below) as a revolution that failed in that it did not involve a restructuring of power along class lines. Rather than ameliorating the conditions of the southern Italian peasantry, the *Risorgimento* marginalized them further. The *contadino* culture of the South was his primary model of a *cultura negata*. As a Southerner, Gramsci was particularly well-equipped to elaborate a critical analysis of that culture and its folkloristic conception of the world. His description involved a diagnosis of its worldview—its entire system of beliefs, superstitions, ways of seeing things and acting—and how that disjointed and episodic worldview was reproduced in various cultural practices, above all, common sense and language. Subaltern culture was defined by a number of negative traits: It was folkloric, commonsensical, religious, supersti-

tious, infiltrated by sedimentations of past history. Language was crucial to Gramsci's analysis, for the *contadino* conception of the world was governed by the dialect. Gramsci underscored that every language—including dialects and other subcultural languages—contains conceptions of the world and of a culture. He also underscored the limitations of the dialect: "Someone who only speaks dialect, or understands the standard language incompletely, necessarily has an intuition of the world which is more or less limited and provincial, which is fossilized and anachronistic in relation to the major currents of thought which dominate world history. His interests will be limited, more or less corporate or economistic, not universal." It is important to recall that the overwhelming majority of Italian immigrants to America were speakers of dialect and members of the peasantry or its urban counterpart. Gramsci's analysis explains the genesis of many of the key terms defined in this lexicon: The feudal remnants at work in the concept of *onore* and *rispetto,* the corporatism of the *famiglia,* the localism of *campanilismo,* the superstitiousness of the *malocchio,* and even the corporatism of the *Mafia,* the most self-denying and self-negating aspect of *la cultura negata.* On the other hand, Gramsci also emphasized the "healthy nucleus that exists in common sense," what he called "good sense." It was this good sense particularly as located in the ethos of *la famiglia* and in the immigrant's personalized version of Catholicism (the two primary institutions of a culture that was essentially anti-institutional) that would serve the first and second generations as their instruments of survival in the New World. Gramsci did not write on the political implications of immigration and how the process of immigration—economically determined in the first instance—could in effect serve as a means of transforming *la cultura negata,* involving the immigrants in a slow cultural revolution by which the folkloristic conception of the world was translated into and emancipated by the American experience.

Gramsci, Antonio. *Selections from the Prison Notebooks* (New York: International Publishers, 1971).

Gramsci, Antonio. *Selections from the Cultural Writings,* ed. D. Forgacs and G. Nowell-Smith (Cambridge, Mass.: Harvard University Press, 1985).

destino n. destiny, doom, fate. In southern Italian *contadino* culture, the ingrained sense of pessimistic fatalism inculcated by *la miseria* or the culture of poverty. Taking the phrase *fato profugus* (propelled or exiled by fate) from Virgil's *Aeneid,* A. Bartlett Giamatti has elaborated on the larger implications of the sense of destiny for Italians: "The phrase will resonate throughout the history of the peninsula, and will mark a people who saw themselves as constantly conquered. Theirs would be a history marked by fatalism, an attitude of melancholy acquiescence in

the conviction that a nameless destiny controls all and all is passing. As a result, they would be a people perceived by foreigners, friendly or hostile, as attached only to the moment, to the sun and song and flesh of today, to the here and now." Giamatti goes on to translate this awareness of fate into the immigrant experience itself.

Giamatti, A. Bartlett. "Commentary." In *The Italian Americans,* ed. Allon Schoener (New York: Macmillan, 1987): 12–13.

dialetto (pl. **dialetti**): dialect; Italy has traditionally been a country of linguistic fragmentation. At the time of the Unification in 1861, only a tiny portion of the population, less than three percent, actually spoke Italian. They spoke one of a very large number of dialects, whose survival was the result of the persisting political and cultural fragmentation of the peninsula after the breakup of the Roman Empire. To give an idea of the linguistic diversity of Italy, consider the famous example of the 500th anniversary of the death of Boccaccio, which was celebrated in 1875 by the publication of one of his stories in different dialects—the publishers came up with no less than 700 dialects! The immigrants were overidingly dialect speakers. As mentioned above (see *cultura negata*), Antonio Gramsci delineated the political and cultural limitations of the dialect. On the other hand, Luigi Meneghello has discussed the power of dialect as a subcultural language:

> There are two layers in the personality of a man; the top ones are like superficial wounds—the Italian, French and Latin words: underneath are the ancient wounds which on being healed have formed scars—words in dialect. On being touched the scars set off a perceptible chain reaction, difficult to explain to those who have no dialect. There is an indestructible kernel of apprehended matter, attached to the tendrils of the senses; the dialect word is always pegged to reality, because they are one and the same thing, perceived before we have been taught reason in another language.

Meneghello, Luigi. "Deliver Us from Evil." In *Italian Writing Today,* ed. Raleigh Trevelyan (Harmondsworth, Eng.: Penguin, 1967).

disprezzato adj. (pl. **disprezzati**): held in contempt or not appreciated. In the Italian American context, a term ritually invoked by immigrants to indicate their mistreatment in the America of the Great Immigration. Jerre Mangione and Ben Morreale illustrate its usage by citing the recollection of an old immigrant: "The Italians were *disprezzati* in those times." They then gloss the comment with another testimony by a better-educated immigrant: "We came to America

in search of bread and felt the inferiority of beggars. Everything about us—our behavior, our diet, our groping, uncertain speech—was interpreted in terms of that inferiority."

Mangione, Jerre and Ben Morreale. *La Storia: Five Centuries of the Italian American Experience* (New York: Harper-Collins,1992): 221.

diva n.: literally, a goddess; a *prima donna* or star of stage, screen, or television; the Italian equivalent of superstar. (*Divo* is the male equivalent of the *diva.*) The term has a long history within the culture of Italian opera where it is applied to the exaggerated and cult-inducing codes of conduct and self-display of the great leading ladies. (See Wayne Kostenbaum's witty account in *The Queen's Throat: Opera, Homosexuality, and the Mystery of Desire,* 1993). At the quotidian level, *divismo* (superstar behavior) can be seen at work in the Italian cultivation of and appreciation for the big personality with all its healthy narcissism, self-flaunting, and posing. As such, *divismo* can be described as the art of theatrical individualism. The negative aspects of the self-assertive Italian personality are described as *protagonismo* (the desire to hog the limelite at the expense of the collective; acting like a *diva* or *divo* without the panache to pull off the performance). Within the context of the common culture of the United States, the conduct of Frank Sinatra and Madonna can be taken, respectively, as second- and third-generation examples of *divismo.*

donna seria n. ph.: literally, a serious woman, a woman who embodies the ideal of womanliness as expressed in the concept of *serietá* (seriousness). Richard Gambino has defined this traditional ideal of the *contadino* family as a "competence to be the cohesive force which binds a family together and thus makes all life possible." He explains that "although the ideal includes the ability to bear children and household skills, it goes much further. It includes life-supporting qualities which must run deep into the being of a person." This is clearly a first- and second-generation ideal, one that is linked to a conception of *la famiglia* as an instrument of survival based on loyalty and self-sacrifice. As Helen Barolini and Mary Jo Bona have indicated in their essays in this volume, the concept has been called into question and reformulated by the new generation of Italian American women who have rethought their traditional role in the light of feminism. It should be pointed out that the *donne serie* were in no way submissive; they were in fact the center of power and authority in the *domus,* serving as disciplinarians and controllers of family finances (see Robert Orsi, *The Madonna of 115th Street: Faith and Community in Italian Harlem, 1880–1950* [1985]: 132–133).

Gambino, Richard. *Blood of My Blood: The Dilemma of the Italian-Americans* (Garden City, N.Y.: Doubleday, 1974): 160–182.

educazione/istruzione n.: education/instruction. Although *educazione* may be translated as education, it also implies good breeding and proper rearing and, in the Italian American context, applies to the formation of children through the mentorship of the family. *Istruzione* denotes formal education or schooling. Richard Gambino explains the distinction between these two terms: "The ideal of child rearing then among the *contadini*, as it remains today among Italian-Americans, was to cultivate young people who were in the old phrase *ben educati*. The simple—and deceptive—translation of this means 'well educated.' *Ben educato* meant raised with the core of one's personality woven of those values and attitudes, habits and skills that perpetuated *l'ordine della famiglia*. In the *Mezzogiorno* the means to accomplish this aim decidedly did not include formal schooling. Pragmatists that they were, the *Meridionali* did not confuse schooling and sound education. As a matter of fact they regarded formal schooling as a natural enemy of the ideal of being *ben educato*." Gambino goes on to explain the historical reasons for this suspicion of formal education.

Gambino, Richard. *Blood of My Blood: The Dilemma of the Italian-Americans* (Garden City, N.Y.: Doubleday, 1974): 247.

espresso n.: a strong coffee brewed by forcing steam under pressure through long-roasted powdered beans. The term derives from *caffè espresso*, "pressed out" coffee, from the past participle of *esprimere*, to press out, to express. But its accessory meanings of coffee made either quickly or expressly for the person who orders it are part of the term's cachet. Although *espresso* is in no way uniquely Italian, it has come to be associated with Italian culture, in part, because most of the elaborate machines for its preparation were devised by Italians such as Bezzara of Milan, the firm that at the turn of the twentieth century manufactured the first commercial machines, and Achille Gaggia, who designed the first piston machine in 1945. Its importance as an emblem of Italian American life has been registered by the painter Ralph Fasanella who often depicts *espresso* rites in his paintings.

famiglia n.: the family. Throughout this volume *la famiglia* refers primarily to the traditional Italian American family and its mores. As Richard Gambino specifies: "*La famiglia* and the personality it nurtured were very different from the American nuclear family and the personalities that are its typical products. The *famiglia* was composed of all one's blood relatives, including those relatives Americans would consider very distant: cousins, aunts, and uncles. It was an extended clan whose genealogy was traced through paternity. The clan was supplemented by an important custom known as *comparatico* or *comparaggio* (godparenthood), through which carefully selected outsiders became, to an important (but incom-

plete) extent, members of the the family." Of course, as Italian Americans have become assimilated, this notion of the "strong family," enmeshed and enmeshing, has been modified, but nevertheless *la famiglia* in contemporary Italian America, as in contemporary Italy, remains the primary institution through which individualism and collective identity are mediated. Luigi Barzini, in his inimitable fashion, summed up the role in this (im)pertinent stereotype: "The Italy of the families is definitely the real Italy, the quintessential Italy, distilled from the experiences of the centuries, while the Italy of the laws and institutions partly make-believe, the country Italians would like to believe was or will be but now is not known."

Italian familism, the accentuation of exclusive family values and actions, was negatively diagnosed in the late 1950s by the American sociologist Edward Banfield who, based on his study of the peasants in the backward region of Basilicata, coined the term "amoral familism." Banfield attributed the backwardness of the region to "the inability of the villagers to act together for their common good, or indeed, for any good transcending the immediate, material interest of the nuclear family." This negative assessment of the Italian family has continued to be a leitmotif in recent sociological writings on the family where the exaltation of the family is seen to engender a distrust of collective action and societal institutions. Tracing the history of the micro-institution of the Italian family back to the fifteenth century, the Italian social historian Carlo Tullio-Altan wrote in *La nostra Italia* (1986): In most of Italian society, in both the North and South, there prevailed, and there still prevails, the moral viewpoint of the individualistic, Albertian family, with its disastrous social consequences." These negative assessments of the Italian family by Banfield and Tullio-Altan are one-sided. For a corrective and more complex analysis of the contemporary Italian family, the reader is directed to Paul Ginsborg, *A History of Contemporary Italy Society and Politics, 1943–1988* (1990). The classic treatments of the Italian American family as a strong and nurturing institution remain those of Richard Gambino and Robert Orsi, and they are obligatory reading for anyone attempting to understand the Italian American identity.

Banfield, Edward. *The Moral Basis of a Backward Society* (New York: Free Press, 1958).
Barzini, Luigi. *The Italians* (New York: Atheneum, 1964): 190–212.
Gambino, Richard. *Blood of My Blood: The Dilemma of the Italian-Americans* (Garden City, N.Y.: Doubleday, 1974).
Orsi, Robert. *The Madonna of 115th Street: Faith and Community in Italian Harlem, 1880–1950* (New Haven: Yale University Press, 1985).

fesso n.; adj.: fool; foolish. See **furbo/fesso**.

festa n.: feast, usually dedicated to the celebration of a saint's day and one of the primary means by which Italian Americans recapitulated the devotional dramaturgies of Italian life and expressed their own popular version of Catholicism, what Robert Orsi has described as "religion in the streets." As the *festa*, always a primary signifier of Italianness, has evolved into its current generalized and secularized form, much of its original structure and meaning has been lost. Focusing on the annual festa of the Madonna of 115th Street in Italian Harlem in New York City, Orsi has described how the *festa* served as the sacred theater of the community:

> *The people who came to the festa assumed well-defined roles and watched others assume well-defined roles. There was almost no flexibility here: a man was never carried down the aisles of the church toward the Madonna, according to my informants. The drama that then took place was then the drama of inner life of Italian Harlem. The streets became a stage and the people revealed themselves to themselves. The immigrants' deepest values, their understandings of the truly human, their perceptions of the nature of reality were acted out; the hidden structures of power and authority were revealed. Within the confines of this sacred street theater, people expressed their rage at the implicit assumptions and demands of their culture, but they did so in a way that was approved and contained. The* festa, *which at certain moments was marked by great hysteria and frenzy and a mood of mourning, allowed people to purge themselves of the many difficult emotions of the* domus-*centered society while it reinforced the cosmic inevitability of that particular ordering. Purged, cleansed, healed and returned to the* domus, *the people set out to live another year.*

Feste can be organized into three types: religious (dedicated to the Madonna [*la festa della madonna*] or the local patron saint [*la festa del santo patrono*]); historical (commemorating a particular event of local significance); gastronomic (*le sagre* or seasonal gastronomic feats celebrating the harvest).

Gambino, Richard. *Blood of My Blood: The Dilemma of the Italian-Americans* (Garden City, New York: Doubleday, 1974): 171.

Orsi, Robert. *The Madonna of 115th Street: Faith and Community in Italian Harlem, 1880–1950* (New Haven: Yale University Press, 1985): xxii–xxiii.

furbo/fesso n.; adj. (alternative, **dritto/fesso**): a clever or crafty person versus a fool or gullible person; when the two interact, the *furbo* is the one who gulls or dupes the *fesso*. Here we approach the pragmatic side of Italian behavior that

values *furbizia* (cunning) as a survival skill. Luigi Barzini defines *furbo* in terms of its opposite: "The imperative which [Italians as realistic people] obey in all their decisions is *non farsi far fesso,* not to be made a fool of. To be *fesso* is the ultimate ignominy, as credulity is the unmentionable sin. The *fesso* is betrayed by his wife, buys gold bricks, falls for deceptions and intrigues, and often accepts the wolf's invitation to lie down with him."

Barzini, Luigi. *The Italians* (New York: Atheneum, 1964): 166.

furbizia n.: cunning; astuteness; the ethos of cunning central to the worldview of the *contadini*.

gabellotto n.(pl. *gabelloti*): the big leaseholders in Sicily and southern Italy who managed the *masserie* (big farms) leased to them by the absentee landlords under the *gabella* contract. In Thomas Belmonte's definition: "The gun-toting estate managers and tax collectors who functioned as an intermediary class of entrepreneurs, many of them shepherds (with no ties to the land). They forged the complex system of attitudes and cultural codes that became, in Sicily (and, to a lesser extent, in Naples and Calabria, a vast but invisible edifice of power and influence that was parallel to that of the official state." The term belongs to the system of agrarian exploitation from which the emigrants of the Great Immigration fled. See *bracciante; latifondo.*

garbo n.: good manners, charm, courtesy, grace, discretion. *Garbo,* a word that cannot be translated exactly, applies to the aesthetics of verbal and social performance and describes the tactfulness and grace by which the social actor keeps his or her scenarios within the boundaries of credibility and taste. Luigi Barzini gives the following examples: "The careful circumspection with which one changes political allegiance when things are on the verge of becoming dangerous; the tact with which unpleasant news must be gently announced; the grace with which the tailor cuts a coat to flatter the lines of the body; the sympathetic caution with which agonizing love affairs are finished. . . ." Although to American ears this may sound like spin-doctoring, *garbo* is in fact a dimension of the art of self-presentation defined by *sprezzatura* and the *bella figura* and, like those two allied concepts, is Other-directed, concerned with displaying elegance in such a way that it becomes the message, a courtesy performed for the subtle decipherment and pleasure of the Other. See *sprezzatura; bella figura / brutta figura.*

Barzini, Luigi. *The Italians* (New York: Atheneum, 1964): 166.

gesto n. (pl. *gesti*): gesture. Italy is traditionally regarded as the land in which the language of gestures has been raised to an art form. As Luigi Barzini writes:

"Italian gestures are justly famous. Indeed Italians use them more abundantly, efficiently, and imaginatively than other people. They employ them to emphasize or clarify whatever is said, to suggest words and meanings it is not prudent to express with words, sometimes simple to convey a message at great distance, where the voice could not carry." It is important, however, to remember that gestures are used as a means of expression by all people and that while some gestures are universal a great many are culturally specific. Since gestures are expressions of body language, they sometimes bring into play what appears to be the most natural, the most "animalistic" element of communication. But the use even of the most obscene gestures is highly codified. People who lack specific knowledge of these cultural codes often stigmatize and parody Italians and Italian Americans in terms of the stereotype of the "gesticulating Italian." Italian Americans themselves have tended over time to lose this highly inflected gestural code. Although gestures range from the staightforward (the hand purse signifying "What do you mean?" or the sexually insulting forearm jerk) to the subtle (the eyelid pull announcing mutual understanding and lateral thumb stroke across the cheek signifying that something has been artfully done), the most prevalent Italian gesture, the horizontal version of the *mano cornuta* (horn-sign) is representative of the intricate protocols of gesturing. It is the gesture par excellence of self-protection and is linked to the mythology of both the *malocchio* (evil eye) and the *jettatore/jettatrice* (the man or woman thought to possess the evil eye but also any figure regarded as the generic bearer of bad luck, a jinx). Since the protocols of its usage with respect to the evil eye are discussed in the entry on the *malocchio,* here we will indicate the importance of this originally phallic gesture to serve as an all-purpose antidote to be used whenever one is exposed to dangerous influences or confronted by the uncanny: It blocks the disastrous forces emanating from the *jettatore,* empty coffins, priests, umbrellas opened in houses, and so on.

Morris, Desmond, Peter Collett, Peter Marsh, and Marie O'Shaughnessy. *Gestures* (New York: Stein and Day, 1979).

giglio n.: lily; the tall tower that is carried—"danced"—by a squad of lifters during the festival of Saint Paulinus in Brooklyn. Saint Paulinus is the patron saint of Nola, a village near Naples, and elements of his legend are reenacted in an annual procession staged by Brooklynites who trace their origins to Nola. According to the fifth-century legend, the villagers of Nola carried lilies to celebrate the return of Paulinus, their bishop, who had voluntarily become a captive of the Vandals in place of a widow's son. The lilies are symbolized by the *giglio,* "a sixty-foot, two-ton, steeple-shaped structure decorated with papier-mâché and plastic representations of saints, angels, birds, vines and

leaves, and flowers and resting on a platform carried a short distance by a squad of 128 lifters," to use the description by Frances M. Malpezzi and William M. Clement. The exorbitance of this display of devotion is typical of the *festa* mind-set.

Malpezzi, Frances M. and William Clements. *Italian-American Folklore* (Little Rock: August House, 1992): 103–105.

Guido (fem. **Guidette**) n.: a pejorative term applied to lower-class, macho, gold-amulet-wearing, self-displaying neighborhood boys and the dominant mass-media stereotype projected onto Italian American young men since the 1970s. The term supposedly derives either from the typical Italian first name (Guido) or from the Italian *guidare* (to drive), a reference to their penchant for cruising in hot cars, those "id-mobiles" that serve as the *guido*'s boudoir. *Guidette* is their gum-chewing, big-haired, air-headed female counterpart.

invidia n. envy. Derived from the Latin *invidere* (to look at with malice), the term is intrinsic to belief in the evil eye and the village culture that produced it. See *malocchio*.

istruzione n. formal learning. See *educazione/istruzione*.

italianità n.: Italianness. Within the history of Italy—that Italy that Metternich disparagingly called a "geographical expression"—the term emerged as part of Italian national awareness during the *Risorgimento* (the movement for Italian unification). Throughout the late-nineteenth and early-twentieth century, it was a key term in the forging of a positive political and cultural identity. The following comments by Verdi on musical difference can be regarded as a typical expression of *italianità*: "An Italian must write as an Italian, a German as a German. Their natures are too different for them too blend"; that "our music, unlike German . . . is rooted principally in theater." In the early part of the twentieth century, it became an expression of chauvinism as reflected in irredentism (the attempt to recover Italian-speaking countries subject to other countries) and in Italy's belated adventures in colonialism. It was coopted by the Fascist regime as part of its jingoist rhetoric.

Deprived of these negative associations, *italianità* is currently used in Italian American studies as a terminological instrument with which to define and to locate—to recover—Italian American identity. See, in particular, Anthony Julian Tamburri, Paolo A. Giordano, and Fred L. Gardaphe, eds. *From the Margin: Writings in Italian Americana* (West Lafayette, Ind.: Purdue University Press, 1991): 5–10.

the immigrants in the New World. As the immigrant equivalent of vaudeville, the *macchiette coloniali* were the mainstays of the Italian American theater in its heyday, 1907–1914. Eduardo Migliaccio, "*il re della macchietta coloniale*" ("the king of the colonial comic sketch"), was their inventor and primary practitioner. Migliaccio in the guise of *Farfariello* (Little Butterfly), the archetype of the poor southern Italian immigrant, performed sketches that satirized and carnivalized immigrant life. As Emelise Aleandri points out: "Fafariello was the street vendor, the rag picker, the organ grinder, the pick-and-shovel man, the uneducated 'greenhorn,' who murdered the English language as well as the Italian. Yet, like Stentorello, Farfariello was hero as well as clown, exposing the weaknesses of the wealthier, more pretentious people around him and somehow triumphing over them." The *macchiette coloniali* can be regarded as the prime examples of Italian American cultural texts.

Aleandri, Emelise. "Italian-American Theater." In *Ethnic Theater in the United States,* ed. Maxine Schwartz Seller (Westport, Conn.: Greenwood Press, 1983): 237–258.

Madonna n.: 1. the Virgin Mary; 2. an artistic representation of the Virgin Mary. The quintessential figure in traditional Italian religious and psychic life through which the feminine ideal is epitomized in the oxymoron of the mother who is a virgin. Luigi Barzini has described how, in Italian life, the cult of the mother is superimposed upon the adoration of La Madonna, "the universal symbol of suffering and self-sacrificing womanhood." He describes the omnipresence of *La Madonna* particularly as manifested in popular religion:

> *The Church itself happily encourages this national tendency. Jesus Christ shares, in Italy, His supreme place with His Mother on almost equal footing. There are perhaps as many churches dedicated to her, in her many manifestations, attributes and specializations, as to Him. The most popular, revered and frequented sanctuaries are hers, famous shrines, the* Madonne di Pompei, di Loreto, del Rosario, del Carmine, del Divino Amore. *There are more miraculous images of her than anyone else, some wafted on the waves from the East, in ancient times, by supernatural means, a few painted allegedly by Saint John the Evangelist, and many done by the great Italian masters. They are especially helpful in the solutions of particular feminine problems: spinsters pray to them to find a good husband, unhappy wives to give them back their husbands' love, mothers to cure the incurable diseases of their children. Most Italian men are also personally consecrated to Mary: they have Maria among the names given to them at christening. Mary is one of the saints officially entrusted with the protection of Italy. There is at least one day dedicated*

latifondo n. (pl. *latifondi*): an extensive landed estate (from the Latin, *latifundium*). In southern Italy, the *latifondo,* a remnant of the feudal system of land ownership, was part of the oppressive agrarian system which effectively excluded the peasant cultivators from owning the land they worked and imposed upon them an exploitative system of primitive share-cropping (mezzadria). See *bracciante; gabellotto.*

lazzaronismo n.: beggary; vagabondry (from the Italian *lazzarone* or beggar; from the Spanish *lazaro* [poor] which in turn derives from the biblical figure of Lazarus the beggar). From the sixteenth century onward the term was applied by the Spanish rulers in Naples to the urban "mob" of Naples (and thence by extension to other cities). The term was pejorative, stressing the wretched conditions of the Neapolitan sub-proletariat and its supposed laziness and dishonesty. Marx called southern Italy, long-stereotyped as the land of bandits, the *Lazaronitum,* by which he meant a class ghetto of the lumpen proletariat. Both the term *lazzarone* and the beggar-image traveled with the immigrants to the United States and became the focus of an extensive anti-Italian campaign in the press. "Italian Beggars in New York—A Nuisance," an anonymous piece that appeared 13 February 1882 in the *New York Times,* is representative in its tone: "People who took a stroll on the lower part of Broadway early yesterday morning had the pleasure of witnessing an unusual sight, even in this cosmopolitan city. This was a thoroughly characteristic specimen of the *lazzaroni* of 'sunny Italy,' without the hand-organ and monkey attachment." The reporter goes on to describe at length the "peculiar style" of the beggar whose "art" is disparaged. The reportage culminates in the beggar's kissing of the gloved hand of a handsomely dressed woman who has given him some coins and who recoils from "the contaminating touch of the *lazzaroni*'s kiss."

Gramsci, Antonio. *Selections from the Prison Notebooks* (New York: International Publishers, 1971).

lupara n.: sawed-off shotgun, meant for shooting wolves and used by Sicilian criminals for its compactness. It has been mythologized in films treating the *Mafia*.

macchietta n. (pl. *macchiette*): the Italian term for caricature, character sketch, or comic impersonation. Particularly popular in Naples, they were brought to New York City by Eduardo Migliaccio who immigrated to the United States in 1897 and went on to become one of the most beloved figures in the Italian-American theatre.

macchietta coloniale n. (pl. *macchiette coloniali*): literally, colonial character sketches ("colonial" refers to the Italian American colony in the United States); Americanized versions of the Neapolitan *macchiette* that treated the adventures of

to her every month, feast days observed not only by the Church but also by government and private business. The whole month of May is her own month, and, at intervals, whole years are consecrated to her.

The immigrants brought with them this cult of the Virgin Mary and their particular Madonna-centric version of Catholicism which was at odds with the American Catholicism that had been previously institutionalized by the Irish. Richard Gambino has described the impact on him of a full-length image of the Madonna that hung from a wall of his grandmother's home. Stressing the dialogical nature of the first generation's immediate rapport with the Virgin and other sacred figures, he concludes: "This was no remote figure of abstract meaning. She was a superhuman individual who easily wore this world as her personal property. To the pragmatic *contadini*, God, the Holy Family, and the saints were personal, worldly powers in direct everyday intercourse with them." Marina Warner, an English writer of Italian descent, has discussed the implications of Mariology from the perspective of a modern woman in *Alone of All Her Sex: The Myth and the Cult of the Virgin Mary* (New York: Knopf, 1976).

Barzini, Luigi. *The Italians* (New York: Atheneum, 1964).
Gambino, Richard. *Blood of My Blood: The Dilemma of the Italian-Americans* (Garden City, New York: Doubleday, 1974): 171.

Madonna/puttana n.: *Madonna/*whore; the mother–whore complex codified by Sigmund Freud in such essays as "A Special Type of Object Choice Made by Men" and "The Most Prevalent Form of Degradation in Erotic Life." Long before Freud, however, the linking of the two antithetical terms was a linguistic commonplace in those locutions that, in Italian, are called *bestemmie* (see entry). Such profanities, which involve the juxtaposition of a sacred name with its opposite, often involve the name of the *Madonna: Madonna puttana* (*Madonna*–whore, being the most typical). It is precisely this contamination between the sacred and profane that the pop singer Madonna quite deliberately puts into play through her sexual persona. In a Catholic tradition that has sacralized woman in the name of the *Madonna,* the mother–whore complex has remained a psychic constellation in the Italian and Italian American male. It has been been treated most notably in Federico Fellini's *8½* (1963) and in a number of films by Martin Scorsese.

madre n. (familiar form, *mamma*): mother, female parent. Sociologists have constantly remarked upon the central role of the mother in Italian and Italian American life. In putting forward his notion of Italy as a crypto-matriarchy, Luigi Barzini writes:

> *The fact that woman is the predominant character of Italian life, even if not the most conspicuous, can be read in many small signs. Almost as many popular songs are dedicated every year to* La Mamma *as to voluptuous hussies or romantic beauties.* Mamma mia! *is the most common expression. What other people call for their mother in time of stress or danger? . . . Wounded Italian soldiers in front-line dressing stations moan* "mamma, mamma, mamma," *almost inaudibly.* "Mamma," *say men condemned to death as they wait for the firing squad to fire." The next most common exclamation is* "Madonna," *which is a supernatural equivalent, as* La Madonna *is the universal symbol of suffering and self-sacrificing womanhood.*

However patriarchial and out of date Barzini's reading may be, it does present the Italian "Great Mother" in words that a male writer from a less matriarchal culture would be reluctant to voice. On the other hand, the reader is advised to counter the masculine (mother-worshipping) reading with descriptions of motherhood by Italian and Italian American women writers. For example, one will find a much darker version of the mother in Grazia Deledda's *La madre,* a canonical Italian novel that treats the mother–son relationship. In the Italian American context, Helen Barolini in her novel *Umbertina* (1979) traces the mother–daughter rapport across four generations, probing the way that intimate rapport is mediated by speech and, perhaps more important, by the unsaid. Consider, for example, Barolini's description of the taciturnity of the first-generation matriarch Umbertina, who was born in Calabria:

> *Umbertina Longobardi had few words of advice to give her daughters before they married. She believed in good food on the table and good linen on the bed; all the rest of housekeeping was so much* fronzoli *[something frivolous and superfluous] for which she had neither time nor temperament. The importance of family and of loyalty to one's husband, her daughters would have acquired from her example; anything else they would find out for themselves.*

Whereas so much of the ethos of the first-generation *donna seria* is expressed here, Umbertina's granddaughter laments the generational silence that separated her from her cherished grandmother who did not speak English:

> *I remember my grandmother Umbertina . . . but I could never speak to her. She spoke another language. We could only look at each other and*

smile. Then she'd tweak my cheek. All my life I've missed speaking to her; she died when I was thirteen.

On the central role assumed by the mother in the Italian American family, see Richard Gambino, *Blood of My Blood* (1974), and Robert Orsi, *The Madonna of 115th Street* (1985). See *famiglia; Madonna; mammismo.*

Barolini, Helen. *Umbertina* (New York: Seaview, 1979): 130, 287.
Barzini, Luigi. *The Italians* (New York Atheneum, 1964): 203.

Mafia/mafia n. (Sicilian dialect, etymology obscure, but its archaelogical derivation is customarily attributed to the Arabic terms *mahyas,* "braggart," and *marfud,* "rejected"; its more immediate derivation is from the adjective *mafioso,* a word used in the Sicilian dialect of the 1860s to denote: "beauty, graciousness, excellence of its kind"): In current Italian journalistic usage, *Mafia,* with a capital "M," refers to the Sicilian underworld organization and its Amercan counterpart; *la mafia,* with a small "m," refers to organized crime in general, and thus includes the Neapolitan *Camorra* and the Calabrian *Ndrangheta.* Italian dictionaries give the following standard definition of *Mafia:* "In nineteenth and twentieth century Sicily, the complex of small associations, bound by the law of secretiveness and *omertà,* that tend to substitute themselves for public authorities in enforcing a primitive form of justice, exercised in the service of private economic interests involving extortion and intimidation."

The journalistic usage and the standard definition, notwithstanding its mention of the code words *secretiveness* and *omertà,* omit reference to the Sicilian sense of the word—the key to understanding the worldview of the Sicilian subculture from which the Mafia emerged. That Sicilian subculture was formed as a response to Sicily's long history as an island colonized by outsiders and, after the unification of Italy in 1861, ruled by a weak Italian state that appeared as another occupying power to be resisted and mistrusted.

In his 1933 entry for the *Encyclopedia of the Social Sciences,* the sociologist Gaetano Mosca pointed out that "the word is employed by Sicilians in two different although related senses: on the one hand, it is used to denote an attitude which until recently has been fairly widespread among certain classes of Sicilians: on the other hand, it signifies a number of small criminal bands." In recognition of the doubleness of the word, a number of writers (Luigi Barzini, Francis A. J. Ianni, A. Bartlett Giamatti) have introduced the distinction between the organization *Mafia* (upper case) and the attitude *mafia* (lower case), the latter term designating, in Barzini's words, "a state of mind, a philosophy of life, a conception of society, a moral code, a particular susceptibility, prevailing among all Sicilians. They are

taught in the cradle, or are born already knowing, that they must aid each other, side with their friend and fight the common enemies even when the friends are wrong and the enemies are right; each must defend his dignity at all costs and never allow the smallest slights and insults to go unavenged; they must keep secrets, and always be aware of official authorities and the laws." Following Barzini's distinction, Ianni gives a more rigorous explanation of the Sicilian usage:

> *When the word is used as an adjective, it describes a state of mind, a sense of pride, a philosophy of life, and a style of behavior which Sicilians recognize immediately. It is* bravura, *but not* braggadocio. *It bespeaks the man who is known and respected because of his ability to get things done. It suggests that he is unwilling to allow the merest hint to insult or slight him, and it insinuates that he has means at his disposal to punish it. He is a "man" of respect who has "friends." In Palermo, even the style of dress, with the hat cocked to one side, the walk which we would call a self-assured strut, the manner of speech and the general air of self-reliance can mark a man as* mafioso *(the Sicilians actually say* mafiusu*). Such a man may or may not be a member of a formal organization in which he has a clearly defined role. Yet even in Sicily, the word* Mafia *when used as a noun, clearly denotes such an organization* as well as *such a state of mind.*

Ianni's description, reproducing as it does the insider's point of view, takes us into the heart of the conflict of interpretations regarding the *Mafia* (upper case). Amplifying the traditional historical interpretations (the organization *Mafia* as a remnant of Sicily's precapitalist, feudal past; the *Mafia* as a by-product of Sicily's long history as a colonized territory), the subcultural reading emerged in the early 1970s (Ianni's *A Family Business* and Henner Hess' *Mafia and Mafiosi: The Structure of Power*) and can also be seen at work in Francis Ford Coppola's *The Godfather Part I* (1972) and *Godfather Part II* (1974). Where does the subcultural reading of the Mafia lead us? It typically culminates in the following accurate generalization: "The Mafia exists as a pattern in Sicilian culture and the organization would be impossible without the pattern" (Ianni's conclusion). The subcultural reading also treats the *Mafia* as a dark and distorting glass through which the image of southern Italian culture can be viewed, as a kind of "crazy mirror" that inverts, displaces, and parodies the family: its codes of honor and its kinship structures. Implicit to the subcultural reading, however, is the danger of rendering normative *Mafia* behavior and mentality when in fact they are deviant—monstrous disfigurations and degradations of Sicilian, Southern Italian, Italian, Italian American, and American (capitalist) culture, all of whose systems the Mafia parodies and inverts as part

of its essential corporate parasitism. The correct metaphor to be applied, in fact, is not the crazy mirror but the biological language of disease in which the virulent parasite infects the host which, in turn, reproduces the pathology of the parasite. Nowhere does this more obtain than in contemporary Italy where the *mani pulite* (clean hands) inquiries of the1980s and after have disclosed that the entire state apparatus has been infected by the *Mafia* virus. The limitations of the subcultural reading have lead recent scholars (Diego Gambetta, in particular) to elaborate a strictly economistic reading of the *Mafia,* one that characterizes the *Mafia* as a "brand name" or "trademark" and describes the skills it deploys as an industry of violence based on the phantom commodity of protection.

Mafia is a complex and, depending on one's (sub)cultural position, a highly ambivalent word. Like the criminal entity it designates, it is a word that keeps two secrets—the secret of its etymology (Gambetta has listed no less than eighteen etymologies, seven of which he regards as apocryphal, an indication that, at least from around 1860, the term was a site for the intersection of reality and fiction) and the secret of its history—(its diachronic evolution from a positive term within the context of the Sicilian subculture to its current status as perhaps the most stigmatizing term in the world's lexicon, the term that has marked Italian Americans as a discredited people). Even though the history of the evolution of the term can be traced, that evolution takes the form of a regenerative or viscious circle: The increase of the lexical or nominal power of the word has repeatedly increased the power of the organizations. All attempts to demystify the term (even those by the so-called *pentiti* or repented who have broken the code of *omertá*) have augmented the power of the term.

No one has expressed more rationally and forcefully what the Italian American response to "whatever is meant by 'the *Mafia*'" should be than the late A. Bartlett Giamatti, former President of Yale University. He wrote:

> *It is finally as foolish to deny the existence of Italian American gangsters and criminal combines of all sorts as it is bigoted to believe that the* Mafia *(or* Cosa Nostra) *is all-pervasive or that in America only Italian Americans are gangsters, or, worse, that because one has an Italian surname one may be 'connected' in some sinister way. Much of the bigotry felt by Italian Americans throughout this century has its origins in fear and prejudice arising out of ignorant assumptions about the mysterious and malevolent* Mafia.

Giamatti's practical suggestion is for the Italian American community to "cease making folk heroes out of thugs, [to cease] peddling the stereotypes bigots

love to hate." This is no easy task. In *Casino* (1995), Martin Scorsese has presented an extremely demystified portrait of *Mafiosi* as fossilized old men operating out of back rooms who, nonetheless, call the shots in Las Vegas. Whatever demystifying power such a film may have, it is countered by the media culture which promotes its own myth of the "*Mafia über alles*" in which every inexplicable instance of violence or corruption is attributed to that great floating signifier the *Mafia*. Italians have an apt word for this: *Dietrologia* (literally, "behindology"—the conspiracy theory industry).

Barzini, Luigi. *The Italians* (New York: Atheneum, 1964): 252–275.
Giamatti, A. Bartlett. "Commentary." In *The Italian Americans,* ed. Allon Schoener (New York: Macmillan, 1987): 18–21.
Hess, Henner. *Mafia and Mafiosi: The Structure of Power* (Lexington, Mass.: D.C. Heath, 1973).
Ianni, Francis A. J., with Elizabeth Reuss-Ianni. *A Family Business: Kinship and Social Control in Organized Crime* (New York: Russell Sage Foundation, 1972): 15–41.
Gambetta, Diego. *The Sicilian Mafia: The Business of Private Protection* (Cambridge, Harvard University Press, 1993).

Mafioso n., adj.: in the general Sicilian context, anybody bearing himself with a visible sense of pride; in the criminal sense, a member of the *Mafia*. See *Mafia/mafia, uomo d'onore, uomo di rispetto.*

malocchio n. (variant spellings, *mal occhio* and *mal'occhio;* variant forms, *occhio cattivo* [bad eye], *occhio morto* [eye of death] and *occhio tristo* [wicked eye]: belief in the evil eye, a superstition Italians share with a number of other Mediterranean cultures. Frances M. Malpezzi and William M. Clements explain its place in the Italian context: "Connected with the deeply rooted fatalism of the southern Italian worldview, *malocchio* reflects a pessimism that perceives potential threats from almost anyone and assumes that good fortune cannot endure. To prosper, according to this worldview, is to invite envy. And envy generates ill feelings that may result in harm befalling its target. *Malocchio* makes concrete the abstract envy that pervades a universe defined by only a limited amount of good."

Jerre Mangione, who has devoted a chapter to the evil eye in *Mount Allegro: A Memoir of Italian American Life* (1942), describes its mechanisms:

> *But the Devil, like God, seemed to be everywhere. Mount Allegro was said to be populated with agents of the Devil whose destiny it was to carry out his evil wishes. These agents could cause disease or some other kind of bad luck by simply looking a person in the eye. Many a poor Sicilian had lost his job that way. If you were not quick to sense that* il mal'occhio *was directed at you, you were sunk. The best way of protecting yourself from the Devil was to carry a pointed amulet, preferably a horn, so that you could*

grasp it when someone with the evil eye looked at you. If you did not have the amulet, then the next best thing you could do was to form your hands in the shape of two horns. Making the sign of the cross would give you the same protection, but the trouble with that was that it was too obvious. It might offend the person with the mal'occhio.

See *invidia, mano cornuta.*

Malpezzi, Frances and William Clements. *Italian-American Folklore* (Little Rock: August House Publishers, 1992): 117–128.

Mangione, Jerre. *Mount Allegro: A Memoir of Italian American Life* (New York: Harper & Row, 1989): 100–116. Originally published in 1942.

mammismo n.: the cult of the mother, particulary as reflected in the privileged relationship between mother and son.

mano cornuta (or *mano di cornuto*) n. ph.: literally, a horned hand; a self-protective gesture made to ward off the *malocchio* (evil eye) and other evil influences. Desmond Morris has identified this ancient gesture as the horizontal horn-sign: "The hand is pointed forward, with the forefinger and the little finger horizontally. The other two fingers are held down in a bent position by the thumb, giving the hand the crude shape of an animal's horned head, lowered to charge." Sometimes the gesturer will jab the hand downwards, as though to ban the evil into the earth. The *mano cornuta* also designates protective amulets made in the shape of this hand gesture.

When the same gesture is directed upward (the vertical horn-sign), it is a gross insult indicating that the person marked by the gesture is a *cornuto* (cuckold). Desmond Morris explains the protocols of its use:

> *It is the sign for a cuckold. Its message is: your wife has been unfaithful to you and has given you the horns of a cuckold. Generalizing from this it becomes a taunt of impotence and stupidity. . . . It is often used jokingly as an anti-virility insult, but in the past it has sometimes been taken so seriously that its use has led to feuds, fights and murder. There are even cases recorded in the present century where a gesturer has been killed for making the horn-sign as an accusation of cuckoldry. More cautious gesturers usually make the sign secretly behind the victim's back, when the message becomes not "you are a cuckold," but "he is a cuckold."*

See *gesto* and *cornuto*.

Morris, Desmond, Peter Collett, Peter Marsh, and Marie O'Shaughnessy. *Gestures* (New York: Stein and Day, 1979).

masciata n.: the matchmaker's message to the family of a prospective bride. A feature of the immigrants' way of brokering marriages, the term derives from *ambasciata* (ambassador, commission, message, errand, negotiation).

menefreghismo n.: indifference, couldn't-care-less attitude.

Mezzogiorno n.: southern Italy as it extends from Abruzzi to Siciliy. Comprising six provinces (Abruzzi, Campania, Apulia, Lucania, also known as Basilicata, Calabria, and Sicily), the Mezzogiorno was the region from which the majority of Italians immigrated to America, especially between 1880 and 1920. Its archaism and changelessness is evoked by its traditional epithet, "the land that time forgot"; its primitiveness and persistent paganism have been formularized in the title of Carlo Levi's novel *Christ Stopped At Eboli,* a phrase borrowed from the peasants in Basilicata who used it to indicate that the refractoriness and remoteness of their land had prevented even Christ from penetrating there and thus their Christ-forsaken, history-forsaken land remained essentially pagan. On the one hand the *Mezzogiorno* was the site of two world cities, Palermo and Naples, the latter a crucible of an extremely rich urban and intellectual life at certain times supreme in Europe. Furthermore, while the hinterlands of the *Mezzogiorno* may have been the place where Christ stopped, the *Mezzogiorno*—Naples in particular—was the place where philosophers began: Thomas Aquinas, Giordano Bruno, Tommaso Campanella, Giambattista Vico, Francesco DeSanctis, Antonio Labriola, Benedetto Croce, Giovanni Gentile, and Antonio Gramsci were all southerners and world-class thinkers who produced, as a genealogy, a philosophical culture equal to the other great national traditions.

The *Mezzogiorno* is regarded as the other Italy—the poorer and less modernized half of Italy; the lower or "inferior" part (southern Italy is termed *Bassa Italia* or lower Italy) that presents itself to the rest of Italy as a "problem" (*il problema del mezzogiorno* or the Southern Question, the subject of a vast polemical debate ever since Unification in 1861). The term *Mezzogiorno* is thus the focalizer of the Italian great divide, the demarcation between *Nord* and *Sud* (North and South) that is more than territorial, more than economic, more than political, more than linguistic and cultural: It is a fault line that runs through the collective and individual Italian consciousness, orienting the Italian psyche in the way ordinary people are oriented in terms of right- and left-handedness. This faultline has led to a vast system of stereotyping and self-stereotyping by which northern and southern Italians define themselves in terms of their territorial Other.

Before he locates the difference between the "Two Italies," Luigi Barzini makes a point of underlining family resemblances. He then proceeds to define the "difference":

> The northerner . . . thinks that there is one practically sure way to achieve [private aims]: the acquisition of wealth, la richezza. Only wealth can, he believes, lastingly assure the defense and prosperity of the family. The southerner, on the other hand, knows that this can only be done with the acquisition of power, prestige, authority, fame.

Barzini sees the difference in ideological terms: The northerner's will to construct himself or herself as a modern *homo economicus,* who observes the Italian equivalent of the Protestant work ethic; the southerner's will to exaggerated individualism, the personalizing and transpersonalizing self that wants above all "to be obeyed, admired, respected, feared, and envied." Here, as is usually the case with Barzini, we move into the realm of (im)pertinent stereotypes, useful in that they reveal the terms in which Italians stereotype themselves.

Frances A. Ianni has succinctly defined the three major themes which shape the culture of the *Mezzogiorno:* "A strong family, a weak political structure further weakened by a dominant religion, and a primitive sense of honor which takes precedence over the law. . . ." Whatever terms are used to describe the culture of the *Mezzogiorno*—we believe that Gramsci's category of *la cultura negata* (see entry) is the most rigorous analytical grid—it is certain that the Italian American experience (from 1880 through the 1980) has been essentially—but far from exclusively, for Italian America is highly diversified—an epiphenomenon of *Mezzogiorno* culture. To forestall any misconceptions that may arise from this use of "epiphenomenon," it is useful to think of the Italian American cultural experience as a complex series of translations and reworkings of the cultural text originally "translated" to America by the first generation of immigrants. That original cultural text, basically oral and behavioral, was itself an epiphenomenon of Italian official or bourgeois culture, the result of all sorts of cultural and linguistic overlappings and historical intertwinings. As of the 1980s and even earlier, a new pattern of immigration has been established whereby the new immigrants, usually highly educated, come from middle- and upper-class strata. See *cultura negata; polentone/terrone.*

Barzini, Luigi. *The Italians* (New York: Atheneum, 1964): 234–251.

miseria n.: wretchedness, poverty. Within the pessimistic worldview of the *contadini* who were locked into the culture of poverty, the term suggests, in Thomas Belmonte's words, the "chronic sense of impending disaster [that] was axiomatic to the south Italian's concept of the future."

morra n.: a mesmerizing traditional game of guesswork and finger throwing.

APPENDIX II

Richard Gambino describes its rules and stategies:

> At a given signal each of two men shoots a hand forward, extending one to five fingers. Each player simultaneously calls out a number guessing the total number of fingers extended by both. The one who approximates closest to the correct total wins. The players are usually surrounded by a group of spectators. The game has a strangely hypnotic effect on all present. And all seem to emerge from a series of matches with a feeling of satisfaction that usually comes from engaging in a strenuous sport. The game is well suited to the pattern of pazienza. No equipment is needed to play but one's own wits and hands. It doesn't stress either competition as such or mere chance. It stresses cleverness in the context of chance situations, a mini-model of life. The good player is the one who learns to read his opponents' patterns and to "psyche him out" by playing tricky patterns. It is the perfect game of the ideal [of pazienza] for it stresses the ability to cope by one's quick wits in a world where chance and the cleverness of others combine to produce the everyday situations with which we are confronted.

Gambino, Richard. *Blood of My Blood: The Dilemma of the Italian-Americans* (Garden City, New York: Doubleday, 1974): 152.

morto di fame n. ph. (pl. **morti di fame**): a starveling; literally, someone dying from hunger. The term has overtones of both pity and contempt. Antonio Gramsci explored the political implications of the *morti di fame* as a "famished" or parasitic stratum in both the countryside and the city. In the everyday Italian American context, it is used as a term of contempt for those whose wretched condition indicates a failure to master the rules of the game, a usage almost impossible for Americans to fathom. Roughly equivalent to the less picturesque "loser" (*schnorrer* is closer), Italian Americans apply it to those who have a leach or looking-for-a-handout mentality that violates the Italian American golden rule of self-reliance. For example, it would be applied to relatives who repeatedly make calls at the time of Sunday dinner in order to be invited to table.

Gramsci, Antonio. *Selections from the Prison Notebooks* (New York: International Publishers, 1971): 272–274.

nonno/nonna n.: grandfather, grandmother. The Italian forms of address within the family are relatively formal. Grandparents—*Nonno, Nonna*—are often called by name, to distinguish them, if both sets are alive: hence Nonna Maria, Nonno Giovanni. Parents (*il padre,* and *la madre*—are called *Papà* (*Babbo* in Tuscany) and *Mamma*—addressing a parent by a first name *all'americana* would be a great breach.

CULTURAL LEXICON

novellatore n. (fem. *novellatrice*): a storyteller. See chapter ten in which Gioia Timpanelli sets out the lexical distinctions pertinent to storytelling (oral and written), including the various regional terms for designating a story.

omertà (Sicilian and southern Italian) n.: silence, the ancient code of silence observed by the Sicilian and southern Italian subculture as part of its non-compliance with public authorities; the rule of silence observed by individual *Mafiosi* ("The duty to keep a secret; the punishment for those violating it is death," according to Mafia statutes); the conspiratorial code of silence and secrecy maintained by members of the criminal underworld as a means of protecting each other when confronted by legal authorities. A. Bartlett Giamatti has explained its derivation and traditional (nineteenth-century) meaning: "*omertà,* derived from *omu,* or 'man' meant, like *mafia,* manliness and self-reliance. But whereas *mafia* meant radical self-assertion and self-reliance in a hostile world, *omertà* meant a negative—silence, not speech; not having recourse in a hostile world to civil (or spiritual) authority; not assisting civil or spiritual authority in its work. *Omertà* meant trusting no one but oneself and therefore being one who could be trusted by family and friends to trust no one who was not family or friend." From this matrix, *omertà* hardened into the criminal code of silence.

In contemporary Italian American studies, the term is used both positively as the expression of a style of subcultural resistance to authority or negatively as a kind of self-censorship and self-distancing that imposes a secret around the inner life of Italian Americans. Gay Talese illustrated the latter sense in his polemical piece "Where Are the Italian-American Novelists?" (*New York Times Book Review,* 14 March 1993). Explaining his reluctance to betray family history in the writing of his autobiography *Unto the Sons* (1993), Talese wrote: ". . . I began to feel that I was violating the tradition of family confidentiality that was fundamental to my father—an assimilated man on the surface, but with interior ties to the ancient southern Italian code of *omertà* (silence) that guided not only the Mafia but also their countrymen who had traveled with them to the New World."

onore n.: honor. It is important to point out that Italy is a shame culture rather than a guilt culture, to use superannuated but still useful terms. Therefore, honor is essentially Other-mediated and Other-directed. As Barzini points out, for Italians in general, honor "means something bestowed from outside, esteem or reverence, rank, dignity, and distinction. . . . " On the other hand, for the southern Italian, *onore,* a remainder of feudalism, is a serious matter, an expression of the individual's sense of self-respect. As Francis A. Ianni writes: "[The southern Italian] social order is internalized in a code of rustic chivalry which exhorts each man, regardless of his age or rank, to protect the family's honor [*onore*] and to

avenge with his own life, if need be, any breach of honor. The code is actually an intergrative behavioral system which reaches outward to embrace all members of the extended family and inward into the the man's own self-image, so that he knows he must defend his honor at all costs and never allow the smallest slights or insults to go unavenged."

Barzini, Luigi. *The Italians* (New York: Atheneum, 1964): 182.

Ianni, Francis A.J., with Elizabeth Reuss-Ianni. *A Family Business: Kinship and Social Control in Organized Crime* (New York: Russell Sage Foundation, 1972): 19–20.

ordine della famiglia n. ph.: literally, "the order of the family," the family system which Richard Gambino defines as "the unwritten but all-demanding and complex system of rules governing one's relation within, and responsibilities to, his own family, and his posture toward those outside the family."

Gambino, Richard. *Blood of My Blood: The Dilemma of the Italian-Americans* (Garden City, N.Y.: Doubleday, 1974): 4.

padrino n.: godfather; literally, little father; in Mafia-speak, "sponsor" or guarantor. See *compare*.

padrone n. (pl. *padroni*): master, owner, boss. In the Sicilian context, a *padrone* (patron) is a powerful and charismatic individual who, as an *uomo di rispetto* (see entry), embodies archetypal Sicilian male behavior. In the context of the Italian American experience, the *padroni* were those middlemen—"the brokers of life, liberty, and the pursuit of happiness in the New World," in A. Bartlett Giamatti's words—who functioned as labor recruiters or agents, operating either in Italy where they sold the peasants on the idea of America or in the United States where they exploitatively employed or found work for Italian immigrants. Mostly Italians or Italian Americans, they formed the oppressive *padrone* system that exploited their countrymen who were hungry for work at all costs.

Giamatti, A. Bartlett. "Commentary." In *The Italian Americans,* ed. Allon Schoener (New York: Macmillan, 1987): 16.

paese n.: country, land, or village. In its many usages, *paese* is deployed as a territorial term that in its most expansive sense designates a country (Italy is the *bel paese*) and in its most restricted sense designates a village or locality. As Frances M. Malpezzi and William M. Clements point out: "It was with the level of *paese* that the average Italian identified most closely. For many people, 'Italy meant only their native town or province.' As a Campanian immigrant to the United States said, 'For me, as for others, Italy is the little village where I was raised.'" See *campanilismo, paesano*.

Malpezzi, Frances M. and William M. Clements. *Italian-American Folklore* (Little Rock: August House, 1992): 29.

paesano n. (pl. **paesani**; regional spelling **paisan** or **paisano**): native, local inhabitant; fellow-countryman; peasant, country person. *Paesano* has long served as the ritual word of recognition between Italian Americans as they learn that they share either a generic Italian identity or a specific regional or local identity linked to their ancestors birthplace in Italy. It has passed into general American usage as a word signifying friend or buddy, a usage underscored in Roberto Rossellini's *Paisan* (1946), a film about the American liberation of Italy during World War II in which the talismanic word was exchanged between Italians and American soldiers as a token of friendship. Within the Italian American context, it was originally employed as an expression of *campanilismo* and regionalism. The first wave of immigrants (1880–1910) tended, upon their arrival in the New World, to seek out *paesani*. As Malpezzi and Clements point out, "Consequently most Italian colonies were actually groupings of immigrants from the same region or village." They go on to cite an observation made in 1918: "In the heart of the nearest city one can find in the Italian colony a Sicilian, a Calabrian, a Neapolitan, an Abruzzian village, all within a few blocks, and each with its peculiar traditions, manner of living, and dialect." The *famiglia* and the territorialism embodied in the concepts of *campanilismo* and *paese* are the defining terms of the worldview of the Italian Americans, at least through the third generation. See *campanilismo* and *paese*.

Malpezzi, Frances and William Clements. *Italian-American Folklore* (Little Rock: August House, 1992): 29–30.

parente n. (pl. *parenti*): relative, kinsman or kinswoman. The Italian and Italian American extended family comprises all cognates (blood relatives) and affines (relatives by marriage). *Parenti* designates all persons related by blood or marriage. In southern Italian culture, *parenti* exhibit clan-consciousness and share responsiblity for the honor of the clan.

Ianni, Francis A. J., with Elizabeth Reuss-Ianni. *A Family Business: Kinship and Social Control in Organized Crime* (New York: Russell Sage Foundation, 1972): 18–19..

passatella n.: the southern Italian and Italian American game of ritual insult. Usually practiced by young men, it is roughly equivalent to what American teenagers in the 1960s used to call "ranking" and what their 1990s conterparts call "dissing."

passeggiata n: walk; the evening stroll in which all of the residents of a small town (it occurs in a modified version in larger cities) put on their best clothing to parade through the town in order to be seen and to look at others. Its main

locus is the *piazza* where Italians enact their rituals of self-display and culturally sanctioned voyeurism and often conduct their courtships as well.

pasta n.: "paste or dough made of flour and water, used dried, as in macaroni, or, fresh, as in ravioli," to cite the *American Heritage Dictionary* (1969). No Italian American cultural lexicon would be complete without a definition of *pasta,* the most hedonistic of ordinary foods and, along with *pizza,* the most universal and tangible symbol of Italianness. Unfortunately, the *American Heritage* definition does not convey the sense and sensuousness of *pasta,* that sublime staple in which the culinary codes of the peasant and the epicurean converge. It would have been more appropriate if the lexicographer had begun, "Pasta, those delicious strands or shapes of dough, that are beloved not only by Italians, but almost equally by Americans." But that is a chef's definition not a lexicographer's. What is wrong with the lexicographer's definition given above is that it imposes a distinction between dried and fresh that goes completely against the way Italians and Italian Americans have organized their universe of *pasta.* For Italians, the determinative distinction is between *pasta asciutta* ("dry" pasta) and *pasta* or *minestra in brodo* (*pasta* served in soup). *Pasta asciutta* is "dry" only in the sense that it is served comparatively dry, with a small quantity of sauce, gravy, oil, or butter. Consequently, *pasta asciutta* is an inclusive term for *spaghetti, lasagne, tagliatelle, ravioli, maccheroni,* regardless of whether these forms are factory-made or homemade. *Pasta in brodo,* on the other hand, is made in smaller shapes: Seeds, stars, rings, etc.; thin strips, *tagliatelle* or *vermicelli.* Let me reiterate: *Pasta asciutta* or "dry pasta" signifies any dish of *pasta* served with a sauce, that is, all of those dishes that the English speaker would think of as "wet"—and in this semantic *pasticcio* (mess) a good lesson in cultural differences can be found. Within this large binary opposition (dry versus wet with respect to the way pasta is served, not made), Italians impose a second opposition: *Pasta compra* (store-bought pasta, that is, factory-made pasta) and *pasta fresca* (pasta made at home for immediate use and usually made with softer flour than the factory-made macaroni).

At least three other things need to be said about pasta. First, "the widespread myth that Marco Polo introduced pasta from China into Italy is not true.," as the celebrated Florentine chef Giuliano Bugialli maintains. Bugialli's hard evidence: "The manuscript of a will, drawn up in Genoa two years before the return of Marco Polo, which leaves the heirs a chestful of dried pasta." This proof sounds like something that would appear in a novel by Umberto Eco: Anyone familiar with Latin literature knows that *pasta* was produced and consumed by the ancient Romans, especially the Romans stationed in Sicily, which was the wheat granary of the Roman Empire. Second, there is a fine poetry at work in the nam-

ing of the various types: *capelli d'angelo* (angel's hair), *lingue di passeri* (sparrows' tongues), *occhi di lupo* (wolf's eyes), *spaghetti alla chitarra* (guitar-string spaghetti, a title referring to the guitar-like wire cutter with which they are made), *strozzapreti* or *strangolapreti* (priest stranglers, supposedly derived "from some fatal episode of clerical gluttony") and so on. And this is to say nothing of the equally poetic names for the preparations themselves. Third, and here we pose a question: Why is *pasta* so quintessentially Italian? Certainly, a number of other cultures prepare it, although not with the same *fantasia* (imagination) and insistence. It is a food whose preparation brings sameness and difference into play and thus there is a kind of aesthetics of variation—predictability and surprise—at work in its infinity of forms and preparations. At the pragmatic and economic level it is typically Italian in that it involves making the most out of the least. Furthermore, it is a food that transcends class marking: It is a poor man's food that easily becomes bourgeois or patrician (when prepared with truffles or caviar). Consider the following two examples. In Michael Corrente's 1994 film *Federal Hill,* a young Italian American man—the Guido as quasi-sensitive male—who lives in the Little Italy of Providence, Rhode Island, prepares his signature dish, *spaghetti aglio e olio* (spaghetti with oil and garlic, the most makeshift of all pastas), with enough panache to seduce his woman guest, a Brown University student who inhabits a completely different world than he but who finds something more commendable than slumming in his *casalinga* (homespun) performance. In Giuseppe di Lampedusa's celebrated novel *The Leopard* (1960), the Prince hosts a dinner party for his provincial guests and vassals who are apprehensive that he may observe the French style of serving "insipid liquid" (soup) as the first course. (The scene is set in the Sicilian provinces in 1860.) To everyone's great relief, the Prince surprises his guest with the most aristocratic of macaroni preparations—*un timballo* (pasta baked in a drum-shaped pastry mold). Its description bears repeating:

> *Good manners apart, though, the appearance of those monumental dishes of macaroni was worthy of the quivers of admiration they evoked. The burnished gold of the crusts, the fragrance of sugar and cinnamon they exuded, were but preludes to the delights released from the interior when the knife broke the crust; first came a smoke laden with aromas, then chicken livers, hard-boiled eggs, sliced ham, chicken, and truffles in masses of piping-hot, glistening macaroni, to which the meat juice gave an exquisite hue of suede.*

With both examples—the proletariat *aglio e olio* and the aristocratic *timballo*—we approach the pleasure principle embodied in *pasta,* something that

the futurist and pasta-phobe F.T. Marinetti sought to refute when he issued the apocalyptic statement: "Pasta is no food for revolutionaries!" See *polenta/pasta, polentone/terrone*.

di Lampedusa, Giuseppe. *The Leopard* (New York: Pantheon, 1960): 62–63.

pazienza n: patience, forbearance, endurance. Richard Gambino has used the term to define a key aspect of the Italian American behavioral code, particularly that of the male. As an interjection, it punctuates daily conversation as *Pazienza!*, an invocation that means patience is called for in a given situation but also suggests that one must adapt oneself to the way the world works.

piazza n.: the town square. The *piazza*, along with the church, is the central architectural, social, and cultural center of Italian life. Whether in the big city or the small town, the *piazza* is the stage where all sorts of social scenarios are enacted: The late-afternoon ritual of the *passeggiata* where the strollers are at once exhibitionists and voyeurs; the improvised dramas and street-theater of everday life conceived as performance; the rite of *dolce far niente* (sweet idleness) observed by habitués who sit in an open-air café and watch the fascinating spectacle presented by the crowd. Alessandro Fontana has written a brilliant analysis of the *piazza* as the scenographic space in which Christ and Pulcinella, the two limit-symbols of the Italian imagination, preside over the sacred and profane dramas lived out in the *piazza*. The *piazza* is one of the main signifiers of Italian life and has given rise to the "piazza-envy" that has afflicted postmodernist American architectural culture in its search for viable public spaces. For example, the architect Charles Moore has constructed the Piazza d'Italia in New Orleans as a tribute to its Italian American community.

polenta/pasta n.: *polenta*, cornmeal mush, along with *risotto* (rice), is the staple in the northern Italian diet; *pasta*, on the other hand, is the staple of the southern Italian diet. These are gastronomic stereotypes based on synecdochic substitutions used to establish the North–South gastronomic boundary: Northern Italians, in fact, have long had their own varieties of *pasta;* Southerners have rice dishes, including *arancini* (Sicilian rice balls) and *supplì al telefono* (Roman rice balls called "telephone croquettes" because when you bite into them the melted cheese flows out in long tentacles like the wire which dangles about the chin when a telephone receiver is picked up). The great divide between the North and the South is often drawn up in culinary terms: The use of butter in cooking in the North versus the greater use of olive oil in the South; *pasta* in the North is made with egg and usually flat and limp (*tagliatelle, lasagne, ravioli*) versus *pasta* in the South which is primarily the stiff brittle factory-made tubular *pasta*, usually without egg (*macaroni,*

spaghetti). See Waverly Root, *The Food of Italy* (New York: Vintage, 1977) who speaks of the North–South gastronomic divide as a poverty line and to whom the above discussion is indebted. See *pasta; polentone/terrone*.

polentone/terrone n. (pl. *polentoni/terroni*): In northern Italy, southern Italians are called *terroni,* a pejorative that means, literally, "earth people" or peasants. Southerners, in turn, designate northern Italians as *polentoni,* as those who eat cornmeal mush as opposed to "real food"—the *pasta* that is the staple in the southern Italian diet. Both terms are derogatory and are expressive of the great divide—territorial, economic, cultural, psychological—between the North and the South. These terms migrated to American with the immigrants. See *Mezzogiorno; polenta/pasta*.

poste n. (pl. of *posta,* a placing or posting): burial debt, an immigrant practice to help defray the cost of a wake and funeral. The bereaved family would set up a table at the wake (originally held in the home) upon which the mourners would place monetary contributions.

prominente n. (pl. *prominenti*): a prominent person in the community, a member of the elite. Other more suggestive ways of indicating such people are *pezzo grosso* (a person of importance, a VIP) or *pezzonovanta* (literally, a ninety-piece coin).

proverbio n. (pl. **proverbi**): proverb. Both Italian and Italian American discourse are infiltrated by proverbs and aphorisms, the oral stock of inherited wisdom and equipment for living. Frances M. Malpezzi and William M. Clements explain their importance and the tactics of their use:

> Jerre Mangione's Uncle Nino believed that proverbs incoporated all the philosophy and ethics one needed to know. He told his nephew, "If you knew all the Sicilian proverbs, . . . you could act wisely in any situation that presented itself." Italian Americans, like members of other ethnic communities, have often encapsulated traditional wisdom, particularly of the practical sort, in terse, witty, often poetic sayings. The natural context for proverbs is conversation. One uses them to comment on someone else's behavior or to defend one's own action and attitudes. Because they are traditional and thus suggest that generations of experience lie behind them, proverbs may be accepted more readily than if the same idea were expressed in one's own words. When used to criticize, proverbs act as a shield since they imply that the negative comment comes not from the individual speaker but from the the whole society whose values have been expressed in the proverbs perhaps for generations.

These proverbs, as depositories of traditional wisdom, tend to embody the ideology of *la via vecchia*. In Giovanni Verga's novel *I Malavoglia* (1881), for example, the patriarch and fisherman Master Ntoni guides family life through proverbs that illustrate the law of familial cooperation and solidarity: "Men are made like the fingers of a hand: the thumb must act like a thumb, and the little finger must act like a little finger." Proverbs circulate throughout Italian American literature but their literary deployment has yet to be systematically studied.

Malpezzi, Frances and William Clements. *Italian-American Folklore* (Little Rock: August House, 1992): 52.

Pulcinella n.: one of the most prominent and influential characters of the *commedia dell'arte*, the Neapolitan buffoon (Punch, in English) usually appeared, as in the famous painting by Tiepolo *A School of Pulcinellas*, in the loose white costume of the *zanni* with a tall conical hat and black half-mask. In Neapolitan scenarios he appeared in many different guises (servant, baker, inn-keeper, merchant, even the head of a household or lover) but always as a farcical figure of misrule, silly yet witty in his dishonesty. Allardyce Nicoll has explained his appeal to the Neapolitans: "The chief quality of his speech seems to have consisted in a kind of stupid wit or witty stupidity essentially gross and vulgar, which often expressed itself by crude similes wherein the finer emotions and things of the spirit were brought down to crass earth; the Neapolitan audiences were not interested in his character; rather they delighted in listening to the gross blunderings and crude comparisons uttered in a diversity of circumstance. . . ." Pulcinella was also a central figure in the Italian puppet shows. Pulcinella traveled to America with the immigrants, and a number of comedy skits dedicated to him were in the repertories of the Circolo Filodrammatico Italo-Americano and the Compagnia Napoletana, two successful Italian American theatrical companies operating in New York City in the 1880s and 1890s.

puttana n.: whore. The ideal of the family-centered and -centering woman (the *donna seria* and *buona femmina*) is countered in the Italian American lexicon by a number of negative terms applied to women who fail to fill the sanctioned roles of good mother, wife, godmother. Although they may appear to the American ear as demonizing terms or patriarchal projections onto the "bad mother," these terms are expressions of the pragmatic ethos of the family that imposes the decorum of *serietá* on women and men alike. Richard Gambino has explained the semantics of these pejoratives:

> *In northern Italy the term* mala femmina *means a "naughty woman," one who is sexually wicked—delightfully or destructively. In southern Italy it*

also has another meaning. In the Mezzogiorno *words for such a woman are not minced. She is bluntly called a* puttana, *a whore, or, more strongly, a* puttana del diavolo, *devil's whore.* Mala femmina *means something else. It means a useless woman, a woman who cannot or does not fulfill her complicated role as the center of* la famiglia. *This woman is sometimes called a* disgraziata, *an "unfortunate one" as the dictionary renders it. As used in the* Mezzogiorno, *mala femmina and* disgraziata *are strongly condemnatory terms, the male counterpart of which is* disgraziato, *one who is vile.*

Gambino, Richard. *Blood of My Blood: The Dilemma of the Italian-Americans* (Garden City, N.Y.: Doubleday, 1974).

Risorgimento n.: resurrection, revival, resurgence; the period of or the political movement for the liberation and political unification of Italy, beginning about 1796 (historians are in disagreement over when the Risorgimento began; 1843 is usually given as the specific moment when national feeling crystalized) and lasting until 1870. In 1860 Italy was unified as a nation-state under a constitutional monarchy. Stanislao Pugliese writes in Appendix 1 (pp. 693–694) of this volume: "Ironically, social and economic conditions worsened for many of the landless peasants in the south, especially after 1870, when protectionist measures were passed to protect nascent industries in the north. A devastating pattern was set: The north becoming more prosperous, and the south becoming more destitute. These conditions would lead to the mass emigration between 1880 and 1920." Although early historians of the period often described the *Risorgimento,* with all its drama as a revolutionary moment, as the "period of poetry," and the post-*Risorgimento* period, with all its pragmatic compromises, as the "period of prose," it was left for Antonio Gramsci (1891–1937) to elaborate a critique of the *Risorgimento* as what he called a "passive revolution" (revolution-restoration: an incomplete "revolution" that, in effect, was a restoration of the original power structure accompanied only by changes in the ruling-class players), a historical process that he termed "transformism" (the process by which the political figures of the oppositional "Left" are incorporated individually into the conservative-moderate political class). See *cultura negata.*

Gramsci, Antonio. *Selections from the Prison Notebooks* (New York: International Publishers, 1971): 272–274.

rispetto n.: respect, often calculated and ritually enacted in protocols that demonstrate that the social actor understands hierarchy and the rules of the game. As with *onore,* we are speaking of the extroverted displays of a shame culture, but also of the symbolic economy of a gift culture that regards these reciprocal ex-

changes of *rispetto* as tokens or gifts through which *communitas* is maintained. Robert Orsi has explained the importance of *rispetto* for the Italian American community:

> . Rispetto *was the essential and fundamental social value of the* domus-*centered society. The men and women of Italian Harlem talked and thought about* rispetto *constantly. They insisted on it in all their dealings with people, and it was the most serious criterion they used to judge the quality of another person. All the complexity of southern Italian history, its centuries of oppression and humiliation as well as of resistance, and all the aspirations of Italian Americans, are contained in the concept of* rispetto, *which means both love and fear, intimacy and distance.*

Orsi, Robert. *The Madonna of 115th Street: Faith and Community in Italian Harlem, 1880–1950* (New Haven: Yale University Press, 1985).

scena madre n. ph.: literally the "mother scene," but roughly equivalent of what is called in English the "big scene." In this volume it is used as a figure to describe Italian American life as a "culture of scenes," that is, family life in its unfolding as heightened drama or quotidian opera.

scomunicato n. (fem. **scomunicata**): a pariah; as defined by Richard Gambino, "Anyone in any family who broke the ordine della famiglia or otherwise violated the onore of the family."

scugnizzo (pl. *scugnizzi*): Neapolitan street urchins. In *The Broken Fountain* (1979), Thomas Belmonte has given the most penetrating analysis of the world of the *scugnizzi* and the brutalizing urban poverty that has produced them and their particular arts of deception and trickery, what Belmonte calls the Neapolitan picaresque.

Belmonte, Thomas. *The Broken Fountain* (New York: Columbia University Press, 1979): 132.

serietà n.: seriousness; the archetypal value of *contadino* and first- and second-generation Italian American culture. Being a "serious person" was always a function of *la famiglia* and was exhibited by the fidelity and commitment with which one assumed a familial persona.

signori n. (pl of *signore*): gentlemen or gentry. In the worldview of the southern Italian peasantry, the "people" regarded the *signori* as enemies, an attitude that, according to Antonio Gramsci, reflected the old dislike of country for town, class discrepancy as manifested in dress, and hatred for the civil servant. Gramsci wrote: "This 'generic' hatred is still 'semi-feudal' rather than modern in character, and

cannot be taken as evidence of class consciousness—merely as the first glimmer of such consciousness, in other words, merely as the basic, negative attitude." Thomas Belmonte illustrates its pervasiveness as a psychic structure: "In the local urban strucure [of Naples], the poor viewed themselves in diminutive terms, as 'the little people,' or *popolino. I grandi signori* was the phrase they applied to all those who were elsewhere in the urban structure."

Gramsci, Antonio. *Selections from the Prison Notebooks* (New York: International Publishers, 1971): 272–273.

simpatico/antipatico (fem. *simpatica/antipatica*) adj.: nice, congenial, likeable, affable. Being (and being perceived by others as being) *simpatico* is one of the characteristics of the model Italian personality which is Other-directed and Other-pleasing. Whether such an ideal of the extroverted self involves the softening or weakening of the personality is problematic; Luigi Barzini speaks of the art of being obliging. Italians and Italian Americans cultivate the non-confrontational self as a means of maintaining humanized and humanizing relationships with others. The immediately grasped (and imposed) distinction of whether someone is *simpatico* or *antipatico* is one of the great dividing lines in Italian and Italian American social life. Indeed, *simpatico/antipatico* are blips on one's social radar. Within Italian American context, the singers Perry Como and Tony Bennett embody the ideal of the *simpatico* whereas Frank Sinatra, at least at times, is *antipatico* (this comment is *antipatico* as well).

sistemare/sistemazione v.; n.: two terms that cannot be exactly translated: *sistemare,* according to the dictionary, means "to arrange, regulate, settle"; and *sistemazione,* inevitably enough, "regularization, arrangement, settlement." With this term, we once again are dealing with the pragmatic side of the Italian and Italian American character. In explaining how *una sistemazione* is "the dream of most Italians," Luigi Barzini runs through a gamut of examples ranging from mothers who want to *sistemare* their daughters with good steady husbands to industrialists who want to *sistemare* competition by establishing strong cartels and iron-bound agreements. As an inclusive term for worldly tactics, *sistemare* means to put things in order, to find a settlement. A comparable term is *arrangiarsi* which means to improvise; to get out of a fix as best one can; to fend for oneself. Its implications are well rendered by William Ward's definition, "to set oneself up nicely—the implication is, 'despite unfavourable circumstances.'" The phrase *l'arte dell'arrangiarsi* has come to epitomize the Italian art of management skills, of making shift, of doing the best one can (by hook or crook). Both *sistemare* and *l'arte dell'arrangiarsi,* then, are typical expressions of the Italian art of making the most out of the least.

Ward, William. *Getting it Right in Italy: A Manual for the 1990s* (London: Bloomsbury, 1990): 172.

spettacolo n.: a spectacle. Luigi Barzini has emphasized the importance of spectacle in Italian life. The Italians have transformed their life-world into a work of art, a great theatrical spectacle addressed to the eye and the other senses. This total aestheticization of life extends to everyday practices which unfold as dramatic performances. This eye-intensive culture of scenes and of the theatricalized individual are also characteristic of Italian American life.

Barzini, Luigi. *The Italians* (New York: Atheneum, 1964): 58–73.

sprezzatura n.: nonchalance, studied carelessness. The term was first defined by the Renaissance courtier Baldassare Castiglione in *The Book of the Courtier* (1528), and thus it designates an aristocratic ideal of behavior. As such, it signifies perfect manners combined with ease and naturalness of bearing indicative of the courtier's disdain (the word derives from *sprezzare,* to disdain) or lack of anxiety to prove his good breeding. In contemporary usage, it designates ease of manner, the ability to do the right thing at the right time, to dress well, etc., without apparent effort: studied carelessness. Derived from the aristocratic and highly-coded milieu of the Renaissance court, this behavioral term can be seen to prefigure *la bella figura,* the concept that governs the everyday presentation of the Italian self. It should be pointed out, however, that *sprezzatura* is a more complicated concept because it involves the art of concealing artfulness and thus leads us into the culture of masks. Although "grace under fire" and "cool" cover some of its semantic resonances, it includes an ironic dimension that these terms lack. Within the spectrum of Italian behaviorial codes, it is the antithesis to *divismo* and other instances of self-display: It is the Italian equivalent of understatement.

storia n.: a term that signifies history as well as story. Jerre Mangione and Ben Morreale have appropriately used it as the title of their comprehensive history-story of Italian America, *La Storia: Five Centuries of the Italian American Experience* (New York: HarperCollins, 1992).

straniero n.: (pl. stranieri) stranger. See *amico/straniero.*

tarantella n.: a lively, whirling Italian folk dance that when danced by couples is characterized by light, quick steps and flirtation between the partners; although its provenance is the Mezzogiorno, it has become the Italian national dance. (See chapter 19 for a detailed definition and an account of its importance in Italian American life.)

teatro dei pupi n. ph.: the Sicilian puppet theater, one of the few surviving

forms of folk puppetry and an important form of entertainment for the immigrants. The puppets are large (up to two-thirds lifesize and heavy) and controlled by a strong iron head rod operated from above stage. Dressed in armor, the puppets represent paladins of the court of Chalemagne and other medieval heroes in conflict with the Saracens. This medieval matter is linked to Sicily's feudal past, and it also provides the principal theme of the decorations on the *carretto siciliano* (the Sicilian cart). The Sicilian puppet theater appears in both *Godfather Part II* (1974) and *Godfather Part III* (1990), and the tradition has been kept alive in America by the Manteo family, whose puppet troupe, Papa Manteo's Life-Sized Marionettes, has been operating since 1919. In addition to the Sicilian puppet theater, a number of other Italian marionette theaters operated in New York City's Little Italy during the late-nineteenth century, including the popular Il Teatro delle Marionette, located at 9 Spring Street, and another one on Mulberry Street that gave performances in the Neapolitan dialect. It should be stressed that the marionette and puppet theaters were imported from Italy and, like opera, were Italian cultural texts that traveled to America. They are to be distinguished from the *macchietta coloniale*, an Italian American construction.

terrone n. (pl. terroni): see *polentone/terrone*.

uomo d'onore n. ph.: a man of honor; the traditional Sicilian ideal of the strong, powerful male who embodies the code honor. According to Henner Hess, "The *uomo d'onore* must not bow to anybody . . . , he must not fear anybody, he must on no account passively accept an affront." The term is synonymous with: *uomo di rispetto, uomo di pancia* (literally, a man of the belly, someone who knows how to keep things to himself), *persona di petto* (literally, a person of heart, bravehearted).

Hess, Henner. *Mafia and Mafiosi: The Structure of Power* (Lexington, Mass.: D.C. Heath, 1973): 65.

uomo di pazienza n. ph: literally, a man of patience, that is, a man who embodies—in the public and private spheres—those masculine qualities sanctioned by the southern Italian ethos. The strategy followed by Richard Gambino in defining the characteristics of the *uomo di pazienza* is instructive. He begins by deconstructing the most flagrant stereotypes that have been projected onto the Italian American male from the outside—from Latin Lover (Marcello Mastroianni) to Machiavellian to "wop" (see entry). He then proceeds to examine certain distortions and displacements of the traditional ideal of manliness that have occurred within Italian culture itself: for example, the concept of *omertà* (the very root of which is *omu*, Sicilian for man), which has been excised over time from its origi-

nal subcultural context where it functioned as a code of masculine, not criminal, silence; or the idea of machismo which is a violation of the masculine ethos. Gambino, then, explains that *pazienza* "includes a man's cultivation and control of his own capacities and special skills—self-reliance and self-control. Hard work and self-denial are also essential component of the ideal, as are firmness of spirit, determination, and the seriousness and probity characteristic of maturity. The ideal of *pazienza* is an ideal of control of life. First and foremost, it is an ideal of inner control, of reserve."

Gambino, Richard. *Blood of My Blood: The Dilemma of the Italian-Americans* (Garden City, N.Y.: Doubleday, 1974): 128–159.

uomo di rispetto (or **uomo rispettato**) n. ph.: a respect-worthy man; in the Sicilian and Italian American subculture, both a respectable citizen and a man who commands respect, that is, a man who exacts respect by a glance, a gesture, or a word; in Mafia-speak, a *Mafioso*. The journalist Gay Talese has described Frank Sinatra's persona as modeled, in part, on the figure of the *padrone*, one of those *uomini rispettati* who are "both majestic and humble, men who are loved by all and are very generous by nature, men whose hands are kissed as they walk from village to village, men who would *personally* go out of their way to redress a wrong." The term is synonymous with *uomo d'onore, uomo di pancia* (literally a man of the belly, someone who knows how to keep things to himself), *persona di petto* (literally a person of heart, brave-hearted). See *rispetto*.

Talese, Gay. 'Frank Sinatra Has a Cold," *Esquire* (April 1966); reprinted in *Fame and Obscurity* (New York: Dell, 1981).

vergogna n.: shame; often used in the anathematizing expression, *Che vergogna!* (What a shame! What a disgrace!). As Robert Orsi explains: "The verdict of *vergogna* (shame) was pronounced by the community when the canons of *rispetto* had been violated. The denunciation of a person or action as shameful was one of the ways the community policed it borders."

Orsi, Robert. *The Madonna of 115th Street: Faith and Community in Italian Harlem, 1880–1950* (New Haven: Yale University Press, 1985): 95.

verismo n.: realism, closeness to truth and reality; the Italian realist or naturalist movement in literature in the late-nineteenth and early-twentieth centuries as exemplified in the Sicilian writer Giovanni Verga's 1881 masterpiece *I Malavoglia* (the surname of the family of fisherman who are the protagonists of the novel; translated into English as *The House by the Medlar Tree*). *Verismo* was carried over to opera where it designates those realistic dramas composed from

1890 to 1910 that treated the violence and passion of contemporary lower-class life. Mascagni's *Cavalleria rusticana* (based on Verga's short story by the same name), Leoncavallo's *I pagliacci* and *Zaza,* Cilea's *Adriana Lecouvreur,* and Puccini'a *La fanciulla del West* are typical *verismo* operas. It is important to stress that the primary Italian cultural text is "realistic." The Italian genealogy of realists unfolds from Dante and the painter Giotto through Boccaccio and Machiavelli, who together straddle the Renaissance, through the Baroque realism of Caravaggio, to the nineteenth-century novelist Manzoni and the Roman dialect poet, Belli. From this perspective, *verismo*—however influenced by French naturalism—is a culmination of an abiding cultural concern with mimesis, one that will find its fullest twentieth-century expression in cinematic neo-realism (1943–1952). In this light, realism as a cultural dominant can be employed to describe a good part of Italian American cultural production from di Donato's *Christ in Concrete* to Scorsese's mean streets cinema. As a more general attitude or cultural orientation, realism can also be used to describe the tactical side of the Italian and Italian American character. The historian John Symonds, in his *Renaissance in Italy* (1881), underscored the "realistic bias which inclined [Italians] to things tangible, palpable, and concrete, compassable by the senses. . . . Realism, preferring the tangible and concrete to the visionary and abstract, the defined to the indefinite, the sensuous to the ideal, determines the character of their genius in all its manifestations." Following Symonds, Luigi Barzini dedicated a chapter in *The Italians* to the Italian predilection for the concrete which he titled "Realism and Guicciardini." Such generalizing formulas, of course, lead us into the realm of (im)pertinent stereotypes but, at least with respect to literary and artistic textuality, realism holds as the aesthetic dominant within Italian culture.

via vecchia/via nuova n. ph.: the old, or traditional, way and the new, or modern, way. In the Italian American experience, these terms frame the conflict between the mindsets of the Old World and the New World, the first generation and the second, the traditional *famiglia* and the assimilating and assimilated family. Insofar as they focus intergenerational conflict, they cover the same semantic ground as do the Japanese words, *Issei* (first generation) and *Nisei* (second generation). Stressing the persistence of *la via vecchia,* Richard Gambino writes: "Among those raised in it, and this to various degrees includes all Italian-Americans, it is impossible to be untouched, if not determined, by *la via vecchia*. An understanding of this pattern life is crucial to any understanding of Italian-Americans of any generation, the most 'assimilated' third- and fourth-generation young people as well as wizened old immigrants. *La via vecchia,* cultivated for centuries,

does not die quickly and certainly not easily." Its cautionary attitude is reflected in the Sicilian proverb: *Chi lascia la via vecchia vecchia per la nuova, sa quel perde e non sa quel che trova* (Whoever forsakes the old way for the new knows what he is losing but not what he will find). As a way of describing the attitude of third- and fourth-generation Italian American families, three mindsets might be seen as manifest in the 1990s: Acculturated families that maintain a modernized version of *la via vecchia* and cultivate an Italian American persona; assimilated families that have completely Americanized themselves and liberated themselves from *la via vecchia,* perhaps preserving the traces of Italianness through foodways; and conflicted families that identify themselves with the Italian American cultural identity but are at odds with the regime of *la famiglia* and the strictures of *la via vecchia,* thereby enacting family life as a psychodrama, one that repeats a modified version of the second-generation conflict.

Gambino, Richard. *Blood of My Blood: The Dilemma of the Italian-Americans* (Garden City, N.Y.: Doubleday, 1974).

wop n.: an offensive American term used derogatorily to designate an Italian or Italian American. Two etymologies are attributed to it: (1) from the anagram derived from *without papers,* referring to those immigrants who arrived in America without proper identification; (2) from the Neapolitan *guappo* (pronounced *guapp'*) designating a swaggering street dandy, a permanent fixture in the world of Neapolitan subculture (*guappo* is derived from the Spanish *guapo,* handsome). As Barlett Giamatti explains, "The prevalence of the [*guappo*] and his visibility in America as a neighborhood cult figure in the Little Italys of American cities, meant the flashy, assertive, dandified *guapp'* became the stereotypical 'wop.'" A less picturesque account was given by an American writer in 1912: "There is a society of criminal young men in New York City, who are almost the exact counterpart of the Apaches in Paris. They are known by the euphonius name of 'Waps' [sic] or 'Jacks.' These are young Italian Americans who allow themselves to be supported by one or two women, almost never of their own race . . . They form one variety of the many gangs that infest the city." Here we get at the heart of the features that inform the definitive stigmatizing stereotype of the Italian American social identity: criminality, aggressively masculine self-display, pack behavior, and dangerous sexuality. The other two most commonly used stigmatizing terms, *guinea* and *dago* (often intensified as *black guinea* or *black dago*), target the swarthiness of the skin and the darkness of the hair and eyes, those physical features of the Mediterranean body taken as signifiers of a dark and ambiguous moral status. *Guinea,* at least putatively, derives either from a proper name such as Gianni or Giovanni or, more indica-

tive, from the proper name of the African country from which slaves were exported (perhaps a projection onto Italians of the outdated term "Guinea Negro" meaning "black slave from Guinea"). There is also an apocryphal version of the derivation that maintains that Italian immigrants arrived in America bearing all their wealth in one gold coin, the guinea. *Dago* derives from the Spanish proper name Diego and originally applied to Spaniards and Portuguese as well as Italians, but a narrowing to "Italian" occurred in the early twentieth century. In sum, all three stigmatizing terms designate the Italian as the dark Other in physical and moral terms. The other discrediting terms derive from physical traits, metonymic associations, especially involving food, or generic foreignness: *greaser, greaseball, spaghetti-bender, meat ball, chestnut-stabber, guinzo* (a conspicuously foreign person), *guinzola, jibboney, pineapple* (a somewhat rare usage for an un-Americanized Italian), *zool*. Some of the above are derived from criminal slang as are the phrases: *guinea football* (a crudely made bomb, especially a timebomb), and *guinea wrench* (a baseball bat used in a fight). Richard Gambino has maintained that the initial stereotyping of Italian Americans as an inferior people has evolved into two master negative (either/or) stereotypes: "spaghetti-twirling, opera-bellowing buffoons in undershirts" or "swarthy, sinister hoods in garish suits, shirts, and ties."

John Fante, in his short story "The Odyssey of a Wop" (1940), has given an insightful description of the negative power of the term. He narrates the story of a second-generation son caught in a linguistic double-bind imposed by his mother and father:

> *From the beginning, I hear my mother use the words Wop and Dago with such vigor as to denote violent distaste. She spits them out. They leap from her lips. To her, they contain the essence of poverty, squalor, filth. If I don't wash my teeth, or hang up my cap, my mother says: "Don't be like that. Don't be a Wop." Thus, as I begin to acquire her values, Wop and Dago to me become synonymous with things evil. But she's consistent. My father isn't. He's loose with his tongue. His moods create his judgments. I at once notice that to him Wop and Dago are without any distinct meaning, though if one not an Italian slaps them onto him, he's instantly insulted. Cristopher Columbus was the greatest Wop who ever lived, says my father. So is Caruso. So is this fellow and that. But his very good friend Peter Ladonna is not only a dirty pig, but a Wop on top of it; and of course all his brothers-in-law are good-for-nothing Wops.*

Giamatti, A. Bartlett. "Commentary." In *The Italian Americans,* ed. Allon Schoener (New York: Macmillan, 1987): 20.

APPENDIX II

A Note on Italian Americanisms

A great number of standard Italian words and phrases, including a good part of the musical and fine arts lexicons, have a long record of use in English since the Renaissance. As Latin declined as the common language of European intellectual life, Renaissance "Italian" (an Italian that was a literary-humanistic language and not yet a national language) came to serve as one of the canonical languages of modern European culture, experiencing a currency it lacked in Italy whose linguistic identity was fragmented into myriad dialects. Since its codification by Dante as the *volgare illustre* (the illustrious vernacular), "Italian" has been a cosmopolitan language, a language made for export. Throughout the Renaissance and its aftermath, the Tuscanized written Italian of intellectuals and literati traveled throughout Europe in a number of highly codified forms: The aulic and oneiric idiom of the lyric poetry of Petrarch who provided Europe with one of its primary forms of poetic expression, the sonnet; the aristocratic Italian of the courts that was disseminated by Castiglione's *Book of the Courtier* (1528) and the various *galatei* or books of etiquette; the technical Italian of musical forms and notation and of the lexicons of the other arts; the exorbitant and conceited Italian of the opera libretto—as artificial as the *castrati* who were responsible for imposing the hegemony of Italian opera on Europe in the eighteenth century—and so on. It was only through the *commedia dell'arte* that the dialectic was made to travel outside Italy.

The schism between the one Italian (the cosmopolitan and elite literary language) and the many Italians of the dialects (the everyday oral languages of local and regional subcultures) has been the dominant feature of the Italian linguistic identity. At the time of Unification in 1861, according to Pier Paolo Pasolini, "approximately 90 percent of Italians were illiterate; that is, not only did they not know how to write Italian, but they were not even Italophonic." Only after the post–World War II period when the age of the mass media set in did a standardized Italian become the norm for the majority of Italian speakers. This schism is reflected in the way Italian has traveled to America. The one Italian (the literary-humanistic language) was imported by the academy and the apparatus of high culture; the many Italians arrrived through the steerage of the immigrant experience.

Since the purpose of this note is to catalogue the lexical contributions of Italian Americans to American English, I shall be not be directly concerned with the adventures of standard Italian and the dialects in the United States. It is important to point out, however, that the immigrants were primarily dialect speak-

ers, although some were bilingual in standard Italian and the dialect. In keeping with *campanilismo*, these dialectic speakers often settled with their *compaesani*, forming little micro-communities of dialectic speakers. On the other hand, some cities or regions constituted themselves as macro-speech communities: San Francisco was dominated by northern dialects; South Philadelphia by southern dialects; New York City was a great babel. Often, different dialectic speakers could not understand each other so they resorted to standard Italian or what has been called a koine through which they communicated.

As Robert McCrum, William Cran, and Robert MacNeil maintain in *The Story of English*, the impact of the Great Immigration (1880–1920) on the lexicon of American English was limited to food words like *pizza, spaghetti, lasagne, espresso, cannelloni, minestrone, parmesan, pasta, tortellini, macaroni, ravioli, broccoli,* and *zucchini.* This confined and highly pragmatic contribution is attributed by the three coauthors to the socioeconomic status of the Italian immigrants: "Unlike the Germans, the less-educated Italians made a more complete adoption of American English." While this observation is valid, it also underestimates the importance of food as a cultural language (one whose taxonomy is as elaborate as any other semiotic system) and the particular significance of food within Italian family life. Food was their primary way of Italianizing America. The coauthors also point out that the other "Italian import whose vocabulary had an influence on the language out of all proportion to its significance in the American-Italian community" was the *Mafia* which contributed its own set of code words: *godfather, the family, capo,* and so on. Furthermore, the media, especially the Hollywood gangster movie, disseminated criminal slang through the "mouthpiece" of the gangster stereotype, ensuring that American English criminal jargon was spoken with an Italian accent. All of this has been grist for the mill of the stereotyping process at work in the American common culture at large. That process has minted and constantly reiterated the stigmatizing image of the inarticulate Italian American, English breaking and broken by English—a permanent exile from language.

If elitist and bourgeois linguistic assumptions are set aside, the dialectic can be seen as a powerful linguistic form of expression that comes from below and from the margins of the world demarcated by official language, always enriching the canonical language by violating and subverting its proprieties. It can be argued that the early history of the Italian American linguistic experience was a continuation of the oral speech of the dialectic tradition—a translation of the dialect experience and worldview into the terms of American English. From this perspective, the Italian American resistance to English as imposed institutionally can be seen, in class terms, as one more residue of *la cultura negata*. Furthermore,

the first generations of Italian Americans—at least those confined to the Little Italys—operated in the language of the "oral sign" (Pasolini) and thus the American English they appropriated and constructed was a "street language," an authentic Italian American dialect. (Here I am speaking of the post-immigrant, post-Italglish experience.) This "street language"—blue-collar, urban, an amalgam of Italian and American subcultural jargons and ghetto-speak—is something more than the prisonhouse of subcultural language to which the common culture has confined Italian Americans in their media representations of lumpen Italians. It is an expression of the urban blue-collar experience Italian Americans have brooked in their "making America" (to use an old Italian Americanism), and it has found positive expression in what might be called the "mean streets" tradition of Italian American dramatic and cinematic art as it extends from Michael Gazzo's 1956 play *A Hatful of Rain* to Martin Scorsese's films which, in effect, have established a cinematic genre in which a number of American and Italian American (Abel Ferrara and Quentin Tarantino) filmmakers work. In other words the Italian American subcultural language has been, in part, the medium through which such artists have entered the common culture. The pressing question of exiting once and for all from the linguistic *Lazaronitum* of Little Italy has been the central concern of third- and fourth-generation writers and intellectuals who have collectively posed the question of what it means to write as an Italian American, a question no longer identical to that of speaking as an Italian American.

At the lexical level and in addition to the food words mentioned above, a small group of Italian Americanisms, usually in dialect form, have passed into American usage since 1860, often being absorbed into urban slang like a number of analogous Yiddish American and African American expressions. On the other hand, since the 1960s, American English has imported a vast array of loan words from Italian which are, in great part, signifiers of Italian style. This linguistic borrowing of style-markers has been fueled by the incursion of Italian brand names into the American marketplace—a phenomenon that Italians themselves call *firmato* (signed, meaning the triumph of designer chic). These developments have greatly altered the linguistic image of Italian which is regarded as a language of stylishness to be imitated and appropriated by the American bourgeoisie. To give two examples: Starbucks Coffee Company has imported the entire "language of espresso" making its American consumers into "speakers" of coffee Italian; in *Breaking Away,* a 1979 film directed by Peter Yates, a college-aged townie in Bloomington, Indiana, adopts an Italian linguistic persona as part of his attempt to break away from his white-bread, middle-American existence, even wooing a college girl in his Italian persona. As a result of the success of Italian, a schism in the linguistic

image of the language has developed in the American common culture: The Italian spoken in Italy and ripe with loan words for appropriation (words "made in Italy," vogue words borrowed from a vogue culture) is placed on one side; while the other Italian—those Italian American words from the Lazaronitum (words made in Little Italy; the remnants of the verbal baggage the immigrants brought with them plus the entries in "John Gotti's Dictionary," the subliterate jargon of "Mafia-speak")—are placed on the other side. This schism is part of the larger cultural divide that characterizes the contemporary Italian American condition. While it is true that a good part of the Italian American lexicon derives from *contadino* culture and its various dialects, it is also true that Italian America has continuously been bicultural, if not strictly bilingual in the sense of sharing the standard Italian. It is important to stress that Italian Americans share a common cultural language with Italians, however that language may have been rerouted through dialects. While some sectors of Italian America maintain an archaic or bastardized Italian (in some cases, still fixed in the immigrant epoch), the Italian spoken in America has been constantly reinforced by new waves of immigration and enriched by contact with contemporary Italy.

The Italian American encounter with and impact upon American English can be seen to fall into three stages. The first was the immigrant experience (1880–1930) which produced the immigrant's idiom now called Italglish. As described by Michael La Sorte in *La Merica: Images of Italian Greenhorn Experience* (1985), Italglish is "basically Italian in structure and sound with an admixture of English loan words that were brought into vocal harmony with the speaker's own habits of pronunciation." The immigrant's idiom was a highly instrumentalized and deformed version of English suited for everyday transactions, a broken English that would establish the ongoing stereotype of Italian Americans as estranged from language. LaSorte, on the other hand, has underscored the creativity of Italglish as an insider's language rich in bilingual puns and as an expressive and often humorous means for brooking the American experience: For example, the number of pejorative puns wrung on *American: Americane* ("American dog") and its Pittsburgh variant *merigan* (a pun on the Abruzzese word *merdacane* or dog excrement) which, according to Frances M. Malpezzi and William M. Clements, refers "to someone who is unimaginative and lacking in feeling." Another example cited by LaSorte is the humorous translation of Hopalong Cassidy into Hopalong Chesadisci (from *che cosa dici* [watta ya say]). Some of these coinages would pass into American English such as the Italian American name for Babe Ruth, known to the immigrant as *Il Bambino* or *Bigga Bambino*. Others would remain confined to the localities that spawned them. For example, *Andare a Flabussce* (to go to Flatbush)—

Brooklynese for dying, from the cemetery located in Flatbush. According to H.L. Mencken, the basic stock of loan words generated by the immigrant experience includes *spaghetti, chianti* (vulgarized as *dago-red*), *ravioli, minestone, Mafia,* and *black-hand* (*mano nera*).

The second period is that of the post-immigrant linguistic experience (1930–1960). As Frances Malpezzi and William Clements have pointed out, Italians who have immigrated to New York City since the late 1940s have had a range of language choices: The regional dialect, official Italian, Italglish, and English. On the other hand, second- and third-generation Italian Americans became progressivly distanced from the Italian linguistic identity as part of the process of assimilation—and some consciously suppressed it. Assimilation, however, also involved a process of selection by which the lexicon of the most crucial Italian American terms would be preserved. Richard Gambino, in 1975, codified many of these terms in *Blood of My Blood: The Dilemma of the Italian-Americans*. A number of these words did enter common American usage: For example, *paesano, compadre* (in the dialect form, *gombah*), *comadre* (*gommah*), *cafone* (*gavone*), *guaglione,* and such pejoratives as *stuonato* (bewildered, "out of it"), *cetriolo* (literally, cucumber; blockhead; dolt), and *scimunito* (adj. foolish; n. blockhead), the latter two words roughly covering the semantic range between *schlemiel* and *schmo*. By the way, none of the above translations of these pejoratives convey their semantic charge for Italian American speakers.

The third period (1960–1995) is a moment of strong ethnicity in which third- and fourth-generation Italian Americans have explored their roots and re-appropriated their linguistic identities. The period is marked by two signal events in the mass media that have altered the image of Italian and Italian speakers. The first was the publication of Luigi Barzini's bestselling *The Italians* in 1964. As part of his anatomization of the Italian national character, Barzini made the Italian cultural lexicon—cosmopolitan as well as subcultural—available to the American public for the first time. Linked to the emergence of Italy in the 1960s as a mecca of mass tourism, what Barzini called the "peaceful invasion," the book often assumed the position of the tourist who was fascinated by the spectacle of Italian life—everyday life staged as theater. (Barzini's candid look at Italian behavior caused shock waves in some sectors of the Italian American community who reacted negatively to the "realism" of the Italian way). Furthermore, the image of contemporary Italy, an Italy in the grips of the "economic miracle" and the embodiment of the society of the spectacle, traveled to the United States in the 1960s through the subtitled films of Fellini, Antonioni, Visconti, and Pasolini which presented a stratified linguistic portrait of contemporary Italy. This would set the stage for the

importation of a series of Italian words and phrases derived from "official" cultures, primarily those of cuisine and design, through which Italian culture traveled to America in the 1970s and 1980s. Perhaps the most important sociolinguistic phenomenon of this period has been, in fact, the wholesale appropriation of Italian cuisine, which has in many respects become the dominant American cuisine. Just as *pasta* had previously replaced *spaghetti* and *macaroni*, *pasta* has now come to mean for many American English speakers an infinite variety of particular shapes: *orecchiette, agnolotti, farfalle,* and so on. Similarly, garlic bread has been displaced by *bruschetta* and *crostini; pane* has been extended to include *foccaccia*. The particular Italian obsession with vegetables has been carried over in such commonly used items as *rucola* (*arugula*), *rape, funghi porcini, portobello* mushrooms, long familiar to Italian Americans.

The second event was the linguistic bomb dropped by Francis Ford Coppola in *The Godfather I* (1972) and *The Godfather II* (1974). Although Coppola worked within the genre of the gangster film, both movies were important exercices in ethnic cinema. Using dialogue in Sicilian, standard Italian, and the Italian American idiom, the films presented the voice-world and sound-world of the Italian American subculture for the first time. The film introduced a whole repertory of terms, proverbs, and technical words that were adopted by the common culture—whether for the purposes of parody or for their expressiveness. This has lead to a massive folklorization of Italian American culture in the media, one that has extracted expressions from the folkloristic conception of the world originally embodied in *contadino* and immigrant culture and rendered them into picturesque formulas in a mass-mediated ethnic folklore that strips them of their semantic valencies.

This period has witnessed a new search for roots, and many third- and fourth generation Italian Americans have come to study standard Italian at American universities or abroad. The notion of a bilingual and bicultural identity has become an ideal, at least, for middle- and upper-class Italian Americans. This appropriation of what Alberto Innaurato in his play *Gemini* has called "Harvard Italian" has produced a rich hybridization, for the indelible primal words of the initial Italian American experience, most of them from the dialect, remain lodged within the archaeological level of the Italian American self. A marvelous example of this is Camille Paglia's reading of Shakespeare's *Anthony and Cleopatra* in *Sexual Personae: Art and Decadence from Nefertiti to Emily Dickinson* (1990). Paglia interprets Cleopatra's "rabid speeches" through the grid of Mediterranean primordial speech:

> A savage vehemence of speech is common among southern peoples, due to the nearness of agriculture and the survival of pagan intensity. Those who live on

and by the land recognize nature's terrible amorality. Cleopatra's sadistic images are normal in Italian terms. My immigrant relatives used to say, "May you be killed!" or "May you be eaten by a cat!" Common Italian American expressions, according to my father, took the form "che te possono" (May such and such be done to you). For example, "May you eyes be torn out," "May they squeeze your testicles," "May they sew up your anus." The similarity to Cleopatra's rhetorical style is obvious.

Further Reading

La Sorte, Michael. *La Merica: Images of Italian Greenhorn Experience* (Philadelphia: Temple University Press, 1985).

Malpezzi, Frances and William Clements. *Italian-American Folklore* (Little Rock: August House Publishers, Inc., 1992).

Pasolini, Pier Paolo. *Heretical Empiricism,* ed. Louise K. Barnett, trans. Ben Lawton and Loise K. Barnett (Bloomington: University of Indiana Press, 1988).

Index

Italian terms that are defined in the Cultural Lexicon are marked by asterisk. The page numbers on which they are found in the Cultural Lexicon are indicated by boldface numerals.

A

Abel, Elizabeth, 323, 324, 325
Abelson, Anne, 251
Acconci, Vito, 481, 530, 532, 533–536, 589
 works of:
 AdjustableWall Bra, 535–536
 Following Piece, 534
 House of Cars, 535
 Instant House, 535
 Project for Pier, 17, 534
 Seedbed, 534–535
*acida (or agida), 668, **703–704**
Africano, Nicholas, 530
Agostini, Peter, 537
Aiello, Danny, 362, 612, 633, 634, 669
Albanesi, Licia, 400
Albertieri, Luigi, 470
Alda, Alan, 564, 601, 608
Alda, Robert, 597–598
Aleandri, Emelise, xxxviii, 224, 358, 362, 379
Aleramo, Sibilla, 230–231
 Una donna, 230–231
Alessandrini, Gerald, 378
*al fresco, 520, 576, 670, **704–705**
*all'americana, 578, **705–706**
Allen, Woody, 52, 668
*all'italiana, **705–706**
Allyn, David (David DiLello), 434
Altieri, Charles, 529–530
Amato Opera Company, 402
Ambrogio, Giovanni, 470

Ameche, Don, 362, 594, 597
American Academy in Rome, 501, 541, 542
*americanata, 584, **706**
American Dream, 168, 169, 174, 219, 445,
 564, 569, 582, 586, 619, 621, 629,
 630, 631, 639, 644, 647, 648, 649,
 652, 677, 679, 682
 "making America," 174
amici di capello, 176–177, 706
*amicizia, 577, **706**
*amico/straniero, 176, 177, **706–707**
Aniante, Antonio, 509
*antipasto, 4, 98, **707**
Antonacci, Greg, 367
Antonioni, Michelangelo, 566, 586
Arden, Tony (Antoinette Ardizzone), 418, 434
Ardizzone, Tony, 186, 187
 Heart of the Order, 186
 In the Name of the Father, 5186
Argento, Dario, 661
Argento, Dominick, 414, 417
*Arlecchino, 441, **707**
Ariosto, Ludovico, 136, 138
Armetta, Henry, 362, 479, 599, 620, 621
Armi, Anna Maria (Anna Maria Ascoli), 270
Aronowitz, Stanley, xxx–xxxi
Arpino, Gerald (Gennaro Pietro Arpino), 471,
 472–476
Arrighi, Mel, 369–370
Arte Povera, 503, 506
Assante, Armand, 362, 601

Attanasio, Paul, 645
autobiographical writing, Italian American, 289–321
 and immigrant experience, 292. *See also* Cassettari, Rosa
 practitioners of:
 Barolini, Helen, 303–307
 di Prima, Diane, 307–310
 Lentricchia, Frank, 313–316
 Mangione, Jerre, 293–300
 Marzani, Carl, 300–302
 Talese, Gay, 311–313
Avalon, Frankie (Francis Thomas Avallone), 418, 437, 440
Avery, Roger, 593

B

Baby, It's You (D: John Sayles), 240–241, 611, 628–629
*bacio le mani!, 576, **707**
Badalucca, Michael, 362
Bair, Deidre, 229
Bakhtin, Mikhail, 543
Balanchine, George, 412, 464, 471, 477
Baldessari, John, 530
Balducci, Carolyn, 230
Balla, Giacomo, 506
ballad operas, 392
Ballard, Kaye (Catherine Gloria Ballotta), 437
balletto, 466
Balliett, Whitney, 449, 452, 455
Bancroft, Anne (Anna Maria Italiano), 362, 594, 598, 601
Banky, Wilma, 599
Banfield, Edward C., xxxiii, 10, 13, 69, 72,
Bara, Theda, 598
Barber, Samuel, 410
Barolini, Helen, xxxv–xxxvi, xliii–xliv, 62–63, 71, 166, 179–180, 185, 186, 302, 303–307, 370, 673
 Dream Book: An Anthology of Writings by Italian American Women, xxxv, 161, 193, 195, 222, 223, 233, 290–291, 303, 304, 305, 306, 345, 673
 Festa: Recipes and Recollections, 303, 306–307
 Love in the Middle Ages, 240
 Umbertina, 71, 128–129, 156, 161, 179–180, 198, 211, 243, 251, 256, 305, 325, 345, 681

Barolini, Teodolinda, 198
Barrile, Anthony, 674
Barthes, Roland, 426, 569–570, 580
Barzini, Luigi, 379
 The Italians, xviii, 353, 604, 667
Basile, Giambattista, 138–139
Bastianini, Ettore, 397
Battle of Algiers (D: Gilo Pontecorvo), 611
Baudrillard, Jean, 652–653
Beat movement, participation of Italian American writers in, 162–163, 272, 275–276, 276–278
bel canto,* 396, 398, 402, 417, 419, 420, 423, 440, **707
Belfiglio, Genevieve, 240
Bell, Rudolph, 11, 12
Bell, Tiffany, 533
bella figura,* 292, 293, 425, 429, 463, 478, 481, 581, 603, **707–708
bella figura / brutta figura,* 292, 314, 427, 463, 604, 611–612, 668, **707–708
Bellini, Vincenzo, 394, 398, 412
 Il pirata, 392
 Norma, 392
bello* (fem., *bella*), 496, **708
Belluomini, Michele, 197
Belmonte, Thomas, xxxvi
Benasutti, Marion, 196
 No Steady Job for Papa, 110, 216, 251, 326
Benjamin, Walter, 17
Bennet, Michael (Michael di Figlia), 362, 476
Bennett, Tony (Anthony Dominick Benedetto), 347, 418, 430, 431, 648
Bentley, Eric, 394
Berio, Luciano, 417
Berlin, Isaiah, 548
Bernadin, Cardinal Joseph, 621
Bernini, Giovanni Lorenzo, 545
Bernstein, Leonard, 412
Berra, Yogi, 71, 479
Bertoia, Harry, 537, 538
Bertolino, James, 280
Bertolucci, Bernardo, xix, 501, 586, 593
bestemmia* (plural, *bestemmie*), 494, **708–709
Betsy's Wedding (Alan Alda), 591, 632
Bhabha, Homi, xliii
Biancamano, Frank, 362
Bianco, Rosso e Verde (ed. Giorgio Calcano), xxxix, 483
Big Night (D: Stanley Tucci), 643
Bildungsroman, 171, 232, 322–324, 324, 325,

326, 327. *See also* coming-of-age novel
Birnbaum, Lucia Chiavola, 161
Bixio, Cesare Andrea, 457
Black Hand, 7
Black Hand (D: Richard Thorpe), 596, 599
Bloodbrothers (D: Robert Mulligan), 628, 681
Bloom, Alan, 15
Blue Velvet (D: David Lynch), 658
Boccaccio, Giovanni, 134, 136–137, 138, 256, 587
*bocce, 102, 117, **709**
Boccioni, Umberto, 506
body image, Italian American, 462–463, 478–483, 631, 631–632
 and ballet, 463
 and folk dance, 463–465
 and food, 482–484
 and gestural code, 480–481
 and nicknames, 481–482
 and space, 479–480
 and spectacle, 480–481
 See also stereotyping
Bogart, Humphrey, 596
Boiardo, Matteo, 138
Boito, Arrigo, 388
Bollati, Giulio, xvi, 615
Bologna, Joseph, 368
Bona, Mary Jo, xxxvi, 161, 165
Bonfanti, Marie (Marietta), 468, 470
Bonfiglio, Giuseppe, 470, 471
Bon Jovi, Jon (John Francis Bongiovi, Jr.), 445, 601
Bonomo, Jacquelyn, 216
Borges, Jorge Luis, xv
Borgnine, Ernest, 593, 596
Borromini, 545
*borsa, 98, 576, **709**
Boulanger, Nadia, 411
Bouzereau, Laurent, 644
Bovasso, Julie, 365, 633
Boyd, Julie, 362
*bracciante, 12, **709**
Bracco, Elizabeth, 601
Bracco, Lorraine, 601, 635, 649
Brancato, Joe, 362
Brancato, Rosemarie, 400
Brandi, John, 280–281
Brando, Marlon, 480, 571, 600, 681, 683
Braudy, Leo, 348, 350, 605
Brazzi, Rossano, 600

Breton, André, 273, 517
Bridges of Madison County (D: Clint Eastwood), 684
Brimelow, Peter, 69
Brito, Phil (Phil Colabritto), 429
Broadway Danny Rose (D: Woody Allen), 51–52, 668
Broccoli, Albert, 602
Brookhiser, Richard, 623
Brumidi, Constantino, 499
Bruno, Giordano, 532
*brutta figura, 311, **709**. *See also* bella figura/brutta figura.
Bruzzi, Stella, 647, 649
Bryant, Dorothy Calvetti, 67, 179, 232, 241
 Tender Warriors, 216
 Ella Price's Journal, 232
Buccellato, Kathy, 471
Bufano, Beniamino, 537, 538–539, 540
*buffone, 619, **709–710**
Bukowski, Charles, 175
Buñuel, Luis, 535
Burckchardt, Jacob, xvi, 210
burino, xxxix
Burri, Alberto, 502–503, 506, 527
Buscaglia, Leo, 623
Buscemi, Steve, 642, 660, 675–676, 681
 Trees Lounge, 642, 643, 675–676
Bush (Bucci), Mary, 67, 252, 255
*busta, 98, **710**
Buti, Carlo, 429

C

Caan, James, 576
Caccialanza, Gisella, 471
Cadmus, Paul, 499
*caffè (café), 8, **710–711**. *See also* caffè-concerto
*caffè (coffee), 710–711. *See also* espresso
*caffè-concerto, 358, **711**
*cafone, xxix, xxxix, 69, 72, 360, 479, 612, 626, 647, 668, 678, **711–712**. *See also* bella figura/brutta figura; educazione
*cafoneria (or cafonaggine), 612, **712**
Cage, Nicolas (Nicholas Kim Coppola), 362, 594–595, 598, 601, 603, 641, 652
Calitri, Charles, 179
Callas, Maria, 399, 411

Calvesi, Maurizio, 505–506
Calvino, Italo, xxi, 141, 300, 587
calzone, 641
Camorra, 617
Campanella, Tommaso, 549
campanilismo, xvi, 13, 63, 109, 616, 617, **712–713**
Campanini, Italo, 393, 394
Candoli, Conte, 452
Candoli, Pete, 452
Canon, Freddie (Frederick Picciariello), 440
canons, Italian American literary (in bibliographic form):
 autobiographical writers, 320–321
 coming-of-age novelists, 328
 dramatists, 381–386
 novelists, 189–191
 poets, 283–288
 women writers, 261–264
Canova, Lou, 668
cantabilità, 456
cantastorie, xxxvii, 135, 292, **713**
cantautori, 459
Canzano, Tony, 438
canzone, 447
Canzoneri, Robert
 A Highly Ramified Tree, 128
Capalbo, Carmen, 362
Capellano, Antonio, 537
Capodicci, John, 362
Capone, Al, 71, 610, 681
Caponegro, Mary, 196, 218, 252, 253, 254
Caponigro, Paul, 530
capozzelli, 118
Capra, Frank, 341, 346, 362, 436, 563, 565, 567, 593, 602, 608–609
 films directed by:
 A Hole in the Head, 608
 It's a Wonderful Life, 608
 You Can't Take It with You, 609
Capucilli, Terese, 471
Carasso, Katherine, 270
Caravaggio, 507, 529
Caravetta, Peter, 162
Carlino, John Lewis, 362, 364–365, 617
 plays by:
 The Brick and the Rose, 364
 Cages, 364
 The Dirty Old Man, 364
 The Epiphany, 364
 The Exercise, 365

 Sarah and the Sax, 364
 Snow Angel, 364
 Telemachus Clay, 364
 screenplays by:
 The Brotherhood, 365
 The Great Santini, 365
 Resurrection, 365
 The Sailor Who Fell from Grace with the Sea, 365
Carminetti, Tullio, 362
carnevale/quaresima, 17, 138, **713–714**. See also *festa*
Carnevali, Emmanuale, 162
Carosello napoletano (D: Ettore Giannini), 447, 465
carpaccio, 618
Carrà, Carlo, 506, 527
Carter, Elliot, 412
Caruso, Anthony, 597
Caruso, Enrico, 129, 389, 395–397, 400, 406, 479
Caruso, Rosemarie, 197, 213, 216, 234, 372
 Shadows of the Morning Moon, 197
 Suffering Heart Salon, 213, 233, 372
casa, 121–129, **714–715**. See also *domus*
casalinga, 631
Casella, Alfredo, 412
Caselotti, Adriana, 399–400, 595
Caselotti, Louise, 399
Casillo, Robert, 349
Cassettari, Rosa, 206, 212, 250, 292, 310
 Rosa: The Life of an Italian Immigrant. See Ets, Marie Hall
Castiglione, Baldassare, 478
Castle, Robert, 667
Cateura, Linda Brandi, 61
 Growing Up Italian, 61, 62
Cather, Willa, 337
Catholicism, Roman, 153, 154, 156, 331, 588, 615
 Italian American view and practice of, 41–59, 115–116, 220, 341–342, 343, 618
 defined as:
 Marianist, 343
 "Mediterranean Catholicism," xxxvii, 41, 333–334, 343
 as reflected in the arts, 331–352, 379–380, 410, 512, 523–524, 535, 605, 635, 636, 637, 663–665, 671–673, 683

INDEX

Causici, Enrico, 537
Cavaliere, Felix, 418, 440, 441
Cavalieri, Lina, 397
Cavallazzi, Malvina, 470
Cavallo, Diana, 198, 232, 325
 A Bridge of Leaves, 325
Cazale, John, 362
Cecchetti, Enrico, 467, 470, 471, 472, 477
Celentano, Adriano, 459
Ceravolo, Joseph, 276
Chandler, Raymond, 659
Chaucer, xvii, 134
Chay, Marie, 196, 204
 Pilgrim's Pride, 209
Chayefsky, Peddy, 624
Cher (Cherilyn LaPiere Sarkisian), 52, 611, 633
Chia, Sandro, 501, 506
ciambelle (dialect, *chiambelli*), 118
Ciannelli, Eduardo, 362, 597
Ciardi, John, 243, 270–271
Cilea, Francesco
 Adriana Lecouvreur, 397
Cimino, Michael, 507, 563, 586, 593, 602, 607, 608, 609–610, 613, 642, 682
 films directed by:
 The Deer Hunter, 564, 593, 609
 Desperate Hours, 642
 Heaven's Gate, 566, 609
 The Sicilian, 610
 Sunchaser, 642
 The Year of the Dragon, 610
cinema, American or Hollywood, Italian American presence in:
 actors and actresses, 564, 593–602, 641–642
 pantheon of as defined by Oscars, 593–595
 typecasting and assimilation of, 595–602
 directors, role of in:
 Old Hollywood/studio system (1930–1960), 565, 602
 New Hollywood/auteurist system (1972–1990), 563–567, 568–569, 585–586
 "New" New Hollywood (1990–1997), 567, 641–643
 pantheon of as defined by Oscars, 593
 See also Capra, Frank; Cimino, Michael; Coppola, Francis Ford; De Palma, Brian; La Cava, Gregory; Minelli, Vincente; Scorsese, Martin
cinema, Italian, 505, 566, 586, 593, 661
cinema, Italian American, 563–690
 canon of, criteria for determining, 567, 606–614
 cultural history of, 585–590, 603–606
 as ethnic cinema, 566–567, 607–614
 generational history of, 606–614
 "Cinema of the Fathers," 565, 608–609
 "Cinema of the Sons and Daughters," 565, 609–614, 634–641
 New Directions in the 1990s, 641–679
 and spectatorship, 571–574, 584–585, 643–649, 679–684
 See also Capra, Frank; Cimino, Michael; Coppola, Francis Ford; De Palma, Brian; Ferrara, Abel; La Cava, Gregory; Minelli, Vincente; Savoca, Nancy; Scorsese, Martin; Tarantino, Quentin; Tucci, Stanley
cinematic representation of the Italian American:
 as figured by mainstream cinema, 567, 568, 591–593, 668
 as figured in terms of the family, 567, 569–585, 591, 622–634
 as figured or stereotyped by genres
 boxing films, 590, 591–592, 607
 crime or gangster films, 590, 607
 Mafia films, 569–585, 666
 Mafia comedies, 632
 neo-gangsters, 643–649
 family-centered films, 591, 620–621, 632–634
 "Guido" films, 590, 628–631
 street films, 590–591
 "wedding films," 591
 working-class films, 628, 670, 681
 See also cinematic self-representation and stereotyping
cinematic self-representation, Italian American:
 problem of, 564
 directorial strategies for, 567
 critical appropriation of traditional genres:
 gangster film as art, 568–585
 gangster film as fatal strategy, 679–684
 neo-gangster and "pulp" as art, 643–668
 elaboration of an ethnic cinema, 634–641
 "mean streets" subgenre as art, 634–641, 650

independent filmmaking, 642–643, 669–679, 681–682
 role of *The Godfather* in, 574–575, 679–684
Citino, David, 282
City of Hope (D: John Sayles), 628
Clark, Dane (Bernard Zanville), 362
Clement (Clemente), Rosemary, 206, 233
Clemente, Francesco, 501, 502, 506
Clements, William. *See* Malpezzi, Francis
Clift, Montgomery, 597, 600
Clooney, Rosemary, 678
Cobb, Lee J., 599
Cobra (D: Joseph Henabery), 600
Cocco, James, 362
Colonna, Jerry, 430–431
Columbo, Chris, 362
Columbo, Russ (Ruggiero Eugenio de Rodolfo Columbo), 417, 418, 420, 421–422
Columbus, Christopher (Cristofero Colombo), xix, 72, 136, 152–153, 154, 155, 341
comare*, 176, 177, 577, **715. *See also* comparaggio cummari' (Sicilian variant), 132, 144
coming-of-age novel, Italian American, 322–328
commedia-ballata, 357
commedia dell'arte*, 360, 441, 462, 586, 587, 620, **715–716
Como, Perry (Pierino), 418, 428–429, 430
compaesano, 95
compagnia, 9
comparaggio* (or *comparatico*), 5, 63, 72, 177, 573, 574, 577, 582, **715–716
compare*, 73, 90, 176, 177, 326, 576, 577, **716. *See also* comare; comparaggio
compatriota*, 395, **716
complimento*, 202, **716–717. *See also* rispetto
comprimari, 407
comune, 157
comunicativa*, 395, 436, 480, **717. *See also* gesto
concittadino*, 395, **717
confetti*, 86, 97, 101, **717
Connolly, Robert, xxxviii
Conrad, Peter, 511, 525, 526, 568
contadino* xxiv, xxxix, 12, 13, 16, 126, 587, 616, **717. *See also* cultura negata; famiglia
Conte, Paolo, 459

Conte, Richard, 598
contraposto, 462
Copani, Peter, 372–373
 Street Jesus, 372
Copley, John Singleton, 499
Coppola, Carmine, 598
Coppola, Francis Ford, xxxiv, 47, 341, 348, 349, 362, 411, 507, 563, 568–585, 586, 590, 593, 598, 602, 605, 608, 635, 642, 643, 644, 649–650, 661, 679, 680, 682
 films directed by:
 Apocalypse Now, 566
 Bram Stoker's Dracula, 650
 The Conversation, 566
 The Godfather trilogy, 69, 568–585, 591, 593, 608, 612, 613, 623, 628, 637, 644, 645, 658, 662, 679, 683, 684
 The Godfather Part I, 123, 161, 349, 365, 464, 482, 565, 568, 574, 575, 578, 591–593, 607, 628, 631, 683
 The Godfather Part II, 25, 161, 349, 378, 464, 574, 575, 577–578, 581, 591, 607, 628, 651
 The Godfather Part III, 161, 349–350, 575, 581, 643, 649
 Jack, 650
 One from the Heart, 566, 652
 The Rainmaker, 650
 and *The Godfather* as Italian American cultural text, 568–585
 manliness according to, 636–641
Coppola, Sophia, 579, 603
Corbino, Jon, 515, 518–519
Corea, Chick (Armando Anthony Corea), 453–455
Corelli, Franco, 397, 398
Corigliano, John, 409, 416
Corio, Anne, 477–478
Cormani, Lucia, 470
corna*, **718
Cornelisen, Anne, 11, 67, 193, 342
Cornell, Don, 430, 432
corno*, 630, **718
cornutismo/gallismo*, **718
cornuto*, 612, 639, **718–719
cornuto e contento* (variant, *cornuto contento*), 599, 612–613, **719
Corrente, 505
Corrente, Michael, 642

· 772 ·

Federal Hill, 642, 646, 680
Corsaro, Frank, 362, 363
Corso, Gregory, 162, 275–276
Cosa Nostra, **719**
Costa, Mary, 402
Costello, Dolores, 599
Costello Lou (Louis Francis Castillo), 437, 479
Costner, Kevin, 610
Covello, Leonard, 65
Coward, Noel, 389, 395
Crane, Hart, 511
creatura, 9
Cristofer, Michael (Michael Procaccino), 368, 370, 374
 The Shadow Box, 368–369
Croce, Arlene, 472, 474
Croce, Benedetto, 139
Croce, Jim, 441
Crosby, Bing, 422, 423, 448
Crouch, Stanley, 660
Crowther, Bosley, 599
Cuberli, Lella, 402
Cucchi, Enzo, 506
cucina, **719–720**. *See also* food and foodways, Italian American
cucina, alta, 618, 677, 678, 720
cucina casalinga (or *casareccia*), 122, **720**
cucina povera, 155, **720**
cugino (dialect *cugine*), 628, **720**
cultura negata, xxvi, 158, 159, 588, **720–722**. *See also* Gramsci, Antonio
Cuomo, Mario, xxiv, xxix, xxxv, xlii, xxxv, xlii–xliii, 157, 314, 478, 548, 621–622, 623

D

D'Acierno, Fosca, xxxviii
D'Acierno, Pellegrino, 255
D'Agostino, Guido
 Olives on the Apple Tree, 116, 342
Dale, Alan, 429–430
D'Alessio, Natalie Mariono, 537
D'Amato, Alfonse, xxxv, 621
D'Amico, Hank, 450
Damone, Vic (Vito Farinola), 347, 418, 430
dance, Italian and Italian American, 462–478
 ballet, 463
 Italian presence in American ballet, 466–470
 Italian American presence in American ballet, 471–477

dancers in exotic and popular styles, 477–478
 See also body image, Italian American; tarantella
D'Andrea, Joy, 537
D'Angelo, Pascal, 292
Daniele, Pino, 459
Danieli, Fred, 476
D'Annunzio, Gabriele, 170, 266
Dante Aligheri, xxviii, 136, 511, 516, 518–519
 Divine Comedy, 203, 587
Dante, Joe, 608
D'Antuono, Eleanor, 471
da Piacenza, Domenico, 465–466
Da Ponte, Lorenzo, xix, 245, 391, 392
D'Arcangelo, Allan, 501–502, 530, 531–532
Darin, Bobby (Robert Waldo Cassotto), 347, 418, 681
Darren, James, 440
D'Arrigo, Elisa, 537
Davis, Miles, 453, 454
De André, Fabrizio, 459
De Andrea, John, 537
De Angelis, Rosemary, 362, 371–372
De Antonio, Emile, xliii
de Beauvoir, Simone, 228–229
De Capite, Michael, 179, 342, 344
 Maria, 118, 213–214, 237, 251, 343, 345
De Capite, Raymond, 179
 Coming of Fabrizze, 110, 124
DeCarlo, Yvonne (Peggy Yvonne Middleton), 598
de Chirico, Giorgio, 505, 506, 513, 525, 527
DeCorsia, Ted, 597
De Filippo, Eduardo, 380
DeFranco, Buddy (Boniface Ferdinando Leonardo), 451–452, 454–455
DeLaurentis, Dino, 602
Deledda, Grazia, 206, 228, 229–230
 Cosima, 229
Deleuze, Gilles, xxxv
DeLillo, Don, 182–189, 315, 341, 345, 589, 681
 works of:
 Americana, 183
 Great Jones Street, 183
 Libra, 182, 183
 Mao II, 183
 The Names, 183
 Ratner's Star, 183

INDEX

Running Dog, 183
Underworld, 539–540
White Noise, 183
Della Chiesa, Vivian, 400
della Femina, Jerry, 346
Dellapicolo, Luigi, 417
Dello Joio, Norman, 410, 413
Del Monaco, Mario, 397, 398
Del Toro, Benicio, 667
Del Tredici, David, 409, 416, 417
De Lucia, Fernando, 395, 397
De Marco, Tony, 477
De Maria, Walter, 538
de Matteo, Donna, 206, 234, 370–371
 plays by:
 Almost on a Runway, 370
 Animal Lovers, 370
 The Barbecue Pit, 370
 Dear Mr. Giordano, 370
 The Ex-Expatriot, 370
 The Flip Side, 370
 The Paradise Kid, 370
 Rocky Road, 370–371
 The Silver Fox, 370
DeMichiel, Helen, 234, 673–674
 Tarantella, 234, 673–674
Denby, Edwin, 463, 479
De Niro, Robert Sr., 530
De Niro, Robert, 18, 24, 51, 362, 377, 564,
 594, 595, 600, 602, 608, 635, 642,
 646, 649, 650, 652, 674
 A Bronx Tale, 481–482, 604, 642, 645, 646,
 680
de Palchi, Alfredo, 162
De Palma, Brian, 341, 348, 362, 507, 563,
 585–586, 593, 602, 607, 608,
 610, 613, 642, 659, 680, 682
 films directed by:
 Blow Out, 566, 661
 Carlito's Way, 642, 644
 The Bonfire of Vanities, 566, 610
 Mission Impossible, 642
 Obsession, 610
 Raising Cain, 642
 Scarface, 564, 585–586, 644
 The Untouchables, 564, 580
 The Wedding Party, 610
De Palma, Donna, 537
Derise, Joe, 435
De Rosa, Tina (Antoinette), 65, 184–185, 228
 Paper Fish, 102, 180, 184, 198, 322, 326–327

Derrida, Jacques, xxii, 506
DeSalvo, Anne, 362
DeSalvo, Louise A., 209, 217
DeSando, Anthony, 646, 674
De Sica, Vittorio, 380, 457
Desmond, Johnny (Giovanni Alfredo De
 Simone), 430
De Sortis, Bettina, 470
destino,* 64, 310, 313, 347, **722–723
DeVito, Danny, 362, 564, 608, 642
De Voto, Bernard, 245
de Vries, Rachel Guido, 67, 216, 255
 Tender Warriors, 216, 251, 326
dialect, xxxix, xlii 587–588. *See also dialetto*
**dialetto, 723*
DiBartolomeo, Albert, 188
DiCaprio, Leonardo, 594, 601
Di Capua, Eduardo, 457, 458
DiCillo, Tom, 642
di Donato, Pietro, 18, 166–172, 177, 187,
 226, 537
 Catholicism of, 167–177, 211, 342
 works of:
 American Gospels, 167, 171–172, 211
 Circles of Light, 116
 Christ in Concrete, xxvii, xliii, 89, 98,
 111, 125–126, 156, 159–160, 166,
 167–170, 172, 187, 238, 324, 326,
 343, 347, 464, 481, 482, 521, 540,
 589, 670, 681
 Immigrant Saint, 171
 Love of Annunziata, 171
 The Penitent, 171
 Three Circles of Light, 115, 171, 213
 This Woman, 125, 170–171
DiFranco, Ani, 445, 446
Di Leo, Fernando, 661
di Leonardo, Micaela:
 Varieties of Ethnic Experience, xvii, xxxi
DiMaggio, Joe, 425, 478
Di Meola, Al, 454, 455
Dion (Dion DiMucci), 347, 377, 418, 438,
 439, 441
Di Palma, Ray, 280
Di Piero, W.S., 282
di Prima, Diana, 162, 171, 217, 235, 251,
 276–278, 291, 307–311, 314, 341,
 344–345
 works of:
 Dinners and Nightmares, 217
 Pieces of a Song, 276, 278

· 774 ·

Memoirs of a Beatnik, 307, 344
Recollections of My Life As a Woman, 308–309
disgraziato, 676
disprezzato* (pl. *disprezzati*), 395–396, **723–724
Di Stasi, Lawrence, xxxv, 625
di Suvero, Mark, 531, 537, 538, 589
diva* (m. *divo*), 397, 404, 441, 492, 600, 616, **724
divismo, xxxvii, 419, 429, 724
Dodd, Bella Visono, 200–201
School of Darkness, 200
Dolci, Danilo, 296
Domenici, Peter, 621
domus, 523, 524, 535, 536, 592, 624, 626, 635, 636, 670, 673
Donati, Enrico, 515, 517–518
Donizetti, Gaetano, 394
L'elisir d'amore, 396
donna, 674
donna seria*, xxxiv, 212, 214, 583, 601, 602, **724
Donnie Brasco (D: Mike Newell), 645
Donofrio, Beverly, 196, 206, 255
D'Onofrio, Vincent, 671
doo-wop groups, Italian American, 438–439
Doria, Charles, 280
Down by Law (D: Jim Jarmusch), 626
Dragonette, Jessica, 399
Dragonette, Ree, 196, 251
Drake, Alfred (Alfred Capurro), 437
Duchamp, Marcel, 532
Dukakis, Olympia, 611, 633
Duncan, Robert, 270
Durante, Jimmy, 362, 418, 435–437, 479

E

Ebreo, Guglielmo, 466
Eco, Umberto, 136, 417, 443, 587
education, Italian American attitude toward, 208–209
schools, hegemonic function of, 219–220
See also educazione/istruzione
educazione/istruzione*, 588, **725
Eliot, T. S., xxviii, 25, 26, 27, 314, 315, 335, 543, 544
Elliot, Patricia, 362
Empson, William, 543
equilibrato, 403
Erziehungsroman, 322

espresso*, 4, **725
Ets, Marie Hall, 206, 310
Rosa: The Life of an Italian Immigrant, 206, 310
Eulo, Ken, 369
Evita (D; Alan Parker), 602, 642
Ewen, Elizabeth, 64

F

Fabbri, Egisto P., 393
Fabian (Fabio Forte), 418, 437, 440
Fabiani, Aurelio, 402
Fabilli, Mary, 270
fabula atellana, 356
Falco, Louis, 476
Falk, Randolph, 539
Fallio, Adele, 470
famiglia*, xx, xxiv, xxxiv, 8, 112, 126, 308, 374, 405, 567, 569, 570, 572, 577, 581, 588, 591, 614, 619, 620, 622, 623, 626, 629, 632, 633, 637, 642, 646, 666, 667, 668, 683, **725–726
family, Italian American, 209–210, 216, 226, 569–570
codes and rituals of, 577
and emotional display and expression through scenes, 9–10, 582, 591
origins of in south Italy, 10–11, 63
stereotyping of, xxxi, 567, 569–570, 591, 619–623
See also famiglia
fantasy history, 569, 623–634
Fante, John, 172–175, 177, 187, 235, 338, 342
works of:
Ask the Dust, 156, 173
The Brotherhood of the Grape, 124, 174, 238
Dago Red, 237
Dreams from Bunker Hill, 173
Full of Life, 173, 174
1933 Was a Bad Year, 173
"The Odyssey of a Wop," 324
The Road to Los Angeles, 173
Wait Until Spring, Bandini, 172, 173, 174, 237, 324
Farentino, James, 362
Farfariello, 360. *See also* Eduardo Migliaccio
Farina, Franco, 402
Farra, Geraldine, 471
Farrow, Mia, 52

· 775 ·

INDEX

Fasanella, Ralph, 18, 346–347, 506, 507, 508, 515, 519, 520–524, 531, 536, 540, 544, 553–554
 as painter of the working-class, 522–523
 paintings by:
 American Tragedy, 522
 Lawrence 1912: Bread and Roses Strike, 522–523
 Death of a Leader, 522
 Family Supper, 482, 523–524, 553, 555, illustrated
 Festa, 560, illustrated
 Iceman Crucified #1, 347, 521
 Iceman Crucified #4, 347, 521–522, 523, 524, 556, illustrated
 Marcantonio for Mayor, 522
 The McCarthy Period, 522
 New York City, 521
 The Tunnel of Lies, 522
 Park Avenue, 521
Faulkner, William, 338
feasts, 115–118
 as expression of Italian American religiosity, 115–116
Federick II, 135
Fellini, Federico, 50, 158, 356, 367, 411, 435, 566, 586, 586, 606
 La Dolce Vita, 50, 651
 8 1/2, 367, 627
Feraca, Jean, 231
 South from Rome: Il Mezzogiorno, 231
Ferlinghetti, Lawrence, 162, 235, 272, 341, 344
Fermi, Enrico, xix
Ferrara, Abel, 567, 608, 642, 643, 650, 662, 663–668, 680–681, 683
 films directed by:
 The Addiction, 664
 Bad Lieutenant, 642, 645–646
 Body Snatchers, 664
 Cat Chaser, 664
 China Girl, 6, 664
 Dangerous Game, 664, 665–666
 The Driller Killer, 663
 The Funeral, 642, 643, 664, 666–668, 683
 King of New York, 642, 663, 664
Ferraro, Geraldine, 208, 314, 478, 621
Ferraro, Thomas J., xxxvi–xxxvii, 444
Ferrini, Vincent (Venanzio Ferrini), 270
fescennia locatio, 355–356

fesso,* **726. See also *furbo/fesso*
festa,* 13, 17, 115–119, 512, 581, 591, 631, **727
festa paesana, 116
Festa. See Fasanella, Ralph
fiabe, 138
Fiedler, Leslie A., 335, 336
Fields, Dorothy Gentile, 233
figlio di papà, 627
Fine, Irving, 412
Fiorentino, Linda, 595, 601
Fitzgerald, F. Scott, 336–337, 424
Flagello, Ezio, 402
Flagello, Nicholas, 414–415
Fo, Dario, 380, 381
Fontana, Lucio, 502, 506, 518
food and foodways, 4–5, 46–48, 122, 306–307, 482–484
 image of, 483
 bread and wine, 109–113
 feasts, 115, 118
 and regionalism, 109. See also *polenta/pasta, polentone/terrone* wakes, 99–100
 weddings, 97–98
 See also *Festa* (Barolini)
Ford, John, 593
Forestiere, Baldassare, 538
Fornaroli, Cia (Lucia), 470
Fortunato, D'Anna, 402
Forum of Italian American Playwrights, 369, 370
Foucault, Michel, 55
Fracci, Carla, 47, 472, 475
Fraiman, Susan, 323, 326
Franchi, Sergio, 435
Francioli, Augusto
Franciosa, Anthony, 362, 363
Francis, Connie (Concetta Franconero), 418, 439, 440
Francis of Assisi, Saint, xliii, 136, 539, 635
Fratti, Mario, 366–367, 374
 plays by:
 The Academy, 366, 367
 The Cage, 366
 The Chinese Friend, 366
 Nine, 367
 The Refrigerators, 366
Freeperson, Kathy (Kathy Telesco), 227
The Freshman (Andrew Bergman), 632
Freud, Sigmund, 335, 493–494

From Here to Eternity (D: Fred Zinnemann), 596
From the Margin: Writings in Italian Americana (Tamburri, Gardaphe, Giordano), xxxvi, 159
Fuderer, Laura Sue, 323–324
Fukuyama, Frances, 69
Fuller, Buckminster, 546
Full of Life (D: Richard Quine), 627
Fumento, Rocco:
 Tree of Dark Reflection, 156
Funicello, Annette, 418, 439–440
furbizia,* 12, **728
furbo/fesso,* **727–728
Furtwangler, Wilhelm, 408
futurism, Italian, 503–505, 533.
 See also Stella, Joseph

G

gabellotto,* 7, **728. *See also bracciante; latifondo*
Gabler, Neil, 602
Gagliano, Frank, 373, 374
 Conerico Was Here to Stay, 373
 The Total Immersion of Madeleine Favorini, 373
galantuomo, 126
Galletti, Anetta, 467
Galli, Rosina, 470–471
Galli-Curci, Amelita, 397
Gallo, Vincent, 666
Gambarelli, Maria, 471
Gambino, Richard, xxii, xxxv, 152, 217, 465
 Blood of My Blood, xxxiv, 88, 176, 212, 464, 571
García, Manuel, 390–392
García, Manuel Patricio, 390
García, Maria Felicia (Maria Malibran), 390–391, 392
García, Pauline (Pauline Viardot), 390
garbo,* 584, **728
Gardaphe, Fred, xxxvi
Gardenia, Vincent (Vincent Cardenia), 362, 363, 378–379, 612, 633
Garibaldi, Giuseppe, xix, 162, 313
Gatti-Casazza, Giulio, 397, 406, 470, 471
Gaudi, Antonio, 539, 546, 547
Gazzara, Ben, 362, 363
Gazzo, Michael, 363–364
 A Hatful of Rain, 363–364

gelato, 618
Gennaro, Peter (Falco Gennaro), 476
Gentileschi, Artemisia, 537
Gere, Richard, 628
Germi, Pietro, 617
Gesta Romanorum, 134
gesto,* **728–729. *See also* gesture
gesture, 353, 356
Giacomo da Lentini, 135
Giamatti, A. Bartlett, xxxv, xl, 621–622
Giannini, Dusolina, 399, 413
Giannini, Ferruccio, 413
Giannini, Vittorio, 413, 414, 416
Giardina, Denise, 188, 244
giglio* and *Giglio,* Feast of, 13–14, 117–118, **729–730
Gigli, Beniamino, 397, 407, 429, 678
Gilbert, Sandra Mortola, 195, 222, 224, 250–251, 278–279, 345
Giles, Paul, 345–346
Gillan, Maria Mazziotti, 66, 158–159, 223, 250, 279–280
 "Public School No. 18," 66, 218–219
Gilman, Charlotte Perkins, 325
Gioffre, Marisa, 371
Gioia, Dana, 243, 282
Giordano, Gus, 476
Giordano, Paolo, xxxvi
Giordano, Tony, 362
Giordano, Umberto, 396
Giorno, John, 278
Gioseffi, Daniela, 61, 232, 233, 250, 280
Giovanitti, Arturo, 268–270
Giuffre, Jimmy, 451
Giuliani, Rudolph W., 669, 679, 683
**giullare,* 135
Giurgola, Romaldo, 507
Giuri, Maria, 470
Give Us This Day (D: Edward Dmytryk; cinematic adaptation of Christ in Concrete), 170, 599, 681
Gizzi, Michael, 282
Godard, Jean-Luc, 657, 659, 662
The Godfather. See Puzo, Mario
The Godfather trilogy. *See* Coppola, Francis Ford
Goethe, 322–323
Goffman, Erving, 425, 583
Golden Boy (D: Rouben Mamoulian), 590, 599
Golino, Valeria, 601

The Good, the Bad, and the Ugly (D: Sergio Leone), 657
Good Morning, Babylon (D: Taviani Brothers), 563, cited
Gordon, Mary, 198, 228, 237, 331, 338, 340, 345
Gotti, John, 479
Gramsci, Antonio, xxiv, xxxiv, xxxv, xxxvii, 158, 405, 532, 588, 622, 640,
 Selections from the Prison Notebooks, xxiv
 See also cultura negata
Grant, Bob (Robert Gigante), xxix–xxx
Grasso, Ella, 208
Graves, Michael, 541, 542
Graziano, Rocky, 590
Greco, Buddy (Armando Greco), 434–435
Greco, José, 477
Greco, Norina, 400
Green, Rose Basile, 160, 165, 204, 239
Greenblatt, Stephen, 55, 155
Gregorio, Rose, 362, 673
Grieco, Rose, 196, 216, 233
Grillo, Joann, 402
Grimm Brothers (William and Jacob), 139
guappo, 581, 667
Guarnieri, Johnny, 450
Guarrera, Frank, 400
Guattari, Felix, xxxv
Guglielmi, O. Louis, 506, 515, 519, 524–527, 531, 553–554, 562
 paintings by:
 The Bridge, 526–527, 554, 562 illustrated
 The Church of St. Vincent de Paul, 525
 Mental Geography, 526
 Nocturne, 525
 Tenements, 525
 Terror in Brooklyn, 526
 The Relief Blues, 525
Gugliotti, Vincent, 362
*Guido (fem. Guidette), 590, 611, 618, 625, 627, *628–632*, 646, 660, 674, 675, 676, **730**

H

Hadley, Jerry, 402
Hall, Stephen, xxxi, xxxv, 621
hamantaschen, 144
Hammett, Dashiell, 659
Harrison, Barbara Grizzuti, 212, 216, 239, 256, 345
 Visions of Glory, 216
Haskell, Barbara, 510, 512, 514
Hawkes, Howard, 593. *See also Scarface*
Hemingway, Ernest, 337, 338
Hendin, Josephine Gattuso, 216
 The Right Thing to Do, 216, 324, 326
Hersholt, Jean, 599
Hilten, Pontus, 503
Hitchcock, Alfred, 610, 613, 646
Holden, William, 599
Holiday, Billie, 423
Holm, Ian, 676
hooks, bell, 660
Hopper, Dennis, 662
Horney, Karen, 248
Horowitz, Joseph, 408
Hunter, Evan, (Salvatore Lombino), 219

I

Iacocca, Lee, 314, 621
Ianni, Francis A. J., 570
 A Family Business, xxxiv
Informalismo, 505–506
Innaurato, Albert, xlii, 235, 368, 369, 374, 619
 Gemini, xxx, xlii, 10, 369
 The Transfiguration of Benno Blimpie, 10, 369, 482
intermezzo (pl. *intermezzi*), 356
invidia*, 625, **730. *See also malocchio*
istruzione*, **730. *See educazione / istruzione*
The Italian (D: Thomas Ince), 568
italianata, 603
Italian American (variants Italian-American; Italian / American):
 terminological implications of, xxxii–xxxiii, 14, 151, 154
Italian American cultural production, 151–690:
 definition and location of, xv–xliv
 literary, 151–330. *See also* literature, Italian American
 artistic and visual, 331–690. *See also* cinema; musical culture; theatrical culture; visual culture
Italian American culture:
 everyday practices, customs, and traditions of, 85–150
 family life, 3–18. *See also* famiglia; family
 the feast, 13, 115–120
 food. *See* food and foodways
 the house, 121–130
 life cycle, 9, 85–108

birth, 86–93
marriage, 93–98
death, 98–103
oral tradition and storytelling, 17, 131–150
the house, 121–130
history of, xvi, xix–xx, xxiii–xxxi
as supplement to Italian culture, xv, xx, xxii
worldview of, as expressed in
 attitude toward death, 9, 52–53
 attitude toward physical reality/materials, 43–46
 family values, 3–18
 linguistic universe, xxiv, 703
 proverbs. *See* proverbs
 religion. *See* Catholicism
 spectacle or scenes, xviii, 9
Italian American identity, 3–84
and Americanization, xvi–xvii, 15–17
contradictions and definition of, xxv, 3–18
linguistic, xxxix–xliv, 17
and gender, 155, 160–161. *See also* men and men's experience; women and women's experience
making of, xv–xliv
and immigrant experience, xx, xxiv, 14
and multiculturalism, 54, 69–74
and religion. *See* Catholicism, Roman
self as spectacle, 604
viv-à-vis Italians, xvi–xvii, 604
See also famiglia; family; *italianità;* stereotyping
*italianità, 67, 71, 159, 174, 179, 183, 185, 186, 187, 188, 305, 344, **730**. *See also* Italianness
Italianness, 271, 272, 278, 405, 441, 444, 519, 535, 544
opera as signifier of, 405–406
It Had To Happen (D: Roy Del Ruth), 596

J

Jackson, Samuel F., 657, 660
Jaffe, Irma, 499, 510, 512
James, Henry, 336
James, Joni (Joan Carmela Babbo), 434
Janetti, Joe, 362
jazz, Italian Americans in, 446–456
 and intersection with African American musical culture, 447
Jefferson, Thomas, 499
Jessel, George, 599

Joffrey Ballet, 473–474
Joyce, James, 335
Judd, Ashley, 598

K

Kahn, Louis, 541, 542
Kant, Immanuel, xvii–xviii, 603–604, 605
Keitel, Harvey, 635, 657, 660, 664, 665, 666
Key Largo (D: John Huston), 595, 660
Kid Galahad (D: Michael Curtiz), 595
King, Morgana, 434
Koestenbaum, Wayne, 406
Koetter, Fred, 542
Kostelanetz, Richard, 535
Kubrick, Stanley, 659

L

La Cava, Gregory, 565, 593, 608
Laciura, Anthony, 402
LaFaro, Scott, 452, 454–455
LaGuardia, Fiorello H., xxxv, 170, 478
LaGumina, Salvatore, xxxiii, 478
Laine, Frankie (Frank Paul LoVecchio), 418, 430
Lamantia, Philip, 273–275
LaMotta, Jake, 590, 594, 608, 635–636, 639, 640, 641
Lancaster, Burt, 624
Lang, Eddie (Salvatore Massaro), 448–449
Langella, Frank, 601
language:
 Italglish (or Italo-Americanese), xli, 361
 Italian Americans' relationship to, xxxix–xliv, 201–202, 587–589
 Italian Americanisms, 760–766
 questione della lingua, 162
 silence, xxxix, xlii, 589. *See also omertà*
 stereotyping in terms of, xl, 604–605
 See also dialect
Lanier, Jennifer, 216
Lanza, Mario (Arnaldo Alfredo Cocozza), 399, 400–401, 418, 595
LaPaglia, Anthony, 601, 676
La Palma, Marina de Bellagente, 282
Lapolla, Garibaldi, 342
 The Grand Gennaro, 126–127, 158, 338
LaRocca, Nick (Dominick James LaRocca), 448
La Rosa, Julius, 418, 431
La Rose, Rose (Rosa Dapelle), 478
LaRue, Jack (Gaspare Biondolillo), 597
LaRusso II, Lewis, 367–368
 The Knockout, 367

Lamppost Reunion, 367–368
Wheelbarrow Closers, 367
La Selva, Vincent, 403
La Sorte, Micael, xli
La Storia: Five Centuries of Italian Experience (Mangione and Morreale), xxv, 300, 448
Las Vegas, 507, 578, 644, 653, 654
 and the Italian American imaginary, 651–652
latifondo, 13, **731**. See also bracciante; gabellotto
Laughton, Charles, 599
Lauria, Dan, 374, 377
Lazaronitum, xxxix, 479, 587, 634, 640
lazzarone, xxxix, 587, 731
lazzaronismo*, **731
Leaving Las Vegas (D: Mike Figgis), 594, 652
Lebrun, Rico, 515–516
Lee, Spike, 640, 669
 Do the Right Thing, 483, 619, 669
 Jungle Fever, 669
 Malcolm X, 611
Lees, Gene, xxxviii
Lentricchia, Frank, xxviii, xxxvii, xliv, 182, 313–316, 350
 Criticism and Social Change, xxxvii
 The Edge of Night, xxxvii, 313–316, 350
 "The Genealogy of Ice," excerpt from, 21–40
 and problem of writing as an Italian American, 21–40
 themes of:
 genealogy traced through grandfathers:
 Tomaso Iacovelli, the storyteller, 29–36, 39–40, 315
 Augusto Lentricchia, the frustrated writer, 36–40, 315
 house, 29
 identity and Italian words, 24
 review of by John Sutherland, xxvii–xviii, 315
 Introducing Don DeLillo, 182
 Modernist Quartet, 350
Leonardi, Susan, 67
Leonardo da Vinci, 499, 546, 615
Leoncavallo, 396
 I pagliacci, 389, 397, 610
 Zaza, 397
Leone, Sergio, 657, 661
Leopardi, Giacomo, 266

Levi, Carlo, xxxix, 342
Liberace, 652
Linfante, Michele, 206, 222, 233, 372
Liotta, Ray, 635, 647
literature, Italian American, 151–330
 history and theory of, 151–164
 genres and registers of:
 autobiographical writing, 281–314
 drama. See theatrical culture
 coming-of-age novel, 315–324. See also Bildungsroman
 novel, 17–18, 122–129, 157–184
 poetry, 259–280
 woman's writing, 66–67, 185–258
Little Caesar (Mervyn Leroy), 568, 585, 595, 614
Little Italy, New York City, 634, 637, 640, 670, 675, 693
Livingston, Arthur, 359
Loggia, Robert, 586
Lollabrigida, Gina, 601
Lombard, Carole, 599
Longo, Robert, 530–531
lontananza, 432
The Lords of Flatbush (D: Stephen F. Verona), 628
Loren, Sophia (Sofia Scicolone), 594, 601, 626
Lorenzo's Oil (D: George Miller), 594, 597
Lorenzo the Magnificent, 292
Love with the Proper Stranger (D: Robert Mulligan), 591, 614, 627
Lovers and Other Strangers (D. Cy Howard), 72, 209, 614
Lucas, Nick (Dominic Anthony Lucanese), 421
Luciano, Lucky, 479, 575, 681
Lucioni, Luigi, 515
Lucretius, 532
Luria, Salvatore, 621
lupa, 12, 626
lupara*, 631, **731
Lupino, Ida, 608
Lupone, Patti, 378, 437

M

Mac (John Turturro), 540, 642, 681
macchietta*, xxvi, 358, 359, 379, **731
macchietta coloniale*, xxvi, xl, 358, 361, **731–732
Machiavelli, Nicolo, 292
MacNeil, Robert, 73
McKim, Charles F., 541
McQueen, Steve, 627

Madalena, Lorenzo:
 Confetti for Gino, 110
*Madonna, 492, 627, 631, 665, **732–733**
 representations of, 12
Madonna (Madonna Veronica Louise Ciccone), 48–49, 155, 211, 308, 340, 348, 441, 445, 478, 481, 483, 491–498, 564, 602, 608, 642, 662, 665, 674
Madonna/puttana, 493, 494, 627, 630, 631, 665, **733**
madre (familiar form, *mamma*), 626, 631, 633, **733–735**
Madsen, Michael, 660
Maestro, Johnny, 438
Mafia, xxx, xxxiv, 7–8, 70, 155, 221, 235, 349–350, 428, 568, 569, 570, 571, 572, 617, 632, 637, 645, 648, 658, 666, 683, **735–738**
Mafiosità, 428
Mafioso, 69, 178, 571, 591, 632, 640, 645, 648, 658, 683, **738**. See also *Mafia*; *uomo d'onore*; *uomo di rispetto*.
Magnani, Anna, 594, 596, 598, 601, 611, 624, 626
Maiorano, Robert, 476–477
Malanga, Gerard, 280
Malfitano, Catherine, 402
malocchio, (variant spellings, *mal occhio* and *mal'occhio*), 87, 227, 625, 633, **738–739**. See also *invidia*; *mano cornuta*
Malpede, Karen, 233
Malpezzi, Frances and William Clements, xxxvi, 625
 Italian-American Folklore, xxxvi, 625
mammismo, 627, **739**
Mancini, Henry, 460, 461–462
Mangione, Chuck, 452–453, 464
Mangione, Jerre, 160, 175–176, 177, 184–185, 293–300, 304, 338, 342
 works of:
 The Dream and the Deal: The Federal Writers' Project, 1935–1943, 299
 An Ethnic at Large: A Memoir of the Thirties and Forties, 297–298, 299–300
 Mount Allegro: A Memoir of Italian American Life, 90, 112, 175, 291, 293–295
 Night Search, 175
 A Passion for Sicilians: The World Around Danilo Dolce, 296–297
 Reunion in Sicily, 128, 295–296

 The Ship and the Flame, 175–176
 La Storia: Five Centuries of Italian American Experience (with Ben Morreale) xxv, 300, 448
Maniscalco, Nancy, 251
mano cornuta, 625, **739**. See also *gesto*; *cornuto*
Mantegna, Joe, 564, 601
Manteo, Agrippino, 378. See also *Papa Manteo's Life-Sized Marionettes*
Marcantonio, Vito, xxxv, 522 , 618, 681
Marca-Relli, Conrad (Corrado), 503, 527, 529
Mariani, Paul, 280
Marianism (or Marianist Catholicism), 339, 343, 344
Mariano, Charlie (Carmine Ugo Mariano), 451
Marinetti, Filippo Tommaso, 503–504, 531
Marini, Marino, 506, 537
Marino, Gigi, 197
Marotta, Kenny, 186–187
 A Piece of Earth, 186–187
Married to the Mob (D: Jonathan Demme), 72, 614, 632
Marshall, Gary (Gary Marscharelli), 362
Marshall, Penny (Penny Marscharelli), 362, 564, 598, 608, 642, 670, 681
Martin, Dean (Dino Crocetti), 347, 418, 422, 429, 430, 432–433, 459, 600, 633, 668, 681
Martinelli, Giovanni, 397, 471
Martino, Al (Alfred Cini), 347, 418, 430, 431, 577
Martino, Donald, 415–416
Martirano, Salvatore, 415
Marty (D: Delbert Mann), 591–593, 614, 626–627, 628, 630, 633, 670, 681
Marzani, Carl, 300–302
 Growing Up American, 301
 Roman Childhood, 300
 Spain, Munich, and Dying Empires, 302
Mascagni, Pietro, 396
 Cavalleria rusticana, 389, 397, 579, 580, 581
masciata, 94, **740**
masks, culture of, 583–584
Maso, Carole, 157, 188, 218, 252, 253–254
 Art Lover, 188
 Ava, 188
 Ghost Dance, 188, 197–198
Mastroantonio, Mary Elizabeth, 564, 586, 601

Mastroianni, Marcello, 481, 600
Mastrosimone, William, 376–377
 Extremities, 376
 The Stone Carver, 376–377
 The Undoing, 376
Mays, Lucinda LaBella, 207, 230
Mazza, Cris, 218, 254
 Animal Acts, 218
Mazzei, Filippo, xix, 245
Mead, William R., 541
melancolia, 447
Melfi, Leonard, 366, 367, 374
 plays by:
 Birdbath, 366
 Encounters: Six One-Act Plays, 366
 Jack and Jill, 367
 Morning, Noon, and Night, 367
 Taxi Tales, 367
men and men's experience, 3–7, 212–213, 216, 311–316, 583, 590 628
 manliness, ideal of, 583, 636–641. See also *uomo di pazienza*
Mencken, H.L., xl, 172
menefreghismo*, 432, 622, **740
Menin (Menini), Peter, 414
Menotti, Gian Carlo, 401, 409, 410–411, 417
 operas by:
 Amahl and the Night Visitors, 411
 Amelia Goes to the Ball, 411
 The Consul, 411
 Goya, 411
 The Medium, 411,
 The Saint of Bleeker Street, 401, 410, 411
Mercer, Mabel, 423, 424
Meredith, Burgess, 597
Merton, Thomas, 335
Merz, Mario, 506
metanoia, 664, 665
Metropolitan Opera House (original), 393, 400, 401, 406, 469, 470, 471
Metropolitan Opera House (at Lincoln Center), 126, 403, 404, 416
Mezzogiorno*, xvi, xxiv, xxxix, xl, 63, 344, 463, 570, 587, 588, 616, **740–741
Michelangelo Buonarroti, 615
Migliaccio, Eduardo, xl, xl–xlii, 358–359, 360–361, 435
Miller, Arthur, 380, 381
Mineo, Sal, 440
Minnelli, Liza, 378, 437, 594
Minnelli, Vincente, 362, 476, 565, 608, 609

miseria*, 207, **741
Modigliani, Amadeo, 506
Modugno, Domenico, 459
Moffo, Anna, 402
Monaco, Aldo, 435
Monaco, Richard, 280
Monardo, Anna, 67, 188, 255, 324
 The Courtyard of Dreams, 216, 251
Mondello, Toots (Nuncio Mondello), 449
Montano, Linda, 536–537
Monte, Lou, 5
Montresor, Giacomo, 392
Moonstruck (Norman Jewison), xxxi, 51, 52, 72, 237, 365, 380, 611, 612, 614, 626, 633–634, 639
Moore, Charles, 542
Morandi, Giorgio, 506, 527
Morello, Joe, 452
Morlacchi, Giuseppina, 468–469
Morlini, Gerolamo, 138
morra*, 117, 621, **741–742
Morreale, Ben xxv, 179
morto di fame* (pl. *morti di fame*), 587, 638, 640, 676, **742
Moser, Joann, 510
Mottola, Greg, 642
Mozart, Wolfgang Amadeus, xix
 Don Giovanni, 391
Murolo, Roberto, 452
Murray, William, 243
Musante, Tony, 362
music, 156
musical culture, Italian American, 387–490
 and American classical music, 409–417
 and American popular music, 417–446
 and jazz, 446–456
 canon of jazz musicians, 486–490
 and opera, 388–406
 See also dance
Musoleno, Rosemary, 402
Mussolini, Benito, 313, 407
Muzio, Claudio, 397
My Cousin Vinny (D: Jonathan Lynn), 72, 594, 614, 629

N

Naish, J. Carrol, 596, 599
Naldi, Ronald, 402
names and surnames, Italian American: 222–223, 370, 594
 "game of the name," Madonna's, 491–498

and passing, 598
Napoli, Joseph, 41
Narrizano, Dino, 362
Negri, Pola, 598, 599
Nelli, Herva, 401
Nelli, Humbert S., xxxiv
Newfield, Jack, 70
Nicholson, Jack, 598, 620
Nigro, Bob, 362
Nivola, Constantino, 537, 538, 540
Nolte, Nick, 597
*nonno (fem. nonna), 620, 633, **742–743**
Novecento (art movement), 505
*novellatore (fem. novellatrice), 132, **743**
nuraghi, 540
Nussbaum, Martha, 225

O

Oddo, Jasper, 374
Odrich, Ron (Rinaldo Basilio Orefice), xxxviii, 456
Olivero, Magda, 397
Olsen, Charles, 270
Olsen, Tillie, 225, 228
*omertà, xxxix–xl, 11, 189, 292, 293, 308, 309, 311, 314, 344, 588, 589, 605, 660, **743**
O'Neill, Eugene, 335
Only You (D: Norman Jewison), 681
*onore, 6, 13, 571, **743–744**
On the Waterfront (D: Elia Kazan), 681
opera, Italian, 266, 388–406, 568, 587
 in America, 389–397
 as a cultural text, , 404–406
 singers of, Italian American, 399–402
*ordine della famiglia, 4, 63, 571, 583, 624, **744**
Orsi, Robert, xii, 13, 154, 334, 341, 447
 Madonna of 115th Street, xxxv
Oscar (D: John Landis), 632
outsiderness, 256–257
Ovid (Publius Ovidius Naso), 134
Ozick, Cynthia, 225, 257

P

Paci, F. G., 343, 344
Pacifici, Sergio, 231
Pacino, Al, 25, 362, 479, 564, 571, 586, 594, 595, 600, 642, 645
 Looking for Richard, 642
Padovani, Lea, 599

*padrino, 176, **744**. See also compare
*padrone (pl. padroni), 426, **744**
*paesano (regional spelling paisan or paisano), 13, 95, 101,111, 160, 426, 617, 678, **744**. See also campanilismo; paese
*paese, 13, 16, 109, 118, 126, **744**. See also campanilismo; paesano
Pagano, Jo:
 Golden Wedding, 88, 111, 342
Paglia, Camille, xxxvii, xliv, 16, 198, 204, 228, 242, 249, 257, 308, 342, 478, 482, 493, 495
 Sex, Art, and American Culture, 350
 Sexual Personae, xxxvii, 42, 45, 58, 350, 503
Pagliughi, Lina, 399
*palazzo, 121, 125–127, **714–715**. See also casa
 palazzo communale, 126
 palazzo ducale, 126
Palladio, Andrea, 499, 545, 546
Palma, Michael, 327
Palminteri, Chazz, 377, 591, 594, 601, 604, 646
 A Bronx Tale (play)
Pandolfi, Frank, 402
pane, amore, e fantasia, 633
Panetta, George, 342
Panto, Peter, 681
pantomime, 356
Panunzio, Constantine, 292
Paolini, Giulio, 506
Paolucci, Anne, 233
Papaleo, Joseph, 179
Papaleo-Vitrone, Lenore, 537
Papa Manteo's Life-Sized Marionettes, 378
pappa, 11
*parente, **745**
Parini, Jay, 187–188, 282
 Patch Boys, 187–188
Paris, Bernard, 248
Parker, Frank, 431
parole abbandonate, xlii
parole femmine, 201
Pasatieri, Thomas, 416
Pasolini, Pier-Paolo, 586
*passatella, 640, **745**
*passeggiata, 8, 480, 496, 603, **745–746**
passing, 222, 223, 567, 609
passione, 447
*pasta, 482, **746–748**. See also polenta/pasta; polentone/terrone

· 783 ·

Pasta, Giuditta, 391
pasticceria, 618
Patti, Adelina, 392
Pavan, Marisa, 596
Pavarotti, Luciano, 388, 401, 403–404
pazienza*, 380, 381, **748
Penn, Chris, 666
Peragallo, Olga, 165, 202
Perniola, Mario, 500
Persichetti, Vincent, 410, 414, 416
Persico, Luigi, 537
Pesci, Joe, 564, 594, 612, 629, 648, 652, 674
Pestalozza, Alberto, 457
Peters, Bernadette (Bernadette Lazzara), 362, 437
Petrarch, 587
Petrosino, Joseph, 599
pezzonovante, 350, 749
Phillips, Flip (Joseph Edward Phillips), 450
piacevolezze, 138
piano nobile, 126
piazza*, 8, 202, 220, 389, 496, 542, 544, 603, **748
 "piazza envy," 542
Piazza, Marguerite, 401–402
Piccinini, Janice A., 65
Piccirilli, Attilio, 537, 538
Picone, Vito, 438
Pietà, 12, 169
pietas, 513, 546
Pileggi, Nicholas, 618, 652
 Casino: Love and Honor in Las Vegas, 651–652
 Wiseguy, 635
Pintauro, Joe, 374–376
 plays by:
 Cacciatore I, II, III, 374, 375
 Men's Lives, 375
 On the Wing, 375
 The Raft of the Medusa, 375–376
 The Snow Orchid, 375
 Wild Blue, 375
Pinza, Ezio, 397
Pirandello, Luigi, 298, 314, 353, 380, 381
Piston (Pistone), Walter, 409, 410, 411–412
Pistone, Joseph, 645
Pistoletti, Michelangelo, 506
Pitré, Giuseppe, 140
Pizan, Christine de, 137
pizza, 483–484
Pizzarelli, Bucky (John Pizzarelli), 455
Pizzarelli, John Jr., 455–456

poetry, Italian American, 266–282
 of generation born before 1945, 268–280
 of generation born 1945 and after, 281–282
Pola, Antonia:
 Who Can Buy the Stars?, 110, 194, 214, 238, 251, 255
polenta/pasta*, 109, **748–749
polentone/terrone* (pl. *polentoni/terroni*), 109, 616, **749. See also Mezzogiorno, polenta/pasta
Poleri, David, 401
Polo, Marco, 136
Ponselle, Rosa (Rosa Ponzillo), 399, 483
Pope, John Russell, 541
Poor Little Rich Girl (Irving Cummings), 619–620
Poretta, Frank, 402
poste* (pl. of *posta*), 100, **749
posteggiatori, 419, 456
Pound, Ezra, 614
Pozzi, Lucio, 501, 508, 530, 532–533
Pratt, Annis, 325
Prezzolini, Giuseppe, 202
Prima, Louis, 347, 418, 429, 678
Prizzi's Honor (D: John Huston), 51, 614, 620, 632, 639
prominente*, **749
Prospero's Books (D: Peter Greenaway), xix, xxi
proverbio* (pl. *proverbi*), 293, **749–750
proverbs cited, 65, 94, 110, 111, 183–184, 208, 290, 293
Puccini, Giacomo, 388, 389, 396, 397, 408, 409
 La bohème, 394–395
 La fanciulla del West, 397
 Madame Butterfly, 397, 400
Pugliese, Frank, 7, 377–378
Pugliese, Stanislao, xxxviii
Pulcinella*, 360, 615, **750
puppet theater, 378. See also Papa Manteo's Life-Sized Marionettes
Purdom, Edmund, 595
Puzo, Mario, 18, 122, 123, 176–179, 181, 210, 235, 244, 341, 344, 349, 568, 570, 586, 681
 works of:
 The Dark Arena, 123, 177, 178
 Fools Die, 123, 179
 The Fortunate Pilgrim, 53, 122–123, 160, 178, 251, 325, 343, 345, 589

· 784 ·

The Fourth K, 179, 651
The Godfather, xxxiv, 73, 156, 160, 178–179, 213, 235, 239, 568, 589
Last Don, 645, 650, 651
The Sicilian, 610
*puttana, 427, **750–751**. See also Madonna/puttana

Q

Quartararo, 401
Quindlen, Anna, 218, 223, 247, 252–253

R

racconto (pl. racconti; Sicilian variant, cunto), 133
Raft, George, 595–596
Randazzo, Terry, 440
Ravazza, Carl, 429
Reilly, John M., 305
Renzi, Mike, 456
Respighi, Ottorino, 412
Restivo, Johnny, 440
Reynolds, Burt, 598
Rhodes, Eric, 595
Ricci, Nino, 343, 344
Ricciardi, Giglielmo, 358
Rieti, Vittorio, 410, 412–413
Riggio, Pasquale, 402
Riis, Jacob, xxxiii, xl
Rimanelli, Giose, 180–182
 Benedetta in Guysterland, 181–182
 The Day of the Lion, 180
 Una posizione sociale, 180
*Risorgimento, xxiv, 153–154, 313, **751**
risotto, 677
*rispetto, 6, 576, **751–752**
Robinson, Edward G., 586, 595, 599, 611, 660
Rocco and his Brothers (D: Luchino Visconti), 617
Rocky (John Avildsen), 72, 591–593, 614, 628, 629–630
Rodia, Sam or Sabato (Simon Rodilla), 537–538, 539–540
Rolandi, Gianna, 402
Rolle, Andrew, xxxiv, 194, 204
Rollini, Adrian, 449
Romaine (Romagnano), Elaine, 220
Roman Holiday (D: William Wyler), xvi
Romano, Rose, 67, 158, 162, 251
 Vendetta, 160
Ronzani, Domenico, 467–468

Roselli, Jimmy, 430
Rosen, Randy, 536
The Rose Tattoo (D: Daniel Mann), 591, 594, 596, 611, 614, 624–626, 633
Rosi, Francesco, 610
Ross, E.A., 3
Rossellini, Isabella, 601, 666, 678
Rossi, Agnes, 196, 252, 254
Rossi, Aldo, 543
Rossini, Gioacchino, 390, 391, 397, 398
 Il barbiere di Siviglia, 390
 La Cenerentola, 392
 La gazza ladra, 393
 Otello, 391
 Tancredi, 391
Rota, Nino, 410–411, 462, 580
Rowe, Colin, 542
Rubenstein, Charlotte, 536
Ruffini, Gene, 374
Ruffo, Titta, 397
Russo, James, 665
Russo, René, 601
Rydell, Bobby (Robert Ridarelli), 418, 437, 440
Ryder, Mitch (William Levise), 418, 441

S

Sacchetto, Rita, 470
Sacco, Nicola, and Bartolomeo Vanzetti, xxxiii, 162–163, 202, 597, 669, 681
Salerno, Henry, 373–374
Salerno, Linda, 537
saltarello, 465
Salvatore Giuliano (D: Francesco Rosi), 610
Salvemini, Gaetano, 301
Sangalli, Rita, 468
San Gennaro street festival, 638
San Giacomo, Laura, 601
Sangiuliano, Iris, 225
Sant'Elia, Antonio, 541
Santori, Edea, 470
Saracco, Lodovico, 470
Sarandon, Susan (Susan Abigail Tomalin), 362, 594, 598, 601, 641
Sargent, John Singer, 499
Sartarelli, Stephen, xxxviii
Sassano, Roseanne, 537
Saturday Night Fever (D: John Badham), 72, 213, 365, 614, 620–621, 627, 628, 629, 639, 670

Savarese, Julia, 179, 196, 214
 The Weak and the Strong, 214, 251
Savella, Marcia, 362
Savelli, Angelo, 515, 518–519
Savoca, Nancy, 362, 608, 670–673, 674, 681
 films directed by:
 Dog Fight, 670
 Household Saints, 642, 643, 670–673
 True Love, 611, 670
Savonarola, 59
Saxon, John (Carmen Orrico), 598
Scacchi, Greta, 601
Scalapino, Leslie, 196, 251, 252, 282
Scanga, Italo, 540–541
Scaravaglione, Concetta, 536, 537
Scardillo, Don, 362
Scarface (D: Howard Hawks), 568, 585, 596, 614
Scarpone, Judy, 362
Scelsi, Giacinto, 417
scena madre, 576, 580, 582, 641, **752**
scena padre, 577, 582
Schinto, Jeanne, 198, 218, 252, 254
Schlesinger, Arthur, 573
Schoener, Allon, xxxv
Sciorra, Annabella, 564, 601, 666, 669
scomunicato (fem. *scomunicata*), 578, 583, **752**
Scorsese, Martin, xxvi, xxxiv, 18, 24, 314, 348–349, 362, 444, 507, 566, 525, 544, 586, 590, 596, 605, 606, 607, 608, 613, 634–641, 642, 643, 644, 646, 647, 650–656, 658, 659, 660, 661, 662, 666, 679, 680, 681, 682
 documentaries:
 Italianamerican, 635
 A Personal Journey with Martin Scorsese through American Movies, 646, 650
 feature films directed by:
 After Hours, 349
 The Age of Innocence, 404, 479, 650, 651
 Cape Fear, 349, 644, 651
 Casino, 644, 646, 651–656, 683
 GoodFellas, 349, 564, 594, 612, 628, 632, 635, 639, 640–641, 644, 646, 647–649, 651, 652, 656, 683
 King of Comedy, 349
 Kundun, 651
 The Last Temptation of Christ, 349
 Mean Streets, xxxiv, 72, 349, 622, 628, 636–637, 638, 639, 640, 665

Raging Bull, xxviii, 21, 314, 349, 564, 590, 594, 607, 608, 628, 635, 638–639, 640, 641, 654, 658
 Taxi Driver, 607, 638
 Who's That Knocking at My Door?, 607, 627, 628, 635, 636, 638, 641
 Italianness according to, 634–636
 manliness according to, 636–641
 "mean streets" cinema of, as sub- or counter-genre and urban artform, 635, 637–639, 650, 679–80
 role of soundtrack in films by, 638
Scott, Campbell, 676
Scott Brown, Denise, 543, 544
Scotti, Antonio, 397
Scotti, Nick, 674
scugnizzo (pl. *scugnizzi*), 396, **752**
Segale, Sister Blandina, 203–204, 205, 221
 At the End of the Santa Fe Trail, 203
serietà, 63, 66, 212, 217, **752**
Serpico (D: Sidney Lumet), 590
Serra, Ray, 362
Servadio, Gaia, 581
servo padrone, 126, 127
Severini, Gino, 506, 512
sfaccimma (variants sfaccimm, sfacccim'), xxix–xxx, xlii
sfinci, 144
Shakespeare, William 134, 615
 The Tempest, xv, xix
Shalhoub, Tony, 676
Shanley, John Patrick, 633
Shaw, Arnold, 426, 433
Shire, Talia (Talia Rose Coppola), 362, 576, 603
Sigismondi, Aristide, 429
Signor Papanti, 466
Signor Titoli, 466
signori (pl. of *signore*), 99, 587, **752–753**
Silipigni, Alfredo, 402
Simmons, Walter, xxxviii, 415
simpatico, 429, 437, 456, 600, **753**
simpatico/antipatico, 600, 633, **753**
Sinatra, Frank, 347, 362, 417, 418, 420, 422–428, 430, 433, 440, 442, 456, 479, 577, 593, 596–597, 600, 629, 651, 681
 as signifier of Italianness, 425–428
Sinise, Gary, 564, 594, 601
Sirey, Aileen Riotto, 62, 208, 212, 249, 255
Sirica, John, xliii
sistemazione, 599, 603, 627, 628, 639, 675,

753–754

Smeal, Eleanor Cutri, 208, 621
Smith, Mary-Ann Tirone, 254–255
Snipes, Wesley, 669
soddisfazione, 576
Sodi, Pietro, 466
Soleri, Paolo, 507, 542, 546–549, 589
 Arcology defined, 546–548
Sollers, Philippe, 587
Somebody up There Likes Me (D: Robert Wise), 590
Somigli, Franca, 400
songs, Italian and Italian American, 456–462
Sorrentino, Gilbert, 162, 188, 235, 275, 335
 Aberration of Starlight, 159
Soviero, Diana, 402
Sorvino, Mira, 594, 601, 641
Sorvino, Paul, 362, 648
Spacagna, Mark, 402
spaghettata, 482
spectacle, Italian and Italian culture of, 604
spettacolo,* 389, 492, **754
Spicer, Dorothy Gladys, 89
Spignesi, Angelyn, 207, 249–250, 253, 257
Spike of Bensonhurst (D: Paul Morrissey), 632
Spinetti, Arthur, 402
sprezzatura,* 292–293, 425, 455, 622, **754
Springsteen, Bruce, 340, 347–348, 418, 441, 443–445
Stabile, Salvatore, 642, 646, 680
 Gravesend, 642, 646, 680
Stallone, Vicky, 608, 670
Stallone, Sylvester, 155, 362, 564, 593, 601, 608, 613, 619, 622, 628, 629, 631–632
 Rocky, 590, 591–592, 593
Stefanile, Felix, 272–273
Stella, Frank, 346, 501, 505, 507, 528–530, 589
 influence of Caravaggio on, 501, 507, 529
Stella, Joseph, 346, 479, 501, 502, 503, 504, 506, 508–514, 515, 516, 518, 519, 524, 529, 530, 531, 553–554, 589
 as hybrid artist, 510, 514
 as outsider, 509
 paintings by:
 American Landscape, 511
 Amazon, 514
 Battle of Lights, Coney Island, Mardi Gras, 512, 554, 559 illustrated
 The Birth of Venus, 346

The Bridge (Brooklyn Bridge), 511, 554, 561 illustrated
Brooklyn Bridge, 511
The Brooklyn Bridge: Variations on an Old Theme, 511
Coney Island, Battle of Lights, 346
Head of Christ, 346
The Holy Manger, 346
Immigrant Madonna, 346
The Madonna of Coney Island, 553, 558 illustrated
New York Interpreted (The Voice of the City), 346, 511, 512
Saint John, 346
Telegraph Pole, 346
Torso, 346
Tree of My Life, 510
The Virgin, 346, 553, 557 illustrated
 relationship to Italian futurism, 509, 511, 512
Stentorello, 360
stereotypes, pertinent/impertinent, xvi, xvii–xviii, 614–623, 668–679
stereotyping of Italian Americans, 61–62, 69–74, 235, 240, 241, 618–623
 by American common culture, xvii, 618–620
 by Hollywood, 564–568, 599, 623–634
 by literary market, 235
 and the *Godfather* trilogy, 568–585
 in terms of:
 cafone image, 69, 668–669
 body image, 478–484, 604, 621, 631–632
 family, 614, 619–623, 623–634
 linguistic identity, 592, 604–605, 630
 Mafia stigma, 69–74, 569, 619
 vis-à-vis the Italians, 604, 617–618
stereotyping of Italy and Italians, xvi, xvii, 614–616
 Italian self-stereotyping in terms of north/south divide, 616–617
 Italian stereotyping of America, 296
 See also Barzini, Luigi
Stokowski, Leopold, 409
Stone, Sharon, 653
storia,* xxv, xxvi, xxxiv, xxxvii, 570, 574, 575, 585, **754
stories and storytelling, 17, 131–148
 Italian American tradition of, 142–146
 See also cantastorie; novellatore
straniero,* **754. *See also amico/straniero*

Straparola di Caravaggio, Giovan Francesco, 138
Streep, Meryl, 684
strega, 87, 624
Strocchetti, Fiordilice, 470
Stuarti, Enzo, 435
Summertime (D: David Lean), xvii, 681
superstitions and folklore, Italian American, 86–103. *See also malocchio*

T

tableau vivant, 356
Tagliabue, John, 273
Taglioni, Marie, 463, 467, 472
Taglioni, Paul (Paolo), 466–467
Talarico, Ross, 250
Talese, Gay, xliii, xliii, 17, 218, 236, 311–313, 378, 425–426, 427
 Honor Thy Father, 181, 235, 311
 Unto the Sons, 112, 291, 311–313, 605
 "Where Are the Italian-American Novelists?", 165, 194, 216, 218, 226, 242, 254, 341, 355, 605
Talia, Shire, 576
Tamagno, Francesco, 394
Tamburri, Anthony, xxxiii, xxxvi
Tangentopoli, 570
tarantella,* 463–465, 484, 576, 578, 582, **754
Tarantino, Quentin, 567, 593, 608, 641, 642, 643, 650, 656–663, 666, 680, 682
 films directed by:
 Jackie Brown, 642
 Pulp Fiction, 593, 594, 632, 642, 643, 645, 656, 657, 658, 660, 662–663
 Reservoir Dogs, 642, 645, 656, 657, 658, 659, 662
 screenplays:
 Natural Born Killers, 657
 True Romance, 583–584, 657, 662
Taylor, Lili, 671
Taylor, Renee, 368
teatro dei pupi,* 581, **754–755
 use of in *The Godfather* trilogy, 581
Tebaldi, Renata, 397
Tedesco, Jo Ann, xxxviii, 371
Teilhard de Chardin, Pierre, 548
Temple, Shirley, 619
Teresa of Avila, Saint, 59
terrone,* **755. *See also polentone/terrone*
Tetrazzini, Luisa, 397
theater and theatrical culture, Italian American, 353–386
 antecedents of in Roman and Italian theater, 355–357
 history of:
 immigrant phase (1870–1920), 357–360
 1950s and 1960s, 363–367
 1970s, 367–374
 1980s and 1990s, 374–378
 See also Forum of Italian American Playwrights
They Drive by Night (D: Raoul Walsh), 596
They Knew What They Wanted (D: Sidney Howard), 598
 cinematic adaptations of, 599
Things Change (D: David Mamet), 632
The Third Man (D: Carol Reed), 614, 615
Timpanelli, Gioia, xxxvii
timpano, 678
tiramisù, 618
Tomasi, Mari, 66, 179, 202, 342
 Like Lesser Gods, 66–67, 237, 243, 324, 326, 343
Tomei, Concetta, 362
Tomei, Marisa, 362, 564, 594, 601, 629
Top Hat (Mark Sandrich), 595
Torgovnick, Marianna De Marco, 210, 223, 241, 247, 256, 257
Tornabuoni, Lietta, 483
Torri, Isolina, 470
Torriani, Gina, 470
Toscanini, Arturo, xix, 157, 397, 399, 400, 401, 406–409, 409, 457, 470, 598
Tosches, Nick, 432, 433, 600
Totò (Antonio de Curtis), 430
Tozzi, Giorgio, 402
Transavanguardia, 501, 505, 506
Travolta, John, 362, 481, 483, 594, 601, 613, 620, 621, 630, 631–632, 657, 658, 660
Tresca, Carlo, 175, 268, 298
Tristano, Lennie, 450–451
Tropiano, Joseph, 676
Tucci, Stanley, 676–679, 681
 Big Night, 676–679
Turco, Lewis, 276
Turner, Victor, 85
Turturro, John, 362, 564, 601, 608, 642, 669, 674
 Mac, 540, 643, 669–670, 681
Turturro, Nicholas, 646
Tusiani, Joseph, 162, 273

29th Street (D: George Gallo), 626, 632
Twombly, Cy, 499, 501
Two Women (D: Vittorio De Sica), 594

U

Ullman, Tracey, 671
uomo d'onore, 571, **755**
uomo di pazienza, xxxiv, 9, 619, 641, **755–756**
uomo di rispetto (or *uomo rispettato*), 426, 571, **756**. See also rispetto
urban imaginary, Italian American, 554

V

Vacarro, John, 362
The Valachi Papers (Peter Maas), 178
Vale, Jerry, 430
Valentino, Rudoph (Rodolfo Alfonzo Raffaele Pierre Philibert Guglielmi), 362, 420, 421, 478, 483, 568, 575, 595, 600, 631
Valerio, Anthony, 160
Valesio, Paolo, 162
Valli, Frankie (Francis Casteluccio), 347, 418, 438, 439, 441
Vance, William, xvi, 242, 499
Vangelisti, Paul, 282
Van Gennep, Arnold, 85, 103
Vannucci, Lynn, 67
Vanzetti, Bartolomeo. *See* Sacco, Nicola
Veccia, Luigi, 398
veglia, 133
Ventura, Charlie, 450
Venturi, Robert, 157, 346, 507, 531, 541, 542, 542–546, 589, 621
 Complexity and Contradiction in Architecture, 501, 541, 543–545, 546
 Learning from Las Vegas, 543, 545, 652
Venuti, Joe, 448, 449
Verdi, Giuseppe, 157, 388, 389, 394, 408, 409
 Aida, 393
 Nabucco, 408
 Rigoletto, 393, 395
 La traviata, 393, 394–395, 400
 Il trovatore, 393
vergogna, 6, 7, **756**
verismo, 214, 396, 397, 411, 413, **756–757**
Vespucci, Amerigo, 152–153, 154, 155, 162
Vestris, Charles, 466
Vestris, Ronzi, 466
Vetere, Richard, 377

Veto, Janine, 216
via nuova, 571, 578, 674, **757–758**
via vecchia, 405, 478, 571, 575, 578, 636, 640, 666, 674, **757–758**
vibrato, 395
Vico, Giambattista, 140–141
A View from the Bridge (D: Sidney Lumet), 611, 627
villa, 123–125
Villa, Claudio, 678
villa padronale, 123, 125
Villella, Edward, 464, 471, 472, 478
Violi, Paul, 281
Virgil, 586
Visconti, Luchino, 388, 566, 586, 617, 650
Viscusi, Robert, xxxvi, 165, 314, 411, 465
visual culture, Italian and Italian American, 499–552
 Italian art:
 classical tradition, 499–500
 presence of in American art, 499–503
 twentieth-century developments, 503–507. *See also Arte Povera;* Corrente, Michael; Futurism; *Informalismo; Novecento; Transavanguardia*
 Italian American art:
 definition and location of, 500–503, 507–508, 514
 immigrant production of, 506–507
 formal registers of:
 architecture, 541–549
 painting, 507–537
 sculpture, 537–541
Vitale, Tony, 674–675, 681
 Kiss Me, Guido, 674–675
vita mondana, 411
Vittadini, Adrienne, 481
Vittoria, Joseph, 621

W

Wagner, Maryfrances Cusumano, 217
Wagner, Richard, 393, 394, 407
Wait until Spring, Bandini (D: Dominique Durrerede), 174, 681
Waldo, Octavia (Capuzzi Locke):
 A Cup of the Sun, 62, 324–325
Walken, Christopher, 584, 662, 666
Walker, Alice, 193
Wall, Donald, 547
Wallach, Eli, 596–597
Wanamaker, Sam, 599

wanda, 97–98
The Wanderers (D: Philip Kaufman), 628
Warren, Fran, 418, 434
Warren, Harry (Salvatore Guaragna), 460–461
Watson, Patrick, 522
Weiss, Carol Lazzaro, 323
Welles, Orson, xxi, 606, 614
 Citizen Kane, 606, 651
Wertmüller, Lina, 617, 674
West, Benjamin, 499
Wharton, Edith, 336, 337, 404, 650
Wheeler, Daniel, 502
White, Stanford, 541
White, Theodore, xxxi
Whitman, Walt, 511
Williams, Tennessee, 376, 380, 381, 611, 624
Wilson, James Q., 69
Winsey, Valentine Rossilli, 62–63, 214, 215
Winters, Shelley, 363
Winterset (D: Alfred Santell), 597
Winwar (Vinciguerra), Frances, 202, 205, 222
women and women's experience, 6, 7, 61–68, 211
 and feminism, 228
 history of:
 first-generation immigrant, 62–65, 205–206, 207–208, 214–216
 formation in Italy, 63–64
 second- and third-generation, 64–65, 211–212
 transition from Italian into Italian American women, 67, 180
 and identity, 61–68
 as family-defined, 209–211:
 grandmotherhood, 62–63, 68, 196–198
 motherhood, 64, 211, 216
 daughterhood, 64, 65–66
 wifehood, 211, 232
 and self-realization, 209, 225–226
 and sexuality, 211
 stereotyping of, 61–62
 womanliness, traditional ideal of. See *donna seria*
women, cultural production of Italian American

 cinema, 608, 642, 670–674
 literature, 193–265
 music and dance, 399–400, 401–402, 434, 437, 439–440, 445–446, 468–472, 491–498
 painting and sculpture, 536–537
 storytelling, 131–150
 theater, 206–207, 365, 370–372
women writers, Italian American, 193–265
 achievements of, 66–67, 247–258
 silence (and silencing) of, 193–196
 historical and social context of, 199–218
 emergence from, 247–258
 internal blocks, 218–235
 external blocks, 235–247
women's writing, Italian American, 66–67
 topoi of:
 godparent figures, 326
 experience of Italy, 188
 family, loyalty to and conflicted relationship with, 251
 grandmother and grandparents, 179, 196–199, 309, 322
 immigrant experience, 203–204
 mother-daughter bond, 179, 206–207, 213, 233
 motherhood and family life, 216–218, 233–234
 Outsiderness/Otherness, 218, 256–257
 rebellion against patriarchy, 308
 individuation and self-discovery, 179–180, 302–311, 324–325
 self-nullification, 213
Woo, John, 659
wop* (*guinea, dago,* and other derogations), **758–759
Wright, Frank Lloyd, 542, 546, 547

Y

Yeats, W. B., 29, 35, 39, 314, 315

Z

Zappa, Frank, 441–443
zarzuella, 359–360
Zevi, Bruno, 542